History of World Costume and Fashion

Daniel Delis Hill

Prentice Hall

Boston Columbus Indianapolis New York San Francisco Upper Saddle River
Amsterdam Cape Town Dubai London Madrid Milan Munich Paris Montreal
Toronto Delhi Mexico City Sao Paulo Sydney Hong Kong Seoul Singapore Taipei Tokyo

Library of Congress Cataloging-in-Publication Data
Hill, Daniel Delis.
 History of world costume and fashion / Daniel Delis Hill.
 p. cm.
 Includes bibliographical references and index.
 ISBN 978-0-13-099223-9 (alk. paper)
 1. Clothing and dress—History. 2. Fashion—History. I. Title.
GT511.H55 2011
391.009—dc22

2010025048

Editorial Director: Vernon R. Anthony
Acquisitions Editor: Sara Eilert
Editorial Assistant: Doug Greive
Director of Marketing: David Gesell
Senior Marketing Manager: Harper Coles
Marketing Assistant: Les Roberts
Senior Managing Editor: JoEllen Gohr
Associate Managing Editor:
 Alexandrina Benedicto Wolf
AV Project Manager: Janet Portisch
Senior Operations Supervisor: Pat Tonneman
Operations Specialist: Deidra Skahill
Art Director: Diane Ernsberger
Cover Designer: Kristina Holmes
Cover images: (a) Nobleman's wife – The Woman
 of Tovi. 18th dynasty (1570–1314 BCE). Location:
 Louvre, Paris, France. Scala/Art Resource, NY;

(b) Narinder Nanu; Getty Images, Inc. – Agence France
Presse; **(c)** Utagawa Kunisada (1785–1864). The
courtesan Tachibana of Tsuru-ya. From the Dedicated
Lanterns series. Oban-size nishiki-e. 37.8 × 25.8 cm.
Victoria and Albert Museum, London/Art Resource, NY;
(d) Bronzino, Agnolo (1503–1572). Eleanora of Toledo
With Her Son Giovanni de Medici, ca. 1545. Oil on
panel, 115 × 96 cm. Uffizi, Florence, Italy. Scala/Art
Resource, NY; **(e)** © ART WOLFE/DanitaDelimont
.com; **(f)** National Portrait Gallery, London;
(g) Image courtesy Knoll, Inc.
Full-Service Project Management: S4Carlisle
 Publishing Services, Carla D. Kipper
Composition: S4Carlisle Publishing Services
Printer/Binder: Edwards Brothers
Cover Printer: Lehigh-Phoenix Color/Hagerstown
Text Font: Times LT Std

Credits and acknowledgments borrowed from other sources and reproduced, with permission, in this textbook appear on appropriate page within text or on page 797.

10 9 8 7 6 5 4 3 2 1

Prentice Hall
is an imprint of

www.pearsonhighered.com

ISBN 10: 0-13-099223-2
ISBN 13: 978-0-13-099223-9

CONTENTS

FOREWORD

JOANNE B. EICHER

Daniel Delis Hill's goal to write a world history of costume has been accomplished in this book. Most contemporary histories of costume published in English (whether for students or general readers) develop a history of Western dress, although titles rarely reveal this focus. As a result, what people wear in the rest of the world beyond Europe and America has been largely ignored or at best, lightly glossed over. The outstanding exception was the work in 1888, *Le Costume Historique* by Albert Racinet, that originally appeared in French, but was translated into English for a 1988 edition. A contemporary historian of dress from the Courtauld Institute, University of London, Aileen Ribeiro says in the 1988 edition that Racinet's original six volumes were not only a vast work, but "without the narrow specilization which marks the age of the 'expert' in our own century." She further extends her compliment, "Racinet's work embraces both the history and the geography of dress, not just in Europe but in the whole world opened up by exploration, trade and empire."

Hill's work similarly acknowledges that from prehistory to present, people throughout the world wear clothing, accessories, and groom themselves, acts that communicate to others who they are and add significance to these everyday acts. The chapters in his book illustrate that all people have a history of dress whether recorded in written or visual form or passed along orally through generations. His history of dress acknowledges a rich area of material culture and an important dimension of life for human beings in our world today and throughout history.

When approached initially to review his initial manuscript, I accepted because his ambitious project aroused my curiosity, wondering whether or not he could fairly present, describe, and analyze the dress of people beyond the Western world. My own interest and scholarship in general are based on a strong commitment to understanding the cultural aspects of dress and their significance throughout history and across the globe, not just as a phenomenon of the contemporary, Western world. No longer can histories of costume be written that begin with Egypt, Mesopotamia, Greece and Rome and then jump directly into the history of Europe and North America, disregarding the rest of human history and the important civilizations of China, India, Japan, the Middle East and the continent of Africa beyond Egypt. Hill's interest in looking across the world and throughout history captured my attention, because such an approach is both timely and needed. I found his timelines used as an introduction to each chapter particularly useful in allowing a reader to make comparisons about types of dress between and among different civilizations with an appreciation for the longer history of other civilizations and their contributions to the history of dress. I agreed to serve as an editorial consultant. My role involved making general comments about the content and structure of the book and serving as a networking resource to connect him with scholars who could provide expertise in regard to specific times and places.

Daniel Delis Hill has accomplished the goal of writing a world history of costume with hard work and diligence, aided by the input of experts who provided feedback that occasionally, if not often, included strong opinions and differing points of view. Listening to other peoples' points of view is not always fun or easy. He rose to the challenge of such critiques by increasing his bibliographic search and library research in response to them as he completed his final manuscript and worked to refine his definitions to make them accurate and socio-culturally appropriate. He has supplemented images available through the usual resources with useful line drawings of his own as an enhancement.

I recommend this book to readers interested in the history of dress throughout the world. Admittedly, a large portion of the book centers on Western fashion history, but he provides readers the opportunity to appreciate how dress from other trajectories relates to Western fashion. To do so, he supplies examples of how details or items of dress from another time and place can be found in fashions in the world of the 21st century. Many readers will find this approach eye-opening as they begin to appreciate that many ideas surface in slightly different ways at different times and in different places, but actually originated in another culture, often at much earlier times.

PREFACE

One of the key purposes of this survey of historical dress is to answer the need for a global view of the subject. Most texts on this topic have been written from a Eurocentric perspective with minimal information on the dress traditions of Asia, Africa, the Islamic world, and the pre-colonial Americas. We include chapters on the cultures and costumes of those diverse regions in our study.

Even by expanding the breadth of this subject to include a global view, though, the approach of this survey is to provide a comprehensive overview of costume rather than an indepth study. Within the limited space of a single volume we provide both descriptive and analytical detail that the reader can use as a point of departure for more specialized research.

Each chapter has been formatted with introductory historical and geographical references. Maps show the geopolitical boundaries of the cultures, empires, or nations of each respective subtopic. Chronological graphs at the start of each chapter feature highlights of historical events and cultural achievements relevant to the era. For those readers who have limited knowledge of world history, or wish a brief refresher of the topic, the text of each chapter opens with a short overview of the significant historical developments.

The core text of each chapter is organized into sections for the dress of men, women, and children. The full range of dress is presented including principal forms of apparel, undergarments, outerwear, shoes, hats, jewelry, and other accessories, and body modification or beauty regimens where relevant. Key terms of clothing or accessory styles are in bold type. Types of silhouette, construction, fabrication, and decorative treatment are detailed. To reinforce the accuracy of the descriptions, many contemporary sources who wrote about dress and culture of their eras are cited, such as Herodotus and Homer in Greece, Ovid and Tertullian in Rome, Einhard at the court of Charlemagne, the chroniclers of the Conquistadores in the New World, and the seventeenth-century diarist Samuel Pepys of London, to name but a few.

Even though the focus of the text is largely descriptive, significant analysis of dress is provided throughout each chapter. The many functions of dress in society are noted and may include analysis of costume for gender or age differentiation, of community membership, of ceremonial purposes, of social status, or of period aesthetics. Of particular importance is the analysis of cross-cultural influences, which is more feasible with the world view of costume presented here than with narrowly focused Eurocentric studies.

The text is thoroughly illustrated with original source materials contemporary with the period of each chapter. Line drawings supplement the primary illustrations with additional details of silhouette, construction, or accessories that may not be fully evident in the photos of sculptures and paintings. Line drawings are also included that show step-by-step methods of dressing such as draping the Roman toga or the East Indian sari.

One particular differentiation of this study from most other histories of dress is a section at the end of each chapter to the twentieth century in which legacies and influences on Western styles of the post-1900 period are described and illustrated. These may be direct stylistic influences such as the Arabian kaftan or modern adaptations of garments first developed in earlier periods like the Minoan flounced skirt or revivals of design elements such as eighteenth-century panniers.

Each chapter concludes with a review that recaps the key types and characteristics of dress of each era. In addition, chapter questions aid readers in reviewing the broad themes and important facts about dress. Recommended research and portfolio projects provide students with ideas for developing a more thorough understanding of dress across the ages. A glossary at the end of each chapter collects the terms of costume with brief definitions for easy reference.

A selected bibliography is compiled at the end of the book with the focus on material written about historic dress. Resources are arranged by chapter topic. Some historical monographs are included that may feature relevant content on dress or culture.

Lastly, the index is arranged to be more than simply another version of a glossary. Instead we include broad categories such as historical themes (Romanesque, Baroque, Victorian), dress analysis (status, ceremony, gender), and cross-cultural influences (Greek/Etruscan, Mayan/Aztec, Ottoman/Indian).

SPECIAL ACKNOWLEDGMENTS

The majority of broad surveys on historic costume have focused primarily on Western dress—that is, the development of Euro-Americal dress. In the twenty-first century, though, the cross-cultural exchanges of fashion and style ideas around the world can occur instantaneously due to the worldwide expansion of advanced technologies of telecommunications and the Internet. In addition, academic coursework has increasingly sought a perspective of cultural studies with a world view. We wish to thank Vernon R. Anthony, Editorial Director at Prentice Hall, for recognizing this need for a study of historic dress with a global view and for his continuing support for the project throughout its development.

The production of academic textbooks on this scale requires a considerable number of support staff and contributors, some of whom have been integral to the process throughout the five years it has taken to achieve our goals. We are especially grateful to Joanne B. Vickers for her adept coordination of the critiques and rewrites between the reviewers and author, as well as her own editing, research, and suggestions.

We wish to express our particular appreciation of the steering team scholars, teachers, and historians who provided critiques of the individual chapters. Joanne B. Eicher of the University of Minnesota put together and led a superlative team of specialists whose reviews and input were invaluable to the success of the completed project:

- Michaele Haynes. Curator, Witte Museum, San Antonio
- Irene Good, Curatorial Associate, Peabody Museum of Archaelogy and Ethnology, Harvand University
- Susan Tomtore, Illinois State University
- Jane Hegland, South Dakota State University
- Catherine Daly, University of Minnesota
- Zujie Yuan, Southwestern University
- Karen Nakamura, Macalester College
- Hazel Lutz, Iowa State University
- Lynn Meisch, St. Mary's College, Walnut Creek, California
- Marilyn Delong, University of Minnesota
- Kathleen Campbell, The Goldstein Museum of Design

In addition to the detailed work of the steering team reviewers, we received volumes of contributions from many colleagues and friends whom we thanked individually but do not list here for lack of space. Futhermore, a comprehensive list of photo credits for purposes of permissions and other contributions is located on page 797.

INTRODUCTION

THE DEVELOPMENT OF DRESS

Evidence from the early Paleolithic period more than 30,000 years ago confirms that, since the dawn of the human race, people have transformed the appearance of their bodies in a wide assortment of ways. Prehistoric carvings and cave paintings have provided intriguing records that document forms of dress ranging from simple ring ornaments to a variety of draped and wrapped clothing. Paleolithic gravesites have yielded artifacts such as stone scrapers for preparing hides, bone needles for sewing, and antler awls for punching holes for easier stitching and lacing. In addition, an abundance of stone beads, pierced shells, drilled animal teeth, and fish vertebrae suggest ring ornaments such as necklaces, bracelets, anklets, and girdles or, perhaps, beadwork stitched to clothing. Some early graves even revealed that prehistoric humans painted their bodies in striking hues of yellow or red ochre.

But why? What motivated these early peoples to alter the appearance of their bodies? And were their impulses for dress so different from ours today?

Anthropologists, ethnologists, sociologists, and other scholars and researchers have attempted to delve into the question of why people wear what they wear. The four fundamental reasons for the development of human dress suggested most are:

- For protection
- For decoration
- For denoting status
- For modesty

CLOTHING FOR PROTECTION

Clothing worn for protection may be indexed under three categories. First is protection from the elements—cold, rain, snow, sun—which is sometimes cited as the most basic reason for the origins of dress. As noted above, artifacts have proven that Paleolithic peoples who migrated into cold, northern climates developed methods of preparing animal hides and stitching them together into clothing for warmth and protection from winter weather. Yet there is no evidence that the need for warmth was the first, let alone the dominant, reason for the development of dress. Indeed, early humans first emerged in the warm, equatorial climates of Africa millennia before migrating into colder regions.

A second form of protective dress was against physical injury. Some anthropologists suggest that, since early societies were under constant threat of extinction, they developed forms of dress principally to protect the genitals when running through underbrush, climbing trees, or other such perilous activities. Hence, with injury averted, fertility would be better preserved. Similarly, injury caused by parasitic insects could be prevented by covering sensitive areas of the body or by wearing dangling or fringed items, which, by their sweeping motion, could help fend off attacks. And following the examples from wildlife whose mud-wallows provided relief from stinging and biting insects, humans may have developed body painting from this need for protection.

The third form of protective dress was supernatural. Around the world today, people still wear mystical images and ornaments to ward off evil. In Africa, the batakari is a type of men's tunic embellished with appliques of hand-stamped magic squares and amulets to protect the wearer from a variety of calamities. Likewise, all along the eastern Mediterranean, various ethnic groups wear clothing and charms that bear stylized motifs representing eyes to shield against the evil eye of those believed to have the power to cast spells.

CLOTHING FOR DECORATION

Decoration is, by and large, thought by most scholars to be the primary reason for the development of human dress. Even into the twenty-first century there are cultures in which clothing is not worn, but there are no cultures in which some form of body decoration does not exist. This awareness of self and the interest in body decoration is believed by many behavioral and social scientists to be a basic human trait that developed in our earliest stages of social evolution.

The history of dress is populated with an endless array of clothing that served no practical function other than decorative. The garnishments worn by the rococo society lady

included towering hair arrangements and fifty-inch-wide wedding cake gowns made with fifty pounds of fabric, supports, swags, rosettes, bows, and other trimmings. Likewise, the Japanese counterpart of the French noblewoman decorated herself in twelve layers of kimonos with enormous sleeves and trains that, as a total look with accessories and makeup, symbolized types of flowers or seasonal foliage.

CLOTHING SYMBOLIZING STATUS

Dress as a symbol of status, arguably, developed as a later phase of dress. Conveying status through dress can be so complex and subtle that to recognize its meaning usually requires special training from the earliest age within a society. Among the solitary or combinations of status that dress may communicate include gender, age, religion, nationality, ethnic group, profession or trade skill, military rank, social station, economic status, marital condition, family connection, and political or sports affiliation.

The occupational uniform is one of the most distinctive, global forms of status dress in modern society. The accoutrement of the police officer, firefighter, and soldier is specialized enough for adults to recognize instantly. Yet it is often only within each of the groups that the subtleties of rank and achievement are discernible. The four stars on the epaulets of a U.S. army general's tunic might be widely understood throughout American society, but the display of his ribbons and medals is more esoteric.

One of the most ancient forms of status dress is clothing reserved exclusively for those of social rank, hieratic privilege, or economic significance. At various times in history, certain types of apparel, accessories, fabrics, trimmings, dyes, and various other luxury goods were reserved for the exclusive use of the elite. These restrictions were often codified into sumptuary laws, which, by design, were enacted to keep society visibly stratified. In 1789, one of the catalysts for the French Revolution was the reinstating of sumptuary laws by the Estates-General; not only were the nobility required to wear certain types of opulent court clothing, but all other classes were excluded from wearing those styles even if they could afford them. Even within the ranking classes, sumptuary restrictions were established to denote status; the rare and precious murex purple was lavishly used as a dye for the clothing of the Roman imperial family, but use of the color was restricted to only border edging for the togas of senators.

CLOTHING FOR MODESTY

In assessing modesty as a purpose for the development of any form of historic dress, researchers must guard against imposing their own ideas of modesty (or shame) into the analysis. The part of the body that may be freely and openly exposed or enhanced by dress in one society may be viewed as immodest in another. The notion of modesty and the emotion of shame at exposing a particular part of the body vary from culture to culture and from era to era. Ancient Athenian women disparaged their Spartan sisters as "hip displayers" for wearing a type of peplos that was open up the side, and the phrase to "dress in the Spartan manner" was a euphemism for indecent exposure. Yet the full nudity of the young Greek male in public was regarded as "a holy offering to the divine," according to Herodotus.

DRESS IN A SOCIAL CONTEXT

For the most part, humans prefer to live together in social groups. Over the millennia, various levels of communications developed within these groups, including dress as one of the more direct forms of visual communication. In some instances, dress as social communication also included sound, such as the jingle of the East Indian ghungrus (bell anklets), or smell, such as the particular scent of Chanel #5, or touch, such as the ikharo (raised scars) of certain African peoples for whom the feel is sensual.

One of the key functions of dress as social communication is the differentiation of the sexes. Gender-role socialization is fundamental to all societies. Customs, roles, and standards of behavior that are particular to one sex often evolved over many generations, and their origins have been lost to time. In more recent eras, some customs and activities, such as sports in the nineteenth century like baseball and basketball were specifically developed solely for one sex. Traditions of dress, likewise, reflected culturally determined views of each sex. In Western societies, men wore their hair cut short, with a few notable exceptions, from the time of Napoleon until the 1960s. Trousers, too, were exclusive to men from the earliest forms in the sixteenth century until the late nineteenth century when women began wearing versions for bicycling.

Another function of dress as a social communication is to designate age. In the early decades of the twentieth century, preteen boys wore knee-length pants called knickers; as they grew older, they looked forward to the rite of passage when they got their first pair of long pants. Similarly, the designation of age might also include body modification, such as the circumcision of prepubescent boys during manhood rites of some African peoples.

Dress also serves as an identification of specific groups within a society. A standardized uniform such as that of the Girl Scouts or a prep school might be both functional and a form of social communication. On the other hand, the looks of certain nonstructured groups might be based on similar components that allow variation and individual expression within the group and yet still maintain the group identity such as the dress of the hippies in the 1960s or the punks in the 1970s.

Possibly one of the most universal purposes of dress throughout history has been sexual attraction. In the study of

historic dress, though, this can be subject to the pitfalls of interpretation based on modern precepts. In examining the artwork of the Minoans, some scholars have suggested that the abbreviated contours of the men's genital pouch, which resembles men's bikini swimwear of today, and the corseted, bare-breasted bodices of women's dresses were designed for sexual attraction. But there is no evidence to support that assertion.

In some instances, though, some revealing cuts of garments and padded exaggerations were undeniably designed for sexual attraction. The padded codpiece of men's hose in the sixteenth century developed into pronounced proportions embellished with ribbons, embroidery, pinking, and other types of eyecatching decoration. Similarly, over the centuries, bodices of women's gowns either have been cut with revealing necklines to display the breasts or padded and contoured to emphasize the shape and dimensions of the bosom.

Dress as sexual communication within a society also includes forms other than clothing. The application of perfume and cosmetics or the modification of the body such as surgical implants and injections are prevalent forms of dress specific to sexual attractiveness and communication within many of our contemporary societies.

CROSS-CULTURAL INFLUENCES

In the twenty-first century, there are few societies around the world that still live in isolation. From the most remote forests of the Amazon basin to the most desolate regions of the Sahara Desert and Arctic tundra, people have become globally connected in ways undreamt of even a generation ago. Satellite telecommunications instantaneously and continually link all five continents of the planet. Languages can be translated automatically over the Internet by sophisticated software, and digitized live images can be transmitted to cell phones and wireless laptop computers worldwide.

From these international connections, cross-cultural influences occur at an ever more rapid pace. Along with the global exchange of ideas in business, the sciences, technology, languages, art, and culture, also is the exchange of concepts, traditions, and designs of dress. But cross-cultural influences are not new in the development of dress. This survey of historic costume includes chapters on the dress of China, Japan, India, Africa, the Islamic empire, and the pre-colonial Americas to give readers the full panoramic view of what, how, and when cross-cultural influences occurred globally rather than solely in the Eurocentric West.

Since the emergence of the earliest settled communities, people have sought out and encountered other people in distant lands. The motives may have been simple curiosity about their neighbors or for trade, or perhaps less benignly, for war of territorial conquest or subjugation through a religion or sociopolitical ideology. Then, as now, ideas of dress were exchanged. But it was rare that new concepts of dress

introduced from one culture into another were not altered. Among the exceptions was the mass adoption of Western attire imposed on the populations of some post-colonial Islamic nations by secularized governments. In most instances, though, the adopted styles were transformed. When the ancient Egyptians were conquered by the Hyksos, the Egyptians adopted new forms of layered clothing from their new rulers but rejected the wool fabrics and textile patterns of the Hyksos; instead, the Egyptians transformed those new types of clothing with goffered white linen, a look that was compatible with 2,000 years of Egyptian dress tradition. Similarly, concepts of dress are sometimes adopted from one culture with the same look but the meaning is transformed. The twenty-first century punks of Tokyo look like their British and American counterparts of the 1970s—replete with slashed black clothing, crested and spiked hairstyles, multiple body piercings, and heavy black makeup—but instead of exhibiting the antisocial behavior reputed of many Western punks, notably drug use and verbally assaulting people in public, the Japanese punks are polite and orderly.

COSTUME AND FASHION

Much has been written and discussed in scholarly circles about the significance of using the term "dress" rather than the assortment of other words like "appearance," "costume," or "fashion." As researchers Joanne B. Eicher and Mary Ellen Roach-Higgins note, "The dressed person is a gestalt that includes the body, all direct modifications of the body itself, and all three-dimensional supplements added to it." In other words, the comprehensive catalog of forms of dress includes not just draped and tailored body enclosures but also attached and handheld objects, body modifications ranging from clipped fingernails and haircuts to tattoos and piercings, and transformations of the muscular or skeletal system. Perfume and even breath mints are likewise components of dress.

Why then is the title of this survey *The History of World Costume and Fashion?* The answer is explained in detail in the section on the "Idea of Fashion" in chapter 14. The differentiation, though, between the terms costume and fashion is significant.

In essence, costume is the traditional dress of a people that confirms a stable meaning in the culture even if customs change. For instance, despite foreign invasions and dramatic cross-cultural exchanges over the centuries, China's costume traditions remained fairly constant for thousands of years.

The concept of fashion, though, emerged in the late Middle Ages. The affluent middle classes sought to elevate their social status by copying the appearance, lifestyle, and behavior of their social superiors. This included adopting the dress of the aristocracy. When sumptuary laws did not prevent the bourgeoisie from infringing on the special status of the elite classes, the nobility opted for new forms of dress to reestablish their social distinction. The cycle then began to repeat

itself with an increasing frequency until changing trends in dress, or fashion, were of an ever shorter duration.

SOURCES FOR THE STUDY OF DRESS

To more comprehensively study historic dress, the student of costume must assemble evidence from a wide variety of sources. The more source material that is available, the more complete the picture of dress from any given period. For some eras, evidence is abundant and may include extant examples of clothing and accessories, written records, and assorted visual references such as paintings and sculptures. In our modern times, consumer and marketing materials such as magazines, catalogs, TV commercials, and other forms of advertising are important sources. Period photos and diaries are valuable as well. Movies are always a favorite source having been a direct influence on mainstream fashion at times.

Certainly, the earlier the period of research, the scarcer and less clear the evidence. In these instances, the researcher must rely on secondary sources, particularly the insights and conclusions of scholars and writers with in-depth, specialized knowledge of historic dress. Even then, there is often dispute and contradiction—everything from descriptive interpretations of source material to the spelling of terms.

As the evidence is collected, each of the sources must be cross-checked against the others to ensure as accurate a picture of historic dress as possible. In examining paintings and sculptures, we must take into account the artistic conventions of the period. Sculptures of ancient Egyptian women appear to depict formfitting tunics, but extant examples found in tombs reveal that the garments were made to fall from the shoulders loosely somewhat like a modern chemise. Nor can extant examples of clothing always be credible; often garments from one fashion era were altered to the new styles of a subsequent period. This is one reason that none of the hundreds of opulent gowns owned by Elizabeth I have survived intact. Even with vintage photos, some images may be suspect since negatives were often touched up, and hand-colored photographic prints were commonly tinted from the imagination of the photographer rather than from the actual clothing. Moreover, as with most portrait paintings, portrait photos usually depicted the sitters' "Sunday best" clothing instead of their everyday attire. And although movies provide animated, 360-degree views of contemporary clothing in motion, the styles often do not reflect the actual fashions of the time but, rather, were designed for creative effect, or sometimes even for an actor's particular look. In her movies, Joan Crawford continued to wear garments made with broad, padded shoulders long after the look ceased to be popular in the late thirties and early forties.

With all the aforementioned tenets in mind—the purposes and origins of dress, the impact of cross-cultural influences, and the importance of assembling evidence from a wide variety of sources—students of historic dress will be well armed in their journey through this history of world costume and fashion.

Chapter 1

PREHISTORY

Upper Paleolithic Period							
Ceremonial burials with ornaments	Decorated tools and hunting implements	Advanced hunting techniques such as the bow and arrow	Extinction of the Neanderthal	Cave painting	Lespugue Venus	Harvesting and grinding wild grains	Lascaux caves cordage made
c. 45,000 BCE			c. 30,000 BCE				c. 15,000 BCE

Mesolithic Period		Neolithic Period			
Incipient agriculture and domestication of animals	Permanent architecture and pottery	Loom weaving		Otzi Ice Man c. 3200 BCE	Cherchen Man c. 1000 BCE
c. 12,000 BCE	c. 10,000 BCE		c. 5000 BCE		c. 1000 BCE

(BCE: Before Current Era; CE: Current Era)

HUMANKIND BEFORE HISTORY

More than 4 million years ago the direct ancestors of modern humans first appeared in the central region of what is today the continent of Africa. These creatures had no fangs or claws, no protective scales or thick fur, no great strength or speed. Instead, these early people had two exceptional advantages for survival: they were bipedal, thereby freeing their hands for gathering food, and they possessed a larger brain than even their closest chimpanzee relatives. As a result of these two characteristics, early humans developed a variety of tools to enable them to hunt and gather food efficiently. They also devised weapons to defend themselves against a violent world of predatory beasts and other groups of people competing for the best hunting territories.

As early humans migrated out of Africa beginning about 1.8 million years ago, they evolved, over many generations, into different physical types. These early peoples enjoyed a collaborative small-scale community, maintaining their fires seasonally in and around caves. Gradually, localized cultures emerged and advanced hunting techniques were developed. They knew the migration patterns of the animals they hunted, and they learned the cycles of plant life and where to find ripe vegetables, fruits, tubers, and nuts throughout the year.

With an easy supply of food resources, these peoples experienced leisure time. About 35,000 years ago, Upper Paleolithic people adapted their tool-making skills to artistic expression and created an extraordinary variety of paintings, drawings, carvings, and sculpture. Cave paintings from the time reveal sophisticated conceptual and rendering skills in depicting animals and elements of their environment. Figurines of animals were carved in a highly realistic style. Tools and utilitarian objects were engraved with complex decorative elements. Although many of these representations may have served as magical symbols or as part of hunting rituals and ceremonies, still others very likely were purely for aesthetic enjoyment.

One important use of ornamental items for Upper Paleolithic peoples was for burial with their dead. Gravesites have been excavated that date back to the time of the Neanderthal, about 40,000 years ago. The concept of an afterlife, in which the dead would need their weapons and clothing, is a dramatic leap in the cultural development of humankind. We surmise from the positions in which bodies were arranged in graves and the fact that the dead were sometimes covered with a red or yellow ochre paint that reverence and ceremony were observed during these burials. Certainly

the living could have benefited from the food, tools, and clothing that went into these graves, but the spiritual significance of these rites evidently outweighed the practical needs of these peoples.

By the beginning of the Mesolithic Period, significant changes in world climate occurred. The last of the vast ice sheets that had covered much of the northern Hemisphere rapidly receded. The great herds of bison and elk changed their predictable migratory patterns and followed the northward expansion of vegetation. Moreover, extinction of the mammoths, giant sloths, and a number of other food species occurred at about the same time. Consequently, Mesolithic peoples began to maintain captive herds of animals as a ready supply of food. In addition, instead of seeking patches of grains and vegetables for harvesting as they ripened in the wild, people began to settle in areas where they could cultivate food-yielding plants. Hence, the domestication of animals and the development of agriculture transformed the precarious existence of early humans as hunters-gatherers and provided for a more stable, controlled way of life.

These raw, rudimentary settlements first developed in the river basins of Mesopotamia, Egypt, China, and the Indian subcontinent about 10,000 years ago. This was the dawn of the Neolithic Era. The advances in technology, architecture, and social integration were rapid and dramatic. The transition from the brief Mesolithic to the Neolithic Period occurred in only a few millennia. From these scattered Neolithic communities arose the great civilizations that history has recorded.

PREHISTORIC CLOTHING

Our knowledge of humans' earliest costumes has been pieced together from sketchy evidence. For instance, stone tools that seemed to be shaped to fit the hand for scraping animal skins have been found at sites dating back 35,000 years. In addition, by examining the kind of wear to the teeth of female Neanderthal and Cromagnons, forensic anthropologists surmise that these early peoples used their teeth as vises to hold skins taut, thereby freeing both of their hands for scraping down the hides for tanning. When these findings are coupled with evidence excavated from Paleolithic gravesites such as bone needles and antler awls, the assumption is that early humans sewed animal skins together to construct clothing, blankets, hut coverings, and other utilitarian items. Yet very little has survived to give us a clue what these prehistoric items looked like.

Anthropologists believe that even before these early peoples began their migrations out of tropical Africa into colder climates where they developed clothing for warmth and protection, they likely adorned themselves with some sort of costume. Simple **body rings** such as necklaces, anklets, wristlets, and hip bands are commonly thought to be the first

Fiber Crafts

We do not know at what point in the technological development of humans the production of fiber crafts was first developed. Possibly prehistoric peoples experimented with twisting filaments of grasses and plant stalks as a result of observing nature, such as entwined vines or the naturally braided remnants of vegetation seen along a flooded riverbank. Or perhaps some clever individual began to explore the use of plant fibers as a substitute for scarce animal sinew, tendons, and other stringy body parts used in craft making.

Whatever inspired the first experiments with twisting and braiding fibers from wild vegetation, we know for certain that early humans were successfully making sophisticated fiber crafts by the late Upper Paleolithic era. A number of prehistoric figurines from about 20,000 to 25,000 BCE reveal carved and incised details that appear to be fringed types of skirts or decorative treatments of hip ring ornaments believed by some scholars to be made of string.

Our earliest surviving evidence of fiber crafts also dates from this late Upper Paleolithic period, c. 15,000 BCE. In exploring the famous painted caves of Lascaux, France during the 1950s, an archaeologist reported discovering in a lump of clay a "carbonaceous imprint [that] presented the very clear characteristics of a twisted cord formed of several strands on which one could distinguish even the puffiness of their twists." Further laboratory tests revealed that the prehistoric cord had been made from three two-ply cords twisted together as shown here in the line drawing of a reconstruction. By twisting the two-ply cords together in the opposite direction from the way the individual cords had been twisted not only strengthened the composite cord but also prevented the component strands from coming unraveled.

With evidence of such highly developed skills in fiber crafts as the Lascaux cord, we can imagine that Upper Paleolithic peoples likely had developed a wide assortment of finger weaving for plaiting, netting, and basketry—techniques that were the prelude to loom weaving and the manufacture of cloth.

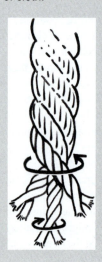

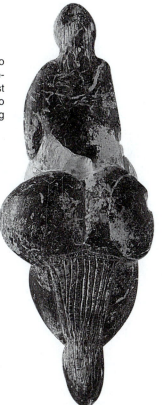

Figure 1-1. Costume historians often refer to certain female figurines of the Upper Paleolithic era as evidence of humans' earliest costumes. The Lespugue Venus appears to wear a body ring about her hips with long fringe at the back, c. 25,000–22,000 BCE.

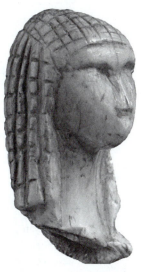

Figure 1-2. The cross-hatched pattern on the hair of the Brassempouy Head has been variously interpreted as a braided coiffure, a hat of some kind, or even netting, c. 30,000–20,000 BCE.

types of dress. Excavations of Upper Paleolithic burial sites have provided a wealth of materials that may have been used in creating ring ornaments including pierced shells, animal teeth, claws, fish vertebrae, bone beads, carved horns, and drilled stones not unlike those still worn by some ethnic peoples today. Similarly, it may be assumed that abundant other natural materials were likewise used but have since perished such as seeds, pods, nut shells, thorns, and flowers. These assorted materials were most likely strung together on finely braided or twisted hairs, animal sinew, or plaited grasses and plant fibers.

The debate of which came first, costume for adornment or for protection against the environment, is an old one. Such questions actually originated as early as the nineteenth century, posed by social scientists like George Darwin (son of Charles Darwin) and Havelock Ellis. By the early twentieth century the argument had evolved into entire studies devoted to the topic. In his 1930 book, *The Psychology of Clothes*, J. C. Flugel maintained that since the earliest species of humans originated in warm climates, the first articles of clothing likely resembled those ring decorations that were still common at the time among certain ethnic groups in Africa, South America, and Asia.

In addition, costume historians look to some of the nude female "Venus" statuettes from the Paleolithic era to suggest that versions of body rings around the hips, the waist, or across the breasts predate constructed clothing. One of the

most frequently referenced examples is the Lespugue Venus found in France. (Figure 1-1.) The striated rectilinear shape just below the buttocks of the figure is thought to be a hip ring with fringe possibly made of rushes, plant fiber strings, or strips of animal hides. Yet another interpretation is that the shape depicts a **loincloth** of plaited grasses attached to a hip ring. The explanation offered for why the fringe would be worn below the buttocks is that such kinetic ring decorations were possibly used for sexual attraction rather than for any sort of modesty as we apply the concept of concealment today. Such ring ornaments also may have symbolized magical powers or mysteries of their spiritual beliefs. However, some art historians and anthropologists dispute whether these carved or incised shapes represent body ornaments at all. In the case of the Lespugue Venus an alternative explanation is that the striated shape may be a reed basket into which the female would give birth. In other instances, rings across breasts may be stick-figure representations of arms rather than ornamental accessories, and crosshatched patterns incised onto carved heads are likely stylizations of hair, not depictions of net caps. (Figure 1-2.) Nevertheless, the tiny sculpted images from our Paleolithic past are intriguing in their vagueness, mystery, and possibilities.

Although we may never conclusively determine which came first, body ornaments or constructed clothing, we do have some solid evidence of actual prehistoric garments. In 1991, a 5,300-year-old mummified body of a man was

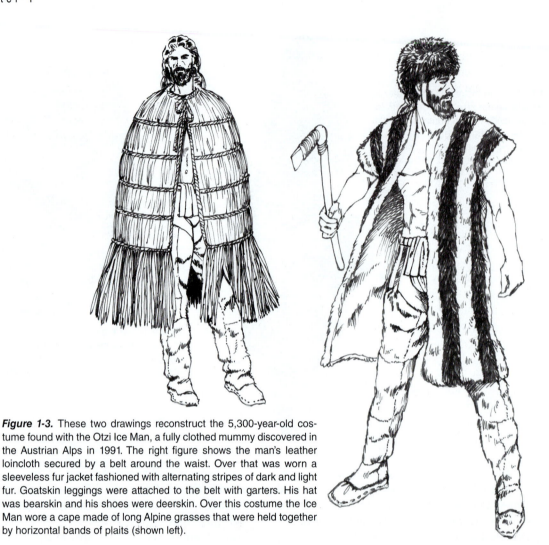

Figure 1-3. These two drawings reconstruct the 5,300-year-old costume found with the Otzi Ice Man, a fully clothed mummy discovered in the Austrian Alps in 1991. The right figure shows the man's leather loincloth secured by a belt around the waist. Over that was worn a sleeveless fur jacket fashioned with alternating stripes of dark and light fur. Goatskin leggings were attached to the belt with garters. His hat was bearskin and his shoes were deerskin. Over this costume the Ice Man wore a cape made of long Alpine grasses that were held together by horizontal bands of plaits (shown left).

discovered in the ice of the Otzal Alps on the Austrian-Italian border. The ancient traveler, nicknamed the Otzi Ice Man, is thought to have been the victim of a sudden winter storm or avalanche. In addition to the well-preserved body, the find yielded a complete ensemble of clothes, tools, and weapons. This rare treasure trove of costume artifacts featured multiple articles of clothing that the Ice Man had worn layered against the frigid northern climate. (Figure 1-3.) Over the lower body he wore a loincloth made of ox hide that was secured by a strip of leather around the waist. His legs were covered by a skillfully sewn set of goatskin **leggings** that were held up by straps attached to the belt—an early type of **garters**. Flaps at the ankles extended over the tops of the feet or may have been tucked into the **shoes** and were held in place by the strips of leather that tightened the shoes. A sleeveless **jacket** was constructed of animal skins sewn in a decorative pattern of alternating vertical stripes of dark and light fur. The seams were expertly stitched with tiny threads of animal sinew, revealing that the Ice Man's tribe included individuals with exceptional

tailoring skills. A hat made of bearskin fitted snugly over the head and was secured by a chin strap. The shoes were made by a complex construction of deerskin **vamps** and bearskin soles cut wide for walking in the snow. An inner layer of knotted grass cords supported the instep and heel of the shoes up to the ankle. For additional warmth, the Ice Man had stuffed his shoes with a thick lining of grass. Over this costume was worn a lightweight, waterproof **cape** made of long Alpine grasses. At the neckline, the grass was plaited and then spread wider to fit over the shoulders. The long strands of grass were held in place by horizontal plaits, and a fringe of grass at the bottom drew away the water.

Of special significance are the decorative elements of the Ice Man's costume. The uniform circular banding of the grass cape and the alternating stripes of the fur jacket tell us that our prehistoric ancestors had a sense of personal style in the production of clothing. Possibly, though, these elements of dress have meaning beyond that of our notion of prehistoric fashion. Could the shape of the bearskin hat or the striped pattern of the fur jacket be symbols of the Ice Man's

clan, just as national costumes and even corporate or military uniforms identify members of specific groups today? Or were these design elements statements of the wearer's social status in the clan? Were the circular plaits of the Ice Man's cape the legacy of his ancestors' ornamental body rings? We probably will never know the answers to these questions about the dress of prehistoric peoples, but for the student of costume and fashion, the possibilities for interpretation and speculation of *why* people wore what they did are as intriguing as *what* they wore.

NEOLITHIC TEXTILES

The development of settled communities occurred at different times in different geographic regions around the world. Sometime in the Mesolithic period between about 12,000 to 10,000 BCE, people learned to domesticate animals and cultivate plants. Herding is often viewed as the easier way of ensuring a food supply, but farming allowed storing surplus food as a hedge against inevitable droughts and floods. During the transition from the Mesolithic and the Neolithic eras, people developed methods of selective breeding of animals that yielded more milk and meat, and eventually better quality fur, such as the fleeces of woolly sheep, which were used in **spinning** yarns and **weaving** textiles from those yarns. Similarly, farmers cultivated nonfood plants such as hemp, cotton, and flax that produced fibers also used in spinning and weaving.

As evidenced by the Lascaux cord of 15,000 BCE, early peoples knew how to process plant and animal fibers for the production of yarn. By the Neolithic period, methods of processing fibers had become highly sophisticated and efficient. **Carding** involved constructing a pair of small, flat boards with handles to which some type of "teeth" were affixed on one side of each. The tangles of a clump of wool could then be worked to make the fibers fluffy and easier to spin into yarns. The problem with carded fibers, though, is that the yarn is weak and can easily break. The more effective method of preparing fibers for spinning strong yarns is by **combing**, which removes tangles and arranges the fibers parallel in a mass. The resulting wool yarn, called **worsted**, forms what is known as a **hard thread** because the fibers are closely packed when twisted together—the type of yarn prevalent in wool suits today.

The other technological advances that facilitated the leap from the hand twisted Lascaux cord to woven fabrics of the Neolithic period included spindles for spinning and looms for weaving. Upper Paleolithic people most likely made yarn by rolling a small amount of fibers with the palm of the hand against the thigh. Over thousands of years, the technique of using a **spindle** for spinning thread was developed and refined. In its simplest form, the spindle is a short wooden stick about ten to fifteen inches long. To spin yarn, the start of a new thread is attached at the tip of the stick,

which is then rotated in a fast spin. Raw fibers are continually fed into the upper end of the thread and twisted together into a filament of fairly uniform thickness and strength by the spinning of the stick. When the spindle reaches the floor, the finished length of thread can be wound around the shaft to prevent it from becoming tangled. A more sophisticated type of spindle is weighted on the end with a whorl—a disk, usually of clay, through which the stick is inserted. The **spindle whorl** minimizes wobbling and prolongs the spin. For ease of adding fibers to the thread, a second type of stick, called a **distaff**, was used to hold a sufficient supply of raw material conveniently at hand.

As with the technological development of the spindle and distaff, we are unsure at what point Neolithic people began to weave cloth on a loom. Most likely the structural concept of the loom evolved from the ancient methods of arranging yarns and plant materials for finger weaving some forms of basketry and netting. But these processes were time consuming and clumsy since the pliant threads were difficult to control. The next phase in the evolution of weaving likely included variations of the unframed **loom**. Lengthwise threads, called the **warp**, were secured to sticks at opposite ends. The sticks could be braced against pegs staked into the ground to keep the warp threads taut and evenly spaced. Just as with freeform finger weaving, another thread, called the **weft**, was interlaced in various over-and-under techniques perpendicular to the warp threads. A needle was used to maneuver the weft thread back and forth through the alternating warp threads. Instead of a loose, mesh-like net, though, the weft threads were tamped closely together forming cloth. (Figure 1-4.) The most common form of Neolithic cloth was a **plain weave** in which the weft thread goes over one warp thread and under the next. By maintaining a continuous weft thread the sides are finished with a **selvedge**, from "self-edge," that prevents the weaving from unraveling. Ancient weavers became inventive and created subtle textile patterns by pairing, or **twinning**, warp threads that produced **twill** fabrics. A **long-float twill** was made by going over three warp threads and under two, which creates a striking diagonal texture to the cloth surface. A variety of **basket weave twills** was formed by laying in two weft threads in each row.

By the emergence of the first great civilizations in Egypt and Mesopotamia, looms had become more structured and efficient. A frame provided consistent stability for the warp thread layout. Most important of all, though, was the development of heddles, which gave the weaver greater control of the warp threads. The **heddles** were little cord loops through which each warp thread was inserted. These cords then were attached to a bar suspended over the loom allowing the warp threads to be manipulated like puppets. Every other thread (or any alternating combination of threads) could be lifted to open a channel across the warp. A thin, rounded device called a **shuttle** carried a quantity of weft thread and was

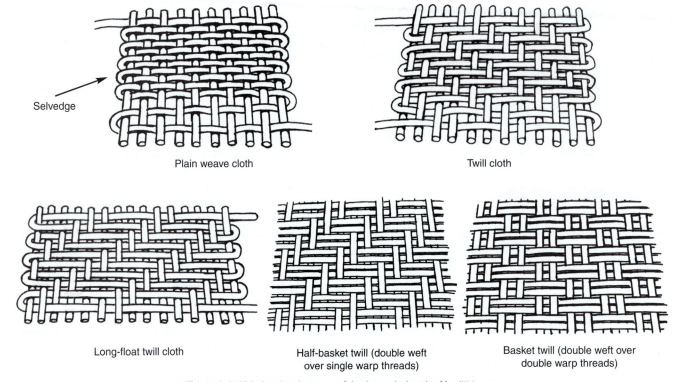

Selvedge

Plain weave cloth Twill cloth

Long-float twill cloth Half-basket twill (double weft Basket twill (double weft over
 over single warp threads) double warp threads)

Figure 1-4. With the development of the loom during the Neolithic era, weavers learned to produce a variety of cloth ranging from basic plain weave to complex basket weave twills.

quickly and easily slid back and forth through the changing channels of warp thread to build the cloth.

Eventually loom frames were made in assorted dimensions and configurations. Besides providing better control of the thread layouts, the loom frame also allowed weaving to be done vertically as well as horizontally. By the end of the first millennium BCE, vertical loom weaving was common from Egypt to China.

NEOLITHIC CLOTHING

North of India beyond the Himalaya Mountains lies the arid Tarim Basin of western China. In the early 1900s, archaeologists discovered numerous gravesites containing remarkably preserved mummies that laboratory tests revealed dated to as early as 2000 BCE. The dry heat of the desert and salt deposits of the dried-up ancient sea bed had preserved the contents of many graves so well that the skin of some mummies still revealed painted motifs on cheeks, and the natural color of their plaited hair and trimmed beards was still discernable. Equally well preserved was a wealth of other perishable artifacts ranging from food offerings to clothing and textiles.

The late Neolithic peoples who inhabited this region were not the ancestors of the ancient Chinese, which is why they are represented here rather than in chapter 9. Indeed, the imperial Chinese did not even annex the Tarim Basin until the Han Dynasty around 120 BCE. The mummies of these Neolithic peoples instead were of Caucasian ethnicity—round eyes, high nose bridges, and fair hair. They are thought to have migrated there from the lands of their origins farther west. Although the Tarim dwellers did not build permanent buildings or develop writing, they did have highly developed skills in crafts, particularly leatherwork and cloth production.

One of the most publicized Tarim mummies has been called "Cherchen Man" by the press, named for the village near which his gravesite was discovered in 1978. This tall man of an imposing six foot six inches was in his midfifties when he died around 1000 BCE. His cheeks, temples, and nose were painted with a yellow-ocher that swirled into short rays at the temple, somewhat like the motif school children today use to draw the radiating sun. His earlobes were pierced and adorned with pieces of bright red wool yarn, which could have supported ornaments that are now lost. He was dressed in a front-closure wrap shirt, trousers, leggings, and thigh-high deerskin boots. In addition, a wardrobe of other clothing was found in the grave including two shirts, two long overcoats, a pair of trousers, and ten hats.

The details of the design and construction of Cherchen Man's clothing reveal a degree of sophistication in

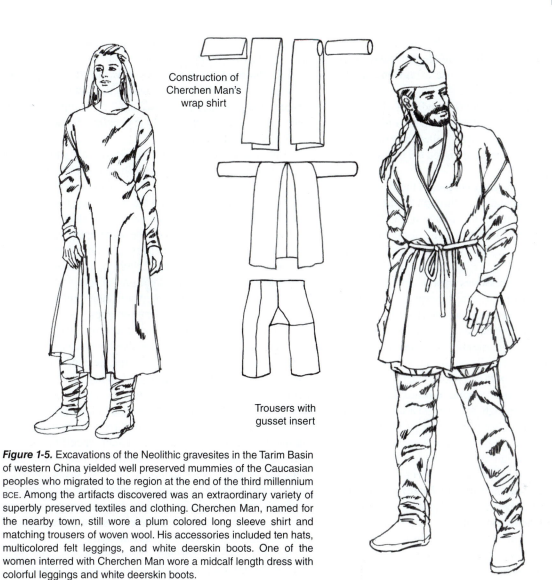

Construction of Cherchen Man's wrap shirt

Trousers with gusset insert

Figure 1-5. Excavations of the Neolithic gravesites in the Tarim Basin of western China yielded well preserved mummies of the Caucasian peoples who migrated to the region at the end of the third millennium BCE. Among the artifacts discovered was an extraordinary variety of superbly preserved textiles and clothing. Cherchen Man, named for the nearby town, still wore a plum colored long sleeve shirt and matching trousers of woven wool. His accessories included ten hats, multicolored felt leggings, and white deerskin boots. One of the women interred with Cherchen Man wore a midcalf length dress with colorful leggings and white deerskin boots.

tailoring, fit, and color style that surprised many researchers. (Figure 1-5.) The shirt he wore was made from two pieces of plum-colored plain weave cloth folded in half at the shoulders and sewn together up the back. The outside edges of the shirt were stitched closed except for the armholes. Two smaller rectangular pieces of fabric were folded in half and sewn to form a tube for the long sleeves, which were attached to the body in a T-silhouette. The capacious width of the shirt allowed the sleeve seam to drop off the shoulder. The shirt is decorated with a bright red yarn whip-stitched as a sort of piping over the armhole seams and around the neck and front opening. The wrap-front shirt was held closed by a cord plaited from five vividly hued yarns: yellow, blue, green, red, and plum.

The two overcoats buried with Cherchen Man were constructed the same as the shirt except longer and more voluminous to fit over other clothing. One coat of chocolate

brown was trimmed with red cuffs and a red border at the hem. Both coats were of heavy twill woven with a three-float weft that gave the surface a rich diagonal texture.

Of particular note are the Cherchen Man's trousers made of the same plum plain weave as the shirt, and accented with identical red piping. Methods for constructing and attaching sleeves to tops had been developed by the Egyptians centuries earlier, but the concept of trousers was revolutionary in the second millennium BCE. Like most of the late Neolithic period peoples of the central Asian steppes, the Tarim people were pastoralists who managed their herds on horseback. They needed clothing that protected the legs and loins against chafing and frigid winds when riding. Wrap skirts were unsuitable for the climate and extremes of weather. The craftsman who cut and sewed Cherchen Man's trousers understood how to fit cloth to the hips and encase both legs in one garment as shown by the

line drawing in Figure 1-5. In addition, the trousers were ingeniously constructed with a diamond-shaped gusset that bridged the crotch to allow greater ease of movement and roomy comfort when astride a horse or sitting cross-legged at a campfire. The waistline was not finished with a band like modern trousers, and beltloops were more than a millennium in the future. Tarim men instead either rolled the excess material at the waist to tighten the fit or girded the trousers with a cord or belt.

From its origins with the early peoples of the steppes, the concept of trousers was disseminated through the dress of the Medes to that of the Persians in the middle of the first millennium BCE, and eventually to the clothing of the migrating peoples of northern Eurasia, from which the Roman army adopted the style.

The Cherchen Man's accessories are as noteworthy as his suit. Among the grave gifts for his afterlife was a collection of ten hats, each of a different design. One was a beret-type made of loose needlework that formed rows of interlocking loops that almost resembles knitting. Another style was shaped like the segmented onion-domes of Byzantine churches. A third hat was like a textile helmet with a neckflap and two thin rolls of felt stitched at the front curving upward like horns. The most compelling hat, though, was a peaked style made of felt. The high soft point probably laid forward as shown in Figure 1-5, or perhaps was even rolled in a shell-like spiral over the crown. This design is better known today as a **Phrygian cap**, named for the central Asian peoples who supplanted the Hittites in Anatolia (modern Turkey) during the eighth century BCE. Later, the hat was adopted by the Persians when they conquered the region.

Only one of Cherchen Man's thigh-high boots of soft, white deerskin remained intact during excavation. The right one was torn away revealing his rainbow striped leggings. These were not stockings of woven or knitted wool. Instead the feet and legs to the knees were wrapped in hanks of wool dyed red, yellow, and blue, and arranged in alternating segments to create a colorfully striped pattern. When worn compacted into boots in this manner, the hanks of wool were gradually transformed into **felt** by the heat, moisture, and pressure. Felt cloth is made without any system of threads. Instead, as the fibers are rubbed together they become firmly and smoothly interlocked. When used to shape hats or shoe vamps, some type of fabric finish or **sizing**, such as shellac or starch, is needed for the soft material to hold its contours.

Buried with Cherchen Man were three Caucasian women and an infant. The best preserved of these female mummies had the upper half of her face painted with yellow ochre spirals and a thin red triangle on each cheek. Her brown hair was braided into which the hairdresser wove red yarn. She wore a calf-length tunic dress of deep red wool woven in a long-float twill. (Figure 1-5.) Tubular long sleeves were attached in a T-shape construction like the Cherchen Man's shirts and coats, except the women's sleeves were only stitched to the dress body at the shoulder, leaving the underarms open as a vent. Possibly the woman would slip her arms through these openings and tuck back the sleeves in warm weather or when doing work where the sleeves might get stained or wet. A green cord was stitched as piping over the seams of the dress and around the neckline. Its hemline was secured with a brown yarn.

Her accessories included pieces of red yarn inserted through pierced earlobes. The knee-high boots she wore were identical to those of Cherchen Man's, and her leggings were of colorful hanks of wool as well. An oblong shawl of blue plain weave accented with two narrow red stripes accompanied the woman in her grave. The warp ends were knotted into a fringe and the weft selvedges were turned and hemmed with long, decorative stitches. None of the female Tarim mummies have been found wearing trousers, indicating the garment was gender-specific to men in their culture, unlike in ancient China, India, and Muslim societies.

From these fascinating finds we discover tangible proof of the advanced skill of spinning, dyeing, weaving, and garment construction in the late Neolithic period. The dress of the Tarim people was complex and richly varied. With no written records or artwork depicting themselves, we are unsure if they painted faces only as part of burial rites or if they adorned themselves with body paint in everyday life. Garments seem to have been gender specific, such as trousers for men and long dresses for women, while other elements of dress were identical for both sexes: deerskin boots, colorful leggings, and ornaments for pierced ears. Most especially, they loved vivid color and sumptuous combinations of hues, revealing their sense of aesthetics and personal adornment. Two thousand years after Otzi Man donned his bearskin hat and striped fur jacket, the Tarim clans were dressing in layered clothing made of long-float twill and warm, soft felt.

REVIEW

Tens of thousands of years ago, our earliest ancestors migrated out of the savannas of Africa to eventually populate every inhabitable corner of the globe. In their isolated regions, these peoples evolved into different physical types from which gradually emerged unique cultures and customs. Part of this cultural development included dress.

The evidence of the earliest costumes mostly comes from nonperishable artifacts excavated from prehistoric sites. Body rings are thought by most historians to have been the oldest form of dress. Numerous gravesites have yielded necklaces, anklets, bracelets, headbands, and hip rings made of pierced shells, animal teeth, vertebrae, horns, and colorful pebbles. Stone tools for processing animal skins and bone needles and antler awls have been discovered in Paleolithic sites proving that a very ancient method for constructing clothing existed.

With the discovery of the Otzi Ice Man, we at last have some tangible evidence of what late Upper Paleolithic peoples wore and how they made their clothing. The Otzi examples from around 3200 BCE not only confirmed many of our theories about early humans' techniques of garment construction but also intriguingly revealed their sophisticated methods of stitching animal hides and furs and of plaiting grasses for apparel that were unknown to us. Moreover, among the surprises of the Otzi find was the element of style indulged by these Stone Age peoples, as evidenced by the Ice Man's striped fur jacket and plaited circular bands of his cape.

While the Ice Man lived in the harsh Stone Age world of northern Europe, elsewhere around the globe, groups of people had domesticated animals, cultivated crops, and settled in permanent communities. These socioeconomic advances marked the Neolithic era. Over time these peoples developed technologies for making useful things: pottery, tools, and cloth and clothing. Extant examples of late Neolithic peoples' expertise in spinning, dyeing, weaving, and garment construction have been found with the mummies of the Tarim Basin of Central Asia. From their gravesites—some of which are more than 4 thousand years old—have been excavated woven textiles ranging from colorful plain weaves to complex twills. These textiles were made into a wealth of garment styles including long sleeve dresses for women and trousers for men. Innumerable accessories such as leggings, boots, shawls, belts, hats, and ornaments for headgear, hair, and pierced ears reveal a love of adornment in these early peoples.

As fine as the Otzi and Tarim artifacts are, they are but the briefest glimpse of the dress of early humans. Although they confirm many theories of ancient clothing manufacture posed by earlier researchers, these tangible examples nonetheless pose more questions than they answer—especially with regard to the cultural significance of what these early peoples wore, how they wore it, and why.

Chapter 1 Prehistory
Questions

1. What evidence provides clues to Upper Paleolithic man's earliest forms of costume?

2. What ornaments and materials were used for producing Upper Paleolithic decorative body rings?

3. What is the argument supporting the assertion that body ornaments preceded constructed clothing? What sources and examples are cited in this chapter?

4. What were some of the articles of clothing found with the Otzi Ice Man? What have these examples of clothing revealed about the dress of Upper Paleolithic people?

5. Describe the construction and function of tools used by Neolithic people in the process for thread and cloth production.

6. What common elements of style and construction are evident in the clothing of the Otzi Ice Man and Cherchen Man?

Chapter 1 Prehistory
Research and Portfolio Projects

Research:

1. Compile an archaeologist's cross-reference journal on evidence of Upper Paleolithic ring ornaments. Document an example from one site found in Europe, Africa, Asia, and the Americas. Identify:

 • Details of the excavation (location of site, discovery, date, archaeologist, institution affiliation, acquisition museum)
 • History of the site's original occupants who produced the artifacts
 • Type of ring ornament
 • Material(s) used in fashioning the ring ornament
 • Speculation on how the ornament was worn and its purpose

 Include a written conclusion comparing and contrasting the similarities and differences of all four ring ornaments.

2. Write a research paper on the late Neolithic textiles and clothing of the Tarim Basin peoples. Select examples other than those featured in this chapter. Describe the types of weaving, plaiting, color combinations, trimmings, stitching, and garment construction discovered in the later period gravesites. Include details of the decorative motifs woven into or painted onto the textiles.

Portfolio:

1. Finger weave a net. With basic household string or twine, cut a dozen warp threads twelve inches in length. Uniformly arrange these parallel to each other about a quarter inch apart on a flat surface. Research finger weaving techniques, and with an unbroken feed of thread, finger weave five different weft patterns, each two inches deep. Keep the spacing of the weft threads spaced about a quarter inch apart to fashion a mesh net.

2. Create a spindle and spin a minimum of two yards of thread. Research types of spindles and whorls used either in ancient times or still used today, and replicate the design with available craft shop materials. Using raw wool or cotton, hand twist a length of yarn for a starter thread and attach to the spindle. Spin a continuous thread at least two yards long. Demonstrate to your class the technique for spinning thread.

Glossary of Dress Terms

basket weave twill: the weave of double (twin) weft threads over double warp threads

body rings: decorative ornaments of shell, bone, beads and similar natural materials worn around various parts of the body

cape: a sleeveless covering usually fastened at the throat and draped over the shoulders

carding: the process of working fibers such as wool or cotton between two paddles affixed with teeth to make the fibers fluffy and easier to spin

combing: a process of removing tangles and arranging fibers parallel in a mass

distaff: a stick used to hold a supply of raw fibers for spinning

felt: a cloth made without any system of threads in which the fibers of wool are rubbed together until they become firmly and smoothly interlocked

garters: a strap or thong of some material used to attach leggings to a belt, or later, to secure hosiery on the leg

hard thread: tight, smooth yarn spun from combed fibers

heddles: cord loops through which warp threads were inserted and lifted to control the weave of the weft

jacket: an open-front outer covering for the torso of varying lengths worn by both men and women

leggings: coverings for the legs originally constructed of patchwork animal hides but later made of woven and knit materials

loincloth: any type of covering worn to protect or conceal the genitals

long-float twill: cloth produced by weaving weft threads over three warp threads and under two

loom: a device or frame for supporting a number of threads uniformly lengthwise, called the warp, through which weft threads are woven at right angles

plain weave cloth: a textile produced from weft yarns woven over and under warp threads one at a time

Phrygian cap: a soft, peaked hat worn with the point laid or rolled forward; named for the migrating steppes peoples called the Phrygians thought to have originated the style

selvedge: the finished edge of a piece of cloth formed by weaving the weft yarn in a continuous filament back and forth through the warp threads

shoes: any one of a variety of constructed or wrap outer coverings for the foot

shuttle: a smooth, rounded tool used to carry weft thread through the channel of warp threads formed by the heddles

sizing: a finish such as shellac or starch applied to fabrics to hold a shape and to protect against moisture and soiling

spindle: a short stick to which was attached the start of a thread and then rotated to spin raw fibers into yarn

spindle whorl: a disk usually of clay attached to the spindle to prolong the spin and prevent wobbling

spinning: the process of twisting fibers such as wool, flax, and cotton into threads or yarns

twill: cloth produced by weaving a weft thread over pairs of warp threads

twinning: the pairing of warp threads to weave twill cloth

vamp: the upper part of a shoe over the instep and toes

warp: the lengthwise threads on a loom

weaving: the process of producing textiles by interlacing or interlocking the warp and weft yarns

weft: the thread woven at right angles across the warp threads

worsted: wool cloth woven from hard thread produced by spinning combed fibers

Legacies and Influences of Prehistoric Styles on Modern Fashion

Since the dawn of humankind, animal skins have been prized materials for making clothing. In modern times, innumerable types of leathers and fur are still used in the design of finely tailored garments for both men and women. The concept of fitting pieces of animal hides—and later cloth—to fit the various parts of the body was a marvelous leap in the social development of early peoples. The Otzi Ice Man's animal hide leggings and loincloth gradually emerged in the Neolithic era as the Cherchen Man's woven wool trousers. This innovative design that fitted about the hips and covered each of the legs in one garment has been among the most significant legacies of all ancient styles on modern dress.

A wide assortment of ring ornaments likewise have remained a constant form of dress and personal adornment throughout the ages. Today ring ornaments are a ubiquitous form of personal adornment enjoyed by both sexes and all ages. From unique pieces of exquisite craftsmanship and the most precious materials to ordinary mass-produced varieties, all sorts of imaginative ornaments encircle necks, wrists, waists, and ankles basically in the same manner as 30,000 years ago.

Similarly another method of personal adornment as commonly practiced today as millennia earlier is body painting. Whereas once the earliest humans dabbed or smeared themselves with mud, chalk, clay, soot, charcoal, or earth, their descendants now indulge in beauty regimens of applying highly specialized cosmetics to disguise perceived physical flaws or to emphasize physiological attributes, or in many parts of the world, to express religious convictions or social conventions.

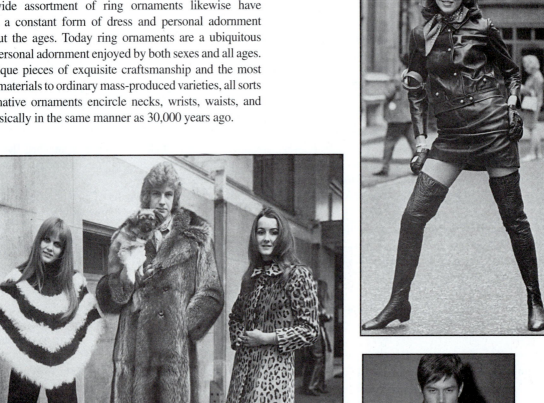

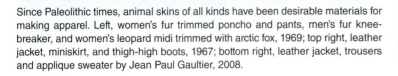

Since Paleolithic times, animal skins of all kinds have been desirable materials for making apparel. Left, women's fur trimmed poncho and pants, men's fur knee-breaker, and women's leopard midi trimmed with arctic fox, 1969; top right, leather jacket, miniskirt, and thigh-high boots, 1967; bottom right, leather jacket, trousers and applique sweater by Jean Paul Gaultier, 2008.

Humans have adorned themselves with ring ornaments for more than 30,000 years. Left, Coro simulated pearl necklaces and bracelets in pastel colors, 1956; right, copper belts by Renoir of California, 1958.

The innovative, complex design of trousers first developed among the Neolithic peoples of the central Asian steppes. The influence of this form of garment has profoundly impacted the modern dress of both sexes, all ages, and all classes. Beltless trousers by Asher, 1963.

The predecessors of modern cosmetic regimens extend back to the body painting of prehistoric peoples. Left, stylized makeup of the flapper, 1928; right, pancake powder from Angel Face, 1954.

Chapter 2

THE ANCIENT NEAR EAST

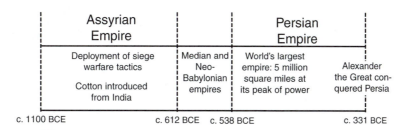

Neolithic Period	Sumerian City States	Akkadian Empire	NeoSumerian City-States	Babylonian Empire	Hittite Empire
Stone walls of Jericho constructed Copper smelting	Writing developed Bronze metallurgy	Sargon I conquered all of Sumer	Invasions of nomadic peoples from the steppes	Hammurabi codified laws	Horse and chariot introduced into warfare Iron forging

c. 7000 BCE c. 3500 BCE c. 2300 BCE c. 2100 BCE c. 1900 BCE c. 1600 BCE c. 1100 BCE

Assyrian Empire		Persian Empire	
Deployment of siege warfare tactics Cotton introduced from India	Median and Neo-Babylonian empires	World's largest empire: 5 million square miles at its peak of power	Alexander the Great conquered Persia

c. 1100 BCE c. 612 BCE c. 538 BCE c. 331 BCE

SUMER AND THE DAWN OF CIVILIZATION

Around 7000 BCE, the flood plains of Mesopotamia, between the Tigris and Euphrates Rivers, were settled by migrating peoples who brought with them fundamental agrarian skills of crop cultivation and animal husbandry. Once these early peoples mastered irrigation, they experienced an abundance of food and fiber crops hitherto unknown to their hunter-gatherer ancestors. By 4000 BCE, the simple Neolithic villages of the southern region of Mesopotamia had developed into sophisticated city-states with cosmopolitan urban centers and complex social structures. Each of these distinct communities shared a common language, Sumerian, and a parallel evolution of culture.

Three great achievements of the Sumerians provided for an entirely new order of human society: formalized religion, the body politic of the independent city-state, and writing.

The theocratic civic system of deities and man's interrelations with the gods dominated Sumerian daily life and gave it meaning. At the head of the socioreligious hierarchy was the king as chief priest and earthly representative of the gods on

high. Through him and his priests, formalized religion shaped society and was expressed in magnificent architecture and art.

As life became more regulated and standardized for the inhabitants of the Sumerian city-states, the community assumed functions that had formerly been the responsibility of the individual or clan. Defense against invaders and the vicissitudes of nature was shared and strengthened by their collective number and communal resolve. A standing army replaced the tribal warriors. Labor became highly specialized and skilled craftsmen mass-produced the necessities for daily life—pottery, basketry, woodwork, cloth, leather goods—in quantities that had not been possible in an unintegrated tribal society. A market economy developed.

The formalization of religion and the regulation of civic functions were given permanence by being recorded in writing. Around 3500 BCE, the Sumerians developed a pictogram form of writing that seems to have been used primarily for record keeping—harvests, livestock, taxes. Within just a few hundred years, this shorthand scripting evolved into the more

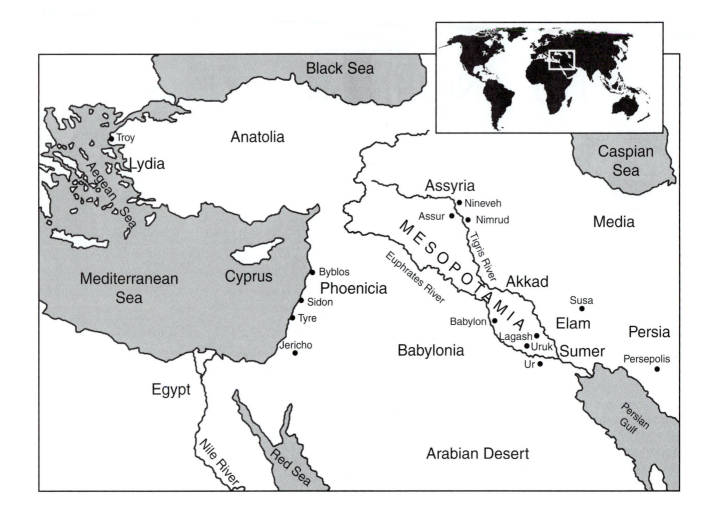

complex cuneiform style of writing and included sentence structure with standardized grammar.

From these stable patterns of life, the Sumerians were able to develop an identity of place—of being from the city-state of Ur, Uruk, or Lagash. Part of this identity was expressed in their dress—garments, accessories, hairstyles, and cosmetics—which was as integral a part of their culture as religion and government.

Among the first beasts domesticated by Neolithic settlers of Mesopotamia were sheep and goats. The wool from these animals provided the early Sumerians with the raw materials for their clothing. The most rudimentary garments of the earliest Sumerians were hardly more than variations of the animal pelts first worn by Paleolithic man over 30,000 years earlier. Hanks of sheep or goat wool, probably still attached to a tanned hide, were stitched or knotted together in horizontal bands to fashion wrap skirts called **kaunakes**. (Figure 2-1.) Lengths of the kaunakes varied and included waist-to-knee or mid-calf styles for men and breast-to-ankle versions for women. The fleecy surface of the traditional kaunakes became imbued with ritual symbolism and continued to be worn for hundreds of years, even as the manufacture of

woven materials became more prevalent. Sculptures of the fourth millennium BCE depict typical Sumerian kaunakes that feature stylized representations of the shaggy petals of wool, which by this time were applied to panels of woven wool or **linen**, a textile made from the fibers of the flax plant.

By the late fourth millennium BCE, fabric weaving had developed into a significant industry of the Sumerian city-states. As noted in the previous chapter, the weaving of threads and yarns probably evolved from the techniques of hand plaiting rushes, grasses, and other plant fibers used in making baskets, mats, and nets. Fragments of woven linen used as wrappings for copper axes were excavated at Susa and carbon-dated to around 3200 BCE. Excavations of the Royal Cemetery at Ur yielded extraordinary examples of wool fabric pieces from about 2600 BCE that still retained vibrant crimson dyes. These surviving fragments of linen and wool fabrics reveal the accomplished degree of spinning and weaving skills that the Sumerians possessed. As a result of the large scale production of textiles, the cloth was woven in such large panels that the nobility, priests, and the wealthy began to wear versions of the kaunakes wide enough to double-wrap the figure, extend over the left

From Fiber to Fabric

Fragments of linen carbon-dated to about 3200 BCE are the oldest known textiles found in Mesopotamia. Linen is woven from threads produced from the fibers of flax plants. Flax, along with jute, hemp, and ramie, among others, are known today as **bast** (or stem) fibers.

Neolithic cultivators learned that flax plants set closely together produce a long, fibrous stalk up to four feet tall with branches limited to the top, but when grown farther apart the plants produce more branches and a greater abundance of seeds, which are processed to make linseed oil. Because the flax fibers extend to the roots, the plants are pulled from the ground rather than cut.

The next step is **retting,** which involves soaking the stalks in water a few days to rot away the woody core and dissolve the gums. Depending on the natural chemistry of the pond, river, or stream, the fibers will range in color from grayish brown to pale yellow ("blonde"). Probably the most ancient method of retting was to spread out the pulled flax in the field and let dew rot the plants although this method took three or four weeks. Modern commercial processes for retting use temperature-controlled tanks filled with purified water.

After the retted plants have dried, the stems are beaten and scraped in a process called **scutching** to clean and extract the fibers. Ancient methods included pounding the stalks with wooden mallets and then raking them between a pair of wooden sticks.

Next is **hackling,** in which the fibers are combed, or drawn through a series of hackles (combs), to remove any remaining wood. The combing process also straightens the fibers.

Several more steps are needed to further clean and whiten the fibers including boiling and bleaching by immersion in lye, followed by more combing.

The resulting lengths of fibers are spun into yarn for weaving. Images of the steps for spinning flax depicted in ancient Egyptian wall paintings show the fibers first being twisted on the thigh. The filaments were then soaked in water and spun wet with a spindle to produce the fine gauge threads for weaving linen.

Linen may be produced as a plain weave, twill, or sumptuously patterned damask. The cloth is usually finished in a process called **beetling,** in which it is dampened and rolled with wooden rolling pins on a hard surface or sometimes beaten with mallets to produce a permanent sheen.

Figure 2-1. Hanks of wool were stitched or knotted together in horizontal bands to fashion the Sumerian wrap skirt called a kaunakes. Limestone wall plaque featuring priest-administrators from Lagash wearing kaunakes, c. 2600 BCE.

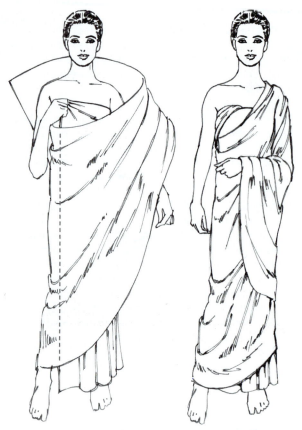

Figure 2-2. With the development of spinning and weaving in ancient Mesopotamia, woven versions of the kaunakes made of linen or wool became the more common form of secular wear. Priests continued to dress in the traditional shaggy wool kaunakes. These sketches represent one form of cloth kaunakes that was depicted in Sumerian sculptures of the late third millennium BCE.

shoulder, and drape around the back to tuck under the right arm. (Figure 2-2.)

By the mid-third millennium BCE, the heavy outer layer of shaggy petals of wool had been eliminated for the most part from secular clothing, and both men and women wore woven fabric garments. Here the term kaunakes refers to form rather than material so that, in this transitional period, we find sculptural depictions of the shaggy style for religious figures and woven fabric versions for secular ones. The group of votive figures discovered in the Temple Square at Tell Asmar depicts the wide variety of fabric **wrap garments** that the Sumerians were wearing by the last half of the third millennium. (Figure 2-3.) Most of the male figures wear a kilt-like wrap skirt that overlapped as much as half the width. Lengths of the wrap skirts varied as much as they had in the cuts of the sheepskin kaunakes with some hemlines extending only to the knees while others reached the ankles. The waists of the wrap skirts were rolled or secured by simple **girdles** or straps of leather. Women's wrap garments were still worn asymmetrically over the left shoulder and tucked into the top edge under the right arm.

One new variation of women's apparel that is noticeable on some of the female Tell Asmar votives is the addition of a **shawl**. Most figures appear to show these layered shawls draped over the left shoulder and probably pinned into place to prevent them from sliding off. At least one Sumerian statue fragment is known that depicts the shawl worn around both shoulders covering the back and with the ends hanging down the front. (Figure 2-4.) The appearance of this new type of textile wrap was significant for two reasons. First, the addition of superfluous garments to the Sumerian costume proved how abundantly available woven fabrics were by 2500 BCE. Second, subsequent cultures of Mesopotamia later adapted the layering of decorative garments such as the Sumerian shawl into components of costumes that denoted rank and ritual.

As woven fabric garments replaced the shaggy wool kaunakes, the textural appearance of cascading tufts of wool, which had been a part of Sumerian costumes for centuries, subsequently became stylized into borders of decorative **fringe** or **tassels** on a variety of garments. The wide assortment of fringe treatments on the garments worn by the Tell Asmar figures range from borders of fringe that are segmented and knotted into points to sumptuous overskirts made entirely of fringe.

Unfortunately, having been buried for 4,500 years, the Tell Asmar sculptures have lost their vivid, polychrome surfaces. As with all ancient cultures, the sculptors of Mesopotamia painted their statuary. The rich variety of Sumerian textile patterns can only be surmised from the extraordinary variations of jewelry designs, wall decorations, and motifs on pottery and other applied arts. Geometric shapes and patterns are prevalent on numerous artifacts and architectural elements. The temple columns from Uruk (c. 3000 BCE), for example, were made of multicolored clay cones that were inserted into a mud base to create a mosaic of repeat patterns including chevrons, diamonds, and triangles. Similarly, inlaid or painted geometric patterns adorned musical instruments, board games, storage boxes, and a host of utilitarian objects that have been excavated from the Royal Cemetery of Ur. Such evidence testifies to the Sumerians' love of decoration, color, and pattern. The formal schematics of geometric designs reflected perfectly the conventions and patterns of the rigidly regulated society of the city-state.

Despite the high level of civilization that the Sumerians developed, they were also a warring people. As the city-states became increasingly urbanized and populations grew, the need for land to sustain their inhabitants increased. Then, too, when natural calamities such as regional floods or droughts occurred, one city-state might face disaster while its neighbor prospered. Hence, the Sumerian city-states were constantly bickering over land or water rights and struggled either to conquer their neighbors or fend off attacks. Besides developing the idea of a standing army, the Sumerians had evolved their ancestors' Neolithic tribal methods of raids into siege campaigns that were planned and directed by a hierarchy of professional military leaders. Later Mesopotamian civilizations would refine those battle techniques into highly sophisticated strategies for imperial conquest.

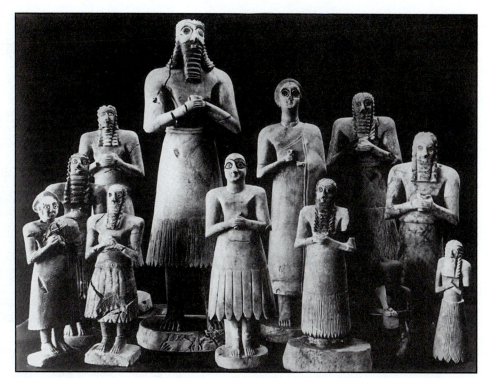

Figure 2-3. Although the wrap garments of the Sumerians were simple in cut, the fabrics were dyed in vibrant colors and embellished with a great variety of embroidery, beadwork, fringes, and tassels. Votive statues from Tell Asmar, c. 2700–2500 BCE.

Key to the success of any military venture is a well-provisioned army, which for the Sumerians included specialized clothing and implements of combat for their soldiers. Two lavishly detailed sources that provide us with a glimpse of how the Sumerian soldier dressed are shown in Figure 2-5. The military uniform of the mid-third millennium BCE consisted of a wrap skirt, a leather **helmet**, and a leather **cloak**. The woolen wrap skirt was cut in a traditional oblong shape with a wide border of knotted fringe at the bottom and was girded at the waist by a strip of leather. The helmet was constructed to fit closely to the head covering the ears and back of the neck. A raised, somewhat pointed dome provided a space between the top of the head and the helmet to cushion against the barrage of stones and baked clay pellets that would rain down upon the soldiers from the battlements of a besieged city. Other protection came from the long leather cloaks that draped over the shoulders and closed across the chest with a wide strip of leather. Military historians suggest that the cloaks were made of leather rather than woven material because copper or bronze disks were affixed to them and to the leather shields to help deflect thrusts of the opponents' spears. Yet the soldier marched barefooted. One can only imagine the tough and callused soles of the soldiers' feet after a lengthy campaign against a distant city-state.

Sculptural representations of the Sumerians always depict both men and women as barefooted, including nobles, priests and even the gods. Not one of the Tell Asmar votive statues shown in Figure 2-3 is depicted wearing shoes. Certainly, footwear was not unknown to the Sumerians. Numerous artifacts have been discovered throughout Mesopotamia to prove

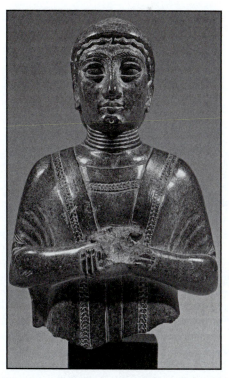

Figure 2-4. As fabric production increased during the late third millennium BCE, layered garments such as shawls and scarves became more prevalent, especially for women's costumes. Woman from Telloh wearing a shawl, c. 2300 BCE.

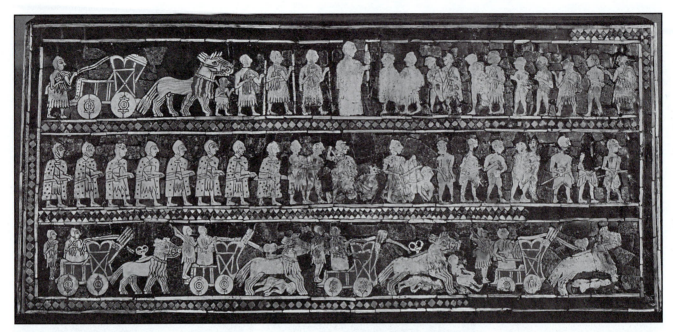

Figure 2-5. Sumerian military uniforms consisted of the traditional fringed wrap skirt, pointed leather helmet, and leather cloak affixed with bronze disks as armature. Foot soldiers marched barefooted and fought with metal tipped spears and leather shields. Top, detail of *Standard of Ur*, c. 2600 BCE; bottom, detail of *Stele of the Vultures* from Lagash, c. 2500 BCE.

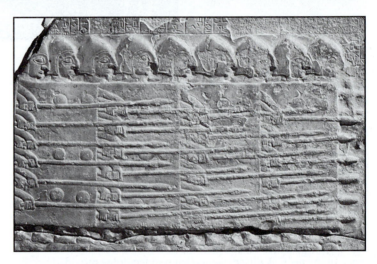

The Era of Metals

Metallurgy is the processing of ores and malleable metals into usable objects. Although some gold nuggets have been found in Paleolithic sites from 30,000 years ago, the actual working of metals is thought to have first emerged sometime in the eighth millennium BCE. In the Anatolia region of present day Turkey, copper artifacts such as ingots and beads have been discovered near what are thought to be man's earliest mining operations. Copper is a soft, malleable metal that was easily hammered into all varieties

of tools, weapons, and ornaments. The Otzi Ice Man discussed in chapter 1 was found with a superbly crafted copper axe.

The flood plains of Mesopotamia lacked deposits of metal ores but the region was rich in raw petroleum materials such as bitumens and asphalts, which were necessary fuels for metal production. Consequently, sometime during the fourth millennium BCE, the city-states of Sumer began importing ores for processing from the mining settlements of the mountains to the north and east. **Bronze**, an alloy of copper and tin, was probably discovered when

copper ores that also contained tin were smelted. By the middle of the third millennium BCE, Sumerian bronze goods were being traded as far west as Egypt and as far east as the Indus Valley.

The Hittites are credited with Mesopotamia's earliest Iron Age technologies in the middle of the second millennium BCE. Improvements in ore smelting processes allowed for temperatures hot enough to melt iron. Since iron tools and weapons were superior to those of bronze, the Hittites were able to rise to empire and dominate the region for five hundred years.

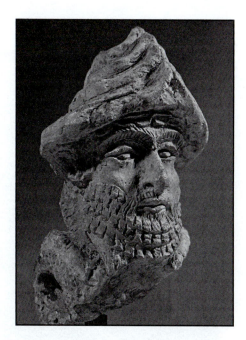

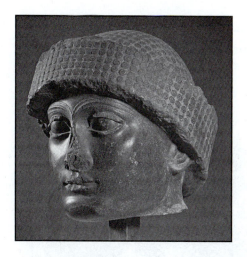

Figure 2-6. Although the cuts of Sumerian garments were mostly simplistic and unvarying for centuries, craftsmen showed great originality and creativity in designing headcoverings and other accessories. Left, tiered bull's horn diadem worn by a god from Girsu, c. 2300 BCE; right, man's hat made of karakul or a knotted textile, c. 2100 BCE.

that the Sumerians enjoyed a thriving trade with regional neighbors, including Egypt. Contemporary with the Sumerian civilization, a number of Egyptian artworks of the Old Kingdom depict various types of sandals worn by men and women. It is curious, then, given the Sumerian indulgence in such wide varieties of hats, headdresses, jewelry, and other accessories, that they seem to have no shoe styles as part of their costume. The earliest known artwork from Mesopotamia depicting a figure wearing that most basic of ancient footwear, sandals, is from the reign of Sargon I, around 2200 BCE, more than a century after the collapse of the Sumerian civilization.

Among the many types of civilian hats represented in Sumerian sculpture are round-domed styles with the brim turned up, somewhat like an oversized modern sailor's cap. These were made of assorted materials including woven fabrics, molded or pieced leather, and raw wool. On the example shown in Figure 2-6, the tight, tiny curls of the **karakul**

lamb's fleece have been stylized into a pattern of whorls all around the hat. One scholar has suggested that the whorls may represent a knotted or textured textile rather than fur. Another version of the same silhouette was made of smooth leather and decorated all over with copper or bronze studs that would have shimmered brilliantly in the Mesopotamian sun. The most elaborate head coverings, though, were reserved for representations of the gods. Curving bull horns with the points meeting at the front were arranged in an ascending stack around a truncated cone of felt or leather. These styles of hats would later be adopted by Assyrian kings as imperial crowns.

Sculptures of women most often depict elaborate coiffures and wigs rather than hat styles. One of the earliest Sumerian sculptures of a woman's head from about 3500 BCE shows flattened indentations and incisions for attaching a fur or possibly human hair wig. Still, a few Sumerian sculptures document two principal types of feminine hats. (Figure 2-7.)

Figure 2-7. Two principal types of hats featured in Sumerian sculptures include a rolled headband with an open crown for maidens and turbans of sophisticated designs for matrons. Left, rolled headband on maiden from Ur, c. 2300 BCE; right, plaited turban on woman from Tell Agrab, c. 2500 BCE.

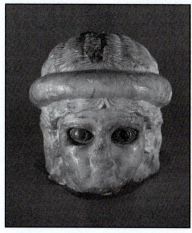

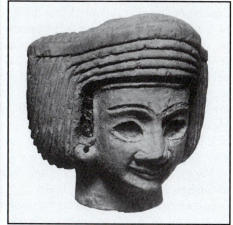

Figure 2-8. Among the royal headdresses found in the cemetery at Ur was a multilayered design thought to belong to Queen Puabi. Thinly hammered ribbons of gold enwrapped a wide wig on which strands of gold and jewel-encrusted ornaments were arranged, c. 2600 BCE.

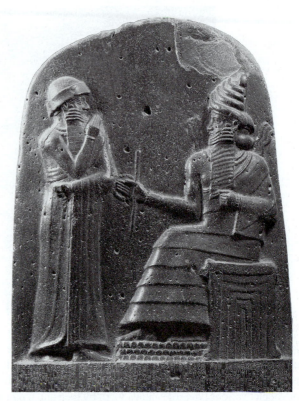

Figure 2-9. Two traditional styles of Sumerian costumes that were adopted by the Babylonians are depicted on the *Stele of Hammurabi*, c. 1760 BCE. The standing figure wears the basic wrap garment covering the left shoulder and tucked under the bare right arm. The seated figure of a god wears the more extravagant tiered costume created by a spiral wrap.

For maidens, the most common style was a large rolled band with an open crown. The band fitted over hair worn down over the shoulders. For matrons, the various arrangements of **turbans** reveal an interesting social dichotomy about Sumerian women. On the one hand, the turbans demonstrate a showy extravagance of style and design while at the same time modestly concealing the hair, a cultural tradition of the Near East that has continued over the centuries to the present.

The most opulent and ostentatious adornments for Sumerian women of high station were the royal **headdresses** worn by the queens and their attendants. The reconstruction drawing of Queen Puabi's headdress in Figure 2-8 shows the high quality of craftsmanship and creativity used in designing these royal headdresses. Thinly hammered and uniformly cut ribbons of solid gold enwrapped a wide wig and held the headdress in place. Around the crown of the head were layers of gold and bead rings, gold beech and willow leaves encrusted with jewels, and a strand of eight-petal blossoms of lapis lazuli and carnelian. From the back towered a sculpted bouquet of gold flowers that arched forward over the queen's head.

Such dramatic finds as the fabric remnants, garment trimmings, headdresses, and jewelry that were excavated from the Royal Cemetery at Ur are but tantalizing glimpses of the richness of Sumerian costumes. Much more, we hope,

remains to be discovered to fill those troublesome gaps in our knowledge of the development of costume in the cradle of civilization.

THE BABYLONIAN AND HITTITE EMPIRES

As discussed previously, the Sumerians achieved great leaps forward in man's cultural and technological evolution, including the development of siege warfare. During the third and fourth millennia BCE, regional power continually shifted from one city-state to another as aggressive, ambitious ensi, the priest-kings of Sumerian city-states, battled to secure dominion over their neighbors. Around 2300 BCE, Sargon I, a ruler from the city of Agade, marched his armies far beyond the gates of adjacent city-states and eventually seized the whole of Sumer. Unlike previous conquering ensi, though, Sargon abolished local priest-kings and consolidated power into a singular imperial authority. However, his dynasty barely lasted a century and his descendants were ousted by invading nomadic tribes from the east. Between 2200 BCE and 1900 BCE, power once again shifted back and forth between

city-states during an era of chaos that many historians call the Neo-Sumerian period. Ironically though, these conquering peoples were Semitic, who retained their respective languages while adopting the Sumerian culture. Written evidence indicates that Sumerian actually became civilization's first dead language during this time.

Around 1900 BCE, Babylon emerged as the dominant hegemony of the region. Over the following two centuries, a succession of powerful kings gradually annexed surrounding territories, strengthening the supremacy and wealth of Babylon. By the middle of the eighteenth century BCE, the mighty Babylonian king, Hammurabi, had conquered and consolidated much of Mesopotamia. A centralized, imperial power once again governed the region.

Although the various migrating peoples who invaded and eventually settled in Mesopotamia spoke and wrote alien Semitic languages, all of them nonetheless shared the Sumerian cultural heritage. The Amorites, Kassites, Elamites, and other distinct ethnic groups that comprised the Babylonian dynasties wrote their unique languages with the ancient Sumerian cuneiform alphabet. Art and architecture followed the precedents established by the Sumerians. Even the most famous contribution of the Babylonians, the codification and promulgation of laws, was significantly rooted in Sumerian tradition.

Likewise, the costumes of the Babylonians were based on Sumerian styles. Depicted on the famous *Stele of Hammurabi* from c. 1760 BCE is the king standing before the enthroned sun god, Shamash. (Figure 2-9.) Hammurabi wears the traditional Sumerian wrap garment draped over the left shoulder and tucked under the bare right arm. His hat is the same style as the Sumerian version shown in Figure 2-6 with its domed crown and brim turned up into a band encircling the head. The garment worn by the figure of Shamash is another style of Sumerian costume. As befitting a god, the extravagant use of fabric is evident in the tiered skirt created by a **spiral wrap** whereby a long tapering piece of material was wrapped around the body to form overlapping tiers. Here, too, the left shoulder and arm are covered, but the right arm is bare. His head covering clearly shows the tiered bull horns denoting divinity.

Although Sumerian clothing styles were the basis for early Babylonian costumes, new types of garments were also adopted from the various migrating tribes of the period. Most notable was the introduction of a cut-and-sewn short-sleeve **tunic** that extended to the knees. Ankle-length versions were worn by women and men of high rank. (Figure 2-10.) This highly functional garment was simple to construct since the sleeves were not set in. It is unclear which of two possible methods were used to make these types of tunics. In one method, two pieces of fabric were cut in a T-pattern, and both sections were then stitched together leaving openings for the neck and arms. The other was made of one piece of material folded at the shoulder

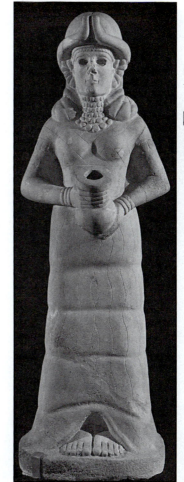
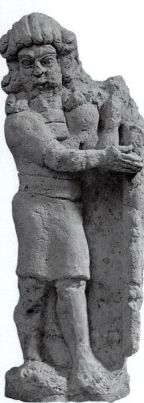

Figure 2-10. A loose-fitting, short-sleeve tunic that extended to the knees was introduced to the Babylonians by nomadic horsemen who invaded Mesopotamia during the migrations of the mid-second millennium BCE. Upper class men and women wore ankle-length versions. Left, figure of a goddess, c. 1750 BCE; right, terracotta figure of a mythological hero, c. 1450 BCE.

line and sewn up the sides with separate tubular sleeves stitched to the armholes. The Babylonian tunic allowed greater freedom of mobility than did the wrap garments, which could easily come untucked or loose from their girdles. Eventually the Babylonian tunic replaced the Sumerian wrap garments, except for costumes of the upper classes. The nobility, priests, and ranking officials adapted versions of the Sumerian wrap garments to be layered over the long tunics. For the ruling classes of Babylonia, the Sumerian styles of clothing were a link to a more ancient civilization than their own and served as a symbol of the legitimacy of their authority.

One aspect of the traditional Sumerian costume that the Babylonians continued to favor was the lavish use of fringe. The bronze statue of Queen Napir-Asu from the fourteenth century BCE shows three different layers of fringed garments.

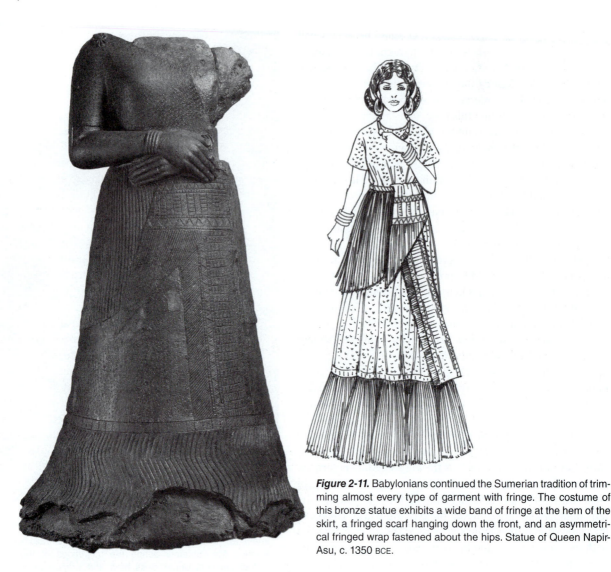

Figure 2-11. Babylonians continued the Sumerian tradition of trimming almost every type of garment with fringe. The costume of this bronze statue exhibits a wide band of fringe at the hem of the skirt, a fringed scarf hanging down the front, and an asymmetrical fringed wrap fastened about the hips. Statue of Queen Napir-Asu, c. 1350 BCE.

(Figure 2-11.) Her short-sleeved tunic is possibly made of a richly woven fabric or decorated with a handstitched pattern—a sewing technique called **embroidery**. The length extends to the floor where it ends in a wide border of fringe. It is not clear if this fringe was attached to the tunic as trim or if the long strands are the cut warp threads of the fabric. Fastened around the hips over the skirt is an asymmetrical wrap garment somewhat like an **apron** that is also heavily fringed. From her belt hangs a scarf decorated with a woven or perhaps embroidered pattern and edged with a wide trim of fringe.

The textiles of the Babylonians were likely the same kinds of woven wool and linen that the Sumerians had developed. **Fine gauge** linen, a fabric woven with a denser count per inch of the finest threads, was reserved for those of the upper classes who probably used it as a lining for woolen or leather garments. Priests were thought to wear garments

made entirely of fine linen that had been bleached to a brilliant white. Coarse linen was used in producing sailcloth, household textiles, and the basic styles of tunics worn by ordinary people.

Around 1600 BCE, Babylon was sacked by the Hittites, an early Indo-European people who had established a substantial empire to the north in what is today modern Turkey. The Hittites are credited with introducing the horse and battle chariot into Mesopotamia. Once they had conquered a region, the Hittites governed through a loose confederation of vassals, which resulted in frequent uprisings from satellite provinces. Consequently, they were constantly at war to preserve order and maintain their control.

Most surviving representations of the Hittites depict warriors and warrior gods. (Figure 2-12.) Their costumes principally were adaptations of the Babylonian short-sleeved tunic over which a wrap skirt was held in place by a wide

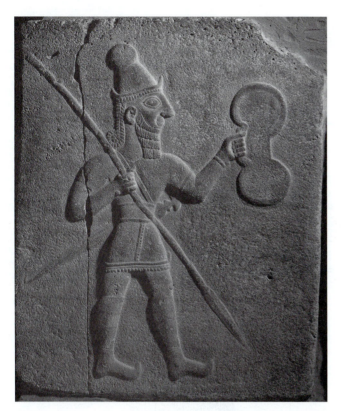

Figure 2-12. The costume of Hittite warriors featured the Babylonian short-sleeve tunic and a short wrap skirt grided with a wide leather belt. Shoes and boots were shaped with an upward curving pointed toe. Relief carving of a Hittite warrior, c. 1200 BCE.

leather belt. The close-fitting skirt extended only to mid-thigh and had a straightline or sometimes a diagonally cut opening in the front. Some depictions of Hittite costumes show the skirt worn alone with a bare torso.

Almost nothing is known about the clothing of ordinary Hittites. We may deduce from the scant sculptural evidence that the T-cut tunic was the prevailing style. Lengths for civilian versions are unknown. Some later Hittite sculptures (after subjugation by the Assyrians) show the hemlines of men's tunics at the knees and women's tunics at the ankles.

The high, pointed style of Sumerian helmet made of leather had been adopted and modified by the Hittites. Versions worn by commanders were sheathed in brilliantly polished copper or bronze and had truncated tops with crests. Smaller, more maneuverable rounded shields, covered in thin sheets of copper or bronze, had replaced the cumbersome phalanx shields of leather used by the Babylonians.

By the beginning of the twelfth century BCE, the weakened Hittite Empire finally succumbed to internal strife coupled with invasions of migrating peoples from the east and the Assyrians from the south. As with the Sumerians, the Hittites were absorbed into the later dominating cultures of Mesopotamia and eventually disappeared altogether.

THE ASSYRIAN EPIC

Contemporary with the rise of the Hittite Empire was the kingdom of Assyria to the south, whose region of dominion encompassed most of the upper Tigris River valley. About the same time that the Hittite Empire began to collapse, the Assyrians launched their territorial expansion. Records from the reign of King Tiglathpileser (1115–1077 BCE) show that the Assyrians believed it was their duty to their gods to conquer and expand the empire: "Assur and the great gods, who have made my kingdom great, and who have bestowed might and power as a gift, commanded that I should extend the boundary of their land, and they entrusted to my hand their mighty weapon, the storm of battle."

During the eighth and seventh centuries BCE, at its height of power, the Assyrian Empire encompassed much of southwest Asia Minor from Anatolia to the Persian Gulf and even included Egypt. The Assyrians had learned valuable lessons from the Hittites about managing an empire. Not only would the Assyrians sack a rebellious city but, in some instances, they would even relocate the entire native population throughout the empire and resettle the city with loyal Assyrian colonists. If a rebellion was particularly egregious, Assyrian monarchs could be utterly ruthless as King Esarhaddon was with Sidon in 681 BCE. As an example to all provinces throughout the empire, the entire city was razed, and resettlement was forbidden.

Emphasis, then, for state-sponsored art was on the glorification of war and, hence, the glorification of their gods. As a result, a wealth of visual information in the form of stone statuary, relief carvings, and wall paintings has survived to give us pictorial documentation of Assyrian dress.

With most official artwork of Mesopotamia, the upper classes and members of the royal court are the subjects represented most often. From these images, it is evident that, for the most part, the Assyrian nobility continued the costume traditions of Babylonia. The short-sleeve tunic was worn under assorted types of wrap garments including variations of the **Royal Cloak**—one of several outer garments exclusive to the king but particularly the spiral wrap. The line drawings in Figure 2-13 are based on a model suggested by the costume historian Carl Kohler. His pattern forms the cloak from a long piece of cloth that is tapered to a point on one end and fringed along the bottom edges. Beginning at the front waist, the cloak is spiral wrapped around the figure three times. With the third wrap, the tapered end enfolds the left arm like a sling and then passes around the neck to tie at the front. A wide belt then girds the layers at the waist. Given the impractical binding of the left arm, though, the garment was likely ceremonial only and worn only for high state or religious events.

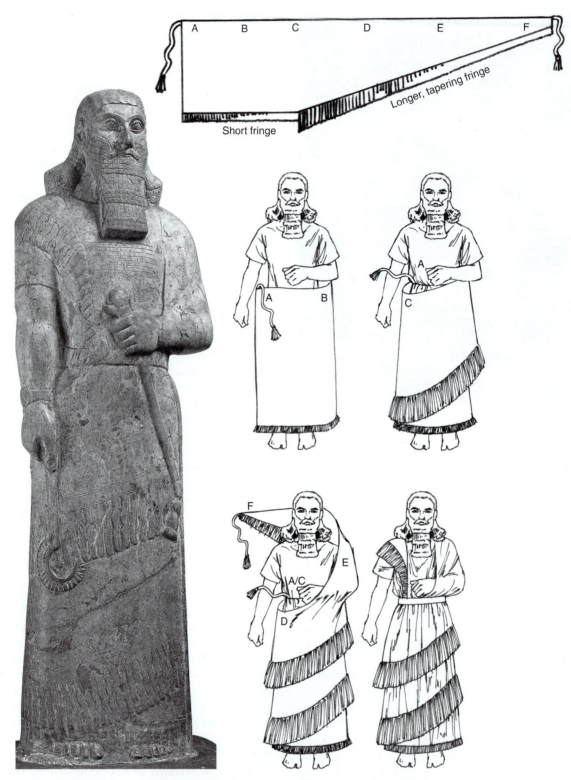

Figure 2-13. The Assyrian Royal Cloak was possibly created by the spiral wrapping of a long piece of tapered material with fringe on two edges. Statue of Assurnasirpal II, c. 850 BCE.

Another new type of ceremonial clothing that the Assyrians introduced was the High Priest's apron. (Figure 2-14.) The richly patterned garment was tied around the waist and draped down the back of the legs to the ankles with tasseled cords and the opening in the front. One side had a straight edge and the opposite side was rounded, both trimmed with fringe. The apron was worn over a knee-length tunic, which also was decorated with wide fringed borders.

The king's diadem was a truncated conical hat made of felt and decorated with gold bands. On the center top was a gold spike, and at the back hung purple tabs called **infulae**. For religious occasions, where the king served as the head of the faith, the diadem was decorated with stacked bull's horns, which curved around to the front with the points turned upward. This religious iconography had first been used on Sumerian statues of gods 2,000 years earlier.

Assyrian military apparel varied widely from the ninth century BCE forward. This was the dawn of the Iron Age in Mesopotamia. To the Assyrians, the most logical application of ironwork was for implements of war. Iron replaced bronze for the production of weapons, shields, mail, and helmets. Examples of pointed iron helmets, some with curved attachments for crests, have been excavated from Assyrian battle sites. Pieces of iron **mail** have also been found by the hundreds at these sites. The metal platelets were pierced for stitching to a leather or linen **cuirass** forming a vest-like armor for the torso.

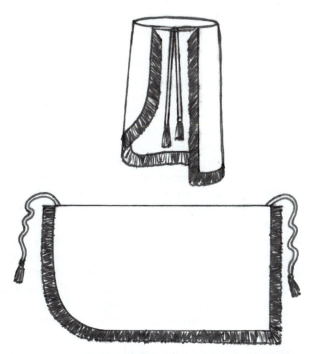

Figure 2-14. Representations of Assyrian priests often include depictions of a wrap apron that was tied around the waist with tasseled cords in the front. One side of the front opening was cut with a rounded corner, and the opposite hung as a straight edge.

Depictions of the costumes for the various specialized forces of the Assyrian army seem to vary significantly. For example, archers represented on the bronze gates of Balawat (c. 850 BCE) appear to be wearing ankle-length tunics of quilted fabric with no fringe. Archers shown in the reliefs from the palace of Kalhu (c. 750 BCE) wear ankle-length tunics covered with iron mail to the waist and fringed at the bottom of the skirt. Still other archers shown in the reliefs at the palace of Nineveh (c. 700 BCE) wear the Hittite style of thigh-length tunic with a wide, fringed sash hanging down the front. Similar variants in military costumes over the decades can be noted among the representations of infantrymen and cavalrymen.

One notable addition to the costumes of Assyrian soldiers was footwear. By the eighth century BCE, several varieties of shoes, ranging from basic sandals to boots, were designed for the military and nobility. The elite mounted archers wore the most elaborate boots, some extending up to mid-calf and others to the knees. Both versions of boots were completely open down the front and were cross-laced with leather thongs. For added comfort and protection, horsemen also wore soft, woven leather or quilted fabric leggings under their boots that extended from ankle to mid-thigh and were held in place by leather straps.

Civilian footwear seems to have been in much more limited use. Most depictions of ordinary people show bare feet. Even kings and courtiers were mostly represented wearing simple sandals except in battle or hunting scenes. The most prevalent style of shoe was a basic **sandal** featuring an innovative low wedge sole and a covered heel that tapered to bare toes. (Figure 2-15.) They were secured by a leather loop for the big toe and a double strap fastened over the arch. This style of shoe apparently was not ornamented or varied much in design. According to one Athenian writer, the Greeks regarded the Assyrian sandal designs as utterly "second-rate."

Unlike with the Sumerians and Babylonians, artwork of the Assyrians more frequently depicted ordinary people. One series of relief carvings commissioned by King Sennacherib (694–681 BCE) records how the colossal winged guardians were quarried and transported to the palace at Nineveh. Hundreds of common laborers, foremen, and support personnel are depicted in various activities, dressed in the costumes befitting their status. Most of the figures wear the simple short-sleeve tunic, which extends to the knees and has no fringe trimming. Figures that appear to be foremen wear tunics with fringed wrap skirts or basic tunics with a fringed sash that cascades down the front.

More telling, though, are the numerous commemorative scenes of siege warfare in which refugee civilians are represented. Of particular significance are the images of ordinary women. (Figure 2-16.) The role of women in Assyria was much more restricted and subordinate than that of their female predecessors in Babylonia. Many of the rights granted

Figure 2-15. In addition to boots worn by the Assyrian elite, simple leather sandals were the most prevalent footwear. The distinctive design of the Assyrian sandal with its innovative wedge sole and tapered heel casing, nevertheless, was regarded as "second-rate" by the Greeks.

to women in Hammurabi's time were rescinded by the Assyrians. Surviving records document that strict regulations even extended to women's costumes, including a requirement for the veil in public. Mostly this restriction meant covering the hair rather than concealing the entire head and face as we see in certain orthodox Islamic cultures today. For women of the Assyrian nobility classes, elaborate hats and headdresses substituted for the veil. (Figure 2-17.)

During the seventh or eighth centuries BCE, cotton was introduced into Mesopotamia from India. Written archives from this period refer to "wool that grows on trees" as a new raw material for spinning and weaving. Cotton is certainly easier to prepare for textiles than flax for linen, and it is less costly than wool.

By the end of the seventh century BCE, the whole of Assyria erupted into uprisings and civil war. Succeeding Assyrian kings had pursued iron-fisted policies toward vassals and neighboring kingdoms rather than forging alliances and partnerships. Among those neighbors that Assyria had battled off and on for almost 200 years was Media, a kingdom on the northwestern edge of the empire. In 612 BCE, the Medes invaded, easily taking city after city. Meanwhile, to the south, Babylon revolted and rushed its forces to join the Medes against the Assyrians. To seal the pact, the crown prince of Babylon, Nebuchadnezzar, married a Median royal princess. Against this powerful alliance, the weakened Assyrian Empire could not endure. Over the next few generations, the Assyrians were absorbed into the Mesopotamian melting pot of ethnic peoples.

The Median Empire was short-lived, however, barely lasting a few decades. The Medes had always been a nomadic people and were inexperienced in governing on an imperial scale. They produced no monumental art, tomb paintings, or sculpture that documented what they looked like or the costumes they wore. Instead, their cultural legacy would endure through their conquerors, the Persians.

THE GOLDEN EMPIRE OF PERSIA

The small kingdom of Persia was a vassal of the Median Empire at the beginning of the sixth century BCE. In just two generations, though, Cyrus the Great (c. 558–530 BCE),

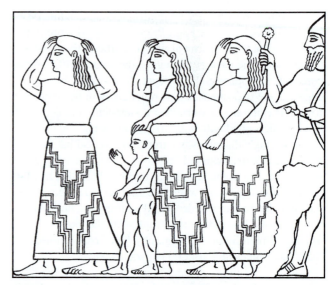

Figure 2-16. Depictions of ordinary people, especially women, in Assyrian artwork were more common than with Sumerian or Babylonian examples. This detail of a ninth-century relief depicts women refugees fleeing the destruction of their city by invaders. They hold their hands to their unveiled hair since they did not even have time to gather belongings or cover their heads. Each woman wears an ankle-length T-cut tunic made of geometrically patterned fabric. Wide rolled belts cinch the waists.

followed by his son, Cambyses II (c. 530–521 BCE), conquered the entire region of Asia Minor from the Black Sea in the north to the Arabian Sea in the south and from Egypt in the west to India in the east—an area encompassing about 5 million square miles. Their subject races ranged from the highly civilized Egyptians and Ionian Greeks to the Neolithic peoples of the Oxus and Indus River valleys.

Unlike the Assyrians, however, the Persians governed their vast empire with much more religious and cultural tolerance. At its peak in the fifth century BCE, the Persian Empire consisted of twenty-nine provinces known as satrapies. Each satrapy was ruled by a governor, called a satrap, who had the power of an absolute monarch in his domain. To keep these satraps in check, the king personally appointed the finance minister and military garrison chief for each province. Otherwise, local customs, religions, and civic laws were largely left in place. From the carvings on the grand stairway at the palace of Persepolis, one can get a feel for just how diverse the nationalities of the Persian Empire were in the fifth century BCE. Depicted in the New Year's procession, during which each satrapy paid its annual tribute and taxes to the Great King, are Medes, Parthians, Ionians, East Indians, Lydians, Bactrians, and Scythians, to name a few, many wearing the distinct costumes of their nationality.

From such a varied mixture of cultures, the Persians appropriated elements from a wide assortment of costumes, but most especially those of the Medes. Herodotus wrote at the time, "No race is so ready to adopt foreign ways as the

Persians; for instance they wear the Median costume because they think it is more handsome than their own." Most likely the costume referred to was the **fitted coat** or jacket and **trousers** first introduced into Mesopotamia by the Medes in the eighth or seventh century BCE. As nomadic horsemen, the Medes had developed a form of protective leggings that were sewn together at the crotch and enclosed the hips to the waist. No images of these Median trousers remain so we do not know how these garments looked or fit nor how they were bound at the waist. However, Cherchen Man's clothing shown in chapter 1 may indicate a common form of both jacket and trousers for these people originally of the steppes. Through the Persians, the trouser and jacket costume was gradually disseminated throughout the region by their armies of occupation and government bureaucracies.

This Persian two-part costume is a marked contrast to the swathing wrap garments, such as skirts and shawls, that had prevailed as the dominant style of clothing in Mesopotamia for millennia. (Figure 2-18.) The Persian style of trousers was cut full about the thighs and tapered to the ankles so they could be tucked into boots. As with Cherchen Man's trousers, these were likely made of a wool twill. However, Herodotus wrote that the Persian warrior's trousers

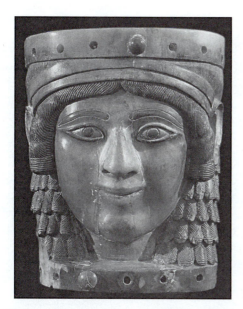

Figure 2-17. Surviving Assyrian records have documented laws that required women to wear veils, which meant covering the hair but not the face. Women of the nobility classes substituted elaborate hats and headdresses for veils. Female head from Nimrud, c. ninth to eighth century BCE.

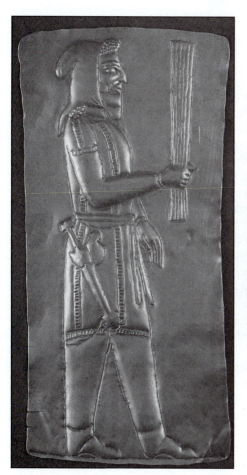

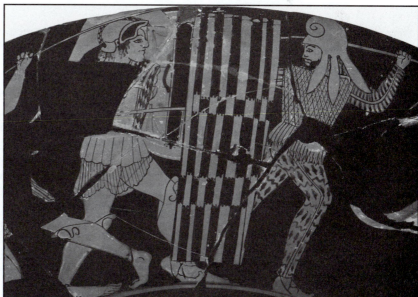

Figure 2-18. The Persians adopted the two-piece trouser and jacket costume from the Medes and spread the style throughout their realm of Asia Minor. Left, gold plaque of a Persian warrior, c. 400 BCE; right, detail of vase painting of a Persian warrior in patterned trousers, c. 480 BCE.

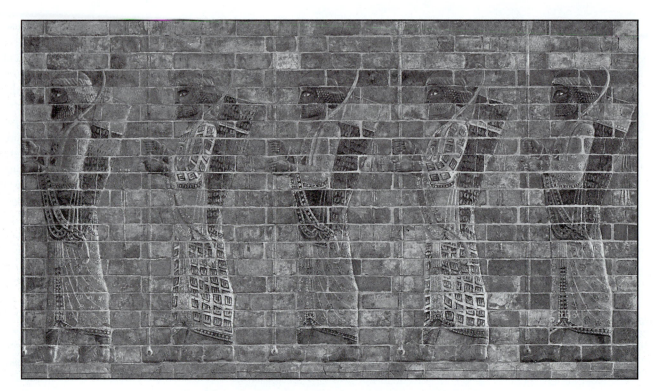

Figure 2-19. The Persian style of the voluminous, sleeved robe, called a kandys, was adapted from a simpler Median design. This elaborate, richly decorated garment was reserved exclusively for the nobility and elite corps of warriors called the Ten Thousand Immortals. Frieze of Archers from the palace at Susa, c. 500 BCE.

were made of leather, and numerous Greek paintings show Persian soldiers wearing vividly patterned trousers that fitted as snugly as modern-day tights.

Another significance in the emergence of the jacket and trouser costume was the need of pattern making and tailoring for a more precise fit for the wearer. We do not know to what extent Persian clothing makers developed standardized measurements for jackets and trousers—waist sizes, inseams, shoulder widths, sleeve lengths—but depictions in artwork indicate that the Persian jacket was fitted and, for the first time in history that we know of, constructed with close-fitting **set-in sleeves**. The skirt of most styles of jackets extended to the knees, although some appear in artwork at mid-calf or cropped short at the hips.

The upper classes of Persia also adapted a style of robe, called a **kandys**, from the Median nobility. This voluminous, flowing garment was constructed similar to the Babylonian tunic. Here, though, the design was wider and had to be gathered at the sides to blouse over a wide girdle forming deep, full folds. The set-in sleeves were fitted at the shoulderline but flared into wide openings at the wrists. The privilege of wearing this garment was later extended to the king's elite bodyguard called the Ten Thousand Immortals. A frieze of brightly colored glazed bricks from the fifth century BCE

depicts these warriors wearing the kandys in a ceremonial procession. (Figure 2-19.) The richly woven and embroidered fabrics are designed with multicolored geometric patterns and representations of fortresses. Priests also wore a variation of the kandys although their version was bleached white and devoid of any ornamentation. For high religious services, however, priests donned a purple kandys that had been colored with a rare dye called **murex purple** made from the ink glands of tiny Mediterranean mollusks. This color was also used for robes of the imperial family and selectively applied as trim for garments of the nobility. The combination of the luxurious, wide kandys-style robe and the splendor of the color purple are thought to have been adapted by migrating tribes like the Dalmatians, who later introduced the garment to the Romans, versions of which survive today in the ecclesiastical vestments of the Catholic Church.

Persian footwear was vastly different from that of their predecessors, the Assyrians. Judging from the hundreds of carved figures at Persepolis, designs of Persian shoes varied greatly. Some figures wear ankle boots with toes that curl up into a point. Other boots extend up to mid-calf and have rounded toes. Regular shoe styles feature straps that fit over the instep like spats. Some shoes are of soft leather and have

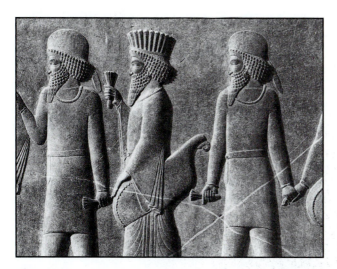

Figure 2-20. Two styles of hats that Persian nobility adapted from Median styles included the fluted felt khula and a high-domed, brimless bowler style. Bas-relief from Persepolis, c. 500 BCE.

a rolled top at the ankles. Still other depictions of shoes include slipper styles and sandals. Xenophon recorded in his *Cyclopaedia* that courtiers at the palace of Darius II "have shoes of such a form that without being detected the wearer can easily put something into the soles so as to make him appear taller than he is."

Hats and headdresses worn by Persian nobility were also adaptations of Median styles. Whereas Assyrian kings wore a type of diadem that tapered upward into a truncated cone, the Persian kings preferred a brimless, cylindrical hat called a **khula** that flared wider at the top. Versions of the khula included an imperial design of purple or crimson felt encrusted with jewels and gold embroidery worn only by the king. Another style of the khula was fluted with a scalloped crown that was worn by high ranking officials and the nobility. One

other hat style commonly depicted in artwork that was probably of Babylonian origin is a high-domed, brimless **bowler**. As with the khula the tall bowler was worn exclusively by the nobility. (Figure 2-20.)

Ordinary Persians wore a close-fitting cap called a **casque**. It was topped with a point that was usually folded or curled forward onto the crown, although some depictions show the point hanging down the back. This style of cap also seemed to have been appropriated from the Medes, who, in turn, had adapted the design from another nomadic tribe of the steppes, the Phrygians. Intact versions of this cap were excavated from Cherchen Man's grave, dating to about 1000 BCE. One variation of the Persian casque included one or two side flaps that protected the ears and a third wider flap at the back for the neck. Soldiers wore a leather version of this style and in battle wrapped a scarf completely around the hat covering the entire head except for the eyes and nose. (Figure 2-21.) For the peasant classes, plain **fillets** or headbands made of leather or fabric were most prevalent when anything at all was worn.

Very few pictorial representations of Persian women exist. This is hardly surprising since the Persians adopted the Assyrian tradition of subordinating women and keeping them secluded in households. Those images that have survived depict the basic ankle-length tunic over which was worn a veil that covered the hair.

A special note should be made about the absence of fringe on Persian costumes. For the first time in the succession of cultures since Sumerians initially wrapped themselves in the shaggy wool kaunakes, the masters of Mesopotamia did not adopt fringe as a symbol of rank and authority or even as a decorative element.

As the fourth century BCE drew to a close, a juggernaut, unlike anything the world had ever known, invaded the northern borders of the Persian Empire. The twenty-one-year-old

Figure 2-21. Ordinary Persians wore a close-fitting cap, called a casque, that featured a pointed top that folded or curled forward. Soldiers often secured this cap with a scarf while in battle. Other versions were adapted from Phrygian styles that included side and neck flaps. Left, figure of a Persian warrior from the Parthenon, c. 450 BCE; right, Phrygian cap, c. 500 BCE.

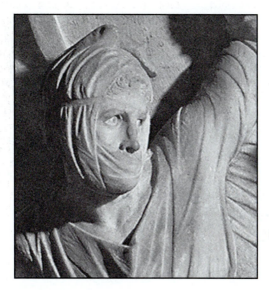

Macedonian king, Alexander, challenged civilization's greatest empire in 334 BCE. Within three years, he stood at the burning palace of Persepolis, his army having defeated the last of the Great Kings of Persia.

REVIEW

In southern climates, Neolithic communities emerged much sooner than in northern regions. In the river basins of Mesopotamia, early settlers developed agriculture and domesticated animals. They built permanent architecture and created advanced technologies such as the pottery wheel and textile loom. In Sumer, three great advancements of civilization were achieved: formalized religion, the city-state, and writing. Later cultures expanded upon what the Sumerians had wrought including the codification of laws by the Babylonians, the advancement of warfare tactics by the Hittites, and the refinement of imperial administration by the Assyrians and Persians.

The costumes of succeeding Mesopotamian civilizations evolved slowly across three millennia. The animal skin skirts of the early Sumerians developed into assorted woven fabric styles of colorful, richly fringed wrap garments. Influences from invading peoples altered the traditional costumes of subsequent Mesopotamian cultures. For example, the cut-and-sewn tunic was adopted by the Babylonians and layered with their versions of wrap garments. A thousand years later, the tradition of these wrap garments survived primarily in ceremonial costumes of the nobility, priests, and kings of Persia. For most ordinary people of ancient Mesopotamia, the simple T-cut tunic prevailed.

By the first millennium BCE, the migrating peoples of Media seized a brief moment of power in Mesopotamia. Through them a radically new concept in dress was introduced to the region: jackets and trousers. Upon the conquest of Media by the Persians, tailored adaptations of the jacket and trouser costume were spread throughout Asia Minor.

Warfare in ancient Mesopotamia required specialized clothing, particularly for the implementation of siege tactics. Helmets, cloaks, and shields were made of strong, durable leather. For added protection, helmets and shields were sheathed in bronze and later, iron. Cloaks, skirts, and cuirasses were covered with disks of metal for additional protection.

By the time Alexander the Great united much of the known world into one vast empire, many different civilizations had left their influences on the cultural heritage of Mesopotamia. Costumes of the region had evolved from the simplest of animal pelt wrap garments to complex, tailored jackets and trousers. Textiles for apparel had emerged from basic woven woolens and linen into a huge array of dyed colors, rich textures, and intricate patterns. The legacy of Mesopotamian costumes survives with us today in our own clothing, ranging from simple wrap shawls and fringed skirts to the set-in sleeve of the suit jacket and the measured fit of trousers.

Chapter 2 Ancient Near East
Questions

1. List the kinds of materials that were used in costumes of Sumer. Which important plant fiber was introduced later and by which Mesopotamian civilization? What were the developments and applications of metals in costume?

2. Which key apparel design innovations were introduced into Mesopotamian costumes? Include the name of the garment with a brief description, and identify the civilization most notably associated with each.

3. Trace the evolution of wrap garments from Sumer to Persia.

4. Which three types of garments were adopted from the costumes of the Medes by the Persians? What is the legacy of these garments today?

Chapter 2 Ancient Near East
Research and Portfolio Projects

Research:

1. Write a paper on the development of trousers in the ancient Near East. Explore the possible links with the styles of the Tarim Basin peoples (chapter 1) and those of the Medes. How did the Persians refine the style and what historical evidence other than that represented in this chapter confirms the fitted Persian trouser?

2. Research the artifacts found in the Royal Cemetery of Ur (c. 2600 BCE). Write a paper describing the items that document textiles, clothing, personal accessories, cosmetics, and other objects relevant to ancient Mesopotamian dress.

Portfolio:

1. Compile a swatchbook of textile patterns depicted in artworks of Mesopotamia. Clearly sketch or paste up detailed photocopies of twenty all-over, repeat patterns and twenty border trims of textiles from across the various eras and civilizations of Mesopotamia. Include written descriptions of each example: name of artwork or location of building structure, culture of origin, date, motif or pattern shown. Attach sketches or photocopies of ten corresponding motifs used as decorations for architecture, pottery, or other applied arts (e.g., palmettes on the garments of the ambassador figures at Persepolis are similar to the decorations carved onto the stairways).

2. Develop a photo album or sketchbook of unconventional styles of trousers worn in the twenty-first century. Select twenty designs worn by women and ten designs worn by men. Write a detailed description of each style including designer or maker, fabric, date, and elements of construction. Include an assessment of why these trouser designs are unconventional.

Glossary of Dress Terms

apron: an open covering usually worn about the hips

bast: the outer layer of stems from plants like flax, jute, hemp, and ramie

beetling: a process of rolling linen with wooden rolling pins on a hard surface to produce a permanent sheen

bowler: a round-domed hat

casque: a soft, close-fitting cap, usually with a point on the top

cloak: a loose-fitting outerwear garment of varying lengths that draped over the shoulders

cuirass: an armor covering for the torso, usually sleeveless

embroidery: decorative stitching on the surface of fabric

fillet: a headband usually tied around the brow

fine gauge weave: fabric woven of very fine threads creating a dense thread count per square inch

fitted coat or jacket: a constructed garment for the torso usually tailored to fit

fringe: decorative border or trim made of hanging threads, yarns, or cords

girdle: a wide belt or sash worn around the waist or hips

hackling: the process of combing flax fibers to remove woody material and straighten the filaments

headdress: any of a wide variety of adornments worn on the head

helmet: protective covering for the head worn by soldiers (and later certain athletes)

infulae: twin tabs attached to the back of royal diadems

kandys: a wide Persian robe designed with set-in sleeves that flare at the cuffs; a Greek term used by scholars of classical antiquity

karakul: a curly wool from lambs of the Near East valued as fur

kaunakes: a Sumerian wrap garment originally made of shaggy sheep or goat pelts; also a term of Greek origin later

applied to the form of woven fabric wrap garment with fringe or petal appliques of raw wool

khula: a brimless cylindrical hat that flares slightly from the crown

linen: fabric woven from the fibers of the flax plant

mail: iron platelets attached to the surface of military garments

murex: a purple dye extracted from the ink glands of mollusks

retting: the process of soaking flax plants to rot away the woody core and dissolve the gums

Royal Cloak: one of several varieties of Assyrian garments worn exclusively by the king

sandals: open shoes consisting of various thongs or straps affixed to a sole

scutching: a process for removing remnants of the woody core from flax plant stems

set-in sleeves: tailored sleeves designed to fit at an angle into the armhole of a garment at the shoulder to ensure a vertical line between the shoulder and the armpit

shawl: a piece of material variously draped over the shoulders or head

spiral wrap: a garment cut or arranged to encircle the body a number of times thereby creating tiers of overlapping material

tassel: an ornament made from threads or cords tied together at one end

trousers: a bifurcated garment covering the hips and legs

tunic: a loose-fitting garment folded or cut with holes for the arms and neck; lengths vary and styles include sleeved or sleeveless silhouettes

turban: a brimless hat usually comprised of a single strip of fabric arranged about the head

wrap garment: any of a wide variety of unconstructed clothing that wraps around the body

Legacies and Influences of Ancient Near East Styles on Modern Fashion

The types of woven wrap garments developed in ancient Mesopotamia survive today in numerous forms. One notable masculine example from the British Isles is the kilt made of plaid textiles that traditionally represent specific regions and clans. Similarly wrap skirts of all different lengths and fabrications continue to be a favorite style for women as well. Just as the simple wrap of the kilt is as effective today as it was 5,000 years ago, so too is the spiral wrap in its projection of an opulent silhouette.

Another type of woven wrap garment that developed in the ancient Near East was the shawl. Modern variations are made of woven and knit materials ranging from synthetics like rayon and polyester to luxurious natural fibers such as vicuna and cashmere.

Among the most prevalent decorative elements devised by ancient Mesopotamians was fringe. Today innumerable types of this kinetic trim are applied to a broad assortment of apparel for both men and women.

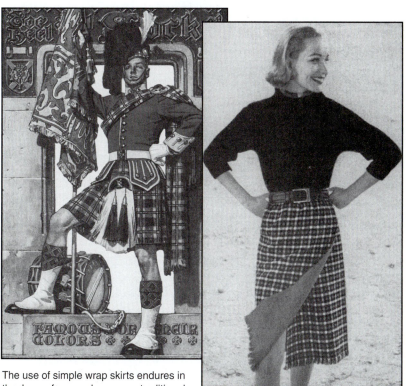

The use of simple wrap skirts endures in the dress of our modern era as traditional men's costumes in Britain and as ubiquitous forms of skirts for women worldwide. Left, Scottish Guards costume, 1927; right, women's reversible wool kilt by Sloat, 1959.

The textile shawl was a wrap garment that first appeared in the ancient Near East more than 5,000 years ago. The many varieties of shawls have continued to be an indispensible outer garment to this day. Orlon shawl from Glentex, 1950.

Fringe developed in ancient Mesopotamia possibly as a manufactured representative of the shaggy fleece surfaces of the kaunakes. Ever since, fringe has continued to be a favorite trim for a wide variety of both men's and women's garments. Fringed gown from Jay Thorpe, 1937.

Chapter 3

EGYPT

Neolithic Period	Pre-Dynastic Period	Early Dynastic Period	Old Kingdom	First Inter-mediate Period	Middle Kingdom
Early settlements along the Nile River basin	Emergence of Upper Kingdom and Lower Kingdom	Dynasties I–II First writing and brick architecture	Dynasties III–VI Pyramids at Giza	Dynasties VII–X Civil wars	Dynasties XI–XII Rock-cut tombs replaced pyramids

c. 10,000 BCE c. 4500 BCE c. 3000 BCE c. 2700 BCE c. 2200 BCE c. 2130 BCE c. 1790 BCE

Hyksos Dominion	New Kingdom	Late Period	Assyrian Dominion	Persian Satrap	Ptolemaic Period
Dynasties XIII–XVII Horse and chariot introduced to Egyptian warfare	Dynasties XVIII–XX Akhenaton and Tutankhamen	Dynasties XXI–XXV	Dynasty XXVI	Dynasties XXVII–XXXI Egypt conquered by Alexander the Great 332 BCE	Greek Dynasties Egypt became Roman province 30 BCE

c. 1790 BCE c. 1575 BCE c. 1085 BCE c. 656 BCE c. 525 BCE c. 332 BCE c. 30 BCE

CIVILIZATION ALONG THE NILE

At about the same time that Neolithic settlements were established in the Mesopotamian basin, similar agricultural communities developed in two separate regions along the Nile River in northeastern Africa. By the end of the fourth millennium BCE the distinct cultures of an Upper Kingdom and a Lower Kingdom had emerged in Egypt. Because the Nile River flows north carrying the waters of Lake Victoria to the Mediterranean Sea, the Upper Kingdom was in the south or up river, and the Lower Kingdom was in the north or down river.

These two cultures were constantly in conflict with each other, eventually resulting in the triumph of the Upper Kingdom around 3200 BCE. From that point forward, depictions of Egyptian kings often included a double or combination crown that featured the bowling-pin-shaped diadem of the Upper Kingdom set into the cylindrical crown of the Lower Kingdom.

The history of ancient Egypt is largely the history of its ruling families. At the pinnacle of this hierarchal social order was the king, the pharaoh, who was also counted among the gods. The vast number of brick and stone monuments built by these kings are enduring testaments to their cultural and civic achievements. For the inhabitants of the Nile Valley, these temples and tombs represented a timeless, well-regulated world that extended back age to age to the very origins of their universe. The Egyptian people felt secure with their gods, kings, and eternal monuments. The harsh realities of famine and flood, invasion and occupation, or royal feuds could have only a temporary, insubstantial place in such a divinely ordered society.

The social order of ancient Egypt was a theocracy. Herodotus wrote that the Egyptians were "religious to excess, far beyond any other race of men." Religion permeated every aspect of life and included a significant commitment of resources to preparing for life after death. The overwhelming majority of what we know of the ancient

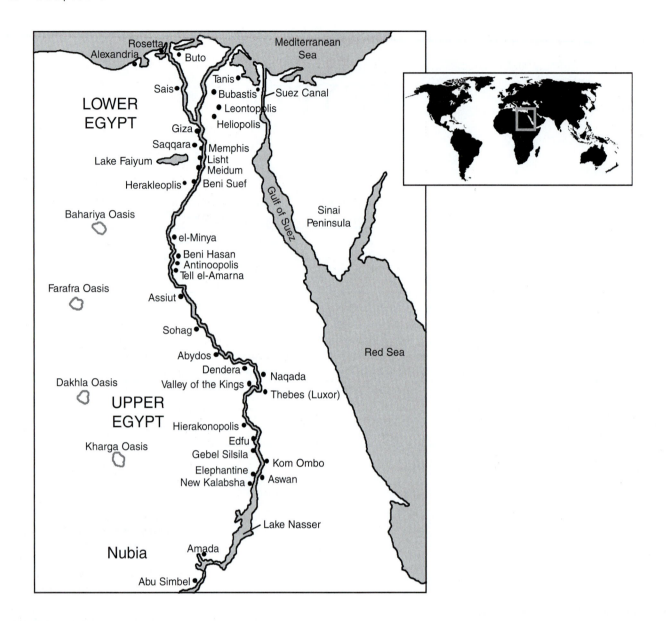

Egyptians comes to us from their tombs and gravesites. The most humble of the populace were buried in the arid sands at the fringe of the flood plains to better preserve the body as a repository of the ka, the immortal spirit. The basic needs of food, drink, and clothing went into these simple burials with the deceased to ensure as comfortable a life in the hereafter as they could afford while living. For the upper classes and the royal families, the tombs built into massive stone pyramids or carved into rock cliffs were filled with all the accoutrements of life. Beautifully rendered wall paintings depicted daily activities and varieties of recreation for the eternal delight and use of the ka. Effigies of servants were included to provide for their master's every want and care. Models of farms, gardens, and boats were arranged as replication of the world they knew and enjoyed in life. Also placed into these tombs were sculpted images

of the deceased to guarantee the permanence of their identity and to serve as a substitute dwelling place for the ka in case their mummies disintegrated.

For millennia the ancient Egyptians enjoyed a robust and vibrant society. The social order that emerged in the autocratic days of the Old Kingdom remained fairly consistent and stable until the Christian era. The social pyramid tapered upward from a broad base of peasants, most of whom worked the fields cultivating grains like wheat and barley, sesame for oil, and flax for linen cloth. Above the peasants were the narrowing layers of craftsmen, scribes and priests, village mayors, district governors, ministers of state and other ranking government officials, nobility and courtiers, and at the summit, the pharaoh and royal family as the capstone of the whole.

The tenant farm was largely self-sufficient, growing its own vegetables and grain, milling its own flour, baking its own

Symbolism in Everyday Life

Religion permeated almost every aspect of the ancient Egyptians' lives. Their beliefs explained the natural phenomena they did not understand, everything from the great cosmic forces of the sun, moon, and stars to their most intimate experiences of childbirth, illness, and death. They regarded each natural event as the province of a certain god and made prayers and offerings to the deity for protection and guidance through their everyday lives. Almost every home had a shrine devoted to an assortment of household gods whose divine powers were suited to the needs of the resident family. More than 1,000 gods were worshiped, the majority of which were represented by an anthropomorphic form as a symbol through which divine power could manifest itself:

- Re, the sun god: a falcon-headed man with a sun disk atop the head
- Hathor, the sky goddess: a cow-eared woman
- Thoth, god of writing and speech: an ibis-headed man
- Anubis, attendant of the dead and protector of graves: a jackal-headed man
- Bastet, daughter of Re, who nightly fought the serpent demon to ensure the next sunrise: a cat-headed woman
- Taweret, goddess of childbirth: a hippopotamus standing upright
- Khnum, a creator god and patron of potters: a ram-headed man
- Sekhmet, goddess of war: a lioness-headed woman

- Seth, god of chaos and storms: a monster-headed (resembling an anteater) man
- Sobek, god of surprise and danger (as in the lurking crocodiles of the Nile): a crocodile-headed man

Elements of the forms of these gods were distilled into simplified symbols representing not only the deity but the aspects of life they influenced or controlled. To capture the divine magic of these symbols, they were painted or incised onto everyday objects ranging from household pottery and baskets to headrests and bedding linens. Portable versions of the magical symbols were made in the form of amulets worn on rings, bracelets, belts, headbands, sandals, necklaces, and wig ornaments. (See page 45.)

Among the most common types of symbols used in everyday life as amulets and personal adornment were:

Ankh, the symbol of eternal life. Gods were often depicted holding the ankh to the lips of the deceased as a gesture of the "breath of life."

Scarab, the symbol of creation and sunrise. When the buried eggs of dung beetles hatched, they appeared to emerge from the ground in a spontaneous creation.

Udjat, the symbol of the eye of Horus. In the legend of the god Horus, he was blinded but regenerated his eyes. The eye of Horus thus symbolized healing.

Sesen, a lotus flower symbolizing rebirth. Because the lotus closes at night and re-opens at sunrise, the blossom symbolized life after death.

Religious symbolism was especially important in the design of temple architecture. Not only did the imagery of symbols like those described above decorate almost every interior surface, but the very structure itself was designed with symbolic meaning. As the "Island of Creation," the temple where the god dwelled, who had created all the elements of life and the universe, was sometimes constructed with serpentine brick walls that undulated as a symbol of the primeval ocean from which the island of the world had emerged. The palm, lotus bud, and papyrus capitals topping the stone columns represented the vegetation of the island world and specifically of the Nile. Ceilings were decorated to represent the sky. Even the floor level ascended at the front and sloped downward at the back to reproduce the shape of the island world as the god creator had made it.

bread, brewing its own beer, and perhaps raising a few goats and pigs. Large estates and temple foundations were also ranches as well as farms with sizable herds of longhorn cattle.

The agrarian-based economy of Egypt was dependent upon the vital waters of the Nile. The Egyptian year was divided into three seasons rather than four that followed the cycles of the river: "Inundation," or the flood season that occurred from June through September; "Emergence of the fields from water" from October through February; and "Drought," lasting from March until June. As the flood waters receded during Emergence, the farmers planted in the soft, damp soil. In the Drought season, they harvested and threshed. During the Inundation, when no

work could be done in the fields, the peasants could pay their tax-labor by working on building projects for the pharaoh, governor, or community temple order.

Scribes were the middle class, white-collar workers of pharaonic Egypt. From about age five, selected boys were schooled in the complicated system of Egyptian writing, which included more than 700 hieroglyphic signs as well as their script form. The Egyptians documented virtually everything and needed a vast army of literate bureaucrats to do the bookkeeping and tax roles, inventory the harvests and manufactured goods, and chronicle the activities of government and deeds of the king. Besides record-keeping for the state, the military and

religious foundations utilized equally as many scribes for similar purposes.

Among the most notable professions of ancient Egypt was medicine. Homer had praised Egyptian physicians as "skilled beyond all men." By the time of the New Kingdom, the medical profession in Egypt was so sophisticated that most doctors were specialists with significant in-depth knowledge of particular ailments and injuries. New generations of doctors were apprenticed rather than schooled. The range of medical knowledge and expertise of the ancient Egyptians is astounding. Surviving papyrus treatises contain detailed information on surgery, ophthalmology, gynecology, and dentistry, as well as a vast array of prescriptions for internal ailments and skin diseases. So skilled were the Egyptian doctors that they served at the imperial courts of Persia and Rome.

The family was the center of Egyptian society throughout all levels of the social pyramid. Marriage was an arranged commercial transaction for all classes; the primary wife often provided one-third of the couple's joint property and the husband the other two-thirds. Depending upon the man's status and wealth, he would also have numerous other wives and concubines who produced children. The infamous practice of brothers and sisters marrying and having children was restricted to the royal family for the purpose of ensuring the purest of divine bloodlines. Despite the high infant mortality rate, large families were common, with a preference for male offspring to carry on the family name, inherit property—as well as government or religious posts—and execute proper rites upon the death of the father.

However, daughters were not neglected. Although Egyptian society was patriarchal and females were regarded as chattel, women enjoyed certain rights and privileges that were rare in the ancient world. Egyptian women could own land and operate businesses. They were even permitted to testify in court and bring legal actions against men. On the royal level, queens have ruled as regents, and, in the case of Queen Hatshepsut, reigned as pharaoh.

Home life for the Egyptian family included a variety of leisure pursuits for the middle and upper classes. The oldest known board games, dating back to about 3000 BCE, are from Egypt. Tomb paintings reveal a love of entertaining with sumptuous banquets accompanied by music on stringed instruments and flutes to which dancers or acrobats performed. The nobility indulged in hunting—but not fishing since that was regarded as a lower class occupation and method of obtaining food. Desert hunts for gazelles, ostriches, or antelope were conducted in chariots with bows and arrows. For the poorer classes, leisure time and activities were afforded during one of the many religious festivals. Peasants and laborers participated in athletic competitions such as ball games and especially water jousting, which was performed with canoes, a team of paddlers, and a participant in each boat bearing a lance.

EGYPTIAN IDEALS OF BEAUTY

The life of the ancient Egyptian was not merely a journey toward death. Volumes of information survive from ancient times on the complexities and vitality of Egyptian social customs, etiquette, commerce, religion, medicine, and law. Among the social customs repeatedly documented in their artwork and writings—and noted by foreign contemporaries such as Herodotus—were their ideals of beauty and practices of personal grooming and body modification.

Their sculptures and paintings reveal standardized ideals of beauty that remained relatively constant for more than 3,000 years. Representations of both men and women were slender and proportioned as if tall in stature—not unlike the ideals of beauty presented in our fashion magazines today. The ideal man possessed a triangular build with broad shoulders, trim waist, and narrow hips. The ideal woman had a small waist and breasts but full, curvaceous hips and thighs.

Even if not blessed with the attributes of ideal proportions, most Egyptians practiced daily grooming and personal hygiene to varying degrees. As inhabitants of a hot, humid climate, personal hygiene was a significant concern for all but the lowest classes. Almost all Egyptians bathed regularly, and the leisure classes often bathed two or three times a day.

The upper classes of certain dynasties also removed all hair from the entire body. Beauty regimens included pumicing away unwanted hair that could not easily be shaved off. In some eras, both men and women shaved their heads or closely cropped their hair against the host of vermin common in the tropical climate of the Nile Valley. Sculptures and paintings of Queen Nefertiti (c. 1379–1362 BCE) and her daughters show their heads shaved, but some historians think that women of the early dynasties and those of the Late Period simply cropped their hair very short for easy maintenance. In either case, a headdress covered the head or an elaborate wig was worn. (Figure 3-1.) Men's facial hair was rare after the Old Kingdom. Although pharaohs were often depicted with intricately braided or curled goatees, these stylized beards were actually detachable adornments that symbolized their divine kingship. On the other hand, some images of laboring peasants realistically depicted men with unkempt hair and even male pattern baldness as well as beard stubble. Equally low in the social hierarchy were female dancers, musicians, and acrobats whose nude images reveal that pubic hair was left unshaven, possibly to emphasize the eroticism of their performances.

Cosmetics were worn by both women and men, most especially for enhancing the eyes and as protection from the glare of the sun. Eyeliner was made of powdered black **kohl**, an ore of lead, and eyeshadows were created by pulverized minerals such as malachite, lapis lazuli, or turquoise. Some records indicate that women tinted their nails with **henna**, a reddish dye extracted from the leaves of the tree by that name,

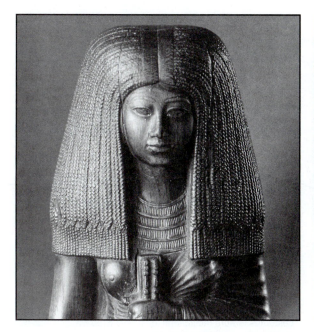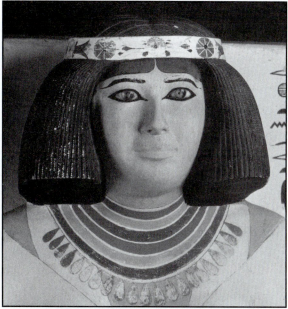

Figure 3-1. Ancient Egyptian women either shaved their heads or cropped their hair very close against the parasitic vermin common in the tropical Nile basin. Instead of natural coiffures, elaborate wigs and headdresses were worn, sometimes reaching enormous proportions. Left, detail of the statue of the Woman from Tovi, c. 1570–1314 BCE; right, detail of a statue of Queen Nofret, c. 2600 BCE.

and daubed **red ochre**, a reddish oxide of iron, on the cheeks and lips. Surviving Egyptian texts from about 2000 BCE provide lists of ingredients and directions for applying skin care formulas that promised the removal of wrinkles, age spots, and other blemishes. Fine pumice was used as an exfoliant for the elbows, knees, and feet.

The application of fragrances became as much a daily ritual as bathing. Unlike cosmetics, though, the use of perfumes, scented bath oils, and aromatic lotions had religious purpose. By the beginning of the third millennium BCE, each of the gods had a special scent associated with his or her unique powers and divine earthly presence. Incense was burned in the temples and during religious processions. At banquets, a small cone of scented wax or rendered fat was affixed to the top of each guest's head that would slowly melt and release its aroma throughout the evening. Perfumes were made in a wide assortment of scents from natural ingredients including flower petals, cinnamon, fruits, almonds, and the musks of certain animals such as the African civet cat.

COSTUMES OF THE UPPER CLASSES

Part of the ancient Egyptians' cultural tradition was a pursuit of bodily cleanliness, which extended to the fabrics of their costumes. Wool was regarded as impure and, until the Roman Period, was seldom used in apparel. Cotton was known to the Egyptians through their Nubian neighbors to the south where it had been introduced from India as early as the second millennium BCE, but the textile fiber was not widely accepted into the Nile Valley until the Ptolemaic Era. Instead, from the earliest days of their civilization, the Egyptians wore almost exclusively linen, woven of processed flax, although some early garments and accessories were made of hemp and rushes. Grades of linen varied from the finest gauge thread counts (per inch) to coarse **sailcloth** and even rough **burlap**. One of the earliest surviving examples of linen from the Second Dynasty was made with a 160 warp/140 weft thread count. Despite artistic representations of garments molding bodies like second skins, extant examples of Egyptian cut-and-sewn clothing confirm that garments were actually worn full and loose for ease of movement. For the upper classes, cascading folds and pleats of fine linen further enhanced the body when in motion with a fluidity and sensuality that greatly appealed to the body-conscious Egyptians. Varieties of sheer linen were especially popular with the upper classes since the fabric only veiled rather than concealed the body.

The earliest images of Egyptian costumes date to around 3500 BCE. A predynastic tomb painting of that time from Hierakonopolis depicts rudimentary stick figures wearing white skirts of an indistinguishable style. The silhouettes seem to indicate that, for women, the garments extended from the waist to the ankles; male figures appear to be

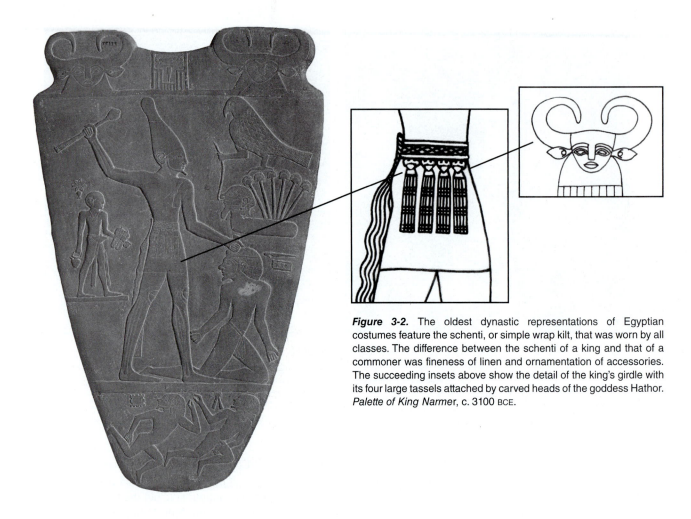

Figure 3-2. The oldest dynastic representations of Egyptian costumes feature the schenti, or simple wrap kilt, that was worn by all classes. The difference between the schenti of a king and that of a commoner was fineness of linen and ornamentation of accessories. The succeeding insets above show the detail of the king's girdle with its four large tassels attached by carved heads of the goddess Hathor. *Palette of King Narmer*, c. 3100 BCE.

wearing a short loincloth with a leopard skin draped over the torso. Due to the crudeness of the renditions, one cannot discern who the figures represent nor their social status although a cloak of leopard skin, including the animal's head, denoted a king or his surrogate, a high priest.

The oldest dynastic depictions of garments on figures date from about 3100 BCE. On the *Palette of King Narmer*—a tray used for preparing cosmetics—is a representation of the king defeating a rebellious Lower Kingdom prince. (Figure 3-2.) The king wears the simple **schenti**, a style of wrap skirt that would be the prevalent male costume for the following three thousand years. In the Narmer example, the schenti is held in place at the waist by a wide girdle of decorated leather or linen. Across the front hang four large tassels attached by carved heads of the goddess Hathor. At the back is a long fringe that represents a lion's tail, a symbol of the Egyptian ruler that persisted as part of the king's costume until the Roman Era. The figure of Narmer also wears a **corselet** that is cut away on the left side and is tied in the front over the left shoulder. Carved folds at the knot suggest that this probably was made of reinforced linen rather than leather. Narmer's diadem is the **Het**, the tall white crown of the Upper Kingdom. Strapped to

his chin is the ceremonial artificial beard of a ruler. Later depictions of this beard often omit the straps.

Also of note from the Narmer palette are the representations of the costumes of the Lower Kingdom. The defeated prince who is about to be slain by King Narmer wears only a belt around the hips with a looped hemp arrangement in the front to protect the genitals. He is fully bearded and wears his own hair long, both of which were considered traits of an inferior culture by Upper Kingdom Egyptians. In addition, one of the Lower Kingdom noblemen shown at the bottom of the palette wears a basic wrap skirt and the other is naked, perhaps symbolizing a before-and-after moral of the story: stripped of his authority, he is also stripped of the identity of that power, his schenti.

Unlike the 3,000-year transition of costume in Mesopotamia, where clothing evolved from simple wrap garments into the complex, tailored jacket and trousers outfit, change in Egyptian costume was more a variation on a theme rather than a measurable evolution. The schenti is a case in point. All four versions shown in Figure 3-3 are from the period of the Old Kingdom. Basically, the four designs are simple wrap skirts made of linen. Stylistically, though, each has a distinctive silhouette.

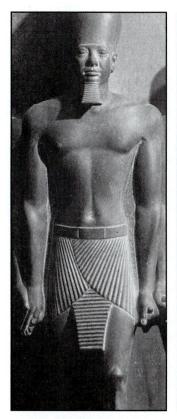

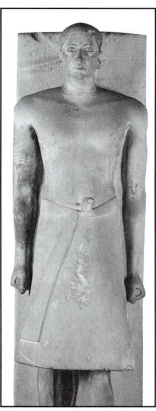

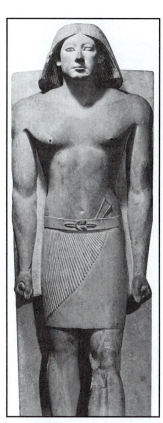

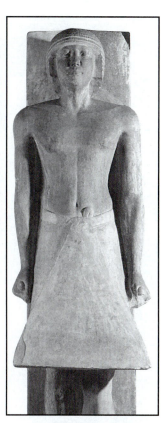

King Mycerinus Ranufer as High Priest Ranufer as nobleman Ty, Master of Horses

Figure 3-3. The basic schenti developed into numerous variations worn by Egyptian kings and noblemen until the Ptolemaic era. The four Old Kingdom styles represented here include the short wrap over a tapered front apron, a simple priest's style, a nobleman's asymmetrical version, and an exaggerated box-pleat front. Details of Old Kingdom statues, c. 2500–2400 BCE.

The schenti worn by King Mycerinus is short, barely covering the hips, and cut away on both sides in the front over a tapered apron. The linen fabric of both the skirt and the apron is uniformly **goffered**, meaning finely pleated. A thick leather belt with a large gold buckle holds the two pieces of the garment in place.

The two styles of schenti shown in the center are actually from the same tomb. The High Priest Ranufer wanted both of his roles on earth to be replicated in his afterlife—his official function as priest represented by the simple white linen skirt, and the court nobleman indicated by his gold-threaded schenti, ornamented belt, wig, and **pectoral**, or wide jeweled collar. (Although the paint of the collar and the wrap skirt has disintegrated, numerous other statues of the era depicting this style of schenti show the pleated side and tie tab painted gold to simulate linen woven with gold threads.)

The most exaggerated style of the schenti is worn by the figure of Ty, a Fifth Dynasty nobleman. Here the design features a triangular projection of fabric in the front. The linen was heavily starched with plant gums and pressed to create

this and similar box-pleat shapes for the front of the schenti. Statues of seated figures wearing versions of this style show that the crisp-edged triangular extension did not fold flat but retained its shape and projected upward from the lap. A tab of fabric extends up from the belt indicating that the wrap garment was tied in the center front with the edge of the fabric at the waist folded over to secure it in place.

The development of this exaggerated style of schenti was an enhancement of costume to further differentiate the classes. Not only were gods, kings, and noblemen depicted wearing this version, but ranking scribes and bureaucrats wore similar varieties. Certainly, the work done by laboring, tradesmen, and merchant classes would ruin the finely detailed goffering and starched box pleats needed to fashion this silhouette. By the time of the New Kingdom, variations of the box-pleat schenti included further exaggeration with lengths reaching to the ankles. Other examples, such as those worn by the ka statues from the tomb of Tutankhamen show elaborately ornamented front and sides of the triangular panel. Other ka figures feature a jeweled and painted or

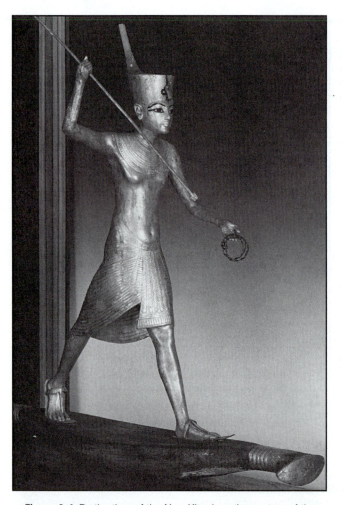

Figure 3-4. By the time of the New Kingdom, the contour of the waist of the schenti was cut or arranged on a sharp angle from the back down to the front. Ka statue of Tutankhamen, c. 1360 BCE.

possibly embroidered apron hanging down the center front of the young king's schenti. In addition, the waistline now was frequently cut or arranged on a sharp angle to the front and attached to a belt or folded waistband that was wide at the back and dipped to the pubic line of the lower abdomen. (Figure 3-4.)

To what extend any form of underwear was worn beneath the schenti is not certain. Conservators of the Tutankhamen Wardrobe Project at Holland's Leiden University have preserved dozens of linen loincloths thought to have been worn as undergarments by the boy king. These loincloths were cut into the shape of a triangle with strings attached at two points. The strings tied around the waist back to front and the third point of the triangular linen was pulled between the legs to be tucked into the front. Since no images of Tutankhamen depict the king wearing only a loincloth, the triangular garment must have been worn as a concealed undergarment.

Around 1675 BCE, a weakened Thirteenth Dynasty fell to an invasion of warring peoples called the Hyksos who would dominate Egypt for over 100 years. Scholars still debate who these Asiatic invaders were and where they originated. For the most part though, these "princes of foreign lands," as later Egyptian records called them, appropriated much of the culture of their new subjects. However, during their brief occupation of the Nile Valley, the Hyksos introduced to the Egyptians the horse-drawn war chariot, bronze weaponry, the vertical loom, and new elements of costume.

Although Asiatic apparel such as the Babylonian wrap robes and shawls were known to the Egyptians of the Old Kingdom, it was the Hyksos who established a broad-scale

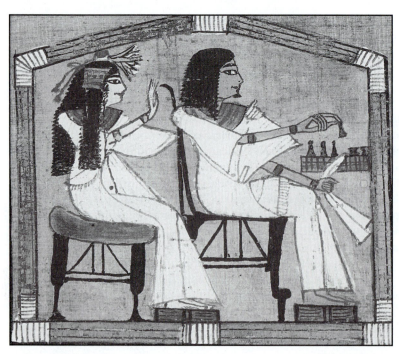

Figure 3-5. Following the occupation of the Nile Valley by the Hyksos in the sixteenth century BCE, the Asiatic influence of layering multiple garments was introduced into Egyptian costume. Long robes and shawls made of finely woven, sheer linen were worn over the traditional schenti and loincloth by the upper classes from the Eighteenth Dynasty forward. Papyrus painting of couple playing a board game, c. 1400–1250 BCE.

Amulets

The most common form of jewelry worn by Egyptians of all classes was the magical **amulet**. The Egyptian word for amulet, "meket," meant "protector." Hundreds of types of amulets were designed with the symbolic motifs that were thought to most likely gain the divine intervention of a specific god. Priests and physicians would utter incantations over the amulets to invoke the gods and attract the good forces needed to ward off the evils of illness, accidents, and other misfortune.

Amulets were made to strict specifications to ensure their proper efficacy. Instructions in religious papyri and inscribed on temple walls detail the names and functions of amulets as well as the materials required for each.

The wealthy wore elaborate amulets made of precious materials like gold, silver, and bronze inlaid with lapis lazuli, carnelian, turquoise, obsidian, and similar rare stones. The colors of these stones themselves were symbolic of divine powers and were thought to enhance the potency of the amulet's magic.

For ordinary people, simpler versions of amulets were mass produced in a glazed clay called **faience** that, when fired, simulated the colors and properties of precious materials. A string imbedded in the wet clay burned away during firing, leaving a hole for attaching the amulet to a bracelet, necklace, ring, belt, sandal, or other accessory.

One of the two most popular amulets across the centuries was the Eye of Horus. In myth, the god Horus had been blinded in battle, but had his damaged eyes restored by the god Thoth. Consequently, the symbol of Horus's eye was worn to ensure good health or recovery from illness or injury. The second most favored amulet was the scarab, represented in the shape of a dung beetle. The industrious little insect lays its eggs in a ball of dung, which it buries in the sand. When the eggs hatch, the young beetles appear to spring to life from the primordial earth. Thus the scarab amulet was a symbol of creation or rebirth, an idea dear to the hearts of Egyptians who were ever mindful of death and the afterlife.

Innumerable other forms of amulets were standardized for various purposes. The ankh represented the kiss of breath provided by the gods to the lips of the deceased for resurrection. The djed pillar was a stylization of the spinal column, which represented endurance and stability in one's life. Amulets in the shape of limbs, hands, feet, or other anatomical features were worn in hope of healing the injured or diseased body part, and those shaped like food or drinking vessels were for the promise of continued prosperity.

Eye of Horus Scarab Ankh Djed Pillar Anatomy Amulet

popularity of these garments throughout the Nile basin. This adaptation of the Mesopotamian tradition of layering multiple garments is a significant development in Egyptian costume. Egyptian versions of the Asiatic Royal Robe, though, precluded the use of "impure" wool. Neither was fringe adopted as a universally applied decorative trim although women's styles sometimes included a narrow fringed border. Instead, the Egyptians created numerous variations of voluminous robes and shawls made of very fine, sheer linen. Innumerable wall and papyrus paintings depict these types of layered robes and shawls, especially from the Eighteenth Dynasty forward. (Figure 3-5.) For men's costumes, the sheer, ankle-length robes were worn over the short, narrow schenti. Sometimes these robes were topped with a short pleated shawl tied around the shoulders and even overlaid with a wide jeweled collar.

During the early development of Egyptian civilization, costume styles for women paralleled those of men. As mentioned previously, the Hierakonopolis tomb painting from 3500 BCE depicts female figures dressed only in white skirts that extend from the waist to the ankles. By the early third millennium BCE, women represented in sculpture and paintings appear to be wearing a form-fitting **sheath** dress called a **kalasiris**. (Color Plate 1.) Some historians have suggested that, to fit the body as represented in artwork of the period, these dresses may have been made of knitted fabrics. In actuality, the many surviving examples of the kalasiris reveal a fit that was more like a loose-hanging **chemise** than a sheath. Just as Mesopotamian sculptors stylized the folds of garment drapery to appear smooth and straight, Egyptian artists similarly minimized the folds and fullness of the kalasiris to emphasize the female form.

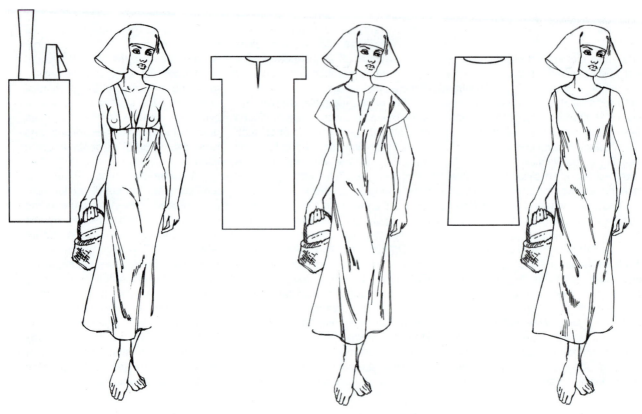

Figure 3-6. The kalasiris was cut in a number of ways. Three preva-
lent silhouettes included the high-waist skirt with shoulder straps,
the basic short-sleeve tunic, and the sleeveless trapezoid chemise.

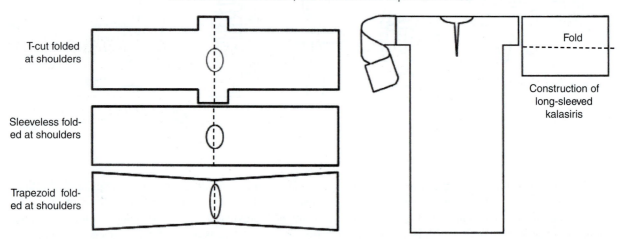

T-cut folded
at shoulders

Sleeveless fold-
ed at shoulders

Trapezoid fold-
ed at shoulders

Fold

Construction of
long-sleeved
kalasiris

The kalasiris was cut in several styles. (Figure 3-6.)
Sometimes the straps were made narrow and crossed the cen-
ter front like a "V" leaving the breasts bare. Similar versions
had a single strap that either fit straight up over one shoulder
or crossed diagonally to the opposite shoulder.

Still other styles of the kalasiris were constructed as
tunics. Variations included sleeveless, short-sleeve, half-
sleeve, and long-sleeve designs. Sleeveless versions were
simply a rectangle of fabric that was folded in half at the

shoulderline and sewn up the sides leaving openings for the
arms and neck. Some later designs were cut as a trapezoid,
narrow at the shoulders and flaring to the hemline. To create
the long sleeves, narrow pieces of material were folded in
half, stitched closed along one side, and then sewn to the
armholes of the tunic. One of the earliest known examples of
a woven fabric garment is a 5,000-year-old kalasiris made in
this long-sleeve style. (Figure 3-7.) Tailoring of set-in
sleeves was not adopted by the Egyptians, even after their

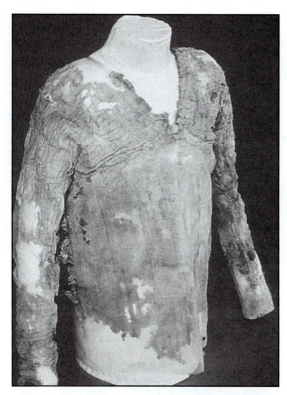

Figure 3-7. One of the oldest surviving examples of a woven fabric garment is this linen kalasiris from a First Dynasty tomb, c. 3000 BCE. The long sleeves were sewn to a tunic-style body that was then crisply pleated at the shoulders.

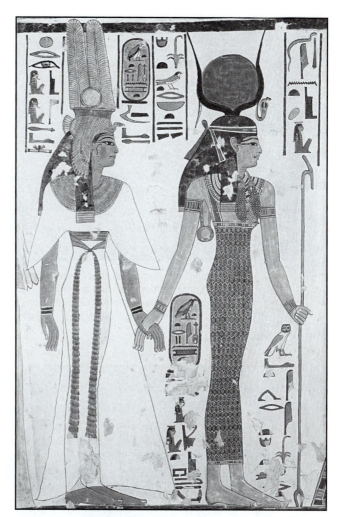

Figure 3-8. As with men's costumes following the Hyksos era, women's styles also adopted versions of the Asiatic robe and shawl. Most often made of sheer white linen, these garments were layered over a white kalasiris and accented with colorful sashes, scarves, and jewelry. Wall painting from tomb of Queen Nefertari, wife of Ramesses II, c. 1225 BCE.

subjugation by the Persians, who perfected that garment construction technique. The length of the kalasiris skirt varied between midcalf and the ankles.

The kalasiris for the upper classes was often sumptuously decorated. It is not clear, though, whether the brightly colored patterns depicted in wall paintings or on statuettes represent **appliquéd** beadwork, embroidery, featherwork, or designs woven into the fabric. Examples of all of these decorative treatments have been found. Remnants also have been found of dresses made entirely of beaded nets, which may have been worn over the nude body or as an ornamental overskirt for the kalasiris. Despite the prevalent use of bleached white linen in most Egyptian apparel, women of the elite classes delighted in the use of color for their clothing and accessories.

Following the occupation of the Hyksos, women's costumes adopted the Asiatic layering of opulent robes and shawls. (Figure 3-8.) As with men's designs of the same garments, women's versions were most often made of sheer white linen that was finely goffered and, many times, trimmed with colored piping or narrow fringed borders. These semitransparent robes and shawls were usually worn layered over a white

kalasiris. However, during the Eighteenth Dynasty, women began to wear only the sheer robes and shawls with nothing underneath. Notable examples of this look include the many representations of Queen Ankhesenamun, wife of Tutankhamen, whose nude body is clearly evident beneath her sheer white robes and shawls. In either case, whether worn over a white kalasiris or the nude body, richly ornamented jewels and multicolored sashes and scarves were also layered over the robes.

Indeed, the accessories worn by the upper classes of ancient Egypt were far more varied, colorful, and creatively designed than much of the apparel. Jewelry, especially, was of exceptional quality and design. Even the mass-produced

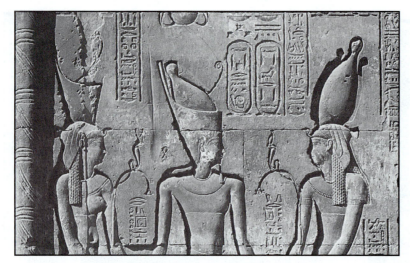

The double crown of a united Egypt featured the bowl-ing-pin-shaped diadem of the Upper Kingdom inserted into the cylindrical crown of the Lower Kingdom. Detail of temple carving depicting Ptolemy VIii, c. 150 BCE.

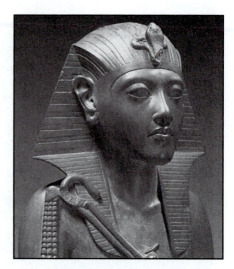

The Khat headdress was made of striped or goffered linen affixed to a headband that bore the uraeus or sacred serpent. Detail of statue of Akhenaton, c. 1375 BCE.

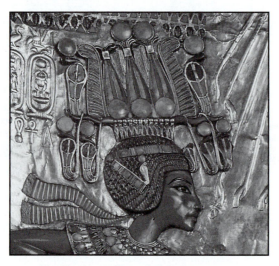

The Hemhemet Crown included numerous components that represented various gods and symbolized the king's divinity. Detail of Tutankhamen's throne, c. 1375 BCE.

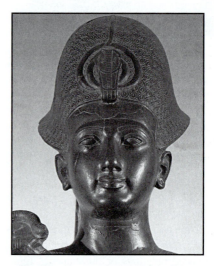

The Blue Crown, often called the War Crown, was made of molded leather attached to a gold headband. Detail of statue of Ramesses II, c. 1250 BCE.

Figure 3-9. Headdresses of the pharaoh.

jewelry worn by those of middle and lower classes replicated in glass, faience, and terracotta the designs made of precious metals and gems for the nobility. Most types of jewelry, though, were imbued with symbolic significance. Motif, color, and material—real or simulated—represented the divine powers of gods and their protection from harm or illness.

Of greater ceremonial importance than jewelry were the headdresses worn by the nobility of ancient Egypt, most particularly the king. (Figure 3-9.) As was mentioned previously, around 3200 BCE, the kingdoms of Upper Egypt and Lower Egypt were united under one ruling family. From that point on, the king was often represented in paintings and statuary wearing a combination crown with the Het, the white bowling-pin-shaped crown of the Upper Kingdom inserted into the **Pschent**, the red cylindrical crown of the Lower Kingdom. In numerous other examples, the two crowns are represented separately as depicted in the relief carving of Ptolemy VIII shown in Figure 3-9 and with the twin ka statues from the tomb of Tutankhamen, one of which is shown in Figure 3-4.

The most common headdress featured in depictions of kings is the **Khat**, which dates back to the Old Kingdom. To those of us who are more familiar with ancient Egyptian costume through the interpretations of Hollywood wardrobe studios, this headdress is the most recognizable style. Striped or finely goffered linen was affixed to a band that fitted low across the forehead and extended around to the ears. Attached to the front of this band was the **uraeus** or sacred serpent that represented the king's divinity. At each side, the linen was cut into rounded tapers and starched into rigid flanges that hung forward onto the shoulders. The rest of the fabric was pulled into a **queue** at the back of the neck simulating the lion's tail of sovereignty. Surviving color renditions of the fabric include white with stripes of a single color, the occasional solid white, or a gold thread weave with goffering. One of the more famous representations of the Khat is the gold mummy mask of Tutankhamen, which has blue stripes made of inlaid lapis lazuli.

By the Eighteenth Dynasty, Pharaonic headdresses had become extravagant, towering diadems. Although numerous varieties of this style of headdress, called the **Hemhemet Crown**, were depicted in artwork down through the centuries, almost all included the same components that symbolized the king's kinship with the gods. In the version worn by Tutankhamen shown in Figure 3-9, a pair of undulating goat's horns, representing the god Khnum, bringer of the Nile's floodwaters, is mounted to a gold **circlet**. Some depictions of this crown show a second set of ram's horns curling downward behind the king's ears. Coiled about the horns here are six uraei although other versions of the Hemhemet Crown show as few as four and as many as eight serpents. Between the horns are the golden disks of the sun god, Amun. Rising from the top of the sun disks are three bundles of reeds, symbols of the fruits of the Nile. Flanking the reeds are stylizations of ostrich feathers incorporated from the headdress of Amun. The Hemhemet diadem was worn atop a variety of head coverings including the Khat, the Blue Crown, or elaborate wigs with gold **fillets** and infulae down the back.

Also beginning with the Eighteenth Dynasty, the **Blue Crown**, often called the **War Crown**, first appeared in representations of the king. This was constructed of molded leather that was lacquered in a vivid blue and accented with other bright primary colors. A gold uraeus descended from the dome to the gold band at the brow and, in some versions, was paired with the head of a vulture. The example worn by Ramesses II shown in Figure 3-9 appears to have been decorated with an overall pattern of circles, which may actually have been attached gold sun disks.

Some of the headdresses of queens were equally ostentatious and imbued with divine symbolism. Prior to the Hyksos dominion, queens were usually depicted wearing only elaborate coiffures and sometimes a jeweled circlet or

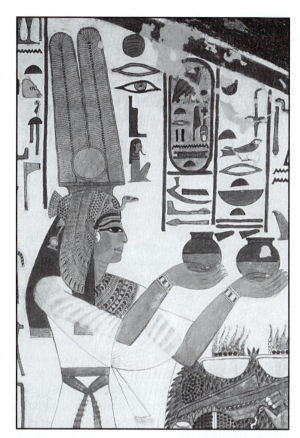

Figure 3-10. From about the sixteenth century BCE forward, depictions of queens and goddesses were often featured wearing the Headdress of Isis. Representing the sacred vulture in flight, the golden headdresses were sometimes surmounted by other religious symbols such as the moon disk of Isis and the ostrich feathers of Amun. Detail of wall painting of Nefertari, c. 1225 BCE.

fillet. From about the end of the sixteenth century BCE, queens—and goddesses—were frequently shown wearing versions of the **Headdress of Isis**. (Figure 3-10.) These ceremonial royal crowns were designed to represent the sacred vulture in flight. Each was made of intricately crafted gold and precious gems. Instead of a uraeus, the head of a vulture projected from the gold band across the brow. The body of the bird covered the crown of the queen's head, and its wings extended down the sides. The feathers were articulated by hinged segments so they could be contoured to fit a variety of wig styles. Atop the headdress was attached any number of figures and ornaments. In the version shown here, Queen Nefertiti wears the moon disk of Isis behind which are inserted two ostrich feathers. Other attachments have included a circle of uraei, a freestanding vulture, or a stylized pair of cow horns honoring the goddess Hathor.

Although the Headdress of Isis was part of an official royal costume, queens also wore a great variety of other extravagant headdresses—some semiofficial and others solely for personal style. (Figure 3-11.) In the former category is the

cylindrical design featured on the famous limestone bust of Queen Nefertiti. It was made of smooth leather and lacquered the same royal blue as the king's War Crown. A magnificent example of a purely decorative headdress is the four-pound cascade of gold and inlaid gems found in the tomb of the wife of Thutmosis III. The reconstruction shown here features richly detailed segments of rosettes that draped with shimmering effect over the queen's black wig.

The headdresses of nonroyal nobility were more subdued than those of the king and queen. The statuary and paintings from the tombs of the upper classes mostly feature elaborate wigs as headdresses although some examples show both men and women wearing beaded fillets or ornamental circlets.

In addition to fine fabric garments and opulent headdresses, the upper classes of ancient Egypt also enjoyed the luxury of superbly crafted sandals. The earliest examples of Egyptian footwear appear in their artwork dating back over 5,000 years. For instance, even though the representation of King Narmer is shown barefoot in Figure 3-2, he is accompanied on the left by his royal sandal bearer. The style of sandal the servant carries has a single thong with a wide leather strap to fit over the arch. Striations etched into the soles indicate that they were made of plaited reeds. Possibly such loose-fitting sandals were an impediment in battle and were only worn indoors, hence the barefoot warrior king.

Most types of sandals that have been found in tombs were made of rushes although a number of leather styles also have

been discovered. Some designs have braided twine thongs that slipped between the big toe and second toe and wrapped around the heel to hold the sandal in place. Others combined the toe thong and a strap over the arch without any heel support. In the tomb of Tutankhamen, several pairs of this latter style were found crafted of reeds and wood. On the inside soles, enemies of Egypt had been represented in hieroglyphics so that, even in his eternal afterlife, Tutankhamen could achieve little victories each time he stepped into his sandals. As shown in Figure 3-4, the pointed toes of the young king's sandals curled up at the ends much as styles still do in modern Egyptian shoes and sandals.

Despite such early representations of sandals like those on the *Palette of Narmer*, most Egyptian art showed figures barefoot, even royalty and gods. Only during the Eighteenth Dynasty did depictions of footwear become more commonplace. Even after conquest by the Assyrians and later the Persians, the Egyptians never adopted the covered shoe or boot as part of their costume.

COSTUMES OF ORDINARY PEOPLE

Images of ordinary Egyptians have survived in large numbers of wall paintings and carved figurines that went into the tombs of the upper classes. These artworks were more than just commemorative records of the life that the deceased had enjoyed on earth. The pictorial representations and miniature models of workers, servants, and family members were

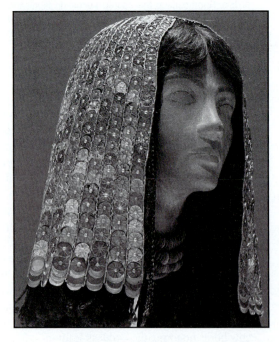
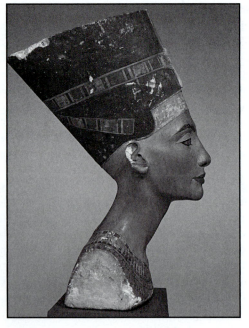

Figure 3-11. In addition to the ceremonial headdresses worn for religious and court functions, queens possessed a wide assortment of other semiofficial and decorative styles. The cascade of gold and precious stones, shown left, was worn at social events by the wife of Thutmosis III, c. 1475 BCE. Queen Nefertiti's famous cylindrical headdress, shown right, was designed to complement the King's War Crown, c. 1350 BCE.

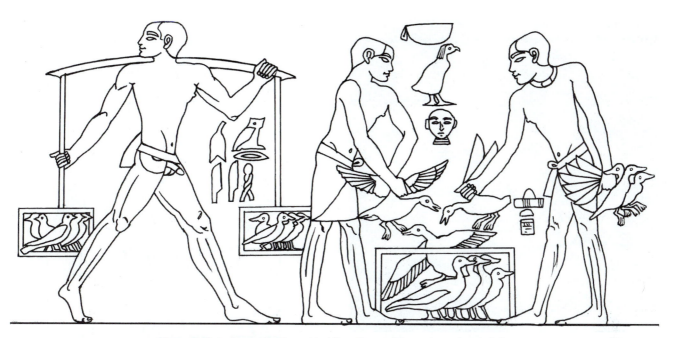

Figure 3-12. In the rigidly hierarchical Egyptian society, costume denoted status. The delivery boy on the left wears a simple loincloth tucked back into its sash to prevent entangling his legs. The more skilled bird handlers wear the traditional schenti. Detail of wall carving from the tomb of Ptahhotep, c. 2450 BCE.

surrogates with which the ka of the deceased could maintain a continuum of all he had known and loved while living.

In addition to recording the types of work done by ordinary people, these paintings and figurines document details of tools, utensils, and other utilitarian items as well as hairstyles and costumes of the lower classes in all their exactitude. For the overwhelming majority of Egyptian commoners, clothing was simple and basic. The two most prevalent types of garments for men consisted of a simple apron-like loincloth or the schenti. The workers depicted in Figure 3-12 show the differentiation of the classes by their costumes. The man who delivers waterfowl from a hunt wears a simple loincloth of linen. Because he has such an active task to perform, he has pulled back the loincloth and tucked it under the belt to prevent becoming entangled in the apron flap of the cloth and losing his master's allotment of birds. The other two workers are more skilled in animal care and prepare the birds for fattening by carefully breaking their wings to prevent their escape from the open pens. These men wear the traditional schenti wrapped about the hips and tied in the front.

It is worth noting that, in examining the way the loincloth is worn by the delivery boy in Figure 3-12, covering the genitals for the purpose of modesty as we think of it today was not a governing factor in the development of clothing for the Egyptians. Indeed, numerous other artworks show men at work wearing this style of loincloth pulled back in exactly the same manner. The purpose of the garment was a convention of social rank. These men

wore the loincloth because they were semiskilled laborers. The delivery boy was a member of his lord's staff and probably was an apprentice to the senior bird handlers. The same type of loincloth, some tucked back like that of the delivery boy, also has been depicted on images of herdsmen, fishermen, boatmen, and farm workers, to name a few. By contrast, though, a significant number of images of common laborers show them completely naked, signifying that these were unskilled peasants of the very lowest classes.

On a social level above the working classes that wore the loincloth were the skilled craftsmen. As noted previously, their costumes were simple versions of the schenti. The higher up the social scale, the better the quality of the schenti. Foremen, overseers, merchants, bureaucrats, and master craftsmen wore finer materials and, by the late second millennium BCE, even added layered garments similar in cut to those of the nobility. The key differences were in the grade of fabric, amount of the material used, trimmings, and accessories.

The same held true for the costumes of women of the lower working classes. Those female laborers who toiled at backbreaking work wore basic schentis of coarse linen barely wide enough to extend from the waist to the knees. (Figure 3-13.) Those women who were house servants of the upper classes or who were married to skilled workers wore unadorned versions of the kalasiris, usually with only enough fabric for a single shoulder strap, and most likely made of lesser grades of linen.

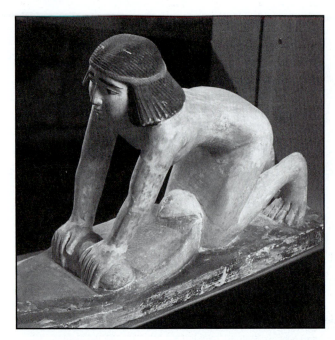

Figure 3-13. Costumes of the lowest castes of women were basic schentis made of poor quality linen. Fabric widths were often barely wide enough to extend from the waist to the knees. Figure of girl grinding grain, c. 2500 BCE.

This also emphasizes another aspect of Egyptian society that affected costume. The same class of workers could wear clothing of different degrees of quality depending on the household to which they were attached. A metalsmith in the service of a wealthy merchant would not dress as finely as a craftsman of the same skill who was employed by the royal family. Depictions of servants, managers, bureaucrats, and scribes who served the royal household or high-ranking nobility often show them dressed in pleated garments, long robes, jewelry, and wigs. Even dancers and acrobats who performed naked still wore decorative sashes, belts, scarves, jewelry, beaded collars, wigs, and ornamental headdresses.

One other aspect of beauty and dress indulged by the Egyptians was body modification. The nude warrior on the *Palette of King Narmer* in Figure 3-2 and the nude delivery boy in Figure 3-12 document that the Egyptians were the earliest civilized people to practice circumcision more than 5,000 years ago. The tradition is thought to have been a rite of passage for prepubescent boys and applied to all classes. Pierced ears, on the other hand, were largely limited to those of the upper classes who could afford the luxuries of fine jewelry. By inserting increasingly larger posts into the pierced openings, the earlobes were stretched to accommodate earrings designed with a tubular shaft rather than thin wires. Tutankhamen's gold mummy mask clearly shows the large holes in his earlobes that had been stretched by his earrings. A less common form of body modification found on Egyptian mummies and represented in some artwork was

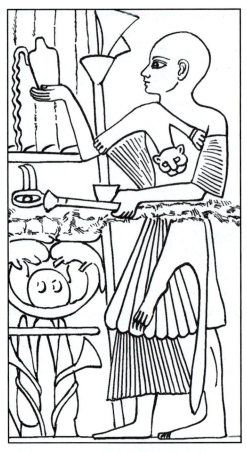

Figure 3-14. Following the Hyksos dominion of Egypt, the costumes of priests became more opulent with layers of bleached white linen garments including tiers of pleated schentis, voluminous aprons, and shawls. As representatives of the pharoah, priest also sometimes wore leopard skins for certain ceremonies. Relief carving of priest making an offering, c. 1000 BCE.

tattooing. Predynastic figurines show body decorations of small geometric patterns made of tattooed dots. By the New Kingdom more representational images were used for tattoos such as the symbol of the god Bes, patron of pleasure and physical delights, which was applied to the thighs or breasts of young females who were courtesans and performers.

RELIGIOUS COSTUMES

For the Egyptians, the entire world was the outward aspect of a complex divine order over which reigned a god-king and a pantheon of zoomorphic deities. Administering to the gods and the king was an arcane bureaucracy of priests and priestesses somewhat akin to medieval feudalism. High priests were the lords of this domain. As with titles and estates of the European Middle Ages, posts of rank in the Egyptian priesthood were hereditary. Until the end of pharaonic society, the continual succession of high priests represented the intricate, esoteric pattern of beliefs that permeated virtually every aspect of Egyptian life.

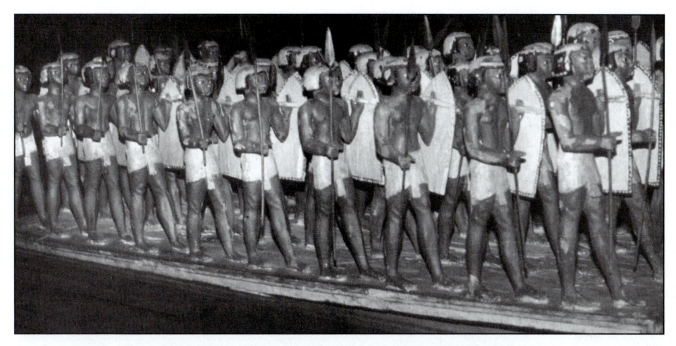

Figure 3-15. The equipment of the Egyptian army was relatively rudimentary, consisting of simple spears, bows and arrows, and shields made of reinforced animal hides. The type of schenti worn by soldiers was comparable in quality to other semiskilled workers although it was cut shorter to allow easier maneuverability. Tomb model of soldiers, c. 2100 BCE.

Yet as we saw with the costume of the high priest Ranufer in Figure 3-3, religious apparel of the Old Kingdom was a simple, unadorned type. For important religious events, though, the high priest would drape a leopard skin over his shoulder with the head of the beast secured in the front. This tradition is thought to be connected to ceremonies when the high priest represented the king before the gods. As with Egyptian costume in general, by the middle of the second millennium BCE, priests wore as diverse an assortment of garments as the upper classes. Depictions of priests from the Eighteenth Dynasty forward show costumes that include the voluminous secular robes and shawls adapted from Hyksos styles. For these layered garments, the fine linen was as sheer and richly pleated as court dress. (Figure 3-14.) One key difference, though, was the complete absence of adornment—no colorful collars, jewels, embroidered sashes, scarves, headdresses, or even wigs.

MILITARY DRESS

In sharp contrast to priests' clothing, military costumes paralleled those of secular society. On the upper scale were the king as commander-in-chief and his officers while at the opposite end were the foot soldiers of the infantry. Prior to the invasion of the Hyksos, the equipment of the armies of Egypt was comparatively rudimentary. (Figure 3-15.) Egyptian

forces fought mainly with spears, bows and arrows, wooden clubs, and shields of reinforced animal hides. They wore no helmets or shoes. Soldiers would have enjoyed a station above that of the peasants and unskilled workers, so they wore the basic schenti instead of a loincloth. Still, the grade of linen for the infantryman's garment was coarse and cut short to extend only about mid-thigh in length.

With the introduction of more sophisticated weapons made of bronze and the war chariot during the occupation of the Hyksos, subsequent Egyptian kings of the Eighteenth, Nineteenth, and Twentieth Dynasties waged wars of conquest. The costumes of the main military forces remained simple whereas those of the kings and officers were as sumptuous as court dress. However, instead of voluminous layered garments, clothing worn into battle fitted snugly and was abbreviated in cut. Depictions of kings in battle such as Tutankhamen against the Nubians and Ramesses III against the Lybians show the accoutrement of the king's military costume. The brilliant blue and glistening gold of the War Crown heralded the king's presence on the field of battle. His multicolored leather cuirass, beaded collar, and embroidered quiver complemented his crown. A richly decorated leather wrist guard protected his arm from the snap of his bowstring. His gilt bow and chariot gleaming in the bright sun must have looked as if the divine Amun himself were leading the charge. Even the king's chariot horses wore jeweled

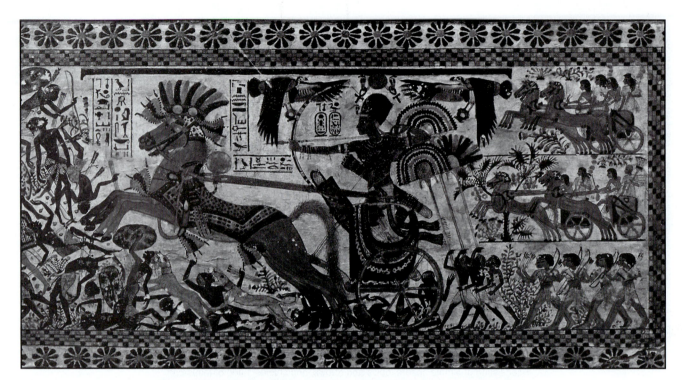

Figure 3-16. The battle costume of the king was as sumptuous as anything he wore at court. The blue War Crown, colorful accessories, and gold gilt accouterments must have appeared to his troops as if the god Amun himself were leading the charge. Battle scenes on a chest from the tomb of Tutankhamen, c. 1360 BCE.

harnesses, feather headdresses, and embroidered coverlets. (Figure 3-16.)

It is difficult to estimate if such representations of warrior pharaohs on tomb artifacts and the walls of public monuments were realistic depictions of the costumes. Very possibly, these images were ceremonial aggrandizements to impress the gods and citizenry. For instance, most warfare scenes show the king alone in a charging chariot, poised to shoot his bow, when in actuality he would have been accompanied by a driver and an arms bearer.

Still, the military apparel of the king was superbly crafted and lavishly decorated. Among the arms and armor found in the tomb of Tutankhamen was a close-fitting cuirass. Howard Carter, the discoverer of the tomb in 1922, described the item as "a bodice without sleeves . . . made up of scales of thick, tinted leather worked onto a linen basis or lining." When new, the multicolored body armor most likely had been lacquered with the same brilliant colors as the War Crown.

Despite the improved weaponry and seasoned, well-trained soldiers, though, the Egyptians could not hold onto their empire, which at its peak extended from the Libyan coastline in the west to the Taurus Mountains in the east and well south into Nubia, modern Sudan. Worst still, throughout the first millennium BCE, the whole of Egypt became subjugated first by the superior military might of the Assyrians, followed by the Persians, Greeks, and ultimately the Romans. The 4,000-year-old civilization of the Nile Valley faded into obscurity to await its rediscovery almost eighteen centuries later.

REVIEW

Across the entire history of Egyptian civilization, a rigidly structured culture and society transcended endless natural calamities, innumerable dynastic intrigues, and a sequence of foreign invasions. This strict social order coupled with consistent and persistent religious beliefs afforded generation after generation a sense of continuity and stability. Reflective of this stability is the relatively unchanged line of costume from beginning to end. Such an enduring consistency of style is especially apparent when compared to the significant evolution of dress through the succeeding civilizations of Mesopotamia during the same expanse of time.

In its breadth, Egyptian costume was affected very little from outside influences. Stylistic changes were infrequent and not particularly innovative with one exception—the adaptation of layered robes and shawls introduced by the Hyksos during the middle of the second millennium BCE. Even then, the Egyptians rejected the use of wool and the textile prints, patterns, and fringe decoration of the Asiatic dress. Instead, the new silhouettes were recreated with finely pleated linen and traditional Egyptian colorations and decorative motifs.

In its depth, Egyptian costume changed only subtly—more of a variation on a theme than radical new designs. For instance, the schenti was a wrap skirt worn by both men and women for more than three millennia. Versions included different lengths, different fabric treatments, and different grades of material. Even with the exaggerated box-pleat fronts and goffered aprons, the style was still that of a wrap skirt.

Such a wide variety of the schenti emphasizes another key aspect of Egyptian costume, that of class differentiation. A long and very detailed pictorial history of Egyptian society has survived in many thousands of artifacts, tombs, and monuments. Male peasants and unskilled laborers of the lowest classes were depicted completely naked while females usually wore a waist-to-knee schenti made of coarse linen. For semiskilled male workers, the costume was a basic loincloth with a front flap. Craftsmen, artisans, priests, bureaucrats, and servants of ranking nobility wore versions of the schenti made of linen in varying degrees of quality. Representations of women of the higher ranking classes showed the kalasiris in variations ranging from a simple skirt with shoulder straps to an embellished tunic with long sleeves.

The most opulent and finest versions of all Egyptian apparel were reserved for the nobility, especially the royal family. Clothing for these upper classes was made of the finest linen, which for layered pieces was sheer enough to be semitransparent. Special treatment of the fabric included weaves of gold threads, fastidious pleats, and starched geometric shapes. Unique to the king and queen were ceremonial and religious costumes, especially headdresses that denoted their direct link to the gods.

As with all their forms of visual arts—architecture, painting, sculpture—Egyptian apparel designs reflected the conservatism and rigidity of their theocratic social order. In their world, everything had a purpose and a place, including clothing. Through that homogeneity, the thread of a continuity of costume and style stretched unbroken across more than forty centuries.

Chapter 3 Egypt
Questions

1. Compare the evolution of Egyptian costume to that of Mesopotamian cultures. Which textile fibers were prevalent in the apparel of each and why? Which decorative elements were significant in the costumes of each?

2. How did costume reflect social status in ancient Egypt? Identify comparisons of specific garment styles.

3. Which key component of Egyptian costume is unique to the king and queen? Identify the variants and their significance.

4. Explain why and how the Egyptians were obsessed with beauty and hygiene. Cite examples of their beauty regimens and the practical or social significance of each.

5. How have Egyptian decorative motifs and styles been revived in the modern era? What were the historical catalysts for interest in Egyptian styles?

Chapter 3 Egypt
Research and Portfolio Projects

Research:

1. Although the tomb of Tutankhamen was discovered in 1922, many of the more pedestrian contents were put into museum storage and only examined in recent years. Catalog the items of dress that were buried with the young king for his use in the afterlife:

 - Textiles
 - Garments
 - Amulets
 - Jewelry
 - Footwear
 - Other accessories
 - Military accoutrements
 - Cosmetics and implements of application and grooming

 Include descriptions of the design and materials of each, as well as how the items were worn, applied, or otherwise utilized in the royal dress.

2. Write a research paper on what the classical writers Herodotus, Strabo, and Diodorus Siculus recorded about Egyptian customs and traditions relating to their clothing, textiles, and ideals of beauty. Make special note of inaccuracies they may have documented solely on hearsay and what evidence we have today that counters those details of the classical writers' misinformation.

Portfolio:

1. Find twenty examples in twenty-first century catalogs and magazines (print or online) that replicate or synthesize Egyptian styles of clothing, decorative treatments, or jewelry. Provide a photocopy or scanned image of each with a description. Include a paragraph with each that explains how these are Egyptian in style.

2. Compile a reference guide of twenty different symbols used by the Egyptians as amulets. Include a photocopy, drawing, or scan of each with a description of what each amulet represents and its intended purpose.

Glossary of Dress Terms

amulet: a small, portable charm in the shape of a symbol representing divine power, specific gods, sacred animals, or body parts

applique: any type of decorative material applied to the surface of fabric including ornaments, beading, feathers, pieced or patchwork leather and fabric

Blue Crown: ovoid-shaped Pharaonic crown lacquered bright blue, usually worn into battle (see War Crown)

burlap: loosely woven fabric made of coarse linen or cotton threads

chemise: a woman's undergarment, or later a dress style, that hangs loosely from the shoulders

circlet: a narrow head band that fit atop the head

corselet: body armor for the torso

faience: a glazed clay used in making tiles and amulets

fillet: a narrow headband that fit around the brow

goffering: fine, evenly pressed pleating

Headdress of Isis: the Queen's headdress in the shape of the sacred vulture

Hemhemet Crown: ornate Pharaonic crowns comprised of ram's horns, ostrich plumes, uraei, and sun disks in various arrangements

henna: reddish dye extracted from the tree of the same name used in cosmetics, especially for tinting fingernails

Het: the white bowling-pin-shaped crown of the Upper Kingdom

kalasiris: a woman's tunic or long skirt sewn with various shoulder straps

Khat: a Pharaonic headdress of striped linen with starched flanges that hung over the shoulders and a queue in the back

kohl: powdered black ore of lead used in preparing eyeliner

pectoral: a wide jeweled collar that sometimes extends over the shoulders; worn by both men and women

Pschent: the red cylindrical crown of the Lower Kingdom

queue: a plait of hair or fabric for a headdress hanging down the back

red ochre: reddish oxide or iron used in cosmetics

sailcloth: strong, heavy fabric woven of linen or cotton and used for clothing or utilitarian purposes such as ship sails

schenti: kilt-like skirt made of linen worn mostly by men but also women of peasant classes

sheath: a straight, form-fitting dress

uraeus (pl. uraei): the sacred serpent symbolizing the king's divinity used on headdresses and royal ornaments

War Crown: another name for the Blue Crown

Legacies and Influences of Egyptian Styles on Modern Fashion

The beauty and creativity of Egyptian ornament and jewelry designs have had such timeless appeal that interest in their decorative motifs have frequently surfaced in the fashion styles of our modern eras. During the late 1790s, when Napoleon led his troops into Egypt, European fashion designers scrambled to keep up with the demand for reproductions of ancient Egyptian motifs for everything from textile prints for clothing and wraps to decorations for snuffboxes, jewelry, and hair ornaments. Throughout the nineteenth century the hybrid neo-revivalisms that marked Victorian decorative styles combined elements of Egyptian design with those of other distinct earlier cultures and eras. When the tomb of Tutankhamen was discovered in 1922, a rage for the stylized, geometric patterns of Egyptian design helped popularize the Art Deco movement. In the 1960s, the Flower Children experimented with ancient mysticisms and inspired interest in the ankh and the all-seeing eye motifs of the East. Even today Egyptian jewelry designs and motifs in textile prints remain popular.

In addition, textural treatments of fabric first developed by the Egyptians, such as goffering and starching textiles to shape, are replicated today by synthetic starches and high-temperature steam pressing.

Various forms of goffering, or pleating, have been a mainstay treatment of fabric for clothing for more than 5,000 years. Left, tuck-pleated blouse of rayon tissue faille by Adelaar, 1948; right, nylon shirtwaist dress by Debby of California, 1951.

Pectoral swimsuit by Margit Fellegi, 1956.

Rayon crepe blouse with Egyptian hieroglyphics print by Alice Stuart, 1946.

Across the ages down to the modern era, Egyptian motifs have been adapted to jewelry by many cultures. Necklace from Franklin Mint, 1988.

Chapter 4

THE AEGEAN

CRETE

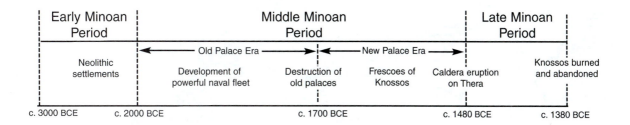

Early Minoan Period	Middle Minoan Period		Late Minoan Period		
	←——— Old Palace Era ———→	←——— New Palace Era ———→			
Neolithic settlements	Development of powerful naval fleet	Destruction of old palaces	Frescoes of Knossos	Caldera eruption on Thera	Knossos burned and abandoned
c. 3000 BCE c. 2000 BCE		c. 1700 BCE	c. 1480 BCE c. 1380 BCE		

PEOPLES OF THE SEA

On the island of Crete the first great civilization of the West emerged during the early second millennium BCE. Its inhabitants were named in modern times for the legendary King Minos, who, according to mythology, kept a half-bull, half-man monster called the Minotaur in a labyrinth beneath his palace. From these island people flowered a culture with a splendor and originality unmatched in the ancient world.

Very little is known for certain about the Minoans despite an abundance of surviving buildings and artifacts. Even their written documents—clay tablets inscribed with a pre-Hellenic linear alphabet—mostly contain inventory lists of agricultural produce and livestock or warehouse stores although a few of these records include a sprinkling of religious dedications. Many historians believe that, like Sumer, the Minoan towns and cities on the scattered islands of the Aegean shared a common culture but functioned under a decentralized system of city-states. At the core of these civic centers was a palace complex that housed the ruling families and provided space for religious sanctuaries and various administrative agencies. No separate temples or monumental tombs were constructed by the Minoans. Although a significant segment of Crete's population was agrarian, much of Minoan culture, commerce, and society centered on seafaring ventures. In fact, so powerful and effective was the Minoan navy that none of the various island palace complexes was even fortified.

Around 1700 BCE, all of the great palaces seem to have been destroyed simultaneously by earthquake, most probably the result of Aegean volcanic activity. From this disaster the Minoans built new palaces that were open, airy, and lavishly decorated. The architecture of the Palace of Knossos, for example, featured designs unknown anywhere else in the

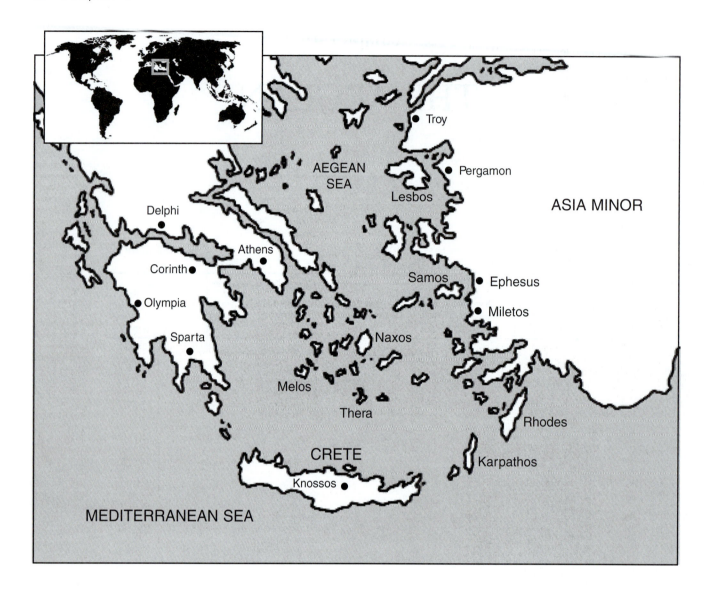

world at the time. Especially notable is the distinctive shape of the columns that tapered downward from the capital like an inverted tree trunk. In addition, Minoan building technology included unparalleled engineering advances such as an underground plumbing system constructed of jointed terracotta pipes with flushing conduits for toilets.

At the peak of their civilization, the Minoans controlled much of the trade of the eastern Mediterranean Sea. The famous eggshell pottery of Minoan manufacture has been found as far east as Syria and as far south as Egypt. Still, despite centuries of trade with the Hittites, Phoenicians, Babylonians, and Egyptians, Minoan culture seems to have been impervious to most influences from other civilizations. The costumes of the Minoans, especially, were unique to their culture and retained their primary characteristics throughout the entire epoch of these remarkable people.

Yet once again, around 1480 BCE, the Minoan islands were devastated by natural disasters, this time of cataclysmic proportions. A caldera eruption on the volcanic island of Thera caused earthquakes, tsunami tidal waves, and choking clouds of ash all over the region from which many Minoan cities did not recover. This disastrous event that included a sinking of a major portion of Thera is thought to be the basis for the legend of Atlantis. Less than 100 years later, the weakened Minoan civilization fell to an invasion of their northern, land-based rivals, the Mycenaeans.

MEN'S COSTUMES

As with most ancient civilizations, representations of how the Minoans looked and dressed—or at least how they wished to see themselves—have survived in their numerous artworks. In addition to the discovery of hundreds of examples of statuettes, incised seals, **repouseé** metalwork, and ceramics, some of the most extraordinary frescoes of the ancient world have been excavated at Knossos and Thera. Unlike the Egyptian and

Thera and the Collapse of the Minoan Civilization

The small volcanic island of Thera was one of the busiest trade centers of the Mediterranean basin in the mid-second millennium BCE. Its Minoan port city of Akrotiri was home to a sizeable population thought to be in the thousands. Spacious, two-, three-, and four-story houses were richly furnished with carved tripod tables, lavishly painted pottery, and finely woven textiles. The walls were decorated with imaginative and colorful frescoes of blue monkeys leaping through trees, prancing gazelles, springtime landscapes, and panoramic scenes of sea battles. Luxurious comforts included bathrooms with tubs and bench toilets that drained away through terracotta pipes into the sewers beneath the paved streets.

We know of all this for certain because, beginning in 1967, excavations on the island revealed that the city had been buried under the ash of Thera's volcano, which erupted with cataclysmic results around 1480 BCE. So massive was the explosion of the volcano—with a destructive force equal to a 600 kiloton atomic bomb—that about half the island sank into the sea. Ash fell over much of the eastern section of the Mediterranean from Crete to Turkey.

Since the modern discovery of Akrotiri, among the controversies debated by scholars have been how and when the volcano erupted, and how it impacted the Minoan civilization on Crete. In 2001, new findings gathered by vulcanologist Floyd McCoy provided evidence of how the eruption of Thera could have led to the collapse of the Minoan civilization.

Probably the foremost factor was the economic loss of Thera, a vital Minoan mercantile center likened to modern Hong Kong or Singapore. Considerable numbers of lead balance weights have been found on the island indicating the prevalence of seafaring commerce. Pottery and other commodity objects and materials from mainland Greece, North Africa, the Levant, and Crete confirm the wide expanse of the Therans' trade in the eastern Mediterranean.

Next was the actual damage to Crete from the eruption of Thera. The layer of ash only covered the eastern portion of the island with a thin coating but still would have caused widespread destruction of crops and livestock.

The ash, though, was minimal compared to the tsunamis that had been unleashed by the explosion. In 1997, British geologist Dale Dominey-Howes tested core samples drilled inland on the island of Crete. In the strata corresponding to the eruption of Thera, he discovered shells of marine life that only live in very deep seas—evidence that high, powerful waves battered the northern coastline of the island. Boats and coastal communities would have been destroyed and farmlands washed away or ruined by salt water.

In addition to the ash and destructive waves, climate was likely altered. An eruption on the scale of Thera would have discharged enormous amounts of sulphur dioxide that could have lowered temperatures around the northern hemisphere for years, causing cold, wet summers and ruined crops.

The impact of these natural disasters also likely undermined the very foundation of Minoan society. No longer sure of their world, they may have abandoned their priest kings and all the certainties embodied in the ruling classes. Weakened by economic disasters and a culture in disarray, the Minoans were unable to resist the invasions of the Mycenaeans from the Greek mainland.

Assyrian methods of painting on dry plaster, the Minoan renderings were true frescoes done by applying pigment to wet plaster. By this process the colors were more permanent and retained their vibrancy despite the ravages of time. Consequently, depictions of fabric colors, patterns, and ornamentation have been better preserved.

Like the Egyptians, the Minoans represented themselves in their artwork with a tall and slender youthfulness. Men were always clean shaven. The ideal masculine aesthetic emphasized broad shoulders, narrow hips, slim waist, and muscular thighs. Some historians think that, to achieve this physiological silhouette, boys and girls may have been harnessed into restricting girdles that cinched their waists from an early age, not unlike children's **corsets** of the Victorian era. This seems doubtful, though, given that some images of nude boys have survived in frescoes in which the protruding baby-fat abdomens of prepubescent childhood are clearly evident. Similarly, the ideal Minoan woman was proportioned with long, lithe limbs, slender waist, and full, rounded breasts. Men were shown as tanned while women were represented with alabaster white skin. Both men and women wore their hair in long, curling locks, sometimes extending to the waist. However, unlike the idealized images of physical beauty in Egyptian art, which were most often static and repetitive, the Minoans depicted a self-conscious, theatrical beauty and grace, somewhat like that of a modern-day matador or ballet dancer.

Since no images show Minoan men completely naked, we presume that it was socially unacceptable for adult males to appear in public fully undressed. Yet early representations of Minoan men indicate that the prevalent style of masculine costume was just barely removed from complete nudity. A number of male votive figurines from the end of the Early Minoan Period show that men wore only a simple pouch covering the genitals that was affixed to a belt in the front and by a thong cord in the back. This type of narrow covering was worn with assorted decorative belts and girdles, some with daggers attached. (Figure 4-1.) Most likely, the covering was made of a soft, supple leather although woven wool is also a possibility. The production

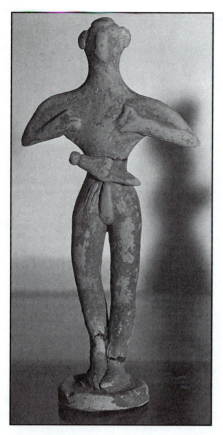

Figure 4-1. The earliest type of costume for Minoan men was a simple thong-like pouch for the genitals attached to a belt. Male votive figure with dagger, c. 2000 BCE.

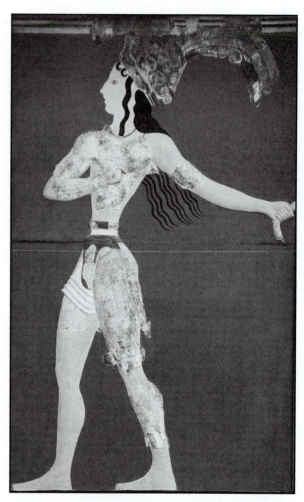

Figure 4-2. By the New Palace Era, the prevalent costume for Minoan men included a wool loincloth with an exaggerated genital pouch. *Prince of the Lilies* fresco from Knossos, c. 1500 BCE.

of woolen cloth was already a ubiquitous cottage industry by this time.

At the height of Minoan culture during the New Palace Era, statuettes and paintings of Minoan men depict these genital pouches with shaped, protruding contours. Frescoes show that this new type of loin covering was brightly colored but not ornamented with decorative patterns, embroidery, or appliques. In addition, the New Palace era style seems to have been cut in a high-rise **brief** silhouette. Some historians refer to this Minoan style of masculine garment as a **codpiece** to differentiate it from draped loincloths. The notion of a codpiece, though, from our modern perspective, implies a sexual exhibitionism, such as the flamboyant display in European men's fashions of the Middle Ages and Renaissance. Costume historian Phyllis Tortora suggests that the Minoan pouch was exaggerated in shape and proportions because it was reinforced for protection during athletic events, but there are numerous representations of Minoan men in ordinary daily activities ranging from farm work to ritual prayer, all of which feature the same shaped genital covering.

The Minoan male costume also sometimes included a fabric loincloth worn with the genital pouch. In the reconstructed

fresco called the *Prince of the Lilies*, the figure wears a short white wool loincloth that drapes down the back with rounded edges and extends around one side to the front in a four-tier **flounce** over the right thigh. (Figure 4-2.) The edges of the fabric are trimmed in crimson, purple, and yellow, and the exposed genital pouch is entirely of royal purple.

In the *Toreador Fresco* at Knossos, which depicts a bull-vaulting ceremony, not only does the young man wear the loincloth with its distinctive pouch but so, too, do his two female companions. (Figure 4-3.) The significance of this cross-gender dressing remains a mystery. It may symbolize the importance of women in Minoan society, perhaps even as an equal to men in this important religious ritual. Whatever the purpose of this mixed-gender use of men's clothing, the depictions of the loincloth and pouch indicate that, even when worn by women, the garment retained its enlarged protruding masculine shape. The white-skinned women are also adorned with numerous bracelets on the wrists and upper arms, and all three figures wear elaborate boots made of pliant leather.

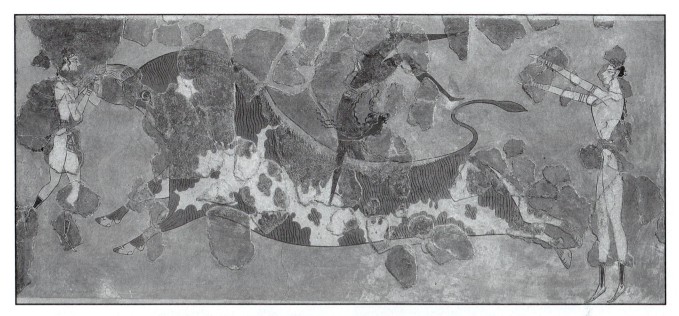

Figure 4-3. In the *Toreador Fresco* from Knossos (c. 1500 BCE), even the two female bull-vaulters wear the exaggerated masculine genital pouch. This cross-gender dressing may symbolize an equality between men and women in participating in this important religious ceremony.

Loincloths with genital pouches were evidently worn by men of all classes. This is an important difference between the Minoans and their contemporaries in Mesopotamia and Egypt. The Minoans do not seem to have had a clear class distinction in costume. The loincloth with pouch shown on the figure in the *Prince of the Lilies* also appears with representations of ordinary people such as the young men depicted on the steatite *Harvester Vase*. (Figure 4-4.) Although the Prince in the fresco wears an elaborate ceremonial headdress and the farmers on the vase have no head coverings, the loincloth pouch styles are identical. Possibly, the wool and leather of the prince's costume were made of finer quality materials and colored with rare dyes but the silhouette is the same as that of the field workers.

Even though the loincloth with a shaped pouch is the most distinctive traditional garment of Minoan men, a few pictorial representations show a type of wrap skirt exclusive of any loin pouch. A fresco at the entrance hall of Knossos depicts a procession of gift bearers in which the men are shown wearing these skirts. (Figure 4-5.) Although this garment is similar to the Egyptian schenti or Sumerian kaunakes, the hemline is cut on an oblique angle from the back to a point in the front.

Figure 4-4. The loincloth with genital pouch was worn by all classes of Minoan men. The farm workers shown on the *Harvester Vase* (c. 1550 BC) wear the same style as the nobleman in the palace fresco.

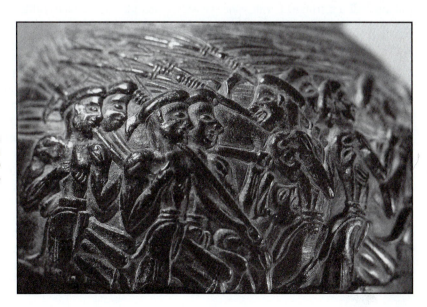

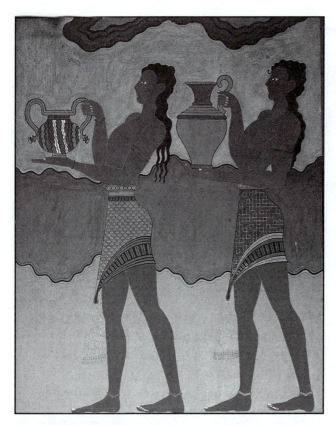

Figure 4-5. For high state or religious functions, Minoan men wore a richly decorated wrap skirt cut to a point in the front with an ornamental tassel. Fresco from Knossos, c. 1500 BCE.

A long, beaded or knotted string tassel is attached to the point and hangs to about mid-shin. The surviving four of the six known figures in the fresco show the identical cut of the skirt, but each exhibits different textile treatments. Some have solid color fabric surfaces, and others are made of intricate, woven patterns. All are trimmed with wide, lavishly embroidered borders. Girdles with rolled edges hold the skirts in place.

Because these processional figures are painted in profile, we cannot discern how the skirts closed. However, another source can provide additional visual information. The same style of Minoan skirt has been found depicted in an Egyptian tomb painting of the fifteenth century BCE. There Minoan ambassadors are represented bearing gifts to the Vizier Rekhmire. We know these are Minoan visitors because the accompanying text refers to them as "envoys of the Land of Keftiu and the isles that are in the midst of the sea" (Keftiu was Crete). They wear the same snugly fitting skirt with the pointed front as seen at Knossos. In these images, though, the Egyptian artist showed that the skirts closed at the center front in an arc from either the left or right side. Since there are so few illustrations of the Minoan men's skirt, most likely it was solely a ceremonial garment worn only for high state or religious functions.

WOMEN'S COSTUMES

The vast majority of representations of female costumes comes from figurines and paintings of goddesses or worshippers. As with all ancient peoples, the Minoans were intensely religious. Yet unlike the enduring, formalized faith of the Egyptians, the beliefs of the Minoans were in transition throughout their history. They worshiped many gods and goddesses in a wide variety of forms, both animate and inanimate. At the head of this pantheon was a "Magna Mater," or Mother Earth Goddess, who was the guardian of households and cities. The most famous image of this goddess is the handler of snakes, that natural symbol of the terrestrial Earth Mother. (Figure 4-6.)

All the goddess figurines wear a variety of full, floor-length **skirts** with a sleeved, open front jacket or blouse. Considering that Mesopotamian women of the mid-second millennium BCE wore wrap garments over simple tunics and Egyptian women wore versions of the tunic-like kalasiris, this separate skirt and top design is exceptional in its originality.

The earliest styles of the Minoan skirt appear to have been a bell-shaped garment that was held in place by a girdle or was rolled over a narrow belt at the waist. Votive figurines dating from about 2000 to 1700 BCE indicate that women's skirts were decorated with horizontal stripes and other geometric patterns. However, this may actually have been an artistic convention for these types of sculptures rather than an actual representation of textile designs. Because these early figurines were so abstractly stylized it is not clear how these skirts were constructed or what sort of tops were worn with them, if any.

By the New Palace Era, though, votive figurines were made in a highly realistic style. From these later statuettes, we can discern with greater clarity the design and decorative details of women's dress. The skirts had developed multi-tiered flounces that were either woven, dyed, or painted with a myriad of decorative patterns. The faience example shown in Figure 4-6 still shows the alternating solid-and-stripe checkerboard effect on its ruffles. Around the same time that the wrap skirt with its pointed front appeared in men's costumes, the flounces of women's skirts adopted a similar pointed front design with richly decorated border trim extending all the way around.

A new addition to most styles of the flounced skirt was a two-sided apron. This garment was cut with deep scalloped edges at each side possibly in imitation of the men's loincloth. Unlike the masculine garment, though, the women's apron was extravagantly embellished with embroidery, appliques, and border trimmings.

The later realistic statuettes also reveal details about the construction of the tight-fitting, short-sleeve tops that Minoan women wore tucked into the girdle or belt of these flounced skirts. Some sculptures and wall paintings from Knossos and Thera show these tops, or **bodices**, with open fronts displaying the breasts. There is debate among scholars as to whether or not the exposure of the breasts was solely ritualistic or the everyday style of the costume. Since

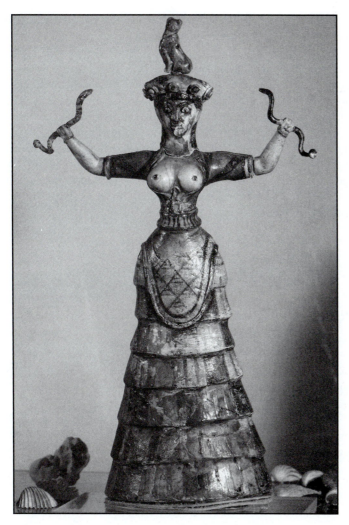

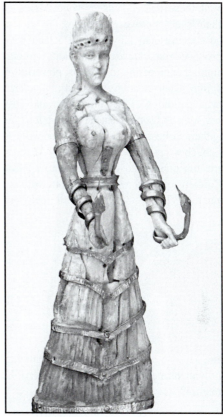

Figure 4-6. The costume of Minoan women included flounced skirts, form-fitting blouses, and constricting corsets. Left, Snake Goddess statuette of faience, c. 1550 BCE; right, Snake Goddess statuette of ivory and gold, c. 1500 BCE.

some depictions of women show the bodices closed, it would seem that the bared breasts represent something out of the ordinary.

As mentioned previously, the Minoan ideal of masculine and feminine beauty included a slender waist silhouette. For women, this was achieved with the help of a wide, rigidly constructed corset, possibly the first of its kind in the world. A marble statue of a goddess in the Fitzwilliam Museum, Cambridge, shows a corset carved in great detail including a sophisticated construction of vertical **stays** around the ribcage, not unlike the designs that would first appear in European fashions 3,500 years later.

Women's accessories are more difficult to catalog with any consistency. Paintings of Minoan women most often show bare heads with luxuriant curls cascading down the back and over the shoulders. Whereas upper class women of Egypt and Mesopotamia of the time wore opulent wigs, Minoan women styled their own hair into elaborate coiffures. One fresco at Knossos depicts a group of court ladies wearing gold bands across their foreheads and multiple strands of

beads in their hair. On the other hand, though, votive sculptures represent a wide variety of headdresses including high, truncated cone shapes, **tiaras** ornamented with poppy pods, and even a soft **beret** style with a cat figurine perched atop as shown in Figure 4-6. The significance of such an odd assortment of headdresses has long since been lost to time.

As for footwear, most representations depict both men and women barefoot. Besides the *Toreador Fresco*, a few images show male figures wearing boots of indecipherable styles; others show simple sandals worn by both men and women. Some archaeologists have suggested that the lack of any significant wear on the soft gypsum stairs at Knossos is probable evidence that the Minoans seldom wore shoes—and perhaps not indoors at all.

REVIEW

The ancient seafaring peoples who lived on the islands of the Aegean Sea developed the first great civilization of the West during the second millennium BCE. Although much is yet to be

learned about these descendants of King Minos called the Minoans, their legacy survives still among the ruins of opulent palaces and the mystical labyrinths of island caves. Their ingenuity produced remarkable achievements ranging from advanced plumbing engineering to the most powerful mercantile navy of its time. Their creativity inspired unique architecture, vase and wall paintings of lyrical beauty, and costumes of extraordinary style and sophisticated construction.

During their earliest history, Minoan men wore simplistic, functional pouches covering their genitals. At the height of their culture, the pouch had developed into an exaggerated shape and dimension, and was often worn with a colorful, woolen loincloth. These loincloths with their brief-styled genital pouches were worn by all classes of Minoan men. However, on high state or religious occasions, male participants donned a style of wrap skirt similar to the Egyptian schenti or Sumerian kaunakes.

Minoan women wore garments that emphasized ideals of feminine beauty and form. Flowing, flounced skirts were graceful and elegant. Tight, short-sleeve bodices emphasized the contours of the female form. Corsets and wide girdles cinched waistlines. Additional components of the women's costume included a two-sided apron possibly made to resemble a man's loincloth. The wide, rounded shape of this garment emphasized the ideal woman's full hips and slender waist.

Chapter 4 The Minoans
Questions

1. How were Minoan costumes unique in the ancient world? What Minoan garments were similar to those of Egypt and Mesopotamia?

2. Describe the Minoan ideal of masculine and feminine beauty. How were these characteristics similar to Egyptian ideals of beauty? How did they contrast?

3. How did the costumes of the Minoans and the Egyptians emphasize their respective ideals of beauty?

4. What modern versions of apparel originated in Minoan costumes?

Chapter 4 The Minoans
Research and Portfolio Projects

Research:

1. Write a research paper on the religious life of the Minoans and how dress for women and men may have been governed by their beliefs and ceremonies.

2. Write a research paper exploring the daily life activities of the Minoans as preserved at Akrotiri on the island of Thera. What evidence is there of Theran trade and communication, food and diet, writing and counting, and social and civic activities?

Portfolio:

1. Prepare a swatch book of twenty textile patterns featured in Minoan wall paintings. Next to each photocopy or digital scan of the textile include a written description of the pattern or motif and colors (if available), and the type of garment made from the fabric. List the location of the wall painting and its date.

2. Construct a replica of a Minoan woman's corset. Refer to examples of votive figurines such as "Our Lady of the Sports" in *Mysteries of the Snake Goddess* by Kenneth Lapatin, 2003 (p. 111). You may use muslin to simulate the leather or metal of the original Minoan style.

Glossary of Dress Terms

beret: an unconstructed, brimless cap made of soft materials

bodice: a feminine garment fitting the torso from the neck to the waist or hips

brief (usually briefs): tight-fitting pants with leg openings cut in an arc from the crotch to the hips

codpiece: a pouch covering for men's genitals

corset: a garment designed to be worn around the waist and sometimes hips to constrict or reshape the figure

flounce: a strip of ruffled or pleated material stitched at one end to another piece of material

repousée: a decorative treatment of metal created by hammering out a shape from one side

skirt: a separate feminine garment worn hanging from the waist; also that part of any garment attached at the waist and covering the legs

stays: the internal structures that give shape and control to corsets or girdles

tiara: an ornamental, crescent-shaped headdress

Legacies and Influences of Minoan Styles on Modern Fashion

Today, we are amazed at how much of what the Minoans created for their dress is yet with us. The modern varieties of constructed tops and blouses seem endless. Flounced skirts continually reappear in new shapes. The idea of the separate blouse and skirt was revolutionary. In modern garment manufacturing, the category of separates is a multimillion-dollar segment of the global fashion industry.

Another innovative Minoan garment was the constricting corset. Although the constructed corset vanished after the Minoans, its concept and purpose were rediscovered 3,000 years later. The corset became a mainstay of fashion over the past 400 years, and survives today in haute couture and lingerie.

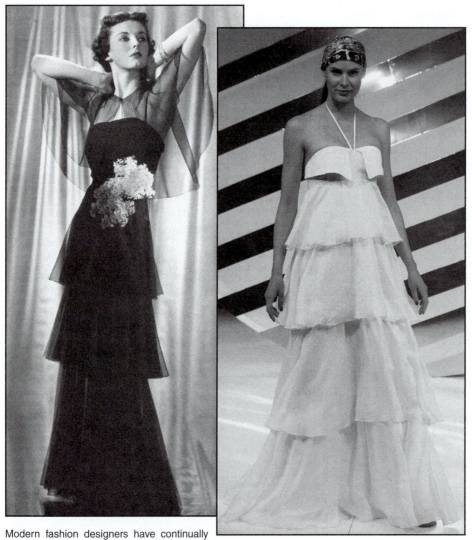

Modern fashion designers have continually applied flounced skirts to their creations for an elegant sophistication. Left, tiered gown by Jo Copeland, 1936; right, flounced gown from Myer, 2009.

Three thousand years before the first designs of European corsets were developed, Minoan women wore versions constructed with vertical stays that constricted the waistline into a tiny contour. Merry Widow corset from Warner's, 1955.

GREECE

Mycenaean City-States

| Migratory tribes | Neolithic settlements | Construction of Mycenaean hilltop citadels | Invasion of Crete by Mycenaeans | Dorian invasions | Destruction of Mycenaean cities | Decline into Dark Ages |

c. 2000 BCE — c. 1600 BCE — c. 1380 BCE — c. 1200 BCE — c. 1100 BCE

Greece

| Tribal wars | Emergence of the Greek citystates | First Olympic Games 776 BCE | Persian Wars 497–479 BCE | Sack of Athens by Persians | Parthenon built | Conquest by Alexander the Great | Roman conquest |

←——— Archaic Period ———→ ←——— Classical Period ———→ ←——— Hellenistic Period ———→

c. 1100 BCE — c. 700 BCE — c. 480 BCE — c. 323 BCE — c. 146 BCE

MYCENAE

Northward across the sea from the great Minoan civilization was a land in turmoil and transition during the early part of the second millennium BCE. From the east and north, migrating, warring peoples poured into the peninsula of what is today modern Greece. These invading tribes displaced the indigenous inhabitants of scattered Neolithic villages and, by the sixteenth century BCE, had established a number of sizeable kingdoms in the region. These were the cities of Homer's *Iliad:* Odysseus' Ithaca, Menelaus' Sparta, and the most powerful of all, Agamemnon's Mycenae, for which these early Greeks have been named.

Mostly, the Mycenaeans battled each other during the early phases of their cultural development, much as the fiercely independent Sumerian city-states had done 1,000 years earlier. The rulers of the Hellenic cities were aggressive and suspicious of each other. Consequently, unlike the Minoans, the Mycenaeans built hilltop fortress palaces that were constructed of heavy, impenetrable masonry. Eventually, though, for the common good, these various kingdoms managed to forge alliances from which they all benefited. For

example, in the vacuum created by the collapse of the Minoan civilization, the Mycenaeans developed the dominant naval forces and mercantile fleet of the eastern Mediterranean. They even invaded and colonized Crete and other former Minoan islands. From this collaboration of Mycenaean kingdoms came a collective security and prosperity.

In addition to this economic cooperation, the Mycenaeans allied themselves militarily. These were the peoples of Homer's Trojan War. They pushed back the Hittites from the coasts of Anatolia and challenged Egypt's empire in the Levant. Of special significance, they kept troublesome pirates at bay all around the Aegean.

By all accounts, the Mycenaeans were the first Greeks. Baked clay tablets inscribed with a linear proto-Hellenic language have been excavated from Mycenaean sites. The modern names of mountains and rivers in southern Greece have Mycenaean origins. The deities of Classical Greece—Zeus, Poseidon, Hera, and Athena—were the gods of the Mycenaeans.

Culturally, though, the Mycenaeans borrowed much from the Minoans. Initially, contact between the two civilizations

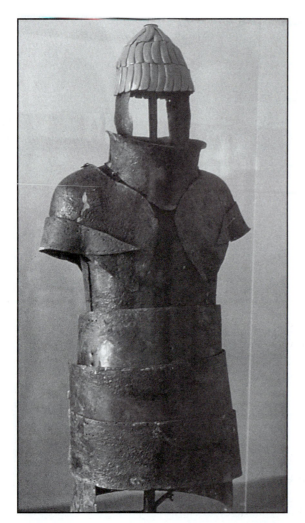

Figure 4-7. Most evidence of Mycenaean costume reflects the prevalence of war and military needs of the culture. Bronze suit of armor from Dendra, c. 1400 BCE.

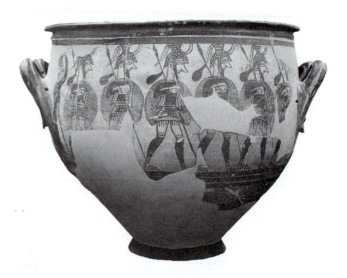

Figure 4-8. Even after occupying Crete, the Mycenaeans retained the Asiatic look of their costumes rather than adopting Minoan styles. Soldiers are shown here as bearded and wearing fringed wrap skirts with T-cut tunics similar to Mesopotamian versions. *Warriors Vase*, c. 1250 BCE.

was through commerce. Then, after the Mycenaeans invaded Crete in the late fifteenth century BCE, they indulged in a 200-year binge of palace building that combined their fortress model with a decorative opulence adapted from the grandeur of Knossos.

Despite being inspired by the splendor of Minoan art and decoration, there is little evidence to suggest that Mycenaean men's costumes were influenced by Minoan styles. Much of the surviving evidence we have of Mycenaean men's dress comes from gravesites and tombs. Since the occupants of these burials were chiefly warlords, the precious objects that accompanied the deceased were primarily military. A significant quantity of swords, daggers, and armature has been excavated from these sites. The suit of armor shown in Figure 4-7 looks medieval at first glance. Most likely, though, this was a ceremonial costume used solely for burial since the weight and limited articulation of the plates of this suit would have made its use in battle impractical.

However, the type of **boar's tusk helmet** that had been found with the armor was a distinctive and common component of Mycenaean military costumes. The exact same style of helmet is also depicted on a number of figures in frescoes from Pylos and Thera as well as some sculptural representations. The pointed dome of the helmet with side cheek guards is a design feature first devised by the Sumerians and may have been brought into the Greek mainland by migrations from Asia Minor during the early second millennium BCE. Despite the possible origins of the pointed dome helmet from Mesopotamian versions, the veneer of polished boar's tusks set in alternating rows of counter direction is uniquely Mycenaean.

Another costume commonality with Mesopotamia—and a differentiation from the Minoans—is the Mycenaean soldier's wrap skirt worn with a T-cut tunic. Each of the soldiers on the *Warriors Vase* shown in Figure 4-8 wears a thigh-high fringed skirt similar in cut and style to that of the Hittites from the same period. A reconstructed wall painting from the palace at Pylos (c. 1250 BCE) also shows soldiers in battle wearing the same styles of wrap skirts as well as the distinctive tusk-covered helmets. The fringe is especially noteworthy as an Asiatic influence since none of the depictions of Minoan men's loincloths or snake goddess skirts appear to show fringed trim.

Also from the Mycenaean frescoes at Pylos are processional figures and a charioteer dressed in short-sleeved T-cut tunics without the wrap skirt, one more difference between the Minoan and Mycenaean masculine dress. (Figure 4-9.) Some of the tunics feature an undecorated border trim at the base of the skirt, others with a similar treatment at the hem of

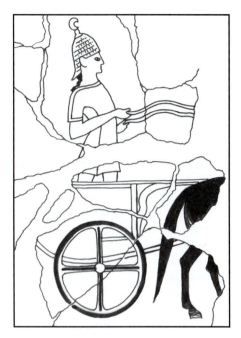

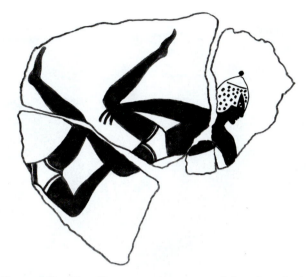

Figure 4-10. Other Mycenaean frescoes at Pylos show battle scenes in which soldiers appear to be wearing a short bifurcated garment somewhat resembling the cut of Minoan men's brief.

Figure 4-9. Mycenaean frescoes at Pylos from c.1250 depict processional and hunting scenes in which men are represented wearing undecorated T-cut tunics and pointed helmets decorated with boar's tusks.

the sleeve, and for the charioteer, a plain border along what appears to be a **bateau neckline** extending down the sleeve. All appear to be made of white fabric without pattern.

One particularly notable difference in Mycenaean armature from that of Mesopotamian or Minoan cultures was the addition of shin guards called **greaves.** The soldiers represented on both the *Warriors Vase* and the frescoes of Pylos show the contours and fit of greaves with short boots. These shin guards probably were made of reinforced linen or leather with straps that tied or fastened around the leg in the back.

One particular point of uncertainty about Mycenaean masculine dress is the question of trousers. The evidence cited most often as proof of Mycenaean trousers is a trio of tiny figures incised on a dagger blade found at Mycenae. All three of the figures lunge forward with lances poised to strike a charging lion. Drawn in profile, the separated legs of the hunters appear to be clad in a bifurcated garment resembling short trousers cropped to just above the knees. Given that, at this time, trousers were common with the masculine dress of Central Asian peoples (see Chapter 1) and the Mycenaeans traded extensively with the peoples of Anatolia, it is an intriguing idea that there might have been a cross-cultural influence. On the other hand, though, the rendering may also simply be an artist's convention representing the separation of a wrap skirt.

One other example of Mycenaean men's dress that is an exception to the prevalent wrap skirt and tunic is from a

fresco in the palace at Pylos. One of the battle scenes depicts soldiers wearing boar's tusk helmets and what appears to be briefs that somewhat resemble the style of the Minoans. (Figure 4-10.) However, the waistbands and leg openings in the painting are accented with contrasting stripes, the cut is not as high on the legs as that of the Minoan style, and there is no indication of the exaggerated genital pouch typical of the Minoan design. Whether the depiction of this Mycenaean garment represented cut-and-sewn briefs, or the fitted arrangement of a loincloth, or an artist's stylization of the short wrap skirt is open to debate.

Only a very few surviving scraps of frescoes provide a glimpse of Mycenaean women's costumes with any clarity. Although a number of early artworks representing females has been found, the stylized, geometric renderings provide little more information than a silhouette of long, bell-shaped skirts. On the surface, some of these stylized female figures appear to be wearing skirts with tiered flounces similar to those of the Minoans. However, four key differences are evident: Mycenaean dresses were cut as a shoulder-to-hem tunic rather than separate bodice and skirt; waists were not cinched with corsets and most not even belted; some styles feature long sleeves; and the hip aprons of the Minoans are absent.

In the highly rendered frescoes of the later period, we can better see the details of how these feminine costumes were made. The sumptuous tunic ensemble worn by the woman shown in Figure 4-11 features what may be an open-front jacket or outer robe with long sleeves that are cut with an undulating cuff trimmed with a contrast edging or piping. The same contrasting colors are applied in panels over the shoulders and along the front opening, the two edges of which are pulled back to the sides of the breasts. Trimming the V-neckline of the under tunic is a border with the reverse

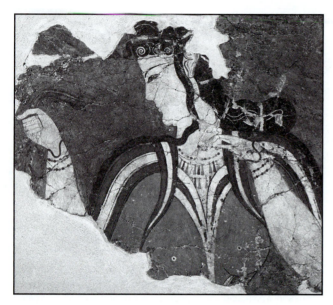

Figure 4-11. Images of Mycenaean women are rare. This fragment of a fresco from a private house in Mycenae depicts a bejeweled noblewoman, c. 1250 BCE. Her long sleeve dress is trimmed with contrast piping at the wrists and features a V-neckline.

coloration of the outer garment—white stripes flanking a center one of sienna. The woman's hair is elaborately coifed and bound with a sienna-and-white striped ribbon that matches the tunic trim. Her accessories also include two types of beaded necklaces and a double strand of beaded bracelets on each wrist.

Although this portrait of a noblewoman was found in a private house in Mycenae, we do not fully understand enough of Mycenaean society to deduce if she represents a member of a ruling family or if she is the wife of a wealthy merchant or craftsman dressed for entertaining. No depictions of ordinary females survive to offer us a clue of what women wore for everyday. In fact, written records from Thebes, Tiryns, Pylos, and other Mycenaean sites that contain lists with categories of occupations, such as metalsmiths, carpenters, masons, potters, and sheep farmers along with inventories of goods they produced, provide few details about their social order. In addition, conspicuously absent is any written documentation of royal houses, historical records, or even literature. Such information would have continued in the oral traditions of the region and eventually merged into the Greek cultures that evolved during the 400-year Dark Age following the collapse of the Mycenaean civilization.

THE GREEK CITY-STATES

The later Greeks, or Hellenes as they called themselves, were the product of an intermingling of the remnants of the Mycenaeans with invading tribes of Dorians from the north and Ionians from Asia Minor. There is much dispute among

scholars of how the individualistic cultures of these Greek-speaking peoples evolved from the eleventh century BCE until around the eighth century BCE. However, by the time of the first Olympiad in 776 BCE, despite rivalries and chronic warfare, they collectively regarded themselves as Hellenes, distinct from the surrounding peoples they viewed as barbarians because they did not speak Greek.

In a short span of time, the Greeks arose from a Dark Age of chaos and struggle for survival to create one of the greatest civilizations in history. Tribes had formed city-states ruled first by kings and then by "tyrants" who seized personal power. In fifth-century Athens, a dynamic political balance of power called *democracy* first appeared. By the seventh century BCE, Greek philosophers had begun to interpret the world rationally in terms of reason rather than religion. The worship of nature was transformed into the science of nature. Intellectual argument, the forerunner of our modern sciences, was broadly popular with all classes of Greek society. Likewise, physical exercise played a significant part in education and daily life. Every town had an open-air gymnasium, and larger cities had several. This aim of a balance of intellectual and physical discipline was, for the Greeks, well expressed in the aphorism "a sound mind in a sound body."

From their humanistic understanding of the harmony between man, nature, and reason, the Greeks developed their extraordinary achievements in art, architecture, literature, philosophy, mathematics, history, and the sciences. This rich heritage, in turn, became the foundation upon which our modern Western civilization was constructed.

WOMEN IN GREEK SOCIETY

Given the high level of education and intellectual pursuits of Greek men, the restrictive, subordinate role of women in Hellenic society almost seems an anomaly. Women were considered inferior to men both physically and intellectually. They could not own property and had no more civil rights than slaves. Respectable women were rarely seen in public and then only when accompanied by other women. Marketing chores and fetching water from community wells were done by slaves or lower classes of women who were regarded as little more than slaves.

On the whole, Greek women lived strictly prescribed and monitored lives in virtual seclusion within the women's quarters of the home. Under the aegis of their fathers, girls of good breeding were principally taught self-control and modesty. Writing in the fourth century BCE, Athenian general Xenophon noted that prior to marriage, girls spent their time seeing, hearing, saying, and doing "as little as possible." Under the dominion of their husbands, they were taught the three purposes of being a wife: to bear children, maintain an orderly house, and train and supervise servants and slaves. Xenophon likened the wife's role to that of a queen bee: "She

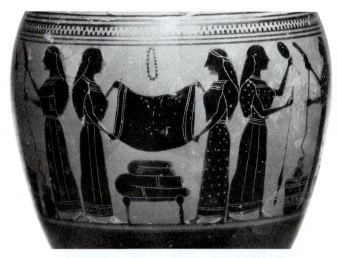 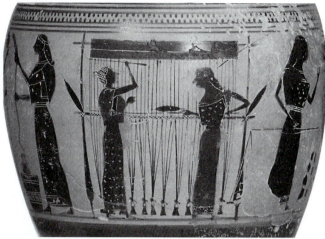

Figure 4-12. Home textile production was a principal occupation for Greek women. Depictions of spinning and weaving processes were commonly applied to pottery and other objects for home use. Detail of an Attic black-figure vase, c. 560 BCE.

stays in the hive and does not let the bees be idle, but the ones who have to work outside she sends out to their duties, and what each of them brings in she receives and saves up until it is needed for use . . . And she has authority over weaving the honeycomb inside, so that it gets woven well and quickly, and she takes care of the offspring born, and nourishes them." As Elizabeth Wayland Barber concluded about Greek women in her book *Women's Work: The First 20,000 Years,* "Basically the wife is to stay at home and work." Only in Sparta were women encouraged to participate in outdoor athletics and public affairs, but then primarily because such activities were thought to produce strong, healthy babies.

GREEK TEXTILES

Within the confines of their houses, Greek women raised their children, prepared meals, and wove textiles. Spinning and weaving, especially, were among the principal occupations of women. Homer tells us that even the wives of ranking noblemen were daily engaged in this task. From the fabrics produced at home, women made clothing, blankets, table linens, and the many other cloths for household use. Thick, heavy fabrics that required **fulling**—the finishing process of shrinking, pounding, and sizing—were commercially produced at textile centers such as Miletus and Megara.

As with the Egyptians, the Greeks have left an abundance of written and pictorial documentation of their domestic chores. Innumerable images of women weaving at looms or spinning threads have survived, particularly in paintings on pottery and other objects made for use in the women's quarters. (Figure 4-12.)

The first step in making textiles was fiber preparation. Until the late sixth century BCE, Greeks wore almost exclusively wool. Although Homer once mentions a fabric "thin and smooth as onion skin" worn by Odysseus that may have been linen, he most often refers to garments and textiles woven of wool. Very likely, linen did not become a widely accepted fabric for apparel until after the Persian Wars. Even then, the material was mostly imported as a finished textile rather than processed and woven in the home. One of the most common uses for linen was in the production of military body armor, discussed later in this chapter. Cotton, too, was rarely used in producing homemade cloth until late in the Hellenistic Period. Likewise, costly silks imported from the East were seldom worn until the era of Roman rule.

Before weaving could begin, women had to spin an adequate quantity of thread. They would start with raw wool just as it had been sheared from the sheep. After thoroughly washing the fleeces, they would sit in a chair with their feet positioned on a low stool to slightly elevate their knees. A large semicircular platter made of wood or terracotta would cover the lap upon which the matted wool was pulled apart and further cleaned of impurities before carding. Daughters of the household even entered community carding contests to prove their training and skill. The prepared fibers were then attached to a distaff and spun into a thread by a weighted spindle (see chapter 1).

By the time the Greeks had emerged from their Hellenic Dark Age, the **vertical loom** already had been in use around the Mediterranean for more than 1,000 years. This innovative design is thought to have been introduced from Asia Minor in

the early second millennium BCE, first into Mesopotamia, and then into Egypt and the Aegean. The importance of the vertical or upright loom was in the greater dimensions of textiles that could be produced on its expandable frame. The size and construction of a home version is depicted in Figure 4-12.

Among the finishing touches that women added to their textiles was embroidery. Greek clothing was famous for its decorative borders and allover patterns that had been meticulously stitched by the mistress of the house. Numerous vase paintings show women seated in chairs with embroidery frames in hand.

To what extent garments were colored is largely deduced from surviving artworks. Vase paintings were actually brush drawings in black and white on terracotta, which reveal great varieties of textile patterns but no colors. On the other hand, Greek sculptures were vividly painted, but only a few statues have retained scant hints of these colors. Palettes of colors from these painted sculptures included the full range of yellows, greens, reds, and violets used in rendering the clothing with no particular uniformity of color application. In other words, there does not seem to have been specific colors reserved exclusively for social status or official rank or profession. Written documents have also provided us with detailed information on the Greeks' love of colorful clothing. Homer described purple-dyed textiles, which we know from the Mesopotamians were colored by ink from the glands of the murex mollusk. Herodotus mentioned that cloaks were commonly dyed in deep reds or sienna browns. And Pliny wrote of the brilliant "flowered colors" of women's clothing.

CLOTHING STYLES

The key element of Greek style in costume was draping. Basically, the garments had no form in themselves; that is, they consisted of various sizes of rectangular pieces of cloth tied or pinned about the body rather than cut-and-sewn to shape. (The exception was the casting and molding of military body armor.) In fact, ancient Greek has no word for tailor or dressmaker. Thus, while draping techniques varied over the centuries, Greek apparel design never underwent the major transformation it did in Mesopotamia.

The most basic costume worn by most men in the time of Homer, especially those of peasant and slave classes, was the **exomis,** also called the **chlaine** when worn ungirded as a cloak. Some artistic representations show the exomis worn by females such as the mythical Amazons or even the goddess Artemis, both of whom needed to have their right arm free to shoot a bow or wield a sword. (Figure 4-13.) But, in reality, Greek women did not dress in such brief and revealing clothes. The exomis was little more than a rectangle of cloth draped around the body and tied or pinned over the left shoulder. The right shoulder and arm were left

Figure 4-13. The exomis was a simple wrap garment worn fastened over the left shoulder. Although exclusively a masculine garment, sometimes it was depicted in sculpture and vase paintings as the dress of the mythical women warriors, the Amazons. *Amazon* by Polykleitus, c. 340 BCE.

unfettered for easier use of farm implements or other labors. The open edges at the side overlapped and were sometimes held closed by a belt or cord tied at the waist. The size of the fabric was cut to fit around the wearer's torso and to extend from the shoulder to mid-thigh. According to Homer, the exomis, favored by shepherds and farmers, was made of wool without any adornment or coloration. In addition, the garment served as a blanket for nights spent out of doors with their fields and flocks.

From the basic exomis of the Homeric era developed the **chiton** of the late Archaic Period worn by both men and women. This was the Greek version of the tunic that had been introduced into Asia Minor more than 1,000 years earlier. Unlike the Mesopotamian tunic and the Egyptian kalasiris, though, the Hellenic chiton was not cut and sewn to fit the body. Instead, the garment was a wide cylinder of fabric with one side stitched or pinned closed although some later versions were made of two pieces of fabric sewn up the sides. (Figure 4-14.) Men's styles were usually short, ranging in lengths from the upper thighs to the knees, except for ceremonial dress, which was made ankle-length. Women's styles almost always

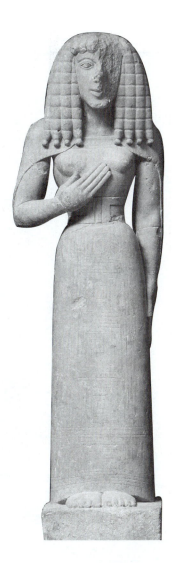

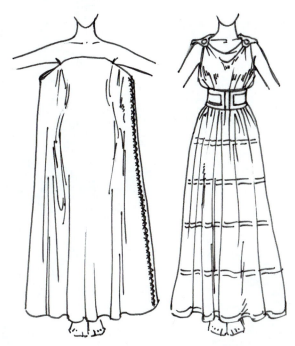

Figure 4-14. The Doric chiton was basically a wide cylinder of fabric sewn up one side. The garment was pinned at each shoulder and held in place by various girdles, belts, and cords. Men's styles most commonly extended to mid-thigh and women's versions were almost always floor-length. The chiton shown here on a statue of the seventh century BCE has been stylized into a form-fitting garment with a smooth skirt and shawl. The drawings above approximate how the Doric chiton actually fit. *Kore of Auxerre*, c. 640 BCE.

extended to the floor. Exceptions were in versions worn by dancing girls or young women in certain "mystery" rites and processions for which the chiton was short.

The simple cylindrical **Doric style** of chiton was held in place at each shoulder by a large pin called a **fibula** that featured a long shaft. Both men and women wore the chiton pinned at both shoulders to distinguish their social status from that of slaves and peasants who wore the shorter exomis tied over one shoulder.

Belts, cords, shawls, and scarves were variously tied around the body to give the chiton a variety of silhouettes. One look exclusive to women well into the Hellenistic period was the double-girded chiton. This was achieved by belting the garment once high on the waist and then blousing the fabric over a second belt a few inches lower. Men, too, indulged in creative ways of binding the chiton. The long ceremonial version worn by the charioteer shown in Figure 4-15 shows the chiton with a wide leather belt fastened around the ribcage in combination with a thin cord

looped under the arms and around the back of the neck to form sleeves.

By the end of the sixth century BCE, a new style, the **Ionic chiton,** replaced the Doric version. Herodotus wrote of how the transition of styles abruptly occurred. He related that, when Athens attempted an imperial domination of Peloponnesus, their siege of Aegina in 558 BCE resulted in a disastrous defeat for the Athenians. The lone messenger who arrived back in Athens with the bad news was set upon by a group of women who stabbed him to death with their fibulae exclaiming that he had no right to live while their husbands, sons, and fathers had perished. The outraged Athenian citizenry subsequently punished all women by forcing them to abandon their Doric chitons—and fibulae—for the fuller, Ionic styles that were fastened by small pins or **tapes** (stitched-on fabric strips tied together). Since the Athenians were the recognized arbiters of high style and taste, most of the rest of the Hellenes soon adopted the Ionic chiton as well.

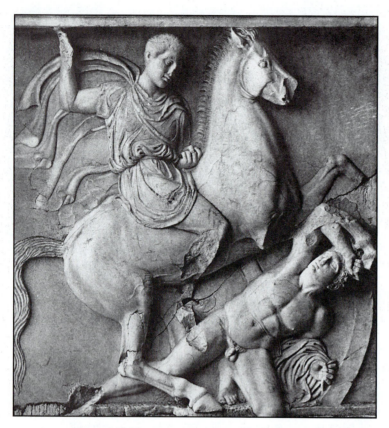

Figure 4-15. The Ionic chiton was a more voluminous garment than the earlier Doric version. Men's styles ranged from thigh-length for everyday wear to ankle-length for ceremonial dress. Left, *Grave Stele of Dexileos*, c. 390 BCE; right, *Charioteer of Delphi*, c. 475 BCE.

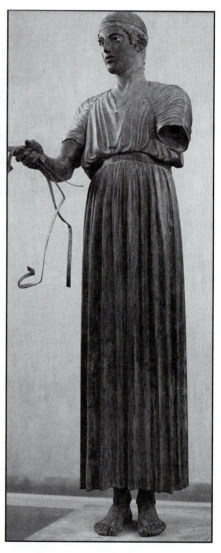

The design of the Ionic chiton was similar to that of the earlier Doric version. Two chief differences were the extravagant use of fabric and the formation of a kind of sleeve. Whereas the Doric chiton had been a narrow, sleeveless model, the Ionic style was voluminous, perhaps as much as twice as wide. Moreover, with the addition of multiple pins or tapes along the top opening of the tube of fabric, depending upon its width, sleeves could be created that even extended to the wrists. (Figure 4-16.)

Both men and women wore the Ionic chiton with sleeves of varying lengths. Relief carvings from the frieze on the Parthenon show young horsemen wearing long-sleeve chitons with skirts at thigh length. Vase paintings from the same era depict bearded, older men wearing the long-sleeve chiton with a hemline to the ankles. As with the Doric versions, for respectable women, the skirts of Ionic chitons were always floor-length.

During the fifth century BCE, lightweight linen became increasingly used for men's and women's Ionic chitons,

particularly in the warmer seasons. Use of this material provided fresh stylistic opportunities such as pleating and other textural surface treatments. (Figure 4-17.) Unlike the uniform, formalized goffering that the Egyptians applied to their linen garments, the Greeks utilized a looser method of creating pleats. A length of wet linen was accordion-folded and tied at each end. The material was then tightly twisted and left to set for several hours. Today, so-called "crinkle" textiles are similarly treated on a mass-production scale. The results were springy, fluid lines of fabric that flattered and enhanced the motion of the body. The look of this diaphanous material with its contouring vertical creases may actually have contributed to the change in artistic styles of the Classical Period. Instead of representing smooth, concealing folds of fabric on figures, sculptors of the fourth century BCE began to depict a "wet fabric" look that revealed and defined the human form.

Students of costume history should be aware of the broad use of the term *chiton* as it appears in so many texts.

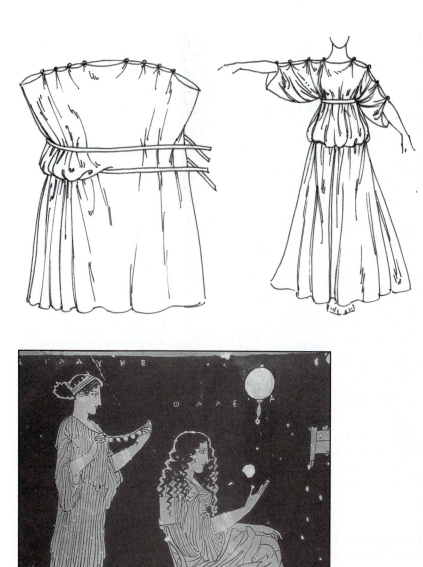

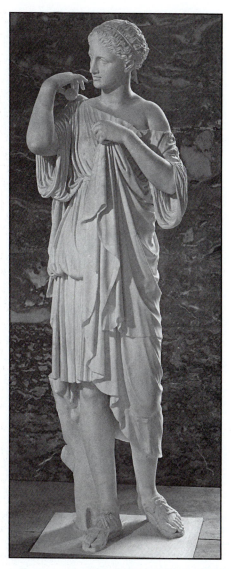

Figure 4-16 Depending upon the width of the fabric used in the Ionic chiton, multiple pins or tapes could be fastened at the top opening to create various lengths of sleeves for both men's and women's styles. Left, red-figure vase painting of woman dressing, c. 450 BCE; right, *Artemis of Gabii* by Praxiteles, c. 340 BCE.

For some historians, the word is applied generically for a range of draped Greek costumes, including the exomis, the Doric and Ionic chitons, and the peplos described below. For our survey purposes here, we have differentiated each of these forms of clothing as a distinct and individual garment.

The **peplos** was worn exclusively by women. (Figure 4-18.) It was styled as a cylinder of wool or linen similar to the form of the chiton, only much longer shoulder to toe. This extra length of material allowed a section to be turned down at the top creating a bib-like flap in the front and a hood-like flap in the back. In fact, respectable women sometimes used this back flap as a head covering to veil themselves when in public. To keep the front flaps from flying up into the face at every turn, the edges were sometimes lightly weighted with metal or terracotta beads. As with the chiton, the peplos was pinned at each shoulder. Early versions of the peplos were worn open at the side, usually the left. By the end of the sixth century BCE, though, only Spartan women still wore the open peplos. Indeed, Athenian women disparaged their Spartan sisters as "hip displayers," and the phrase to "dress in the Spartan manner" was a euphemism for indecent exposure.

The peplos was treated as variously as the chiton to achieve different looks by attaching girdles and belts or

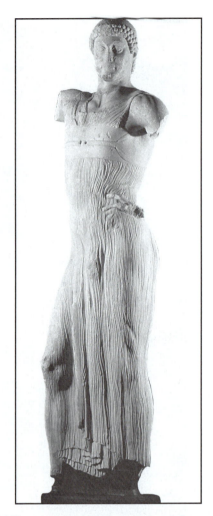

Figure 4-17 Pleated fabric in Greek apparel was prepared by folding accordion pleats and then twisting the material while wet, leaving it to set up for several hours. The springy, crinkled texture produced by this method flattered and enhanced the contours and motion of the body. Charioteer from Motya, c. 450 BCE.

binding the garment with ribbons, tapes, cords, and scarves. In viewing Greek artwork of the Classical period and later, it is easy to confuse representations of the peplos with those of the chiton, especially on sculptures that were created with the clinging, wet fabric look. The most prevalent arrangement of the peplos featured a full blousing of the fabric over the belt that hung about the hips like a short skirt. This silhouette has been adapted to modern fashions as the **peplum.**

By the close of the fifth century BCE, men's preferences in clothing styles changed all across Hellas. Instead of the chiton, which required fastening with pins or tapes and girdles or belts, men opted for loose-fitting wrap styles of garments. Young men preferred the short cloak called a chlamys, and older men chose a larger type of cloak called a himation. Prepubescent boys were still restricted to the short chiton.

The **chlamys** was simply a rectangle of fabric worn over the left shoulder and fastened with a clasp to the right or sometimes in the center front. (Figure 4-19.) Most young men wore nothing else under the chlamys although the weather and cooler seasons governed the layering of other clothing underneath. Representations of the garment in vase paintings reveal a wide variety of decorative textiles ranging from colorful border treatments to all-over patterns of flora, geometric designs, or stars. Since the chlamys also could serve as a blanket, numerous pictorial images show travelers, hunters, or soldiers dressed in the garment, frequently with a hat.

Women wore an abbreviated version of the chlamys called a **chlamydon.** It, too, was a simple rectangle of fabric but sometimes was pleated or folded to create a ruffled edge. (Figure 4-20.) The chlamydon fit asymmetrically over the right shoulder and around the torso layered over a chiton or peplos. Whereas men pinned the chlamys with a single large brooch, women fastened several pins in a row on

Male Nudity and Female Modesty in Public

As noted earlier in this chapter, the Greek custom of sequestering women in the home led to traditions of feminine dress that virtually shrouded a woman whenever she had to go out into public. By contrast, the garments worn by men were for utility or class distinction but not at all for the purpose of modesty, meaning concealing the naked body. Indeed, male nudity was not only acceptable in public, it was actually required for competitive sports, for certain ceremonial processions, and in the activities at the gymnasium. Herodotus explained that the nude display of masculine beauty was "a holy offering to the divine." This may explain why some forms of men's costumes were worn draped to reveal rather than conceal—the chiton tucked up to hip- or thigh-length, the chlamys open at the front, and the himation wrapped about the hips rather than the shoulders.

This offering to the gods may also explain why Greek artists so often depicted the male figure nude while simultaneously sculpting or painting the female fully clothed. In fact, the evolution of the nude female body in Greek art was a slow transition from the heavily attired kore statues of the seventh century BCE, through the "wet" drapery figures of the Parthenon decorations, and finally to the fully nude figures of the Hellenistic Period. Yet even as the representations of nude females became increasingly visible in public arenas, women continued the tradition of veils and layered, concealing costumes whenever venturing outside the home.

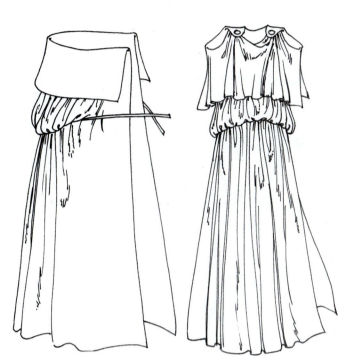

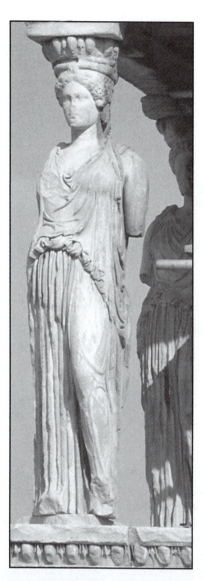

Figure 4-18. The peplos was worn exclusively by women. Early versions were designed as open at one side with the top edge of the fabric turned down to create a bib in the front and a hood in the back. Later styles were sewn closed into a cylinder of material. Various girdles, belts, and bindings gave the peplos a wide assortment of looks. Caryatid from the Erectheum, c. 450 BCE.

Figure 4-19. The chlamys was a short cloak worn by younger men. It fastened in the front, most often revealing rather than concealing the wearer's nudity. Red-figure vase painting depicting Orpheus, 440 BCE.

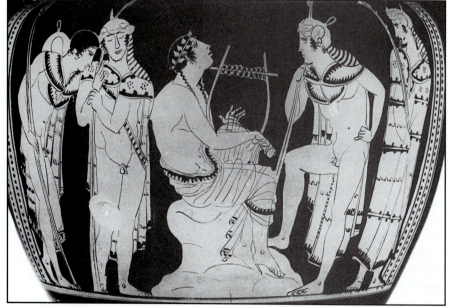

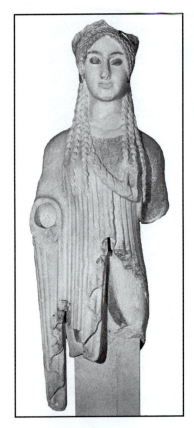

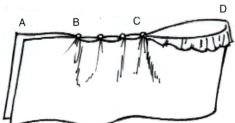

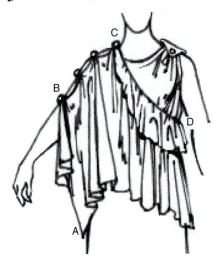

Figure 4-20. The chlamydon was a short band of material worn asymmetrically by women over a chiton. One edge could be folded over to create a pleated or ruffled edge, and the other end could be variously pinned over the right shoulder. Attic Kore, c. 500 BCE.

one side of the chlamydon to create the same type of small oval openings made for the sleeves of the Ionic chiton.

A much greater rectangle of fabric—about six feet by nine feet—was needed for the **himation.** This garment was swathed about the body in various arrangements without any fastenings or bindings. (Figure 4-21.) Just as with the chlamys, men most often wore the himation as a solitary garment and were nude underneath. In fact, many sculptures and vase paintings of younger men dressed in the himation have the garment so nonchalantly draped that the figures are more or less carrying it over one arm rather than wearing it.

When completely wrapped around the body, little more than the head, hands, and feet would show. More importantly, by the late Classical period, wearing the himation imparted an aura of noble dignity. Sculptural representations of scholars, philosophers, statesmen, and other such dignified personages were most often shown wearing the himation rather than the Ionic chiton (or possibly the chiton was concealed underneath). Moreover, when younger men such as pupils or disciples were depicted in attendance of these avuncular figures they, too, wore the himation.

In addition, women found a supreme expression of modesty in wearing the himation over their full-length chitons when in public. They were able to envelop themselves completely in fabric, covering virtually everything except their eyes in some instances.

HATS, SHOES, AND ACCESSORIES

Greek men rarely wore hats or head coverings with everyday dress although a great variety of styles are to be found in the images on vase paintings. For extended periods of working out in the sun or for traveling, the most common style of men's hat was the **petasos,** a broad-brimmed design with a shallow crown and chinstraps. When not in use, the petasos was pushed off onto the back and held there by the chin straps around the neck. Another prevalent hat style was the **pilos,** a conical design usually with a narrow, floppy brim. Materials used in **blocking** men's hats—the shaping on wooden block forms—included straw, felt, and leather.

On the other hand, women wore a greatly diverse assortment of hats and headdresses. The sharply pointed, wide-brimmed **tholia** shown in Figure 4-21 was worn pinned to the hair atop a veil or shawl when women went outside into the midday sun. A version of the petasos that fitted more snugly over the head was also worn in public, especially for traveling. Mostly, though, women entwined their elaborate coiffures with various adornments. At the front of their heads they inserted tiaras made of carved ivory, bone, wood, bronze, or silver. Over the crown, they arranged ringlets and braids with ornate combs and pins. At the back, they bound up **chignons,** or buns, with ribbons, or tied on **snoods** of linen and fine mesh, or attached intricately arranged turbans.

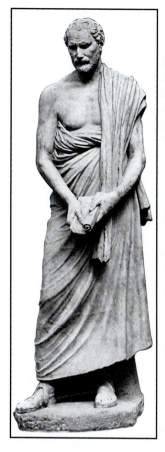
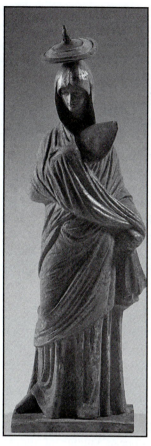
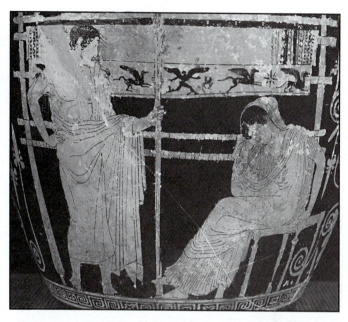

Figure 4-21. The himation was created by draping a large rectangle of fabric about the figure in a variety of techniques. Men wore the himation as a solitary garment whereas women layered it over a chiton. Left, statue of Demosthenes by Polykleitus, c. 340 BCE; center, figure of a maiden from Tanagra, c. 280 BCE; right, detail of a vase painting showing the male and female arrangement of the himation, c. 440 BCE.

The most prevalent styles of footwear for both men and women were sandals. Finely carved sculptures reveal in exacting detail the vast array of styles, many cut with complex arrangements of thongs and straps. In addition, the leatherwork of Greek sandals was richly tooled or vividly painted with intricate decorations. It is no wonder that the Hellenes disparaged the plain Assyrian styles of sandals as second rate. More rustic types of sandals were made with wide pieces of leather sewn to the sides of the soles, and some even included a closed heel. Horsemen and travelers wore ankle boots made of soft leather with reinforced soles. By the fifth century BCE, Persian styles of boots that were open down the front and secured with laces became favored by working class men. However, the Greeks never adopted the curling, pointed-toe sandals or boots of the East, even in Ionia. Hoplites, slaves, and the peasant classes usually went barefoot.

MILITARY COSTUME

Our knowledge of Greek military costumes and armature, both from written and artistic evidence, is considerable. However, the Hellenic civilization was an Iron Age culture and surviving specimens of the soldier's arms and armor are few in number, most having rusted away in the damp climate of the Greece peninsula.

The military costume is comprised of three components: clothing, armor, and weaponry. The purpose of a soldier's clothing was protection against the elements and against the chaffing of armor. The primary pieces of body armor consisted of the helmet, cuirass, and greaves. Weaponry included a vast array of specialized aggressive implements and defensive devices such as swords, daggers, spears, clubs, battle axes, bows, slings, and shields, of which the purposes and descriptions are too extensive for a general costume survey.

Early Greek culture during the transitional Dark Age between the collapse of the Mycenaean civilization and the emergence of the Hellenic city-states centered on war and survival. At times, individual city-states fought each other and sometimes collectively stood against invaders on their borders. The *Iliad* is an epic story of war, much reflective of the priorities, exigencies, and attitudes of the Greeks at war. Homer provides us with a wealth of detail on the equipment of warriors including many descriptions of body armor.

Beginning with the helmet, it should be noted that the styles of the early Greeks differed significantly from the pointed design of their geographic predecessors, the Mycenaeans, and their neighbors in Mesopotamia. Instead, the Greeks developed a hemispherical covering contoured to fit close to the skull. Cheek guards, first seen with the Sumerian helmets and later applied to Babylonian and then Mycenaean designs, were

extended and strengthened in Greek versions. In addition, the surmounted crest of the officer's helmet used 1,000 years earlier by the Hittites also was adapted to the Greek style. Homer relates that Hector's infant son was frightened by the "shining bronze of the helmet and its horsehair plume dreadfully nodding." Although artistic renditions of soldiers often show all figures wearing crested helmets, this was an aesthetic convention since the ordinary foot soldier, called a hoplite, would have worn an unadorned style made of leather or iron.

By the late eighth century BCE, the **Corinthian helmet** was the most widely used type among the various Greek armies of the Iron Age. (Figure 4-22.) Over the subsequent centuries, the helmet design underwent significant changes. Around 650 BCE, modifications were made to allow better coverage of the neck and greater maneuverability of the head by curling the back of the helmet outward into a neck guard. The solid cast extensions for the cheek pieces had evolved from separate flaps that originally had been affixed to the crown by a hinge or tab of leather. These face guard extensions were flexible enough so that the helmet could be pulled over the head quickly and easily. When not in use for battle, the Corinthian helmet could be pushed back on top of the head where the grip of the cheek guards would hold it in place about the brow. By the Classical Period, the Greek helmet had developed the silhouette most familiar to us from sculptures, vase paintings, and coins. The dome was now larger to accommodate an insert of leather or fabric to cushion blows. The eye openings, nose guard, and vertical slit for the mouth not only effectively protected facial features but also created a menacing appearance, which provided a psychological advantage against a nervous enemy. As with the elaborately crested styles of Homer's era, this type of helmet probably was only worn by the elite. The simple cap-style helmet of the soldier shown in Figure 4-23 is more representative of what most hoplites wore.

This bas-relief of the ordinary footsoldier also provides a clear representation of the cuirass that all soldiers wore in one form or another. Hoplites most probably were issued a lightweight version constructed of strips of coarse linen glued into layers about a quarter of an inch thick. These panels were attached to a kind of vest that covered the torso and was tied into place by tapes at the shoulders and one side. A peplum or short skirt of overlapping strips of reinforced linen covered the hips. The cuirass was further secured by wide leather belts attached around the waist and ribcage, providing another layer of protection as well. For soldiers of wealthier families, the cuirass was sometimes sheathed with scales of bronze or iron although this added weight that in itself could be a detriment in battle. Decorative motifs were sometimes painted or tooled onto the border of the peplum, the shoulder flaps, and the bodice.

The more ornate metal cuirasses that were much favored by sculptors in depicting heroes and gods in battle were most likely ceremonial rather than functional. Although Homer refers to the "bronze-shirted" Greeks with their "breastplates" that were "brightly-gleaming," such descriptions are inconclusive as to whether or not soldiers wore full body armor of metal or simply bronze disks attached to a leather corselet. The earliest surviving example of a solid metal cuirass is a bell-shaped design dating to the eighth century BCE from a gravesite at Argos. The front and back plates of this type of cuirass were held together by a series of catches along the sides and the shoulders. As with the armor of European knights of the Middle Ages, the cumbersome construction and weight of a solid metal cuirass would have hindered the soldier trying to get back on his feet once he had fallen. It is thus thought by most historians that the solid metal cuirass was a ceremonial military or funeral costume and not actual armor used in battle.

Completing the body armor of the Greek warrior was a pair of greaves, or shin guards. We first saw the use of this

Figure 4-22 Between the eighth and fifth centuries BCE the Corinthian style of helmet evolved to include a rolled neck guard in the back, an extended nasal tab, and longer cheek pieces. The dome of the crown was enlarged for padding that more effectively cushioned blows, and ear openings allowed warriors to better hear commands above the din of battle. The menacing mask-like appearance of the Corinthian helmet contributed a psychological advantage as well.

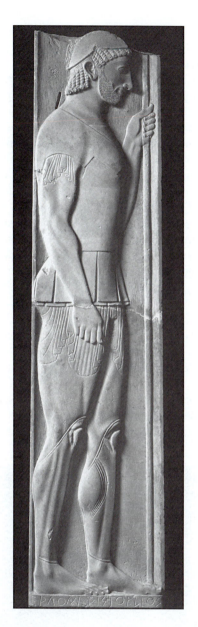

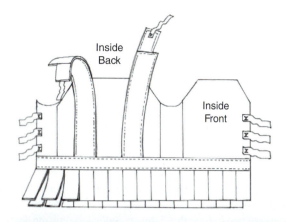

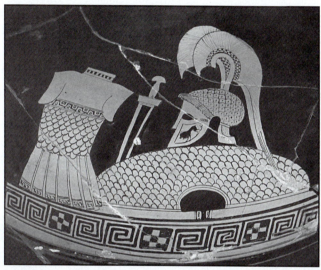

Figure 4-23 The three basic components of a hoplite's body armor were the helmet, cuirass, and greaves. The cuirass was likely made of heavily reinforced linen attached to a vest-like lining that tied around the torso. Greaves also may have been made of reinforced linen or molded leather and extended from the knees to the ankles. Metal cuirasses and greaves were most likely reserved for the elite or may have been ceremonial only. Left, *Stele of Ariston*, c. 510 BCE; right, detail of a vase painting, c. 470 BCE.

military accouterment with the Mycenaeans during the thirteenth century BCE, yet we do not know for certain how their greaves were made or how they attached to the legs. Homer tells us that the Greek heroes were "well-greaved" but provides few details about this armature. Only Achilles' style of greaves is described as being made of metal, variously translated by scholars to mean a white metal such as tin rather than bronze. Possibly, that white metal was selected because most of the other warriors wore greaves made of molded white linen similar to that used for the cuirasses.

Whether of metal, molded linen, or leather, greaves were unique to the military costume of the Greeks at the time. Those foreign armies with whom they did battle—Persians, Scythians, Lybians—did not wear anything similar, even after encountering these effective armatures on the battlefield.

Greaves encased the lower legs from the knees to the ankles and were secured by leather straps or colorful ribbons that threaded through pierced openings or rings in the back. Gradually, though, from the late Classical Period into the Hellenistic era, greaves were abandoned as new tactics in warfare demanded lighter, more effective armature.

Beneath all the assorted pieces of body armor, the Greek soldier usually wore a basic chiton, which is evident in the stele bas-relief shown in Figure 4-23. This undergarment of soft wool prevented chaffing and blisters from the rough texture of the coarse linen cuirass and the leather binding straps.

The second most prevalent garment worn by soldiers was the chlamys. Not only did it serve as a blanket for bivouacking but it could actually be used defensively in battle. Soldiers

similarly used their chlamys to buffer blows and ward off thrusts of spears or swords when their shield was damaged or lost.

THEATRICAL COSTUME

Theater performances were an important state-sponsored part of Dionysian celebrations. Plays were written in competition for the festivals with the winning poet receiving a crown of laurel and a cash prize. Until late in the Hellenistic Period, theater attendance was almost exclusively male, especially for the ribald and risqué comedies although some courtesans were admitted on occasion.

All the characters' parts, including those for females, were acted by men with the aid of elaborate costumes. (Figure 4-24.) The most important part of a Greek theatrical costume was the **mask,** which probably evolved from painted disguises applied to the faces of festival revelers. Due to the large size of the open-air theaters, exaggerated visual effects were more important than the nuances of facial expression. Hence, masks were molded and sculpted of canvas and wood and vividly painted to be recognized from the back rows of the theater. Openings were left for the eyes and mouths, the latter of which sometimes had protruding lips to serve as voice-amplification trumpets. By the sixth century BCE, tall masks were constructed to completely cover the entire head and included towering wigs, headdresses, hats, or helmets that further defined the character being portrayed.

In addition to masks, theatrical costumes were made with many of the tricks of the trade that are still employed today. Platform shoes gave the figures a more balanced proportion when wearing the oversized tall masks. Tragic figures set the audience mood by wearing chitons and himations dyed in dark colors; comic figures and lovers wore lighter and brighter colors. Fabrics were painted to resemble richly embroidered garments for figures representing the wealthy. Costumes depicting foreigners were painted with recognizable motifs of those cultures. Characters representing barbarians, which for the Greeks including the Persians, were represented by tight-fitting leather trousers and tunics. Comedy caricatures were created with all sorts of grotesque padding and appendages, including exaggerated phalluses.

REVIEW

The era of the Greeks lasted for almost two millennia—from the invasions of the Aegean lands by Greek-speaking Indo-European peoples around 2000 BCE until the Roman occupation in 146 BCE. During this time, the Mycenaean kingdoms emerged, dominated the region for a few centuries, and then disappeared into an anarchic Dark Age. After 400 years of tribal wars, new independent city-states rose from the ruins of

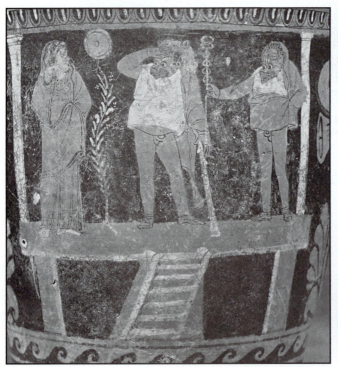

Figure 4-24. In addition to masks, some of which completely covered the head, theatrical costumes sometimes included grotesque padding and exaggerated appendages. Apparel fabrics were painted to simulate rich embroidery or were vividly dyed to set the audience mood for a character. Details vase paintings depicting performances of comic actors, c. 430–350 BCE.

their predecessors. In an amazingly brief time, the inhabitants of this land, the Hellenes as they called themselves, created the world's most advanced culture centered on an ideal harmony of man, nature, and reason. They recognized and embraced the changes that produced growth and development in all their aspirations. From the fruit of their achievements came the seeds of our modern medicine, science, philosophy, fine arts, and democratic forms of government.

Costumes of both men and women were comprised largely of the draped rectangle of cloth, primarily woven of wool. Linen was used selectively, and, by the Roman Period, silk and cotton were imported in greater quantity. Apparel was not cut and tailored to fit the body. Instead, combined layers of different sizes of fabric and the innumerable methods of pinning, binding, and belting these pieces of material created a myriad of looks.

The earliest type of Greek clothing, the exomis, was simply a rectangle of cloth wrapped around the figure and tied over one shoulder. A later variation of this garment was the chiton, worn pinned or tied over both shoulders and held in place by a girdle or belt at the waist. Women's versions of the chiton were mostly floor-length, and men's everyday styles extended in lengths from the thighs to the knees. Another garment worn by both men and women was the himation. This six-by-nine-foot panel of material was draped about the figure in a host of techniques. The himation was a favorite of mature men and a popular outer garment for women who layered it over their chiton to reinforce their modesty in public. Younger men preferred a short cloak, called a chlamys, that was pinned in the front, revealing rather than concealing their nudity. Women wore the peplos, with its turned-down flap of material that created a bib in the front and a hood in the back. Numerous other rectangles of fabric were worn as capes, scarves, and shawls depending upon ceremony, season, or weather.

Whereas development and change were inherent in Greek culture, conservatism and tradition governed the core styles of their costume design. At a time when the Persians were tailoring jackets with set-in sleeves and fitted trousers, the Greeks were still swathing themselves with simple, rectilinear pieces of fabric. The draped styles that were unique to them were as important a cultural identity as their form of government, language, and the arts.

Chapter 4 The Greeks
Questions

1. What elements of Mycenaean military costume are common to those of Mesopotamia?

2. What were the three steps required for Greek women to produce home textiles? Describe the tools and materials they used.

3. What was the key element of Greek style in costume? Compare the evolution of Greek costume with that of Mesopotamian costume in the first millennium BCE.

4. Describe an exomis. What is the difference between an exomis and chlaine?

5. What were the differences between the Doric chiton and the Ionic version? Which style was the earlier, and what event purportedly initiated the changeover?

6. Describe what dressing "in the Spartan manner" meant to Greek women. To which garment did the characterization apply and why?

7. Compare how Greek men and women wore the himation. What was socially significant about the women's versions?

8. Which cultural circumstances encouraged Greek men to display their nudity?

9. What were the three components of Greek body armor and how were they made?

10. Describe five "tricks of the trade" employed by the Greeks in producing theatrical costumes.

Chapter 4 The Aegean
Research and Portfolio Projects

Research:

1. In a research paper, compare and contrast the dress of the Hellenes with that of their predecessors on the Greek mainland, the Mycenaeans.

2. Write a research paper on the references to dress in Homer's *The Iliad*. Examine where cross-cultural influences may be indicated, especially those from the Near East (Troy).

Portfolio:

1. Compile a reference guide of Greek footwear as depicted on sculptures. Feature photocopies or digital scans of ten different men's styles and five women's styles. Provide a written description of each next to the illustration, including details of construction where clear in the example, and name of sculpture with date.

2. Demonstrate for the class on a live volunteer or a mannequin how to drape a Doric chiton and an Ionic chiton. Use muslin if wool is not available and any type of safety pin.

Glossary of Dress Terms

bateau neckline: a collarless, horizontal slit along the shoulder seam; also called a boatneck

blocking: a technique of rigidly fixing the shape of a hat

boar's tusk helmet: Mycenaean pointed-dome helmet embellished with a surface of boar's tusks

bodice: the fitted part of a dress that covers the torso

chlamys: a short masculine cloak secured with a single brooch

chignon: a tight twist or roll of hair usually worn by women at the back of the head

chiton: a loose-fitting, tubular garment of varying lengths, usually pinned at the shoulders and girded at the waist; worn by both men and women

chlaine: a short cloak draped and pinned like the exomis except not girded

chlamydon: a decorative band of fabric, often ruffled or pleated, worn by women asymmetrically over the chiton

Corinthian helmet: a close-fitting, round-domed helmet usually forged with nasal tabs and cheek pieces

Doric chiton: a basic tunic made by draping a narrow piece of fabric about the body and fastening at the shoulders with fibulae

exomis: a masculine garment made from a short rectangle of fabric that is wrapped around the torso, pinned at one shoulder, and girded at the waist

fibula (pl. fibulae): a large pin with a long shaft used to fasten garments in place

fulling: a fabric finishing process for increasing the bulk and weight of cloth by shrinking, pounding, pressing, and trimming

greaves: shin guards made of leather, reinforced linen or metal

himation: a huge rectangle of fabric that swathed the body without any fastening or binding

Ionic chiton: a wide, voluminous tunic girded at the waist and fastened at the shoulders with several small pins that formed sleeves of varying lengths; worn by both men and women

mask: a theatrical or ceremonial covering for the face or head worn to create a disguise or represent a character

peplos: a feminine garment formed by girding a wide cylinder of fabric with a section at the top turned down to form a bib-like flap

peplum: a short skirt-like drapery formed by the deep blousing of fabric over the belt of the peplos; in modern use it is a short skirt attached at the waist of variously constructed modern garments

petasos: a wide-brimmed hat, usually made of straw or softly constructed materials

pilos: a masculine conical hat, usually with a narrow brim

snood: a sack-like net or piece of fabric worn on the back of the head by women to contain their hair

tapes: strips of fabric sewn to the inside edges of clothing and tied together to hold the garment in place

tholia: a sharply pointed, brimmed sun hat worn by women

vertical loom: an upright loom with an expandable frame that allowed for greater widths of fabric to be woven

Legacies and Influences of Greek Styles on Modern Fashion

The distinctive look of ancient Greek clothing was achieved through the soft, fluid draping of fabric. Modern fashion designers have emulated Greek styles by similarly applying swathes of material in swags and wraps around the body, especially as a decorative accent to a constructed garment. One notable exception was Madeleine Vionnet who, in the 1920s and 1930s, created flowing Greek-looking gowns by cutting fabric on the bias and draping the material to the natural contours of the body.

The most prevalent Grecian-inspired silhouette in modern times has been the peplum. The recurring use of short flared skirts on women's jackets, tops, and skirts recall the bloused draping of the ancient Greek peplos.

In addition to adapting the fluid lines and soft contours of ancient Greek clothing to modern styles, fashion designers have rediscovered a favorite fabric texture of the Hellenes: crinkled pleating. The Greek technique of fixing twisted pleats to produce a springy, clinging texture is similarly achieved today by mass production and applied to a broad range of textiles and garments.

The Greeks produced a clinging fabric texture by fixing twisted pleats during the fulling process. Modern designers have rediscovered this look and applied it to a wide range of materials and garments. Crinkled rayon broomstick skirt by Zero Zero, 1994.

Modern designers have variously interpreted the fluid draping of the ancient Greek chiton and himation. Left, gold lurex and chiffon gown by Irene, 1958; right, draped satin gown, 1937.

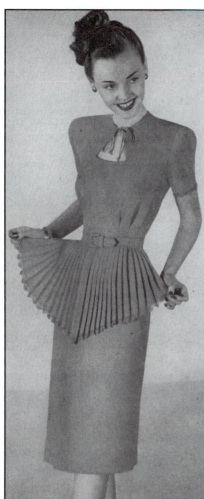

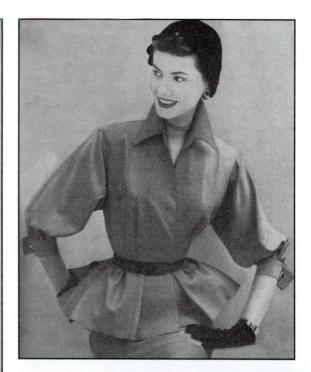

The silhouette of the peplum—the flared skirt of a jacket or top—was derived from the skirt-like appearance of excess fabric that bloused over the girdle of the Greek peplos. Left, rayon crepe peplum dress from Berkely Juniors, 1946; top right, peplum suit by Pat Hartley, 1950; bottom right, silk/acrylic blend peplum suit from Christian Dior, 1988.

Chapter 5

ETRURIA AND ROME

Etruscan City States

| Arrival of Etruscans in Italy | Adaptation of Greek alphabet | Wars with Greek colonies | Expulsion of kings from Rome | Wars with Roman Republic | Conquest by Rome |

Villanovan Period — Archaic Period — Classical Period

c. 1000 BCE c. 700 BCE c. 480 BCE c. 280 BCE

ITALY BEFORE ROME

During the twelfth century BCE, massive migrations of peoples from the east disrupted the Hittite and Egyptian Empires in Asia Minor and caused the collapse of the Mycenaean civilization in the Aegean. Over the next 200 years these migrations continued to push westward into northern Europe spilling down into the Italian peninsula. By the beginning of the first millennium BCE an Iron Age culture became firmly established in the north central region of Italy called Etruria. The early inhabitants of this land have been labeled the Villanovans by scholars because the earliest artifacts of these proto-Etruscans were first found near the village of Villanova. Between about 1000 BCE and 700 BCE, a dozen sovereign city-states developed in Etruria with a common language, culture, and religion. The cities coexisted within the boundaries of economic rivalry but did not battle each other for dominion over their neighbors as had the Sumerians, Mycenaeans, and Greeks. The Etruscans were never united into a single kingdom or confederation, nor did their independent city-states even forge lasting alliances with one another. This short-sighted self-interest later allowed Rome to pick off the Etruscan cities one by one. Even during the ten-year siege of Veii by the Romans, no neighboring Etruscan city sent help.

By the middle of the eighth century BCE, though, the peaceful, rural world of the Etruscans was radically altered by two great economic upheavals. First was the colonization of nearby lands by the sea-faring Phoenicians, from whom the Etruscans developed maritime skills—including piracy—and international commerce. Second, and more importantly, was the colonization of southern Italy by the Greeks, from whose advanced culture the Etruscans completely transformed their civilization.

One of the foremost influences of Greek culture on the Etruscans was writing. An adaptation of the Hellenic alphabet was developed and disseminated among all the Etruscan city-states in a very short period during the late seventh century BCE. Although the Etruscans never produced great literature, philosophies, or drama that we know of, their writings have documented their religion and history. Also from the Greek colonists, the cities of Etruria imported vast quantities of painted vases whose pictorial style Etruscan artists eagerly adopted. In fact, so taken were the Etruscans with the Greek Archaic style of painting and decoration—often called the orientalizing period of Etruscan art—that they never quite evolved stylistically to the classical phase later created by the Athenians during the fifth century BCE.

Further cultural transformations resulted from dramatic economic changes. The technological advances of Corinthian shipbuilding technology were integrated into Etruscan designs making for faster ships with larger cargo holds. When the

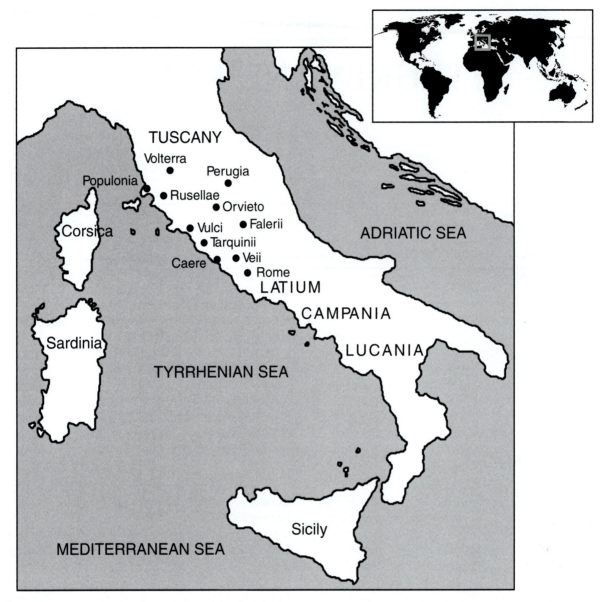

Principal Etruscan City States

Greeks introduced the cultivation of the vine and wine making into the fertile valleys of north Italy, the Etruscans quickly became exporters of wine to points all around the Mediterranean. Trade generated wealth and created class hierarchies that had been unknown to their ancestors, the Villanovans. Such commercial rivalry with the Greeks was a contributing cause of the wars with the Hellenic colonies during the late sixth century BCE.

All of this is not to say that the Etruscans wholly adopted the Greek culture. To the contrary, the Etruscans retained much of their unique characteristics even after a lengthy contact with the Greeks, Phoenicians, and Romans. For example, as the Greeks became more humanistic in their religion, the

Etruscans avidly preserved divination and other mystical traditions. Similarly, even after democracy was developed by the Athenians and the Romans established a republic, the Etruscans maintained their ruling nobility. Of particular distinction between Etruscan society and that of the Greeks was the status of women. Indeed, contemporary Greek sources, such as the fourth-century BCE historian Theopompus, wrote how shocked they were to see respectable women at sporting events, or flaunting masses of fine jewelry in public, or worst of all, attending banquets on dining couches alongside male guests. And although the Etruscans adopted some elements of Greek dress, they mostly preserved favored traditions of their national costume.

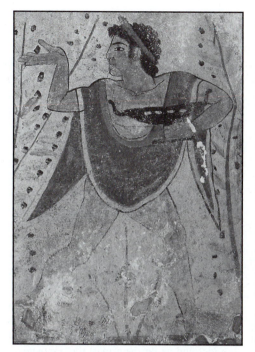

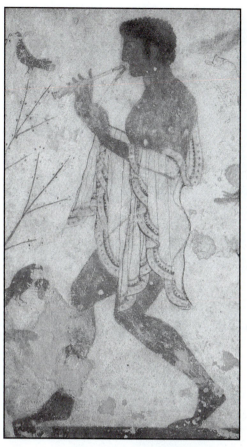

Figure 5-1. Younger Etruscan men wore versions of a tebenna, a loosely draped cloak. Left, wall painting from Tomb of the Leopards, c. 450 BCE; right, wall painting from the Tomb of the Trichinium, c. 470 BCE.

ETRUSCAN CLOTHING

What we know of Etruscan dress has come to us primarily from sculptures and tomb paintings. No extant examples of clothing have been found, nor are there any known descriptions in their writings.

The principal garment of Etruscan men was a narrow, semicircular type of cloak called a **tebenna**. In some artwork, the tebenna also appears to be a wider, rectilinear cut somewhat like the Greek chlamys. The garment was worn alone over the nude body much as Greek young men wore the chlamys except that the Etruscan tebenna was not fastened by a pin. The illustrations in Figure 5-1 show two ways in which men wore the tebenna. The flute player has casually draped the cloak around the back and over the arms with the front open. His version appears to be made of a sheer fabric, perhaps fine linen, trimmed all around with a decorative border. The dancer holding a wine kylix wears his tebenna hanging loosely across the front with the ends tossed over the shoulders. His tricolor version is opaque, suggesting a heavier woven fabric than that of the flutist. Curiously, both methods of draping the tebenna would have required a constant struggle with the garment to keep it from falling off since neither arrangement was fastened in place by pins, knots, or bindings.

Another garment that was native to the Etruscans was the men's loincloth called a **perizoma**. (Figure 5-2.) The cut was possibly like a triangular or T-shaped diaper that wrapped around the hips at the back and through the legs to the front. The three overlapping ends were tucked into place and secured by a roll at the waist. Some figurines show perizomas with decorative borders around the leg openings. Most sculptures that represent the perizoma are of soldiers and date from the mid-sixth century BCE or earlier. Some historians have suggested that this garment design was a surviving Minoan influence, yet the brief style with its exaggerated genital pouch worn by Minoan men had disappeared almost 800 years earlier. Moreover, Etruscan figurines of warriors after about 550 BCE either depict nude soldiers bearing arms or else show the Greek costume of helmet, greaves, and cuirass over a short chiton. One point of irony, though, is that so many figurines of Etruscan warriors wearing the perizoma were exported to Greece that these surviving artifacts sometimes have been mistakenly included as examples of Archaic Greek costume.

The perizoma is also sometimes erroneously cited as evidence that the Etruscans rejected nudity as an acceptable display for men in public. However, innumerable representations of nude males have survived in sculpture and

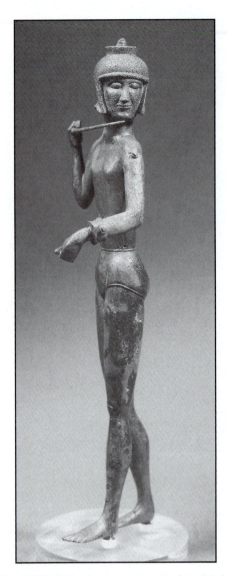

Figure 5-2. The perizoma was a type of men's brief that fitted around the hips and closed in the front. A rolled waistband held the garment in place. Bronze warrior, c. 550 BCE.

bateau neckline. Sleeves were cropped at the elbows and the skirt hemline extended to the ankles. (Figure 5-3.) Judging from the depictions in some paintings, bands of contrasting fabric around the upper arms indicate that the sleeves were attached to the T-cut tunic in the Egyptian style of the kalasiris rather than set-in at the shoulder as with the Persian kandys. Some examples appear to have the open ends at the elbows cut on an angle with the longer edge in the back. These tunics were most often worn ungirded, much more resembling the silhouettes of women's garments from Mesopotamia than the Greek chiton or peplos. In fact, this style of dress may have been one of the reasons why Herodotus believed the Etruscans originated from Lydia in Asia Minor.

Women also wore versions of the tebenna as a layered garment. These cloaks were draped or fastened about the body in a wide assortment of techniques. Some were draped across the hips at the front like an apron and then looped around the upper arms to overlap in the front. Others were draped in exactly the opposite way with the cloak in the back and the ends brought forward under the arms to be flung over the shoulders to the back. Still others were worn asymmetrically over one shoulder and under the arm of the opposite side.

The colorful wall paintings that depict these native styles of men's and women's clothing also reveal the Etruscan delight in wearing vivid colors and textile patterns. A favored decorative treatment of women's tunic dresses featured bands of contrasting colors across the shoulder seams, down the arm seams and even along the side seams of the skirt. Unfortunately, no examples of Etruscan clothing survive so we cannot accurately determine from these images if the multicolored assortment of bands, borders, and allover patterns were woven into the fabric, appliqued, or embroidered. Nor can we ascertain which materials were preferred by the Etruscans. Some depictions of younger men wearing the tebenna represent the fabric as semitransparent suggesting that it was a finely woven linen, perhaps imported from Egypt. Other paintings appear to show heavier fabrics, most likely made of wool. Compare, for example, the renderings of the garments worn by the flutist and the dancer in Figure 5-1.

Probably the most notable component of the native Etruscan costume was the pointed-toe boot. These fanciful shoes were constructed of soft leather with thick soles and tapered, V-front throats for easy slip-on without laces. Red was a prevalent color of boots as depicted in tomb frescoes and painted sculptures. Between the Asiatic silhouette of curling, pointed toes and the vivid colors, the Etruscan shoe was further evidence for Herodotus that these inhabitants of Etruria were the descendants of Lydian immigrants. Possibly the pointed-toe boot was reserved for ceremonial or religious occasions. Various forms of the sandal were actually the most common footwear worn by both men and women. Later influences of Greek footwear design introduced lace-up boots and the pointed-toes disappeared.

paintings, a great many of which precede influences from the neighboring Greek colonies. Etruscan artistic renditions show nude men publicly dancing, engaged in various competitive athletics, and poised in combat. Unfortunately, no written documents have survived that shed any light on Etruscan social customs such as how apparel was worn and when nudity was acceptable. But we may surmise that, although the Etruscans did not share the Greek notion of honoring the gods through the everyday display of nude masculine beauty, neither did the men of Etruria shy away from nudity in sports, revelry, or battle.

One of the most commonly depicted women's garment is a tunic-style dress that featured a scoopneck or a straight, horizontal open seam across the shoulders known today as a

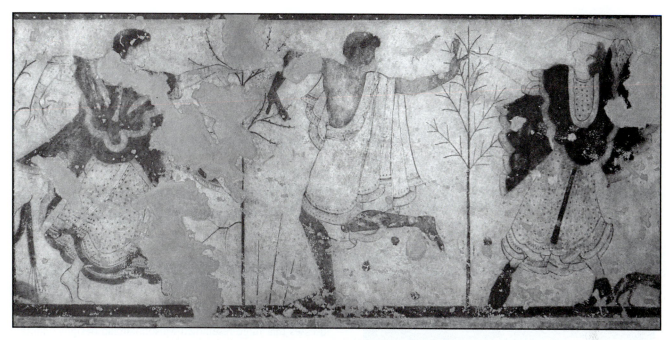

Figure 5-3. Etruscan women primarily wore a T-cut tunic that featured a scoopneck or bateau neckline, half sleeves, and an ankle-length hemline. Details of wall painting from the Tomb of the Triclinium, c. 470 BCE.

GREEK INFLUENCE

Classics scholars have debated for decades on the degree to which Etruscans absorbed Hellenic culture. The adaptation of the Greek alphabet spread rapidly throughout the twelve city-states of Etruria because priests could now preserve in a tangible form the sacred words, divinations, prayers, and ceremonies of their religion. On the other hand, the economic shifts to wine making and seafaring commerce took many years to develop from Greek models. Exactly what the Etruscans borrowed and how they integrated Greek culture into their native customs are not always clear. This conundrum equally applies to Etruscan clothing.

Part of the difficulty in deciphering specifically what Greek garments the Etruscans adapted to their dress is hindered by so much of the abbreviated art produced by the Etruscans. For instance, the stylistic formula for an Etruscan sarcophagus most often included a large, detailed portrait head upon a vague, dwarf-like body reclining on a banquet couch. Because these bodies were minimized, details of the costumes are seldom precise and clear. Yet many figures seem to show women wearing versions of the chiton and himation. At what point in time Etruscan women discarded their constructed, sleeved tunics in favor of the chiton with its variations of pins and bindings is unclear. In Figure 5-4, the line art is of an incised image on an Etruscan funerary cista of the late fourth century BCE that depicts two figures from the story of the Judgment of Paris. Although the male figure appears nude,

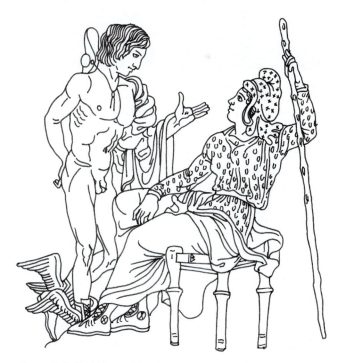

Figure 5-4. Depictions of Greek apparel in later Etruscan artworks usually illustrated Greek topics rather than recorded changes in Etruscan costume. These figures are from the story of the Judgment of Paris as rendered on an Etruscan funerary cista, c. 300 BCE. The male wears the Greek petasos and himation; the female wears a himation, Phrygian cap, and lace-up boots with a girded Etruscan tunic.

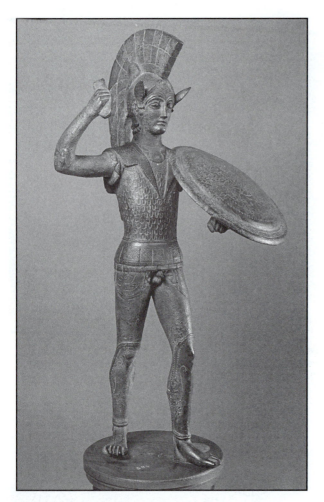

Figure 5-5. By the beginning of the fifth century BCE, Etruscan figurines of soldiers depicted the Greek hoplite costume instead of the native perizoma and tebenna. Bronze warrior, c. 450 BCE.

he actually wears boots, a petasos pushed off onto his back, and a himation—or possibly a tebenna—wrapped around one arm. The female figure wears a star-studded Phyrgian hat, himation, and laced-up boots with her Etruscan tunic. The representation of a sleeved tunic rather than a chiton suggests a transition of the feminine costume during which Etruscan women wore the cut-and-sewn tunic in combination with Greek wrap garments and accessories. By the third century BCE though, Greek styles of costume seem to have fully replaced the traditional Etruscan styles, at least with the upper classes, whose images survive in tomb art.

The clearest evidence of Greek influence on Etruscan costume is with military dress. Virtually the entire ensemble of Greek hoplite body armor was copied by the Etruscans. The bronze figurine shown in Figure 5-5 includes a crested helmet with the cheek guards turned up, ornately decorated greaves, and a mail-encrusted cuirass over a linen chiton or tunic. This and numerous similar figures of Etruscan warriors are dressed almost identically to contemporary representations of Greek hoplites—down to their bare feet.

REVIEW

Where the Etruscans originated is one of the great mysteries of the ancient world. There is no clear trail of their migration or, as Herodotus maintained, of their immigration into Italy from Asia Minor. Yet within the early part of the first millennium BCE, a common culture, social structure, and religion were firmly established in a dozen city-states of Etruria.

During the eighth century BCE, the Etruscans encountered Greek colonies to the south and underwent a dramatic transformation of their culture. They adapted the Hellenic alphabet to preserve the sacred words of their religion. They expanded their economy from a regional to an international market by developing new industries such as pottery production and wine making inspired from Greek models. They became urbanized and wealthy.

Despite the innumerable influences and borrowings from the Greeks, the Etruscans nevertheless retained much of the native characteristics of their cultural heritage. Especially evident of their uniqueness was their costume. Women wore tunic-style dresses that more resembled Mesopotamian designs than the Greek chiton or peplos. Their cloak, called a tebenna, was cut in a semicircle and draped in techniques quite unlike anything the Greeks wore. Most unique of all, though, were the Etruscan pointed-toe boots favored by both men and women.

Men of Etruria likewise wore clothing that was quite different from any Greek styles. Masculine versions of the tebenna were sometimes draped similarly to the rectangular Greek chlamys, except they were cut semicircular and worn without fastenings. The most distinct Etruscan men's garment, though, was the perizoma, which was a simple loincloth designed to fit like modern-day briefs. Since the garment was only featured on figurines of soldiers, it may have been exclusively a military costume and was not worn by civilians.

Some Greek styles of clothing, most notably the himation, are apparent in later Etruscan statuary and paintings. At the height of Etruscan wealth at the beginning of the fifth century BCE, this large garment afforded both women and men an indulgence of greater yardage of opulent fabrics than the shorter tebenna. Likewise, during the same time, the Etruscan military adopted almost completely the Greek hoplite's costume, including helmet styles, decorated greaves, and the skirted cuirass over a short chiton.

From their encounter with the radiance of Greek culture, the Etruscans evolved into a sophisticated, urbanized society. The city-states of Etruria grew immensely wealthy and, for a while, even expanded their borders northward. Yet they were unable to recognize the value of lasting alliances against common foes so that one by one the Etruscan cities were conquered by the Romans.

Still, the decades of contact with the neighboring Greek colonies proved crucial not only for the development of Etruria and later Rome but also for Western civilization as a whole. Their relations formed the bridge through which the civilization of the classical world would spread across Europe.

Chapter 5 The Etruscans
Questions

1. Identify and describe the styles of costume that were uniquely Etruscan.

2. Which elements of Greek costume were later adopted by the Etruscans?

3. What do Etruscan tomb paintings reveal about the textiles of their dress?

4. Which two features of Etruscan costume may have led Herodotus to suggest that the inhabitants of Etruria originated in Asia Minor?

Chapter 5 The Etruscans
Research and Portfolio Projects

Research:

1. Write a research paper on which foreign influences of dress are thought to have changed Etruscan costume during the Orientalizing Period (c. 750–575 BCE) and the Greco-Roman era (c. 575–200 BCE).

Portfolio:

1. Compile a pictorial cross-reference guide comparing the changes in Etruscan men's and women's dress during the Orientalizing era and the Greco-Roman era. Use photocopies or digital scans of Etruscan sculptures, murals, and vase paintings to catalog the primary types of garments and accessories that changed. Annotate each image with a brief paragraph indicating the change and the suggested foreign influence. Include specifics of the artwork sources such as location (e.g., Tomb of the Rooster), type of work (bronze sculpture, wall mural), and date.

Glossary of Dress Terms

perizoma: a close-fitting men's loincloth cut from a single piece of fabric and arranged into a form of briefs

tebenna: semicircular cloak worn by both men and women

ROME

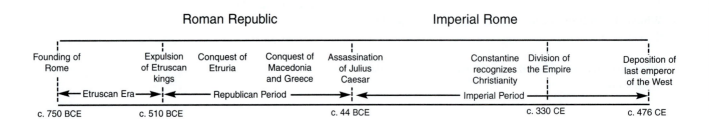

Roman Republic Imperial Rome

Founding of Rome | Expulsion of Etruscan kings | Conquest of Etruria | Conquest of Macedonia and Greece | Assassination of Julius Caesar | Constantine recognizes Christianity | Division of the Empire | Deposition of last emperor of the West

←— Etruscan Era —→ ←——— Republican Period ———→ ←——— Imperial Period ———→

c. 750 BCE c. 510 BCE c. 44 BCE c. 330 CE c. 476 CE

CONQUER OR PERISH

By traditional accounts, Rome was founded in the mid-eighth century BCE as a farming village along the Tiber River. Over the following 250 years, Etruscan kings transformed this community of thatched huts into a robust, commercial urban center. These monarchs of Rome pursued ambitious foreign policies, patronized the arts—especially styles of the Greeks— and embarked on extensive civic building programs. Yet social and economic stability was elusive. Domestically, the ruling nobility was ruthless and brutal against a largely peasant population. Externally, constant threats surrounded the early Romans from the Etruscan city-states to the north, invading Gauls to the east, Carthaginians to the west in Sardinia, and Greek colonies to the south. As a consequence of these dangers, vast resources of treasure and men had to be committed to developing and maintaining a powerful army.

Despite the cultural and economic achievements that the Etruscan kings brought to the city-state of Rome and its surrounding Latium region, a revolt in 510 BCE ousted the tyrannical Tarquin royal house. The authority of Rome's body politic then came into the hands of the former king's council, a group of about 100 clan elders that became the Senate of the Roman Republic. Over the subsequent centuries this constitutional senate appointed a series of co-rulers whose skill and determination led Rome to military victories of conquest all around the Mediterranean. By the time of Julius Caesar, Rome's dominion stretched from Britain across much of modern-day Europe to Mesopotamia and southward across the whole of North Africa. Under a single efficient government lived people of innumerable races, tongues, religions, cultures, and traditions. Whereas the genius of Greek culture shone most brilliantly in the intellectual—creativity, philosophy, and reason—the Roman genius lay in action—engineering, law, and government. At the end of the Republican Period, newly founded Roman cities had been built around the entire Mediterranean basin and dotted the valleys of the Danube, the Rhine, and the Thames. The common links these cities shared spread Latin civilization throughout the Western world.

At the end of the first century BCE, decades of civil war were finally brought to an end by Julius Caesar's heir, Octavian. A grateful senate bestowed upon him an imperial authority for which he took the title Caesar Augustus. During the

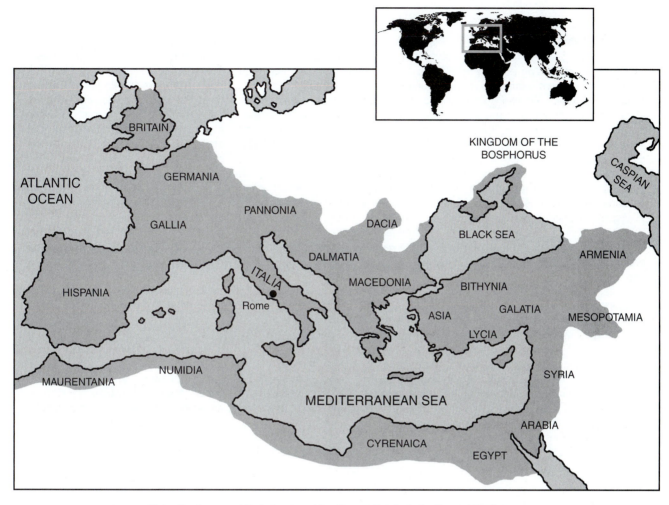

Major Provinces and Protectorates of the Roman Empire in the Second Century CE.

forty-five-year rule of Augustus, the ancient republic faded from the living memory of most Romans. For the next 300 years, a succession of emperors reigned over the greatest empire the world had ever seen. Some rulers expanded the boundaries of the empire ever farther in all directions, and others glorified Rome's achievements with grand public works at home and in provincial cities.

So vast was the territory governed by the Romans that, in 325 CE, Constantine the Great established an eastern capital at the Greek port of Byzantium—which he renamed Constantinople—to administer those provinces. Barely 100 years later, migrating tribes from the north poured into Italy, and in 476 CE, deposed the last Latin emperor of the Western Empire. In the east, the Roman Empire survived for another 1,000 years as the Byzantine Empire.

ROMAN TEXTILES

The writings of Roman poets, dramatists, and historians contain little information about everyday apparel or the social significance of how garments were worn. Descriptions of clothing are brief and, too often, vague. Furthermore, such documentation does not always translate clearly, especially if the only surviving examples are later Greek or Arabic translations of Latin originals. Our best sources of information on how the Romans dressed are the visual arts. Sculptures and paintings from the late period of the republic onward were rendered in a highly realistic style and provide very precise details of Roman costume. However, since Rome was an Etruscan city until the end of the sixth century BCE, we must look to that civilization for the origins of Roman clothing.

Despite the moderate climate of central Italy, the Etruscan Romans are thought to have worn clothing mostly made of wool. As in all the cities of Etruria, the finer grades and quality of woven wool were reserved for the nobility and wealthy middle classes. Coarser, unadorned wool fabrics for clothing of lower classes were manufactured in great quantities in commercial textile centers including those of Greece and Asia Minor. The agrarian peasant and laboring masses likely produced some weaving at home, but unlike the Greeks, home production of textiles was not a significant

Roman Textile Dyes, Patterns, and Embellishments

The tradition of making apparel from vividly dyed fabrics continued from Etruscan times. Roman women delighted in wearing ensembles of three or more garments, each of which was a different color. We can glimpse variations of these chromatic combinations from the wall paintings of Pompeii and the encaustic mummy portraits produced for Roman colonists in Egypt. (Color Plate 2.) Brilliant jeweltones abound in the painted representations of women's costumes—especially in palettes of blues, greens, and reds. Black, gray, earthtones, and other dark, somber colors appear less frequently since these were usually representative of mourning. In the first century BCE, the poet Ovid advised women that they should celebrate the many colors available for their clothing: "All kinds of colors . . . swansdown, amethyst, emerald, myrtle, almond, chestnut, rose, yellow of wax, honey pale—colors as many as flowers born from new earth in the springtime . . .

so many colors, or more, the wool absorbs. . . ."

Roman men similarly wore colorfully dyed clothing, but less often than women, and rarely in such a rainbow of contrasting combinations. Togas were invariably white but on occasion may have been draped over a vividly dyed tunic. Masculine outer garments, though, such as cloaks, capes, and hooded **poncho** styles are shown in numerous paintings in almost every color including the very brightest hues.

Although the use of vibrant color in Roman costume was ubiquitous, pattern was not. Allover textile designs made by intricate weaves, appliques, or embroidery were not especially popular with Roman men or women for their dress. This is a significant distinction of Roman costume from those of other ancient civilizations. The cultures of Mesopotamia, Egypt, and the Aegean commonly incorporated the same motifs into their costumes that they employed in decorations of architecture, interiors, and the applied arts. The Romans, on the other hand, loved elaborate ornamentation and

decorative patterns for use on interiors, furniture, jewelry, pottery, and personal objects, but rarely for clothing. The exception was for religious apparel. Augurs and priests of Eastern mysticisms are often depicted wearing richly patterned garments including multicolored stripes, embroidered gold stars, and various motifs reminiscent of Persian designs.

One other important textile embellishment was the addition of the **clavi**, which were purple stripes of various treatments along the borders of the toga. The hues of purple ranged from crimson to a murex violet. The **augusta clavus** featured a double band of narrow stripes and was worn by high-ranking officials. The **latus clavus** was the widest border at about four inches and adorned the togas of senators. Freeborn children of all classes wore versions of the clavus: girls until about the age of twelve and boys until about the age of fifteen. In the later imperial period, the clavi lost their significance as symbols of rank and became merely decorative, often embroidered with intricate ornamentation.

occupation of all classes of Roman women. Large estates that were isolated from urban centers produced much of their own cloth through slave labor.

Linen was used more selectively for clothing. Garments made of linen and linen blends were for warm weather or were worn layered under heavier woolen pieces. The upper classes indulged in wearing the finely woven linens imported from Egypt although the Romans did not favor pleated fabrics as had the Egyptians and Greeks.

Once cotton began to be imported from Mesopotamia and Egypt sometime during the second century BCE, fabric blends of wool and cotton or linen and cotton became common. Measure for measure bolls of cotton were much less expensive than wool fleece and considerably easier than flax to prepare for spinning.

As the Roman Empire expanded ever farther east, merchants encountered silk traders who provided spooled threads for commercial textile producers as well as the finished fabric. Silk threads sometimes were combined with flax or wool to create a material with a lustrous finish that draped more fluidly than plain wool or linen. By the time of the first imperial families, pure silk fabric was imported in greater quantities, the finest grades of which literally could

be worth their weight in gold by the time they reached the markets in Rome. Young women of the imperial period especially loved the sensuousness of the material. The philosopher Seneca commented in the first century CE that everywhere in Rome he saw "silken clothes, if one can call them clothes at all, that in no degree afford protection to the body or to the modesty of the wearer, and clad in which no woman could honestly swear she is not naked."

CLOTHING, CLASS, AND CITIZENSHIP

The Romans of the fifth century BCE were heirs to the costume traditions of the Etruscans. During the development of the republic from a small city-state of Etruria to a world superpower, some Etruscan styles continued to be worn with little change and others evolved into garments that became uniquely Roman.

The most distinctive Roman garment was the **toga**, which originated from the semicircular tebenna of the Etruscans. Although originally worn by both men and women, by the second century BCE the toga became solely a masculine garment. At this time it was cut as an ellipse and folded lengthwise to create the traditional semicircle. Unlike the Etruscan

tebenna or the Greek himation, though, the toga became quite large, eventually extending as long as eighteen feet.

As with Greek costumes, draping created the distinctive characteristics of Roman dress, most particularly the precise arrangement of the toga. In its simplest form, the toga was a wrap garment without any pins or knots to fasten it into place. To arrange a toga the wearer first draped it over the left shoulder with about one-third of the length hanging to the ground in the front. It then was wrapped across the back, forward under the right arm, and up over the left shoulder again to be held in place by the weight of the heavy wool fabric.

By the Imperial Period the ellipse was cut into an oblong shape with rounded corners. It was unequally folded to form a short outer flap of fabric layered over a wider inner one. (Figure 5-6.) Draping this later version of the toga involved a standardized arrangement of the folds. The sweep of the short flap of material across the front of the thighs created the **sinus**. As a form of toga etiquette, the section of the outer flap that hung down the back could be pulled up to cover the head when the wearer entered a temple or went into public while in mourning. The final step in arranging the toga involved pulling up a handful of the fabric from the underfold just above the waistline and bunching it into the **umbo**. This swag of material was sometimes used as a sort of pouch to carry objects or even as a place to rest the right hand as men today often do with trouser pockets.

In examining statues that depict the toga, one is inclined to think that the garment simply would be loosely wrapped about the body and tossed over a shoulder. In actuality, the protocol of wearing a toga was exacting by law and required skill and experience. Writing in the second century CE, the Roman historian Tertullian complained that the toga "is not a garment, but a burden." Indeed, although draping a toga was an arduous task in itself, a more difficult challenge was keeping it clean out in the dusty, sooty streets of a Roman city. Moreover, for the working classes, the heavy garment was especially hot in warm weather, and the unpinned draping required a constant struggle to keep it in place while maneuvering through daily tasks.

Even so, it was also a privilege to wear the toga because it denoted Roman citizenship regardless of class. For a freeborn man to go into public where he was not known without his toga was to run the risk of being mistaken for a foreigner, exile, slave, or other social undesirable. Yet despite the commonality of the toga across all but the lowest classes, members of the upper classes, the patricians, were seldom confused with the common citizenry, the plebians. As mentioned previously the addition of the purple clavi proclaimed rank. In addition, patricians could afford the finest woven wool and wool blends, including the lustrous silk blends, all of which were recognized on sight for their costly quality. The upper classes also owned numerous togas and might frequently change into fresh ones throughout the day to appear always in pristine white as evidence of their wealth and social status.

Other Roman apparel that had evolved from Etruscan styles included an adaptation of the perizoma called the **subligaculum**, sometimes shortened to **subligar**. Whereas the perizoma had been part of early Etruscan military costumes, the subligaculum was a civilian garment. Basically it was a linen loincloth worn like a diaper with a rolled waistline to hold it in place. Athletes, gladiators, circus performers, and slaves wore versions of the subligaculum in public since nudity was socially unacceptable to the Romans. The subligaculum also served as a form of underwear for the upper classes.

The garment most common to all Roman men regardless of class and citizenship status was the **tunica**. Modeled on the Etruscan style, men's tunicas were usually cut in a T-shape and stitched at the sides and shoulders with openings for the neck and arms. (Figure 5-7.) A variation was sometimes cut as a straight-edged rectangle with only armholes at the shoulder rather than sleeves. The wealthy wore a short, narrow undertunic, the **subucula**, made of linen over which was layered a wider, knee-length tunica of fine quality wool. In colder climates and seasons, two or even three subuculas might be donned against the chill. For ordinary men the tunica was the principal clothing for everyday wear and was made of coarser grades of wool, linen, or cotton. Most often the tunica was belted at the waist and sometimes even double girded in the Greek manner, blousing the excess fabric into a peplum over the lower belt. To wear a tunic ungirded was viewed as slovenly, much as an untucked shirttail is regarded today.

Around the beginning of the third century CE a variation of the tunica called the **dalmatic** was introduced from the Dalmatian region of the Balkans. It was much wider than the traditional tunica and its sleeves were longer and fuller with deep armholes. As with the tunica, the dalmatic was girded in a variety of methods. By the fifth century CE, the dalmatic had been adopted by the early Christian as a component of ecclesiastical vestments.

During the second century BCE, Rome completed its conquest of Greece. In addition to sending home shiploads of stolen art and treasure, the Romans appropriated countless slaves including innumerable master craftsmen and artisans. From these importations of bronze, marble, and human beings came a sweep of Hellenic influences all across Roman culture. The poet Horace wrote, "Conquered Greece led her proud conqueror captive."

The most widespread influence of Greek costume on masculine Roman styles was an adaptation of the himation called the **pallium**. Upper classes used this cloak as outerwear over, or sometimes in place of, the toga in winter and inclement weather. Unlike the toga with its standardized draping, the pallium could be wrapped about the figure in any manner that the wearer chose. It could also be

Figure 5-6. The toga represented citizenship for freeborn Roman males regardless of class. Draping the toga involved a standardized arrangement to create its unique silhouette. The sweep of the fabric across the front was called the sinus and the swag of material at the waistline provided a sort of pouch called the umbo. Statue of Emperor Titus, c. 80 CE.

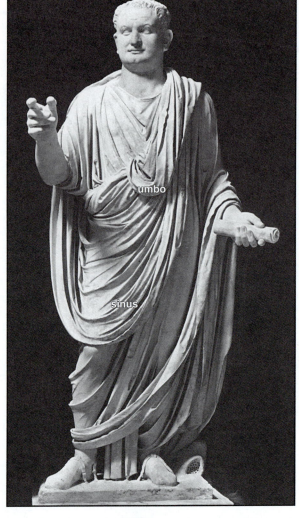

Toga of the Republican Period (Top, full size; bottom, folded for draping.)

Toga of the Imperial Period (Top, full size; bottom, folded for draping.)

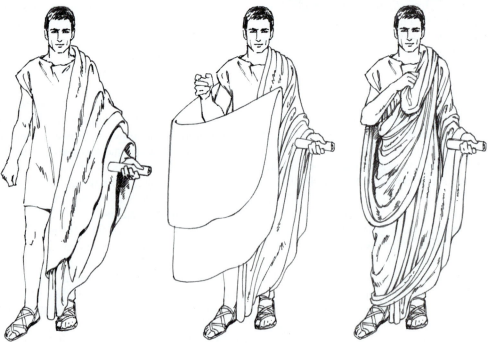

Figure 5-7. The short-sleeved, knee-length tunica was the garment most commonly worn by Roman men. Upper classes layered a heavier woolen version over an under tunic called the subucula made of linen or finer wool. Most tunicas were worn girded at the waist. Bas-relief of Roman metalsmith, c. first century CE.

tied or pinned into place for a more secured fit than the toga.

What is not certain among scholars, though, is how and why the Romans adapted the toga, tunica, and perizoma from the Etruscans but not their version of the himation. One suggestion is that the himation was a later Greek influence on Etruscan costume that occurred well after the Romans had overthrown their Etruscan rulers in the sixth century BCE. The most common representations of the himation in Etruscan funerary sculpture are dated from the late fifth and into the fourth centuries BCE. Consequently, the first time the Romans were particularly inspired by Hellenic costume on a mass scale was only after Greece became an imperial province.

Yet the Greeks were not the only neighboring peoples whose native costumes were adopted by the Romans. Surprisingly, it was contact with the Germanic tribes of the north rather than with the Persians in the east that ignited a Roman interest in trousers. (Figure 5-8.) The **feminalia** (also called **bracchae**, braccae, or bracae) was a pair of full, loose-fitting trousers based on designs worn by the north European peoples. The bifurcated garment was basically two pieces of fabric cut in rectilinear shapes to enclose the hips and legs, and then sewn together. Unlike the tailored, fitted trousers of the Persians, the feminalia was simply pulled on and girded at the waist irrespective of how

the inseam or leg length fit. As a standard, though, the Romans preferred pant hemlines cropped just below the knees whereas the German styles extended to the ankles. Some sculptures show that the trousers were held up by either rolling the excess material at the waist over a belt or simply by girding the gathered material at the waistline. Initially, the feminalia was part of the Roman military costume. Later in the Imperial Period, civilians adopted the feminalia in varying lengths, particularly for use in rough labors, fieldwork, and hunting.

Men's winter outerwear consisted of a number of types of cloaks, capes, and wrap garments. (Figure 5-9.) The **paenula** was a bell-shaped cloak with an open front worn by wealthier classes. This type of cloak was often made of finer, more water-resistant weaves of heavy wool, and even fur for the northern provinces. Hemlines usually reached to mid-calf in length and sometimes completely covered the arms past the fingertips. Some silhouettes were shorter at the sides with pointed or rounded wedge shapes in the front and back. Styles of the paenula made for city wear were richly trimmed with appliques or embroidery all around the border.

For traveling or inclement weather, a **cucullus**, or hood, could be paired with the paenula. Variations ranged from a narrow hood that was stitched or pinned to the paenula to a wider style of hood with a **capelet** that covered the shoulders.

Another hooded outerwear garment that was simpler in design was the **birrus** (also burrus). The drawing in Figure 5-9 shows how the semicircular cloak and hood of the birrus were cut from the same single piece of material. The fabric was folded in half and then the top of the hood and the front of the cloak were stitched together so that the birrus had to be pulled on over the head like our modern **poncho**. Hemlines extended in various lengths from the hips to mid-calf. Made of poorer quality materials such as coarse linen or wool, this garment was primarily worn by the rural peasant classes and slaves.

Two kinds of wrap garments worn as masculine outerwear were the **laena** and the **lacerna**. The laena was a circle of woolen fabric that was folded in half for double warmth and wrapped about the shoulders creating a short cape. It was pinned at the front and sometimes to the side, resembling the Greek chlamys. The lacerna was a larger, rectangular wrap cut with rounded edges similar to the toga. Like the pallium, the lacerna was layered in almost any casually wrapped arrangement the wearer preferred.

WOMEN'S CLOTHING

To a great extent, Roman women owed the freedom of their social status to the legacy of Etruscan women. Just as with their predecessors in Etruria, Roman women enjoyed a far more open role in their society than Greek or Mesopotamian women. As citizens of Rome, freeborn women could own property, participate in public events, and even pursue an education. They had greater freedom of movement outside the home than their secluded Greek sisters. Although Roman women could not engage in politics, they could be active in

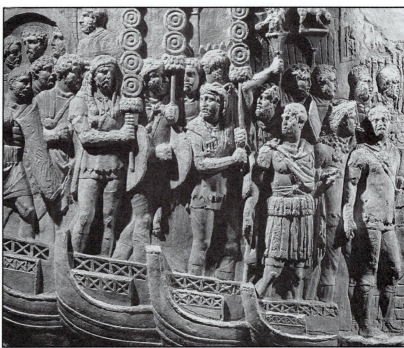

Figure 5-8. The feminalia was a type of trousers adopted by the military from the northern Germanic peoples. Roman styles were cut as loosely as the Teutonic versions with little attention to tailoring or fit. Although Germanic men wore their trouser lengths to the ankles, Romans preferred hemlines cropped just below the knees. Left, bas-relief of Germanic captive, c. second century CE; right, soldiers from Column of Trajan, c. 113 CE.

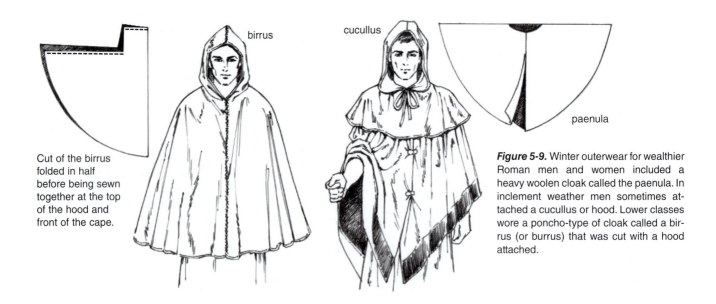

Cut of the birrus folded in half before being sewn together at the top of the hood and front of the cape.

birrus

cucullus

paenula

Figure 5-9. Winter outerwear for wealthier Roman men and women included a heavy woolen cloak called the paenula. In inclement weather men sometimes attached a cucullus or hood. Lower classes wore a poncho-type of cloak called a birrus (or burrus) that was cut with a hood attached.

social, economic, and religious arenas. Women of high status were often involved in patronage, community development, and civic functions. They dispensed state and private largess throughout their communities ranging from charitable gifts to extensive building programs. Their role in managing the household and contributing to family decisions was more dominant than that of Greek women. Cato the Elder wrote, "We rule all peoples; our wives rule us." The Roman matron secured a dignity and respect that even the women of Etruria had not known.

Roman women also were expected to be educated, especially since, as mothers, part of their responsibility was to raise sons to be good and proper citizens. Of all the ancient civilizations, Rome could claim the most literate female population. On many a Roman tombstone women are credited with roles and skills that required reading and writing—even the medical profession in one example. Numerous funerary portraits and wall frescoes depict women holding wax writing tablets and a stylus. (Color Plate 2.)

This is not to say, though, that women were accorded equality with men. The degree of liberties afforded to women largely depended upon the prominence of the men in their family. Marriages were still arranged for economic or social advantages. Family structures were still strictly patriarchal. Women could be divorced for adultery but men could not. Personal property could be owned by women but was almost always managed by a male family member. Not all classes of women were educated, though, especially those in rural or small communities who may not have had access to tutors or to the informal schools of the forum sponsored by larger towns and cities. Furthermore, the chief role of women in Roman society was traditionally viewed as that of mother and homemaker, with anything else being secondary.

The dress of Roman women reflected not only class distinctions but also the idea of feminine respectability. In this regard, the costume of Roman women closely resembled that of the Greeks with its layers of concealing garments and subdued fabrics. The exception was in veiling, which was not as strict a social custom for Roman women although matrons usually covered their heads when in public. On the Ari Pacis (Altar of Peace), for example, is a relief carving that includes representations of a number of women in a ceremonial procession, some of whom are not veiled. Basically, the dress of a Roman woman was comprised of three garments: an under tunic, an outer tunic, and an outerwear wrap. (Figure 5-10.)

The feminine version of the subucula was usually cut as a floor-length, sleeveless chemise made of linen or lightweight wool. This under tunic was comparable to our modern **slip** and was never to be worn in public as a solitary garment. Women would wear it singly, though, in the privacy of their quarters as a housedress and even to bed as a nightgown.

Over the subucula women wore the **stola**, a T-shaped tunic with long or elbow-length sleeves. Following the wave of Greek influences in the second century BCE, the top seams of the sleeves sometimes were not sewn together but rather were pinned with a row of small, ornate brooches. The fabric then draped across the shoulders and arms imitating the look of a Greek chiton. The distinction, though, was that the Roman stola was a cut-and-sewn garment made with attached sleeves, but the chiton was a wide tube of fabric draped and pinned to form sleeves. The stola was floor-length and, if worn by a matron, was trimmed at the hemline with a narrow border called the **instita**. Some scholars have translated Latin descriptions of the instita to mean a pleated ruffle or train of

some sort while others think it may have been a colored edging that corresponded to the clavi on men's togas.

Wrapped about the two tunics was a voluminous outer garment, the **palla**. Roman sculptures and paintings of women reveal that the palla was cut as a square, rectangle, or even round-edged oblong like the toga. As with the Greek himation, the palla was draped about the body in a variety of ways. The most common technique was similar to the drape of a toga. One end of the garment hung forward from the left shoulder to the feet; the rest of the fabric then wrapped around the back and either forward under the right arm or over the right shoulder to be carried on the left arm. However, women had to take care not to arrange the palla identically to the style of the toga. Ironically, although by law men wore the toga with pride of citizenship, for women of the imperial era, the toga was a mark of disrepute, most notably that of an adulteress or prostitute.

Other types of undergarments were worn more selectively. As with the subligaculum for men, a form of **brassiere**, or binding for the breasts, and a type of brief were worn by female athletes and circus performers. (Figure 5-11.) Sometimes, matrons also wore these garments as underwear, especially if their outer clothing was made of diaphanous silk. The **mamillare** was a long, narrow piece of fabric used to cover the bust. To arrange it, the woman centered the fabric strip at the back, brought the two ends to the front across the breasts, and then tucked each end into the band of fabric under the opposite arm. The **strophium** was a long-line brassiere that covered the breasts and the upper ribcage by tightly encircling the torso with a long strip of material. The binding of the strophium could even be extended down the torso to the waist as a type of binding girdle. The bottom half of women's underwear, the subligaculum, wrapped about the hips in the same diaper form as the men's style creating a similar type of brief.

ACCESSORIES AND HAIRSTYLES

As with fashion of our modern times, the addition of accessories to a basic costume provided infinite variety of style and a sense of newness for Roman women. The options of feminine accessories included a colorful and decorative array of scarves, shawls, jewelry, shoes, belts, and to a lesser degree, hats. Such a wide assortment of costume accents could change the fairly standardized arrangement of the stola and palla into something fresh and new everyday.

Scarves were made in all sorts of sizes and fabrics depending upon intended use. As mentioned previously, matrons usually covered their heads while in public. Even though the palla was adequate for this purpose, many women preferred a separate scarf called a **flammeum** that they affixed to a diadem or to their coiffures with decorative hairpins. A similar head-covering scarf, the **ricinium**, was dyed dark colors and worn by widows during mourning. Other larger scarves, especially those made of silk, were pinned around the shoulders creating a short capelet. Still others were more like

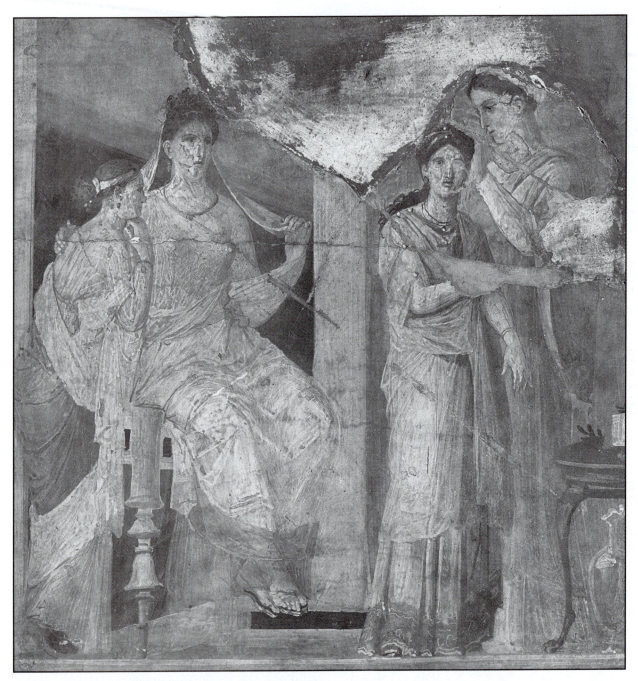

Figure 5-10. The costume of a Roman woman consisted of three basic garments. The subucula was a slip-like under tunic worn beneath the stola, or outer tunic. Layered over these was an outerwear wrap, the palla. Painting from Herculaneum, c. 75 CE.

our modern handkerchief such as the smaller, utilitarian **sudarium**, or the larger **orarium** that was carried or worn pinned to a sleeve as a symbol of the woman's social status. Introductions of new textile patterns and color combinations for these accessories were often initiated by influxes of immigrants from distant lands whose exotic designs and motifs of their native heritage became stylish trends of the time.

Roman jewelry was produced in the same varieties as women wear today: necklaces, bracelets, brooches, rings, earrings, and anklets. For Roman men, wearing jewelry was mostly restricted to garment pins and finger rings, especially styles bearing familial insignia. The popularity of certain motifs as applied to jewelry corresponded to periods of conquest and commercial expansion. By the second century BCE, when

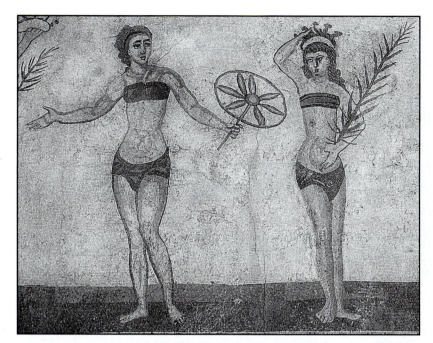

Figure 5-11. Women's underwear was formed by pieces of fabric variously wrapped about the body. The mamillare was a form of brassiere and the feminine version of the subligaculum fit like a diaper. Mosaic of female athletes, c. 300 CE.

Greece became a province, a flood of immigrant metalsmiths and jewelers introduced Greek designs on a mass scale. Most popular of all were the **cameos** carved of shell and precious stones. During the early part of the imperial period when Egypt and Syria were absorbed into the empire, a taste for exotic, oriental designs prevailed. Exquisite wire **filigree** and **granulation techniques** created tiered cuff bracelets and pectoral-sized necklaces of jewel-encrusted gold. Even the working classes donned trinkets and jewelry made of base metals crafted with detailing in imitation of finer pieces. When the empire expanded eastward into Mesopotamia, Roman jewelers designed Persian styles of brooches and pendants with large cabochon gems or necklaces with massive tubular beads of carnelian, lapis lazuli, and amber.

Of equally great a variety as scarves and jewelry were Roman shoe styles. The most common type was the **carbatina**, which was a basic sandal. The sole was made of a single piece of ox-hide to which was stitched an intricate network of leather strips and lacings that covered the arch, heel, ankle, and toes. Both men and women wore this style of sandal. The **campagus** was a short lace-up boot with an open front similar to earlier Persian styles. A separate piece of leather was often inserted like a tongue to prevent tight laces from cutting into the skin. The **pero** was a similar style of boot that extended over the calf almost to the knee and was mostly worn by field workers and laborers. Other boot styles were similar to the earlier Etruscan models constructed with soft leather uppers and thick soles but without the curling toes and vivid red polish. Indoors, upper class women wore the **soccus,** a type of slipper made of lavishly tooled leather or opulent fabrics. The soccus was sometimes richly embellished with gold thread, silk embroidery, and even pearls and gems.

It should be noted that shoes were far more than mere accessories for Roman citizens. Like so many components of Roman attire, the design and craftsmanship of the shoes were a statement of class. Although in Etruria and Greece, going into public barefooted was not a sign of peasant class or poverty, such was not the case in Roman society. Despite sculptures of emperors posing barefooted, only peasants and slaves actually went unshod.

For the most part, Romans seldom wore hats. Both men and women wore a felt or straw version of the Greek petasos when traveling or working in the fields. The **pileus** was a small, round, brimless hat made of felt that fit like a skullcap, or inverted bowl, and was worn by craftsmen or other middle-class males. Women who went out into the sun either covered their heads with a scarf or a fold of the palla, or carried a non-folding kind of **parasol**.

Roman women did not wear the kind of elaborate headdresses that noblewomen of Egypt and Mesopotamia preferred, nor the decorative little hats or tiaras of the Greeks. Instead, most upper class women preferred to arrange their natural hair in extraordinary coiffures, many of which were enhanced by the addition of human hairpieces. (Figure 5-12.) Blonde hair became popular during the first century CE when Rome battled the northern Teutonic tribes. The golden tresses of enslaved Gauls were sheered and made into full wigs or hair extensions to match a Roman woman's bleached hair. For women who preferred their ethnic Latin coloration, **ebony** dyes imported from Egypt were used to conceal any silvery signs of aging. Middle- and working-class women and matrons seldom indulged in the luxury of spending hours with an **ornatrix** (hairdresser). More often they simply bound up their hair with a **vitta**, a narrow band of woolen material. The

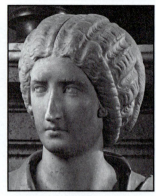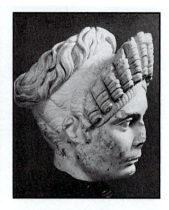

Figure 5-12. Instead of headdresses or hats, Roman women preferred to wear their natural hair—sometimes enhanced with human hair pieces—arranged in elaborate coiffures. Left to right: Flavian Lady, c. 90 CE; Empress Julia Domna, c. 200 CE; Faustina the Younger, 148 CE.

vitta was also used to create the conical hairstyle called a **tutulus**, which designated the status of a matron as a mater familias, or wife of the head of an extended family.

MILITARY COSTUME

The most detailed pictorial documentation we have of the Roman army and its costumes is from the Column of Trajan (c. 113 CE) and the Column of Marcus Aurelius (c. 180 CE). Each of these 125-foot-high marble monuments is decorated with a narrative bas-relief that spirals up the entire surface of its single, gigantic column. Literally thousands of figures depict Roman soldiers in tableaus of combat, or laying siege to great cities, or capturing prisoners for slavery. Interspersed throughout these complex scenes of war are also dozens of vignettes representing mundane activities of the soldiers' daily life. They are shown setting up camp, building fortifications, transporting supplies, grooming animals, unloading ships, and clustering in groups to hear from their commanders. Even eighteen centuries after these figures were carved, the details of their costumes and accouterments are still precise and clear. For accuracy the sculptors drew on contemporary models and reproduced in exactitude the armor, weapons, and clothing of the imperial Roman army—down to the special insignia of individual units.

From these carvings we may examine some of the common components of Roman military costume and armor. (Figure 5-13.) Over a simple woolen tunic, the soldier wore a cuirass, called the **lorica**, made of varying quality and design. The legionnaires' lorica was a basic leather corselet with strips of steel attached in assorted arrangements. Later versions were made with lighter, overlapping scales of metal that provided greater ease of movement. High-ranking officers such as centurions or tribunes wore a solid metal lorica molded in two pieces shaped as an idealized athletic torso. For senators and generals the surface of the lorica was often elaborately decorated with incised, inlaid, or repoussé ornamentation.

The Roman helmet underwent innumerable changes from the Republican Era into the early part of the Imperial Period. The earliest styles greatly resembled the conical domed types with hinged cheek guards typical of Asiatic civilizations. This is especially curious since so much of Roman costume was derived from Etruscan styles, and the Etruscans had wholly adopted the Greek military dress by the fifth century BCE. Costume historian Mary Houston has suggested that perhaps nationalistic motives had led the Romans to reject later Etruscan costumes that had been transformed by Greek influences. After all, during much of the first half of the Republican Period, Rome constantly battled both Etruscans and Greeks. Whatever the reason, the Roman helmet evolved into a close-fitting design with an outward curving neck guard, hinged cheek pieces, and a visor over the brow. The helmets of officers or the emperor's bodyguard, the Praetorian Guards, were crested with red-dyed plumes or horsehair.

Although gladiators sometimes wore leather or metal greaves into combat, Roman soldiers wore none. For ceremonial dress, though, ornamented greaves might be included on special occasions. Oddly enough, the soldier's shins were completely exposed by trousers that extended only to below the knees and by short boots or sandals that laced only to the ankles. Why the boots or sandal lacings were not extended higher or the trouser legs cut to extend to the ankles is not known.

The most prevalent type of cloak worn by Roman soldiers was the **sagum** (also saggum). It was made of heavy, coarse wool that was dyed any number of shades of red ranging from scarlet to rust. Lengths varied as well with some hemlines only to the thighs while others reached almost to the ankles. A ceremonial cloak called the **paludamentum** was worn exclusively by a general as he led his troops out of a city to battle or back home from a victory. Made of the finest wool, the general's cloak was lavishly embroidered with gold threads and fringed in gold, crimson, or purple.

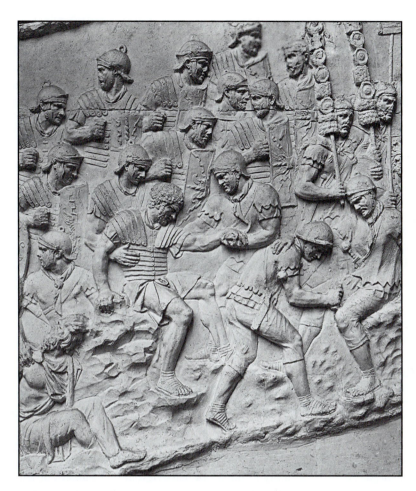

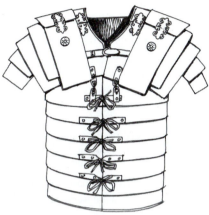

Figure 5-13. The Roman soldier's basic clothing was a short tunica and the feminalia. Over these were worn a cuirass, called a lorica, made of bands of steel attached to a leather corselet. The close-fitting helmet featured an outward curving neck guard, cheek pieces, and visor. Greaves were only worn by officers for ceremonial purposes, not battle. Completing the costume was the red-dyed sagum, a heavy woolen cloak. Left, bas-relief from the Column of Trajan, c. 113 CE; right, reconstruction of a steel-plated lorica, c. 100 CE.

REVIEW

The history of the Roman civilization is a story of how the descendants of Iron Age peasants, squatting in a mud-hut community along the Tiber River, came to dominate much of the Western world. Their legacy was an epic struggle to conquer or perish that eventually established an empire extending from Britain to Mesopotamia and all around the Mediterranean basin.

As the former subjects of Etruscan kings, the Romans retained many cultural traditions of their urbane, Hellenized masters. Roman clothing, particularly, was based on Etruscan styles. Textiles used for apparel were the same wool and linen produced throughout Etruria. One significant difference was that the Romans abandoned wearing richly patterned and ornamented fabrics—at least until the later Imperial Period. Some types of Etruscan garments remained largely unchanged, such as the T-shaped tunic. Other kinds of Etruscan clothing gradually evolved into silhouettes unique to the Romans. For example, the variably worn tebenna of the Etruscans became the Roman toga with its strict protocol for draping and its symbolic significance of class and citizenship.

Other direct influences on Roman costume came from the immigrants and enslaved peoples of conquered nations who introduced to the Romans on a mass scale new types of garments, textiles, ornament, and accessories. From the annexation of Greece came the himation, renamed the palla for women and pallium for men. From the Balkans came a voluminous, wide-sleeved tunic called the dalmatic. From Gaul came trousers adapted into the feminalia. Indeed, from all corners of the empire came so many innovations of clothing and accessories that even the toga changed in style and eventually disappeared.

Yet unlike the gradual acceptance and adaptation of foreign influences on their culture, customs, and costumes, governance of the enterprise that was the Roman Empire remained brittle and inflexible. The historical circle of chaos to order to chaos again ultimately brought about a collapse of the Western Empire and an abrupt evolution of the Eastern Empire. Today we marvel at the monuments of Roman engineering, architecture, and art that have survived throughout the world over which Rome ruled. Still other Roman monuments endure in our modern age through our concepts of law and government, in our calendar, in the rituals and costumes of our religions, and in the very roots of our languages.

Chapter 5 The Romans
Questions

1. What were the prevalent textiles used in Roman apparel? How did these fabrics differ from those of the Etruscans? How were they similar?

2. Which garments and decorative elements signified the social status of Roman men, both civilian and military?

3. Which elements of the silhouette of the toga make it unique to Roman costume?

4. Compare the different ways in which the toga, pallium, laena, and lacerna were worn. How was the use of the toga different from the other three garments?

5. How were the costumes of Roman women similar to those of Greek women and how did they differ? Identify the garments of both cultures by their respective names.

6. What were some of the cross-cultural influences of Roman dress and from where did they originate? Under what circumstances were these influences introduced into Roman culture?

Chapter 5 The Romans
Research and Portfolio Projects

Research:

1. Write a research paper comparing the role of women in Etruscan and Roman society with that of women in ancient Greece. Include examples of how costumes of Etruscan, Roman, and Greek women reflected their role in society.

2. Write a research paper on how Roman law regulated dress by class and gender: types of clothing, insignia, colors, textiles, and accessories.

Portfolio:

1. Using photocopies or digital scans of sculptures and wall paintings, compile an accessory handbook on Roman women's accessories and hair arrangements. Catalog thirty examples of hairstyles, thirty examples of jewelry, ten styles of footwear, and five types of scarf arrangements, each with a short description. Include information on the artwork such as date, location, materials (jewelry), and textile colors or patterns (paintings).

2. Research and construct a lifesize model of a Roman soldier's lorica. Substitute posterboard for metal and fabric for leather. Demonstrate to the class how a soldier put on the lorica and how easily he could maneuver wearing one.

Glossary of Dress Terms

augusta clavus: a double band of purple or crimson stripes added to garments of high-ranking officials

birrus (also burrus): a semicircular cloak with an attached hood

bracchae (braccae or bracae): another name for feminalia

brassiere: a feminine undergarment designed to cover and support the breasts

cameo: a small relief carving on a gem, shell or stone in which the raised design is on a layer of one color and the background is a layer of a contrasting color

campagus: a short boot with an open front that was laced closed over an inserted tongue

capelet: a short cape that just covers the shoulders and upper arms

carbatina: the basic Roman sandal that covered most of the foot with an intricate network of leather strips and laces

clavus (pl. clavi): purple stripes added to the border of a toga denoting social status

cucullus: an outerwear hood sometimes made with a capelet that was pinned or stitched to a paenula

dalmatic: a wider form of the tunica with fuller, longer sleeves

ebony: a black dye produced from the Egyptian hebni plant used for coloring hair and fabrics

feminalia: loose-fitting trousers adapted from styles of the Germanic tribes; also called bracchae, braccae, or bracae

filigree: intricate ornamentation composed of alternating spirals

flammeum: a woman's scarf worn to veil the hair

granulation technique: the application of miniscule beads of metal to produce intricate patterns for jewelry and decorative items

instita: a narrow border of color or pleated fabric at the hemline of the stola designating the status of the wearer as a matron

lacerna: a large, rectangle of fabric cut with rounded edges and worn as men's outerwear

laena: a masculine cape made by folding a circular piece of fabric in half and pinning around the shoulders

latus clavus: the wide purple border of a senator's toga

lorica: a soldier's cuirass, usually made of a leather corselet affixed with metal plates

mamillare: a type of brassiere made from a narrow strip of fabric wrapped around a woman's torso

orarium: a small scarf of silk or embroidered material carried by women as a symbol of rank

ornatrix: a Roman hairdresser

paenula: a men's bell-shaped cloak with an open front

palla: a square, rectangle, or round-edged oblong of material worn by women as an outerwear wrap

pallium: a long, wrap garment adapted from the Greek himation and worn by men as outerwear

paludamentum: a lavishly decorated cloak worn by generals in ceremonial processions

parasol: a lightweight umbrella carried by women for protection from the sun

pero: a men's knee-high workboot worn by plebians

pileus: a small, round, brimless skullcap for men

poncho: a men's closed cloak with a hole in the center for the head

ricinium: headcovering scarf of dark colors worn by widows during mourning

sagum (also saggum): a soldier's cloak made of heavy, coarse wool and dyed red

sinus: the swag of fabric created by draping the toga across the front of the thighs

slip: a modern feminine dress-like undergarment

soccus: a woman's slipper made of opulent materials and worn only indoors

stola: the outer tunic of a woman's costume

strophium: a band of fabric worn by women as a type of long-line brassiere that was sometimes extended over the waistline to serve as a corset

subligaculum: a linen or wool loincloth worn as a form of briefs by both men and women; also called a subligar

subucula: a short, sometimes sleeveless, under tunic worn by both men and women

sudarium: a small scarf carried by women to serve as a handkerchief

toga: the primary outer garment of male Roman citizens that was arranged according to a strict protocol of drapery

tunica: the Roman version of a T-shaped tunic constructed of two pieces of fabric sewn at the sides and shoulders with openings for the neck and arms

tutulus: a conical arrangement of a woman's hair that symbolized her status as a matron

umbo: the swag of fabric at the front waistline of the toga sometimes used as a pouch

vitta: a narrow band of material used to bind up a woman's hair

Legacies and Influences of Roman Styles on Modern Fashion

The most notable Roman garment, the toga, disappeared into obscurity after the collapse of the empire and survives in modern times only as a costume for history dramas or collegiate fraternity parties. However, some peripheral types of garments and elements of Roman style have descendants in fashions of today.

Stylish Roman women knew the importance of accessories to add flair to their standardized dress of the stola and the palla. A variety of colorful scarves in assorted sizes could be arranged about the hair, draped over the shoulders, pinned to their tunic, or carried as a handkerchief. Women of the modern era have similarly used scarves to accent basic suits and dresses or to give freshness to a favorite outfit.

A number of their more practical garments were precursors to similar forms of modern clothing. Versions of the functional cucullus are standard issue for military and police forces around the world. In addition, the practical support and figure control of the mamillare was rediscovered in the construction of the brassiere. Likewise, the panty had its antecedent in the Roman subligaculum. Just as the subucula served as a concealing undergarment for the woman's diaphanous stola, the modern slip prevents see-through of dresses made of lightweight fabrics. For men, the subligaculum (adapted from the Etruscan perizoma) with its tight fit and brief cut was reinvented in the 1930s, first as a French swimsuit, and then becoming a ubiquitous style of men's underwear.

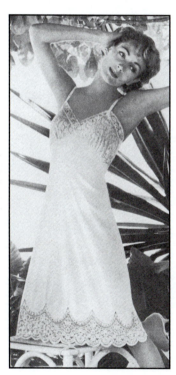

The Roman subucula was worn by respectable women under their semitransparent stola to conceal the body when they were in public. The modern slip serves the same purpose for women today. Nylon tricot slip by Van Raalte, 1958.

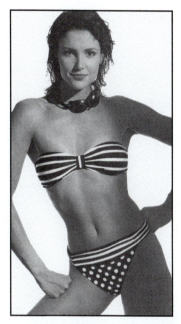

The Roman mamillare and subligaculum forecast the cut of modern women's bra and panty and the design of the two-piece swimsuit. Bikini swimsuit of Antron/Lycra by Edith Thais, 1987.

The Roman subligaculum was the precursor to the many forms of men's brief style underwear and swimwear. Cotton ribbed briefs from Speed, 1938.

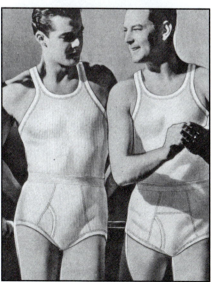

Chapter 6

BYZANTIUM

The Byzantine Empire

Founding of Constantinople	End of the Western Roman Empire 476	Justinian (527–65)	Territorial losses in the West	Rise of Islam	End of the Iconoclastic Schism	Split of the Eastern and Western Church 1054	First Crusade 1078–85	Invasions of the Mongols	Turks captured Constantinople
330			600	800		1000	1200		1453

THE ROMAN EMPIRE OF THE EAST

At the beginning of the fourth century CE, the strategic and economic importance of the Roman provinces in the east had become significant enough for Constantine the Great to establish an eastern capital in the region. He selected the Greek city of Byzantium, which he renamed Constantinople. After an energetic six-year building program, the city was officially inaugurated as the new Rome.

In the subsequent two centuries, the Western Empire was ravaged by wave after wave of migrating peoples from the east and north, ultimately resulting in the sack of Rome and the deposing of the last Western Roman emperor in 476. In the east, the Byzantine Empire survived the onslaughts and flourished. Under the rule of Justinian (527–65) the Byzantines even recaptured sections of Italy, Spain, and North Africa for a while. By the middle of the seventh century though, the emerging Islamic empire began to overrun many of the Byzantine provinces of Asia Minor. Led first by the Arabs and later by the Turks, the Muslims quickly expanded their conquests across North Africa and into Spain. Despite some periods of reconquest, by the

fifteenth century, the Byzantine Empire had been reduced to a narrow domain in Greece and the Balkans. Finally, in 1453, the golden city of Constantinople fell to the relentless Muslims.

By the sixth century, the authority of the Byzantine state was firmly based both on Christianity and Hellenism—a distinct break with its past, the pagan world of the Latin West. Justinian and his successors particularly sought to establish social and ethnic unity through the doctrine of one state, one religion. Both church and state steadfastly emphasized a single dogma despite the numerous conflicts provoked by such an autocratic policy.

In the early seventh century, Emperor Heraclius (610–41) made Greek the official language, providing further commonality for the diverse peoples of the empire. Laws were adapted from Latin originals and translated into Greek with modifications that reflected Christian ethics. The Byzantine bible was in Greek.

Heraclius also decentralized the government by establishing administrative districts called "themes," each of which was run by a governor and a military aristocracy whose task was to provide for the military management and

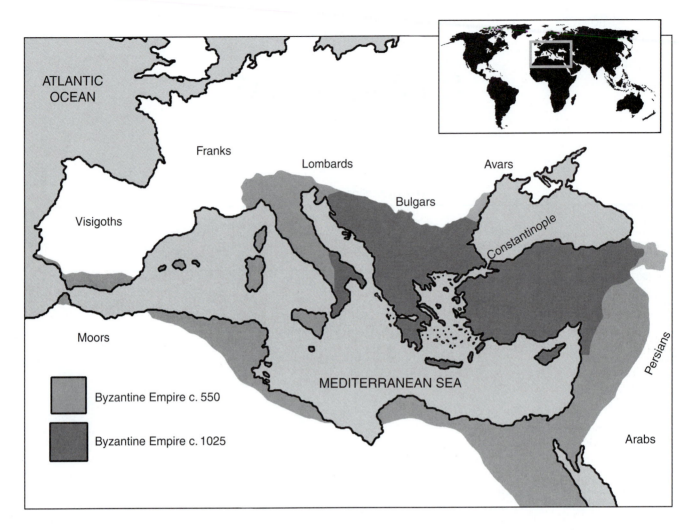

ATLANTIC OCEAN

Franks

Lombards

Avars

Bulgars

Visigoths

Constantinople

Moors

Persians

MEDITERRANEAN SEA

Arabs

Byzantine Empire c. 550

Byzantine Empire c. 1025

the subsistence of their province. Eventually, this early form of feudalism led to challenges to the emperor's authority by the autonomous nobility. Mounting civil discord in the themes resulted in a destabilization of the economy and a weakening of military defenses, which opened the door for territorial losses to barbarian tribes in the north, Turks in the east, and Arabs in the south.

BYZANTINE SOCIETY

The foundation of Byzantine society was the "oikos," a Greek word meaning *household*, which consisted of a circle of family members, in-laws, servants, slaves, and even concubines and close friends. Surviving tax roles, wills, and litigation records document that, irrespective of class, Byzantine kinship groups were identified by family names that were transmitted from generation to generation. Peasant households were just as likely to have an established family name as were households of the nobility. Although not all members of a kinship group lived under the same roof, in urban areas families were often housed in

multistoried buildings constructed around a common courtyard, each with its own entrance, and in rural regions many families lived in complexes of freestanding houses somewhat like a self-contained village.

The social structure of the Byzantine household was patriarchal although legal documents indicate that widows could own property and act as head of the household. Empresses sometimes reigned in their own right or wielded great power as regents of minor sons. However, for the most part, women of all classes were segregated from the outside world, though they were not as rigidly secluded as their ancient Greek predecessors. Still, Byzantine houses were commonly designed with a gynaikonitis, or women's apartments, according to the *Chronography* of Michael Pellus (c. 1060). In most instances, women were rarely permitted to dine or interact with male visitors outside the kinship group for fear of dishonor to the family. Wrote Cecaumenus in the late eleventh century: "An unchaste daughter is guilty of harming not only herself but also her parents and relatives. That is why you should keep your daughters under lock and key . . . in order to avoid any venomous bites."

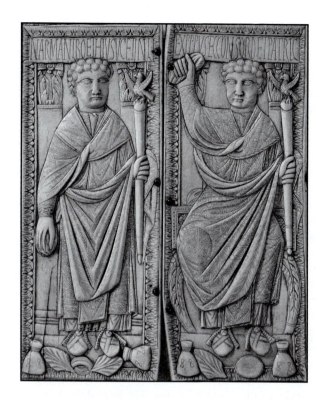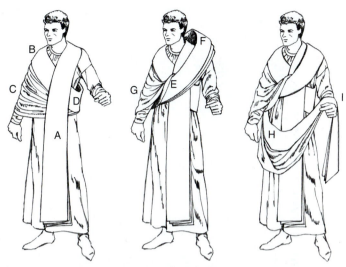

Figure 6-1. Later versions of the toga picta were richly embroidered and folded with a wide decorative border on the outside. The draping of transitional Byzantine toga styles varied dramatically from earlier imperial arrangements. Ivory diptych of Boethius, c. 487.

Marriages of all classes were strategically arranged for social advancement. Children as young as seven—regarded as the age of reason since that was when they learned to read the psalter—were betrothed although they had to wait till age twelve for girls and fourteen for boys to be married. Adoption also provided opportunities for creating family ties or fortifying existing ones, a practice that even legally extended to the adoption of an unrelated adult male as a brother.

The family also set the future careers of their children to the best advantage of the kinship group. Military families prepared boys as soldiers. Feudal obligations to regional themes and to the emperor required trained and armed men to defend the state in exchange for family rank, power, and privileges. For broken engagements or failed marriage proposals, children might be committed to a cloister, which was itself a type of wealthy Byzantine oikos. Girls could be sent to convents as young as age ten. Prepubescent boys entering the clergy were commonly castrated since eunuchs were highly valued by the church as a third sex, freed from corrupting, natural impulses. The extensive and complex Byzantine bureaucracy was likewise in constant need of literate, educated clerks and officials.

EARLY BYZANTINE IMPERIAL COSTUME

The Bishop of Rome, the Pope, was the head of the Roman Catholic Church of the West, but in the east, the emperor was the representative of Christ on earth for the Orthodox Church.

This development in Eastern Christian doctrine was the adaptation of an ancient heritage from the Near East—the divine kingship of Egypt and the priest-king of Mesopotamian cultures. Although the Byzantine emperors could not claim the status of gods, they were unique and exalted as both head of the Church and ruler of the empire.

The raiment of a Byzantine emperor had to reflect the dignity and majesty of this dual role. During the fifth and sixth centuries, the costume of Byzantine rulers gradually developed from the Western Latin styles into an Asiatic look. The most notable change was with the toga. Already by Constantine's time, draping the toga had changed in technique for reasons that since have been lost in time. In the fifth century, Byzantine emperors began to arrange the toga as a narrowly folded band with a richly ornamented edge turned outward. (Figure 6-1.) As with previous versions of the **toga picta**, the garment was arranged by first draping the folded band of fabric over the left shoulder with a length hanging to the ankles in the front (A). The toga then wrapped around the back and to the front again over the right shoulder (B), where the folds were pulled loose to cover the right arm (C). The folded band continued around the waist under the front-hanging length (D), and to the front again under the right arm (E). As the folded band was pulled taut up over the left shoulder a second time (F), the loosened material over the right arm formed a sort of wide sleeve (G). The two layers overlapping at the left shoulder are clearly evident in the carvings of Boethius shown here.

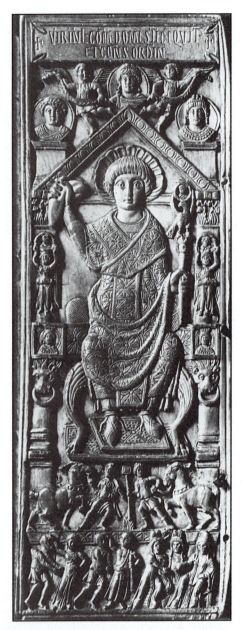

Figure 6-2. The three primary components of the early Byzantine imperial costume included the T-cut tunica talaris worn under a wide dalmatic, over which the toga picta was draped. ivory panel of Anastasius, c. 517.

from the fifth century until the High Middle Ages lack the kind of detail and precision from which costume historians can readily determine styles of garments and accessories. Consequently, some costume historians have been confused by the stylized rendering of the transitional toga styles. For example, the vertical front draping of the folded toga shown in 6-1A is often carved in early Byzantine sculptures with such vagueness that some historians have thought that the draping began over the right shoulder. The Anastasius panel is a case in point that is often used to illustrate this suggested type of Byzantine toga arrangement. (Figure 6-2.) Because the sculptor has carved the front draping of the toga exactly in the center, it is difficult to tell which shoulder the draping goes over first. However, even as the draping of the imperial toga of the Western Empire began to change in the third century, the first wrap always began over the left shoulder—a tradition that began nearly 800 years earlier with the Etruscan version of the toga. The significance of this distinction is to better link the transition of the toga into an imperial scarf that developed in the Late Middle Ages.

The imperial Byzantine toga was usually worn over two basic garments—the **tunica talaris** and the dalmatic. The design of both garments had remained largely unchanged from styles of the Western Empire. The long-sleeved tunica was cut in two lengths. For court functions, the hemline usually extended to the ankles, and for riding horseback or other exerting activities the preferred length was at the knees. The tunica's shape was still either that of a T-pattern cut from one piece of cloth including the short sleeves or with close-fitting long sleeves sewn to the T-cut body. The wide dalmatic was layered over the long tunica, sometimes ungirded. Its silhouette often was a seven-eighths length as shown in Figures 6-1 and 6-2 with full sleeves of about twelve inches wide usually cropped at the elbows.

Early transition styles of the dalmatic retained the clavi at the borders or as vertical stripes down the front. In the Byzantine imperial court, the clavi became more decorative than symbolic and was lavishly embellished with heavy embroidery of gold thread, gems, and pearls. By the mid-sixth century, the clavi had mostly disappeared in favor of the **tablion**, an elaborately decorated rectangular piece of fabric applied to the front of the paludamentum of the emperor, empress, or certain high-ranking court officials. The male figures in the Justinian and Theodora mosaics of San Vitale show how large the tablion was in proportion to the length of the cloak. (Figure 6-3 and Color Plate 3.) Although the tablions in these examples appear to be appliqued or inset at an angle, this is a stylization of the artist to indicate the asymmetrical draping of the cloak fastened at the right shoulder.

By the time of Justinian, the metamorphosis of the imperial costume from Western Roman styles to a distinct Eastern look was complete. Constantine's **stephanos**, a simple, jeweled band of fabric worn tied around the head, had evolved into the more elaborate crown called a **stemma**. Near

After one more wrap around the back, the band is brought to the front under the right arm a third time (H) and unfolded to be draped over the left arm (I). This style of toga was depicted on a number of figures representing emperors through the middle of the sixth century.

The high quality and exceptional realism of Roman sculpture and painting that had been adopted from the Greeks was lost to the Dark Ages after the collapse of the Western Empire. Even the most superlative examples of art

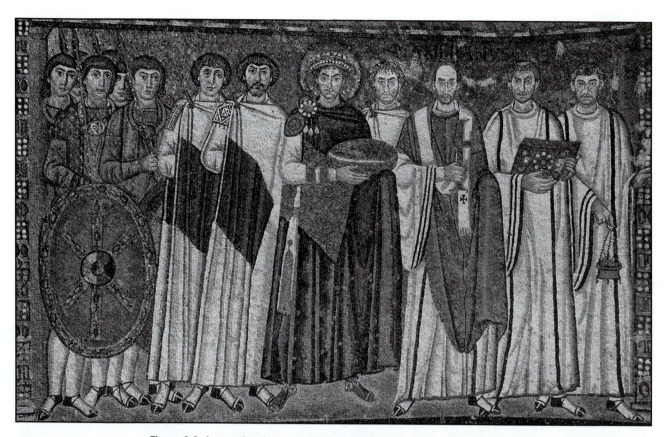

Figure 6-3. Among the changes to the imperial Byzantine costume in the sixth and seventh centuries was the evolution of the clavi into the tablion, an ornamented rectangle applied across the front of the paludamentum. Additionally, a hat-style crown called a stemma replaced the jeweled band of the Western imperial costume. Mosaic of Justinian and retinue, San Vitale, Ravenna. c. 547.

Eastern influences are evident in the design of the Byzantine stemma with its upwardly flaring shape that resembles the ancient Persian khula. Similarly, the infulae of royal diadems from Mesopotamian cultures have transformed into **pendoulia** made of gold chains with beads of precious stones or pearls and pendants attached to the base of the stemma. Only the emperor and empress were allowed to wear this ornate headdress feature although fabric infulae were later adapted to the back of ecclesiastical headdresses that are worn still today.

Instead of a toga picta, Justinian wears an imperial purple paludamentum fastened asymmetrically at the right shoulder with a large, jeweled fibula. Across the front is a tablion of gold and crimson embroidery. Visible under the emperor's right arm is the other half of the tablion. Were the cloak to be worn with its opening pinned at the throat instead of the shoulder, the tablion would extend as a wide rectangle across the entire front of the torso. Four other male figures in the Justinian and Theodora mosaics wear cloaks with tablions, also fastened at the shoulder with the center opening at the right side. All of their rectangular appliques appear to be solid purple, symbolic

of service to the imperial family, although the tablion's fabric could have been ornamented with a finely detailed embroidery or made of an intricate woven pattern or texture that was too delicate to represent in mosaic.

From the side opening of the cloaks worn by Justinian and two of Theodora's male attendants, we see the hemlines of knee-length tunicas. All three figures wear their long-sleeved tunicas girded at the hips rather than the more common method at the waist. On the shoulders of each tunica is a **segmentum**, a small, circular or square appliqué of an ornate pattern or sometimes pictorial scene. Justinian's visible segmentum is the more richly embroidered and appears to be jewel-encrusted. None of the secular figures wears the layered dalmatic.

In the San Vitale mosaics, men's accessories are minimal. All of the men are bareheaded except Justinian. Protocol may have required the military leaders to remove their helmets and the clergy to attend the procession without their diadems in the presence of the emperor. Each man wears woven silk or linen **hosa** to cover his legs rather than the trousers of their Western predecessors. Justinian wears purple

Byzantine Silk Industry

The variety of opulent textile colors and patterns as shown in the San Vitale mosaics attest to the thriving silk trade the Byzantines enjoyed with the East in the fifth and sixth centuries. Such silk textiles were rare and expensive luxury goods, made all the more costly by Persian merchants whose profit surcharges were viewed as exorbitant by the Byzantines.

Justinian first attempted to compete with Persia in the silk trade by engaging the Christian Abyssinians of northeast Africa to establish direct trade routes to India through the Red Sea and then transport the silks across the Byzantine lands of the Levant to Constantinople. When the Abyssinians were unable to break the Persian monopoly, Justinian then attempted to fix prices for imported silks. A crisis of supply and demand resulted when Persian merchants refused to sell the fabric at all to the Byzantines.

Consequently, according to the historian Procopius of Caesarea, around 550, a group of Nestorian monks who had learned the secrets of sericulture, or silkworm farming, in China, smuggled silkworm eggs and mulberry seeds in a hollow bamboo cane past Chinese inspectors to Constantinople. There they established the first Western silkworm farm. The Byzantine silk industry quickly became a highly lucrative state monopoly that eventually expanded into the textile centers of Syria, Egypt, and Greece.

Byzantine silk textiles were of such high quality and exceptional design that they were widely imported all across Europe by kings, nobles, wealthy merchants, and church officials. A significant number of Byzantine silk textiles have survived because they were carefully stored in church treasuries as coverings for sacred icons, reliquaries, and other religious artifacts. (Figure 6-4.)

 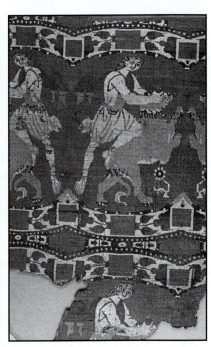

Figure 6-4. The quality and design of Byzantine silk textiles rivaled that of Chinese and Indian production. Many fine examples of Byzantine silks survive today from church vaults, having been preserved as coverings for religious artifacts. Left, fragment of silk tapestry Taming the Beast Charioteer, c. 650; center, detail of silk Shroud of St. Germanus, c. 1000; right, fragment of silk textile depicting man wrestling a wild beast, c. 690.

hosa, and the other male figures wear white. The lengths of hosa extended above the knees where they were bound with silk cords or soft leather thongs. All the men's shoes are similar in design with an Asian-style pointed toe, an enclosed heel, and an open instep. With such a delight in excessive ornamentation on garments, though, it is surprising that Byzantine men did not wear jewelry other than fibulas and rings at court.

The material of the tunicas and hosa seems to be solid white silk or linen. The cloaks were most likely of fine wool with tablions of woven silk or embroidery. Why these high-ranking officials are dressed solely in white (except

for the gold-colored cloak of one of Theodora's attendants) is unknown. Since Justinian carries a gold paten for the Eucharistic bread and Theodora bears a jeweled wine chalice, it is thought that the procession is a religious gift-giving event. Hence, the emperor, as Christ's representative on earth, and the male courtiers are more priestly in their white, gold, and purple—the same colors in the dress of the attending clergy. The ranking military officers next to Justinian and the women in Theodora's retinue, though, wear brightly colored silks adorned with brocaded patterns, segmentae, and jeweled cuffs and hemlines.

Imperial Byzantine women's costumes evolved from the Roman tunic (stola) and outerwear wrap (palla). By the sixth century, the feminine tunic was always made long-sleeved and extended to the floor. The long, close-fitting sleeves worn by the women in the San Vitale mosaic indicate that they are dressed in tunics rather than dalmatics. Women's cloaks were cut in a semicircle or rectangle. Unlike with Western Roman women, the Byzantines did not ordinarily use these cloaks to veil their heads, despite their Greek heritage.

The textiles of the tunics and cloaks depicted in the mosaics are richly patterned and decorated. Among the motifs represented on garments are red rosebuds, blue ducks, circles within octagons, and allover floral prints. The tunic of the woman next to Theodora shows how the Western clavi was adapted to Byzantine apparel as ornamentation with its vertical gold stripes and zig-zag edging. Various shapes of segmentae are on both the tunics and the cloaks. Instead of an appliqué, some of these segmentae probably were woven into the material in a method called **tapestry darning**. In this process the weft of the wool or linen ground is replaced by a pattern darned in and out of the warp usually in squares or circles of about eight to ten inches in width.

Byzantine women's costumes included a greater variety of accessories than men's. All of Theodora's attendants wear their hair up under close-fitting, turban-like headdresses. Each headdress is styled differently with a variety of ornament and pattern. The more important the personage, the larger the headdress. Jewelry was large and colorful—heavy gold necklaces with multiple pendants, wide jeweled cuff bracelets, dangling earrings of precious stones and pearls, and rings set with oversized gemstones. Two of the attendants wear a fringed or beaded sash to gird their tunics, and one woman holds a matching fringed sudarium. The shoes are almost hidden by the hemlines of their tunics, but we can discern pointed toes, another Asian influence.

Theodora's costume mirrors that of her husband's rather than conforming to the tunic and wrap ensemble of her female attendants. Her floor-length tunic is made of white silk, possibly a sumptuous brocade, trimmed with thick, gold embroidery. Instead of a tablion, her purple cloak is decorated with an embroidered border depicting the three wise men bearing gifts. Her crown is more elaborate than the emperor's and sits atop a jewel-embellished turban or head roll similar to that worn by ancient Sumerian women. Another Asiatic influence is the revival of the wide, jeweled collar, called a **maniakis**, or **superhumeral**, that had been an element of royal Egyptian costumes.

The San Vitale mosaics provide evidence of how Asiatic influences had changed imperial Roman costume in the two centuries since Constantine founded an eastern Empire. Once established, though, Byzantine costume evolved slowly and changed little until the ninth century when the end of the Iconoclastic Schism inspired a revitalized pursuit of opulence.

LATE BYZANTINE IMPERIAL COSTUME

During the eighth and ninth centuries, the Byzantine Empire suffered turmoil, violence, and destruction from within by the Iconoclasts who believed that icons were idols that promoted image-worshiping. After more than 100 years of conflict, a restoration of orthodoxy was achieved and with it began a second golden age of art and literature. During this period of cultural revival and enrichment, imperial costumes became more sumptuous and heavy. Garments were made of a vividly colored, thick, stiff silk fabric called **samite** that could more easily support the stress and weight of gold-thread embroidery and jewels. In fact, gold was used abundantly for imperial raiment. An account from 1544 reported that cloth-of-gold removed from a Byzantine empress' grave was melted down to produce thirty-six pounds of pure gold.

Most garment styles changed little, though. The toga picta was preserved as the elaborately ornamented ritual scarf called a **lorum** (also loros). However, representations of the lorum in artworks of the era are not clear on how the folded garment was arranged. (Figure 6-5.) The carving of Constantine VII from around 945 appears to show a break with tradition. The lorum seems to wrap first over the right shoulder instead of the customary left, then around to the front under the right arm, over the left shoulder, and end with a third wrap to the front across the hips to the left forearm. Similarly, a tondo from about 1120 featuring John II Komnenos shows a different application of the lorum. Here the scarf seems to follow the arrangement of the toga picta as shown in the line drawings in Figure 6-1, but now includes a fourth wrap around the hips and up over the right shoulder before spreading open on the left forearm.

One of the new types of garments added to the emperor's official costume was the imperial pallium. (Figure 6-6.) Basically, this was a long, wide piece of fabric that draped over the shoulders with a hole for the head. The back portion was much longer than the front and was either pulled around to the front to be carried over the left arm or was allowed to drag as a train. In the aftermath of the Iconoclastic Schism, this variant of the pallium was thickly encrusted with jewels and raised embroidery. Both the emperor and empress wore versions of the garment.

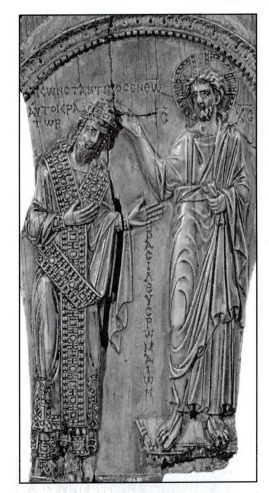

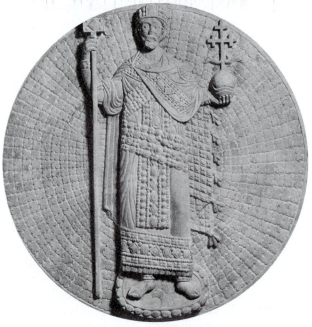

Figure 6-5. The toga picta evolved into an ornamental ritual scarf called the lorum. In later Byzantine artworks, the arrangement of the lorum appears variable. Top, carving of Constantine VII Porphyrogenneto, c. 945; bottom, John II Komnenos tondo. c. 1120.

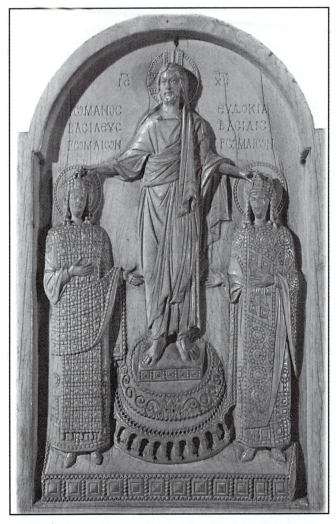

Figure 6-6. The imperial pallium was a long, wide piece of fabric with a hole for the head. The back portion was longer than the front and was usually pulled to the front to be carried over the left arm. Christ Crowning Romanus IV and Eudoxia, c. 949.

It should be noted that some costume historians regard the imperial Byzantine pallium as a version of the lorum rather than a separate garment. The explanation is that the lorum evolved from the toga picta as a scarf, which in turn evolved into the shawl style. The problem with this argument is that both the lorum and pallium are contemporary with each other. Numerous examples of artworks from the late Byzantine period show emperors wearing one or the other garment. This suggests that either style—the lorum or pallium—was subject to the emperor's preference, or perhaps was dictated by new ceremonial protocols. Moreover, the scarf-like and shawl-like constructions of the two garments are too distinct for both to be categorized as lorums.

A new development in women's imperial costumes is the addition of a **thorakion**, a large scarf shaped like an

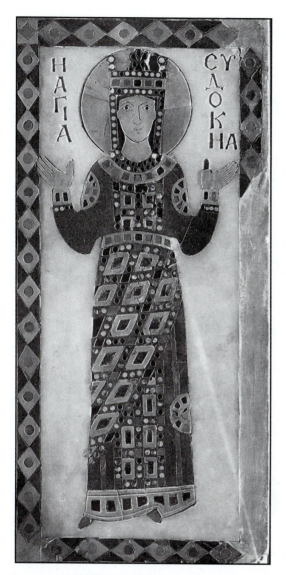

Figure 6-7. An addition to women's imperial costume was the thorakion, a large scarf shaped like an inverted teardrop shield that was pinned or stitched to the front skirt of the empress' tunic. Inlaid marble of St. Eudokia, c. 1300.

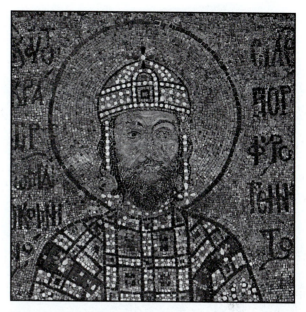

Figure 6-8. Emperors of the late Byzantine period wore a round-domed diadem called a camelaukion. The covering of the crown provided an additional surface that could be embellished with jewels and ornament. Detail of John II Komnenos mosaic in the south gallery of the Hagia Sophia, c. 1140.

inverted teardrop shield that was pinned or stitched to the front skirt of the tunic. (Figures 6-7 and 6-12.) Most depictions of this accessory show the thorakion attached at the front waistline and wrapped around the right side. A few examples are known that show the shield shape wrapped to the figure's left. The shape of the shield is representative of the Archangels Michael and Gabriel, defenders of Christ and Christendom. Although most thorakions were lavishly ornamented to match the pallium and maniakis, some versions bore a design of the cross as was often depicted in artwork representing the archangels carrying their shields.

The figures of Constantine VII, John II Komnenos, and Romanus shown here all wear a new type of round-domed diadem called a **camelaukion**. A clearer representation of

this new form of crown can be seen in the twelfth-century mosaic of John II Komnenos. (Figure 6-8.) Covering the top of the crown created an additional surface that could be embellished with jewels and ornament. The pendoulia were retained at the sides, and sometimes added in the back.

Although the lorum, imperial pallium, thorakion, and camelaukion were new additions to the imperial Byzantine costume of the late period, the primary components remained much as they were in the time of Justinian. The illuminated manuscript portrait of Nikephoros III Botaneiates shown in Figure 6-9 depicts the emperor dressed in a traditional tunic with narrow sleeves beneath an ankle-length dalmatic with a maniakis. The crown is a round-domed camelaukion. These basic components of the imperial Byzantine costume would continue virtually unchanged after the fall of Constantinople in 1453 with the imperial costumes of czarist Russia and the royal houses of the Balkans.

COSTUMES OF ORDINARY BYZANTINES

Even though the great majority of Byzantine art depicts religious iconography and imperial portraiture, representations of ordinary Byzantines are plentiful. Biblical themes are frequently centered on common people, whom artists of the era painted or carved in contemporary terms; that is, representations of the ancient peoples of the Bible were dressed in anachronistic Roman attire rather than ethnic costumes of the Old Testament. The late tenth-century ivory panel from

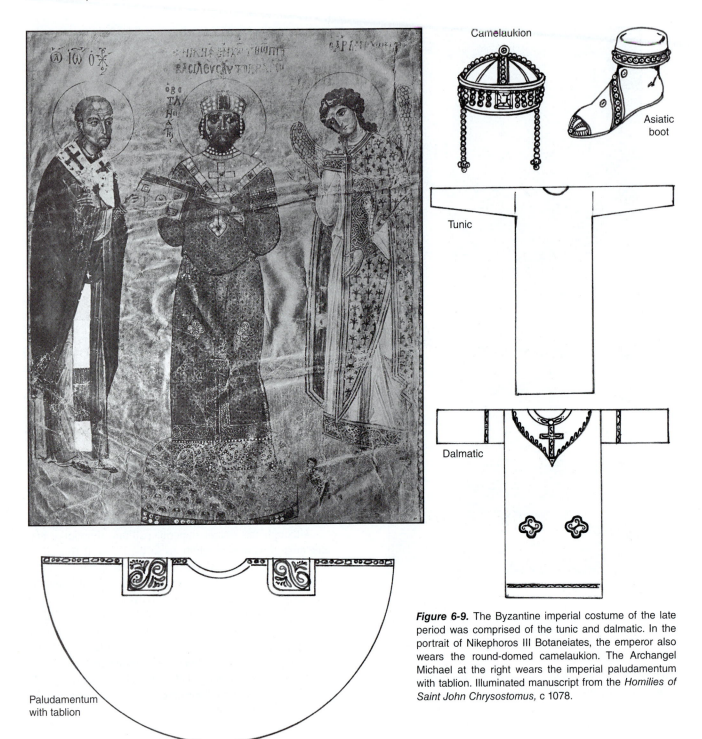

Figure 6-9. The Byzantine imperial costume of the late period was comprised of the tunic and dalmatic. In the portrait of Nikephoros III Botaneiates, the emperor also wears the round-domed camelaukion. The Archangel Michael at the right wears the imperial paludamentum with tablion. Illuminated manuscript from the *Homilies of Saint John Chrysostomus,* c 1078.

Camelaukion

Asiatic boot

Tunic

Dalmatic

Paludamentum with tablion

a Byzantine reliquary casket shown in Figure 6-10 illustrates the toils of Adam and Eve in which the male figure wears a typical Roman knee-length tunica with long sleeves rolled to the elbows. The basic T-cut style girded at the waist has remained unchanged since the days of Caesar Augustus. Similarly, the figure of Eve wears a basic T-cut, ankle-length tunica with a wide belt. The only hint of Byzantine influence on either garment is an ornamental collar treatment. Neither have the peros changed, the knee-high peasant's boots with lace-up fronts worn by men and women.

In addition, a number of images in Byzantine art representing the lower classes such as shepherds indicate that the Greek exomis was still commonly worn in the region more than 1,500 years after its introduction in Hellas.

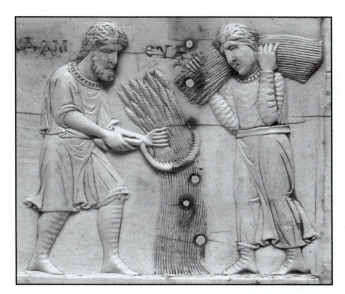

Figure 6-10. The costumes of ordinary Byzantines were frequently represented in biblical themes. Here a toiling Adam is dressed in a typical Roman T-cut tunica with peasant's lace-up boots. The figure of Eve wears a belted, ankle-length tunica. Ivory panel from a reliquary casket, c. 1000.

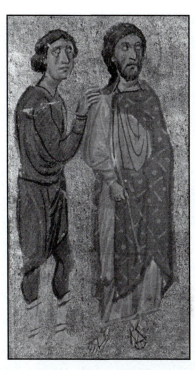

Figure 6-11. Men of the more affluent merchant and craftsman classes wore longer tunicas made of finer grades of wool. Over these were layered colorful palliums variously draped about the shoulders like the Greek himation or pinned to the right like the Roman sagum. Detail of an illuminated manuscript *Christ Before Pontius Pilate,* c. 1190.

The middle classes are variously represented in mosaics and manuscripts as worshippers or in crowd scenes. (Figure 6-11.) More distinguished male figures often are shown in a mid-calf or ankle-length tunica with the woolen pallium variously draped about the shoulders like the Greek himation or pinned to the right like the Roman sagum. Women's costumes were similar, only the hemline of the tunica was floor-length concealing all but the tips of the shoes. Often an unembellished dalmatic was layered over the tunicas of both men and women.

The omission of the clavi is a notable departure from the earlier Roman dress. Younger men were depicted with a plain, long-sleeve tunica usually of a solid color. Their outer garment was also a pallium.

One female duo that illustrates an unusual Byzantine costume style is from the crown of Constantine IX. (Figure 6-12.) It is doubtful that these are portraits of the imperial family since they are exuberantly dancing although the fabrics of the apparel are lavishly patterned and colored. The upper garment appears to be a short dalmatic with three-quarter sleeves, a maniakis at the neckline, and segmentae on the shoulders and bodice. The embroidered cuffs of the tunica worn beneath the dalmatic show at the wrists, and a thorakion made of the same material as each tunica hangs down the front of the skirt. As the women dance, they appear to be twirling patterned scarves above their heads. The colorful, vividly patterned outfits of these figures easily could be the predecessors of the festive folk costumes of Central European countries like Bulgaria, Romania, and Serbia.

BYZANTINE MILITARY COSTUME

Where the imperial Roman armies had been organized mostly for conquest and occupation, the Byzantine military focused on defense. During the transitional period of the fourth through the seventh centuries, the Eastern Empire had to contend with Sassanid Persians and Huns from the east, Arabs from the south, and Goths, Lombards, Bulgars, and a dozen similar marauding tribes to the north and west. By the eighth century, the well-organized Byzantines could effectively defend their empire with a standing army numbering only about 120,000.

The migrations of peoples that eventually led to the fall of the Western Roman Empire greatly impacted the availablity of manufactured and raw materials necessary to the Byzantine military. Northern iron ore mines were abandoned, ore-processing centers ceased regular production, and skilled metalsmithing labor diminished. In addition, trade routes with centers of metalwork production were continually disrupted by the movements and resettlements of tribes. Consequently, metal became scarce and was largely reserved for the production of weapons and helmets. Only the elite could afford the extravance of full body armor.

Initially, Byzantine military costume was primarily the same as that of the Western Empire. The basic components of a knee-length tunica, sagum, cuirass, and close-fitting

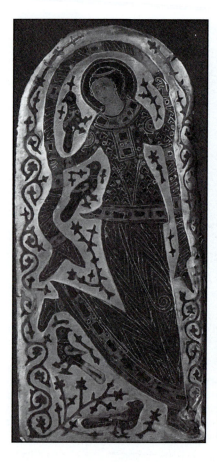 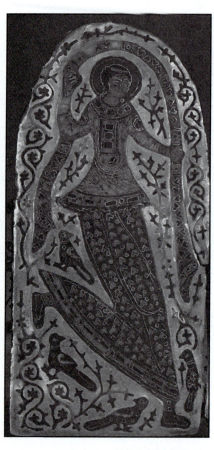

Figure 6-12. The unusual Byzantine costume style depicted in each of these panels from the crown of Constantine IX (c. 1050) includes a short dalmatic with three-quarter sleeves over a long tunica with a thorakion attached to the front of the skirt. The women dance twirling vividly patterned scarves above their heads.

helmet comprised the Eastern legionnaire's uniform. Fundamental changes began to occur, though, as early as the fifth century. Most notable was that the feminalia was replaced by long hosa that extended above the knees. These styles of stockings were bound above the knee with leather thongs or strips of linen or wool. Later depictions of longer. thigh-high hosa show garters stitched to the tops and affixed to a belt at the waist beneath the tunica. In addition, the military tunica followed the style of civilian wear and adopted long sleeves. Many representations of soldiers from the late period show the wide-sleeved dalmatic layered over the tunica. Boots of varying heights replaced sandals. Greaves were no longer worn even in ceremonial dress.

At the top of the military organization pyramid were the imperial guards—a legacy from the Caesars. In Figure 6-3 the depictions of palace guardsmen represented in the Justinian mosaic carry spears and shields but do not wear helmets or cuirasses. Because of the tight arrangement of the figures, their swords are not visible but were likely strapped to their left hips. Large gold **torques** around their necks symbolize the guardsmen's dedication to the emperor as well as their status as the emperor's personal bodyguards. This unusual addition to the costume of the Byzantine imperial guard may be an influence from Greek lore in which the fierce Gauls fought completely nude except for neck torques as symbols of their tribal loyalty.

Due to sporadic shortages of processed metals, the cuirass soon became reserved for the elite branches of the military. Instead of the lorica, with its overlapping bands of iron or steel, Byzantine imperial guards and army officers wore the **squamata**, a cuirass designed with a sheath of small, metal scales attached to a leather or linen bodice. (Figure 6-13.) Some versions of the squamata extended only to the waist, others covered the hips, and ceremonial styles included skirts and elbow-length sleeves covered with scales. Whatever the design, the squamata is most often depicted on figures of imperial guardsmen, generals, emperors, and even archangels.

After the imperial guard, the cavalry was the supreme class of the military. The Byzantines had learned the lessons of the Western armies, which had been little match for the hordes of mounted barbarians that overran Europe. As a result, the Byzantine military substantially built up its cavalry and recruited the finest horsemen in the empire—especially those tribal warriors from its hinterlands in Asia Minor. Many times these skillful, armed riders turned the tide of battle, even against overwhelming numbers. They were trained to ride at full speed, shooting arrows from the saddle, thrusting their lances, or slashing with a sword.

The most variable component of the Byzantine military costume was the helmet. Military historians cannot explain how or why the highly engineered Roman helmet of the

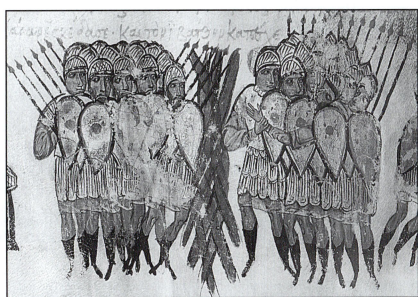

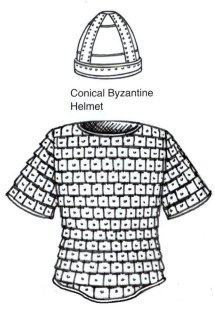

Conical Byzantine
Helmet

Squamata

Figure 6-13. By the fifth century, fundamental changes had occurred in Byzantine military costume. The short Roman trousers were replaced by long hosa. The preferred style of helmet was a shallow, conical shape without cheek pieces or visor. The scale-covered cuirass, called a squamata, was reserved for the elite branches of the military. The kite shield, shaped like an inverted teardrop replaced the round or oblong Roman versions. Illuminated manuscripts from the *Chronicle of John Skylitzes,* c. 1300.

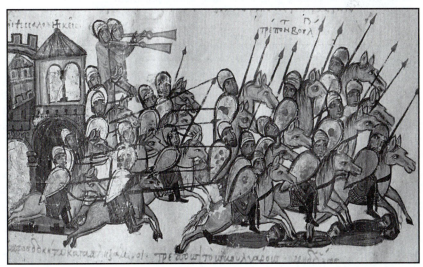

imperial era was discarded in favor of the pointed-dome styles preferred by the Byzantines. One suggestion is that the influence spread from the foederati—barbarian mercenaries who armed themselves with traditional battle implements and armor, including the conical helmet. Another style of Byzantine helmet that appeared after the ninth century was an ornate, scalloped-edge version that appeared in numerous illuminated manuscripts depicting the imperial guard. Most likely, though, these were ceremonial helmets worn to designate those of the highest ranks when at court. The more commonly represented helmet in manuscript illuminations was constructed in a shallow conical shape without a visor or cheek pieces as shown in Figure 6-13.

In the late period following the Iconoclastic Schism, **kite shields**, shaped like inverted teardrops, replaced the round and oblong-shaped versions. The base construction was of wood, often covered with layers of linen reinforced with glue

or gesso. Regimental emblems and colors were painted on the front.

ECCLESIASTICAL COSTUME

At the same time that Constantine devised the plan to split the Roman Empire into eastern and western geopolitical units, he also established Christianity as the state religion. In choosing Byzantium as the capital of the Eastern Empire, he centered New Rome in the heart of the most Christianized region of the empire. Although Constantine's vision was to have the East and the West function as two halves of the same coin, in fact, he set in motion a division that within less than a century had become irrevocable.

Just as the empire was geographically and politically split East and West by the end of the fourth century, so too was the doctrine of Christianity. In the West, the Bishop of

Rome was the acknowledged head of the Catholic Church. Roman Catholicism maintained its independence from any state authority and became a centralized institution—the sole interpreter of Christian faith and order. In the East, the emperor was Christ's direct representative on earth. Church doctrine and even the very nature of Christ were defined by a series of councils that included state officials as well as the church hierarchy. The Greek Orthodox Church positioned itself as a "Universal Church" that included all Christians worshiping in their own languages with their own regional traditions and customs. For the Orthodox Christian, there was little distinction between religious and secular matters. It is this diffuse Eastern view of authority, as opposed to the centralized discipline of the Catholic West, that lies at the heart of the split of the Christian Church in the first millennium.

Our primary sources of how the early Christians dressed during the imperial Roman era are a few surviving examples of artwork. Not only were so many of these works destroyed during the periods of state purges, but many Christians themselves viewed such images as idolatrous and obliterated many of the figural representations. Gradually, though, in the catacombs of Rome and in small churches isolated in rural regions, religious narratives were created in fresco, mosaic, and sculpture. The fifth century ascetic monk Nilus of Sinai advised his followers, "Fill the Holy Church on both sides with pictures from the Old and New Testaments . . . so that the illiterate who are unable to read the Holy Scriptures may, by gazing at the pictures, become mindful of the manly deed of those who have genuinely served the true God, and may be roused to emulate their feats." These figures of biblical characters and church fathers were dressed in the same clothing as any other Roman of the day. A common representation of Christ was a shepherd wearing a short tunic and bearing a lost lamb over his shoulders. Depictions of apostles and saints wear tunics of various lengths and usually have a pallium draped about the shoulders.

As with the images of saints and biblical characters in early Christian artwork, representations of priests and church officials were likewise dressed in ordinary apparel. Only after Constantine established Christianity as the state religion did the church begin to appropriate components of the imperial costume as priestly vestments.

The emperor's tunica talaris became the liturgical **tunica alba**—later the **alb**—an ankle-length tunic of white linen with narrow, long sleeves. In the mid-sixth-century mosaics of Bishop Ursicinus and Saint Apollinarus shown in Figure 6-14, only the narrow, purple-banded sleeves of the alb are visible.

Over the alb was worn a dalmatic, also derived from the imperial costume. The huge sleeves of the ecclesiastical version are evident in the figures of Bishop Maximianus and the two clergymen standing to the right of the emperor in the Justinian mosaic. (Figure 6-3.) The liturgical dalmatic was made of white linen, wool, or even silk. Extending vertically from the shoulders to the hemline were single or double clavi of crimson or purple that stood out in sharp contrast against the white fabric. The same stripe is often repeated on the wide sleeves of the dalmatic as a single, double, or sometimes, a triple band. Ecclesiastical use of the clavi persisted even after the element had mostly disappeared from the garments of the ruling classes.

Instead of adapting the imperial paludamentum, the liturgical outer vestment became the **chasuble**. Possibly derived from the Roman paenula, the circular garment was constructed from two semicircles or cut from a single large piece of material, each version with a hole in the center for the head. Variants included ovoid shapes that were shorter at the sides to leave the hands free, and even designs with slits at the sides for easier arm movement. By the fifteenth century, the sides of the chasuble became so short that it was later called a "fiddle-back" because when the garment was laid out flat, it resembled the figure-eight form of a violin. The chasuble was the more colorful and richly decorated of the ecclesiastical garments. A secular version called the **casula**—Latin for "little house"—was worn by both sexes during the Middle Ages.

The outermost component of early ecclesiastical costumes was the **stole**, an adaptation of the imperial lorum, which itself had evolved from the earlier toga picta. The stole was a long strip of material, usually silk, draped around the shoulders in various ways. The transitional Byzantine style represented in the mosaics of Bishop Ursicinus and Saint Apollinarus shows the stole applied asymmetrically around the shoulders as diagrammed in Figure 6-15. Later Western versions were simply draped over the shoulders with the two loose ends hanging down the front.

By the end of the sixth century, the alb, dalmatic, chasuble, and stole were codified by ecclesiastical authorities as liturgical vestments. The universality of this fundamental costume expressed the universality of Christendom and Christianity despite its many schisms and regional disparities.

During the following centuries, colors of liturgical vestments became more uniformly symbolic. White or silver represented innocence and the purity of Christ's blessing, and was worn for consecrations, confirmations, or coronations. Red, signifying blood, was used on occasions that commemorated the sufferings of Christ, the Apostles, and martyrs. Green was the color of spring's renewal from pagan times and became associated with the Resurrection. Various shades of green ranging from emerald to lime were worn before Lent and after Trinity. Deep violet signified intercessional and penitential mourning, and black was worn for funerals and masses for the dead. By the Late Middle Ages, color also indicated hierarchal rank in the Western Church: white for the Pope, red or crimson for a cardinal, purple for a bishop, and black for a priest.

Following the irreconcilable break of the Western and Eastern Churches in the eleventh century, ecclesiastical garments and accoutrement of the two sects evolved differently.

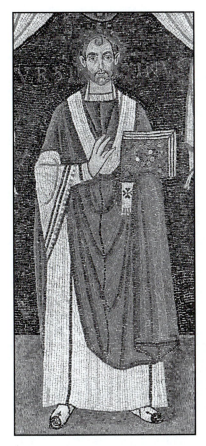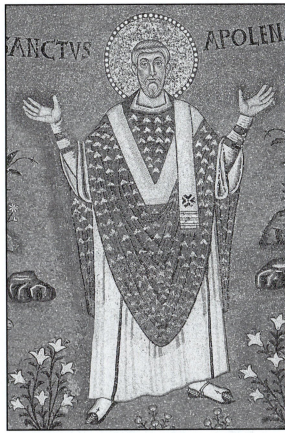

Figure 6-14. Early liturgical vestments were adaptations of the imperial costume. The emperor's tunica talaris became the priest's tunica alba (later the alb). Over the tunica was worn a long dalmatic with wide sleeves. Instead of the paludamentum, though, the outermost ecclesiastical garment was the chasuble, a large, circular cloak. Mosaics of Bishop Ursicinus (left) and Saint Apollinaris (right), Sant' Apollinare in Classe, c. 550.

The line drawings in the two facing pages of Figure 6-15 illustrate the basic components of bishops' costumes from the two churches in the Late Middle Ages.

In the East, the alb became the **sticharion**, sometimes made fuller with the addition of **gores**, or inset panels of fabric, at the sides. Modern styles of the sticharion may be of any color and are most often made of silk or velvet.

The dalmatic of the West became a vestment primarily of the Pope and his deacons. It was worn under the chasuble during mass, benedictions, and processions but never on penitential days. Priests were permitted to wear the dalmatic only on specified days. In the East, the dalmatic became the **sakkos** with shortened sleeves and fuller girth. Later styles of the sakkos were constructed with open sides that were joined by bows of ribbon or buttons with corded loops. In the nineteenth century, some Greek Orthodox styles of the sakkos featured an edging of tiny bells at the open sides. The fabric was usually a richly brocaded or embroidered silk.

The outer garment of an Eastern priest's costume that corresponded to the chasuble was the **phenolion**. The key difference between the two is that the phenolion was shortened in the front rather than the sides for easier arm movement. This design was achieved by moving the opening for the head off center in the circular cut.

The stole led to the development of two related garments in later Greek vestments. The **omophorion** retained much of the draping technique shown in the sixth-century mosaics of Bishop Ursicinus and Saint Apollinarus. The omophorion remains an outer-layered vestment today. The **epitrachelion** was a later addition that was also derived from the stole. It was cut with an opening for the head at one end, and the two front panels were fastened together with pins, hooks, or buttons with loops. The epitrachelion is still used today and always layers over the sticharion but beneath the phenolion of a priest.

In the Latin Church, the **cope** is a topmost garment that is primarily for processional use although today it sometimes replaces the chasuble as a vestment for mass. The semicircular cape is open in the front and fastens across the chest by a broad ornamented band. Originally, the cloak was hooded for mass and Church functions held outdoors.

Eastern Church liturgical vestments of a bishop in the Late Middle Ages.

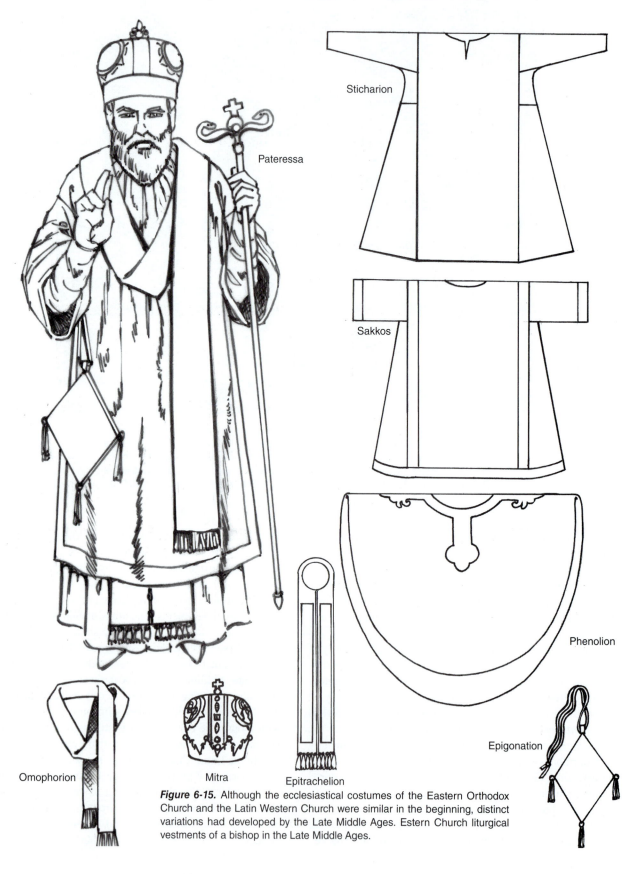

Sticharion

Pateressa

Sakkos

Phenolion

Epigonation

Omophorion

Mitra

Epitrachelion

Figure 6-15. Although the ecclesiastical costumes of the Eastern Orthodox Church and the Latin Western Church were similar in the beginning, distinct variations had developed by the Late Middle Ages. Estern Church liturgical vestments of a bishop in the Late Middle Ages.

Western Church liturgical vestments of a bishop in the Late Middle Ages.

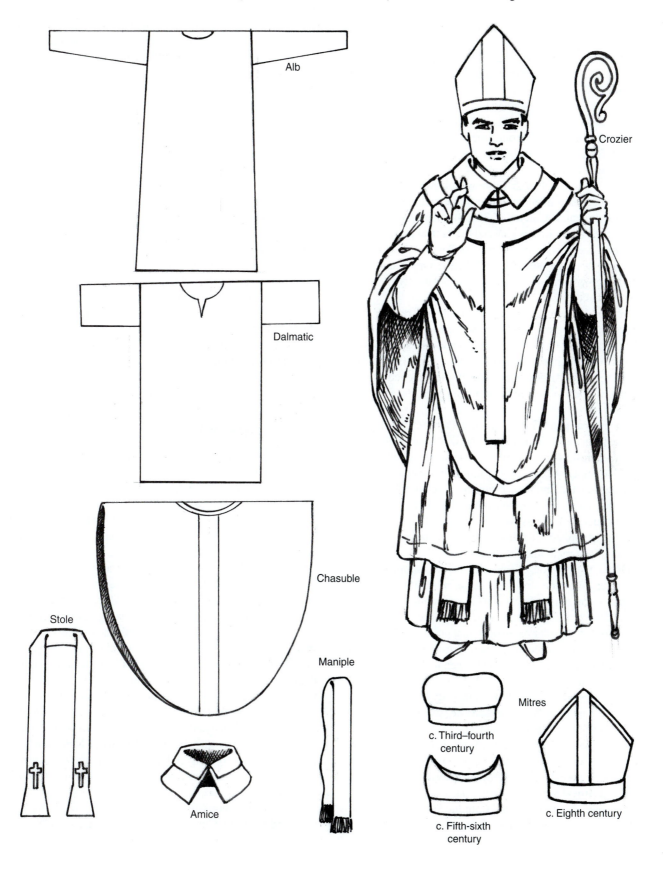

Alb

Dalmatic

Chasuble

Stole

Maniple

Amice

Crozier

Mitres

c. Third–fourth century

c. Fifth-sixth century

c. Eighth century

During the eighth and ninth centuries the hood became stylized into a symbolic embroidered flap that hung down the back. Between the thirteenth and the eighteenth centuries, the back flap changed form and size a number of times ranging from a small triangle to an enormous shield shape.

In the Greek Orthodox Church, the cope became the **manduas** that was worn only by higher ranks of the priesthood. It was cut much fuller and longer than the Western cope so that the abundance of brocaded or embroidered silk spilled as a shimmering train all around the priest. Instead of a broad band of fabric across the front, the manduas was pinned closed at the throat.

The costumes of both Eastern and Western Churches developed accoutrement particular to hierarchal rank. At the Second Ecumenical Council of 381, the Bishop of Constantinople (the Patriarch) was elevated to political pre-eminence equal with the Bishop of Rome (the Pope) "because Constantinople was the New Rome." As the Greek and Latin Churches grew ever farther apart, so too did the styles of their ecclesiastical dress.

In Rome, the Pope's diadem became a **mitre**. The earliest versions were conical headdresses with decorative bands called **orphreys**. Gradually, these headdresses evolved to feature two horn-shaped projections at the sides. By the ninth century, the horned effect at the sides had lengthened and was turned so the points were in the front and back, the shape that continues today.

The **mitra** of the Greek Orthodox Patriarch was entirely different from the Latin headdress. As with many elements of Eastern ecclesiastical vestments that were based on the Byzantine imperial costume, the mitra also was modeled on the diadem of the emperor. From the Late Middle Ages to today, the mitra was shaped somewhat like the ancient Persian khula. Its bulbous dome was made of gilded metal or cloth of gold applied to a frame. Jewels and holy icons in gold and enamel adorned much of the surface.

One of the symbols of authority that was adopted for ecclesiastical vestments from the imperial costume was the **maniple**. It was a narrow silk scarf that was pinned to the left forearm sleeve of higher ranking church officials. Its origin was the folded consular mapp (also mappula), a folded handkerchief originally used by emperors to begin gladiatorial games or chariot races, which can be seen in the right hand of the emperor in Figures 6-1 and 6-2.

The corresponding symbol of authority for Eastern vestments is the **epigonation**. The scarf became stylized into a large lozenge-shaped pendant attached by a chain or cord to the belt and hung down the right front. It is made of heavy stiff fabrics that are lavishly embroidered and jeweled. Tassels often decorate the bottom three corners.

The **pastoral staff** or **crozier** was an insignia of cardinals, bishops, and abbots of the Catholic West. The symbolism linked ranking church officials to the early Christian idea and iconography of the Good Shepherd, protector of his flock. The five-foot staff of wood or metal was carried in the right hand for processions but held in the left during benediction. The curving, "bent" shepherd's crook became the prevalent type after the eleventh century and was elaborately carved with grapevine tendrils and other symbols of the faith.

The **pateressa** of Eastern bishops was similar to the crozier except it was topped by twin serpents flanking a cross representing the inextricable duality of the combined power of the empire and the church as protectors of Christianity.

One article of liturgical vestments that was unique to the Latin Church was the **amice**. It was an oblong strip of white linen that tied or pinned around the neck and folded over the outer garments into a collar. The Greek Orthodox Church did not have a comparable vestment. Instead, in certain regions of the East, high, stiff collars were stitched to the manduas.

Of unique importance in Eastern Church costume is the **kalumaukion**, a tall, cylindrical headdress of black wool felt. Sometimes, the kalumaukion is covered by a hoodlike veil of sheer linen or silk dyed black. **Lappets** attached to either side of the veil symbolize that the priest has shut out the distractions and noise of the world. Like the Greek mitra, the design of the kalumaukion may have been influenced by ancient Persian styles. The veiled kalumaukion prevails still in the liturgical vestments of the Eastern costume.

MONASTIC COSTUME

Christian monasticism began in the early fourth century in the deserts of Egypt. Men who were seeking more of a spiritual life than was often possible in the everyday world began to live as hermits, devoting themselves to prayer, penance, and manual labor. By the sixth century, groups of monks had banded together to form communities throughout the Near East and Europe. Around 529, Benedict of Nursia established a monastery with strict rules of obedience to superiors and seclusion from the society of ordinary people. The Benedictine order quickly spread all across the Byzantine Empire, North Africa, and Europe.

As the Benedictines grew in wealth, several reformed orders were founded between the tenth and twelfth centuries. In 910, William the Pious founded an abbey at Cluny to revive the Benedictine rule in its original strictness. Within less than two centuries, more than two thousand Cluniac monasteries were built. In 1084, Bruno of Cologne established a contemplative order called the Carthusian in which monks took vows of silence and lived in isolation and poverty much like the earlier hermits. In 1098, Robert of Molesme led a group of monks from his rich and comfortable monastery to found the strictest, most fundamental order of any then existing, the Cistercians.

Of all the monastic orders that emerged in the first thousand years of Christianity, the Benedictines, Cluniacs,

Carthusians, and Cistercians were the most dominant. Their orders served as powerful missionary agencies among the migrating tribes of the time. All through the Early Middle Ages, monasteries helped keep alive learning and knowledge by copying manuscripts and producing original volumes on medicine, philosophy, and history. In addition, even though the monks lived in isolation from the outside world, they established hospitals and schools. Their monasteries often became the political center of communities that grew up around them providing rules and order for the parishes.

From the earliest days, monks wore the simplest of clothing. Desert hermits were content with rags for their dress, or at best, basic, unadorned tunics made of coarse materials. To don scratchy "hair shirts" or "sackcloth" garments made from the poorest quality of wool put all novices to the test of their convictions.

The practical purpose of the Roman peasant's cucullus later was adapted to the long-sleeved, ankle-length tunic of the monks. Some wore the hooded capelet as a separate garment while others attached versions of the hood to the tunic or a long cloak. From about the sixth century forward, the hood was cut variously to create assorted tubular styles of cowl-necked head coverings. The **cowl** became the the most distinctive element of a monk's dress, or **habit**. (Figure 6-16.) To "take the cowl" meant to join a holy order.

Another peasant's garment that was adapted to the monk's costume was the **scapular**, or work apron. These types of aprons initially tied around the neck and waist, and covered the entire front of the body similar to a modern butcher's apron. In later styles of monk's habits, the scapular became a long, rectangular piece of fabric that loosely draped over the back and front of the tunic with a hole in the center for the head.

For travel or wandering in the wilderness, monks also wore heavy cloaks dyed in the same colors as the habit of the order. Some cloaks had a separate hood attached that could be layered over the hood of the tunic for additional protection in inclement weather. The double hoods can be seen in the painting by Fra Angelico in Figure 6-16.

Only after monastic orders were established did monks' costumes become uniform in make and identifiable to the order. The Benedictines wore long black tunics with a hooded cowl attached at the neckline. The Cistercians took their vows of poverty to the extreme by wearing cowled habits made of undyed wool, the white cloth symbolizing the spiritual joy of their hearts. Later orders such as the Franciscans wore habits made from wool dyed in earthtones ranging from butternut gray to chocolate brown. The Carmelites were known as magpie friars because they wore a black cowled cloak over a white tunic.

Accessories were solely functional. A plain leather strap, cord, or woolen sash girded their tunics. Most often monks went unshod. Both the Augustines and the Franciscans were

Figure 6-16. The most distinct element of a monk's habit was the cowl-necked tunic. The cut of the cowl, color and quality of the wool fabric, and layers such as the scapular or hooded cloak varied by order. Detail of the *Crucifixion and Saints* by Fra Angelico, c. 1445.

known as the "barefoot friars." When monks wore shoes, they strapped on simple leather or reed sandals. In the eighth century, the Byzantine monk Stephen Sabaites of Great Laura wrote that a monk who went for a seclusion into the desert need take only his tunic, hood, sheepskin cape, belt, sandals, leather bag for his bible, and a knife for cutting roots and wild palms.

Women, too, shared in the development of monasticism. The sister of Saint Benedict founded an order of nuns in the mid-sixth century. The duties of the nuns were basically the same as those of the monks: prayer, worship, labor and service in their communities. The nun's habit was similar to that of a monk's—a simple tunic and scapular. Colors of nuns' habits were likewise neutral black, white, or gray. The significant difference was the headcovering, which for a nun was a veil rather than a hood. During the Late Middle Ages, nuns' head coverings adapted layers and shapes of secular feminine headdresses that were retained into modern times. (Figure 6-17.)

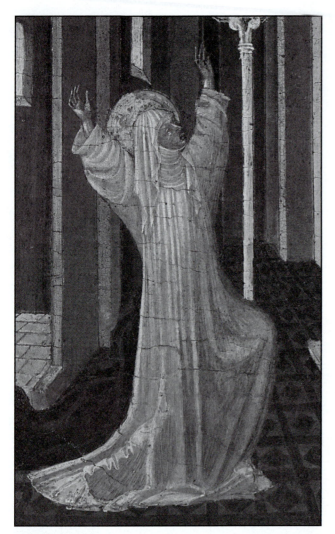

Figure 6-17. The simple tunic and scapular of the nun's habit were similar to those of the monk's. Rather than a cowl though, nuns wore various arrangements of veils as head coverings. In the Late Middle Ages, the head coverings of some orders of nuns adopted shapes of secular feminine headdresses. *St. Catherine Receiving the Stigmata* by Giovanni di Paolo, c. 1460.

REVIEW

The New Rome that was established by Constantine on the site of the Greek city of Byzantium flourished and endured 1,000 years after the fall of the Western Empire. Although the Byzantines viewed themselves as Roman, their culture evolved with Greek influences, particularly the adoption of the language, as well as adaptations of Asiatic influences in art, architecture, and dress.

During the fifth and sixth centuries, the Byzantine imperial costume changed significantly from the Western Latin styles. The wide, fully enwrapping toga developed into a folded band of fabric, which itself later became an ornamental ritual scarf. Although the T-pattern tunica and the wide dalmatic continued as the basic dress for both men and women of the imperial court, the decorative elements changed. The clavi was simplified into an ornamented rectangle called a tablion that was applied to the front of the imperial cloak. Clothing and accessories were lavishly embellished with opulent fabrics and mixtures of rich patterns. New components were added to the emperor's costume such as a domed crown, a shawl-like pallium, hose, and pointed-toe boots. The toga and trousers disappeared.

For ordinary Byzantines, costume changed little from the early styles of the Western Roman Empire. Peasants and working class citizens continued to wear T-cut tunicas, heavy cloaks, and work boots for centuries. Middle classes enjoyed the advantages of finer fabrics and longer cuts of their garments, but the basic combination of tunica and pallium persisted well into the Late Middle Ages.

When the empire was split geographically and politically into East and West, so too was the doctrine of Christianity. By the fifth century, ecclesiastical dress became more standardized, and Church officials appropriated elements of the imperial costume as priestly vestments. The tunica, dalmatic, and even the clavi were adapted and codified into a liturgical costume. Variations between the styles of the Eastern Orthodox Church and the Western Latin Church evolved during the early Middle Ages and were distinctive by the tenth century.

As a result of the far-reaching expanse of the Byzantine Empire in its early years, Byzantine costume styles spread into the Balkans, Central Europe, and as far away as Russia. Styles of court costumes in these regions reflected the influence of Byzantium's opulence and grandeur centuries after the collapse of the empire. Even today, many elements of the Byzantine imperial costume survive in the liturgical vestments of the Eastern Orthodox Church.

Chapter 6 Byzantium
Questions

1. Describe the metamorphosis of the masculine imperial costume from Western Roman styles to the distinct Eastern look of Justinian's era.

2. Identify Asiatic influences in Byzantine costume.

3. How did the Byzantine silk industry originate? How have so many examples of Byzantine silk textiles survived?

4. How were the costumes of ordinary Byzantines comparable to the styles of the earlier Western Empire?

5. How did the Byzantine military costume differ from that of the Roman legionaries?

6. Compare and contrast the ecclesiastical costumes of the Eastern Orthodox Church and the Western Latin Church of the Late Middle Ages.

7. In general, which elements distinguished the habit of a monk? What were the origins of these costume elements?

Chapter 6 Byzantium
Research and Portfolio Projects

Research:

1. Write a research paper on how Justinian's economic policies affected the development of the Byzantine textile industry. Examine the impact of Justinian's conquests of textile centers in the West. Explore sources in addition to Procopius that provide information on the Byzantine acquisition and development of sericulture.

2. Write a research paper on the evolution of the status and roles of women in Byzantine society from the fifth through the tenth centuries. Examine how the influences of Greek and Asiatic traditions altered the Western Empire's conventions of the Roman matron. Include details of how women's dress changed to reflect the shift in status.

Portfolio:

1. Design a pair of full color "paper dolls" about thirty inches high representing the Bishop of Rome and the Bishop of Constantinople, each of which wears only a basic tunica as his foundation garment. Create a complete, full color set of paper doll ecclesiastical garments and accessories as they appeared in the Late Middle Ages. Demonstrate for the class how the components of each ensemble were layered. Describe which elements the two costumes share in common and those that are different. Also explain the religious and symbolic meaning of the decorative treatments, colors, and textile patterns you apply to your paper dolls' clothing.

2. Compile a reference guide to styles of Byzantine jewelry. Catalog photocopies or electronic scans of ten examples each of women's earrings, necklaces, rings, brooches (or fibulas), and bracelets that best represent the uniqueness of the Byzantine blend of Hellenic and Asiatic design and opulence. Include with each illustration a description of the item: dimensions, materials, date, and ownership if cited.

Glossary of Dress Terms

amice: an oblong strip of white linen that tied around the neck and folded into a collar over the outer garments of Latin Church priests

camelaukion: a round-domed diadem worn by Byzantine emperors of the late period

casula: a circular sleeveless garment worn by both men and women as outerwear like a closed cloak

chasuble: a circular cloak-like garment worn as an outer vestment by priests

cope: a processional outer cloak of the Latin Church fastened across the chest with a wide, ornamented band

cowl: the tubular type of collar affixed to a monk's habit that formed a hood

crozier: a processional staff of wood or metal carried by ranking Latin Church officials as a symbol of the Good Shepherd

epigonation: a large lozenge-shaped pendant attached by a chain or cord to the belt and hung down the right front of Eastern Church vestments

epitrachelion: a long, apron-like vestment with a hole cut for the head and two panels in the front

gores: inset panels of fabric used to add fullness to a garment

habit: the distinctive costume of a religious order

hosa: tight-fitting, circular woven hose

kalumaukion: a tall, cylindrical priest's headdress of the Eastern Church

kite shield: a teardrop-shaped wooden shield covered with linen reinforced by gesso or glue

lappets: flaps of fabric at the sides of a priest's hat or headdress

lorum: (also loros): an ornamental ritual scarf worn by Byzantine emperors of the Late Middle Ages

manduas: a full cloak with a long train worn by higher ranks of priests in the Eastern Church

maniakis: a wide, jeweled collar usually affixed to a garment but sometimes worn separately

maniple: a narrow scarf pinned or draped over the left forearm of Latin ecclesiastical garments

mappa: (also mappula): a folded handkerchief originally used by Western Roman emperors to begin gladiatoral games

mitra: the jeweled, bulbous headdress of ranking officials of the Eastern Church

mitre: versions of headdresses worn by ranking officials of the Latin Church

omophorion: the Eastern version of a liturgical stole

orphrey: a decorative band of embroidery applied to ecclesiastical vestments

pastoral staff: another name for crozier

pateressa: the processional staff of Eastern Church bishops topped with twin serpents symbolizing the Empire and Church as protectors of Christianity

pendoulia: pendants attached to gold chains with pearls and precious stones affixed to the base of the crown

phenolion: the Eastern version of the chasuble cut shorter in the front for easier arm movement

sakkos: the ecclesiastical dalmatic of the Eastern Church designed with shortened sleeves and a wider girth

samite: a thick, stiff silk textile, often interwoven with gold threads

scapular: a long, apron-like piece of fabric that fit over the shoulders and loosely draped down the front and back of a monk's or nun's habit

segmentum: (pl., segmentae) small circular or square appliqués of decorative patterns or pictorial scenes usually sewn to the fronts and upper sleeves of tunicas or dalmatics

squamata: a cuirass sheathed in small, overlapping metal scales attached to a leather or reinforced linen bodice

stemma: the ornate, jeweled crown of early Byzantine emperors

stephanos: the emperor's jeweled band of fabric worn tied around the head

sticharion: a liturgical undertunic made fuller with the addition of gores of the Eastern Church

stole: a long strip of material draped variously around the shoulders as the outermost component of early ecclesiastical costumes

superhumeral: another name for maniakes

tablion: an elaborately decorated rectangular piece of fabric applied to the front of the paludamentum

tapestry darning: a method of weaving in which a pattern is darned in and out of the warp

thorakion: a large, decorative scarf shaped like an inverted teardrop attached to the skirt of a woman's dalmatic

toga picta: a style of the imperial toga from the late Western period in which the garment was arranged as a folded band of fabric with an ornamented edge turned outward

torque: a collar necklace worn by the emperor's bodyguards as a symbol of their loyalty

tunica alba (later the alb): a liturgical ankle-length tunic of white linen with tight-fitting long sleeves

tunica talaris: a masculine long-sleeved, T-cut tunica of various lengths

Legacies and Influences of Byzantine Styles on Modern Fashion

For many fashion designers of the modern era, the term "Byzantine" has conjured images of excessive ornamentation, magnificent jewels, and opulent fabrics. Yet some fundamental changes in garment construction also laid the foundations for silhouettes used today. The numerous forms of the smock that have appeared in fashion are heirs to the capacious design of the dalmatic. The cowl collar used so frequently for knit tops and dresses was originally an element of ecclesiastical costumes. And the layered, bib-like scapular and its derivative, the jumper, first evolved with Byzantine ecclesiastical over garments.

The modern jumper and apron-like scapular evolved from Byzantine ecclesiastical overgarments. Left, scapular pantdress by Estevez, 1969; right, jumper miniskirt, 2006.

The cowl collar has been adapted to modern fashions in numerous forms including the turtleneck. Left, cowl collar coat of Orlon acrylic by Yvonne, 1962; right, cowl collar dress of worsted-wool jersey by Pauline Trigere, 1951.

Chapter 7

NORTHERN EUROPE IN THE EARLY MIDDLE AGES

Europe of the Migrations

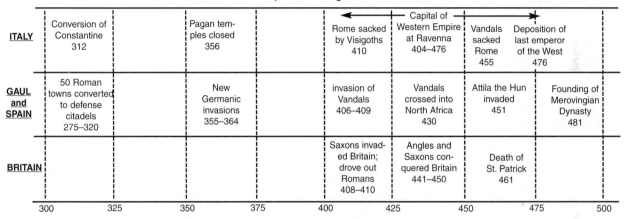

	300	325	350	375	400	425	450	475	500
ITALY	Conversion of Constantine 312		Pagan temples closed 356		Rome sacked by Visigoths 410	Capital of Western Empire at Ravenna 404–476	Vandals sacked Rome 455	Deposition of last emperor of the West 476	
GAUL and SPAIN	50 Roman towns converted to defense citadels 275–320		New Germanic invasions 355–364		invasion of Vandals 406–409	Vandals crossed into North Africa 430	Attila the Hun invaded 451	Founding of Merovingian Dynasty 481	
BRITAIN					Saxons invaded Britain; drove out Romans 408–410	Angles and Saxons conquered Britain 441–450	Death of St. Patrick 461		

The Early Middle Ages

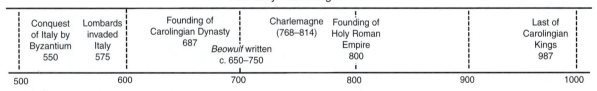

500	600	700	800	900	1000
Conquest of Italy by Byzantium 550	Lombards invaded Italy 575	Founding of Carolingian Dynasty 687 — *Beowulf* written c. 650–750	Charlemagne (768–814) Founding of Holy Roman Empire 800		Last of Carolingian Kings 987

ONSLAUGHTS OF THE TEUTONES

Since the latter days of the republic, Rome had confronted invasion after invasion of migrating tribes from the north and east. Collectively referred to as Teutones by the Romans, these invaders were actually very distinct peoples who more often than not fought each other just as fiercely as they did the legionaries. By the middle of the fourth century, Franks, Burgundians, Lombards, Angles, Saxons and, most particularly, Vandals were among the larger ethnic groups that pushed across central and northern Europe.

During this time, most of the citizens of the Roman Empire suffered civil wars, excessive taxation, recurring outbreaks of plague, and mismanagement by weak, ineffective emperors. All combined, these conditions probably contributed more to the decline and fall of the western empire than the onslaught of the barbarian hordes. In fact, in many cases, the citizens of the provinces collaborated with their Teutonic conquerors in the hope of relief from the burdensome taxes, forced billeting of soldiers, and the many other perceived inequities of imperial law and government.

141

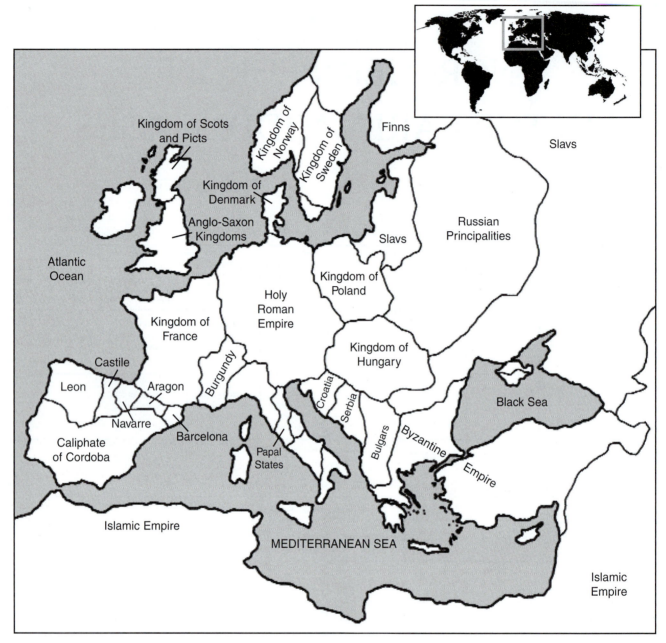

Europe at the end of the first millennium

As the migrating peoples came into contact with Roman civilization, many of them soon were attracted to the prospects of a better life among the Romans they overran. Richer foods and drink, an abundance of servile labor, and warm winter quarters in well-built towns and villas induced a number of these peoples to abandon their nomadic ways and settle in the regions they had forcibly occupied. For brief periods, these invaders established small kingdoms and merged Roman law, culture, and methods of civic administration with their native customs and religions.

However, assimilation, order, and stability for any of these ethnic groups were short-lived during this tumultuous era. By the end of the fourth century, a massive invasion from the Baltic brought the Visigoths (Western Goths) and their cousins the Ostrogoths (Eastern Goths) down across the Danube. In 410, the Visigoths invaded Italy from their settlements in Gaul and took the city of Rome. After more than 800 years of security from foreign invasions, the ancient capital was plundered, and Rome's citizens were herded off into slavery. The shock throughout the empire was profound.

Yet the Visigoths did not enjoy the kingdom they subsequently established for long. Around 430, an army of Mongols, called the Huns, swept in from the Asian steppes. The Visigoths were pushed westward, in turn forcing the Vandals into Spain from which they soon crossed into North Africa. When the Huns withdrew back to Asia after the death of their leader, Attila, Italy was quickly occupied by the Ostrogoths. In 476, the Ostrogoth warlord, Odovacar, deposed the last emperor of the West, thus closing the epoch that was the Western Roman Empire.

EUROPEAN SOCIETY IN THE EARLY MIDDLE AGES

For the succeeding three centuries following the collapse of the Western Roman Empire, the territories that comprise modern Europe were continually fought over by various ethnic invaders. During this time the foundations of medieval European civilization were laid with the blending of Romano-Teutonic culture and Christianity. It was the beginning of the Middle Ages, a vague term first coined by Renaissance historians who viewed the 1,000 years between the glorious age of antiquity and the revival of classicism in their own great age as a middle period of Gothic barbarism—an era since often labeled the Dark Ages. To the east, the Byzantine Empire became Greek, turning away from its past links with the pagan Latin West. In the south, the followers of Muhammedanism swept up from the deserts of Arabia to establish an Islamic empire that eventually stretched from India to Spain.

Survival was the obsession of Europe's invaders, with war and violence as the primary means to that end. The customs and social structures of the Franks, Slavs, and Germanic tribes were born of the harsh experience of migratory life barely sustained day to day in the brutal forests of northern climates.

Survival also hinged on a stable population with large numbers of women and children. Demographic research of cemeteries from the early Middle Ages have confirmed that infant mortality rates were as high as forty-five percent and life expectancy was barely more than forty years of age. Hence, women of childbearing age were highly valued by the community. Frankish laws of the time assessed stiff fines for causing the death of a woman of childbearing age, but less than a third as much for menopausal women.

The family unit, or parentela, was centered on the protection of the kinship group. Armed companions were always ready if a family member needed defense, or if a poor man faced a financial crisis, as in a cash fine, everyone was obliged to contribute. An individual outside of a parentela had no right of protection.

Marriages were thus arranged by the head of the parentela, principally for the purpose of ensuring the family's survival and extending its security. The father of the bride was paid a sum of money as a token of the purchase of paternal authority over the woman and assurance of the bride's virginity. A woman who was not a virgin was unmarriable, and an adulterous married woman was usually put to death by strangulation since her offspring was in question, hence undermining the legitimacy of the parentela and its hereditary rights. Male adultery, though, was not punished.

Polygamy, too, continued as a sanctioned male privilege until the tenth century. In addition to the official first wife, men could take a second-class wife, that is, a free woman, as well as a number of slave concubines. The children of these unions were accepted into the parentela but with lesser rights and opportunities than the children of the first wife.

With the emphasis among the Teutonic peoples on survival and protection of the kinship group in a violent, chaotic world, the education of boys focused more on physical training than refinement of the intellect. Horseback riding, hunting, running, and swimming were critical training for the next generation of clan leaders.

Although Christianity became the state religion throughout the Roman West in 391, the process of Christian acculturation of the peoples who invaded Europe took centuries to complete. At the heart of the resistance was the tradition of the parentela—the extended kinship group of blood relatives, in-laws, concubines, offspring, and slaves—which the Church ultimately destroyed by imposing monogamous, indissoluble marriage. Christian ideas emphasized the individual over the family so that adultery, for instance, was viewed as much of a sin for men as for women.

Among the steps that aided the transition to a Christianized West was the creation of new sacred places such as basilicas and monasteries to replace the pagan temples and sites of magic and myth. In addition, the cult of saints, liturgical processions, and sacraments like the eucharist transformed pagan ideas of evil magic into the work of the devil and beneficial magic into the intercession of the saints. The pagan beliefs that once centered on a religion of fear of the external world were gradually and irrevocably countered by the Christian idea of hope and the internal conscience of the individual.

TEUTONIC COSTUME

Very little evidence of the peoples who invaded the Roman Empire has survived. Most often, these hordes were living a nomadic or refugee existence and had to travel lightly. For those tribes that were powerful enough to briefly establish a kingdom, war—offensive or defensive—and survival were their primary concerns. Consequently, there was no great flowering of arts and letters from which we might have an extensive variety of pictorial representations or written descriptions of their costumes.

Furs and the Cult of Animals

Hunting was the single most important part of a Teutonic boy's education and training. It prepared him with more than just lessons in horseback riding and the use of weapons to supply the hearth with venison and boar. Through hunting, boys cultivated aggressiveness, courage, resourcefulness, and other military values critical to the survival of northern peoples.

Moreover, the war between man and beast yielded a close relationship with domesticated hunting animals such as bulldogs, mastiffs, and other running dogs. Hunting falcons were even more prized since they were so difficult to train. Frankish law of the early Middle Ages assessed stiff fines for the theft of a good hunting dog, and penalties could include humiliation of the thief by forcing him to kiss the dog's posterior in public. Punishment for theft of a falcon was even more severe with fines three times the cost of a slave and the bird being allowed to devour five ounces of flesh from the thief's chest.

An even more complex relationship developed between the Teutonic hunter and his wild prey—one of imitation mixed with fear. During this era wolves were common in the northern forests. In winter, packs commonly approached towns and villages where livestock and even pet dogs were devoured. Although traps were more frequently used to kill wolves, hunting parties were often sent out especially in spring to eradicate breeding females and newborn cubs.

Despite being a widespread terror to medieval populations, wolves were not regarded as dangerous as wild boars. When hunted, these aggressive animals attacked with razor sharp tusks that easily could, and often did, kill the unwary or overconfident man. Sows were never hunted since they always ran away rather than attack. To the Franks, a distinctive parallel was drawn between the aggressive boar and the warrior-hunter, and the fleeing sow and women. Animals, thus, demonstrated the natural roles of male and female: aggression and passivity; superiority and inferiority.

From this Germanic cult of animals came family names that reflected the envied qualities of wild beasts. Bern-hard, for example, meant strong bear, and Wolf-gang meant walks like a wolf (endures long distances). On the other hand, to call a man a rabbit was to accuse him of running scared from a battle, or to refer to someone as a fox was to imply he was a traitor.

Also from the cult of animals came the custom of dressing in furs. Although prehistoric humans had used hides as coverings for many thousands of years, the Teutonic peoples attached special significance to jackets and capes made of fur. Being clad in fur was viewed by the Romans as a sure sign of the savage barbarian, but to the Franks, furs served multiple purposes. Besides being practical for northern European winters, the furs were symbolic of the animal's best qualities, especially the predator's instinctive skills at killing. Rather than wearing the furry side of the pelt out, though, the hair was turned inside the garment for fear of looking so much like the actual beast that a person might become possessed by the spirit of the animal.

Roman sources provide some cursory information on the appearance and apparel of the invaders. Tacitus mentions that the Teutones wore skins of sea creatures, meaning seals, in addition to garments of woven materials. The historian Sidonius Apollinarius wrote in the mid-fifth century that the inhabitants of northern Gaul wore trousers, tunics made of striped fabrics, and red cloaks edged with green. In addition, sculptural depictions of captured invaders as prisoners were prominently featured in the decorations of Roman commemorative columns and triumphal arches. (See chapter 5, Figure 5-8.) Roman artists certainly would have seen these captives firsthand when they were put on exhibit in processions and public victory celebrations.

Most importantly of all, though, are the surviving objects that have been excavated from burial sites in the peat-bogs of northwestern Germany, Holland, and Denmark. More than 400 such finds have been documented. Amazingly, the acidity of the peat marshes has preserved a wealth of perishable materials including the corpses themselves that became mummified by immersion in the bogs. These graves have yielded woven and knitted textiles, animal skins, reed baskets, bronze ring-money and ornaments, wooden utensils and implements, even entire burial carts.

The most common garment found with many of the male bodies was a **saie**, a short cloak similar to that of the Roman sagum. Only a few of the men wore any other clothing. Tacitus recounts that the Teutonic infantry wielded spears and charged into battle either completely nude or wearing only a short cape. (Figure 7-1.) As with the Greek chlamys and Roman sagum, the cloaks of the barbarians were draped around the shoulders and fastened in place with a metal fibula although some simpler pins included slivers of wood or bone and even thorns.

Among the other styles of men's clothing found in the peat-bog graves were various types of trousers. Most were basic, rectangular cuts of woolen material that were sewn at the sides. As with the Romans, the trousers were simply pulled on, and the fabric at the waist was either rolled or girded by a leather strap. Pant lengths mostly extended to the ankles although some were cropped at the knees. Some figures had secured the hems of their trouser legs with strings against winter drafts. Others wore swathes of fabric wound around the shins somewhat like **gaiters**. An illustration in the late fifth-century Breviary of Alaric shows a figure wearing the longer trousers with the shins bound in leg-wrappings. (Figure 7-2.)

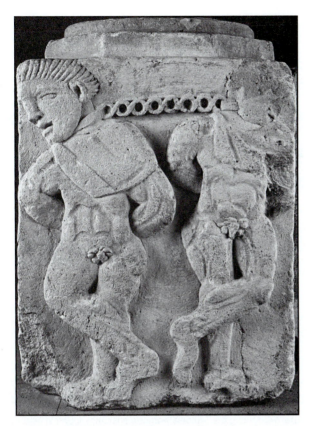

Figure 7-1. Written and pictorial documentation of the migrating peoples of the fifth century indicate that their infantry warriors went into battle either completely nude or wearing only a short cape. Roman monument from Mainz, Germany, depicting chained Teutonic captives, c. fifth century.

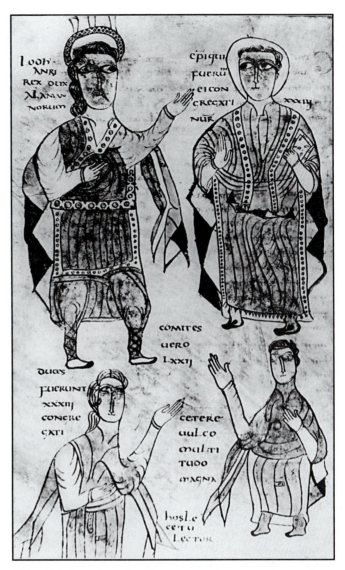

Figure 7-2. Even Romanized Teutones continued to prefer wearing trousers under their tunics. Pant hemlines at the ankles were usually bound by strips of leather, cords, or even string. Breviary of King Alaric II, c. 506.

One exceptional costume discovered in the Thorsbjerg peat-bog featured a pair of trousers complete with socks stitched at the ankles like modern tights, except the fabric was woven, not knit. More remarkably, the Thorsbjerg trousers included belt loops sewn at the waist. Even the Persians, whose trousers and jackets were tailored to fit the wearer, had not developed belt loops that we know of. Yet the Thorsbjerg trousers are not unique in their design. A thousand miles away, in what is modern-day Bulgaria, is the tomb of a fourth or fifth century Roman official that contains wall frescoes depicting apparel of the provinces. (Figure 7-3.) One representation is of a servant carrying his master's trousers, replete with belt, belt loops, and attached socks.

Over these trousers men commonly wore tunics of varying lengths made of wool or linen. Most were sleeveless, but a few of them were constructed with set-in long sleeves. Whereas the Egyptian kalasiris and the Roman tunica sometimes included tubular sleeves stitched to the T-cut body of the garment, the sleeves on the tunics of these early Northern European peoples more closely resembled

the Persian styles. The difference was that the set-in sleeves of their garments were crudely attached and lacked the more sophisticated techniques of tailoring employed by the Persians. Possibly, the technique for set-in sleeves had been learned from migrating peoples who had come across Asia Minor, but subsequent generations lost that precision tailoring skill.

Some of the more basic peat-bog graves contained corpses—both male and female—that were thought to have been executed criminals or captives from rival tribes, or perhaps even human sacrifices. They were found with strangulation ropes still tightly looped around their necks. Most were buried naked; others wore only roughly cut cloaks made of coarse wool, patchwork leather, or animal skins. In addition

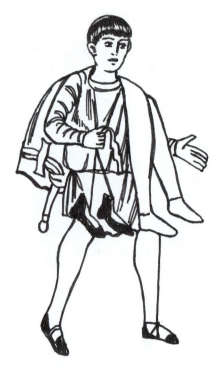

Figure 7-3. The use of belt loops for trousers was possibly developed sometime in the third or fourth century. At least one peat-bog example of trousers with belt loops has been found. In this drawing of a figure from a Roman tomb of that era, a servant carries trousers that clearly show a belt inserted through belt loops. Drawing of figure from a Roman fresco in Silistra, Bulgaria, c. 350.

Figure 7-4. Among the Teutonic women's costumes found in peat-bog graves were these styles from Huldre Fen, Denmark. Left, plaid wool skirt with lambskin cape; right, wool peplos. Both, c. third to fifth century.

to their cloaks, the men sometimes wore kilt-like wrap skirts. The corpse of one man was dressed in a knee-length type of woolen skirt girded at the waist with the upper torso bare. Another male figure of the same period wore a wrap garment made from a large piece of wool material that extended from the armpits to the knees and was bound with leather straps over the shoulders.

Two superbly preserved examples of women's costumes were excavated in 1879 from the peat-bogs of Huldre Fen in Denmark. (Figure 7-4.) One woman was buried with two lambswool capes, a woven plaid shawl and a wool plaid skirt. The contrasting plaid pattern was woven from the alternation of two yarns of natural wool, a golden brown and a dark brown. In the 1950s, a fabric restoration expert determined that the skirt had been woven with gathers at one end of the piece of material to better fit at the waist. The matching plaid shawl with a bird's bone pin is thought to be the woman's covering for her torso instead of a tunic. Over the shawl and skirt would have been draped the lambskin capes.

In a nearby burial site dating from the same period, the corpse of a young woman was found wearing a peplos similar to that of the ancient Greeks. The garment was five and a

half feet in length and nine feet in circumference. Just as with the earlier Greek style, the Huldre Fen peplos was pinned at each shoulder thereby creating the openings for the neck and arms. A leather belt bound the voluminous width of material snugly at the waist. In his research of the bog burials, Danish professor Peter Glob suggested that this style of peplos must have been a common garment for women of the region because so many pairs of ornamental brooches had been found in other burial sites where the fabrics did not survive.

One remarkable female costume was discovered in Egtved, Denmark. (Figure 7-5.) A young woman of around twenty years of age had been buried in a coffin made of a hollowed-out log that was halved to form a lidded container. Her woolen tunic has a surprisingly modern silhouette with its half sleeves, bateau neckline, and cropped hemline that exposed her midriff. The short skirt was constructed of open strands of corded wool knotted at the waistline and hem. She wore no undergarments. A woven wool belt with a large tassel at one end was fastened around her waist. A round bronze disk, called a **bractiate**, decorated with a spiral motif and a spike in the center was attached to the belt in the front. Such disk-shaped fastening plates were common to the Nordic inhabitants of northwest Europe. One historian has suggested that the brevity of her costume was for comfort in

Figure 7-5. A remarkable costume discovered in a peat-bog in Egtved, Denmark included a cropped, half-sleeve tunic with a bateau neckline and a thigh-high skirt made of open cords of wool. A round bronze bractiate was attached to a woven wool belt and worn around the exposed waist, c. third to fifth century.

Figure 7-6. Among the types of women's hats recovered from the peat-bogs was a hand-knotted or crocheted bonnet of dyed woolen yarn. Huldre Fen bonnet, c. third to fifth century.

an overheated hut. Yet another historian speculated that the abbreviated costume may have been for sexual display while the spiked disk served to "deter the man who admired it from inspecting too closely."

The examples of accessories that have been excavated from the peat-bog graves and similar sites of the period vary widely in quality and purpose. For example, hair ornaments range from simple knotted cords of wool to finely carved bone combs. Belts were made of leather straps, braided woolen cords, or strips of woven materials. Some belts featured decorative knotted tassels, such as that of the Egtved girl, or were affixed with bronze, wood, or bone ornaments. Types of shoes included leather ankle boots stitched at the back with leather strips instead of thread and rolled at the tops. Sandals were basic thong types or copies of the more elaborate Roman styles that encased the foot with interwoven straps and laces attached to a thick leather sole. Among the more common accessories that have been found in the gravesites of the northern tribes are metal fibulas and innumerable pieces of jewelry. The quality of craftsmanship varies from designs of coiled bronze wire to intricately worked gold with inlays of glass and precious stones.

A significant number of hats and hoods have also survived from the peat-bog burials. All have been close-fitting designs of patchwork leather or woven wool, most with chin straps of the same material. An unusual man's hat found at Muldbjerg reveals how skilled the Nordic peoples were with their needlework. The round woolen hat is decorated all over its outer surface with hundreds of knotted loops somewhat resembling our modern **terrycloth**. A similar testament to the sewing skills of these northern tribes is the delicate, openwork bonnet found on the mummy of a young woman in the peat-bog of the Arden Forest. (Figure 7-6.) It is made of an ochre woolen yarn, hand-knotted or perhaps **knitted** in a technique similar to **crocheting**. Even the woman's blonde hair with its elaborate braids coiled up under the cap had survived.

Such compelling finds as the clothing from the peat-bog burials are exceptional and rare for the period of the migrations. After Europe fell into the Dark Ages, public and private patronage of the arts and literature largely ceased so that pictorial and written documentation of costumes is scarce.

MEROVINGIAN DYNASTIES (481–751)

In northwestern Europe, a loose confederation of tribes called the Franks had been recruited by the Romans as foederati—mercenaries who accepted pay and land grants for their military services. The Franks successfully fought off the Visigoths, Vandals, Saxons, and Angles to retain and eventually expand their territorial holdings of what is today France. In the midfifth century, the chieftain, Merovich (for whom the first Frankish dynasty was named) consolidated power and established a sort of capital in the occupied Roman city of Cologne. His grandson, Clovis, married a Catholic Burgundian princess and, by his conversion to Christianity, led the way for all the Franks. Soon afterward, Clovis headed what is sometimes

referred to as the first crusade to drive the pagan tribes out of Europe. His military leadership helped expand the kingdom of the Franks to ultimately encompass most of modern day France, Belgium, and Germany down to the Italian Alps.

Even with a settled permanence in towns and cities, an adapted Roman bureaucracy, and a royal court, the Merovingians sustained their military culture throughout the sixth, seventh, and eighth centuries. New invasions of ethnic groups such as the Lombards, Bavarians, Slavs, and Avars required a powerful standing army for defense. It is primarily from this impetus that we have any evidence of early Frankish costume—from the warrior gravesites with all their furnishings and from the few depictions of Frankish warriors crudely executed in stone and metal.

The basic costume of the Merovingian Franks is clearly depicted in the bas-relief from an altar of the eighth century. (Figure 7-7.) The three male figures, representing the Magi in adoration of the Christ child, wear a long-sleeved **gonelle** or tunic girded at the waist. The many volutes and folds of the drapery indicate that the gonelle was a wide, loose-fitting garment. Underneath the gonelle the Franks wore the traditional Teutonic trousers called **braies**. Depending upon the season, braies were made of linen or wool, and were cut in lengths varying from the knees to the ankles. The lower legs were covered by knee-high hose called **pedules**, which were made

of woven linen or wool. These were not tight-fitting knit hose like those familiar to us today but instead had to be bound with leather or fabric straps to stay up.

One striking example of a Frankish nobleman's gonelle is represented on a gold figurine from the sixth century. (Figure 7-8.) Although these types of tunics were usually worn belted, this version is ungirded. It is difficult to tell if this particular garment was tailored to fit at the waistline or if the sheathing contours are an artistic convention. The marked difference of this gonelle from most other sculptural representations is that the fabric appears to be woven or embellished with an allover pattern of squares with crossbars in each. This same design is repeated in a border trim around the neckline, down the center front, and at the hem. Possibly the material is an embroidered wool or brocaded silk. We presume that the fabrics adopted by the Romanized Franks were similar to those of the Romans—linen for undertunics, wool for outer garments, and silk for apparel of the elite classes.

Beneath the gonelle, he appears to be wearing a short version of braies that extends to just slightly below the hemline. The lower legs and feet of the figurine are bare, which may indicate that he is dressed for the indoors.

Such an elaborate fabric for a gonelle would indicate that the man was of noble rank, but probably not a Frankish Heerkonige (literally meaning "honorable king"). This figure

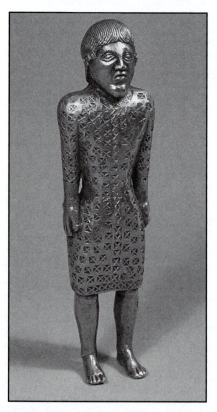

Figure 7-7. The basic costume of the Merovingian Franks consisted of a long-sleeved gonelle over a pair of braies tucked into tightly bound pedules. Detail of bas-relief from the Altar of Duke Ratchis, c. 740.

Figure 7-8. As Frankish noblemen became Romanized, they adapted their traditional costumes to include richly embroidered woolens and brocaded silks. Gold figurine of Frankish nobleman, c. 500.

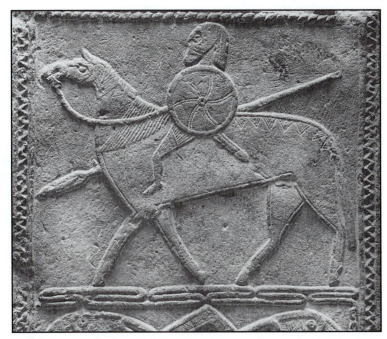

Figure 7-9. Judging from the full beard and long hair of this mounted warrior, he may represent a Heerkonige, meaning honorable king of the Franks. Bas-relief from Hornhausen, Germany, c. 650.

is the portrait of an urbane, Romanized individual with his clean shaven face and closely cropped hair. Frankish kings, though, were often noted as having long, flowing beards and cascades of uncut hair—the only males in their society allowed to wear their hair in this fashion.

Given this description, the bas-relief of a Frankish warrior found at Hornhausen, Germany, might be a depiction of a Heerkonige. (Figure 7-9.) The horseman clearly has a full beard and long hair that may extend over the shoulders behind the shield. His costume is mostly concealed behind a round shield although his trousers are visible below that. Despite the rough carving and eroded surface, we can still see the stylized folds of the baggy pant legs tapering to a textured band—possibly fur wrappings—around the thighs just above the knees. By the time of this carving in the seventh century, the Catholic Franks no longer fought in combat completely nude but instead only stripped bare to the waistline of their trousers. His ankle boots are undefined except for an incised line to indicate their mid-calf height.

Much more is known about Frankish military costume than of civilian apparel because of the numerous warriors' graves that have been found. These were usually status burials of chieftains, clan leaders, and princes of the Merovingian house. Since so many fragments of high quality wool and linen fabrics have been discovered with the remains, it is evident that the Franks buried their warrior elite fully attired in their finest clothes. In addition, the numerous accessories such as buckles, pins, fibulas, and jewelry excavated from these sites attest to the finery in which the warriors were dressed for their journey "into the keeping of the Lord," as a funeral is described in *Beowulf.* Some tombs and graves also contained magnificent treasure, coins, furniture, and even the remains of horses. Primarily, though, these were weapons burials that included various kinds

of finely crafted armor and armaments. Although this funerary tradition was not unique to the Franks, far fewer weapons burials are known from the Goths, Vandals, Angles, and Saxons.

In fact, armor and weapons were a form of treasure throughout the Middle Ages. Frankish law estimated that a helmet was equivalent in value to a sound horse, a sword (without scabbard) was worth three oxen, and a good chain mail coat was valued at two horses or six oxen. A later code assessed the value of twenty oxen for "a warrior's full military equipment," which would have included helmet, mail vest, shield, sword, bow, and arrows. Consequently, such military accoutrement were the luxuries of the nobility only. In describing the arms and armor of one sixth-century nobleman, Gregory of Tours observed that the warrior was protected by a corselet of chain mail, a metal helmet, and a **gorget**, or mail throat guard; his weapons were a spear and quiver of arrows, presumably with a bow.

Most regular soldiers had no armor, only a shield and an aggressive weapon of choice. Before the seventh century, the Franks were particularly noted for their skill with the battle axe called a **francisca** (also franciska or francisque). Sidonius Apollinaris wrote of the Frankish expertise at hurling these S-shaped axes with deadly aim. Later, the broad-blade long swords became more popular with military leaders, and spears were more common for ordinary soldiers. Also in the late Merovingian period, the **scramasax**, a large single-edged knife similar to the nineteenth-century Bowie, was more widely used by all ranks of military men.

The helmet became a costly rarity that was reserved for the elite. Processed iron was scarce in the northwest, and marauding tribes continually disrupted trade routes from the south and east. Instead of adopting the round-domed design of the Greco-Roman helmet, the Franks preferred the Asiatic pointed dome style. Most historians believe this silhouette was

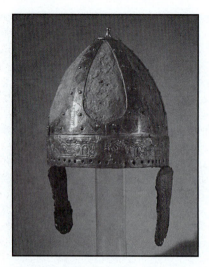

Figure 7-10. Merovingian helmets and armaments were as treasured as gold or jewels during the early Middle Ages. More weapons burials are known by the Franks than any other ethnic group. Spangenhelm, c. 550.

introduced to the ethnic groups of northern Europe by earlier migrating peoples from the east. By the Merovingian period, the battle helmet of the Franks, called a **spangenhelm**, was fashioned in a highly sophisticated form. The typical example shown in Figure 7-10 features an iron frame constructed into a conical shape to which iron plates were attached for the exterior. The interior was padded with a leather or fabric lining. Cheek pieces were hinged to the base of the helmet and a chain mail neck-guard was welded across the back. A number of the spangenhelm had nose-guards riveted to the front although many of those had been broken off in battle before being placed in the graves. Especially fine examples of these helmets included gilding and ornate engravings.

Evidence of the costumes of ordinary Frankish women is virtually nonexistent. Many historians speculate that, given the close ties of the Merovingians with the Western Roman Empire, the basic stola, without the instita, and the palla were probably adapted to wear in the northern climate. Based on the scoopneck cut and the bordered hemline of the men's tunic shown in Figure 7-8, we may presume that women's floor-length tunics were probably similarly finished.

The best preserved evidence of the Merovingian women's costume was discovered in the tomb of Queen Arnegunde (c. 550–570), wife of King Clotaire I. Since this was the tomb of a queen, the richness of her apparel and accessories is exceptional. Closest to her body was a fine woolen chemise that extended to the knees. Over this was a knee-length undertunic made of a violet ribbed satin. A jeweled leather belt encircled the hips twice around and was knotted in the front. Her lower legs were covered with woven wool pedules that were bound with crossed strips of leather. Upon her feet she wore black **gallicae**, or leather slip-on ankle boots. This style of boot later became the French galoche from which we derive the name

galoshes. Outermost was a floor-length red silk tunic with an open front that was pinned closed at the chest by two large round brooches. The wide cuffs of the long sleeves were edged with elaborate embroidery of gold-thread rosettes. A long red silk veil covered the head and reached to her waist.

The decorative motifs applied to accessories, armor, armaments, and utilitarian objects were largely abstract and geometric. Even those rare representations of animals and nature were stylized into flat, geometric patterns. One exception was renditions of the cicada, a symbol of immortality, which were more realistically crafted. (When the grave of King Childeric was excavated in the seventeenth century, more than 300 gold cicadas were found stitched to his cloak.) For the most part, though, the Teutonic peoples preferred to embellish the entire surface of their ornaments with decorative patterns that cleverly conformed to the shape of the object. One of the favored methods of decoration was **cloisonné**. (Figure 7-11.) This technique of metal work is thought to have been introduced into Europe from Asia Minor by the migrating Goths. Tiny strips of gold—the cloisons—were soldered edge-up to the base of the object. Garnets or other precious stones were then cut to fit the intricate pattern and inserted into the compartments formed by the cloisons. In other examples of this craft, enamel pastes were painted into the shapes and fired to create a jeweled look.

CAROLINGIAN DYNASTIES (751 –987)

During the first half of the eighth century, the Merovingian throne was successively passed to a series of weak kings who kept themselves secluded in idle isolation on their estates. Governing authority was in the hands of so-called "mayors of the palace" whose responsibilities included managing the royal domains and the king's business. So powerful were these mayors that the office became hereditary during this time. Finally, in 751, Pepin the Short petitioned Pope Zacharias for recognition as King of the Franks in name as well as in the authority he exercised as palace mayor. Needing a strong ally against the threat of the invading Lombards, the Pope consented. Pepin immediately deposed the last Merovingian king and exiled him to a monastery.

Although the Carolingian Dynasty began with Pepin, it derives its name from his more famous son, Charles the Great—or, in French, Charlemagne, and, in Latin, Carolus Magnus. Charlemagne consciously strove to imitate Constantine and establish a viable Christendom in the West. To this end, during his forty-six-year reign, Charlemagne was at war almost constantly, leading more than sixty military expeditions himself. Many wars were defensive against "the detestable and oath-breaking barbarians" whom Charlemagne forcibly converted to Christianity. Other wars were solely expansionist. By the beginning of the ninth century, the Kingdom of the Franks encompassed almost all of Western Europe. For his deeds in the name of Christianity, Charlemagne was crowned the first Holy Roman Emperor by Pope Leo III in 800.

Figure 7-11. Barbarians favored ornaments that were embellished over the entire surface with decorative patterns. From the Sutton Hoo Ship Burial, c. 630: left, brooch; center, shoulder clasps; right, buckle.

At the splendid palace Charlemagne built in Aachen (today's Germany), he established a center of learning, encouraged philosophic debate, and sponsored the arts. His biographer, Einhard, a secretary in the emperor's court, wrote that Charlemagne was "beyond all kings in making search for wise men . . . whereby he made his kingdom radiant with fresh knowledge, hitherto unknown in our barbarism." One of the Holy Roman Emperor's chief projects was to recover the true text of the Bible, which had been thoroughly corrupted by miscopying over the centuries. A second achievement was a codification of law for the myriad of peoples he now ruled.

The Carolingian Renaissance did not last much beyond the death of Charlemagne. The vast Holy Roman Empire disintegrated into partitioned kingdoms that were weakened by civil war and invasions by Normans, Magyars, and Arabs. From its ruins eventually rose the nations of France, Germany, and Italy.

Charlemagne may have inherited the crown of the caesars but he did not dress the part of an imperial Roman. Even though he is shown on coins of his realm dressed in a toga and crowned with a laurel wreath, only on two occasions did he ever dress as a Roman emperor. Einhard tells us that for state occasions he instead preferred the splendor of vividly colored and richly decorated Frankish costumes. His elaborate gold fibulae were inlaid with oversized gems, his belt and shoes embroidered with gold thread and jewel encrusted, the hilt and scabbard of his sword cast of solid gold and adorned with precious stones.

Charlemagne's everyday dress, Einhard notes, "varied little from the common dress of the people." Indeed, the emperor would jeer at his hunting companions who would ride through woods and thickets in finery that would get torn and soiled. The equestrian figurine of Charlemagne from the early ninth century shows the components of the traditional Carolingian costume in precise detail. (Figure 7-12.) He

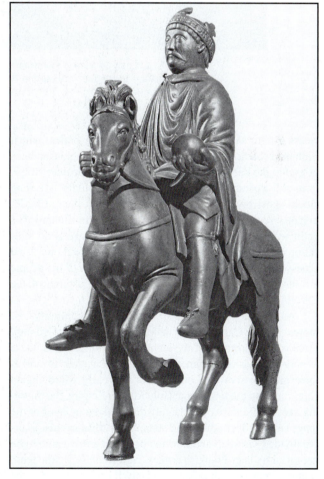

Figure 7-12. Although Charlemagne was crowned Holy Roman Emperor by the Pope, he only wore a toga and laurel wreath diadem on two high-state occasions. Instead, he much preferred the common dress of the Franks—the gonelle, braies, and pedules. Statuette of Charlemagne, c. 800.

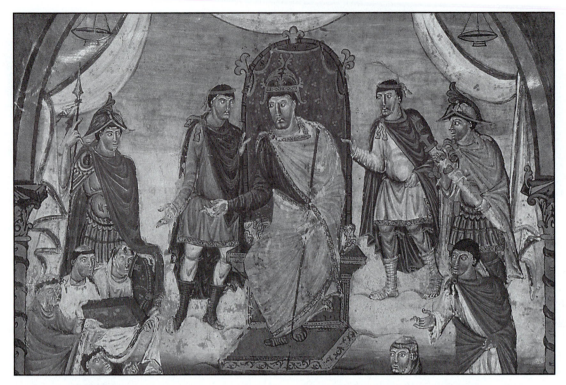

Figure 7-13. A new addition to the military costume of the Carolingians was the broigne, a leather cuirass molded to simulate the Roman lorica. Detail of illuminated manuscript of Charles the Bald, c. 875.

wears a long sleeve gonelle and close-fitting braies, which Einhard recorded were made of linen. His woolen pedules extend to the knees where they are bound with leather straps. Over this costume fastened on the right shoulder is a long cloak—possibly made of thick wool dyed blue, Charlemagne's favorite color for apparel according to Einhard. His gallicae feature pointed toes and flat soles. There is no indication of rich textile patterns, embroidery, or jewel-encrusted accessories. This is a portrait not only of a man of his people but also a portrait of the native masculine costume of the Carolingian Franks.

As with the Merovingians, the quality of the military costumes of the Carolingians denoted social rank. Ordinary Frankish infantrymen of the eighth and ninth centuries were as poorly provisioned with weaponry, and especially armor, as their predecessors had been under the early Merovingian chieftains. By the time of the Holy Roman Empire, the throwing axe, the francisca, had largely disappeared in favor of the long, single-edged knife, the scramasax. Military historians are divided on when and how the bow and arrow came to be deployed by later Frankish armies. Nevertheless, by the tenth century, units of both infantry and cavalry were skilled at the use of the bow.

The clothing of the ordinary soldier probably varied little from the earlier migratory period. Their simple gonelle was made of coarse wool and worn over rough-gauge linen or woolen braies. Most likely, they did not wear pedules but instead bound the hems of their long braies with twine or leather thongs.

The military costume of the elite was extensive, including iron helmets, chain mail vests and gorgets, leather cuirasses, and metal-sheathed shields. Similarly, weapons for the nobility included superbly wrought swords, ornamented scabbards, high quality daggers, spurs, and all manner of equestrian equipment. The nobility also wore finely tooled leather gloves, shoes, belts, and bindings for their pedules.

One new development in the military costume of the Carolingians was the introduction of the **broigne**, a leather cuirass molded and constructed to resemble the Roman lorica. Even the skirt of splayed leather strips was revived for the full effect of the Roman centurion. In Figure 7-13, the attendants on each side of the king wear the skirted broigne and a crested, ceremonial helmet. These attendants of the king were courtiers of high social status, not commoners from the ranks of the army. They could afford to have a custom-made broigne. This Roman-revival costume lent a theatrical air of legitimacy to the Holy Roman Empire as heir to the ancient dominion of the caesars.

Women's costumes of the Carolingian era had gradually evolved one step further from the Merovingian adaptations of Roman styles. This transition is clearly evident in an exceptional group of six life-size statues of female saints from the late eighth century. The women are variously

dressed, but the lengths and layering of their garments are an unmistakable departure from the Roman stola. Two of the figures are identically dressed in plain clothing with veils covering their heads while the other four wear lavishly decorated costumes.

The more plainly dressed saint shown on the left in Figure 7-14 wears at least four layered garments. Her unadorned floor-length tunic is simply made with close-fitting long sleeves. Even though the uniform carving of the folds of the skirt appears to represent pleats at first glance, it is evident from the other statues that this is actually a sculptural stylization for depicting a voluminous garment. The hemline of the tunic also reveals a long undertunic of some type, possibly a linen chemise like that found in the tomb of Queen Arnegunde. Of special significance is the casula, a circular cloak with an opening for the head similar to the ecclesiastical chasuble discussed in chapter 6. Secular versions of the casula would become more common in the Late Middle Ages, but the style may have originated as early as the eighth century. The outermost garment of the figure is a narrow shawl or scarf that covers her head with the ends draped back across opposite shoulders. All six of the women wear the Frankish ankle boots, the gallicae.

In contrast to the female figure dressed in the unadorned casula, her companion on the right wears an elaborately decorated costume. The detailed carving at the cuffs of her sleeves indicates that she wears three layers of tunics. The inner most garment has tight, long sleeves with wide, embroidered cuffs. Nothing of its collar or hem shows. Over that is a second tunic with a type of sleeve that flares from the elbow to the wrist. Judging from the bunched folds, the cuff of this sleeve would probably cover the hands when the arms were down at the sides—a style that would become increasingly popular in the later Middle Ages. The outer tunic is of a simple silhouette with a scoop-neck collar and three-quarter-length sleeves that likewise flare from the elbow to the cuff. We have seen this funnel-shaped type of sleeve before on the Persian kandys. Unlike the kandys, though, this style of tunic does not appear to have set-in sleeves but rather was constructed from two T-cut pieces of material sewn together to make the front and back of the garment. Because the border trimmings at the collar, cuffs, and skirt hemline are carved in high relief, we may speculate that the ornamentation is heavy embroidery, perhaps even jewel encrusted.

Both the opulence of these garment decorations and the variations of Asiatic sleeves are influences from Byzantium. Three possibilities could account for the introduction of Eastern styles to the West. First, despite the difficulties of transportation during the early Middle Ages, trade between Europe and Constantinople managed to continue. Second, the Byzantine Empire had maintained territories in southern France and Italy well into the seventh century, during which time cross-cultural exchanges were likely. Third, the Holy Roman Emperor Otto II married a daughter

Figure 7-14. The two distinctive characteristics of women's costumes of the Carolingian Period are lengths and layering, both of which are marked departures from the Roman stola and subucula. Detail of female saints from Santa Maria in Valle, Tempietto, c. 790.

of the Byzantine emperor in the tenth century and brought to the Carolingian court the customs and styles of her eastern homeland.

In the illuminated manuscript depicting an enthroned Otto III, we see how the length and layering of women's garments have evolved 200 years after the Carolingian versions described above. (Figure 7-15.) The undertunic is now so long that it pools about the feet and must have made walking precarious at best. The layered outer tunic is likely just as long except that the excess material has been pulled up to blouse over a girdle worn low on the hips. The ornamented Byzantine collars are now so wide that they extend across the shoulders. Another panel of embroidered decoration extends down the center front of the tunic and disappears beneath the

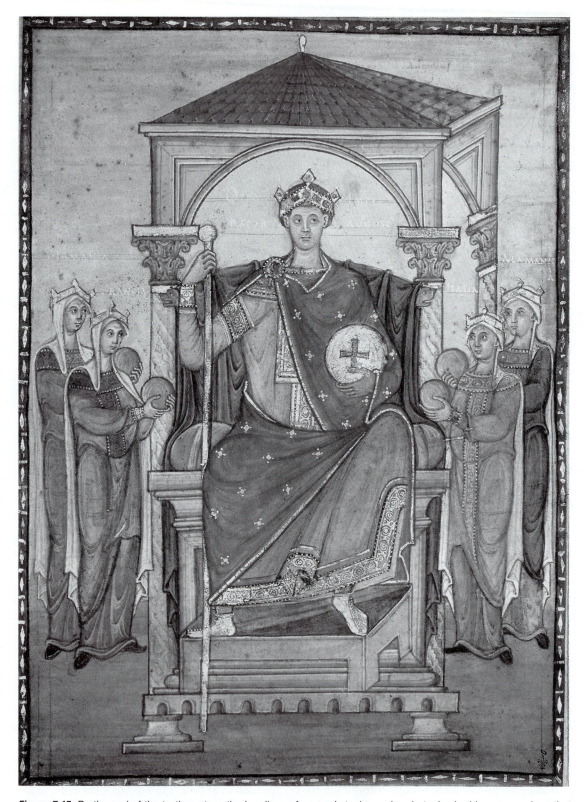

Figure 7-15. By the end of the tenth century, the hemlines of women's tunics and undertunics had become so long that excess fabric pooled about the feet. Veils also became lengthy, extending almost to the floor. Illuminated manuscript of Otto III, c. 1000.

bloused fabric at the girdle. Instead of a cloak, the outermost layer of garments is a **couvrechief** or headcovering made of silk or fine, semitransparent linen. These veils have become so long that they reach almost to the floor.

Embroidered tunics with long trains and headcoverings of fine materials were worn only by women of the elite classes. Rare depictions of ordinary women of the era show simple T-cut tunics cropped at the ankles and without the excess of material bloused over the girdle. Headcoverings were short, some hardly more than kerchiefs tucked or bound to cover the hair.

THE ANGLO-SAXONS

During the Teutonic migrations of the fifth century, Roman Britain was invaded by three groups of Germanic peoples, the Jutes, Saxons, and Angles, the latter of whom were to give their name to the island they conquered. The Romans were driven out by these fierce warrior tribes, never to return, and the native Celts were dispossessed of their homeland. By the eighth century, the closely tied Angles and Saxons had gradually merged their cultures into several petty Anglo-Saxon kingdoms.

Evidence of the Anglo-Saxon costume of the early Middle Ages is scarce, and extant garments are unknown. The climate and soil conditions of the British Isles are not conducive to the preservation of such perishable materials as fabric and leather. Nevertheless, historians suggest that the Anglo-Saxons continued the costume traditions of most other northern peoples with masculine garments that included the gonelle, braies, pedules, and cloaks fastened with fibulae.

Women's clothing is also thought to have been similar to that of the Merovingians and Carolingians. An illuminated manuscript in the British Museum from the time of King Ethelred (978–1016) depicts a woman dressed in a simple long-sleeved tunic, girded by a wide sash and layered with an unadorned cloak. (Figure 7-16.) Her long veil is wrapped around her neck and hangs down the back like those shown in Figure 7-15. Except for her bare feet, this representation of an Anglo-Saxon costume is basically that of her continental predecessors with one distinct variation. The Anglo-Saxon headdresses of this later period began to include infulae or ornamented ribbons attached to the back and brought over the shoulders to hang down the front. In the eighth century, Bishop Aldhelm had remarked on the "long ribbons sewn to their headdresses and hanging to the ground." In the example shown here, those ribbons appear to be embroidered and end with fringed trapezoidal tabs.

As with the dynasties of Europe during the early Middle Ages, the ruling families of the Anglo-Saxons buried their chieftains and warlords with great ceremony and lavish grave furnishings. In 1939, the richest archaeological find in

Figure 7-16. The veils of Anglo-Saxon women featured long infulae, or decorative ribbons, attached to the back and hanging almost to the floor. Portrayal of Pompa from of an Anglo-Saxon illuminated manuscript, c. 980.

England, called the Sutton Hoo Ship Burial, was excavated near Ipswich. In addition to the imprint and hardware of an eighty-foot ship (the wood had long since decayed), an extraordinary treasure of sixth and seventh century artifacts was unearthed. Since no remains of a body were found, many historians believe this was a cenotaph, or memorial burial, for King Aethelhere who was drowned in battle though his body was never recovered. Among the most spectacular items from the Sutton Hoo find is a helmet made of iron, bronze, and silver. Besides the traditional pointed-dome construction with cheek pieces and neck guard, the helmet also has a remarkable visor designed as a man's face, replete with moustache, eyebrows, and beard. The reconstruction model shown in Figure 7-17 demonstrates the high quality of metal craftsmanship that was available to the Anglo-Saxon ruling families of Britain. Instead of being a portrait of the king, some researchers think the visor mask is a surreptitious tribute to ancient traditional pagan beliefs because the facial features of the mask actually represent a flying dragon motif. The long neck of the beast extends up from the brows to the crest of the helmet, its wings form the eyebrows, its body the

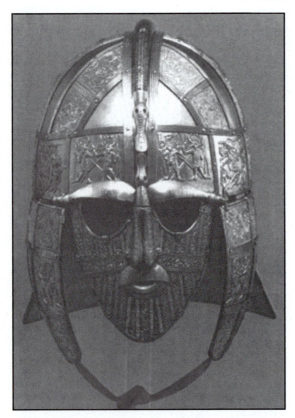

nose, and the tail the moustache. Although the helmet is purely ceremonial, probably created as a surrogate for the lost king, it was still designed with the construction of an actual battle helmet. The pointed dome, flaring neck guard, and hinged cheek pieces closely resemble the components of other helmets found throughout northern Europe of this time. Of special interest is the **wala**, a reinforced C-shaped metal crest attached across the dome for added protection from sword blows. This construction feature became a standard element of helmet designs in the late Middle Ages.

Besides the helmet, other military pieces excavated from the site include a gold and jewel-encrusted sword and scabbard. The actual blade was too rusted to recover but may have been the short, single-edged **seax**, for which the Saxons were named. A chainmail coat called a **byrne** by the Anglo-Saxons was neatly folded but too badly fused by rust to separate the links. By bulk, the byrne is thought to have covered the body to at least the knees. The remnants of a shield, several spears, and a throwing axe were also found although no evidence of a bow and arrow. In fact, as with the Merovingians, when and how the Anglo-Saxons developed proficiency with the bow and arrow is unclear. Historian Malcolm Todd refers to the bow and arrow in Anglo-Saxon England as an "exotic" weapon because it was rarely used at this early date.

Among the utilitarian items found in the Sutton Hoo burial were silver bowls and spoons, gold jewelry, fragments of a lyre, a lamp, bucket, purse with coins, and a large whetstone for keeping the weapons sharpened for battle. The jewels and

Figure 7-17. Among the treasures discovered in the Sutton Hoo ship-burial was a masked helmet constructed of iron, bronze, and silver. The stylized facial features of eyebrows, nose, and moustache may represent a flying dragon from Anglo-Saxon pagan lore. Reconstruction of the Sutton Hoo mask, c. 650.

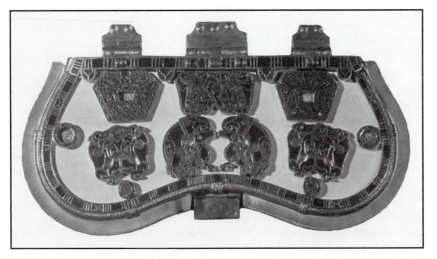

Figure 7-18. The ornamentation of objects found in the Sutton Hoo ship-burial reveals two aspects of Anglo-Saxon taste that differ from that of the other northern European cultures of the era. The purse lid is an example of decorative design with open spaces rather than an entire surface densely covered with patterns. In addition, the mushroom motif created in cloisonné is particular to Anglo-Saxon ornaments. Left, gold and enamel purse lid from Sutton Hoo, c. 650; right, cloisonné mushroom patterns.

ornaments from the Sutton Hoo site reveal two important departures of design from that of their mainland cousins. (Figure 7-18.) The purse lid, for example, exhibits a decided change from the Teutonic "horror vacui," meaning a preference for covering every inch of surface with some kind or decoration. The open white enameled spaces on the purse lid actually emphasize and isolate the groups of intertwined beasts and men rather than losing them among a mass of swirling, geometric patterns. A second design element that is particular to Anglo-Saxon taste is the so-called "mushroom" motif in cloisonné. These distinct shapes were found in a great many metalwork designs not only on many Sutton Hoo items but also on artifacts from numerous other Anglo-Saxon burial sites. However, the mushroom motif is not known in the ornamentations of other northern European cultures of the era.

REVIEW

Throughout the first half of the first millennium CE, waves of migrating peoples moved southward and westward across the Roman Empire. Powerful tribes such as the Goths and Vandals carved out territories and soon established independent kingdoms. Eventually, Italy itself was overrun by the invaders, thus ending the Western Roman Empire and plunging all of Europe into the Dark Ages.

As the various ethnic groups settled and assimilated Roman culture, they merged elements of their native costumes with those of Roman styles. As early as the fifth century the costume of the Merovingian Franks included a long-sleeved adaptation of the Roman tunica. Tribal kings and warlords donned clothing made of fine linens and imported silks emulating patrician Roman taste. Women adopted versions of the Roman stola and palla.

The Teutonic peoples also introduced Asiatic influences acquired during their migrations across Asia Minor and Central Europe. Instead of adopting the round-domed helmet style of the Roman legionaries, they introduced conical versions from the Near East. They wore knee-high hose and favored the pointed-toe boots reminiscent of Persian styles. Their jewelry and accessories were often richly ornamented with motifs of Byzantine orientalism.

By the Carolingian era, the costumes of the Franks reflected new influences from three sources: Christianity, Byzantine culture, and Roman revivalism. From ecclesiastical costumes came the influence of lengths and layering. Sleeves and hemlines became fuller and longer on women's clothing. Byzantine apparel ornamentation was adapted to Western styles in the form of opulent fabrics and lavishly embellished collars, cuffs, and hemlines. As founders of the Holy Roman Empire, the Franks viewed themselves as heirs to the authority and grandeur of the caesars. For high state occasions, Charlemagne dressed in a toga. His palace guards revived the molded torso cuirass of the centurion. The veil returned for women.

By the end of the millennium, the migrating tribes had built nations and dynasties. Christianity provided an international commonality for the diverse ethnic peoples. Urbanization, wider travel, and extended commerce began to change the economic landscape. The Dark Ages drew to a close.

Chapter 7 Northern Europe in the Early Middle Ages
Questions

1. What did excavations of the peat-bog burials reveal about the dress of the Teutonic peoples? Identify the important costume finds from the peat-bog burials and what they confirm about the manufacture of clothing and accessories in the early Middle Ages.

2. What were the basic components of the Merovingian masculine costume? Describe the chief characteristics of each.

3. Which differences distinguish Frankish military fittings from those of the Romans?

4. What is cloisonné, and how did it appeal to the barbarians?

5. What are the three ways in which Byzantine influences were introduced to the West in the Carolingian era?

6. The Sutton Hoo purse lid exhibits which two Anglo-Saxon design motifs that are different from those of their Continental cousins?

Chapter 7 Northern Europe in the Early Middle Ages
Research and Portfolio Projects

Research:

1. Write a research paper on how the acceptance of Christianity by the Teutonic peoples altered their dress. Explore the cultural impact of these changes in costume by gender and class. Include references to new laws imposed by the Franks and Burgundians that governed dress.

2. Write a research paper on how Christianity changed the customs and social structure of the Teutonic parentela. Examine particularly how the rites of engagement, monogamous marriage, and child rearing were altered, and how those changes affected dress.

Portfolio:

1. Create a mock-up set of cloisonné jewelry constructed in paper including a fibula, bracelet, bractiate, and sword hilt. The design pattern should simulate the horror vacuii treatment of Teutonic styles. At least one item should include the Anglo-Saxon mushroom motif. Use thin, pliable posterboard cut in one-eighth inch deep strips as the cloisons.

2. Develop a reference guide of apparel and accessories found in the peat bogs of northern Europe. Catalog the items by category and gender. Include photocopies or digital scans of each item with a paragraph describing the material of the item, key design elements, date of manufacture, and location of the burial site.

Glossary of Dress Terms

bractiate: a round bronze ornament attached to a belt and worn at the front of the waist

braies: the Frankish style of trousers cut in varying lengths from the knees to the ankles; most often made of wool and sometimes linen

broigne: a leather cuirass constructed to simulate an athletic male torso

byrne: Anglo-Saxon coat of chain mail

cloisonné: decorative metalwork created by soldering metal strips edge up to a metal base; the resulting compartments were filled with jewels, glass, or enamel

couvrechief: a woman's long head covering made of silk or sheer linen

crochet: a technique of knitting or knotting threads with a hooked needle to produce openwork fabrics

francisca (also franciska or francisque): an S-shaped battle axe

gaiters: the wrapped coverings for the leg between the knee and instep

gallica (pl. gallicae): Frankish slip-on ankle boots worn by both men and women

gonelle: a Frankish version of a T-cut, knee-length tunic with various types of sleeves; usually of wool

gorget: a piece of armor attached to a helmet to cover the neck

knit: a fabric production technique of intertwining yarn or thread in a series of connected loops made with knitting needles

pedules: hose made of circular woven linen or wool usually worn to the knees but sometimes extended to the lower thighs

saie: a short cloak, mostly worn by men, especially soldiers

scramasax: a large, single-edged knife or short sword

seax: a short, single-edged sword for which the Saxons derived their name

spangenhelm: a Frankish helmet constructed in a conical shape with hinged cheek pieces and a nose guard

terrycloth: a fabric woven with a surface treatment of loosely looped threads

wala: C-shaped metal crest attached to Anglo-Saxon helmets

Legacies and Influences of Styles from the Early Middle Ages on Modern Fashion

The innovative developments in clothing of the Dark Ages that were precursors of modern fashions occurred in the construction details more than with the silhouette or evolution of garment styles. The earliest documented belt loops for trousers are from this period—a significant creation that actually was forgotten by the beginning of the Middle Ages. New forms of accessories for military costumes included gaiters to secure trouser legs, still a common element of certain soldier's uniforms today. Handknitting techniques developed by the migrating tribes produced

beautifully rendered textures similar to our modern terrycloth and crocheting. The rich surfaces and decorative qualities of cloisonné that the Teutonic peoples treasured are still crafted for jewelry, accessories, and home items today.

Documented examples of trouser belt loops date from the Roman era. Dutchess ad, 1926.

Protective wrappings for the lower legs, called gaiters, have remained in use by soldiers since the Dark Ages. World War I American doughboy, 1918.

Knit hats are among the artifacts recovered from Teutonic grave sites of the Dark Ages. Modern mass produced knit cap, 2007.

The rich, colorful technique of cloisonné has been applied to fine and costume jewelry and other decorative accessories for centuries. Torques by Van Cleef & Arpels, 1975.

Surviving examples of clothing from peat-bog burials of the Dark Ages reveal sophisticated, complex techniques of knitting that included surface treatments with knotted loops which presaged modern terrycloth. Terrycloth bathrobe and towel, 2008.

Chapter 8

THE ISLAMIC EMPIRE

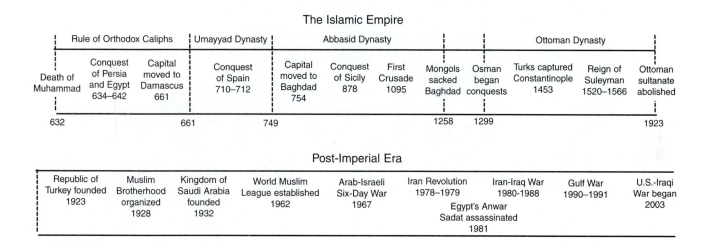

The Islamic Empire

Post-Imperial Era

Republic of Turkey founded 1923	Muslim Brotherhood organized 1928	Kingdom of Saudi Arabia founded 1932	World Muslim League established 1962	Arab-Israeli Six-Day War 1967	Iran Revolution 1978–1979	Iran-Iraq War 1980–1988	Gulf War 1990–1991	U.S.-Iraqi War began 2003
					Egypt's Anwar Sadat assassinated 1981			

FROM ARABIA TO EMPIRE

In 610, the Prophet Muhammad began his teachings of the One God in his hometown of Mecca, a small city situated on the trading routes of the Arabian peninsula. The new religion he founded was Islam, literally meaning "submission" (to the will of God). Over a period of twenty years, Muhammad recorded in short verses his moments of divine inspiration, which after his death in 632, were collected into a text that formed the Quran.

Muhammad's successors were called caliphs—from khalifa, meaning "vicar"—who began the spread of Islam through conquest. The original intent, though, was not so much the conversion of neighboring peoples as it was their subjugation for economic reasons. Historian Alexander Vasiliev wrote, "Arabia, limited in natural resources, could no longer satisfy the physical needs of its population, and threatened with poverty and hunger, the Arabs were forced to make a desperate attempt to free themselves from the hot prison of the desert." With the wealth and power of a growing empire under his control, the fifth caliph established a dynastic monarchy, the Umayyads. In less than a century, these rulers of Arabia carried the green flags of Islam into Byzantine Syria where they established a capital at Damascus. To the east, they conquered the Sassanian Persians and drove into the Indus Valley to the fringes of the Chinese empire. In the west they took Egypt quickly, but were slowed for several decades by the fierce resistance of the Berbers of North Africa. Finally, in 710, they reached the Atlantic and crossed into Spain, swiftly sweeping over the entire Iberian Peninsula. Only the formidable Pyrenees and the determined Franks to the north stopped the Islamic armies from advancing into western Europe.

Although the Umayyads set about governing their vast new empire with deference to local customs, they soon faced a growing unrest from its very heart in Persia (modern day Iraq and Iran). There, converts to Islam found that they did

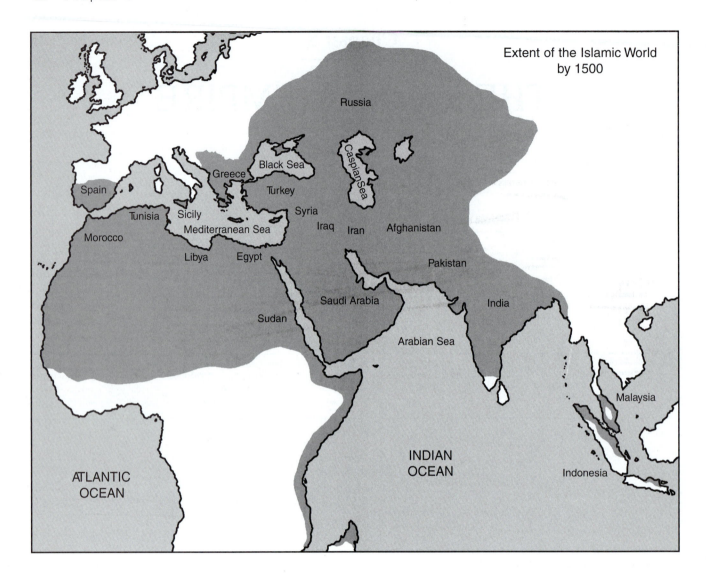

Extent of the Islamic World
by 1500

not enjoy the same legal and social privileges as the occupying Arabians. Led by a descendant of Muhammad's uncle, Abbas, the Umayyad caliph was overthrown in 749 and the Abbasid dynasty was founded with its capital in Baghdad.

The Abbasids satisfied a key need of converts to Islam. The new rulers held that public life should be regulated by Islam but that the conquered peoples could fashion a local government according to their own customs and culture. This concept provided for an impartiality of the Abbasids toward the various schisms that divided the faithful. As a result, the successful Abbasid caliphate lasted more than 500 years, falling to Mongol invasions in 1258.

For the following few decades, the Islamicized Mongols ruled the Islamic empire from Iran. In 1299, the Turkish emir, Osman, began a conquest of neighboring emirates—wresting dominion from the Mongols and seizing western territories from a weakened Byzantine Empire. From his name were derived the names both of the dynasty he founded and the imperial Islamic state his conquests forged: Ottoman (Westernized from the Arabic form of his name, Othman). Between 1359 and 1683, the descendants of Osman expanded the Ottoman Empire from the Caspian Sea in the east to the Danube in the north, south to Arabia and all of North Africa. In 1453, the Ottoman Turks at last conquered the golden city of Constantinople and brought to an end the 2,000-year continuum of Roman civilization. The dynasty established by Osman would rule until 1923 when the Turkish Republic was formed following the Ottoman defeat in World War I.

EMERGENCE OF ISLAMIC NATION-STATES

In the fifteenth century, Europeans began to venture out across the globe in search of direct maritime trade routes to the rich markets of Asia. Columbus sought the spices of India and found the Americas. The Portuguese inched down the coast of Africa throughout much of the 1400s before taking that last daring journey across the Arabian Sea to the shores of a Moghul India. Over the subsequent 400 years, one Islamic

country after another was occupied by European powers in their quest for colonial territories and economic monopolies. By the nineteenth century, ubiquitous contact with the West had inspired many Muslim leaders to attempt a modernization and cultural transformation of their homelands based on progressive Western models of industrialization, education, and most significantly, secularized government.

But in the West, secularized nationalism had replaced allegiance to faith, and religion and politics were intentionally separated to free government, science, and technology from the constraints of religion. Muslims, though, found divine meaning and spirituality in political events. Hence, the idea of a secular democracy was problematic to most Islamic peoples. As Karen Armstrong notes in her book on Islam, "Part of the difficulty lay in the way that the West formulated democracy as 'government of the people, by the people, and for the people.' In Islam, it is God and not the people who gives a government legitimacy."

Consequently, in the first decades of the twentieth century, secularism in many postcolonial Islamic states manifested itself as an attack—sometimes brutal—on religion and the religious. In Turkey in the 1920s, Mustaga Kemal, known as Attaturk, closed the madrasas (Islamic schools), introduced a Western style constitution and legal system, and instituted dress policies requiring the adoption of Western fashions. Suddenly, veils disappeared and Turkish women dressed as flappers with bare arms, cropped hair, and skirts to the knees. In Iran, the Pahlawi shahs abandoned the country's Muslim identity in favor of a secular nationalism that reveled in the glories of its ancient Persian heritage. The Soviet Union divided its Muslim territories into individual republics based on ethnic and linguistic similarities, but all were governed under the secular umbrella of Communism. Despite its title as an Islamic Republic, Pakistan developed its first constitution in 1956 with religion assigned to a largely symbolic status. In Indonesia, Sukarno strictly regulated the political activities of religious groups, urging his people to practice Islam privately. King Faysal of Syria summed up the sweeping secular nationalism of the modern Islamic states when he avowed: "We are Arabs before being Muslims, and Muhammad was an Arab before being a prophet."

From the beginning of the modernization process by the secular governments of Islamic nations, most Muslims resented the exclusion of religion from public and political life and resisted the coercive policies of social change. From a collective feeling of disenfranchisement, marginalization, and oppression emerged groups of fundamentalist Muslims— sometimes referred to as Islamists—who were against Western ideas of secularism and the materialistic systems of capitalism and socialism. This fundamentalism did not represent an attempt to return to the past or to reassert traditional doctrine but, rather, fundamentalists sought to create a new religio-political order that integrated the sacred with the power of a modernized state.

The Muslim Brotherhood, founded by Hasan al-Banna in Egypt in 1928, set out to reform Islamic social and political institutions for the masses without the excesses of a secular ideology. Islam for the Brotherhood was a total way of life, incorporating a demonstrative public faith with the benefits of Western science, technology, and economics. Members founded schools and hospitals, built factories, developed legal and literacy programs, and established a scout movement. Within a generation the message of revivalist Islam espoused by the Brotherhood spread throughout Muslim lands, and participation swelled into the millions.

Despite the success of the Brotherhood, though, some fundamentalist idealogues reacted to the perceived continuous threat of religious and cultural annihilation with violence and terrorism. In the 1950s and 1960s, Sayyid Qutb led a fundamentalist movement in Egypt that condemned Western ideas of political sovereignty as denying God's authority. He called for a universal jihad, or holy war, against the secular regime of President Nasser, for which he was imprisoned and executed in 1966.

When the Arab armies were defeated by Israel in the Six-Day War of 1967, the secularist policies of Islamic states were further discredited. Throughout the Middle East in the postwar years, there was a sharpened dissatisfaction with secular nationalism and, as a consequence, a resurgence of religion. By the 1970s, almost every Muslim society contained an activist fundamentalist wing. Militantism and violence proliferated. In 1981, Egyptian President Anwar Sadat was assassinated by Islamists who were dissatisfied with the 1978 Camp David Accords with Israel, which had been unacceptable to the Palestinians. In Iran, the shah was overthrown by Islamists in 1979, and the cleric Ayatollah Khomeini established a fundamentalist government that replaced secularist policies with the shariah—the systematic codes of behavior derived from the Quran and the example of Muhammad.

Inspired by the views of both Qutb and Khomeini, the Taliban took control of Afghanistan in 1994 and became sponsors of militant Islamists. Among the most extreme groups was al-Queda, which began exporting terrorism in the name of Islam around the world. "The fear and rage that lie at the heart of all fundamentalist vision," concludes Karen Armstrong, "nearly always tend to distort the tradition that fundamentalists are trying to defend, and this has never been more evident than on September 11, 2001." Following the attack on the United States that fateful day, Western military action toppled the Taliban in Afghanistan and the regime of Saddam Hussein in Iraq. By all accounts, though, the majority of the world's 1.2 billion Muslims view the extremism current in some segments of the Islamic world as counter to the spirit of Islam.

In the twenty-first century, many Muslim populations continue to struggle with a way to merge the transcendent Islamic ideal with modern state structures. It remains an even more difficult challenge to maintain a pan-Islamic

Figure 8-1. As with most isolated, ancient societies, spinning, weaving, and apparel production were a principal occupation of early Arabian women. Detail of miniature by Bihzad, c. 1495.

solidarity given the sectarian ideologies, ethnic diversity, and the varied geographic heritage of the nations of the former Islamic empire.

ISLAMIC TEXTILES

Home textile production was a principal occupation of Arabian women. For most of the ancient nomadic population, the devices for spinning, dyeing, and weaving were made of light materials such as cedarwood that could be transported easily. Their small handloom known as a **mattarih**, was compact and cleverly constructed to dismantle. As Bedouin women tended to flocks or trod along in a migration, they would spin sheep's wool or goat hair on a wooden spindle called a **maghzal**. Raw materials could be curried directly from the animals or collected by the children from shrubs where animals had scratched. Upon camping near an oasis the women could dye their yarns and weave in their secluded quarters. (Figure 8-1.) They produced textiles for apparel, tents, blankets, rugs, saddle liners, and assorted travel bags.

Commercially produced fabrics and dyed yarns were readily available from thriving urban textile centers such as Jeddah and Jauf, as well as from merchants offering imported fabrics from India and China. The many trade routes crisscrossing the Arabian peninsula also provided women in almost every village and town with access to a wide assortment of yarns and finished textiles.

The earliest textiles used in Arabia were made primarily of wool that was produced and processed regionally. The "hard" or longer fibers of wool from the shaggy breeds of sheep were used in weaving durable textiles for tents, storage bags, and other hard wearing utility items. The "soft" or short, crinkly fibers of lambs and karakul were woven into fabrics for clothing and accessories.

Goat's hair and sometimes even camel's hair were also used in cloth production. The materials produced from these fibers were often too coarse for apparel but were especially suitable for utilitarian textiles.

Small amounts of cotton were grown in some of the southern coastal regions of Arabia. Some historians believe that cotton cultivation was introduced from India during the late first millennium BCE. Still other researchers suggest that the influence came from the Sudan and Egypt during the Roman era. Whatever the original source, demand for cotton cloth in Arabia always exceeded supply given the cool comfort and easy care of the fabric. The importation of cotton textiles and thread continued to be a substantial trade business throughout the history of Arabia. As the Islamic empire expanded into North Africa and Spain during the seventh and eighth centuries, Arabian traders spread the knowledge of cotton cultivation and cloth

production into these regions. Some types of cotton fabrics manufactured in the West today originated in textile centers of the Islamic empire: **muslin** was derived from Mosul in present-day Iraq, and cotton **damask** came from Damascus in Syria.

Despite the possible influences of nearby Egypt and Mesopotamia, linen does not seem to have been adapted much to Arabic apparel. Some written documents of the Ottoman era indicate that linen threads were sometimes combined with cotton to create a blended material used for household textiles. Fine linens may have been used for scarves or veils, although cotton gauze produced the same semitransparent effect and was much less costly.

For upper classes and special costumes such as bridal ensembles, silk was preferred. Until the end of the sixth century, silk was imported from China. After the Byzantines established their state-sponsored silk industries, greater quantities and varieties of the fabric were more readily available to the Arabians. By the ninth century, the court historian to the Caliph al-Mutawakkil made note that his master and all members of the royal household wore silk exclusively. In the thirteenth century, some of the largest silkworm farms and silk production centers of the Byzantine Empire, such as Bursa in northeastern Turkey, had fallen into the hands of the expansionist Ottomans. With the conquest of Constantinople in the mid-fifteenth century, the Islamic empire became a principal source for silk textiles in the West. Records show that by 1500 a strict order of guilds in Bursa operated more than a thousand silk looms. Stringent regulations categorized and set standards for the quality of silk fabrics. **Atlas** was a monochrome satin, sometimes brocaded or pressed with hot irons for a **moiré**, or **"watered" silk**, pattern that resembled the wavy lines of wood grain. **Serenk** was woven with a yellow base and at least two other colors. **Kemha** featured intricate patterns woven in a wide range of colors and accented with gold, gilded silver, or silver threads. The most valuable silk was **seraser**, which was woven almost entirely of metallic thread. **Kadife** was a plain **velvet** with varying densities of **pile**—the cut loops of silk thread forming the fuzzy surface. **Cut velvet** was created by reducing the pile in places to form a pattern or design. The most prized velvet was **çatma**, which incorporated gold or silver thread.

The tanning of skins for leather hides and crafts was primarily a masculine chore, although both Bedouin men and women made leather goods. Sheep, gazelles, camels, and goats provided leather for saddles, totes, water skins, buckets, belts, shoes, and boots. For the upper classes, master craftsmen produced superior leatherwork in layered appliques of exquisite quality and design. (Figure 8-2.) Besides applying layers of contrasting colors, leather workers also embroidered their crafts with colorful silk or metallic threads, added debossed patterns, or affixed metal ornaments and jewels.

Only a few natural fabric dyes were regionally available to the Arabians. In the south, juice from the abal shrub produced a reddish brown, and yellow ochre came from wild rhubarb. Palettes of red, orange, and russet came from

Figure 8-2. One of the chief design characteristics of Islamic leather goods was the layering of pierced, contrasting appliques that added a richness of depth and pattern. Canteen, c. 1580.

assorted madder plants. Other natural dyes were imported in prepared powder or dehydrated form, such as saffron for yellows and indigo for deep blues. Certain reds and pinks could also be obtained from the indigo plant by a slow oxidation of the leaves in a variety of acidic solutions. The mixture of indigo and yellow dyes produced the vivid green of the Islamic flag and a variety of other green hues worn for mourning and pilgrimages. By the nineteenth century, European industrial centers mass-produced inexpensive, color-fast chemical dyes in vast palettes of colors that were imported by textile makers all over the Islamic empire.

Following the Western industrial revolution of the late nineteenth century, a huge array of machine-loomed fabrics and ready-to-wear clothing flooded the market places of even the most remote Islamic communities. Except in some parts of fundamentalist Islamic nations, home production of textiles and garments declined significantly. Brightly colored cotton print **calicos** and checked **ginghams** replaced traditional textile patterns in clothing and utilitarian fabrics. The new ethnic markings in many Islamic costumes became imported plaids, checks, and houndstooth patterns. By the middle of the twentieth century, synthetics and blends became commonplace throughout the Islamic world. The new artificial silk, **rayon**, proved more durable and colorfast than natural silk. Nylon was well-suited to nomadic and agrarian accoutrements such as tents, satchels, cords, ropes and outerwear. Today, polyester and blends, such as poly-cotton, poly-rayon, and poly-wool, provide easy-care commodity fabrics that all classes enjoy.

COSTUMES OF ARABO-ISLAMIC MEN

The inhabitants of ancient Arabia were about equally divided between nomadic clans who migrated across the deserts and urban dwellers and farmers who had settled along the fertile

Figure 8-3. Ancient Arabian costumes were similar to those of the Sassanian Persians. Masculine garments included long-sleeved tunics, baggy trousers, and finely-crafted leather boots. Repoussé esilver plate depicting King Shapur II hunting, c. fourth century.

coastlines and oases. Until the first millennium CE, most Arabians lived in relative isolation from the great civilizations around them. Trade routes made some inroads into Greater Arabia but largely bypassed the vast central and southern desert wastelands. Until the seventh century, Arabia remained largely an undeveloped fringe of the Mesopotamian civilizations and only sporadically received infusions of change. Nevertheless, the early development of Arabian culture and costume was directly influenced by their closest neighbors from Persia in the north and the Roman Levant.

We have few images of the early Arabians—mostly primitive rock carvings, none of which provide any distinct representations of their ancient costume styles. In addition, early Islamic mandates forbade the creation of imagery depicting the natural world, especially people. Due to these restrictions, many historians look first to Mesopotamia as the probable source for the origins of Arabian dress.

The Sassanians who conquered Mesopotamia around 225 CE were the direct cultural heirs of the Achaemenid Persians, rulers of the region until Alexander the Great. Through this heritage, the cut-and-sewn costumes of the Sassanian men included Persian-styled tunics, trousers, and elaborately tooled leather boots. Unlike the tailored and fitted garments of their predecessors, though, Sassanian clothing was more flowing and looser fitting for ease of layering. In the silver plate shown in Figure 8-3, King Shapur II wears full, baggy trousers that flutter in folds at the back of the leg. His long-sleeved T-cut tunic is girded at the waist and the full

skirt ruffles over his thighs. A goffered scarf tied about his hair billows in the breeze and a tasseled scarf pinned to his shoulder undulates on the far side.

In the early decades of the Islamic empire's expansion beyond Arabia, the Muslims spread more than just the faith of Muhammad and the teachings of the Quran. Among the lasting cultural influences that the Arabians introduced with their conquests was their costume. We are reminded by Middle East historian Frances Kennet that, today, "the standard attire worn throughout the Muslim world first originated in the Arabian Peninsula."

In Arabia at the dawn of the Islamic empire, the most common masculine garment was the long, loose-fitting tunic called a **kaftan** (also caftan). In its simplest form, the Arabian tunic was probably T-cut in the same manner as the Roman tunica and Egyptian kalasiris. Kaftans were often worn girded by a wide sash that was sometimes long enough to wrap about the waist several times. Some versions of the tunic-styled kaftan were exceedingly wide and had sleeves that flared to trumpet-shaped openings at the wrists, somewhat resembling the silhouette of the Persian kandys. Later designs retained the flared sleeves but developed their fullness from the addition of gores at the side seams. This fullness in girth and the sleeves was important for ease of movement, especially for the kneeling postures of prayer five times each day.

In the nineteenth and early twentieth centuries, the tunic-style kaftan was called a **merodan**. It featured a short **placket** in the front, usually with three to five buttons, that

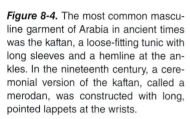

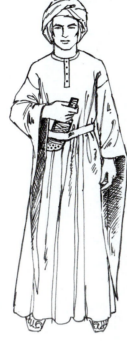

Figure 8-4. The most common masculine garment of Arabia in ancient times was the kaftan, a loose-fitting tunic with long sleeves and a hemline at the ankles. In the nineteenth century, a ceremonial version of the kaftan, called a merodan, was constructed with long, pointed lappets at the wrists.

Nineteenth-century ceremonial merodan

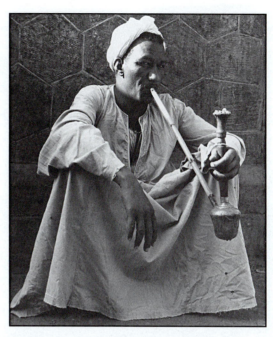

Figure 8-5. The modern version of the Arabian kaftan is the thawb, which commonly features a button-front placket at the neckline, patch breast pocket, and side slit pockets at the hips. Variations include styles with collars and finished cuffs.

opened from a round neckline. Although gores were still employed for a wide girth, even more fullness was provided by the addition of **gussets**—diamond- or triangular-shaped panels—inserted under the arms to join the side seams with the sleeve seams. For special occasions, such as religious festivals and family events, men wore a style of merodan constructed with the under half of the sleeves cut into long lappets that tapered to a point from the wrists to about ankle length. (Figure 8-4.)

The modern version of the kaftan is the **thawb** (also thob). (Figure 8-5.) It is often tailored with a banded-type collar and finished cuffs. A button-front placket extends from the neckline, some as deep as to the waist. Variations of the thawb include an attached shirt collar. A chest patch pocket and deep, side-slit pockets at the hips are common to the style. Sleeves and girth are cut narrower than with the earlier merodan, although the underarm gussets and side gores still provide ample looseness for airy coolness and freedom of movement. Usually the favored fabric today for the thawb is cotton, polyester, or poly-cotton blends in white or cream. Dark-colored wool or wool blends are worn during winter.

The term kaftan also applies to a long, front-closure robe. Most often these were worn closed over tunic-shirts and trousers although, for upper classes, men also wore the kaftan robe open over a long, tunic style kaftan. In most combination ensembles, the two kaftans were made of different fabrics and the outer robe was left open to reveal the contrasting colors and mixed textile patterns of the two garments. (Figure 8-6.) Sleeves of the outer kaftan were often cropped to half or three-quarter length to emphasize the vivid contrast of the layered fabrics.

Examples of imperial kaftans from as early as the fifteenth century have been preserved in the Topkapi Palace in Istanbul. This collection reveals the opulence and master craftsmanship of royal silk costumes at the peak of the Ottoman rule. Many are of kemha silk with large quantities of gold thread woven into the patterns. Most are lined with lightweight plain weave silk although some include fur linings. For men of the Ottoman ruling family, many outer kaftans with cropped sleeves were made with separate sleeves for the lower arms called **kolluks** that attached with loops to tiny buttons. Note in the examples shown here that, despite the superb tailoring and almost invisible seams, the sleeves are simply T-cut instead of set in. Some outer kaftans also were cut with short hemlines cropped at the knees to allow ease of riding horseback. The **merasim kaftani** was a long ceremonial robe worn by the sultan to receive foreign diplomats and for other court functions. It featured nonfunctional, floor-length sleeves that had slits at the shoulders through which the arms passed.

Layering of garments has been a tradition in Arabia since ancient times. Both men and women layered multiple garments of varying styles and materials depending upon socioeconomic class. Perhaps the influence of this custom derived from the layered costumes of nearby Persia or even Roman Egypt and Syria. However, unlike with the slave and peasant classes of many cultures, at no time was a Muslim man permitted to be seen fully naked. Text in the Quran declares: "O ye children of Adam! We have given you clothing to cover your genitals." (7:26, 27)

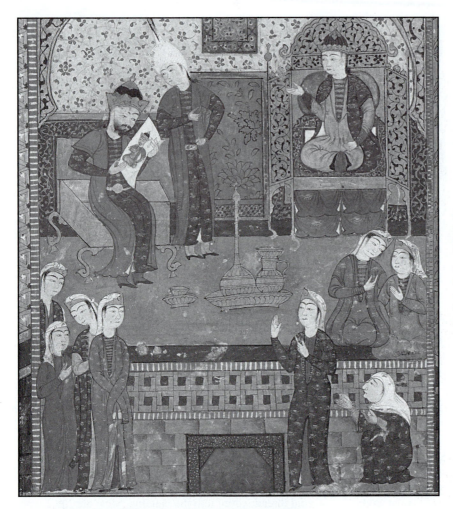

Figure 8-6. The front-closure, robe-style kaftan was ordinarily made of a textile pattern or color that contrasted with the inner tunic-style kaftan. The ensemble was worn with the outer kaftan open to display the contrasting fabrics. Left, detail of "The King of Persia's Palace" from the *Book of Kings* by Abu'l-Qasim Manur Firdawsi, c. 1540; bottom, detail of miniature of young man holding a flower, c. 1490.

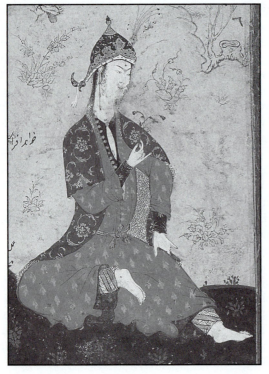

Those types of apparel that are categorized as undergarments of the Arabian costume include loincloths, trousers, and shirt-like undertunics. Whereas in the West undergarments were to be concealed, Arabian undergarments were simply the inner components of a layered costume. For example, the undermost garment was usually a basic loincloth called an **izar**. But written accounts from early periods indicate that field workers often removed their kaftans for hard labor, wearing instead only the basic izar. By the time of the Ottomans, peasants in the eastern regions of the empire adopted the **fouta**, a wrap skirt that sometimes was formed into a loincloth by pulling the back edge up through the legs to tuck into the front waist.

Over the izar or fouta was layered the **fanilla**, a pull-over T-cut under tunic with a high, circular neckline and short sleeves. Lengths varied from just at the hips to the knees. The fanilla was worn mostly by the middle classes and not by peasants or laboring classes. Today manufactured Western-style short- and long-sleeved shirts often are worn as a substitute for the traditional fanilla.

Although trousers are classified as an undergarment of Arabian costume, like the izar and fouta they could be worn without an outer kaftan depending upon need. Soldiers,

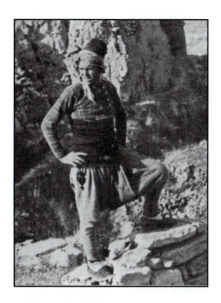
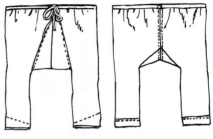

Modern Sirwaal

Figure 8-7. The Arabian version of trousers, called a sirwaal, was cut almost twice as wide as Western styles. Gussets inserted at the crotch provided for a loose, comfortable freedom of movement. Left, etching of a man and woman from Widdin, 1892; right, Ottoman Turk, 1915.

hunters, horsemen, and tradesmen frequently discarded their kaftans for the simple tunic shirt and trousers to more easily perform their tasks.

The Mesopotamian influence of trousers spread southward to Arabia probably during the late first millennium BCE where the garment suited the nomads well. The loose bagginess of trousers was cool in the hot climate while at the same time offering protection from hours of horseback riding. Trousers also provided modesty for the kneeling and prostrate positions of Islamic prayer rituals. The Arabians called their style of trousers the **sirwaal**. (Figure 8-7.) They were constructed with a wide girth through the hips. Various gussets were inserted at the crotch for added fullness. Unlike the snug fit of the Teutonic braies or the Roman feminalia, the crotch of the sirwaal sagged to the knees in gathers of excess fabric. A drawstring waistband held the trousers up. Close-fitting legs usually extended to the ankles although knee-length was common in the Ottoman period. Beginning in the fourteenth century, upper classes sometimes wore a type of trousers called **çatsir**, which had cotton socks attached at the ankles. This style is believed to have been introduced from China in the thirteenth century by the invading Mongols.

The earliest form of Arabian men's outerwear was a long cloak called a **mishlah**, which in its most basic form was a long, square, rectangular, semicircular, or trapezoidal piece of heavy wool that draped over the shoulders and pinned or tied at the neck. As with the Greek chlamys and the Roman sagum, the Arabian mishlah served multiple purposes, including as a pillow or blanket. Later styles such as the one shown in Figure 8-8 were cut with scalloped or decorative top borders that could be turned down over the shoulders into a wide collar. For the cloaks of upper classes, ornamental shoulder braid called **soutache** or other varieties of applique and trimmings were common. Wealthier men might also don a mishla woven of soft, fine camel hair. Prior to the nineteenth

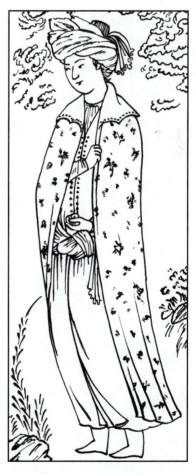

Figure 8-8. Early Arabian outerwear, called a mishlah, was primarily a simple square or oblong piece of fabric tied or pinned at the neck. Later versions were cut with scalloped or decorative top edges that were turned down to form a collar. Young man in blue cloak after Riza, c. 1587.

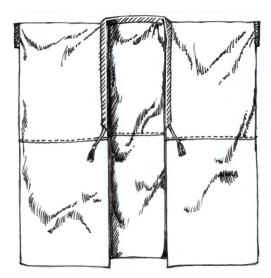

Figure 8-9. The modern masculine cloak, called a bisht, is constructed of two long pieces of fabric stitched together horizontally in the middle. The armholes at the wide folds at the sides are sometimes reinforced with embroidered cuffs.

century, men's cloaks were produced in a wide range of colors. In the modern era, the colors of the mishla are more often subdued earth tones or black.

Another form of outerwear is a derivative of the mishla called a **bisht**. (Figure 8-9) It is constructed of two long panels of fabric stitched together horizontally in the middle. As with the kaftan robe styles and the mishlah, the bisht is open in the front for easy access to a sword or dagger. Armholes were cut at the side fabric folds of the wide shoulder line. Sometimes embroidered cuffs were sewn at the openings. If a bisht needed to be shortened, the excess material was removed from the center stitch line rather than the bottom hem to preserve the balanced proportion of the garment.

Western-style jackets were only introduced into men's costume during the late nineteenth century. Called a **cote** by the Arabians, the word probably derived from the British waistcoat and generically included a wide variety of silhouettes. Jacket styles ranged from sleeveless vest-like outerwear to traditional long-sleeve versions with notched or shawl collars. The short-waisted bolero jacket was adopted by the

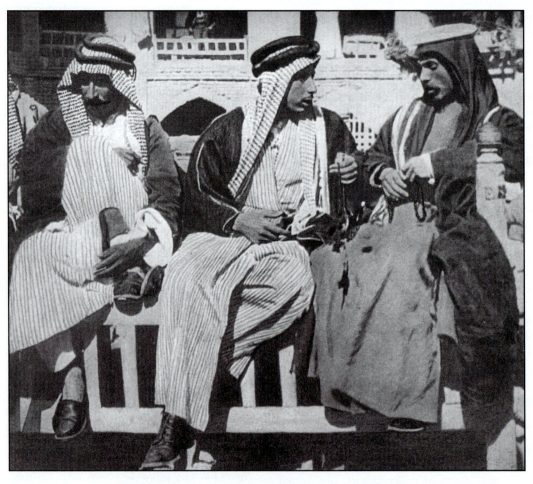

Figure 8-10. The modern ghutra, or Arabian men's headcovering, is formed by a large square piece of fabric folded into a triangle and draped over the crown. It is usually held in place by an agal, a double circlet of black goat's hair. Photo of Arabian men, 1922.

late period Ottomans, most likely from Spain through contact with North Africa.

One of the most distinctive elements of an Arabian man's costume is the head covering. It can consist of one to three pieces. The more commonly worn variety is a small, round skullcap called a **tagiyah** (also taagiyyah). Sometimes these skullcaps are called prayer caps since Muslim men traditionally covered their heads during prayer rituals. In actuality, these caps were designed to prevent sweat and hair oils from ruining the headcloth. For this purpose they were usually made of white cotton for easy laundering. Wealthier classes who mostly spent quiet lives indoors wore skullcaps made of silk with finely embroidered ornamentation. Today, the tagiyah is common in all colors and with all manner of machine-made quilting, embroidery, appliques, and ribbon trim.

Atop the tagiyah, men wore the **ghutra** (also ghoutra), a large, square piece of fabric folded diagonally to form a triangle. (Figure 8-10.) One point of the triangle draped down the back and the other two hung at the sides of the head. The straight edge of the fold was placed across the forehead,

usually with a pinched peak in the center, completely covering the tagiyah. The dangling side corners were sometimes pulled back and variously affixed to the head. One side may be draped asymmetrically across to the opposite side of the headdress or both ends could be crisscrossed over the crown. The most common fabrics for the ghutra are plain white cotton or cotton blends although checks and stripes in assorted colors are also popular. Among Bedouins and Muslims of regions farther east, brighter colors and decorative textile patterns are more prevalent. The light cotton fabrics protect the head against the direct sunlight, and the swathes of material help retain moisture. In addition, when in battle, Muslim warriors wound the ghutra around the head covering all of the face except the eyes to keep sand out of their mouths as they shouted their paeans of battle and praise to Allah.

To secure the ghutra in place, a double circlet called an **agal** (also igal or igaal) made of black goat's hair is fitted about the crown. The word agal is similar to the term for a nomad's tethering rope, which may have been the original source of the head piece.

Figure 8-11. The elaborate arrangements of turbans evolved from draping the points of the ghutra back over the head. The size, shape, and ornamentation of turbans varied much more than the principal garments of Arabian men's costumes. Detail of miniature from *Sehinsahname of Murad III*, c. 1580.

Another way in which the ghutra was sometimes worn was as a turban. Although today the turban-styled ghutra is more prevalent among the laboring classes and rural farmers, in earlier eras, turbans were symbolic of rank and class. During the Ottoman era the stylized arrangements of fabric atop the head reached enormous proportions for the nobility and ranking religious clerics. (Figure 8-11.) Some were decorated with lavish plumes, stalks of dyed bristles, silk tassels, or cascades of fringe. Some turbans were arranged around tall, conical or gourd-shaped felt hats that were covered with opulent silk fabrics. The tapering, truncated black or red **fez** of modern Turkey was derived from these turban support hats. The size, shape, and arrangement of turbans varied greatly over the centuries and seemed to reflect more of the personal style of the court or dynasty of the time than a standardization of costume that was common to all Islamic-affiliated peoples.

MILITARY COSTUME

Over the nearly 1,300 years that the Islamic empire evolved as a political, dynastic entity (632–1923), the military costumes and armaments understandably changed dramatically. Numerous written records of the earliest conquests by the Arabian caliphs reveal their army to be more of a loosely banded confederation of ethnic clans from throughout the empire than a traditional military organization. Early descriptions of these invading forces documented by Byzantine officials and Christian church leaders cover a wide range of appearances and costume styles. Although these varied groups were united under the green flag of Islam, each retained its own distinct adaptation of Arabian costume. Fabric colors, embroidered ornamentation, and head coverings, in effect, were comparable to the insignia of army units.

The arms and armor of the early Arabians were relatively basic. Each warrior carried a curved sword, the **scimitar**, and a small, round shield of reinforced leather. Tucked into his sash were a long, curved dagger, the **yataghan**, and often a second shorter, straight dagger, the **khanjar**. Later, as the imperial state began to regulate all aspects of government, including the military, costumes of soldiers became more standardized. The common foot soldier of the Abbasid army was simply attired in a basic tunic-style kaftan, trousers, and ghutra wrapped around the head and neck. Except for a reinforced leather or linen shield, they had no other armor.

The elite military branches of the Islamic empire—the cavalry, archers, siege engineers, and officers—were better outfitted with arms and armor than the ordinary foot soldier. (Figure 8-12.) Metal helmets were made with shallow, pointed domes accented with a spike in the center top and leather neck guards. The spike on an officer's helmet often

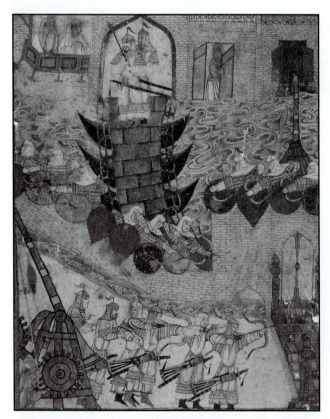

Figure 8-12. In addition to metal helmets and specialized weaponry, the elite Islamic forces wore thick leather garments, sometimes reinforced with metal plates. Detail of a siege from a thirteenth-century Islamic miniature.

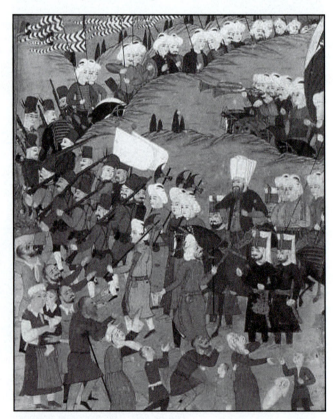

Figure 8-13. The Ottoman military adopted modern weapons of warfare such as artillery and modified military costumes for maximum field performance. Kaftans were shortened to the knees and trousers were tightly bound with gaiters. Detail of miniature from *Pasaname*, c. 1630.

included a tuft of colored horsehair as a distinction of rank. Instead of a suit of chain mail such as that worn by the Crusaders, the Muslim warrior preferred a leather kaftan covered with metal plates. Although these armored kaftans were quite heavy, their front-closure design made it easy to remove quickly for hand-to-hand combat.

During the sixteenth and seventeenth centuries, artillery made armor useless. The Ottoman military not only adopted the modern weapons of warfare, but modified the traditional native costumes for maximum performance. Riflemen needed the ease to climb rugged terrains for ambush or entrenched battle. As a result, kaftans were cropped at the knees and trousers were tightly bound with gaiters. (Figure 8-13.) By the nineteenth century, the military costume of the Ottoman Empire was virtually identical to Western khaki uniforms with narrow trousers and fitted jackets.

COSTUMES OF ARABO-ISLAMIC WOMEN

As with men's costumes of the Islamic empire, women's costumes consisted of multiple layers and kaftan ensembles. The origin of early Arabian women's apparel was, likewise, probably from Mesopotamia, particularly derived from Persian designs.

The same cut-and-sewn T-style tunic of ancient Persia possibly appears in one of the earliest surviving images of women in Islamic art from a ninth-century wall painting in an Abbasid palace. (Figure 8-14.) Although crudely rendered, the garments are long-sleeved with floor-length hemlines. It is not clear if the tunics are girded to form a peplum at the hips

or if the stylized shapes represent a scarf or sash. (At least one researcher has suggested the women actually wear a skirt and short tunic although that tradition is not typical of women's dress in the ancient Middle East.) Swirling masses of deep folds indicate that the tunics were cut wide. The gold colored costume of the woman on the left is opulently decorated with an allover print or embroidery of chevrons and a scalloped border at the hem, and the blue costume of the woman on the right is accented with vertical gold stripes and a matching hemline border. A double strand of gold beads or possibly coins hangs around the hips of each dancing girl. Their braided hair is unveiled but they wear small, close-fitting caps and pearl or bead ornaments behind the ears.

From this tunic style developed the feminine kaftan of Arabia. Throughout the Middle Ages the silhouette of women's tunic-kaftans changed little. During the Mongol occupation, new decorative elements were introduced from the East. Collar treatments featured circular stand-up styles including variants that were cut high in the back and tapered to a shallow edge in the front, or half collars that extended only partially around the neck with a wide gap at the front. The depth of placket front closures varied in length from the center of the breasts to as low as the waist.

Covered buttons of assorted sizes and spacing along the front closure added ornamental interest to plain kaftans. A wide variety of buttons were made by covering small, convex disks made of bone, wood, shell, or metal with muslin topped by the fabric that matched the garment. Buttons made of contrasting colors or materials did not suit the taste of Ottoman women.

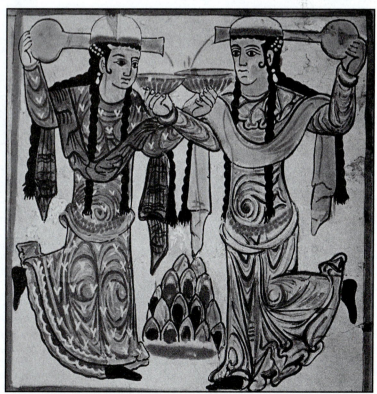

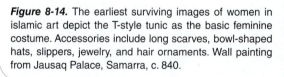

Figure 8-14. The earliest surviving images of women in islamic art depict the T-style tunic as the basic feminine costume. Accessories include long scarves, bowl-shaped hats, slippers, jewelry, and hair ornaments. Wall painting from Jausaq Palace, Samarra, c. 840.

Indeed, the application of buttons, button loops, and buttonholes to garments was a significant leap in costume design. At what point the creation of buttons and toggles for fastening clothing occurred is unknown. Possibly the innovative form of garment closure was introduced through trade in the east with China, where button loops had been in use since the Han Dynasty (c. 200 BCE–220 CE). Even if covered disk buttons were not the invention of the Arabians, we know from artwork as early as the Abbasid period that they especially enjoyed the practical and aesthetic application of buttons to clothing. Very possibly it is from contact with the Islamic empire—either through the frontiers with Spain or through the returning Crusaders—that buttons were introduced into Europe during the late Middle Ages. Among the earliest records of button use in Western clothing comes from regulations of the French clothing guilds from around 1250 that specifically established rules and penalties for button makers.

Sleeve styles of the feminine kaftan also began to be modified during the Mongol era. Cuffs were extended to hang several inches beyond the fingertips in the Chinese style. Such extra long sleeves were features of costumes of the upper classes. For middle and lower classes, sleeve styles changed very little from the T-cut tunics of the Persians. Environment induced the evolution of some practical variations. Narrow, close-fitting sleeves were preferred in the western mountainous areas where colder seasons prevailed. Capacious, airy sleeves became the standard in the desert interior.

One of the unique construction elements that Arabians gave to their kaftan designs was the introduction of gussets to the underarm seams. In fact, this is one of the primary differences between women's and men's costumes. In designs of women's kaftans, the gussets were usually much more vividly colored or made of contrasting textile patterns. Besides adding a decorative element to the kaftan, gussets

provided a comfortable fullness to the garment especially suited for a nomadic existence. In some instances, especially in the Hijaz, a region in western Arabia, gussets evolved into lappets that were lavishly embroidered or constructed of colorful patchwork. Today, among certain Bedouin tribes, the arrangement of gussets, lappets, appliques, and embroidery designs are still used as clan indicators. (Figure 8-15.)

Another component of women's costume that parallels that of men's is the outer robe-style kaftan. At what point women began to wear the open-front robe layered over a tunic-styled kaftan is not certain although the practice most likely originated during the height of the opulence of the Abbasid imperial court during the late Middle Ages. As with men's versions, the feminine kaftan robe of the upper classes was often worn open to reveal the contrasting colors and textile patterns of the tunic kaftans underneath. Sleeves of women's kaftan robes were made in greater variations particularly in shortened cuts that exposed the long sleeves of the inner kaftan. The outer kaftan worn by the woman on the left in Figure 8-16 is made with the extra-long sleeves that cover the hands. Her companion wears the merasim kaftani with its nonfunctional long sleeves hanging at the back of the arms. The slits at the shoulders allow the woman to display the contrasting fabric of a second kaftan robe, beneath which shows her tunic-style kaftan made of a third brightly colored fabric.

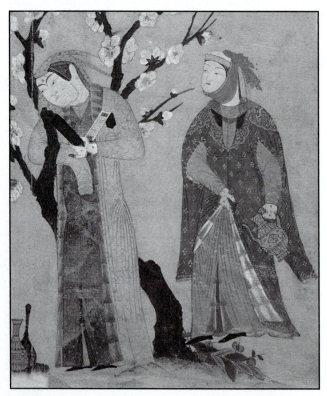

Figure 8-16. During the Ottoman period, women's outer kaftans were designed with two types of exaggerated sleeves. One style was cut to extend beyond the woman's fingertips, which reinforced the image of feminine modesty. The other style was a long, non-functioning sleeve that hung from the shoulders behind the arms.

Figure 8-15. In certain designs of Bedouin kaftans, the underarm gussets evolved into exaggerated lappets. These extensions were decorated with lavish embroidery or appliques that often denoted tribal heritage.

By the beginning of the Ottoman period, feminine costumes might be layered with four or five garments. In addition to the two outer kaftan robes, she wore an inner tunic-style kaftan of a third material and a plain undergarment of white silk or possibly cotton. Layered undergarments for women also included the **sidaireey**, which was a sleeveless vest-like top that served as a type of brassiere. Other variations of the sidaireey were constructed with long sleeves and ankle-length hemlines much like the Western chemise.

The type of feminine undergarment that may be comparable to the masculine loincloth was the **dislik**. Little is known about the development of Muslim women's intimate apparel though. Even erotic Islamic paintings do not clearly show early forms of underwear that correspond to Western lingerie. Women of the late Ottoman era in the eighteenth and nineteenth centuries are known to have worn a dislik constructed like Western-styled bloomers that tied at the waist and the knees. However, the constraining corset of Western fashions was not adapted to Arabo-Islamic costumes, even though women in certain parts of the Islamic empire, particularly Egypt, Turkey, and Persia, preferred tight-fitting jackets, vests, and bodices.

Another layered undergarment for women was the sirwaal. Unlike with men's versions, women's trousers could not be worn without an outer garment in mixed company or in public. The sirwaal was an ideal garment for modest women since it allowed them great freedom of movement without having to struggle with keeping loose kaftans closed. An Islamic proverb advises that "Allah has mercy on women who wear trousers." Only in the later Ottoman period did women begin to wear the sirwaal and tunic or jacket top without an outer kaftan although this practice was primarily confined to use in the women's quarters known as the harem. By the second half of the twentieth century, in certain Islamic regions such as Yemen and other parts of the southern Arabian peninsula, women shortened their kaftans to about mid-calf so that lavishly embroidered sirwaal hemlines could be displayed.

Women's outerwear, too, followed the styles of men's costumes. In Figure 8-17, we see examples of three common

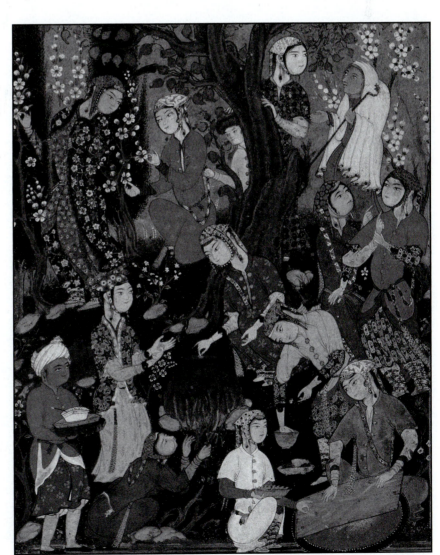

Figure 8-17. The sirwaal was an ideal garment for modest women that afforded them freedom of movement without having to struggle with keeping loose kaftans closed. Detail of a miniature depicting women picnicking in a garden, c. 1575.

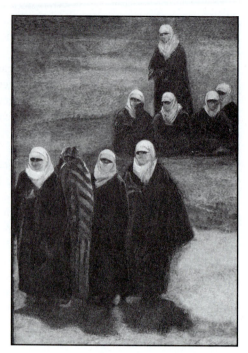

Figure 8-18. The Arabian milaya was a voluminous outer cloak that covered women completely from the top of the head to the ground. This was only worn when women ventured out into public. The modern version is called an abaaya in the Middle East. It is most commonly made of black or deep indigo fabrics that best conceal bright colors and textile patterns of kaftans underneath, although white is worn for special occasions. Left, detail of a miniature showing women in the gallery of a mosque for services, c. 1540; right, engraving of Muslim women from *Harper's*, 1892.

Hijab and Veiling

The concept of **"hijab"** (also hejab and hijaab) is derived from the Arabic term "hajaba," meaning "to veil, to seclude, to screen, to conceal, to form a separation, to mask." In her study of Islamic dress, Faegheh Shirazi submits that today hijab is understood in popular Islamic culture primarily to mean "concealment donned by women as a religious obligation . . . and as practiced or understood by Muslim women in various Islamic societies."

Hijab, though, is more complex and subtle than merely a functional or cultural form of clothing. The idea of feminine modesty is deeply rooted in centuries of Islamic tradition. In the 1990s, an Iranian fatwa, or Islamic legal opinion, reasserted this ancient view: "The body is the instrument of the soul [that] must not become a plaything of the desires, passions, and debauchery of anyone." Hence modesty demonstrated through the concealment, or veiling, of feminine beauty is a moral commitment under Islam.

Garments suitable for hijab are given to girls at puberty by their parents. Upon marriage, a husband is expected to provide his wife with the appropriate hijab dress, without which, explained an Afghan woman, the bride would think she was "not worth protecting or honoring."

Related to female modesty is a personal safety concern in certain Islamic societies, not only for the women themselves but for their male relatives. In Iran and Afghanistan, for example, women not properly dressed in hijab may encounter verbal and even physical assaults in public from unrelated males. In addition, the men of their family may be punished by the state authorities for allowing their women to exhibit what is regarded as offensive public behavior. Even male merchants, drivers, and tailors who serve improperly dressed women can be held accountable for undermining order.

Besides the religious aspects, veiling for many Muslim women has other purposes, such as conveying messages of class and social status within the community. The quality of the fabric, the rarity of the dyes, the number of pleats, the sumptuousness of the embroidery, and the cleanliness of the garments worn as veiling are important elements for projecting information about the wearer's class and clan. Some subtleties of veiling even distinguish rural women from urbanites.

Moreover, for some women, notably in postcolonial Egypt and Palestine, the shrouded body also became a political statement of nationalist pride. Women reveiled as a rejection of the influence of the West and the secularism of modern Islamic governments. The uniformity of hijab dress emphasized the importance of community over Western individualism.

Lastly, veiling has very practical, utilitarian purposes in many regions. The head-to-toe chaadaree discussed later in this chapter can be likened to the ubiquitous Western raincoat. Depending on the fabric of the garment, it can protect the woman from the intensity of the sun, heat, and humidity as well as provide warmth in damp, snowy seasons.

types of feminine outer garments. The woman in the upper left wears a simple oblong cloak that is fur-trimmed and extends almost to the ankles. The elderly woman at the upper right has covered her head and shoulders with a plain shawl, probably of wool trimmed with embroidery around the edges. In the left foreground, the woman in the long cloak is a young girl in a star patterned hip-length jacket with half sleeves. These types of jackets were introduced from China by the Mongols in the thirteenth century.

For women who had to go into public to attend mosque or do their marketing, dressing in **hijab**, or full concealment of the entire body by veiling, was required in some Islamic societies. (Figure 8-18.) Appropriate hijab dress not only referred to the amount of the body exposed, but also to the proximity of clothing to the body. Even the contours of the feminine form was to be disguised beneath the layers of clothing.

In Arabia, the **milaya** (also milaaya) was a voluminous oblong cloak that covered the shoulders to the ankles, or in some versions, the entire person from the top of the head to the ground. The cloak was usually made of black or deep indigo cotton since dark colors most effectively concealed the bright colors and patterned textiles of the kaftans underneath. Striped fabrics of muted colors also were common in rural areas. The modern Arabic name for this outer cloak is **abaaya**.

The full Arabic ensemble that covers the woman head to toe, including a veil that exposes only the eyes, is known as a **burqa**. The term has become a generic label in mass media for any veiled body covering worn by Muslim women globally, although the Arabic word actually applies only to the styles of the Middle East. Not only do the terms for veiling differ among Islamic ethnic groups and regions, but the forms and aesthetics are equally varied.

For women of central Asia, particularly Afghanistan and Pakistan, two principal forms of veiling garments are suited for hijab requirements. The **chaadar** is a large scarf-like head covering about two yards long that is wrapped tightly over the head and allowed to drape around the shoulders. It is worn with shawls of lengths varying between midcalf and the ankles, usually over a tunic and trouser ensemble. The **chaadaree** is a more elaborate ensemble comprised of three pieces. (Figure 8-19.) The **teka** is a cloak sewn with vertical pleated panels that covers from head to foot; a **kulla** is a small, bowl-shaped cap; and the **rooy** is a long face mask with a net-like section over the eyes called a **chishim band**. Both the chaadar and chaadaree are made in numerous varieties with a wide assortment of fabrics, pleating, embroidery, and other decorative treatments.

In the Middle East, one of the most common forms of face veils is the **milfa**, which today is usually made of black gauzy materials woven of cotton, linen, silk, and even synthetics. As in ancient times, this half veil only covers the

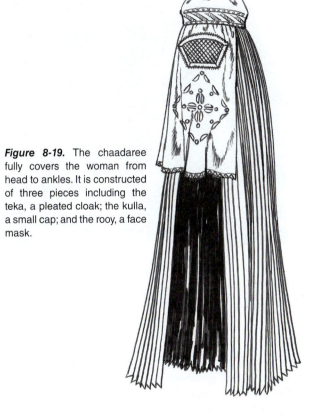

Figure 8-19. The chaadaree fully covers the woman from head to ankles. It is constructed of three pieces including the teka, a pleated cloak; the kulla, a small cap; and the rooy, a face mask.

lower part of the face, most often fitting across the nose bridge, but sometimes worn just beneath the nostrils. (Figure 8-20.) The full face mask of the burqa that covers all except the eyes is still prevalent among Bedouin and rural village women. The construction, shape, and decoration of these masks remain unique to certain ethnic groups generation after generation. Some styles of the burqa mask are made of pieced leatherwork and feature only almond-shaped slits for the eyes. The leather can be polychromed with intricate patterns or can be affixed with coins, cowrie shells, mother-of-pearl buttons, beads, and silver or brass ornaments. Pierced coins attached to masks are passed from mother to daughter, many of which date back to the late Ottoman Empire. The weight of some of these masks can be considerable, limiting the wearer's range of motion.

For urban Arabic women today, the type of veil that is closest to the burqa face mask is the **Meccan veil**, so called because it resembles a style thought to have originated in that city centuries ago. It is sumptuously embroidered, often with silver or gold threads, and may even include jeweled accents. Its long face veil is attached to a high headdress of the same rich material. Only the wealthiest of women wear the Meccan veil and then only on special occasions.

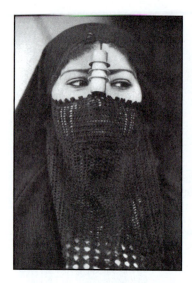
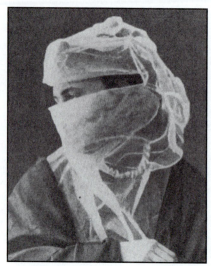
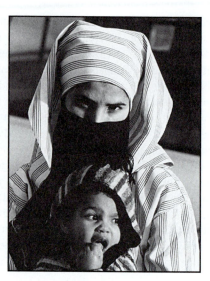

Figure 8-20. The veil not only demonstrated a woman's modesty but it protected against the intense sun and blowing sand. Today half veils that cover from the nose-bridge down are the most commonly worn. The full face mask of the burqa that conceals all except the eyes is preferred by rural Arabic women. Left, Bedouin woman from 1922; center, Ottoman woman from 1909; right, Moroccan woman, 2001.

As mentioned previously, scarves have traditionally been used in a wide variety of ways since the earliest eras of civilization. Both women and men layered scarves over kaftans, or tied long, narrow versions around the waist as sashes, or applied them as head coverings. The ninth-century dancing girls in Figure 8-14 wear scarves, probably of silk, draped around their hips and shoulders. One figure has a scarf loosely arranged around the neck as a soft collar. For modern Arabian costumes, scarves are still a popular accessory. Bright colors and bold prints are favorites where hijab is less restrictive. Machine-made Lurex embroidery, dazzling sequins, and patterned appliques of silk or synthetic materials accent today's styles. Wispy fabrics such as organza, chiffon, tulle, georgette, and nylon mesh are especially favored since their translucent colors can optically change when layered with contrasting hues.

The **mukhnug** is an enormous scarf—measuring about five feet wide by ten feet long—that is often worn by unmarried Middle East women as a combination hood and shawl. It is folded in half lengthwise and stitched together at one end, leaving an opening for the face. (Figure 8-21.) The train is allowed to hang down the full length of the back but the excess material is pulled to the front and carried over one arm.

Although women's and men's costumes developed with similar types of garments and layered ensembles—excluding hijab dress—the most pronounced distinction of apparel between the genders was their head coverings. With rare exception, women did not wear turbans. However, women of the upper classes, especially of the royal court, sometimes

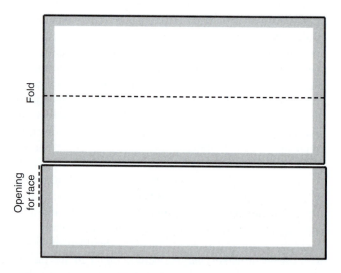

Fold

Opening for face

Figure 8-21. The mukhnug is an enormous scarf worn as a combination hood and shawl by unmarried women. It is folded in half and sewn closed at one end, leaving an opening for the face.

embellished hats and head coverings with embroidered scarves or pieces of patterned fabric that emulated turbans. The key difference is one of arrangement and scale, which for women was usually asymmetrical and considerably smaller in size than men's turbans.

The variety of feminine Islamic headdresses created over the centuries has been prolific. The earliest head coverings were simple scarves and shawls, not unlike those of Assyro-Persian and Greek women. The legacy of the modern kulla

may date back to Romano-Byzantine models; the Abbasid dancing girls depicted in Figure 8-14 wear a style similar to that of the Roman girl shown in Color Plate 2. From China, the Mongols introduced headdresses that were variously ornamented with strands of pearls or beads, plumage of exotic birds, or towering tiers of opulent fabrics. Combinations of materials swathing women's head coverings reflected the same taste for pattern-mixing preferred for kaftan ensembles. During the Ottoman era, influences from the West set women's headdresses askew on the crown, angled to one side or the other, or perched forward onto the brow. Scarves were pleated, ruffled, or crimped and allowed to drape fluidly over shoulders and under chins from complex arrangements atop the head. Shimmering silk tassels and fringe added kinetic visual interest; jeweled appliques created sparkle and textural richness. (Figure 8-22.)

One final accessory of note is the **tikka** (also dikka) or trouser belt. The waistband of the traditional sirwaal is commonly sewn as a closed tube all around except for a small hole in front, much like Western styles of drawstring pants. The waistband of earlier styles of trousers were sometimes two or three inches wide into which a tikka was inserted with a specialized threader. Designs of the tikka were often elaborately embroidered or decorated with beadwork, even though they would be concealed by the waistband. The ends were embellished with tassels or silk cords that were tied into complex knot patterns. As gifts to brides, some tikkas were embroidered with phrases from love or erotic poetry. One caliph's daughter from the ninth century received more than 1,000 tikkas as wedding gifts, some of which were studded with precious stones.

REVIEW

The Islamic empire was born of two driving forces that set the peoples of Greater Arabia on the course of conquest in the mid-seventh century. First was a growing population in a land of limited resources. Second was their unification by a new, monotheistic faith inspired by the Prophet Muhammad. Within less than a century, the green flags of Islam had been carried to the borders of China's empire in the east and across North Africa into Spain in the west. Throughout this vast territory the Arabians spread their religion and culture, including styles of their traditional costumes.

Ancient Arabian clothing designs were probably derived from Persian costumes, and included the cut-and-sewn T-style tunic and trousers for both men and women. From these basic apparel designs developed the long, tunic-style kaftan and the outer robe-style kaftan, commonly worn together as an ensemble. Layering of multiple garments was an important feature of both masculine and feminine costumes. Undergarments for both genders included a wide-seat trouser called the sirwaal as well as various forms of under-tunics and loincloths.

Until the late Ottoman period Arabian men's and women's costumes were similar. One key difference was the head covering. Men wore a combination headdress that featured a skullcap over which was draped a large piece of fabric called a ghutra. From the various arrangements of this scarf-like head covering developed turbans of all sizes and shapes. Women did not wear turbans, although they often draped scarves over assorted styles of hats, some inspired by Western and Asian designs.

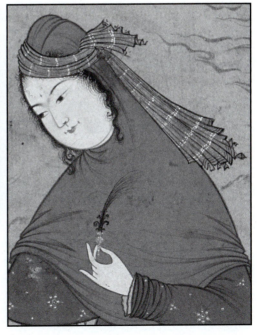

Figure 8-22. Headcoverings for Islamic women evolved into a myriad of elaborate styles during the Abbasid era and especially the Ottoman period. Influences from the Byzantine court and the introduction of Chinese styles by the Mongols inspired a host of lavish varieties of hats and headdresses, even though the basic kaftan ensemble changed little. Left, detail of a wall painting in Isfahan Palace, Iran, c. 1675; center, detail of a miniature from an album of Murad III, c. 1500; right, detail of a miniature from the Clive Album, 1620.

Another primary difference between the masculine and feminine Arabian costume was outerwear. For men, simple cloaks and robe-like garments were the most common. For women, though, the culture of the Islamic empire had preserved the ancient Assyro-Persian tradition of garments that concealed, particularly veils. In Islamic teachings, the hijab dress codes reflected modesty as well as religious devotion. Arabian women's veils were adapted regionally throughout much of the Islamic world, and ranged from basic, sheer coverings for the lower half of the face to the voluminous abaaya and chaadaree that covered the entire person head to foot.

Although following the First World War, the Islamic empire was broken into dozens of separate countries, principalities, and emirates, the basic components of Islamic dress remained constant across most of these lands. Some new regimes encouraged the adoption of Western apparel as a symbol of modernization, but with limited success. Instead, traditional dress, particularly the reveiling of women, became representative of religious conviction and nationalistic pride.

Chapter 8 The Islamic Empire
Questions

1. What were the key influences of Persian costume on Arabian styles? What unique design elements added distinction to Arabian versions?

2. Identify the main categories of silk textiles produced by the state-sponsored industries of the Islamic empire.

3. What types of natural dyes were available to the early Arabians prior to the Western industrial revolution?

4. Describe the basic components of the masculine Arabian costume. How are these men's garments similar to women's styles?

5. What are four primary differences between Muslim women's and men's costumes?

Chapter 8 Islamic Empire
Research and Portfolio Projects

Research:

1. Write a research paper on how the concept of hijab is supported by the Quran and the life examples set by Muhammad. Compare and contrast modern applications of hijab in Islamic states with those of Muhammad's time.

2. Research examples of Persian, Greek, Sassanian, Romano-Byzantine, and Mongol artwork (other than those in this chapter) that reveal possible cross-cultural influences on Arabian clothing and accessories. Provide photocopies or scans of the artworks with culture and date. Write a detailed description of each costume element, noting the design construction, decorative embellishments, and fabric or other materials, and explain how they were adapted to Arabo-Islamic costume.

Portfolio:

1. The Arabo-Islamic tunic kaftan is an example of cross-cultural influence that has been adopted by Western fashion designers in a variety of ways. Sketch a woman's eveningwear adaptation and a men's loungewear version that incorporate the elements of an Arabo-Islamic silhouette. Retain the details such as length, collar and neckline treatment, sleeves, and gussets of the original, but design a look that would appeal to Western tastes.

2. The rooy features a net-like eye panel called a **chishim band** made of drawn work hand embroidery or knitwork. The patterns are often inspired by the lacy designs used in architecture as window screens. Design a rooy with a chishim based on a typical window grill from each of Islamic imperial eras: Umayyad, Abbasid, and Ottoman. Attach photocopies or scans of the windows on which your three designs were based, and identify the building and date of construction. Include a paragraph describing the key elements of each window and how each contrasted with the previous era.

Glossary of Dress Terms

abaaya: the modern version of the milaya or outer cloak worn in public by women in many traditional Islamic regions

agal (also igal or igaal): a double circlet worn by men to hold the ghutra in place

atlas: a monochrome satin sometimes brocaded with elaborate patterns

bisht: a wide men's cloak with holes cut at the sides for the hands

burqa: the Arabic version of women's veiling that covers the figure from head to foot

calico: an inexpensive, coarse cotton fabric often printed with bright colors and patterns

çatma: a type of satin-weave velvet that incorporated gold or silver thread

çatsir: trousers with socks attached at the feet

chaadar: a woman's draped partial head covering usually worn with a shawl

chaadaree: a woman's ensemble worn in public comprised of a cap, mask veil, and long cloak that covered from head to feet

chishim band: the net-like eye panel of a rooy

cote: a Western-style jacket most likely named for the British waistcoat

covered buttons: convex disks covered with fabric used to fasten two sections of a garment through buttonholes or loops

cut velvet: patterns or designs created in velvet by reducing the pile in places

damask: a richly patterned fabric with the the design woven into the material

dislik: a type of feminine undergarment comparable to the masculine loincloth

fanilla: a men's short-sleeved T-cut tunic usually worn as an undergarment

fez: a truncated conical men's hat commonly worn in Turkey and Egypt

fouta: a men's kilt-like wrap garment that was sometimes fashioned into a loincloth by pulling the back edge through the legs and tucking it into the front waistband

ghutra (also ghoutra): a large square piece of fabric folded diagonally to form a triangular head covering for men

gingham: a yarn-dyed cotton fabric most often woven into checks or stripes

gusset: a diamond- or triangular-shaped panel of fabric inserted at the seams of garments to add volume

hijab: the concept of women's veiling

izar: a men's basic loincloth

kadife: a plain velvet with varying densities of pile

kaftan (also caftan): a simple T-cut tunic of varying lengths worn by both men and women; also a front-closure robe usually worn over the tunic-style kaftan

kemha: a rare silk woven in assorted colors and accented with gold or silver thread

khanjar: a short, straight dagger

kolluk: a set of detachable sleeves that hook or button onto the cropped sleeves of a kaftan

kulla: a small, bowl-shaped cap worn by women of central Asia as part of the chaadaree ensemble

maghzal: a wooden spindle used by Bedouins

mattarih: simple handlooms that could be dismantled for easy transport

Meccan veil: a long veil attached to a high headdress, both of which are made of sumptuous materials

merasim kaftani: a ceremonial robe that featured nonfunctional, floor-length sleeves that had slits at the shoulders through which the arms passed

merodan: a style of kaftan with sleeves cut with long lappets that tapered to a point at about knee-length

milaya (also milaaya): an early, voluminous feminine cloak the covered most or all of the body

milfa: the most common form of women's face veil usually made of semitransparent fabrics

mishlah: a men's long woolen cloak cut in various geometric shapes

moiré: a pattern of wavy lines pressed into silk

mukhnug: an enormous scarf worn by unmarried women as a combination hood and shawl

muslin: durable, plain-weave fabric made of cotton

pile: the cut loops of silk thread that form a fuzzy surface such as that of velvet

placket: a layer of fabric that reinforces garment fasteners such as buttons and buttonholes

rayon: a cellulose-based synthetic fiber sometimes called the new silk

rooy: a woman's long face mask with a net-like section over the eyes worn as part of the chaadaree ensemble

scimitar: a long, curved sword

seraser: silk woven almost entirely of metallic thread

serenk: silk woven with a yellow base and at least two other colors

sidaireey: a sleeveless vest-like top that served as a type of brassiere for women

sirwaal: trousers constructed with a wide girth across the hips worn by both men and women

soutache: a narrow, flat braid usually affixed to the shoulders of men's outerwear

tagiyah (also taagiyyah): a men's small, round skullcap

teka: a woman's cloak sewn with vertical pleated panels that covers from head to foot worn as part of the chaadaree ensemble

thawb (also thob): a modern version of the kaftan that often includes finished cuffs and collars

tikka (also dikka): a trouser belt inserted into a drawstring-style waistband

velvet: a woven fabric produced by cutting loops of silk thread to form the pile

"watered" silk: a moiré pattern pressed into the fabric that resembles woodgrain

yataghan: a long, curved dagger

Legacies and Influences of Islamic Styles on Modern Fashion

The kaftan has been the most prevalent garment of the Islamic empire to have been adapted to modern Western dress. In addition, Hollywood's Arabian costume dramas—notably movies such as *The Sheik* in 1927 and *Lawrence of Arabia* in 1962—also have inspired fashion designers to create versions of the kaftan—usually spelled "caftan" in Euro-American press and advertising copy—for both couture and ready-to-wear collections. Since the early twentieth century, the kaftan has continually been reinterpreted as loungewear for both women and men, and even as women's eveningwear.

Hollywood has inspired fashion designers to create kaftans both as loungewear and eveningwear. Left, after-six caftan by Bill Blass, 1968; center, fringed caftan, 2008; right, men's embroidered caftan by Rudolph Moshammer, 1971.

Chapter 9

CHINA

Neolithic Period	Xia Dynasty	Shang Dynasty	Zhou Period	The Qin	Han Dynasty
Early settlements along the Yellow River basin Irrigation developed	Writing developed Bronze casting	Silk production Chariots used in warfare	Confucius d. 479 BCE Iron metallurgy developed	The Great Wall begun 215 BCE	Civil service established

c. 7000 BCE c. 2100 BCE c. 1600 BCE c. 1100 BCE c. 221 BCE c. 206 BCE c. 220 CE

Period of Disunity	Tang Dynasty	Weak interim dynasties	Song Period	Yuan Dynasty	Ming Dynasty	Qing Dynasty
Fragmented tribal kingdoms of the "Six Dynasties"	Reunification and expansion to the world's largest empire Woodblock printing developed	Weak interim dynasties	Gunpowder used in warfare Peking sacked by Genghis Khan 1215	Repressive rule by the Mongols Visit of Marco Polo 1275	The Forbidden City built in Peking Portuguese colony founded at Macao 1550	Manchu rule Revolution and abdication of the last emperor 1912

c. 220 c. 618 c. 907 c. 960 1280 1368 1644 1912

Modern Era

Japan occupation of China 1931–1945	Mao Tse-tung's "Cultural Revolution" 1949	President Nixon's visit to China 1972	China's first fashion magazine: *Shizhuang* 1979	China Garment Designer's Association founded 1993	Beijing's first Fashion Week 1997	2008 Olympics held at Beijing

THE THIRD GREAT CIVILIZATION OF ANTIQUITY

Like the early civilizations of Egypt and Mesopotamia, Neolithic China began to develop along a river basin, the Huang-ho, or Yellow River. By the middle of the third millennium BCE, according to traditional Chinese history, a monarchal governing system had been established. As with Egypt, the history of China is a history of its dynasties. Among the achievements of the early rulers were water conservancy and engineered irrigation. During the second millennium BCE, the kings of the Xia and Shang Dynasties consolidated the numerous regional agricultural communities of the northern territories into a single feudal state. Fiefs were established under a local aristocracy who governed a large, agrarian peasant class. Great strides in cultural development were made during this era. Chinese writing had been developed, and in a short period, literature emerged as a refined art during the Shang period, including a history of the dynasty's emperors. A money economy was created—with cowrie shells as a form of currency. Artisans mastered bronze casting and jade carving. Silkworm farming and silk textile production became a secret, state protected process.

185

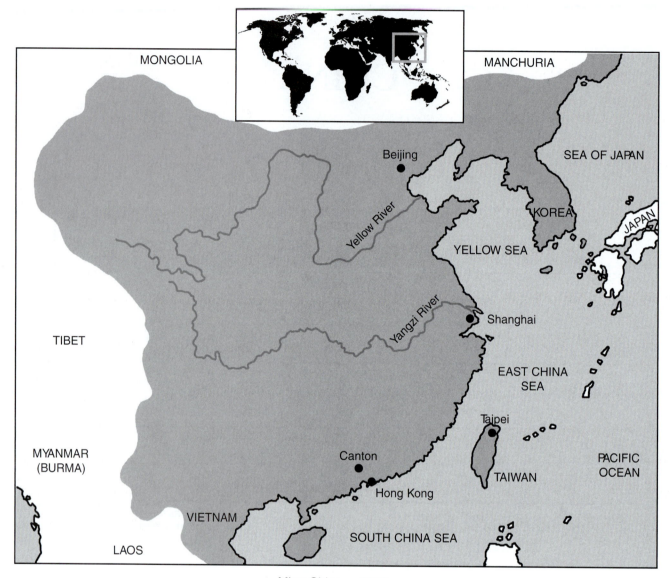

Ming China c. 1500

At the dawn of the first millennium BCE, the Zhou, a nomadic tribe from western regions, overran China and deposed the Shang. Although the Zhou were not military or cultural innovators, they expanded the empire with new conquests. Their tenuous hold over the Chinese feudal society led to the refinement of weaponry and war tactics. Iron replaced bronze for the manufacture of arms and armor. The crossbow was perfected and mastered by horse archers.

The Zhou were unable to sustain their control of the empire beyond the fifth century BCE. They constantly battled feudal warlords who themselves incessantly fought their neighbors for regional power and control. This "Warring States" period lasted almost 200 years, concluding when the warlord of the Qin province subdued his last rival and restored order in 221 BCE. The Qin ruler adopted the title Shih

Huang-ti, meaning "First Emperor." His accomplishments include expanding the empire south to encompass Canton and the vast Yünnan plateau, and building the first phases of the Great Wall.

When the First Emperor died, the imperial succession was challenged by several noble houses. Within three years Liu Pang, a warlord of the Wei Valley, succeeded in taking the throne establishing the Han Dynasty. The Han rulers instituted many cultural and legal reforms that would have a substantial, lasting impact on the Chinese people. The status of feudal lords was gradually diminished and power became centralized in the emperor. A competent civil service based on ability and training was formed. The Han conquered new territories including parts of Korea and Indochina. They undertook construction of new roads, canals, and irrigation

projects. To pay for their armies and building programs, the Han levied burdensome taxes that caused regional uprisings among the peasants. Professional armies divided the empire into three sections to maintain peace. When the last Han emperor died in 220 CE, the leaders of these armies ruled their provinces as independent states.

For the following 400 years, China remained a collection of petty states that relentlessly battled each other unsuccessfully for dominance. Around 589, Li Yuan, a local official of the house of Sui, supported by his son Li Shimin, formed an alliance with tribes from central Asia to subdue the warlords and, later, found the Tang Dynasty. The 300-year rule of the Tang emperors was one of China's most brilliant eras. Lost territories were recaptured including Korea and Indochina. New conquests extended Tang dominion over western territories as far as the Oxus River where they were halted by the Arabs who were carving out their own Islamic empire. By the eighth century, the Tang Empire was the largest the world had ever known. This was a golden age of Chinese culture, especially poetry and the visual arts. Woodblock printing allowed for the reproduction of books and the dissemination of standardized laws and regulations throughout the country. However, despite the enrichment of culture under the Tang rulers, imperial policies of the late ninth century led to unrest. Conscription labor forced a particular hardship on the peasant classes. Confucian bureaucrats and academicians instigated the destruction of thousands of Buddhist monasteries and communities, despoiling the temples of their wealth. When the last Tang emperor died in 906, the country was plunged once again into chaos, with rivaling warlords battling each other for dominance.

Finally, in 960, the house of Song emerged victorious and established the third of the great dynasties in Chinese history. The peace and prosperity provided by the Song emperors led to a second cultural renaissance. Government emphasis was on schools and education, from which the Chinese enjoyed one of the highest literacy rates in the world at that time. Experiments with movable type advanced printing technology. New forms of theater and literature were produced. Gunpowder was tested as an explosive for catapults in warfare. A special legacy of the Song Dynasty was the transition of Chinese society from its feudal Middle Ages to the modern society that would prevail until the end of the nineteenth century. Key to this transformation was the writings of Zhu Xi (1130–1200) that reinterpreted Confucianism and defined the orthodox view of Chinese society; that is, an ordered society has a well-defined hierarchy in which everyone knew his place and everyone made his contribution to the common good.

Despite a well-ordered society and the advances in warfare technology, the Song were unable to hold off the invasions of the fierce Mongols. In 1279, Kublai Khan completed a brutal conquest of China and established the Yuan Dynasty. Yet the Mongols were never secure in their hold on China, and almost immediately the Chinese people rebelled against their foreign rulers.

In 1356, Zhu Yuanzhang seized the southern provinces and began systematically to expel the Mongols. By 1368, he had succeeded in ousting the Yuan rulers from their capital in Peking and drove the Mongol forces to the northern borders of the old Song Empire. Zhu Yuanzhang then became the first emperor of the Ming Dynasty. The Ming restored Chinese orthodoxy, especially the scholar-bureaucrat class of the Tang and Song eras. Of literary importance was the completion of an encyclopedia in 1407 that compiled all past Chinese intellectual achievements, including official histories of previous dynasties. Trade with the West introduced new food crops such as the sweet potato and peanut. The capital was moved from Nanking to Peking where the Forbidden City complex of palaces was constructed. Later Ming emperors lived in seclusion in their palaces and allowed corrupt ministers to govern. By the seventeenth century, excessive and unequal taxation led to peasant uprisings. Armies were not paid. Bribery of officials became rampant. In 1644, a Manchurian tribal chief combined forces with the commander of the northern army to take Peking and overthrow the Ming.

Once again, a foreign ruling house, the Manchu, governed China. The Qing Dynasty remained in power by restoring and stabilizing the economic and political policies of the early phase of the Ming era. The Manchu maintained strict state control over all areas of Chinese life. By the beginning of the nineteenth century, though, a flood of Western traders and missionaries brought with them modern science, industry, and technology. Conflicts between the Qing rulers and foreign powers led to humiliating defeats and treaties for the government of China throughout the late 1800s. Finally, in 1912 the Chinese people revolted against the oppressive Manchus and forced the abdication of the last Qing emperor. After almost 5,000 years of monarchal rule, China became a republic.

CHINESE TEXTILES

At what point the Neolithic inhabitants of the Yellow River basin began to weave fabric is not known. Historians believe that the first woven materials for ancient Chinese apparel originated from the process of twisting hemp into cords to make baskets and other other utilitarian objects. Possibly around the mid to late third millennium BCE, the spindle was developed, and hemp was spun into finer threads that could be woven into a rough fabric somewhat akin to the coarse linen produced in Egypt and Mesopotamia at the time.

Wool is not thought to have been introduced into China until perhaps the late Shang Dynasty. Sheep and goat herding was first developed by the migrating tribes of Central Asia. Most likely, these nomads traded woven wool and raw fleeces with their agrarian neighbors farther to the east. Woolen fabrics and especially curried fleece were used as

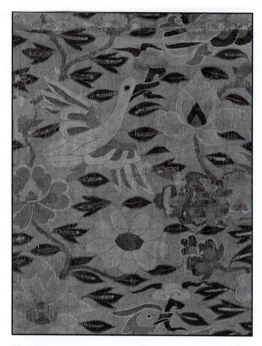

Figure 9-1. Silk production was first mastered by the Chinese during the Shang Dynasty. The earliest surviving examples date to around the twelfth century BCE. Silk damask fragment from Song Dynasty, c. twelfth century.

smuggled silkworm eggs into Constantinople and established silk production in the West. Although Byzantine silk textiles soon rivaled those of China in quality and design, Chinese silks were still eagerly sought by buyers throughout Europe and the Islamic empire.

Silkworm farming, called sericulture, is the ancient process of hatching the eggs of the Bombyx mori moths and raising the caterpillars, called silkworms. Since the caterpillars feed primarily on mulberry leaves, huge plantations were developed to meet the needs of sericulturists. Sophisticated techniques of plant grafting and leaf harvesting were mastered over the centuries, assuring a consistent supply of foliage for the millions of cultured caterpillars kept on farms. When at last the silkworms reach maturity, they spin a cocoon of a continuous filament of silk for the chrysalis stage. The sericulturist either kills the chrysalis with steam or carefully winds off the silk just before the moth would emerge. If the moth breaks through the cocoon, the silk thread is ruined. The most lustrous silk was produced from a live harvest of the filament, but timing had to carefully judged, and sufficient skilled labor had to be available.

Each silkworm cocoon will produce between ten and twenty feet of a single silk filament. About 600 silkworms are needed to produce about five square feet of woven silk. In ancient times, silk textiles were produced in two grades. A heavy stiff variety was called **luo**, and a thin, gossamer type was called **ling**. By the Tang period silk cloth was divided into several categories including **jüan** for damask, **duan** for satin, **rong** for velvet, **jin** for brocade, and **shou** for sheer weaves. Later, all of these classifications were further divided into subcategories based on pattern or form of weaving.

Textile patterns were applied in several methods. Damasks and brocades were woven with yarn-dyed threads to create raised designs on the surface of the fabric. (Figure 9-1.) Some polychrome patterns were produced by waxing parts of the fabric where color was not to take, similar to the way **batik** is produced today. Other designs were added to woven silk by stretching the fabric between two boards perforated with patterns into which dyes were applied somewhat like modern silkscreen printing.

CHINESE MEN'S COSTUMES

As is the case in most studies of ancient costumes, available sources do not provide a clear or comprehensive picture of Chinese dress of the earliest periods. The written descriptions in contemporary sources and the depictions in period artworks most often represent apparel of the Chinese ruling classes. The clothing styles of common people are often ignored in official records and are seldom featured with any detail in ancient works of art.

Throughout China's history, though, costume has been an inseparable component of ideology, politics, social hierarchy,

linings for clothing or household purposes such as carpets and bed coverings. The durability of wool was particularly useful for saddle rugs and temple hangings. Unlike in ancient Greece and Mesopotamia, wool was not the prevalent fabric for apparel in early China.

The cultivation of cotton was probably introduced from India sometime in the late first millennium BCE. Only centuries later, though, toward the end of the Ming Dynasty, did cotton replace woven hemp as the most common fabric for clothing of the masses. At present, extant examples of woven cotton are not known prior to the Song era.

Silk is the preeminent fabric most associated with Chinese clothing—both historically and today. Chinese legend holds that the use of silk as a textile fiber dates to about the middle of the third millennium BCE although no evidence has been found to support this legacy. The earliest fragments of silk fabric were found at Anyang and had been used as wrappings for late Shang era bronze vessels, perhaps dating to the twelfth or eleventh century BCE. It is also during this period that the written character for silk first appears in Chinese texts. From the earliest times, silk was an important trade commodity. The production of silk became a state monopoly of the early dynasties and its secrets were stringently guarded for centuries. During the sixth century CE, though, Byzantine monks who had been working in the silk farms of China

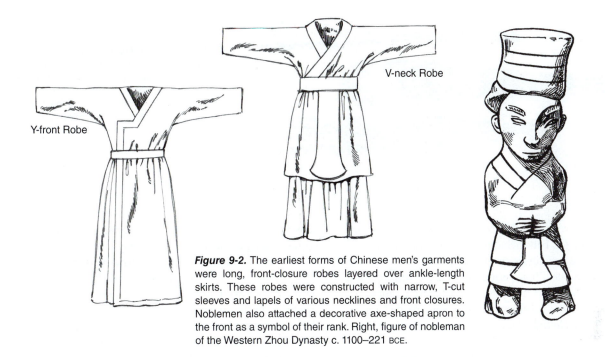

Y-front Robe

V-neck Robe

Figure 9-2. The earliest forms of Chinese men's garments were long, front-closure robes layered over ankle-length skirts. These robes were constructed with narrow, T-cut sleeves and lapels of various necklines and front closures. Noblemen also attached a decorative axe-shaped apron to the front as a symbol of their rank. Right, figure of nobleman of the Western Zhou Dynasty c. 1100–221 BCE.

and the military. Although thousands of regional costume variations have been created over the millennia, certain distinctive clothing designs and silhouettes can be identified with specific eras.

Since humans inhabited the region of modern China early in prehistoric times, historians extrapolate from the evidence found in Stone Age sites that the ancestors of the Chinese first dressed in wrap garments made of skins. Once the production of textiles was developed, it is surmised that basic wrap garments continued to be the primary type of clothing for possibly several centuries. From these simple wraps evolved the masculine, front-closure robe, probably in the Shang era. It is thought that, during the following Zhou period, this simple garment was refined to its classic silhouette. In the *Book of Rites of the Zhou* (the third century BCE copy of an earlier text), costume was codified as an instrument of social identity and status. In addition to styles of robes, certain textile designs and colors were set according to ceremonial rite. Each image or symbol had its own significance. For instance, designs of the dragon stood for decisiveness, mountains for stability, the tiger for loyalty, and rice for sustenance. These and hundreds of other symbols were worn in combination depending upon the ceremony or cultural event. The robes of the emperor may have been embellished with as many as twelve motifs, and the clothing of the nobility may have featured up to nine designs according to rank.

The style of robe that the Zhou nobility wore was most likely similar to that of the preceding Shang Dynasty

although surviving evidence of robe styles from the Xia or Shang Dynasties has not been found, and representations of the human figure in early Chinese art are usually too crude or too stylized to discern clearly the apparel construction. A number of jade figurines of noblemen from the Zhou era depict a costume that includes a knee-length robe layered over one or more long skirts. The front of the robe was decorated with an axe-shaped apron called a **fu**. (Figure 9-2.) Sleeves were narrow and T-cut rather than set in. In fact, the T-cut design would remain the style of construction for Chinese robes to the present time. The robes of the Zhou period featured wide **lapels**, or extensions of the collar, that edged the front openings of the robe, usually to the hemline. These lapels were cut on a diagonal to form a V-neck at the front when closed. Among the variants of lapel designs was one cut with a squared top edge resembling a "Y" with a foot that extended over the right breast. Both lapels and cuffs were lavishly embroidered.

The robe was girded by a wide leather belt called a **ge dai** or a silk sash called a **da dai**. By the last quarter of the first millennium BCE, a new type of wide girdle, the **gou luo dai**, became popular due to the addition of bronze or silver hooks for fastening the ends. These hooks, called **dai gou**, were cast in a wide variety of lengths ranging from an inch to almost a foot. They were inlaid with intricate patterns of gold or silver, sometimes combined with jade, turquoise, and other precious stones. (Figure 9-3.) Versions of the wide gou luo dai created for the imperial family and high ranking officials were superbly crafted and often embellished with pearls or

Figure 9-3. By the last quarter of the first millennium BCE, bronze and silver hooks called dai gou were attached to wide girdles for fastening the ends. Many were inlaid with intricate patterns of contrasting metals and precious stones. Dai gou, c. third to first century BCE.

gold and silver ornaments. For court dress, various pendants were hung from the belt including bronze mirrors, sheathed daggers, incense containers, or seals of office.

During the late Zhou period, around the fifth to third centuries BCE, two dramatic changes in Chinese costume occurred. First was the development of a long, one-piece wrap robe known as **shenyi**. Although layering skirts under a

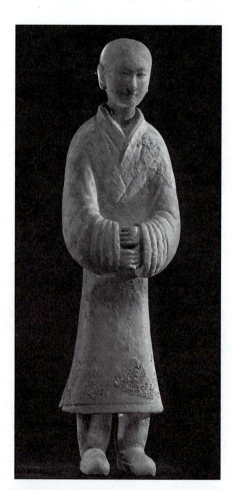

Figure 9-4. During the Han Dynasty, the one-piece wrap garment called the shenyi became a popular substitute for multiple layers of robes and skirts. Figure of nobleman of the Han Dynasty, c. 206 BCE-220 CE.

shorter robe continued to be a traditional feature of Chinese costume, the practical one-piece shenyi was adopted nationwide by the beginning of the Han Dynasty. (Figure 9-4.)

Among the Han style variations of the shenyi was the addition of the **xuren**, or extended lapel. (Figure 9-5.) The left front side of the shenyi was cut into a wide triangular point that was wrapped around the torso creating a spiral hemline. The point was girded in the front. The lapel was made of a contrasting color or textile pattern to emphasize the diagonal lines of the spiral wrap.

Sleeves of the shenyi also developed into assorted shapes and sizes quite unlike the narrow, close-fitting styles of earlier robe designs. The most prevalent forms were large, lantern-shaped sleeves gathered into wide cuffs usually made of the same contrasting fabric as the lapels. A bell-shaped variation of this sleeve style was cut with a huge, oval cuff with openings that could measure up to four feet wide and drape to below the knees.

The second innovative costume change of the late Zhou period was the introduction of **hu-fu**, an ensemble of long trousers and a short jacket robe. (Figure 9-6.) Exactly when and how trousers were introduced into Chinese costume is still debated among historians. Most likely, the practical use of trousers was an influence from the styles of the nomadic peoples of Central Asia like those worn by Cherchen Man featured in chapter 1. In the northwest territory, the Chinese warlord Wuling of Zhao is thought to be the first ruler to broadly effect dress reform by appropriating the hu-fu ensemble from his tribal neighbors to better suit the needs of his mounted archers. The close-fitting jacket and trousers eliminated the billowing sleeves and flapping skirts of wrap robes as the horsemen rode at full speed into battle while taking steady aim with their bows. Whatever the origins, by the close of the first millennium BCE, the hu-fu trouser ensemble was a common form of dress throughout China. The comfortable and practical hu-fu would remain popular, especially with lower classes and the military, for the following 2,000 years.

During the centuries of disunity following the end of the Han Dynasty, costume changes were minimal. As with many cultures in times of crisis, a look to the past often provided a

Figure 9-5. One variation of the shenyi that became popular during the Han Dynasty featured the xuren, or extended lapel. The left front of the robe was cut into a wide point that could be wrapped around the torso creating a spiral hemline. Both men and women wore the spiral-wrap shenyi.

Shenyi with an open
xuren, or extended lapel

Shenyi with xuren spiral-
wrapped and girded

degree of security in something familiar and certain. Chinese costumes of this time continued the traditions of the Han and Zhou Dynasties.

When at last the first emperor of the Tang Dynasty reunified the warring factions and restored order, revised guidelines for dress were published by imperial edict in 621. Class distinctions were reinforced by various clothing reforms. Crafts guilds, merchants' associations, medical societies, and trades organizations had hierarchal components of dress that identified the nature of their work. A new type of round-neck tunic replaced the front-closure robe as the prevalent garment for many segments of middle and lower classes. A restriction was placed on wide sleeves, reserving the extravagance for the nobility. Fabric colors defined rank among members of the Tang bureaucracy. Purple was designated for those of the higher ranks, red for upper middle ranks, green for middle ranks, and blue for the lowest ranks. One short-lived dress regulation for high-ranking officials was the **fish tally pocket**, a small leather or fabric bag attached at the waist. Inside the bag was carried a fish-shaped ornament made of copper or bronze that served as a pass when entering or leaving the palace or city gates. Since the eyes of a fish always remain open, the ornament also symbolized constant vigilance and devotion to the emperor's service.

So pervasive and effective were the costume reforms of the Tang era that styles of men's dress changed little for the following several centuries. The Song court maintained the basic silhouettes of men's round-neck tunics and shawl collar robes but extended sleeves to the largest ever—some reaching such an enormous width that the wearer had to keep his arms bent at the elbow to prevent dragging the cuffs on the ground. After the Mongols established the Yuan Dynasty, however, the exaggerated sleeves of the nobility were abandoned for the more familiar, narrow cuts of Han styles that had survived in remote provinces.

The next large-scale costume reform occurred in the reign of the Ming Dynasty emperor, Hongwu. The new regulations, disseminated throughout the empire in 1393, had taken almost twenty years to codify. Most of the costume changes were actually revivals of Tang and Song styles—a

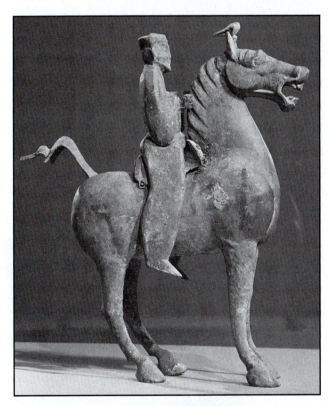

Figure 9-6. During the late Zhou Dynasty, the jacket robe and trouser ensemble was introduced. The style may have been influenced by clothing designs of Central Asia such as those worn by Cherchen Man featured in Chapter 1. Horse and Rider from Wu-wei, Kansu, c. third century CE.

reaction to the foreign tastes and styles of the occupying Mongols during the Yuan era.

Costume, once again, rigidly defined social status and official hierarchy. For important ceremonial rites, the nobility, ranking civil officials, and military leaders were required to wear various robes of red satin. Status was displayed by the number of white satin stripes attached to the wearer's headdress. One stripe was worn by bureaucrats of the lowest ranks, and up to seven were accorded officials of the highest station.

Another element of costume that denoted rank was an embroidered square fabric badge, called a **buzi**, that was applied to the front and back of an official's outer robe. This outer robe with its dual patches was known as a **ming-fu**. The badges depicted various birds as representations of status: the highest ranks wore the crane, the golden pheasant, and the wild goose; middle ranks wore the silver pheasant and the egret; and the lower ranks wore the oriole, the quail, and the flycatcher.

The ming-fu would remain a common regulation garment of the Chinese civil service into the early twentieth century. The student of costume history may recall a similar status applique, the tablion, attached to the cloaks of the Roman and Byzantine ruling classes. Unlike the cloaks of the West, Chinese robes opened asymmetrically and did not bisect the decorative patch in the front.

Nonceremonial public attire for the upper classes was usually a round-neck robe with a right front-closure that tied at the waist. An innovative silhouette of Ming robe design featured narrow extensions of fabric attached at the side slits. (Figure 9-7.)

During the Ming period, the emperor donned a specially decorated garment called a **chao-pao**, meaning **dragon robe**. Intricately embroidered roundels depicting a sinuous, writhing dragon were applied to certain prescribed areas of the garment. The dragon robe of the emperor had as many as twelve dragon roundels—three in the front and back, one at each shoulder and two at each side seam. Other ritual symbols were embroidered on the front skirt and sleeves, including stylized representations of water, fire, rice, and similar images relevant to ceremonial rites. In the later part of the Ming Dynasty and into the Qing, the dragon robe was worn by both men and women of the imperial family though these styles had fewer dragon roundels. (Figure 9-8.)

By the middle of the seventeenth century, invading Manchurian tribes succeeded in overthrowing the Ming and establishing the Qing Dynasty. Although the Manchu adopted much of the Ming culture, they introduced many of their native customs to the empire they now governed, including elements of their costume. For men, two key style innovations were popularized. An influence from the Manchu cavalry was the **ma gua**, a short, T-cut jacket that was worn over a robe and trouser ensemble. Versions of the ma gua were cut with hemlines ranging in length from the ribcage to the hips. Most unique of the Qing costume was the **ma-ti xiu**, or **horse hoof cuff**, attached to the sleeves of robes and tunics. (Figure 9-9.) Its ogee curve design resembled a horse's hoof in profile. Since the length of the cuff usually covered the hand entirely, it most often was worn turned back over the sleeve except for ceremonial or other formal functions.

Another influence of Manchu dress on Chinese costume was the ubiquitous use of buttons by almost all classes. Although forms of spherical button-and-loop fasteners had been selectively used on garments as early as the Han Dynasty, most Chinese robes were tied closed with ribbons at the right side or were simply wrapped closed and held in place with a belt or sash. The Manchurians most likely adapted the use of flat disk buttons from the Ottoman Empire possibly as early as the fifteenth century. By the eighteenth century, buttons and loops were common on both men's and women's clothing of all except the lowest peasant classes. Even today, Western-style buttonholes are rarely applied to traditional Chinese robes, tunics, vests, and jackets.

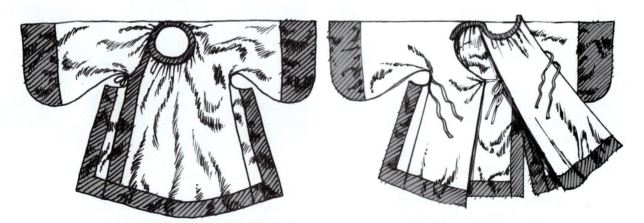

Figure 9-7. Variations in the silhouette of robes during the Ming Dynasty included narrow extensions of fabric attached at the side slits.

Figure 9-8. The imperial chao-pao, or dragon robe, featured embroidered roundels depicting a writhing dragon. Some dragon robes also included other symbols of the emperor's authority and duty to his people. Detail of scroll painting of Ming Emperor Yongle (1403–1425.)

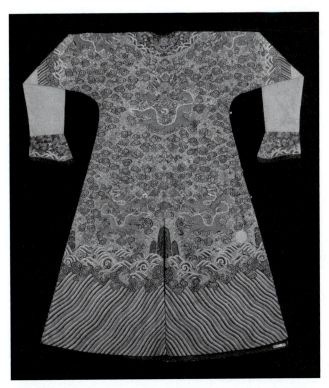

Figure 9-9. The horse hoof cuff of the Qing Dynasty was a unique addition to the design of Chinese apparel. Imperial dragon robe, c. early nineteenth century.

By the late nineteenth century, large numbers of Chinese men went abroad for education or business expansion. Breaking with the feudal codes of Qing tradition, these young men cut off their braided queues and adopted Western suits. Following the revolution of 1911–12, which ousted the Qing rulers, clothing reforms of the republic dismantled the Manchu costume regulations. The first significant step was to abolish the display of social status by clothing and headgear. Uniforms were prescribed for the military and civil servants. Professional men, teachers, businessmen, and especially the younger generation eagerly modernized their wardrobes with Western apparel. Yet despite the urging of the government, not all Chinese immediately—or completely—adopted Western styles of clothing. Instead, most men preferred adaptations of the traditional round-collar tunic of varying lengths and loose trousers, over which was worn a short vest.

When the Communists took over in 1949, the regime imposed upon the entire population the "liberation costume," called **jiefang yifu.** It consisted of a short, high-collar tunic that buttoned in the center front and loose-fitting trousers. Civilians wore dark blue or black, and administrators wore assorted shades of gray. As intended, this drab, utilitarian uniform eliminated all outward evidence of rank or even gender. Chinese costume historian, Adolphe Scott wrote, "This was a worker state and the new dress was decreed a fitting symbol of the new struggle." Barely a dozen years later, though, the severity of the liberation costume was assuaged by the easing of restrictions on textile colors and patterns for apparel. By the end of the 1950s, women mostly had begun to wear tunics and trousers made of soft colors and even petit-prints. Men—primarily the young—gradually began to experiment with Russian-made import shirts of subdued colors. Today, Western styles of clothing are as common as the traditional tunic and loose trouser.

MEN'S HEADGEAR

From the earliest times of ancient China, men wore their hair long. Indeed, one form of criminal punishment was to cut off the offender's beard and hair. For convenience, most men tied their hair back into a simple queue or at the sides in pigtails. More elaborate hairstyles of complex knots and plaits came to reflect the social status of the wealthier classes who had the leisure time and servants for such indulgences. Sometime during the Shang Dynasty, men began to attach extravagant hair ornaments of bone, wood, and jade to these sophisticated arrangements.

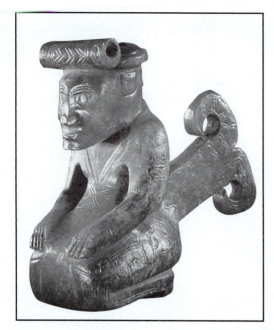

Figure 9-10. Complex designs of men's headgear evolved from extravagant hair arrangements of the Shang and Zhou Dynasties. Jade carving of kneeling man with cylindrical headdress, c. twelfth to eleventh century BCE.

At about the same time, complex designs of hats and headdresses developed as symbols of rank and for ceremonial purposes. The late Shang era figurine of a kneeling man wearing an ornamented hat shown in (Figure 9-10.) reveals how elaborate men's headgear had become by the end of the second millennium BCE. During the Zhou Dynasty, such styles of hats and headgear were codified by the state as a manifestation of etiquette and ceremony. For example, *The Book of Rites of the Zhou* established the tradition for the emperor and high-ranking officials to wear the **mian guan** when attending sacrificial rites. The mian guan was a cylindrical cap topped by a long board called a **yan** from which hung strings of jade beads. (Figure 9-11.) The number of strings varied according to rank. At each side of the mian guan near the ear hung a pearl or a pendant of jade known as **chong er**, meaning "stuffing the ear." These symbolized a refusal to listen to slander or malicious gossip.

The headgear regulations of the Zhou were further refined during the Han Dynasty. Besides maintaining versions of the mian guan, many new headgear forms were added. A small cap made of green bamboo bark, called a **chang guan**, was designed for civil officials to wear when making sacrificial offerings. The **wu guan**, a small cap adorned with martin's feathers, was worn by imperial attendants. The **fa guan**, a black cap with red stripes, was provided for judges and other high-ranking officials with the number of stripes denoting rank. Lower level functionaries who were not entitled to wear regulation hats wore instead kerchiefs that could be folded into assorted shapes.

Cage caps were introduced during the late Han Dynasty. These tall cylindrical caps were fashioned of lacquered black gauze through which could be seen the regulation cap of the official. Ear flaps that extended down the side of the head are believed to have originated as a device for preventing court attendants from whispering into each other's ear during court ceremonies. In Figure 9-11, both of the ministers who accompany the emperor wear the semitransparent cage cap.

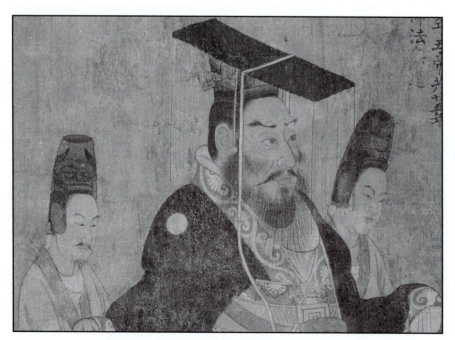

Figure 9-11. The mian guan was a ceremonial hat topped with a long, flat board decorated with strings of beads on each end. Pendants of jade or pearls hung at each side near the ears symbolizing the refusal to listen to slander. Detail of *Portraits of the Emperors* by Yen Li-pên, c. seventh century.

The prosperity of the Tang Dynasty led to new opulence and creativity in costume. The **fu tou** originated as an arranged kerchief stitched with four ribbon appendages. Two of the ribbons were looped and tied in the back, and the other two were looped atop the head and tied in the center. From this silhouette evolved the fu tou hat, featuring a hemispherical shape rising in the back and two gauze-covered "wings" where the back kerchief ribbons had once been tied. (Figure 9-12.) In later variations, especially during the Yuan era, the wings were replaced with rigid, straight tails that slanted downward in the back. The dome of the fu tou also was molded into new shapes, some rounded like a melon and others more conical.

In the late Ming and early Qing periods, the influence of Western hat styles introduced by European colonists and traders generated a host of new designs ranging from British "pork pie" hats with up-turned brims to corrugated caps that somewhat resembled modern lampshades. Rank was designated by the addition of a jeweled ornament in the center of the crown. Rubies, red coral, and sapphires were reserved for the highest ranks while lapis lazuli and crystal were for the lowest echelon. Another type of regulated decoration for hats of this period was the application of plumage and quills of various colors. The peacock feather, or **shang-ong**, was awarded for distinguished public service. The blue pheasant plume, called a **lan ling**, was a military decoration emblematic of the highest deeds of valor. One other element denoting rank was the addition of red silk fringe that radiated from the center ornament and spread over the crown of the cap.

These are but a few of the principal hat designs of the upper classes and government officials. Caps and hats of ordinary people were less regulated by imperial edicts. For centuries the peasants had worn wide brimmed styles for protection from the sun and elements while in their fields.

Shallow conical hats woven of rushes have come to symbolize the Chinese laboring classes. Craftsmen, tradesmen, and merchants usually wore variations of the **xiao-ma**, or small hat, a style that remained common until the Communist takeover in 1949. Some variants were plain skull caps made of silk while others were the "melon skin" version, which had a wider, brimless crown with a silk covered button on top. During the early Communist period, the only sanctioned style of hat was the soft peaked cap with a visor, sometimes called a **slouch cap** in the West. Following the 1960s, hats were more utilitarian than a specific component of costume.

MILITARY COSTUMES

China's earliest dynasties were feudal powers that struggled to maintain a centralized authority over warring states and continually fought off invasions from marauding border tribes. A well-provisioned standing army was required to ensure peace and order. According to costume historian Zhou Xun, the earliest forms of military costume were formed by simple garments constructed of animal hides, particularly rhinoceros and shark skins. By the Shang Dynasty, tunics and robes were made of the heavy lo variety of silk, reinforced with thick pads of cotton. For officers and military officials, plates of bronze forged in the scalloped shape of fish scales or willow leaves were applied over the breast of quilted outer garments. Officers also wore the **dou wu**, or round-domed helmet. The version shown at the left in Figure 9-13 was cast of bronze and included a fixture on the center top for attaching the tail feathers of birds of prey. The outside was ground smooth and highly polished, but the interior was left rough since it was padded with a lining of leather or fabric. The back was open and the depth was shallow, barely covering the ears. The iron dou wu shown at the right reveals an advance in technology from the earlier

Figure 9-12. The fu tou hat originated from styles of the regulation kerchief. The hemispherical shapes and the wings at the back evolved from looped ribbons that were once stitched to the earlier kerchief styles. Lacquered black gauze cap, c. ninth to tenth century.

Figure 9-13. The dou wu was a round-domed helmet worn primarily by officers. Early versions were a single cast bronze with open backs. By the Han era, helmets were cast of iron and reinforced with a layer of plates. The back was closed and cheek and nasal guards were added. Left, bronze dou wu, c. fifth to third century BCE; right iron dou wu, c. first to third century CE.

bronze style. In addition to the added protection of a **nasal**, or nose guard, the entire head was covered all around to a depth below the jawline.

Few early depictions of Chinese military costumes exist. A recently discovered bronze mirror from about the third to first century BCE is incised with crudely rendered silhouettes of warriors in battle. Most of the figures wear the hu-fu, or short robe and trousers ensemble, and what appears to be a close-fitting skull cap with a visor, somewhat like a modern baseball cap. The majority of the warriors posture with bows and arrows, although some carry long-handled battle axes and daggers. No shields are depicted.

The most detailed representations of ancient Chinese military costumes were carved on life-size terracotta statues for a Qin era emperor's tomb, c. 221–206 BCE. (Figure 9-14.) This army of 6,000 soldiers, horses, and chariots provide a

time capsule of military attire, hairstyles, accessories, and weaponry in precise detail. A number of variations of armor have been cataloged from the tomb site including long, wide armor for infantrymen and shorter, narrow armor for cavalrymen. For officers, iron scales were attached to a vest-like garment made of leather that fitted over the head and tied or buckled into place. Two types of metal scales were used in making this armor, fixed and movable. Fixed scales were attached to a solid metal underplate and usually covered the chest and back. Movable scales were applied to flexible materials such as leather or fabric and covered the shoulders, waist, and abdomen. The armor of officers was constructed with numerous small scales, some of which were arranged into intricate patterns. On the other hand, the armor of ordinary soldiers was affixed with large scales that were simplistically arranged to cover the most area with the fewest

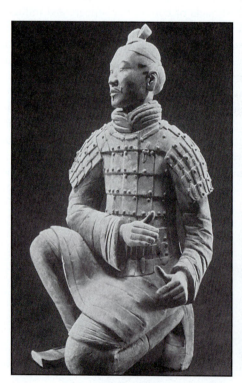 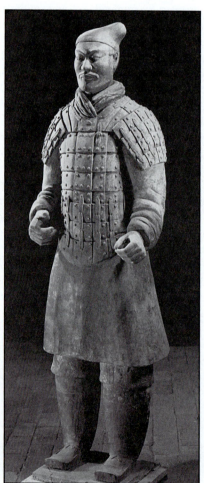 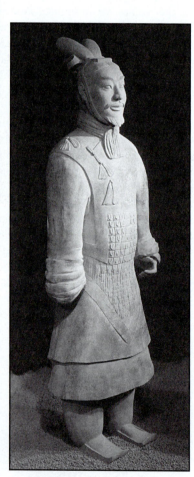

Kneeling Archer Foot Soldier Officer

Figure 9-14. From the Qin era through the Ming Dynasty, Chinese warriors donned armor constructed of iron scales affixed to leather or fabric garments. For the armor of officers, smaller scales were used, many of which were arranged in decorative patterns. For regular soldiers armor was made with large metal scales simplistically arranged to cover the most area with the fewest pieces. Terracotta figures from the Qin Shihuangti tomb, c. 221–207 BCE.

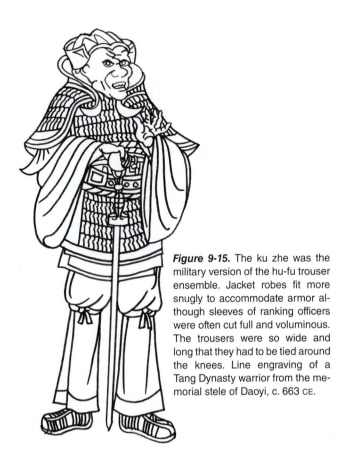

Figure 9-15. The ku zhe was the military version of the hu-fu trouser ensemble. Jacket robes fit more snugly to accommodate armor although sleeves of ranking officers were often cut full and voluminous. The trousers were so wide and long that they had to be tied around the knees. Line engraving of a Tang Dynasty warrior from the memorial stele of Daoyi, c. 663 CE.

pieces. So successful were these metal-scale garments that they remained the prevalent style of Chinese armor well into the Ming Dynasty when firearms and artillery made such accoutrement obsolete. By the Qing era, the metal plates of armor had been reduced to decorative patterns of brass, copper, or steel studs applied to thickly padded jackets and apron-like overskirts.

Besides the exceptional detail of armor, the soldier figures of the Qin Shihuangti tomb present a wide variety of military clothing. The most common is a variation of the hu-fu trouser and jacket ensemble called the **ku zhe**. (Figure 9-15.) The jacket robes fit more snugly than civilian styles so that armor could be pulled on and fastened easily and quickly. Sleeves for high-ranking officers were often cut full and voluminous. The trousers, though, for both officers and regular soldiers were exceedingly wide and cut so long that in many representations the feet are completely covered. To keep from tripping over the extended cuff hemlines, the trousers were tied around the tops of the knees with ribbons and the excess fabric pulled up to blouse over the bindings. As with the metal scale armor, the ku zhe remained a common style of military costume for centuries. During the Qing Dynasty, puttees replaced the ribbons of the wide-legged trousers.

Following the revolution of 1911–12, the republic adopted versions of Western military uniforms, including mixtures of elements from French, British, German, and American styles. In the 1930s, officers even emulated the Japanese and wore a fitted tunic with numerous patch pockets and jodhpurs with its wide flared thighs, close-fitting hips, and tapered calves. After the Communists came to power in 1949, the entire military, from high-ranking officers to the peasant draftee, dressed in the same high-collared tunic and trouser. By the 1950s, though, officers began to distinguish themselves from regular soldiers by plastering the breasts of their tunics with medals in the Russian manner. Today, the Chinese military uniform is based more on the Western model with all the insignia of rank and division.

CHINESE WOMEN'S COSTUMES

The earliest clear representations of women's costumes date to the Han Dynasty. Basically, feminine garments paralleled the cut of men's styles although with some subtle variations. Long robes that closed to the right front were the more prevalent attire for women of all classes. For women of higher social status, sleeves were capacious, and hemlines pooled into wide bell shapes around the feet. Spiral-wrap robes also became as popular for women as for men during this era.

Women also wore short jacket robes and trousers. Although the hemline of the robe usually extended to about mid-calf, civic regulations forbade women from wearing this ensemble as a ceremonial costume because it was regarded as casual and, therefore, disrespectful. In addition, a variation of the feminine trouser worn under the robe was a form of leggings, sometimes referred to as crotchless trousers. Stitched to the tops of these leggings were ribbons or cords that could be tied to a sort of garter belt at the waist to hold them up.

One of the remarkable innovations in Chinese women's apparel was the jacket and skirt ensemble that emerged as a distinct and common style of the late Han era. (Figure 9-16 and Color Plate 4.) Indeed, for the following 2,000 years, the combination of a jacket or tunic and a skirt remained the favorite costume for almost all women except those of the lowest classes who preferred the ease of trousers for their labors.

The jackets varied greatly in design dynasty to dynasty. Jackets that were worn untucked over the skirts had hemlines that ranged from a short cut above the natural waistline to a longer, fingertip length. Other jackets were basically short robes that were tucked into the skirts. The jacket shown in Figure 9-16 is belted just beneath the breasts and features wide half sleeves. It is worn over a short robe with long, narrow sleeves that extend over the hands beyond the fingertips.

The skirts were always wrap styles with a wide waist band and a sash sewn to each side for tying in place. The length of the skirt depended on where the woman preferred to wear the waist band. The most common variation was worn

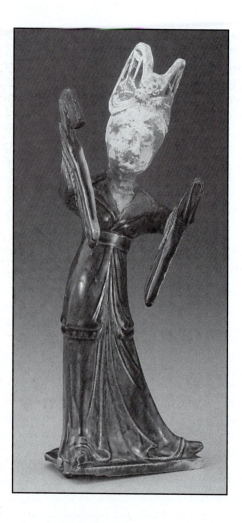

Figure 9-16. One of the remarkable innovations in early Chinese women's costume was the jacket and skirt combination. Jacket styles varied from short robe versions that were tucked into the waistband of the skirt to fingertip lengths worn out over the skirt. Jackets for court ladies featured sleeves that extended several inches beyond the hands. Skirts were invariably wrap styles with a sash sewn to each side for tying into place. Female dancer wearing layered jacket robes over a wrap skirt, c. ninth century.

high, covering the breasts and fitting under the armpits. Another method was wrapped around the torso just under the breasts. So pervasive was the wrap skirt that a great many extant versions have been found in gravesites dating from the Han era through to the Qing. Some styles are of silk gauze, designed to be worn as a layered sheer overskirt, while others are lined silk or satin to be worn singly.

Sometime during the Six Dynasties of the third to fifth centuries CE, costumes of court ladies were embellished with **xian shao**, meaning "beautiful ribbons and flying swallow-tails." (Figure 9-17.) The look was created by sewing overlapping triangles of fabric to the hem of a shortened outer skirt and extending the ribbons of the skirt's waistband to floor length or longer. As women walked, especially out of doors in a breeze, the silk triangles and ribbons of the **swallowtail costume** fluttered about them creating an ethereal appearance. In later versions, the ribbons were eliminated in favor of a long, ribbon-like cut of the triangles at the hem of the skirt. By the Tang Dynasty, court women returned to the jacket and skirt ensemble, relegating the swallowtail costume to dancers and theater performers.

From the Song into the Ming period, the prevalent costume for women was the jacket and skirt. Numerous variations of the jacket had developed including one with a closure at the center front from the Yuan era, which was retained by the new Ming dress regulations. Adaptations of the front-closing jacket evolved into knee- or calf-length overdresses. Some versions were made sleeveless or with half sleeves to reveal the contrasting colors and textile patterns of the under tunic or robe.

An unusual trend briefly popular during the seventeenth and eighteenth centuries was patchwork garment construction thought to be an influence from the theater. Overdresses called **shui tian yi**, meaning **paddy-field dress**, were made of assorted pieces of material stitched together in rectilinear shapes that resembled the segmented patterns of rice paddy fields.

The Manchus of the Qing Dynasty did not regulate women's costumes as stringently as the Ming. Except for ceremonial apparel, Han women were allowed to continue the traditional styles of their ancestors, which included almost any combination of jacket robes, trousers, wrap skirts, vests, tunics, and overdresses. Women of the royal family, though, were subjected to a strict observance of formal dress. In most instances, regulation wear was the jacket and skirt. One of the variations of the front-closure jacket introduced by the Manchu was a sleeveless vest cut with a large flap, called the **lute lapel**, that buttoned on the right over the center-front opening. (Figure 9-18.)

In the early years of the Chinese Republic, especially in the 1920s and 1930s, the most popular style of garment for urban women was the silk or satin **qi pao**, a simple sheath dress, usually with slits at the sides or in the front. Most had T-cut sleeves for daytime wear although Western style set-in sleeves became more common in the 1930s. Hemlines also followed the trends of European styles: knee-length in the 1920s, and midcalf in the 1930s. (Figure 9-19.) Sophisticated Chinese women dared to wear sleeveless versions of the qi pao for evening functions. For urban working classes and rural women, the basic trousers and tunic best served their lifeways. After the Communist revolution of 1949, women were required to wear the same chieh fang i fu, or liberation costume, as men. However, within just a few years, women led

Figure 9-18. A style of Manchu vest featured the lute lapel, which was cut with a large flap that buttoned to the right over the center-front closure.

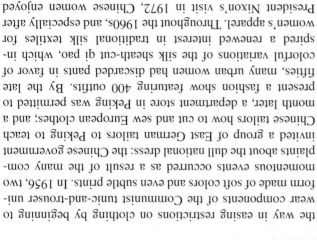

Figure 9-17. The xian shao, meaning "beautiful ribbons and flying swallowtails," featured an overskirt adorned with long ribbons and triangles of fabric stitched to the hemline. As women walked, the silk triangles and ribbons fluttered about them creating an ethereal appearance. Detail of scroll painting *Lady Feng and the Bear* depicting court lady wearing swallowtail costume, c. fourth century ce.

the way in easing restrictions on clothing by beginning to wear components of the Communist tunic-and-trouser uniform made of soft colors and even subtle prints. In 1956, two momentous events occurred as a result of the many complaints about the dull national dress: the Chinese government invited a group of East German tailors to Peking to teach Chinese tailors how to cut and sew European clothes; and a month later, a department store in Peking was permitted to present a fashion show featuring 400 outfits. By the late fifties, many urban women had discarded pants in favor of colorful variations of the silk sheath-cut qi pao, which inspired a renewed interest in traditional silk textiles for women's apparel. Throughout the 1960s, and especially after President Nixon's visit in 1972, Chinese women enjoyed greater access to a myriad of imported Western ready-to-wear separates, coordinates, sportswear, dresses, and suits.

WOMEN'S HEADDRESSES, SHOES, AND ACCESSORIES

Women of ancient China arranged their long hair in queues, plaits, and knots as elaborate as those of men. One difference between the sexes was that women of upper classes often used false hair pieces, particularly strands attached to twin braids that hung over the shoulders as long as the knees. They also adorned their hairstyles with a variety of ornaments and pins made of wood, bone, or jade, according to their station. Stylized representations of women from as early as the Shang

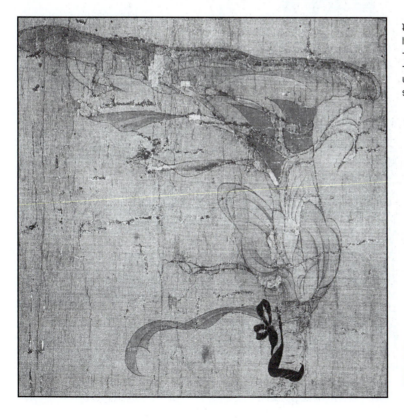

Dynasty depict symmetrically arranged hairpins with large, ornate carvings on the ends. Many of the actual hairpins discovered in early tombs were carved into geometric shapes symbolizing various birds or feathers. By the Zhou era, recorded ceremonial regulations included a rite of passage for young women in which they received a special set of hairpins indicating they had come of age and were betrothed.

During the Han period, aristocratic women began to wear the **bu yao**, a hairpin ornament from which dangled pendants or strings of beads. By the Ming Dynasty, the bu yao was called the **kingfisher feather hairpin** because it had become elaborately tiered with multiple strands of jewelry that shimmered like the iridescence of the Paradise Kingfisher's feathers. (Figure 9-20.) These pendant-type hairpins survive today in certain traditional ceremonial costumes such as wedding headdresses.

Also during the Han Dynasty, women adapted versions of the men's cage cap for ceremonial functions. The tall, black lacquered gauze styles of women's cage caps were almost identical to those worn by the ministers in Figure 9-11. On the other hand, the two-tiered design shown in Figure 9-12 was reduced in size to sit atop women's elaborately arranged hairstyles rather than fit around the crown of the head.

Unless a regulatory code required a hat, though, most women preferred to wear their hair in sumptuous coiffures ornamented with pins, jewels, and silk flowers. Records of the Tang era describe numerous hair arrangements including the "fairy-viewing bun," the "happy-travelling bun,"

Figure 9-20. The kingfisher feather hairpin was ornamented with multiple tiers of jewels.

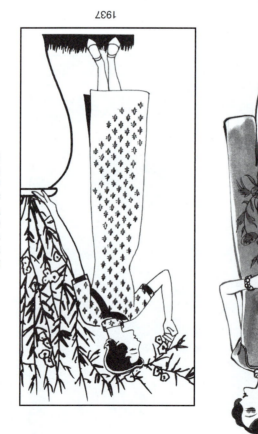

1937

1928

Figure 9-19. In the decades following the revolution of 1911–12, Chinese women adapted traditional garment details and motifs to silhouettes of Western dresses. The qi pao was a sheath-like dress often made with a round collar and side or center slits. Hemlines also followed the trends of European fashions.

the "obedient bun," the "worried bun," the "lingering bun," and the "lily bun," to name a few. By the Song Dynasty, wire frames were incorporated into hair arrangements to build towering headdresses of flowers over a mound of hair called a "heavenward bun." Pomades were applied to the hair to add sheen and fix the strands into place about the wire structures.

Wire headdresses, high hairstyles, and attachments of false buns remained common practices through the Qing period. Variations occurred with each succeeding dynasty. For example, aristocratic Mongol women of the Yuan era attached a two-foot high, flat wire structure, called a **gu gu guan**, to the back of their coiffures that was wrapped in satin or silk and decorated with pheasant feathers or willow branches. Similarly, the Manchu women of the Qing Dynasty introduced the **liang pa tou erh**, or **two-handle headdress**. (Figure 9-21.) Originally, the batwing shape was created by twisting strands of hair around a horizontal wire frame topped by a gilded "handle" with rounded ends. Later versions expanded the frame to over a foot wide and covered the wire with black satin decorated with silk flowers and jewels. Styles of these wire headdresses survived only in the traditional theater following the founding of the republic in 1912.

Women's shoes of ancient China were divided into three categories: **xi**, or best shoes; **jue**, or everyday shoes; and **xie**, or boots. Xi were primarily worn on special occasions and

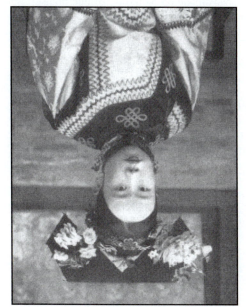

Figure 9-21. The two-handle headdress was unique to the Manchu women of the Qing Dynasty. The batwing shape was created by a wire frame that supported a gilt, rounded-edge stick at the top. The frame was covered with black satin and decorated with silk flowers. Photo of Princess Tsaizhen, c. 1910.

ceremonies. Ancient styles were made with wooden soles and silk uppers. Jue were usually sandals made of hemp or reeds. A thin-soled house slipper was also included in this category. Leather boots originated with the nomadic peoples of the western plains and were mostly worn by men, especially in the military. Similar styles of boots were made of silk for aristocratic women to wear in cold weather or when traveling.

By the late Han Dynasty, a new footwear design, called the **cloud-patterned-toe shoe**, was developed for the ceremonial costumes of both women and men of high rank. (Figure 9-22.) The name derives from exaggerated toe caps that usually were padded into a scalloped contour resembling stylized clouds. These decorative toe caps protruded from beneath the hemline of the robe. Because of the richness of the fabric coverings, especially lavishly embroidered silk or multicolored brocade, and the ornamental toe caps, these styles of footwear were also called "treasure-patterned shoes."

The cloud-patterned-toe shoe was replaced during the Yuan Dynasty, when Mongol styles of curled toe shoes and boots were adapted to official ceremonial dress. Despite the revivals of Tang and Song costume styles during the Ming era, the curled toe shoes remained the preferred footwear.

Although the Manchu conquerors who founded the Qing Dynasty adopted much of the Chinese culture of their predecessors, foot-binding was not accepted. Nor did the Manchu force Han women to discontinue the practice. The unique style of women's footwear introduced by the Manchu was the **stilt platform shoe.** (Figure 9-23.) A modern block was carved with concave sides of varying shapes and affixed to the sole of the shoe. Most stilt platforms were painted white although the upper parts of the shoe were made of colorful silk or satin brocade. Costume historian Adolphe Scott suggests that the stilt platform style developed as a class and ethnic distinction so that Manchu women could stand above native Chinese women. Since the Manchu were originally from the rainy north, it is more likely that the design originated from the practical function of keeping the feet and skirt hems dry.

Like so many traditional costume styles of China, the platform shoe disappeared from use, except in the theater, in the years following the 1911–12 revolution. Inexpensive, mass-produced Western shoes quickly flooded stores and marketplaces along with Western styles of ready-to-wear, lingerie, and accessories.

MODERN CHINESE FASHIONS

With the reopening of economic relationships in 1972 with the United States and the death of Mao in 1976, attitudes toward dress for both women and men became even more relaxed. Both began to wear brighter colors and bolder textile patterns. Accessories were accented with English words like "happy" or "beautiful" rather than "serve the people." Throughout the

1980s and early 1990s, the Chinese went through a period of unprecedented experimentation with dress style. China's first fashion magazine, *Shizhuang*, was published in 1993. In 1979, the China Garment Designer's Association was established to promote the work of mainland designers through fashion events and international trade shows. The organization's Golden Scissors Award is comparable to the Cory. In 1997, the China Garment Designer's Association joined with the manufacturing and retail division, the China Garment Association, to launch the first annual Beijing Fashion Week as an international stage for Chinese fashion and to "promote competitiveness in the Chinese garment industry." By the beginning of the twenty-first century, nearly fifty Chinese universities were offering degree programs in fashion and textile design. More than 1,000 factories were installed with computer-aided design systems (CAD) to maximize mass production and manufacturing efficiency.

Foot-binding and the Golden Lotus

At what point in Chinese cultural history foot-binding originated is not clear. One legend holds that the favorite concubine of a Han period emperor had such tiny feet that envious court ladies began to bind their feet and the feet of their young daughters. The first documented reference to bound feet is from the Tang Dynasty in the tenth century in which the court women were celebrated for their tiny feet and beautiful shoes.

Methods of foot-binding were neither standardized nor universally practiced. At about the age of three a girl's feet were tightly bandaged forcing all but the big toe to curl under, breaking the bones to create a high-arched instep. The final compressed form of the foot was called jinlian, or golden lotus, which was ideally less than four inches in length.

Much has been written about why women were such willing practitioners of this painful, deforming custom. In Chinese society, the Neo-Confucian ideas of the dynastic eras glorified virtuous women. This cult of female chastity inculcated women with the concept of the "mindful body" and the control and concealment of pain as the embodiment of civility. Foot-binding thus reflected some of the highest standards of civility since young girls were taught to endure the suffering caused by foot-binding, but the resulting disabled feet were ritualistically scented, powdered, and then concealed by bindings, socks, special shoes, leggings, and layers of skirts.

Women who bound their feet wore specially shaped shoes that resembled a tiny half-boot with a narrow, pointed toe. Most styles had a platform heel that caused further discomfort by forcing women to walk forward on their bent, crushed toes.

The discipline of foot-binding embodied a refinement and class distinction that became widely practiced by women throughout China who aspired to elite status. Women of the upper classes who bound their feet could hardly walk unattended, and became largely confined to their quarters. Consequently, they were believed to be rendered incapable of succumbing to infidelity. A folk rhyme of the nineteenth century supports this notion: "Bound feet, tiny feet, past the gate can't retreat."

Only ethnic groups, peasants, and the lowest laboring classes were exempt from the tradition of foot-binding. Poor women who needed to work in rice fields, tea farms, and silk factories could not afford to be crippled.

Attempts to ban foot-binding first emerged during the late nineteenth century, but the custom was only officially outlawed in 1911. A rigorous education campaign by the newly formed Chinese Republic explained to the masses the health advantages of natural feet. Furthermore, asserted the government, China was losing face in the eyes of the world by being ridiculed as backward and weak. The campaign was so successful that the centuries-old practice of foot-binding was eradicated within a single generation.

Figure 9-22. The cloud-patterned-toe shoe was a ceremonial slipper worn by both men and women. An exaggerated toe cap was made with a scalloped edge, resembling a stylized cloud.

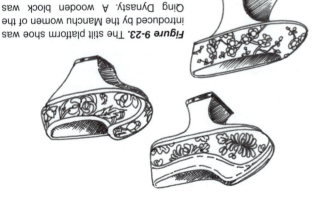

Figure 9-23. The stilt platform shoe was introduced by the Manchu women of the Qing Dynasty. A wooden block was carved with concave sides of varying shapes and affixed to the soles of shoes.

The big question, though, was posed in an article header by the *International Herald Tribune* in 2004: "Can the Chinese make the big leap onto the world stage of design?" That same year, when Giorgio Armani made his first trip to China, a journalist asked him to name his favorite Chinese designers or labels, to which he could only shake his head and admit he did not know the name of any.

Much has been written in the fashion press of China's struggle with a fashion identity. Style tastes and apparel fits are not the same in China as they are in the West. Chinese design- ers brilliantly modify Western styles to suit the domestic mar- ket, but "when they take their own designs abroad, it still does not work out," observed Tony Xiaoming Zhang of Shanghai- based Newel Apparel. Although China dominates the world's mass production side of the apparel industry, and despite the various efforts of government agencies to promote China's fashion designers, even the most optimistic advocates of their nation's fashion industry admit that change and progress are slow. Gradually, Shanghai is emerging as the creative fashion capital of China, but industry leaders think it will take many more years of cultivating creative design talent and aggressively marketing the products of that talent to make it a worldwide fashion center on a par with Paris, Milan, New York, and Tokyo.

REVIEW

The Neolithic settlements of the Yellow River basin gradually developed into the world's third great civilization of antiq- uity. But while the ancient civilizations of Egypt and Mesopotamia vanished, that of China endured. Today, the people of China can claim the oldest continuously recorded history in the world. As with Egypt, that history is measured by its dynasties. From the second millennium BCE until the establishment of a republic in 1912, the Chinese people were subjects of an imperial feudal society with all the trappings of a hierarchal order, including regulations of dress.

The earliest textile clothing styles of the Chinese were wrap garments, most likely made of coarse materials woven from hemp fibers. Sometime during the Shang Dynasty, silk production was mastered and became a state monopoly. At about the same time, simple wrap garments evolved into so- phisticated robe styles made with complex lapel and sleeve constructions. For centuries, both men and women wore sim- ilar versions of layered robes. By the late Zhou period, new types of garments appeared. Trousers, which may have been introduced from the nomadic peoples of Central Asia, were adopted by both men and women. During the Han Dynasty, the skirt and top ensemble emerged as the most popular cos- tume for women, and it would remain the favorite of all but the lowest peasant classes for the following 2,000 years.

Across every dynasty, costume was a key signifier of of- ficial rank or social station. In each era, virtually every aspect of apparel was strictly regulated by imperial decree. Almost all garment styles, accessories, textile colors, symbolic imagery, trimmings, and ornamentation were codified by function, rank, and gender. For example, the official patches on the ming-fu robes of ranking bureaucrats depicted specific birds according to one's station. Similarly, the jewel or ornament af- fixed to the crown of an official's cap designated rank and duty. Ceremony also governed costume styles. When holding court, the emperor wore the dragon robe, which was embroi- dered with symbols of his authority and responsibility to his people. For sacrificial rites the imperial family and nobility wore cloud-patterned-toe shoes that symbolized a divine connection with the heavens. Other examples of ceremonial dress included robes embroidered with sacred animals such as the tiger, python, and mythical phoenix, or headdresses embellished with plumage from the crane, symbol of longevity, and the pheasant, symbol of hope.

It took two revolutions—one for the republic in 1911 and one for the Communist regime in 1949—to sever the feudal order and tradition of both society and costume. Over its 5,000-year history, Chinese costume had helped preserve na- tive traditions and perpetuated the most enduring cultural identity the world has ever known. This pageantry of silks and satins, embroidered dragons, painted phoenixes, and jewelled headgear is a lasting testament to the remarkable civilization that fostered its development.

Chapter 9 China
Questions

1. What is sericulture? What is its process? How does it relate to Chinese costume history?

2. Identify the most common style of Chinese garment worn by both men and women during the earliest dynasties. What were the unique qualities of the garment's construction?

3. What were the two dramatic changes in Chinese costume that occurred during the late Zhou era?

4. Name four reasons for the official regulation and codification of Chinese costume by most imperial dynasties.

5. Which two foreign dynasties governed China? Identify changes in Chinese costume influenced by these foreign conquerors.

6. Identify five elements of Chinese men's headgear that had symbolic purposes. Specify the symbols and their significance.

7. What was the primary distinction between the construction of the armor of Chinese officers and that of regular soldiers?

8. What was the most prevalent Chinese women's costume of the past 2,000 years? Why is this costume variety notable in costume history?

9. Identify and describe three unique elements of Manchu women's costume during the Qing Dynasty.

Chapter 9 China
Research and Portfolio Projects

Research:

1. Write a research paper on imperial regulatory codes that governed Chinese men's and women's dress. Explore the evolution of the restrictions and privileges across the dynasties and the differences prescribed for class and gender.

2. Write a research paper comparing and contrasting the trouser costumes of the Tarim Basin people (see chapter 1) with the styles of the early Chinese. Note construction, textiles, woven patterns, dyes, trimmings, and accessories of each culture.

Portfolio:

1. Find illustrations of five different qi pao dresses from vintage Chinese (or Chinese-American) catalogs, magazines, or museum collections dating prior to 1960. Sketch modern reinterpretations of each qi pao in color using the key design, construction, and decorative elements of each vintage design you choose. Update each of your designs with modern lines and fabrics while still retaining the flavor of Chinese style. Include a photocopy or digital scan of the vintage model, and label each with the source and date.

2. Construct a life-size model of a mian guan (nobleman's ceremonial hat) and a liang pa tou erh (Qing two-handle headdress for women). Use craftshop materials to ornament each according to prescribed Chinese customs. Demonstrate for the class how each was worn.

Glossary of Dress Terms

batik: a method of dyeing fabric in which sections that are not to be colored are coated with a water-resistant substance

bu yao: a woman's hairpin ornament from which dangled pendants or strings of beads

buzi: an embroidered square badge attached to the front and back of an official's robe

cage cap: a tall, cylindrical cap made of lacquered gauze worn by both men and women

chang guan: a small cap made of green bamboo bark for officials to wear during sacrificial rites

chao-pao: the dragon robe of the imperial family

chong er: pendants of jade or pearls that hung at the sides of the mian guan symbolizing a refusal to listen to gossip

cloud-patterned-toe shoe: ceremonial shoes with large, scalloped-edged toe caps resembling stylized clouds

da dai: a silk sash for men's robes

dai gou: metal hooks attached to belts for fastening the ends

dou wu: a round-domed bronze or iron helmet worn by officers of the early dynasties

dragon robe: an imperial garment decorated with embroidered roundels depicting a dragon

duan: satin fabric

fa guan: a black cap with red stripes worn by judges and other high-ranking officials

fish tally pocket: a small leather or fabric bag containing a fish-shaped ornament that served as a pass for officials

fu: an axe-shaped apron attached to the front of men's robes in the Shang and Zhou Dynasties

fu tou: a masculine cap featuring a split hemispherical design with one round shape for the crown and one rising higher in the back

ge dai: a man's wide leather belt

gou luo dai: a man's wide girdle affixed with metal hooks for fastening the ends

gu gu guan: a high, flat wire structure affixed to the back of women's coiffures of the Yuan Dynasty

horse hoof cuff: a flared cuff design that resembled a horse's hoof in profile

hu-fu: an ensemble of long trousers and a short jacket robe worn by both men and women

jiefang yifu: the Communist "liberation costume" consisting of the same style of high-collared tunic and loose-fitting trousers for both men and women

jin: silk brocade

jinlian: meaning golden lily, the name of the deformed woman's foot resulting from binding

jüan: silk damask fabric

jue: the everyday shoes worn by middle and lower classes

kingfisher feather hairpin: a woman's elaborately tiered hairpin made of multiple strands of jewelry

ku zhe: a military version of the hu-fu that featured a snug-fitting jacket robe and baggy trousers tied about the knees

lan ling: a blue pheasant plume adornment awarded to soldiers for the highest deeds of valor

lapel: an extension of the collar that is variously folded against the breast

liang pa tou erh: a Manchu woman's batwing-shaped headdress of the Qing Dynasty

ling: a thin, gossamer silk fabric

luo: a heavy, stiff silk textile

lute lapel: a sleeveless vest cut with a large flap that buttoned across the center-front opening

ma gua: a men's short, T-cut jacket worn over a robe and trouser ensemble

ma-ti xiu: the horse hoof cuff on robes and tunic of the Qing Dynasty

mian guan: an imperial ceremonial cap topped with a flat board from which hung strings of beads

ming-fu: the robe of an official to which was stitched an embroidered fabric badge of rank

nasal: a strip of metal attached to a helmet to protect the nose

paddy-field dress: a woman's overdress made of assorted pieces of material stitched together in shapes resembling the segmented patterns of rice paddy fields

qi pao: a simple sheath dress of the early twentieth century, usually with slits in the sides or front

rong: silk velvet

shang-ong: a peacock feather adornment for men's caps signifying distinguished public service

shenyi: a long, one-piece robe worn by both men and women

shou: sheer silk textiles

shui tian yi: a woman's paddy-field dress, which was made of patchwork material

slouch cap: a soft peaked cap with a visor worn during the early Communist era

stilt platform shoe: shallow slippers attached to high, carved wooden platforms worn by Manchu women of the Qing Dynasty

swallowtail costume: an overskirt trimmed at the hem with long triangles of fabric and long ribbons

treasure-patterned shoes: ceremonial shoes of men and women made of rich embroidery or brocade

two-handle headdress: a woman's headdress made of a horizontal wire frame and gilt stick over which was draped black satin

wu guan: a small cap adorned with martin's feathers worn by imperial attendants

xi: an individual's best shoes, usually worn only for special occasions and ceremonial rites

xian shao: a woman's swallowtail costume that featured long ribbons and triangular pieces of silk sewn to the hem of a shortened overskirt

xiao-ma: various types of men's small caps including silk skull caps and brimless "melon skin" hats

xie: any of a variety of men's or women's boots

xuren: a wide, pointed extension of the left lapel that wrapped around the torso creating a spiral hemline

yan: a cap board affixed with strings of beads denoting rank

Legacies and Influences of Chinese Styles on Modern Fashion

World events often focused the attention of Western fashion designers upon the costumes of distant lands. Following the overthrow of the last Qing emperor in 1912, Chinese-inspired designs repeatedly appeared in Western fashions throughout the teens and twenties. In 1949, the Communists took over in China and once again the ancient culture of the East was brought to the world's center stage. In his 1951

collection, Christian Dior featured the round, open front mandarin collar, box jackets, and cone-shaped "coolie" hats. Similarly, when Richard Nixon went to the People's Republic of China in 1972 to begin a normalization of relationships, fashion designers and interior decorators incorporated motifs and silhouettes of Chinese design into their work for years to come.

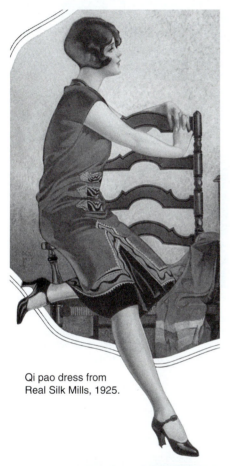

Qi pao dress from
Real Silk Mills, 1925.

The so-called "coolie" hat of the early 1950s was an adaptation of the Chinese peasant's field hat. Veiled felt hat by Hattie Carnegie, 1951.

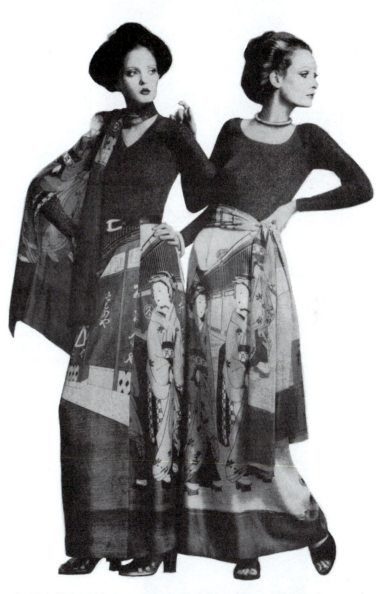

In 1972, Richard Nixon made an epochal visit to China and began the normalization of relationships that had ceased with the Communist takeover in 1949. Soon afterward, many Western designers were inspired to incorporate Asian motifs and silhouettes into their collections. Silk chiffon wrap skirts by Hanae Mori, 1974.

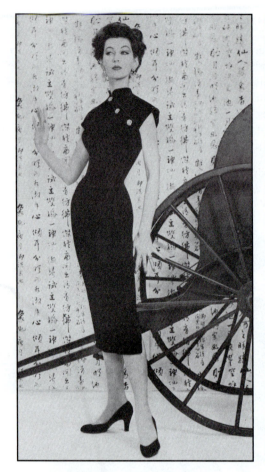

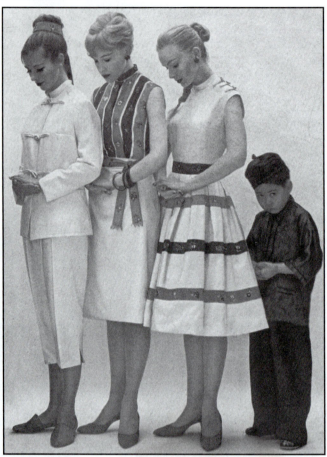

Throughout the 1950s, the constant notoriety of Communist China in Euro-American media and political arenas inspired Western fashion designers to adapt elements of traditional Chinese costume such as the mandarin collar. Left, rayon velvet qi pao by Suzy Perette, 1955; right, mandarin collar tops from Junior House, 1959.

Qiana nylon evening gown by Gene Berk, 1973.

Chapter 10

JAPAN

Jomon Period	Yayoi Period	Kofun Period	Nara Period	Heian Period
Neolithic settlements Rice cultivation Pottery and finger weaving	Silkworm farming Manufacture of silk textiles Hierarchal social order	Burial mound building	State-sponsored Buddhism	Literature in the newly developed Japanese script
c. 1500 BCE	c. 300 BCE	c. 300 CE	c. 710 CE	c. 794 CE / c. 1185 CE

Kamakura Period	Muromachi Period	Edo Period	Modern Japan			
Warrior rule of the shoguns	Noh theater Coinage introduced Invasion of Okinawa 1609	Expulsion of Westerners; withdrawal into isolation Perry landed at Yokohama 1854	Restoration of imperial rule 1868	War with China 1895	Russo-Japanese War 1904–5	Tokyo Olympics 1964
				Annexation of Ryukyu Islands 1879	China-Japanese War 1937–45	
1185 CE	1333 CE	1615 CE	1868 CE			

AN ISLAND CIVILIZATION

The first peoples to migrate to what is today the island nation of Japan are believed to have crossed land bridges from Asia during the last great Ice Age about 30,000 years ago. Following the submersion of the land bridges, later peoples migrated to the islands of the Japanese archipelago by boat. Over the subsequent millennia, these hunter-gatherers subsisted in isolation from the Paleolithic advances achieved on the mainland. Between about 1500 and 1000 BCE, new populations from Korea and China introduced a Neolithic culture that included communal settlements, rice cultivation, fishing with nets, and pottery manufacture. The name for this period—Jomon—actually means pottery decorated with cord-markings.

Beginning around 300 BCE, and continuing sporadically for the following few centuries, new waves of migrants fleeing the turmoil of the mainland introduced bronze and iron metallurgy, the potter's wheel, sericulture, and silk weaving. This was the Yayoi era, so named because of an early archaeological site that yielded artifacts from that time. The Yayoi peoples profoundly changed the culture of the island. They established hierarchal social orders led by war chieftains. Advanced iron weaponry brought in from the continent allowed for easy conquest of the indigenous peoples. By the end of the period, around 300 CE, political consolidation had led to the emergence of an emperor, the mikado, and the first identifiable Japanese state.

The Kofun Period is named for the practice of burying emperors and nobles in huge earthen mounds, called kofuns. At this time, diplomatic and economic ties with the Chinese led to the introduction of new technologies in arms and armor and the importation of horses and oxen.

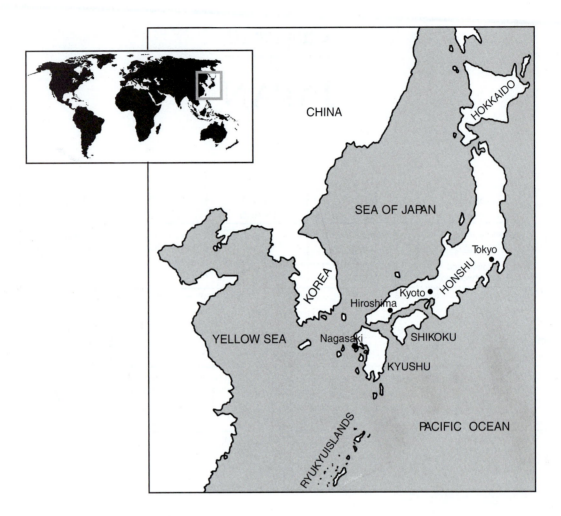

The following era, the Nara Period, is defined by the establishment of an imperial capital in the city of Nara modeled on the Chinese Tang court. In addition to the socio-economic influences from China, Buddhism became the state-sponsored religion in Japan and rapidly spread throughout the country.

In 794, the emperor moved the capital from Nara to Heiankyo, for which the Heian period gets its name. The hereditary imperial family strengthened its authority by sharing power and privilege with an educated aristocratic bureaucracy and wealthy Buddhist monasteries. Modern historians refer to the Heian Period as Classical Japan. Anthologies of poetry and chronicles of history were written in a newly developed Japanese script. Painting became increasingly secular, and painted scrolls were avidly collected by the nobility. New processes for creating exquisite slipware ceramics and decorative glazes were developed.

Between the eleventh and twelfth centuries, the Japanese feudal order shifted from centralized imperial governance to a fragmented warlord control. These petty warlords, or shoguns, were supported by fiercely loyal bands of warriors called samurai, a name meaning "to stand at the side of." In 1185, a powerful shogun established a military government at Kamakura. The weakened imperial court endured even as the shoguns ruled.

At the beginning of the fourteenth century, a series of ineffectual Kamakura shoguns lost control of their vassal warlords, and civil war once again erupted throughout the country. In the north, a dynasty of chieftains from the Hojo clan succeeded in gradually subduing the warring factions and consolidating authority over most of the region. Within three generations, the Hojo family had assumed the mantle of shogun and established a military capital at Muromachi.

During the Muromachi era, improved methods of agriculture and food supplies caused a surge in the population. As a result, a new consumer economy developed, bolstered by the introduction of coinage. Cultural achievements during this medieval period included the emergence of the Noh theater—adventure dramas that plumbed the depths of human experience and appealed to all levels of society. Indeed, the Muromachi era is especially marked by a societal laissez faire that inspired creativity and entrepreneurialism throughout the population. Both the influences of Noh theater and the broad creative freedom of the era had a powerful impact on Japanese costume discussed later in this chapter.

The Ainu Peoples

Japan's society is comprised of a number of ethnic and social minority groups. The origins of some of these peoples are uncertain although various theories of migration and immigration have been proposed by scholars.

One particularly unique people are the Ainu, who inhabit the Hokkaido and Sakhalin Islands in northern Japan and the tip of the Kamchatka peninsula. Their ancestors are believed to be of a Mongoloid or possibly even a Caucasian type distinct and different from the ethnic Japanese. During the Jomon era, the Ainu developed their own language and earthenware culture independent of their neighbors to the south. Over the centuries, the Ainu and Japanese maintained a peaceful co-existence through trade. By the 1400s, though, expansionist Japanese regimes had extended territorial conquests into the north, displacing or subjugating the Ainu. Gradually Japanese policies were enacted to reform the Ainu by outlawing their language, restricting intermarriage with ethnic Japanese, and imposing Japanese law and culture.

Only in the most remote areas were the Ainu able to maintain their cultural traditions and social customs. After a certain age, men never shaved, allowing mustaches and beards to grow full length. Both men and women cut their hair at the shoulders. Beginning at puberty, women tattooed their foreheads, mouths, arms, and, sometimes, genitals. Their clothing was traditionally made of barkcloth called **attush** prepared from elm tree fibers. For everyday dress, the Ainu wore a long-sleeved wrap robe made of plain barkcloth. During the late Edo period, manufactured textiles such as cotton replaced the barkcloth. Robes for special occasions called **chikarkarpe** were lavishly embroidered and appliqued. (Figure 10-1.) Seal skin, fox fur, and bear hides were made into outerwear wraps. The feathered skins of gulls and cormorants and the sleek skins of trout and salmon were also made into accessories and appliques.

After centuries of forced assimilation by Japanese regimes, the Ainu were relegated to the official status of "former aborigines" in the 1930s, which fostered racism and discrimination against them. Only in the 1980s did Japanese cultural organizations begin to advocate the revival of the Ainu language and preservation of their vanishing culture.

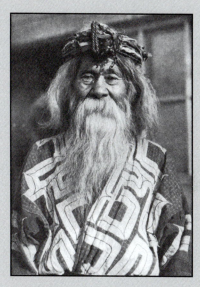

Figure 10-1. Ainu chieftain wearing a tanbark headdress and appliqued chikarkarpe, 1921.

However, the cycle of war and disorder returned in the fifteenth and sixteenth centuries. A complicated system of vassals and lords had developed in which loyalties shifted erratically. Disorder soon prevailed across the land.

Despite the disunity and chaos, Japan extended its imperial reach southward by invading the Ryukyu Islands in 1609. Since the seventh century, the Ryukyu kingdoms, centered on Okinawa Island, had been culturally and economically linked closely with China. Because China had broken relations with Japan, the Muromachi rulers permitted the Ryukyu kingdoms semi-independence as a sort of protectorate in order to reestablish trade with China. Not until 1879 did Japan fully annex the Ryukyu Islands to establish the Okinawa Prefecture.

The Muromachi Period came to an end after a series of powerful shoguns consolidated authority over vassal provinces through ruthless conquest. A final battle in 1615 ended imperial authority and stripped the court of all but its symbolic and ritual purposes. Soon afterward, the last elements of instability—Western trade brokers and missionaries—were expelled from Japan, and the country achieved order and unity through isolation. Only limited trade with China and the Dutch was permitted until the nineteenth century.

In the mid-nineteenth century, the shogun ruler came under increasing pressures from both outside and within. Militarized nations demanded access to Japan and the highly educated samurai class demanded modernization. Finally, in 1867, the shogun restored power over the state to the new emperor upon his accession. Modern Japan was born.

However, the real rulers of Japan were a group of young, well-educated samurai whose principal aim was to make Japan a world power. The oligarchy of progressives abolished feudalism and centralized the government. They established a conscript military based on the French model. The reformers also built a national network of schools and universities with programs aimed at turning out loyal, patriotic citizens of all classes. Japan adopted a westernized legal system, which quickly moved to control international trade treaties, regulations, and tariffs. Most important of all, Japan's new leaders brought about an industrial revolution sponsored by the government. The state built railroads and telegraph systems, took over mining and the shipyards, and established mass-production factories. Within a generation, Japan had acquired the modern apparatus of an industrial nation.

Modernization and industrialization allowed Japan to triumph in its war with China in 1895 over the dominion of

Korea, and the war with Russia in 1904 –5, which was a reaction to the threat of czarist imperialism following the completion of the trans-Siberia railroad. The Japanese military thus acquired an influence over the government with disastrous consequences for the future.

By the beginning of World War I, Japan had the most powerful navy in Asia. It declared war on Germany and, following the armistice, was awarded former German colonies in the north Pacific. Japan's expansionist intents toward China resumed in 1931 with its invasion of Manchuria. The armies of Japan honed their military skills and technologies over the following years, ultimately declaring war on China. After Japan entered World War II as an ally of Germany, its military occupied vast territories ranging from Burma to China on the continent and most of the islands of the north Pacific. The war with Japan ended only when the United States dropped atomic bombs on Hiroshima and Nagasaki in 1945. In the post-war years, Japan rebuilt and refocused its energies on economic development. Within a generation Japan had established itself as a global economic power. To showcase its remarkable success, Tokyo hosted the 1964 Olympics.

EARLY JAPANESE TEXTILES AND COSTUME

Costume historians face three barriers in trying to trace the origins of Japanese dress through the Jomon and Yayoi periods. Foremost is the difficulty in interpreting the highly stylized clay figurines, figural stone carvings, and pottery

Figure 10-2. Chinese immigrants introduced silk production and the rectangular frame draw loom to Japan in the early part of the current era. By the Nara Period, Japanese dyers developed unique textile designs featuring native motifs and color preferences. Kyokechi (block print dyeing), c. eighth century.

painting of the eras. Until about the fourth or fifth century CE, most figural artworks barely have a recognizable humanoid form, much less any discernable details that might represent clothing. Furthermore, until the eighth century CE, no written Japanese documentation exists. Finally, no extant garments have been found from these early periods.

Nevertheless, some sound conclusions can be extrapolated from the bits of tangible evidence we have. As mentioned previously, archaeological finds have indicated that during the first millennium BCE, migrations of groups of people from the mainland brought with them elements of Chinese culture, which certainly would have included textile traditions and apparel styles of the Zhou and Han eras.

Textile production was one of the technological advances brought to Neolithic Japan during the migrations. Impressions of coarsely woven materials on clay pottery from the first millennium BCE indicate that a rudimentary form of spinning and weaving was already established centuries before the introduction of sericulture and silk manufacturing. Later Japanese chronicles note that the peasant classes traditionally spun yarns from a variety of plant fibers. Hemp was the most plentiful and is still commonly used for utilitarian purposes such as netting and cording. Fibers for spinning also were extracted from wisteria vines, ramie, and the beaten pulp of the kozo shrub.

The question of when silk was first produced in Japan is clouded by legendary accounts in later historical chronicles as well as the absence of any surviving examples from the period of migrations. One account sets the date of 188 CE as when the Chinese emperor sent a gift of silkworm eggs to the mikado of Japan. This seems improbable, though, since Chinese silk production was a highly lucrative state monopoly and sericulture was a strictly guarded secret. More likely, the introduction of sericulture to Japan occurred in the late third and early fourth centuries when thousands of refugees from China immigrated during the turmoil of the Six Dynasties period. Whatever the origins, Japan had a significant silk production industry centered at Uzumasa by the fifth century.

The Chinese immigrants also introduced the draw loom with its enclosed rectangular frame that allowed flexibility in the regulation of fabric widths. Previously, the Japanese used basic free-hanging looms that could only produce textiles as wide as the weaver could reach.

From these new looms and an abundance of domestic silk thread, the Japanese began producing unique fabrics quite apart from Chinese types. **Aya** was a heavy plain weave with a smooth twill surface. It was ideal for supporting embroidery and appliques as well as dying techniques such as **rokechi** (batik), **kokechi** (tie-dying), and **kyokechi** (block-print dying). (Figure 10-2.) Most famous of all Japanese silks was the **nishiki**, a multi-hued brocade of intricate and beautifully colored patterns. Later, during the medieval period, heavier tapestry weaving was introduced from China by Buddhist

priests. The Japanese name for tapestry cloth is **tsuzure-ori**, meaning vine-weaving, because the many colored threads are so intertwined. Such luxurious fabrics as the richly patterned nishiki or vividly dyed aya were reserved for the wealthy and aristocracy of the early eras. Even though textile patterns and color combinations began to develop a distinctive Japanese look, the garments for which these silks were made followed Chinese silhouettes well into the Heian Period around the ninth and tenth centuries.

JAPANESE MEN'S COSTUMES

The earliest artworks that provide any clear representations of Japanese clothing date from arozund 300 to 500 CE. The largest body of figural artwork from this period is comprised of cylindrical clay funerary effigies called haniwa. These sculptures were effigies of imperial retainers who, in earlier times, had been buried alive in the tombs of their masters. The great majority of the haniwa depict warriors wearing the traditional Chinese military costume, the ku zhe, with its snug-fitting, short jacket robe girded at the waist and voluminous trousers tied about the knees. (Figure 10-3.)

These stylized figures do not include sufficient detail to discern with any clarity what types of accessories prevailed with these costumes. Since Japanese clothing was adapted from Chinese versions, it may be safe to presume that Japanese noblemen appropriated headdress styles and perhaps even the elaborate hair arrangements from the aristocrats of mainland courts. Clearly, many of the haniwa figures feature hats and elaborate coiffures or pointed military helmets typical of the late Han Dynasty.

The only concise evidence we have of what ordinary Japanese men wore during this era comes from a Chinese document submitted to the Wei court by the governor of Taifang at the end of the third century CE. The commoners of "Wa"—the Chinese name for Japan—reportedly wore only simple wrap garments arranged over one shoulder, possibly somewhat like the square robes that Buddhist monks still wear today.

Vague as the evidence is of early Japanese dress, the one certain fact is that the influence of Chinese styles was prevalent well into the first millennium CE.

Between the seventh and tenth centuries, the Japanese Heian elite avidly continued to model their social hierarchy, ceremonies, and especially costumes after those of the Chinese Tang court. Despite such strong influences from the mainland, it was also the beginning of a transition away from merely duplicating Chinese culture. Key to the foundation of a Japanese national identity was the development of writing their language. The Heian perfected a distinctive calligraphy free of cumbersome Chinese ideographs. Written in its new native script, Japanese poetry and literature

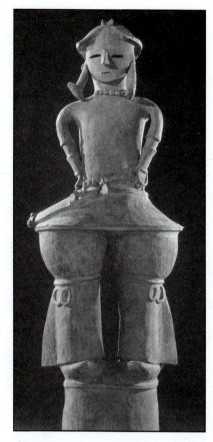

Figure 10-3. The earliest clear representations of Japanese men's costumes appear on cylindrical funerary effigies called haniwa. Most masculine dress of this period replicated Chinese styles, especially the military ku zhe with its snug-fitting jacket robe and voluminous trousers tied at the knees. Detail of a haniwa figure of a warrior, c. 300-500 CE.

flourished, expressing their ideas of beauty, heroes, and romance.

Costume, too, began to evolve into something different. For Japanese men, the loose trousers adopted from the Chinese now became enormous—in actuality, more of a divided skirt than trousers. This garment was called a **hakama** and was often worn in layered multiples of two or three. (Figure 10-4.) In summertime the inner layers were made of cool, sheer silks and even gauze. The textiles of the nobleman's hakama could either contrast in color or pattern with the tunic or be made of the identical material. Either way was regarded as proper court dress. Silk cords ran through the hemlines of the cuffs that could be drawn tight at the ankles in the event of a sudden fray or other emergency. Later designs of the hakama would be cut so long that the hemlines trailed behind, forcing the wearer to take slow, shuffling steps. Supposedly, this long trailing hakama developed as an impediment to violence and rash actions in the palace. Many aristocrats also wore the style in their country estate homes to express their contempt for vulgar brawling.

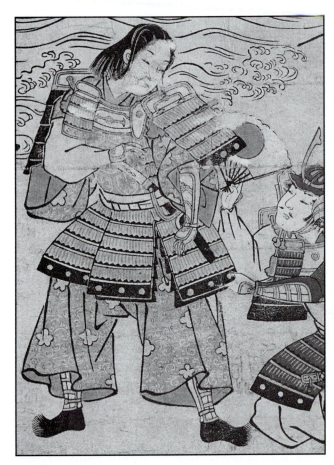

Figure 10-4. Men's trousers, called hakama, were cut so full that they fitted more like a divided skirt. Some featured silk cords stitched through the hemline at the ankles that could be drawn tight for ease of mobility. Detail of woodblock print depicting a samurai warrior by Harunobu, c. 1760.

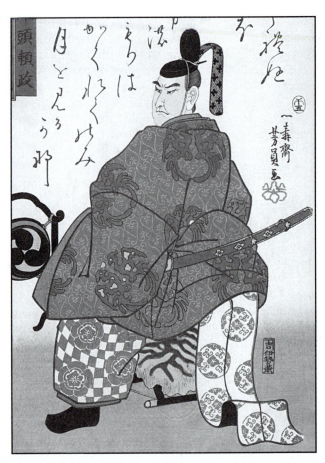

Figure 10-5. The sokutai was a style of men's kimono that included a trailing panel in the back that could extend as long as twelve feet. Woodblock print from *Famous Generals of Japan* by Yoshitora, 1858.

Layered over the hakama was the **kimono**, a wrap robe girded at the waist. At this early phase of development, the design of the Japanese robe was not much distinguishable from the Chinese styles. The cut was a front-closure with side slits and capacious sleeves. Hemlines varied from about mid-calf to the ankles. A wide, richly embellished sash was tied around the waist and allowed to hang down the front like an apron in the Chinese manner.

One variation of the masculine court kimono that differed from the Chinese robe silhouette was the addition of an extended panel in the back that trailed as a train, some as long as twelve feet. This style of kimono was called the **sokutai**. (Figure 10-5.)

Beneath the kimono was worn a **kosode**, which literally meant "small sleeve." Not only were the sleeves less voluminous than the outer kimono, but the opening at the cuff was partially sewn closed, allowing a space just wide enough for the hand. At this time, the kosode was a simple under-kimono worn by both men and women although today the garment is better known as a feminine outer kimono.

By the eleventh and twelfth centuries, the imperial Heian court had become decadent and obsessed with excess. Some Western historians view the Heian etiquette as effeminate because men were consumed with the adoration of beautifully attired women, romance poetry, and the arts. In addition, male courtiers even adopted the use of facial powder and rouge, and masculine clothing rivaled women's styles in the use of flamboyant fabric colors and textile patterns. In their preoccupation with aesthetics, personal finery, and decorum, the nobles of the court lost touch with the remote feudal warlords who continually battled each other for local control.

In 1185, the last of the civil wars was quelled by the gifted clan leader, Yoritomo. He stripped the imperial court of its authority, leaving the aristocrats to serve only in ritual functions. Instead, Yoritomo established himself as a military dictator, called a shogun, with a new capital at Kamakura.

Among the effects the Kamakura military regime had on men's costume was the imposition of sumptuary laws to curb the kind of opulence and trappings indulged by the imperial court. Legend holds that, when one provincial military

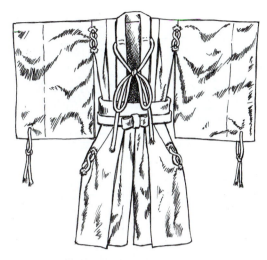

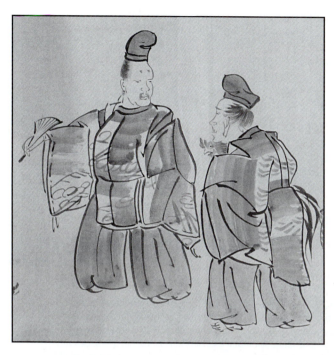

Figure 10-6. During periods of shogunate sumptuary laws, austerity prevailed in the costumes even of the upper classes. Samurai wore the hitatare, a short, square-cut robe with trousers of varying lengths. Detail from *Paintings from Daily Life*, c. nineteenth century.

governor appeared at the shogunate court dressed in an ensemble of ten kimonos, Yoritomo furiously drew his sword and sliced off one of the governor's sleeves as a rebuke for his pride and disrespect.

Besides austerity in fabric color and textile patterns, Kamakura men's costumes evolved a modified silhouette of courtier's styles. The samurai warrior class was aware that culturally they were inferior to the nobles of the imperial court. One way they could establish a distinct culture of their own was with their attire.

Instead of the sokutai robe, the samurai wore a plain **hitatare**, which was a short, square-cut robe sometimes tucked into the hakama. (Figure 10-6.) During the Kamakura Period, to prove humility and austerity, many samurai wore hitatare made of linen and even hemp rather than silk. Fabrics were usually dyed in subdued, solid colors such as indigo, black, and earthtones. Rather than silk cords laced through the cuffs of the sleeves and trouser legs, leather or hemp was used. In later periods, heavy silk and richer textile patterns gradually were permitted for formal functions at the shogunate court. This ensemble of hitatare and hakama would remain the basic costume of the samurai late into the nineteenth century.

Hunting was an important training activity for the samurai. Not only did it keep the warrior's riding and archery skills well honed, but it provided recreation and escape from the refined formality of their lord's household. The hitatare was adapted as a hunting costume, called a **kariginu**, by sewing the sleeves closed only at the bottom of the armhole and leaving the top shoulder seams open. Before shooting his bow, the samurai would put his arms through the open seams thereby pushing the huge, billowing sleeves down at his sides. To identify with the youthful, vigorous samurai, noblemen appropriated the slashed sleeves of the kariginu to their court robes.

Men's accessories of the Kamakura Period were minimal and subdued, even for the social elite. The most elaborate items were hats. The **kammuri** was a small skull cap with a rounded appendage rising straight up from the back. (Figure 10-7.) These hats were usually made of a black lacquer although the base material varied from paper-lined gauze to linen or silk. The kammuri was held in place by a silk cord or white paper string looped over the top and tied under the chin. This was an adaptation of the Chinese fou tao cap first introduced during the Heian era. Men of the imperial or shogunate court wore a kammuri with a **yei** inserted into a slit at the back. This wide, flat ribbon of lacquered black fabric or gauze swept up and back in an arch and sometimes featured an underside of colorfully patterned silk. A more elaborate high hat, called the **eboshi**, was constructed of a heavy, stiff silk in a conical silhouette. It fitted over a small lacquered cap and perched precariously at the center of the crown. Later the eboshi was made of lacquered paper with carefully arranged dents and folds to simulate silk.

Footwear for the upper classes imitated the styles of the Chinese court. The cloud-toe-cap slippers of Tang and Song dress became the Japanese **asa-gutsu**, which were designed with similar turned-up toes. Most shoes were made of leather although some featured sculpted papiermache or silk uppers with thin leather soles.

During the Kamakura era, a new decorative addition to the wide sleeves of men's kimonos was the **mon**, or family

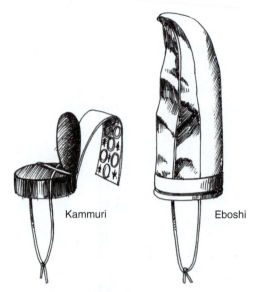

Kammuri Eboshi

Figure 10-7. Men of the upper classes wore a small skull cap called the kammuri. The most common style of the kammuri featured a rounded appendage sticking up in the back. The yei was a wide, flat ribbon of lacquered silk that was inserted into a slit in the back of the kammuri. The other most popular style of men's hat was the eboshi, a high hat of various shapes. Later versions of the eboshi were made of lacquered paper constructed with dents and wrinkles to simulate heavy silk.

Figure 10-8. The mon was a family crest applied to the sleeves of kimonos and home decorative or utilitarian items. Most designs were circular in shape, but later motifs included freeform images such as birds and flowers or geometric symbols of interlocking squares and circles.

crest. Since the shoguns and samurai were a warrior class, the application of the mon to apparel probably evolved from the use of crests on battle pennants and camp tents. These emblems were most often circular in shape although a wide variety of rectilinear and freeform designs later became popular. Motifs ranged from beautifully rendered representational images such as cranes, wisteria, chrysanthemums, butterflies and seashells to abstract geometric symbols like lozenges, interlocking squares, and joined circles. (Figure 10-8.) The mon was applied to garments by various methods including embroidery, stencil-dying, painting, and appliqued patches. For those patriarchs who preferred a consistency in representations of their family's crest, a woodblock stamp could be carved and used repeatedly to stamp the crest on garments and home furnishings in a technique called **ban-e**. In some instances the crest was adapted as an allover pattern called a **komon**, meaning "small design," that was woven into the body of the textile. The mon was also applied to the kimono of servants as a form of household livery.

Very little is known about what ordinary men wore during these transitional periods in which the forms of costume derived from Chinese models began to evolve into distinctive Japanese styles. Most representations of commoners depicted in scroll paintings are incidental to landscapes or city scenes and thus lack detail. The lowest classes—peasants and laborers—are often shown in a basic cotton loincloth, the **fundoshi**, commonly worn as a thong in the back, similar to the costume of

modern sumo wrestlers. Most ordinary men, though, wore a short cotton kosode cut in lengths ranging from mid-thigh to mid-calf. (Figure 10-9.) Coarsely woven leggings, called **habaki**, covered the lower legs to the knees where they were tied into place with hemp cords. Most often, the lower classes went barefoot. But depending upon the tasks of the day or the distance needed to travel, both men and women stepped into a pair of **waraji**, or rice straw sandals. Long laces made of twisted rice straw fitted between the first and second toes to be variously tied over the instep and around the ankles. Headwear for laboring men was usually a piece of fabric tied as a sweatband or small turban. For traveling or field work in the hot sun, both men and women wore the **kasa**, the Japanese version of the distinctive conical straw hat common throughout Asia.

Although a new military dictatorship was established at Muromachi during the fourteenth century, few significant changes in men's costume occurred. At the shogunate court, the austere warrior ethic persisted. At the imperial court luxurious kimono styles endured although with subtle variations developing periodically: the neck facings widened or narrowed, the corners of sleeves were cut rounder or more oblique, or the crests became bolder or more subdued.

During the Muromachi era, the most notable impact on costume came not from the shogunate or imperial courts, but from theater. Prior to the great age of the shoguns, the performing arts were mostly circus acts and mimes that appealed to the common people. From this tradition emerged the Noh musical theater. Its ceremonial plays dramatized legends and tragedies of distant ages in a highly formalized method. This stylized presentation and the themes of Noh plays were greatly admired by patrons of the samurai class. Shoguns of

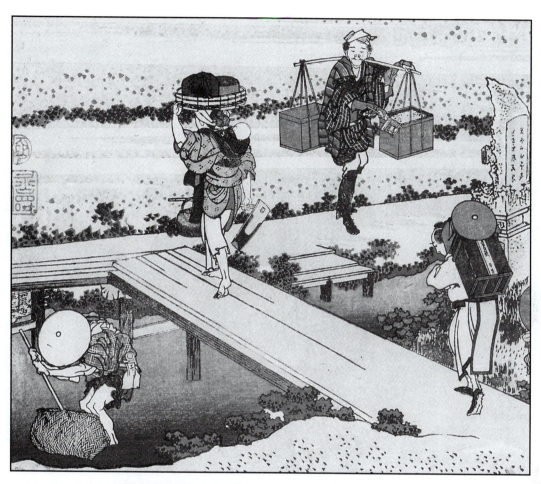

Figure 10-9. The apparel of ordinary Japanese men consisted of a basic loincloth, the fundoshi, and a short kosode. Leggings, called habaki, or cropped trousers protected bare legs in cold weather. Detail of *Fuji Seen from Nakahara* by Hokusai, c. 1820.

the late fourteenth and early fifteenth centuries sponsored the best Noh playwrights and actors of the time, thus setting the high standards of quality for the performing arts that are valued to the present day.

The question for the student of dress is when and how the costumes of the Noh theater came to represent the most sumptuous apparel of the era, especially given the samurai contempt for excessively lavish dress. Costume historian Seiroku Noma offers one possibility in the Japanese tradition of rewarding retainers, a custom that had continued from the Heian Period. As a sign of respect and appreciation for a service well done, a man of rank or wealth would remove an article of clothing or an accessory to present as a reward. In the case of the samurai or shogun, that was usually their finest garment, the **haori**, a loose, three-quarter-length outer kimono constructed with an open front to reveal the plain kariginu underneath. The haori was usually made of the richest fabrics of all the samurai's apparel and only worn on special occasions. Since such gifts had to be used by the recipient as a courtesy to the presenter, Noma suggests that this was how the Noh theater regularly came to

feature opulent costumes in performances. Logically, with a sprinkling of such luxurious garments in the troupe's wardrobe, the rest of the costumes likewise had to be of a similar fine quality, which was possible with the patronage of a powerful and wealthy shogun. By the beginning of the seventeenth century, even the most provincial Noh theater groups dressed in lavish costumes and performed dazzling spectacles in the tradition first developed at the shogunate courts.

The significance of the gorgeous Noh costumes lay in its influence during what is sometimes called an age of hedonism in the sixteenth and seventeenth centuries. In this period of political turmoil among the vassals of the shogun, Japanese culture underwent a significant change for the common people in which entrenched tradition lost its authority. Both men and women daringly sought the new and novel, including fresh ideas about clothing. Noh theater audiences were captivated by the costumes they saw—intoxicating fabric colors, vivacious textile patterns, symbolic layering of garments, and dramatic silhouettes with huge sleeves, wide sashes, and voluminous trouser legs. A merchant's journal entry of 1614

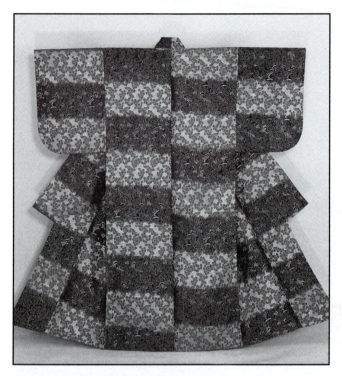

Figure 10-10. Men's kosodes of the Edo Period included patchwork designs such as the katami-gawari, which literally meant "half the body different," and the dan-gawari that featured freeform appliques or regimented checkerboard patterns. Dan-gawari, c. 1800.

noted that "everyone is wearing gay and costly brocades, and even servants spend all they have for a kimono."

Men's kosodes were designed with such fanciful imagery and patterns that in scroll paintings and screen art, the male figures are sometimes difficult to distinguish from the female. Patchwork robes, called **dan-gawari**, were made by sewing appliques of different materials to a kosode. Some varieties of the dan-gawari were constructed from large panels that created a checkerboard of distinctly opposite patterns such as a floral against a plaid or a dark, dense pattern against a light, open design. (Figure 10-10.) The **katami-gawari**—literally meaning "half the body different"—was a kosode bisected vertically into halves of contrasting patterns.

In a reverse of social influence from the bottom up, the samurai class began to surrender to the delights of wearing beautiful clothes, which for some time already had been an indulgence of the merchant and craftsman classes. The **jimbaori** was a battle vest that could be worn over armor for additional protection. For ceremonies and court functions, though, versions made of sumptuous silks were often layered over the kosode or hitatare. (Figure 10-11.) By the seventeenth and eighteenth centuries, these masculine robes were made of fabrics as lavish as anything from a Noh drama. Ranking officers were immediately recognizable by the opulence of the brocades used to make their jimbaori.

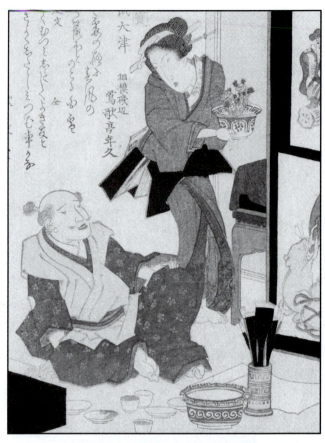

Figure 10-11. Samurai warriors wore a wrap vest, called a jimbaori, over their armor in battle. For court functions or religious ceremonies a samurai often layered a jimbaori over his kosode or hitatare. *Otsu Painting of a Rat* by Keisai Eisen, c. 1828.

Also during this time, extraordinary suits of lightweight, flexible armor, called **gusoku**, were constructed for high-ranking samurai. (Figure 10-12.) The cuirass was made of small lacquered leather or, less commonly, iron plates tied together with colorful silk lacing. Some of the plates were wrapped in gold or silver foil that shimmered brilliantly in the bright sun of a battlefield. Shoulder guards, greaves, gorget, and helmet neck guard also were constructed in this method.

In 1615, an imperial counselor put down a rebellion and became the new shogun. To keep free of imperial court intrigue at Kyoto, he established his military center far to the north in Edo (modern Tokyo). The Edo Period became an era of enforced peace when the Round Eyes from Europe were expelled and Japan withdrew into isolation except for limited trade with its closest geographic neighbors and, occasionally, the Dutch.

Kimonos of the Edo era are distinguished by new types of fabrics and decorative motifs applied by innovative techniques rather than changes in silhouettes. By this time, the Japanese wrap robe styles had become fairly standardized in construction. Throughout the 250 years of the Edo Period, alternating cycles of sumptuary restrictions and extravagance

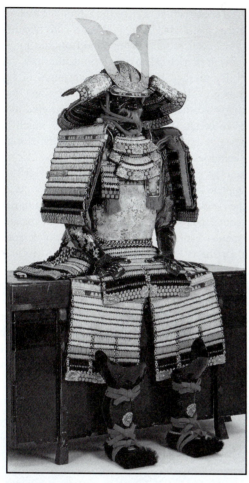

Figure 10-12. During the Edo Period, high-ranking samurai wore suits of armor called gusoku. The cuirass, shoulder guards, greaves, gorget, and helmet neck guard were constructed of leather or iron plates tied together with colored laces. Gusoku of Shimazu Nariakira, c. 1830–50.

repeatedly occurred. One legend from the late seventeenth century recounts how a wealthy merchant's wife visiting the capital from the provinces attempted to impress the shogun with her beauty and taste. As the shogun passed by her rented room en route to a ceremony, her servants lifted a screen to reveal their mistress resplendent in the finest gold brocades. The shogun was so incensed at such presumption that the woman and her merchant husband were exiled from the region, condemned to wear the plainest kimonos, and suffered the confiscation of all their property. The result was that everyone put away their colorful kimonos and went about in the most somber attire they owned. Even vividly colored home textiles and bedcoverings were replaced with more subdued versions.

Sumptuary edicts were usually quite specific. A series of orders enacted in 1683, for example, forbade anyone of the servant class to wear any bit of silk. Ornamentation of garments, including the family crest, was prohibited. Even puppets at festivals could not be shown in rich fabrics.

New methods of textile production, within the strict guidelines of the sumptuary laws, contributed to the gradual ease back to extravagance in kimono design. One such phase occurred in the late seventeenth century in which **genroku**, a vigorous, almost gaudy style of pictorial decoration, was produced on textiles, apparel, and home accessory items. The most famous proponent of the style was a painter called Yuzen who developed a method of applying his realistic scenes to fabric by a rice-paste resist method somewhat like modern batik. He even collected many of his best kimono designs into a catalog, called a **hi-inagata**, from which orders could be customized. Yuzen-dyeing, as the technique came to be known, was later combined with tie-dying, embroidery, and appliques to create kimonos with vivacious designs. (Figure 10-13.)

Figure 10-13. In the late Edo era, Yuzen-dyed fabrics were characterized by extravagant, almost gaudy pictorial decoration. During periods when sumptuary laws were eased, men indulged in wearing kimonos made with Yuzen-dyed designs. Detail of print depicting Ichikawa Danjuro VII wearing a butterfly-patterned kimono, c. 1820.

Following the restoration of imperial authority in 1867, Japan was increasingly opened to trade from America and Europe. Upper class men attempted to wear Western suits but were uncomfortable in the restricting cuts of tailored jackets and trousers. It was not uncommon to see men of the late nineteenth century wearing a derby hat and leather lace-up shoes with the kimono and hakama. In modern Japan, Western styles now prevail for the business day although at home and for special ceremonial events such as weddings or funerals, many men will don the traditional Japanese national costumes. The modern kimono, hakama, and haori are still cut and draped as they have been for centuries. Silk remains the preferred fabric, but wool and cotton have become more common.

JAPANESE WOMEN'S COSTUMES

As discussed previously, the earliest clear depictions of Japanese costumes are from the cylindrical funerary effigies called haniwa, dating from the fourth or fifth century CE. Of the few female haniwa figures that have been found, most show the short robe and wrap skirt ensemble that had been common in China since the Zhou Dynasty. (Figure 10-14.) Some hints of textile patterns are incised into the clay such as zigzagged lines or interlaced circles, but these are also the same motifs found on pottery, so they may not actually represent fabric designs. Also, like the male haniwas, these stylized figures only offer a vague hint of accessories, headdresses, and hairstyles.

During the Nara and early Heian Periods, Japanese men's and women's costumes were modeled on Chinese robe styles. The construction of both the masculine and feminine kimono was a straight, T-cut silhouette with wide, flowing sleeves. The opulent fabrics imported from the Tang textile centers inspired rich nishiki interpretations by Japanese weavers. By the late Heian era, the costumes of Japanese noblewomen evolved differently than their Tang and Song counterparts. At the Heian court, women layered numerous kimonos to create the **juni-hitoe** costume, which literally meant "twelve-layers." (Figure 10-15.) By the eleventh and twelfth centuries, the juni-hitoe often displayed as many as two dozen layers although a layer was not necessarily formed by a complete kimono. The linings of sleeves or cuffs might be stitched with a contrasting hue that could be turned back for a second color. The under kimono—or kosode—was mostly made of solid color silks, some of which were sheer enough for the color of the layer beneath to form a third blended color.

The stratified harmony of colors for the juni-hitoe was carefully arranged to show at the neckline, hemline, and cuffs of the wide sleeves. A sophisticated protocol for arranging and displaying the colors had developed by the tenth century. Great care was given in layering the colors thematically based on flower festivals and even poetry.

Figure 10-14. Haniwa figurines that represent women most often show costumes of short robes and wrap skirts. This ensemble was copied from Chinese models that had been common on the mainland since the Zhou Dynasty. Haniwa figure of a woman, c. 300–500 CE.

Figure 10-15. The juni-hitoe literally meant "twelve layers" although a woman's court costume might actually display more than twice that number of layers. The stratified harmony of colors was achieved by a strict protocol that included arranging colors based on flowers that were appropriate for the season.

Colors that were named for flowers or trees could only be worn in combinations appropriate to the season of those blossoms or leaves. Eventually, these harmonious arrangements became standardized and included formulas such as "wisteria layers," "azalea layers," "willow layers," "maple layers," and "pine layers." A surviving tenth-century document from the Industrial Bureau of the Imperial Household details how precise the dyers had to be to achieve the correct hues for the juni-hitoe kimonos.

Another departure from the influences of China occurred in the realm of standards of physical beauty. There is no evidence that the Japanese ever attempted copying Chinese techniques of foot-binding. However, the upper classes stained their teeth black—a process that had to be repeated every two or three days. The best representations we have of this look is found on Noh theater masks carved to represent aristocrats. Blackened teeth remained a body enhancement well into the late nineteenth century. A report in *Cosmopolitan* in 1891 noted that the practice had only been abandoned within the previous decade although a few "old grande dames" could still be seen this way. "How it originated," the journalist wrote, "is a question which the Japanologists have never answered." Instead, he continued, most cultural historians were content to "tell the old tale of masculine jealousy, which is supposed to be responsible for this disfigurement of their women after marriage, in order to make them less attractive to other men." Of course, such a view is clearly a Eurocentric perspective and only reinforces the mystique of the blackened teeth practice.

Between the thirteenth and seventeenth centuries, women of the shogunate courts discarded the layered big-sleeved kimonos for the narrow-sleeved kosode. (Women of the imperial court, though, continued to wear the multiple layered juni-hitoe, which is still worn today by female members of the imperial family for weddings and other high rituals.) The most common feminine costume of this era was a plain white kosode worn tucked into a pair of long trailing trousers, the hakama. Neither garment was embellished with any decoration, not even the family crests of their husbands. Some women, such as those shown in Figure 10-16, even vied with their samurai husbands for austerity in dress.

At the height of the Muromachi Period, the samurai began to indulge in some outer garments made of fine fabrics, such as the two-tone katami-gawari or the sleeveless jimbaori battle vest. Women, likewise, renewed their interest in richly decorative apparel and began to wear a new type of outer kimono, called an **uchikake**. (Figure 10-17.) This was a formal robe with a long train and capacious sleeves that was layered over the plain solid-colored kosode and hakama trousers for receiving visitors or for special ceremonies. The uchikake could be worn either open in the front to display the kosode or wrapped and secured with a narrow sash. In warm weather, the girded uchikake was often slipped off the shoulders and allowed to drape about the hips with the long sleeves trailing to the floor. This was known as the **koshimaki** style, which is still worn this way today for certain rituals.

By the Edo Period, women's kimonos were as standardized in cut and design as those of men. All classes wore the basic kosode although lower classes dressed in cotton versions made of basic colors and simple textile patterns. Even so, for weddings and important family events, even servants had at least one silk kimono. Women of the wealthy merchant classes and the aristocracy followed trends of kimono designs as they evolved between the periods of austere sumptuary edicts from the shoguns. The pictorial Yuzen-dyed kimonos of the seventeenth and eighteenth centuries remain some of the most spectacular garments in Japanese costume history. (Figure 10-18.)

Another key element of Japanese women's costumes during the Edo era was the emphasis on accessories. As noted previously, the silhouettes of the kimono had become relatively standardized by the seventeenth century. One form of costume innovation occurred with fabric decoration, such as the lively Yuzen-dyed pictorials. Another was enhancing the size, materials, and arrangement of the sash, or **obi**. Prior to the Edo Period, the obi was a blindstitched cord or narrow belt about two or three inches wide. These sashes were purely functional to keep the kimono from becoming disarranged. They were kept narrow so as not to compete with the luxuriant textile patterns of the kimonos. Legend holds that during the great Edo fire of 1657, which destroyed a huge section of

Figure 10-16. During the periods of shogunate sumptuary restriction women of the samurai class vied with their husbands in austere dress. The most common feminine costume for home attire of the early Edo Period was the plain white kosode worn tucked into trailing trousers. Figures from *Oeyama Emaki* scroll painting, c. sixteenth century.

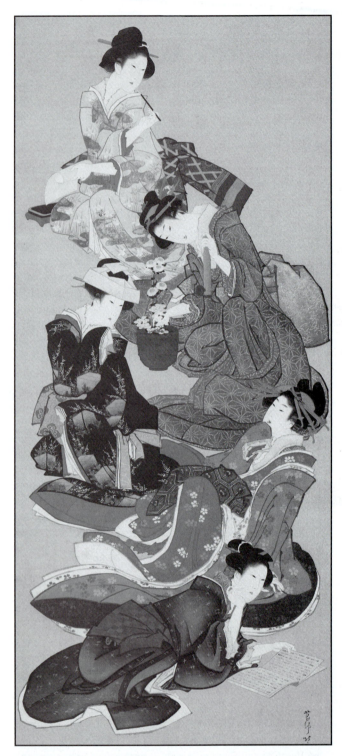

Figure 10-17. For special ceremonies and family events, upper-class women of the Edo era wore the uchikake, a large outer kimono made of sumptuous silk textiles. It was cut with a long train and capacious sleeves. *Five Beautiful Women* by Katsushika Hokusai, c. 1800.

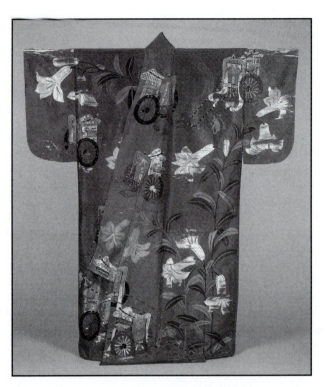

Figure 10-18. Yuzen-dyed kimono designs of the late Edo Period featured exuberant pictorials such as landscapes, city scenes, birds, and insects. Yuzen-dyed carts and lilies, c. 1675.

the city, women were forced to flee in such haste that their obis came loose, causing their kimonos to fly open exposing their nakedness. As a result, the long, flat woven obi first appeared. Instead of simply tying the obi about the waist, which could come loose during exertion, the new styles wrapped about the waist several times and were held in place with complex knots and bows. (Figure 10-19.)

At about the time that the obi was widened and emphasized with a prominent knot or bow, fabrics for the kosode became increasingly soft and fluid. In contrast, the obi was now made of opulent, heavy brocades and tapestry weaves. Today the obi often attracts more attention than the kimono although Japanese women strive to strike a harmonious balance between the two garments. Despite the extravagance of the obi, it must never overwhelm the kosode.

In his book on kimonos, Norio Yamanaka notes that there are as many as 500 different ways to tie the modern obi. Many of these special arrangements reflect their inspiration in their names, such as the "taiko bridge," "double drum," and "plump sparrow." Many obi require more than a dozen steps to wrap and arrange the bow properly.

Another accessory of the Edo Period that reflected women's status in Japanese society was the **ichimi-gasa**, or umbrella hat. As women of the samurai class went into public, they wore a wide brimmed or large domed hat from which was attached a veil all around. Some lengths of the veil extended only to the shoulders, and others could be as long

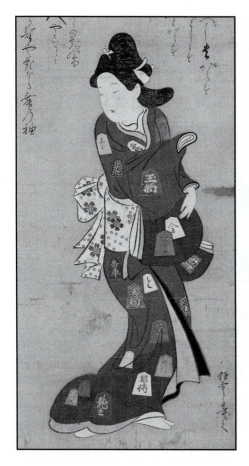

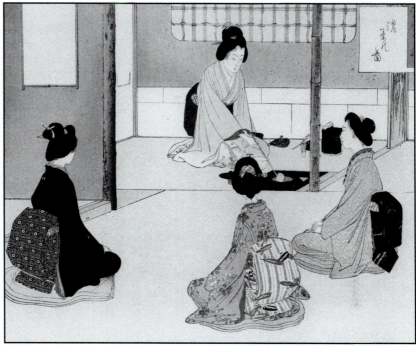

Figure 10-19. During the Edo Period, the kimono sash, or obi, which previously had been a narrow belt used solely for holding the kimono in place, now became an elaborate arrangement of complex knots and bows. Left, detail of woodblock print by Mizuno Toshikata, c. 1900; right, detail of woodblock print by Mizuno Toshikata, c. 1880.

as mid-calf. In familiar surroundings, such as the neighborhood marketplace, the veil might be pulled back on the shoulders or folded atop the brim.

While out of doors, all classes of women wore heavy, raised wooden clogs called **geta**. Most styles had two slats of wood attached perpendicular to the soles, which required slow, short steps to keep from toppling off them. A leather or corded thong ran between the first and second toes to hold the shoe in place. Upper class women wore geta that were black lacquered and affixed with thongs of braided silk. A pair of white cotton mitten socks, the **tabi**, kept the feet warm in inclement weather. An enduring custom in Japan is to leave the shoes at the door or in an exterior foyer. Inside the house, both men and women wore slippers, sandals, or only the tabi.

Other types of accessories that changed during the Edo Period were hair ornaments and headdresses. For centuries, Japanese women took great pride in their long, lustrous black tresses. Innumerable paintings and figurines depict women with their hair flowing down across shoulders and cascading down the back such as those shown in Figure 10-16. By the seventeenth century, though, women began to pull the hair back from the forehead and pile it atop the crown in assorted arrangements of twists and buns. Since silky soft hair was difficult to

keep in place with just braids, knots, or pins, Japanese women began to apply a thick, waxy ebony pomade to the hair. Depending upon the social status of the woman, her sleek, sculpted hair style was further enhanced with the addition of hair ornaments. Respectable women might add a single lacquered comb with subtle inlays or a silk flower to one side. Only the geisha, courtesans, and women of the theater wore a profusion of hair ornaments, which might include combinations of pendant hairpins, clusters of lacquered chopstick hairpins, bouquets of silk flowers, colorful silk ribbons, or lacquered paper caps. (Figure 10-20.) Because Japanese women traditionally slept upon a concave wooden headrest, the hair styles would hold for more than a week.

In the modern era, Japanese women did not begin to experiment with Western styles of fashion until the late nineteenth century, despite commonly seeing European and American visitors. In 1886, the empress first appeared in public in "foreign" attire, which included a satin gown with a tightly corseted bodice and bustle skirt. This created quite a scandal among the traditionalists of the court since, according to one journalist of the time, Japanese men considered a woman "vulgar if her bodily contours above and below the waist are too prominent." However, it was mostly the educated upper classes who adopted the fashions of Paris until

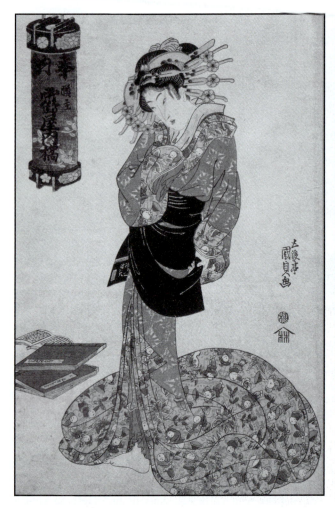

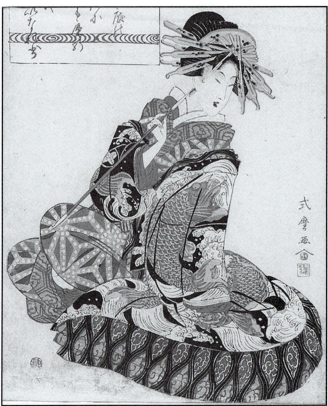

Figure 10-20. Women of the Edo era began to arrange their hair atop their heads in elaborate coiffures held in place by the application of thick black pomade. Courtesans, geisha, and women of the theater added a profusion of hairpins, combs, silk flowers, and ornaments. Left, the courtesan Tachibana of Tsuru-ya by Utagawa Kunisada, c. 1840; right, detail of woodblock print of the courtesan Ainare by Kikumaru, c. 1800.

the age of consumerism after the First World War when ready-to-wear imports flooded Japanese markets. Then a broader spectrum of urban working and middle classes opted for Western clothing.

MODERN JAPANESE FASHION

Today, Tokyo is often called the "Paris of the East," one of the world's five capitals of fashion, along with Paris, Milan, New York, and London. The roots of this phenomenal achievement originated in the 1960s and 1970s with the hard work and creativity of just a few individuals: Kenzo Tadaka, Yohi Yamamoto, Rei Kawakubo, Issey Miyake, and Hanae Mori. These designers took their talents to the West, establishing themselves internationally on the fashion runways of Paris and New York. Their fresh views of designing clothes contrasted sharply with the West's obsession with defining and revealing the female form in tight-fitting, transparent styles. Instead, the Japanese applied the aesthetic of concealment in the tradition of the kimono. Whereas in the West, fad diets, aerobics classes, and plastic surgery were variously combined to transform the

body into a work of art, Japan's fashion designers constantly experimented with new shapes and proportions that could alter the body by alienating its form. "The idea is not to be iconoclastic, to make sweeping changes" said Rei Kawakubo, "but to be careful not to do things in the same way."

During the time Kawakubo and her colleagues were making names for themselves in the West, the fashion industry in Tokyo took root and grew rapidly. In the 1970s, a group of prominent designers founded the TD-6 (Tokyo Designers 6). In 1985, Tokyo's Council of Fashion Designers was established to support and promote young, promising talent. Each year there is a new supply of eager designers who have graduated from Bunka Fukuso Gakuin, the largest fashion college in Japan, or from one of the other Tokyo-based institutes like Vantan, Sugino, and Tokyo Fashion College.

However, despite the innovation and creativity of Japanese fashion, since the mid-nineties, style in Japan increasingly has been driven by a consumer youth, loosely labeled the otaku. Originally the term was applied to young men who were fixated on comics for adults. By the beginning of the twenty-first century, otaku was used to describe someone with an obsessive

Figure 10-21. Tokyo street wear from the mid-1990s into the twenty-first century often adopted Western-styled tribal identities such as punk, surfer, biker, and hip-hop styles. Especially popular were kawaii, or cute girl looks. Photo of Tokyo kawaii dress, 2004.

interest in fashion (or computers). That obsessiveness, more often than not, manifested itself in the adoption of Western-styled tribal identities: hip-hop, goth, punk, surfer, biker. Because Japan today is essentially a classless society, young people selected formulaic styles with personal meaning to distinguish themselves from one another. (Figure 10-21.) The looks, though, did not carry with them the cachet of the originals. For instance, Tokyo's punks might resemble their British and American counterparts from the 1970s, but instead of nonconformist behavior, the Japanese punks are polite and deferential.

Among the more prevalent street looks of the new millennium in Tokyo was the hip-hop style, for which young men dressed in work boots, triple-fat goose-down jackets, and baggy, oversized jeans. The punk or goth look in Tokyo was purely retro-seventies bondage style with one exception, a black vinyl kimono worn by some girls and, less often, boys. An even more incongruous look was that of the yamamba, an adaptation of the sixties surfer girl, replete with deep tan, teased, bleached blonde hair, pearlized lipstick, white eyeshadow, and clothes of

neon-bright colors. Some men likewise adopted the tanned, blonde, Beach Boys look. Most Japanese girls, though, opted for the kawaii, or cute look. This was usually characterized by pastel-colored clothes embellished with prints or appliques of furry animals, particularly teddy bears. As a result of this myriad of street looks in Tokyo, the *New Yorker* noted in 2004: "Because the Japanese are fanatical about fashion in the way that the Brazilians are about soccer or the Germans are about cleanliness, walking around Tokyo can feel like being trapped in an endless Halloween party."

REVIEW

Between the late second millennium BCE and the beginning of the first millennium CE, Japan was periodically invaded by migrations of peoples from the mainland. With each successive group of immigrants came more advanced influences of Chinese civilization including rice cultivation, metallurgy, weapon technology, applied arts, and architecture. Even Japanese imperial social hierarchy was based largely on the Chinese model. Silkworm farming, textile production, and wrap styles of clothing likewise were introduced from China during these formative eras.

From the earliest figural forms of Japanese art—the cylindrical haniwa effigies—representations of masculine costumes mostly show adaptations of the Chinese military outfit with its snug-fitting jacket robe and baggy trousers tied at the knees. Figurines of women similarly show jacket robes and wrap skirts typical of Chinese Han styles. During this same period, a silk textile industry emerged in Japan. In addition to adapting Chinese weaving methods and dyeing techniques, Japanese weavers developed the intricate, multi-colored nishiki brocade with its rich designs of native motifs and patterns.

By the Heian Period of the seventh and eight centuries, Japanese men and women wore virtually the same costume based on styles imported from the Tang court in China. The T-cut wrap robe, called a kimono in Japan, evolved with a myriad of sleeve widths and lengths. One key difference between the Chinese and the Japanese cut of the sleeve was at the cuff. Whereas Chinese sleeves ordinarily had wide open ends, Japanese kimono styles most often were sewn closed except for a narrow slit for the hand. The Japanese form of Han trousers also developed a distinct silhouette very different from its mainland inspiration. For the upper classes, trousers became voluminous and were cut so long that the excess fabric trailed behind, forcing the wearer to take slow, shuffling steps.

As Japanese culture split into two influences, the imperial hierarchy and the warrior class of the shogun court, costume likewise diverged. The imperial styles became ever more lavish and included the feminine juni-hitoe, or "twelve layers" of kimonos. On the other hand, sumptuary laws issued by the warlords affected the greater populace with an imposed

austerity and simplicity. Periodically the restrictions were eased and opulence resurfaced, inspired in part by the extravagant costumes of the Noh theater and, at other times, by creative interpretations of sumptuary guidelines.

By the Edo Period, the kimono had become relatively standardized for both men and women. Costume evolution occurred with the new emphasis on accessories. For men, the jimbaori, or battle vest, was made of the finest silks. For women, the kimono belt, called the obi, became an extravagant sash with hundreds of bow variations.

As Japan once again opened its ports to the world in the late nineteenth century, businessmen and upper-class women began to experiment with Western fashions. By the end of the First World War, vast quantities of cheap ready-to-wear were imported from America and Europe and the masses gradually adopted Western clothing styles.

In the 1970s and 1980s, Japanese fashion designers established themselves as a creative and imaginative force in Paris and New York. By the beginning of the twenty-first century, Tokyo had become a world fashion capital.

Chapter 10 Japan
Questions

1. Which costume influences from China are revealed by the Japanese haniwa figurines?

2. Which two key advances in textile production were introduced to Japan by Chinese immigrants?

3. Identify three variations of the masculine kimono, and describe the differences between each.

4. What were the principal components of the samurai's suit of armor? How were the components constructed?

5. Identify and describe the multilayered costume worn by women of the Heian imperial court. What was the protocol for wearing this costume?

6. During the Edo Period, why was there such an emphasis on accessories? Describe how the obi evolved between the sixteenth and eighteenth centuries.

Chapter 10 Japan
Research and Portfolio Projects

Research:

1. Write a research paper on the Ainu culture. Explore what influences may have come from the Chinese and which ones may have been from the ethnic Japanese. Explain how Japanese prohibitions and reforms altered Ainu culture.

2. Write a research paper on the development of Japanese textiles and how they eventually became differentiated from those of China.

Portfolio:

1. Research a method of tying an obi and sketch the steps in a style guide with written instructions. With a length of cloth appropriate for the obi style you selected, demonstrate to the class on a mannequin or volunteer the proper way to drape and tie the sash.

2. Compile a reference guide of men's and women's hats and headdresses across the dynasties. Select twenty different styles for each gender and illustrate with a photocopy or digital scan. Include a written description next to each specifying type of headcovering, materials, date, dynasty, and site or source of origin.

Glossary of Dress Terms

asa-gutsu: formal shoes with turned up toes

attush: barkcloth made from elm trees worn by the Ainu peoples

aya: a heavy, plain-weave silk fabric with a smooth twill surface

ban-e: the woodblock print of a family crest that could be repeatedly stamped on fabric

chikarkarpe: lavishly embroidered or appliqued robes of the Ainu peoples

dan-gawari: kimonos made with appliqued patchwork designs

eboshi: a men's high hat of various styles, made of heavy, stiff silk or lacquered paper formed to simulate silk

fundoshi: men's cotton loincloth usually worn by working classes instead of trousers

genroku: the exuberant, somewhat gaudy style of pictorial decoration applied to textiles by dyeing, block printing, painting, or embroidery

geta: women's raised wooden clogs

gusoku: a samurai suit of armor made of lacquered leather or iron plates tied together with colored laces

habaki: men's woven leggings usually worn out of doors by laborers

hakama: large trousers worn by both men and women

haori: a men's loose, three-quarter-length outer kimono made of fine silks for special ceremonies

hi-inagata: catalogs of kimono designs produced by dyers, weavers, and artists

hitatare: a short, square-cut kimono worn by the samurai

ichimi-gasa: a wide-brimmed hat with a veil all around the edge that concealed a woman from public view

jimbaori: a battle vest worn by samurai over their armor

juni-hitoe: predominantly a woman's costume featuring multiple layers of kimonos arranged by a protocol of color harmonies

kammuri: men's skull cap with rounded appendage sticking up in the back

kariginu: a men's hunting kimono with open shoulder seams through which the arm could be freed to shoot a bow

kasa: conical straw hats worn by field workers or travelers

katami-gawari: a kimono constructed with bisected halves of contrasting fabric literally meaning "half the body different"

kimono: a long-sleeve, T-cut wrap robe worn by both genders

kokechi: a textile tie-dyeing technique

komon: the small woven repeat design of a family crest woven into the body of textiles

koshimaki: the style of wearing the uchikake off the shoulders and draped about the hips over a belt

kosode: a small-sleeve kimono originally worn as an undergarment by both men and women

kyokechi: the woodblock print dyeing of fabrics

mon: the decorative family crest applied to garment sleeves, battle pennants, and home utilitarian items

nishiki: multicolored brocade of intricate patterns

obi: a belt or sash worn over the kimono by both men and women; in the Edo era, mostly associated with women's costumes as a wide sash arranged with complex knots and bows

rokechi: a form of resist dyeing similar to batik often done with the application of a rice paste

sokutai: a men's court kimono with an extended panel in the back up to twelve feet long that trailed as a train

tabi: white cotton mitten socks worn by both men and women with sandals

tsuzure-ori: silk tapestry weaves

uchikake: a woman's decorative outer kimono cut with a long train and capacious sleeves

waraji: sandals made of rice straw

yei: a wide, flat ribbon of lacquered fabric attached to the back of a man's kammuri

Influences and Legacies of Japanese Styles on Modern Fashion

Following the opening of Japan to Western trade by Commodore Perry in 1854, Western markets developed an insatiable appetite for all things Japanese—furniture, garden designs, art prints, jewelry, and particularly the silk kimono. Variations of the traditional kimono were tailored as women's loungewear and continually exported to Europe and America into the 1930s. Modern fashion designers have also found inspiration in the simple construction of the kimono's wrap styling and T-cut sleeves for interpretations ranging from day dresses to evening gowns.

Left, yellow silk kimono with embroidered storks and apple blossoms by Ethel Harris, 1905; right, kimono by Alexander McQueen, 2008.

Chapter 11

INDIA

Indus Valley Civilization		Vedic Period		Dark Ages	Gupta Period	Medieval Period
Cities of fired brick	Invasion of Aryans	Hinduism and Buddhism established	Invasion by Alexander the Great 327 BCE	Conquest by the Persians (Kushan)	The Golden Age of literature and fine arts	First Muslim invasion 712
c. 2300 BCE		c. 1500 BCE		c. 327 BCE c. 320 CE	c. 500	c. 1180

Turkic Dynasties	Tughluq Dynasty	Mughal Empire	British India	Independent India			
Reign of the Delhi sultans	Muslim conquests of southern India	Establishment of an imperial bureaucracy 1600 British East India Company founded	Alliances with Indian Rajas English law imposed and slavery abolished	Independence from Britain 1947	Mahatma Gandhi assassinated 1948	States reorganized on linguistic basis 1956	Indo-Pakistani War 1971
1180	1320	1526	1757	1947			

CIVILIZATION OF THE INDIAN SUBCONTINENT

The two great river basins of the Indian subcontinent, the Indus in the west and the Ganges in the east, were the earliest centers of urban development in south Asia. By the third millennium BCE, riparian cities constructed of fired brick dotted the length of the river valleys. These cities were contemporary with those of Ur and Babylon in Mesopotamia and the Old Kingdom cities of Egypt. Like the civilizations of their neighbors to the west, the Indus culture had writing (yet to be deciphered), highly developed visual arts, and sophisticated technologies such as pottery and textile production.

Sometime between 1700 and 1500 BCE, invasions from the northwest by the Aryans, a pastoral Indo-European people,

may have contributed to the collapse of the Indus Valley civilization. As the Aryans settled in the region, they introduced cultural changes including the Sanskrit language, a strict social hierarchy, and beliefs in reincarnation. These ideas of faith were set down in Vedas—collections of hymns and rituals of behavior that became the basis of Hinduism at the end of the first millennium BCE.

Other new beliefs also emerged during the Vedic Period, most notably Buddhism. A Buddha is not a god, but rather an "enlightened one" who has achieved nirvana, or freedom from the cycle of death and rebirth into misery. The Buddhist religion developed from the teachings of Shakyamuni Buddha (c. 563–483 BCE), whose primary message was that a misunderstanding of the self and nature led to all the suffering in the world. To help achieve a state of enlightenment, Buddha

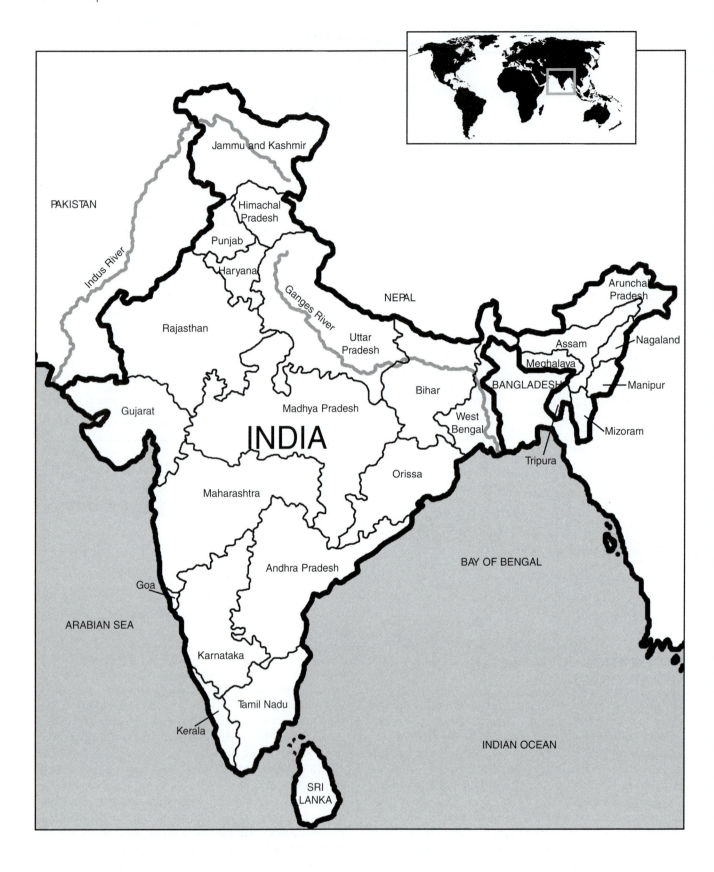

propounded an ethical code against killing, stealing, lying, and other evils that harm fellow beings.

The Aryans had not formed a centralized, imperial union of the lands they settled. Instead, for the 2,000 years following their arrival, most of the Indian subcontinent was carved up into a patchwork of small kingdoms, some of which briefly rose in regional dominance. At the end of the Vedic era, new invasions from the northwest brought the Kushans, who established a Persian imperial presence for more than two centuries.

Beginning around 320 CE, the Gupta clan began to forge an empire by conquest and marriage that eventually included all of India except the southernmost tip of the peninsula. The Gupta period was a golden age of literature, sculpture, painting, and architecture. Also under the Guptas, Hinduism supplanted Buddhism as the officially sanctioned religion.

At the end of the fifth century, the Huns invaded India, bringing to an end Gupta authority. During the following few centuries in what is usually referred to as the medieval era, locally significant dynasties emerged, largely based on coalitions of clans.

Although the Muslims first invaded northern India as early as 712, the Islamic empire was unable to sustain a hold over the region. Finally, at the end of the twelfth century, the Muslims conquered and held the northern tier of India, establishing a sultanate at Delhi. In 1320, the Tughluq Dynasty succeeded as sultans. Within a century, their conquests extended over most of India. During the early period of Muslim dominion, the ruling elite drew on whatever administrative resources were available for managing such a vast empire. The court included a diversity of Islamic sects while they left in place the local administrative systems, whether Hindu or Buddhist.

In 1526, India was once again invaded by a fierce and seasoned army, led by Babur, a Turkish chieftain from Afghanistan. Because one of his ancestors was the Mongol warlord Genghis Khan, his family came to be referred to as the Mughals, or Moguls. The early Mughal rulers sought to consolidate power by eliminating the old sultanate form of vassal fiefs. Instead, a highly efficient bureaucracy with checks and balances was formed to administer law and collect revenue. To ensure the timely payment of taxes and tribute, the Mughals maintained a standing army throughout India. From this great wealth, the Muslim elite sponsored a renaissance of music, literature, and art that blended Indian traditions with Western Islamic tastes. The famous Taj Mahal and the Great Mosque of Delhi were built by the Mughals.

By the beginning of the eighteenth century, the Mughal rulers had gradually lost vast portions of their empire to powerful, local chieftains. This crumbling of centralized imperial authority was advanced by alliances between local rulers and European mercantile agencies like the British East India Company, which had established trade routes to India in the early 1600s. With the support of its military might and modern technology such as railroads and telegraphs, the British took control of political power during the early nineteenth century. This foreign political unification in itself fueled a growing Indian nationalism. Over the following decades, British concessions and reform acts eventually led to independence for India in 1947.

In the postcolonial years, India was fortunate to have visionary leaders like Jaraharlal Nehru and Indira Gandhi (no relation to Mahatma Gandhi), whose focus and energy were directed to the modernization of India through technology and industrialization, social reform, and expanded international trade. Nehru helped create a secular society with a republican constitution in 1950 that established a separation of state and religion. In 1956, he helped further unify the nation by reorganizing the Indian states on a linguistic basis that allowed some degree of cultural autonomy on the local level. During the 1970s and 1980s, Prime Minister Indira Gandhi secured India's place on the world stage through international policies that demonstrated keen foresight. For instance, before intervening in the Pakistan civil war in 1971, which was driving millions of refugees into India, Indira Gandhi skillfully gained the support of Russia through a treaty of friendship and cooperation to offset threats of interference from the United States and China. In addition, under her leadership, India joined the nuclear power nations in 1974 by successfully testing a nuclear bomb, and a year later, entered the space arena by launching its first satellite. From the 1990s into the twenty-first century, India continued its drive to modernization—especially in computer technology—and global economic power. The "tryst with destiny" that Nehru had called India's independence in 1947 has become a triumph of self-sufficiency that has vastly improved the education, life expectancy, and standard of living for all its citizens.

INDIAN TEXTILES

Historians of Indian culture assert that the spinning and weaving of cotton originated first in the Indus Valley sometime during the late third millennium BCE. During the same era, goat's wool, called **urn**, meaning "hairy covering of an animal," was also spun and woven into textiles, especially for utilitarian items such as rugs, blankets, tote bags, and camel saddle covers. Sheep's wool is thought to have been introduced from the north during the Vedic era. However, no extant examples of woven materials from ancient India have survived so we can only speculate on the colors and patterns of fabrics as represented in artwork.

By the late Vedic era, the use of textiles and apparel was associated with certain ceremonies and frequently mentioned in sacred texts of the Vedas. Indeed, fabric and clothing were mystically linked to a person's spirituality and earthly existence. Even different parts of garments were consecrated to various deities, which were cited in the Vedic literature. For instance, in performing specific ceremonies, pleated materials were thought to protect the wearer from ill will by providing

Mordant Dyeing

In general, animal fibers such as wool, camel's hair, and silk will absorb and retain dyes fairly well, but vegetable fibers like cotton are not as amenable to the dyeing process. The preparation of these plant fibers requires additional chemical treatments to ensure thorough dye absorption and to attain the desired shades of color. These chemicals, or **mordants**, also make textiles colorfast—that is, resistant to fading from washing or exposure to light. The most common mordants used since ancient times are metal salts made from compounds of alum, iron, tin, or chromium. Other natural mordants are vinegar, lime, caustic soda, urine, and a variety of recipes made from mixtures of leaves, fruits, and ashes.

We do not know for certain what processes the ancient peoples of India used to prepare mordant dyes, but the skilled techniques of mixing and the sequence of applying mordant and dye were probably similar to those used by hand dyers today. For example, the blending of the juices from the taproot of a plant called chay with alum produces a vibrant red, but when mixed with an iron salt compound the colors range from violet to brown.

Certainly, by the time of the Indus Valley civilization, the peoples of ancient India had mastered a substantial variety of dyeing methods and the use of numerous mordants. The oldest known Indian textiles with vegetable dyes made with alum or metal salt mordants date to various periods of the Middle Ages between the eighth and fifteenth centuries. These fragments of resist-dyed indigo patterns and of block prints in red, brown, violet, and black were excavated at a caravan site near Cairo, Egypt, providing evidence not only of the array of sophisticated dyeing methods known to the early Indians, but also of the widespread demand for their textiles.

Even today, despite the mass availability of synthetic dyes and inexpensive milled fabrics, the handicraft of mordant resist dyeing and block printing is still practiced in some parts of India. The sumptuous patterns and vibrant colors of Indian textiles continue to have universal appeal.

obstacles for any evil spirit. Another example was the dangling pleated front of a garment called the **nivi** which invited Vayu, the wind, to dance among its folds.

Another source that provides evidence of the sophistication and quality of Indian textiles in ancient times comes from Megasthenes, the Greek observer of India in the late fourth century BCE. He noted that the Indians "love finery and ornament. Their robes are worked in gold, and ornamented with precious stones, and they wear also flowered garments made of the finest muslin."

Silk also was a fabric mentioned in the Vedas and commonly used in Vedic rituals. Trade in silk textiles with China possibly predated even the arrival of the Aryans. How and when India developed sericulture of its own is uncertain. Legend holds that a Chinese princess who was sent to marry a Kushan prince in the third century CE smuggled silkworm eggs out of China hidden in her wedding trousseau. Silk production in India never achieved the commercial status of that of China, Constantinople, or Islamic Persia. In some regions, Hindu rulers issued sumptuary restrictions, and silk was forbidden to certain classes and ethnic groups. Even Indian nobility many times preferred garments made of high quality, fine-gauge cotton over those of silk. Only during Islamic rule did silk become a favored fabric for the clothing of the ruling classes. By then, weavers had developed opulent silk brocades known as **kinkhab**, meaning "little dream," which were woven with shimmering gold or silver threads. **Patola** was a type of patterned silk formed by interlacing pre-dyed warp and weft threads. The Mughals especially liked striped patola for emphasizing the vertical lines of trousers and long jackets.

What types of looms and spinning devices the ancient Indians used are not known for certain. The earliest mention of the spinning wheel is found in the writings of fourteenth-century chronicler Isami. From this evidence it is believed that the spinning wheel, the **charkha**, was introduced by the Muslims. In fact, it is an irony of history that the charkha became a national icon of Hindu India despite its Islamic provenance.

The spinning wheel greatly boosted production of yarn and increased the export trade in textiles. Both men and women wove cloth, but mostly men and boys operated the large looms that produced commodity fabrics. Tons of white hand-spun, handwoven cotton cloth, called **khadi**, were shipped as far as China, Africa, and Europe for local dyeing and embellishment. By the Mughal era, Indian weavers had developed superb textiles of great complexity and variety. (Figure 11-1.) A multihued textile resembling tapestry, called **jamdani**, was produced by laboriously threading a bamboo needle through the warps rather than a shuttle. **Butidar** was a floral brocade named for the intricate patterns of tiny flowers called butis. Probably the best-known Indian weaving in the West is the **dhurrie**, a heavy, flat-woven cotton material used for bedspreads, cushion covers, and especially floor rugs.

Color symbolism in Indian apparel has been a prevalent form of personal expression since ancient times. **Raga** means both dye and mood. For example, madder red is the color of lovers because it could never be washed away, and saffron yellow was the color of the earth worn by yogis, seers, and other wanderers of the land. More than 300 indigenous plants were used to prepare a vivid palette of natural dyes prior to the introduction of synthetic colors in the nineteenth century. In addition to brilliant solid colors, labor intensive methods of tie-dyeing produced **laheria** cloth,

Figure 11-1. The origins of spinning and weaving in ancient India are unknown. The earliest extant textiles date to the Medieval Period, by which time Indian weavers had developed complex techniques for producing rich, elaborate patterns. Fragment of paisley print silk fabric, c. 1800.

noted for its complexity of multicolored stripes and checks. Resist-dyeing techniques were combined with woodblock printing to create lavishly patterned textiles called **ajrakh**, some of which were printed on both sides with perfect registration of pattern to pattern.

ANCIENT INDIAN MEN'S COSTUMES

In the 1920s, archaeologists first discovered evidence of an Indus Valley civilization that flourished about 4,000 years ago. Among the artifacts found were the earliest representations of Indian costume depicted in a few carvings, seals, and bronze and clay figurines. The majority of male figures are nude, some rendered with anatomical exactness and superb artistry, others stylized to the point of abstraction. A few tiny images on seals show nude males adorned with rows of elaborate necklaces and bracelets, while others depict silhouettes of men dressed in knee-length skirts. It is not known at this point if these images reveal that most Indus Valley men were unclothed except for possibly upper classes.

One finely carved figurine found at an early site represents a bearded priest or deity who wears a lavishly decorated wrap robe over the left shoulder and tucked under the right arm, somewhat like the priest's kaunakes of Mesopotamia. (Figure 11-2.) The recesses of the allover trefoil, or clover-leaf, pattern were filled with a red paste, which could indicate either a woven motif, block print, embroidery, or appliques. No fragments of textiles from the Indus Valley era have been found so it is uncertain if the fabric was woven locally or imported, perhaps from Sumeria or China. An upper armband and fillet around the head are accented with circular ornaments indicating a sense of ensemble costume possibly for religious symbolism, status identity, or purely decorative purposes.

The scant few artifacts from the Indus Valley sites are tantalizing but provide little substance for understanding or mapping the development of early Indian costume. Only with the flowering of the Vedic culture do we find sufficient evidence of costume styles clearly presented in literature, sculpture, and painting.

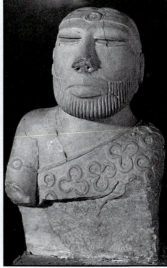

Figure 11-2. One of the few Indus valley civilization figurines that depicts details of a male costume is this alabaster figure of a priest or deity from around 2000 BCE. The garment appears to be a wrap similar to the Mesopotamian kaunakes of the same period. The trefoil patterns are filled with a red paste, which could represent a woven, printed, or appliqued design. The fillet and armband have matching ring ornaments.

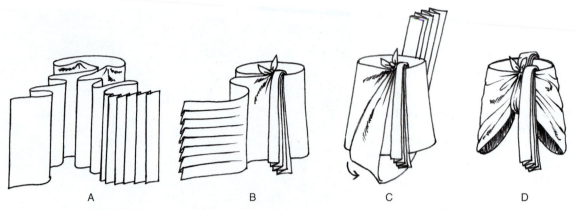

A B C D

Figure 11-3. The dhoti is a long loincloth arranged around the waist as a wrap garment with an overlap of material in the front. A pinch of fabric at the top edge of each side is tied at the navel. (A.) The excess material on the wearer's left is then pleated vertically and tucked into the front. (B.) The excess material on the right is pleated horizontally and pulled between the legs to the back. (C.) At the back, the pleats are tucked in, snugly forming the legs of the dhoti. (D.)

The basic masculine garment that developed during this early period became the prevailing type of clothing for both men and women of India for the following 2,000 years. It is a form of long, baggy loincloth called the **dhoti**. (Figure 11-3.) To arrange the dhoti, a length of fabric is first wrapped around the waist with an overlap in the front. A pinch of the top edge on each side is tied together at the navel. The excess length of fabric on the wearer's left side is then pleated vertically and tucked into the front. The excess material on the right is pleated horizontally and pulled between the legs to the back, where it is tucked into the waist to form the "legs" of the dhoti. Innumerable variations of the dhoti developed over the centuries. Some methods of wrapping the dhoti are distinctive enough to be specifically identified with specific regions of southern Asia.

The excess length of a dhoti might be arranged in a wide assortment of ways. The most common was to tuck it at the navel to form a dangle of fabric down the front. Pressed pleats or pinch pleats at the tuck created a decorative enhancement. If the excess length was too long to hang as a simple front dangle, it could also be folded or knotted into a loop. The other end of the excess fabric might also be twisted and wrapped about the waist like a thick belt, or allowed to drape as a swag over the hips or thighs. For upper classes, an exceedingly long piece of fine-gauge cotton fabric might even be carried over one arm or wrapped around the torso and shoulders.

Most of the time men did not wear any clothing on the upper body. Priests and other men of high-rank often wore a narrow scarf called a **dupatta** that was draped or tied around the torso and shoulders like an ornamental sash. Some styles were tightly pleated or trimmed with fringe at the ends. As with many aspects of Indian costume, the methods of draping the dupatta frequently were governed by rite and spiritual

purpose. The group of seated noblemen shown in Figure 11-4 depicts two simple arrangements of the dupatta that wrap from the back and drape over one or both shoulders. Other methods of draping the dupatta can be complex and formal, such as the example in drawing 11-4D representing the arrangement of a man's wedding dupatta.

As seen thus far, men's costumes of the early eras were comprised of pieces of fabric wrapped around the body in various ways. These were not static costumes with standardized components and formulas of arrangement. Stylistic trends shifted era to era, and new looks occurred as tastes changed. A myriad of proportions, combinations of garments, border treatments, fabric colors and prints, and accent details such as knots, twists, and loops reflected the fluid aesthetics of the ancient Indians.

In the years following the brief conquest by Alexander the Great in 325 CE, other invasions from the West introduced new types of costume to India. During the second and third centuries CE, the Kushans established a Persian satrap in northern India. With these Persian peoples came the tradition of tailored garments that extended back for centuries to the first Medo-Persian empires of the sixth century BCE. Three new forms of cut-and-sewn apparel were introduced by the Kushans, including coats, trousers, and tunics. (Figure 11-5.) The tunic worn by the Kushans was a T-cut short-sleeve style with a round neckline. The sculpture of a Kushan king shown drawn here depicts a tunic hemline at mid-calf although other carvings of Kushan nobles show a short variant cut at hip-length. The trousers represented on Kushan statuary appear to be fitted and tapered to the ankles. Because trousers were worn under the tunic it is not known what method was used to secure the trousers at the waist. The long-sleeved coat of the Kushans was slightly longer than the tunic. It was fastened at the neck but otherwise left open down the front with

Techniques of draping the male dupatta viewed from the back.

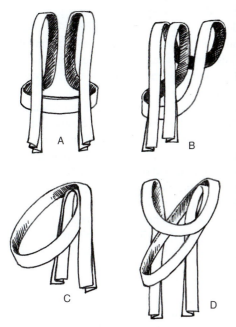

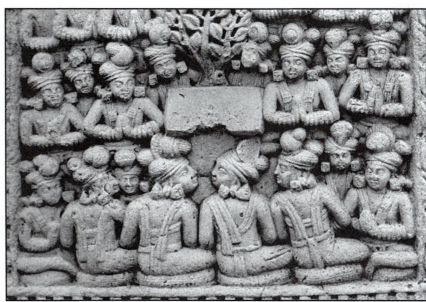

Figure 11-4. The dupatta was a scarf draped around the torso in complex and formal arrangements often governed by rite or ceremony. The bottom row of men shown in the carving above wear either arrangement A or B represented in the line drawings at the left. Detail of the west pillar from the gate of the Great Stupa at Sanchi, c. 100–200 CE.

Figure 11-5. With the invasions of peoples from the north and west, cut-and-sewn garments were introduced to India. The Kushans brought with them Persian styles of constructed tunics, jackets, trousers, and boots. Statue of Kushan King Kanishka, c. 200-300 CE.

no hint of buttons or tie strings. Detailed carving on the Kanishka statue indicates that some form of top-stitching, embroidery, or perhaps even beading was used along the edging of the front opening and the hemline of the coat.

Despite the long rule of the Kushans and cultural infiltration by other invaders from the West, the tailored types of Persian clothing were not widely adopted by the Indian masses. Instead, indigenous men continued to prefer loose-fitting, wrap types of garments. Even more than a century after the establishment of the Turkish sultanate in Delhi, Marco Polo noted during his visit to Tamil in 1290 that he was unable to find a tailor or seamstress who could make a coat for him.

In addition to the dhoti and the dupatta, two new loose-fitting wrap garments became popular during the Gupta period. In certain regions, upper class Hindu men began wearing the **lungi**, a wrap skirt varying in length from the knees to the ankles. Some lungis are sewn closed up one side forming a tube skirt. Most are made of fine white cotton although vividly colored silk is favored for special occasions. When going on a pilgrimage, Hindu men often choose a color that pays homage to the god with which the hue is symbolically associated. Color might also be selected to display modern political affiliations during elections. In the nineteenth century, men began securing their lungis with wide leather belts.

Another garment also worn by men of high status was a long mantle called a **pravara**. Made of the finest materials,

including silk, the pravara wrapped around the shoulders in a variety of arrangements. On occasion the pravara was worn in combination with a dupatta as the outer layer to hold it in place.

The dhoti was the garment of choice for most men of ancient India who could afford the significant amount of fabric needed for properly arranging the garment. As noted earlier, great quantities of plain white cotton material were produced for local consumption as well as export. Yet for the lowest castes—peasants, laborers, sailors—even the necessary yardage for a dhoti made of this basic commodity fabric was often beyond their means. Consequently, prepubescent boys usually played and worked naked. Men, though, at least donned a loincloth, called a **vasas**. The term literally means "wearing cloth" and was formed with just enough material to wrap around the hips and pull between the legs to tuck into the back waistband.

ISLAMIC TO MODERN INDIAN MEN'S COSTUMES

Although the Muslims had established a foothold in India by 712, no concerted effort was made for a complete Islamic conquest of the entire country until the twelfth century. At that time, an army of Turks first conquered much of northern India and founded an Islamic sultanate in Delhi. From this stronghold, Muslims gradually expanded their dominance southward by conquest, treaty, proselytizing, and cultural influence until most of the peninsula was under Islamic dominion by the fifteenth century.

Unlike previous invaders, such as the Aryans or Kushans, the Muslims were not tolerant of the religions and culture of their new subjects. Initially, the Turkish sultans segregated Muslims from the indigenous peoples. Muslims were the overseers of local labor and administrative resources. Eventually, Islamic teachers began converting the Hindus, especially those of the lowest castes where the Muslim concept of equality in the eyes of their god had great appeal. By this method, Islamic culture—including clothing styles—was disseminated throughout much of India.

The most striking garment worn by the Islamic men of India was the **jama** (also jamah), a Persian word variously meaning robe, wrapper, gown, and coat. By the Mughal period, the jama was standardized into a long-sleeve, knee-length coat with a front closure that wrapped left to right. The inside flap was tied with ribbons under the left arm and the outside flap was tied, pinned, or buttoned at the right side. As can be seen by the striped version shown in the lower right panel of Figure 11-6, the sleeves were not set in but rather were a T-cut straight across the fabric. The bodice of the jama was fitted with an attached skirt that flared into a wide bell shape. Jama styles of the eighteenth and nineteenth centuries had circle skirts that were gathered into a full, dense arrangement of folds.

Beneath the jama, Muslim men wore a form of trousers called the **chudidar trouser**. The basic silhouette of the chudidar was full around the hips with a tapered, close fit from the knees to the ankles. A **bracelet cuff** was formed by cutting the trouser leg hemlines long enough to shape concentric folds about the ankles resembling stacks of bracelets called **cudi**. The same effect sometimes was created at the wrists by excessively long sleeves.

Although the jama was occasionally worn as the sole top garment, men of upper classes usually wore a shirt-like undertunic known as a **kudta** that tucked into the capacious trousers. Most styles of this under tunic were long sleeved although some paintings show short-sleeve versions.

On high state occasions, men of the ruling family layered the **kurdi**, a fitted vest, over their jama. (Figure 11-7.) The kurdi's peplum style skirt extended to just below the hips, creating a tiered effect over the full skirt of the jama.

Silk was the favored fabric of the Islamic court. Colors and textile patterns ranged from vivid solid colors to bold vertical stripes and sumptuous brocades. A French visitor to the court of Delhi in 1660 wrote that the men's jamas and kurdis were made of "gold brocade, or a thick satin, and they applique them with gold or silver lace, or galloons, or they embroider them." Jama coats also were often made of the sheerest silk to reveal colors and patterns of garments layered underneath.

For the masses, the chudidar trouser became the **salwar**, a loose, cut-and-sewn type of straight-leg pant with a drawstring waist referred to in the West as a **pajama** (or pyjama in British texts). (Figure 11-8.) The salwar was cut on the bias and lacked the pockets or pressed creases at the front and back like its Western counterpart. By the beginning of the twentieth century the salwar and dhoti were the two most common traditional bottom garments for Indian men.

A variation of the chudidar called **jodhpurs** emerged in the mid-nineteenth century as an evolution of the wide-seated chudidar trouser combined with the close-fitting cut of European trousers. The trim, fitted jodhpurs with their distinctive wide flare at the hips became popular with the nobility of India, from which British colonial officers adopted the look as a component of the masculine riding habit. During the 1910s, jodhpurs were also adapted to women's riding habits. By World War I the jodhpur silhouette was the standard issue uniform for U.S. doughboys. In addition, the style was appropriated by various sports and military organizations, and became a common type of work pants for field surveyors, archaeologists, aviators, and construction foremen during the early twentieth century. (See page 256.)

MILITARY COSTUME

Since so little is known about the ancient Indus Valley civilization, it is not certain if its inhabitants were a warring people. If so, most likely their experience was limited to

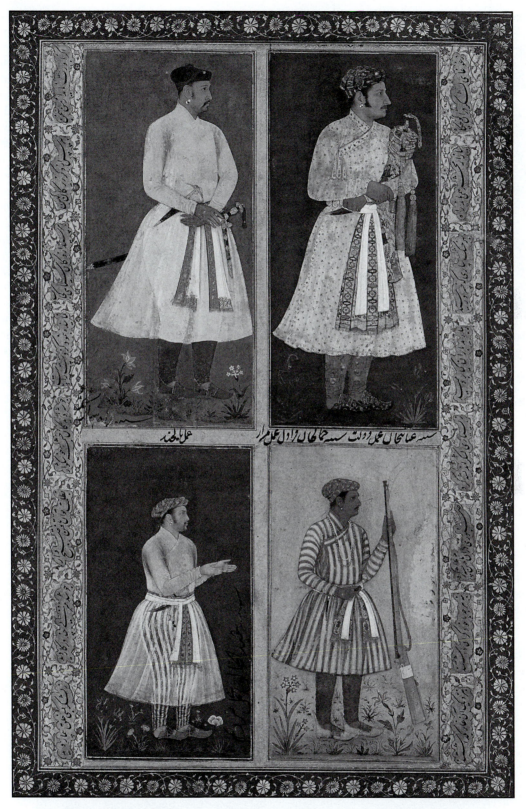

Figure 11-6. The Islamic conquerors, known as the Mughals, brought to India Turkish styles of tailored garments. The jama was a long coat with a wide, bell-shaped skirt. The chudidar trouser was cut full at the hips and narrow at the ankles. Under the coat often was worn a short under tunic, called a kudta, with a wide, wrapped sash at the waist called a cummerbund. Miniature of four Mughal courtiers from the *Kevorkian Album*, c. 1615.

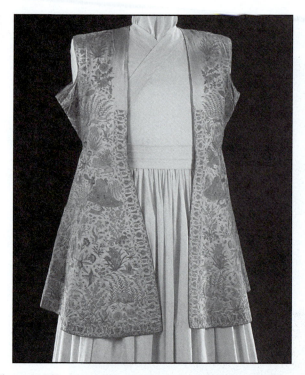

Figure 11-7. For men of the ruling Mughal families, a long, fitted vest, called a kurdi, was layered over the jama for special occasions such as state functions or royal weddings. Mughal silk embroidered kurdi, c. 1630–1660.

raids and skirmishes with neighboring communities using only unsophisticated weapons and tactics. It is thought that the invading Aryans first introduced battle techniques along with the war chariot and possibly the compound bow into India from Asia Minor during the mid-second millennium BCE. A thousand years later, Persian records indicate that skilled warriors from the satrap that included northern India served in the imperial army as early as the fifth century BCE. Certainly these soldiers would have brought back home knowledge of Persian arms and armor, only some of which they evidently adopted. Chroniclers who accompanied Alexander the Great noted that the Indian armies were fierce combatants with spears, swords, and massive bows that required one end to be planted into the ground to shoot. The earliest representations of Indian military events, though, only date from about the first century CE. These relief carvings reveal a wide variety of specialized arms and battle tactics including sieges and use of the elephant corps. (Figure 11-9.)

The military costume of the ancient Indian soldier offered less protection than those of the Persians or Greeks. Instead of metal or leather helmets, the Indians wore tightly bound turbans or fought bareheaded. The dupatta was wrapped about the torso in a spiral that served as a sort of

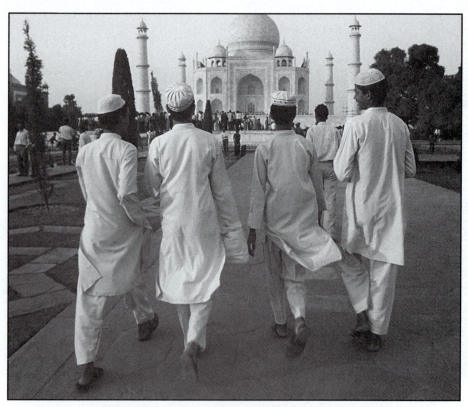

Figure 11-8. The most common form of men's trousers is the pajama, also known as a chudidar or salwar. Unlike Western trousers, the pajama was cut on the bias and sewn without pockets.

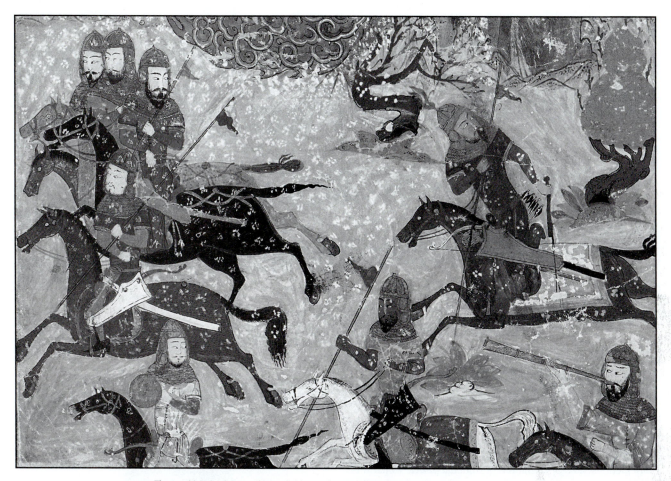

Figure 11-9. In the twelfth and thirteenth centuries, new forms of arms and armor were introduced by the invading Muslims. The pointed helmet, chain mail, round shield, and curved sword and dagger of the Islamic Empire were adopted by the Indian military. Detail of a miniature from the *Shah-nama*, c. 1430.

cuirass. Costume historian Roshen Alkazi suggests that constructed cuirasses, long tunics, and wrap skirts covered with metal plaques were introduced by the Kushans in the early first millennium CE although such garments are not clearly represented in artwork of the period. Infantrymen of the ancient era carried long shields with an arched top that protected head to knee. Following the Gupta period, wall carvings show smaller round shields and no indication of the dupatta arranged as a cuirass or any type of metal-plated garments.

After the conquest of most of India by the Muslims in the twelfth and thirteenth centuries, new forms of weaponry and armor were introduced. Curved swords and daggers made of the finest Damascus steel were an integral part of Muslim soldier's costume. The same styles of armor described in chapter 8 are commonly depicted in Indian manuscript paintings of the early Islamic era. (Figure 11-9.) Elite soldiers, such as those in the cavalry, wore the shallow-domed, pointed helmet with a spike in the center of the crown. As with their Ottoman counterparts to the west, Indian officers added a horsehair tuft to the center spike. Some helmets also featured a chain mail gorget and neck guard. A capelet of the same chain mail provided some protection from arrows and downward sword blows.

Like all advanced military leaders of the sixteenth and seventeenth centuries, the Mughals abandoned metal armor since it was useless against artillery. Richly ornamented ceremonial helmets and shields modeled on the ancient battle forms continued to be produced into the twentieth century for palace guards or military leaders to wear at state functions.

During the British imperial period Western-styled uniforms were gradually adopted. For religious considerations, though, some units were permitted to continue wearing turbans instead of the standardized military caps or hats.

Figure 11-10. For more than 2,000 years, the most prevalent men's headcovering in India has been the turban. Variations range from the large, opulent patka of the no-bility to the low, pie-shaped pagdi of the peasant castes. Left, bas relief head from the Bharhut Stupa, c. 100 BCE; center, detail of miniature of Shah Janan, c. 1616; right, photo of the Rana of Dholpur, c. 1895.

INDIAN MEN'S HEADWEAR AND ACCESSORIES

Just as with the numerous arrangements of the dhoti, the Indian turban was worn in a wide assortment of ways across the centuries that varied by region. (Figure 11-10.) Some of the earliest depictions of men's turbans represent the **patka**, which was a voluminous headdress often wrapped asymmetrically with the dome positioned on the left side. (The term patka also applies to a long, narrow piece of material used as an ornamental scarf or sash usually tied or tucked at the waist.) For men of the upper classes, the patka was adorned with jeweled ornaments, plumage, and embroidered ribbons. Although there was no universal style for arranging the turban in any given period of ancient India, the innumerable variations identified the wearer's caste, religion, and regional origin. Some turbans were wrapped to leave the ears exposed, to half cover the ears, or to completely conceal one ear or both. The **pagdi** (also pag)—a low, squat turban mostly associated with lower classes—is thought to have originated with one of the tribes that invaded at the end of the Vedic era. This became the most prevalent type of men's turban throughout India. By the Islamic period the pagdi was often wrapped to form a flat, pie-shaped style, which is still widely worn today. One of the most common types of turban prevalent throughout modern India is the **gamcha** worn by peasants and laborers to block the intensity of the sun, to absorb sweat, and to cushion the head while carrying heavy loads. (Figure 11-11.) In the twentieth century, the **khadi**—a small, ovoid cap named for the commodity woven cotton from which it was made—became a significant component of the Indian national costume. Today the style is more commonly referred to as the "**Gandhi cap**" because the

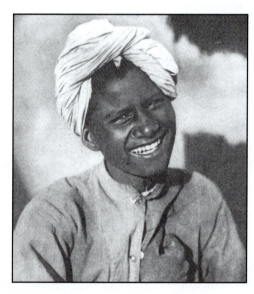

Figure 11-11. The gamcha is one of the most common types of men's turban worn extensively by the peasant and laboring classes. Photo of peasant boy, 1921.

nationalist leader Mahatma Gandhi wore one to symbolize his rejection of British colonialism.

The earliest representations of Indian footwear appear on statuary and carvings of the late Vedic era. Sandals were made with a single thong that fit between the first two toes and attached to a wide strap that looped over the instep. Textured striations carved into some sculptures indicate that early sandals were probably made of reeds. During the invasions at the end of the Vedic era, leather boots of various types were introduced although almost exclusively worn by the military and ruling

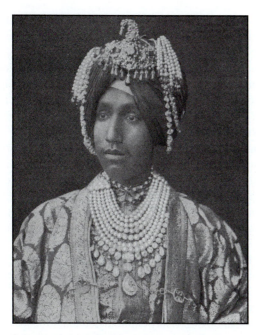

Figure 11-12. Jewels of the Indian nobility were legendary even in ancient times. Both men and women extravagantly affixed gemstones, pearls, and gold ornaments to clothing and accessories, and layered ropes of pearls and jewels around the neck and wrists. Photo of the Maharajah of Patiala, 1906.

classes of the occupiers. The statue of the Kushan king in Figure 11-5 shows heavy leather boots with stirrups around the ankles and instep. With the Muslims came pointed-toe slippers and boots made of colorful or intricately patterned silk, or masterfully tooled leather including cowhide, goatskin, and even exotics like gavial and python skins.

Body ornaments included sumptuous jewelry of all kinds from the earliest eras. Many statues of Indian nobility and deities display an abundance of gorgeously detailed necklaces, bracelets, earrings, torques, arm bands, and hair ornaments. Both men and women pierced their ears and elongated the holes by inserting ever larger earspools until the fleshy dangle extended to the shoulder. When not wearing earspools, hoop and pendant earrings were attached to the stretched earlobe dangle. The entire upper edge of the ear sometimes was pierced and decorated with multiple studs or hoops, a technique adopted by the Western punks of the late twentieth century. Even in modern times the superb quality and lavishness of the jewels layered on by the rulers of India were legendary. (Figure 11-12.)

THE WESTERNIZATION OF INDIAN MEN'S CLOTHING

Despite the centuries of contact with Europeans—as early as the end of the fifteenth century by the Portuguese—Indians only gradually and subtly adopted Western attire. Even in the nineteenth century, when boatloads of inexpensive ready-to-wear were imported from Britain, few Indians dressed fully as a European. As Emma Tarlo notes in her study of dress and identity in India, the interest in Western clothes "was related more to what they represented than to either their practicality or their aesthetic appeal." Urban businessmen, colonial bureaucrats, judicial court clerks, and those who had been educated abroad, called "England-returneds," displayed their modern, affluent status through their Western wardrobes. However, in actuality, most European clothes were heavy and constricting in the humid, tropical climate of the subcontinent. Many Indian men maintained a dual sartorial identity, dressing for work in European clothes but changing into traditional garments at home.

More important, though, Western dress was incompatible with many of the most fundamental social and religious values of India. Wearing foreign clothes was a violation of caste for some and was regarded as an impure act by devout Hindus. Etiquette also was at cross purposes between cultures: the European man viewed bare feet and a hat worn indoors as uncivilized; the Indian man considered a covered head as a sign of respect and viewed wearing shoes inside as polluting the house. Moreover, wearing Western attire necessitated lifestyle changes on a more basic level. For example, a man in a sack coat suit and starched shirt collar, not to mention a corseted woman in a Victorian bustle dress, could not sit on the floor and eat a meal with the fingers. Thus, the Indian who adopted Western attire also had to make adjustments for other foreign customs ranging from new forms of furniture appropriate for the clothing to alien manners and utensils for eating.

Rather than a transition to Western dress, as occurred in the urban centers of late nineteenth-century Japan and postcolonial Africa, India instead underwent a gradual Westernization of native clothing on two fronts. First and most significantly was the adaptation of foreign textiles to Indian styles. The use of imported cloth did not conflict with the traditions of caste, religion, or nationalist sentiment in the way that European ready-made clothing did. To the contrary, with the advent of aniline dyes in the mid-nineteenth century, the vividness and range of colors produced in foreign-made fabrics were particularly popular in India. In addition, British textile manufacturers shrewdly mass produced fabrics with traditional Indian motifs, prints, and patterns, ensuring an even wider market for their products throughout India.

The second front of Westernization occurred with the gradual mixing of European cut-and-sewn clothing with the draped styles of India. In rural areas, European clothes, even mass-produced ready-to-wear, were not easily accessible and were often more costly than ensembles of draped pieces of cloth. Hence, the elite of a village might invent new costumes that combined, for instance, a tailored frock coat with a lungi, or a placket-front shirt layered with a dupatta. Such hybrid compromises enabled the wearer to appear modern and knowledgeable of the mysteries of Western civilization, and at the same time to express his link with tradition.

In the early decades of the twentieth century, a nationalist spirit swept India, passionately urged forward by leaders such as Gandhi. As early as the 1910s, Gandhi had experimented with forms of traditional Indian dress that could portray a rejection of colonialism and reassert socioeconomic values that he thought were more appropriate to India. His choice of wearing only khadi in the form of the most basic peasant's loincloth was symbolically significant but did not, in the end, stem the tide of the Westernization of Indian clothing.

In the postcolonial years, Indian politicians could not embrace the craft-based society that Gandhi's khadi wraps and caps represented and still position India on the world stage of modernization and industrialization. A compromise menswear look was found in the sherwani pajama, which neither appeared to be based on Western apparel styles nor owed anything to the legacy of ancient Indian traditions of wrap garments. (Figure 11-13.) The **sherwani** is

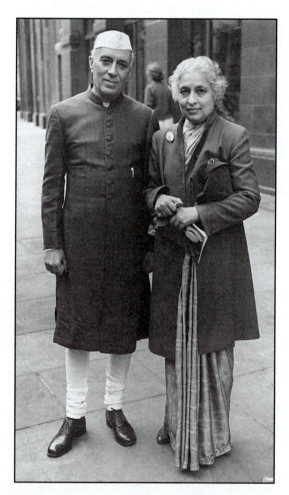

Figure 11-13. The sherwani is a lined jacket with a round, stand-up collar, padded shoulders, and besom pockets. Known in the West as a Nehru jacket, the style was named for Prime Minister Jawaharlal Nehru, who popularized the garment in the early postcolonial years. Photo of Nehru, 1955.

a knee-length jacket with padded shoulder construction, front-button closure, and besom pockets. Most sherwani feature a round, stand-up collar although collarless types are common. Side slits allow ventilation and freedom of movement. In the late 1960s, Western fashion designers adapted the round-collared sherwani to menswear as the **Nehru jacket**, named for Prime Minister Jawaharlal Nehru who popularized the look.

Similar in design to the sherwani is a shirt variation called a **kurta**. (Figure 11-14.) Most kurtas feature a round, stand-up collar and a button-closure placket or keyhole front although collarless variations are also popular. Casual styles are usually cropped at the hips, and formal versions extend to below the knees. Wedding kurtas are often made of sumptuous fabrics and lavishly embroidered and beaded.

Today, the wardrobes of many urban Indian men contain an abundance of Western styled ready-to-wear, including that American icon of apparel, jeans. Yet Indian men also enjoy the comfort and ease of the occasional kurta, and many possess a silk dhoti or lavishly embroidered lungi for special occasions that might inspire the spirit of tradition.

INDIAN WOMEN'S COSTUMES

As rare as artifacts are that depict men's costumes from the ancient Indus Valley civilization, representations of women's apparel are more scarce. One exceptional find is of a copper figurine of a nude woman dating to the first half of the second millennium BCE. (Figure 11-15.) The details of the sculpture show numerous ring ornaments—bracelets, arm bands, and a pendant necklace—but no clothing. Possibly, just as with other Neolithic cultures of temperate zones around the world, the populace went unclothed except for those of social rank or religious importance. The latter may be represented by the terracotta figurine shown here from about the same time wearing a short wrap skirt girded with a three-strand belt. Her oversized hat probably does not depict an actual headdress since it bears two cups in which was found residue of burnt incense. She is thought to represent a priestess or, perhaps, a goddess. The short skirt, wide girdle, and abundance of jewelry probably symbolize her highborn or divine status.

Although the Vedic texts refer to specific women's garments in numerous passages, we have no visual evidence of what these looked like. No extant garments or artwork depicting costumes of the era have been found.

In the post-Vedic period of conquests by foreign invaders, though, numerous sculptures and figurines were produced with superb details of clothing styles. Women's costumes were almost identical to those of men including the dhoti, trousers, wrap skirts of varying lengths, and the dupatta.

One of the most famous sculptures in India of this era is of a Yakshi, or female guardian spirit, from around 250 BCE.

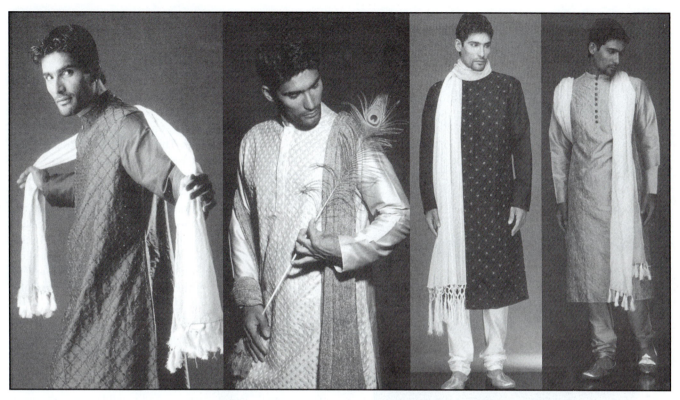

Figure 11-14. The kurta is a type of men's pullover shirt with various collar and neckline treatments. Casual versions are usually cropped at the hips, and formal styles extend to below the knees. Wedding kurta pajama sets with dupattas from Sahil, 2004.

Figure 11-15. Rare examples of female figurines from early Indus Valley sites provide some detail of ancient feminine costume but also pose many questions. Did the copper figurine of the nude woman on the left indicate that most ordinary women of the Indus Valley civilization were unclothed except for ring ornaments? Was the girded skirt of the terracotta figurine on the right a status garment reserved exclusively for highborn women or representations of female deities? Too few examples of artwork depicting women's costumes have been found to establish with any certainty the early traditions of Indian feminine dress. Left, copper figurine of a woman, c. 2000–1500 BCE; right, terracotta figurine of priestess or goddess, c. 2000–1500 BCE.

Figure 11-16. One of the earliest sculptures of a female from the post-Vedic era is the figure of a Yakshi from about 250 BCE. She wears a lungi, or long wrap skirt, that is secured about the hips with a five-strand chain belt. A long, pleated hip patka is folded into a loop like an apron at the front.

(Figure 11-16.) She wears a lungi, or long wrap skirt, that is tied in the front, thereby causing the cascades of diagonal folds over the legs. These radiating folds of fabric often represent the draping of a dhoti, but this figure is carved in the round so the back clearly shows that her lower garment does not have a front-to-back tuck of the bottom edge. Her long pleated hip patka is arranged like an apron that is double folded into a loop over a five-strand chain belt.

The Yakshi also exhibits an ideal feminine beauty of voluptuousness that features broad hips, a narrow waistline, and full, melon-shaped breasts. Her form is the essence of fertility and sensuality, and would remain the ideal feminine form in India for the following 2,000 years. The arrangement of wrap clothing and accessories, and the construction of cut-and-sewn garments in the modern eras would be governed by the Hindu tradition of defining and accentuating the feminine figure. Muslim Indian dress for women would take quite a different approach.

In addition to the lungi, women of ancient India wore a variety of bottom garments. The **ghagra** was a wrap skirt of mid-calf to ankle length. Later, invading tribes introduced two cut-and-sewn garments for women—the **shaluka**, a long vest-like tunic, and a version of the salwar that was so voluminous that it probably fitted more like a divided skirt. Both the shaluka and the salwar were initially limited mostly to the foreign clans who settled in the north. By the Islamic era, the shaluka was made with sleeves of varying lengths, and the salwar had become less voluminous. This later tunic and pant outfit became known as the **Punjabi ensemble**.

With the invasions of the Muslims beginning in the eighth century, new types of cut-and-sewn garments for women were introduced to India. The silhouettes of the baggy trousers and long tunic-style jackets of the Muslims were in the Kushan-Persian tradition of 1,000 years earlier. The women's jacket, or jama, and chudidar trousers, were identical to the masculine versions except for the women's jama skirts were ankle-length. (Figure 11-17.)

Because of the tropical climate and distance from orthodox Islamic centers in Istanbul and Mecca, most Muslim women of India were initially less restricted in dress and custom than their cousins to the west. For the most part, they were free of the shroud-like veils and cloaks worn by women of the Ottoman Empire. Paintings of the Mughal era commonly depict women in mixed company without face veils. During the reigns of orthodox sultans, however, feminine dress became more restrictive, reflecting the traditional secluded status of Muslim women. The burqa was similar to the modern Arab abaaya that covered the woman from head to toe when she had to appear in public. As with the traditional shapeless abaaya, the Indian burqa completely concealed the woman in yards of plain black fabric, or for certain occasions, white material.

Possibly because of the influence of the Muslim feminine costume, Hindu women of the Islamic era adopted a constructed top garment, called a **choli**, for the first time in the history of their native costume. At first the choli was cut more like a bandeau brassiere that simply covered the breasts with a panel of material and tied in back. Eventually, short sleeves were added although the back remained open with attached tie strings. Most modern versions of the choli are closed in the back and constructed as a pullover. On the one hand, the choli concealed the bosom from public display, yet it also gracefully enhanced the feminine contours with elegant and striking fabrics.

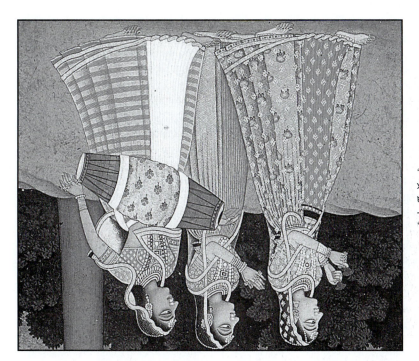

The choli was paired with the ghagra, or wrap skirt, that, by this time, featured a panel of contrasting material in the front that was pleated or gathered. (Figure 11-18.) A variation of this look was achieved with a skirt that was wrapped smoothly about the waist but affixed in the front with a pleated scarf somewhat like a narrow apron. Both styles of the ghagra could also be layered with a dupatta, which some Hindu women continued to wear as a top instead of the choli. Once the torso was adequately covered, the excess material could be variously draped around the hips and tucked into the ghagra.

It should be noted, though, that in the precolonial period, rural women of central and southern India commonly wore no tops. Marco Polo even wrote of the Hindu women's state of undress in the thirteenth century on his eastward journey. Despite centuries of Muslim influence, followed by the imposition of British colonialism and Christian missionaries, women continued to leave bare their shoulders and breasts. Even today in some remote villages of the south the custom-ary dress of women principally consists only of long skirts and head coverings. As a striking cultural comparison with the West, though, if these village women accidentally expose their legs to a male, they are as embarrassed as a Western woman would be upon discovering an undone blouse button that exposed her bra.

The ensemble of the dupatta, choli, and ghagra is the precursor of the most prevalent style of modern Indian cos-tume for women, the **sari** (also saree). Indeed, some his-torians erroneously refer to the wrap skirt and scarf arrangements of the ancient or medieval eras as the sari. But in actuality, as a distinct garment, the sari developed only during the late seventeenth century, according to costume

Figure 11-17. Women's costumes of the Mughal era were almost iden-tical to men's versions, including baggy trousers and a close-fitting jama with a full skirt. Except during the periods of orthodox Islamic rulers, Indian Muslim women were less restricted with face veils than their cousins in Ottoman provinces to the west. Detail of Mughal miniature, c. eighteenth century.

Figure 11-18. During the Mughal period, the typical costume of Hindu women in-cluded the cropped choli top and a pleated front ghagra. Detail of a silk painting depicting women musicians, c. 1760.

historian Arabina Biswas. It is the arrangement of the torso scarf, the **odhni** (also orhni or odhani), that confuses many researchers. By the late Mughal period the dupatta as worn by women had evolved into a longer, wider scarf called the odhni, which literally means "covering." In certain regions, Hindu women used the odhni not only as an upper torso garment but also as a head covering, which they could pull across their face as a gesture of respect and modesty in the presence of elder family members and people of senior status outside the home.

Although the sari is actually a single garment, it may be worn in combination with an underskirt, or petticoat, and a choli. There are numerous ways to drape the sari, some of which have become characteristic of regional tribal costumes. The most common style today is the **nivi sari** with its distinctive pleated front. (Figure 11-19.) The draping method begins with a single piece of fabric six yards in length and about forty-five inches wide. These oblong textiles are not just yardage of any cut fabric but rather are woven to size with finished borders and a decorative end, called a **pallav**, as part of the cloth panel. Changing trends in border width, the

design of the pallav, and the type or color of fabric are key barometers of Indian women's fashion.

According to researcher Chantal Boulanger, to arrange a sari, begin tucking the fabric into the petticoat on the right side of the abdomen, and work to the left tucking across the front. (A.) At the left hip, form a single pleat and tuck that into the petticoat. (B.) Continue tucking the fabric around the back and forward to the right hip, where another single pleat is folded and tucked into the petticoat forming the closing of the sari skirt. (C.) With the remaining length of material, make five or six overlapping pleats in the front, each pleat about four fingers in width, and tuck into the petticoat. The rest of the fabric is pulled to the back, completely around the body again, forward under the right arm, then draped loosely across the chest, and finally over the left shoulder. (D.) The pallav is usually allowed to dangle down the back, its eye-catching designs fluttering with the woman's movement. The art of arranging and wearing a sari fascinated Western colonists who were unable to analyze the swirls of floating fabric, yet appreciated the graceful lines of the soft pleats and spiral draping.

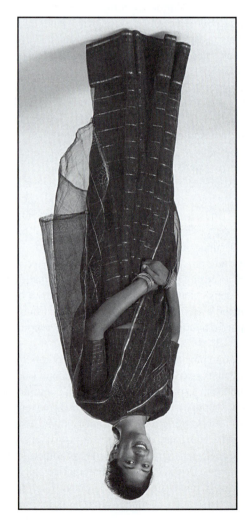

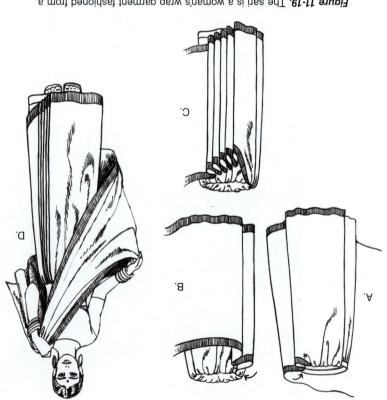

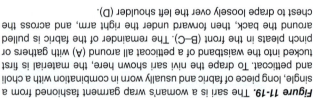

Figure 11-19. The sari is a woman's wrap garment fashioned from a single, long piece of fabric and usually worn in combination with a choli and petticoat. To drape the nivi sari shown here, the material is first tucked into the waistband of a petticoat all around (A) with gathers or pinch pleats in the front (B–C). The remainder of the fabric is pulled around the back, then forward under the right arm, and across the chest to drape loosely over the left shoulder (D).

Of special importance is how the sari of the postcolonial years has become an egalitarian form of dress. The common use of foreign fabrics, particularly the many new synthetics, and the democratic drape of the nivi sari have helped lead Indian women toward a new society that negates caste and the stigma of colonial segregation. In its modernist wake, though, the ubiquity and democracy of the nivi sari have also led to the vanishing of the tribal sari with its many unique and specialized varieties of draping, knots, and decorative treatments.

INDIAN WOMEN'S ACCESSORIES AND COSMETICS

The seemingly infinite varieties of headdresses and hairstyles that appear in artwork of India across the centuries attest to the Indian woman's love of personal adornment. In the many carvings of female figures in the Sanchi temple decorations, for instance, are dozens of different styles of elaborate turbans, tiaras, and headdresses. Some versions of the feminine turban imitated the form of the conch shell, twisting up to one side in a uniform spiral, and still others appear to have been unique freeform arrangements wrapped around curls, braids, and buns. The turban was revived as a prevalent headcovering for women during the Islamic eras, but then was increasingly replaced by the odhni, or veil, in the seventeenth and eighteenth centuries, particularly in northern India. Ceremonial headdresses of highborn women were opulent confections of gold or silver wire filigree encasing jewels, pearls, and carved jade and coral. (Figure 11-20.)

In addition to lavish headdresses and coverings, Indian women have traditionally enjoyed wearing a profusion of jewelry since ancient times. The figurine of a woman from the Indus Valley culture shown in Figure 11-15 wears no clothes but is laden with finely detailed jewelry. The number of ring ornaments and placement on the body often reflected spiritual tradition and social status. Ears were pierced and stretched with earspools. Noses were pierced through the nasal septum and at the nostril sides for studs. Prevalent still today is the custom of wearing some type of gold ornament against the skin because gold is believed to have the power to purify anything it touches. In addition to stacks of bracelets, layers of necklaces, multiple earrings, and nose rings, ancient Indian women also encircled their ankles with chains, bangles, or thick anklets of tiny bells called **ghungrus** such as those shown in Figure 11-16. Today, ornaments for the feet such as anklets and toe rings are made of silver, or brass for the poor, so as not to pollute the purification power of gold by being trod upon or becoming soiled from contact with the ground. Following the invasion of the Greeks and Persians in the post-Vedic period, chains of coins called **nishkas** became popular for necklaces, bracelets, and hip girdles. These coin chains also served as dowries and heirlooms passed down from mother to daughter over generations—a custom that survives still in many rural areas of northern India.

Hip girdles have been an important component of feminine costumes for centuries. The **mekhala** (also mekhla) is a multistrand chain or beaded belt that fits around the hips to emphasize and exaggerate the width. A hip scarf called the **kamarband** was used for the same purpose as the mekhala but could be made of various fabrics and arranged with elaborate combinations of twists, loops, bows, knots, pleats, and dangles. The kamarband was adapted to men's formalwear in the nineteenth century as a sash called the **cummerbund.**

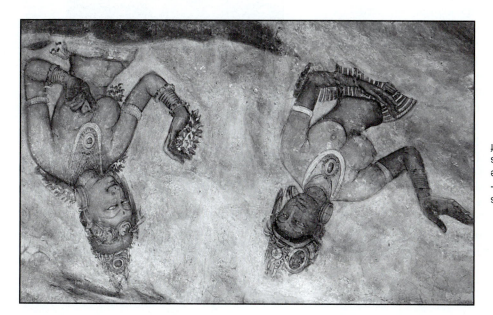

Figure 11-20. Ceremonial headdresses of highborn Indian women were elaborate constructions of gold or silver wire filigree studded with gems and precious stones. Frescoes from the palace of Sigiriya, c. 475 CE.

Figure 11-22. Women in a bridal party traditionally adorn themselves with elaborately painted patterns called mehndi. Designs commonly represent symbols of fertility such as flowers and fruits.

kohl used for eye liner and a stick of rouge, suggesting that women tinted their lips and cheeks. Also in these ancient sites have been found cockle shells containing green eyeshadow and white carbonate of lead that probably was used to whiten the skin. Where women of the West pluck their eyebrows into fine, arching lines, many women of India prefer heavy eyebrows, and apply dark eyebrow pencil to thicken and shape theirs for more prominence.

Another form of cosmetic adornment for both Indian women and men is body painting. The tradition of painting a "third eye," called the **bindi,** in the center of the brow dates back to the late Vedic period. Formerly the red dot was made with a paint mixture of henna blended with mercury, considered by the Hindu to be the seed of the god Shiva, and sulphur, the female element. For women the bindi is associated with marriage and fertility. (Male ascetics and yogi apply the bindi to represent truth and enlightenment.) In modern times the bindi is still commonly applied, but with paint free of toxic chemicals. It is still most frequently a simple red dot although for special occasions such as weddings, it is sometimes a star, lozenge, oval, droplet, paisley, or floral shape. The bindi can be applied by painting, drawing, stamping, or even adhesive jeweled appliques. (Figure 11-21.) Since the 1970s, bindi paint sets have provided women with multiple color options to match their wardrobes.

Mehndi is body painting most commonly associated with women in a bridal party. The night before the wedding, the bride's closest female friends and relatives gather for a celebration during which they paint lavishly decorative patterns on almost any part of the bride's body, but primarily on the hands, feet, and arms. For large bridal entourages, many of the attendants may also wear the mehndi. Designs are usually filled with stylized flowers and fruits, symbolizing fertility. (Figure 11-22.)

cient times. Artifacts from Indus Valley sites include sticks of ics, which women of India have liberally applied since ancient times. Artifacts from Indus Valley sites include sticks of

As with men, personal adornment also includes cosmetics, which women of India have liberally applied since ancient times. Artifacts from Indus Valley sites include sticks of

with pointed, curling toes of men. Muslim women wore the same styles of slippers thongs may actually be depictions of chain or beaded footornaments. Muslim women wore the same styles of slippers with pointed, curling toes as those of men.

Artwork depicting women's shoes are extremely rare prior to the Islamic era. Sandals appear to have been the most common form of footwear although representations of toe thongs may actually be depictions of chain or beaded foot ornaments.

Figure 11-21. The bindi, or "third eye," is a painted dot or ornamental applique placed on the brow between the eyes. It is symbolic of marriage and fertility. Jewelled wedding bindi, 2009.

Figure 11-23. Indian fashion designers of the twenty-first century are reinterpreting traditional Indian costumes with new cuts, fabrics, colors, and accessories. Left, silk lengha with beaded and embroidered top and veil by Asif Chowdhury, 2003; right, sari with gold embroidered and beaded borders and crinkled spaghetti strap choli from Sahil, 2004.

ETHNIC CHIC AND FASHIONS IN THE NEW MILLENNIUM

Just as with Indian men's clothing during the colonial era, women's traditional styles underwent a Westernization that began with the adaptation of European milled cloth to feminine costumes. Next came the phase of mixing European and Indian garments, which was limited primarily to Victorian and Edwardian petticoats and lightweight, lacy blouses. Only elite Indian women fully dressed in European fashions, and then not so much in admiration of the styles as a display of cooperation with the British in the progressive development of India. The phase of women's dress development during the nationalist decades prior to World War II brought expanded options for the sari. Fashion change came not so much with new silhouettes or draping methods but with greater varieties of fabrics, colors, and print treatments. Synthetic materials like silky rayon and nylon were fresh and new.

In the last quarter of the twentieth century, the most recent phase in the historical progression of Indian women's dress featured "ethnic chic," as the fashion press christened the look. For the elite and middle classes of India, ethnic chic is the wearing of peasant types of clothing and tribal fabrics. It is a cultural revival that venerates Indian aesthetics over Western fashion. However, it is only through a sufficient distance—socially as well as geographically—that modern women of upper classes don village clothes. Ethnic chic, notes author Emma Tarlo, "relies merely on the hollow ideas of identification without any real attempt at participation." One of the main influences for the emergence of ethnic chic has been the Indian film and television industry. The female stars frequently wear a wide assortment of colorful, exotic regional outfits—often out of context and unrelated to the ethnic groups for whom the styles are traditional dress.

At the end of the 1980s and into the 1990s, ethnic chic began to evolve into a cult of exclusivity with the advent of "artwear" fashions. According to a report in *India Today* in 1989, artwear fashions were one-of-a-kind clothes created by a designer and artist team. Because of the handcrafted production of artwear, only a few dozen garments were made by each team, some of which cost up to $2,000 each.

From the 1990s into the new millennium, fashions for Indian women have continued to offer inventive variations that exceed the boundaries of traditional styles of the sari and choli. (Figure 11-23.) The sari was revitalized with new fabrics and especially with new attitudes. In place of the bulky petticoat, some Indian women donned slim, contouring Lycra trousers instead. Still other sophisticated women discovered the glamour and sex appeal of the feminine figure silhouetted in a sari and nothing else. Similarly, the choli was recut in

halter styles and with deep surplice necklines. In place of the choli, some women opted for the **sthanapatta**, a brief bandeau of colorful knits that tied or fastened in back. For formal occasions, particularly weddings, full gathered skirts, called **lenghas**, were paired with tops ranging from cholis to Western styled tunics and corsets.

In 1999, when the chief of the France Luxury Group visited India, he told the press that the Indian fashion industry was "disorganized and directionless, despite its creativity and elegance," and needed a "fleet with a navigator." The following year, the Fashion Design Council of India was formed and presented the first Lakme India Fashion Week in New Delhi. The emphasis of the annual Fashion Week shows is less on couture and more on globally marketable prêt-a-porter collections, featuring combinations of Western clothing in an Indian style and fresh interpretations of traditional Indian costumes. Although the current $50 million Indian fashion industry is barely one percent of the country's $7 billion textile industry, in the twenty-first century, Indian fashion is continuing to attract international attention. In its report of the 2004 Lakme India Fashion Show, the *Washington Post* observed: "Fashion experts and industry insiders say it is only a matter of time before one of the top fifty [Indian designers] makes that elusive breakthrough and becomes an international style icon."

REVIEW

The Indian subcontinent has been home to great civilizations and high cultural development since ancient times. Over the millennia, the natural abundance of the region and its many fertile river basins lured invaders, some of which passed through only briefly, such as the Greeks, and others who settled in the conquered lands, contributing to the cultural evolution of India.

The origins of Indian costume are veiled in time with little evidence of how the earliest inhabitants dressed. Figurines from the ancient Indus Valley civilization reveal that both men and women wore basic wrap garments that resembled styles from Mesopotamia. By the Vedic era, literature documented descriptions of clothing and textiles, including woven cotton and a variety of mordant dyeing techniques, both of which are thought to have first originated in India. By the end of the first millennium BCE, superbly detailed sculptures and carvings show the richness and variety of Indian wrap garments and accessories. Both men and women wore the dhoti, a sort of baggy loincloth arranged around the hips with a section of fabric that passed between the legs to be tucked in at the waist.

Another wrap garment common to both genders was a long skirt, called a lungi, some of which were sewn closed at the side. Similarly, men and women also wore the dupatta, a scarf-like upper garment that was draped or tied around the torso and shoulders in a great variety of techniques. These and numerous variations of wrap garments remained the most prevalent styles of Indian costume to the present day.

All except the lowest castes of Indians adorned themselves lavishly with accessories. The pakka was an ornamental scarf of assorted lengths and fabrics that was draped, twisted, knotted, or looped around the hips or torso. For men, the long piece of fabric used to form the pakka was also applied to the arrangement of the turban, which could range in style from a simple flat pie shape to voluminous headdresses adorned with feathers and jewels. Both men and women wore multiple pieces of jewelry—necklaces, bracelets, anklets, rings, nose studs, earrings.

Even though cut-and-sewn clothing was introduced to India in the late first millennium BCE, these types of garments were not initially accepted by the Indian masses. Only later, after the Islamic invaders consolidated authority over the northern half of the peninsula were constructed garments adopted by large segments of the Indian populace. The jama, a long coat with a wide, bell-shaped skirt, and the chudidar trouser were worn by both men and women of the Mughal era. By the modern period the Islamic costume had evolved into the kurta pajama, a loose-fitting pullover shirt and trouser, or the sherwani pajama, a tailored jacket with front-button closure and trouser.

During the late Islamic era, Hindu women began to wear an ensemble that combined traditional types of wrap skirts and scarves with a cut-and-sewn cropped top called the choli. Later the scarves and skirts would be combined into the sari, a costume styled from one long piece of fabric that wrapped about the hips like a skirt and draped over the torso and shoulders like a decorative scarf. Today the sari is one of the most distinctive and recognizable national costumes in the world.

In the late twentieth century, a cultural revival inspired Indian fashion designers to recreate the tribal sari and explore variations such as exclusive artwear versions. In 2000, Indian designers entered the international fashion arena with the launch of the Lakme Indian Fashion Week sponsored by the newly formed Fashion Design Council of India. Today's Indian designers blend Indian style with Western silhouettes to create fresh interpretations of traditional costumes that year after year achieve global acclaim.

Chapter 11
India Questions

1. What are the similarities between costumes of the Induss Valley civilization and those of ancient Mesopotamia?

2. What are the two basic components of the Indian masculine costume of the post-Vedic era? Describe an example of how each was draped.

3. What were the two most prevalent constructed garments worn by both men and women of the Islamic era in India? Describe the silhouettes of each.

4. Describe the Indian national men's costume that emerged in the mid-twentieth century. Identify for whom the coat and the cap were named.

5. What was the precursor ensemble to the modern sari? Give the names of the garments and a description of each.

6. Describe how the modern nivi sari is draped.

Chapter 11
India Research and Portfolio Projects

Research:

1. Write a research paper on how the introduction of Western clothing to India during the British colonial era impacted the caste system and indigenous social behavior. Discuss how the adoption of European garments was so controversial to the people of India. Cite examples of how and why Indian and European garments were mixed to form new and distinct costumes in the nineteenth century.

2. Prepare a short fashion journalist's report on each of the Lakme India Fashion Week shows beginning with first one in 2000. What were the title themes of each show? When and where were they held? How was each show received internationally? Identify and describe the fashions of a different designer from each year who blended India style with Western silhouettes, and the work of a different designer from each year who reinterpreted traditional Indian clothing. Provide sketches, photocopies, or downloaded Internet images of the fashions if available.

Portfolio:

1. Demonstrate for the class the draping of a nivi sari or one of the numerous tribal saris on a mannequin or live model.

2. Sketch a mehndi decoration for a lifesize hand using traditional Hindu motifs. Attach a written description of the symbolic significance of the motifs.

Glossary of Dress Terms

ajrakh: richly patterned textiles produced by woodblock printing

artwear: Indian fashions produced in the late 1980s and early 1990s that were one-of-a-kind styles created by a designer and artist team

bindi: usually a dot of color, usually red, applied in the center of the forehead by both women and men, although some bindi are painted to resemble flowers and other ornamental shapes

bracelet cuff (also chudidar cuff): concentric folds of fabric formed at the ankles by long trousers or at the wrists by long jacket sleeves

butidar: a floral brocade named for the intricate patterns of tiny flowers called butis

charkha: a spinning wheel thought to have been introduced to India during the Islamic era

choli (also coli): a cropped feminine top usually with short sleeves, some with an open back with tie strings

chudidar trouser: a wide-seated pant cut on the bias that tapers from the knee to the ankle forming concentric folds called a bracelet cuff; worn by both men and women since the Mughal period

cudi: stacks of bracelets

cummerbund: a men's wide sash or waist treatment, usually worn with a tuxedo, that was derived from the Mughal kamarband

dhoti: a long loincloth tied or tucked at the waist with a portion of fabric pulled between the legs

dhurrie: a heavy, flat-woven cotton material used to make rugs and similar utilitarian textiles

dupatta: a narrow or folded scarf that draped around the torso and shoulders, and for women as a head covering

ethnic chic: a revival of village costumes worn by middle and upper classes in settings removed from the original sources

gamcha: the turban worn by peasants and laborers to protect against the sun and cushion heavy loads

Gandhi cap: a man's small, ovoid cap made of khadi; *see also* khadi

ghagra (also ghaghra): a women's gathered wrap skirt extending between mid-calf and ankle length

ghungru: an anklet of bells worn by Hindu women

jama: a long-sleeved, knee-length coat worn by both men and women of the Mughal period

jamdani: a multihued textile resembling tapestry produced by laboriously threading a bamboo needle through the warps rather than a shuttle

jodhpurs: tight-fitting trousers cut with a wide flare at the hips and thighs

kamarband: a feminine hip scarf made of various fabrics and arranged with assorted twists, bows, and dangles; also a long sash worn about the waist by Mughal men, the predecessor of the tuxedo cummerbund

khadi: durable, white hand-spun and handwoven cotton textiles; also the generic name for small caps made of the material

kinkhab: opulent silk brocades

kudta: an under tunic usually worn beneath the jama by Mughal men of upper classes

kurdi: a long vest worn over the jama by men of the Mughal ruling families

kurta: a men's collarless pullover shirt with a front-button placket, although some styles feature a round, stand-up collar or even a pointed Western type collar

laheria: tie-dyeing noted for its complexity of multicolored stripes and checks

lengha: a woman's full, gathered skirt usually worn for formal occasions

lungi: an ankle-length wrap skirt for men and women, some of which are sewn closed at the side

mehndi: body painting for women on special occasions, particularly weddings

mekhala (also mekhla): a feminine multistrand chain or beaded belt worn about the hips

mordant dyeing: the chemical process used to treat yarns and textiles for better absorption of dyes and to make hues colorfast

Nehru jacket (or shirt): a masculine top based on the Indian sherwani that features a round, stand-up collar and button-front closure; named for Indian Prime Minister Jawaharlal Nehru

nishka: a chain of coins worn by women as a hip girdle, belt, necklace, or bracelet

nivi: the pleated front dangle of a wrap garment; more commonly known today as the contemporary method of draping a sari with pleats at the front

odhni: a long, wide scarf worn by women as an upper garment and sometimes as a head or face veil

pagdi: a low, squat turban most often associated with lower classes

pajama (British pyjama): see salwar

pallav: the decorative end of a sari that is usually left dangling in the back over the left shoulder

patka: a large turban sometimes wrapped asymmetrically with the dome to one side of the head; also a long, narrow piece of material used as an ornamental scarf or sash tied at the waist

patola: patterned silk cloth woven of tie-dyed yarns that form elaborate, vividly colored patterns

pravara: a men's long mantle that was draped around the shoulders in assorted arrangements

Punjabi ensemble: a feminine costume featuring a long tunic and dupatta worn over pajama-like trousers

raga: a term for a dye and an individual's personal mood

salwar: a loose, baggy trouser, usually called a pajama, worn by both men and women

sari (also saree): a women's wrap garment arranged by first tucking a long piece of fabric into the waistband of a petticoat all around and then draping over the torso to hang loosely over the left shoulder

shaluka: a cut-and-sewn vest-like garment worn by women

sherwani: men's tailored knee-length jackets with front-button closures and round, collarless necklines or mandarin style collars

stanapatta: a feminine bandeau top that ties or fastens in the back

urn: the wool of goats or sheep; (literally meaning "hairy covering of an animal")

vas (also vasa): a narrow loincloth usually worn by men of peasant or laboring classes

Legacies and Influences of Indian Styles on Modern Fashion

Influences of Indian costume on Western fashions have included the jodhpur trouser, which was introduced into Europe by returning British colonists in the late nineteenth century. The distinctive silhouette of the jodhpur with its flared hips was first adapted to the male riding habit. By the 1910s, women, too, adopted jodhpurs for their riding habit and other similar sportswear costumes. During World War I, the American military applied the cut of the jodhpur to the doughboy's standard issue uniform.

Another Western adaptation of Indian dress imported by nineteenth-century European colonists was the pajama suit (pyjama to the British). The comfortable, loose fit of the uncreased straight-leg trousers and kurta was adopted as loungewear and sleepwear by Victorian men. In the twentieth century, the pullover pajama top was replaced by the front-closure shirt.

Also in the nineteenth century, the kamarband sash worn by Indian leaders and military officers was adapted by Europeans as the cummerbund for men's formal attire.

In the late 1960s, the pop counterculture of the West, particularly in Britain and America, took an interest in Eastern mysticism. Pop icons such as the Beatles made world headlines when they journeyed to India to study with Hindu religious leaders. As a result, the sherwani jacket with its round, stand-up collar was appropriated by Western menswear fashion designers in 1968 and called the Nehru jacket. Revivals of the Nehru collar reappeared in menswear collections in the early 2000s.

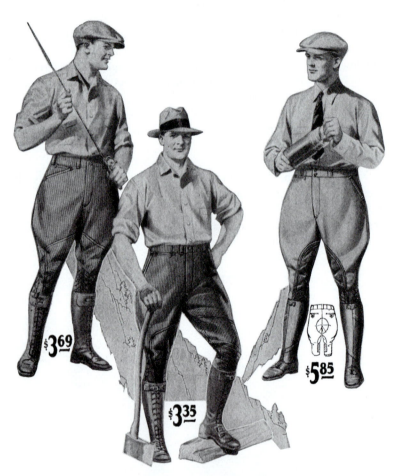

Corduroy and moleskin jodhpurs from Montgomery Ward, 1927.

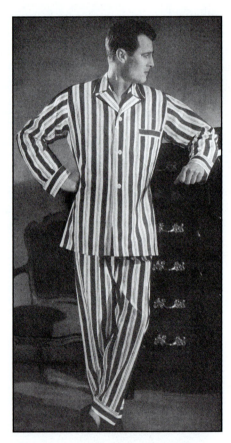

Men's cotton pajamas by Weldon, 1948.

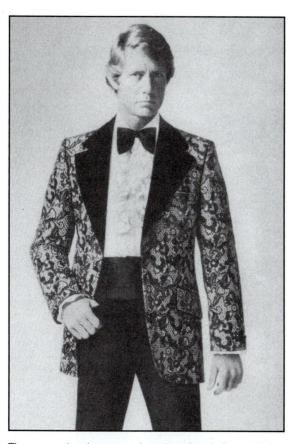

The cummerbund was an adaptation of an Indian sash that was introduced to Western men's evening dress at the end of the nineteenth century. Jacquard tuxedo jacket and satin cummerbund from Delton Formalwear, 1973.

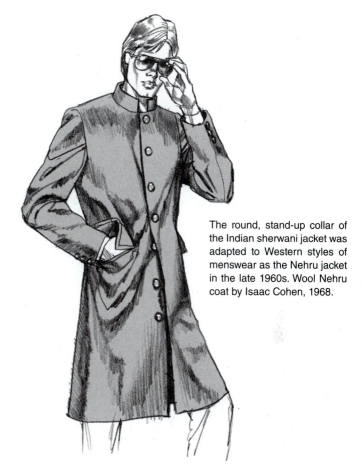

The round, stand-up collar of the Indian sherwani jacket was adapted to Western styles of menswear as the Nehru jacket in the late 1960s. Wool Nehru coat by Isaac Cohen, 1968.

Chapter 12

AFRICA

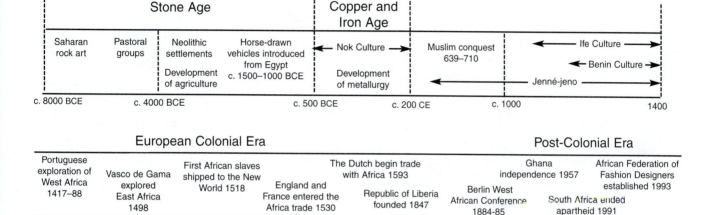

Stone Age				Copper and Iron Age			
Saharan rock art	Pastoral groups	Neolithic settlements	Horse-drawn vehicles introduced from Egypt c. 1500–1000 BCE	← Nok Culture →	Muslim conquest 639–710	← Ife Culture →	
		Development of agriculture		Development of metallurgy		← Benin Culture →	
						← Jenné-jeno →	
c. 8000 BCE	c. 4000 BCE		c. 500 BCE	c. 200 CE	c. 1000		1400

European Colonial Era					Post-Colonial Era	
Portuguese exploration of West Africa 1417–88	Vasco de Gama explored East Africa 1498	First African slaves shipped to the New World 1518	The Dutch begin trade with Africa 1593		Ghana independence 1957	African Federation of Fashion Designers established 1993
		England and France entered the Africa trade 1530	Republic of Liberia founded 1847	Berlin West African Conference 1884-85	South Africa ended apartheid 1991	

EARLY AFRICA

Between about 8000 and 4000 BCE, the northern tier of Africa underwent a gradual, unrelenting desiccation in which fertile grasslands teaming with vast herds of animals were transformed into the arid desert of today. During this prehistoric period, the inhabitants of the region left innumerable images of themselves and the wildlife they encountered incised, drawn, and painted on rock surfaces. Men are often represented with spears, bows, arrows, and quivers revealing the technological sophistication of these Stone Age peoples. Depictions of women feature exaggerated breasts and curvaceous hips, typical of fertility imagery in early African cultures. Some images of females carry digging sticks indicating that women gathered wild roots and vegetables to supplement meat brought back by the hunters and the milk provided by their cattle and goats. Also evident in many of the rock art renderings is a wide variety of complex, multipart costumes.

Rock art from the late Stone Age documents the slow cultural and technological development of the early Africans. Around 4000 BCE, images of herding and pastoral life replaced hunting scenes. (Figure 12-1.) Neolithic settlements gradually were established along lake shores and rivers where sources of food and water were relatively constant, and some degree of safety for the community was provided. Rock and cave drawings depict round, wattle-and-daub huts similar to some types still constructed today throughout Africa. Numerous early drawings show men in boats fishing with spears. Between 1100 and 400 BCE, horse-drawn vehicles were introduced, probably through trade with Egypt, and became a new theme in rock art. At about the same time, camels appear in rock art of the north, suggesting not only the steady desiccation of the Sahara but also the prevalence and persistence of trans-Sahara commerce despite the extreme conditions.

The transition of Sub-Saharan peoples from pastoral to agricultural lifeways occurred gradually over several centuries

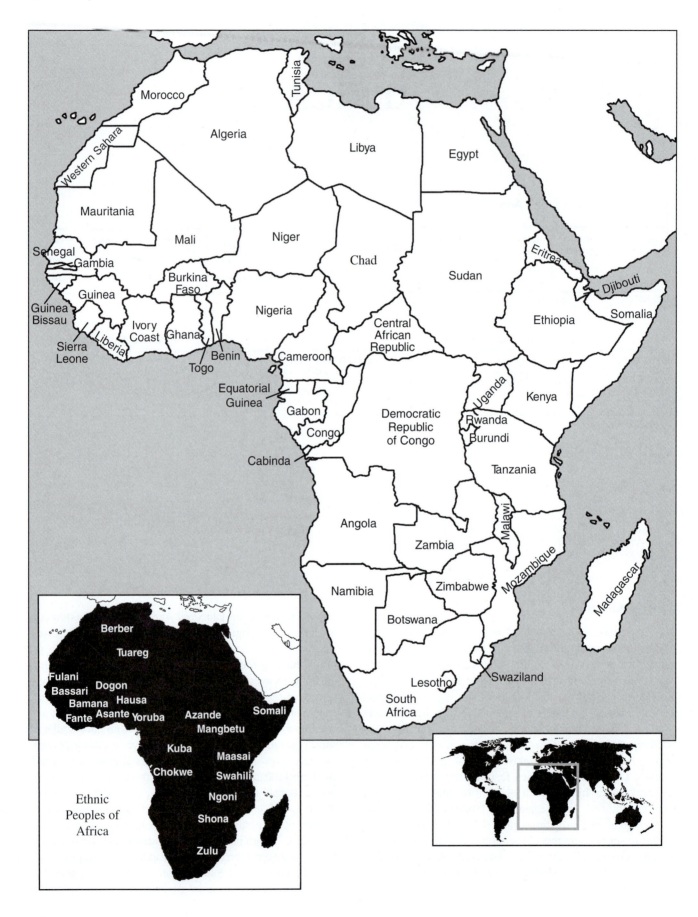

Ethnic
Peoples of
Africa

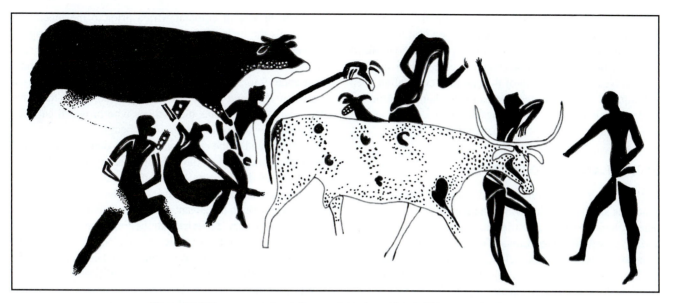

Figure 12-1. Numerous rock paintings and drawings of early African peoples document their cultural and technological development. The oldest images in the north, dating between 8000 and 4000 BCE, depict animals of the savannahs, indicating that the Sahara was once a lush grassland populated with great migrating herds. Rock art from later periods represent the earliest forms of clothing as simple loincloths. Drawing of rock painting from Tassili, Algeria, c. 3000–1500 BCE.

from about 500 BCE to 500 CE. Scholars link this cultural and economic transformation with the introduction of metallurgy. During the first half of the first millennium BCE, the fundamental technology of smelting metal ores may have made its way from Egypt through Sudan and into central Africa, or possibly even from Carthage to Niger and southward. With the development of iron tools to work the land, as well as iron weapons to defend it, some indigenous cultures gradually changed from pastoralists to cultivators.

As these groups of people established more settled societies, they built permanent communities that expanded into independent city-states and even large empires with centralized administrations. Among the more famous civilizations that emerged between 500–1800 CE were the Ghana, Mali, Benin, and Ife states in West Africa, the Hausa empire of Central Africa, and numerous Bantu kingdoms in the south. Urban centers within these states became prosperous points of contact along a network of robust trade routes. In addition to foodstuffs and raw materials like salt, ivory, and gold, manufactured goods such as pottery, basketry, cloth, jewelry, and metalwares moved in vast quantities along these trade routes. A wealth of surviving examples of these ancient goods attest to the sophisticated, specialized industries of the early African peoples.

Along with trade came cross-cultural exchanges—most regionally, but some from as far away as Arabia, India, and China. These trans-Africa and foreign contacts helped advance technologies such as metal smelting and weaving but also altered language, customs, aesthetics, and dress.

ISLAMIC CONQUEST

Following the death of Muhammad in 632, his successor, or caliph, united the Arabic clans under the banner of the new religion, Islam, and sent out his armies to conquer neighboring lands. The Sassanid Persians to the east had been weakened by centuries of conflict with the Byzantines, and the Byzantines to the north and west likewise had been weakened by internal religious strife, war with Persia, and the constant defense of an extensive frontier. Hence, in less than a decade the Arabs managed to conquer enormous territories and established an empire that stretched from India to Egypt. North Africa, though, posed a considerable challenge to the Arab invaders. A coalition of indigenous Berber peoples mounted stiff, persistent resistance to repeated invasions well into the early part of the eighth century.

When at last the Arabs conquered the whole of North Africa, they established an Islamic social order to which the subjugated peoples gradually conformed. Rather than being compelled to convert to Islam, the populations of North Africa were slowly assimilated into the religion. In turn, the African converts spread the teachings of Islam across the Sahara to the Congo Basin and along the eastern coast down to Madagascar.

Among the economic changes introduced into Africa by the Arabs was multicropping. Cotton, sugar, and rice were some of the trade crops the Arabs brought to the continent. Advanced technologies from the Arabs included the lost wax process of casting metal, vertical loom weaving, and leatherwork.

As subsequent generations of northern and eastern Africans adopted Islam, they often blended traditional elements of indigenous dress with the capacious, concealing costumes of the Arabs. For example, elite Fulani men of Nigeria wear an adaptation of the cut-and-sewn kaftan over voluminous trousers in the Ottoman style, but the garments are lavishly hand embroidered (by men) with assorted motifs and spiritual symbols from African tradition.

EUROPEAN COLONIZATION

In 1957, the British colony of Gold Coast was granted independence and became the modern nation of Ghana. Although other colonial African countries had achieved independence a few years earlier, like Libya, Tunisia, and Morocco, and some states even decades earlier, such as Egypt (1922) and the Union of South Africa (1910), the establishment of Ghana meant that an all-black independent government was a realizable alternative to European colonial rule. At last, it was to be Africa for the Africans.

Initially, though, Africa had been the focus of invasions by Europeans with three objectives: the expansion of commerce, the spread of Christianity, and the establishment of anti-Muslim alliances. The Portuguese were the first Europeans to venture beyond the Canary islands off the Atlantic coast of Morocco, systematically working their way down the western shoreline to the Cape of Good Hope between 1417–1488. At the end of the century, Vasco de Gama pushed on around the cape and explored the east coast of Africa on his way to India.

The commerce-driven Portuguese were astonished by the complexity and sophistication of the African civilizations they encountered during their explorations. Almost as soon as contact with the various cultures was established, trade commenced—at first by silent barter, and later through standardized mercantile weights and measures. The Portuguese exported from Africa ivory, gold, amber, wax, indigo, pepper, sugar, and, beginning in 1441, slaves. In return, the Africans received horses, cloth, metalwares, beads, and wine. In the sixteenth century, corn, tobacco, sweet potatoes, tomatoes, oranges, lemons, and limes were introduced to Africa from the New World.

For more than a century, the Portuguese maintained a European monopoly on West African trade. In 1530, though, both England and France sent their first expeditions to the African west coast, followed by the Dutch in 1593. Over the next 200 years, European powers battled each other, as well as powerful African states, to maintain precarious toeholds at key points along the continent's shoreline. There they built forts, supply depots, and trading posts near the market centers of the African kingdoms. Until the nineteenth century, no European power was seriously interested in inland exploration, much less colonization.

The history of colonial Africa prior to the nineteenth century is the history of the slave trade. As rival European powers rushed to establish colonies in the New World, the demand for labor exceeded supply. Various sources estimate that about 9 to 15 million slaves were exported from Africa between 1500 and 1800. The principal sources of the slave trade were the Africans themselves, who provided captives from raids or wars with neighboring peoples.

By the end of the eighteenth century, though, slavery had been prohibited by law throughout most of Europe. In addition, the rapid expansion of the industrial revolution in the eighteenth and nineteenth centuries resolved many labor shortage issues through the advances of science and technology.

The importance of Africa to the Europeans then shifted from slavery-based economics to the politics of the Old World and their rivalries to maintain a balance of power. In 1871, the patchwork of German principalities that had once comprised the heart of the Holy Roman Empire were united into one nation: the Second Reich. Led by Prussia, a coalition of these assorted states had defeated France in the Franco-Prussian War (1870–71) and emerged as one of the three great world powers—after Britain and the United States. When the German Chancellor Otto Von Bismark convened the Berlin West African Conference in 1884, his intent was to facilitate the partitioning of Africa into clearly demarcated colonies and protectorates with modern, military-backed administrations. "My map of Africa lies in Europe," Bismark had declared. Fourteen nations participated in the scramble for African territory. Not only were the African colonies—as well as those in Asia—viewed by the Europeans as sources of raw materials needed to fuel the burgeoning industrial revolution, but these distant lands were important trade markets for the goods produced. Just before the Berlin conference, ninety percent of Africa was ruled by Africans, but by 1900 only Liberia and Ethiopia remained independent.

The consequences of Europe's imperial objectives in Africa were endless wars of resistance by the indigenous peoples, among the more famous of which was the Zulu uprising of 1879. Moreover, the politics of Europe were sometimes played out in conflicts on African soil such as the Boer War (1899–1902) between the British and the Dutch Afrikaners who were supported by the Germans. In addition, in the aftermath of the two World Wars, African territories changed hands among European powers and boundaries were repeatedly redrawn, further adding to the political confusion and instability.

In the twentieth century, colonial rule in Africa profoundly changed the cultures of its subjugated peoples. As railroads expanded across the continent, ancient trading systems such as the trans-Sahara caravans collapsed. Large plantations exploited indigenous labor and forced peasant farmers into sharecropping. The development of roads for

Mystical Powers
and Bogolanfini Cloths

In the region of Mali, Niger, Chad, and Sudan, the Bamana peoples traditionally practice male circumcision and female excision, the surgical removal of the clitoris. Blacksmiths perform the surgery on boys and postmenopausal female potters conduct the procedure on girls. Immediately after the excision surgery, the girl is wrapped in a specially mud-dyed cloth called **bogolanfini** (also bokolanfini or shortened to bogolan). The Bamana believe that a mystical power called nyama is released during the excision and its supernatural energy can be captured in the cloth. The complex stages of designing, staining, and washing the mud cloth is thought to imbue it with a nyama of its own that is sufficiently powerful to guard the girl and her sponsors during the ritual. The bogolanfini cloth is later worn for her marriage ceremony and used as the swaddling wrap for her first baby. Some girls may choose to present the cloth to her excision sponsor, and the female elder may wear it to ward off evil and, after death, be buried in it. Other bogolanfini cloths are made into masculine wrap skirts worn by hunters as protection from dangers in the forest and from the nyama released when an animal is killed.

Preparation of a bogolanfini cloth begins with a large rectangular piece of locally woven cotton cloth. The patterns of geometric symbols are meticulously applied by men or women who paint a mixture of black, mineral-rich mud, sometimes intensified with vegetable dyes, directly onto the fabric. The circles, zig-zagged lines, and other mystical shapes are formed by leaving thin strips or sections of the fabric unstained.

During the 1970s, interest in bogolanfini from Europe and America inspired African male artisans to study the techniques of mud dying to produce export pieces used in ethnic clothing and as decorative wall hangings. (See Figure 12-18.)

motor transport made possible the inland cultivation of cash crops such as coffee, cotton, and cocoa. In urban areas, wage employment gave families new economic freedom.

Western primary education was introduced on a large scale by Christian missionaries, and colonial regimes sponsored secondary school education for training functionaries for military and administrative service. As a result, in many Islamic areas, Muslim education systems like those of Algeria or Sudan were marginalized. Also, the increase in literacy set the stage for a rise in nationalism and the emergence of a liberating momentum that undermined European authority.

Three interrelated forces in the second half of the twentieth century contributed to the liberation of Africa. First was an unprecedented population growth. Modern medicine, healthcare, and hospitals greatly curbed infant mortality and enabled the population of post–World War II Africa to surge from 200 million in 1950 to 800 million in 2000. Second was a rising nationalism across the continent that proved costly for Europeans to resist, most notably the urban terrorism and guerrilla warfare against France in Algeria. Furthermore, as the Cold War intensified, colonial powers were mindful of Russian calculations and preferred to avoid persecution that might open the door for Communism. Third was self-preservation through economic progress and political harmony.

The decolonization of Africa was a far more painful process than anticipated, though. Coups d'état supplanted democracy with totalitarian military regimes such as those of Idi Amin in Uganda and Omar Gaddafi in Libya. Civil wars pitted ethnic groups against one another like the Hausa and the Ibo of Nigeria or the Hutu and the Tutsi of Rwanda.

Nationalism sometimes perpetuated feudalism through the establishment of elite chieftainship aristocracies like those of Gambia, Lesotho, and Sierre Leone. Nationalism also manifested itself as repressive Islamic fundamentalism in Guinea, Senegal, and Mauritania. Apartheid became codified in South Africa, enduring until the 1990s.

The economic promise of an independent Africa likewise fell short of hopes for many new states. The rush to implement plans for infrastructure improvements, industrialization, and expanded development of mining and agriculture led to debt. With the oil crisis of the 1970s and the global recessions of the 1980s, African nations suffered more economic setbacks. Furthermore, the quadrupling of the population put such a strain on the food supply that, by the 1990s, about twenty percent of Africa's export earnings went to imported food.

However, success stories have provided models and inspiration for all postcolonial nations of Africa. Botswana for instance has developed a progressive economy, ethnic homogeneity, and political stability through regular competitive elections. Following the end of the Cold War, a greater number of liberated African states became politically pluralistic, affording their citizens opportunities to change regimes through the ballot box. Beginning in the 1980s, the International Monetary Fund imposed economic strategies on debtor countries to reduce state controlled prices, trim bloated public payrolls, and maximize exports, thus restoring positive growth rates and reducing inflation. Christianity and Islam continued to expand rapidly, providing education, healthcare, and financial aid to those hitherto neglected, particularly women in remote regions. The African nationalist vision and struggle for liberation

remains a shared continental experience—a commonality, even as the modern states reconcile ancient traditions, diverse cultures and ethnicity, and contrasting religions with the global modernism of the twenty-first century.

AFRICAN TEXTILES

We do not know how early any of the African peoples began to weave textiles. Most likely, since Neolithic times, fibers from grasses, bamboo, palms, and bark had been twisted or spun into threads and cords to use in rudimentary finger weaving for the production of nets, sacks, mats, and similar utilitarian items. Later, the cultivation of cotton and loom weaving was possibly introduced through Egypt and the Sudan during the Roman period. The vertical loom is thought to have been brought in by the Arabs after the seventh century CE either through trade along the east coast or more likely from the North African holdings of the Islamic empire. Although no extant African textiles have survived from ancient times, fragments of woven vegetable fibers have been excavated from burial sites at Igbo-Ukwu in Nigeria dating from the ninth century, and bits of woven cotton have been found in Tellem graves in Mali that date as early as the eleventh century.

The first African imports of woven textiles were probably from India in the early first millennium CE. For centuries, the eastern coast of Africa enjoyed a thriving trade across the Indian Ocean with the civilizations of Asia. When the Portuguese established trading posts along the west coast of Africa in the fifteenth century, European manufactured cloth was of particular demand by the Africans. Cloth was as significant a source of wealth as livestock. Royal treasuries often contained the finest examples of both imported and indigenous textiles for use by the elite on high state or religious occasions.

The division of labor between men and women for producing cloth varies culture to culture in Africa. Spinning is the particular domain of women. The ancient drop spindle used in Egypt more than 5,000 years ago was still commonly used throughout Africa well into the twentieth century, particularly among nomadic peoples whose women could spin while trekking between campsites. Weaving produced by women is usually done on a wider dimension—up to about thirty inches wide—than that of men, and is used principally for full-length wrap garments, back totes for babies, blankets, and tents. In the north central tier of Africa, the vertical broad loom is favored by women but the horizontal version is more traditional elsewhere. Male weavers usually prefer the narrow horizontal or treadle loom, although Kuba men of the Democratic Republic of Congo use the wider vertical loom for raffia cloth. Male weavers most often produce narrow strips of cloth about three to six inches wide that are then cut in equal lengths and sewn selvage to selvage to make cloth for garments and accessories. Sometimes these strips

of fabric also are worn as ornamental sashes called **leppi** (also lappa).

One of the finest varieties of indigenous African textiles is **kente** cloth. (Figure 12-2.) The word kente originated with the Fante peoples of Ghana from their word "kenten," meaning basket, but became most associated with weaving of the neighboring Asante. Genuine kente is the narrow-band textile woven on horizontal treadle looms by men. Panels were then stitched together to form larger pieces of cloth. Prior to the twentieth century, the richly patterned fabric was restricted for use only by the Asante elite, but during the colonial era became accessible to a wider market, especially as an export commodity. More than 300 named patterns of kente have been documented, one of which, called **adweneasa**, is so complex that the name literally means "my skill is exhausted." Some patterns involved the blending of cotton and silk to produce glistening, vividly colored designs. Since the Second World War, kente cloth is frequently woven of less costly rayon to achieve the same silky effect.

Another type of Asante cloth is called **adinkra**, which means "saying goodbye." The term "nkra" means message. Originally adinkra was worn for funerals but in the twentieth century became adapted to other special occasions. Adinkra is a plain weave cotton that is covered with stamped patterns of geometric symbols that convey various meanings. For example, a crescent moon is associated with feminine ideas of patience; a simple X represents a two-story house that symbolizes authority; and concentric circles are the sign of the king and his greatness. The repeat motifs are traditionally applied with stamps carved into calabashes and inked with a dense, black tar-like substance.

Similar to the kente cloth of the Asante is **aso-oke** cloth of Nigeria's Yoruba people, which is also a strip-woven fabric stitched together into large wraps or tailored garments like tunics and trousers. The patterns and quality of the strips

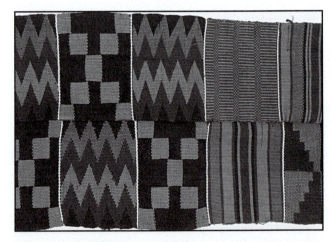

Figure 12-2. Kente cloth is a richly patterned fabric made of narrow panels of woven textiles stitched together. Kente cloth, c. 1900.

bespeak the social status, occupation, or wealth of the wearer. In the post–World War II era, the Yoruba began weaving cloth with shimmering Lurex yarns. The result, called **shine-shine**, is worn for marriage ceremonies and other festivities.

The term "**country cloth**" is generally used today by art historians to identify West African fabrics woven with homespun thread. Garments and household textiles made of country cloth are highly prized because they are often tinted with special medicine dyes that are believed to possess supernatural powers. Imported machine-made threads cannot be used for country cloth since they lack the necessary ancestral link to capture the powers of the medicine. Chiefs, warriors, and hunters particularly wear clothing made of authentic country cloth to protect them from dangers, terrestrial or spiritual.

Similarly, the Akan **batakari** is a men's tunic made of strip-woven fabrics and decorated with stamped magic squares, appliques, and pendant amulets such as horns and claws that the wearer believed would provide protection from evil and harm.

The Kuba of Central Africa are especially well known for woven **raffia**, which is the supple fiber from the fronds of the palm tree by that name. The plain, tan colored raffia cloth is decorated all over with various surface embellishments, especially lavish embroidery of rectilinear shapes and patterns stitched mostly in sharply contrasting black. (Figure 12-3.) Another favored decorative treatment is an intricate applique patchwork of dyed barkcloth or other raffia pieces. For the Kuba elite, a cut-pile or cutwork raffia cloth is meticulously produced by women who cut the delicate threads to form textural surface patterns that complement the embroidered or dyed designs. Once finished, the richly patterned panels of raffia cloth are sewn together to form various wrap garments, some up to twenty feet long, or used in the construction of cut-and-sewn clothing such as tunics.

Other prevalent types of woven materials include the **ikaki** of Nigeria's Igbo, which is a brightly colored cotton cloth handwoven with stylized motifs of animals or eating utensils, among others. **Pelete bite** is a cut-thread cloth of the Ijo created by women who painstakingly cut and remove tiny sections of threads to form lacy, delicate patterns. The **kanga cloths** of east African peoples are block-printed fabrics with vegetation motifs, paisley-like borders representing the region's cash crop, the cashew nut, and in the twentieth century, sometimes the text of proverbs.

Instead of woven materials, some peoples such as the Azande and Kuba produced barkcloth called **nogi** (also noge) for clothing and utilitarian items. Sections of the inner bark of certain trees were pounded with a wooden or ivory beater until it developed a soft, felt-like texture. The bark strips would then be sewn together to make larger pieces for aprons, loincloths, skirts, and bedding. Barkcloth was often rubbed with natural oils and redwood powder to achieve reddish brown colors, or immersed in mud for black.

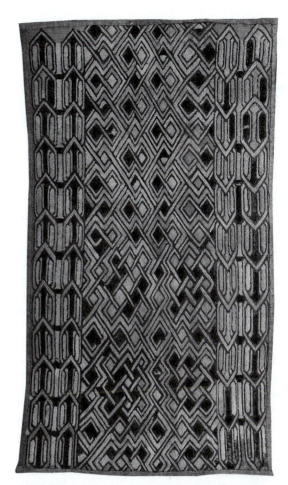

Figure 12-3. The Kuba peoples wove fibers from the raffia palm into panels of tan cloth that were then richly embellished with appliques, embroidery, and cut-pile treatments. Kuba raffia textile, c. 1900.

Just as block-printed imagery had symbolic meanings, color also had special significance for Africans. Red not only meant blood and death but also power and authority, so it was often reserved for ranking warriors and chieftains. Golds and yellows denoted longevity and prosperity. Vivid blues signified joy and a tribute to the sky and the great spirits that dwelled there. White was for purity and independence, evoking the unfettered spirits of the ancestors. Green symbolized peace and harmony like that found in the lush vegetation of the forest. Dark browns, deep indigos, and black represented mourning, depending upon the wearer's relationship to the deceased.

Resist-dyed patterns were made by assorted methods. The intricate blue and white **adire** patterns of the Yoruba are achieved by painting designs onto white cloth with a starchy paste made from the cassava yam. When the cloth is dyed, the yam paste repels the color preserving the white ground of the fabric. The **ukara cloth** of the Igbo people and the **ndop cloth** of the Hausa of Mali are blue dyed fabrics with white patterns produced by stitching a design over the white cloth before immersing into the blue dye.

The intricate designs are sketched by men but sewn and dyed by women. When the stitchery is removed, the dotted white pattern is revealed. West African cloth with multicolor dyed prints is produced by a tie-dye technique also called ndop, or **doma**, and **duop**, among others. Tiny patterns are formed by tying off pinched sections of the material before dyeing. The more colors and the more complex the patterns the more costly the cloth.

NORTH AFRICA

The region of North Africa that stretches westward from Egypt to the Atlantic Ocean is the Maghreb. These ancient lands that are today Libya, Tunisia, Algeria, and Morocco shared more with the Mediterranean cultures over the ages than with their sub-Saharan neighbors to the south. Over a 2,000-year period the Phoenicians, Greeks, Carthaginians, Romans, Byzantines, Vandals, and finally, the Arabs colonized or conquered the region. Through each phase of military and political dominance, the prevailing civilization introduced new types of art, architecture, civil engineering, religion, language, custom, and costume. Century by century, indigenous lifeways of North Africa blended with those subsequent layers of imported cultures, continually adapting and evolving.

The inhabitants of the Maghreb are light-skinned peoples whose ancestors are thought to have migrated to the area from southwest Asia sometime during the late Neolithic period. The Greeks who colonized North Africa during the fifth century BCE viewed the indigenous peoples there as barbarian, from which came the name "Berber." Herodotus noted that there were numerous autonomous clans whose religions, customs, and especially hairstyles varied widely. When the Arabs conquered the region in the eighth century CE, they named the land Barbary after its people.

Classical writers described the Berbers as remote clans who preferred to live in isolation far from the colonial centers along the Mediterranean. The Greek geographer Strabo likened the clusters of Berbers scattered about the sandy Maghreb to the spots on the tawny fur of a leopard. The migration of the Berbers southward into wider ranges of the Sahara only became possible with the introduction of the camel from Arabia sometime at the end of the first millennium BCE. Many clans chose a more nomadic way of life to wander deeper into the African continent, thus remaining largely impervious to the influences—and taxes—of the civilizations that occupied the Mediterranean coastline.

The possessions of the nomadic Berbers had to be light, durable, and easily transportable. Textile weaving and leather tanning thus were critical to their survival in the desert. By the time of the conquest of the Maghreb by the Arabs in the eighth century, the Berbers were well known for their sturdy tents, practical camp accoutrement, and high-quality leather goods. For centuries, they had traded their textiles and leather totes, water bags, saddles, and scabbards with the Saharan caravan merchants who in turn transported the goods to the cities of the north and to the black kingdoms in the south.

Weaving and leatherwork have traditionally been the tasks of Berber women. (Figure 12-4.) Today among the clans of the Berber-speaking Tuareg, it is still the responsibility of women to obtain the materials to build and furnish a tent. So integrally linked are women and their tents that the term "ehen" refers to both a wife and a tent.

As noted in chapter 8, the Arabs initially governed their empire as an elite class, preferring to levy stiff poll taxes on non-Muslims rather than convert them. They also developed an affinity for Berber peoples as slaves, especially since enslaving "peoples of the book"—Christians and Jews—was prohibited. To avoid both taxation and slavery, many Berber clans accepted the new faith of Islam and ultimately became a proselytizing force themselves.

The dress of the ancestral ethnic Berbers was described in Romano-Byzantine accounts as tunics and baggy trousers for men and long kaftan-like gowns for women. If indeed the Berbers had migrated from central Asia during the first millennium BCE, their styles of clothing most likely resembled those of the Medes and Persians. The transition to the styles of their Islamic conquerors in the period after the eighth century was probably not a dramatic leap for the Berbers since the desert-dwelling Arabs, too, had been subjects of the Assyro-Persian empires, and had likely adapted the costumes of Mesopotamia to their environmental needs.

Cotton and linen were used to make basic everyday clothing, and wool was primarily used in outer wraps and garments. Among the subtle changes in Berber dress was the substitution of turbans for the Phyrgian cap and scarf as a masculine head covering. The latter style is featured on coins of the Maghreb kingdoms prior to the Arab invasion. Another adjustment for the Muslim Berbers was the discarding of cut-and-sewn garments, boots, and leather accessories when making the pilgrimage to Mecca. Such luxuries as the Berbers' famous tooled leather goods and sumptuously embroidered clothing were regarded as worldly attachments that had to be abandoned to be truly humble in heart and sincerely penitent of sin.

The teachings of Islam likewise influenced and changed the Berber love of surface ornament and decoration. The warnings in the Quran against idolatry meant that figural representation, including flora and fauna motifs, had to be reinterpreted. More significantly than the decorative aspects of figural embellishments was reconciling the pictorial representations and symbols of the "evil eye." This deep-rooted superstition is a belief that certain people have the power to cast spells of bad luck with a glance—a fear shared by many cultures around the Mediterranean. To protect against misfortune from the evil eye, non-Muslims wear representational

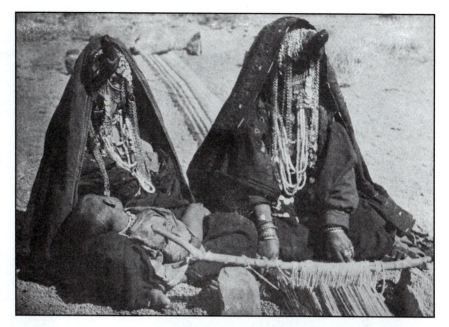

Figure 12-4. Arabicized Berber women adopted the fully concealing costume of the Muslims according to the teachings of Islam. Many Berber women, though, continued to adorn themselves with numerous shiny coins, sparkling beads, and other glistening ornaments to ward off the evil eye. Berber women weaving, 1912.

symbols of the human eye and hand. For the Muslim Berbers, though, nonrepresentational symbols had to be developed. Eyes were stylized into diamond shapes in bands. Hands with all five fingers extended (as in "five in your eye") were translated into zigzags, triangles, and other geometric shapes grouped in fives. In addition to serving as protection against evil, these arrangements of shapes served as symbols of good fortune as well. The motif of five vertically stacked diamonds represents the tree of life with its blessing of longevity and health.

These mystical symbols were adapted to weaving patterns and textile embellishments like appliques and embroidery that remain very much a part of Berber tradition today. For instance, the hooded capes of Berber men from the Atlas Mountain region in Morocco feature broad, horizontal bands in bright red with an appliqued or embroidered elliptical shape in the center that resembles a hypnotic reptilian-like eye.

For women, protection against the evil eye could be managed by jewelry. The shapes of coins, beads, and amulets glinting in the desert sun were believed as effective as woven or embroidered symbols to ward off evil. Moreover, jewelry is portable wealth for the nomadic Berber, and the display of a woman's abundant family treasure is still a significant statement of status.

WEST AFRICA

When European colonists first encountered the architectural ruins and artifacts of early African civilizations, they presumed they had found evidence of imported labor and skills from the Islamic empire. During the 1970s, in the region between the Bani and Niger Rivers of Mali, archaeologists excavated sites that dated to as early as the third century CE, more than 1,000 years before the first contacts with the Muslims of North Africa. Because these sites were near the modern city of New Jenné, the culture is referred to as the Jenné.

A great many terracotta figures from the ancient Jenné peoples representing both males and females have been found in gravesites and ritual mounds. Although most sculptures are thought to date from the later period of the Jenné culture, possibly between the eleventh and fifteenth centuries, the costumes, accessories, and body adornment of the figures probably represent traditional styles from hundreds of years earlier.

The female figures most often show a hip ring with an apron in the front. (Figure 12-5.) Striations in the clay flaps possibly indicate that the apron was made of grass or cord fringe with decorative plaits at the top edge. A similar form of ritual apron called a **nogetwe** was still worn by women of the Uele region into the early twentieth century. The nogetwe was made of dried banana leaves dyed black.

The hip ring apron of the Jenné figurines as well as the nogetwe may have been variants of the feminine **cache-sex**, or pubic adornment. Attached to beaded, braided, or chain hip rings were assorted types of fringe and ornaments, usually over the pubic area but sometimes also covering the buttocks. Strands of metal or glass beads, fringes of leather or dyed cords, and even pendants of cowrie shells were arranged to dangle over the crotch. Whatever the decorative elements, the purpose was for sexual display to attract the attention of males.

On the other hand, many of the Jenné male figures appear to wear a close-fitting fabric loincloth that fitted

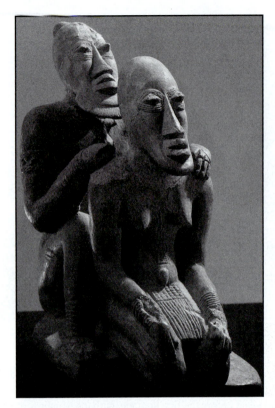

Figure 12-5. Clay figurines of women from the ancient city of Old Jenné reveal costumes comprised of a hip ring with a grass or fringe apron and jewelry including beaded necklaces and multiple bangles on the wrists and ankles. Terracotta figure of a seated man and kneeling woman, c. 1100–1400 CE.

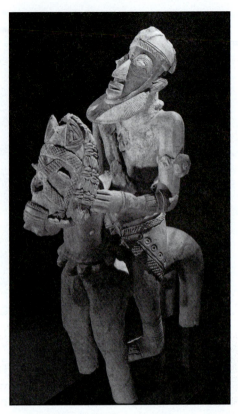

Figure 12-6. Jenné figurines of men usually depict a close-fitting fabric loincloth that fitted between the legs and tucked with an overlap at each hip. Men as well as women enjoyed an abundance of jewelry, which included arm bands. Terracotta figure of man riding a horse, c. 1100–1400 CE.

between the legs and tucked at each hip. (Figure 12-6.) Some of the loincloths of these figure feature incised and painted lines replicating the textile patterns of the Jenné.

Figures of both men and women of the Jenné culture are depicted with an abundance of jewelry. Intricately beaded necklaces and earrings, and numerous armbands, bangles, cuff bracelets, and anklets are frequently depicted on sculptures of the Jenné. The earliest types of jewelry most likely were made from drilled stones, shells, seeds, pods, clay, and animal bones or teeth. Although copper metallurgy was known in West Africa as early as the fifth century BCE, historians think that the early Africans did not begin casting metal in the lost-wax process until the technology was introduced by the Muslims between the tenth and thirteenth centuries.

To the southeast of New Jenné in the region of modern Nigeria live the Yoruba tribes. Between about 800 BCE and 600 CE, their ancestors developed a highly sophisticated culture that included communal farming, pottery, and metal smelting. This ancient culture came to be known as the Nok, named for a small town near which hundreds of fragments of terracotta figurines were excavated. The majority of the ancient sculptures are of heads, most of which bear no clear

distinction of gender. Some heads, though, are obviously masculine since they feature incised or relief beards and moustaches. These heads, many lifesize, are thought to have once been attached to wooden body mannequins as funerary memorials to the Nok ruling elite. Hair arrangements of the heads and figurines are varied but reveal a keen attention to personal style. (Figure 12-7.) Of the rare full figures that have survived, all are small scale, which most likely were worn as pendants or girdle ornaments. Though most of the figurines are not greatly detailed, some depict thick strands of necklaces, cuff bracelets, anklets, and waist or hip rings. This tradition of applying numerous ring ornaments survives still today throughout much of rural West Africa. As for clothing styles, both men and women evidently wore a simple, short wrap skirt or a narrow loincloth secured by a belt at the waist. Figures of both genders, though, are more commonly represented unclothed.

What happened to the Nok is unknown. Within a couple of centuries after the Nok disappeared, the city-state of Ife emerged as the dominant cultural center of the region. For the Yoruba peoples, Ife was, and remains, the sacred "navel of the world," where creation took place and kingship originated. By 1000 CE, Ife was a thriving metropolis with

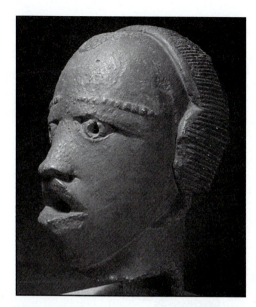

Figure 12-7. Figural artifacts of the Nok culture suggest that these ancient peoples enjoyed sufficient leisure time for attention to personal style since hair arrangements on the clay sculptures are elaborate and greatly varied. Terracotta Nok head, c. 500–200 BCE.

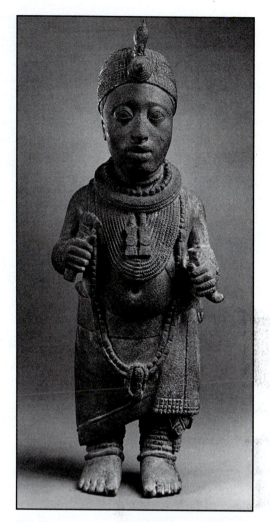

Figure 12-8. The sculptures of Ife royalty represent the traditions of most West African costumes including layers of beaded jewelry, bangles, and wide collars for both men and women. The fringed wrap skirts of the king and queen were status garments worn for public display at important ceremonies such as coronations and weddings. Bronze sculpture of an Oni, c. 1100–1200 CE.

defensive city walls, moats, paved courtyards, and roadways radiating to surrounding farmlands.

At the height of its cultural flowering, Ife's artisans sculpted exquisitely lifelike busts and figurines representing members of the royal family. The fine detail of these sculptures depicts with naturalistic clarity the personal ornaments, garments, and accessories of the Ife nobility. Most Ife figures wear layers of beaded jewelry, bangles, anklets, and wide collars. Statues of royal couples appear to wear identical adornment, even to the rings on their toes, although there may be subtle but distinct gender differences that have been lost in time.

The Ife king, called an oni, in Figure 12-8 wears a wrap skirt secured by a wide, fringed sash, the ends of which hang down the left side. The crest on the crown and the double pendant on the beaded bib proclaim the divine right of the oni to rule in Ife.

Other full figures of Ife royalty depict similar costumes with variations primarily in the arrangement of the wrap skirts. Additional layers of necklaces or a different count of bracelets or anklets indicate that the royal costume was comprised of ritual components but not rigidly standardized. For special public appearances, a Yoruba king of the modern era still wears prescribed costumes that bear reference to his ancient lineage and the sacred authority, or ashe, of his ancestors. In addition to necklaces, bracelets, and sumptuously beaded wrap garments, today's Yoruba rulers wear special high crowns made of a wicker cone covered with beaded fabric. A beaded fringe veil completely covering the face not only protects the king from the profane gazes of ordinary folk, but when enthroned in state, he is

believed to be transformed, and the faces of his ancestors stare out at the audience from behind the veil.

About 120 miles down the Niger Delta from Ife, a group of the Edo people founded the city of Benin during the tenth century CE. Edo legend holds that sometime in the twelfth century, its people invited a prince from Ife to marry the daughter of a Benin chieftain and rule as king. The present ruling family of Benin claims royal descent from this king. Over the succeeding generations, Benin kings adopted much of the Ife culture, including the production of royal memorial portraits and commemorative artwork. When the British invaded in the nineteenth century, they seized hundreds of sculptures, carved ivory tusks, and brass palace plaques depicting Benin history. These many superbly detailed artworks provide documentation of the traditional royal costumes as

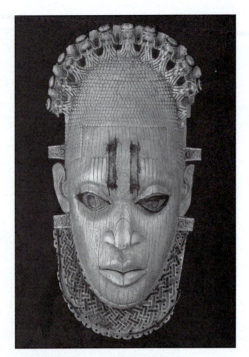
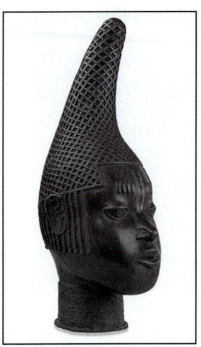

Figure 12-9. Portrait busts of Benin queen mothers feature one of two styles of ceremonial headdress. The earliest version is a tall skullcap of red coral beadwork topped with lateral rows of ornaments across the dome. The later "chicken's beak" crown has a high, forward-pointing peak covered with red coral beads. Left, ivory portrait mask of Benin queen mother, c. 1520; right, bronze portrait head of Benin queen mother, c. 1550.

well as the influences of contact with Westerners that began with the Portuguese in the mid-fifteenth century.

Where the Ife portrait busts are notable for their naturalistic rendering, the most striking hallmark of the Benin sculptures is their detail of costumes. The numerous portraits of Benin queen mothers usually feature one of two styles of ceremonial headdress. (Figure 12-9.) The earliest versions of the queen's crown were tall skullcaps made of red coral beadwork with lateral rows of ornaments across the dome. Later, the **ede-iyoba**, meaning "chicken's beak," was a crown with a high, forward-pointing peak covered with a pattern of red coral beads. Royal Benin women of today simulate the pointed crown with a coiffure of hair arranged high and adorned with red coral headbands and hair ornaments.

The oba, or king, wore a less ostentatious crown made as a skullcap of red coral beadwork fringed around the sides with shoulder-length strands of matching beads. Styles of the crown after the eighteenth century included a pair of rounded wing-like appendages that oral tradition suggests represented the barbels, or "whiskers," of the sacred mudfish.

The official memorial portraits of the kings, traditionally commissioned by the heir to the throne after the death of the oba, sometimes included palace plaques showing the full coronation regalia. (Figure 12-10.) This ritual costume usually included a high collar of red coral beads, called the **odigba**, that covered the neck and jaw up to the mouth. Beaded chest and

hip sashes, brass spiral cuff bracelets, beaded anklets, leopard's tooth necklaces, and carved ivory masks affixed to a belt were additional decorative and symbolic elements of the oba's official regalia. Those kings who had distinguished themselves in battle were sometimes depicted holding the **eben**, a broad, leaf-shaped sword. The only textile garment worn by the king was a knee-length wrap skirt, called the **ododo**, that was made of a richly embroidered cloth. In most instances, the ododo is shown wrapped right to left around the waist and pulled up in the front to be tucked at the left hip, forming an asymmetrical flap. In modern times, the royal wrap garment was made of red cloth that in some variations was cut in strips of overlapping scallops to simulate mudfish scales.

Women also wore a single wrap garment that was draped around the waist in the same manner as the masculine type. The only difference seems to have been the length, with women's styles extending to mid-calf or to the ankles.

The Benin sculptures are so richly detailed that even the patterns of scarification are accurately delineated. On the foreheads above the brows of both kings and queens are raised scars called **ikharo**, which literally means "tribal mark of eye." Other patterns of scarification seem to have varied in design, density, and placement on the body suggesting some personal discretion of the individual.

Today in West Africa, scarification remains a widely practiced form of permanent body enhancement. To the Western

Figure 12-10. The coronation regalia of the Benin oba, or king, included a high collar of red coral beads, brass spiral cuff bracelets, beaded chest bands, anklets, leopard's tooth necklaces, and carved ivory heads attached to a belt. A skirt of embroidered red fabric was wrapped or draped around the waist to be tucked at the left hip. Brass palace plaque depicting a Benin oba with attendants, c. 1550–1650.

view, the idea of scarification conveys a negative connotation, but to the peoples of Africa, altering the surfaces of their bodies is an important social process that provides marks of beauty, status, and even tactile sensuality. Ga'anda women of Nigeria, for instance, begin the process of scarring much of their body from the neck to the knees upon their arranged betrothals, sometimes as early as age five. The process of cuts and healing is executed in several stages, which, after each phase, the groom's family makes a brideswealth payment. When the final marks are healed, and the last of the groom's gifts are delivered, the wedding may then take place.

So important is scarification to many groups that it is even applied to some types of masks used in masquerades. In carving the masks, sculptors take special care to shape the patterns and symbols that will convey to the spectator a specific meaning. Depending on its purpose, the mask with its depictions of scars might represent feminine beauty, masculine prowess, ancestral linkage, spiritual authority, or any of a host of other mystical, complex meanings.

Color on a mask also provides visual symbolism that is immediately understood by those who have been initiated. To the Chamba of Cameroon, red paint is the color of blood and masculine mysteries such as hunting rituals, and black is the color of night signifying feminine powers like those of witches. White accents around the eyes of the ebony masks of the Poro of Guinea are supposed to represent the clear vision and farsighted guidance of their ancestors. The blue masks of Nigeria's Gelede project the mystical powers of older women who are revered as "owners of the world." Besides the symbolic significance of the colors, in many instances the pigments are mixed with powerful, magical medicines that are considered dangerous to touch by anyone except high-ranking retainers.

The masquerades might be public events for the entire community such as weddings, funerals, and agricultural ceremonies, or they might be an instructional part of a secret ritual for a selected few such as performances at the circumcision rites of boys. The variety of masks and costumes used in masquerades of West Africa are as numerous as the clans and communities of the region. Some masqueraders wear costumes that completely conceal the performer, while others might don only a headdress or helmet mask and wrap skirt. Among the more common forms of masquerade costumes are

the bands of raffia or other vegetation fibers arranged in full, bushy tiers to conceal the dancer beneath a shapeless—and hence, ethereal—form. (Figure 12-11.) As the performers dance and whirl, the fringes of the raffia create a mesmerizing, powerfully kinetic appearance of the supernatural. At the other end of the masquerade spectrum are the young Bassari men of Senegal who celebrate their transition into manhood by wearing elaborate circular masks of palm fibers and feathers with a mesh center hiding the face, but display their youthful, athletic bodies by coating their skin with red clay and wrapping a narrow, colorfully patterned skirt about the hips.

Since the nineteenth century, textiles have become integral to certain masquerade costumes. At key festivals of the Yoruba of Nigeria, masquerades are conducted to honor their ancestors. Spirit maskers wear a head-to-toe sack-like covering with an immense train made of a patchwork of strip woven cloth and imported textiles. The masqueraders can manipulate the excess fabric to form shapes that evoke an ancestral apparition. Encased in a worldly cage of cloth, the dancers are believed to be temporarily transformed into the spirit of one of the deceased ancestors. Other West Africa peoples combine cloth with carved masks to represent a

Figure 12-11. Masquerades were important social events for a community. They celebrated weddings and agricultural ceremonies, provided closure at funerals, and instructed neophytes during initiation rites. Mende masquerade costume, Sierra Leone, c. 1960s.

range of human and animal characters. Some costumes also mix raffia with yards of cloth to further enhance the mystery of the indefinable being concealed underneath.

CENTRAL AFRICA

The many ethnic groups scattered across the central region of the African continent developed cultures that shared much in common with those of the great ancient civilizations of the west. As with the kingdoms of the Yoruba and Benin, the social, political, and economic order of the many small kingdoms of Central Africa was sustained by a ruler who was the chief priest and cultural guardian as well as the chief justice and principal secular administrator. The kings of Central Africa, like their counterparts in the west, lived in palace complexes with a court of aristocrats and administrators. The royal presence of the king and his display of splendor at public ceremonies were crucial for the stability and continuity of his people. For some Central African kingdoms, like that of the Kuba of the Democratic Republic of Congo, a royal treasury was maintained and contributed to by each king. These repositories of wealth included accumulations of textiles, jewelry, clothing, masquerade costumes and masks, furniture, umbrellas, and numerous items of regalia. For other kingdoms like those of the Azande and Mangbetu, the treasury was dismantled and buried with the deceased king.

One of the oldest and most powerful kingdoms of Central Africa is that of the Kongo of the Zaire River Basin. This was the kingdom encountered by the Portuguese in the 1480s when they advanced their explorations of the continent southward to what is now Angola. Like most ethnic groups of Africa, contact with Europeans profoundly altered their cultures. An engraving of the Kongo court from the 1660s depicts the king and court during a ceremonial event. (Figure 12-12.) A blending of European and African elements is evident in the illustration. The king wears a cut-and-sewn tunic over a wrap skirt, both of woven cloth, combined with the skin of a leopard, symbol of his authority, and strands of beads and earrings. His ministers seated to the right also wear tunics with square-cut or V-shaped necklines. The guards and audience wear simple, plain wrap skirts tied at the waist and extending to the knees. Yards of richly patterned raffia cloth cover the ground and the dais upon which the king is enthroned. An assortment of flywisks attached to a pole are at the king's right hand. Other regalia include a European-style banner with emblems of power placed directly behind the king's head.

For everyday dress, the principal symbol of the Kongo king's authority was a specially constructed cap, the **mpu.** Some caps were made of a single cord of raffia worked in a spiral from the center of the crown to the outer edge. The unbroken line of the spiral symbolized a long life. Other types of mpu were made of sumptuously embroidered squares of woven raffia, each with a symbolic meaning of its own, sewn together to fashion a tall dome.

Headdresses and coiffures were of special significance to the peoples of the Zaire River basin. Even into the twentieth century, for the elite of many groups, whether they adopted Western clothing or retained customary types of wrap garments, the most important status symbol was a hat or headdress. (Figure 12-13.) Innumerable varieties of materials were employed to shape headgear, including reeds, vines, cordage, bark, palm fronds, twigs, and animal skins.

Attached to these elaborate structures were all manner of imaginative combinations of shells, feathers, basketry, and ornaments of bone, ivory, or metal. Red feathers were a particularly favorite decoration since the color red is commonly associated with power and rank. Hat pins similarly were made of a variety of materials, some with lavishly carved ends that symbolized magic, family heritage, or social rank.

Figure 12-13. Elaborate headdresses and hair arrangements served as symbols of status and ethnic identity. Distinctive headgear shapes were constructed with wood, basketry, or wire frames and adorned with feathers, fur, shells, beadwork, and precious materials. From the Zaire River Basin c. 1910: left, the wife of Mangbetu chief; center, the wife of Mayogo chief; right, Bangba warrior.

Figure 12-12. Almost from the first contact with Portuguese in the 1400s, the ruling class of the Kongo kingdom of the Zaire River Basin adopted elements of European culture and dress, blending and modifying Western elements with their unique traditions. Here the king wears cut-and-sewn cloth garments layered with indigenous woven raffia wraps and animal skins. Illustration from *Description de L'Afrique* by Olfert Dapper 1686.

For high-ranking women of some groups, status was also conveyed by hairstyles and hair ornaments. Human hair attachments from war captives or acquired from the open market were woven into complex arrangements that might include a frame of basketry or looped cording. Large combs made of bound porcupine quills or carved bone, ivory, or wood were inserted into the elaborate coiffures to hold them in place and add a decorative touch.

The masquerade costumes of Central African peoples are as diverse in design and purpose as those of their northwestern neighbors. The Kuba employ a wide assortment of helmet masks and costume elements that accent the body but do not conceal it like the raffia-encased styles of Guinea and the Ivory Coast. Notable among the Kuba are the number of feminine masks and costumes that represent the sister-wife of Woot, the mythical ancestor and founder of the Kuba kingdom. Feminine elements of the costume include a mask with a woven raffia wig with painted stylized locks, a beadwork and cowrie shell cap, and a female wrapper of embroidered raffia cloth. Although male dancers wear the costumes, the audience recognizes the tribute to the cultural role of women in Kuba society. For funeral masquerades of kings and those of high rank, the masks and costumes are lavishly embellished with cowrie shells, which was a form of currency and wealth for generations. Sumptuous beadwork and complex painted patterns of triangles and stripes also adorn Kuba masks. Another uncommon masquerade costume is the representation of the Pygmy, the diminutive people of the forest. The bulbous head masks and simple skirt wrap costumes of the Pygmy spirits are less ornate than the royal styles because they simultaneously symbolize commoners and non-Kuban peoples, without whom the ancestral Kuba kings could not have ruled.

EAST AFRICA

The eastern region of Africa stretches from the headwaters of the Nile in Sudan southward to the lower Rift Valley in Mozambique. The peoples who populate this vast territory are, perhaps, the most ethnically complex and diverse of the continent. During the migrations of people into Africa at the end of the first millennium BCE, Bantu-speaking pastoralists came to dominate the region, displacing and sometimes mingling with the Nilosaharan ethnic groups who inhabited the area. Some Bantu retained their pastoral economies and others adopted agriculture. During the second half of the first millennium CE, a robust maritime trade developed between the Arabs and the communities of the east African coast. The indigenous coastal peoples converted to Islam and came to be known as the Swahili, a derivation of the Arab term for "shore." Later, merchants from India and China established trade routes to East Africa, and at the end of the 1400s, the Portuguese arrived.

As with the Muslim conquest of the north, Islamic influences significantly altered the Swahili culture. Art, architecture, language, and dress were transformed to meet the needs of the new religion. Based on the tenets of the Quran, for example, figural imagery in art was replaced by nonrepresentational motifs and symbols. Similarly, Swahili men and women adopted concealing dress and costume elements such as turbans and veils. Many subtle blendings of the new and the old persist still. For example, the talismans once used for mystical protection and as tokens of spiritual reverence of their ancestors were adapted to Islam as prayer amulets and genealogical links to ancestors. For Swahili male leaders, the ankle length tunic-style thawb of Arabia is combined with African wrap textiles worn as sashes of office diagonally across the torso. In addition, an embroidered pillbox-like cap proclaims the aristocratic patrilineage of the wearer, a style similar to the mpu of the Kongo kings.

Further south and inland, peoples of East Africa resisted Islam well into the nineteenth and twentieth centuries, thus preserving their traditional customs and dress. Innumerable varieties of wrap garments and ring ornaments were worn by the diverse non-Muslim groups of the region. (Figure 12-14.)

Figure 12-14. Non Muslim peoples of East Africa preserved their dress traditions including wrap garments, ring ornaments, and body modification like scarification and tattooing. Shilluk warrior, Sudan, 1922.

Types of wrap clothing ranged from simple loincloths and cloaks to multiple-layered wrap skirts arranged in a myriad of looks. The method of tying or tucking the fabric of a garment at the waist or securing it with a cord, belt, or girdle is often an important aspect of ethnic customs preserved from one generation to another in the face of modern cultural encroachment, especially the easy access to mass-produced ready-to-wear imports. As throughout Africa, the subtle arrangement of wrap garments, the use of color, the selection of textile print or pattern, and the application of adornment were often specific to gender, age, and status, such as the Maasai examples discussed later. Textiles ranged from domestically produced or imported plain weave cloth to opulent royal cloth woven with silk for the regalia of leaders.

As noted previously in the chapter, the modernization of postcolonial Africa and the accessibility of inexpensive imported ready-to-wear, especially following World War II, have significantly impacted traditional customs of dress. Notable has been the disappearance of what we in the West view as full nudity—the exposure of the genitals and bared female breasts. Yet the ethnic groups whose culture included this custom of undress often had divergent perspectives.

Among the Nuba agriculturalists of Sudan and Ethiopia, for instance, both men and women completely shaved their bodies and closely cropped the hair on their heads, which to them was a splendor worth exhibiting unclothed since a smooth, hairless body distinguished them from animals and bearded Muslims. Even without cloth garments, these ethnic groups were not undressed since they adorned themselves abundantly with necklaces, bracelets, anklets, earrings, belts, and hair ornaments. In addition, girls coated their skin with a silky layer of red or yellow ochre blended with scented oil. Mature women displayed their accumulated patterns of **keloids,** or raised scars, that confirmed their progress to adulthood. Sexually active young men painted patterns over most of their bodies as a social statement and an expression of personal aesthetics. (Figure 12-15.) Hunters might have chosen the spots of a leopard, and warriors might have experimented with symbols representing the speed of an ostrich. Only the elderly, pregnant women, or the sick wrapped themselves in cloth.

Such aesthetic attention to the body is particularly prevalent with the pastoral peoples of East Africa. The Maasai of Kenya and Tanzania use strictly regulated dress

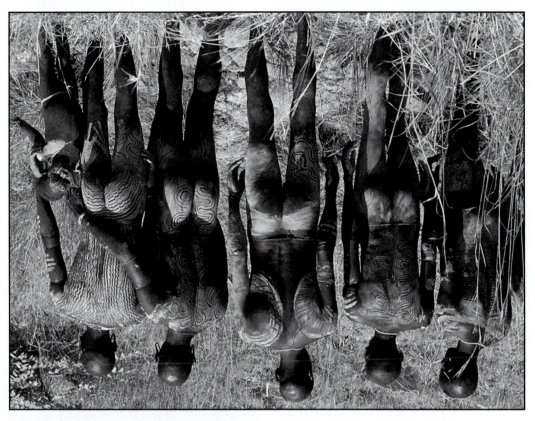

Figure 12-15. Although some ethnic groups did not wear cloth garments or conceal their genital areas, they nevertheless possessed costume traditions that often included body paint, scarification patterns, ring ornaments, and accessories that were gender specific and projected social status, age, and wealth. Painted Surma men of Ethiopia, 1970s.

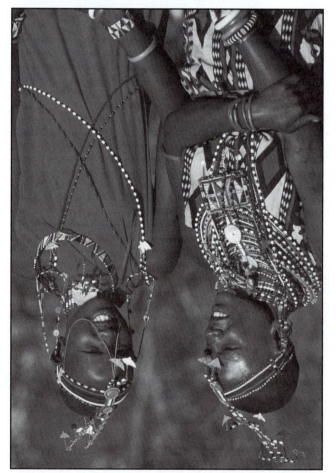

Figure 12-16. The sumptuous costumes of the Masai of Kenya and Tanzania defined and visually expressed differences in ethnicity, age, gender, wealth, and social status. To this end, the color schemes and patterns of beadwork were strictly regulated to maintain these identity messages within the community. Two Maasai women, 1980s.

and ornamentation to emphasize ethnic identity, gender, age, wealth, and social status. Until recently, beadwork was lavishly applied to leather skirts, aprons, cloaks, headbands, and jewelry worn as everyday attire by both men and women. (Figure 12-16.) Today, though, these sumptuous costumes are primarily reserved for special occasions like initiation ceremonies. Leather has been replaced by kanga cloth and other imported fabrics, and beadwork has been limited mostly to jewelry and accessories.

Color rules were also rigidly followed by the beadwork fabricators. The earliest Maasai color schemes were red for cattle blood, black or deep blue for the storm cloud-laden sky, and white for the sustenance of milk. The greater the number of dark beads the higher the status of the wearer.

In addition to the color scheme, the type of beadwork garment, accessory, or jewelry signified a specific stage of the Masai's life cycle. Following prepubescent circumcision, boys undergo the stages of training to become warriors. They wear specific necklaces, earrings, and belts to denote their progress.

Earlier warriors once painted their faces and coated their braided hair with red ochre before a battle to symbolize power and to intimidate foes. During the colonial era the practice culminated in a lion hunt instead of combat, and the lion's mane was stitched onto a headdress that encircled the face. Feathers were substituted for the mane for warriors who had not yet killed a lion. In more recent times, though, the headdress has been abandoned since killing lions and ostriches is prohibited by law.

During the nineteenth century, masquerades were gradually abandoned throughout much of East Africa. Some of the more isolated Bantu peoples of Malawi, Tanzania, and Zambia still practice masquerading, particularly for funerals. Most spirit masks and costumes are similar to the stylized helmet mask and raffia styles of Central and West Africa. **Nyau masks** of the Chewa of Zambia, though, feature carved wood portraits that are sometimes enhanced with feathers, rags, raffia, and other materials that suggest the actual appearance of the deceased. Beneath the concealing costume, the performer maneuvers on stilts, which adds to the spectral appearance of the costume.

SOUTHERN AFRICA

As Bantu-speaking peoples migrated into Southern Africa during the first millennium CE, the cultivating groups built river basin villages and established chiefdoms, while the pastoralists remained more nomadic, following the changing pasture lands with their cattle season by season. Among the ethnic groups that eventually rose to prominence in Southern Africa were the Shona, builders of the magnificent stone citadel at Great Zimbabwe, and later the Nguni of the famous Zulu kingdom.

Little is known about the dress of the ancient Shona of Great Zimbabwe. Sometime during the second half of the 1400s, the kingdom suffered a significant and rapid decline, and the Shona shifted their capital to nearby Khami. However, the number of ceramic spinning weights found at the Great Zimbabwe site reveals that the ancient Shona extensively practiced spinning and weaving. In addition, thousands of imported Chinese porcelain beads have been excavated suggesting the importance of beadwork as personal adornment.

This beadwork tradition in Southern Africa is best documented with the artifacts and photographic records of the Zulu. As with the Maasai to the northeast, beadwork for the Zulu denoted social rank, gender, marital status, and life cycle changes. Until the early twentieth century, beadwork was applied to simple leather aprons, wrap skirts, cloaks, belts, ring ornaments, and jewelry by the ranking women within the royal compound. As imported glass beads became more accessible, the privilege of beadwork was extended to all women of the community. With the abundant availability and

expanded color varieties of mass-produced beads, traditions of beadwork patterns, motifs, and color arrangements were altered over the decades, reflecting changes in personal expression and social significance. One of these new developments was the popularity of the **ubala abuyise**, or love letter necklace. The necklace was a beaded square attached to a simple bead string that girls would make for young men as part of their courtship ritual. The choice of colors and arrangement of the beads conveyed a variety of messages ranging from an expression of love to anxiety about the young man's fidelity. Since the acceptance of a love letter is not regarded as an engagement pledge, young men may wear several necklaces from different young women.

Unlike with the Maasai, though, dress for the Zulu was not elaborate and included few accessories except for special occasions like weddings. Through the early part of the twentieth century, garments were mostly made of patchwork leather. Wrap skirts, aprons, and cloaks were the principal clothing for both men and women. Zulu warriors additionally adorned their beaded kilt-like wraps with pelts and tiers of feathers, and tied strips of fur to the arms and legs, all of which projected a vision of kinetic energy and aggression to their foes. Unmarried Zulu women often wore only a small beaded leather apron that was barely more than a loin covering, while pregnant and lactating women wore wide leather aprons that extended from the arm pits to below the knees. Lavishly beaded ceremonial ensembles for women, such as that of the bride shown in Figure 12-17, were designed to expose much of the body, especially the breasts and thighs, since the Zulu felt that the beauty of a young woman's graceful form reflected the inner beauty of her character. Her veil of beaded panels not only expressed her modesty but also proclaimed her social status as the daughter of a wealthy family.

Masquerades for the Bantu-speaking peoples of Southern Africa were crucial to the social and cultural life of their community. Beginning with the ritual of circumcision, boys were instructed in the behavior expected of them as adults. The initiates formed an age regiment called a butho headed by an age-mate leader, usually a son of the chief. Two variety of costumes were used for the stages of initiation. Trainers did not conceal or disguise themselves, but rather donned props and costume elements that symbolized enemies (including Europeans in earlier years), dangerous animals, and harmful spirits to better instruct the initiates on methods of combat, survival, honor, and protection of their homes, community, and king. At various stages of their instruction, the butho members dressed in ceremonial costumes of confirmation, not unlike the Western tradition of mortarboard and gown worn at graduations. Many of these costumes featured symbolic military garb like warrior sashes, collars, arm and leg bands, as well as mock weapons all made of reeds, twigs, foliage, and feathers. Helmets of reeds and other types of vegetation concealed the identity of the initiate as a dedication to their king, who sponsored the butho.

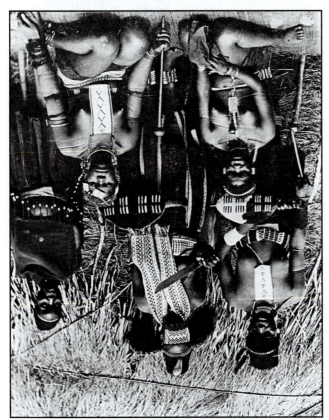

Figure 12-17. Elaborate beadwork such as this bridal ensemble and veil from about 1900 proclaimed the wealth and status of the young woman among the Zulu.

MODERN AFRICAN FASHION

Since the earliest days of colonialism, Europeans viewed Africa as an export market for the manufactured goods produced in homeland industrial centers. Among the first items traded with the Africans were manufactured textiles and clothing, which had an immediate impact on indigenous dress. With the industrial revolution of the late nineteenth century, inexpensive milled fabrics and mass-produced ready-to-wear clothing became increasingly available to Africans. During the twentieth century, the accessibility and affordability of Western clothing dramatically influenced changes in traditional costume styles, and many times replaced ethnic garb altogether, particularly in urban areas. The affluent classes of the postcolonial era from the 1960s into the 1980s preferred the contemporary fashions of Paris, Milan, and New York. The conventional idiom of African dress—flowing wrap garments and oversized tunic styles in country cloths—was viewed as quaint, a relic of a remote past. The larger populace (of non-Muslims), though, continued to experiment with mixing Western fashions with traditional indigenous styles.

Concurrent with this postcolonial redefining of African dress emerged a continent-wide interest in developing fashions that asserted pride in being African. In 1958, the first president of Ghana wore kente cloth on his state visit to the United States as a powerful symbol of his nation's cultural heritage. In the 1960s and 1970s, tailors, artisans, and others in the apparel and accessory industries became inspired by the black nationalists in Europe and America who wore garments of kente, headwraps, and similar looks as a statement of pride in their African ancestry.

At the forefront of this Pan-Africa cultural movement was Chris Seydou (1949–1994) of Mali. In the 1970s, Seydou had apprenticed in the tailor shops of his homeland, and, at age twenty-six, went to Paris to work with Yves Saint Laurent. Seydou designed his own fabrics based on simplified adaptations of bogolanfini patterns. He applied these boldly graphical prints to Western-styled silhouettes such as

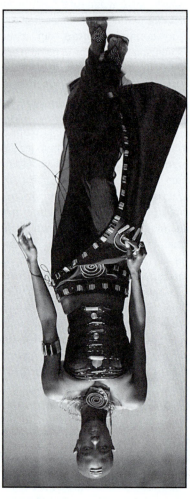

Figure 12-18. Malian fashion designer Chris Seydou created his own interpretations of bogolanfini patterns and applied them to fitted Western clothing styles. Hat, jacket, and skirt by Chris Seydou, 1992.

tailored jackets, skirts, and blouses rather than the traditional flowing robes and wraps of Africa. (Figure 12-18.) Seydou's designs successfully blended the rich traditions of African style with European couture for a sophisticated look that appealed to both Westerners and urbanites of Africa. He even changed his name to reflect this bridge between the two worlds, adopting "Chris" in honor of Christian Dior. In 1993, Seydou helped establish the African Federation of Fashion Designers to foster and promote African style worldwide.

The legacy of Seydou today is a burgeoning African fashion industry that has achieved international acclaim. Nigerian designer Seidnaly Alphadi of Cameroon became the president of the African Federation of Fashion Designers following Seydou's death in 1994, and traveled the world promoting the fashion and accessory creations of the organization's members. Important regional events include the

Figure 12-19. The South African Fashion Week was launched in 1997 to showcase regional design talent. Soon after, Zambia and Kenya were among other African nations to host globally publicized fashion events. Runway model wearing brass and bead jewelry from Maro Designs, Nairobi, Kenya, 2004.

South African Fashion Week, launched in 1997 and held each August to showcase the creations of local talent. Zambia and Kenya soon followed with globally publicized fashion weeks as well. (Figure 12-19 and Color Plate 98.) The Internet also opened the world to African style, contributing to the commercial success of designers such as Ann McCreath of Kenya, Katoucha of Guinea, Guenet Fresenbet of Ethiopia, Esterella of Cameroon, Angy Bell of the Ivory Coast, and Oumou Sy of Senegal, among many others.

Today's generation of African designers continues to explore the cross-cultural possibilities of merging Western clothing styles with traditional African textiles, or the reverse, with adaptations of African garments made of Western fabrics and materials. In the twenty-first century, wrote Jean Loup Pivin for *Revue Noire*, African designers "draw their modernity from the source of their countries, for Africa is not just a reservoir of a living age-old tradition, it is also rooted in the now commonplace modernity of Lycra and knitwear, anchored in the hazy identity of urban culture." These are the creative challenges—and the expressive opportunities—of modern African designers.

REVIEW

The Stone Age peoples of Africa have left innumerable images of themselves incised and painted on rock surfaces all across the continent. These ancient drawings provide documentation of the evolution of hunter-gatherer tribes into pastoral societies, and eventually into settled agricultural and fishing communities. As influences from the ancient Mediterranean civilizations filtered southward, Africans adopted new technologies such as the wheel, metallurgy, and textile production.

The earliest indigenous textiles were produced from available vegetable fibers extracted from grasses, seed pods, trees, and bamboo. Simple finger-weaving techniques produced fishing nets, sleeping mats, basketry, and similar utilitarian items. The first looms for making fabrics may have been introduced as early as the Roman era, probably through the Nile River basin corridor. As cultivating communities were established in the sub-Saharan regions, cotton became an important textile fiber crop. Even with the widespread availability of loom weaving, though, some groups continued to make barkcloth by pounding sections of treebark into soft pieces of fabric-like material.

By the time the first African civilizations had built cities, costume was already an integral component of social structure and ethnic identity. Among the earliest forms of dress represented in some of the most ancient rock art images were ring ornaments and body paint or possibly scarification and tattoos. More clearly articulated sculptures and figurines of later eras reveal that both men and women adorned themselves with an abundance of necklaces, bracelets, earrings, anklets, hip rings, and headbands, even with an absence of clothing. Status within the ethnic community was made evident by the size, shape, design, and materials used in these ring ornaments.

Clothing also came to be a status symbol within the social hierarchy of the group, whether denoting age, wealth, or rank. For the great majority of Africans prior to contact with the Muslims and European colonists, basic wrap garments of varying shapes and dimensions were the most common forms of apparel. Loincloths, wrap skirts, aprons, cloaks, and scarves were made of fur, leather, barkcloth, and woven textiles. Decorative elements such as block printing, painted motifs, appliques, embroidery, beadwork, and trimmings of feathers, ivory, bone, cowries, and metal reinforced hierarchal distinctions.

In addition to jewelry and other ring ornaments, a wide variety of accessories also served as symbols of status and ethnic identity. Most notable are the distinctive silhouettes of headdresses constructed with wood, wire, or basketry frames and adorned with an opulence of feathers, fur, shells, beadwork, and precious materials.

Ethnic identity and aesthetics were also reaffirmed through body modification. Applications of tattoos and scarification followed ancestral patterns and motifs passed across the generations. Pierced ears, noses, and lips were adorned with jewelry or stretched over time to display sizeable plugs and disks. For millennia, circumcision has been a common rite of passage for boys into manhood.

Although contact with Westerners has altered indigenous African cultures and their costumes, many peoples continued to preserve elements of their customs and identity. In the postcolonial period, ethnic groups experimented with mixing traditional wrap garments and accessories with imported styles of ready-to-wear. African fashion designers have recently expanded on this cultural shift by combining the textiles of Africa with the clothing styles of the West, or by reinterpreting traditional African garments with Western fabrics and materials.

Chapter 12 Africa
Questions

1. What are the earliest types of costumes depicted in ancient African rock art?

2. Identify the characteristics and production methods of kente, bogolanfini, and raffia cloth. With which ethnic group and region is each textile most associated?

3. What are the two most prevalent types of garments represented on ancient Jenné sculptures? How do these differ from the types of garments represented in the artwork of Ife and Benin?

4. What are some forms of body modification used as ethnic identification?

5. What are the two principal types of masquerades, and what purposes do they serve? Describe a costume representative of each masquerade type, citing ethnic origin and nationality.

6. How is African style expressed in modern fashions by indigenous designers?

Chapter 12 Africa
Research and Portfolio Projects

Research:

1. Describe examples of traditional (non-Western) African dress for men or women that define each of the following:

 - ethnic identity
 - social status
 - ruling authority
 - wealth
 - age
 - marital status
 - gender
 - life-cycle changes

 Select a different ethnic group for each one of the classifications, and identify the nationality.

2. Name three contemporary African fashion designers not mentioned in this chapter. Provide a brief biography of each, featuring nationality and accomplishments, and describe one of their designs that best exemplifies a cross-cultural mix of African and Western styles.

Portfolio:

1. Sketch two fashion designs of your own creation that reflect African style:

 • Design an outfit (women's or men's) that blends African textiles with Western fitted garment styles. Include notes in the margins on garment details such as construction, trim, and accessories. Attach photocopies or swatches of the textiles selected for the design with a written description of each, including types of cloth, color schemes, and ethnic origin.
 • Create a design based on traditional African clothing that is made of Western fabrics. Include notes in the margins on garment details such as construction, trim, and accessories. Attach photocopies or swatches of the textiles selected for the design with a written description of each, including fabric types and color schemes.

2. Design a miniature adinkra cloth with at least four panels. The size of each panel should be no larger than five by ten inches, and each must feature a different traditional African motif. Attach a description of the motifs and their African symbolisms.

Glossary of Dress Terms

adinkra: Asante plain weave cloth embellished with a grid of stamped designs of spiritual symbols

adire: Yoruba resist dyed cloth with intricate blue and white patterns

adweneasa: a pattern of West African kente so complex that its name translates to mean "my skill is exhausted"

aso-oke: Yoruba strip-woven cloth with designs that represent the social status, wealth, or occupation of the wearer

batakari: an Akan men's tunic decorated with stamped magic squares, appliques and pendant amulets such as horns and claws that the wearer believed would provide protection from evil and harm

bogolanfini cloth: locally-woven cotton cloth painted or handstamped with patterns of geometric symbols in a mixture of black, mineral-rich mud, sometimes intensified with vegetable dyes, directly onto the fabric

cache-sex: women's pubic jewelry or decorative covering for the genitals and sometimes buttocks

country cloth: a general term for any variety of West African textiles woven with homespun threads

doma (also duop): multicolor tie-dyed cloth of West Africa

eben: a broad, leaf-shaped sword carried by Benin kings during ceremonies

ede-iyoba: a crown once worn by Benin queen mothers constructed with a high, forward-pointing peak covered with red coral beads

ikaki: brightly colored cotton cloth of the Igbo woven with stylized motifs of animals and household objects

ikharo: raised scars on the foreheads of Benin royalty; literally meaning "tribal mark of eye"

kanga: block-printed fabrics of East Africa with vegetable motifs and paisley-like borders

keloids: patterns of raised scars

kente: a richly patterned, strip-woven textile of cotton, cotton/synthetic blends, or in recent decades, of rayon

leppi (also lappa): a strip of kente worn as a sash

mpu: cap of Kongo kingdom rulers, often made of a single thread of raffia worked in a spiral to symbolize long life

ndop: Hausa cloth made with blue and white patterns

nogetwe: a West African woman's ritual apron made of dried banana leaves dyed black

nogi (also noge): barkcloth of the Azande and Kuba made by pounding pieces of tree bark with a wooden or ivory beater until it developed a soft, felt-like texture

nyau: funerary portrait masks of the Chewa

odigba: a high collar of red coral beads worn by Benin kings

ododo: a wrap skirt made of richly embroidered cloth worn by the king of Benin

pelete bite: cut-thread cloth produced by Ijo women who meticulously cut and remove tiny sections of thread to form lacy patterns

raffia cloth: textiles woven from the fiber of raffia palm fronds popular with the Kuba, among others

shine-shine: a variant of West African aso-oke cloth woven with Lurex yarns

sora: women's long, flowing wrap skirt

ubala abuyise: a Zulu "love letter" necklace made of beads representing courtship messages presented to young men by young women

ukara: blue dyed fabric of the Igbo with white patterns produced by stitching a design over white cloth before immersing in a blue dye

Legacies and Influences of African Styles on Modern Fashion

The most prevalent influences of African costume styles on modern fashion are represented in the ethnocentric dress that became expressive of black cultural identity in the West beginning in the late 1960s. Specialty boutiques and direct mail retailers offered interpretations of the dashiki for both men and women. Headdresses and hairstyles that were evocative of African styles were adapted to Western looks and wardrobes. As Carol Tulloch wrote of the modern headtie in *Defining Dress,* "The seemingly innocent function of what was just a length of cloth, qualified by its established profile as a humble utilitarian apparel, belied the headtie's subversive message of black-consciousness, and the acceptance of blackness as a cultural force, and finally Africa as the epicentre of black culture."

In addition, African motifs and decorative patterns were copied or adapted to textiles, both for African-styled clothing as well as modern Western fashions. In the 1960s, Maulana Karenga established a Pan-African celebration in December called Kwanza. The three colors of the Kwanza flag symbolize "black for the people, red for their struggle, and green for the future and hope that comes from their struggle." Celebrants are encouraged to dress in styles of African attire that feature the Kwanza colors.

African styles and motifs have also been appropriated by nonethnic designers for the mystique, beauty, and exoticism of the look. In a 1967 fashion show, for example, Marc Bohan at Dior presented a straw cape similar to the raffia coverings of African masqueraders and stacks of metal rings about the necks of his models imitating Ubangi collars.

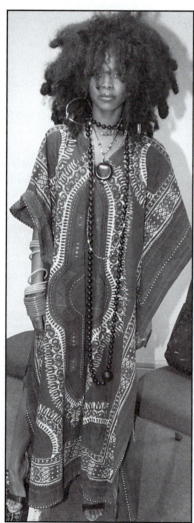

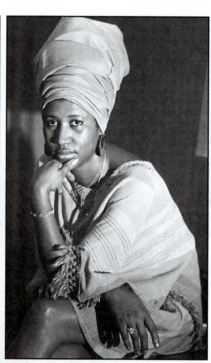

Ethnocentric clothing and textile motifs were used by many blacks in the West to display pride in their African heritage. Left, African print caftan, 2005; center, singer Aretha Franklin in headwrap and belted dashiki, 1970; right, author Eldridge Cleaver wearing a dashiki, 1969.

African beadwork jewelry worn for the Mickael Kra fall runway show, Paris, 2005.

Chapter 13

THE ANCIENT AMERICAS

The New World Before 1500

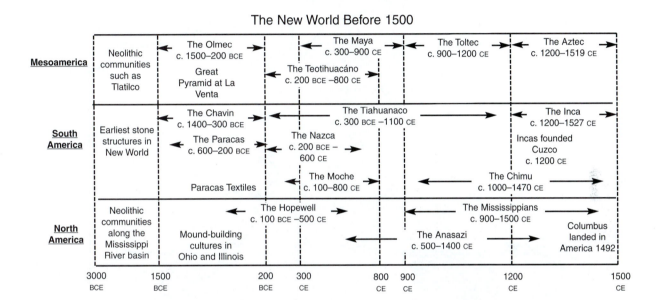

Mesoamerica	Neolithic communities such as Tlatilco	The Olmec c. 1500–200 BCE	The Maya c. 300–900 CE	The Toltec c. 900–1200 CE	The Aztec c. 1200–1519 CE	
		Great Pyramid at La Venta	The Teotihuacáno c. 200 BCE –800 CE			
South America	Earliest stone structures in New World	The Chavin c. 1400–300 BCE	The Tiahuanaco c. 300 BCE –1100 CE		The Inca c. 1200–1527 CE	
		The Paracas c. 600–200 BCE	The Nazca c. 200 BCE – 600 CE		Incas founded Cuzco c. 1200 CE	
		Paracas Textiles	The Moche c. 100–800 CE	The Chimu c. 1000–1470 CE		
North America	Neolithic communities along the Mississippi River basin	The Hopewell c. 100 BCE –500 CE		The Mississippians c. 900–1500 CE		
		Mound-building cultures in Ohio and Illinois		The Anasazi c. 500–1400 CE	Columbus landed in America 1492	

3000 BCE 1500 BCE 200 BCE 300 CE 800 CE 900 CE 1200 CE 1500 CE

ANCIENT MESOAMERICA

The region of Mesoamerica extends from the Valley of Mexico—the location of Mexico City—southward into Central America. Sometime between 7000 and 5000 BCE, bands of hunter-gatherers began to settle in the area and cultivate indigenous crops such as corn, tomatoes, beans, and squash. By the beginning of the third millennium BCE, Neolithic villages had been established throughout the region. Despite climactic and terrain contrasts, ranging from tropical rain forests to semi-arid mountains, a common culture emerged among the peoples of Mesoamerica. Archaeological evidence has revealed that even the most isolated communities participated in regional trade. Obsidian blades and jade ornaments have been excavated far from the natural sources. Examples of decorated pottery typical of one area have been found in distant burial sites. Even fragments of cotton textiles have been found in areas some distance from where the cotton plant was grown.

As the ancestors of these early settlers migrated from Asia across the land bridge of the Bering Straits around 30,000 to 40,000 years earlier, they had developed forms of protective clothing for survival in the frigid climate of the northwest. Over the millennia, as the waves of new migrations gradually pushed southward into warmer regions, heavy layers of clothing were unnecessary. Some costume historians, such as Chloë Sayer and Wilfredo du Solier, suggest that, by the time Mesoamerican hunter-gatherers began to settle and develop Neolithic societies, they had long since become acclimated to the semitropical climate and were virtually unclothed. Dress most likely had

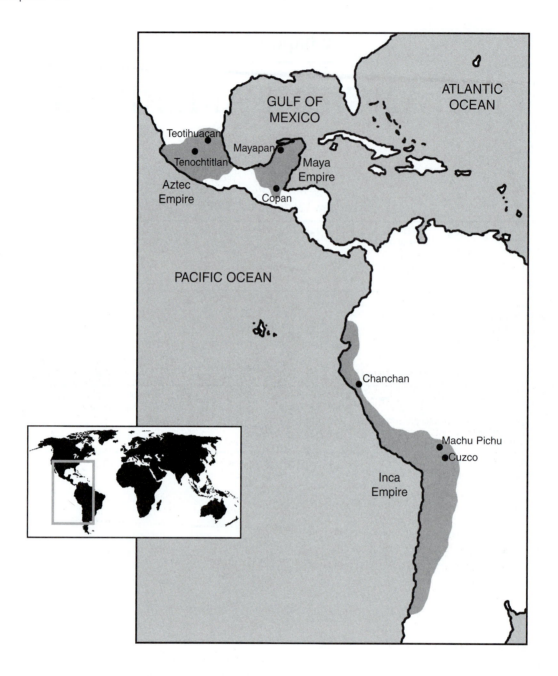

become simple ring ornaments—bracelets, necklaces, belts, anklets, collars—and body paint. Numerous pierced shells and beads have been discovered in gravesites of the period. Remnants of vermillion in burials suggest that the mineral was pulverized and used as body decoration. Even so, the skills of tanning animal skins and sewing or constructing prepared hides into utilitarian objects such as totes, blankets, and waterskins would have been preserved generation after generation. Numerous stone scrapers, bone needles, and antler awls have been found in early occupation sites throughout Mesoamerica.

WEAVING AND TEXTILES

The precursors to cloth weaving evolved in Mesoamerica as early as the six millennium BCE. The ancient over-one-under-one method of finger weaving rushes and grasses into mats and baskets gradually led to more sophisticated techniques of textile production. Among the oldest examples of weaving found in Mesoamerica was **twining**, the twisting of two or more weft threads (horizontal) to enclose, or entwine, rows of warp threads (vertical). (Figure 13-1.) Another early form of finger weaving was **netting**, in which pliable yarns were looped or

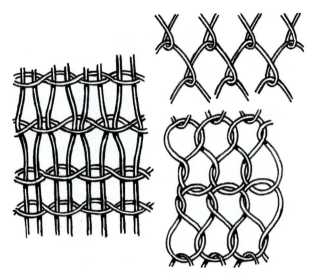

Figure 13-1. Basketry, twining, and netting are the oldest forms of textile production in Mesoamerica. Fragments of woven fibers found in the region date to as early as 4800 BCE.

Figure 13-2. The telar de cintura, or backstrap loom, allowed the weaver to control the tension of warps by leaning into a strap or slat that fitted around the back. Terracotta figurine of woman weaving with backstrap loom, c. 600–900 CE.

knotted together in rows to create a close-meshed textile. Fragments of basketry, twining, and netting have been found from as early as 4800 BCE.

The next step in the evolution of the production of textiles was loom-woven cloth. How and where the loom first developed in the Americas is unclear although most historians believe the earliest loom weaving first appeared with the southern Andean cultures perhaps as early as the ninth millennium BCE. Two types of looms were widely used throughout Mesoamerica by the end of the first millennium BCE. The **telar de cintura**, or **backstrap loom**, was a simple apparatus with no rigid framework. (Figure 13-2.) To prepare for weaving with a backstrap loom, a set of vertical warp threads was stretched between two horizontal sticks. One stick was tied to a tree or pole and the other stick was attached to a wide strap or wooden slat that fitted around the back of the weaver. The tension of the warps was controlled by the weaver leaning backward or forward. Clay figurines and codex paintings mostly depict women as weavers although men are sometimes represented as well. The backstrap loom is still used today by many rural peoples of the region.

Since the backstrap loom only allowed for cloth to be woven as wide as the weaver could reach, another form of simple loom was developed that could be extended for weaving larger pieces of material. The **staked loom** was worked upon a horizontal frame with wide warp rods that were staked into the ground. This form of loom eventually was adopted all across North America and evolved into the vertical loom still used today by Navajo and Pueblo groups.

Three types of fibers were used for the production of yarn. "Hard" fibers were harvested from more than two hundred species of plant leaves such as those of the agave and yucca. A second category included resilient filaments from the inner bark of plants such as the nettle. Seed-pod fibers comprised the third and most prevalent category, particularly cotton. The first two types of fibers were hand twisted into yarns by rolling the filaments on the leg. Examples of loom weavings of yucca found in the Candalaria Cave in Coahila reveal expert skill in producing firm, uniform threads. Cotton, though, was spun with various types of wooden spindles.

Wool was not known in Mesoamerica until introduced by the Spanish in the sixteenth century.

Unfortunately, the fabrics woven from these organic plant fibers were highly vulnerable to fungus and bacteria that accelerated decomposition in the hot, humid climate of Mesoamerica. The rare examples of textiles that have survived from ancient times were most often found in dry caves that had been used as burial sites. The earliest extant fragment of a cloth woven on a loom in Mesoamerica comes from the Tamaulipas region and dates between 1800 and 1400 BCE. Another site that has yielded over 600 pieces of fabric is the Mayan sacred well of Chichén Itzá, in which textile wrappings for sacrificial offerings were preserved in the thick mud at the bottom.

Research on these surviving fragments as well as written information in the Mesoamerican codices reveal that a wide

assortment of dyes and dyeing techniques were used for coloring yarns. Flowers, fruit, leaves, roots, chipped wood, insects, and earth were among the natural sources for making dyes. Deep blues, greenish blues, and blue-blacks were produced from the indigo plant. Purple was derived from blackberries and from Pacific mollusks that secrete a dense ink similar to that of the Mediterranean murex, source of the royal purple of Tyre. Shades of red were created by boiling chips of wood from the brasiletto tree. Brilliant red **cochineal dyes** were made by drying and pulverizing the bodies of the American scale insect. Orange and red-orange came from the seed pulp of the annatto. Yellow was extracted from the flowers of the acacia and shades of gold from peach blossoms.

Complex, time-consuming processes were required to produce textile dyes. Some plant materials had to be combined with just the right amounts of lime, alum, chrome, or even human urine and boiled for days to achieve the best tones and consistency.

A wide variety of techniques for dyeing fabrics created vivid combinations of color and pattern. Over-dyeing, or twice-dyeing, was sometimes used to make colors not easily obtained from natural sources. For example, shades of green were made by immersing yellow-dyed yarns into indigo blue. Tie-dyeing of threads before weaving, a process called **ikat**, produced soft-edged patterns of color. By tightly binding warps or wefts before immersing the fabric into dye, patterns resulted from areas not penetrated by the dyes. Another method of resist-dyeing was a form of batik in which tree resin or beeswax was applied to the fabric in a pattern before dyeing.

In addition to dyed threads, Mesoamerican textiles were colored by freehand painting techniques in which pigments were applied to fabric with feathers, frayed twigs, and fur brushes. Decorative appliques included feathers of tropical birds and dyed rabbit fur. Instead of dyes, some intricate textile patterns were woven from contrasting yarns made of natural white cotton and tawny cotton.

THE OLMEC

At the dawn of the second millennium BCE, many of the peoples of Mesoamerica had settled in Neolithic communities and developed cooperative agrarian societies. Their lands and labor were communal. Everyone shared in working the farmlands and fishing the lakes and streams to provide food. Additionally, the whole populace shared in the labor of constructing communal dwellings and storehouses and in crafting utilitarian wares. Pottery especially was important for storing and cooking food and as trading goods with neighboring villages. Woven mats, tanned animal hides, and gourd bowls were produced in large quantities. An abundance of personal ornaments was evidence of a successful, well-fed community with some degree of leisure time.

From the excavations of the Tlatilco settlement, a lakeside village in the central valley of Mexico, a wealth of clay figurines has been discovered that tell us much about the society of these Neolithic communities. Class distinctions do not appear to have been an emphasis of the social order of these people. There are no figures glorifying kings or representations of priests or gods. Instead, the tiny sculptures mostly depict affectionate couples, nursing mothers, dancers, acrobats, flutists, and dozens of similar domestic subjects. The great majority of these figures are unclothed although representations of both males and females feature elaborate headdresses or hair arrangements and a great variety of body ornaments. (Figure 13-3.) Some of these sculptures are decorated with such exacting detail that we can discern cowrie shells attached to rush-woven hats. Other headdresses appear to be basketry shaped with vines or skull caps made of gourds, both of which are still worn today in rural areas of central Mexico. Of the hundreds of Tlatilco figurines that have been found, few seem to depict the same headdress or hair arrangement, suggesting that personal style rather than tribal tradition of costume prevailed.

One of the common costume traits of the Tlatilco figurines is the frequent use of large, round earspools known today in Spanish as **orejeras**. The process for stretching the pierced earlobes to accommodate large plugs took many

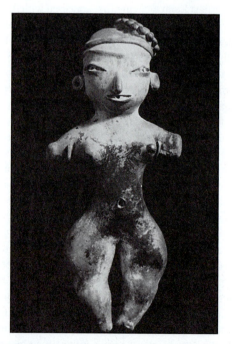

Figure 13-3. Neolithic Mesoamericans were unclothed except for a wide variety of decorative ring ornaments such as necklaces, bracelets, anklets, and arm bands. Terracotta figurines of the period reveal that these early peoples enjoyed sufficient leisure time to indulge in elaborate hair arrangements and lavish headdresses for both men and women. Clay figurine of Tlatilco woman, c. 1700–1300 BCE.

years of inserting a sequence of ever larger disks to stretch the skin. Earspools were made of polychrome wood or terracotta, carved jade, and polished stone.

Around the middle of the second millennium, the eastern Olmec people began to emerge as the dominant group in the region. Historians disagree on the dates of the Olmec culture, but archaeological evidence indicates that there were two eras of Olmec prominence. The first flourished at San Lorenzo from about 1200 to 900 BCE and the second at La Venta between 900 and 400 BCE.

The Olmec established a hierarchal, theocratic society led by shaman priests and warrior chieftains. Their spiritual beliefs centered on the worship of the nahual, or guardian spirits. At the top of their pantheon of divine spirits was a jaguar-monster that was believed to have mated with the Earth Mother and produced the human race at the dawn of time. Some Olmec sculptures depict priest figures draped in the complete skin of a jaguar, not unlike the way Egyptian priests wore the skin of the leopard.

The costume of the Olmec continued the traditions of the tribal peoples of the region that preceded their rise to prominence. Most sculptures of the early Olmec period represent nude figures, both male and female, wearing assorted types of ring ornaments. However, great attention was devoted to elaborate headdresses and hair arrangements for both men and women. (Figure 13-4.) Costume historians of Mesoamerican cultures marvel at the great variety and inventiveness of hairstyles, noting that rarely are any two identical.

Metallurgy was introduced late in the Olmec era, most likely from the Andean peoples to the south. The selective use of metal is one of those baffling mysteries of Mesoamerica—like the use of the wheel on toys but not for any practical application such as carts or wagons. Metalsmithing likewise was implemented extensively for making jewelry and ornaments but not for tools or weapons.

The earliest gold, silver, or copper jewelry and ornaments from Mesoamerican gravesites date from the sixth to fifth century BCE. New forms of jewelry and body ornaments became popular at this time. Instead of single noseplugs through the nasal septum, multiple hoops were applied so that a stack of five or six thin rings rested upon the upper lip. Similarly, ears were pierced all around the outer edge into which were inserted a row of thin rings, similar to a look indulged by some urban youth of the late 1990s. Although noseplugs and earspools were continued by subsequent cultures of the region, the multiple nose rings and rows of earrings seem to have been a unique and short-lived trend of the late Olmec period.

The Olmec were a warring people whose aggressive ambition led them to establish dominion over the many communities of central Mexico. Sculptural representations of Olmec warriors show that they fought nude except for a helmet and shield. These accoutrement of battle do not seem to have been created in any uniform fashion. Some figurines carry a small round shield while others of the same period are shown with long, rectangular versions. Styles of helmets varied from thick reed hats with chin straps for ordinary soldiers to close-fitting leather styles adorned with carved jade rings for their chiefs. (Figure 13-5.)

Although a significant number of Olmec sculptures represent nude figures, many others of the late period depict common elements of costume for the first time in Mesoamerica. Why the Olmec began to wear clothing in the later period is unclear. Costume historian Chloë Sayer thinks this was a cultural evolution reflective of the sophistication and affluence of the agrarian communities of Mesoamerica. "Costume represented economic power," affirmed researcher Margot

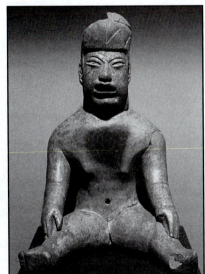

Figure 13-4. The Olmec continued many of the cultural traditions of the early Mesoamerican peoples they eventually dominated. In addition to wearing decorative ring ornaments, the Olmec devoted great attention to inventive hair styles and headdresses. Olmec terracotta figurines: female left, male right, c. 1300–800 BCE.

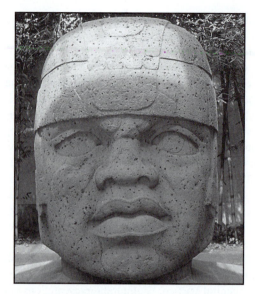

Figure 13-5. The battle helmets of Olmec warrior-kings were probably constructed of leather or thickly padded fabrics and adorned with rings carved of jade or obsidian. Colossal Olmec Head, c.1300–800 BCE.

Schevill. Another possibility is that, since the Olmecs formalized their beliefs into a religion, clothing, with its shapes, colors, and patterns, came to symbolize aspects of that religion. Or, perhaps, as administrators of the first empire in the Americas, the Olmec may even have used costume as a method of unifying diverse communities into one realm. "Cultural cohesion is broader than community affiliations," notes Schevill.

Whatever the motivation or inspiration, Olmec men began to wear a type of loincloth called a **maxtlatl**. A narrow piece of fabric fitted between the legs and was held in place in the front and back of the waist by a thickly wound sash called in Spanish a **faja**. The long ends of the loincloth were left to drape over the sash. (Figure 13-6.) This style of loincloth would become the most common masculine garment throughout Mesoamerica, and it would endure as a native costume of the region into the nineteenth century.

At about the same time that men initially donned the loincloth, Olmec women began to wear a short wrap skirt called a **cueitl**. Sculptural representations indicate that the skirts were possibly made of plaited long grasses or woven fibers with long fringe. (Figure 13-7.) Many of the depictions of the cueitl feature a wide waistband that fitted snugly about the hips rather than high upon the waist. Because far more sculptures have been found representing nude females, some historians think that the wrap skirts were only worn for ceremonial occasions, and then only by elite members of the social order. Even so, within the following few centuries, Mesoamerican women's costumes commonly featured some type of wrap skirt across all classes.

Why the Olmec empire vanished remains a mystery. Theories range from a catastrophe, such as a lengthy drought, to uprisings by city-states within their domain. Whatever the cause, the Olmec empire collapsed sometime in the fifth to fourth century BCE. Yet the cultural influence of the Olmec throughout Mesoamerica was profound and enduring. Their ideas of a theocratic state, a hierarchal social order, a calendrical system, writing, and even common forms of costume were adapted by the civilizations that succeeded theirs.

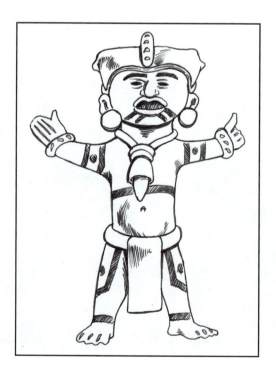

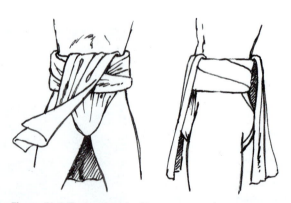

Figure 13-6. During the late Olmec era, men began to wear a loincloth, called a maxtlatl. A narrow piece of fabric fitted between the legs and draped over a sash in the front and back. Versions of the Olmec maxtlatl remained the most common masculine garment in Mesoamerican cultures until the nineteenth century. Left: clay figurine of man wearing a maxtlatl, c. second century BCE to fifth century CE.

Figure 13-7. The short wrap skirt, called a cueitl, worn by Olmec women was made of plaited grasses or woven fibers with fringe. Clay figurine of Olmec woman, c. 1300–800 BCE.

THE TEOTIHUACÁNO

The next civilization to emerge in Mesoamerica was centered around the city of Teotihuacán, located just north of modern Mexico City. Little is known of the origins of the people who built this magnificent metropolis between 100 BCE and 650 CE. Centuries later, the Aztecs still performed ceremonies at the site, giving the city its current name, variously translated to mean "the city where all go to worship the gods," or simply "the place of the gods." At its height, Teotihuacán and its surrounding suburbs were the most populous single urban center in the Americas with an estimated 200,000 inhabitants.

Colossal pyramids and lavishly decorated temples were constructed of lava rock for permanence. Wide intersecting streets and plazas were paved with stones. Traces of paint survive on almost all structures, including streets and curbs, testifying to the Teotihuacáno love of abundant, brilliant color.

How all the huge stone slabs for these architectural marvels were transported remains a mystery since none of the ancient peoples of the Americas are known to have used wheeled vehicles, even hand carts or barrows. Curiously, though, numerous toys with wheels and axles have been found.

The many frescoes and sculptures left by the Teotihuacáno attest to a complex calendrical system of worship involving a number of related deities. At the head of this pantheon of gods was a feathered serpent, Quetzalcoatl, carrier of the sun, for which the largest pyramid temple was built.

Surprisingly, despite the wars of the earlier Olmecs and the subsequent conflicts between city states, Teotihuacán was not substantially fortified; nor are there any depictions of warriors in their artwork. Excavated caches of small obsidian spear points, darts, and clay pellets for blowguns are believed to have been used for hunting rather than battle.

Such evidence may explain why they were unable to prevent the violent and dramatic destruction of their city that occurred sometime in the mid-seventh century. Some historians suggest that unknown nomadic invaders attacked and burned the great gleaming city. Even though the remnants of its people built a new city nearby, the Teotihuacáno civilization never fully recovered and declined steadily over the following two centuries. The last of the surrounding Teotihuacáno communities had disappeared by the ninth century.

Although the costumes of the Teotihuacáno were principally based on traditional styles established earlier by the Olmec, new types of garments were also introduced. Costumes of the ruling class, particularly, entered an era of splendor and vitality. Almost all men still wore the maxtlatl and faja combination irrespective of status. However, priests and the socially elite began to wear constructed garments and clothing that required substantial pieces of fabric. A sleeveless tunic, called a **xicolli**, was made of two rectangular pieces of material stitched together at the sides and top except for arm and neck openings. Lengths of this tunic usually extended to the hips although for high-ranking priests the lengths reached to mid-calf or the ankles.

A second key addition to men's and women's costumes of the Teotihuacán period was the **quechquémitl**, a short, poncho-style cape variously cut as an oval, circle, or rectangle with an opening in the center for the head. Innumerable examples of clay figurines have been found featuring versions of the quechquémitl decorated with all sorts of geometric symbols and patterns. (Figure 13-8.)

Similarly, both men and women of official rank wore a new form of ceremonial headdress that was characteristic only of the Teotihuacáno. Clay figurines of the era often wear an open-crown ovoid shape about four times as wide as high with a flap extending over the center front. No extant examples have been found, so costume historians are not certain if the hats were made of woven straw and painted or perhaps constructed of patterned fabrics stretched over vine frames. Although the shape of the headdress is identical on the various sculptures, the decorative patterns painted on them vary widely in pattern and color. Motifs range from chevrons and serrated circles, perhaps symbolizing mountains and the sun, to more representational leaf and feather shapes.

The costumes of Teotihuacáno women also featured new additions. As mentioned above, women wore the same styles of the quechquémitl as the men. If there were gender differences in decorative motifs or colors, they have been lost to time.

The cueitl, or wrap skirt, that first appeared centuries earlier with the Olmec became a standard garment for Teotihuacáno women. (Figure 13-8.) Instead of a short fringed (or grass) skirt that fitted around the hips, though, the cueitl was a single, rectilinear piece of fabric that

Figure 13-8. For Teotihuacáno women, a short, poncho-style cape called a quechquémitl and a wrap skirt called a cueitl became standard components of the feminine costume. Painted clay figure of highborn Teotihuacáno woman, c. 350–650 CE.

Figure 13-9. A dramatic change in Teotihuacáno women's costume was the introduction of a tunic top called the huipilli. Most styles of this tunic were worn loose, although some sculptural representations show the huipilli girded with a decorative fabric belt. The huipilli has remained a basic feminine garment through Mesoamerica to this day. Painted clay figure of highborn woman, c. 800–1200 CE.

wrapped about the waist. As with the quechquémitl, the many representations of the cueitl on clay figurines show a delightful assortment of painted patterns, suggesting that, although the garment may have had a uniform silhouette in Teotihuacáno society, individuality possibly found an outlet with choices of color and textile patterns. Later, the Aztecs would strictly regulate even these costume elements.

The most dramatic and significant change in women's costume of this period was the addition of the **huipilli**, a sleeveless tunic blouse that extended in lengths from the hips to just above the knees. The huipilli was constructed similarly to the masculine xicolli—two rectangular pieces of fabric sewn together at the sides and shoulderline with openings for the neck and arms. Some versions may have been made from a single long piece of material folded at the shoulderline and stitched up the sides. These tunics usually were worn loose although some later sculptures show it girded with a decorative fabric belt. The example in Figure 13-9 depicts a belted, hip-length huipilli with elaborate crenelated hemline worn over a richly patterned wrap skirt. Types of the huipilli survive today in indigenous costumes throughout Mexico, especially vividly colored silk styles.

The accessories for both genders of the Teotihuacáno were similar and continued the traditions of their Olmec ancestors. Elaborate hair arrangements and headdresses, large

earspools, and an abundance of jewelry and ring ornaments are commonly featured on the sculptural representations of these people.

Besides new styles of costume, the Teotihuacáno developed a new ideal of beauty achieved by body modification. Many of their sculptures include head shapes that appear to represent an elongated skull. Some historians think that the Teotihuacáno were the first Mesoamerican people to artificially flatten the skulls of high-born infants into frontal occipital deformation although the custom is more often associated with the Maya. The process involved compressing the baby's head between two boards tied with cords. Not only was this head shape regarded as the epitome of beauty but its distinctive shape was a recognizable sign of high social status. Only the elite classes engaged in this practice.

THE MAYA

At about the same time that the Teotihuacáno were establishing themselves as heirs to the Olmec, to the south, in the area of the Yucatan Peninsula, the Mayan civilization emerged. Rather than a unified empire with a centralized imperial authority, the Mayan culture was a loose confederation of many independent city-states. Somewhat like the community

development in ancient Mesopotamia, these urban centers with their satellite support villages rivaled each other, and between about 300 and 900 CE, various city-states in turn rose to regional prominence.

As with the Olmec and Teotihuacáno cultures, Mayan society was rigidly hierarchal. Each city-state was ruled by an elite class of priests and royal families headed by a priest-king, who was also the military commander-in-chief. The Maya developed highly sophisticated forms of architecture, exquisite relief carvings and sculpture, vividly colored mural painting, and greatly varied pottery. They devised an accurate 365-day calendar more than 1,000 years before the Western Gregorian calendar. Their writings commemorated the historical events of their culture with precise dates tied to this calendrical system. True recorded history in Mesoamerica began with the Maya.

Although the Maya endure today as an ethnic group of the region, the civilization of their ancestors disintegrated during the first half of the tenth century. Later written Aztec tradition holds that the Mayan cities disappeared following an invasion of northern "barbarians" called the Chichimecs. More recent studies by meteorologists and geologists instead theorize that the Maya suffered an economic catastrophe brought on by a severe and prolonged drought tied to global conditions of around 940–950. Whatever the cause, the great Mayan cities were abandoned and the survivors scattered into small agricultural communities, which is how the conquistadores discovered them in the sixteenth century.

In addition to a wealth of images painted on ancient pottery and recorded in murals, wall carvings, sculptures, and codices, we have detailed written accounts of Mayan culture and costume from sixteenth-century chroniclers such as Bishop Diego de Landa and Fernández de Oviedo. Although the great Maya civilization had long since vanished, its traditions and legends survived in the oral histories of its people. Landa interviewed these descendants of the Stargazers and preserved the data he collected in his book, *Relación de las Cosas de Yucatán*, which includes many accounts of Maya costume and personal adornment.

The costumes of the Maya evolved from the Olmec tradition and were similar, but not identical, to those of the Teotihuacáno. Mayan men wore a loincloth, called an **ex**, that was arranged differently than that of the Teotihuacáno maxtlatl. Instead of two separate pieces as shown in Figure 13-6, the Maya fashioned the ex from one long piece of material. (Figure 13-10.) Oviedo described the ex as a long band of cotton fabric wrapped around the waist twenty or thirty times and passed through the legs back to front. The starting end of the ex hung in the back as a flap over the buttocks, and after twisting the length around the waist, the front end was pulled to the front between the legs to drape over the thighs.

Figure 13-10. Mayan men wore a loincloth, called an ex, that was made of one long piece of fabric wound around the waist and passed between the legs. The ends of the fabric hung as flaps in the front and back.

Over the loincloth, the upper classes of Mayan men sometimes wore a wrap skirt of various types, usually referred to as a **hip-cloth** although the ancient indigenous name is not known. Wall carvings, vase paintings, and depictions in codices mostly show lengths that extend only to the upper thighs. Images of high-ranking priests and dignitaries, though, often are shown in knee- or ankle-length wrap skirts, some of which are layered with short outer versions. (Figure 13-11.) The texture of the garments in some bas-reliefs indicate that the fabric was possibly quilted or even sumptuously adorned with beadwork or embroidery. Paintings reveal wrap skirt materials made of luxuriant, multicolored textile patterns of complex designs.

A new type of garment that was common to all Mayan men was the **tilmatli**, a large, rectangular piece of fabric worn as a cloak. Commoners tied their tilmatli asymmetrically at the right shoulder. Most lengths extended to the mid-calf. The magnificent ceremonial tilmatli of the nobility was made with brocaded materials that were splendidly embellished with fringe, embroidery, and appliques of feathers, beadwork, and gemstones. (Figure 13-12.)

The tunic-style xicolli of the Teotihuacáno became a front-closing sleeveless jacket for Maya nobility. (Figure 13-13.) Bishop Landa described the xicolli as made of "cotton and feathers woven into a kind of many-colored jacket with two flaps." Depictions of the xicolli mostly show hemlines cropped at the waist or hips although a few clay figurines and codex renderings show lengths to mid-calf.

The Mayan city states were constantly at war with each other, raiding for slaves and sacrificial victims or battling for farmlands and water resources. The warrior class was a significant segment of Mayan society. A commoner was restricted from wearing richly colored attire, furs, jewels, or plumage until he had proven himself in combat by killing an opposing warrior or bringing home a captive. Even men's hairstyles were regulated according to military achievement.

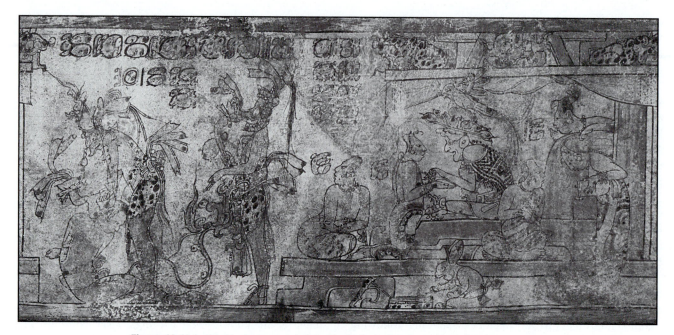

Figure 13-11. In this Mayan vase painting, dignitaries wear wrap skirts of various lengths, called hip-cloths, made of richly patterned fabrics and trimmings. The figure of the king seated on the upper dais is draped in a tilmatli lavishly decorated with feather appliques. The bound captive shown seated at the far left has been stripped to only an ex. Composite roll-out photograph of a vase painting, c. 600–900 CE.

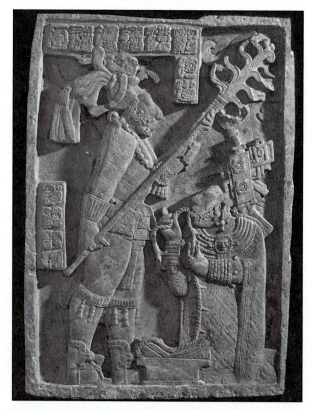

Figure 13-12. Mayan men adopted for their costume a simple, rectilinear cloak, called a tilmatli. Ceremonial styles worn by priests and the nobility were lavishly decorated with fringe, embroidery and feathers. Wall carving of sacrificial blood-letting, dedicated 709 CE.

Ranks were attained by the number of kills or prisoners. After twenty such deeds of glory, the warrior joined the most elite class of officers, known as the cuachic, who shaved their heads except for a single lock over the left ear. These men were permitted the privilege of wearing the befeathered xicolli and embroidered tilmatli.

In addition, the cuachic wore a type of cuirass, called an **ichcahuipilli**, into battle. It was constructed as a round-neck, sleeveless tunic that was padded, quilted, and adorned with feathers. Ordinary warriors dressed only in a simple maxtlatl and painted their bodies with combinations of vermillion, ochre, and black soot. Even without metal armaments, the Maya were skilled with a variety of weaponry including the bow and arrow, which was tipped with points made of flint, obsidian, or bone. Long spears were hurled by hand and shorter, lightweight lances were flung from a handled wooden device. Flat war clubs, referred to a "swords" by the Spaniards, were embedded along the edges with razor-sharp blades of obsidian. Blowgun darts and slings were equally effective.

Mayan men also wore specialized costumes for a ceremonial ball game translated from glyphs as "pitz." The rules of the game are not fully understood, and regional variations apparently existed. But in all cases the ball game seemed to have been more than a sporting event. The home team played against a group of captives who may have been weakened by

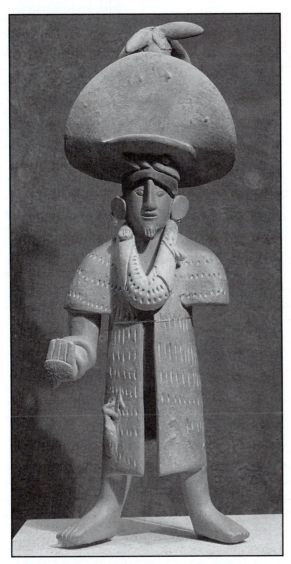

Figure 13-13. The xicolli was constructed as a sleeveless, open-front jacket for Mayan men of upper castes. As with the tilmatli, ceremonial styles of the xicolli were made of colorfully patterned textiles adorned with feathers or ornaments. Clay figure of Maya nobleman wearing a xicolli and broad-brimmed hat, c. 600–900 CE.

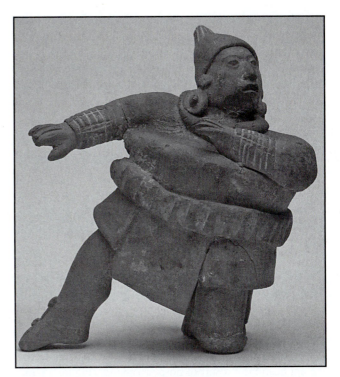

Figure 13-14. Mayan warriors donned a special protective costume to play a ceremonial ball game. Safety equipment included wrist guards, a knee pad, and a leather wrap skirt to prevent friction burns when skidding on the pavement. Clay figure of ball player, c. 600–900 CE.

starvation or injury to assure the outcome. The losers were decapitated in a blood sacrifice to the gods.

The costume of a Mayan ball player featured several pieces of safety equipment. The player shown in Figure 13-14 wears a leather skirt to protect the buttocks and thighs from skidding on stone or compacted dirt surfaces. A wooden yoke, called a **bate** in name-glyphs, is fitted around the waist although its function is unknown. A wrist guard at the right hand and a full arm guard on the left indicate that the rubber or leather ball was struck or blocked at these points rather than with the hands and feet. A single knee pad suggests a pattern of play in which the player could go down only on one knee.

The great variety of masculine images—and costumes— in Mayan art attests to the male-dominated social structure of their culture. As a result, images of women are comparatively rare in Mayan artwork. Of those depictions in sculpture and codices, most are representations of female deities or women of high social rank. These figures wear primarily a wrap skirt, known in Mayan glyphs as a **pyq** (also pic), and a tunic top, the huipilli, both made of colorfully patterned textiles. Later documentation of Mayan women's costumes record that skirts were stitched closed on one side forming a tubular skirt, a style still worn today by many Maya. At what point the transition from an open wrap garment to a closed sewn style is not clear.

The huipilli was cut with the same variety of necklines and lengths as those of the Teotihuacáno. A common design element for the huipilli was a crenelated hemline, which may have been a symbol of social status similar to the instita of the Roman matron.

Other representations of female Mayans in art are shown wearing the quechquémitl. Renderings of women in Mayan codices illustrate a new form of the quechquémitl. The rectangular style has been turned at a forty-five-degree angle so that the corners form points in the front, back, and over each arm. Gradually, the pointed quechquémitl replaced the traditional ovoid or squared version as the most prevalent style, which is still worn in this manner today.

Both male and female Maya practiced a variety of body modifications to achieve their ideal forms of beauty. The elongated skull with a flattened occipital bone was particularly prized by the Maya. As with the elite Teotihuacáno, Mayan infants of noble birth were strapped into a device made of two boards bound together to compress the child's skull before the segments of the occipital bone fused. All of the court figures painted on the vase in Figure 13-11 display this characteristic profile.

One other physical alteration that children of the nobility exhibited was called the "silver look," which was a sort of cross-eyed squint. A silver disk-shaped pendant was suspended from a lock of the child's hair to hang between the eyes gradually forcing the eyes to turn inward toward the nose.

Facial hair was not considered attractive in any form. One Spanish official wrote in the seventeenth century that Mayan men used tweezers to pluck out the follicles one by one. Bishop Landa was told that, in the past, Mayan mothers scalded the faces of their infant boys to prevent the growth of facial hair.

Another distinctive Mayan modification may have been the application of a sort of nose prosthesis. (Figure 13-15.) Ferdinand Anton submits that the Maya fashioned wedge shapes from latex to insert under the skin of the nosebridge and forehead. Statues and portrait busts show numerous variations of the nose enhancements. Some taper to a point on the forehead while others protrude from the forehead in a hatchet shape. Still other nose shapes begin as a series of beaded bumps upon the forehead. Not all experts on Mesoamerican culture agree with the idea of a prosthesis, suggesting instead that the naturally large proboscis of the Maya was simply exaggerated in paintings and sculptures by artists.

Scarification and tattooing were also practiced extensively by the Maya. Landa wrote that men tattooed large sections of their bodies, including their faces, because the more tattoos they displayed, "the more brave and valiant they are considered." There does not seem to have been a regimented pattern for these tattoos and scars. Although given the Mayan penchant for religious symbolism, the lines and shapes likely represented aspects of their beliefs. Women, too, were tattooed with more delicate designs on the upper torso except for the breasts. Their facial marks were much more subdued than men's, appearing in sculptures primarily as a thin, decorative line or two on each cheek extending from the sides of the mouth.

In excavating Mayan gravesites, a number of skulls have been found with altered teeth. Some upper class men and women had their front teeth drilled and inlaid with jade. Still others had all of their front teeth filed into pointed shapes, perhaps as a devotional tribute to the jaguar spirits they revered.

In addition to physical alterations, the Maya continued the Mesoamerican tradition of personal adornment with elaborate hair arrangements and an abundance of large, opulent jewelry and ornaments. Noseplugs, called **nariguera**, were inserted into the pierced septum. Commoners wore simple wooden or terracotta nariguera, while the designs for the nobility were made of jade, amber, mother-of-pearl, and precious metals. The elaborate orejeras, or earspools, previously mentioned, varied from sizeable round spools to long pendants made of feathers, gems, and beads. Both men and women adorned themselves with narigueras and orejeras.

For the first time in an ancient Mesoamerican culture, shoes are clearly depicted in artwork. The animal hide sandal style, called **cactli**, worn by the warrior-priest in Figure 13-12 features a high back with a ruffled edge encasing the heel. It is tied around the ankles with large knots in the front and over the toe thongs. (Figure 13-16.) Depictions of sandals with lower

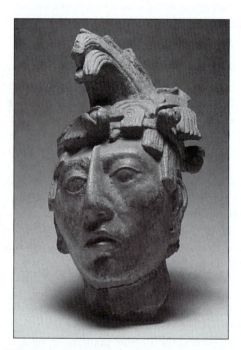

Figure 13-15. Some historians suggest that the Maya elite applied a latex attachment to the nosebridge to achieve the exaggerated profile depicted in their artwork. Clay portrait of Mayan lord, c. 350–650 CE.

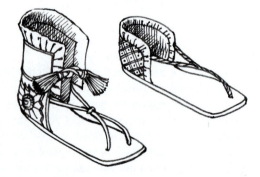

Figure 13-16. Mayan sandals, called cactli, were primarily worn by priests and the elite for ceremonial purposes. The designs featured a high, back heel casing decorated with fur, feathers, ornaments, and a ruffled edge.

heel casings also appear in wall carvings and murals. Most appear to be richly decorated with beadwork, fur, feathers, tassels, and embroidery. These types of ornate sandals were part of a ceremonial costume and were not worn every day. Later, a simple thong sandal made of untanned deer hide or plaited reeds became the standard form of footwear for the Maya.

THE AZTEC

As the great Mayan civilization disintegrated after about 950 CE, a number of nomadic peoples from the north invaded Mesoamerica and established regional dominance. Among these new arrivals were the Huaxtec, Mixtec, and Toltec groups. During the tenth and eleventh centuries, these diverse peoples provided some order and stability during which flowered a brief renaissance of exceptional art and architecture. The evidence they left behind in their artwork and cemeteries indicates that they adopted much of the Mayan and Teotihuacáno cultures. Their religion, social hierarchy, military tactics, agricultural techniques, architectural design, and applied arts mirrored those of their predecessors. Their costumes, too, followed the traditions of the Maya and Teotihuacáno, including the tunic, wrap skirt, and poncho-style cape for women and the loincloth and rectangular cloak for men. Even personal adornments such as noseplugs and earspools were adopted. What does not appear to have been retained from the earlier cultures were the more extreme forms of body modification: elongation of the skull, filed or inlaid teeth, and crossed eyes.

By the twelfth century, however, the region was once again in turmoil as individual city states rose in power and just as quickly collapsed. Those established cultures, such as the imperial Toltec, lost their centralized authority and were dispossessed of their cities and lands by migrating tribes. From this new wave of nomadic peoples emerged the last great Mesoamerican civilization, the Aztec.

The Aztec were so named during the colonial period because they had originated in an area of north central Mexico called Aztlán. In their indigenous language, they called themselves Mexica, the namesake of the modern nation. Legends from surviving codices tell of the wanderings of these people throughout the twelfth and thirteenth centuries until they arrived at an island in Lake Texcoco. There, they witnessed an eagle perched upon a cactus, which was a prophesied sign from their patron deity that they had arrived in their destined homeland. On this spot, they founded the city of Tenochtitlán around 1325. Over the next century, their community prospered. To sustain its growing population, the Aztecs waged wars of conquest, eventually establishing dominion over more than 350 communities across Mesoamerica. From these conquered lands they exacted tribute of food, raw materials, pottery, metals, textiles, and clothing.

The costume traditions of the Aztec continued in a straight line from the Olmec through the Teotihuacáno and Maya into the Toltec culture. In fact, besides adopting much of the culture of their predecessors, to further secure the right to claim a direct heritage from the Toltec, Aztec kings married into the remnants of that royal family.

The Aztec version of the men's maxtlatl, later known as a **taparrabo** during the Spanish colonial era, was wrapped about the waist and through the legs from the back like those of the Maya and Toltec. A distinctive difference, though, was the large, looped knot that was tied at the waist in the front. (Figure 13-17.) Another variant that appears frequently in codex illustrations does not include a back flap, meaning that the starting end of the long band of fabric was twisted into the sash instead of left hanging as in Figure 13-10. In either instance, the maxtlatl was made of plain white cotton edged only with a striped border. Only rarely are extravagantly decorated styles depicted as part of a priest's or nobleman's costume for high religious rites.

The hip-cloth that was occasionally worn by the elite classes of Mayan men became a more prevalent masculine

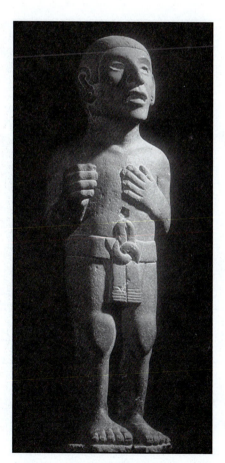

Figure 13-17. Aztec men continued the Mesoamerican tradition of wearing the maxtlatl. A new variation featured the addition of a large looped knot in the front. Sculpture of Aztec commoner, c. 1400–1500 CE.

garment for all classes of Aztec males. It was formed from a square piece of woven cotton or other fiber folded diagonally in half to shape a large triangle. The pointed ends then were tied into a looped knot, usually at the right hip. Most hip-cloths were made of white material, frequently with a simple, striped edge. The Tarahumara Indians of Sonora, Mexico, still wear this style of domestically made hip-cloth, although today with men's manufactured shirts and jackets.

After the maxtlatl, the most common masculine Aztec garment was the tilmatli, later called the **manta de hombres** during the colonial period. The tilmatli is an excellent example of how costumes were strictly regulated by social rank. The common man's cloak was usually woven of coarse fibers from the yucca or palm. Men of elite classes were permitted more finely woven cotton materials, including richly textured brocades for the lords of the realm. (Figure 13-18.) In one instance, the nobles of a city-state who failed to pay the prescribed annual tribute were forced to wear the rough-woven tilmatli of the lower classes as punishment. Lengths as well as materials were also

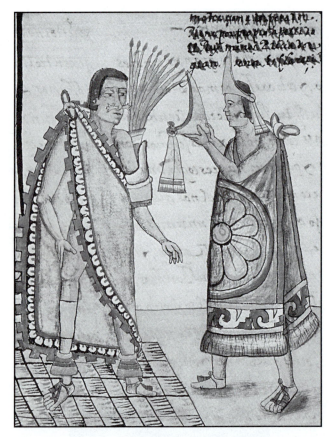

Figure 13-18. In addition to the looped maxtlatl, most Aztec men wore a cloak, called a tilmatli. As with all Aztec apparel, the tilmatli was strictly regulated by rank and social status, including fabric, length, ornamentation and even method of tying about the shoulders. Detail of vellum painting depicting the crowning of Montezuma II, sixteenth century.

restricted by status. Ordinary Aztec men were forbidden to wear lengths below the knees. The hemlines of the cloaks of the elite swept majestically about their ankles in a vision of vivid color and shimmering feathers. Even the manner in which the tilmatli could be tied denoted social standing. Only the highest ranking priests and noblemen could tie or pin their cloaks in the center front; all others had to tie theirs at the right side. However, as with the Maya, a valiant warrior could earn the privilege of wearing luxury apparel—an imperial reward system that encouraged young men to excel in battle.

Two similar Aztec men's garments paralleled the design and function of their Mayan counterparts. The xicolli and the ichcahuipilli were sleeveless jackets with cords or ribbons that tied in the front.

The xicolli fit loosely and was not girded. Lengths varied from the hipline to the knees. In the codices, the garment is most often associated with deities and priests during special rites. However, a number of drawings also feature the xicolli worn by civic leaders, suggesting that the jacket may have been a form of badge of office. In the *Codex Mendoza*, ambassadors pursuing their mission wear the fringed xicolli and carry feather or reed fans representing their official status.

The ichcahuipilli was the same form of warrior's padded cuirass as that worn earlier by the Maya. It was more of a snug-fitting, sleeveless vest than a jacket. Styles were usually cropped at the waist, and many included a peplum made of feathers. Two versions of the ichcahuipilli are illustrated in the codices: a front-closure jacket style and a pullover tunic. Except for the length, the jacket variety appears to be identical to the xicolli in many renderings. Most are shown with tie-fronts, some knotted with the distinctive loops.

The most spectacular Aztec costume was the warrior's **tlahuiztli**, a bodysuit that included long sleeves and trouser legs. (Figure 13-19.) What makes the tlahuiztli particularly amazing is that, despite the Aztec wholesale adoption of traditional Maya and Toltec costumes, this was unique in ancient Mesoamerica. It was constructed of feather-covered cotton with tie cords to secure the opening in the back. Rank and status were designated by the color and pattern of the feathers, insignia, ornaments, and extraordinary headdresses. The costumes represented various nahual spirits, such as the jaguar, eagle, and coyote, or death demons.

Many of the tlahuiztli featured mask-like headdresses that completely covered the head except for the face, which was exposed through the gaping, fanged jaws of a fierce beast or demon. Historians have offered various ideas of how these headdress masks were constructed. Fray Diego Durán's interpretation of the *Codex Mendoza* suggests that quilted cotton was used to form the animal head. Another possibility is a lightweight frame, perhaps built of pliable green vines,

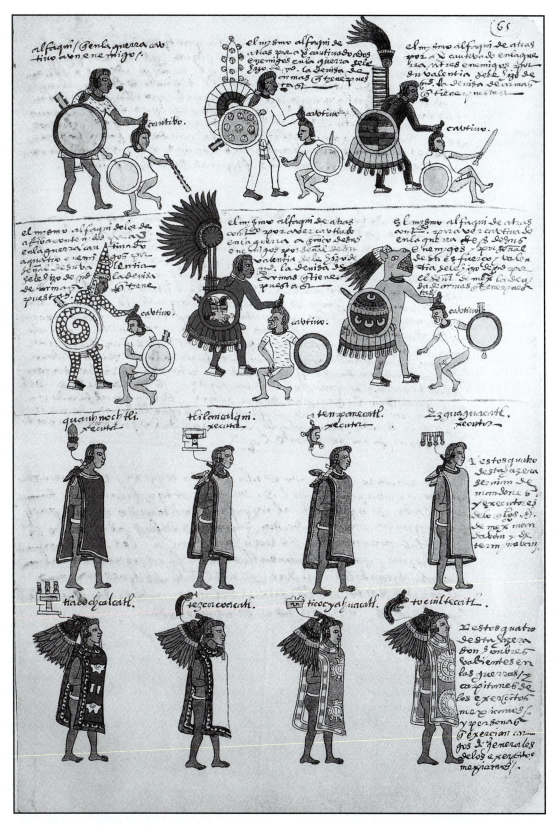

Figure 13-19. A page from the sixteenth-century *Codex Mendoza* records the ranks and dress of Aztec warriors. Costumes include the tlahuiztli body suit on the second row representing a pointed head demon and a jaguar spirit.

Figure 13-20. The costume of Aztec women always included a top of some kind. The huipilli was worn by all classes although the quality of materials and decoration varied by caste. Unmarried girls dressed in unadorned huipillis and cueitls, and married women wore versions with striped edges. Drawing of a mother training her daughter to spin thread from the *Codex Mendoza*, sixteenth century.

over which was applied the feather-covered fabric that matched the bodysuit.

Two other forms of displaying military rank were crests and shields. Warriors who had demonstrated exceptional valor were awarded an arrangement of plumes that was worn either as a bonnet headdress, an attachment to the tlahuiztli mask, or an adornment affixed to a frame tied onto the back and rising up behind the head. The most prized plumage was the long, iridescent green or red tailfeathers of the quetzal bird. Feather embellishments on shields also proclaimed the rank and achievements of a warrior. Aztec defensive shields, called **otalli**, were crafted of reeds and reinforced with hides or thin panels of hammered copper. Feathers were attached in designs representing tribal insignia, religious motifs, or emblems of civil office. A tier of longer feathers was tied along the bottom of the shield. The psychological factor of these feathered costumes and crests in battle must have been significant, instantly signaling to any opposing warrior that he faced a seasoned, skilled combatant.

The costumes of Aztec women continued the traditional feminine styles of the Maya and Toltec. The cueitl, which became the **enredo** of the colonial period, was the most common basic garment worn by all Aztec women. Some codex drawings seem to depict a side-stitched tubular version of the cueitl. Both types of the skirt were secured about the waist with a belt or sash. As with the men's tilmatli, class and ceremonial context determined the quality of fabric, patterns, and colors of the garment. The most costly styles were trimmed with striped borders woven of velvety soft yarns made by blending the downy underbelly fur of rabbits with the finest grades of cotton. When worn for ritual dances, the cueitl was additionally decorated with symbolic appliques such as skins of the snake, ocelot, or coyote and painted motifs representing hearts, bird gizzards, leaves, and other natural imagery.

All classes of Aztec women wore a huipilli with the cueitl. (Figure 13-20.) It was constructed identically to the earlier style of the Maya—two pieces of fabric sewn at the sides and top except for neck and arm holes. V-necklines were stitched with a patch of material at the depth of the point to prevent tearing. Unmarried girls usually wore an undecorated huipilli and cueitl while married women wore the two garments trimmed with colorfully striped borders. Highborn women were permitted to wear huipilli embellished with embroidery at the sides and back, and even some featherwork on the front. Today, the tunic top of ancient Mesoamerican women still survives as the native **huipil**, a sleeveless blouse of varying widths, lengths, and fabrics.

The other principal garment adopted from the Maya and Toltec by Aztec women was the quechquémitl. It was usually layered as a sort of closed cape over the huipilli although some representations in Aztec art indicate it was acceptable as the sole top garment in place of a huipilli. Like the huipilli, the V-neck of the quechquémitl was stitched with an applique to prevent tearing. Ceremonial styles for upper classes were fringed, trimmed with tassels or feather borders, and embellished with other featherwork, ornaments, and needlework. In modern Mexico, the Mixtec descendants of the Aztecs have abandoned the quechquémitl although indigenous peoples of some northern groups still include it as a component of their costume.

Among the changes from earlier Mesoamerican cultures that occurred with Aztec accessories and personal adornment was an overall simplification. Except for high religious, military, or state occasions, even the nobility opted for less ostentatious jewelry, accessories, and hair arrangements. Sandals became ubiquitous for all classes. Gone were the Mayan elite standards of beauty, such as the elongated heads, crossed eyes, pierced noses, filed teeth,

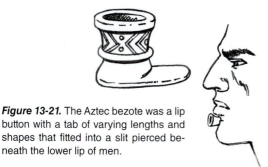

Figure 13-21. The Aztec bezote was a lip button with a tab of varying lengths and shapes that fitted into a slit pierced beneath the lower lip of men.

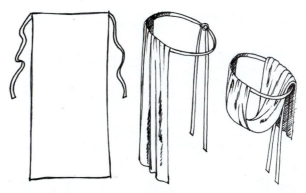

Figure 13-22. The loincloth of the Andean peoples, called a wara, featured ties sewn to one end that wrapped around the waist and were knotted in the back. The panel of fabric fit between the legs from the front and formed a flap in the back.

and tattoos. Body modifications were primarily limited to earspools for both men and women. However, the lip button, known as a **bezote**, was applied only by men. The bezote resembled a miniature tobacco pipe and was inserted into a slit below the lower lip with the tiny bowl resting outward on the chin. (Figure 13-21.) Lower classes seem not to have bothered with these ornaments (or were denied the privilege of wearing them). Most men of all classes cut their hair short at the jawline without embellishment. Ranking warriors, though, wore the **temillotl**, meaning "column of stone," which featured a tuft of hair gathered at the top of the crown. Married women usually arranged their hair in a bun at the nape of the neck or in braids. Young girls left their hair long and free.

THE ANCIENT ANDEANS

About 10,000 years ago, the earliest indigenous peoples of South America began to develop Neolithic settlements along the Pacific coast in the area of modern Ecuador, Peru, and Chile. From these prehistoric communities emerged a series of independent cultures, which even today are shrouded in mysterious anonymity. The peoples of these societies left no writing, no documentation of their origins, or hints of the extinction of their culture. Even the last great civilization of the region, the Inca, might have vanished into obscurity were it not for the eyewitness accounts of the conquistadors and Spanish colonial chroniclers.

Likewise, textile production and costume traditions of the ancient Andean peoples are veiled in the mists of time. Extant fragments of woven cotton fabrics have been dated to as early as 8600 BCE, the oldest known examples of weaving in the world (and predating pottery in the region by more than 6,000 years). From this evidence, it appears that weaving represented a significant investment of the labor energies of Andean cultures.

The evolution of the textile traditions of the ancient Andeans cannot be mapped with the limited amount of material thus far discovered. Yet a few tantalizing glimpses of the full maturity of Andean textile production have surfaced. In particular, from the necropolis of the Paracas Peninsula of Peru has come an astounding cache of Andean

textiles dating between 450–175 BCE. From more than 400 burial bundles, which enwrapped the desiccated mummies of the Paracas elite, dozens of examples of sophisticated fabric structures have been found, from plain weaves to complex tapestry weaves. Nonwoven structures such as embroidery, knit looping, and braiding are also common. All of this proves that centuries before these techniques were developed in Mesoamerica, the Andean cultures had mastered weaving techniques that produced exquisite and imaginative textiles.

It is possible, too, that the backstrap loom originated with the Andean peoples and was imported into Mesoamerica. A bowl in the British Museum from the Moche era (c. 100 BCE–700 CE) is painted with the images of two weavers with a backstrap loom tied to a tree.

So far, the bodies from the Paracas funerary bundles that have been opened were those of men of advanced years. The deceased had been seated naked in a flexed position and wrapped with layers of clothing and cloths. Seven distinctive garments were worn by Paracas men although in what combination is not clear. The sheer bulk of the layers is thought to have represented the status of the man in life. The largest bundle contained forty-four pieces of apparel.

Because the ancient Andean cultures had not developed writing, we do not know the names of their apparel. Instead, modern researchers have opted to give these garments Incan names. The loincloth, called a **wara**, was uniquely constructed by the Paracas. It was made from a rectangular piece of cotton fabric with two ties sewn at opposite sides of one short end. (Figure 13-22.) The ties were wrapped around the waist from the front and knotted in the back with the long ends hanging free. The fabric was then pulled between the legs covering the genitals and over the ties in the back to form a short flap.

Less common among the garments found is a short skirt that wrapped about the waist three or four times. Like the

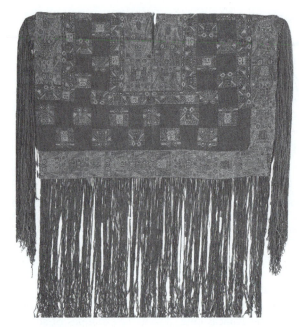

Figure 13-23. The unku was a tunic worn mostly by high-born men of Andean cultures. A rectangular piece of fabric was folded in half at the shoulderline and sewn up the sides except for armholes. A vertical slit for the neck was typical of Andean garments. Fringed ceremonial unku, c. 200–700 CE.

loincloth, the wrap skirt was a rectangular piece of fabric with ties sewn at opposite sides of one end. The ties then encircled the skirt and was secured in a knot. Some were trimmed along the bottom edge with fringe, but most seem to have been decorated with a row of woven fabric tabs.

The greatest variety of Andean men's garments that has been found are tops. An extraordinary assortment of tunics, poncho-like capes, and cloaks were arranged in the Paracas burial bundles. A consistent pattern of layering these garments around the deceased has been documented, but archaeologists have not been able to determine why the number of the garments vary so dramatically. Some bundles yielded a large number of one garment—up to thirty tunics, or thirty-six poncho-type capes, or twenty cloaks in each—and few or none of another.

The Andean tunic, called an **unku**, was made much like its counterpart throughout the ancient world. A length of material was folded in half at the shoulderline and sewn up the sides except for armholes and a vertical slit for the head. (Figure 13-23.) Unlike the tunics of many other ancient cultures, the Andean unkus were not cut to size and tailored. Rather, they were woven specifically to size and shape with finished edges done on the loom. In addition, instead of a round or horizontal opening for the head, the Andeans wove in a vertical slit that created a V-neckline in the front and back. Some unku were cropped at midriff, others at the waist,

and still others below the hips. Widths sometimes extended so wide that they appeared to have sleeves from the excess material hanging off the shoulders.

The **manta** (also **yacolla**) was the masculine cloak. It was woven as a rectangle with wide borders of contrasting colors and decorative motifs. Fringe or tabs trimmed one or both of the long edges. The manta was draped lengthwise over the shoulders and pinned at the front. Ceremonial cloaks worn by priests and the elite were lavishly embroidered or spectacularly decorated all over with featherwork. (Color Plate 5.)

The **esclavina** (Spanish for a rectangular poncho-like cloak) was likewise loom-woven to size and shape. Like the unku, it, too, varied in width and featured a vertical slit for the neck. (Figure 13-24.) This was much more of an everyday garment than the manta. Most were woven with simple open fields, although borders and necklines were commonly embroidered.

Men's headdresses were composed of two elements. First was a long, rectangular headcloth that was usually woven as a lightweight fabric with the texture of crepe. The long sides of the headcloth were edged with two C-shapes, one reversed so that a gap in the border was formed at the center of each short end. The headcloth was wrapped about the crown to form a turban-like covering. Over the headcloth was tied one or more **llautu**—long, narrow fabric bands used to secure the arranged headcloth in place. (Figure 13-25.) Each end of the lluato was embellished with fringe or "fingers"—four or five tubular fabric attachments, usually made of the same material as the band.

THE INCA

What happened to the Paracas people remains a mystery. A number of subsequent cultures rose to prominence in the region and similarly vanished, leaving overlapping evidence of their highly developed cultures for archaeologists to puzzle over. In the late twelfth century, a warring group from the east invaded the region and began a systematic conquest of the many diverse Andean communities. These were the Inca who became the inheritors of centuries of developments in architectural design, civic planning, agriculture, religion, social order, and the applied arts. They excelled as organizers and builders. Around 1200, they founded a new capital, Cuzco, which became a glorious urban center filled with architectural and engineering wonders. They extended road systems throughout the empire, over which they could quickly mobilize an army. At the height of their dominion, the Inca governed a population of 10 million across areas of modern Ecuador, Peru, Chile, and Bolivia.

At the beginning of the sixteenth century, the Inca ruled the largest empire ever in the Americas. Then, in 1532,

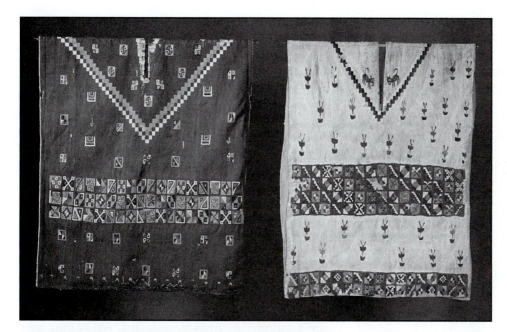

Figure 13-24. The esclavina was a poncho-style outer garment commonly worn by men of all castes in Andean cultures. It was loom woven to size and shape and featured the traditional vertical slit neckline. Inca esclavinas from the south coast of Peru, c. 1380–1520.

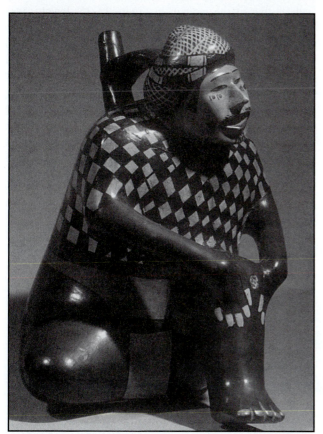

Figure 13-25. The headdress of the Paracas and Inca men was arranged with two pieces of material. The headcloth, was wrapped about the head like a turban. The llautu was a narrow band of fabric that secured the headcloth in place and added a decorative element. This ceramic jug represents a man wearing the headcloth, llautu, a checked poncho-like cape, and white loincloth. c. 600–800 CE.

Francisco Pizarro and a troupe of conquistadors arrived at the first Inca town in their quest for gold and riches, spelling the beginning of the end of the last great indigenous civilization of the New World.

In addition to ships filled with treasure from the conquered Inca, colonial officials sent home to Madrid written accounts of the new subjects of the king of Spain. Among the topics detailed in their reports were descriptions of Inca clothing, which they observed first hand. Felipe Guaman Poma de Ayala even illustrated his records with hundreds of meticulously rendered sketches.

From de Ayala's drawings and the descriptions of other chroniclers, it is clear that the costumes of Inca men were basically the same as those worn by the Paracas over 1,000 years earlier. Principally, most ordinary Inca men wore the loincloth and a tunic top of varying lengths. Noblemen dressed in the splendor of wrap skirts, feathered cloaks, and headdresses with dazzling gold ornaments and jewels.

An important accessory for Inca men was the **ch'uspa**. These were small fabric bags used to carry coca leaves, which men (and women) chewed for the stimulating effect. The straps of the bags were tied around the waist or the torso with the bag over the chest. Some varieties with short straps were worn tied to the wrists. The textile colors and decorations of the bags also communicated the social and marital status of the man. Ch'uspa are still used today by the Andean people but less often for coca leaves than coins.

The feminine costume of early Andean peoples was simpler with far fewer components than that of their Mesoamerican neighbors. All classes of Andean women wore a T-cut tunic called an **anuca**. (Figure 13-26.) Versions that extended

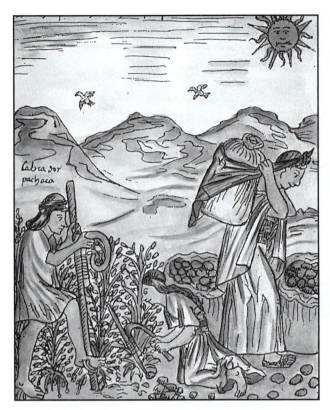

Figure 13-26. The basic costume of early Andean women included a long, T-cut tunic, the anuca, and the lliclla, or shawl. Class distinction was maintained by the quality of the materials and the decoration, which for upper class women included appliques of feathers. Detail of codex painting from the sixteenth century depicting a woman wearing the anuca and the lliclla; her daughter (center) wears only the anuca and her son (left) the short unku.

women and the nobility was the quality of materials. The tunics of highborn women were made of finer grades of cotton and even vicuña.

Another form of everyday attire for Inca women was a basic wrap dress called an **anaku**. These were fashioned from a large rectangle of cloth that was pinned at the shoulders and belted at the waist.

Around the shoulders women tied the **lliclla**, a basic square or rectangular shawl. For peasant classes, the lliclla was made of coarsely woven cotton or plant fibers such as the yucca. But the upper classes wore vicuña, sometimes adorned with exotic, tropical plumage and affixed at the neck with a large gold or silver straight pin called a **tupu**.

Accessories included simple thong sandals, called **usuta**, made of woven reeds and cords for ordinary women or deerskin and vicuña wool for the elite. The **nañaka** was a woman's headcloth that fitted close to the head and hung down the sides and back. Sometimes the headcloth was tied into a sort of flat turban to cushion a load-bearing strap such as that of the woman in Figure 13-26. Jewelry was less conspicuously worn than in Maya or Teotihuacáno societies. Pendant earrings and earspools are shown on numerous representations of elite women although all women most likely applied some ornament to the ears for special occasions.

Andean women did not indulge in body modification to the extent of the Maya or Aztec. One form of painful alteration practiced by high-born Inca women involved scalding their gums with boiling hot herbs for several days. When the outer layer of the skin became detached, the gums were scarlet red, against which their teeth shone brilliantly white. Instead of tattoos, Inca women preferred staining their skin with dye made from the crushed red berries of the achiote shrub. This luminous red was accented with black oil-based body paint to create bands around the limbs and other decorative patterns.

below the knees were made with a side slit for ease of movement. The anuca could be worn loose or girded with a wide sash that wrapped about the waist several times with the ends tucked under. Later accounts recorded by the Spanish note that the only difference in costume styles between ordinary

Inca Quipu

As with all Andean civilizations, the Inca had not developed writing. The imperial administrative clerks, however, had a form of record-keeping and communication by a textile device called a quipu (also khipu) or "talking strings." Llama wool strings attached to a cord were variously knotted as a method of accounting for administrative purposes such as reporting the census or the amount of wool and grain in storage houses. The colors of the strings represented the nature of the object being counted: yellow for gold, white for silver, red for the warriors headcount, green for the number of the enemy killed in battle. Since the variety of standardized colors was limited, most colors had multiple meanings. The number and placement of the knots on each string were additional pieces of information. The Inca used a decimal system of counting in units of ten and multiples of ten centuries before the Europeans devised their metric system. Inventories of items followed a prescribed placement of knots. For example, the knots used for counting weaponry corresponded to the order of importance of the weapons to the Inca military with lances first, then arrows, bows, and axes.

The quipo was also a critical form of communication that could easily be transported by runners to any part of the empire. A quipucamayu, or keeper of the quipus, would translate the colors and knots to the rulers for quick decisions on warfare, natural disaster relief, or other events of vital importance.

During the 400-year colonial period, the descendants of the Inca gradually adapted many styles of Western apparel. They fused their favorite traditions of textile weaving, colorations, and design with these new types of garments. Today, the rich decorative patterns and motifs of 500 years ago are still found in the ponchos, shawls, hats, scarves, tote bags, and a dozen other forms of textiles.

ANCIENT NORTH AMERICA

As discussed earlier in this chapter, about 40,000 years ago, the Americas were first inhabited by humans who migrated across the Bering land bridge from Asia. Despite the temperate climate and plentiful food supply, the populations of North America remained sparse compared to the more densely occupied Mesoamerica. It is perhaps for this reason that the Paleo-Indians, as forensic anthropologists categorize these early peoples, remained nomadic hunters-gatherers far longer than those in the south. The earliest evidence of Neolithic farming communities in North America has been dated to about 2800 BCE in the southern region of the Mississippi River. Beginning around 1700 BCE, these early aboriginal groups began building monumental earthworks to bury their chiefs and to provide elevated platforms for sacred buildings. During the following two millennia, the various cultures of North America developed copper metalwork, pottery, basketry, and textile weaving.

By the time of the first Europeans, more than 200 distinct groups had emerged, each with its own language, religious traditions, and social structures. In many cases, though, these divergent peoples shared a common regional culture, including crafts, tool-making, hunting and agriculture methods, and clothing and accessory styles. Since North American peoples did not have writing and no extant costumes have survived from the precontact period (before European colonization), a study of Native American costume is based on descriptions chronicled by early explorers and settlers, and extrapolation from the surviving artifacts of dress that were impervious to decay.

Following contact with colonists in the sixteenth and seventeenth centuries, Native American dress changed dramatically. Loom-woven textiles such as wool and manufactured clothing were introduced. Glass beads imported from China, Germany, and France replaced shell, bone, and quills for making appliques and jewelry. Processed leather, smelted metals, and knitted accessories also contributed to the alteration of millennia-old costume traditions. As colonial influences increased, these and other indigenous customs and lifeways vanished quickly. Much of the imagery we have of early Native Americans—paintings, photos, engravings—reveals this mix of European attire with tribal garments and accessories.

For the purposes of this general costume survey, the many distinctive cultures of North American aborigines are examined collectively by the four geographic areas they inhabited: the arctic tiers, eastern woodlands, central plains, and western regions.

THE ARCTIC AND SUBARCTIC

The lands that are today Alaska, Canada, and Greenland have been inhabited by the Inuit peoples, better known as the Eskimos, for millennia. Much of this region is a vast wilderness, locked in snow and ice most of the year. Yet through extraordinary hunting skills, adaptability, and ingenuity, generations of the indigenous peoples who lived there not only have survived, but have flourished.

A component to their success in such a harsh environment has been the remarkably sophisticated types of clothing they developed. Their source of materials for clothing included tanned animal skins and fur from bears, caribou, foxes, wolves, wolverines, and seal. In the subarctic inland region, beaver, squirrel, and muskrat fur substituted for seal. Sinew from whales and deer served as thread; needles and awls were made from animal bone, especially that of polar bears because of its particular hardness.

Of necessity, clothing had to be carefully fitted to protect against the extreme climate. The Eskimo tailor was highly skilled at cutting skins and furs into garments with gussets and darts for a somewhat custom fit.

Both men and women basically wore the same costume. (Figure 13-27.) A T-cut tunic was constructed with long sleeves stitched to the armhole (not set-in) and many times a hood. Lengths varied from the hips to the knees. Women's tunics were cut fuller to fit over a baby sling. Layered under the tunics were knee-length sealskin trousers fitted at the waist and knees with drawstrings. The legs were tucked into the tops of high boots. Eastern Eskimos wore ankle-length trousers, including a footed version for women.

The major outerwear garment was a hooded coat, or **parka**, called an **anorak**, that layered over the tunic. The hood was edged with a long-haired fur, such as that of a wolverine, so ice crystals that formed from breathing could be brushed off easily. Decorative motifs included a pair of triangular appliques of contrasting white fur at the neckline of men's anoraks to represent walrus tusks. For women an oval inset of white fur on the abdomen symbolized the womb. Some Eskimo hunters wore a parka made with two caribou ears on the hood and a mock tail in the back as a disguise for hunting in the open tundra. For hunting in a kayak, a waterproof parka that could fit over the opening of the canoe was made of tanned walrus, whale, or seal intestines sewn together in horizontal bands.

Besides boots, the most common accessories for both men and women were gloves and mittens. To prevent losing a glove, each was loop stitched or tacked to the cuff of the tunic or parka by a cord. Women with infants usually wore

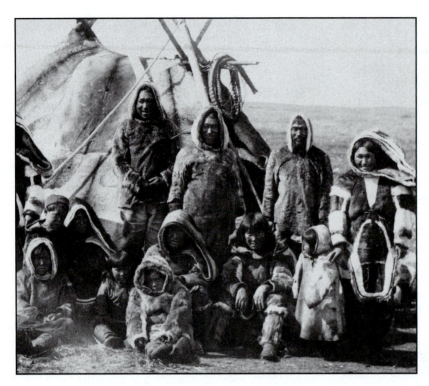

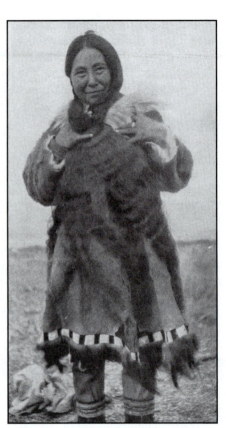

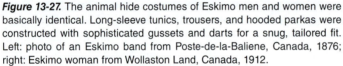

Figure 13-27. The animal hide costumes of Eskimo men and women were basically identical. Long-sleeve tunics, trousers, and hooded parkas were constructed with sophisticated gussets and darts for a snug, tailored fit. Left: photo of an Eskimo band from Poste-de-la-Baliene, Canada, 1876; right: Eskimo woman from Wollaston Land, Canada, 1912.

only one mitten, keeping the other arm withdrawn from the sleeve inside the jacket to position the baby more easily for nursing.

Snow goggles were developed by the early Eskimos to prevent snow blindness or glare from the sea ice. Ivory, bone, and, for those inhabitants near the subarctic tree line, wood were carved to cover the eyes except for deep, narrow slits that provided shade. A leather cord was knotted through a hole at the outer edge of each side of the goggles and tied around the head to hold them on the nosebridge.

The Eskimos practiced several types of body modification. Body piercing for both genders included the earlobes, nasal septum, and the space under the lower lip. (Figure 13-28.) The **labret** was a lip plug similar to the Aztec bezote. Men inserted a pair of labrets to symbolize walrus tusks while women usually preferred a single, wide piece of ivory with strands of beads attached. Labrets were originally ornamented with shell, bone, ivory, and stone beads, but after contact with European traders, vividly colored glass beads became highly prized and even served as currency for pelts. Both sexes wore earrings of varying

Figure 13-28. Body piercing for the Eskimo included the earlobes, nasal septum, and the space below the lower lip. Men wore earrings with strings of beads attached that draped under the chin. Men's labrets, or lip plugs, were usually worn in pairs to symbolize the tusks of the sacred walrus. The feminine labret was often an oval piece of ivory ornamented with strings of beads.

designs ranging from button styles to long pendants. Men preferred a single earring or a matched pair with strings of beads attached to each that draped under the chin.

Tattoos also were applied to both men and women although the more complex designs adorned women, covering large portions of their thighs, breasts, arms, hands and abdomen. Men's tattoos were most often limited to the face and hands. The predominant motif among the Arctic peoples was the circle that represented safety and protection. Missionaries discouraged tattooing so women began to transfer the complex designs from their skins to their garments with lavishly detailed beadwork.

THE EASTERN WOODLANDS

The descendants of the Paleo-Indians who inhabited the lush, temperate woodlands between the Mississippi River basin and the Atlantic coast evolved into divergent groups such as the Cherokee, Chickasaw, Creek, Natchez, Delaware, Huron, Iroquois, and Mohawk, to name but a few of the dozens. Despite the uniqueness of their languages, the eastern Native Americans shared a considerable similarity in culture, especially costume.

The basic garment worn by men of the Eastern Woodlands peoples was a soft, animal hide loincloth that fitted between the legs with flaps in the front and back that draped over a leather cord or belt. (Figure 13-29.) Older men of higher social rank in some northern groups also wore a fringed apron or a wrap skirt layered over their loincloth. When traveling or on a hunt, leggings were worn for additional warmth and protection. Instead of a tubular construction, the leggings were made of flat pieces of buckskin with cords that tied in the back. As a decorative element, these garments were often fringed at the edges. For men of the northern groups, a loose, front-closure jacket made of various pelts and patchwork combinations was worn over the torso. A cape or poncho-like covering made of bearskin, raccoon, and other thick furs served as outerwear.

The most common garment for women was a wrap skirt of buckskin cut in lengths extending from mid-thigh to mid-calf. (Figure 13-30.) Leather cords secured the

Figure 13-29. Most men of the pre-colonial North American groups wore some variation of an animal skin loincloth. Painting of Carolina Indian shaman by explorer John White, 1585.

Figure 13-30. The principal garment worn by pre-colonial women of the Eastern Woodlands was a wrap skirt usually made of buckskin. Painting of Secotan woman by John White, 1585.

waist. For some groups wrap skirts were worn open to the hip at one side while other styles were wide enough to overlap ends. Versions of the skirt included long fringed edges that hung to mid-calf or even the ankles. Some tribes of the mid-Atlantic region such as the Delaware had developed rudimentary twining and finger-weaving of hemp or other plant fibers, which they used for skirts and men's tobacco bags. Women's upper torsos were left bare. In cooler weather, outerwear included fur cloaks. Short leggings made of deerskin covered the legs below the knees.

Both men and women wore soft-soled buckskin footwear called **moccasins**. Among the variants of the moccasin was the "**hock boot**," which was cut from the bent section of an animal's hind leg, or hock, to form a natural curve for the heel. Thongs of assorted lengths secured the loose-fitting moccasins. For additional warmth, moccasins were lined with cattail fluff, grass, or deer hair.

Other accessories included a wide assortment of personal ornaments. Examples of river pearl jewelry, tortoiseshell rattles, and bone pins found at the Indian Knoll site in Kentucky date to around 3000 BCE. Copper beads, earrings, pendants, and bracelets were made as early as the mid-second millennium BCE. Nuggets of ore were beaten into thin, flat sheets and rolled to shape. Exquisitely carved bone and antler combs featured sacred imagery and were worn by women during special tribal rites. (Figure 13-31.)

Among the most important possessions of Eastern Woodlands peoples was **wampum**, the tiny, tubular beads made from the purple-and-white core whorl of a whelk shell. These drilled cylindrical bits of shell were strung together on sinew or thin leather cords to create belts, bracelets, headbands, and appliques for apparel. Since Native Americans recorded important information with pictographs rather than writing, the patterns fashioned in wampum beads served as tribal documents and communications across nations. Certain stylized images were universal among the groups such as a hatchet shape to signify war or figures holding hands to mean peace.

THE GREAT CENTRAL PLAINS

The Great Plains of North America extend from the Mississippi River basin westward to the Rocky Mountains. It is a vast, monotonous landscape subject to hot, arid summers and frozen, snowy winters. The early inhabitants of the region were successful nomadic hunters who followed the migrations of the massive herds of buffalo and elk. They were inventive with methods of ambush and traps to capture their quarry. In the seventeenth century, herds of wild horses—the descendants of escaped animals introduced to the New World from Spain—were domesticated by these groups, thus dramatically altering their lifeways. The horse made hunting more efficient. It served as a beast of burden and a tangible form of wealth. In less than a century, millennia of cultural and economic tradition underwent an abrupt transition into something utterly new. Yet even this significant shift only lasted a few generations before the western expansion of the white man in the nineteenth century forever changed how the peoples of the Great Plains lived and dressed.

These Native Americans comprised the groups whose names are most familiar to us today through Hollywood movies and television westerns: Cheyenne, Blackfoot, Apache, and Comanche among others. By the nineteenth century, the later transitional phases of Western indigenous cultures were empirically documented by explorers such as Lewis and Clark, artists like George Catlin, and an endless succession of government bureaucrats and military officials. From the artists' depictions and the written descriptions by early chroniclers, the costume historian can reconstruct much of what the diverse peoples of the North American West wore. Many elements of their aboriginal dress survived even then despite the introduction of influences such as European styles of clothing and alien materials like manufactured textiles, processed metals, and glass beads.

An examination of the costumes of the Plains peoples shows that certain factors are common to all these groups.

Figure 13-31. Among the types of personal ornaments favored by the peoples of the North American Eastern Woodlands were bone and antler combs. Many were exquisitely carved with stylized animals and other sacred imagery. Antler combs from the Seneca Tribe, c. 1640–1680.

Garments had to be easily packed and transported for their nomadic way of life. The seasonal extremes in weather required clothing that was adaptable either by addition or subtraction in layering, or addition or subtraction in the construction of garments—long sleeves or sleeveless, for example. Ceremonial costumes were made for movement and sound with feathers, fringes, and horsehair tassels that fluttered in the wind and beads, bells, or shells, that clattered and jangled with each step. Finally, distinct tribal differences in clothing and accessories are often blurred because of the continual trading and gift exchanges between the groups that led to similarities in costume.

The basic masculine loincloth of the Plains groups was cut and worn identically to that of the tribes in the Eastern Woodlands. A long piece of buckskin fitted between the legs and draped over a belt forming fringed flaps in the front and back. Leggings were likewise similar to Eastern versions except the Plains Indians preferred thigh-high lengths with cords at the top that tied to the belt of the loincloth.

Men's tunics differed from Eastern styles in that they were constructed more like pullover shirts, complete with sleeves of sorts. (Figure 13-32.) Two full-size skins of deer, antelope, bighorn sheep, or small buffalo were matched for size and shape. The hides were cut just at the forelegs and the two lower pieces sewn at the shoulderline with an opening for the neck. The upper torsos of the two hides were bisected along the spine to make four pieces for the sleeves, sometimes leaving the forelegs as decorative dangles. Ceremonial tunics were lavishly ornamented with finely crafted quillwork, feathers, horsehair tassels, and fringe.

Buffalo hides with the fur left on them were used to make capes and ponchos for cold-weather outerwear. Sometimes

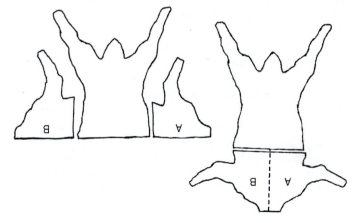

Figure 13-32. The masculine tunics of the Plains Indians were constructed of two full-size deer skins matched for size and shape. The shoulder section of the each hide was bisected and used for the sleeves with the forelegs left as decorative dangles. Plains Indian tunic of fringed antelope hide, c. 1900.

the tanned skin was decorated with drawings or paintings of imagery representing the wearer's dreams.

The most distinctive masculine accessory of the Plains Indians was an elaborate feather headdress most often called a **warbonnet**. (Figure 13-33.) It was made with the tail feathers of the golden or bald eagle. Two types of the warbonnet were most common, a simple corona of feathers that encircled the crown, and a **double-trailer bonnet** with two rows of feathers that draped down the back. The warbonnet was worn by warriors as tribal recognition of exceptional valor, each feather symbolizing a heroic act. Colorful quillwork across the headband and ermine pelts at the sides added to the magnificence of the headdress.

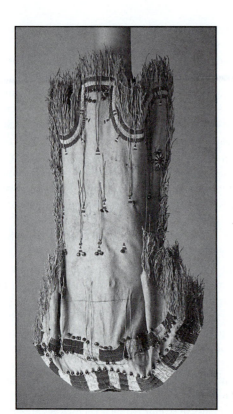

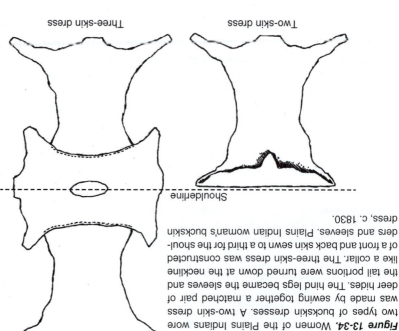

Figure 13-34. Women of the Plains Indians wore two types of buckskin dresses. A two-skin dress was made by sewing together a matched pair of deer hides. The hind legs became the sleeves and the tail portions were turned down at the neckline like a collar. The three-skin dress was constructed of a front and back skin sewn to a third for the shoulders and sleeves. Plains Indian woman's buckskin dress, c. 1830.

Two-skin dress

Three-skin dress

Shoulderline

The principal garment of women was a long, tunic-style dress. (Figure 13-34.) To achieve a longer length than that of a man's tunic, the **two-skin dress** was made from a matched pair of full-size deer or antelope hides. The neckline was formed by folding down the tail portion of the skin and sewing the two halves together. The hind legs became the sleeves. The untrimmed edges at the sides were stitched closed and fringed. The **three-skin dress** was more commonly used by groups of the north central regions such as the Arapaho, Crow, and Dakota. The garment was constructed of front and back hides sewn to a third that formed the shoulders and sleeves.

Buckskin leggings, capes, and moccasins were the basic feminine accessories of the Plains peoples. In addition, women of the most prosperous families wore a wide collar, called a **dentalium cape**, that covered the shoulders and upper torso similar to the ancient Egyptian pectoral. It was made of several rows of tiny dentalium shells strung together in circular bands with a hole in the center for the head. Dentalium shells were also used as appliqués for prized utilitarian objects such as men's pipe and tobacco bags. For the Plains peoples, shells were a form of money.

Elk's teeth were also applied to women's garments to symbolize the preeminence of the family. The arrangement of rows of drilled elk incisors on feminine outer tunics and capes represented having a prodigious hunter in the family who provided significantly for the group. (Figure 13-35.) The

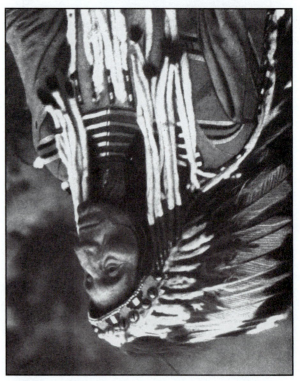

Figure 13-33. The elaborate eagle-feather headdress, called a warbonnet, was the most distinctive accessory of the Plains Indians. Richly patterned quillwork on the headband and ermine pelts at each side added to the opulence of the warbonnet. Flathead chief wearing warbonnet with ermine dangles, c. 1910.

to produce these kinds of lavish decorations for clothing and accessories. Porcupine quills and sometimes stripped bird quills were cut into uniform lengths and dyed colors. These multi-hued quill beads were then appliqued in symbolic and spiritual patterns on almost all outer surfaces of clothing, such as the chief's tunic in Figure 13-33, and especially on accessories like belts and moccasins. Later, manufactured glass and ceramic beads replaced natural quills for the production of decorative appliques.

The most distinctive jewelry of the Plains Indians was designed with tubular **hairpipe beads** made of hollowed-out animal bones. European traders named these beads after the clay narrow-stem tobacco pipes common in the colonial period. As a Native American ornament, hairpipe beads probably originated from the use of bones as a spiritual symbol in Paleolithic times. Skeletal imagery in the decorative motifs of pottery, baskets, painted hides, and canyon petroglyphs reflected aboriginal beliefs that the essence of life resides and is reborn in bones. By the colonial era, the most common uses of bone hairpipe beads for women was in necklaces and hair ornaments. For men, the hairpipe beads were usually arranged horizontally in rows for breastplates, symbolizing the ribcage or the essence of their life force.

THE SOUTHWEST AND PACIFIC COAST

The area west of the Rocky mountains incorporates three distinct geographic features: the Great Basin extending from New Mexico to Oregon, the Columbia Plateau stretching across Idaho and Washington into Canada, and the meandering Pacific Coast. These regions feature vast, flat mesas, deserts that dip below sea-level, and precipitous mountain rains. Yet despite so much of the territory being inhospitable,

motif is still popular today for some Plains Indians in the preparation of ceremonial costumes.

Quillwork likewise represented prosperity in that a group with plenty of food had the leisure time and resources

Figure 13-35. Elk's teeth were sewn in rows over women's capes, ponchos, or tunics to represent a highly skilled hunter in the family. Plains Indian woman wearing an elk-tooth tunic, c. 1890.

Soft-soled and Hard-soled Moccasins

Although traditional Indian dress varied widely from group to group, one key component common to almost all was the moccasin. The origin of the word "moccasin" has been attributed to the Algonquians, whose word for shoes, "mohkussin," may have been a source for the English translation.

Two types of moccasins were common, both of which were designed for their environment. The soft-soled moccasin was prevalent in the Eastern Woodlands for easy, sure-footed travel over leaf and pine needle-covered terrain. Hard-soled moccasins best suited the peoples of the Great Plains to protect from the harsh cactus or prairie grass-covered ground.

Soft-soled moccasins were usually made of a single piece of soft tanned hide from deer, elk, moose, or buffalo. A wide variety of U-shaped and complex elliptical patterns were cut to form the moccasin. The edges of the hide that were to be sewn together were then hole-punched with an awl and whip stitched with sinew. So distinct were the stitched seams that the tribe could be identified by its footprints. Sometimes flaps were added at the opening that could be turned up to protect the ankles or folded down as a cuff.

The hard-soled moccasin was likewise cut and constructed in many varied ways, except the soles were reinforced with a thick piece of rawhide. The front toe was usually shaped to turn up at the end to prevent the sole from catching on sharp objects and tearing the seam or causing injury.

Decorative treatments of moccasins included beads or quillwork that were as distinctive to the tribe as the construction. For some Indians of the Great Plains, long, trailing fringe was added to the heel so that as the wearer walked, his footprints in the dust were obliterated.

aboriginal peoples settled along the few permanent rivers and thrived in dense population clusters.

In the southwestern region, the Hohokam of Arizona and the Anasazi of New Mexico and Utah evolved early farming communities during the early first millennium CE. Probably due to their proximity to Mesoamerican civilizations, these North American peoples developed highly sophisticated irrigation methods and complex communal architecture such as that of Chaco Canyon, New Mexico. A prolonged drought is thought to have caused the collapse of these cultures some-time in the fourteenth century.

The heirs of these first Southwestern cultures became known as Pueblos, from the Spanish word for village. Among the skills inherited by these descendants was textile weaving on looms rather than the rudimentary finger-weaving of east-ern groups. The same fibers familiar to the weavers of Mesoamerica—yucca, cotton, hemp—were utilized by the Pueblos to weave textiles with a type of backstrap loom or a large, upright framed loom. After the introduction of domes-tic sheep during the Spanish colonial period, wool became the prevalent fiber in Pueblo textiles.

As a result of the production of woven materials, the costumes of the Southwestern groups varied from those of other North American peoples. Men's loincloths were more fitted, possibly woven to shape, and attached with strings at each side that were tied for a more secure fit. Front and back aprons likewise were constructed with strings at each side that were tied at the hips over the loin-cloth. Instead of a buckskin tunic or poncho, precontact Pueblo men wore a type of T-cut tunic made from a rec-tangular piece of cotton folded in half and cut with an opening for the neck. Rather than stitching the sides and undersleeve edges together, though, strings were attached for tying the garment closed. Cotton leggings were even-tually replaced by the white cotton trousers adopted from Mexican costumes of the early nineteenth century. Richly patterned blankets and ponchos were worn as outerwear. (Figure 13-36.)

The precontact dress style of Pueblo women was fash-ioned from two rectangular pieces of fabric pinned together at the shoulderline. A belt held the front and back panels in place but the sides were left open. This style of dress disappeared in

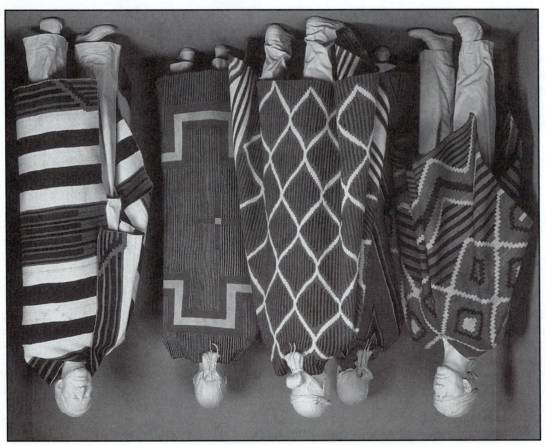

Figure 13-36. Textile weaving became a highly developed skill among the Pueblo groups of the American Southwest. Garments such as ponchos with a vertical-slit neckline reflected a close contact with Mesoamerican cultures. Navajo poncho and blankets, c. 1840–1870.

the nineteenth century when Pueblo women were taught to sew by the wives of colonial settlers.

In addition to moccasins, Pueblo women wore soft-leather, thigh-high boots that were treated with a white clay for a pale finish. The long upper part of the boots was accordion folded in three or four sections to fit below the knee when performing sedentary chores such as weaving. For horseback riding or walking through scrub, the uppers could easily be pulled up over the thighs.

The accessory most associated with groups of the Southwest is **turquoise** jewelry. (Figure 13-37.) Both men and women adorned themselves with pieces of the bluish-green precious stone. Turquoise was a sacred natural material linked to legends of creation and especially to water ceremonies. Some of the earliest examples of turquoise jewelry found in western American sites date to the fourth century CE. Pieces of the stone were made into polished beads, disks, and **tesserae** pieces for mosaic inlays. A ninth-century cuff bracelet found at Ceremonial Cave, Texas, reveals that pieces of turquoise were affixed with pine-pitch adhesive to tightly woven basketry bands. In the eighteenth century, silver metallurgy was introduced by the Spanish and adapted by the Southwestern peoples for their ornament designs.

Farther to the north and along the Pacific coast, the western American groups wore less sophisticated costumes and accessories than their Pueblo neighbors. These coastal peoples wove simple materials of cedar or yew bark fibers on a two-bar loom using a twining technique instead of a shuttle. The coarse materials were mostly used in fashioning utilitarian items such as totes and mats but were also applied to basic clothing garments.

Figure 13-37. Turquoise jewelry and ornaments were produced by the peoples of the Southwest as early as the fourth century CE. The precious stone was sacred and symbolized creation and life-giving water. Hohokam turquoise bead necklace, c. 1000–1200 CE.

For the most part, though, men wore nothing and women wore only a short apron tied at the back. Capes, leggings, and moccasins made of animal skins were usually limited to use in winter weather or when traveling.

REVIEW

The various groups of today's Native Americans evolved vastly different levels of cultural sophistication over the millennia since their ancestors first crossed the land bridge from Asia more than 30,000 years ago. At the time the first Europeans began to explore the New World, some indigenous peoples were hardly more than hunters-gatherers while others had built great cities and developed writing, calendars, metallurgy, and methods of weaving exceptional textiles.

In ancient Mesoamerica, the Olmec established the earliest imperial civilization in the Americas during the late first millennium BCE. They introduced a hierarchal social order, structured religion, and new technologies such as metallurgy to the groups they conquered. They also imposed forms of standardized clothing, which may have been the Olmec attempt to achieve cultural cohesion. For men, the principal garment was the maxtlatl, or loincloth. By the beginning of the current era, variations of this loincloth had become the standard masculine garment throughout the temperate climates of the Americas. Olmec women initially adopted a short wrap skirt called a cueitl.

During the evolution of subsequent Mesoamerican civilizations, new types of clothing were added to these basic garments to create distinctive tribal costumes. In the early centuries of the first millennium CE, the Teotihuacáno developed a poncho-style cape called the quechquémitl that both men and women wore. For women, the huipilli, a sleeveless tunic blouse, was layered over the cueitl wrap skirt.

The Maya later included two new forms of outer garments for men. A hip-cloth was a form of wrap skirt worn over the loincloth, and the tilmatli was a rectangular cloak. For the upper classes, these garments were made of fine quality textiles and richly decorated with appliques of feathers, fur, embroidery, and ornaments. Mayan men also wore particular types of battle armor and specialized costumes for ceremonial ballgames. Mayan women continued the Mesoamerican tradition of the wrap skirt and tunic top from earlier cultures. Distinctive Mayan elements included a crenelated hemline as a symbol of highborn status.

The Aztec appropriated most of the Mayan costume styles with few variations. Women layered a poncho over the tunic top and wrap skirt ensemble. Men wore the basic loincloth but added a flourish with an elaborately looped knot in the front. Aztec costume was strictly regulated according to social status; everything from the types of fabric permitted by rank to the way in which clothing was arranged. For instance,

Aztec men of noble birth wore long cloaks of fine materials that were tied in the center front, but the cloaks of ordinary men were of coarse fibers and always worn tied at the shoulder. Of particular note is the Aztec tlahuiztli, a warrior's body suit constructed with trousers and long sleeves—a garment silhouette unique among the indigenous costumes of the Americas.

To the south of the Mesoamerican civilizations were the Andean cultures. We know very little about the early peoples of the region because they had no writing and left scant evidence of their existence. One cache of artifacts, the Paracas burial bundles dating to the last half of the first millennium BCE, provides a glimpse of the highly evolved textile weaving traditions of the early Andean cultures. Many of the Paracas garments are similar to those adopted by the early Mesoamericans including men's loincloths, wrap skirts, cut-and-sewn tunics, cloaks, and ponchos. More than 1,000 years later, those same styles of clothing were worn by the Inca who governed the greatest empire of the Americas at the time of European colonization. From the Inca, we also get a clearer perspective of Andean women's costumes, which included a simple long tunic with a shawl worn by all classes. As with the Mesoamerican cultures, the apparel of the Inca nobility was made of finer materials and featured lavish embroidery, sumptuous featherwork, and finely crafted metal ornaments.

In North America, climate and ceremony were the prevalent factors in costume design. For most groups, the predominant material used for making clothing was animal hides. Only in the Southwest was textile weaving comparable to the great civilizations to the south.

In the coldest regions of the arctic and subarctic tiers, the Eskimo developed costumes constructed with sophisticated gussets and darts to ensure a snug, tailored fit. Both men and women wore long-sleeve fur parkas, sealskin trousers tucked into knee-high boots, and hooded tunics made of various animal hides.

In the temperate zones of North America, the many diverse peoples inhabiting the woodlands of the east, the vast central plains, and arid western mesas shared a great many cultural traditions with one another, including clothing styles. For hundreds of these groups, the basic masculine garment was a buckskin loincloth, although it was arranged in a great variety of ways, each of which reinforced tribal identity. Animal skin leggings, tunics, ponchos, capes, and moccasins also were common among most of the precolonial North American Indians. For women, variations of a buckskin wrap skirt or tunic dress prevailed.

Among the elements of costumes that were distinctive to regional groups was the eagle-feather warbonnet of the Plains warrior, often made all the more magnificent with the addition of colorful quillwork on the headband and ermine pelts dangling at each side. In the Southwest, vividly colored turquoise stones were cut and polished for application to jewelry and accessories. The Eastern peoples adorned themselves with beautifully wrought ornaments of hammered copper and exquisitely carved combs of bone or antler.

Throughout the Americas, the lifeways and traditions of all indigenous peoples changed irrevocably with the arrival of Europeans. Mass-produced materials such as manufactured textiles, metals, beads, and ornaments substituted for traditionally produced natural components in the making of clothing. Ready-to-wear apparel provided new ideas of fit and comfort as well as offering a tempting variety of ensemble combinations. Missionaries forced upon Indians the European concept of modesty with concealing types of clothing. Within barely a century of first contact with colonists, the millennia-old traditional styles of Indian costumes had been transformed.

Chapter 13 The Ancient Americas
Questions

1. Trace the evolution of the Mesoamerican women's skirt and tunic top costumes from their origins with the Olmec, through the Teotihuacáno, Maya, and ultimately to the Aztec. Identify the names of the garments by each culture. Which elements did each civilization add to give their version of costume a cultural distinction?

2. Compare and contrast male and female body modifications of the Maya and Aztec. How were these modifications achieved? Name and describe the forms of ornaments applied by body piercing.

3. Which poncho-style garment was introduced by the Teotihuacáno for both men and women? How did the Aztec modify this garment? How is the Aztec variant different or similar to the modern Mesoamerican version?

4. Which garment did the Aztecs create that was unique in all the Americas? Name and describe the construction and purpose of this garment.

5. What were the seven distinctive types of men's garments discovered in the Paracas burial bundles? Give the Incan name of each and a description.

6. What was the sophisticated distinction of Eskimo costumes and how was it achieved?

7. Which three forms of costume accessories are most identified with the groups of the Eastern Woodlands? Which materials were used to create these personal ornaments?

8. Describe how the Plains Indians constructed a masculine tunic and a woman's three-skin dress.

9. Which three decorative elements are most associated with appliques and ornaments of the Plains Indians? Which natural materials were used and how were they prepared?

Chapter 13 The Ancient Americas
Research and Portfolio Projects

Research:

1. Write a research paper on the development of weaving among the Andean peoples. Explore the types of fibers and dyes used in preparing yarns. Include specifics of motifs and patterns woven into the textiles and their symbolism.

2. Write a research paper on the forms of precolonial dress of the North American Indians that have been revived or preserved in the twenty-first century. Include examples of the merging of modern fit, construction, and materials that are applied to the ancient styles.

Portfolio:

1. Research the quipu in detail and make one with a full range of colors. Pin the central cord in an oval to a foamcore board and pin the knotted message strings in a radiating arrangement. At the end of each message string attach an explanation of what the color represented to the ancient Inca and what the placement and count of the knots record.

2. Using an inexpensive synthetic suede, cut the shapes of animal hides to construct a three-skin dress similar to that shown in Figure 13-34. Then sketch a color design for beadwork based on an actual tribal pattern to scale for the dress. Present the dress and the drawing to the class and explain the symbolism and significance of the beadwork embellishment.

Glossary of Dress Terms

anaku: the wrap skirt of an Inca woman worn pinned at the shoulders and belted at the waist

anorak: the Eskimo long-sleeve hooded coat made of various furs

anuca: a T-cut tunic worn by early Andean women

backstrap loom: a frameless apparatus with warp threads stretched between two sticks, one of which is attached to a wide strap that fits around the back of the weaver for controlling the tension of the warps

bate: a wooden yoke that fit around the waist of Mayan ball players

bezote: the Aztec men's lip button made with a tab that inserted into a slit beneath the lower lip

cactli: animal hide sandals of Mesoamerica

ch'uspa: a small bag used by Andeans to carry coca leaves

cochineal dyes: brilliant red dyes produced by drying and pulverizing the bodies of the American scale insect

cueitl: a Mesoamerican woman's wrap skirt

dentalium cape: a wide collar made of rows of tiny dentalium shells strung together in circular bands to fit over the shoulders of Plains Indian women's tunics

double-trailer bonnet: a variation of the Plains Indian warbonnet featuring two rows of feathers that draped down the back from the corona

enredo: the Spanish name for the Aztec women's wrap skirt

esclavina: the Incan poncho cut with a vertical slit for the neck

ex: the Mayan men's loincloth made from a single, long piece of fabric wrapped around the waist several times and passed between the legs

faja: Spanish term for a thickly wound sash worn by Mesoamerican men to hold the loincloth in place

hairpipe beads: hollowed-out tubular animal bones used in ornaments of the Plains Indians

hip-cloth: a Mesoamerican men's skirt tied about the hips or girded at the waist

hock boot: a moccasin cut from the bent section of an animal's hind leg that forms the natural curve of the heel

huipil: the modern Mesoamerican version of the huipilli usually cut as a sleeveless blouse of varying widths, lengths, and fabrics

huipilli: the sleeveless tunic blouse of ancient Mesoamerican women

ichcahuipilli: a Mesoamerican warrior's cuirass constructed as a round-neck, sleeveless tunic that was padded, quilted, and adorned with feathers

ikat: a form of tie-dyeing in which threads were tightly bound before immersing into dye

labret: an ornamental lip plug worn by Inuit men and women

llautu: a long fabric band tied about the headcloth of Incan men

lliclla: a square or rectangular shawl worn for everyday by Incan women

manta: the Spanish name for the Incan men's cloak worn draped lengthwise over the shoulders lengthwise

manta de hombres: the Spanish name for the Aztec men's cloak

maxtlatl: Mesoamerican men's loincloth made of a long, narrow piece of fabric that fit between the legs and was held in place by a sash or belt

moccasin: soft-soled footwear sometimes formed as a wrap of buckskin secured by thongs or sewn from soft pieces of animal hides

nañaka: Inca women's cloth headcovering

nariguera: noseplugs of various materials inserted into the pierced nasal septum

netting: looped or knotted rows of pliable yarns that form a meshed material

orejeras: Spanish term for large, round earspools

otalli: an Aztec warrior's defensive shield crafted of reeds, hides, and copper plates

parka: a hooded coat

pyq (also pic): a Mayan women's wrap skirt that sometimes was sewn closed at the open side to form a tubular variation

quechquémitl: a short, poncho-like cape worn by both men and women of Mesoamerica

quillwork: beads cut from porcupine or birds' quills that were dyed and appliqued to clothing and accessories of North American Indians

stake loom: an adjustable horizontal frame with wide warp rods that were staked into the ground

taparrabo: the Spanish name for the Aztec men's loincloth that featured a large looped knot in the front

telar de cintura: the Spanish name for a backstrap loom; see also backstrap loom

telmatli: a Mesoamerican men's long, rectangular cloak

tessera (pl. tesserae): pieces of polished stone used as inlay for jewelry or mosaics

three-skin dress: the women's tunic of northern Plains Indians constructed of front and back hides sewn to a third skin that formed the shoulders and sleeves

timillotl: the Aztec warrior's tuft of hair gathered at the top of the crown

tlahuiztli: an Aztec warrior's bodysuit constructed with long sleeves and trouser legs and decorated with featherwork; most versions featured a mask headdress representing a sacred animal or death demon

tupu: large gold or silver straight pins worn by upper-class Incan women to secure their shawls

turquoise: a bluish-green gemstone cut and polished for making jewelry and tesserae or bead appliques

twining: finger weaving of two or more weft threads to entwine rows of warp threads

two-skin dress: the Plains Indian women's tunic made from a matched pair of full-size deer or antelope hides

unku: the Incan tunic made of a length of material folded at the neckline and sewn up the sides

usuta: Incan sandals made of reeds and cords for commoners and deerskin for upper classes

wampum: tubular beads made from the purple-and-white whorl of a whelk shell and used by North American Indians as appliques or to make pictographs on documentary belts

wara: the Inca name for the Andean men's loincloth

warbonnet: the elaborate feather headdress of Plains Indian warriors

xicolli: a Mesoamerican men's sleeveless tunic of varying lengths, some of which were open in the front like a vest

yacolla: the Inca name for the wide, Andean men's cloak

Influences and Legacies of Mesoamerican Costume on Modern Fashion

Many forms of precolonial Mesoamerican costume survive today among the indigenous peoples of Central and South America including wrap skirts, tunics, and ponchos. Similar types of these garments have been found throughout the world both preceding and concurrent with Mesoamerican versions. Similarly, among the favored decorative elements used for costumes globally are feathers. The Maya, Inca, and Aztec created entire garments lavishly decorated with feathers. Today the fluidity and luxuriant texture of plumage continue to delight both fashion designers and wearers.

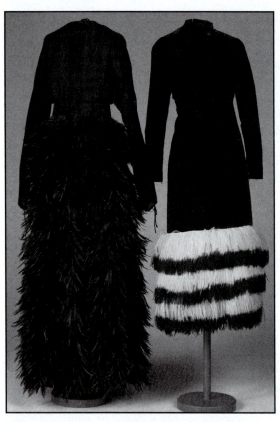

Left, Sonny and Cher wearing fringed and beaded leather tunics, 1968; right Paris Hilton in fringed leather dress, 2003.

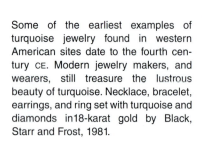

Left, feather gown by Donald Brooks, 1976; right, feather dress by Balmain, 1970.

Some of the earliest examples of turquoise jewelry found in western American sites date to the fourth century CE. Modern jewelry makers, and wearers, still treasure the lustrous beauty of turquoise. Necklace, bracelet, earrings, and ring set with turquoise and diamonds in 18-karat gold by Black, Starr and Frost, 1981.

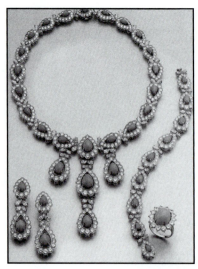

In 1910, the *Ladies' Home Journal* fashion section featured a number of dress designs based on "a careful study of the customs and clothing of the American Indians." The styles included adaptations of beadwork, fringe treatment, fur trim, and fabrics that "represent as nearly as possible the skin of the original garment." Embroidered motifs such as the Arapahoe symbol for "rain" and "morning star," the Blackfoot design for dragonflies, and several Navajo blanket patterns were copied as decorative embellishments. Appliques and beadwork were "intended to represent the old porcupine quill embroidery." Turquoise and silver jewelry accessorized the ensembles. "What could be more truly American?" concluded the fashion editor.

Since then to our present time design elements from North American Indian costumes have similarly inspired modern interpretations. The popularity of fringed leather, geometric patterned beadwork, and silver-and-turquoise jewelry have been a mainstay of American fashion. Left, a "tanned-skin, fur trimmed" tunic and skirt with embroidered Indian motifs; right, embroidered dress of white charmeuse with white silk fringe. Both designs by Eleanor Hoyt Brainerd, 1910.

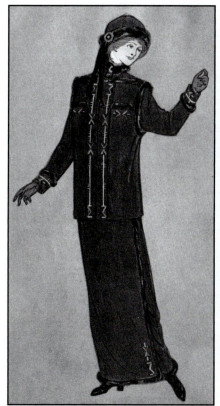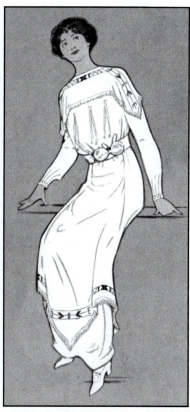

Silk fabrics with American Indian motifs by Mallinson, 1928.

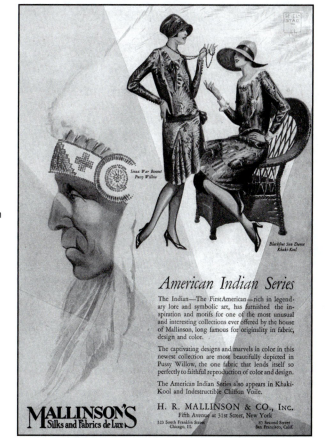

Chapter 14

THE LATE MIDDLE AGES

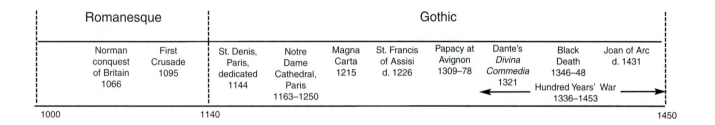

Romanesque			Gothic							
Norman conquest of Britain 1066	First Crusade 1095	St. Denis, Paris, dedicated 1144	Notre Dame Cathedral, Paris 1163–1250	Magna Carta 1215	St. Francis of Assisi d. 1226	Papacy at Avignon 1309–78	Dante's *Divina Commedia* 1321	Black Death 1346–48	Joan of Arc d. 1431	
								Hundred Years' War 1336–1453		

1000 1140 1450

FROM ROMANESQUE TO GOTHIC

During the second half of the first millennium, the roiling confusion of tribal migrations and shifting empires such as those of the Carolingians and Ottonians kept Europe in a perpetual state of instability. By the eleventh century, though, two widespread cultural institutions—Christianity and feudalism—had begun to provide some cohesion and coherence all across the land.

In essence, feudalism was an economic system based on land tenure. A king or land-owning overlord would grant a vassal the rights to a fief, or agricultural estate, that was paid for in service, usually military. As vassals came to hold ever larger estates, they often fought one another to protect or extend their lands, sometimes becoming powerful enough even to ignore their obligations to the king. The many castles standing today with their thick walls, high towers, and encircling moats recall this era when government was singular, personal, and absolute.

At that time, Christianity, too, evolved into an absolute force. The pagan barbarians had all been converted and the Church's authority was present in every village and nobleman's court. As discussed in chapter 6, the end of the first millennium had been an age of Christian fervor and reform movements that were manifested particularly in the spread of monasticism. The vast number of monasteries and convents that were founded during this era grew wealthy from bequests made by those seeking salvation in the hereafter. Ultimately many monasteries owned huge estates that operated with the same feudal organization as a vassal's manor. Even the head of the abbey or priory was often a member of the nobility, giving a religious sanction to the feudal stratification of society into rigidly separated classes.

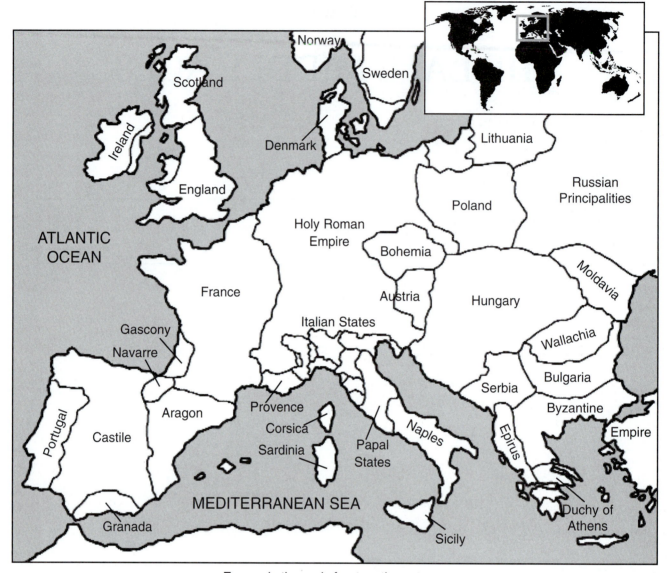

Europe in the early fourteenth century

In the early Middle Ages, Christian zeal was also demonstrated by frequent pilgrimages to holy shrines and by crusades to regain the Holy Land from the Muslims. This great movement of population in these Christian pursuits helped further establish the Church as the preeminent leader of the masses—the supreme feudal lord.

In addition to the expanding economies of feudalism, both Christian and secular, vast building programs were sponsored by the Church and the newly independent civil authorities of chartered cities. The preferred style of architecture at the time emulated that of ancient Rome with round arches, heavy walls, masonry vaulted ceilings, and an overall blocky appearance of rectangles, cubes, and cylinders. Based on these endeavors to revive the splendors of Roman engineering and design, this period from the eleventh century to about mid-twelfth century later came to be labeled the Romanesque era.

During the mid-twelfth century, though, dramatic change occurred. In architecture, new types of construction inspired by ideas introduced from the Near East by the Crusaders began to supplant those of the Romanesque style. The debut of a new form of architecture was in the construction of the magnificent abbey church of St. Denis in Paris, dedicated in 1144. Lofty walls were pierced with airy windows and with high doorways topped by pointed arches. Soaring vaulted ceilings appeared to be delicate webbing stretched over seemingly insubstantial ribs. The style of architecture—and the era—was Gothic. The term "Gothic," though, was first used during the Renaissance by critics of the architectural style because they supposed it had been introduced by the Goths, the invading northern peoples who had been instrumental in the destruction of classical civilization. In its time, the Gothic style was simply referred to as the modern style or French

Heraldry

Heraldry is the official process for devising, granting, and blazoning armorial bearings. The term "blazon" may have been derived from the German word "blausen," which means to blow a horn, as in proclaiming the start of a tournament.

The origins of heraldry are thought to have occurred during the first Crusade in the early twelfth century. As a rallying point for the soldiers of each fief, cloth banners were designed bearing distinctive emblems or motifs in colorful geometric shapes that could be recognized easily by the largely illiterate masses. Eventually, these emblems were adapted to seals, signet rings, shields, and surcoats worn over the armor—hence the term "coat-of-arms." By the beginning of the thirteenth century, these coat-of-arms emblems became hereditary.

When the Crusaders returned home to Europe, they introduced the new decorative form of armorial bearings into tournaments, which were a form of training for knights. Only the knightly classes were entitled to participate in tournaments. Heralds, who were deputies and advisors to the knights, were responsible for arranging the tournaments and ordering the personal equipment used by the knights in jousting and warfare. The heralds then became the experts on armor and the pedigree of the coats-of-arms. Their expertise thus became known at heraldry.

The elements of a coat-of-arms were imbued with symbolic meaning. Some examples of color symbolism included:

- yellow or gold: generosity
- white or silver: sincerity
- blue: loyalty
- red: military fortitude
- green: hope
- purple: sovereignty and justice

Pictorial representations used in coats-of-arms likewise had significant meaning:

- lion: deathless courage
- bear: ferocity in the protection of kin
- wolf: one whom it is dangerous to assail or thwart
- bull: valor
- eagle: lofty in spirit and judicious
- heart: charity
- hand: faith and sincerity
- leg, foot, or shoe: strength and stability
- buckle: fidelity to authority

style. Sculptures and decorative elements soon echoed the tall, narrow lines of Gothic architecture. Even the silhouettes of fashions and accessories adopted the long, thin Gothic look.

The period of the late Middle Ages from the end of the twelfth century into the fifteenth century not only saw spectacular changes in European architecture but also in the very fabric of society and culture. Monarchies, especially in France and England, became strongly assertive against the independence of lesser lords and the Church. Government became more centralized under the king, providing stability and a comparatively ordered feudalism. With confidence in law and order, cities thrived, attracting people who escaped generational ties to the land and feudal oppression. A middle class, comprised of merchants, craftsmen, bankers, physicians, and lawyers, among others, grew in wealth and influence. Guilds were formed to organize specialty craftsmen, maintain quality production standards, and protect industries. Universities were founded. A reliable banking system was developed. International market fairs were established as outlets for the exchange of goods from far and wide. It is from these new alignments of economic and social forces that the Gothic era emerged.

This was also the period of chivalry and a new importance of women in society. The cult of chivalry that determined social relations in the late Middle Ages evolved through romance literature and songs of the era in which the Gothic warrior, or knight errant, followed a formal code of conduct that blended Christian virtues with notions of what they imagined had been the nobility of the Romans. From this formal code of knightly behavior developed the aristocracy's court of love in which respect for the lady was prerequisite. The chivalrous game of courtly love revolved around a discrete, chaste intimacy between lovers that included exchanged glances, subtle gestures, and even wearing certain colors or emblems. From these social games of the nobility developed standards of a courtier's manners, or courtesies as we know them today.

These changes in social behavior and the affluence of an expanding middle class inevitably led to the emergence of a concept new in the annals of human history: fashion.

THE IDEA OF FASHION

"Fashion," as defined by *The Encyclopaedia of Fashion*, "is a mobile, changing reflection of the way we are and the times in which we live." These two key elements—change and mobility—are what distinguish fashion from costume. In the preceding chapters, the term "fashion" seldom has been used, and then only to mean the way in which something is formed. Costume historian James Laver wrote, "Fashion is a quite modern invention. However far we go back in time or far away in space, we find tribes, however primitive, who have some form of dressing up, even if they only do it on special occasions . . . But such dressing up has nothing to do with fashion." In examining the largely static styles of apparel and accessories of many of the cultures presented in this survey so far, "costume" is used to mean the traditional dress of those societies. Costume, or traditional dress, wrote Anne Hollander, "creates its visual projections primarily to illustrate the confirmation of established custom, and to embody the desire for stable meaning even if custom changes." Even when a new element was introduced to a prevailing costume style,

such as Greek or Persian ornament to Roman dress as the empire conquered those nations, the new designs were assimilated into the standardized forms of dress to become themselves part of the tradition. Such introduced elements were not evolving trends that superceded existing styles, making the current mode obsolete, but instead were added to the repertoire of continuing costume custom. Indeed, for some cultures, such as those of ancient Egypt and China, costume traditions remained fairly constant for hundreds of years, despite periodic radical changes in the political landscape or economies, and hence, shifts in custom.

In the late Middle Ages, however, a new concept of change emerged from the vicissitudes of the era. A burgeoning middle class with disposable wealth sought to elevate their social status through conspicuous consumption. They built grand homes and filled them with rich furnishings. They strove to emulate the appearance and manners of their social superiors by copying their clothes and behavior. And they were mobile, traveling on pilgrimages, on business, and for pleasure, thus carrying representations of new modes of dress far from the origins of style at court or in urban centers. The problem, then, was that the aristocracy resented this infringement upon their special status, and to preserve the clear demarcation between their class and the usurping social inferiors, they enacted sumptuary laws. These regulations restricted the types of fabrics, trimmings, and the cuts of clothing by class—restrictions which the rich merchants and craftsmen largely ignored. When this attempt at class restriction failed, the nobility abandoned the styles of clothing that were being copied by the aspiring bourgeoisie and adopted new forms of dress to reestablish their distinction. "And thus fashion is born," wrote J. C. Flügel in *The Psychology of Clothes*. "There is now a movement from both ends; one from the lower social ranks in the direction of those who stand higher in the scale, and another from these latter away from their own former position, which has now become fashionably untenable." This phenomenon of changing trends in fashion eventually led to an increasingly shorter duration of styles so that by the end of the Middle Ages, clothing designs evolved within decades rather than centuries.

In addition, the idea of fashion trickled down through the social ranks even to the working classes. In a remarkable find excavated from a fifteenth-century cemetery in Herjolfsnes, Greenland, extant clothing included a men's woolen hood, a buttoned tunic, and a woman's gown with a full, gored skirt. The European colonists clearly preferred the fashions of the day rather than adopt the more practical Arctic costumes of the native Inuits.

MEN'S DRESS OF THE ROMANESQUE ERA

Men's clothing from the eleventh century to the second half of the twelfth century changed little from that of the Carolingian era. The Frankish tunic, or gonelle, was still constructed as a long-sleeve, T-cut outer garment that extended to the knees for

commoners and longer for the nobility. One new distinction of silhouette was a fullness of fabric at the waistline that bloused over the belt. (Figure 14-1.) Men of the upper classes also wore an under tunic, similarly cut, but made of lighter-weight materials, particularly linen. Besides the typical tight-fitting, tubular sleeves of the gonelle, variations of sleeve styles included half sleeves for layering over a long-sleeve under tunic, fingertip-length sleeves that were turned back to form a cuff, and wide, full sleeves with a bell-shape flare at the wrist. Wool was the prevalent material used although in warmer seasons and southern climates, a heavy-gauge linen was common.

During the transition period from the Romanesque to the Gothic era, the gonelle was gradually replaced by the **bliaut** (also bliaud), a more closely fitting, tailored tunic. The style was first adopted by the nobility and made of costly materials including imported silks and embroidered fabrics. Instead of the one- or two-piece construction of the gonelle, the bliaut was made with a separate bodice and skirt as well as set-in gores at the hips for a more tailored look. The fullness of the skirts was frequently gathered or pleated at the waist. Hemlines extended from below the knees to floor-length.

Men of the peasant and laboring classes continued to wear the shapeless gonelle made of roughly rendered textiles.

It is unclear from the figural artwork of the Romanesque period if the coverings for men's legs were braies, the loose-fitting trousers of earlier periods, or if they were the new

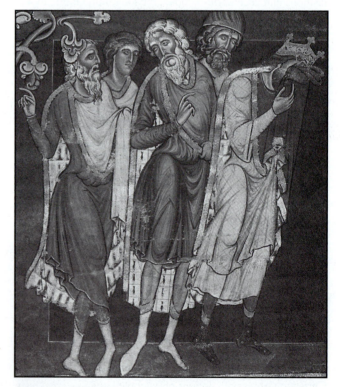

Figure 14-1. During the Romanesque era, men's outer tunics were cut basically the same as styles from the Carolingian period. One variation was a fullness of material at the waist that bloused over the belt. Figures from an illuminated manuscript of the story of David, c. 1150–1175.

forms of tailored hose, called **chausses**, that replaced the baggy pedules of the Carolingians. Most costume historians suggest that, at this time, men increasingly wore thigh-high hose held up with tie strings stitched to the tops that attached to a waist belt beneath the bliaut. A form of cut-and-sewn linen drawers or diaper-like undergarment replaced the braies. Sometimes hose extended only to the knees and were secured with leather thongs or ribbons or were allowed to droop casually. Also, in cold weather or for travel, woven ankle socks of contrasting patterns and colors were layered over the hose.

The woolen cloak continued to be the basic type of outerwear worn by all classes of men. The aristocracy enjoyed styles made of finer grades of wool and embellished with embroidery or appliques. Cloaks were pinned in the front or to one side with metal or jeweled fibulas by the wealthy and slivers of bone or wood by ordinary men.

Except for travelling or outdoor activities, men usually went bareheaded. Styles of hats worn outside ranged from skull caps that tied under the chin to wide-brimmed hats like the Greek petasus made of straw, leather, or felt. Hooded capes and poncho-styled cloaks continued in common use, especially for the working classes.

Men's shoes primarily remained the round-toed boot of varying heights for out of doors and slipper-style shoes or soft-soled ankle boots for indoors. Beginning in the twelfth century, and recurring throughout the Middle Ages, men's shoes featured a pointed toe, which may have been influenced by Ottoman styles brought back by the Crusaders. This early style of pointed-toe shoe was called the **pigache** and included variants with toes that curled up at the end. Also inspired by Islamic imports was finely crafted leatherwork with rich ornamentation that became especially popular in Spain and Italy. Peasants wore heavy workboots or carved wooden clogs for field work.

WOMEN'S DRESS OF THE ROMANESQUE ERA

Costume of ordinary women during this period remained basically the same as that of the Carolingian era. Simple, long-sleeve, T-cut tunics draped loosely from the shoulders to the floor and were girded at the waist, usually by a belt or sash that wrapped around two or three times. If the under tunic was embellished with a decorative border at the hemline, then the outer tunic was pulled up and bloused over the girdle to display the embroidery or applique trim underneath. The tunic styles of affluent women featured sleeve variations that date back centuries. The most common flared from the elbow to a wide cuff, revealing the form-fitting sleeves of the under tunic.

By the late twelfth century, at about the same time of the development of the masculine bliaut, women began wearing a new form of outer tunic called a **chainse**. (Figure 14-2.)

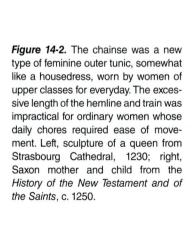

Figure 14-2. The chainse was a new type of feminine outer tunic, somewhat like a housedress, worn by women of upper classes for everyday. The excessive length of the hemline and train was impractical for ordinary women whose daily chores required ease of movement. Left, sculpture of a queen from Strasbourg Cathedral, 1230; right, Saxon mother and child from the *History of the New Testament and of the Saints*, c. 1250.

This was the everyday clothing of upper class women, a sort of long house dress probably made of linen for easy laundering. Not only did the excessive length and train, with a hemline that pooled about the feet, represent the status of women who could afford superfluous fabric for clothing, but the garment was impractical for doing most types of domestic chores typical of ordinary women. Like the men's bliaut, this form of women's long-sleeve tunic was made to be more form-fitting than earlier styles. Some were constructed with laces at the center back or at one or both sides that could be drawn tight to define the contours of the waistline. Other styles appear to have been made with a separate bodice and a skirt that was cut full enough to be pleated. To further emphasize a woman's slenderness, a long belt was wrapped around the waist from front to back and then fully around the hips to be fastened in the front. Sometimes two separate belts were used, one at the waist and a second for the hips. In studying garment terms of this period, the student should be cautioned that a number of costume historians suggest that the chainse was an undergarment, but texts of the Middle Ages clearly describe it as a separate, outer garment.

Versions of the tight-fitting chainse also became popular with men during the late twelfth century although the long design appears to have been preferred by men of more mature years.

Women's outwear continued to be woolen cloaks, short capes, and the casula like that shown in chapter 7, Figure 7-14.

Unmarried young women usually wore no head covering while indoors. They grew their hair to the waist, or longer, and braided it singly or in two long plaits at either side of the head. Married women continued to veil their hair although the arrangements of knots and buns were not completely concealed. By the end of the twelfth century, upper class women began to arrange the veil to cover all of the head except the face. Also at that time, a new type of headdress came into fashion consisting of a linen **toque**, a small, brimless hat, or a rigid open circlet, both often heat-crimped or pleated to add shape and texture. The little headdresses were secured under the chin by a linen band called a **barbette** (also barbe). The circlet was usually worn over the veil that covered the hair and helped secure both the hair arrangement and the scarf. The neck was covered by a **wimple**, a scarf that draped under the chin and fastened to the headcovering above the ears. (Figure 14-3.)

Women's undergarments were limited to the full-length chemise, usually of linen, and tailored, woven hose, also of linen.

MEN'S DRESS OF THE THIRTEENTH CENTURY

As the Gothic style of architecture and art swept across Europe during the late twelfth through the thirteenth centuries, dramatic new changes in costume similarly occurred

Figure 14-3. At the end of the twelfth century, women began to arrange layers of veils over circlets or small toques to more fully cover the hair. A linen band called a barbette was attached to the headdress and fixed under the chin to hold the arrangement in place. Sculpture head of French Noblewoman, c. 1200–1250.

that reflected the influence of the strong verticality of the new art style.

By the beginning of the 1200s, the snug-fitting bliaut was replaced by a new construction of the tunic called a **cote** (also cotte), cut in a single piece with a full skirt. Lengths ranged from the knees to the ankles. A slit was usually added in the front and back of longer versions for ease of riding a horse. Sleeves were wide at the armhole and tapered to a close fit from the elbow to the wrist.

For the upper classes, the cote was most often worn as an under tunic. Layered over the cote was another new tunic style called the **surcote**, probably derived from the wide-sleeved dalmatic, which was still part of the ceremonial dress of sovereigns and high-ranking court officials. The most distinctive style of the surcote was sleeveless, cut with various wide necklines and deep armholes. (Figure 14-4.) Other varieties were made with half sleeves or even long sleeves constructed in the same tapering manner as the cote. The length of the surcote was ordinarily shorter than that of the cote, adding contrasts of color and sometimes fabric textures to the ensemble. As with the cote, a slit in the front and back, sometimes extending up to the waist, allowed for ease of movement.

Some historians distinguish a short version of the sleeveless surcote as a **cyclas**, which was laced to fit tightly around the torso although the origin of the word is unclear. One suggestion is that the cyclas evolved from a sleeveless tunic that was first worn by Crusaders over their armor to add

color and distinction to the otherwise monotonous look of metal armature.

Another area of confusion among costume historians is men's outerwear of the Middle Ages. During the thirteenth century, the **gardcorp** (also gardecorps or gardcor) developed as a sort of overcoat with voluminous sleeves or long hanging sleeves with slits along the inseam below the shoulder through which the arms passed. The tops of the sleeves were usually given fullness with tucks or gathers at the shoulder seam. Other sleeve varieties of the gardcorp were short and wide with the entire inseam open almost like a cape. (Figure 14-5.) This sleeve treatment with the slits recalls the merasim kaftani of the Ottoman nobility and may be a design influence introduced to Europe by the Crusaders.

Two other types of men's outerwear in the thirteenth century were open-front cloaks and poncho-like garments. The full, circular **mantel** of France (mantle in England) was a long, front-closure rain cape that draped around the shoulders and fastened at the neck with an adjustable cord. The **garnache** was a loose, flowing, cloak-like garment with two tabs that fastened across the chest just below the neck. Some variants were open at the sides, and others were stitched closed part way up from the hem, leaving deep arm openings. Other styles were made with short, wide sleeves. The

Figure 14-4. The surcote was a new form of loose-fitting outer tunic cut with various wide necklines and deep armholes. Sleeveless versions were usually cut shorter than the under cote to reveal contrasting fabric colors and textures. Detail of illuminated manuscript depicting the poet Konrad von Altstetten with his lady, c. 1275–1300.

hérigaut was a similar, but less elegant, outerwear garment with long, wide sleeves with slits for the arms to pass through. Some styles had front-closures and others were pulled over the head like a poncho.

Another pullover garment was the **tabard**, which fastened at the sides under the arms with a fabric tab. This was a short adaptation of the monk's floor-length scapular. Later, the tabard would become part of a servant's livery, which usually featured the household's heraldic emblem on the front.

As a display of wealth and status, the nobility and affluent middle classes lined their tunics and outerwear with fine furs like sable, fox, and ermine. Collectively such fur-lined apparel was known as a **peliçon.**

The costumes of professional men also became a form of class distinction in the late Middle Ages. Physicians, lawyers, and university masters wore specially tailored long

Figure 14-5. Men's outerwear of the thirteenth century included a new type of overcoat called the gardcorp. Among its many sleeve variants was a long tubular style with slits along the inseams for the arms to pass through. A similar sleeve was made with the entire inseam left open to form loose, cape-like sleeves like that shown here on the King of the World allegory from the west front portal of Strousbourg Cathedral, c. 1280.

tunics and cloaks made of fine materials and cut with many of the elements of civilian long costumes. Hooded garments particularly became a standardized feature of the professional man's costume. (Figure 14-6.) By the end of the thirteenth century, university students and masters in Paris and London were specifically required by strict regulations to wear hoods of the same cloth as their tunics and cloaks. Today, the stylized stoles that drape around the shoulders and hang down the back of the robes worn by faculty and graduating students are ceremonial remnants of medieval hooded costumes.

The various styles of the long costume with their excessive use of material, both in the construction of pleats, gores, and flared sleeves as well as the layering of garments, were luxuries of the affluent in the Middle Ages. The dress of ordinary people hardly changed until near the end of the era. The shapeless T-cut tunic of the Roman plebe was still the most common garment for peasant and working class men. (Figure 14-7.) If hose were worn, they were the baggy chausses, otherwise the legs were bare.

Figure 14-6. Hooded garments became a standardized costume of professional men such as physicians, lawyers, and teachers. The hood of the physician's surcote shown above is padded and quilted. Side slits at the hips were for easy access to his purse, which was attached to a hip belt underneath. Illumination from the *Anatomy of Guido de Vigevano, c.1345.*

Men's accessories did not follow the extravagance of the long costume. Caps and hats for the upper classes remained fairly small relative to what would develop during the following century. The **calotte** was a larger form of the medieval skullcap that now covered most of the top and back of the head. The **coif** (also coiffe) was a small linen cap with a chin strap shaped somewhat like a modern baby's bonnet without the visor. All classes of men wore the coif by the end of the thirteenth century although the quality of the material distinguished the classes. Similarly, the **capuchon** (also chaperon) was an adaptation of the peasant's hooded cloak made of fine fabrics and modified into a wide hood and collar. (Figure 14-8.) Head coverings for the lower classes continued to be functional, wide-brimmed hats and hooded cloaks, like the Roman cucullus and birrus shown in chapter 5, Figure 5-9, that best served for field work year round.

Shoes of the thirteenth century were widely varied including closed styles with tabbed buckles or laces and slip-on boots of all heights. For indoors, upper-class men wore hose of woven fabrics tailored to fit with attached leather soles. Pointed toes reappeared during the third quarter of the twelfth century but were less exaggerated than previous styles.

Figure 14-7. The costumes of ordinary people changed little prior to the late thirteenth century. The shapeless T-cut tunic of the Roman era still prevailed as the basic garment. Baggy chausses covered the legs, and ancient forms of hoods and cloaks still served as winter outerwear. Shepherds on the Royal Portal of Chartres Cathedral, c. 1150.

Figure 14-8. In the 1300s, stylistic changes to garments began to filter down the social strata to the working classes. The coif was a small linen cap that tied under the chin, similar to the modern baby bonnet. The capuchon was an adaptation of the hooded cloak modified into a wide collar and hood. Illuminated manuscript from the *Maciejowski Bible*, c. 1250–1300.

Figure 14-10. During the twelfth century, the chain mail hauberk developed into a full-body suit featuring long sleeves with mittens and footed leggings. The chain mail hood fitted snugly over the head, covering the ears, brow, and chin. Figure of knight from the interior wall of Reims Cathedral, c. 1250.

EARLY MEDIEVAL MILITARY DRESS

The warrior of the Middle Ages—the knight errant—was, even in his time, romanticized in literature, poetry, song, and artwork. Under the feudal system of the era, a vassal paid his lord for land privileges through military support, providing not only his well armed services, but many times an armed contingent of relatives and tenants from his estates.

One of the earliest and most detailed sources of medieval military costume is the Bayeux Tapestry, a strip of embroidered linen depicting more than fifty scenes that commemorate the Norman conquest of England in 1066. In the battle scenes, the soldiers wear a hooded, knee-length tunic called a **hauberk** (also **hawberk**) made entirely of chain mail. (Figure 14-9.) Wide sleeves extended to the elbows. The skirt of the hauberk was slit in the front and back for horseback riding. These loose panels of heavy mail were often fastened at the knees forming trouser legs to keep the ends from flapping about in combat. The Frankish conical helmet with a nasal tab similar to that shown in chapter 7, Figure 7-10 fitted over a chain mail hood, which had replaced the need for mail neck guards of the earlier helmet styles.

During the twelfth century, the hauberk evolved into a more lightweight, full-body suit including long sleeves, mittens, and footed leggings all of chain mail. (Figure 14-10.) A slit on one side of the wrists of the mittens allowed the hands to be extracted yet still keeping the mitten attached to the sleeve. The hood now fitted snugly about the head covering the ears, brow, and chin. In the 1200s, the conical helmet was replaced by a cylindrical type that covered the entire

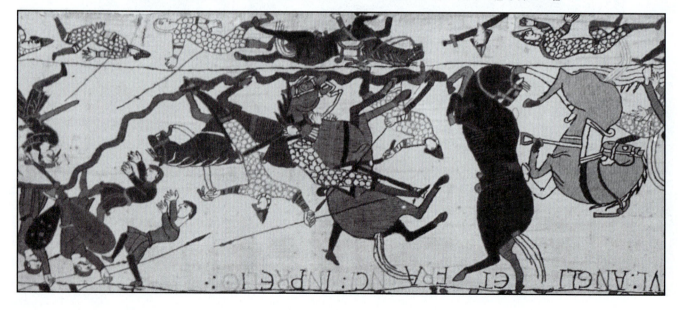

Figure 14-9. The chain mail tunic, called a hauberk, was the most common form of armor worn by knights of the early Middle Ages. The skirt was split for riding, and the loose ends were commonly fastened at the knees forming trouser legs to prevent the ends from flapping about during combat. A scene of Norman invaders at the Battle of Hastings from the Bayeux Tapestry, c. 1070–80.

head like an inverted pail with slits for sight and vents for breathing.

Beneath the chain mail shell, soldiers wore thick garments to protect from chaffing. Under the mail tunic was a tightly fitted **gambeson**, a padded or quilted jacket usually made of linen but sometimes of leather, and, later, even silk. A padded skullcap, or coif, likewise protected the head from the rough metal links of the mail hood. During the Crusades, a sleeveless or short-sleeved surcote was worn over the chain mail suit. Not only did this outer covering of fabric reduce heat absorption from the hot sun by the chain mail, but it eliminated glare from the shimmering metal. Another use of this armorial surcote was for the display of the knight's family emblem or a coat-of-arms. In the confusion of battle, especially enhanced by the limited vision through the narrow eye slits of the new types of helmets, the brightly colored emblems on tunics and shields provided a rallying point in the midst of the melee as well as helped prevent knights from accidentally striking their comrades.

Only knights and nobility could afford the costly chain mail suits and helmets. The light calvary of squires who served the knights in battle and the infantry troops still wore versions of the old Carolingian leather broigne or the padded gambeson, if any form of protection at all. Depending upon the wealth of their feudal lord, some soldiers also had small round-domed caps made of metal, which they wore over thick woolen caps.

WOMEN'S DRESS OF THE THIRTEENTH CENTURY

By the beginning of the thirteenth century, the feminine bliaut, with its complex construction of tucks, gathers, and pleats, was replaced by a simpler cote and surcote that fitted straight to the hips and then flared into a full, exceedingly long skirt. In most instances, both garments were girded although a number of sculptures and paintings show them worn without a belt. The two outside statues of the allegorical group of virtues shown in Figure 14-11 represent examples of both the cote and surcote. The figure on the outside right reveals the full, deep cut of the upper sleeve under the arm and the typical rounded neckline closed by a row of buttons. The large arm openings of the sleeveless

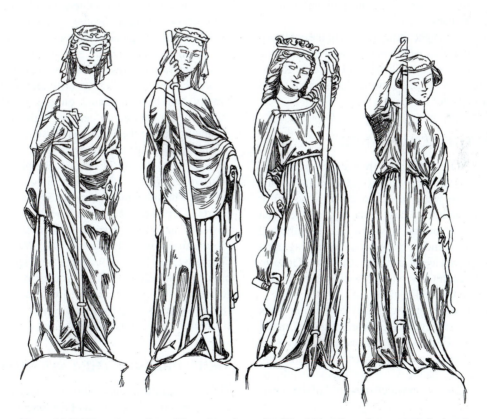

Figure 14-11. Women's versions of the cote and surcote of the thirteenth century were similar in cut to those of men's styles except for the excessive trains. Cotes featured soft, fitted shoulders and deep arm openings for wide upper sleeves such as those on the figure at the far right. Sleeveless surcotes were cut with deep arm openings to the hips, like those on the figure at the far left. Winter outerwear continued the same types from the Carolingian era. The two figures in the center above show the poncho-style casula and the open-front mantel. *Virtues Trampling Vices* from the west facade of Strasbourg Cathedral, c. 1275.

surcote on the figure at the outside left are evident at the shoulderline. In a flair of style, the surcote is pulled up to her right side and tucked into the deep cutaway, or possibly pinned into place, to display the cote hemline, which probably was of a fine fabric of contrasting color or pattern. Other styles of the surcote featured half sleeves or long, wide sleeves that often were turned back to display the tight-fitting sleeves of the cote underneath.

The two central figures of the Strasbourg *Virtues* depict the prevailing forms of women's outerwear in the thirteenth century. As had been worn by women since the Carolingian era, the poncho-style casula continued to be a popular cold-weather outer garment. Hooded versions were adaptations from men's dress of the time. Similarly, the open-front cloak on the other figure is a continuation of the circular style from the Romanesque era. Instead of the traditional fibula to fasten the cloak, it is secured by a pair of **agraffes**, or clasps with a ring in back through which was looped a cord, ribbon, or chain across the chest.

Women's accessories of the thirteenth century did not undergo a significant change. Various forms of small hats were draped with netting or scarves and held in place by wimples and barbettes. Also, the same types of slippers and short, softly constructed boots from the previous century continued with little change.

Because of the long, tight-fitting sleeves of the cotes and the concealing headdresses with wimples, women had little opportunity to wear bracelets, necklaces and earrings. Rings, belt clasps, agraffes, and brooches were the most common forms of women's jewelry.

PRELUDE TO THE RENAISSANCE

At the dawn of the fourteenth century, feudalism was already in decline. Economies of the expanding cities and most of the vast agricultural estates were now centered on a system of wages and taxation paid in the coin of the realm rather than labor and service. The income from tax revenues allowed monarchs to pay for a standing army instead of calling upon vassals for periodic service of a limited duration. Government became more centralized, and power shifted from the dispersed nobility to the royal court.

Serfs became free peasants who paid rent for the lands they farmed or else worked for wages on great estates and in the cities. Higher wages and more concessions to workers from landlords and merchants were granted due to a shortage of labor following the outbreak of the Black Death, or bubonic plague, of 1346–48, in which one-third of the population of Europe died.

War also altered the economic and social conditions of the previous feudal era. The Hundred Years War (1336–1453) between France and England hastened advances in warfare technology including the advent of the longbow, and later, the use of gunpowder and the development of cannon. The intermittent periods of instability in Brittany, Normandy, and the Bordelais provided opportunities for a new urban economy to emerge in the towns of Flanders. Italian city-states developed republican forms of governments. War between the Ottoman Turks and the remnants of the Byzantine Empire in the east opened doors for maritime dominance by Western powers. The war needs for metal and mining strengthened the business of international banking and investment finance, which, in turn, provided stability through tighter controls of credit and debt.

The fourteenth century was also the dawning of a new spirit that soon radiated across all classes—the emergence of humanism, which fostered radical, new ideas of the individual. The absolute authority of the Church diminished despite the fervent inquisitions to root out suspected heretics. The papacy abandoned the seat of St. Peter in Rome and relocated to Avignon for most of the century. Art and literature began to reflect a secular humanism expressive of the notion of ideal beauty that inspired poets like Dante, Boccaccio, and Petrarch, and artists such as Giotto, Masaccio, and Botticelli. Greater importance was attached to the perfection of the human form in the visual arts and, indeed, to outward appearances in general. For instance, images of the Virgin Mary evolved from the benevolent mother figure of the thirteenth century into the elegant noblewoman of the fourteenth century, whose idealized beauty was reinforced through her sumptuous clothing and accessories.

From these economic and social changes emerged a transformation of dress unlike any before. Where clothing throughout Europe of the twelfth and thirteenth centuries largely had been modeled on the French international styles, in the fourteenth century national distinctions developed. Among the independent states of Italy, imaginative form and luxuriant textiles hallmarked the clothing and accessory styles of the region, helping to catapult the courts of Italy into influential arbiters of fashion for all of Europe. The splendor and opulence of fashions at the royal courts of France and Burgundy reflected the ambition and power of their rulers despite the domestic and international crises caused by the Hundred Years' War. Similarly, Spain, Germany, and England adapted new silhouettes from the cultural trendsetters in Paris, Venice, and Florence to their regional tastes, which included textiles, colors, and decorative elements inspired by the Moors in the West and Byzantines in the East.

MEN'S DRESS OF THE LATE GOTHIC PERIOD

The most significant innovation in costume of the fourteenth century was the replacement of the long, flowing Gothic line in favor of increasingly shorter, more fitted designs. Long costumes, though, remained constant for ecclesiastical, academic, and ceremonial court dress. Between about 1330 and 1350, a number of new types of garments as well as marked alterations of previous styles became popular on a

Figure 14-12. Influenced by tight-fitting military jackets and tunics, the pourpoint replaced the cote as the basic men's garment during the mid-1300s. The pourpoint was tailored with darts and seams to fit the contours of the body. Short skirts that ranged from mid-thigh to mid-calf reflected the change of men's fashion from the long, vertical lines of the early Gothic period. Detail of an manuscript from the *Roman du Roi Meliadus*, c. 1352.

wide scale, crossing national boundaries as well as social strata. Especially following the end of the Black Death in 1348, clothing became more colorful and revealing for both genders—seemingly a survivors' counteraction to the dark and penitent years of horror.

A short, tight-fitting jacket called a **pourpoint** (also known as a **gipon** or **jupon**) was most likely modeled after the trim, padded gambeson worn under a chain mail tunic. Unlike the earlier armorial undergarment, though, the pourpoint was cut and shaped to fit the body with darts and seams tailored to the natural contours of the torso. (Figure 14-12.) Some designs featured a row of tiny buttons down the entire front-closure while others continued the same forms of back or side laces as the gambeson. Long sleeves likewise fitted snugly in most pourpoint designs although regional variations quickly developed. In France, a popular sleeve style was cut wide at the armhole and tapered to the wrist, while in Italy, the sleeve was gathered at the armhole and the elbow, forming a balloon-shaped fullness over the upper arm. The quilting and padding that had been applied to the gambeson as protection and support of armor became adapted to the pourpoint for shaping a more flattering masculine silhouette. Thick layers of cotton wadding broadened the chest and shoulders and emphasized slender, youthful waistlines. Around 1350–1360, lengths of the pourpoint skirts initially were at or just below the knees, but soon rose to mid-thigh by the last quarter of the century. By the beginning of the fifteenth century, the short version, now more commonly referred to as a **doublet**, had scandalously short skirts that

barely extended to the hips. By the end of the century, some styles of the doublet were even cropped at the waist without a skirt, particularly in Italy. Youths and men with athletic builds unhesitatingly took to the new short tops, causing a flurry of condemnation for immodesty from the Church and civic officials. Contemporary chronicler Matteo Villani wrote scathingly against those who indulged in "strange and unaccustomed fashions and indecent manners in their garments."

With the new shorter, contoured designs of pourpoints, the baggy "round" hose of the preceding era was replaced by made-to-measure styles cut on the fabric bias for a smooth, tight fit. Ribbons or laces attached to the tops of the hose were tied to strings with metal tips or "points" that were sewn to the underside of the pourpoint, from which the garment got its name. Short drawers made of linen tucked into the tops of the hose. Sometime during the 1370s, hose leggings were stitched together with the insertion of a gusset in the back and a lace-up codpiece in the front to create a sort of constructed tights. Over the following decades, hose for men of the upper classes were often made of richly patterned materials, including woven textures and embroidery, to draw attention to the shapely masculine legs.

As the pourpoint grew in popularity, the loosely draped surcote was replaced with the **cotehardie**, an outer tunic style that was more fitted through the shoulders and waist. In the mode of the era, the cotehardie was usually short, cropped between mid-thigh and mid-calf. Sleeves were most commonly cropped at the elbows, often with a long streamer of fabric, called a **tippet**, hanging from the back. Various forms of wide or double-wrapped belts girded the hip line of the cotehardie, even on the shortest variants.

During the late fourteenth century, a dramatic new style of the masculine outer tunic developed called the **houppelande**. This new silhouette was fitted through the shoulders then flared into a fullness that was gathered into thick, regular folds or pleats in both the front and the back. (Figure 14-13.) These folds probably were tacked into place to hold their uniform shape. Ankle-length versions were preferred by men of high rank or maturity, and knee- or mid-thigh lengths were more common with young men. By the end of the fourteenth century and especially in the fifteenth century, youths dared the sexual display of hemlines cropped at the crotch, and even shorter in Italy. Skirts were frequently cut with vents either at the sides, front and back, or all four points. Houppelande sleeve designs varied greatly. The most notable were the enormous bell-shaped styles, some draping to the floor, and often edged with exuberant cut-patterns or sumptuous fur trim. Another exaggerated element of the houppelande, and other men's upper garments, was a high, stiff collar, some of which enclosed the entire neck up to the ears.

In the second half of the fourteenth century and especially throughout the fifteenth century, sleeves, tippets, collars, hemlines, cloaks, and hoods were flamboyantly edged

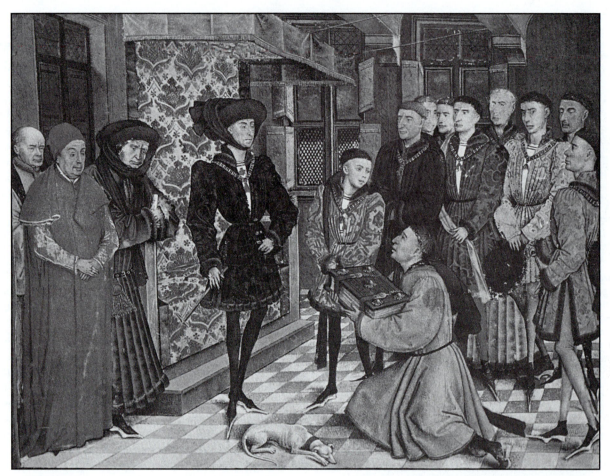

Figure 14-13. In the second half of the 1300s, a new form of men's outer tunic swept through Europe. The houppelande was fitted at the shoulders and then flared into a fullness below that was arranged into deep, even folds or pleats. Hemlines varied from ankle-length versions worn by men of high rank to short styles cropped above the crotch preferred by young men. Above, detail of illuminated manuscript from the *Chroniques de Hainaut,* c. 1446; right, Allegory of the Sun in *Liber Cosmographia*e, by John Foxton, c. 1408.

with **dagging** (also dagges), a scalloped or crenelated cut. (Figure 14-14.) This decorative treatment was not solely confined to the garments of the wealthy. Illuminated manuscripts show grooms, servants, even field workers and shepherds wearing clothing accented with dagging.

The **huque** (also huke) was adapted from a short scapular-like garment originally worn over armor. Similar to the tabard, a huque was open at the sides except without tabs under the arms. The huque was primarily a fashionable top garment for the upper classes, often lined with fur for winter wear. Some designs included stitched pleats or deep folds on the front and back like those of the houppelande. (Figure 14-15.) Lengths varied from mid-thigh to mid-calf.

Another civilian adaptation of military apparel in the late fourteenth century was **particolored** garments. As marriages of nobles merged two great families, the coat-of-arms of both houses were combined to form a divided or even multipart

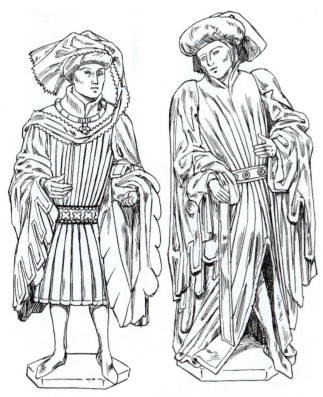

Figure 14-14. From the second half of the fourteenth century through the fifteenth century, the edges of sleeves, collars, and hemlines were edged with scalloped or crenelated cuts called dagging. The decorative treatment became applied to all sorts of garments of all classes, even those of field workers and shepherds. Mourning figures from the mausoleum of Isabella of Bourbon, c. 1476.

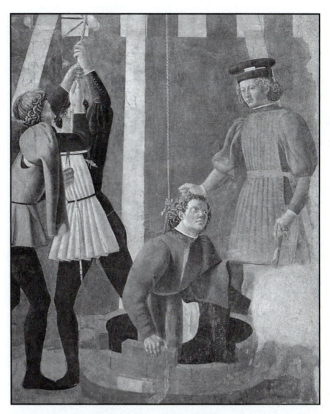

Figure 14-15. The huque was a men's pullover, open-side garment of various lengths worn as a fashionable outer covering primarily by the wealthy. For winter wear, versions were made of heavy wool lined with fur. Detail of a fresco by Piero della Francesa in the Church of San Francesco, Arezzo, c. 1455.

escutcheon. Clothing and accessories, too, of both men and women began to be constructed with sections of contrasting fabrics. As with the crests of the aristocracy, garments were divided or quartered into panels of different colors or patterns. (Figure 14-16.) Divided hose made with each leg in a different color were especially popular well into the sixteenth century.

In the second half of the fourteenth century, the short houppelande was gradually replaced by the **jacket** (jaquette in France), which was worn by all classes of men. The primary differences between the two short garments were the jacket's separate skirt and bodice construction, and its shaped, padded shoulderline. Variants include vertical pleats in the front and back similar to those of the houppelande, but not as full and deep. Hemlines of the jacket skirt were usually at mid-thigh although shorter versions were equally popular. The neckline was often collarless and cut as a deep scoop in the back and a V-neck in the front, sometimes to the waist with laces across the chest. Sleeves were cut in a wide array of styles ranging from close-fitting cylinders to full, sack-like versions and even revivals of the long, hanging sleeves with slits for the arms to pass through. (Figure 14-17.) In Italy, jacket sleeves were designed as two detachable pieces for the forearm and

upper arm, which were laced together at the elbow and to the bodice armhole. For the wealthy, the jacket was made of costly materials and layered over a doublet. For men of working classes, the jacket was made of serviceable wool or coarse blends of wool and linen, and worn over a simple tunic-style shirt.

Winter outerwear for men of the late Gothic era continued to be the same types of capes and cloaks as the garnache and héricault of the thirteenth century. The notable difference was in the innumerable forms of dagging, which included trimming done along the edges with fringe, buttons, embroidery, and fur.

Men's hats and shoes of the fourteenth and fifteenth centuries became ostentatious complements to the plethora of flamboyant clothing designs. As mentioned previously, a trend for pointed-toe shoes periodically was revived throughout the late Middle Ages, with origins perhaps as early as the twelfth century. From the late fourteenth century into the third quarter of the fifteenth century, an extreme design of men's shoes became popular among courtiers. The "**poulaine**" (in France) or "**crackow**" (in England) featured exaggerated points at the toes that extended forward several inches in a tapering length. (Figure 14-18.) The name poulaine is derived from the French word for Poland, and the English term crackow comes from the

Figure 14-16. One of the fashionable innovations of men's clothing in the fourteenth century was the particolored garment, which was constructed with blocks or panels of contrasting colors or patterns. Detail of the *Conversion of St. Paul* by Luca Signorelli, c. 1470.

Figure 14-17. The men's short houppelande was gradually replaced by the jacket, which became adopted by all classes. The primary difference was the separate construction of the jacket's bodice and skirt. In this detail of the *Martyrdom of St. Erasmus* by Dirk Bouts, c. 1470, the young men wear versions of the jacket showing the skirt seam at the waist. The older man in the foreground wears an elaborate houppelande made without the deep, vertical folds across the chest.

name of the Polish court of Krackow where the earlier versions of the pointed-toe shoe had remained a favored style even when it had been abandoned elsewhere in Europe. Some reports indicated that points of the poulaine reached lengths in excess of two feet requiring additional support from whalebone. In addition to leather shoes and boots, the pointed-toe design was adapted to carved wooden clogs, called **pattens**, usually worn out of doors or during winter when the cold of stone floors penetrated the soft, thin soles of poulaines. Negotiating stairs or the uneven terrain of garden walkways wearing poulaines and pattens required a cautious, methodical elegance—an indulgence usually reserved for leisure classes. Although the style of exaggerated pointed toes remained prevalent in France, northern Europe, and England for over a century, the poulaine was short-lived in Spain and Portugal during the mid-fifteenth century and was not widely adopted in Italy or Germany.

For traveling, hunting, and riding, men continued to wear regular types of pull-on boots with tapering toes, but not the impractical, excessive lengths of the poulaines. Short

ankle boots with a V-throat were common for all classes. Knee- and thigh-high riding boots, some with exquisite leathercraft, were for the wealthy.

Men's styles of headgear in the late Gothic period developed into extraordinary constructions of frames, fabric, and trim. (Figure 14-19.) Felt blocked hats, formed over wooden blocks or molds, were made with round, cone-shaped, or flared crowns of assorted heights. Brims were equally varied from short rolled edges to wide flat disks. The **bourrelet** was initially a light, wicker hoop over which men rolled their hoods when not pulled down to cover the head and shoulders. This circular headgear evolved into hats with huge rings that were arranged with layers of pleated materials or fabrics edged with dagging. For working classes, the hood developed a pretentious tubular extension at the back of the head called a **liripipe**. To keep the long tail from flipping about while working, men sometimes wrapped the liripipe around the

Figure 14-18. Men's shoe designs of the late fourteenth century, called poulaines, adapted a revival of pointed toes that became modified into exaggerated dimensions, some of which reportedly exceeded two feet in length. Pattens, or carved wooden clogs used for muddy streets and garden paths, were similarly designed to include a long point to support the extended toes of the poulaines.

head and tucked the tip under, forming the **coronet hood**. Innumerable other types of headcoverings ranged from continued styles of simple toques and skullcaps to fanciful turbans inspired by the exoticism of the Ottomans.

In the early part of the fifteenth century, a distinctive new trend in men's hairstyles called a **bowl cut** appeared first in the Burgundian and French courts and soon after in England and

Figure 14-19. Men's hats and headgear of the late Middle Ages developed into a vast array of designs and shapes. Among the most distinctive silhouette of the period was the bourrelet, formed by a large roll of material around the crown with the center piled high with assorted arrangements of pleated, slashed, or folded fabrics. Above, detail of an illuminated manuscript depicting the coronation of Charles VI, c. 1380; right, detail of the Ghent altarpiece by Jan Van Eyck, c. 1430.

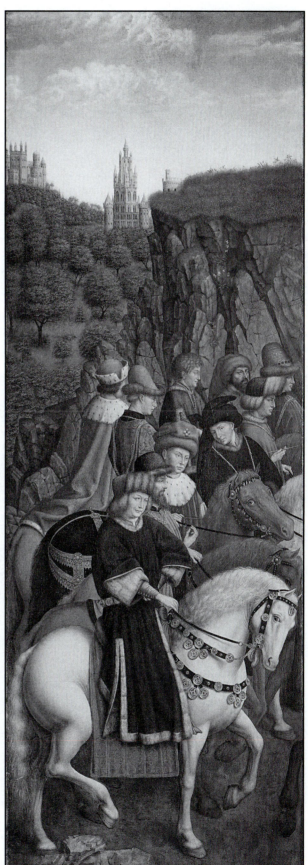

Spain. In effect, the hair was cut short as if a bowl had been inverted upon the head as a trimline guide. Below the edge of the crop around the ears and neck, the scalp was shaved. Many of the courtiers in Figure 14-13 wear the fashionable bowl cut. The trend disappeared during the third quarter of the century and seems not to have taken hold much in Italy or Germany.

MILITARY DRESS OF THE LATE GOTHIC PERIOD

During the 1300s, the knight's chain mail suit began to be layered with sections made of iron or steel plates riveted together. The **brigandine** was a sleeveless cuirass made of horizontal bands of metal that fitted snugly over the mail tunic covering the torso and hips. Some brigandines were sewn between layers of padded material. Outer sheathing was often brightly colored and embellished with heraldic emblems. In addition to the brigandine, shaped sheet-metal rondels fitted over the shoulders and kneecaps, and greaves were strapped over the shins.

From these early forms of plate armor evolved the full suit of armor familiar to us today from castle corridors, romanticized history paintings, and Hollywood movies. (Figure 14-20.) By the early fifteenth century, a knight's armor consisted of many components that concealed almost the entire body head to toe. A rounded helmet was constructed with a bowl or skull, usually of two hemispheres, a visor, and various pieces to fit around the neck. In later helmet designs, a coxcomb crest projected over the dome from the brow to the nape of the neck. The **pauldron**, a convex epaulet covering each shoulder, usually included a ridge or flange to deflect sword blows away from the head.

Breastplates protected the entire torso and ordinarily featured a thigh-length skirt of metal bands called a **tasset**. Upper and lower arm bands fitted into an elbow-cop that could be a simple metal cap attached to a leather strap, or it might be fashioned as a large, butterfly-shaped piece with an indented center to allow the arms to bend. **Gauntlets** were either made as mittens with articulated plates over the knuckles, or as gloves with overlapping platelets protecting each finger. The upper leg guard, called a **cuissard**, and the greaves were capped at the knee by a shell- or fan-plate. In keeping with the fashion of the early fifteenth century, some styles of the **solleret**, or armorial shoe, even featured a long, hinged toe extension to accommodate the leather poulaines worn underneath. Chain mail continued to be used to protect

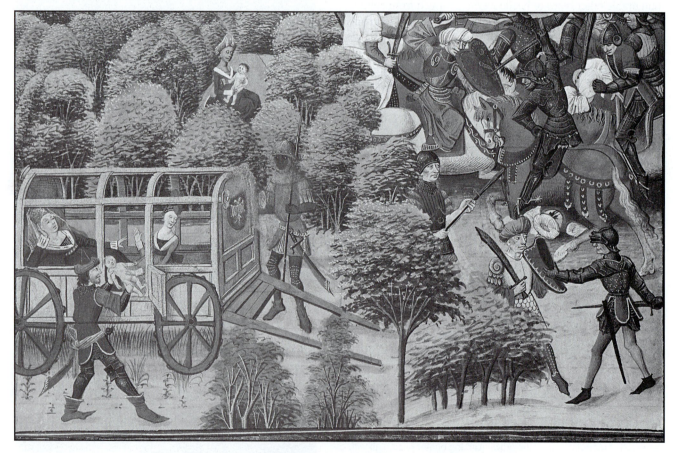

Figure 14-20. The transition from the chain mail hauberk to the full-plated suit of armor occurred during the fourteenth century. Construction of articulated steel plates afforded the knight greater protection than chain mail alone and a comparable ease of mobility. Detail of an illuminated manuscript from *Renaud de Montauban*, c. 1450.

open areas that plate armor could not cover, especially the under arms, inner arms, groin, and sometimes the neck.

By the end of the fifteenth century, the use of wheellock, and, later, flintlock guns and other artillery in warfare began to make suits of armor ineffective. In the sixteenth century, **proof armor** was made so thick and heavy to be sure-proof against musket balls that the weight was unendurable. Eventually, the plate armor was abandoned and replaced with lightweight, reinforced leather. Even so, the Gothic suit of armor of the noble knight continued to be made for ceremonial display well into the seventeenth century.

WOMEN'S DRESS OF THE LATE GOTHIC PERIOD

For about the first half of the fourteenth century, the design of women's cotes, now called **gowns** in contemporary English texts, was form-fitting through the shoulders, torso, and over the hips, flaring into a full, floor-length skirt. Sleeves were similarly close-fitting, sometimes with cuffs that covered the upper parts of the hands to the knuckles.

There is often confusion on the difference between the gown and the feminine cotehardie. Both were cut with a similar fit although the cotehardie is most often described as having a lower neckline and sleeves decorated with tippets. Costume historians who specialize in apparel of the Middle Ages, such as Mary Houston and Joan Evans, suggest that the key difference was use. The cotehardie was a form of gown worn for out-of-doors activities like riding and garden soirees, but the gown was largely for wear indoors. In fact, the cotehardie was commonly layered over the gown in cold weather.

Around the mid-1300s, the sleeveless surcote with its deep armholes evolved into the highly stylized **surcote ouvert**, which was worn only by ladies of the highest station. (Figure 14-21.) It was cut with a low décolletage that appeared to be barely more than straps over the shoulders. A wide panel, called the **plastron**, covered the front and back torso to just below the hipline. Royal records indicate that the plastron was often made of fur, especially ermine. A vertical strand of hinged brooches frequently ornamented the front of the plastron. A full skirt was sewn to the ends of the plastron and to connecting bands of fabric at the hips. The deep cutaway sides were made to dip below the hips to display the jeweled belts worn low on the gown underneath.

As with men's dress of the late fourteenth century, radically new silhouettes of feminine apparel were introduced, providing endless opportunities for women to seek personal expression in their choices of clothing. Not only could they choose from several cuts of gowns but also from numerous layered combinations of garments and a wide assortment of imaginative accessories. Among these exciting new styles of garments was the houppelande, which was adapted from men's versions. (Figure 14-22.) Shoulderlines were soft and fitted. The fullness of the bodice was gathered or pleated under a

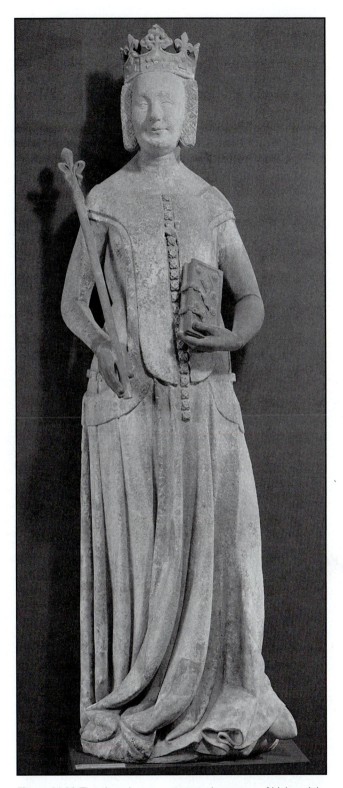

Figure 14-21. The sleeveless surcote worn by women of high rank in the mid-1300s developed into a stylized version called the surcote ouvert at the end of the century. The new design featured a low décolletage and deep cut-aways at the sides. A torso panel, usually of ermine, called the plastron was stitched to the front and back. At the hips a full, gathered skirt was sewn to bands of fabric. Statue of Jeanne de Bourbon, 1380.

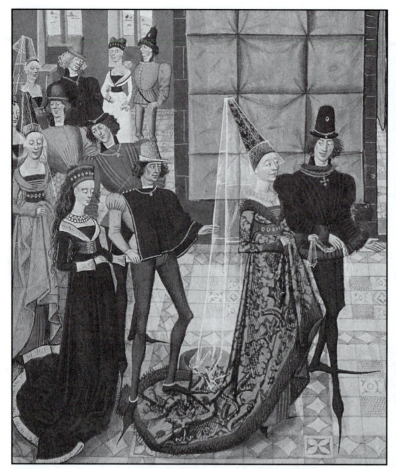

Figure 14-22. The women's houppelande was constructed with soft, fitted shoulder-lines and a fullness below that was gathered into deep folds or pleats. Where men ordinarily belted the houppelande at the hips, women girded theirs above the natural waistline. In addition, the feminine houppelande retained the long train and assorted sleeve styles of the earlier surcote. Left, detail of an illuminated manuscript from *Renaud de Montauban*, c. 1450; right, portrait of a couple by Filippo Lippi, c. 1440.

girdle that set above the natural waistline. This short-waisted silhouette emphasized the preeminent element of feminine beauty of the time, the protuberant abdomen. To achieve this pregnant profile, women even inserted bags of padding under their gowns. But the look "connoted elegance rather than fruitfulness," suggests art historian Anne Hollander. Even when artists of the time painted the female nude, such as Jan Van Eyck's rendition of Eve, the rounded belly was not only "erotically pleasing," but also alluded to "the refined and elevated quality of women's beauty by thus referring to their possible customary appearance in sumptuous clothing."

In addition, except in hemline lengths, women's houppelandes were as varied as men's styles when it came to extravagant types of sleeves, collars, and necklines. Huge sleeves flared to bell shapes that reached to the floor, often edged with fur or dagging. Sometimes, the open ends of the wide sleeves were gathered at the cuff to form voluminous sack sleeves. Also, the tubular hanging sleeves with slits for the arms to pass through reappeared.

Houppelande collars ranged from the high-standing form with winged tips at the front opening to simple, turned-down circles. The daring V-neckline sometimes plunged to the waist revealing the contrasting fabric of the gown underneath. The edges of the neckline were sometimes turned back into revers, which were lined with fur or a different color of fabric.

Gossamer, almost transparent scarves were draped around the bare shoulders and neck to be either pinned to the bodice of the gown underneath the houppelande or pinned closed at the throat and tucked into the gown's neckline. Highly detailed portraits of the time clearly show these tiny straightpins in place.

Under the gown, women wore only a lightweight, sometimes sheer, linen chemise and knee-high stockings that were gartered with silk ribbons or tie strings.

Outerwear styles remained the same as in the twelfth and thirteenth centuries: open-front mantels held closed with a cord or chain across the front, pullover casulas, and hooded cloaks.

Figure 14-23. The early versions of women's bourrelets were made with a wide ring that curved up at the sides. Designs with smaller rings frequently were embellished with an abundance of decorative lappets or mounds of pleated fabric. By the third quarter of the fifteenth century, the roll of the bourrelet had developed into a narrow ovoid shape that arched high over a domed cap or the hair and was wrapped in scarves or nets. Left, detail of an illuminated manuscript depicting Isabeau of Bavaria, c. 1420; center, detail of *Jardin d' Amour*, c. 1415; right, detail of *Meeting of Solomon and the Queen of Sheba*, c. 1470.

The most spectacular women's accessories of the late 1300s through the mid-1400s were the hats and headdresses. At the same time that the men's bourrelet developed from a frame and a rolled hood, a similar version appeared for women. (Figure 14-23.) Initially the feminine bourrelet was a wide, circular shape with sides that curved upward slightly. Lavish trimmings and decorative treatments such as dagging were applied to the roll and the fabric arrangements in the center. Smaller rolls that perched forward onto the brow were embellished at the sides and back with cascades of lappets or pleated material. By the third quarter of the fifteenth century, the roll had evolved into a tall ovoid shape that appeared almost folded in half with a deep point at the front and back. The roll was fitted over a high-dome cap or pinned to the hair piled atop the head and wrapped in sumptuously patterned scarves or nets.

A second form of headdress, even more extraordinary than the bourrelet, was the **horned veil**. (Figure 14-24.)

Figure 14-24. The horned veil headdress was made from a light frame of wire or whalebone shaped to form two points at the temples. One or more veils were then pinned to the structure in delicate arrangements that could reach towering heights. Above, detail of "May" from *Trés Riches Heures du Duc de Berry* by the Limbourg Brothers, c. 1415; right, detail of an illuminated manuscript depicting educated court ladies with books, c. 1460.

A light frame of wire or whalebone was affixed to a base cap and shaped to form two points at the temples. This foundation was then covered with a starched veil that was carefully pinned to the supports. In addition to the horned veil variety, numerous other veiled headdresses were symmetrically arranged with even greater towering effects. Not only did the draping of these veils require a delicate hand but also dozens of pins; in 1391, records indicate that the wife of Charles VI purchased 9,800 straightpins of assorted sizes for her veils. Clearly, these headdresses were solely for the upper classes whose leisurely activities would not disturb the fragile arrangements.

The women's headdress of the late Middle Ages that today is probably most familiar through cartoon princess characters and school productions of *Romeo and Juliet* is the high, pointed hat called the **hennin**. It gradually evolved from a heightening of the small toque, first into a fez-like cap, and then into a tall cone that projected as high as two feet at an angle from the back of a woman's head. The base might be covered with opulent silk brocades, cut velvets, tapestries, and embroidered fabrics, such as the hennin shown in Figure 14-22. A huge, airy veil was attached to the tip of the point and arranged so that a short length hung over the brow and the longer section draped down the back almost to the floor. Sometimes the woman would drape the veil over one arm to prevent sitting on it.

Certainly, these were not the only forms of women's hats, caps, hoods, and headdresses of the period. Just as with men's headgear, women's designs were vastly varied and fanciful.

The two most prevalent shoe styles for women were ankle boots with laces or buckles and low, slipper-style shoes for indoors. For excursions into the garden or out into damp weather, women slipped into wooden pattens carved in the same shapes as men's versions. During the period that men wore poulaines, women's shoes also featured pointed toes although without the exaggerated lengths.

Other accessories included the increasing popularity of customized gloves made of silk, velvet, or soft leather. As necklines of gowns inched lower, women once again began to wear necklaces, ranging from simple chains with pendants and strands of coral beads to extravagant collars of gold filigree inset with jewels. Small purses of brocades or tooled leather with elaborately worked metal clasps were attached to hip belts and tucked inside houppelandes.

CHILDREN'S DRESS OF THE MIDDLE AGES

Newborns were tightly wrapped head to toe in **swaddling clothes**, formed with envelopes of blankets bound by bands of linen. (Figure 14-25.) This practice was thought to ensure that the child would grow straight of back and limb. Toddlers of both sexes wore simple sleeveless or half-sleeved short

Figure 14-25. Newborns were wrapped in swaddling clothes comprised of blankets bound with strips of linen. Children wore versions of adult styles. Above, sculpture of infant in swaddling clothes, c. 1450; right, detail of fresco by Andrea Mantegna in the Ducal Palace of Mantua, c. 1474.

tunics. Children of upper classes dressed in garments made of fine materials often with trimmings similar to those of their parents. Older children wore miniaturized versions of adult clothing. Among the extant garments excavated from the Herjolfsnes, Greenland gravesite was a girl's gown from the 1400s tailored identically to women's styles, including set-in long sleeves, a separate bodice, and a skirt with gores for added fullness.

REVIEW

The High Middle Ages was a period of rapid and dramatic social, political, and economic change throughout the Western world. The feudal order and authority of the Church that had brought stability in the wake of the tumultuous Dark Ages diminished as European society and culture emerged into the Gothic era. Governments became more nationalized and centralized under monarchies. The new economies of urban manufacturing and international trade created a vibrant middle class with aspirations for social advancement. The newly rich burghers and merchants displayed their new wealth by copying the lifestyles—and clothing—of the aristocracy. In turn, the nobility repeatedly adopted new forms of dress to reestablish their distinction. The influence of these changing trends of style traveled across national boundaries almost instantaneously, thus establishing the two key elements that distinguish fashion from costume—constant change and mobility of style.

Although clothing styles prior to the second half of the twelfth century had changed little from those of Carolingian periods, the Gothic era inspired new silhouettes of garments for both men and women that reflected the long, vertical lines of the new forms of architecture and decoration. The men's long bliaut was made with pleats and gathers in the front for added verticality. The women's chainse was similarly constructed with a more form-fitting bodice and a full, gathered skirt. From the cut of these long, flowing garments evolved the cote and surcote in the thirteenth century. Both men and women layered versions of the outer tunic, the surcote, over contrasting styles of the cote.

The next most significant change in fashion occurred in the 1300s when new shapes of garments were created and hemlines were cut shorter. The men's tight-fitting pourpoint was a type of jacket initially made with a skirt cropped at the knees. By the end of the century, versions of the pourpoint had skirts barely to the hips. Similarly, the long surcote was replaced by the fitted cotehardie as an outer tunic, which also was cut with short hemlines.

At the end of the fourteenth century, the houppelande became the most popular men's outer garment. This new design was fitted through the shoulders but flared into a fullness below that was gathered into thick folds or pleats in the front and back.

For women of the late 1300s, the cote became a form-fitting gown over which was layered a houppelande similar in design to the men's version. Although the gown retained the long train of the cote, it now featured a much deeper cut of the neckline. Women of high station wore a variation of the sleeveless surcote, which included open sides to the hips and fur-lined panels in the front and back.

In addition to the advent of new silhouettes and changing styles of sleeves, collars, necklines, and hemlines, garments of the late Middle Ages were lavishly decorated by trimmings and variations of dagging that, in themselves, became new fashion trends. Likewise, particolored constructions provided new looks to hose, tunics, jackets, and accessories.

The most flamboyant fashion trends occurred with accessories of the 1300s and 1400s. The pointed toes of men's poulaines reached exaggerated lengths. Hats for men and women became fanciful arrangements of opulent materials applied to structured rings, domes, cones, and towering frames draped with veils.

Fashion, thus set on its course during the Middle Ages, led to an increasingly shorter duration of trends so that, by the beginning of the Renaissance, styles changed within years instead of generations.

Chapter 14 Late Middle Ages
Questions

1. Which two key elements distinguish fashion from costume? Explain how these two characteristics of fashion developed in the High Middle Ages. Which social and economic changes in the High Middle Ages set the stage for the development of fashion? What was the result of the phenomenon of fashion in the High Middle Ages?

2. Which two new garments, worn by both men and women, developed during the early Gothic period of the twelfth century? Describe how these garments differ from their Romanesque predecessors. Which characteristics of Gothic architecture were reflected in these garments?

3. What was the prevailing combination of tunic and outer tunic for both men and women of the thirteenth century? How did these differ from the Gothic styles of the twelfth century?

4. Describe the type of knight's armor depicted on the Bayeux Tapestry. How did this form of armor change in the twelfth and thirteenth centuries? What were some key innovations of the plated suit of armor?

5. What was the most significant change in men's clothing styles of the fourteenth century? Give examples of how this innovation affected both men's and women's clothing.

6. Describe the common features and the differences between the design of the men's houppelande and the women's version.

7. What were some examples of fashion exaggerations and excesses applied to men's and women's accessories of the fourteenth and fifteenth centuries? Identify by name the types of decorative treatments and accessories.

8. How did fashion trends of the affluent classes impact the styles of ordinary people?

Chapter 14 Late Middle Ages
Research and Portfolio Projects

Research:

1. Write a research paper on the coded system of dress described in fifteenth-century texts such as Jean de Bueil's *Le Jouvencel* and La Sale's *Jehan de Saintre*. Examine how dress was used to make public statements about the wearer, such as heraldic emblems, and how subtleties of dress were used as private messages meant to be understood only by an individual or a select group.

2. Write a research paper on the sumptuary laws of the Late Middle Ages. Investigate how the wealthy merchant classes and middle classes adopted the dress styles of the nobility and yet stayed within the regulations.

Portfolio:

1. Research the design of the horned veil headdress and the hennin and construct a lifesize example of each. Demonstrate for the class how veils were arranged over each style of headdress.

2. Compile a photo album of modern fashions whose legacies are from the Late Middle Ages. Visit a local mall and, with permission of store managers or owners, take photos of ten examples each of men's and women's color-blocked clothing that recalls the particolored styles of the fifteenth century. In addition, take photos of ten examples each of men's and women's crested garments that reflect the modern adaptation of heraldry. Label each photo with the type of garment (men's sportshirt, women's capri pants) and the maker's name.

Glossary of Dress Terms

agraffes: a pair of round clasps with rings in the back through which a cord, ribbon, or chain was looped to secure a woman's cloak in the thirteenth and fourteenth centuries

barbette (also barbe): a linen chin strap used to secure a woman's cap and veil arrangement

bliaut (also bliaud): a close-fitting, tailored outer tunic made with a separate bodice and skirt; worn by both men and women of the late twelfth century

bourrelet: initially a light, wicker hoop over which men rolled their capuchon; later a men's or women's hat with a large circular or ovoid roll of material that fit around the crown

bowl cut: a men's short hairstyle cut as a bowl shape on top of the head with a shaved scalp around the ears and neck in the fifteenth century

brigandine: a sleeveless, military cuirass made of horizontal bands of metal and often covered with padded material; thirteenth century

calotte: a men's large skullcap that covered most of the head in the thirteenth century

capuchon (also chaperon): a men's hood made with a wide collar in the thirteenth and fourteenth centuries

chainse: a women's form-fitting, long-sleeve outer tunic made with an excessively long train; worn by women of affluent classes as a housedress of the late twelfth century

chausses: form-fitting hose cut to measure for both men and women

coif (also coiffe): a men's small linen cap shaped like a modern baby's bonnet that tied under the chin in the thirteenth century

color-blocking: construction of garments with panels of contrasting fabrics

coronet hood: a men's hood with the liripipe wrapped around the head in the fourteenth century

cote: a snug-fitting under tunic with a full shirt cut in a single piece with the top; it replaced the bliaut in the thirteenth century

cotehardie: a men's short outer tunic that was fitted through the shoulders and waist; fourteenth century

crackow: the English name for the poulaine; see poulaines

cuissard: the upper leg guard of a plated suit of armor in the fourteenth and fifteenth centuries

cyclas: a men's short version of the sleeveless surcote

dagging (also dagges): a scalloped or crenelated cut to the edge of fabric

doublet: a men's tight-fitting jacket cropped at the waist or with a short shirt above the hipline in the fifteenth century

gambeson: a padded or quilted jacket worn under the hauberk to prevent chaffing from the chain mail

gardcorp (also gardecorps and gardcor): a form of men's overcoat of the thirteenth century that featured voluminous sleeves, some of which were long tubes with inseam slits through which the arms passed

garnache: a men's loose and flowing cloak-like garment with two tabs that fastened just below the neck, some with open sides and others stitched closed part way up from the hem to leave deep arm openings; worn in the thirteenth century

gauntlet: the articulated metal mitten of a plated suit of armor in the fourteenth and fifteenth centuries

gipon: another name for pourpoint; see pourpoint

gown: a women's long-sleeve tunic of the fourteenth century cut to be form-fitting through the shoulders and torso with a full, floor-length skirt

hauberk (also hawberk): a chain mail tunic with hood, short sleeves, and slit skirt in the eleventh century; a full body suit of chain mail including hood, long sleeves, mittens, and footed leggings in the twelfth century

hennin: a high, conical hat usually with a veil affixed to the tip

hérigaut: a men's basic outerwear garment with long, wide sleeves with slits through which the arms passed in the thirteenth century

horned veil: a woman's headdress shaped by a wire or whalebone frame over which veils were arranged in the fourteenth and fifteenth centuries

houppelande: a formal outer tunic of the affluent classes; men's styles were fitted through the shoulders and flared

below to a fullness that was gathered into deep folds or pleats in the front and back; women's versions were similar in design except for the excessively long trains and décolletage necklines

huque (also huke): a men's open-sided pullover garment, usually fur-lined and made of rich materials in the fifteenth century

jacket (jaquette in French): a men's short top garment made with a separate bodice and skirt in the fourteenth and fifteenth centuries

jupon: another name for pourpoint; see pourpoint

liripipe: a tubular extension of fabric at the back of men's hoods in the fourteenth century

mantel (mantle, English): an open-front cape fastened in the front with an adjustable cord

particolored: juxtaposition of contrasting pieces of material in the construction of garments

pattens: carved wooden clogs usually worn out of doors or during winter when the cold of stone floors penetrated the soft, thin soles of poulaines

pauldron: a convex epaulet covering the shoulder of a plated suit of armor in the fourteenth and fifteenth centuries

peliçon: any of a variety of fur-lined garments ranging from under tunics to outer cloaks

pigache: pointed-toe shoes of the twelfth and thirteenth centuries

plastron: the fur-lined panel on the front or back of a surcote ouvert

poulaines: shoes with exaggerated points at the toes that extended forward several inches; late fourteenth century through mid-fifteenth century

pourpoint: a men's short, tight-fitting jacket cut and shaped to fit the body; fourteenth century

proof armor: heavy-gauge metal used in suits of armor in the fifteenth century as "sure-proof" protection against artillery

solleret: the articulated metal shoe of a plated suit of armor in the fourteenth and fifteenth centuries

surcote: an outer tunic, usually sleeveless, worn by both men and women over a cote of contrasting color in the thirteenth and fourteenth centuries

surcote ouvert: an elaborate surcote made with a low neckline, deep cutaway sides, and a fur-lined panel at the front and back; fourteenth century

swaddling clothes: an arrangement of blankets bound with strips of linen used to wrap a newborn baby that was thought to ensure straight limbs and back

tabard: men's pullover outer garment with open sides that fastened under the arms with fabric tabs in the thirteenth century

tasset: the thigh-length skirt of metal bands on a plated suit of armor in the fourteenth and fifteenth centuries

tippet: a long streamer of fabric that hung from the back of short or half sleeves on a variety of garments

toque: a small, round cap worn by both men and women; styles of the twelfth century were often crimped or pleated along the edges

wimple: a scarf attached to a headcovering worn by women to cover the neck

Legacies and Influences of Styles of the Late Middle Ages on Modern Fashion

The fashion innovations of the late Middle Ages were revolutionary in their originality, imaginativeness, and variety. Stylistically, many of the design elements first introduced more than 600 years ago have since been continually revived and applied to fashion trends throughout subsequent eras down to our modern times.

Equally revolutionary was that, for the first time in history, fashion permeated almost all classes of society whether something as basic as a new silhouette such as the tailored cote and jacket or some pervasive decorative feature like dagging or particolored construction. Today, the concept of fashion for the masses continues through the mass production and distribution of ready-to-wear, which instantaneously disseminates fashion trends from Paris, Milan, and New York to all corners of the globe.

Modern interpretations of gowns of the Middle Ages feature a form-fitting bodice with narrow sleeves and a drop-waist line. Green rayon satin gown, 1939.

Cut-away designs as applied to modern sportswear, eveningwear, and outerwear fashions had antecedents in the surcotes, huques, and gardcorps of the fourteenth and fifteenth centuries. "Mantlet" with deep arm openings, from Dickins & Jones, 1911.

As skirt hemlines rose in the early 1900s, young women daringly donned hosiery embellished with embroidery, decorative inserts, and appliques to attract attention to their legs just as young men had done in the fourteenth century. Silk stockings by Peck & Peck, 1912.

Modern color-blocked construction of apparel and accessories for both men and women recalls particolored styling of the Middle Ages.

Color-blocked shirt from Damon, 1963.

Color-blocked wool jersey sweater from Susan Davis, 1950.

Bias wrap tri-tone dress by Pat Hartley, 1953.

Color-blocked windbreakers from Mighty-Mac Boatwear, 1961.

Taffeta gown with petal dagging around shoulders from Beautime, 1950.

Chapter 15

ITALY AND SPAIN
IN THE RENAISSANCE, 1450–1600

Fall of Constantinople to the Ottoman Turks 1453	Ferdinand and Isabella united Spain 1469	Columbus landed in the New World 1492	Michelangelo painted the Sistine Chapel ceiling 1508-12	Conquistadores established New Spain in the Americas 1521–33	Philip II ruled Spain, the Spanish New World, the Netherlands, Milan, and Naples 1556–98	The Spanish Armada 1588

1450 1500 1550 1600

THE ITALIAN RENAISSANCE

In the history of Europe, the term "Renaissance" is usually applied broadly to the period from the mid-fifteenth century through the sixteenth century. The application of the word Renaissance, or renascitá in its Italian form, meaning rebirth, can be traced back to writings of the sixteenth-century art historian Giorgio Vasari who described the era as a great revival of the arts and learning that emerged after centuries of barbarism following the fall of the Roman Empire. Surrounded by innumerable surviving examples of architecture from antiquity and the rediscovery of Roman sculpture and design, Italian artists took measure of their work by the achievements of their Classical predecessors. Architects combined the balance and proportion of Classical design with modern engineering to create lofty domes and harmonious interiors. Painters redefined pictorial space through the mathematical optics of perspective. Sculptors sought a dynamic realism. Classical literature was recovered from the musty libraries of ancient monasteries and translated from Islamic copies of lost originals.

Most particularly, the Renaissance was a revolution in thought that emerged from new ideas in education. To better prepare young men for a life of service to their community, universities developed programs based on the humanities—grammar, rhetoric, history, and literature. These subjects were taught by humanists whose neo-Platonic philosophy placed man at the center of the universe.

The idea of humanism, and of the individual, so easily took root in Italy because of the political lay of the land in the Middle

Italian Textiles of the Early Renaissance

In Renaissance Italy, the commercial exchange of cloth produced in the textile centers of Florence, Lucca, Genoa, and Venice was second only to foodstuffs in value and importance. A thriving import trade with northern countries, especially England, assured the woolen cloth industry ample supplies of raw material. The wool from local sheep was too poor in quality, given the warm climate and brief cool seasons. The fourteenth-century chronicler Giovanni Villani noted in his statistical survey of Florence that 80,000 bolts of wool had been produced in a peak year. By the end of the 1400s, the Italian textile industry rivaled those of Flanders, England, and Spain in capital investment, production volume, and quality.

In addition to wool, the manufacture of silk cloth developed in Italy as early as the twelfth century. Sericulture, or silkworm farming, was introduced in Palermo and Granada by the Muslims in the late first millennium CE. When the Normans conquered Sicily, the art of silk manufacture spread to the Italian peninsula where plantations of mulberry shrubs, the food of silkworms, flourished.

The methods of producing woolen and silk fabrics were highly complex operations involving as many as twenty-six steps that included preparing the raw materials, spinning, dyeing, weaving, and then the final stages of fulling, or the process for washing, drying, stretching, and trimming. Among the advantages that Italy had over other European textile producers in the 1400s was a natural abundance of alum, which was an essential chemical agent used as a mordant for dyeing cloth. In addition, Italy's many streams and rivers provided the year-round water sources necessary for fiber and fabric preparation. Labor, too, was a less costly commodity in Italy than in northern countries due to the constant influx of immigrants from all around the Mediterranean.

By the beginning of the sixteenth century, Italian silks were among the finest produced in the world and were even imported by the court of Suleiman the Magnificent for his personal wardrobe. The intricate patterns of brocades, sumptuous cut velvets, and vividly colored plainweaves of Italian silk manufacture are represented in the many finely detailed and realistic portraits of noble families of the time.

Ages. The Italian peninsula was comprised of several small, tenaciously independent city-states. These were the first true secular states of Europe. To this day many native-born inhabitants of the old city-states will refer to themselves not as Italian, but after their namesake hometowns: Florentine, Sienese, Pisan, Venetian, Genoese, Milanese. The traditions of feudalism that prevailed throughout the agrarian kingdoms of continental Europe could not be sustained in urbanized Italy. Instead of the hierarchal order of a supreme overlord and vassals like that of France, Burgundy, and England, the sole arbitrator of a ruler's legitimacy in Italy was force; what a ruling family could hold was theirs. Even the popes governed as jealous princes, donning armor to lead armies in defense of the borders of the Papal States.

Such a lack of geopolitical unity not only paved the path for humanism, but also provided an extraordinary diversity that contributed greatly to the cultural enrichment of the Italian Renaissance. When individualism combined with an insatiable quest for knowledge, the result was a universal man, epitomized by Leonardo da Vinci whose innovative contributions in painting, sculpture, architecture, civil engineering, hydraulics, aerodynamics, geology, botany, anatomy, and other branches of knowledge astound us even today.

The spirit of individualism was also the driving force that led to the exploration of the world. The Renaissance was an era of great discovery in which the globe was circumnavigated and most of the habitable regions of the world were visited by Europeans within a few decades. Yet the quest for scientific knowledge was not the primary purpose of the explorers. Instead, they had set out to find new trade routes to known lands—West Africa, India, China, and Japan. Trade with these remote lands made European urban centers prosperous and powerful. From their New World colonies, unimaginable treasure poured into the royal coffers of Spain and Portugal.

Thus, the Italian Renaissance was more than a rebirth. It was a transitional period when medieval man's view of his world was shattered. It was an age of discovery, of startling new ideas about God and humankind, of changing economies and political hierarchies. It was the emergence of a world that was entirely new, entirely modern, and truly global.

From these dramatic changes and the vast new sources of wealth came major shifts in the power and presence of nations in Europe. By the beginning of the sixteenth century, France, Spain, and the Holy Roman Empire vied with each other for control of much of Italy through claims on territory by marriage, heredity, and international alliances. For almost forty years, beginning with the invasion by the French in 1494, European intervention in Italy was relentless. By the middle of the sixteenth century, Milan and Naples were firmly established as Spanish dependencies. Florence had changed from a republic to a duchy ruled by the Medici whose family ties were also dependent upon Spain. Even in the independent Papal States and Republic of Venice, Spain's pervasive influence was felt not only in diplomatic, economic, and military purposes but even in courtly manners and fashion.

MEN'S DRESS OF THE EARLY RENAISSANCE

As discussed previously, not only do the artistic and political developments of the Renaissance begin and end at different times in different sections of Europe, but so do the transitional

clothing styles that bridge the late Middle Ages with the Renaissance. Where the decorative styles of Gothic dress, such as the houppelande and poulaines, persisted in the north well into the third quarter of the 1400s, fashions in Italy instead began to reflect the balance and geometric symmetry of Classicism that were being applied to architecture, painting, and the decorative arts.

Men's jackets of the second half of the fifteenth century incorporated this geometric symmetry particularly in the square body lines and arrangement of pleats in both the front and the back. Jackets were masterfully tailored to fit closely through the shoulders and torso. Usually, jackets were collarless and often made with a wide, deep V-neck at the center back. This allowed for the display of the contrasting fabric and the short, circular collar of the doublet worn underneath. Pleats were constructed through an evenly spaced sequence of gores inserted above the natural waistline or sometimes as high as the upper chest. (Figure 15-1.) Jacket sleeves were varied and included narrow cylinders, huge sacks, and long, hanging tubes with slits for the arms. The most popular jacket sleeve style of the era, though, was full from the shoulder to the elbow and close-fitting from the elbow to the wrist. For active young men who preferred greater ease of movement, jacket sleeve seams were only partially stitched at the top of the shoulder leaving the underarm open, and some sleeve seams were completely open the length of the arm with laces for loosely tying the gap closed. Hemlines of jacket skirts ranged in length from short smooth peplums above the hips to fully pleated crops at the knees. By the beginning of the sixteenth century, young men favored jackets cropped at the waist without a skirt. In the portraits of the Italian nobility and their household servants, these various jackets were often depicted as being made of richly patterned brocades and cut velvets.

Beneath the jacket was worn a form-fitting doublet made with a shallow turned-down collar. By the 1480s, variations of the doublet became alternatives to the jacket as an outer garment. Most doublets were constructed with a separate bodice and short skirt sewn together at the waist. Points were stitched beneath the doublet skirt at the waistline to which thigh-high hose were attached with laces. For short doublets cropped at the waist, men wore joined hose with strings sewn at the waistband that tied to the points at the hemline of the doublet. Moralists of the era particularly objected to what they viewed as the immodesty of the short jackets and doublets and tight hose. In Chaucer's *Parson's Tale*, the new fashions were attacked for their "horrible discordinat scantinesse" that displayed the "shameful membres of man."

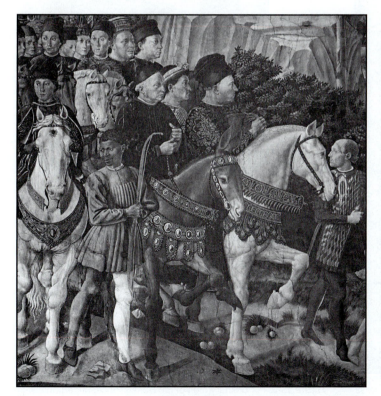

Figure 15-1. In the Italian Renaissance, men's garments were styled with a balance and geometric symmetry that reflected the rediscovery of Classicism. Men's jackets featured square body lines with close-fitting, cylindrical sleeves and short skirts. Long vertical pleats in the front and back reinforced the geometric detailing of men's clothing. Details of *Procession of the Magi* by Benozzo Gozzoli, 1459.

The innermost top garment was the **camicia** (also camisia, camise, camisa), or basic men's shirt. Most were sewn with full **raglan sleeves**, which were fashioned by diagonal seams from the neckline to the side seam under each arm in the front and back. Common men wore shirts of coarse linen cut with narrow sleeves and minimal gathers at the neck; men of wealth had shirts made of fine-gauge linen cut with full, wide sleeves and generous gathers or pleats at the collar. The excess material of the sleeves could be pulled through the slits and open sleeve seams of doublets and jackets to form decorative puffs of plain white fabric against the colorful outer garment.

Men's hose of this period were made in two styles. The traditional set of two leggings continued to be the most prevalent choice for lower classes. Because almost all hose were made of woven fabrics, movement was somewhat restricted. Men of working classes performing exerting labors often untied their hose and rolled them down or let them droop around the lower legs. For men who could afford cut-to-measure hose, the joined form was the most popular. The smoother, tight fit was achieved by cutting the fabric on the bias. The genitals were covered by a contoured flap that tied into place,

and the seat of the hose was tailored with contoured cuts and gores that assured an accurate yet comfortable fit. Both types of men's hose were made in a wide assortment of colors, including particolored patterns. By the end of the fifteenth century, particolored hose were made of complex, intricate insets of geometric shapes. (Figure 15-2.)

The baggy linen drawers of the late Middle Ages continued to serve as underpants for men of working classes although peasants commonly wore nothing beneath their work tunics and skirted jackets. As joined hose became more tailored and form-fitting, men of upper classes opted for briefer types of underpants that would not bunch up and ruin the smooth look of their hose. For the most delicate fit, styles were cut to the barest minimum, almost like modern bikinis, and made of fine, sheer linen and secured with drawstring waists or lace-up flies. (Figure 15-3.)

Men's outerwear continued to be front-closure cloaks, capes, and poncho-style hukes of varying lengths and fabric weights. The particolored techniques of design do not seem

Figure 15-2. One of the enduring design elements of Gothic dress was particoloring, or the insets of contrasting colors of fabric. By the end of the 1400s, men's particolored hose in Italy became flamboyant displays of personal style particularly for young men. Detail of *Stories from the Life of St. Benedict* by Luca Signorelli, 1498.

Figure 15-3. For ordinary men of the Renaissance, underpants were short adaptations of the medieval linen braies. Men of upper classes favored brief versions made of sheer linen that did not interfere with the smooth lines of their hose. Detail of *The Baptism of the Converts* by Masaccio, 1427.

to have been applied to outerwear although contrasting linings were common. Edges trimmed with flamboyant dagging had gone out of style by the last quarter of the 1400s.

The most popular form of men's footwear was round-toed, footed hose reinforced with soft, leather soles. Slip-on ankle boots and calf-high boots were favored for travel, such as those worn by many of the men in the Benozzo Gozzoli *Magi* fresco shown in Figure 15-1. The tops of the soft leather, calf-high boots were often trimmed with scalloped edges or fringe and turned down for a more secure fit.

In keeping with the Renaissance mode of classical simplicity, most Italian men's hats abandoned the richness of fabric and excessive ornamental trim that continued to be popular in northern countries during the same time. Instead, the most prevalent styles were small and brimless, usually with a pliable, unconstructed form although numerous designs were also rigidly blocked to shape. Soft wool felt dyed in assorted shades of red was the predominant material. The clusters of men in the Gozzoli *Magi* fresco show the wide variety of hat and cap silhouettes that were worn by men of all classes. In Italy, men's hats and caps of this period did not serve effectively as elements of class distinction. For instance, the attendants depicted shepherding the animal caravans in the Gozzoli painting wear silhouettes similar in shape and color to those of the aristocrats.

WOMEN'S DRESS
OF THE EARLY RENAISSANCE

At many of the Italian courts during the latter part of the Renaissance, women featured prominently in cultural and political influence. Among the more famous women of the era were Caterina Sforza, Elizabetta Gonzaga, Isabella d'Este, and her younger sister Beatrice. These women of the leisured classes, and many like them, were not the damsels of the Middle Ages who were preoccupied with courts of love and the subtleties of social graces. Instead, many women of the Italian Renaissance were highly educated and spoke multiple languages. They sponsored literary salons, the think-tanks of their day, in which they freely discussed politics, philosophy, and the humanities. And they were arbiters of fashion. Some of these women were as renowned for their wardrobes as for their intellects. So great was Beatrice d'Este's collection of sumptuous dresses—many lavishly embroidered with gold thread and ornamented with pearls and jewels—that her mother complained that her wardrobe room resembled a "sacristy hung with all the canonicals." These ladies of the Renaissance chose styles of dresses that reflected the revived harmony and balance of Classicism. Yet they also indulged in regional pride by having those dresses made with the famous textiles of their homeland. As these female trendsetters led, so followed the rest of the noble houses and affluent middle classes of Italy.

The three principal styles of Italian women's dresses in the late fifteenth century are represented in the *Miracle of the Spini Child* fresco by Domenico Ghirlandaio. (Figure 15-4.) As with menswear of the period, women's dresses incorporated the bilateral, geometric symmetry of Classicism with strong structural lines of vertical pleats intersecting with horizontal yokes, seams, and belts. Elements of construction were squared, rounded, triangular, or cylindrical. However, the most notable difference in the silhouette of these dresses compared with designs of the north is the length of the hemlines. Instead of pooling about the feet in a cumbersome train, skirts were now tailored to the height of the wearer with hems extending to just at the floor or slightly shorter.

The basic gown for everyday wear can be seen on the young girl standing at the right and on the matron in the background to the left. The bodices are close-fitting with a rounded or squared neckline of varying depths. Both examples are girded above the natural waistline. The matron is probably a nurse or household companion for the young noblewomen so her dress is of basic black with a belt of the same material. The sleeves are a close-fitting, tubular style made without the excess of material or slashes that would distinguish her as an aristocrat. Her camicia, or long chemise, is only visible at the neckline.

The girl at the front wears a similar style of dress except hers is layered over another dress. When one views the painting in color, it is evident that Ghirlandaio has depicted a semisheer blue fabric for the outer dress, most likely a gossamer silk through which the red of the dress underneath glows. In addition, the young girl has pushed up the sleeves of the blue outer dress to fully display the vivid red sleeves of the under gown from the elbow to the wrist, which are laced along the open underseam. The girl's white linen chemise is a high-neck variety with an interwoven ribbon and full sleeves that puff through the laces of the under dress.

The young woman standing in the foreground to the left also wears two dresses layered over a chemise. The sleeveless design of the outermost dress is cut in a single piece from the shoulder to the hemline without a seam at the waistline. Instead, lacings at the sides under the arms, and sometimes in the back as well, gave this form of dress a contoured fit. In some representations of this type of over dress, the sides are left open somewhat like the masculine huke. Also typical of these over dresses is a deep V-neck front that, in this instance, reveals the laced bodice of the red gown underneath. The red sleeves of the under dress are accented at the elbows by puffs of the same ivory brocade as the over dress. The white linen of the chemise shows at the bodice neckline and through the lacings of the sleeve.

The decorative slashes on sleeves became most extravagant toward the end of the fifteenth century. In Ghirlandaoi's portrait of Giovanna Tornabuoni shown in Color Plate 6, the

Figure 15-4. Three primary styles of gown were common in Italy of the late 1400s. The typical basic dress shown on the matron in the left background of Ghirlandaio's *Spini* fresco featured a close-fitting bodice with a rounded or squared neckline of varying depths. Sleeves were narrow tubular styles, and bodices were laced to be form-fitting. Belts fastened above the natural waistline. Variations of the basic dress for upper classes included segmented or slashed sleeves to display puffs of linen from the fine linen chemise underneath like the style shown on the young girl standing in the right foreground. The sleeveless over dress worn by the woman in the left foreground was cut in a single piece of material from the shoulder to the hemline without a seam at the waistline. Laces at the sides and back provided a contoured fit. Sometimes the sides were left open like a huke. A deep V-cut front opened to the waist to display the under gown. Sleeves were styled with slashes or open seams. Detail of *Miracle of the Spini Child* by Domenico Ghirlandaio, 1486.

Figure 15-5. Instead of wearing headdresses that completely covered the hair like those of northern European women, Italian ladies of fashion, instead, favored elaborate hairstyles accented with ribbons, jewels, veils, and other decorative ornaments. *Portrait of Battista Sforza* by Piero della Francesco, 1465.

and sheer veils. Small round, oval, or crescent-shaped caps, known today as "**Juliet caps**," were sometimes pinned at the back of the crown, often over a chignon. Long braids that hung down the back were wrapped in a tube of fine fabric and bound by colorful ribbons and silk cords. All manner of jewels were affixed to hairstyles.

Just as modern cosmetic color palettes and application techniques have changed decade to decade, beauty regimens for women of the Italian Renaissance changed significantly in the late fifteenth century. In the early to mid-part of the 1400s, women plucked their hairlines at the forehead and shaved the hairline at the back of the neck for the maximum display of alabaster skin. Eyebrows were plucked to the thinnest of lines, or sometimes removed entirely, along with eyelashes, for a hairless emulation of Classical sculpture. By the later part of the century, hair removal was abandoned. Instead women concentrated their beauty efforts on acquiring or enhancing blonde hair and eyebrows. Compare the hairline in the portrait of Battista Sforza shown in Figure 15-5 with that of Giovanna Tornabuoni shown in Color Plate 6 from twenty-five years later. Women would sit on rooftops wearing hats with open crowns through which their hair could be spread over the brim to bleach in the sun. Various citrus concoctions were added to their tresses to accelerate the process. While in the sun, exceedingly wide hat brims and even veils helped preserve pale white skin, which continued to be highly prized. Sun-browned complexions were a trait of peasants. Even veils worn in the streets had less to do with modesty than the protection of the skin from the sun. In addition, many a dove was boiled in its feathers to produce a bath oil that was thought to enhance the pale suppleness of a woman's skin. In the event nature had not accorded the lady an alabaster complexion, a dusting of white lead powder could provide a deceptive simulation.

MEN'S DRESS OF THE SIXTEENTH CENTURY

The glorious moment in history that was the High Renaissance in Italy lasted but a brief period—from about 1495 to 1520. It was in this short span of time, though, that the genius of Leonardo, Raphael, and Michelangelo reached full flower, in which their observation of nature and quest for originality produced the artistic icons of the era: Da Vinci's *The Last Supper* fresco in Milan, Raphael's *The School of Athens* fresco in the Vatican, and Michelangelo's statue of *David* in Florence.

The remaining decades of the sixteenth century have come to be labeled by art historians as Mannerist, meaning an intellectual formalization by artists of the achievements of the Renaissance masters. Instead of researching and observing nature, artists studied art. This new phase of art emphasized grace, elegance, and virtuoso display of technique. These conceits filtered into all aspects of culture in the 1500s—literature, architecture, music, court etiquette, and, particularly, fashion.

under dress sleeves feature slashes at the shoulder, the back and side of the upper arm, and the elbow. Gold thread laces secure the openings over the fine white linen of the chemise.

Outerwear for women remained the same types of cloaks and capes as earlier in the era. For formal occasions, women of the most affluent patrician families had cloaks made of the same luxuriant fabrics as their dresses. Also, as with men's styles of the period, many women preferred cloaks made with linings of contrasting colors.

Women's shoes are rarely depicted in artwork beyond the glimpse of a toe. The styles were similar to those of men's flat-heel, round-toe slipper designs made with a fabric or soft leather upper.

Instead of the exaggerated headdresses that completely covered the hair of women of northern Europe, Italian women preferred to display elaborate hairstyles and hair ornaments. (Figure 15-5.) Young, unmarried women usually wore their hair long and flowing. Married women of the wealthy classes had time (and assistance from servants) to fashion fanciful arrangements of braids, knots, and buns intertwined with silk ribbons, strands of pearls, gold chains,

In the transition period of the late fifteenth century through the first quarter of the sixteenth, Italian dress began to lose its distinctive style by adapting foreign elements. Most notable in men's clothing was the application of **slashing**. Unlike dagging, which was a scalloped or crenelated cut at the edge of garments, slashing was a decorative treatment of fabric that literally involved the cutting of slits of varying lengths on the surfaces of clothing. **Pinking** was the perforation of material with tiny holes or slits in a row. Tradition holds that the trend of slashing originated with the Swiss military during the Battle of Nancy in 1477. Having routed the forces of the Duke of Burgundy, the Swiss pillaged the duke's camp, shredding the pavilions, banners, bed linens, and any other textiles they found and stuffing the brightly colored fabric strips into the tears of their clothing. Seeing the festive effect this created, some soldiers intentionally slashed their good clothes to insert strips of material to form decorative puffs of contrasting colors and patterns through the cuts. The Germans especially relished the decoration and symbolism of slashing and exuberantly applied it to virtually every inch of their clothing. (See Chapter 16.)

The Italians, on the other hand, adapted slashing only minimally from the 1490s until the mid 1500s when the trend reached a broader application under the influence of the Spanish. Initially, though, the prevalent placement of slashing on men's garments was the upper section of hose, and to a lesser degree, the sleeves of jackets. (Figure 15-6.) The use of decorative slashing as applied during the transition to the sixteenth century should not be confused with the open seam construction of sleeves and bodices that had been popular in Italy for decades. The latter required laces tied over the open seams to fashion the little puffs of linen from the camicia underneath. But slashes were arranged cuts in the fabric, often as small as a couple of inches in length, through which the fabric of an undergarment could be displayed.

As discussed previously, the Italian peninsula was the stage for almost constant warfare for fifty years during the last quarter of the 1400s and the first decades of the 1500s. The ubiquity of military costume in every city and town was a powerful influence on the look of men's everyday clothing. The doublet continued to be the principal outer garment for the torso. Necklines were cut wide and deep in both the front and back. Sleeves became voluminous, and the arm opening dropped off the natural shoulderline emphasizing long necks and long, cascading hair. In the military fashion, doublets were commonly cropped at the waist to which the hose was attached. Another type of military garment appropriated by civilians was the variety of full skirts called **bases**. The examples shown in Figure 15-7 are constructed with deep, columnar pleats called **organ-pipe folds** that were stitched together to hold their shape. Slits were made at the back, front, and sides for horseback riding and battlefield maneuvers.

Because of the wide, open necklines of doublets, the styling of men's shirts became more varied and interesting.

Figure 15-6. Slashing literally involved the cutting of slits in fabric through which showed puffs of material from garments or linings underneath. Italians adapted slashing only minimally until the mid-1500s when Spanish fashions influenced a broader application of the treatment. Detail of the *Trial of Moses* by Giorgione, 1505.

The use of **ruches**, or tightly stitched gathers that formed a ruffle around the neckline of the shirt, forecast the higher collars and ruffs that began to appear in the second quarter of the century. Fine pleating, delicate needlework, and contrasting edging were among the design elements applied to shirts at the neckline.

After decades of war with France and the Holy Roman Empire over the control of Italy, Spain had emerged as the preeminent power in the peninsula by the 1530s. Milan and Naples had become Spanish dependencies and Florence a duchy with ties to Naples by marriage. Consequently, the courts of Italy, including those of independent Venice and Rome, came under the influence of Spanish culture, most especially fashion.

The 1533 portrait of Charles V by Titian illustrates the transition of men's clothing from the full, flowing styles of the High Renaissance as seen in the *Bolsena* fresco to clothing that encases and distorts the figure with an austere elegance. (Figure 15-8.) The emperor's doublet fits tightly and is padded to form a slight protuberance over the abdomen, which is emphasized by a belt that dips low in the front. The high, stiff collar is a revival of Franco-Burgundy styles of a

Figure 15-7. Men's fashions of the High Renaissance in Italy were particularly influenced by military costume. Close-fitting doublets were cut with wide, deep necklines like those of soldiers. Attached to the doublets were bases, or short skirts, constructed with columnar organ-pipe folds. Other design elements such as the opulence of huge sleeves reflected the grandeur of the period. Detail of the *Mass of Bolsena* by Raphael, 1512.

century earlier. Equally stiff and restrictive are the **upper stocks**, or trouser-like upper hose, that fitted about the hips and thighs. No one is certain where the development of the separate stocks and hose first occurred although many costume historians suggest Germany as the origin. These upper stocks were fastened to the hemline of the doublet with laces or points. Some were worn with separate legging-style hose and others were made as a single garment with the hose attached. The upper stocks worn by Charles V feature horizontal bands of silk that are slashed at regular intervals all around through which shows a lining of light-colored fabric.

The design change of this period that is most disconcerting to modern tastes was the contours and dimensions of the codpiece. Costume historians are no exception. Douglas Russell refers to the shape of the new style as "repulsive in the extreme." Lynn Schnurnberger avows it is "the most embarrassing enhancement to manly appeal." And Aileen Ribeiro sees it as "the shape of a permanent erection." Whereas the look of men's hose in the 1400s with its simple, contoured covering for the genitals projected a "quality of sexual provocation," as Anne Hollander refers to it, the codpiece of the 1500s, instead, became a stylized, assertive declaration of masculinity. Now the codpiece was a tailored

accessory—cut and sewn into a projecting horn shape, padded, and accented with ribbons, bows, pinking, and assorted other decorative treatments. Even the hose of prepubescent boys were fashioned with the exaggerated shape of a padded codpiece. Only in the last quarter of the century did this element of men's clothing gradually disappear.

The jacket of the mid-sixteenth century was made full and loose in contrast to the snugly-fitted doublet and upper stocks. It was designed as a geometric mass featuring wide lapels, oversized puffed sleeves, and an overall square cut. The illusion was of broad, masculine shoulders beneath an orderly, symmetrical casement of heavy, rich fabric. Even the wide lapels of fur that were so popular on this style of jacket appeared as severe wedge shapes rather than softening elements.

Indeed, the rigidity of the doublet with its restrictive collar, the tight bands of the upper stocks, and the enveloping mass of the jacket purposefully forced the posture proudly erect into an aloof, forbidding carriage. Such clothing complemented the severe temperament of the Spanish court and its fervid obsession with the efforts of the Counter-Reformation.

By the second half of the 1500s, men's fashions had begun to form the standardized components that would evolve into

Figure 15-8. The transition of men's clothing styles of the mid-sixteenth century was influenced by the Spanish. Garments encased and distorted the figure. Trouser-like upper stocks, a padded codpiece, and jackets with wide lapels and oversized sleeves exaggerated the masculine silhouette and physical proportions. *Charles V with His Dog* by Titian, 1533.

Figure 15-9. During the second half of the 1500s, men's fashions developed the standardized components that would become the modern three-piece suit: vest, trousers, and jacket. *Alessandro Alberti and Page* by an unknown painter, 1560.

today's three-piece suit: vest, trousers and jacket. (Figure 15-9.) At the courts of Spain and Italy, the doublet continued to be padded in the front. In the 1570s, the tailored protuberance reached such distended proportions that the garment came to be known as the **peascod-belly** or **"goose-belly" doublet**. Yet the bulge was confined solely to the front of the garment. The fashion was still very much for a trim, youthful waistline despite the rotund frontal projection.

The Spanish style of sleeves for doublets and jackets in the second half of the sixteenth century narrowed to a close-fitting tube. Sometimes, cuffs were enhanced with a small ruffle or edging, but the visual emphasis moved away from the shoulders and upper arms and shifted to the collar and trousers. The huge leg of mutton puffs were now reduced to small rolls of fabric or rows of tabs called **piccadils** (also pecadils, pickadils or picadills) at the armhole seam.

The high, open-throat collars that had been revived by the Spanish in the early decades of the 1500s came to be decorated with white linen ruffles at the top edge by mid-century. At first, collar ruffles were small and subtly casual, but by the 1550s, they became substantial accents encircling the head just under the ears. Within a generation, those gently pleated collars evolved into the **ruff**, a wide circle of heavily starched, uniform ruffles. By the end of the sixteenth century, the ruff grew ever wider and was layered in tiers for added dimension. (Figure 15-10.)

Men's hose of the period continued to be made in the same two types as earlier in the century, either a pair of leggings or the joined tights style. Although knitting techniques had dated back thousands of years, the labor required for producing a single pair of handknit hose was significant—as

Figure 15-10. The ruff was a formal, wide collar of heavily starched, uniform ruffles that encircled the head. The style developed from softly pleated collars during the mid-1500s and expanded to huge dimensions by the end of the century. Lace trim was added to the ruffs of both men and women. Portrait of *Alessandro Farnese, the Duke of Parma*, by Frans Pourbus, the Younger, 1590.

Figure 15-11. Styles of upper stocks evolved into voluminous variations by the second half of the sixteenth century. Pumpkin hose, or melon breeches as they are sometimes called, were constructed as a pair of padded sack-like leggings over which vertical panes of fabric were sewn. Portrait of a captain with his dog and a cupid by Titian, 1550.

long as six months. Still, the very wealthy began to enjoy the comfort and sleek fit of knit hose, especially made of silk, more and more in the early 1500s despite its exorbitant cost in materials and labor. In a 1499 property inventory of Scotland's Princess Margaret is a listing of "two pairs of hosen, knit." After Queen Elizabeth tried on her first pair of knitted silk hose in 1561, she refused to wear hose of any other kind the rest of her life. In 1589, an Englishman, William Lee, invented a "loome" for machine-knitting hose "from a single thread, in a series of connected loops." Soon afterward, mass production of machine-knitted hose and socks made what had been an exclusive luxury item for the wealthy affordable and available to virtually all classes.

The upper stocks that first appeared at the beginning of the 1500s became fuller in the later decades of the century and were cut in various shapes and lengths. One variety, aptly called **pumpkin hose**, or sometimes known as **melon breeches**, was constructed as a pair of silk or velvet sack leggings over which vertical **panes**, or narrow strips of material, were sewn to the waistband and the garter-like thighbands. (Figure 15-11.) Pumpkin hose were worn either with the thighband pulled down over the leg and showing, or tucked up under the volume of the breeches so that the bottom ends of the outer panes rolled under. Padding helped keep the globular shapes. The balloon-like lining of the breeches was

made with a fullness of fabric that could puff between the outer panes thus continuing the earlier look of slashing.

The tailored, geometric formality of these types of trunk hose still suited the staid fashions of the Spanish court from which it spread throughout its realm of dominion.

In Venice during the last quarter of the sixteenth century, a form of knee breeches then developed from the variants of upper stocks and pumpkin hose. They were cut full through the hips and thighs but tapered to the knees where the fabric was gathered at a banded hem. As this style of breeches spread to the north, they became known as **Venetians** and would be the model for men's trouser designs of the seventeenth century.

Two new forms of men's outerwear were introduced by the Spanish. The **mandilion** was a type of cape with sleeves that was worn loosely draped over the shoulders. Some depictions of the garment in paintings show it rakishly slung

over only one shoulder with the richly embroidered sleeve hanging asymmetrically in the front. The other new form of outerwear came to be known as the **Spanish cape** as it became adapted to northern European menswear. It was basically a short, hooded cape cut as a three-quarter circle and usually cropped to about the hips. Although the long peaked hood could actually be used, it was mostly ornamental, often with lavish embroidery.

Men's shoe styles had begun a significant shift in design during the late fifteenth century. The pointed-toe poulaines that had been popular for so long in the north were not widely adopted in Spain and Italy. By the first quarter of the sixteenth century the slipper-style shoe and ankle boot with their tapered toes were replaced by a new shape that emphasized breadth rather than length. (Figure 15-12.) For those styles that had a low throat at the toes, a strap across the instep was needed to keep the loose-fitting shoes on the foot. In addition to the new wider shape, pinking and slashing were added to complement the decoration of other masculine garments. Some slashed shoes were even made with a fabric lining to form puffs such as those in Figure 15-11.

Of the numerous varieties of men's hats that were popular in Europe in the sixteenth century, two particular types prevailed in Spain and Italy. (Figure 15-13.) From about the end of the first quarter, men's hats became small, pie-shaped designs with a low crown and narrow brim. A wide assortment of these shallow hats with soft crowns became common across all classes. Some included gathers stitched along the rim for an informal touch. Feathers were the most ubiquitous ornament. Although Philip II of Spain occasionally allowed a bit of gold cord trim to his hats, men of the Italian courts preferred the extravagant adornment of jewels in the northern style, especially pearls.

In the last quarter of the 1500s, courtiers all over Europe adopted new hat styles with high, slightly tapering crowns and narrow brims that are thought to have originated in Spain. These new forms of headgear required a rigid construction made of pleated fabric over a frame or panels of material, particularly leather, sewn together like the segments of an orange. For the first time since the disappearance of the bourrelet, hats of the aristocracy attained a look of formality even when worn slightly cocked to one side of the head. Men of the middle and lower classes continued to wear the soft, shallow caps well into the seventeenth century.

Changes in men's grooming of the sixteenth century included very short hair and the return of beards and mustaches. In keeping with the decorous and formal atmosphere of the Spanish court, though, men carefully trimmed and shaped their facial hair to the contours of their faces. Generations of the Hapsburg men of Spain throughout the sixteenth and seventeenth centuries were especially fond of contoured beards, because the carefully shaped facial hair helped disguise the familial trait of their pronounced underbite and jutting, triangular jawline.

WOMEN'S DRESS OF THE SIXTEENTH CENTURY

In Italy, women's transitional dress of the High Renaissance followed the changes of men's designs. The styles of gowns worn in the first quarter of the 1500s became fuller and more flowing, mirroring the oversized doublet sleeves and pleated bases of men's clothing. Necklines were wide and low revealing the edging of an undergown or the chemise. The

Figure 15-12. Men's shoe styles changed from narrow, pointed designs to wide, round-toe versions. Patterns of slashing and pinking covered all surfaces of the upper shoe, and some varieties included fabric linings to form puffs through the slits.

Figure 15-13. The most prevalent men's hat style of the mid-sixteenth century was a small, pie-shaped design with a low crown and narrow brim. These soft, unconstructed caps were popular across all classes. At the end of the 1500s, the formal Spanish hat with its high, tapering crown and narrow brim became the favored style for aristocrats. Leather versions were made in segments stitched together, some of which were decorated with slashing and leather tooling. The high hat design was also achieved with fabric-covered frames.

Figure 15-14. Italian women's gowns of the transitional period in the early 1500s mirrored the full, flowing forms of men's fashions. Necklines were cut wide and deep, and sleeves were massive. The bodice was still laced tightly to be form-fitting and was girded above the natural waistline. Skirts were pleated or gathered for an opulent fullness. Under gowns of contrasting colors were displayed at the hemline, bodice, and particularly the sleeves. Detail of *Sacred and Profane Love* by Titian, 1515.

crimson satin under dress of the woman in Figure 15-14 is displayed by the large puffed sleeve across her lap and a glimpse of the embroidered crimson hem at the bottom of her outer dress. Massive sack sleeves, made all the more voluminous with gathers at the shoulder, were similar in style for both men and women of this period. Outer dresses were still

constructed in one of two ways. Those cut from a single piece of fabric, neckline to hemline, utilized laces at the sides or back for a snug fit of the bodice but still with a fullness below. Those dresses made with a separate bodice and skirt tailored the bodice for a close fit and used pleats or gathers sewn to the waistline for a full, flowing skirt. As with earlier

Lacemaking

One particular element of formality in dress that had wide appeal all over Europe in the second half of the sixteenth century was lace trim. Some historians place the origins of lacemaking with ancient peoples such as the Egyptians whose fingerweaving created intricate open-mesh patterns of loops and knots fundamental to lacework. Similarly, other precursors of lacemaking like the delicate openwork embroidery and open cutwork of Byzantine textiles date to the early Middle Ages. However, lacemaking, as we know it today, cannot be precisely pinpointed to a

specific place and time according to *Lace Magazine.* Apparently at the end of the fifteenth century, different methods of lace production developed in Flanders and Italy at about the same time. The Flemish devised a sort of loom made of a small pillow with pins inserted over the surface to form a specific pattern. Wooden bobbins were used to twist and cross multiple threads to create the airy network of lace (often called **pillow lace**). In Italy, though, a needle was used to produce stitched openwork lace, called **needlepoint lace**, by embroidering over a base of threads arranged in various patterns. By the mid-1500s, the

two methods of lacemaking had blended, quite possibly through a cross-cultural influence of Spain, which possessed sections of the Netherlands as well as large portions of Italy. When the Spanish royal court adapted lace trim to its clothing and accessories, the fashion quickly spread throughout Europe. During the last third of the century, great lengths of lace were applied to enormous ruffs, such as that shown in Figure 15-11, as well as to collars, sleeve cuffs, headdresses, undergarments, handkerchiefs, and other accessories.

dress styles, though, the waistline seam was above the anatomical waist, which was girded by narrow fabric or leather belts.

With the conclusion of the Italian wars in 1535, Spain dominated most of the peninsula, Sardinia, and Sicily. As a result, Spanish culture and style likewise came to eclipse much of the originality and regionalism of Italian court fashions. Moreover, as the dazzling wealth from the New World and the global power of Spain grew in the first half of the sixteenth century, eyes from all over Europe turned to the women's fashions of the Hapsburg court in Madrid. The Spanish styles, though, were neither innovative nor flattering to the feminine form. The soft voluptuousness of Italian designs was discarded in favor of a stiff, conical silhouette. Even more severely than with men's clothing, Spanish women's fashions stylized the lines of the body. Black was the prevailing color for apparel, although deep values of some colors such as burgundy, pine green, or chocolate were indulged. For high state occasions (and imperial portraits), gold brocaded silks and gold embroidered velvets were worn to symbolize Spain's great wealth.

The two key design elements in Spanish women's fashions were the bodice and the farthingale. The gown bodice was pinched and pointed at the waist, fitting tightly and smoothly in a straight line over a constricting corset. Thick padding compressed and concealed any contours of the breasts. Designs of the mid century featured open necklines sometimes as wide as the shoulders. By the last quarter of the 1500s, though, the bodice completely encased the torso and included a high, standing collar. A starched ruff of fine linen or lace was attached to the collar and closely encircled the head up to the ears. (Figure 15-15.) At the end of the century the enormous **cartwheel** or **platter ruff** was adapted to the Spanish bodice. Sleeves were usually made of two parts—a large decorative outer sleeve over a close-fitting inner sleeve. Among the design variations of the outer sleeve was a gigantic bell shape with an open top seam pinned at the wrist. Other styles included versions of the old Gothic hanging sleeves with slits in the front through which the arms could pass.

The Spanish style skirts of the era were constructed as smooth cones that closed down the center front with ties. Silk cords or ribbons affixed with ornate metal tips called **aiglets** secured the front-closure of the skirt. Sometimes the center closure was left open to display an underskirt of a contrasting but equally sumptuous fabric. To ensure a wrinkle-free draping of the skirt, a structured, conical-shaped petticoat called a **farthingale** was fitted underneath as a support. Thin, lightweight circular bands of supple wood gave the farthingale its contours and strength. The heavy, stiff fabric and the wide circular shape of the skirt allowed women to appear to glide as if on casters, further reinforcing an impression of ethereal majesty.

Among other forms of garments that reflected the stiff, conical silhouette of Spanish dress was the **ropa**, a long, open-front outer gown. (Figure 15-16.) The design is thought

Figure 15-15. In Spanish women's dress, the gown bodice was pinched and pointed at the waist, fitting tightly and smoothly in a straight line over a constricting corset. Thick padding compressed and concealed any contours of the breasts. At the end of the century the enormous cartwheel ruff was adapted to the collar. Sleeves were usually made of two parts—a close-fitting inner sleeve over which a decorative outer sleeve was sewn at the shoulder. Skirts were constructed as smooth cones that closed down the center front with ties. To ensure a wrinkle-free draping of the skirt, a hooped petticoat called a farthingale was fitted underneath as a support. *Infanta Isabella Clara Eugenia* by Sanchez Coello, 1585.

to have originated in Portugal as a variation of the Moorish kaftan. The ropas were cut from a single piece of fabric shoulder to hem. Most were sleeveless with piccadils or a roll of fabric at the shoulder although some versions also had puff or funnel sleeves. Variations of the ropa became particularly popular throughout Western Europe during the second half of the sixteenth century.

In Italy, the silhouettes of Spanish dresses were adopted by court ladies but modified to local tastes. Instead of the artifice of the rigid, geometric skirts, most Italian noblewomen maintained the flaring cone shape but preferred to

Figure 15-16. The Spanish ropa was an open-front outer gown that may have originated as a variation of the Moorish kaftan. Most styles were sleeveless with some form of decorative treatment at the shoulder. Versions of the ropa were adapted throughout Europe in the late sixteenth century. *Marguerite of Parma* by Antonio Moro, 1570.

busy street markets and spend her day bending, reaching, and stooping in the daily activities of her home life. Oversized sleeves were a waste of fabric and would only drag through fireplace ashes or knock over kitchen crockery.

Long, open-front cloaks, primarily in black, remained the most common form of women's winter outerwear. Short capes ranging in lengths from the hips to mid-calf were worn both indoors and out in cool weather. Hooded versions were primarily for travelling. Ornamental trim was usually kept to a minimum on these functional garments. The pullover casula disappeared as collar widths and sleeve volumes of dresses increased. At the end of the sixteenth century, tailored, loose-fitting jackets for riding and other out-of-doors activities were made of thick, fine wool for upper-class women. Some jackets were cut almost like men's doublets with short peplums and assorted decorative treatments, and others were made with short skirts of about knee length.

The principal feminine undergarment of the 1500s was the long chemise made of fine-gauge linen for the wealthy and coarser linen or blends for ordinary women. Like men's shirt styles, the collars and necklines of the chemise were often elaborately detailed with decorative stitchery and pleating. By midcentury, wide ruffled collars of chemises were turned back over the necklines of dress bodices, forecasting the elaborate ruffs of the later decades. In addition to the chemise, one or more petticoats with tie-sash waists were worn under farthingales by Spanish noblewomen and under the chemise by the Italians.

At what point bifurcated undergarments first came into use for European women is unclear. Roman women had worn a diaper-like subligaculum, and Teutonic women had worn the same styles of braies under their tunics as men. Following the conversion to Christianity, though, women of the Middle Ages submitted to dogmatic restrictions against wearing any garment that fitted between the legs. The stories of the Crusaders' wives and daughters being locked into chastity belts are cultural myths invented during later periods. Even after men's joined-hose became common for men, women continued to wear the separate knee-high stockings. Thus, it is first in the sixteenth century that we find clear pictorial evidence of women's **drawers**, or long underpants, such as those shown in Figure 15-18. In her study of undergarments, Phillis Cunnington suggests that the use of drawers originated in Italy during the 1500s, and through Catherine de' Medici was introduced into France. "But there is no evidence that the fashion crossed the Channel [to England] during this period," Cunnington concludes.

The constricting corset, too, as a specific form of undergarment, came into widespread use in the 1500s. Paradoxically, just as classical ideas of naturalism were being applied to sculpture, painting, and the decorative arts, fashions became contrived and artificial, shaping and disguising the natural human form. These early types of corset were made of heavy linen in two halves reinforced with thin wooden slats or whalebone and laced together in the front and back. In France, this two-part corset was called a **corps**, meaning

soften it by omitting the farthingale and adding gathers at the waistline. The padded, corseted bodice was retained but the exposed neckline and shoulders endured late into the fourth quarter of the century, well after the Spanish style featured high collars. In addition, the austerity of somber colors did not appeal to most Italians who instead substituted richly patterned fabrics of local manufacture. (Figure 15-17.) Although slashing had briefly waned in Italian fashions, it reemerged under the auspices of Spanish influences.

Contrivances such as the farthingale, ruffs, and huge double sleeves were accoutrement of the upper classes. Through most of the sixteenth century in Italy and Spain, women of working and middle classes wore simplified versions of the courtly styles made of coarse linen or wool. The shape of the pointed-front bodices was adapted to the cut of their dresses but without the layers of padding and the constricting corset underneath that would have impeded taking care of the tasks of daily life. The farthingale was utterly irrelevant to the housewife who had to push her way through

Figure 15-17. Spanish influence on women's fashions of Italy included the padded, corseted bodice with its pointed waist and the conical profile of the skirt. Instead of adapting the structured farthingale for a smooth, rigid skirt line, though, Italian court ladies preferred the softer draping of pleats and gathers. In addition, sumptuously patterned Italian fabrics were favored over the somber, dark solids of the Spanish designs. *Eleanora of Toledo and Her Son*, by Agnolo Bronzino, 1550.

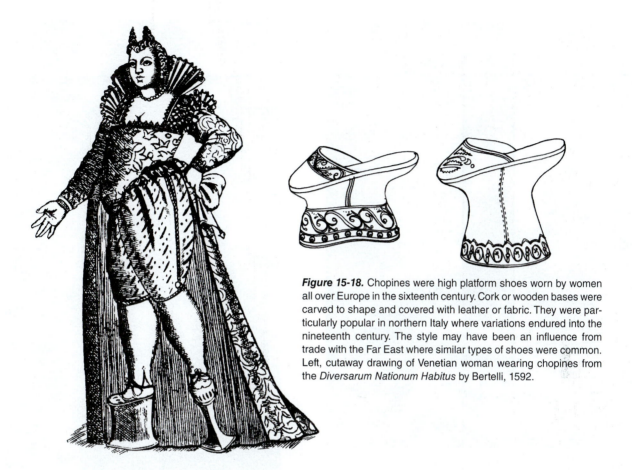

Figure 15-18. Chopines were high platform shoes worn by women all over Europe in the sixteenth century. Cork or wooden bases were carved to shape and covered with leather or fabric. They were particularly popular in northern Italy where variations endured into the nineteenth century. The style may have been an influence from trade with the Far East where similar types of shoes were common. Left, cutaway drawing of Venetian woman wearing chopines from the *Diversarum Nationum Habitus* by Bertelli, 1592.

body, and in England, it was known as a **pair of bodys**. Some varieties of the corps were covered with colorful fabrics and worn on the outside over the dress. A number of iron casings shaped like a perforated corset are preserved in museums as corsets of this period although most costume historians agree that these devices were either orthopedic braces or fantasy pieces from a later date.

Through the mid-1500s, women of both Spain and Italy continued to wear their hair up and fixed in place at the back with a wide assortment of small caps, turbans, or hair ornaments. In the second half of the century, Spanish noblewomen, though, adopted men's styles of caps including the low, shallow shapes and, later, the high domed varieties such as that worn by Princess Isabella in Figure 15-15.

Women's shoes are more clearly represented in innumerable engravings, sketches, and paintings of the late 1500s than prior to the Renaissance. Styles closely followed those of men's designs—flat-heel, round-toe slippers, some with straps across the instep, and later in the century, wider varieties, often with decorative pinking. The most distinctive types of women's shoes of the period were the high platform **chopines**. (Figure 15-18.) Bases were made of fabric- or leather-covered cork or carved wood, and ranged from a few inches in height to almost two feet. Since only women of

upper classes (or leisure status such as courtesans) could indulge in such fashionable excesses, they usually had servants in attendance to steady their balance as they gingerly strolled about the city. These platform shoes possibly were adapted from similar types brought from China and Japan. Depictions of women wearing chopines in paintings and drawings of the late 1500s show either an extra long skirt with a hemline at the ground completely concealing the shoes or a regular hemline that covered only the tops of the shoes but left exposed the tall platforms. Although versions of the chopine became popular throughout Europe, the style endured longest in northern Italy, particularly soggy Venice where variations continued in use into the nineteenth century.

CHILDREN'S DRESS OF THE SIXTEENTH CENTURY

Both genders of infants and toddler children were dressed in long, loose tunics, which allowed mothers to change diapers easily. Styles of the little gowns were usually T-cut with short or half sleeves and cropped at the knees or ankles, depending on the child's toddling aptitude. Between about the ages of three and five or six, boys of upper classes were dressed as girls in diminutive gowns and accessories

Figure 15-19. Although toddler boys were ordinarily dressed as girls with gowns and feminine accessories, by the age of five or six they adopted miniature versions of menswear, including hose, jackets, doublets, cloaks, and even small-scale armaments. Detail of the *Portrait of the Vendramin Family* by Titian, 1547.

Figure 15-20. As with boys, girls of the sixteenth century were dressed in diminutive versions of women's apparel. For the Spanish princesses, that included the rigid, padded bodice, high collar, stiff ruff, farthingale, and heavy skirt. Detail of the *Daughters of Philip II* by Sanchez Coello, 1580.

modeled on women's styles. Older boys wore in miniature the same full array of clothing styles as men including hose, doublets, hukes, jackets, and cloaks. (Figure 15-19.) Even the exaggerated, stuffed codpieces were applied to boy's hose, upper stocks, or pumpkin breeches. Boys of aristocratic families were trained young in hunting and military skills for which they wore small-scale daggers and swords as accessories. Little princes often were fitted with ceremonial suits of armor.

Girls, likewise, wore miniature versions of women's gowns. Portraits of the Spanish royal family depict the somber young daughters already in training for regal bearing by being trussed up into constricting bodices, high collars, ruffs, and farthingales. (Figure 15-20.)

REVIEW

The Renaissance in Europe was a transitional period in which the medieval world dominated by the legalism and absolutism of a feudal order was abruptly eclipsed by the brilliance of a

new age in which man, as the individual, was placed at the center of the universe. Classical literature, art, and architecture were rediscovered. Explorers discovered oceans, lands, and cultures hitherto unknown to Europeans.

This era of rebirth from the darkness of the Middle Ages emerged first in Italy and then spread to northern Europe in different phases from the late fifteenth through the sixteenth century. With the wealth from its New World holdings and its military might, Spain became the preeminent power in the 1500s. Even much of Italy came under the authority of the Spanish. From the royal court in Madrid, economic, diplomatic, and cultural influences radiated throughout Europe.

Prior to Spanish dominion in Italy, though, clothing styles during the Renaissance reflected the design, balance, and geometric symmetry of Classicism as it was then applied to the arts. Men's jackets were cut with square body lines and evenly placed pleats. Cropped doublets were fitted with bases, or short skirts, constructed with even, organ-pipe folds. Necklines

became wide and deep, creating new emphasis on the camicia, or basic linen shirt. Voluminous sleeves and full skirts of both men's and women's garments were expressive of the grandeur of the Renaissance. Women's gowns featured a dramatic change in silhouette from the long Gothic lines with trains that pooled about the feet to floor-length hemlines cropped to the height of the wearer. Instead of the exaggerated headdresses of Northern Europe that completely concealed the hair, Italian women, instead, preferred to display elaborate hairstyles accented with small caps and hair ornaments.

With Spain's rise to power in the early 1500s, fashion styles shifted to the formal, austere designs from Madrid. Rather than the full, flowing styles of the Italian Renaissance, men's clothing encased and distorted the figure. Jackets and doublets fitted snugly and sported a padded front called the peascod belly. Shirt collars evolved from soft, simple pleats to the enormous platter ruffs with their rigidly uniform ruffles. Upper hose, called stocks, similarly expanded into formal, geometric variations such as pumpkin hose and voluminous knee breeches known as Venetians.

Women's fashions of the sixteenth-century Spanish court were equally rigid and formal. The gown bodice fitted tightly over a constricting corset that compressed the contours of the bosom. High-standing collars and wide, stiff ruffs forced the head erect. Skirts flared smoothly over a conical, structured farthingale.

In addition, new technologies led to fashion change. Methods of lace production were refined, providing elegant options for fashion accents. Machine-knit hose replaced the need for cut-to-measure tailoring to achieve a smooth, sleek fit.

These new forms of fashion—upper stocks and breeches, the farthingale and corset, platter ruffs, lace trim, and knit hose—were radical innovations in European dress. Throughout the sixteenth century, figure-altering silhouettes swept Europe in waves, demonstrating the internationalism of fashion. Moreover, changes occurred with an increasingly rapid frequency that instilled in the arbiters of style an insatiable desire for constant innovation, thus setting the stage for the fashion drama of the seventeenth century.

Chapter 15 Italy and Spain in the Renaissance
Questions

1. How did Classicism influence Italian fashions of the Renaissance? What specific garments and design styling reflected the adaptation of Classical elements?

2. Which two key design features of Italian men's and women's outer garments provided emphasis on the camicia? What were some of the design enhancements of the Renaissance camicia?

3. Describe the three principal styles of Italian women's dresses in the late fifteenth century.

4. How did Italian women's headgear differ from that of northern European women of the late fifteenth century?

5. Which significant changes occurred with men's hose of the 1500s? Which variants evolved during the last decades of the century? How were these later styles constructed to achieve their distinctive silhouette? Which technological advancement altered the way men's and women's hose were made?

6. Identify by name and describe three garments or accessories that dramatically altered the silhouette of men's fashions in the sixteenth century.

7. Identify the three primary silhouettes of men's hats in the sixteenth century in the order in which they developed.

8. Describe the difference in Flemish and Italian lacemaking techniques of the 1500s.

9. What were the distinctive elements of the Spanish woman's dress, and how did they reflect the formality of the royal court.

Chapter 15 Italy and Spain in the Renaissance
Research and Portfolio Projects

Research:

1. Write a research paper on the emergence of humanism during the Renaissance and how that philosophy impacted dress in Italy and Spain.

2. Write a research paper comparing how Classicism was applied to architecture, painting, and dress of the Renaissance.

Portfolio:

1. Research the construction of sixteenth-century ruffs and make one of paper. Use paper doilies for lace trim. Demonstrate to the class how the ruff was put on and worn.

2. Prepare a pattern swatch book of 100 Italian brocade patterns of the Renaissance. Use photocopies or digital scans of different textile patterns depicted in paintings c. 1450–1600. Arrange chronologically. Label each with the source (name of painting, artist, and date of work) and a brief description of colors and pattern motifs in the fabric.

Glossary of Dress Terms

aiglets: ornamental metal tips attached to tie strings and binding ribbons to prevent fraying

bases: men's short, full skirts usually constructed with vertical columnar pleats

camicia (also camisia, camise, camisa): a basic, long-sleeve men's shirt or woman's chemise, usually made of linen

cartwheel ruff: enormous, round collars of ruffles that encircled the head

chopines: women's high platform shoes

corps: the French term, meaning "body," for a constricting lace-up corset

drawers: long underpants of varying lengths worn by both men and women

farthingale: a woman's hooped, conical-shaped petticoat

goose belly: another name for peascod belly; see peascod belly

Juliet cap: a small round, oval, or crescent-shaped cap that fit at the back of a woman's head

mandilion: a type of cape with sleeves worn loosely draped over the shoulders.

melon breeches: another name for pumpkin hose; see pumpkin hose

needlepoint lace: Italian lace made by embroidering over a base of threads arranged in various patterns

organ-pipe folds: deep, columnar pleats usually fashioned for men's bases

pair of bodys: the English name for a constricting corset fashioned of a front and back panel laced together

panes: vertical strips of fabric sewn over pumpkin hose to create the illusion of slashing

peascod belly: a protuberance of padding tailored to the front waist of men's doublets and jackets

piccadils: small rolls of fabric or rows of tabs at the armhole seam of women's bodices and men's doublets

pillow lace: Flemish lace produced on a sort of loom made with pins inserted into a small pillow to form a pattern

pinking: the perforation of material with tiny holes or slits in a row

platter ruff: another name for cartwheel ruff; see cartwheel ruff

pumpkin hose: trousers made with large, balloon-like leggings padded to shape and covered with vertical strips of fabric

raglan sleeve: a sleeve sewn to the bodice of a garment along a diagonal seam from the neckline in the front and back to the side seam under each arm

ropa: a Spanish woman's long, open-front outer gown, usually sleeveless with a decorative treatment at the shoulder

ruches: tightly stitched gathers that form ruffles at the edge of material or a puckered pattern on the surface

ruff: formal collars of stylized ruffles that encircle the head worn by men and women

slashing: slits of varying lengths cut into fabric as a decorative treatment

Spanish cape: a short hip-length cape cut as a three-quarter circle with a decorative hood attached

upper stocks: men's trouser-like upper hose that fit about the hips and thighs

Venetians: knee breeches cut full through the hips and thighs but tapering to the knees

Legacies and Influences of Sixteenth-Century Spanish and Italian Styles on Modern Fashion

The fashion innovations of the sixteenth century in Spain and Italy were contrived, constricting, and contorting, but at the same time fresh and exciting in their visual diversity. Many of the silhouettes and fashion details that characterize the styles of the 1500s continually recur in our modern styles with fresh adaptations and applications.

The high-neck collars of the Spanish court had themselves been a revival of styles from a century earlier. During the Edwardian era (1901–1910), England's Queen Alexandra popularized the regal look anew. The style was quickly appropriated by all classes and made widely available through the mass production of inexpensive ready-to-wear adaptations.

Lace, too, became more readily available to all classes through advances in mass-production technologies of the industrial revolution. By the beginning of the twentieth century, fine-quality machine-made lace covered entire garments and accessories from blouses and parasols to wedding gowns. Although abundantly available and affordable, the delicacy and luxuriousness of manufactured lace limited its use primarily to formal, or at least "Sunday-best," apparel.

Despite the impracticality of slashing, with the need for a constant vigilance against tears and fraying, some forms were adapted to modern fashions. Piccadils, particularly, were decorative treatments that trimmed innumerable sleeves, pockets, and hemlines of all sorts of women's garments.

The constricting corset continued to be popular in variations from the sixteenth century until the late 1960s when the miniskirt made heavy foundation garments obsolete. Newly engineered versions of the corset were again reintroduced at the end of the 1970s to alter the feminine profile just as in the days of old. Since the 1980s, varieties of the corset also have been adapted as a form-fitting outer top for young women.

Another sixteenth-century silhouette that was revived in modern times was the rigidly smooth, cone-shaped skirt. In the 1950s especially, layers of stiff petticoats—some made with hoops of wire or crisp synthetic fabrics—formed the support foundation for full circular skirts, just as the farthingale had 400 years earlier.

Inspired by England's Queen Alexandra, high-neck collars became a prevailing style for women's apparel in the Edwardian era. Ready-to-wear blouses from Franklin Simon, 1908.

New techniques of textile mass production during the nineteenth-century industrial revolution made lace affordable for virtually all classes. Its application ranged from accent trim to entire garments made of lace. Lace-trimmed dress, 2008.

Among the forms of slashing that have been adapted to modern fashions are panes, or strips of fabric, through which an undergarment shows, and piccadils, the rows of looped tabs used as edge trim. Left, crepe rayon dress by Kasper, 1957; center, gabardine wool suit jacket with pockets trimmed with piccadils by Janet Norwood, 1950; right, rayon crepe blouse with decorative slashing by Bates, 1946.

The smooth, conical silhouette of sixteenth-century Spanish skirts reappeared in the 1950s with the aid of layered stiff petticoats. Dresses of nylon tulle banded with satin by Von Marek, 1957.

In the late 1980s, the revival of the corset appeared not only as a constricting undergarment but also as an outer top similar to versions of the sixteenth century. Cotton corset tops by Dina, 1987.

Chapter 16

THE NORTHERN RENAISSANCE

ENGLAND	Henry VIII reigned 1509–47	Henry VIII became head of Church of England 1535	Reigns of Edward VI 1547–53 and Mary Tudor 1553–58	Elizabeth I became Queen 1558–1603	Frances Drake circumnavigated the world 1580	First English colony in America at Roanoke 1585	England defeated the Spanish Armada 1588	Shakespeare wrote his first play 1590
1500								1600

FRANCE	Francis I reigned 1515–47	Leonardo da Vinci in France 1516–19	The Louvre Palace begun 1547	Henry II 1547–59 persecuted Protestants	France surrendered claims to Italian territories 1559	Catherine de' Medici ruled as regent for Charles IX 1560–88	Reign of Henry III 1574–89 marked by religious civil war	Religious reconciliation in reign of Henry IV 1589–1610
1500								1600

GERMANY and FLANDERS	Antwept became Portugal's trade center 1501	Albrecht Durer visited Italy 1506	Martin Luther wrote his Protestant doctrines 1513–17	Charles V 1519–56 united Spain and the Holy Roman Empire	Germans sacked Rome 1527	Copernicus asserted the rotation of the planets around the sun 1543	Hapsburgs repulsed Turks in Hungary 1532	Netherlands became independent from Spain 1581
1500								1600

THE RENAISSANCE IN NORTHERN EUROPE

The cultural phenomenon that occurred in Italy in the late fifteenth century—a rebirth of secular learning and a rediscovery of Classical art and literature—spread to Northern Europe only gradually in the 1500s. The legalisms and social traditions of feudalism were tenacious north of the Alps, particularly in recalcitrant England. The humanist notions of the individual and independent thought were resisted across all strata of society, even by the best educated. During the second and third decades of the sixteenth century, though, significant economic and political changes occurred to lay the groundwork for a northern renaissance.

In France, the energetic, enlightened Francis I ascended the throne in 1515. During his thirty-two-year reign he eagerly imported the Italian Renaissance into France, bringing in Leonardo da Vinci, Andrea del Sarto, and Benvenuto Cellini, among others, whose ideas of Classicism supplanted the lingering International Gothic style in art and architecture. The new royal palace at Fontainebleau was decorated in the grand Italianate manner to glorify the monarchy. A lavish array of paintings and sculpture depicted secular symbolism and humanist themes. This in itself was a significant change in medieval concepts where the Church always had been the preeminent feudal authority. The new forms of architecture, interior decorations, and artwork of the French Renaissance asserted that it was the king and not the Church who now held supreme power.

The importation of Italian influences into France increased during the second half of the century under the aegis of Catherine de' Medici who was queen to Henry II, son of Francis I. She summoned from her homeland tailors, accessory craftsmen, perfumers, cooks, and other similar talent to elevate the sophistication and elegance of the French court.

371

After her husband's death, Catherine continued to be the power behind the throne of her three sons, Francis II, Charles IX, and Henry III. It was during this period that France was in turmoil from religious civil wars. At Catherine's urging, first her husband and then her sons pursued an aggressive agenda against the emergence of Protestantism. The destructive conflicts were finally ended by Henry IV who issued the Edict of Nantes in 1598 providing for tolerance of Protestants in France.

The confederation of German states, loosely bound together as the Holy Roman Empire, was the center of Europe's most profound break with it medieval roots—the Reformation. Between 1513 and 1517, the Wittenberg clergyman, Martin Luther, refined and lectured on his ideas of salvation by personal faith rather than intercession by priests. Luther also objected to the abuses of the Church such as the selling of indulgences, or pardons for sins. In 1517, he nailed his theses—or protests—to the church door and Protestantism was launched.

The doctrines of Protestantism appealed to the masses and the movement spread quickly. Advances in printing technology, beginning with Gutenberg's development of moveable type and the mechanical printing press in the 1430s, made possible the dissemination of Protestant pamphlets and hymns, as well as a German version of the Bible. German princes who wished to better enhance their own power and wealth at the expense of Rome's authority encouraged the Protestant movement.

Northern humanists also embraced the break with Rome and the resulting freedom of academic debate and advancement in the sciences. For example, in 1547, Copernicus was able to publish his theories that the planets orbited the sun despite denouncements from Rome. In the arts, the ideas of the Italian Renaissance were brought to Germany by its great masters, most notably, Albrecht Durer, who had twice visited Italy.

Flanders—now Belgium and the Netherlands—was a possession of the Spanish Hapsburgs in the sixteenth century. The citizens of the large commercial centers in Flanders were tolerant and cosmopolitan. Theirs was a concern more for commerce than for ideological allegiances. In 1501, Antwerp was chartered as the distribution center for Portuguese imports of rare spices and goods from India and the Far East. As a result, the city quickly became the financial capital of Western Europe with banking branches as far away as Italy.

Despite the efforts of Catholic Charles V and, later, his son Philip II, Protestantism took firm root in Flanders. Religious unrest led to political instability resulting in a direct intervention of Spanish armies in 1566. For almost twenty years, Flemish communities were in constant revolt for which they were subjected to Spanish oppression and brutality. In the end, the drain on the finances of the Hapsburgs was too much, and Spain finally ceded the northern provinces to the Protestants who established a Dutch republic.

Protestantism also paved the way for a revitalization of Flemish art, which in the previous century had reached such prominence in the High Gothic style. The earlier dominance of medieval religious motives in art eventually yielded to Renaissance-inspired experiments in landscape, still lifes, portraiture, and social genres. Sixteenth-century Flemish artists were keenly interested in the interrelationships of man and nature. The greatest and most original Flemish painter of the era was Pieter Bruegel in whose works the everyday activities of ordinary people are depicted with a fresh naturalism and wit.

In England, the sixteenth century was the era of the Tudor dynasty. Henry VII had brought an end to the devastating War of the Roses in the late fifteenth century and established a stable government, which, upon his death in 1515, had amassed a huge surplus in the royal treasury.

His son, Henry VIII, was a tall, stout man with a hedonistic appetite for athletics, fine clothes, beautiful women, and food. He was well educated and an accomplished musician, but the court of Henry VIII was not a center of Renaissance learning and humanist ideas. While much of the rest of Western Europe began to adapt the classical principles of the Italian Renaissance to their national arts in the early 1500s, English architecture and art continued to excel in the Gothic mode.

Although the Reformation came to England as early as 1519 with the distribution of printed copies of Luther's theses, Henry VIII and his government staunchly opposed the movement. The king himself even wrote a book attacking Protestant doctrine and was given the title of "Defender of the Faith" by the pope. All of this changed, though, when Rome denied Henry a divorce from his wife of eighteen years, Catherine of Aragon, who had failed to produce a male heir. England's break with Rome occurred gradually over several years culminating in the Act of Supremacy in 1534 by which Henry became the head of the Church of England.

During the regency of Henry's only son, Edward VI, who was only nine at his accession in 1547, Protestantism expanded throughout England as fiery preachers evangelized from their pulpits, and printing presses flooded every hamlet with anti-Catholic pamphlets. Religious services were ordered to be held in English instead of Latin. A new prayer book in 1552 altered the communion service to repudiate the Catholic idea of the mass as a sacrifice. But when Edward died in 1553, his Catholic sister, Mary, became queen.

Mary I, daughter of Henry VIII and Catherine of Aragon, was a thirty-seven-year-old spinster who lacked administrative and political skills. In an attempt to secure the succession, she married the future king of Spain, Philip II. As a result, England was brought into war with France and ultimately lost Calais, the last English territory on the continent. Even worse, Mary attempted a reversion to Catholicism with a campaign of persecution that left her with the nickname of "Mary, Bloody Mary." She died childless in 1558, despised by her subjects.

Henry VIII's surviving daughter, Elizabeth, ruled for forty-five years (1558–1603). Although Elizabeth was a Protestant, she steered a middle course in religious affairs to better unite the moderates of both faiths. She was shrewd in politics and adroit in management. Costly wars with Irish and Scottish lords caused her to turn a blind eye to English adventurers like Francis Drake and Walter Raleigh whose privateering—some would say piracy—netted the crown substantial profits.

It was the Elizabethan era that most historians attribute as the English Renaissance. The flourishing of culture was manifested less in the visual arts and architecture than in literature, music, and drama. It was as much an age of Shakespeare as that of Elizabeth Gloriana.

MEN'S DRESS IN THE NORTHERN RENAISSANCE 1500–1550

Across northern Europe, the first quarter of the 1500s was a period of transition for men's dress. Late Gothic styles persisted throughout France, Germany, Flanders, and England combined with some adaptations of Italian designs. In a second phase from about 1520 into the 1550s, elements of German styles were incorporated into the mix of Gothic and Italian looks due, in part, to the international socio-political changes swept in by the Reformation. During the third phase from the mid-1500s through the end of the century, Spanish influences dominated.

Despite lingering forms of Gothic apparel in the first decades of the sixteenth century, men's fashions underwent some significant modifications with distinct influences from Italy. As word of the extraordinary achievements of the High Renaissance spread, educated men of the north traveled to Italy to experience the rebirth of classicism and see the marvels of art and architecture in Florence, Rome, and Venice. In addition, Italian scholars and artists by the dozens were invited to the courts and urban centers of the north. Furthermore, the repeated invasions of Italy by the French, Spanish, and Germans during this period brought all classes of soldier and officer into contact with Italian clothing styles, both military and civilian. From these cross-cultural encounters came the influences of the new Italian designs on the dress of the north.

The first noticeable change was with the necklines of men's doublets and jackets. The high collars of the Gothic styles were eliminated in favor of the open, square and oval lines that had developed in Italy at the end of the 1400s. (Figure 16-1.) As with the Italian outer garments, the deep necklines required a new emphasis on the shirt because so much of it now showed. For the upper classes, shirts were made of fine linen detailed with ruching, gathers, pleats, tucks, ruffles, and other decorative construction elements applied at the collar and cuffs.

The Italian silhouette of the doublet and jacket with its snug-fitting bodice and voluminous sleeves well suited men

Figure 16-1. During the early decades of the sixteenth century, the clothing of men in northern Europe was influenced by fashions of the Italian High Renaissance. Among the changes were wide, square- and oval-cut necklines and voluminous sleeves for jackets and doublets. New emphasis was placed on the shirt, which was finely detailed with decorative treatments at the neckline and cuffs. *Benedikt von Hertenstein* by Hans Holbein, 1517.

of the north. Either garment could be worn independently although the appropriately attired aristocrat would wear both, with the longer jacket layered over the doublet. Jacket skirts were somewhat uniform in length, usually to the knees, but doublets might have skirts at mid-thigh or cropped at the waist. (Figure 16-2.) In England, a type of doublet called a **paltock**, often sleeveless, was cut with a deep U- or V-front opening into which was inserted a panel of fabric called a **stomacher**. The stomacher might be pinned into place or tied to the paltock with laces. Sometimes, the stomacher was made with fabrics of contrasting colors or patterns.

Although bases are known to have been worn in the north during this period, it is often difficult to determine in portraits if the figures are wearing separate bases or skirted jackets. In either case, bases and jacket skirts were less full than Italian styles. Instead of deep, columnar folds, gathers

Figure 16-2. Knee-length Italianate bases and jacket skirts remained popular with men of northern Europe into the mid-1500s. *Henry VIII* by Hans Holbein the Younger, 1537.

were stitched to drape softly, or pleats were spaced to lie flat around the hips.

Adaptations of the huge Italian sleeves appeared as gigantic puffed half-sleeves on an open-front outer robe called a **chamarre**, or **schaub** in Germany and Flanders. The English versions shown in Figures 16-1 and 16-2 feature the typical dropped shoulder line and wide lapels that helped create the illusion of broad masculine shoulders. Lengths were at the knees although some extended slightly longer. The chamarres of the wealthy were made of rich brocades, velvets, and embroidered satins, often lined with fur. The plain woolen, long-sleeve types worn by middle classes served as outerwear, and even as a sort of uniform for scholars and clerks.

In France at the time of Francis I, a variation of the chamarre omitted the puffed sleeves and instead was cut like a rectilinear cape. This style is depicted in the Clouet painting of Francis shown in Figure 16-3 and in a similar, full-length equestrian portrait of the king in the Musée Conde. In both representations, the edges of the robe that ordinarily would drape to the hands have been turned back and tucked under the elaborately embroidered lapels displaying the satin lining and exposing the slashed sleeves of the jacket.

Joined hose were still laced to the underside of the doublet or jacket as they had been with the earlier pourpoint. Flamboyant particolored construction disappeared during the first decade of the 1500s. As with the Spanish and Italian styles of hose and upper stocks during the second quarter of the century, codpieces became exaggerated, padded horn shapes that were decorated with pinking, embroidery, ribbons, and other similar trimmings.

Men's outerwear remained basically the same as that of the end of the fifteenth century. Circular and ovoid capes and cloaks of heavy wool were the most common, although longer oblong styles were often preferred for travel.

Toward the end of the 1400s, the long, pointed poulaine had been replaced by shallow, broad styles of footwear called

Slashing

Slashing was far more prevalent in northern Europe than in Italy. As described in the previous chapter, the technique originated with German and Swiss mercenary soldiers, called Landsknechten, who spread the innovative look to the civilian populace in the late 1400s. Indeed, the Germans applied slashing far more exuberantly than anyone else.

Virtually every surface was embellished with assorted shapes and sizes of slashes and pinking—crescents, zig-zags, diagonals, S-cuts, V-cuts, U-cuts. Some men even went so far as to slash off the lower part of one leg of their hose at the knee or mid-thigh exposing a bare leg or a stocking of a contrasting color.

This latter method may have led to the development of separate upper stocks over nether hose. The portrait of

Henry, Duke of Saxony, from 1514 already shows a very early use of upper stocks. (Figure 16-4.) His knee-length version is bound about the knees with ribbons over smooth nether hose covering the lower legs.

By the middle of the sixteenth century, slashing had become popular throughout Europe for both men and women although the technique was less vigorously applied than with the Germans.

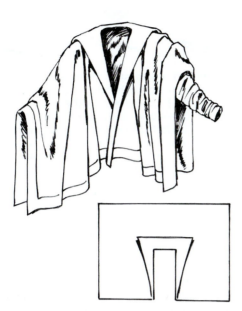

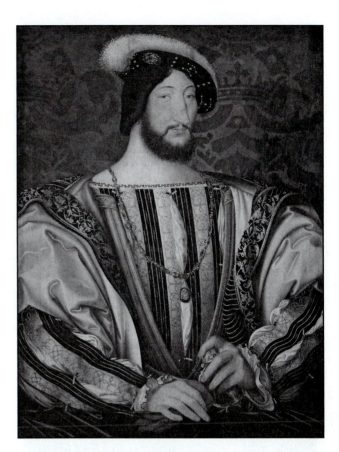

Figure 16-3. The French variation of the chamarre was cut as a rectilinear cape rather than the more typical open-front robe. *Francis I* by Jean Clouet, 1525.

duckbill shoes. (Figure 16-5.) The wide shape of men's shoes reflected the broad silhouettes of the jackets, capes, and cloaks. By the beginning of the sixteenth century, the blunt, squared toes of shoes became so wide that it is difficult to imagine how the wearer kept the shoes on when walking, let alone climbing stairs or horseback riding. For duckbills that had a low throat—some barely covering the toes—straps across the instep were needed. Boots were most commonly worn by ordinary men, especially rustics whose daily work took them into rough terrains. But such utilitarian footwear was usually devoid of decorative slashing that might get snagged on brambles and brush. High-quality leather riding boots that extended to the knees and even mid-thigh were adopted by elite classes from the Spanish during the 1540s.

Men's hats also underwent an overall change in dimension and shape. Although a wide variety of hats continued to be popular into the middle of the sixteenth century, the leaders of fashion—the nobility and wealthy middle classes—introduced the new, smaller forms of headwear from Italy. The close-fitting, pie-shaped styles with narrow, upturned brims worn by Henry VIII and Francis I in Figures 16-2 and 16-3 became the most prevalent types of hats throughout northern Europe except in Germany. The flat, horizontal profile complemented the wide, horizontal expanse of shoulder lines and footwear. Men of the Holy Roman Empire, instead, still opted for the large variants of late Gothic hats,

which they further enhanced with enormous arrangements of ostrich feathers, streamers, and swags of fabric.

MEN'S DRESS IN THE NORTHERN RENAISSANCE 1550–1600

As discussed in the preceding chapter, by the middle of the sixteenth century, Spain emerged from decades of wars with England, France, and the Holy Roman Empire as the triumphant, super power in Europe. Tons of gold, silver, and other treasure poured into the royal exchequer from vast holdings in the New World and trading centers in the Far East. The eyes of monarchs and nobility from all the courts of Europe turned toward Madrid to take note of the look and courtly standards of such power, wealth, and authority.

Many historians credit Catherine de' Medici with inspiring the changes in French clothing designs for both men and women in the mid-sixteenth century. Even though her Florentine family had sent her off to provincial Paris to marry the future Henry II in 1533, she continually brought in the latest fashions, accessories, and other stylish accoutrement from Italy and Spain until her death in 1589.

Spanish styles came to influence the clothing designs of Tudor England through three sources. Catherine of Aragon, the first wife of Henry VIII, was the daughter of Isabella and Ferdinand of Spain. Through her, the prevailing Italian fashion trends were introduced via Madrid. In 1554, Mary I, daughter

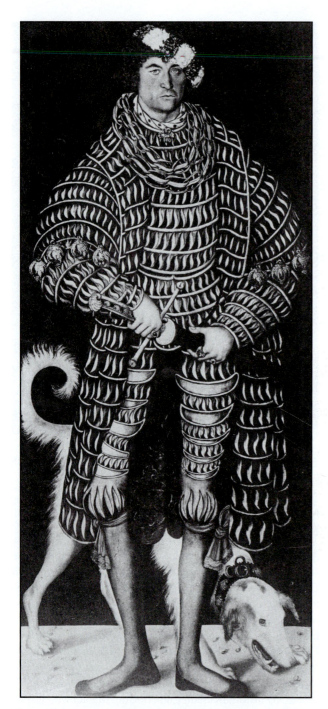

Figure 16-5. In Germany, wide-toe styles of shoes, called duckbills, had begun to replace the pointed poulaines in the late fifteenth century. By the beginning of the 1500s, the blunt, squared-toe designs had become the prevailing style for men and women of all classes across Europe. For duckbills cut with low throats that barely covered the toes, straps across the instep were necessary to keep the shoes on. Slashing and pinking were lavishly applied in a wide assortment of patterns and sizes.

Figure 16-4. Aspects of German fashions that spread throughout northern Europe in the first half of the 1500s included slashing and pinking applied to almost every garment surface. From the cropping of hose developed upper stocks, a form of breeches worn separately over lower leggings called nether hose. In addition, wide duckbill shoes were adopted by all classes of men. *Duke Henry the Pious* by Lucas Cranach, 1514.

of Henry VIII and Catherine, married the future Spanish king, Philip II. The queen and the English court eagerly copied the styles of the Spanish entourage. Finally, Tudor clothing styles were influenced by Spanish designs through England's commercial ties to nearby Flanders, a Spanish possession. Not only were English raw materials like wool and flax exported to the Flemish guilds for processing and manufacturing into textiles, but English-made fabrics were also sent across the channel for dyeing and fulling. In return, boatloads of finished materials were imported from Flanders including many types of apparel. The steady mercantile and diplomatic contacts between the English and the courts of the Hapsburg governors in Flanders encouraged Spanish influences in fashions especially during the 1540s and 1550s.

Although men's short, skirted jackets and knee-length bases remained popular in northern Europe much longer than in Spain and Italy, the new silhouettes of German trunk hose (as adapted from the Spanish styles) and cropped, narrow jackets began to supplant the remnants of Gothic styles in the 1540s.

The broad expanse of jackets was soon reduced to the natural breadth of the shoulders, and the voluminous puff sleeves were replaced by close-fitting tubular sleeves. (Figure 16-6.) In lieu of exaggerated shoulders, padding the front of the jacket or doublet into a protruding peascod belly became the new fashion throughout Europe. In Germany and England, the trend evolved some forms in which the distended, pointed waistline of the doublet became so elongated that it overlapped the codpiece.

The necklines of jackets and doublets also changed dramatically in the second half of the sixteenth century. During the transition period of the 1540s and 1550s, collars reappeared, replacing the deep, open oval and square necklines. As jacket collars rose, so did shirt collars, many of which were edged in soft ruffles or pleats. By the third quarter of the century, jacket collars for the elite classes followed the Spanish style of fitting up to the ears with stiffly starched, formal ruffs. Variations of the ruff continued to widen until, by the end of the century, the platter or cartwheel ruff extended as wide as the shoulders. Ruffs with lace trim or made entirely

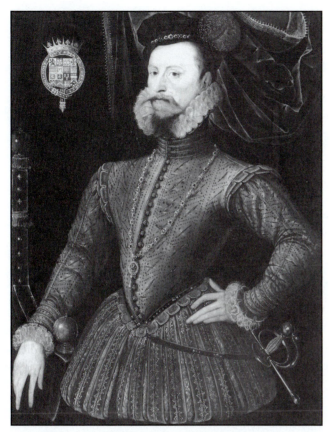

Figure 16-6. Men's doublets and jackets of the second half of the six-teenth century were narrow through the shoulders and sleeves. The front of the tight-fitting bodice was padded into an exaggerated protru-sion called a peascod belly. Upper stocks had ballooned into globular pumpkin hose, which were layered with vertical strips of fabric called panes. *Robert Dudley, Earl of Leicester*, by an unknown artist, 1570.

of lace were reserved for men of the highest ranks until the 1600s when sumptuary regulations were relaxed and lace be-came more widely available.

Another significant development in the second half of the 1500s was the expansion of the upper stocks into globu-lar melon breeches or pumpkin hose. The style worn by the Earl of Leicester in Figure 16-6 was constructed with verti-cal strips of fabric called panes that held their balloon, or pumpkin, shape over a padded lining. The panes were often made of a costly brocade or embroidered material, or even tooled leather, and the lining was a less expensive plainweave silk or satin. As much as forty yards of fabric were needed to provide the necessary volume for some cuts of pumpkin hose. During the mid-century, the lining formed puffs of ma-terial between the panes, complementing the slashing on sleeves, hats, and shoes. At the end of the century, variants of the pumpkin hose were reduced to barely more than short rolls around the hips. (Figure 16-7 and Color Plate 7.) For the middle classes, pumpkin hose developed into various cuts of

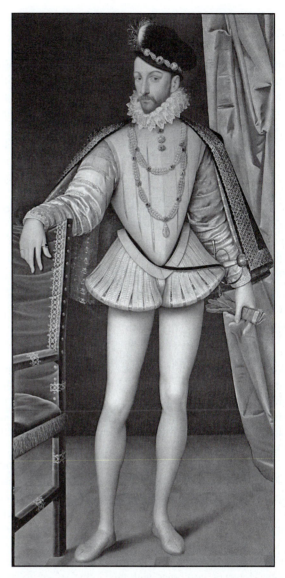

Figure 16-7. By the last quarter of the 1500s, some forms of pumpkin hose were shortened to barely more than rolls around the hips. The codpiece gradually disappeared beneath the sack-like shapes of pumpkin hose and baggy breeches. Also abbreviated in cut was the Spanish cape that was more decorative than utilitarian. *Charles IX* by an unknown painter, 1585.

knee breeches without the elaborate layer of panes. The enor-mous Venetians were popular in Protestant circles, especially among the Puritans in Flanders and England for whom the style demonstrated conservative modesty. In England, simple knee breeches were known as **slops** (sloppes). **Canions** were extensions of trunk hose covering the thighs, usually cropped at the knees, that were made to coordinate or contrast with the full, upper section. The volume of pumpkin hose and the new forms of breeches concealed the codpiece, making it irrele-vant to the evolving masculine profile. By the 1590s, the cod-piece had disappeared.

As Spanish fashions were adopted by men throughout northern Europe, new types of garments were introduced. The mandilion was a form of cape with sleeves that courtiers wore casually over one shoulder like that of the young Englishman in Color Plate 7. The Spanish cape, such as that shown in Figure 16-7 was a short circular outer garment that draped about the shoulders more as a fashion accessory than for warmth or protection from weather.

From Spain also came the tall hats made of opulent textiles or exquisitely tooled leather. Innumerable variations were common with narrow brims and high, tapering crowns—some flat topped and others rounded.

The Spanish style of shoes also replaced the broad, duckbill German forms. Toes were somewhat blunted at first but then became more narrow and pointed by the end of the century. Slashing and pinking remained a popular form of shoe embellishment until the 1570s.

WOMEN'S DRESS IN THE NORTHERN RENAISSANCE 1500–1550

As the armies of France, Spain, and Germany moved in and out of Italy throughout the late fifteenth and early sixteenth centuries, the influences of the dress of the High Renaissance were disseminated throughout northern Europe. Even though women of the north continued to wear many forms of late Gothic clothing and accessories into the first decades of the 1500s, elements of Italian styles increasingly took hold.

The Hans Holbein painting of *Lais Corinthiaca* depicts an idealized German beauty as an ancient Greek courtesan. (Figure 16-8.) The gown she wears is representative of the late Gothic silhouette transformed by Italian enhancements. The close-fitting bodice contours the natural feminine form by shaping the bosom and waistline, and the skirt flares into a fullness of flowing drapery like the gowns of a half century earlier. However, combined with the Gothic-styled gown are significant new elements. The squared neckline is wide and deep, revealing the white linen chemise with its ruched edges and scalloped cuffs. The huge, full oversleeves are still laced to the bodice to allow decorative puffs over the shoulders although many other designs of this period now featured both the inner and outer sleeves sewn to the bodice. Unlike the Italians, though, the northern women delighted in an abundance of slashes and pinking.

For women who preferred to demonstrate modesty, some styles of the chemise were made with a high neckline that covered most of the upper torso exposed by the Italian décolletage. Another form of concealment was the **partlet**, a cut-to-shape dickie of sorts that filled in the open areas of the shoulders and neck. Partlets were usually made of fine materials, often in colors to contrast with the bodice, that tucked into the neckline and were pinned into place.

Just as northern European women were catching up with the fashions of the Italian High Renaissance during the

Figure 16-8. Gowns of northern European women in the first decades of the 1500s were a mix of late Gothic designs with Italian Renaissance elements. The form-fitting bodice and full skirt were reminiscent of fifteenth-century styles, but the wide, deep necklines and huge oversleeves were influences from Italy. *Lais Corinthiaca* by Hans Holbein, 1526.

second quarter of the sixteenth century, the influence of Spanish styles began to make an impact.

Dress at the Spanish court in the first half of the sixteenth century came to reflect the awesome power and wealth of the Catholic Hapsburg monarchy. Where men's clothing became ever more exaggerated in its illusion of virile masculinity, with the inflated profile of broad shoulders and the display of the padded codpiece, women's clothing redefined the female form into a chaste stylization upholstered in splendor.

Among the style changes inaugurated by the Madrid court was a restriction against open necklines. Partlets, high-collared chemises, and even veils resolved the issue at first until bodices began to be constructed to completely conceal the upper torso to the neck. As bodices were redesigned, they were heavily padded to provide a smooth lay of the fabric. By the 1530s, though, the padding evolved into the **busk**, a torso panel made of layers of linen stitched or pasted over reinforcements of whalebone, wood, horn, or metal. The busk was inserted into the front of the bodice compressing the breasts and smoothing the torso into an inverted cone shape. (Later the term "busk" was used synonymously for corset in contemporary writings.)

Another innovative alteration of the gown was created by the farthingale, a stiff, hooped petticoat that shaped the skirt into a smooth cone. The full, soft pleats and gathers of Italian Renaissance skirts that accentuated the hips and flowed with the movement of the woman disappeared in favor of a rigid geometry.

These fashion artifices were quickly adapted by the aristocracy in France, England, and Spanish Netherlands in the 1530s, but not until the second half of the century in Germany. The change in northern European styles is strikingly evident when comparing the Holbein painting of *Lais Corinthiaca* from 1526 with the portrait of Jane Seymour, Henry VIII's third queen, from 1536. (Figure 16-9.) In England, the open front Spanish gown with its busk bodice was known as a **kirtle** until the 1540s when the separate bodice and skirt became popular and the term began to apply only to the skirt. Jane's gown is not a replication of Spanish styles, but rather it is an adaptation still with features of earlier Italian elements. Youthful Jane, and her counterpart in France, Catherine de' Medici, embraced the drama of the busk and farthingale, but retained the revealing Italian neckline with its deep decolletage. Similarly, the undersleeves of Jane's bodice are not slashed but rather have open seams, Italian style, pinned with jeweled clasps through which puffs of her chemise are arranged. Another sleeve form popular in Spain, England, and France at this time was the vast funnel-shaped oversleeves that likewise were revivals of styles from earlier decades.

The same luxuriant gold brocade used for the undersleeves of Jane's bodice was also used for her petticoat, or underskirt, held smoothly conical by a farthingale and displayed in the inverted V-front opening of the gown. Only the front of the petticoat was made with sumptuous materials such as brocades or cut velvets to match or coordinate with the gown. The sections that were covered by the skirt of the gown were made of plainweave silks or other less expensive fabrics.

In Germany, the gowns of upper-class women were constructed with close-fitting bodices to which very full, gathered skirts were sewn. (Figure 16-10.) Unlike the high-waisted styles of Renaissance Italy, the waistline of gowns in Germany was lower, fitting snugly at the natural waist with tight lacing. As women of the elite classes began to adopt the corset in the second half of the century, the lacing on the outside of garments disappeared. This external lacing, though, was kept by provincial women where it was still a common element of German regional folk costumes into the nineteenth century. So tightly fitting were the bodices of the early 1500s that belts, if worn, were solely decorative accessories that hung low on the hips, similar to the manner of the old Gothic designs. Across the bosom, panels of contrasting material were lavishly embroidered with gold or silver thread and embellished with pearls, jewels, or gold ornaments. The wide, square neckline was usually filled with the linen of a high-collared chemise or a sheer linen partlet. Sleeves were also close-fitting without the massive volume of the Italian

Figure 16-9. Spanish influences began to appear in women's fashions during the 1530s. The busk was a padded torso panel inserted into the front of the bodice for a compressed, flat front. A stiff, hooped petticoat called a farthingale shaped the skirt into a smooth cone. *Jane Seymour* by Hans Holbein, 1536.

forms. Instead, sleeves were sometimes formed by several segments of different fabrics laced together. At the elbows, lacing could be loosened to allow for large puffs of the chemise to show. Another Gothic element that continued to be popular in Germany was the long cuff, usually covering the hand to the knuckles and embroidered to match the bodice.

Women's accessories of the first half of the sixteenth century were also a mixture of the new with the old. The Gothic barbet and wimple are still seen in northern paintings even into the 1510s although the towering hennin and horned headdresses had evolved into smaller variants. In France and England at the start of the century, the **gabled hood**, sometimes called a **pediment headdress**, was worn by aristocratic women. (Figure 16-11.) It was fashioned from a light wire frame shaped like the gabled roof of a house over which was draped velvet or a heavy brocade. Long lappets of richly embroidered ribbon hung down the front. Some hoods were constructed in sections with alternating light and dark or plain and elaborate fabrics.

Figure 16-10. The gowns of German women in the early sixteenth century featured snug-fitting bodices, usually laced tightly, with low waistlines. For upper class women, richly embroidered or embellished panels were stitched across the bosom. Deep, open necklines were usually covered by smooth, sheer partlets or linen chemises. Sleeves were narrow with long cuffs that extended to the knuckles. *Three Women of Fashion* (Princesses Sibyl, Emilia and Sidonia of Saxe) by Lucas Cranach, 1530.

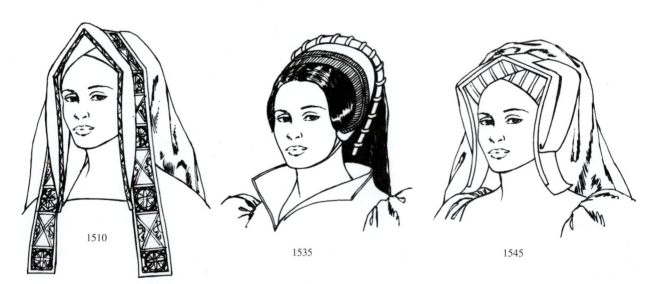

1510

1535

1545

Figure 16-11. At the beginning of the 1500s, the gabled hood was a variation of women's Gothic headdresses that completely covered the hair. In the 1530s, the hood became shorter with cropped lappets that were pinned to the top. By mid-century the French hood was a crescent-shaped cap that exposed the hair.

By the 1530s, the hood had been modified into a shorter, wider style. The angular gabled shape continued but the lappets were cropped and turned up to be pinned to the top. The hood covering the hair was also shortened and sometimes worn pinned up as with that of Jane Seymour in Figure 16-9.

Catherine de' Medici is credited with the next phase of the evolution of the hood in the 1540s. The so-called **French hood** was redesigned into a crescent-shaped cap that sat back on the head exposing the hair. A chin strap was required to hold the heavily ornamented cap in place. The lappets had disappeared, and the hood was shortened to about shoulder length. Catherine Howard, Henry VIII's fifth wife, introduced the French version to England's court.

In Germany, hats were wide brimmed and pinned into place at an angle over **cauls**, or hairnets of gold thread, such as those shown in Figure 16-10. A profusion of ostrich plumes was often set in a flower-petal arrangement all around the brim.

Jewels and jewelry were much more important as a fashion accessory in the sixteenth century than during the Gothic era when wimples, veils, and high collars concealed ears and necks. The wide, open necklines provided a natural foil for displaying exquisitely crafted necklaces, chokers, pendants, and ropes of pearls. In Germany, massive gold chains draped over the shoulders and richly jeweled collar necklaces encircled the throat, sometimes worn two or three stacked up to the chin. Sizeable gold brooches with multiple pearl pendants were pinned to the flat-fronted bodices and to headdresses. Jeweled belts were fastened about the waistline of the bodice and often included a vertical strand of jeweled links pinned down the front of the skirt. Bracelets were less common because cuffs were often jewel-encrusted or cut so long with embroidered ruffles that the wrists were completely covered. Neither were earrings used since headdresses covered the ears. In the 1520s and 1530s, matching sets of five rings were worn on various fingers, including the thumb and upper joints, like those of two of the women in Figure 16-10. Anne of Cleves, Henry VIII's fourth wife, brought the German trend to England, which was still popular in 1547 when Princess Elizabeth had her portrait painted wearing multiple rings. Bodices, sleeves, and the V-front opening of skirts were likewise edged with dozens or, for the gowns of queens, hundreds of pearls and gemstones, setting the course for the opulence and decorative excess of bejeweled apparel in the second half of the century.

Few portraits of the first decades of the 1500s show women's shoes and then usually just a shadowy edge or tip. However, genre etchings and sketches of the middle and peasant classes depict innumerable examples of the feminine versions of men's wide-toe styles. Some included straps across the instep and all varieties of slashing. By the 1530s, as with men's shoes, women's styles narrowed to the natural contours of the foot although slashing and pinking continued into the third quarter of the century.

WOMEN'S DRESS IN THE NORTHERN RENAISSANCE 1550–1600

As noted above, the initial influences of Spanish fashions first appeared at the courts of France and England due in part to their queens, Catherine de' Medici and Catherine of Aragon. In 1554, though, the wave of Spanish styles hit England in a flood when Mary I married Philip of Spain. His entourage of courtiers, administrators, and diplomats brought with them the rigid, encasing, dark-colored ensembles of the Madrid court. Such styles were the look of authority, or the "rhetoric of power" as historian Christopher Breward calls it. Mary and the nobility of England completely surrendered to Spanish styles, including the covered shoulders and high, stiff collars. Similarly, Spanish fashions were increasingly adapted to the clothing styles of Flanders, France, and by the third quarter of the century, Germany.

In France, the severe hourglass lines of Spanish styles were less long-lived than in England and Flanders. By the late 1570s, Marguerite of Valois, wife of the future Henry IV, is reputed to have initiated a change in the conical Spanish silhouette because the narrow contours were not flattering to her wide hips. Instead, to disguise her physical shape, she introduced the **bolster**, a padded, tire-like roll that tied around the hips. As a result, all women of fashion now appeared to possess broad hips. (Figure 16-12.) Instead of hoops of graduated dimensions creating a cone shape, a new **French farthingale** was made with a uniform stack of hoops arranged in a cylinder from the outer edge of the bolster to the skirt hemline. Still other variations seem to have been made with a single hoop that edged the bolster and was held in place by strips of fabric that radiated from the waist like the spokes of a wheel. Because of its shape, it is sometimes called a **wheel** or **drum farthingale**.

The shift of the new French farthingale lower on the hips than was possible with the high, conical Spanish style allowed for other significant changes in the gown silhouette. The bodice now became elongated with a lower, sharply pointed waistline that extended below the hips in front. As a result, corsets could be laced even more tightly to produce tiny waists. Myths of the day included tales of young aristocratic women who died suddenly from suffocation due to laces too tightly drawn. Although no coroner's records verify such legends, Dr. Ambroise Pare wrote in 1579 that the "powerful compression exercised by busks" were among the causes for abortions. In addition, essayists and social critics of the time lambasted stylish women for their martyrdom to fashion, suffering compressed ribs "overlapping each other," and blisters, scabs, and "their very skin. . .eaten and consumed to the very bones."

The longer line of the French bodice provided opportunities for new styles of collar treatments as well. The designs of the bodices depicted in the painting *Evening Ball for the Wedding of the Duc de Joyeuse* shown in Figure 16-12 are

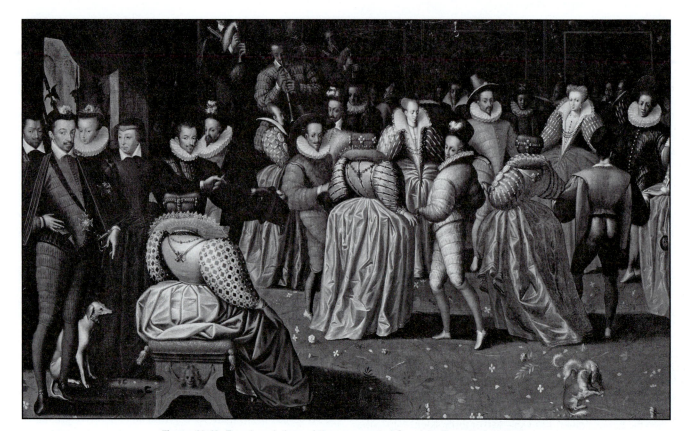

Figure 16-12. French variations of the exaggerated Spanish silhouette included a wide, drum-shaped farthingale over a padded hip bolster. A lower hip line allowed for a longer bodice with an extended waistline. Huge leg-of-mutton sleeves were padded, and stand-up Medici collars edged the neckline. Detail of *Evening Ball for the Wedding of the Duc de Joyeuse* by an unknown artist, 1580.

constructed with deep, open V-necklines that plunge to the waist. Wide lapels curl up and back over a contrasting stomacher or lined busk, and high, standing collars extend the width of the shoulders. For French women who preferred the closed, straight bodice, the wide platter ruff was adapted from Spanish and Flemish models.

In addition to the French alterations of the farthingale and the flat-front bodice, the Spanish double sleeves were replaced as well. Instead of various puffed, hanging, or funnel-shaped outer sleeves over narrow tubular inner sleeves, the French developed huge **leg-of-mutton sleeves**. The style was padded to be smoothly full and balloon-like at the shoulders, tapering to a narrow wrist, which was accented with small, turned-back cuffs trimmed with lace. Slashes and puffs continued to be a favorite decorative element for women's gowns although, at this time, the treatment was mostly confined to the sleeves.

In England, the Spanish silhouette prevailed when Elizabeth ascended the throne in 1558. In the allegorical painting commemorating her accession shown in Figure 16-13, she wears the typical flat-front bodice with a high, cylindrical

collar and short ruff. Her double sleeves are the typical puff outer sleeve over a narrow, tight-fitting undersleeve. The front opening of her conical skirt is unfastened to display her heavily embroidered petticoat. In comparing the design to that of the Spanish princess in chapter 15, Figure 15-15, the style is basically the same. The severe silhouette had become virtually a symbol of the royal Hapsburgs and remained the style at the Madrid court into the seventeenth century, long after it had been discarded in most of northern Europe.

As the daughter of Henry VIII, Elizabeth thoroughly understood the importance of image. In an attempt to preserve the trappings that manifested her unique station and the special status of those of her court, between 1559 and 1597 she issued a series of ten sumptuary laws based on rank, income, and the value of property owned. But the efforts were futile since, for generations, such laws largely had been unenforceable, as proved the case in sixteenth-century England. The middle classes prospered greatly during Queen Bess' forty-five-year reign, and they enjoyed exhibiting their success with large homes, sumptuous furnishings, servants, stables of

fashion appealed greatly to Elizabeth. By the 1560s, she had abandoned the sobriety of the dark colors and subdued fabrics of the Spanish styles adopted during Mary Tudor's reign. Vivid colors were applied to both women's and men's apparel—crimson, peacock blue, golden ochre, and a myriad of vibrant jeweltones. Garment surfaces were variously embellished with allover decorations of embroidery, braid, pinking, sequin spangles, seed pearls, and gemstones.

Ever more surface for decoration was possible in the 1570s when the new French styles appeared at the English court. The huge leg-of-mutton sleeves, long bodices, wide, drum-shaped skirts, and platter ruffs increased the yardage upon which lavish ornamentation could be applied. (Figure 16-14.)

In addition to receiving innumerable gifts of jewelry, accessories, and fine fabrics from courtiers and diplomats, the queen also received a substantial clothing allowance paid by the exchequer. In an inventory of 1599, the Queen's Great Wardrobe catalogued more than 1,300 items. One lady-in-waiting was tasked with the duty of recording daily everything removed from the Wardrobe and documenting at the end of the day any jewels or pearls that were lost or any accessories mislaid. A staff of tailors, seamstresses, embroiderers, and cleaners were retained to care for the royal wardrobe and remake discarded garments into new fashions. Because of this tradition, none of Elizabeth's fabulous gowns have survived.

By the 1580s, fashions at the English court had evolved into an imbalance of exaggerated parts adapted from French styles and mixed with Spanish and German elements. In viewing Elizabethan paintings, the casual observer might think that the painters of the period had no sense of proportion and even less understanding of how to depict clothing. But, in fact, the human form had virtually disappeared into an aggregation of padded and framed shapes of even greater artificiality than the earlier Spanish styles.

The English bolster, called a **bum roll**, was wider than its counterpart in France, some measuring up to forty-eight inches out from the waist and literally forming a ledge on which the arms could rest. The English version of the wheel farthingale was constructed to tilt forward in the front to allow for the long, pointed waistline of the bodice. The English did not like the hard-edge break of the fabric over the edge of the farthingale so they added a circular frill or flounce to soften the line.

During this time the corset was adopted to ensure that English noblewomen could display as small a waist as the French ladies had come to be noted for. The English corset, called a pair of bodies, or in some contemporary writings, simply a busk, was made in two pieces, a front and back panel that could be tightly laced. The most desirable form of corset was constructed with stays made of horn since that material was stronger than wood or whalebone, and the corset would hold its constricting shape better. Metal, though strongest, rusted, a problem for corset makers through the nineteenth century.

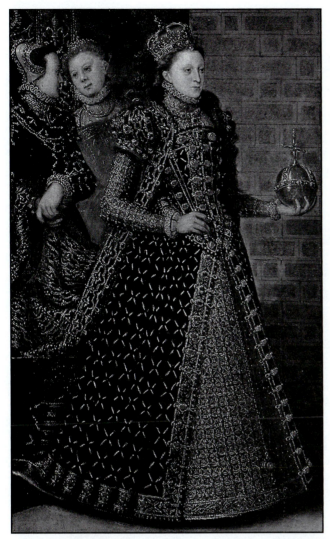

Figure 16-13. When Queen Elizabeth I ascended the throne in 1558, the severe Spanish silhouette still prevailed in England. Aristocratic women wore a flat-front bodice with a high collar, ruff, and double sleeves. The conical farthingale is covered by a petticoat with a lavishly embroidered front panel that is displayed in the inverted V-opening of the skirt. Detail of *Queen Elizabeth I and the Three Goddesses* by Joris Hoefnagel, 1569.

horses, and especially fine clothes. Wrote one courtier wryly at the time:

> For though the laws against it are express,
> Each lady like a queen herself doth dress,
> A merchant's wife like to be a baroness.

From the other end of the spectrum the Puritan pamphleteer George Stubbes complained of how sweeping the obsession with fashion had become even for ordinary folk, for whom even ready-made shirts were superfluously embroidered with "needleworke of silk" costing anywhere from ten shillings to ten pounds each.

Besides the statement of power and wealth asserted by opulent clothing, the novelty of new and interesting trends in

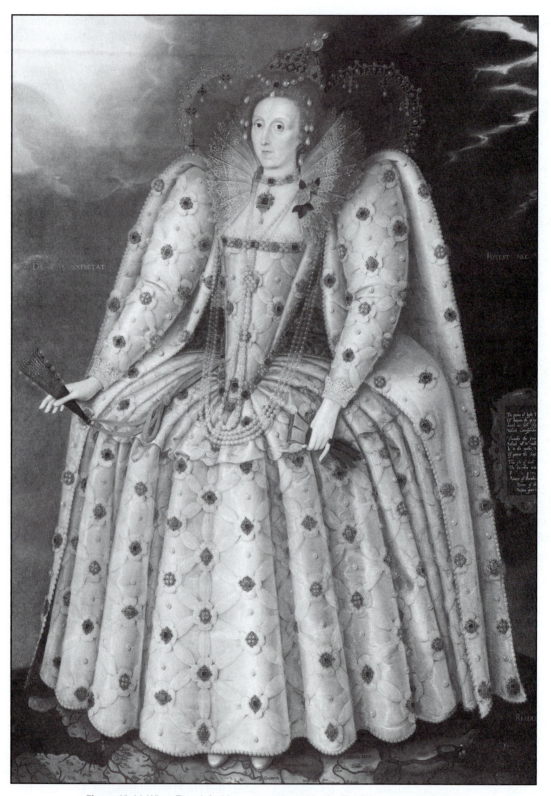

Figure 16-14. When French fashions were adapted by the English in the late 1570s, ever more surface for decoration was possible. Embroidery, braid, pinking, sequin spangles, seed pearls, and gemstones embellished virtually every open area of Queen Elizabeth's hundreds of gowns. The image projected from such magnificent opulence was one of power, wealth, and majesty. The "Ditchley" *Portrait of Queen Elizabeth I* by Marcus Gheeraerts the Younger, 1592.

At the beginning of Elizabeth's reign, the high, stiff Spanish collar was most common, as seen in Figure 16-13. The ruff had evolved from the soft, unstructured ruffles that had been added to the collar of the chemise a generation earlier. By the 1560s, the ruff was a formal, stylized arrangement of starched ruffles that attached separately to the high collar of the bodice.

One key development that made possible the wide formal ruff was the formulation of an inexpensive, soluble starch in the mid-1500s. The Dutch had perfected a wheat-based starch that had to be boiled before application. Previously various vegetable gums with unreliable properties had been used as a starch as early as the ancient Egyptians. The tedious work involved in producing symmetrical, uniformly fluted ruffs with starch and heated rolling irons was excruciatingly labor intensive. Ruffs, then, were yet another fashion reserved for the affluent classes and then, primarily worn only for special occasions. One English social satirist of the time referred to the ruff as "outlandish habiliments" that were "farre-fetched and deare bought."

One variant of the Spanish ruff that Elizabeth wore frequently was the **rebato**, a delicate circle of ruffled lace, cutwork, or gauzy linen that rose high behind the head and dipped forward over the bodice. (Figure 16-15.) Some wide ruffs were full circles like a wheel, and others were broken in the front or back by a V-shape gap. Still others emulated the French stand-up collars, later called the **Medici collar** after Catherine de' Medici, the queen mother, that attached to the neckline of the bodice at the shoulders and back of the neck. At the end of the century, the wired flat **whisk** first appeared, shaped like a Romanesque window with a rounded top at the back of the head and a straight edge across the front. Less formal than the ruff but still an element of status were the innumerable turn-down collars made of crisp white linen. Some were short, not unlike the modern shirt collar, and others lay wide over the shoulders. These plain types of collars were the favorite styles of the middle classes and especially the Puritans.

As the ruff grew wider in the last quarter of the sixteenth century, some extending the breadth of the shoulders, a support was necessary for it to hold its shape. Various types of light, web-like metal frames called an **underpropper** or **supportasse** attached to the bodice collar beneath the ruff to support and tilt the circle of linen ruffles up in the back and forward at the front. (Figure 16-16.)

These new forms of collars that fitted high about the neck forced women to adapt new forms of hairstyles and headdresses. The crescent-shaped French hood was modified in the 1560s with an inverted crease in the center forming a heart shape. This new type of French hood was introduced to England by Mary, Queen of Scots, when she returned to her homeland from an exile in Paris. Both versions of the French hood remained popular in France, England, and the Netherlands until the late 1570s when the ruff began to expand in

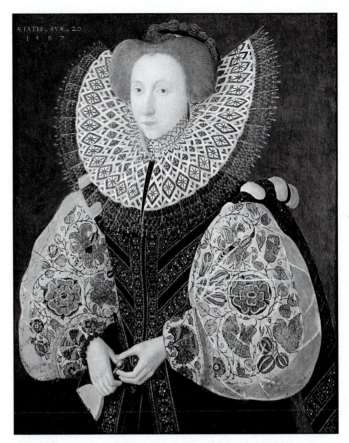

Figure 16-15. The rebato was a wide, delicate collar of ruffled lace, cutwork, or fine gauzy linen. Supported by a light, wire underframe, the rebato rose behind the head and tilted forward over the bodice in the front. *Portrait of Unknown Woman* by John Bettes, the Younger, 1587.

Figure 16-16. By the end of the sixteenth century ruffs became so wide that special supports were required for them to hold their shape. The underpropper, also called a supportasse, attached to the collar of the bodice beneath the ruff and tilted the fragile circle of starched ruffles up in the back and down in the front.

circumference. The heavy velvet drapery covering the hair at the back of the cap had to be abandoned to prevent fragile collars from becoming dishevelled or crushed. Since the ruff originated with the Spanish Hapsburg court, the aristocracy of northern Europe once again looked to Madrid for fashion guidance. The new designs of hats featured small, narrow brims but tall crowns, echoing the verticality of the columnar collar, bodice, and farthingale. Some hat styles were made of fine felts, brocades, or even tooled leather with crowns towering up to a foot high. Clusters of feathers, placed at the back or the front, and jeweled ornaments were affixed to the high, flat-top domes. Around the hatband, ladies pinned ropes of pearls or jewel-encrusted ribbons. The weight and dimensions of some of these hats required a slow, deliberate movement of the head to prevent the top-heavy headwear from toppling off. Women of middle and merchant classes adopted the new tall silhouettes but of a more moderate, manageable height. The preferred material for the middle classes was usually black felt ornamented with feathers and simple hatbands of satin ribbons.

Along with the profusion of exaggerated sleeves, collars, bodices, and farthingales, and the excessive coatings of ornamentation was an abundance of accessories for the lady of fashion to carry or attach to belts and necklaces. Small purses were made of leather or opulent fabrics and often decorated with embroidery, beads, sequins, or painted motifs. Just as today, the lady kept in her purse silk or linen handkerchiefs, some trimmed with lace, and an assortment of personal care items such as tiny scissors, tweezers, or even ivory toothpicks. Gloves for the privileged classes were fitted by custom tailoring and lavishly embroidered and ornamented with jewels. The gauntlet cuffs of gloves were cut wide to fit over the ruffled or turned-back sleeve cuffs. Fans were made in a variety of styles including folding circular and semicircular shapes as well as flat pieces of embroidered fabric attached to a handled frame. Feathers were also affixed to a carved handle as a fan.

Women's shoes in the second half of the sixteenth century were less exaggerated in shape and design than in the earlier decades when duckbill shapes and allover slashing were popular. The contours of shoes retained a blunt toe until the 1570s when the shape became slightly pointed. Slashing disappeared in France and England sooner than in Spain and Germany. An early version of high heels was introduced in France in the 1590s although the wide, tapering heels were only about an inch high. Chopines had a brief popularity in northern urban centers, but the climate and weather north of the Alps lacked the amenable year-round opportunities for strolling out of doors that Venice enjoyed.

As mentioned above, such "outlandish habiliments" as chopines, feather fans, lace handkerchiefs, and beaded bags were solely in the realm of the fashion-conscious elite. Ordinary women, especially those of the laboring or peasant classes, were free of the vagaries of fashion, particularly corsets, and dressed in simple garments made of homespun

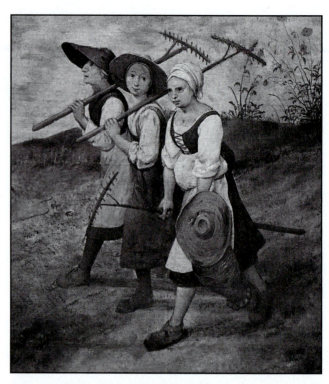

Figure 16-17. The clothing of ordinary women, especially those of laboring classes, was basic and functional. Bodice laces were to secure the garment rather than to constrict the waist into a fashionable profile. Short skirts saved on fabric use and provided greater ease of movement. Shirts or chemises were simple and close-fitting. Ankle boots, aprons, and wide straw hats were for utility not adornment. Detail of *Haymaking (July)* by Pieter Bruegel, 1565.

fabrics or inexpensive, ready-made clothing produced by tailors' apprentices. (Figure 16-17.) Depictions in sixteenth-century social genre paintings show short skirts with hemlines just below the knees that allowed greater ease of movement and saved on fabric. The sleeves and necklines of chemises were less full or detailed than styles worn by the wealthy. Bodices were variously laced, some in the front, others in the back or at the sides similar to women's gowns of the previous century. Hose, if worn at all, were the cut-and-sewn styles of rough woolen materials until manufactured knitted hose became more widely available at the end of the century. Utilitarian aprons, broad-brim sunhats, hair kerchiefs, and sturdy leather ankle boots were the basic accessories. Personal adornment with jewelry, ribbons, fancy belts, or embroidered handiwork was superfluous except for special occasions such as weddings.

CHILDREN'S DRESS IN THE NORTHERN RENAISSANCE 1500–1600

Children of the sixteenth century dressed in diminutive versions of adult clothing. (Figure 16-18.) Until about the age of five or six, boys of wealthy families wore masculine V-front doublets over long skirts, both made of fine fabrics. Bodices

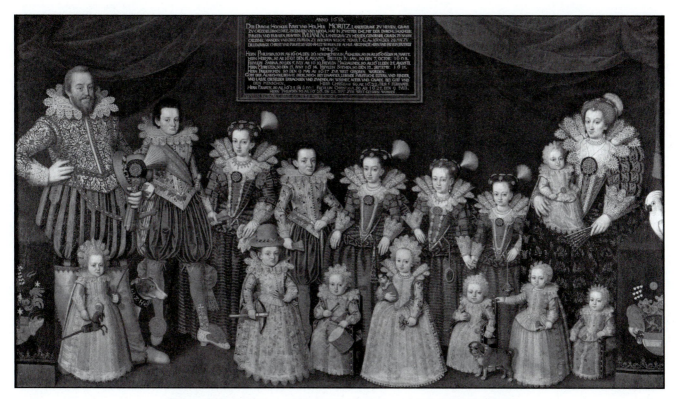

Figure 16-18. Children were dressed as miniature adults in small-scale versions of their parents' clothes. Boys wore doublets with long skirts until they were out of the nursery, after which they donned hose or breeches. Girls were trained young to endure corsets and the other trappings of feminine fashions. *Family of Moritz the Learned* by August Erich, c.1590.

were tailored to fit snugly but not constricting. A boy's hair was long and usually coiffed in the back with braids or chignons pinned up. Often the only way to tell the sexes apart in some family portraits is by the miniature swords, daggers, or other masculine toy possessed by the boys. Once out of the nursery, boys then wore any of the variants of hose, including padded codpieces or, late in the century, knee breeches over nether hose.

Aristocratic girls were inculcated from a young age with ideas of fashion and its relevance to their class. From their toddler years these girls learned to suffer with binding corsets, cumbersome farthingales, padded sleeves, and long stiff bodices. Later, as the ruff grew in dimension, children were even subjected to the discomfort of these wide, starched collars. Contemporary records of the time, though, indicate that for play and work activities, girl's bodices were less restricting, and corsets and ruffs were not worn.

Toddlers of the lower classes wore simple woolen or linen shirts or chemises of varying lengths until they were old enough to don gender-appropriate apparel. Basic garments were usually made or bought too large, allowing room to grow into their clothing.

REVIEW

In northern Europe, a cultural renaissance developed later than it had in Italy due in part to the persistence of feudalism and its agrarian economy. By the first quarter of the sixteenth century, though, enlightened, educated, and dynamic monarchs such as Francis I of France and Henry VIII of England began importing not only the ideas of the Italian Renaissance but also the artists, humanists, and other creative minds of the time. With this cultural exchange came Italian influences on fashion as well.

During the early 1500s, men's clothing exhibited a mix of Gothic silhouettes with Italian details. Among the innovations was the elimination of the high collars for wide, open necklines. New emphasis was then placed on the linen shirt, which was detailed with innumerable construction elements such as ruches, pleats, and ruffles. The huge Italian sleeves were modified into short puff versions that created an illusion of broad masculine shoulders. Italian knee-length bases were softened with gathers and fluid draping rather than the formality of deep columnar pleats.

Women's fashions in the early sixteenth century likewise were transformed by elements of Italian design. In addition

to the wide, squared neckline, sleeves became voluminous, some still laced to the bodice to allow for puffs of linen from the chemise. The close-fitting bodice shaped the natural feminine form, and skirts flared into a fullness reminiscent of earlier Gothic styles.

By the second quarter of the sixteenth century, German influences permeated fashions all across northern Europe. Slashing and decorative pinking were more generously applied to the entire ensemble of both men and women. Upper stocks over nether hose developed for men. Wide shoes called duckbills were adopted by all classes.

As Spain's wealth and power reached its zenith in the mid-1500s, the nobility throughout Europe began to emulate the look of the Hapsburg court in Madrid. For men, the broad expanse of puff-sleeved jackets was reduced to the natural width of the shoulders. The padded peascod belly was applied to jackets and doublets. High collars reappeared, edged first with ruffles and pleats, and by the last quarter of the century, huge platter ruffs of starched linen and lace. Padded pumpkin hose and knee breeches evolved from earlier forms of upper stocks.

Similarly, aristocratic women of northern Europe closely copied the styles of Madrid. The voluptuous lines of the Italian gown were replaced by the linear artifice of a corset and flat-front bodice. Sleeves were narrow; necklines rose into erect, high collars. Skirts were stiff and held smooth by a conical, hooped farthingale.

By the 1580s, the French introduced variations of the Spanish styles that quickly spread to England and the Netherlands. The farthingale was redesigned into a drum shape and fitted over a bolster at the hips. With the lower placement of hip interest, the corset could be laced even tighter, allowing for a longer line of the bodice. Waistlines extended to a deep point in the front. Huge leg-of-mutton sleeves were padded, and stand-up Medici collars edged the neckline.

As the Renaissance gradually spread across northern Europe in the sixteenth century, the last vestiges of isolated regionalism faded in the wake of powerful ideas and influences that soon became international. Similarly, localized fashion trends evolved quickly and leapt borders to be adapted, modified, and returned in a new form. The pursuit of the cycle of style and fashion intensified with each succeeding decade until, by the end of the century, virtually all but the lowest classes and religious ideologues eagerly sought fresh innovation and greater variation in their clothing.

Chapter 16 Northern Renaissance
Questions

1. Which three phases of regional dress influences affected fashions across most of northern Europe in the sixteenth century? Give specific examples of the design elements that were widely adopted by both men and women.

2. Name and describe four men's garments that developed from upper stocks in northern Europe between 1530 and 1600.

3. Which influences of Italian High Renaissance fashions were adapted to women's gowns of northern Europe? Which elements of Gothic designs persisted?

4. Which two women are often credited with introducing Spanish fashions to the courts of northern Europe during the first half of the sixteenth century? What was their connection with the court of Madrid?

5. How did Elizabethan dress project the "rhetoric of power"?

6. Why did sumptuary laws fail in northern Europe?

7. Describe the development of the northern European women's headdresses from 1520 to 1590. Specify the names of the different styles and describe the designs.

8. How was the Spanish dress modified for French women in the last quarter of the sixteenth century? Which fashion innovations resulted?

9. Describe five styles of collars that were prevalent in Elizabethan England in the last quarter of the sixteenth century. What kinds of collar structures were necessary for later designs to hold their shape?

Chapter 16 Northern Renaissance
Research and Portfolio Projects

Research:

1. Write a research paper on the cross-cultural influences Catherine de' Medici introduced from Renaissance Italy into northern Europe throughout her lifetime.

2. Write a research paper on how dress was impacted by the Reformation and the Counter Reformation in northern Europe. Compare and contrast the distinctions between Protestant and Catholic standards for ordinary people as well as those of the royal courts.

Portfolio:

1. Compile a style guide of men's trousers in the Renaissance. Trace the evolution from the emergence of upper stocks through the varieties of breeches at the end of the sixteenth century. Illustrate each with a photocopy or digital scan from contemporary artwork. Include a descriptive paragraph of the garment type, source or title of the artwork, artist, and date.

2. Research the lacemaking techniques used in the sixteenth century and construct a working model to demonstrate to the class.

Glossary of Dress Terms

bolster: a padded, tire-like roll that tied around hips adding fullness to skirts

bum roll: the English name for the hip bolster

busk: initially a torso panel made of layers of linen pasted over reinforcements of whalebone, wood, horn, or metal that was inserted into the front of the woman's gown bodice; later the term was used synonymously for the laced corset in Elizabethan writings

canions: extensions of trunk hose covering the thighs, usually cropped at the knees and made to coordinate or contrast with the full, upper section

caul: a woman's hairnet worn as a decorative hair covering to which was pinned a hat

chamarre: a men's open-front outer robe

drum farthingale: another name for the French farthingale; see farthingale

duckbill shoes: shallow, broad styles of footwear worn by both men and women in the first half of the 1500s

French farthingale: a petticoat made with a uniform, vertical stack of hoops

French hood: a crescent-shaped cap that sat back on a woman's head exposing the hair

gabled hood: a woman's headcovering fashioned from a light wire frame shaped like the gabled roof of a house over which was draped velvet or a heavy brocade

kirtle: the English version of the open front Spanish gown with its busk bodice; after the 1540s, the term applied only to the skirt

leg-of-mutton sleeves: full, padded sleeves that tapered to a narrow wrist

Medici collar: a stand-up collar that attached to the neckline of the bodice at the shoulders and back of the neck; named after Catherine de' Medici, the French queen mother

paltock: a type of men's doublet, often sleeveless, cut with a deep U- or V-front opening

partlet: a cut-to-measure neck covering that filled in the open areas of women's bodices

pediment headdress: another name for the gabled hood

rebato: a delicate collar of ruffled lace, cutwork, or gauzy linen that rose high behind the head like a halo and dipped forward over the bodice

schaub: the German version of a chamarre

slops (also sloppes): the English name for men's simple knee breeches

stomacher: a reinforced, fabric-covered panel that was inserted into the front opening of a doublet or gown bodice

supportasse: a web-like metal frame that attached to the bodice collar beneath the ruff to support and tilt the circle of linen ruffles up in the back and forward on the bodice

underpropper: another name for supportasse; see supportasse

wheel farthingale: another name for the French farthingale, so called because of the spoke-like supports that radiated from the waistline; see French farthingale

whisk: a wired, flat collar shaped with a rounded edge at the back of the head and a straight edge across the front; worn by both men and women at the end of the 1500s

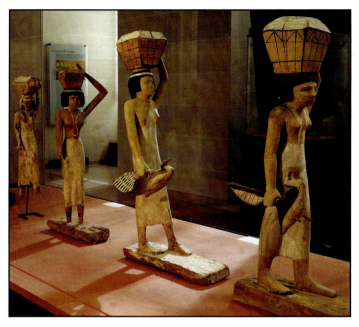

Color Plate 1. Figures of Egyptian women wearing the kalasiris, c. 1950 BCE.

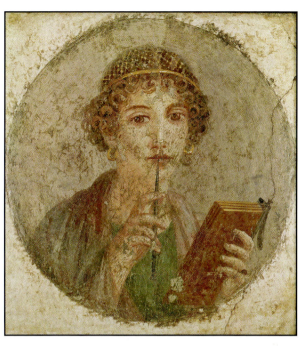

Color Plate 2. Mural of a Roman Girl from Pompeii, c. 50 CE.

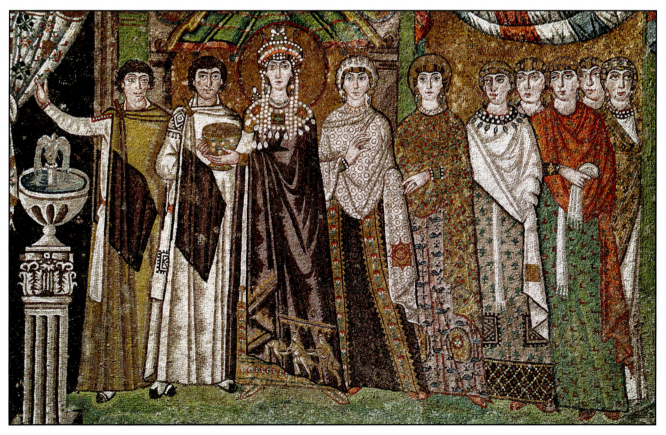

Color Plate 3. Mosaic of Empress Theodora and Retinue, Church of San Vitale, Ravenna, Italy, c. mid-sixth century CE.

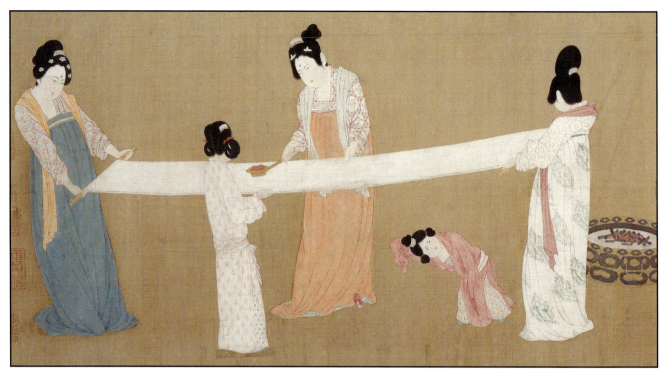

Color Plate 4. Detail of "Ladies Preparing Newly Woven Silk," c. twelfth century. Copy after T'ang era original by Zhang Xuan.

Color Plate 5. Inca feather decorated Ceremonial Cloak, late nineteenth century.

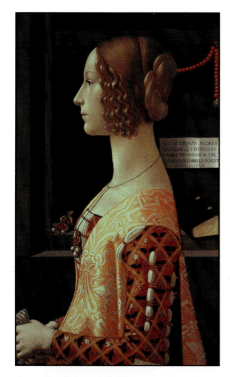

Color Plate 6. Portrait of Giovanna Tornabuoni by Ghirlandaio, 1488.

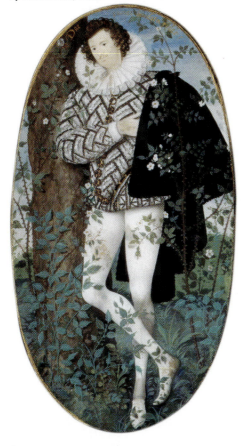

Color Plate 7. "Young Man among Roses" by Nicholas Hilliard, 1588.

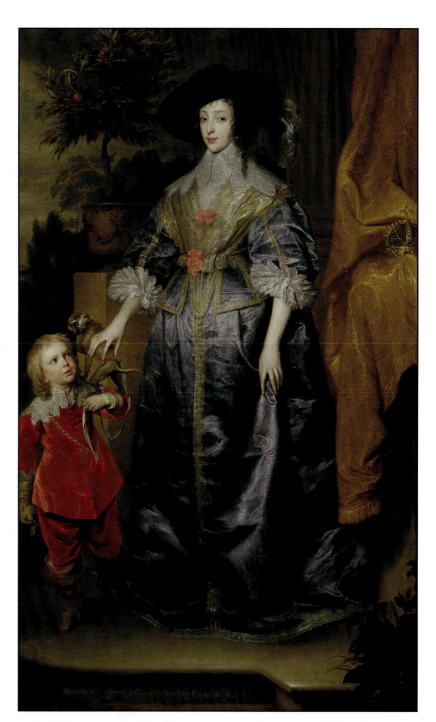

Color Plate 8. "Queen Henrietta Maria with Sir Jeffrey Hudson," by Anthony Van Dyke, 1633.

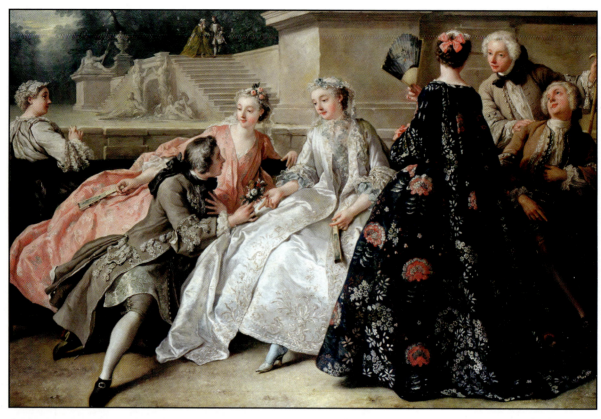

Color Plate 9. The Declaration of Love by Jean Francois de Troy, 1731.

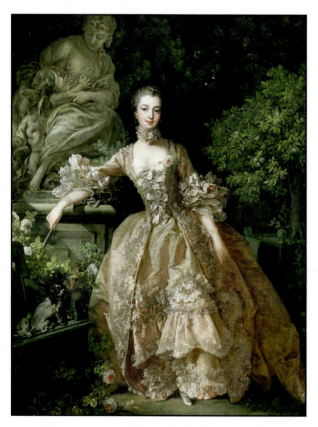

Color Plate 10. Marquise de Pompadour by Francois Boucher, 1755.

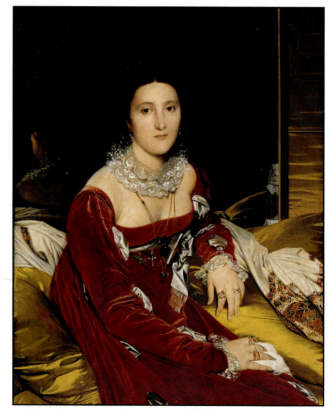

Color Plate 11. Marie Marcoz, Vicomtesse de Senonnes by Jean Domenique Ingres, 1814.

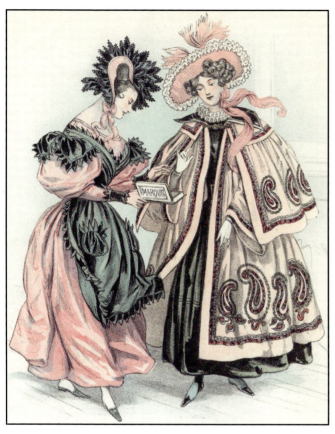

Color Plate 12. Flamboyant excess of the Romantic Age. Fashion plate from *Le Follet Courrier des Salons,* 1830.

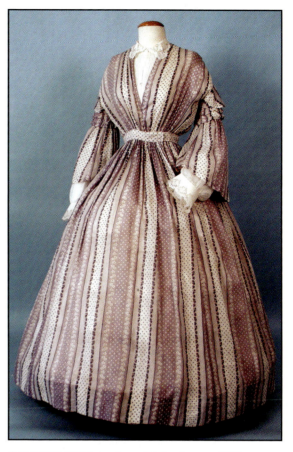

Color Plate 13. Lilac cotton print day dress, c. 1855.

Color Plate 14. Peach silk faille reception gown, 1888.

Color Plate 15. Men's long sleeve aquatic shirts and trousers in stripes or solids. *Ferrymen Playing Cards* by George Caleb Bingham, 1847.

Color Plate 16. Dresses with mushroom cap sleeves from *Delineator*, 1897.

Color Plate 17. S-bend silhouettes from *Delineator*, 1902.

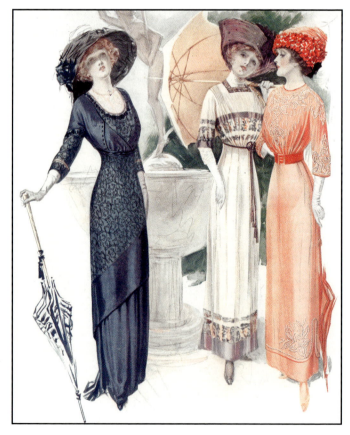

Color Plate 18. Hobble skirt styles from *Delineator*, 1911.

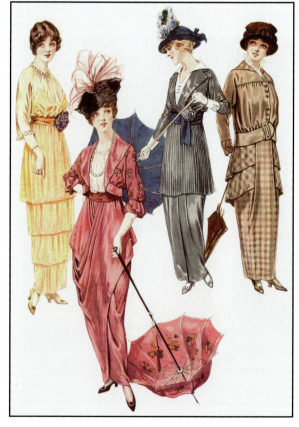

Color Plate 19. Columnar tunic dresses from *Delineator*, 1914.

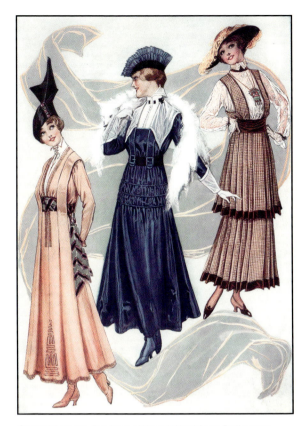

Color Plate 20. Designs of World War I from *Delineator*, 1915.

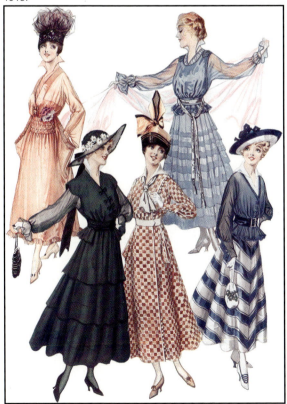

Color Plate 21. Short hemlines from *Delineator*, 1916.

Color Plate 22. Military influences and fabric-rationed narrow silhouettes during World War I from *Delineator*, 1918.

Color Plate 23. Dropped waist styles by Pacific Mills, 1923.

Color Plate 24. Short chemise dresses from Darbrook Silks,1926.

Color Plate 25. Colorful, deco shoes from Goodyear-Welt, 1926.

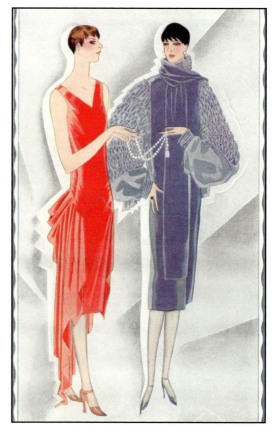

Color Plate 26. Evening dresses from Shelton Mills, 1928.

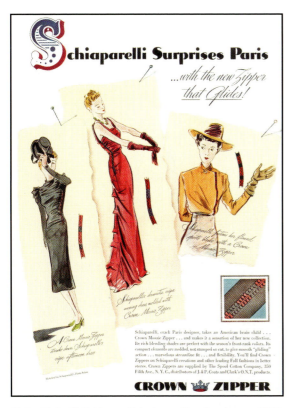

Color Plate 27. Schiaparelli designs with color zippers, 1938.

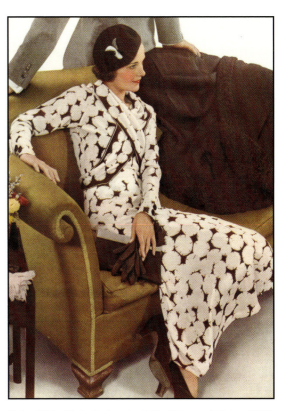

Color Plate 28. Ankle-length skirt by Echarpe Fabrics, 1932.

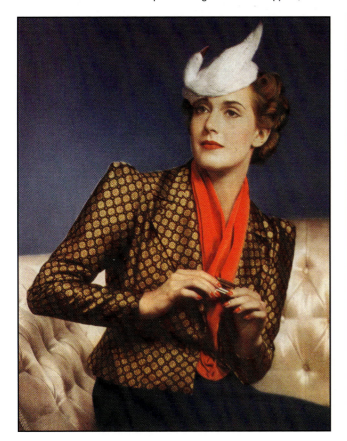

Color Plate 29. Pagoda sleeves from Grossman & Speigel, 1936.

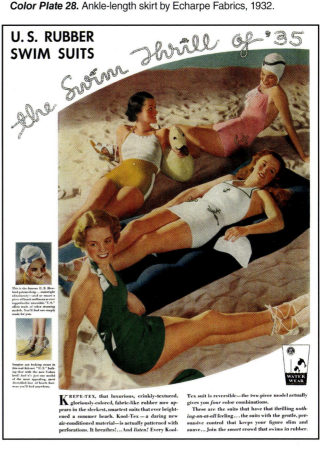

Color Plate 30. Kool-Tex reversible rubber swimsuits, 1935.

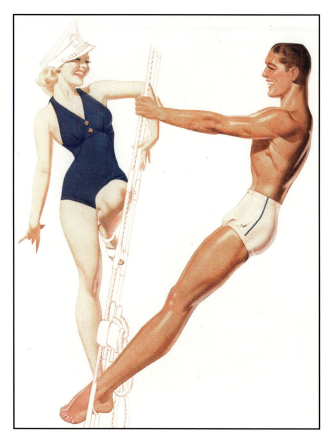

Color Plate 31. Formfitting knit swimwear from Jantzen, 1938.

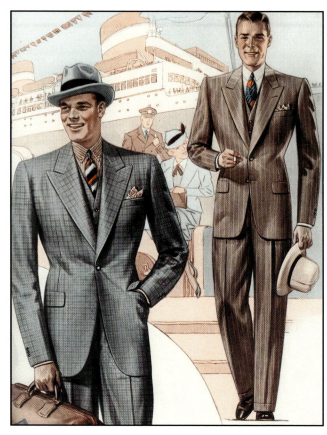

Color Plate 32. The athletic suit silhouette from Krafft & Phillips, 1937.

Color Plate 33. Earthtone colors for dress shirts by Jayson, 1937.

Color Plate 34. Hickok men's jewelry and accessories, 1936.

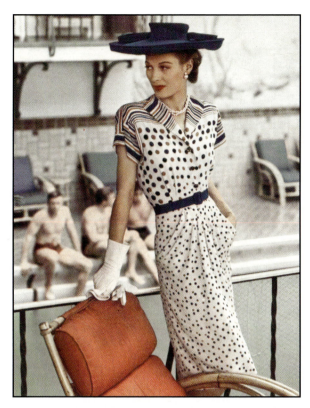

Color Plate 35. World War II silhouette of squared shoulders, narrow hips, and hemlines at the knees. Enka Rayon dress, 1942.

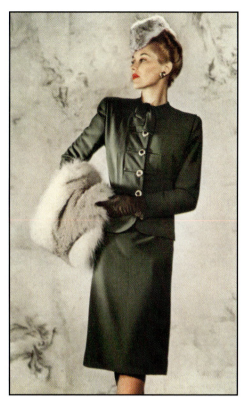

Color Plate 36. World War II L-85 suit by Adele Simpson, 1943.

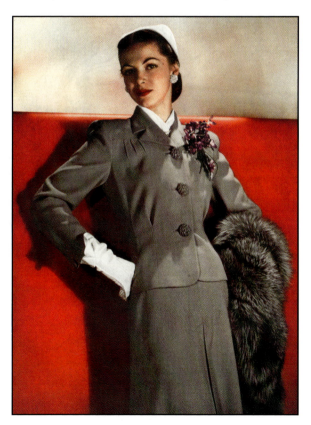

Color Plate 37. Narrow wartime utility suit by Mandelbaum, 1943.

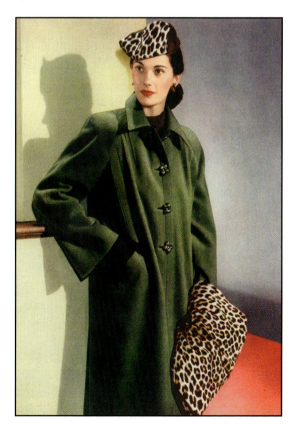

Color Plate 38. Raglan shoulder coat in sueded wool from the House of Swansdown, 1944.

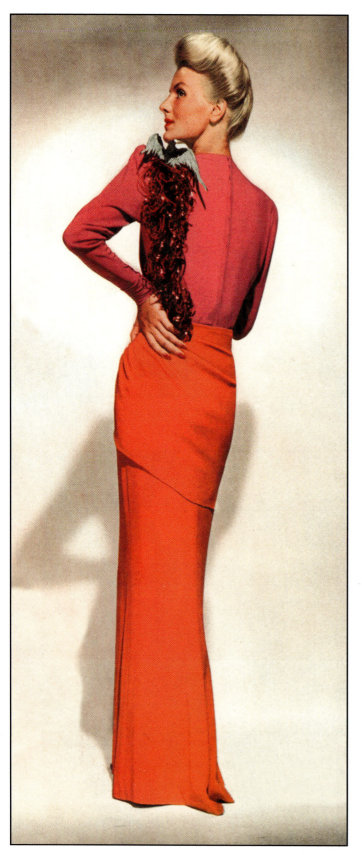

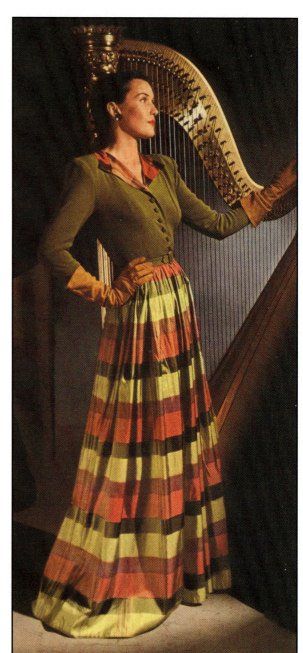

Color Plate 40. Rayon gown by Rémond Holland, 1944.

Color Plate 39. "Finger Silhouette" gown by Adrian, 1943.

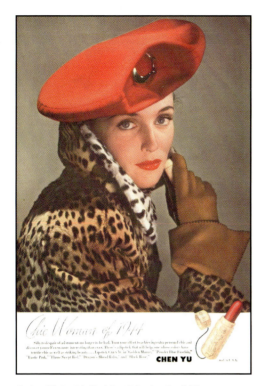

Color Plate 41. Red lipsticks for the "chic woman of 1944" from Chen Yu Cosmetics, 1944.

Color Plate 42. Hats of the Second World War were worn forward over the brow if the hair was up, or back on the head if the hair was down. Hats from Stetson, 1944.

Color Plate 43. Ready-to-wear adaptation of New Look styling by Enka Rayon, 1948.

Color Plate 44. Bolero jacket, linen vest, and pencil skirt from Izod of London, 1949.

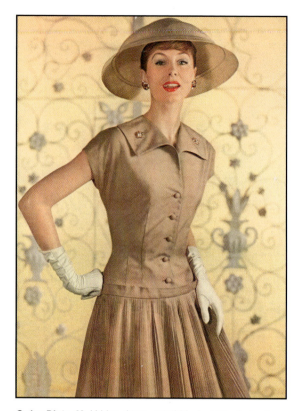

Color Plate 45. Velveteen sheath and flared theatre coat with fur collar by Alan Graham, 1951.

Color Plate 46. H Line dress, or middy, in cotton/orlon by Nelly Don, 1956.

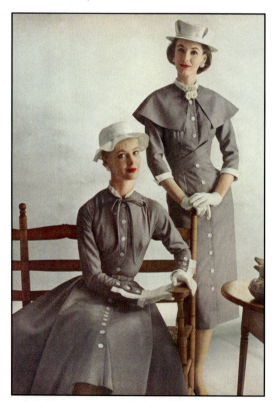

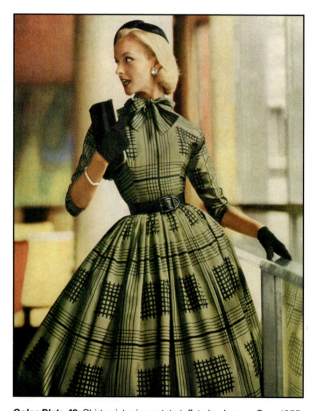

Color Plate 47. New Look variants in Arnel sharkskin by Mr. Mort, 1957.

Color Plate 48. Shirtwaister in acetate taffeta by Jeanne Carr, 1955.

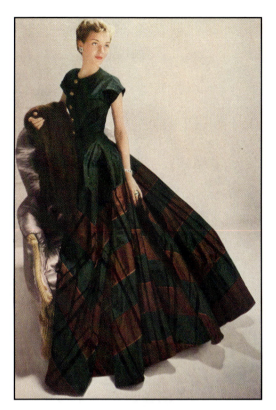

Color Plate 49. Post-World War II silk opulence by
Rémond Holland, 1948.

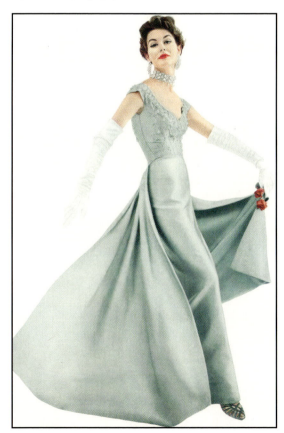

Color Plate 50. Gown of acetate satin by Gothe, 1953.

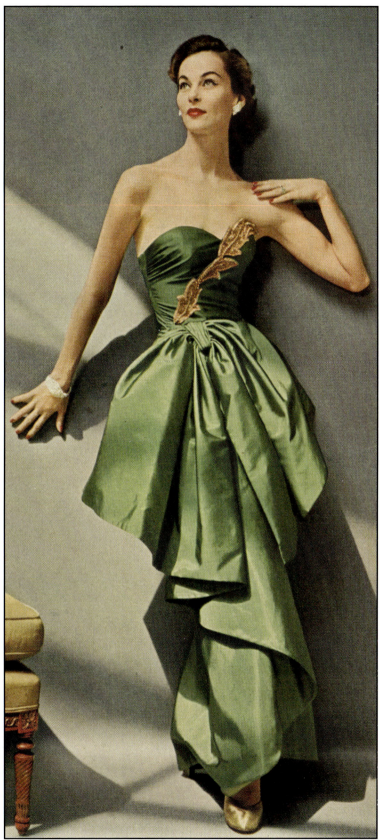

Color Plate 51. William Rose gown of rayon faille, 1951.

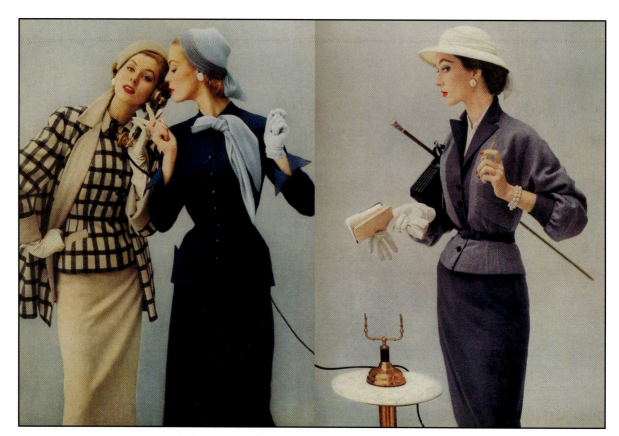

Color Plate 52. New Look suits from House of Swansdown, 1953.

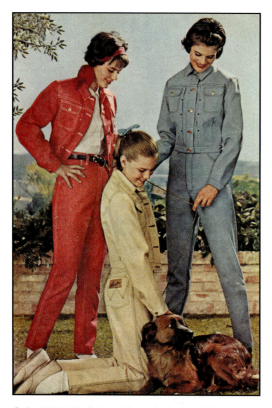

Color Plate 53. Colored denim jackets and jeans from Wrangler, 1959.

Color Plate 54. Wash-and-wear casual knitwear, 1956.

Color Plate 55. Orlon acrylic sweater twinset from Blairmoor with tailored Orlon/wool slacks from Davenshire, 1955.

Color Plate 56. The dichotomy of New Look coats, snugly fitted or capaciously flared. Lassie Maid coats, 1954.

Color Plate 57. Constructed swimsuits with modesty skirts by Catalina, 1955.

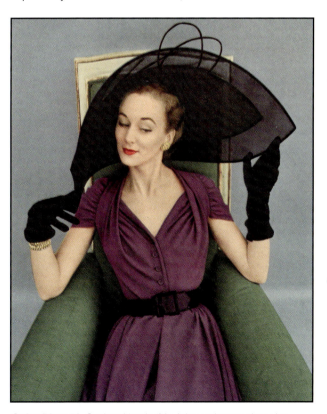

Color Plate 58. Sculpted hat by Mr. John and rayon dress by Jacques Fath, 1951.

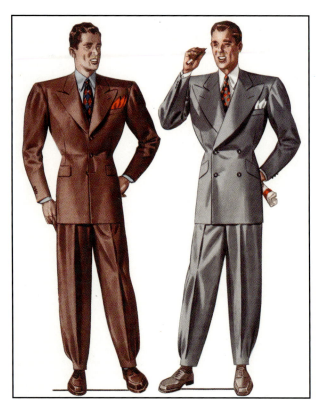

Color Plate 59. Young men's swank suits prior to the L-85 restrictions from Pioneer Tailoring, 1942.

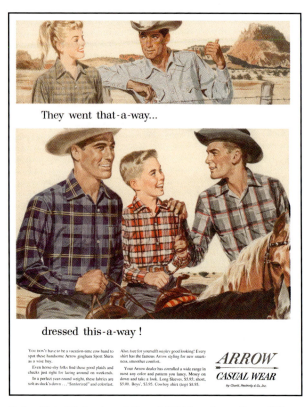

Color Plate 60. Cowboy styling of 1954 from Arrow Casual Wear.

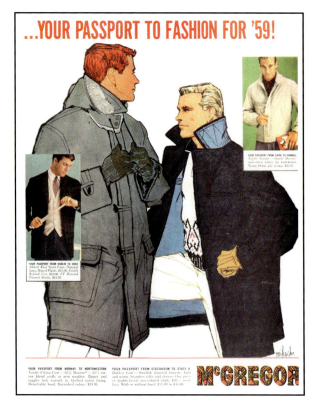

Color Plate 61. Toggle or duffle coat and suburban from Mc-Gregor, 1959.

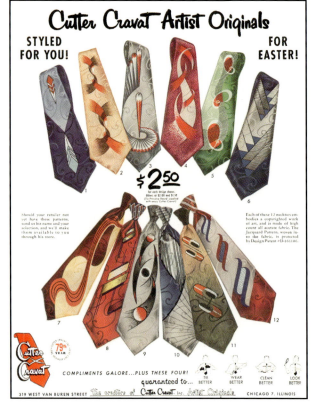

Color Plate 62. Woven acetate neckties from Cutter Cravat, 1951.

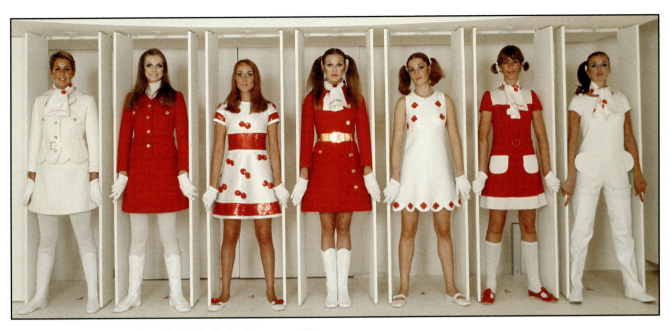

Color Plate 63. Red and white collection by Andre Courreges, 1968.

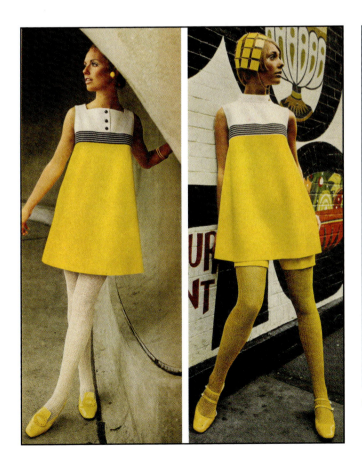

Color Plate 64. Left, A line miniskirt; right, mini-tent with shorts.
By Robbie Rivers, 1967.

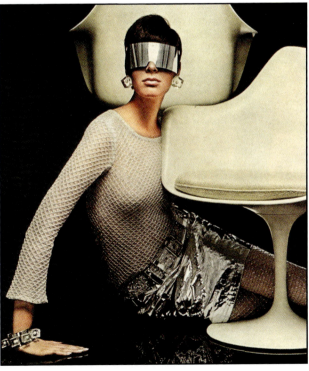

Color Plate 65. Space age knit top and hose from Knoll Textiles, 1968.

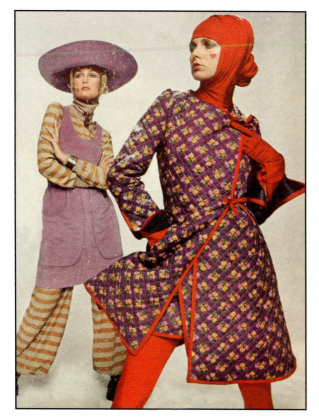

Color Plate 66. Left, velveteen jumper over harem pants; right, Tartar wrap coat over wrap skirt by Giorgio Sant' Angelo, 1969.

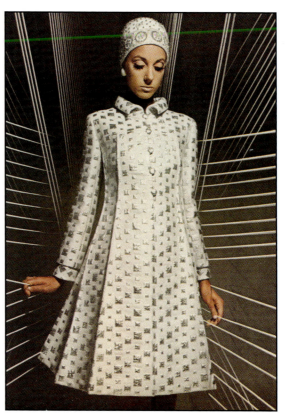

Color Plate 67. Flared evening coat with side pleats of Qiana by Mila Schon, 1968.

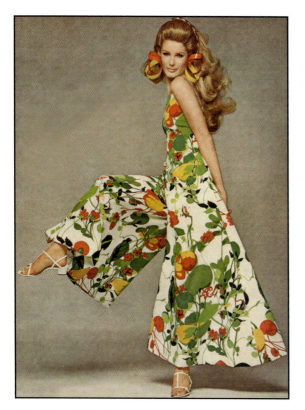

Color Plate 68. Floral cotton jumpsuit by Adele Simpson, 1967.

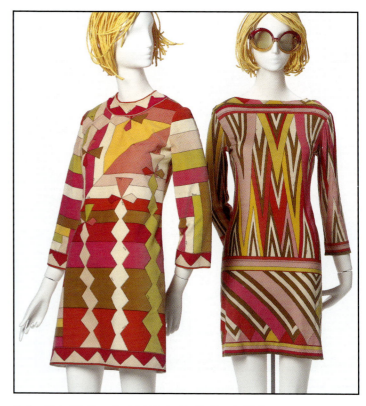

Color Plate 69. Op art miniskirts by Emilio Pucci, 1968.

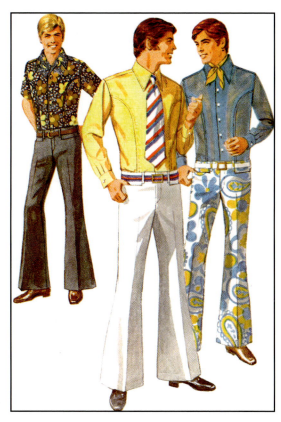

Color Plate 70. Flower power fitted shirt and hiphugger bell bottoms from SImplicity Patterns, 1969.

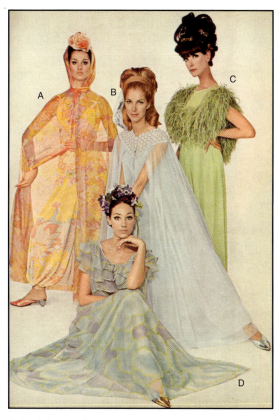

Color Plate 71. From 1966: A. Harem pajama and cape by Rodriguez. B. Norman Hartnell nightgown. C. Cape and nightgown by Fontana. D. Fontana's ruffled nightgown.

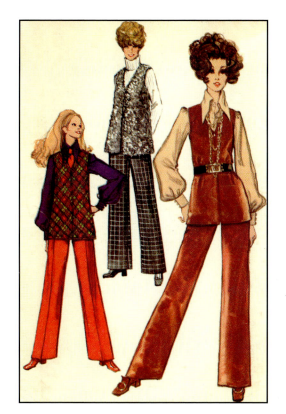

Color Plate 72. Vest pantsuits from Simplicity Patterns, 1969.

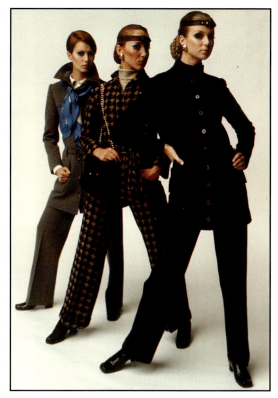

Color Plate 73. Pantsuits by Yves St. Laurent, 1968.

Color Plate 74. Jewelry and hip belt from Swarovski, 1966.

Color Plate 75. Metal jewelry and accessories by Vendome, 1969.

Color Plate 76. Fashion news of the contrasts of the mini and midi hemlines, *Life* cover, August 21, 1970.

Color Plate 77. Dress-for-success suit with bow blouse from Vogue Patterns, 1977.

Color Plate 78. Bicentennial red, white, and blue suit separates from Simplicity Patterns, 1976.

Color Plate 79. Boy's poly/cotton blazers, vests, and slacks from J.C. Penney, 1978.

Color Plate 80. Jacket, vest, and baggies in vibrant colors from Bobbie Brooks, 1972.

Color Plate 81. Beachwear coordinates from McCall's Patterns, 1974.

Color Plate 82. Ribknit sweater, macrame hip belt, and hot pants, 1971.

Color Plate 83. Muscle shirt, tennis shorts, and terrycloth warm-up suit from Simplicity Patterns, 1973.

Color Plate 84. Peacock revolution color and pattern in men's shirts by Vera, 1969.

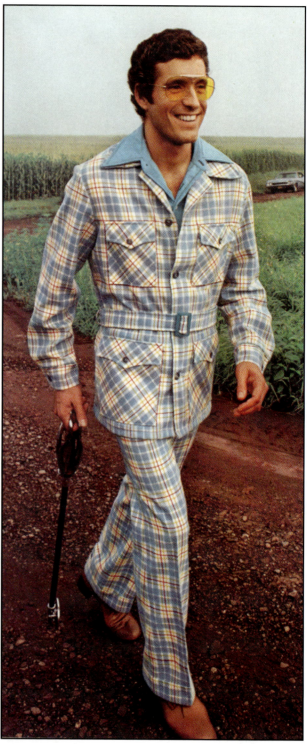

Color Plate 86. Polyester double knit leisure suit from Jockey Sportswear, 1973.

Extroverted Shirts. If you're fat and forty, forget it.

All of a sudden, it's Spring. And along comes Arrow with flowers in every color except Shrinking Violet. Shirts that can stop — as well as start — any conversation. High-band, 4½ inch collars, rounded double- and triple-button cuffs, in a taper that's measured in ounces, not pounds. Introverts, beware. These shirts are not really for every one. Or at least, not for every body. **=Arrow=**

Mach II by Arrow

Color Plate 85. Fitted peacock shirts from Arrow, 1971.

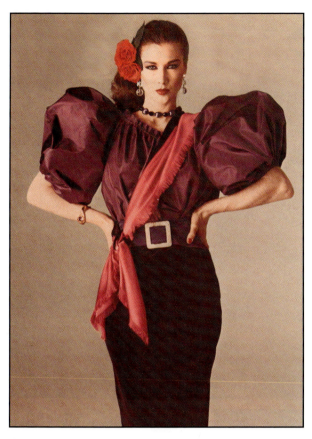

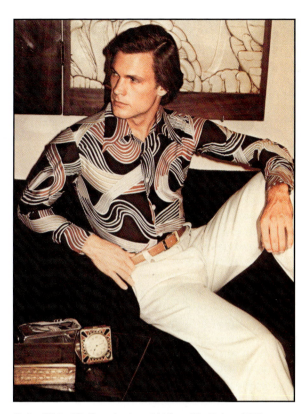

Color Plate 88. Op art nylon shirt from Mr. Henry, 1975.

Color Plate 87. Revival gigot sleeves and velvet evening skirt by Yves St. Laurent, 1979.

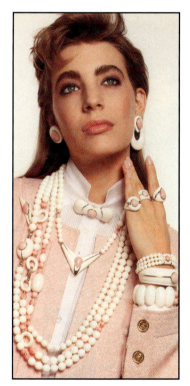

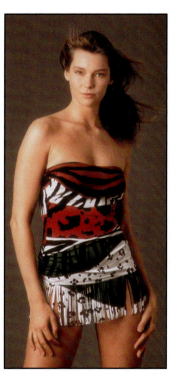

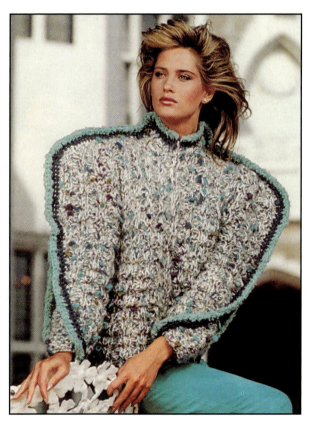

Color Plate 89. Deco revivalism from Louis Bartholomew, 1986.

Color Plate 90. Strapless, fringed maillot swimwuit by Randolph Duke, 1988.

Color Plate 91. Eighties big shoulder drama in knitwear by Vivienne Poy, 1985.

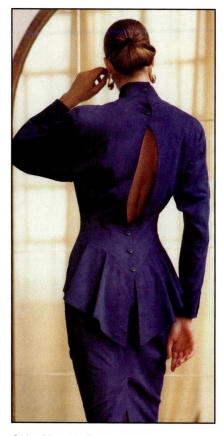

Color Plate 92. Sculpted look peplum dress by Vakko, 1986.

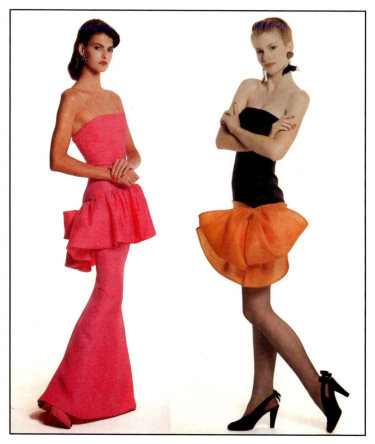

Color Plate 93. Big bows and hip interest for evening impact by Yves St. Laurent, 1987.

Color Plate 94. Branded fashions and accessories from Gucci, 1984.

Color Plate 95. Coat and sweater in bold shapes and colors from Mondi, 1987.

Color Plate 96. Sportsjackets in bold patterns and vivid hues by Enrico Coveri, 1986.

Color Plate 97. Young men's trim suiting from Cotler, 1984.

Color Plate 98. Nylon Thinsulate jacket and knit skipants from Roffe, 1987.

Color Plate 99. Button-down shirt, skinny tie, and distressed jeans, 1984.

Color Plate 100. Big shoulder silhouette from Kenzo, 1986.

Color Plate 101. Bustier peplum tunic by Karl Lagerfeld for Chanel, 1993.

Color Plate 102. Ralph Lauren velvet hacking suit, 1996.

Color Plate 103. Oscar de la Renta at his spring 1996 showing.

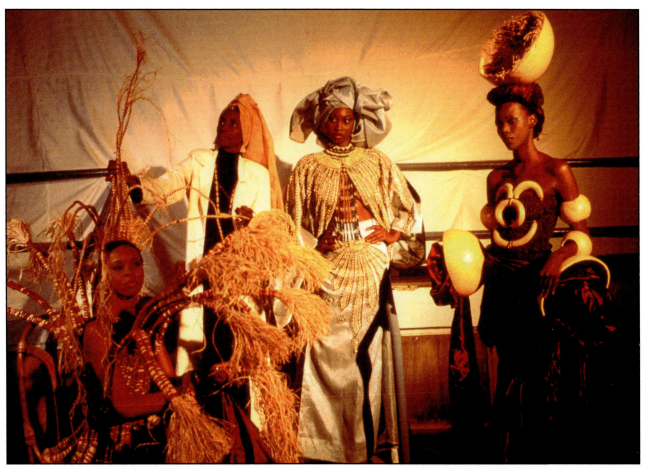

Color Plate 104. Afrocentric styles by Oumou Sy, Senegal, 2000.

Color Plate 105. Mandarin collar jacket with founced miniskirt from Ellen Tracy, 1995.

Color Plate 106. Fur trimmed double-breasted jacket from Bill Blass, 1995.

Color Plate 107. Vest top with asymmetrical micromini and sheer overskirt by Matthew Williamson, 2001.

Color Plate 108. Tile print sheath by Todd Old-ham, 1996.

Color Plate 109. Pink carnation and peony lace poodle dress by Isaac Mizrahi, 1995.

Color Plate 110. Jean-Paul Gaultier's screen print muscle shirt worn by actor Robin Williams, 1995.

Color Plate 111. Zip-around waistband jeans by Pedro Diaz for Pistol Pete Jeans, 2004.

Color Plate 112. Men's skirts from Comme des Garcon Homme, 2008.

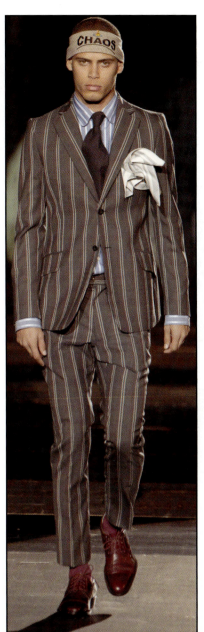

Color Plate 113. Men's slim silhouette suit with low-rise, ankle-cropped trousers by Vivienne Westwood, 2007.

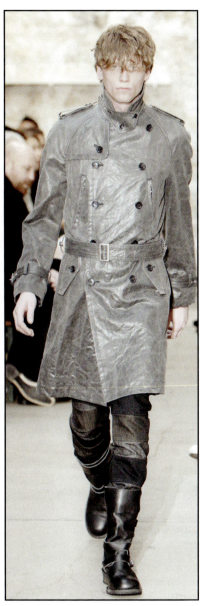

Color Plate 114. Kneebreaker trench coat by Junya Watanabe, 2006.

Color Plate 115. Computerized "smart clothes" by M.I.T. students, 2003: left, Red Roadster with solar panel hat that powers a cell phone and a vest with a GPS navagation device; right, Nex coat wired to receive email that projects onto sunglasses.

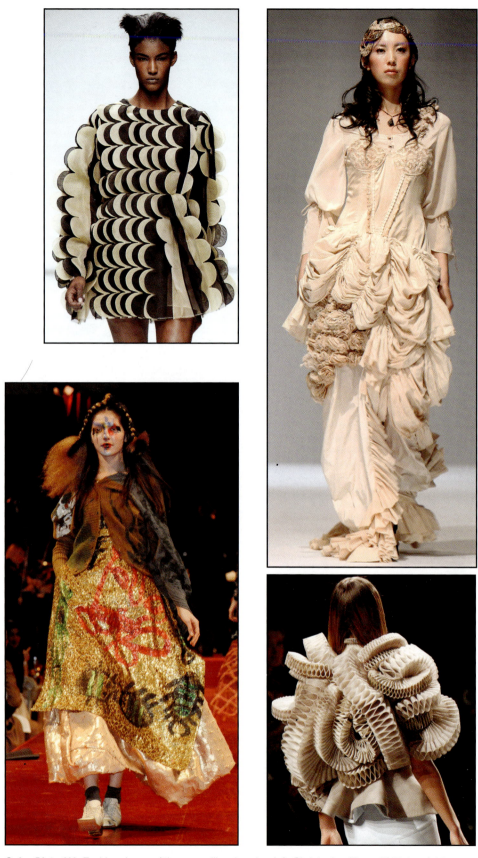

Color Plate 116. Fashion drama of the new millennium: top left, Christopher Kane, 2009; top right, Junya Tashiro, 2009; bottom left, Vivienne Westwood, 2008; bottom right, Ricardo Tisci, 2008.

Legacies and Influences of Sixteenth-Century Northern European Styles on Modern Fashion

Among the fashions of the Renaissance that have repeatedly reappeared in modern designs have been interpretations of sixteenth-century collar treatments. No longer the status symbol of the affluent, the French V-neck collar of lace, the Medici collar, the soft ruffled neckline of the Renaissance chemise, and the starched, pleated ruff have been frequently adapted to women's fashions—both couture and ready-to-wear— throughout the twentieth century and to the present.

Similarly, lavish embellishment of fabrics with sparkling gemstones, gleaming pearls, and glittering silvered sequins also have been popularized with mass production. Faux pearls, faceted glass or crystal "gems," and synthetic sequins have been applied to everything from eveninggowns to denim jackets. The purpose of adorning garments with dazzling jewels may no longer be to display wealth and project an image of power, as with Elizabeth I, but the dazzling and eye-catching effect still achieves a stunning effect for the wearer.

For men, one of the most distinctive styles that survived from the sixteenth century was the knee breeches. From the mid-nineteenth century through the mid-twentieth century the cropped silhouette of Venetians or English slops persisted as specialized sports attire for golfers although now tailored with pockets and fly-front closures. Just as with their Renaissance antecedents, the golfer's knickers still fitted loose and baggy and were worn over knee-high stockings. For a short period in the 1910s and 1920s, golf knickers were even appropriated as sportswear by women.

Delicate lace and finely pleated collars have repeatedly appeared in modern fashions especially in ready-to-wear. Top left, lace gown with matching ruff collar by Henri Bendel, 1936; right, white cotton blouse with pleated collar by St. John, 1982. Reprinted with permission from St. John Knits, Inc. Copyright 1982, St. John Knits, Inc.; bottom, jacket with white lace collar, 2004.

The stand-up Medici collar was named for the French queen, Catherine de' Medici, at whose court the style became popular in the sixteenth century. Top, white linen Medici collar on black faille velvet gown by Mme. Francis, 1913; bottom, white linen Medici collar by Timothy Crowley, 1915.

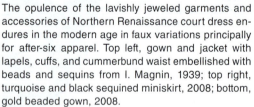

The opulence of the lavishly jeweled garments and accessories of Northern Renaissance court dress endures in the modern age in faux variations principally for after-six apparel. Top left, gown and jacket with lapels, cuffs, and cummerbund waist embellished with beads and sequins from I. Magnin, 1939; top right, turquoise and black sequined miniskirt, 2008; bottom, gold beaded gown, 2008.

Chapter 17

THE SEVENTEENTH CENTURY

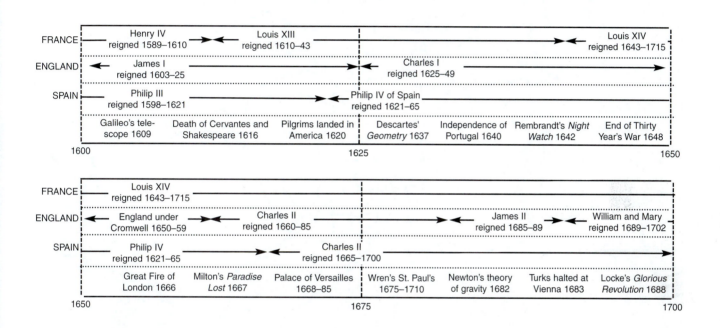

FRANCE	Henry IV reigned 1589–1610	Louis XIII reigned 1610–43		Louis XIV reigned 1643–1715
ENGLAND	James I reigned 1603–25		Charles I reigned 1625–49	
SPAIN	Philip III reigned 1598–1621	Philip IV of Spain reigned 1621–65		

| Galileo's telescope 1609 | Death of Cervantes and Shakespeare 1616 | Pilgrims landed in America 1620 | Descartes' *Geometry* 1637 | Independence of Portugal 1640 | Rembrandt's *Night Watch* 1642 | End of Thirty Year's War 1648 |

1600 1625 1650

FRANCE	Louis XIV reigned 1643–1715			
ENGLAND	England under Cromwell 1650–59	Charles II reigned 1660–85	James II reigned 1685–89	William and Mary reigned 1689–1702
SPAIN	Philip IV reigned 1621–65	Charles II reigned 1665–1700		

| Great Fire of London 1666 | Milton's *Paradise Lost* 1667 | Palace of Versailles 1668–85 | Wren's St. Paul's 1675–1710 | Newton's theory of gravity 1682 | Turks halted at Vienna 1683 | Locke's *Glorious Revolution* 1688 |

1650 1675 1700

A NEW EUROPE

The seventeenth century was the culmination of an expansion of European power around the world that had begun a century earlier with the discoveries of Columbus and Vasco de Gama. Spain, with the wealth from its holdings in South and Central America, had dominated Europe of the 1500s. However, at the beginning of the seventeenth century, voyages of colonization and exploitation sponsored by the English, Dutch, and French laid the foundations of their powerful empires that would last into the twentieth century. The founding of Virginia in 1609 by the British, of Quebec in 1608 by the French, and of New Amsterdam on Manhattan Island by the Dutch in 1612 marked a significant new chapter in world history.

On the home front in Europe, the destruction and disunity caused by the religious wars of the Reformation and the Counter-Reformation in the sixteenth century reached a crescendo in the Holy Roman Empire during the first half of the seventeenth century with the Thirty Years War (1618–48). Layered over the convulsions of religious conflicts were the

393

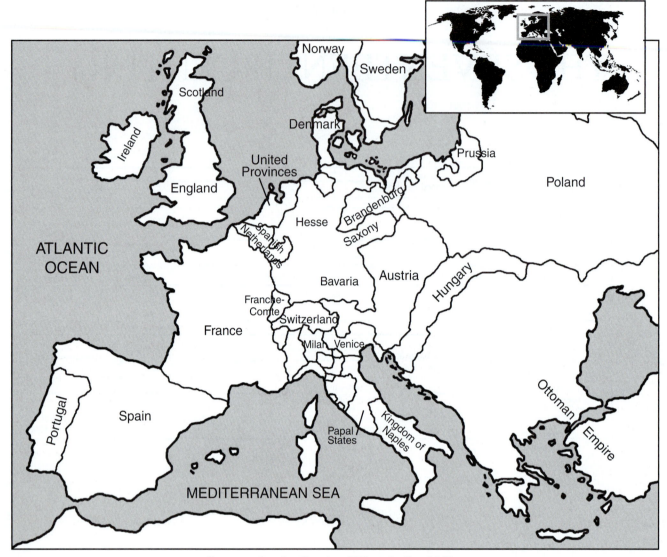

Europe after the Treaty of Westphalia, 1648

rivalries of the European powers whose conceits are reflected in the phases of the Thirty Years War. Sweden and Denmark wanted control of the Baltic shores. France saw an opportunity in the German struggle to renew its ancient campaign against the Hapsburgs. Even the Dutch and English were drawn into the conflict as the territories of the Rhineland changed hands, threatening trade routes to Italy. In the end, the Treaty of Westphalia in 1648 granted freedom of worship and full sovereignty of the German states. An equally important result of these wars was the redrawing of the political map of Europe along lines that are familiar to us today with new territorial gains by France and the independence of the Dutch republic and Swiss canons.

In the new Europe of the seventeenth century, the three principle powers that emerged into prominence were England, France, and Holland. Spain's power diminished precipitously during this period, having twice suffered bankruptcy and losing Portugal and the Netherlands among other territories. As a consequence of Spain's decline, Italy suffered a similar fate through overtaxation and mismanagement by Spanish viceroys. Even independent Venice was impacted by an economic failure from which it never recovered.

Following the death of Elizabeth I in 1603, her cousin, James Stuart of Scotland, ascended the British throne becoming James I of England. James maintained exalted ideas of the divine right of kings, which repeatedly led to conflicts with parliament. He was lazy when it came to the tedium of routine government business, preferring instead games and diversions with his court favorites. His pursuit of pleasure and luxuriousness more than doubled the Crown's debt.

Upon the death of James in 1625, his son and successor, Charles I, continued the lavishness of the monarchy and the equally dangerous disregard for parliament. Finally, in 1629, Charles dissolved parliament and refused to call another session for the next eleven years. Without parliament to appropriate funding, Charles imposed special taxes and borrowed money, deepening the Crown's debt. In addition, Charles supported changes in religious traditions that infuriated the powerful Puritans whose struggle had been to "purify" the Anglican Church of its pre-Reformation ritual. In 1642, civil war erupted. Charles was captured four years later, and, following a second civil war between the army and Scotland, the king was beheaded in 1649.

For the next decade, England was governed as a republic, or Commonwealth, led by the commander of the army, Oliver Cromwell. The monarchy as well as the House of Peers were abolished. Under the aegis of the religious conservative Cromwell, the Puritans imposed an extreme moral code that attempted to stamp out drunkenness, swearing, gambling, and a host of other social habits. Such repressive laws proved distasteful to much of the populace and undermined the constitutional experiment of the republic. When Cromwell died in 1659, England faced anarchy from a power struggle between rival factions of the army and parliament. In 1660, a majority of monarchists in parliament invited Charles I's exiled son to return to England and rule as king.

Never forgetting that England had done without a king for eleven years, Charles II wanted only to enjoy life surrounded by his mistresses and dogs. His hedonistic court rejected the rigors of Puritan morality and indulged in all manners of caprice, especially the pursuit of fashion.

When Charles II died childless in 1685, his brother became James II. However, James attempted to restore Catholicism to an official and preeminent status in England. He replaced Protestants in high positions in the army and government with Catholics, and he received the papal envoy at Whitehall. Such actions increased antagonism against the Crown throughout the country. Barely three years after James ascended the throne, a group of prominent Englishmen sent for William of Orange, ruler of Holland, a grandson of Charles I, and husband of James' eldest daughter. When William landed in England with a Dutch army, James discovered he had no support and fled to France in 1688.

William III and Mary II ruled jointly after having agreed to a Bill of Rights produced by a convention of delegates from all over Britain. From this agreement, monarchal powers were bridled, including depriving the king of the authority to maintain an army in time of peace, and parliament was required to be called more frequently.

Despite the foibles and crises of the Stuart dynasty, England continued to develop into a world power in the seventeenth century. The British mercantile fleet expanded the domain of England's colonies the length of the North American Atlantic coast as well as dotting islands and continents with settlements around the world. From these holdings and commercial ventures came great wealth to British ports, marketplaces, and banks.

One of England's primary competitors and trading partners was the Netherlands. In 1602, the Dutch East India Company was chartered and given full authority by the government to establish, regulate, and protect trade in the eastern seas. Over the course of the seventeenth century, the Dutch acquired colonies in Africa, the Americas, India, and dozens of islands from the Caribbean to the Pacific. Ships laden with spices from the Indies and textiles from China and India docked in ports all around Europe and the Mediterranean. The 1600s are regarded as the golden age of Dutch prominence and culture.

From the great wealth of trade came power. The Seven United Provinces of the Netherlands were governed by an oligarchy of nobility and regent families comprised of wealthy burghers. For decades, the Netherlands struggled against Spain to win its freedom. Exhausted financially, Spain at last recognized the sovereignty of the United Provinces in 1648. When the Dutch lost a war against France and England in 1672, William of Orange, later to become king of England, became ruler of Holland, the largest and wealthiest province. In his efforts to check French expansionism in the 1690s, William's war efforts put a considerable strain on Dutch resources from which the republic never recovered.

As Spain's dominance in Europe steadily declined in the seventeenth century, France emerged as the greatest power of the age. At the end of the 1500s, Henry IV had established a tenuous truce in the bloody religious wars that had torn the country apart for decades. But when he supported a Protestant candidate for a German state dukedom, he was assassinated by a Catholic zealot in 1610.

Henry's son, Louis XIII, was an effete and disengaged monarch who left the exigencies of government and foreign policy with his chief minister, Cardinal Richelieu. The cardinal built up a vast network of patronage through a centralized bureaucracy. He tolerated Protestantism and brought back a degree of national stability. He also avoided war until the last possible moment when France was drawn into the Thirty Year's War against Spain. Upon Richelieu's death in 1642, Cardinal Mazarin assumed the mantel of office, continuing the centralized policies of government his predecessor had so efficaciously implemented.

In 1643, five-year-old Louis XIV ascended the throne under the regency of his mother, Anne of Austria, and Mazarin. Louis learned the functions of government under the tutelage of Mazarin, and when the cardinal died in 1661, the young king saw no need to replace him. Louis continued to consolidate power and authority by never calling into session the Estates General and by ruthlessly overriding regional privileges of the nobility, clergy, and political leaders. He built the magnificent palace of Versailles outside Paris and moved his court there in 1682. To prevent plots and

The Age of Baroque

The period of about 1600–1750 has come to be known as the Baroque. The term is thought to have originated from the Portuguese word "barroco," meaning an irregularly shaped pearl, but some historians think the word is from the Italian "baroco," a barrier or stumbling block in medieval scholastic logic. In either case, the name for the era was applied as a pejorative by nineteenth-century critics who regarded the style of art and architecture as decadent, over-ornamented, and grotesque. The name has endured, but modern scholars view the dynamic styles of the artwork of the period as a revolutionary change from the static, measured works of the Renaissance. Baroque art was operatic, exuberant, colorful, extravagant, and virtuoso. Above all, it was emotional—expressive of sensuousness and passion. For the Church of the Counter-Reformation and the imperial monarchies of the seventeenth century,

Baroque art served as a means of grandiose propaganda. The fluttering draperies, exaggerated facial expressions, and theatrical gestures of the figures in paintings and sculptures were intended to stir the viewer into sharing the emotions of the scene before them—the ecstacy of a saint or the glorification of a king.

A scientific and intellectual revolution occurred simultaneously with the dynamic revolution in art. Even more profoundly than with the Renaissance humanists, the great thinkers of the seventeenth century sought explanations of natural phenomena in science rather than theology. Rene Descartes published arguments that stressed the importance of deductive methods of analysis—doubt everything and then identify those truths that are not open to question. The certainty of mathematics was the key to understanding. From this principle, Isaac Newton advanced his theories of gravity and velocity, which were published in his *Principia Mathematica* of 1687.

Coupled with a mathematical view of the universe was the development of precision instruments for collecting and measuring data. Galileo Galilei's 1609 telescope provided proof of Copernicus' solar-centric system of astronomy. In medical science, William Harvey discovered the circulation of the blood and disproved long-standing beliefs that the heart propelled air as well as blood through the veins.

Indeed, by the end of the century, the scientific findings of the era produced what has been called a crisis in the European mind. Educated men questioned the very foundations of Christian beliefs, even proposing that the Bible should be subjected to textual analysis like any other document. This was an intellectual revolution that exalted skepticism and secular perspectives over traditional religious teachings. From this revolution stemmed the great age of enlightenment in the eighteenth century.

rebellions by the nobility, Louis established a refined court etiquette in which nobles competed to serve the king with everything from dressing rituals in the morning to preparations for bed at night. Like satellite planets around the sun-king, the nobility flocked to Versailles. Only those in favor received the income privileges of office and rank. Those nobles who were out of favor were exiled to their provincial estates to be burdened with taxes and loss of pensions. Part of the court ritual was fashion, and the nobility pursued every change and fresh nuance with vigor, certain of close scrutiny by the king.

Part of the greatness of France in the seventeenth century came as a result of the Thirty Year's War in which substantial territorial gains from Spain were achieved along the Pyrenees and from Spanish Netherlands. Territory was also ceded to France by the Hapsburgs of the Holy Roman Empire in Alsace and other regions on the German western frontier. Another part of France's rise to power and influence stemmed from the weaknesses of other European states. England was preoccupied with the restoration of Charles II who was grateful to France for granting him sanctuary during his exile. The republic phase of the Netherlands saw a focus more on mercantile supremacy than on political power. To the east, the Germans were struggling for preservation against the invading Turks.

In a series of four wars between 1667 and his death in 1715, Louis fought to expand the dominion of France and to achieve glory for himself. The costs of these wars were enormous and nearly bankrupted the nation. Further endeavors to achieve self-glory centered on religious conflicts. As a Catholic, Louis began to withdraw privileges granted to Protestants under Henry IV. He destroyed churches, closed schools, and billeted soldiers in Protestant homes. By the mid-1680s, more than 200,000 Protestants had left France, including a significant number of skilled craftsmen. This mass exodus dealt the French economy yet another blow, furthering the slide toward ruin that would result in revolution in the eighteenth century.

MEN'S FASHIONS 1600–1650

Fashions for men in the early years of the seventeenth century were largely a continuation of styles from the late 1500s. At the heart of the lingering styles were the new traditionalist dynasties at the courts of Paris and London, and the emergence of the influential Protestant burghers of the Netherlands.

Although France had eclipsed Spain as the fashion innovator of Europe during the 1580s, the disinterest in sartorial trend-setting of the Bourbon king, Henry IV, helped stall the

kind of rapid changes that had occurred during the reigns of his Valois predecessors. In fact, Henry had so little regard for the way he looked that on occasion he reportedly appeared at court wearing garments patched at the elbows. Even for high state functions he would simply layer himself with dazzling diamond-laden accessories over old-fashioned styles of clothing.

Similarly, in England, the first of the Stuart monarchs, James I, was not a vanguard of fashion. Although he lavishly indulged in the luxuriousness of embroidered fabrics, costly laces, and jewels, he did not encourage innovation in men's clothing styles. Even his wife, Anne of Denmark, insisted that the drum farthingale be worn at court years after it had been abandoned on the Continent.

In the Netherlands, the Protestant mercantile classes selected styles of clothing that, on the one hand, expressed their sobriety and industriousness while on the other hand proclaimed their divinely ordained social status without resorting to ostentatious splendor. The result was a retention of outmoded styles produced in dark, austere colors, particularly black, but made of the finest materials according to the individual's affluence and rank.

Despite the forces of conservatism in the early seventeenth century that deterred the kind of frequent and dramatic innovation of fashions that had developed during the late 1500s, subtle but distinct stylistic changes nevertheless occurred. In addition, the nobility at the courts of Paris and London and the governing classes of the Netherlands had not lost sight of the importance of sumptuous fabrics and opulent accessories in projecting their aristocratic status, even if the silhouettes of their garments remained conventional. Both Henry IV and James I encouraged the beautiful people of their courts to dress resplendently though not radically.

Richard Sackville, the Earl of Dorset, was one such courtier whose portraits from the 1610s reveal the slow evolution of men's fashions of the time. (Figure 17-1.) Among the elements that are similar to styles from the end of the previous century were the tight-fitting doublet with its pointed waist and the voluminous, baggy trunk hose cropped at the knees. The short Spanish cape had endured and was still worn jauntily over one shoulder primarily as a rich, decorative accessory rather than around the shoulders as outerwear for warmth. So, too, had the wide, flat whisk continued to be popular. The starched ruff remained common for older men, some versions enduring well into the 1640s in Holland.

New to the look of men's fashions was the trim, tapered contours of the doublet without the exaggerated protrusion of the peascod belly, which disappeared around 1600. Leg-of-mutton sleeves were reduced to close-fitting tubular types, and upper arm puff sleeves became **shoulder caps**, sometimes referred to as **wings**. Trunk hose were no longer layered with panes or padded into globular melon shapes. For everyday wear or for activities such as hunting and military

duties, men preferred narrower knee breeches made with less material and fewer gathers or pleats than formal court styles.

As mentioned in the preceding chapter, new forms of collars that began to replace the ruff developed at the end of the 1500s. Variants of the sheer linen turned-down collar included the **golilla** in Spain and Italy, which was a wired,

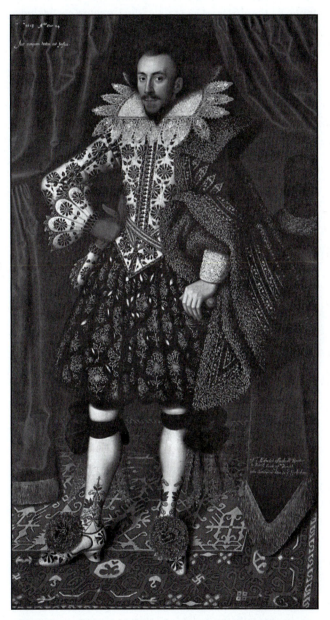

Figure 17-1. Men's dress of the early 1600s remained similar to styles from the end of the previous century. Doublets continued to be tight-fitting, though without the peascod belly, and knee-length trunk hose were full and baggy. Whisks and ruffs were still rigidly starched and supported by wire frames. The elaborate Spanish cape remained a popular accessory, still worn in the same manner over one shoulder. One key change was shoe design, which featured high heels and gigantic rosettes attached to the instep strap. *Richard Sackville, Earl of Dorset* by William Larken, 1613.

stand-up version. Another form of the turned-down collar, the **falling band**, fitted high on the neck but lay flat over the shoulders. Some falling bands became so large that they draped over the shoulders like a capelet.

Other notable changes in men's accessories included new types of shoes. Although forms of higher heels on men's shoes had emerged in the late 1500s, the shapes became more varied and reached heights of two inches or more in the 1610s. Decorative shoe treatments included appliques, embroidery, and ornate cutwork lined with contrasting colors. Massive **roses** (also rosettes) of lace, embroidered linen, spangled velvet, and other luxuriant materials were affixed to the tops of instep straps. Another exaggerated decorative accessory was elaborate types of garters tied either above or below the knees. Those worn by Richard Sackville in Figure 17-1 feature huge velvet bows trimmed with a delicate cascade of imported Dutch lace. The ankles of men's netherhose were also decorated with lavishly embroidered sections called **clocks**, from a Dutch word meaning bell-shaped.

In 1610, Louis XIII succeeded Henry IV as king of France. Unlike his father, Louis was a man who enjoyed fashionable dress. He encouraged his courtiers to be inventive and imaginative with fashion. A vivid rainbow of colors soon replaced the somber palette and dense fabric patterns of earlier Spanish influence. Fanciful names were given to the new fashionable hues such as "kiss-me-my-love" and "mortal sin." The "arbiters of elegance," as the style-setting favorites of the king came to be known, were honored by having certain trends named after them. A new form of earring, a clever hairstyle, a refined draping of a cloak, a reshaped riding spur, all were named—for the moment—after its inventor. With innovation and experiment once again inspiring frequent changes in dress, France had resumed its position as the leader of fashion in Europe by the second quarter of the century.

Men's doublets of the 1630s now showed a marked difference from the tight-fitting versions that had prevailed in various forms for decades. The cut was loose and fuller with a raised waistline. (Figure 17-2.) The new, looser fit was reinforced by being worn only partially buttoned at the top and left open down the front. The short skirt of earlier doublets was extended for a longer line down over the hips. Some hemlines still retained a pointed front, and others were cropped with a straight edge. Two different designs of the doublet resulted from the longer skirt. One was traditionally constructed with the bodice and skirt as separate pieces sewn together; the other was made of single pieces from the shoulder to the hem without a seam at the waist.

Sleeves of the new doublets were varied though most were plain, cylindrical types. For the wealthy, sleeves were fuller, some in a revival style of the Italian Renaissance with a puffed fullness between the shoulder and elbow but close-fitting over the lower arm.

Another revival indulged by the affluent classes was slashing. The front of the doublet across the chest, the back over the shoulderblades, and the sleeves were variously slashed to reveal the bright white linen of the shirt. Some sleeves featured the open seam along the full length of the arm, a Gothic style that first appeared in the late Middle Ages.

The fit of men's breeches in the 1630s was still baggy and loose but cut much straighter and less full than a decade earlier. Most were commonly knee-length although lace and ribbon trim, ruffles, or looped fringe at the cuff added length so that some breeches extended to mid-calf. Hooks and eyelets replaced the laces and points for attaching breeches to the doublet. A series of hooks were stitched onto the waistband of breeches, which engaged eyelets on an inner belt sewn to the doublet.

With the new, looser fit of the doublet with its open front, the shirt became a greater focal point than it had been since the early 1500s. Instead of simply being an undergarment, the shirt was an integral part of the total look of a man's dress. Styles were cut full with voluminous sleeves so that puffs of the fine-gauge linen could show through the slashes on the doublet. Sections of the shirt that were to be visible, especially cuffs and sleeve surfaces, were often embellished with embroidery, cutwork appliques, or lace trim. One extant example that has been preserved is the shirt that Charles I wore to the scaffold in 1649, which was embroidered all over and accented with tiny bow appliques.

The prevalent outerwear for men of the seventeenth century was still the cape. The short, circular Spanish cape continued to be popular through the first quarter of the century. It was most often used as a fashion accessory by the nobility although it functioned as outerwear when needed. New cape styles were cut longer than the old Spanish version, some extending to about the knees, and versions for travel cropped at mid-calf. Other types were made as a full circle instead of the earlier three-quarter circle cut. Closely placed buttons—sometimes more than two dozen—were also added to the front closure. A form of military cape that was adapted to civilian wear featured additional openings cut from the shoulder to the hem at the sides. A row of buttons and buttonholes flanked the side slits to which could be attached a sleeve insert to form a coat of sorts. (Figure 17-3.)

Two kinds of men's tailored overcoats developed from the new silhouette of the loose doublet. The **cassock** was a long-sleeve, front closure coat cut on a wide A-line, usually without a waist seam. Most were made of heavy, durable wool or wool/linen blends. Hemlines were ordinarily cropped between mid-thigh and the knees.

An outerwear leather version of the doublet was called a **buff coat**. (Figure 17-4.) The name comes from the color of the soft buckskin used to make the coat. Designs varied, including long-sleeve and vest-like sleeveless versions, and separate bodice and skirt constructions. Slits were made in

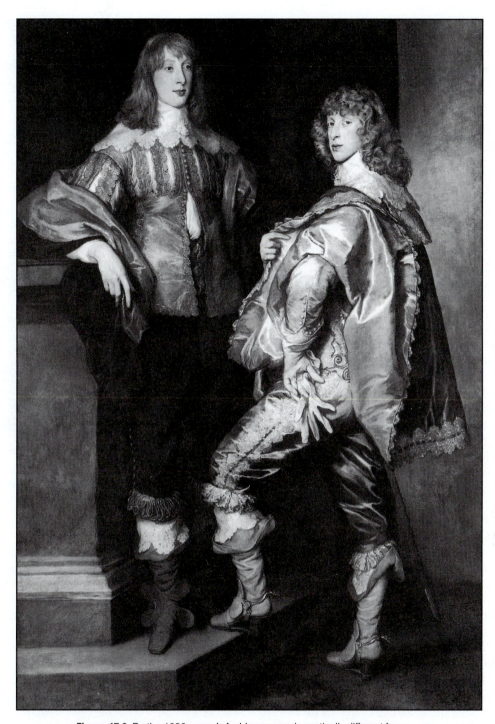

Figure 17-2. By the 1630s, men's fashions were dramatically different from styles of the early seventeenth century. Doublets were constructed with a raised waistline and a fuller, looser fit. Hooks and eyes replaced laces and points for attaching the breeches to the doublet. *Lord John and Lord Bernard Stuart* by Anthony Van Dyck, 1637.

Figure 17-3. New cape styles of the 1630s and 1640s were more practical and versatile than the short Spanish cape had been. Separate sleeves could be attached to a row of buttons and buttonholes at side vents to form a coat of sorts.

the skirt at the back, front, and sides for ease of horseback riding. Most buff coats were unembellished although some portraits of the time depict an edging of colorful embroidery or ribbon trim or the bodice closure accented with a wide border of scarlet **shag**, a deep pile textile.

In addition to the starched ruff and falling band forms of collars, the soft ruff became increasing popular for the upper middle classes in the 1620s. It was basically constructed as layers of ruffled linen that lay softly over the shoulders. Some soft ruffs were layered with lace or edged with lace trim, and others were arranged into soft, fine accordion pleats. It should be noted that all of these collar types were worn concurrently as seen in the Hals-Codde painting shown in Figure 17-5 although the rigid ruff became increasingly less common during the second quarter of the century.

The crowns of men's hats were to rise and diminish, and alternately, the brims to expand and shrink in width throughout the seventeenth century. The tall hat with the narrow brim of the late 1500s continued into the 1610s, especially in England and the Netherlands. By the age of the cavalier in the second quarter of the century, the crown of the hat was lower by half, but the brim quadrupled in width from Elizabethan styles. Huge sprays of plumes jutted up across the back adding to the imposing size of the hat. Except for the absence of slashing, these forms of hats recall the styles favored by the Germans almost a century earlier. Conservative Protestant groups maintained the austere tall hat with a medium brim despite the alternating trends.

Men's shoes continued to feature high heels of assorted shapes. By the 1630s a new, square-toe form appeared although it did not entirely replace the prevalent round-toe styles. Another new development was the addition of slap soles, which were thick pieces of leather attached to the shoe or boot at the toe but left loose at the heel. (Figure 17-6.)

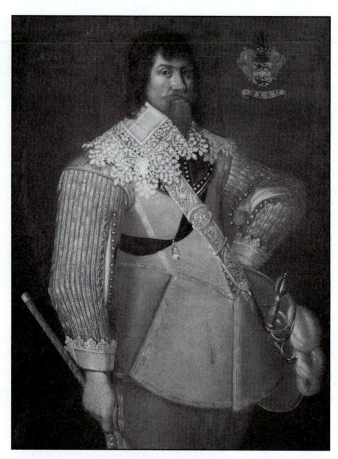

Figure 17-4. A leather version of the doublet, called a buff coat, was so named because of the tawny-colored buckskin used to make the garment. Slits were cut in the back, front, and sides for ease of horseback riding. Most buff coats were plain or only minimally decorated. *Portrait of Daniel Goodricke* by unknown artist, 1634.

When the wearer walked, the sole slapped against the heel, no doubt attracting the desired attention to the fashionable man.

During the first half of the seventeenth century, fine leather boots became an important enough accessory to be commonly worn at court and even on formal occasions such as balls. Unlike the high, close-fitting Spanish styles of the late 1500s, the new forms of men's tall boots widened from the ankle to the knee in a funnel shape. The tops could either be turned down or allowed to droop casually. Some types of boots were so wide at the top that they virtually forced the wearer to walk with a bow legged swagger. Rosettes were still sometimes attached to the top of the instep strap on regular shoes, but boots were most often ornamented with decorative pieces of leather called **latchets** that were cut in various geometric and amoeboid shapes.

For men of most classes, armaments were an indispensible dress accouterment. Swords and daggers were carried virtually at all times, including to church. Except on formal occasions such as balls, courtiers even wore their arms in the presence of the king. Prior to the 1600s, these forms of arms

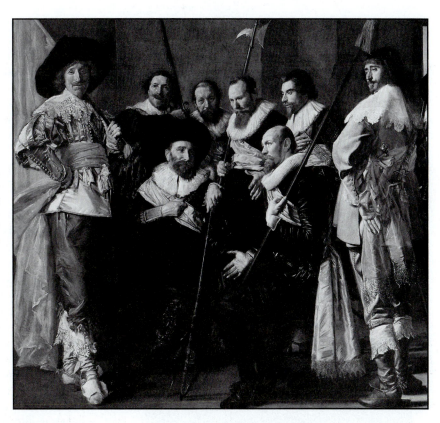

Figure 17-5. A variety of collars was worn by men in the 1630s. In addition to the newer forms of falling bands and soft, flat ruffs, the starched ruff with its wire support lingered until mid-century, particularly in Holland. Detail of *The Company of Captain Reynier Reael* by Frans Hals and Pieter Codde, 1637.

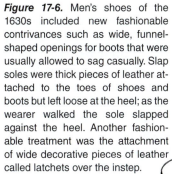

Figure 17-6. Men's shoes of the 1630s included new fashionable contrivances such as wide, funnel-shaped openings for boots that were usually allowed to sag casually. Slap soles were thick pieces of leather attached to the toes of shoes and boots but left loose at the heel; as the wearer walked the sole slapped against the heel. Another fashionable treatment was the attachment of wide decorative pieces of leather called latchets over the instep.

material. The middle class cavaliers shown in Figure 17-5 wear in combination both the baldric and a silk sash.

As the ruff disappeared in France and England, a preference for long, luxuriant hair for men returned. Some men wore a **love lock** at one side of the head, represented by a strand of hair tied with ribbon bows symbolizing a romantic token of a lady's affection. Such well-groomed, shoulder-length hair cuts were as much an element of class distinction as fine clothing, with the emphasis being on well-groomed.

When long hairstyles were worn by men in combination with satins, rosettes, embroidery, and lace, the total look from our modern view seems effeminate. But as art historian Anne Hollander notes, "Although it has sometimes looked feminine to unaccustomed eyes, the long loose hair often worn by men was recurrently adopted as a feature of basic masculinity, Samson-style." So important was this virile image of long, healthy hair that, when Louis XIII began to suffer from male pattern baldness while still in his early twenties, he began to wear wigs as a disguise. Later, as wigs became more extravagant, they, in turn, came to be elements of fashion and class distinction.

MEN'S FASHIONS 1650–1700

During the second half of the seventeenth century, France continued to dominate as fashion leader in Europe. Many new styles came from the fashion-conscious court of Louis XIV. In England, the austerity of the British experiment as a

were holstered to a strong leather belt that fitted around the waist or hips. From the time of Louis XIII, though, swords were attached to a **baldric**, a wide leather strap that hung diagonally from one shoulder to the opposite hip. Upper classes and military officers invested in the best quality of finely tooled leather for their baldrics.

The military look of the baldric inspired the development of soft, casual sashes made of opulent materials that were similarly draped diagonally over the torso. These long, narrow sashes were often trimmed on the ends with wide borders of lace or cutwork. Some sashes were decorated at the shoulder or hip with a detachable rosette of lace or a contrasting

Sleeves were similarly cropped short at the elbows or slightly below. Cuffs became wide, full ruffles to balance the truncated silhouette of the sleeve and waistline. Slashing as decoration for both the bodice and sleeves disappeared although some styles still featured the shoulder-to-cuff open seam to reveal sleeve puffs of the fine linen shirt. For the nobility, sleeves with panes of opulent fabrics were made fuller and lined with white satin to emphasize the revived decorative treatment.

A new form of trim called "fancies" in England was made from bunches of **ribbon loops** that were stitched in clusters around doublet cuffs and at the waistband and knees of breeches. Records of the time indicate that more than 200 yards of ribbon were used to trim some men's suits. For the merchant classes of Holland and England, clusters of ribbon loops were commonly composed of the same material. For courtiers though, clusters were thickly arranged with combinations of ribbons in a variety of bright colors, different widths, and contrasting weaves.

With the new, cropped lines of the doublet, exposure of the shirt was more pronounced. The tunic-style shirt body was still cut wide forming volumes of folds and gathers that hung loosely from beneath the open front of the doublet, or they were tucked into the waist of the breeches. Sleeves also became fuller with wide, ruffled cuffs embellished with lace trim or embroidery. Shirt collars were made in a broad assortment of soft styles ranging from simple turned down varieties to tiered ruffles. Equally as many versions of the separate falling band collar remained popular well into the 1670s.

The most dramatic changes in men's fashions occurred with the silhouettes of breeches. The style worn by the man in Figure 17-7 is called **petticoat breeches**. This form of breeches got its name because the legs were immensely wide and looked more like a divided skirt or petticoat than breeches. The leg circumference of some extant petticoat breeches measures sixty-two inches. Most styles were knee-length although some extended to mid-calf.

A similar type of breeches thought to have originated in the Rhineland of Germany was called **rhinegraves**. These were less full than the petticoat breeches and lacked the abundance of gathers at the waistband, but featured wide, tubular legs open at the knees.

In addition to the decorative treatment of ribbon loops, the cuffs of men's petticoat breeches were sometimes enhanced by attaching **cannons** (also canons) to the stockings at the knees. The wide ruffles of the cannons shown in Figure 17-7 repeat the circular fullness of the breeches and of the cuffs and collars on the doublet and shirt. The cluster of ribbon loops sewn to the cuff of breeches is sometimes also labeled cannons by some fashion historians.

In England, pamphleteers and social critics chastised the court of Charles II for so easily adopting French fashions and etiquette. In a 1661 publication, John Evelyn questioned why the English "so well conceited of themselves" would so

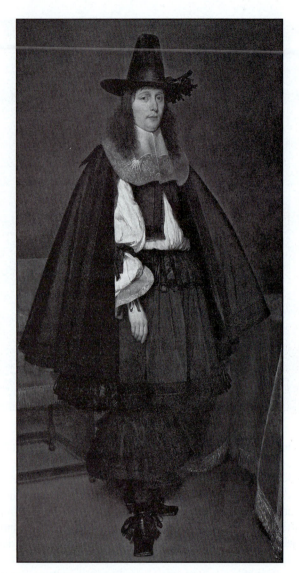

Figure 17-7. By the mid-seventeenth century men's doublets became shorter, some cropped above the waistline. Most were worn fastened by the uppermost buttons only. Petticoat breeches got their name because the legs became so wide that they looked more like a divided skirt than breeches. Wide ruffles called cannons were attached to the tops of stockings at the knees or to the hems of breeches. *Portrait of a Young Man* by Gerard Ter Borch, 1660.

republic ended when parliament called back Charles II from exile in France to reestablish the monarchy. In Spain, fashions continued to reflect a glorious past locked in an ossified courtly style. Despite war and economic concerns, men of the Netherlands and Germany eagerly combined the trends of fashions from Paris with their preferences for dark colors and rich fabrics.

Doublets of the 1650s and 1660s became shorter with many styles cropped above the waistline. (Figure 17-7.) As with earlier designs, front closures still included a compact row of buttons down the front, of which only a few at the top were fastened leaving the shirt exposed from the chest down.

readily submit in matters of style to the French "of whom they speak with so little kindness." However, just as important as national pride to the king was the nation's economy. In 1666, Charles made an attempt to not only establish an English version of male dress, but also to encourage native textile and apparel manufactories. He and his brother, the Duke of York, appeared at court wearing a totally new ensemble of clothing. The short doublet had been replaced with a collarless, long-sleeve garment called a **waistcoat**, better known today as a **vest**. It was cut to be close-fitting with a buttoned front closure and extended to the knees. Published accounts of the time suggest that the vest was modeled on the "Persian" (meaning Ottoman) kaftan. Instead of being made of imported silk, though, the English vest was made of durable home-grown wool.

For the next several years into the mid-1670s, English courtiers and their tailors explored ways to enhance the vest and yet maintain the integrity of its design. For example, pocket openings changed from vertical slits to horizontal, sometimes covered with flaps, other times with finished edges to form **welt pockets**.

Over the vest was worn a variation of the long-sleeve overcoat with a narrower silhouette than that of the cassock. The new form of jacket was still loose-fitting and was usually worn open. The hemline extended longer than that of the vest to just below the knees.

With the narrower cut of the vest and overcoat, the wide petticoat breeches had to be abandoned for a more trim style although the ruffled cannons remained. Hemlines of breeches were gathered at the knees into a close-fitting banded cuff forming bloused legs.

At about the same time that the English court was experimenting with the vest and long overcoat, the French also began to alter the silhouette of menswear. In the mid-1670s, the doublet was replaced by a new form of a collarless, fitted jacket called a **justaucorps** (also justacorps). (Figure 17-8.) The jacket skirt was long and flared from the waist with a hemline cropped anywhere from several inches above the knees to a few inches below. Vents at the sides and center back of the skirt prevented crushing the smooth construction when horseback riding. The center front opening was edged with a row of closely placed buttons although only the uppermost were fastened. Sleeves were narrow and cut to three-quarter lengths in early versions of the jacket but then extended to the wrist by the 1680s. Turned-back cuffs grew in width and circumference as the sleeve lengthened. Pockets were shallow and placed low, sometimes below the fingertips so that, to reach inside, the wearer had to lean down. Instead of satin rosettes and ribbon loops as decorative elements, the new jacket styles were edged with thick fringe and ornamented with excessive amounts of gold, silver, scarlet, or black braid called **passementerie**.

As the wide forms of collars disappeared in the 1670s, due largely to the increased volume and length of wigs, a new

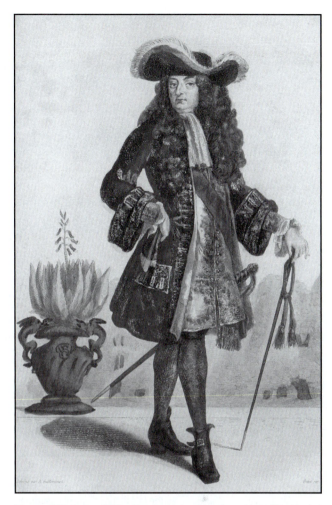

Figure 17-8. In the 1670s, the doublet was replaced by a fitted jacket called a justaucorps. The jacket skirt was long and flared from the waist. Sleeves were narrow and cut in three-quarters length with wide, turned-back cuffs. Engraving of Louis XIV, 1670.

type of neck treatment developed. According to fashion lore, the French court appropriated a form of military neckwear from a regimental uniform of Croatian mercenaries who were employed by the crown at the time. The result was the **cravat**, a linen scarf that wrapped around the neck and was secured in place at the center front with a wide, stiff bow of contrasting, colorful material. For the wealthy, the cravat was trimmed with a wide border of fine lace that hung down the front of the jacket in varying lengths.

To accommodate the cravat, shirt collars were simplified into basic, close-fitting bands, or even eliminated altogether. As the jacket sleeve became longer and the cuff became wider, the shirt sleeve cuffs also became longer. By the 1680s, the wide, soft ruffles of lace or cutwork at the cuff hung out from under the jacket sleeve covering the entire hand. This fashion contrivance required special care to keep the ruffle turned back over the jacket cuff, especially at the

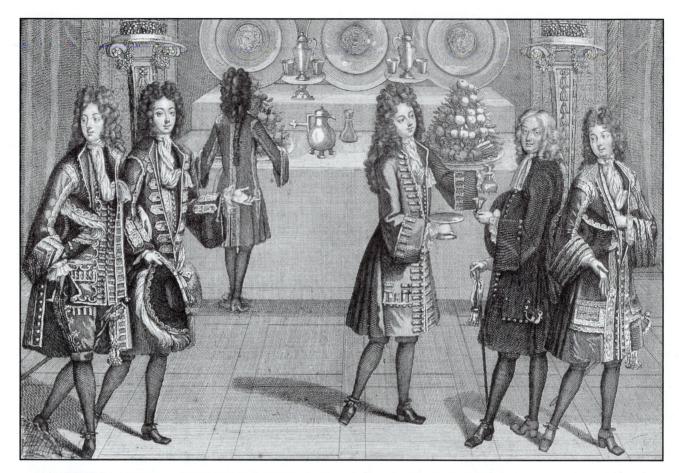

Figure 17-9. In the 1680s, the long vest was combined with the fitted jacket and narrow, tapered breeches. Baroque splendor was reflected in the lavish trimmings of passementerie, embroidery, and fringe. One of the Versailles "apartements" engravings by Antoine Trouvain, 1694.

dinner table to avoid dipping the lace into wine glasses or dishes of food.

Even with the long skirt of the justaucorps, petticoat breeches and other wide-leg styles continued to be popular in France into the late 1670s. Although ribbon loops were not applied to the new styles of jackets, they continued to be a prevalent decoration for the waistband and cuffs on breeches. During the early 1680s, breeches narrowed, and legs were tapered to close-fitting cuffs or knee bands.

At what point in the late 1680s the vest, called a waistcoat in England, was adapted to men's fashions by the French—and hence, the rest of fashionable Europe—is unclear. By the early 1690s, both the long-sleeve and sleeveless vest styles were prevalent throughout the Continent among all classes of men except the peasantry. As with the original design introduced by Charles II, most vests extended to the knees and were collarless or had low, stand-up banded types of collars. The button-front closure was now worn fastened low at the waist instead of high on the chest at the neckline. Horizontal pockets continued to be placed

just below the fingertips. Pocket flaps with multiple buttons replaced the welt slits.

The jacket continued to evolve into a more structured, architectural look compared to the fluid, frilly styles of a decade earlier. Collarless necklines and smooth shoulderlines were necessary to accommodate the volumes of tresses from the huge wigs. (Figure 17-9.) A trim, fitted silhouette of jackets prevailed through the end of the decade and into the eighteenth century. The flare of the jacket skirt was further emphasized with the addition of fan-pleated gores in the back. Vents at the sides and center back were retained from earlier styles. Sleeves became wider with a funnel cut from the shoulder to the wrist to balance the substantial turned-back cuffs. Cuffs became so wide that they covered almost one-third of the lower sleeve, some extending nearly up to the elbow. As with the pocket styles of the vest, jacket pockets also were usually horizontal and placed low in the front with a large, buttoned flap covering the opening.

Although the cut of the vest and jacket for the country gentleman or urban merchant and that of the court aristocrat were

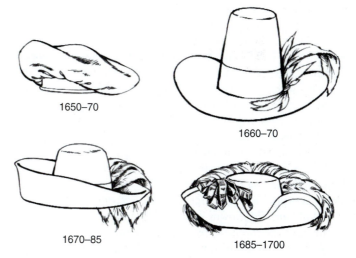

Figure 17-10. Men's hat styles of the second half of the seventeenth century alternately changed vertical and horizontal shape and dimension. The tall steeple crown hats of the 1660s were replaced by shallow, wide-brimmed types in the 1670s. By the 1680s the deep, wide brims were cocked on three sides. Throughout the period, soft berets were also popular and varied in size from small caps to large pillow-like sacks.

1650–70

1660–70

1670–85

1685–1700

basically the same, there was a significant difference between the classes when it came to materials and decorative treatment. Thick, plush velvets and heavy satins were the most favored materials of the nobility. Baroque splendor was achieved by expanding the use of military braid and fringe from the jacket to the vest. Color palettes of fabrics once again became more vivid after a period of muted and subdued hues. The whole range of reds—scarlet to burgundy—were especially popular as foils for the dense profusion of glistening trim.

Since the knee-length vest and long jacket completely concealed the breeches, they became simpler in cut and lacked extravagant decorative enhancements. Cannons had disappeared. Smooth, silk knit hose covered the lower part of the legs.

Men's outerwear at the end of the 1600s included two new styles of heavy woolen overcoats. The **Brandenburg coat** was adopted by the French from the soldier's greatcoat of the powerful German province Hohenzollern Brandenburg. The style was wide and full with large sleeves and a hemline almost to the ankles. Military braid trim was used to form button loops down one side of the front opening through which braid trim buttons fastened the coat closed. This capacious overcoat was not only warm but protected the clothing from soot, snow, mud splatters, and similar threats to fine fabrics when the wearer was out of doors in winter.

The shorter **surtout**, translated literally as "over everything," was also a new type of overcoat of the late 1600s. It was narrower and shorter than the huge, enveloping Brandenburg, resembling more the trim, fashionable justaucorps. The surtout featured wide cuffs and large patch pockets, both sometimes made of striking materials that contrasted with the body of the coat.

Other accessories at the end of the seventeenth century included new forms of the cravat. The style shown in Figure 17-9 was called a **steinkirk knot** (also steinkerque). Supposedly, in 1692 the French army was surprised in an early morning attack by the Dutch, and in their hurried dressing, the French

inserted the twisted ends of their cravat through a buttonhole of their jacket. To commemorate the French victory, the men of Paris began wearing the ends of their cravats tucked into a jacket buttonhole. As a result of this new technique of arranging the cravat, neckwear styles became longer to more comfortably drape in a twist down the front of the shirt and extend through a buttonhole. In addition, the stiff, formal bows used to secure the cravat were abandoned for the more casual steinkirk knot. Despite the easy look of the twisted steinkirk, the cravats of the upper classes were still made of costly lace or cutwork. Designs shown in portraits of the royal family included trimmings of pearl tassels at the ends.

Men's hats of the second half of the 1600s alternately continued to rise and shrink in height and width decade by decade. (Figure 17-10.) In the 1660s, the tall **sugarloaf** or **steeple crown hats** towered in a truncated conical shape with brims of narrow or moderate widths. By the mid-1670s, crowns flattened and brims widened with deep, upturned edges. At the end of the 1680s and through the 1690s, hats remained wide but developed brims that were cocked on three sides. Throughout this period, men also wore assorted types of soft berets ranging in size from small caps just covering the crown to massive pillow-like sacks that sagged down one side of the head.

Feathers and ribbons remained the favorite decorative elements for hats. The ostentatious bouquets of ostrich plumage that topped the hats of the 1630s and 1640s were replaced in the 1660s by smaller clusters of long, slender pin feathers, especially those of pheasants. By the 1680s, a profusion of lacy feathers once again ornamented men's hats, this time as short fringe around the edge of the upturned brim or the hat band. Puritans and other conservative Protestant groups preferred unadorned hats although the occasional cluster of ribbons appears perched on one side of a wide brim in portraits of the time. Because wigs became so high and full at the end of the century, most men simply carried their hats, which became effective for sweeping gestures when bowing to a lady.

Wigs remained a fixed accessory for men even after Louis XIII died. His son, Louis XIV loved his hair and wore it long and full until, like his father, he began to bald prematurely. Even then he had special wigs made with a network of spaces through which his own hair could be blended with his wigs. The wealthy wore wigs made of human hair, which were so costly that a new type of criminal stalked city streets—the wig snatcher. Middle classes who pursued the pretenses of fashion on a more modest scale wore wigs made of horsehair or even coarse goat hair. Through the early 1680s, wigs were a mass of loose, irregular curls that fell low over the shoulders. In England, these were called **periwigs**, from the French word "perruque," meaning head of hair. The crowns were flat, usually with a casual treatment of the forelocks or bangs. From the mid-1680s into the eighteenth century, the crowns of wigs gradually increased in height and became longer and fuller with locks extending half way down the torso in the front and back. These became known as **full-bottomed wigs**. By the late 1690s, the hair was parted in the center into two high peaks that swept upwards from the forehead. At the end of the century, the aging Louis XIV began to wear his full-bottomed wigs dusted with white powder. Immediately both male and female courtiers adopted the look, irrespective of their age. As one young court lady explained to a perplexed foreign visitor, the trend was "to appear wise" in deference to their elderly monarch.

Throughout the decades that wigs were such a key element of men's fashion, many men still preferred their own hair to the discomfort—and cost—of false locks. Diarist Samuel Pepys recorded in 1663 the double anxiety he suffered in deciding to try a periwig; first was the exorbitant cost of three pounds for a simple wig, and second was having his own hair sheered off for the proper fit. By the 1690s, the massive, full-bottomed wigs made of human hair cost as much as sixty pounds, the equivalent of $3000 today. However, those men who opted to maintain their natural hair usually copied the cuts and long, full arrangements of wig styles.

Figure 17-11. Men's shoes of the late seventeenth century featured square toes and thick, high heels. Rosettes and latchets were replaced by assorted types of buckles. Long shoe tongues stood upright or were folded down to display a lining of contrasting color.

Men's shoe designs of the third quarter of the seventeenth century retained the blunt, squared-off toe and high heel of mid-century styles. One difference from earlier versions was the extension of the shoe tip about two inches beyond the foot's toes. By the 1680s, the shoe tip had returned to a closer fit of the foot, but had become wider with an even more pronounced square look. (Figure 17-11.) The giant rosettes and stiff bows were replaced by metal buckles of various shapes and sizes. High, squared tongues projected up the shin or were turned down over the shoe to reveal a lining of contrasting materials and colors. Thick, high heels remained at about two to two-and-a-half inches in height. Louis XIV is noted for having favored heels of red leather or satin, but the style was reserved solely for him.

WOMEN'S FASHIONS 1600–1650

As with men's apparel at the beginning of the seventeenth century, women's clothing retained many of the contours and design elements from the end of the previous century. Throughout Europe, women still wore the drum farthingales and flat busks to shape the silhouette of the gown. Even when the French court of Louis XIII abandoned the style in the 1610s, the look lingered in England, Spain, and the Netherlands until around 1620.

Even so, the wide, circular skirts and conical bodices of the Elizabethan era were modified slightly for a perceived change in fashion. The wife of James I, Anne of Denmark, insisted on the formal grandeur provided by the farthingale. (Figure 17-12.) The version she preferred, though, differed from that of her royal predecessor. The top edge of the farthingale was tilted at a more acute angle with an elevated back and dropped front. A cartwheel ruffle radiated from the waistline to soften the geometric contours of the farthingale. Another notable change was the shortened hemline that revealed two adaptations of masculine fashions, colorful hose with clocking at the ankles and high heel shoes with gargantuan rosettes. In addition, the padded leg-of-mutton sleeves were replaced with close-fitting cylindrical types that were cropped several inches short of the wrist. The archaic Spanish hanging sleeves endured, though. The tightly laced bodice over a corset did not change in its constricting structure from earlier styles. The long line of the bodice with its deep, pointed stomacher at the front easily adapted to the new form of tilted farthingale. However, because Queen Anne was proud of her white, well-formed bosom, she initiated plunging necklines that exposed the breasts to the nipples. The intent of preserving the farthingale and the continued use of sumptuous fabrics were an attempt to preserve the majesty and grandeur of the courts of Elizabeth I and Henry III. Between the tight-fitting bodice, the short hemline, the cropped sleeves, and the breasts spilling out at the top, the overall impression today is that the court gown of the early seventeenth century was

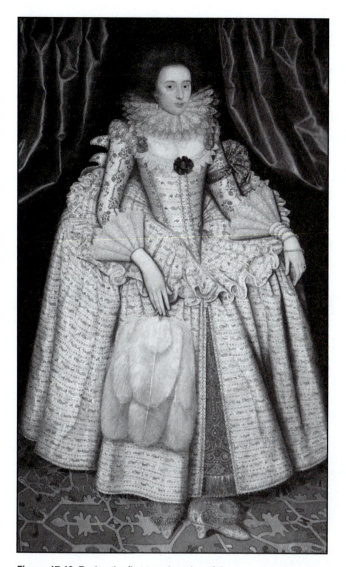

Figure 17-12. During the first two decades of the seventeenth century, women's dress varied little from the styles of the late 1500s. Wide, circular skirts shaped by drum farthingales, and conical bodices fitted over constricting corsets remained the prevalent court dress in London and Paris. These lingering styles were viewed as an attempt to preserve the grandeur and majesty of the courts of Elizabeth I and Henry III. *Mary Curzon* by William Larken, 1610.

too small for the wearer—looking almost as if she had outgrown the fit.

The one place where the farthingale continued to evolve through the seventeenth century was at the court of Madrid. For decades, the Spanish had been accustomed to fashion leadership and continued to develop versions of the styles from the era of their supremacy. By the mid-1600s, the shape and size of the Spanish court farthingale changed from the traditional narrow, conical silhouette that had prevailed for more than a century to a broad, elliptical form. The princess and her young ladies-in-waiting shown in Figure 17-13 wear

this new type of farthingale. The skirts are variously decorated with appliques of bold, contrasting stripes that emphasize the expanse of fabric. The separate bodice is still fitted tightly over a constricting corset, even for little girls. A wide peplum attached to the V-front bodice drapes over the hard edge formed by the top frame of the farthingale. The sleeves and necklines are less standardized than the bodice and farthingale, providing opportunities for varieties that reveal French influences, including the horizontal collar treatment and the narrow, shortened sleeves.

By the 1620s, a significant transformation had begun with women's fashions. The hoops and hip rolls vanished. For the first time in 100 years the fabric of skirts draped naturally from the waist to the floor. The stiff, architectonic silhouette disappeared completely, and women's clothing became softer, rounder, and more vertical.

In the 1630s, this new softer look was achieved by a restructuring of the gown. (Figure 17-14.) The bodice became much reduced in size with a shortened, high waistline and a deep decolletage neckline that revealed a substantial amount of cleavage. The open front of the bodice was filled with a stiff stomacher usually made of a matching fabric although some were covered with lace. Portraits of the period show some stomachers secured across the front with three of four narrow brooches or straps of fabric. The waistline point in the front formed more of a rounded U-shape than the decades-old V-tip.

Another significant change in the construction of the gown was the shorter sleeves, many variants of which were also short—some cropped as high as the elbows. Undersleeves often extended to a three-quarter length. For the first time since antiquity, women's arms were bared. A fullness returned to the shape of sleeves but this time with a softness unlike the padded artifice of the earlier leg-of-mutton styles. Some versions of sleeves featured open seams the full length of the arm to display linings or undersleeves made of a contrasting white or ivory satin. Ribbons sometimes were tied around the sleeves to divide them into two or more puffs. Other sleeve styles featured a revival of the vertical Renaissance panes over a satin lining.

Cuffs were formed in a wide assortment of shapes and sizes. Turned-back cuffs were made of fine gauge or sheer linen with lace trim. Variations also included tiers of lace or even a ruff of lace encircling the elbow or lower arm. Some cuffs reflected the new softness of the gown with unstarched lace borders that fluidly hung down the forearm and drooped in the back.

The skirt and bodice of the gown were now sewn together. Because the waistline was raised and the wide farthingales were gone, the long line of the skirt reinforced the look of verticality. The open skirt front was not tailored as a sharp, inverted V-cut like the Elizabethan styles, but rather was parted at the waistline by a gap from the rounded U-tip of the stomacher. Separate skirts of fine brocades and satins

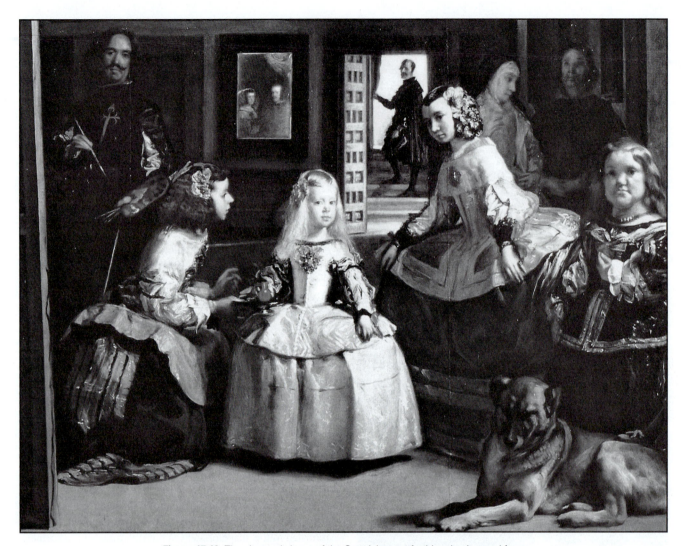

Figure 17-13. The size and shape of the Spanish court farthingale changed from the conical silhouette to a wide, elliptical form in the early seventeenth century. Attached to the flat front bodice was a a wide peplum that softened the hard edge of the hoops. Detail of *Las Meninas* by Diego Velazquez, 1656.

were worn underneath the gowns for a display of contrasting fabric at the front opening. Also unlike its predecessor, the under skirt of the 1630s and 1640s was more than just a rich panel in the front sewn to a plainweave silk or linen, because now women often carried the skirt of the gown, revealing the fabric all around. (Figure 17-15.)

The open-front gown was less popular in England than on the Continent. Instead, ladies preferred the closed-front gown, or even more, the short jacket and skirt. The typical jacket and skirt ensemble is represented in the 1633 portrait of Queen Henrietta by Van Dyke. (Color Plate 8.) The open-front jacket bodice is lined by a matching stomacher with a U-cut point. A peplum is sliced into short tabs called **basques**. English women usually girded their gown or jacket bodices with wide velvet or satin sashes tied into a rosette bow. Sleeves are soft, full, and cropped short. Decorative

panes and open seams are less common than with the French or Dutch styles. Cuffs are as equally varied as their mainland counterparts.

Collars and neckwear were sumptuous and complex. In the Netherlands, Spain, Italy, and parts of Germany, the ruff endured in various forms well into the 1640s. In Figure 17-14, a lingering version of the whisk is shown attached to wide neckline of the bodice. In France and England, the same new forms of collars that replaced the ruff on men's fashions were adapted to women's styles. Innumerable varieties of the falling band were popular with women. Some were starched and high, tucking in just under the chin, and others were soft, flat, and wide, extending out over the shoulders. As necklines plunged low, fashionable but modest women opted for multi-layered arrangements of neckwear made of sheer linen, lace, or cutwork. Forms of the partlet were revived to fill in the

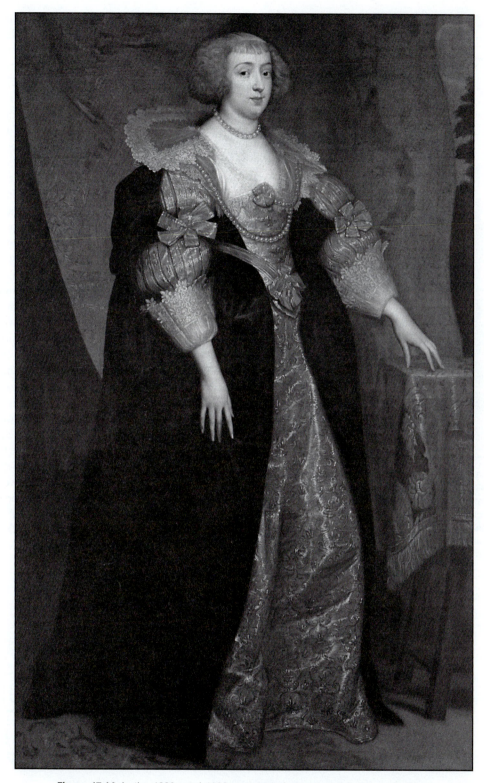

Figure 17-14. In the 1620s and 1630s, women's fashions underwent a significant transformation. Farthingales and hip rolls disappeared. Skirts draped naturally from the waist to the floor. The bodice was reduced in size and shortened with a raised waistline. Necklines plunged low. The open front of the bodice was filled with a stiff stomacher. Sleeves were short, cropped to the elbow in some designs. *Margaret of Lorraine* by Anthony Van Dyck, 1632.

deep, square necklines of bodices. Over this was sometimes fitted a large square neckerchief that was diagonally folded in half forming a triangle and arranged around the shoulders with one point in the back and the other two points pinned or tucked into the stomacher at the front. Queen Henrietta wears a lace-trimmed, gold striped neckerchief in Color Plate 8. Capping her whole arrangement of neckwear is a wide falling band.

With the return of full, puff sleeves, the wide, circular cape was the most popular form of outerwear. Lengths ranged from short, hooded capelets that barely covered the shoulders to long, cloak-like versions extending almost to the ankles. A burgeoning fur trade with Russia assured that fur-trimmed or fully fur-lined capes were affordable to the middle classes although rare furs such as sable were still luxury items for the wealthy. The working masses were content with the warmth and comfort of basic woolen overcoats modeled on the masculine cassock.

Women's hats of the early seventeenth century also were based on men's designs like the wide-brimmed cavalier hat worn by Queen Henrietta in Color Plate 8. In Holland and Germany the steeple hat with its high crown and wide, curling brim was copied from masculine versions. For indoors, women wore an extraordinary variety of close-fitting caps, some completely covering the hair and others pinned at the back of the head somewhat resembling the French hood of the previous century. (Figure 17-16.) Respectable middle-class matrons preferred caps constructed of layers of white linen, some with rigid bases swathed in starched petals of sheer linen. Younger women wore the same forms of caps but indulged in fabrics of vibrant colors and rich textures.

Women's shoe designs likewise followed those of men's styles in the first decades of the 1600s. The curved shape of the high heels and the curvilinear cut of the uppers were virtually identical for both genders. Giant rosettes of lace or

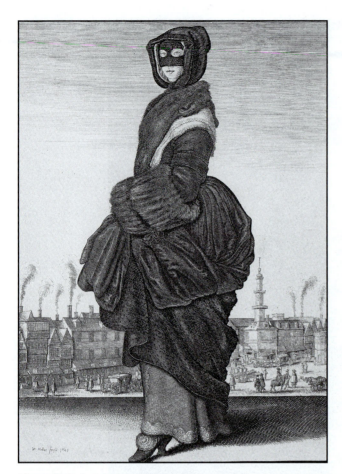

Figure 17-15. In the 1630s and 1640s, the open-front gown was constructed with the skirt sewn to the bodice. Underskirts were made of rich materials all around rather than just in the front as in earlier styles since women sometimes lifted the trains of their gowns to carry them. Engraving of woman in outdoor winter attire from *The Four Seasons* by Wenceslaus Hollar, 1643.

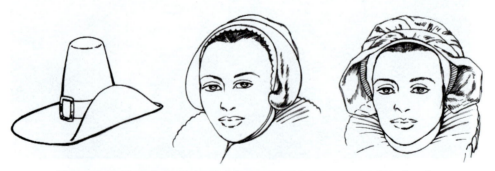

Figure 17-16. Through the first half of the seventeenth century women's styles of hats followed men's designs. The middle and working classes, though, preferred more modest and practical forms of head coverings. An extraordinary array of close-fitting caps was available by mid-century. Some styles sat back on the head like the French hood of the previous century. Others covered the hair in layers of white fine gauge or sheer linen. Younger unmarried women often chose caps made with fabrics of vibrant colors and rich textures.

ribbons were equally popular for decorating the instep straps of women's shoes. However, when men's styles became square-toed with heavy heels in the 1630s and 1640s, women's shoes remained more delicate with slender contours, curved heels, and pointed toes.

WOMEN'S FASHIONS 1650–1700

"Fashions are now, and will remain, French," concluded renowned costume historian Millia Davenport, summing up the designs of women's clothing from the second half of the seventeenth century through most of the twentieth. One of the most important developments in the French fashion industry was the profound division in the craft of tailoring that occurred in 1675. A group of seamstresses was granted royal permission from Louis XIV to form a guild of female dressmakers to produce women's apparel. This development had far-reaching significance because, by that time, all of Europe was copying French fashions and methods of apparel production. Of course, female sewers had been an important segment of the clothing profession for centuries. Usually as a cottage industry, women sewed for hire, stitching yards of seams, trim, and finishing details. They excelled at embroidery, cutwork, lacemaking, and other surface embellishments, but they were never tailors trained in the technology of patternmaking or the cut and fit of complex garment construction. Now at the end of the seventeenth century, women dressed women. However, the essential shape of women's fashions would remain in the hands of men, especially corset makers, for more than a century as we shall see with the evolution of women's fashions in the next chapter.

By the third quarter of the 1600s, the silhouette of women's gowns shifted proportions to a longer torso. (Figure 17-17.) The waist of the bodice dropped to its natural line although the constricting corset and busk continued to form a smoothly flattened conical shape. The stomacher extended in deep V-contours from the waist to well below the hips in the front. To stiffen the center front of the stomacher (or busk, or corset), a wide rigid stay of ornamented wood, bone, or metal was inserted into the center front. One of the popular decorative treatments of the stomacher in the 1660s was an application of numerous ribbon bows called an **eschelle** down the front, sometimes arranged in descending sizes of bows from the top down. Necklines dropped to encircle the shoulders in a close-fitting ovoid cut. Full, gathered sleeves were pushed off to the sides with shoulder seams low on the upper arm. Sleeve lengths remained short, variously cropped between the elbow and forearm.

The last of the cartwheel ruffs finally vanished by the 1650s even in Holland and Germany. The high, starched styles of falling bands had evolved into numerous softer forms of neckwear for women who chose to cover the vastly exposed neck and shoulders—although many younger women preferred to remain bare, displaying their alabaster skin and cleavage. Matrons and Puritans opted for heavier, opaque linen collars that concealed all with cape-like versions of neckwear.

Skirts continued to fall naturally from the waist without the contrivance of hoops except in Spain and the dominions influenced by Madrid. The open front over a contrasting underskirt remained prevalent. Some versions of the open-front skirt were made with a row of buttons that allowed the option for an open or closed treatment. For aristocratic women, open-front skirts were sometimes pinned closed with jeweled brooches.

By the end of the 1680s, the design of gown bodices had been altered to be less revealing. (Figure 17-18.) Many costume historians credit the second wife of Louis XIV with this influence in part because of her conservative religious views and also because of her mature years. The neckline was narrowed and raised, covering the shoulders and forming a squared shape. The armscye of the sleeve was also raised back to the shoulderline. The sleeves remained cropped short but were less full.

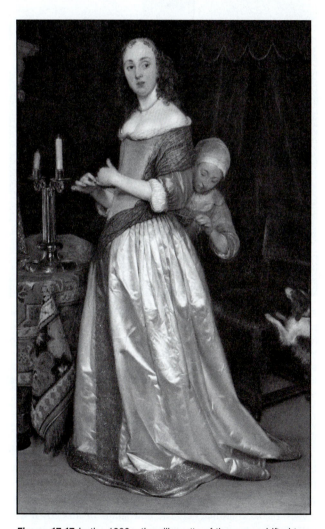

Figure 17-17. In the 1660s, the silhouette of the gown shifted to a longer line with the waist of the bodice at the natural line. The stiff busk and constricting corset continued to shape the bodice into a smooth, flat-front cone. Necklines widened to encircle the shoulders and the sleeve armscye seam dropped onto the upper arm. Sleeves remained short. Detail of *Lady at Her Toilette* by Gerard Terborch, 1660.

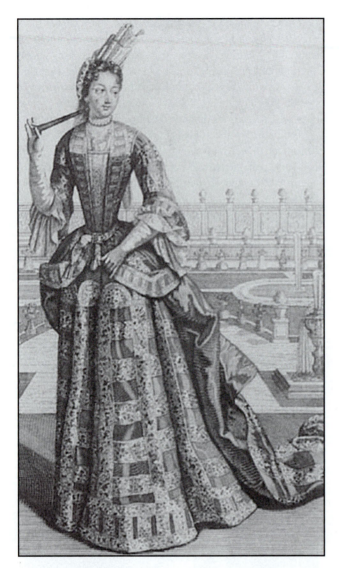

Figure 17-18. In the 1680s, a new form of gown called a mantua featured a construction in one length from the shoulder seam to the skirt hem. The sides of the gown's open-front skirt were pulled back upon the hips to form a bustle effect with a cascading train in the back. The exposed underskirt was often lavishly embellished with all types of trim and decoration. Engraving of Madame la Duchesse de Chartres by Antoine Trouvain, 1697.

The new construction of the gown was cut in one length from the shoulder seam to the skirt hem but was open completely down the front. The opening in the front of the bodice was buttoned or pinned closed or filled with an embroidered corset, busk, or stomacher. The new shape of this gown was called a **mantua** (also manteau).

Another significant development in the style of women's gowns at the end of the century was the **bustle** effect created with the open-front skirt. Each side of the skirt was pulled back high upon the hips and arranged into swags of fabric that cascaded into a long train. English

women wore a small hoop bustle at the hips to add further dimension.

With such a full display of the underskirt, it was often made of more opulent materials than the gown itself. The example shown in Figure 17-18 reveals the lavish embellishments of embroidery, tassels, ribbons, and lace trim, all together at once. The ostentatious look is almost Byzantine in its excessive richness. Some underskirts were so heavy that special stays had to be attached to the bodice and corset to support the weight and ensure the proper draping. Of course, these skirts are representative of French court dress worn by the highest-ranking women. For the fashionable upper middle classes and minor aristocracy, simpler fabric combinations were selected to achieve the new bustle-effect silhouette. A more sumptuous look of the petticoat was achieved with a textural treatment created by tiered ruffles, tucks, or horizontal bands of trim.

The influences of menswear on women's fashions in the late seventeenth century were most evident in the distinctive riding ensembles. Women's jackets were tailored exactly as men's styles including a fitted waist, close-fitting sleeves, large cuffs, a high neckline, a flared fingertip-length skirt, and even pockets. Women's linen riding shirts were cut full with long sleeves and simple collars. Even cravats were tied about the neck in the same arrangements that were fashionable for men, which in the 1690s included the steinkirk. Men's styles of riding boots and gloves, wide hats with cocked brims, and wigs were likewise appropriated by equestriennes. Except for their long, full skirts, observed Samuel Pepys, "no one could take them for women at any point whatever, which was an odd sight."

In addition to the riding jacket, women wore a variety of outerwear when outdoors. Variations of the warm, capacious cassock were especially popular for travel in winter. Capes of various sizes served for brief treks outside or for sitting through services in unheated churches. Another wrap garment that became increasingly popular toward the end of the century was the **stole**, a narrow scarf-like wrap of cloth or fur worn around the shoulders and draped over the arms.

Types of women's undergarments remained the same as those of mid-century. Corsets were embroidered across the front to fill in the gaps of open-front bodices. Long-sleeve, ankle-length chemises and knee-length drawers were made of fine linen or sometimes silk. Both garments were frequently embellished at the hemlines with narrow bands of exquisite black thread embroidery. Sleek-fitting knee-high hose were knit in a vast array of textured patterns and often decorated with clocking at the ankles.

The most common forms of women's headwear continued to be an infinite variety of small, close-fitting caps including coifs with chinstraps, diminutive satin turbans, and starched headbands. Colorful cauls of crocheted silk were affixed to buns at the back of the head. Ribbons,

Figure 17-20. Women's footwear of the late 1600s was completely distinct from men's styles. Heels were much more delicate and toes were sharply pointed rather than squared. Surfaces were richly patterned with embroidery, cutwork, and appliques. Backless slippers called pantoufles became the most popular informal shoe worn in the home.

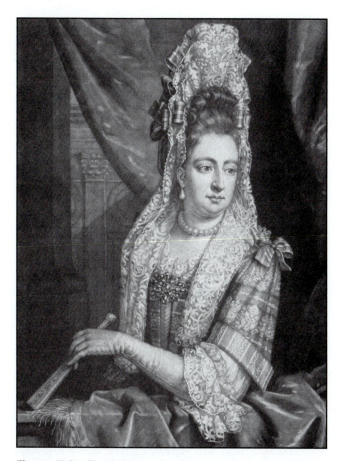

Figure 17-19. The fontange (or commode as it was called in England) was a small cap that pinned to the back of the head. Attached to the cap was a tall wire frame layered with tiers of lace, ribbons, and ruffles. *Queen Mary II of England* by an unknown artist, 1694.

bows, and feathered ornaments were also inserted into elaborate hair arrangements where caps or hats might crush delicate curls. In addition, some men's hat styles continued to be adapted to women's outdoor attire, as noted with the description of riding ensembles. In the 1660s, the tall steeple crown hats were carefully perched at an angle atop masses of curls. In the 1670s and 1680s, women's hats featured the more shallow crowns flattened with wide, up-turned brims.

At the end of the century a totally new form of head-dress prevailed over all others. The French **fontange**, or **commode** as it was called in England, was a small round or oval cap pinned to the back of the head. Attached to the top of the cap was a tall wire frame over which were arranged tiers of lace, ribbons, cutwork, and linen ruffles. (Figure 17-19.) Some versions included long lappets of lace that draped over the shoulders. Hairstyles were piled high, often with false hair attachments, to emphasize the vertical drama of the fontange.

Although women's shoes at the beginning of the 1600s were identical to men's styles, by the end of the century, the contours of feminine footwear were decidedly differentiated. Heels were much more delicate, some tapered to a fine point that resemble the pencil-point shapes familiar to us today. Toes were sharply pointed and somewhat extended in length. Surfaces were completely covered with lavish embroidery, appliques of passementerie, or cutwork shapes of richly patterned brocades. (Figure 17-20.) Large metal buckles were rarely used on women's shoes since they could catch on the long hems of petticoats. Some shoes featured cutaway sides with straps across the instep and others completely sheathed the foot up to the ankles. Tongues rose about two inches above the cut of the upper shoe. Backless slippers or **mules**, called **pantoufles** (also pantoffles or pantofles), were the most popular informal shoe worn in the home.

Other women's accessories of the seventeenth century included a wide assortment of winter accoutrement. Much has been written about the severity of northern European winters during the second half of the seventeenth century. Modern climatologists have identified a period of low solar activity between 1645 and 1715 as the Maunder Minimum during which winters were longer and colder with heavier snowfalls than average. Hence, the proliferation of so varied an assortment of winterwear was motivated more by necessity than fashion. For example, when venturing out of doors, women endured having their hair mussed by tying on face masks to protect against the cold and windburn of winter. The woman in Figure 17-15 wears a soft woolen half mask with strings at the temples and across the top of head that ties in the back. She also carries a large fur muff although this had been a recurring accessory since the late Middle Ages. In the seventeenth century, men, too, used fur muffs. Pepys wrote of carrying his wife's

"last year's muff"—having just bought her a new one—against the "great frost" of November 1662.

The assortment of other accessories that a woman might hold, carry in a purse, or attach to a belt included handkerchiefs, fans, mirrors, and necessaries such as scissors and combs. In the late 1600s, the **pomander ball** was revived from the Middle Ages. Perfumed pieces of fabric, porous wood, or even locks of hair were inserted into tiny hollow containers that were pierced with decorative perforations. As sleeves exposed more arm, elbow-length gloves were possible. In Figure 17-19, Queen Mary II wears a pair made with piping along the outer seam and embroidery on the back of the hand.

Ladies of the court liberally indulged in the application of cosmetics with sometimes deadly consequences. If a woman (or man) did not have the prerequisite white skin a dusting of rice flour would help. To conceal wrinkles and pockmarks, a liquid foundation made of vinegar and lead would be applied over the face and neck although its telltale hard edge was difficult to disguise. Cheeks and lips were reddened with a cream tinted by cinnabar, a poisonous red sulfide of mercury.

Tiny black **patches** made of satin, velvet, or leather were glued to the face as beauty marks. Shapes ranged from simple dots to ornate stars, crescent moons, and hearts. In France, the beauty patch came to be known as a **mouche**, literally meaning "housefly." The placement of the patches evolved into an unspoken social language, especially effective in communicating to the opposite sex. A patch near the lips or at the corner of the eye signaled a flirtatiousness. Married women wore a patch on the right cheek, and betrothed women wore theirs on the left. Men signified political allegiances with the shape and location of their patches. One of the necessaires carried by both men and women was a tiny **patch box**—the forerunner of the modern compact—that contained extra patches and a mirror for reapplying those that may have fallen off at the ball or dinner party. The trend of patches would continue for several decades into the eighteenth century.

CLOTHING OF ORDINARY WOMEN

As noted in the section on men's apparel, numerous genre painters of the seventeenth century, especially in Holland and France, produced thousands of canvases depicting ordinary people in everyday activities. With almost photographic accuracy, these pictures of tavern and church interiors, market squares and city streets, and indoor views of domestic home life provide a wealth of garment and accessory detail. From these many snapshots of daily life, the costume historian can gauge how the clothing of the common masses was influenced by the fashion trends of the aristocracy across the entire era.

The clothing of middle class women usually followed the silhouettes of the court fashions but without the quality of fabrics and richness of trim. Bodices were closely fitted over corsets, necklines plunged low, sleeves were full and decorative, and the open-front skirts of gowns revealed petticoats of contrasting colors. In the early decades cartwheel ruffs

Figure 17-21. The clothing of lower class women had to be practical and functional. Bodices were separate garments worn without stays or corsets. Chemises were made of plain, serviceable linen without collars. Petticoats were superfluous but aprons were indispensible. Skirt hemlines were usually short, conserving fabric and providing greater freedom of movement. Detail of *Maidservant* by Johannes Vermeer, 1660.

prevailed, only without costly lace trim or cutwork. Later, plain linen collars corresponded to the lavishly embroidered or lace falling bands of the elite classes. A significant variety of coifs and other forms of caps and headdresses were preferred to the befeathered steeple hats and fontange.

The clothing of women in the lower classes changed less often than that of their middle class sisters. Their clothing had to be practical and functional. (Figure 17-21.) Bodices were separate garments, worn without stays or a corset. Some varieties were laced closed on the outside similar to styles of the previous century although buttons were much more common for all classes. Sleeves were close-fitting, often without cuffs. Shirts (or chemises) were plain linen, usually without collars, which were a superfluous expense and an additional burden on washday. Hemlines were usually short—above the ankles—not only conserving the use and cost of fabric but providing freedom from tripping on skirt hems while kneeling or stooping. Long aprons protected the skirt and provided a handy wipe cloth. Ordinary women might have one or two garments decorated with embroidery for special occasions such as weddings, but otherwise clothing was largely unadorned. Even

colors were haphazardly mixed without concern for clashing hues. Head coverings were simple linen caps without the starched hairbands and carefully arranged layers.

CHILDREN'S CLOTHING

The practice of swaddling babies continued through the seventeenth century. The newborn was first dressed in a long tunic-style gown of linen and then bound the length of the body with a long strip of fabric in a spiral wrap. A small cap called a **biggin** covered the infant's head and was secured under the chin with strings. Diapers were called **clouts** (also tailclouts) and were usually made from discarded linen shirts or chemises. Some other types of infantswear of the period are described in a dialog written in *The French Garden* by Peter Erondell in 1605, in which the mistress of the house instructs the nurse on dressing her baby: In addition to the gown and biggin (and presumably a clout), the complete ensemble included a bib, apron, coat of "changeable taffeta" with satin sleeves, and a **muckminder** (handkerchief). A rattle for teething called a **coral** (also corall) was attached to a chain and put in the crib with the baby. Marine coral was used since it was believed to bring good luck, and some rattles featured little bells as an added element to ward off evil.

Some paintings show swaddled babies also covered with a long wrap usually of a fine brocade or embroidered material that was called the **bearing cloth**. This was used as a receiving garment for presenting the baby to visitors while the mother was still confined to her bed in the days after giving birth. The bearing cloth also was used for presentation of the baby at the christening.

After a couple of months, the swaddling bands were eliminated entirely and the baby was "short-clothed" or "short-coated," meaning dressed in a waisted gown that covered the feet. Long, waisted aprons also continued to be part of the toddler's dress, most of which were tied around the neck like a long bib. By the time the child began to walk, long strips of material known as **leading strings** were attached to the armholes or shoulder seams of the gown to help guide the child in his ambling about. Some costume historians suggest that leading strings evolved from the ornamental Spanish hanging sleeves that were still popular for adult fashions in the early decades of the century. Still other researchers submit that the lappets of material seen in paintings of children were decorative only and that leading strings were actually separate cord-like attachments.

By the time children were about five or six years old, boys and girls were dressed in gender-appropriate clothing. Boys still wore floor-length gowns, but bodices were designed like men's doublets. The gowns of girls were virtually miniatures of women's styles, including tight-fitting bodices reinforced with stays and necklines and sleeves cut in the fashion of the day. A diary entry by Lady Anne Clifford in 1617 noted that her daughter had been fitted for her first corset ("whalebone bodies") at age three.

The Van Dyke painting shown in Figure 17-22 depicts three of Charles I's children wearing these forms of dress. In an earlier

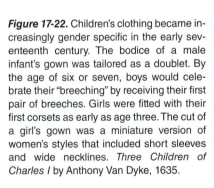

Figure 17-22. Children's clothing became increasingly gender specific in the early seventeenth century. The bodice of a male infant's gown was tailored as a doublet. By the age of six or seven, boys would celebrate their "breeching" by receiving their first pair of breeches. Girls were fitted with their first corsets as early as age three. The cut of a girl's gown was a miniature version of women's styles that included short sleeves and wide necklines. *Three Children of Charles I* by Anthony Van Dyke, 1635.

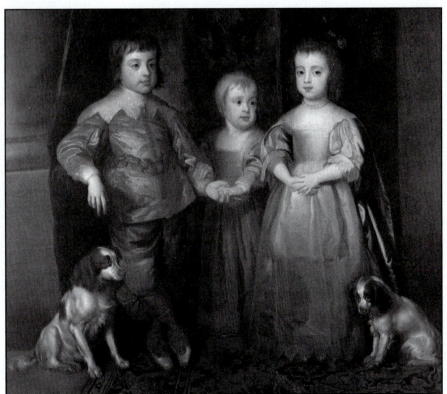

version of this painting, the artist represented the six-year-old Prince of Wales in the doublet gown he actually wore everyday, but the king protested that it was an undignified portrayal for the heir to throne. In this second version, the prince is dressed in a diminutive version of a court gentleman's suit featuring a high-waisted doublet with side vents and ribbon loop decorations at the waistline. His accessories include a broad lace falling band and shoes with huge rosettes. On the other hand, his younger brother James standing in the background wears the traditional biggin and infant's gown with a lace-trimmed linen apron covering the front. The Princess Mary standing on the right is dressed in a blue satin gown with a tight bodice, wide square neckline, and slashed half-sleeves with leadstrings down the back. A waisted apron of sheer linen protects without concealing the lavishly embroidered, lace-trimmed gown.

REVIEW

During the seventeenth century a new Europe emerged—one in which imperial expansion dotted the globe with colonies, and the Thirty Years War redrew the geopolitical map of the continent into the national boundaries familiar today. It was the era of the fatalistic Charles I, whom the English people beheaded for his unyielding ideas of divine kingship and his disregard for his subjects. It is also the period of the Sun-King, Louis XIV, whose self-glorification inspired the magnificence of Versailles and expanded the boundaries of France. In the arts, it was the age of Baroque whereby art and architecture expressed theatrical drama, passion, and virtuosity. In the sciences, great thinkers like Isaac Newton and Galileo laid the foundations for the age of reason to dominate the next century.

During the first quarter of the seventeenth century, dress changed little compared to the stylistic transformations of the late 1500s. Men continued to wear tight-fitting doublets with stiff whisks and ruffs about the neck and baggy trunk hose cropped at the knees. Women still wore gowns shaped by constricting corsets, flattening busks, and drum farthingales.

By the 1620s, though, men's clothing began to evolve new silhouettes more rapidly. The doublet was cut loose and full with a raised waistline and short skirt. New forms of garment technology included the use of hooks and eyes to replace the old points and laces used for attaching breeches to doublets.

In the second half of the century, dramatic changes in men's fashions included petticoat breeches, so named because the legs were immensely wide and resembled a divided skirt. During the 1660s and 1670s, the knee-length vest, called a waistcoat in England, was introduced along with the justaucorps, a fitted jacket with a long, flared skirt. The contours of breeches returned to a narrower cut. This combination of jacket, vest, and breeches was the prototype of the masculine three-piece suit of today.

A new emphasis on masculine accessories led to a broad assortment of hat styles ranging from tall steeple-crown variants to unconstructed berets of varying dimensions. Wigs became important to the well-dressed man of the seventeenth century for all but the lowest classes. The new, looser fit of the doublet and breeches influenced the introduction of softer types of collars including the wide, falling bands and tiered, soft ruffs. By the end of the century, collars virtually disappeared due to the long "full-bottomed" wigs and the development of the cravat.

Among the innovations of women's fashions in the early seventeenth century was the abandonment of hoops. Skirts now fell naturally from the waist, and the bodice was restructured with a shortened, high waistline. New emphasis was placed on the fabric and colors of underskirts as women began to carry or pin up the outer gown skirt. Necklines plunged to a deep decolletage, and sleeves were cropped short exposing bare arms for the first time since antiquity.

By the second half of the 1600s, women's gowns shifted proportions to a longer bodice with the waist dropped to its natural line. The new construction of the gown was cut in one length from the shoulder to the hem. The open-front skirt was draped back at the sides forming a bustle effect. The opening in the bodice front was filled with an embroidered corset or stomacher.

In the early decades of the 1600s, women's accessories largely followed the styles of men's designs, particularly shoes and hats. In the later decades of the century though, women's accessories were more delicate and refined. Shoes featured high, pointed heels and were made with richly decorated surfaces. A vast array of hats included close fitting coifs, layered caps and bands, and the towering fontange with its cascades of lace and ruffles.

For children, gender-appropriate elements were more apparent than in earlier eras. Girls were fitted for their first corsets at age three, and the bodices of male infant gowns were tailored as doublets. By the age of six or seven, girls were fully attired as diminutive women, and boys celebrated their "breeching" with their first pair of breeches.

Chapter 17 The Seventeenth Century
Questions

1. Which key elements of sixteenth-century men's and women's fashions continued into the first quarter of the seventeenth century?

2. Which changes to men's doublets, breeches, and collars occurred between 1600 and 1620?

3. What were the three chief forces of conservatism in the early seventeenth century that deterred the frequency of fashion innovation?

4. Compare the design innovations of men's doublets and breeches in the second quarter of the seventeenth century with those of the third quarter.

5. How were women's gowns dramatically restructured in the 1630s? What shift in the silhouette of gowns occurred in the 1660s?

6. Identify the three methods of filling the open-front bodice of a gown.

7. By the end of the 1600s, four basic components of men's dress formed the prototype of the modern suit. Name and describe the construction or arrangement of these seventeenth-century garments.

8. What elements of seventeenth-century men's shoes and periwigs survive in modern men's fashions?

9. What were the chief design features of the mantua?

10. What was the significance of French women receiving royal permission to form a guild of seamstresses in 1675?

11. Describe how children's clothing in the seventeenth century became more gender differentiated than in previous eras.

Chapter 17 The Seventeenth Century
Research and Portfolio Projects

Research:

1. Write a research paper analyzing how the stylistic and cultural characteristics of the Baroque era were reflected in the fashions of the seventeenth century. Examine how the contrast between the exuberant emotionalism of the Baroque style in the arts and the intellectualism of the period were applied to fashion.

2. Write a research paper on how the French fashion industry emerged as Europe's preeminent style leader in the seventeenth century. Explore the development of women's guilds and the evolution of female workers from seamstressing to tailoring.

Portfolio:

1. Compile a cross-reference guide featuring the elements of men's seventeenth-century dress that have survived in men's clothing, accessories, and grooming of today. Illustrate each comparison with a photocopy or digital scan. Include a paragraph with each describing the fashion element in its seventeenth-century form and how it has evolved in modern styles.

2. Research the methods in which women's and men's cravats were tied in the seventeenth century. Select three of each gender's dress and draw a step-by-step diagram illustrating how to tie each. Pick one for each gender and demonstrate to the class how the fashionable man and woman of the era would have assembled a cravat.

Glossary of Dress Terms

baldric: a wide leather belt worn diagonally around the torso to which was attached a sword scabbard

basques: short, tab-like sections of a jacket or bodice peplum

bearing cloth: a long wrap of fine material used to cover a newborn for presenting to visitors

biggin: a small infant's cap secured by chin strings

Brandenburg coat: a heavy overcoat adapted to civilian wear from the soldier's greatcoat of the German province of Hohenzollern Brandenburg

buff coat: a long- or short-sleeve doublet made of buckskin

bustle: the gathering of material at the back of a skirt, sometimes over a frame or padded support

cannons: wide ruffles or lace trim attached to the tops of hose at the knees or to the cuffs of breeches

cassock: a man's large, long sleeve overcoat with a front button closure

clocking: lavishly embroidered sections along the ankles of men's and women's silk hose

clouts: (also tailclouts) and were usually made from discarded linen shirts or chemises

commode: the English name for the fontange; see fontange

coral: an infant's teething rattle made of marine coral and attached by a chain to the crib

cravat: a neck scarf variously arranged or knotted

eschelle: the decorative application of numerous ribbon bows to the front of a stomacher

falling band: a wide, flat collar worn by both men and women; made of fine linen, with or without lace trim, or fashioned entirely of lace or cutwork

fontange: a woman's small round or oval cap to which was attached a tall wire frame covered with tiers of lace, ribbons, or ruffles

full-bottomed wig: a massive wig styled with high peaks that swept upward from the forehead and long, full locks that extended half way down the torso

golilia: a starched, wired version of the men's split collar

justaucorps: a fitted jacket with a long, flared skirt cut with vents at the sides, front, and back for horseback riding

latchets: decorative pieces of leather cut in geometric or amoeboid shapes that attached to instep tops of men's boots

leading strings: long strips of material attached to the armholes or shoulder seams of a toddler's gown to help guide the child while learning to walk

love lock: a strand of hair tied with ribbon bows symbolizing a romantic token from an admirer

mantua (also manteau): the construction of a gown cut in one length from the shoulder seam to the skirt hem but open down the front displaying an underskirt and a decorated corset or busk

mouche: the French term for beauty patches, literally meaning "housefly"; see also patches

muckminder: a handkerchief usually pinned to an infant's gown or bedding

mule: a woman's backless slipper

pantoufles (also pantoffles or pantofles): a woman's backless slipper worn informally at home

passementerie: ornamental braid woven into various shapes and strands

patch box: a compact of sorts fitted with a tiny mirror and extra beauty patches

patches: tiny pieces of fabric or leather cut into assorted shapes and strategically attached to the face

periwig: a men's full wig arranged as a mass of loose, irregular curls that fell low over the shoulders

petticoat breeches: breeches cut with immensely wide legs that resembled a divided petticoat

pomander ball: tiny, hollow containers pierced with perforations through which scents aired

rhinegraves: a narrower form of petticoat breeches thought to have originated in the Rhineland of Germany

ribbon loops: decorative clusters of ribbons attached to men's doublet cuffs and at the waistband and knees of breeches

roses (also rosettes): an ornament of ribbon, lace, or other fine textile that is gathered and tufted from the center to resemble a flower blossom

shag: a deep pile textile applied as decorative appliques to doublets, cloaks, and jackets

shoulder caps: crescent-shaped pieces of fabric sewn to shoulder seams; also called wings

steeple crown hat: a brimmed hat with a crown shaped as a tall truncated cone

steinkirk knot (also steinkerque): a twisted cravat knot inserted into a jacket lapel buttonhole worn in honor of a French military victory

stole: a narrow scarf-like wrap of cloth or fur worn around the shoulders and draped over the arms

sugarloaf hat: another name for steeple crown hat

surtout: an overcoat cut shorter and narrower than the voluminous Brandenburg

vest: an upper body garment worn over the shirt but beneath a suit jacket; see waistcoat

waistcoat: British term for vest

welt pockets: the opening of an interior pocket finished with a raised edge seam

wings: see shoulder caps

Legacies and Influences of Seventeenth-Century Styles on Modern Fashion

Arguably the most significant development of men's fashions in the seventeenth century that has impacted modern menswear most was the ensemble of a jacket, vest (waistcoat in England), and breeches—the prototype of today's three-piece suit. With the addition of the cravat at the end of the 1600s, the basic components of men's most prevalent attire for the following 300 years were established.

Of the numerous varieties of seventeenth-century men's accessories that are still relevant today, shoes probably best exhibit surviving design elements. The legacy of the decorative rosettes is the modern use of tassels and fringe that have been common on men's shoes since the 1920s. High heels for men were revived briefly in the early 1970s, but have been a standard feature of cowboy boots for more than a century.

Although groomed, long hair for men has been a recurring fashion since the Middle Ages, the extravagant mounds of curls and lengths of the "full-bottomed" wigs of the seventeenth century were unparalleled. When men began to grow their hair long in the late 1960s, many comparisons were made between the modern look and that of the periwigs, both of which were criticized as effeminate in their respective eras.

For modern women, the shoulder-wide lace and cutwork collars that evolved from the seventeenth-century falling band collars have been a mainstay design element of fashion ever since. Interpretations have ranged from exquisite accessories for formal occasions to feminine accents for day dresses and blouses.

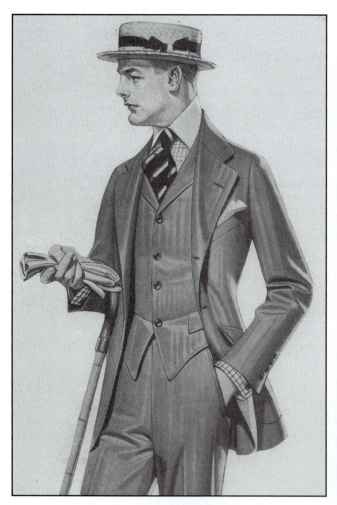 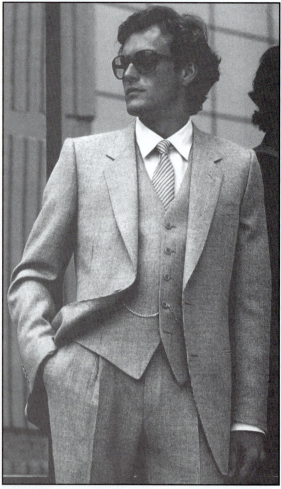

The introduction of the vest in the 1660s also inspired new designs of the jacket and breeches for an ensemble that forecast the staple of men's wardrobes to the present. Left, saxony three-piece suit by Kuppenheimer, 1916; right, worsted three-piece suit by Canali, 1981.

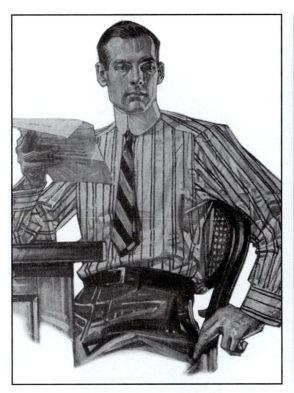

The cravat was developed by the French in the last quarter of the seventeenth century. Its modern version, the necktie, has remained largely unchanged since its development at the end of the nineteenth century. Left, striped necktie, 1912; right, Anna Sui logo necktie, 2003.

Elements of men's shoe designs of the seventeenth century survive today in the adornments of tassels, fringe, and braid. The thick, high heels of Louis XIV reappeared briefly on men's platform shoes in the mid-1970s. Cowboy boots, though, not only retained the high heel but also decorative treatments similar to styles of the 1600s such as tooled leather, embroidery, and appliques. Left, men's platform shoes by Bally, 1973; center, leather tassel loafers, 2000; right, men's cowboy boots by Giorgio Brutini, 1988.

The soft ruffs and capelet-sized lace or cutwork collars of the seventeenth century have continually recurred in various adaptations for women's fashions to the present. Top left, velvet gown with Honiton lace collar by Baron de Meyer, 1919; right, organdy blouse with pleated ruff and tiered cuffs, 1957; bottom left, acetate rayon blouse with wide lace collar from Camellia, 1947.

Chapter 18

THE EIGHTEENTH CENTURY

Queen Anne of England reigned 1702–1714	George I of Hanover reigned in England 1714–1727		George II of England reigned 1727–1760	Frederick the Great reigned in Prussia 1740–1786	
England and Scotland united 1707	Louis XV of France reigned 1715–1774		John Kay invented the flying shuttle 1733	Madame Pompadour became mistress of Louis XV 1745	
Pompeii discovered 1711	Watteau's *Pilgrimage to the Isle of Cythera* 1717	Smallpox vaccine developed 1721		Fielding's *Tom Jones* 1749	

1700 1725 1750

Gregorian Calendar adopted 1752	George III of England reigned 1760–1820	Louis XVI of France reigned 1774–1793	The American colonies declared independence 1776	Beginning of French Revolution 1789	Napoleon overthrew the French Directory 1799
	James Hargreaves invented the "spinning Jenny" 1767	Voltaire's *Candide* 1759		David's *Oath of the Horatii* 1785	Discovery of the Rosetta Stone in Egypt 1799
Rousseau's *Discourse on the Arts and Sciences* 1750	James Watt's steam engine 1765	Diderot completed the *Encyclopaedia* 1772	Britain recognized Independence of American colonies 1783	Death of Mozart 1791	

1750 1775 1800

THE AGE OF ENLIGHTENMENT

Until the eighteenth century, Western institutions and beliefs were largely determined by tradition and authority derived from religious doctrine. But by the beginning of the 1700s, a categorical shift in the way men thought occurred. Tradition was replaced by reason—a process of analytical thinking and study rooted in the achievements of men like Isaac Newton and John Locke. From this process developed the secular humanitarianism that marks the era so profoundly.

In France, a group of writers called "philosophes" epitomized the enlightened humanitarians. These men were not so much philosophers as they were propagandists who explained and applied scientific methods of observation and experiment to the human experience. They attacked aristocratic privilege and especially the intolerance and prejudices of religion. The philosophes maintained that all men were capable of understanding the truth—the truth of just laws and of freedom of speech and dissent.

Although France ceased to dominate Europe politically in the eighteenth century, it retained a cultural supremacy. Paris was the intellectual capital of the West. Louis XV had moved his court to the city, freeing the aristocrats from the constraints of Versailles. Fashionable and intelligent women such as Mme. Geoffrin and Mme. de Lafayette established salons at which proponents of the Enlightenment exchanged and refined their secular ideas. The genius of the age was Francois-Marie Voltaire whose poetry, plays, and propaganda expressed the attitudes of the philosophes with a wit and irony that had broad appeal. Jean-Jacques Rousseau's writings viewed government and authority as answerable to the will of the people. Denis Diderot completed the twenty-eight volumes of the great *Encyclopaedia*, despite attempts by the

423

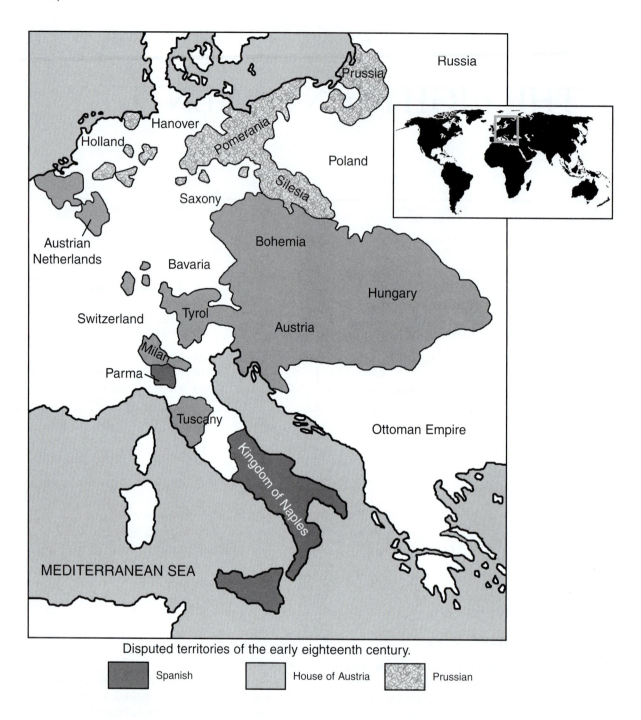

Disputed territories of the early eighteenth century.

Spanish House of Austria Prussian

government and the church to suppress it, which included contributions from most of the great figures of the age.

Among the avid readers of the rational-humanitarian works by the philosophes were the monarchs and ministers of European powers. These rulers modeled their governments on the archetype of French absolutism, though tempered with influences from the Enlightenment—within limitations. For example, although judicial torture was abolished and religious tolerance was generally decreed, freedom of speech and writing remained restricted. Rulers of the era now thought in terms of state interests rather than family interests, but the abstract concept of the state did not mean of the people. Enlightened despotism was not a response to public opinion. For instance, when Frederick II of Prussia cleared the royal hunting grounds of forests for agriculture, his intent was the state before royal pleasure, and the economy of the state before food for his subjects.

In addition to intellectual leadership, France was the arbiter of style, fashion, and taste of the period. Apart from the impact of English scientific inquiry and significant

contributions of the Austrian and German courts to music and theater, the culture of the Enlightenment was preeminently French. Urbane civility rooted in the protocol and etiquette of Versailles dominated the courts of Europe. French was the language of diplomacy. The modes of French society were emulated from court to country manor across the continent; the fashions of Paris set the trends from London to St. Petersburg.

In art, three styles prevailed, each emanating from the academies and studios of Paris. The century opened with the Rococo style, a term later applied by historians that merged the Portuguese word barocco, meaning irregular in shape, with the French word rocaille, an ornamental shell motif used in decoration. Rococo art was a highly refined, visually playful style characterized by soft colors, delicate lines, and sensuous, curving forms. Arabesques, C-curves, and S-shapes abounded in the interior decorations of salon suites, palaces, and churches of the early eighteenth century. In painting, the work of Jean-Antoine Watteau, Francois Boucher, and Jean-Honore Fragonard epitomized the French Rococo style. Luxuriant fabrics, lush vegetation, erotic nudes, flying putti, and free, tour-de-force brushwork hallmark their paintings.

By the 1760s, though, the Rococo style was eclipsed by Neoclassicism, partly inspired by the excavations of Pompeii and partly by reinterpreted political ideas of republican-humanitarianism. The perceived grandeur that was antiquity—both visual and literary—was adapted to architecture, sculpture, and painting. Historical pictures, such as Jacques-Louis David's *Oath of the Horatii* and *Death of Socrates*, were morality tableaus replete with archaeological details and costumes. Thomas Jefferson applied the balance and formality of Greco-Roman architecture to Monticello, his Virginia plantation home. Jean-Antoine Houdon's sculpture of George Washington depicted the American president leaning on the Roman fasces—a bundle of rods symbolizing the authority and power of the state.

At the end of the century, and transitional to the nineteenth century, was Romanticism. Artists, composers, and writers of the period exalted the emotions of almost anything that aroused them—love, exoticism, sentiment, revolution, violence, hero-worship, nature, or romanticized history. It was the poetry of William Wordsworth, the symphonies of Beethoven, and the paintings of Theodore Gericault and Francisco Goya that demonstrated the wide range of emotional expression of the Romantics.

Historically, Europe of the eighteenth century was more homogeneous than it had been since the feudalistic Middle Ages. Until the last quarter of the century the social and political order of European states remained fairly stable. Wars were fought by small armies of mercenaries or conscripts trained in formal maneuvers with campaigns limited to fair seasons. The most significant territorial changes occurred at the periphery of Europe where the diminished Ottoman Empire lost territory to Russia and the Austro-Hungarian state of the Hapsburgs.

In France, Louis XV and Louis XVI were weak monarchs who lacked the vision and administrative skills of their ancestor, Louis XIV. Inequities of taxation burdened the nation except for the privileged nobility who were exempt. A vast bureaucracy drained the treasury. The enormous colonial holdings in North America and the extensive trade with India produced great wealth, but primarily for financiers and bankers. Smuggling was rampant costing the state lost revenue and the expense of policing. The industrial revolution that enriched Britain was delayed in France by protective guilds. Events spun out of control until 1789 when the people of Paris ignited the ruinous French Revolution.

In the 1700s, England dueled with France for colonial power. When Queen Anne died without an heir in 1714, Parliament invited the Protestant ruler of Hanover—related to the Stuart house by marriage—to accept the English throne as George I. During periods when the British government had competent leadership, almost half the world was brought within England's grasp. In the second half of the century, commerce pointed the way to new wealth by capital investment in the technologies of the industrial revolution. Invention begot invention, especially in the textile manufactories. Even with the loss of the American colonies, Britain continued to experience unprecedented production and economic prosperity.

Compared with the cultural dominance of France and the colonial expansion and industrial development of England, the fragmented and factious principalities, bishopric states, and kingdoms of the Holy Roman Empire remained provincial. Religious conservatism and lingering feudal traditions prolonged the backwardness of the region. Serfdom persisted and urban development was slow. The mercantile middle classes were largely insignificant. Gradually, though, two powerful states came to dominate central Europe. Brandenburg-Prussia along the Baltic Sea and the Austro-Hungarian kingdom of the Danube added territory—and more importantly, population—to their holdings in the 1700s. The succession of rulers of the German states were enlightened despots who imitated the style of the French court. Under princely patronage, German composers such as Bach, Haydn, Mozart, and Beethoven produced the greatest music of the era.

THE AMERICAN REVOLUTION

England's colonies in America had been settled largely by emigrants seeking political, religious, social, or economic changes from the Old World order. Some wanted an opportunity to worship God in their own particular way or to participate in forming new governments; others wanted to be free of demeaning class structures or to have a more level field in business competition. Thus, in effect, the American Revolution that culminated in a war for independence had been brewing for 150 years prior to 1776.

The conditions and events that led to the actual breaking away of the American colonies from England, though, were

primarily economic. The colonial mercantile system basically meant that colonies existed for the benefit of the Mother Country. Natural resources and manufactured goods from the colonies were for the sole use of England and, in turn, the colonies were a ready market for English products. For this economic benefit, England provided government and military support. However, from the perspective of the American colonists, the mercantile system was oppressive and unfair. They were not allowed to buy, sell, ship, or manufacture under conditions that were advantageous or the most profitable. This left many colonists feeling like unwanted and ill-used relatives. When England imposed direct taxation on the colonists in 1763, Americans were aroused by the cry of "taxation without representation," and the spark of revolt was ignited. Following a series of what Americans viewed as "intolerable acts" from Parliament over the next ten years and bloody conflicts with British forces, the Continental Congress approved the Declaration of Independence in 1776.

Dress in the American colonies followed European trends. Prior to the Revolutionary War (1776–1783) the elite classes of the colonies—the social circles of the royal governors and ranking military officials, the wealthy merchants of the north, and the planters of the south—adopted the fashions from London and Paris. The latest styles were brought back by travelers returning from Europe or were made available through widely circulated fashion plates and imported miniature mannequins called fashion babies. Dress for ordinary people was likewise an adaptation of European styles that were made for comfort and convenience. Aprons, kerchiefs, and caps were practical rather than decorative accessories.

In the years before the Revolutionary War began, a widely publicized boycott of British imports became a way for colonists to show their patriotism. Women were encouraged to do home spinning and weaving. Homespun wool replaced imported silks and linens. Lavish ornaments and trimmings were rejected. Only the elitist Tories continued to engage in the luxuries of European fashions.

Once the war was won, however, Americans eagerly renewed their interest in fashion. At George Washington's inaugural ball of 1789, one observer wrote that "the dresses were rich and beautiful according to the fashion of the day." Similarly, a British traveller wrote in 1795 that, upon attending the theater in Philadelphia, he would have thought himself still in England "judging by the appearance of the company" around him.

THE FRENCH REVOLUTION

When Louis XVI called into session the Estates-General in 1789 for the first time in 175 years, one of the first orders of business was to invoke archaic sumptuary laws from the previous century. Nobles, clergy, and the Third Estate—representatives of the common people—were required to wear "appropriate" dress for their station. Nobles displayed their privilege of rank with gold-embroidered silk brocades and plumed hats. Purple satin robes and crimson velvet caps denoted the religious hierarchy. And the members of the Third Estate were expected to wear dark and somber attire without hats as a symbol of their social inferiority and anonymity, despite their representation of ninety-five percent of the population.

The enactment of sumptuary laws, though, was a negligible insult compared to the seriousness of the dynamic events that led to the French Revolution (1789–1795). The state had been bankrupted by costly wars. Food shortages and inflationary prices of all goods were rampant. Peasant uprisings were widespread, and on July 14, 1789, a rioting Paris mob took the Bastille, a prison stronghold in which royal troops were garrisoned. The following month, the Third Estate took over the Estates-General and proclaimed it the National Assembly. For the next five years the old order was dismantled and a republic established with a constitution. Various factions seized control of the Assembly in succession. The king was deposed and executed in 1792. The infamous Reign of Terror sent thousands to their deaths by the guillotine.

Within the first months of the revolution, rococo dress was entirely discarded. The tyranny of fashion—corsets, panniers, silks and velvets, wigs, beauty patches, facial powder and rouge—were symbols of the aristocracy and, thus, the injustices of the ancien regime. Clothing for both men and women became simpler and sober. Skirts were deflated to narrow contours, and bodices were modestly covered with wide fichus. Men donned plain frock coats and vests with simple cravats. Only with the stability of the Directoire government in 1795 did fashion once again began to effervesce with drama and change.

DEVELOPMENTS IN TEXTILE PRODUCTION

In an effort to protect home textile industries, France, England, Holland, and various German states imposed an assortment of arcane import regulations and tariffs on foreign made fabrics, raw materials, and manufacturing equipment during the late seventeenth and early eighteenth centuries. In 1662, a textiles commission in London cited the flood of cheap fabrics like cotton from India and silk from China as the cause for a depression in British textile manufacturing; the result was more than thirty laws by 1715 restricting the importation of textiles. But cotton fabrics remained in high demand, so the stringent bans on textile imports only fueled robust smuggling activities and inventive ways around compliance.

The days of labor-intensive methods of textile production were numbered, though, despite the political influence of long-established guilds. In England especially, the technologies of the industrial revolution expanded into the textile industry with new and faster techniques for manufacturing.

Fashion Marketing

Almost 200 years before our modern concept of marketing began to develop as an integral part of business, the fashion industry of France established a network for disseminating fashion news and for advertising its products.

French fashion dolls, more commonly called **fashion babies,** were miniature mannequins dressed in diminutive replicas of the latest fashions—complete with accessories and coiffures—sent to merchants all over Europe by the preeminent textile manufacturers of France. Upon arrival at the distant centers of apparel commerce, these fashion babies created quite a sensation with fashionable ladies eager to be first in acquiring the newest styles of gowns or hats. In addition, fashion babies were displayed at regional and international trade fairs where artists could make sketches of the latest styles for the production of fashion plates.

In the tradition of seventeenth-century engravers such as Antoine Trouvain and Nicolas Bonnart, fashion portfolios were printed and sold throughout the 1700s. These prints were highly rendered with exact details of styles from Parisian society. The *Galerie des Modes et Costumes Francais* featured about five hundred fashion plates of the 1770s and 1780s based on illustrations by Watteau de Lille and Le Clere among others. (Figure 18-1.) Equally popular were style manuals such as the *Treatise of the Principles of Dressing the Hair of Women*, which contained more than 3,000 illustrations of French hairstyles and headdresses of the 1770s.

In addition to fashion babies and fashion portfolios, numerous precursors of today's fashion periodicals were launched in Paris and London during the eighteenth century. The *Mercure de France* published articles on fashion as early as the 1720s. In England, the *Lady's Magazine* began publishing fashion plates in the 1770s that were based on the styles seen in the shops of mercers (fabric merchants) in London's Covent Garden or Oxford Street. *Ackermann's Repository* included hand-colored fashion plates with swatches of fabric produced in English textile mills.

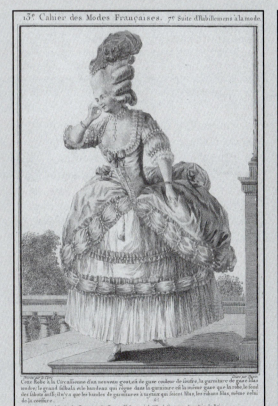
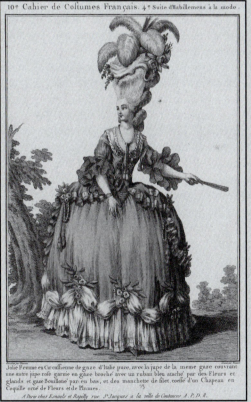

Figure 18-1. Fashion plate portfolios were among the methods used by the textile and fashion industries of the eighteenth century to disseminate fashion news on a mass scale. The examples shown here are from the *Galerie des Modes et Costume Francais*, which included nearly 500 plates of French styles of the 1770s and 1780s that were widely distributed throughout Europe.

Capital flowed freely to induce constant improvements and growth. In 1733, John Kay invented the **fly shuttle**, which literally flies through the warp threads to rapidly produce the filler in the weaving process. Between 1754 and 1767, James Hargreaves developed machines that could spin multiple yarns simultaneously. His improved **Spinning Jenny** of 1770 allowed more than 100 spindles to wind uniform yarn at the same time. A decade later, Samuel Crompton invented the **mule spinning** frame—so called because the early versions were powered by a pair of the beasts. Mule spinning, which still exists today, was achieved by drawing out and twisting a fine length of yarn onto a cone or cylinder. Fine quality yarns could now be produced in sufficient quantity to satisfy the growing needs of England's weavers. In 1785, Edmund Cartwright patented the steam powered loom making possible the location of factories away from fast-flowing water sources.

By the 1770s, bans on cotton imports had been lifted in both England and France. Within a decade production of cotton fabrics in England rivaled that of wool. Printed cotton, called **calico**, was immensely popular, not only with ordinary people but with upper class women who wore informal cotton dresses at home. To compete with the colorful imports from India, textile manufacturers in France and England looked to technology for help.

Prior to the industrial revolution, cotton prints were produced by the laborious process of applying layers of dyes with segmented woodblocks. Fabrics with light-colored grounds were first imprinted with a basic outline of the pattern in a dark brown. A dot at each corner of the block provided the guides for positioning subsequent blocks to achieve the multiple colors. In the 1750s, Christophe Oberkampf, a Bavarian printer working in the French textile factory at Jouy, experimented with engraved copper plate printing that produced one-color images up to a yard square. (Figure 18-2.) However, the Scotsman Thomas Bell is usually credited with perfecting the process in 1783 with his development of an engraved roller print machine that could register up to six colors. Today, high-speed roller presses can produce over 200 yards of multicolored fabrics a minute.

Discoveries in chemistry also led to new developments for methods of bleaching. In 1724, R. Holden of Dundee, Scotland, began bleaching linen with a compound made from kelp. In 1774, Swedish scientist C. W. Steele refined the process for bleaching vegetable fibers with chlorine, producing brilliant white cotton and linen textiles.

MEN'S FASHIONS 1700–1750

Compared to the rapid cycles of fashion change that occurred in the 1600s, men's styles of the eighteenth century evolved slowly and subtly until the last two decades. Instead of markedly distinct transformations decade to decade, the silhouette of men's clothing gradually became simplified until

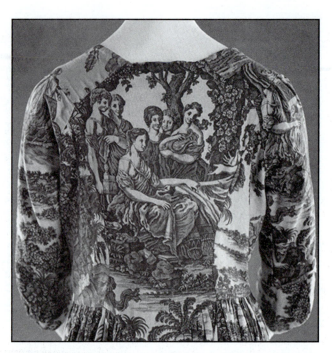

Figure 18-2. Printed fabrics were initially produced by a laborious process of applying dyes with small woodblocks. By the 1750s, the technique for printing on fabric was improved with the development of engraved copper plate printing, which could produce images up to a yard square. In the 1780s, a roller print machine was developed that could register multiple colors on a wide format. English dress made of copper plate printed cotton, c. 1795.

the cut and line of masculine attire in the 1780s was decidedly different from that of the early 1700s.

The three principal pieces of men's apparel were already standardized by the beginning of the century. Basically, a suit consisting of a jacket, vest, and knee breeches was worn by all classes, differentiated by quality of materials and precision of tailoring. For the aristocracy, a further distinction was made between a gentleman's dress suit for everyday wear and the formal, full dress suit for special social events and court ceremony. The former was made of fine wool with little adornment and tailored in a loose, comfortable cut; the latter was made of exquisite silks and brocades with stiff linings and heavily embroidered decorations.

Until about 1720, the jacket retained the basic inverted funnel silhouette introduced at the close of the reign of Louis XIV. (Figure 18-3.) The shoulders and waist were close fitting with a flared skirt that was usually cropped at the knees or sometimes a few inches below. Necklines were collarless. Three-quarter length sleeves repeated the inverted funnel line of the jacket body with narrow cylinders for the upper arms that gradually widened to a large reversed cuff. For country activities such as riding and hunting, men often wore jackets without sleeve cuffs that could get caught in the underbrush. Although buttons were sewn along the full length of the front closure, most men ordinarily fastened only the uppermost

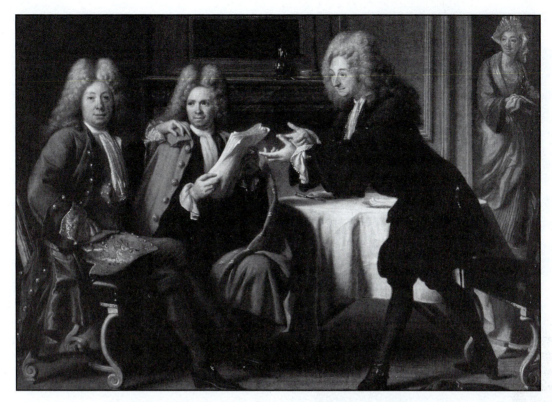

Figure 18-3. Men's suits of the early 1700s were designed basically the same as styles of the late seventeenth century. The funnel-shaped jacket featured narrow shoulders, a trim waist, and a flared skirt cropped at the knees. Vests were also fitted, some with long sleeves and large cuffs. Breeches were cut straighter though still full through the seat and thighs. *The House at Auteuil* by Levrac Tournieres, 1715.

buttons. Covered buttons and especially military-style metal buttons were also a popular decorative element attached to cuffs, pocket flaps, and back skirt pleats. A second row of nonfunctioning buttons sometimes lined the outside edges of the buttonholes on the left side of the jacket for a symmetrical look. Pockets were raised to about hip level after being positioned at the fingertips for decades.

The collarless vest (waistcoat in England) was likewise fitted, some made with three-quarter or long sleeves and others sleeveless. Long-sleeve varieties often included turned-back cuffs that were slightly smaller than the jacket sleeve thereby forming a layered effect of contrasting colors and fabrics at the wrists.

Breeches were cut straighter but remained full through the seat with the excess material gathered into a wide waistband in the back. A button closure secured the waistband in the front. The length of the legs extended to just below the knees where the band was fastened by a buckle or buttons or tied by short ribbons. Sometimes, a combination of fasteners was used.

Men's shirts continued to be of linen, made all the whiter in the eighteenth century with new developments in bleaching. Since jackets and vests were more fitted and contoured than in the previous century, shirts were also cut narrower.

Shirt sleeves remained full, though, to allow puffs of linen and ruffled cuffs to show from under the three-quarter length jacket and vest sleeves. Shirts were usually collarless or featured a shallow banded form of collar to allow for the arrangement of the cravat.

During the second quarter of the century, men's jackets shortened slightly, and the cut of the front closure began to curve toward the back; as a result, the jacket was worn open. The flare of the skirt reached its fullest of the century with the addition of deep fan pleats in the back. (Figure 18-4.) For formal dress jackets, the skirts were stiffened with a lining of horsehair or layers of canvas. Lavish embroidery accented the curve along the edges of the front closure of court dress jackets. Sleeves remained at three-quarter length with wide turned-back cuffs. Styles of exceedingly wide reversed cuffs that extended up to the elbow were called **boot cuffs**.

Vests underwent the most dramatic change during the mid-decades of the century. By the 1740s, vests were already inching shorter, exposing more of the breeches. Although styles were still made with and without sleeves, the sleeveless variety began to be more commonly worn. Buttons were now fastened at the waistline rather than the neckline to allow for the new fuller forms of neckwear. For formal dress, vests were often made of a rich brocade that complemented but

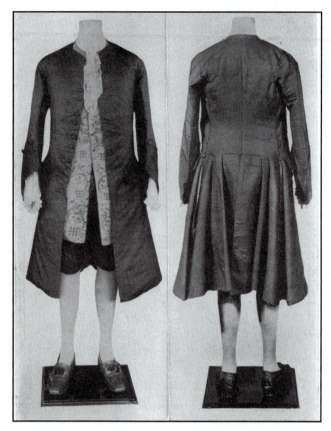

Figure 18-4. The flare of men's jacket skirts reached its fullest during the second quarter of the century. Deep fan pleats were inserted at the back, and stiff linings added shape. Sienna silk jacket with yellow lining, yellow brocade vest, and chocolate silk breeches, c. first quarter of eighteenth century. Private collection.

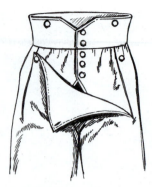

Figure 18-5. The fall front closure for men's breeches was introduced in the mid-eighteenth century and remained a common construction element into the early nineteenth century.

Younger men sometimes preferred the **solitaire**—a simple, wide ribbon, usually black, tied into a bow in the center front.

Men's wigs continued to be an important status accessory in the eighteenth century. The full-bottomed wig remained the prevalent form until the second quarter of the century when it disappeared except for court wear and certain professional costumes. By the 1740s, the fashionable masculine silhouette required the appearance of a small head. Wigs were made without high peaks on the crown, and, instead of volumes of curls over the shoulders, the length was gathered into a **queue** formed by braids or left loose to hang down the back. These braids combined with the puffed curls at the temples were given assorted names such as the **brigadier** that featured two rows of curls, or the **major** with one row, or the **catogon** that formed a club shape from doubling up the braid into a loop at the nape of the neck. For more formal occasions, the braid was sometimes encased in a triangular black satin bag called a **crapaud** and secured by a drawstring tie or a ribbon bow. Also for formal dress, wigs continued to be powdered white. Men who chose to wear their natural hair replicated the cuts and arrangements of wig styles with varying types of queues in the back and tufts or rolled curls at the temples. (Figure 18-6.)

Outerwear for men included versions of long, tailored coats and oversized capes. The **roquelaire** (also roquelaure) was a long, bell-shaped cloak with a wide, flat collar and front closure that fastened with a row of large buttons. A variation of the roquelaire from the second quarter of the century featured slits at the sides for the arms to pass through. An outdoor jacket that developed in England in the first half of the century was the **frock coat**. Based on the cut of the dress jacket, the frock coat was usually made without pockets or fan pleats in the back and included a rounded, flat collar that could be turned up against a chilly wind. In the second half of the century, continental men's fashions were influenced by English styles—an Anglomania that spread the style of the frock-coat across Europe. A greatcoat called a **redingote** is thought to have developed from the heavy, utilitarian riding coats of couriers and coachmen. It was a long coat, cropped at mid-calf or even the ankles, and constructed with a wide,

also contrasted with the embroidered jacket. Increasingly, the everyday types of jacket, vest, and breeches were made of the same material, especially velvets or subtly patterned silk.

By the 1740s, breeches were more snugly fitting. A front-flap closure called a **fall** buttoned up each side to the waistline concealing a center button-front fly. (Figure 18-5.) Some forms of the flap were cut shorter, covering only about three-quarters of the fly. The fall type of closure would remain a common construction element into the early nineteenth century. Legs of breeches became so narrow that knit hose were sometimes more easily pulled over the kneebands and turned down rather than tucked underneath.

In the early part of the century, the fine gauge linen cravat was still the finishing accessory for men's suits. Aristocrats continued to indulge in lavishly lace-trimmed varieties. Cravats were tied in a wide assortment of knots and arrangements, including the steinkirk, which remained popular until mid-century. In the 1730s, a pleated square of crisp linen called a **stock** was fastened around the neck forming a sort of high collar over which was tied a cravat. By the 1740s, the cravat began to be replaced by the **jabot**, a longer form of neckwear with a cascade of ruffles that hung down the front of the vest.

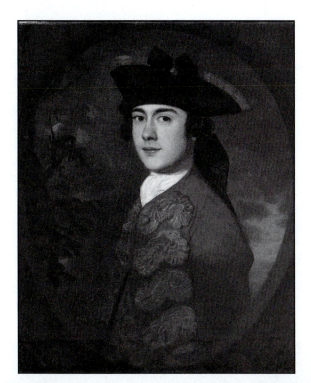

Figure 18-6. By the 1740s, men abandoned the large, full-bottomed wig styles to achieve the fashionable masculine silhouette of a small head. Wigs and hairstyles featured small, puffed curls at the temples and various forms of queues for the arrangement of the length at the back of the head. With the smaller wigs men could once again wear hats, the most popular of which was the tricorne with its brim cocked on three sides. Portrait of an unknown gentleman by Joshua Reynolds, 1755.

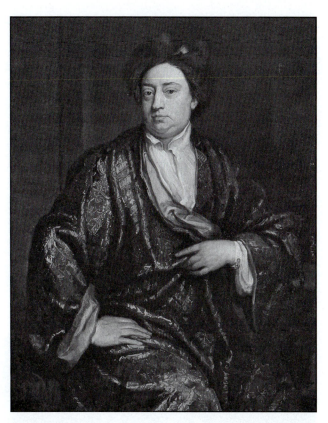

Figure 18-7. For working at home or receiving guests informally, men wore versions of lounging robes over a shirt, breeches, and sometimes a vest. Since men did not don their wigs for such casual attire, they wore assorted types of hats and turbans to keep their closely sheared heads warm. *Charles Sackville, Earl of Dorset* by Godfrey Kneller, 1706.

double collar, the topmost part of which could be turned up and buttoned to cover the face up to the eyes.

The three-piece suit was dress attire—even in its more rustic forms—worn for appearing in public. When working indoors and receiving intimate friends or those of subordinate classes, men dressed informally in what is often called a negligee or nightgown. This was not sleepwear in the modern use of the term but was similar to modern lounging robes. (Figure 18-7.) Over their shirt, breeches, hose, and usually, but not always, a vest, men wore a long, wrap robe with sleeves of varying lengths. These T-cut day robes were made of fine silks, brocades, or colorful cotton prints from India, some edged with fur. This was a status form of dress that had begun in the late part of the previous century but became more common in the eighteenth century. A strict social protocol allowed men to receive peers and those of subordinate classes while wearing a robe, but the robe was never to be worn in the presence of someone of a higher social rank.

Part of the dishabille—or "undress"—attire included comfortable fabric slippers and a small hat. Wigs were not worn as part of the casual home attire. Since most men of

the upper classes still cropped their hair short for a better fit of their wigs, a cap was necessary to keep the head warm. Some caps were made as exotic turbans to complement the Eastern look of the robes; others were simple skullcaps with turned-up brims made of fine fabrics or even fur.

Another matching accessory of the day robe was a **toylett cloth** that tailors usually provided from the same material as the robe. The toylett cloth was a square or rectangular piece of fabric used to cover a dressing table on which men would place their combs, brushes, and other accouterments of personal grooming. Later, the term toylett was transferred from the cloth to the implements and even the activity of grooming: the "toilette."

With the reduction in the size of wigs, men could once again wear hats. The most prevalent type of hat was blocked with a shallow dome and the brim cocked up on three sides forming a triangle—the **tricorne hat**. For the aristocracy, the masses of feathers and clusters of ribbon loops were gone, replaced instead with a thin edging of ribbon or braid trim around the brim. The types of tricorne hats worn for everyday and by ordinary men were usually unadorned.

The elements of shoe designs also were reduced. The tall, upright tongues were cropped back to the top of the vamp, and the high heels were lowered to about a half-inch to one-inch high. Plain buckles remained the most common decorative feature until the end of the century. For the active country gentry and military men, knee-high boots with thick soles and low heels were preferred when out of doors.

Other accessories of gentlemen that were tucked into the capacious pockets of vests and jackets included snuff boxes to contain pulverized tobacco imported from the American colonies. Combs were necessary to curry wigs that may become dishevelled from riding, dancing, or errant winds. Watches were still expensive but increasingly important to mercantile classes for whom time was money. All gentlemen carried fine linen handkerchiefs to dust off snuff remnants or residue from powdered wigs. In winter, made-to-measure gloves of soft leather and fur muffs kept the hands warm.

MEN'S FASHIONS 1750–1799

During the third quarter of the eighteenth century, men's fashions continued a slow but decided evolution of cut and detail. Jackets were trimmed to fit more narrowly. The large fan pleats in the back of the skirt were substantially reduced by 1760 and had disappeared altogether by the end of the 1770s. The stiffening materials of the skirt were eliminated, making the draping of the jacket softer. The side vents shifted toward the back. The cut of the front opening curved to the sides forcing men to leave the buttons mostly unfastened although some portraits of the period show one or two buttons fastened at the middle of the chest. Other significant developments in the design of the jacket included the addition of collars, an influence from the design of the frock-coat. The jackets depicted in Figure 18-8 feature one collarless neckline and three constructed collars including a low, stand-up banded collar, a narrow rolled collar, and a flat, spread collar. Sleeves were

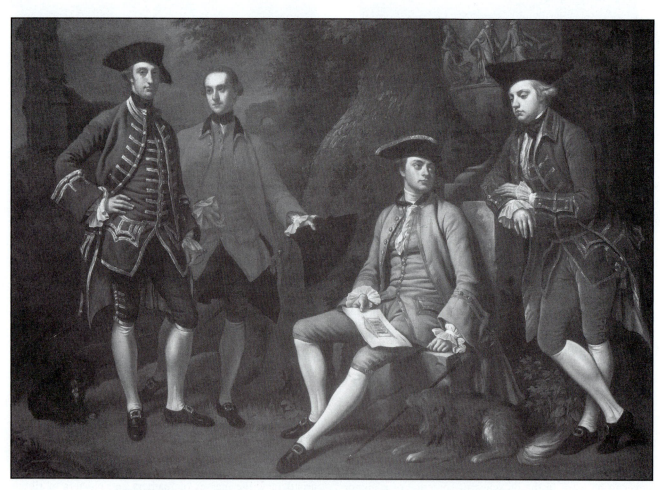

Figure 18-8. In the 1760s, men's suits continued a slow evolution. Jackets fitted more narrowly, and the fan pleats of the skirts were much reduced. The cut of the front opening curved to the sides, and collars of various types were added. Vests were shortened to mid-thigh. Breeches were tailored for a smoother fit over the thighs. *A Conversation Piece: James Grant, John Mytton, Thomas Robinson, and Thomas Wynn* by Nathaniel Dance, 1761.

extended to the wrist with a narrower funnel cut and cuffs that were less deep. In the 1770s, some sleeves were cylindrical the full length of the arm to the wrists with only braid trim as a cuff. Ornamentation continued to be subdued on most jackets except for court dress jackets, which were lavishly embroidered with heavy gold or silver thread along the turned-back edge of the cuffs and the edges of the front opening.

Vests were now predominantly sleeveless. Their length continued to shorten throughout the second half of the century. In the 1760s, the hem was at mid-thigh; by the end of the 1770s, the vest was cropped at the hips; and in the 1780s, at the waist. The slit skirt receded into basques. The button-front closure ended in a wide V-cut front, which, when coupled with the narrow shoulders and the curved opening of the jacket, formed a portly, pear-shape to the masculine body even on slender young men.

As vests became shorter, more attention was focused on the fit of breeches. The thighs were tailored to encase the legs more smoothly. A row of about three to five buttons fastened the breeches at the side seam of the knee, and a kneeband with a buckle ensured a taut, snug line.

Finely knit white silk hose were usually tucked into the bottom of the breeches legs, but it was common for men to roll the tops of their hose over the kneeband. Monochromatic clocking often decorated the ankles.

Brightly bleached white linen shirts remained largely unchanged except for the sleeves, which narrowed as jacket sleeves became more cylindrical and close fitting. All shirts were pull-overs; the open-front style would not be introduced until the end of the nineteenth century. Shirt cuffs retained the ruffle or lace trim that showed at the wrist one or two inches below the jacket cuff. At the end of the 1770s, collars reappeared on shirts as short tabs turned down in the front over the crisp, pleated stocks. Long, fluid jabots still adorned the open neckline of the vest. The black ribbon solitaire disappeared in the late 1760s.

Variations of the tricorne hat included the addition of buttons on one or each cocked edge to which a cord or tab was secured to the crown. (Figure 18-9.) A small ribbon bow or rosette in various colors was inserted into the left front tab to designate military rank or proclaim a political affiliation. A multitude of informal caps and turbans continued to be worn at home in place of wigs until the 1790s.

Figure 18-9. During the third quarter of the 1700s, some styles of the tricorne hat included tabs or cords that affixed to buttons on the cocked edges of the brim. Ribbons or rosettes were inserted into the tabs to designate military rank or political affiliations.

White powdered wigs and natural hairstyles remained small and close to the head with various treatments of the queue through the 1750s and 1760s. The center part of the hair was replaced by a smooth, brush-back sweep from the brow. In the 1770s, the Continental look included a fuller, raised foretop called a **toupee**.

Round-toe shoes with large buckles and low heels remained the standardized style of footwear. For riding, hunting, and similar outdoor activities, a form of spats or leggings called **spatterdashes** became popular with the country gentry in the 1760s. These knee-high tubes of leather were secured over the instep of the shoes by the spur straps.

The most exaggerated Rococo fancifulness and affectation in men's fashions appeared briefly in the 1770s with a group of Englishmen who came to be called the Macaronis. (Figure 18-10.) These were rebellious, aristocratic young men with a penchant for Continental etiquette and style,

Figure 18-10. In the 1770s, the Macaronis were a group of rebellious young Englishmen who adopted exaggerated fashions and manners. Their jackets and breeches fitted tightly, and vests were shortened to the hips. Fabrics were vividly colored and patterned with bold stripes. Wigs rose several inches higher than the trend at the time. Despite the fashion drama, though, the Macaronis had little influence on the prevailing styles of the day. Anonymous caricature of a Macaroni at his toilette, 1773.

adaptations of which they brought back to England from their Grand Tours, particularly Italy, hence the name Macaroni. Their coats and breeches fitted tightly; vests were cropped at the hips. Fabrics were vividly colored or patterned with bold stripes. Trimmings included frogs, tassels, braid, ribbon, and oversized buttons. Wigs were styled several inches above the head and topped by small hats. Shoes featured higher heels, often polished red, and rosettes. A particular affectation of the Macaronis was the carrying of two watches—one for correct time, and the other "to tell what time it isn't." Although lampooned in the press with caricatures and ridiculed in public as effeminate, the Macaronis were highly skilled swordsmen who could effectively curb the tongue of an unaware abuser. Nevertheless, the fashion trends of the clique had no broad influences although other groups of young men in both England and France made similar rebellious fashion statements in subsequent decades.

The most dramatic and rapid cycles of changes in men's clothing of the eighteenth century developed in the last two decades. During this period, cataclysmic geopolitical and cultural changes shattered order and conventions globally. On one side of the Atlantic, a revolution led to the emergence of a new nation "conceived in liberty," the United States, and on the opposite shore, a revolution brought to an end the absolutism of the ancien regime of France by the birth of a republic. In the arts, the polarities of grandiose Neoclassicism and sentimental Romanticism extinguished the vivacious Rococo style, profoundly influencing fashion in the wake of the movements.

In the 1780s, Neoclassicism led the evolution in men's fashions. Throughout the second half of the century, artists, the literati, and the intelligentsia of Europe had been intrigued with the rediscovery of antiquity. Excavations at Pompeii and Herculaneum yielded magnificent treasures of a glorious Rome. Exhibitions and widely distributed engravings of nude statues inspired tailors to rediscover the natural anatomy of the human form. From these aesthetic influences, tailors set about to transform the artificial, pear-shaped Rococo man into the noble vision of the nude Greco-Roman hero. The harmonious truth of the masculine anatomy as defined and expressed by Neoclassical aesthetics was delineated in cloth—sculpted according to the principles of the tailor's craft. By the end of the eighteenth century, men's clothing was designed to suggest a youthful, athletic male build with a broad chest and shoulders, a small, tapered waist, a flat abdomen, and long, slender legs. This new aesthetic of male proportions has been the foundation of men's attire to the present. For men who lacked the ideal physique, new developments in tailoring compensated with cut, line, padding, and fabric to minimize or disguise imperfections.

By the late 1780s, the new masculine silhouette had been achieved. (Figure 18-11.) The jacket was much reduced and simplified in its contours. Gone were the big

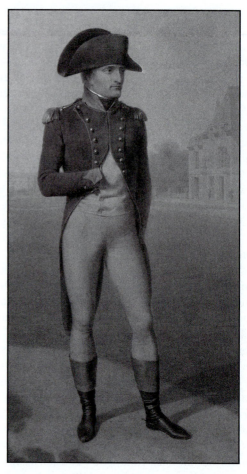

Figure 18-11. Neoclassicism influenced the changes in men's fashions of the 1780s. A new masculine silhouette transformed the pear-shaped Rococo man into the Greco-Roman hero with an emphasis on the youthful male anatomy. The jacket front was cut away, and vests were shortened to the waistline framing the hips and thighs. Breeches became form-fitting to delineate the muscular shape of men's legs. Detail of engraving of *Napoleon Bonaparte as First Consul* by Jean-Baptiste Isabey, 1799.

cuffs, wide pocket flaps, and full skirts. Close-fitting tubular sleeves were made without cuffs or constructed with flat turned-back cuffs. Because of the narrow cut of the jacket, most were worn open or only buttoned at mid-torso. Following the onset of the French Revolution in 1789, the vividly colored or patterned silk textiles of the aristocracy were abandoned in favor of wool and more subdued colors. Most ornamentation likewise disappeared except on military uniforms.

In the early 1790s, the fashionable jacket developed completely new lines. A double-breasted cutaway front was cropped slightly above the natural waistline. High, turned-down collars and various types of lapels were adapted from overcoats. (Figure 18-12.) The double-pleated back of the skirt returned, anchored by large buttons placed above the waistline.

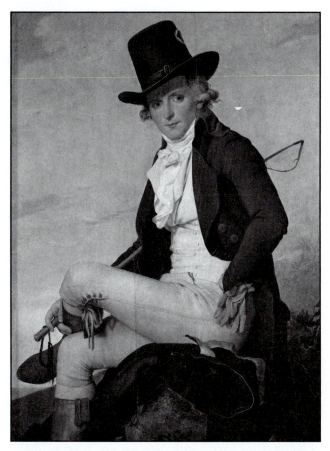

Figure 18-12. In the 1790s, men's jackets were made with a cut-away front and the addition of various types of lapels. Vests were shortened to the waistline. Breeches retained the button flap front despite the gaping edges caused when seated. *Charles Seriziat* by Jacques-Louis David, 1795.

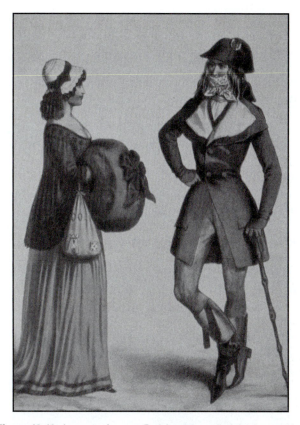

Figure 18-13. A group of young Parisian men called the Incroyables demonstrated their rebellion against the Neoclassical ideal in fashion by adopting looks that were exaggerated in size and detail. Clothing was baggy and loose. Breeches were longer and jacket lapels wider. Wigs were discarded for natural hair that was cut in shaggy styles. Incroyable by an unknown artist, 1795.

Vests were shortened to the waistline where they were visible a few inches below the cutaway of the jacket front. Often vests were constructed with a double-breasted front closure to prevent gaping buttons for those men who lacked the requisite flat abdomen. Vests made of fabrics that contrasted with that of the jacket were preferred to the suit of one cloth that had been so popular with the aristocracy in previous decades. Solid colors—especially neutral earthtones in light or medium values—were more prevalent than patterns, except for vertical stripes, which enhanced the slenderness of young men.

The high cut of the vest and open cutaway design of the jacket exposed and framed the hips and thighs. As a result, breeches became even more form-fitting, emphasizing the thighs and crotch in the first pronounced masculine sexual display since the codpiece disappeared 200 years earlier. The waistband was raised to be concealed under the hem of the vest. The drop-front flap remained the standard construction despite the gaping edges when seated, which are evident in Figure 18-12. To ensure the smoothest fit across the front of

the breeches, ribbon **suspenders**, called **braces** in England, were passed over the shoulders and buttoned to the front and back of the waistband.

With a focus on shapely, muscular legs, men of slight physiques sometimes strapped on false calves of quilted padding that tied at the knees and ankles to fill out the delineating fit of white knit hose.

One of the reactions against the Neoclassic ideal of the nude hero manifested itself in the fashions of a group of rebellious Frenchmen called the Incroyables (meaning incredibles). Like the English Macaronis of the previous generation, these young men rebelled by wearing exaggerated adaptations of the prevailing fashions of the day. (Figure 18-13.) Some historians have characterized their total look as "slept-in" or "careless." Their jackets featured enormous lapels and a squared skirt instead of a cropped front with tails. Short vests, some with lapels, were often made with horizontal stripes as an antithesis to fashionable Neoclassical verticality. Breeches were baggy with a longer, **pantaloon** cut extending lower over the calf. Their

accessories likewise were new and vital. One Incroyable shown here wears the new two-sided **bicorne hat** with the back brim cocked higher than the front. Neckwear became as exaggerated as the lapels. Cravats reappeared in longer lengths that wrapped thickly about the neck up to the ears and over the chin. In reverse of the frilly jabot, the cravat was simply tied into a short bow at the throat. Part of the dishevelled look of the Incroyables stemmed from their hairstyles. Instead of wigs, they wore their natural hair long and loose. Not only did they make no attempt to imitate the carefully coiffed rolls, curls, and queues of fashionable wigs, they went to the other extreme with cuts such as the hedgehog, with its thick, spiky fringe across the top of head.

At the close of the century, the most significant development in men's fashion was the emergence of **trousers**, which evolved from two influences. First, as noted previously, breeches had already begun to lengthen over the calves into pantaloon styles by the early 1790s. Second, during the French Revolution, the loose, ankle-length trousers called **sans-culottes**, literally meaning without breeches, were widely adopted as a statement against aristocratic fashions. (Figure 18-14.) However, the popularity of trousers was not immediately universal, and forms of the knee breeches were to survive well into the second decade of the 1800s.

Throughout the last quarter of the eighteenth century, other forms of menswear changed less dramatically than the components of the suit. Outerwear included familiar forms of military-styled greatcoats, some of which developed layers of two or three wide capelet collars. The redingote remained popular and also developed new types of wide collars and lapels. Full, circular capes with capelet collars were common for all classes.

Underwear consisted of various types of knee-length linen or flannel underdrawers with a drawstring or button-front waistband and slit fly. In winter, a collarless or banded-collar linen shirt would be layered under the outer dress shirt.

Shoes changed little until the 1790s when new shapes were introduced. The men in Figures 18-13 and 18-14 wear a flat, shallow slipper style with sharply pointed toes. The large, shiny buckles that had been prevalent for decades were replaced with small laces tied in bows or diminutive ribbon rosettes.

The two-edged bicorne hat, which had largely replaced the tricorne by 1790, became more of a military or civil service uniform style. Gentlemen opted for the many top hat varieties, called round hats at the time, that were rigidly blocked in felt or fitted over a wire frame in silk. (Figure 18-15.) Some top hats were ornamented with wide ribbon hatbands and buckles, and others had little more than a narrow leather strap buckled around the crown as a hatband.

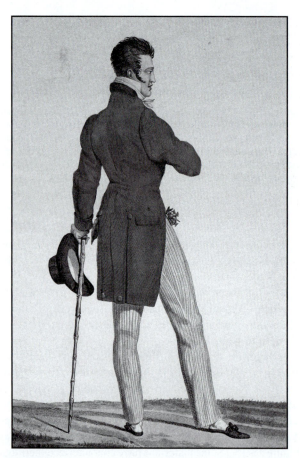

Figure 18-14. Long trousers for mainstream menswear first appeared in Paris in the late 1790s. Their design was influenced partly by the longer pantaloon breeches and partly from the long sans-culottes of the working classes. The style did not have universal acceptance, though, until the second decade of the nineteenth century. Fashion plate from *Costumes Parisiens* by Horace Vernet, 1797.

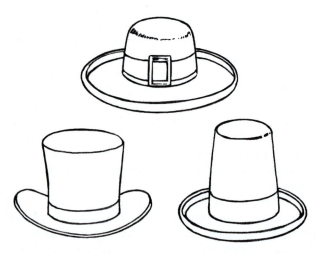

Figure 18-15. Men's top hats, called round hats in the 1790s, were radically new in fashion circles. Most were made of silk or felt and ornamented around the dome with ribbon or leather hatbands and buckles. The tricorne and bicorne gradually became more associated with military and civil service uniforms.

WOMEN'S FASHIONS THROUGH THE 1760s

Through much of the eighteenth century, women had four basic forms of dress from which to choose. First and most prevalent was the one-piece open-front gown. A stomacher filled the front space of the bodice and a petticoat or underskirt filled the front opening of the skirt. Second was the closed gown, which was constructed with a bodice and skirt sewn together at the waist. The third version was a loose, flowing robe called a **sacque**, or **sack gown**, that fell freely from the shoulders. This was a short-lived style that disappeared in the 1730s. A separate bodice or jacket and skirt was fourth, both pieces of which were made of the same material to appear as a single garment. Related to this category was the two-piece ensemble of a riding jacket and skirt, each made of different, contrasting materials.

The drama of women's fashions through most of the eighteenth century occurred primarily with the shapes of skirts and in surface decoration. Until the 1790s, the essential cut and contours of bodices were still governed by the complex engineering and construction of corsets, a specialized craft executed exclusively by men. (Figure 18-16.) In her study of modern dress, *Sex and Suits*, Anne Hollander suggests that the cloud-like visual fantasies of women's ensembles were the result of the inadequate skills of female dressmakers who, throughout the eighteenth century and even well into the nineteenth century, could sew superbly but seldom mastered the technical craft of tailoring. Instead, they were largely "modistes," or stylists, who "had license to add startling or outrageous productions on top of the dressmaker's simple shapes."

The evolution to the more fantastic fashions of the age did not begin until the second decade of the 1700s, though.

Initially the open-front mantua gown and petticoat continued to be extensively worn owing in part to the conservative influence of Louis XIV's second wife—a style that endured until the king's death in 1715.

Although French fashion led eighteenth-century Europe, many innovations and influences came to Paris from England. A striking example was the reintroduction of hooped petticoats that first appeared at the court of Queen Anne sometime in the early 1710s. The revived style of hoops was at first conical shaped, somewhat like the Spanish farthingale of the mid-sixteenth century but, shortly afterwards, changed to a wider bell silhouette. (Figure 18-17.) The hooped petticoat was worn under both the closed gown and the underskirt of the open-front gown adding a volume and uniformity of profile remarkably different from the freeform bustle treatment of the mantua.

By the late 1710s, the French had adapted the configuring look of hooped skirts, and the style spread across the continent. Some costume historians, though, argue that the French version of the hooped petticoat actually evolved from feminine theatrical costumes that had skirts lined with wide, heavily starched underskirts to make actresses' waists appear tiny. Still another theory is that hoops were an influence from the minor courts of the eastern German states where the Spanish Hapsburg farthingale had endured since the mid-1600s.

Whether an influence from England, Germany, or the Paris stage, the frame construction of skirt supports became increasing larger and more complex throughout the second quarter of the century. These support structures were called **panniers** (also paniers), meaning basket in French, possibly because the form resembled a pair of

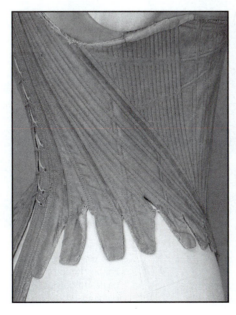
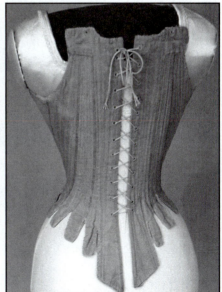

Figure 18-16. Tightly laced corsets ensured a smooth, tapered fit of the gown bodice. This example from about 1785 is made from sixty-eight pieces of whalebone stitched into brown cotton.

baskets on the hips or because wicker was sometimes used in the construction of the frame. (Figure 18-18.) Whalebone encased in fabric, though, was used most for making the hoops. Ready-made hoops could be bought from a hoop-maker's workshop or made-to-measure hoops could be specially ordered to size.

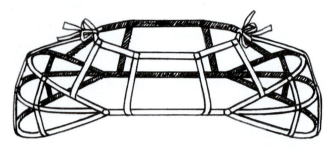

Figure 18-18. In the second quarter of the eighteenth century, complex frame supports for skirts called panniers were made primarily of whalebone encased in durable fabrics although wicker or wire were also used. Panniers were tied about the waist and extended the width of the skirt laterally from the hips.

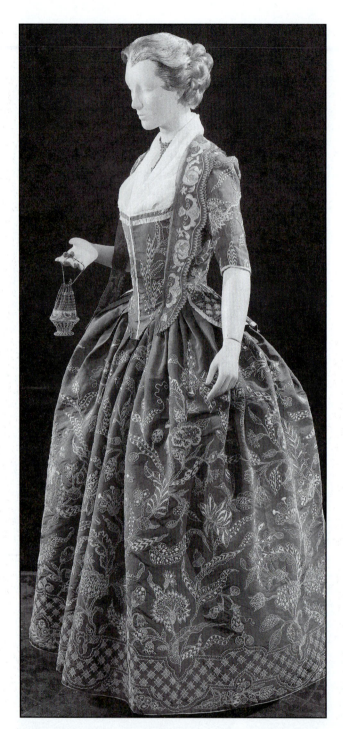

Figure 18-17. Hoops were reintroduced to women's fashions at the court of Queen Anne. The first versions were conical but within a few years evolved into a bell shape. Hooped petticoats were worn under the skirts of both open-front and closed gowns. Embroidered faille gown with peplum bodice, c. 1715.

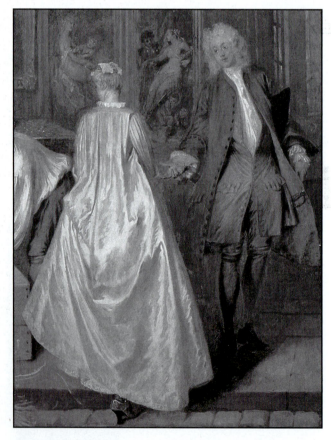

Figure 18-19. The sack gown, or robe a la francaise, was made with box pleats at the back neckline that draped loosely over dome-shaped hoops. Open-front versions were worn over a matching petticoat and bodice. Detail of *Gersaint's Gallery Signboard* by Antoine Watteau, 1720.

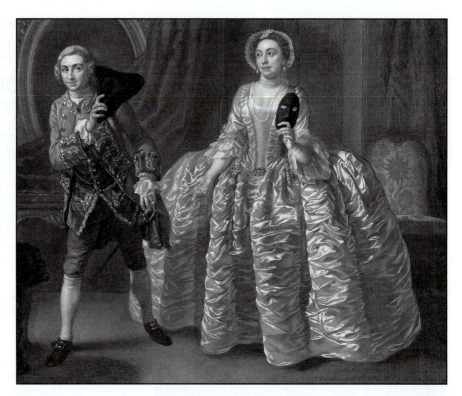

Figure 18-20. During the 1740s and 1750s, hoops widened laterally and flattened in the front and back. Gowns were so wide that ladies often had to enter through doors sideways. David Garrick and Mrs Pritchard in the play *The Suspicious Husband* by Francis Hayman, 1747.

Around 1720, a new form of gown became fashionable for the elite classes. The robe-like sack gown was designed with box pleats at the back neckline that fell loosely to the hem. (Figure 18-19 and Color Plate 9.) This gown is the **robe a la francaise**, also sometimes called a **Watteau gown** after the painter of the era who often depicted women wearing this style of garment. Types of the sack gown through the 1730s included a closed version that draped loosely from the shoulders over dome-shaped hoops and an open-front variant worn over a matching petticoat and bodice or embroidered corset. When the back pleats were stitched to the tapered contours of a bodice, the style is called a **robe a l'anglaise**, an early example of Anglomania that periodically influenced French fashions. Sleeves of the sack gowns were usually cropped at the elbows and ranged in design from simple, flared cuts with ruffles to wide funnel shapes with huge reverse cuffs.

In the 1740s, hoops widened at the hips and flattened at the front and back into an elliptical shape somewhat resembling a narrow version of the Spanish court style a century earlier. (Figure 18-20.) Women were forced to enter doors sideways. To find a place to sit, the wearer would scan a room seeking armless chairs or wide divans to prevent the volume of fabric from being crushed or, worse, the panniers riding up and lifting skirt hems.

Bodices fitted tightly over constricting corsets. Closures could be in the front, back, or both, secured by laces, tapes, or hooks and eyes. Open-front bodices were filled by richly decorated stomachers pinned or hooked to the **robings** or flat folds of fabric along the finished edges of the bodice opening. The eschelle, with its ladder of bows in descending sizes from neckline to waist, was revived from the previous century by the Marquise de Pompadour, the mistress of Louis XV. (Color Plate 10.) Other methods of filling the open fronts of bodices included decorative treatments such as embroidery or coverings of opulent fabric added to the surface of corsets. For those bodices that were designed wide enough to close in the center by hooks, laces, or pins, a long scarf of linen or lace called a **fichu** was sometimes secured by a brooch at the decollete neckline to conceal the closure. Necklines of bodices were deep, cut in either a square or a wide, off-the-shoulder oval. Sleeves remained short—mostly extending to the elbow or upper forearm—with tiers of soft, full ruffles called **engageantes** at the cuffs.

Petticoats most often were made of the same fabric or color as the open-front gown, giving the ensemble the unified look of a single garment. (Figure 18-21.) The hemlines of petticoats were a few inches shorter than the outer gown to prevent the wearer from stepping on the edge while climbing stairs or rising from a seat.

Unlike gowns and petticoats, which were made by female dressmakers, women's jackets continued to be made by male tailors throughout the 1700s. Consequently, the style of women's jackets mirrored those of men's designs,

as they had when first adapted to the feminine wardrobe in the previous century. Since women wore flat-front corsets, even when horseback riding, the silhouette easily followed men's versions without the addition of darts, tucks, or yokes to accommodate the contours of breasts. Like men's jackets, women's styles were narrow through the shoulders and body. The jacket skirts were cropped at the knees and

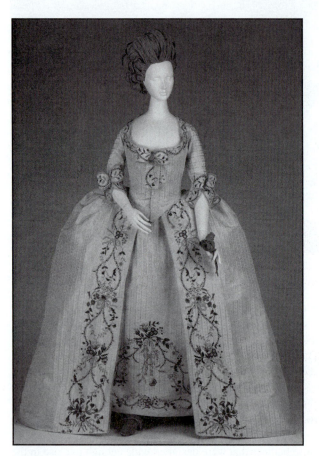

Figure 18-21. The petticoat of an open-front gown most often was made of the same material or color and with similar decorative treatments as the overskirt. As a result, the entire ensemble had the unified look of a single garment. Open-front gown with matching petticoat, c. 1760.

flared into a fullness formed by fan pleats. Vents at the sides and back prevented the jacket skirt from being crushed while in the saddle. As sleeve, pocket, and collar treatments of men's jackets changed, women's styles followed the masculine trend. Many women even adopted the masculine pull-over shirt and cravat to wear with their riding jacket.

Another informal type of jacket, called a **casaquin**, was made as a substitute for the conical decollete bodice. A matching skirt of the same fabric gave the illusion of a gown. The casaquin, too, required made-to-measure tailoring but was designed with short basques cropped at the hips instead of the knee-length skirts of riding jackets.

Women's outwear in the first half of the century was limited to full, circle-cut cloaks, capes, and other forms of wrap garments that could envelope the expanse of the hooped skirts. For winter, long cloaks were made of heavy wool, some lined with fur, and featured front closures with frogs or large buttons. Some cloaks and capes included voluminous hoods that could fit over delicately coiffed hairstyles. Slits allowed gloved hands to pass through at about elbow length. Stoles, capelets, shawls, and similar short wrap garments sufficed for chilly interiors.

The most common form of underwear for women was the linen chemise. Most were full and hung loosely from the shoulders to the knees. Necklines were cut wide and often edged with lace or ruffles to show around the decolletage of the bodice. Sleeves, though, were cropped at the elbow and were not meant to be visible beneath the engageantes of the bodice sleeves. Knee-length linen drawers were still rarely worn by women except the upper classes. Wool or silk knit stockings fitted above the knees and were secured by garters.

The most widely varied women's accessories in the first half of the 1700s were hats. For indoors, innumerable variations of linen and cotton caps covered the hair in varying degrees. (Figure 18-22.) Styles ranged from simple coifs interlaced with a brightly colored ribbon to tiered hoods with long lappets tied or pinned at the top or back of the head. Most formal hats were small and decorative—barely more

Figure 18-22. An endless variety of hats and caps—both formal and informal—were available for women to wear indoors. For everyday domesticity, white linen or cotton caps covered the hair in varying degrees. For receiving visitors, formal hats were small and decorative.

than hair ornaments in some instances. A favorite type of the period resembled a lily pad with a ruched or lace-trimmed edge that sat flat atop the head. The **pompon**, named after Madame Pompadour, was a hair ornament made from a small piece of fabric that matched the gown and embellished with lace, ribbons, and other decorative trim. Also, small clusters of ribbon bows, usually accented with colorful silk flowers or lace streamers, were interwoven into low, compact hairstyles arranged on top of the head.

Shoe styles remained similar to those of the late 1600s. (Figure 18-23.) Toes were sharply pointed and tongues stood high. Some heels towered to three inches but remained thick and blocky despite their elegant ogee curves. Formal styles were made with matching clogs to protect the fabric covering when a lady stepped from the carriage onto a wet pavement. Shoes of upper class women were covered in sumptuous silk brocade or lavishly embroidered. Oversized metal buckles were strikingly set off by rich, solid colors of satin. Open-back slippers called mules were popular throughout the century for wearing at home.

Despite the extravagant Rococo froth and frills that decorated gowns, the use of jewelry in the eighteenth century was subdued. Simple lockets on small gold chains were a favorite necklace. The occasional jeweled brooch adorned the bodice. Mostly, though, wrists and throats were left bare. At mid-century, Madame Pompadour sustained the trend of understated jewelry by preferring lustrous pearl necklaces, earrings, and bracelets, which appeared translucent against her pale skin.

The use of cosmetics for both women and men reached an apogee in the eighteenth century. Writing of her impressions of the ladies at the court of George I in 1716, Lady Montague noted that "All the women have literally rosy cheeks, snowy foreheads and bosoms, jet eyebrows and scarlet lips." The efforts to achieve this painted look required a time-consuming beauty regimen as complex as any today. **Ceruse**—white lead in a waxy base—was

liberally applied to the face, neck, and bosom despite the known dangers of lead poisoning. Rouge, commonly called Spanish red, was daubed onto the cheeks and lips by a hair pad coated with the coloring. Aristocratic women indulged in painful processes to remove hair from the face and arms. Plaster hair removers and quick lime pastes were the most common depilatories. Eyebrows were sometimes completely shaved off and replaced with false eyebrows made of mouseskin. The furry arch could be shaped and placed above the natural eyebrow ridge for a wide-eyed allure, not unlike the penciled brows of Hollywood actresses in the 1930s. Jonathan Swift wrote of this practice of the time, "Her eyebrows from a mouser's hide, stuck on with art on either side." For women who were content with their natural eyebrows, a lead comb was used to blacken and shape them. Decorative patches that were first used by courtiers in the late 1600s remained popular through most of the eighteenth century. The etiquette and language of patches continued to be refined and embellished. The shape and placement of one or more patches upon the face—or bosom—bespoke of passion, political affiliation, aloofness, and numerous other subtle forms of social communication.

WOMEN'S FASHIONS 1770s–1790s

French court dress reached its most extravagant in the 1770s under the fashion leadership of the wife of Louis XVI, Marie Antoinette, and her dressmaker, or "maitresse couturiere," Rose Bertin. Costume historians sometimes use pejoratives such as "preposterous," "absurd," and "wayward" to describe the gowns of the queen and her entourage during this period. Yet Marie Antoinette and her dressmaker actually inspired dramatic changes in fashion that followed one another in quick succession through the 1770s and 1780s.

The quintessential French Rococo gown was the formal robe a la polonaise, named to commemorate the partitioning of Poland in 1774. The most pronounced design element of the **polonaise** was the arrangement of an overskirt into large swags draped over the sides and back of a petticoat. (Figure 18-24.) A series of cords or tapes stitched to the underside of the skirt and threaded through rings could be drawn to shape the swags into various-sized festoons. Other versions of the polonaise featured ribbons or silk cords attached on the outside at the waist and looped underneath the skirt to form the puffs.

New forms of expanded panniers added the necessary support for draping the polonaise. In addition, hoops became more rounded in the back for an even more pronounced dimension of the skirt. Excessive surface decoration gave the polonaise gown its "wedding cake" look. Three-dimensional garnishments were formed by tacking or tying off sections of the overskirt into balloon-like bows and sausage-shaped

Figure 18-23. Shoe styles of the first half of the eighteenth century were constructed with sharply pointed toes and long tongues. Carved heels became higher but remained thick and blocky. Richly colored satins or sumptuous brocades were used for covering the uppers. Backless slippers called mules continued to be common for informal dress at home.

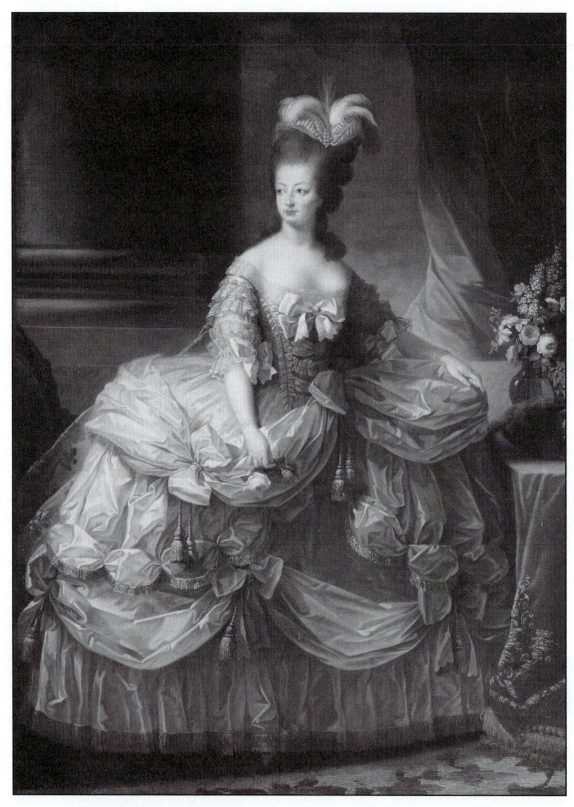

Figure 18-24. The formal polonaise gown was made with an overskirt that could be arranged into large swags draped over the sides and back of a petticoat. Cords or tapes threaded through rings attached to the underside of the skirt were drawn to shape the puffs of fabric. *Marie Antoinette* by Marie Vigee-Lebrun, 1778.

puffs. Appliques and trimmings of ribbon bows, fringe, tassels, lace, rosettes, ruffles, and silk flowers were almost dizzying in their visual richness.

Bodice necklines of the 1770s were cut ever deeper exposing a substantial amount of the bosom. Fashionable women of more demure natures wore chemises with ruffled necklines that provided more coverage, or they simply inserted a fichu, which allowed them to display as much or as little of their shoulders as they chose. A revival of the standing Medici collar was sometimes added to these deep, open necklines although the ruff was not as wide as its sixteenth-century predecessor. The contours of the bodice remained smoothly taut over an excruciatingly tight corset. The sharp tip of the V-front waistline was extended longer than with previous bodices thereby emphasizing the mounds of fabric at the hips formed by the polonaise. Sleeves were still short and accented with tiered engageantes.

Less exaggerated forms of the polonaise were popular outside the French court into the early 1780s. Promenade gowns were not as wide as formal court styles and the polonaise swathes of fabric were less voluminous. A "shepherdess" version featured a hemline shortened to the ankles although the style was short-lived. Decorative treatments, however, were sometimes as lavish as on the royal gowns.

In sharp contrast to, and concurrent with, the fanciful polonaise, were simple chemise style gowns made of white muslin. Inspired by Rousseau's writings espousing the virtues and simplicity of country life, Marie Antoinette began to wear the **robe en chemise** at the end of the 1770s as an informal dress when at her model farm, the Trianon. The style is also called the **robe a la creole** indicating that it may have originated in the French West Indies or New Orleans. When the court painter Elizabeth Vigee-Lebrun exhibited a portrait of the queen wearing a version of the chemise gown in the art salon of 1783, the style became widely adopted, especially in England. (Figure 18-25.) The design was revolutionary in its simple lines and construction. Gone were the rigid hoops, broad panniers, and constricting, flat-front corsets—at least for these softer forms of dress. Basically, the gown was a wide tunic of white muslin with a drawstring at the neckline. Assorted types of wide sashes girded the garment above the natural waistline. For the first time since the Renaissance, the natural contours of the female form were defined rather than reshaped by clothing. Soft ruffles trimmed the neckline, wrists, and sometimes the hem of the skirt.

As the popularity of the chemise gown spread, new interpretations were designed to keep the look fresh. Later in the decade, wide flat collars and plain tubular sleeves gave the chemise gown new appeal. By the mid 1780s, the fashion silhouette shifted to a bust-and-bustle profile. (Figure 18-26.) In addition to ruffles or wide collars at the

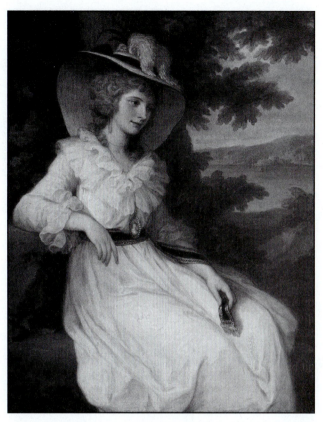

Figure 18-25. Although introduced in the late 1770s, the casual looking chemise gown only became widely popular in the mid-1780s. Chemise gowns were mostly made of white muslin with hip pads instead of rigid hoops for a graceful draping of the gathered skirt. Soft ruffles accented the neckline, sleeve cuffs, and sometimes the skirt hem. A satin or ribbon sash secured the gown slightly above the natural waistline. *Lady Elizabeth Foster* by Angelica Kauffman, 1784.

neckline, exaggerated emphasis was added to the bustline with the insertion of linen neckerchiefs or fichus that were arranged to billow out into a pigeon breast profile. A padded roll, called a **rump** in England, was tied about the hips, thrusting out the gathers at the back the skirt.

A new type of jacket called a **caraco** (also caracao) was designed for this new bust-and-bustle silhouette. This form of jacket was a substitute for the smooth-fitting gown bodice similar to the casaquin of the second quarter of the century. Some versions of the caraco included short basques or a peplum.

Following the same bust-and-bustle lines as the caraco was an adaptation of the men's redingote from England. (Figure 18-27.) The **redingote gown** featured a fitted jacket with narrow sleeves, a cutaway front, and a full-length half skirt in the back. Styles of the late 1780s and early 1790s adopted the deep collars and wide lapels of men's jackets as well. Jackets and skirts were usually made of contrasting

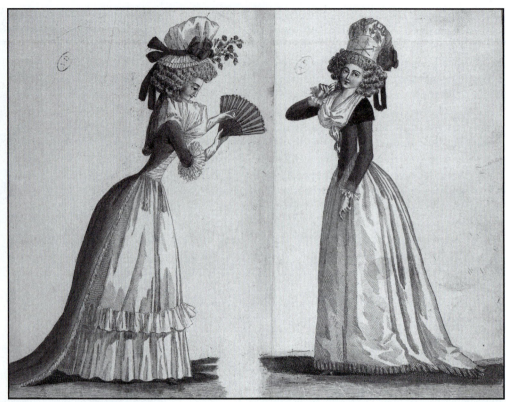

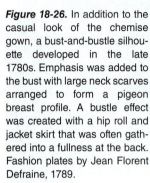

Figure 18-26. In addition to the casual look of the chemise gown, a bust-and-bustle silhouette developed in the late 1780s. Emphasis was added to the bust with large neck scarves arranged to form a pigeon breast profile. A bustle effect was created with a hip roll and jacket skirt that was often gathered into a fullness at the back. Fashion plates by Jean Florent Defraine, 1789.

materials although some extant ensembles in museum collections are of the same cloth.

In 1789, the French Revolution erupted. During the six years of tumult encompassing the Reign of Terror and the brief period of the republic, women's fashions were influenced by military elements. The redingote gown, now called the "Nationale," was made of royal blue worsted wool with a red, stand-up collar edged in white. Similarly, fabric prints were labeled with patriotic names such as "Equality," "Liberty," or "Republican." Combinations of red, white, and blue were enthusiastically applied to all forms of clothing. The simple chemise gown remained of white muslin but sashes, hats, scarves, gloves, purses, and watch fobs were adorned with ribbons and cockades in the patriotic tricolors.

Finally in 1795, some order was restored under the Directoire (Directory), and the public was ready to forget the horrors of the Reign of Terror and enjoy life again. Reactions against the repressions and austerity of the revolution years led to extreme change—in society and in fashion. Much has been written about the excessive promiscuity and notorious infidelities of the postrevolution period, of which not a little was blamed on the fashions a la grecque that trendsetters in high society began to experiment with. Stories abound of young women wearing the chiton-inspired gowns made of muslin so sheer that their chemise and garters were visible.

Some women reportedly even discarded their undergarments altogether.

In the majority of instances, though, women accepted the classical gown styles but also retained their under-chemise, hose, and drawers. Despite the layers of under-garments, the soft, fluid fabrics and columnar silhouette of the Directoire gown emphasized the nude female form much like the new cut of men's breeches and coat delineated the youthful male anatomy. (Figure 18-28.) Some historians view the advent of women's Neoclassical styles as an abrupt break with the artificial fashions of the ancien regime. In actuality, the Directoire gowns were the next evolution of the chemise gown. The long tunic cut of the Neoclassical gown hung straight from the shoulders to the floor. Some gowns were even pinned rather than sewn at the shoulder seams in imitation of the Hellenic predecessors. A sash, ribbon, or silk cord was tied just under the bosom. Despite the narrow, clinging look of the gown, the cut was exceedingly full, especially at the center back. Low scoop necklines were gathered or secured with a drawstring tie. Sleeves were shortened to the upper arms or removed entirely to form sleeveless varieties.

In England during the early 1790s, the chemise gown continued to be the most popular style. Some military influences and patriotic embellishments appeared in English women's fashions inspired by the revolution across the

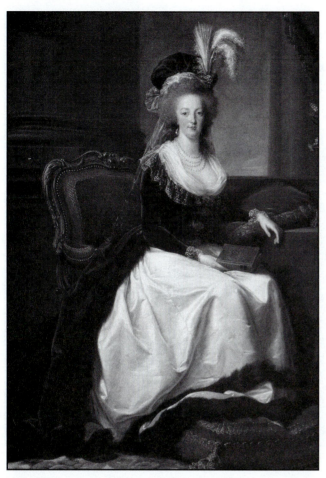

Figure 18-27. The redingote gown featured a fitted cutaway jacket with a floor-length skirt in the back. During the French Revolution, elements of men's military coats were adapted to the women's version. The redingote was often worn over a simple chemise gown. Detail of a portrait of Marie Antoinette by Elizabeth Vigee-Lebrun, 1785.

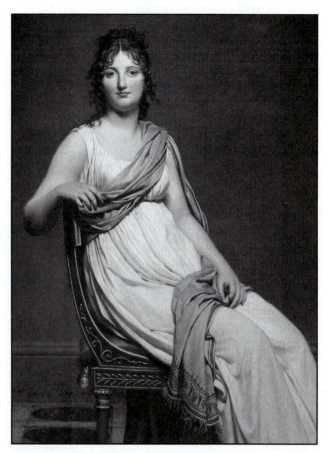

Figure 18-28. As with men's fashions of the late 1790s, the styles of women's gowns reflected the influences of Neoclassicism. The corset was discarded, revealing the natural female form for the first time since the Renaissance. Gowns were cut as a long, full tunic that was girded just under the bosom in imitation of the Greek chiton. *Madame de Verninac* by Jacques-Louis David, 1799.

channel. Red, white, and blue cockades and hair streamers showed support for Britain's official disapproval of the anarchy in France. During the Reign of Terror, young women appeared at balls wearing thin red ribbons around their necks in callous mockery of guillotined victims.

One significant impact of the French Revolution on English fashion, as well as on the English textile and apparel industry as a whole, was the arrival of so many French expatriates fleeing the turmoil of their homeland. Numerous dressmakers, tailors, fabric designers, accessory makers, and merchants closed up shop and left Paris for London. Among those who arrived in England was Marie Antoinette's dressmaker, Rose Bertin, who brought with her the bust-and-bustle silhouette of the redingote gown and, more importantly, the Neoclassical gown. Also fleeing to England from Paris was the German engraver Niklaus von Heideloff whose influential magazine the *Gallery of Fashion* was published in London from 1794 to 1803.

The Greek influence on English fashions took hold gradually. The most pronounced element of the Neoclassical silhouette that impacted English fashions in the 1790s was the raised waistline. The necklines and sleeve lengths were not as provocative as those of the French gowns. Nor did English women wear pink hose and sandals to simulate nudity in the French mode a la grecque.

During the late 1790s, the high-waisted style was applied to a new form of overgown. The length extended only to about mid-calf over an underskirt of a contrasting color or textile pattern. (Figure 18-29.) Various types of bodices were sewn to the short skirt, but the most innovative was the **surplice** closing, which was made of two deeply overlapping panels of fabric, usually without fasteners. The woman seated at the right shown here in the Heidlehoff plate wears a gown with a surplice bodice.

Even as the silhouette of gowns became reduced in girth from the wide, hooped Rococo look to the columnar

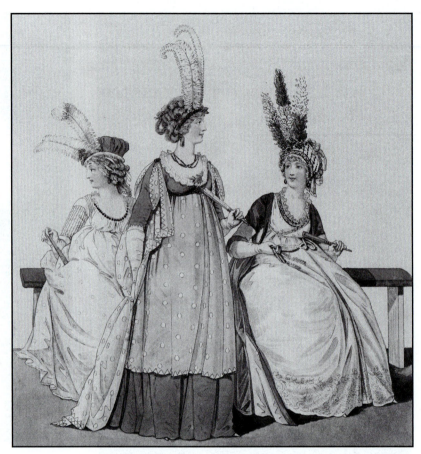

Figure 18-29. In the late 1790s, a formal version of the high-waisted Neoclassical gown with a short hemline—cropped at about mid-calf—was layered over a floor-length petticoat of contrasting fabric. Aquatint fashion plate from the *Gallery of Fashion* magazine by Niklaus von Heideloff, 1796.

Directoire styles, the full, circle-cut cape and cloak remained the most common forms of outwear. As hairstyles reached monumental dimensions in the 1770s, capacious hoods called **caleches** (also calashes) were constructed with collapsible semicircular supports made of wire or wicker to cover the head easily. In the 1790s, though, many young women preferred to suffer through chilly evenings in their light, airy Neoclassical gowns with only a shawl or scarf to cover bare arms rather than conceal their voluptuousness under heavy cloaks. After hoops were abandoned, greatcoats returned but were mostly worn for travel or severe weather where a cloak would be inadequate.

Hairstyles of the second half of the century changed decade by decade as dramatically as the silhouettes of gowns. (Figure 18-30.) In the 1760s, the low, center part yielded to hair swept back from the forehead into a much higher mound. Rows of curls encircled the back of the head ear to ear. By the 1770s, the volume of hair piled atop the head reached extraordinary heights. Flour paste stiffened arrangements that were to be accented with objects such as delicate wire ships with billowing silk sails or miniature villages. The illusion of height was further enhanced by plumes, ribbon loops, ruffles, and assorted other hair ornaments. Cartoonists of the day delighted in lampooning the extreme coiffures. Hairstyles of the

1780s, though, reflected the softer, more natural fit of clothing. The heights were significantly reduced but the volume was still considerable with masses of curls and long locks in the back. As the Neoclassical look became more fashionable, hairstyles were reduced in bulk and arranged l'antique. Ringlets ornamented the front and sides, and the volume at the back, if not cut short, was variously arranged up into a compact mass at the back of the head. By the end of the 1790s, daring young women cropped their hair short and combed it into loose, feathery curls all about the head.

Hats were designed to accommodate the hairstyles. (Figure 18-31.) As coiffures increased in height and volume during the 1760s and 1770s, hats either were made small enough to perch at an angle—usually forward onto the brow—or were expanded into gargantuan dimensions to encompass the hair. Women who preferred lower hairstyles enjoyed the greater variety of hats, many of which were precursors for popular styles of the 1940s and 1950s. Wide, shallow platter styles and smaller, crownless saucer hats were pinned flat to chignons atop the head. Materials used in hats included straw, velvet, felt, and silk for formal types. Innumerable forms of linen or cotton day caps were worn informally in the home. By the 1780s, the height of coiffures was reduced, but the sizeable volume of hair

Detail of *Lady Charles Spencer* by Joshua Reynolds, 1766.

Detail of *Georgina, Duchess of Devonshire* by Joshua Reynolds, 1786.

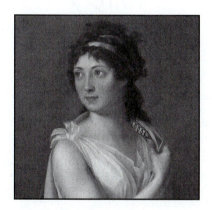

Detail of *Portrait of Unknown Lady* by Jacques Louis David, 1800.

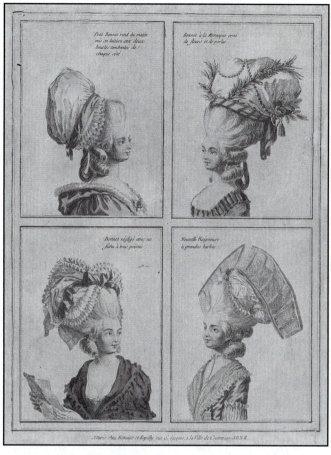

Hairstyles from *Gallerie des Modes at Costumes Francasis*, 1778.

Figure 18-30. Hairstyles in the 1760s were swept back from the forehead with higher volumes atop the head than in preceding decades. By the 1770s, hair arrangements of upper-class women reached their most extreme heights, accented with decorative objects and ornaments that reinforced the towering volume. In the 1780s, coiffures were reduced in height but the volume remained full with masses of untamed curls and long locks in the back. At the end of the century, Neoclassicism inspired interpretations of short, simple hairstyles from Antiquity.

remained, still requiring large hats. But since hairstyles were softer and less formally structured, wide-brimmed hats with large crowns could more easily fit the head. The influence of men's styles in the 1770s and 1780s included a small-scale version of the tricorne, which was adapted to women's fashions primarily as an accessory of the riding habit. The men's top hat also became a favorite shape in the 1780s, to which women added plumes, jeweled ornaments, sheer scarves, and massive ribbon clusters. During the Directoire period, a puffed linen cap with a ruffled edge called a **mobcap** became popular and remained a common form of women's hat into the 1820s. A drawing of Marie Antoinette on her way to the guillotine shows the doomed queen in this type of simple headcovering. The cap was later called the **Corday cap** after the political assassin, Charlotte Corday, who murdered a prominent leader of the

revolution. As l'antique hairstyles reshaped women's heads into a compact profile elongated at the back, new, close-fitting types of bonnets in the same elongated contours first appeared at the end of the century. Some were brimless with a long veil attached, looking somewhat like a truncated herrin from the Middle Ages, and others featured a short, visor-like brim.

In the 1760s, shoes lost the sharp pointed toes and chunky heels that had prevailed for decades. The new styles were made with rounded toes and more slender, tapered high heels. (Figure 18-32.) Uppers continued to be covered with rich fabrics and ornamented with buckles, satin bows, or small rosettes. In the 1780s, black leather ankle boots with low heels and lace-up tongues were adopted from English riding habits for outdoor wear. By the 1790s, high heels were replaced by flat, heelless slippers to complement the Neoclassical

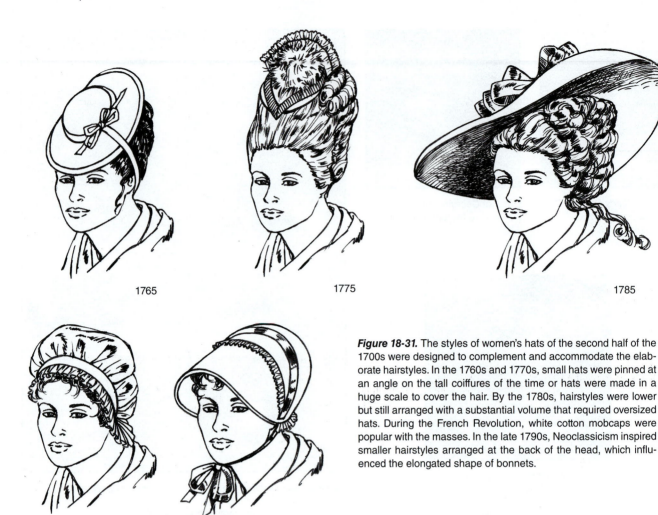

1765 1775 1785

1795 1799

Figure 18-31. The styles of women's hats of the second half of the 1700s were designed to complement and accommodate the elaborate hairstyles. In the 1760s and 1770s, small hats were pinned at an angle on the tall coiffures of the time or hats were made in a huge scale to cover the hair. By the 1780s, hairstyles were lower but still arranged with a substantial volume that required oversized hats. During the French Revolution, white cotton mobcaps were popular with the masses. In the late 1790s, Neoclassicism inspired smaller hairstyles arranged at the back of the head, which influenced the elongated shape of bonnets.

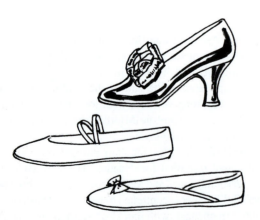

Figure 18-32. New styles of women's shoes in the third quarter of the 1700s featured round toes and slender, tapered heels. In the 1790s, flat, heelless slippers complemented the Classical chemise gowns. Some daring young women even discarded hose and donned sandals that laced up the calf for a purer interpretation of the mode l'antique.

silhouette. The sides were shallow, and the throat scooped low on the foot to the toe cleavage. Shoe uppers were fashioned of solid-colored satin, velvet, or soft leather instead of the opulent Rococo textiles of Louis XV. At the end of the century, some young women braved exposing bare feet and stepped into Greco-Roman styles of sandals that laced up the calf.

The variety of accessories of a well-dressed woman in the late eighteenth century became extensive. Since sleeves remained cropped to the elbows and rose to the upper arms in the 1790s, long silk gloves were not only an elegant accessory but they kept the arms covered during chilly evening fetes. For riding or outdoors wear, made-to-measure gloves were custom made of fine leather, some with wide gauntlet cuffs that extended over the forearm sleeve of the jacket or coat. Jewelry remained a subtle accent, both for the excessively decorated Rococo lady and for the simply accoutered Neoclassical woman. In the 1790s, adaptations of Greco-Roman jewelry were decorated with motifs from antiquity such as palmettes, coin profiles, and Greek key patterns.

Figure 18-33. One of the most important accessories for ladies of the eighteenth century was a beautifully painted or carved ivory fan. A form of courtly etiquette developed for the use of fans to convey a lady's mood or to communicate a signal to an admirer. Left, handpainted Dutch linen fan, c. 1750–1780; right, Chinese import fan of carved ivory, c. 1775–1790.

Small drawstring or clasp bags were used to carry cosmetics, vials of fragrance, and small personal grooming implements. The bags were attached to ribbons or silk cords and tied or pinned to the waist. Both women and men carried mirrored compacts for applying patches. Like the facial patch, fans also developed as a form of courtly etiquette. To open a fan in the presence of someone of higher rank was a serious faux pas. In addition, the painted vignettes on a fan might be used to express a woman's mood or to signal a message to an admirer. (Figure 18-33.)

CLOTHING OF ORDINARY PEOPLE

Eighteenth-century genre painting continued the tradition of depicting realistic street scenes and domestic interiors populated with the common people in the various activities of daily life. The tableau shown in Figure 18-34, provides a glimpse of how ordinary people dressed in the mid-1700s. Men wear jackets, vests, and breeches of plain wool broadcloth with no pretentious adornment of braid or ribbon trim. The suit and hose of the young bridegroom in the center are ill-fitting, suggesting home-made garments rather than the tailor-made versions of the upper classes. His hair is cropped at collar length without a queue or rolled curls at the temples. None of the men wear wigs.

The gowns of ordinary women likewise lacked the superfluous (and costly) ruffles, trim, and decorative elements of the Rococo gowns of the aristocracy. Even the bride standing in the center wears no hoops with her best gown nor even a corset, as is evident by the contours of her bosom. A utilitarian linen apron covers the front of her closed front gown. Her bold plaid shawl clashes with the vertical stripes of her gown. All the women have their hair modestly covered by some form of loose, white linen headcovering. There was no time for elaborate coiffures, even for such a special occasion.

CHILDREN'S CLOTHING

Until the second quarter of the 1700s, newborn infants continued to be dressed in swaddling clothes. The baby wore a long, tunic-like gown and a tailclout, or diaper, over which blankets were wrapped and tightly bound by long strips of fabric. Coifs tied securely under the chin were worn day and night. Infants of aristocratic families were introduced to class distinctions with their long christening gowns made of white satin and sheaves of delicate lace.

Through the first half of the century, children continued to be dressed as miniature adults. Toddler boys wore gowns and aprons until they were about five or six when they celebrated their breeching with their first pair of knee-length breeches. The boy's jacket, vest, hose, shoes, tricorne, and even cravat were diminutive replicas of men's styles. (Figure 18-35.) From about age three or four, girls of upper classes were trussed up in constricting corsets, cumbersome panniers, and all the other Rococo accoutrements of adult women. (Figure 18-36.)

In the Age of Enlightenment, though, new ideas of child care and dress percolated from lofty intellectual quarters down through the social strata. John Locke had written as early as the 1690s that human beings were born with a natural right of freedom that extended even to the physical freedom of comfortable clothes for all ages. In the mid-eighteenth century, Jean-Jacques Rousseau echoed this notion when he wrote, "Before the child is enslaved by our prejudices, his first wish is always to be free and comfortable." Similarly, a popular play of the 1740s referred to the swaddled baby as "a miserable little pinioned captive."

Figure 18-34. The basic styles of clothing of ordinary people in the 1700s largely followed the trends set by the upper classes. Men wore jackets, vests, and breeches made without adornment. Women's gowns were simple, closed-front versions worn without corsets and hoops. Detail of *The Village Betrothal* by Jean-Baptiste Greuze, 1761.

During the third quarter of the 1700s, the practice of swaddling had largely been abandoned. Likewise, a new form of clothing for toddler boys developed that replaced the gown and apron. Playsuits were made with ankle-length trousers that buttoned to close-fitting, long-sleeve jackets. (Figure 18-37.) The wide ruffled collar of the white linen or cotton shirt draped over the shoulders. By the time a boy was about age six, the toddler suit was replaced by the **skeleton suit**, so called because of the snug fit of the long trousers, jacket, and vest. Then, at puberty, boys were breeched with their first pair of knee-length breeches like those worn by Gainsborough's famous *Blue Boy*. It is unclear, though, how boyswear came to include long trousers perhaps as early as two decades before adult men (of upper classes) began wearing them. Perhaps dress reformers of the time observed the comfort and protection of long trousers that, for decades, had been worn by working-class men and sailors.

By the 1780s, girls, too, enjoyed a new freedom in their dress. The constricting corsets, tight bodices, panniers, and massive skirts had been discarded. Instead, small-scale versions of the chemise gown were designed for girls. The examples shown in Figure 18-37 are made with open necklines, loose half-sleeves, and full skirts girded at the waist with wide satin sashes. The white fabric of the dresses and the under chemises, shown at the neckline of the girl seated on left, was most likely cotton, which was increasingly imported from India and America at the time.

REVIEW

The eighteenth century in Europe was the Age of Enlightenment in which religious tradition and feudal authority were challenged by a secular humanitarianism derived from science and logic. Through much of the era, France was at the forefront of intellectual and creative leadership. All of Europe—from London to St. Petersburg—looked to the salons and court of Paris for the models of etiquette, diplomacy, literature, the visual arts, and especially fashion.

At the beginning of the 1700s, fashions for both men and women continued a slow evolution of styles first developed at the end of the previous century. For men, the knee-length jacket, vest, and breeches had become the standardized dress

Figure 18-35. In the first half of the 1700s, boys were dressed in the same suit styles as adult men. Jackets, vests, and breeches were tailored as small-scale versions of their father's attire. Boys of upper classes were even required to wear properly knotted cravats or jabots. *George Booth* by William Dering, 1745.

Figure 18-36. Girls were dressed as miniature versions of their mothers. For girls of upper classes, that included a constricting corset, panniers, wide skirt, and layers of other accessories in imitation of adult women. Detail of *The Morning Toilet* by Jean-Simeon Chardin, 1741.

for all but the lowest classes. During the second quarter of the century, jacket skirts became fuller with deep fan pleats and vests were shortened to mid-thigh. The front-flap closure for breeches was introduced. The high, full-bottomed wig was replaced by smaller styles with queues. For casual dress in the home, men wore lounging robes and caps or turbans in a manner often called "undress" or dishabille.

In the third quarter of the 1700s, men's suits changed slowly but significantly. Collars were added to jackets; vests were predominantly sleeveless and cropped at the hips. The tricorne hat became the most ubiquitous, recognizable men's accessory of the time.

The most dramatic and rapid cycles of change in men's fashions occurred in the last two decades of the century. Inspired by Neoclassicism in the arts, the masculine silhouette of the 1780s was tailored to the ideal physique of the youthful Greco-Roman hero. The contours and details of jackets were reduced and simplified. In the 1790s, the jacket front was cut away and the vest shortened to the waist to frame the hips and thighs. Breeches became form-fitting to delineate the muscular shape of men's legs. Longer pantaloon styles extended to mid-thigh. At the close of the century, ankle-length trousers

emerged as an adaptation of populist clothing of the French Revolution. Tall top hats reappeared after an absence of over 100 years.

The two primary characteristics of Rococo women's fashions were the shape of skirts and the excessive surface decoration. Hoops were revived in the late 1710s and evolved into panniers in the 1720s. Through mid-century, hoops continued to widen at the hips forming an elliptical shape to the skirt. Gown bodices remained smoothly fitted over constricting corsets, and sleeves were cropped short at the elbows. In the 1770s, the polonaise gown was introduced at the French court. An overskirt was arranged into large puffs draped over the sides and back of a petticoat. Hairstyles of the decade reached enormous heights, and the decoration of garments, hair, and accessories was the most lavish of the era.

During the revolutions in America and France, women's dress became simpler and plainer. In the English colonies, the abandonment of opulent fashions was symbolic of American independence and patriotism, while in France it represented a rejection of the tyranny of Rococo fashion, and hence, a rejection of the tyranny of the aristocracy.

Figure 18-37. During the second half of the eighteenth century, dress reform advocates encouraged the development of clothing for children that afforded freedom of movement. Swaddling infants was abandoned. For toddler boys, a jacket and trouser playsuit, called a skeleton suit, replaced the gown and apron. Girls were freed of their corsets and panniers and dressed in versions of the loose, comfortable chemise gown. *The Willett Children* by George Romney, 1789.

As with men's fashions of the 1700s, the most dramatic changes in women's styles—also influenced by Neoclassicism—occurred during the last two decades. In the 1780s, a revolutionary new type of loose chemise gown swept Europe. Hoops were abandoned and some women even discarded their corsets to wear the style. By the 1790s, interpretations of modes a la grecque included a columnar chemise gown with short sleeves and a high waistline just under the bosom.

Important developments were made in children's clothing as well. Instead of dressing children as miniature adults with all the trappings of adult fashions, new forms of clothing were designed to allow children greater freedom of movement. During the second half of the eighteenth century, toddler boys were dressed in a jacket and trouser playsuit instead of the gown and apron. Older boys also wore ankle-length trousers more than a dozen years before the style was adopted by adult men. Girls were freed of their corsets and tight bodices by versions of the loose chemise gowns made of comfortable cotton or linen.

At the close of the eighteenth century, the transition from the ancien regime to a postrevolutionary world had begun. Industrial, political, and social revolutions had forged a new Europe. On the threshold of the nineteenth century, the fashions of men, women, and children reflected the rejection of the old order and paved the path for the modern era ahead.

Chapter 18 The Eighteenth Century
Questions

1. Identify five important technological developments of the Industrial Revolution that improved textile manufacturing.

2. What were three methods of mass marketing employed by the French fashion industry in the eighteenth century?

3. Which changes occurred in men's jackets, vests, and breeches in the second and third quarters of the 1700s?

4. How did Neoclassicism influence the design of men's clothing in the last two decades of the eighteenth century? Contrast the silhouette of the well-tailored Rococo man with the ideal Neoclassical man. Describe the changes in silhouettes of the jacket, vest, and breeches that defined the Neoclassical man.

5. How did women's skirt hoops evolve between 1720 and 1760? What were panniers, and how did they alter the silhouette of the skirt?

6. What is the key design element of the polonaise gown? Describe the construction of two versions of the polonaise.

7. What was revolutionary about the chemise gown? Include a description of the design of the chemise gown.

8. How were women's fashions of the 1790s influenced by Neoclassicism?

9. Which important developments occurred in children's clothing in the second half of the eighteenth century?

Chapter 18 The Eighteenth Century
Research and Portfolio Projects

Research:

1. Write a research paper on how the art movements of Neoclassicism and Romanticism altered men's and women's fashions of the late eighteenth century.

2. Write a research paper on the new ideas of healthful dressing that emerged during of the Age of Enlightenment. Investigate how the corset, cosmetics, and children's attire were impacted by the advocacy of comfort and freedom in dress proposed by the philosphes and medical profession of the era.

Portfolio:

1. Design a pair of 30 × 40 posters comparing the antifashion looks of the Incroyables with the antifashion looks of today's urban youth. Feature an enlarged photo or your own drawing of an example of an Incroyable and a modern teenager. Label each antifashion element of the model's dress with a description and explanation of why it was contrary to popular fashion. Include details of accessories and grooming.

2. Compile a cross-reference guide depicting ten influences of eighteenth-century men's clothing styles on women's fashions. Illustrate each influence with a photocopy or digital scan of the masculine prototype and a corresponding example of women's style. Label each with a description of the garment, component, or detail.

Glossary of Dress Terms

bicorne hat: two-sided hat, some with the back brim cocked higher than the front

boot cuffs: exceedingly wide, reversed cuffs extending up to the elbow on the sleeves of early eighteenth-century jackets

braces: see suspenders

brigadier: men's hair arrangement of braids combined with two rows of puffed curls at the temples

caleches (also calashes): women's capacious hoods constructed with collapsible semicircular supports made of wire or wicker

calico: a plain-woven cotton textile, often produced in multi-color prints

caraco (also caracao): a women's short jacket made with long, narrow sleeves, a fitted bodice, and a gathered peplum at the back; worn as a substitute for the gown bodice in the last quarter of the 1700s

casaquin: women's short jacket made with narrow sleeves and a fitted bodice; worn as a substitute for the gown bodice in the second quarter of the 1700s

catogon: a club-shaped queue formed by doubling up the braid into a loop at the nape of the neck

ceruse: white lead in a waxy base used as a facial makeup

Corday cap: a mobcap named after the political assassin Charlotte Corday who murdered a prominent leader of the French Revolution

crapaud: a triangular, black satin bag that encased the queue at the back of the head

engageantes: tiers of soft, full ruffles at the cuffs of women's sleeves

fall flap: the drop-front panel of men's breeches or trousers

fashion babies: miniature mannequins dressed in replicas of current fashions

fichu: a woman's long scarf made of linen or lace worn around the shoulders and knotted in the front

fly shuttle: the automated device to weave a woof thread between the warp threads

frock-coat: a men's out-of-doors jacket made with a knee-length skirt and fitted body

jabot: a long neck scarf with a cascade of ruffles that hung down the front of the chest

major: men's hair arrangement of braids combined with one row of puffed curls at the temples

mobcap: a woman's puffed, linen cap with a ruffled edge widely worn during the Directoire era; also called a Corday cap

mule spinning: a method of drawing out and twisting a length of yarn onto a cone or cylinder

panniers (also paniers): a framework of whalebone wicker encased in fabric that fastened about a woman's hips to extend the shape of the skirt laterally

pantaloons: breeches with legs cropped at mid-calf

polonaise: the arrangement of an overskirt into three large swags draped over the sides and back of a petticoat

pompon: hair ornaments made from small pieces of fabric embellished with decorative trim

queue: the length of men's hair secured by a tie or braid at the back of the head

redingote: men's long greatcoat constructed with a wide, double collar, the topmost of which could be turned up to cover the face

redingote gown: women's fitted jacket with a cutaway front and a full length half skirt in the back worn over a chemise gown in the 1780s and 1790s

robe a l'anglaise: a form of the sack gown with the back pleats stitched to the contours of a bodice

robe a la creole: a loose form of chemise gown made of cotton that may have originated in the French West Indies or colonial New Orleans

robe a la francaise: the robe-like sack gown of the 1720s and 1730s; also called a Watteau gown

robe en chemise: a simple gown of the 1780s and 1790s cut as a full tunic of white muslin with a drawstring neckline and girded at the waist with sash

robings: the flat fold of fabric along the finished edges of the open-front bodice

roquelaire (also roquelaure): a long, bell-shaped cloak with a wide flat collar and a front closure that fastened with a row of large buttons

rump: a padded roll that tied about the hips under a full, gathered skirt

sack gown (also sacque): a flowing, robe-like gown with a box pleats at the back neckline that fell loosely to the hem

sans-culottes: loose, ankle-length trousers worn by the lower classes of France; literally meaning without breeches

skeleton suit: a boy's playsuit of the late 1700s so called because of its snug fit

solitaire: a simple, wide ribbon collar, usually black, worn by young men in the mid-eighteenth century

spatterdashes: men's knee-high leather leggings secured by spur straps

Spinning Jenny: a machine that spins multiple yarns simultaneously

stock: a pleated linen square fastened around the neck to form a sort of high collar

surplice: a garment closing constructed with two deeply overlapping panels of fabric, usually worn unfastened

suspenders: bands of fabric or leather secured at the waistband of breeches or trousers and passed over the shoulders to hold up the garment; also called braces

toupee: the raised foretop of a wig or hairstyle

toylett cloth: a square or rectangular piece of fabric used to cover a dressing table; ordinarily made from the same cloth as a lounging robe

tricorne hat: a shallow-domed hat with the brim cocked up on three sides

trousers: a bifurcated garment covering the waist to the ankles

Watteau gown: the style of sack gown depicted in paintings by the Rococo artist Antoine Watteau; also called the robe a la francaise

Legacies and Influences of Eighteenth-Century Styles on Modern Fashion

Among the most distinct elements of eighteenth-century women's fashion were panniers. Modern interpretations of the pannier silhouette had mass appeal in the fashions of late 1910s and early 1920s, and again in the 1950s. In most decades since the First World War, though, the look of panniers has appeared periodically in numerous fashion collections. Most recently, designers like Karl Lagerfeld, Jean-Paul Gaultier, and Vivienne Westwood have relished the theatrical drama of pannier gowns.

Another influence of the 1700s on modern women's styles is the loose-fitting sack gown. Eveningwear gowns of the 1950s and 1960s especially were layered with sack-like jackets made from the same fabric. Some of these loose-fitting jackets were even constructed with box pleats at the back neckline or shoulder yoke.

For modern men, the dishabille of the Rococo man's casual home dress became the lounging robe, variants of which include the smoking jackets of the late nineteenth and early twentieth century. As a garment of class distinction, these forms of robes were often made of elegant fabrics such as silk or rayon brocade to distinguish them from bath or dressing robes.

Gold and white silk gown with quilted gold brocade sack coat by Lanvin-Castillo, 1957.

The day robe worn by affluent men in the eighteenth century evolved into various forms of casual jackets and lounging robes of the modern era. Above: three generations of men wearing lounging robes over collared shirts and neckties, 1910; left, matelasse lounge robe from John Davis, 1935.

The eighteenth-century pannier silhouette has inspired modern fashion designers to create innumerable variations.

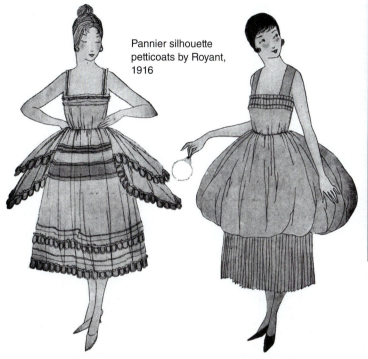

Pannier silhouette petticoats by Royant, 1916

Petal ball gown of black velvet and cream satin by Charles James, 1951.

Striped silk dress by Lucile, 1916.

Ruched satin dress by Hannah Troy, 1953.

Ball gown of tulle accented with feathers by Henri Bendel, 1938.

Chapter 19

THE NINETEENTH CENTURY
1800–1850

Napoleon crowned emperor 1804	War between U.S. and England 1812–1814	Napoleon defeated at Waterloo; exiled 1815	Reign of George IV of England 1820–1830	Reign of Charles X of France 1824–1830
U.S. purchased Louisiana from France 1803	Wars of independence in Latin America 1806–1828	Restoration of French monarchy: reign of Louis XVIII 1815–1824	U.S. Monroe Doctrine 1823	
	Goya's *Third of May, 1808* 1814	Spain ceded Florida to U.S. 1819	First steamship crossed the Atlantic 1819	Lord Byron's *Don Juan* 1824

1800 1825

U.S. Erie Canal opened 1825	Reign of William IV of England 1830–1837	Victoria ascended the English throne 1837	Victoria and Prince Albert wed 1840	Elias Howe invented sewing machine 1846
Independence of Greece 1829	Louis Philippe ruled France 1830–1848	Samuel Morse developed the telegraph 1837	Turner's *Rain, Steam and Speed,* 1844	U.S. war with Mexico 1846–1848
Victor Hugo's *Notre-Dame de Paris* 1831	Darwin's voyage of the *Beagle* 1831	Daguerreotype photography invented 1839		Charles Dickens' *David Copperfield* 1850

1825 1850

THE NEW WORLD ORDER 1800–1850

Perhaps more than in any other period in history, Europe and the Americas in the nineteenth century were dramatically altered by rapid and profound changes—political, social, and economic. In the 1800s, the borders of European and New World nations were gradually defined and carved into the framework of today's countries. Industrialization undermined the lingering vestiges of economic and social feudalism and replaced it with an egalitarianism based on the manipulation of capital and labor rather than ownership of land. Science triumphed with advances in medicine and technology. In the arts, Neoclassicism was supplanted by the emotionalism of Romanticism.

Initially, however, the political turmoil of the French Revolution extended into the following century affecting the stability of all of Europe. In the closing months of the eighteenth century, the Directory of France had been dissolved and a consulate government formed with Napoleon Bonaparte as First Consul. In 1804, he crowned himself emperor and reestablished a royal court in Paris. Over the following ten years, Napoleon waged wars of conquest and defense across Europe until his defeat and exile in 1815. A provisional government

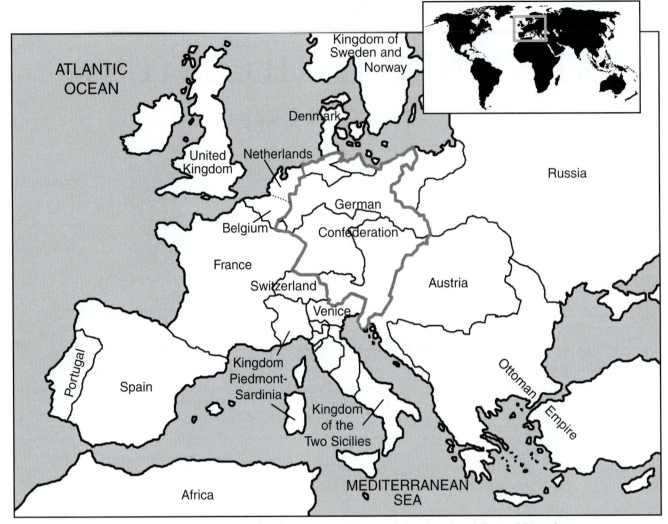

Europe of 1815 redrawn by the Congress of Vienna following the defeat of Napoleon.

established a constitutional monarchy and brought from exile the brother of Louis XVI as the new Bourbon king, Louis XVIII. For ten years he reigned with only a nominal part in the affairs of state. When his brother succeeded him as Charles X in 1824, though, the royal court attempted to restore the pre-revolutionary order of the *ancient régime*. The people of Paris revolted in 1830 and overthrew the Bourbons. The crown was then offered to Louis Philippe of the House of Orleans. Under the bourgeois Orleanists, France experienced a period of calm, economic expansion and prosperity for the following eighteen years. In 1848, the disenfranchised lower classes united into a socialist workers' revolution that ousted the monarchy and formed a second republic.

England in the first half of the 1800s was a strange contrast of the old and the new. Socially and politically, it remained essentially the same England of the eighteenth century with the landed aristocracy controlling the destiny of the nation. On the other hand, the industrial revolution was changing the basis of economic wealth from land holdings to industry and finance. Another contrast of the old and the new was the monarchy. The insanity of George III and the scandalous behavior of his son, who became George IV in 1820, weakened the monarchy, particularly in light of the powerful leaders in Parliament at the time. In 1830, the unpopular George IV was succeeded by the amenable but ineffectual William IV who reigned only seven years. His niece, eighteen-year-old Victoria became queen in 1837. Her reign spanned the remainder of the century, giving the era its name. The young queen immediately set about raising the status of the monarchy from the ignominy of previous reigns. She represented a moderating influence on politics by presenting the views of the people to the government. In 1840, she married her handsome cousin, Prince Albert of Saxe-Coburg-Gotha, who added his intelligence and moral purpose to the English monarchy.

Over the decades following the end of the Napoleonic wars, the nations of modern Europe took shape. In 1815,

The Invention of the Sewing Machine

The most important technological development in the fashion industry of the nineteenth century is the sewing machine. In 1830, Barthelemy Thimmonier of France invented a crude machine that could sew about 200 stitches a minute, over five times faster than the swiftest hand-sewer. When he set up a factory to produce men's coats for the French military, an angry mob of tailors attacked and destroyed the operation. Thimmonier barely escaped with his life and abandoned the refinement of his invention to others.

In 1845, American watchmaker Elias Howe developed an improved sewing machine that incorporated a curved eye-point needle that moved horizontally with an underthread shuttle. Howe's sewing machine operated with a hand crank that could run 250 stitches a minute.

At about the same time, Isaac Singer developed a sewing machine with a straight needle that moved up and down and had an adjustable lever that held the fabric in place for easily stitching a long straight or curved seam. Equally important, Singer's machine was operated by a foot treadle, freeing the hands for the manipulation of the fabric.

In addition to sewing machines produced for commercial use, including versions for sewing leather, inexpensive models were widely available for home use by the 1850s. In 1860, *Godey's Lady's Book* declared the sewing machine "the queen of inventions." A table of garment and time comparisons produced by the magazine showed that a man's shirt sewn by hand took more than fourteen hours of sewing, but the same garment stitched on a machine took only one hour and sixteen minutes.

Treadle sewing machine, 1894.

the thirty-nine German states that comprised the remnant of the Holy Roman Empire were organized into a German Confederation. Switzerland became an independent confederation of cantons. After a lengthy and bloody revolution, Serbia, Rumania, and Greece won independence from the Ottoman Empire in 1829. The following year, with support from England and France, Catholic Belgium declared its independence from Protestant Netherlands.

Similarly, in Latin America, the seeds of revolt emerged from the disorder and destruction of the Napoleonic wars. Spain had lost its navy in the Battle of Trafalgar in 1805, and Napoleon deposed the Spanish Bourbons in 1808. In remote isolation from Spain, the colonists of Latin America formed committees of independence called juntas. Between 1811 and 1824, the nations of modern South America gained their independence. To the north, the United Provinces of Central America was formed as an independent nation in 1823, and a year later Mexico adopted its constitution.

In 1800, the United States was comprised of sixteen states with the addition of Vermont (1791), Kentucky (1792), and Tennessee (1796) to the original thirteen colonies. Three years later, the territory of the United States more than doubled with the Louisiana Purchase, and a westward migration that came to be known as Manifest Destiny led to the addition of fourteen new states stretching coast to coast by 1850. The United States gained additional territory through Spain's ceding of Florida in 1819, the annexation of Texas in 1845, and the acquisition of Oregon from Britain in 1846. Initially, nationalism

united the country, especially in the War of 1812–1815 against Britain and the Mexican-American War from 1846–1848. Increasingly, however, sectionalism in the slaveholding South and industrialization in the populous North formed a palpable division that extended across the nation. By mid-century the issue of slavery, and with it, the balance of power between slave states and free states were reaching a crisis point that would only be resolved by civil war.

ECONOMICS AND SOCIETY

The new political order that evolved in Europe and the Americas during the first half of the nineteenth century occurred in part from changes in Western economics and society. The industrial revolution that had begun in England in the mid-eighteenth century grew at an increasingly rapid pace in the early decades of the 1800s. Mechanization in the spinning and weaving of textiles spread to France, Holland, and the United States, followed by techniques for the manufacture of iron and steel and, finally, the actual means of generating power. Industrialization was slow to expand into Germany and Switzerland until mid-century and into Italy and Spain only late in the 1800s.

As industrialization rapidly increased, so, too, did the development of fast and efficient forms of transportation and communication. Nations entered into a frenzy of building turnpikes and canals. In 1807, American entrepreneur Robert Fulton successfully applied a steam engine to a paddle boat, allowing shippers to defy wind, tide, and a river's

downstream current. The first experiments with a steam lo-comotive were by the Englishman George Stephenson in 1814. By mid-century England had more than 6,000 miles of rails; France 2,000 miles; Germany 3,500 miles; and, at the time of the Civil War, the United States had 30,000 miles of track. Alongside railways followed lines for the telegraph soon after its invention by Samuel Morse in 1837, making communications over great distances instantaneous.

In England, Belgium, and the Netherlands, free trade boosted industrial development. In France, protectionism was enforced into the 1830s, during which French textile production flourished. The United States experimented with forms of protectionism until the 1820s, but then prospered in the free trade arena where exports of cotton textiles soon rivaled those of India.

Advances in manufacturing technology broadened the accessibility and affordability of textiles and clothing that previously were available mostly for the privileged classes. In 1801, Joseph-Marie Jacquard perfected a loom for weav-ing textiles of intricate designs by raising or lowering the warp. The type of textile with raised patterns still bears the inventor's name: **jacquard**. In 1808, John Heathcote devel-oped a bobbinet lacemaking device and during the next two decades established factories in England and France to mass produce machine-made lace. In 1816, Marc Brummel in-vented the circular knitting machine, which produced a tubu-lar form of fabric with no seams. The first **elasticized fabrics** were developed in the 1820s with the addition of rubber to thread, but they were subject to deterioration in extreme tem-peratures. In 1839, U.S. inventor Charles Goodyear discov-ered the vulcanization process, which improved the strength and resiliency of processed rubber.

In addition to new developments in manufacturing tech-nology, new methods of work-flow production led to mass production. Standardized goods with uniform components could be produced rapidly and with a regulated quality—a precursor to the assembly line. In the clothing industry, cer-tain types of garments such as cloaks, overcoats, and acces-sories like gloves and scarves were mass produced even in the late eighteenth century. In 1825, the first ready-to-wear fac-tory was built in the United States to produce men's military attire—a significant portent of events to come.

These revolutions of industrialization, communication, and transportation sped the rise in power and wealth of the middle classes. The new, broader middle class of the nine-teenth century encompassed social gradations that almost blended imperceptibly at the extremities. At the top, banking families, manufacturing barons, and merchant princes were comparable in wealth to the landed aristocracy. At the oppo-site end of the middle class spectrum were the clerks and civil servants who assumed a social superiority over the working classes, though they were not paid much better.

From this expanding middle class developed a pervasive bourgeois attitude in life and society that rejected the revived traditions of European aristocracy and, instead, sought the

conveniences of modernity and a familial intimacy. Fashion trends now largely emerged from the great ladies of the upper middle classes of Paris and London whose passion for elegance and refinement centered on their homes and intimate social cir-cles. The uninspired and unimaginative royal courts of Louis XVIII, Charles X, and Louis-Philippe provided little fashion leadership during this period of social transition. The wave of Anglomania that had swept Paris at the end of the eighteenth century continued well into the first quarter of the 1800s, due in part to the salons of English ladies living there at the time. English dandyism, influenced by Beau Brummel and others of the circle of the Prince Regent, spread a refined romanticism of masculine fashion and manners to the Continent.

In literature, music, and the visual arts, the Neoclassicism of the late eighteenth century and of the Empire period dis-solved into the Romantic Age. Literature, music, and art of-fered escapism from the banalities of the new capitalistic social order. Writers, composers, and artists expressed in their works the sublime beauty of nature, the melodrama of romanticized history, and the picturesqueness of distant lands. The onion-top domes of the Brighton Pavilion of George IV conjured images from the *Tales from the Arabian Nights*. Lord Byron's lyrical poetry recounted sagas of Greek pirates and Muslim slaves. Eugene Delacroix's vivacious canvases depicted exotic narra-tives of Africa and the Near East. Beethoven's symphonies stirred the soul with exhilarating new sounds.

From these influences of the Romantic movement, fash-ion abandoned the prescriptions of Neoclassical costume to pursue variety. By the 1830s, fashions had adapted a wide mixture of elements from the costumes of earlier periods and distant cultures. A return of Elizabethan leg-of-mutton sleeves and corseted, cinched waists was inspired, in part, by the costumes of Shakespeare's plays performed both in London and Paris. The revival of decorative treatments such as medieval dagging was an influence of the historical fiction of Victor Hugo and Sir Walter Scott. These and numerous other influences and inspirations of the Romantic Age fos-tered a confusing array of looks in which stylistic novelty rather than innovation prevailed. By mid-century the Roman-tic movement had largely crystallized into an effete formula of eclectic borrowings. The time was right for something to-tally new. In the early 1850s, a new force of style and fashion took the lead—once again centered in Paris and once again emanating from a revitalized royal court.

Beginning in the early nineteenth century, the rapidity of change in the styles of women's fashions outpaced that of men's. Whereas the design of feminine apparel became in-creasingly more complex and varied, men's clothing became standardized into garments that articulated and encased the body with a uniform look that only evolved slowly and con-servatively. Women's fashion in the nineteenth century de-manded novelty and rapid cycles of change, but men's clothing retreated from Rococo splendor into a codified bour-geois formula of sober plainness, largely eschewing color, decorative treatment, and especially abrupt change.

WOMEN'S EMPIRE GOWNS 1800–1820

At the court of Napoleon, Neoclassicism remained the inspiration for women's fashions. The assorted interpretations of the Greek chiton in white muslin such as that shown in chapter 18, Figure 18-28, continued to be the prevailing look in both Paris and London during the Empire period. Indeed, today the silhouette of a dress or coat with a high waistline just under the bosom is commonly called an **Empire waist**. Columnar gowns were cut in one piece from the shoulders to the hem to drape about the figure and reveal the feminine form. The deep decollete necklines were shaped by drawstrings in the facings or by front edges that crossed on diagonal lines to define and lift the bust. A sash or ribbon secured the gown just beneath the bosom forming a high-waisted silhouette that emphasized the breasts. Some gowns were sleeveless, but most had either T-cut or set-in short sleeves that bared much of the arms.

By 1802, some of the first influences of Romanticism began to alter the silhouette of the Neoclassical gown. Changes were subtle but significant over the remainder of the decade. The high-waisted bodice and skirt were constructed as separate pieces stitched together. (Figure 19-1.) The seam was usually concealed by a sash or ribbon. Bodices became complex designs sometimes made with multiple pieces. The **fall-front bodice** featured a center panel in the narrow back section and two side panels into which were sewn two pieces of lining material that fastened across the inside front to support the bust. The center back closure was ordinarily fastened with a row of buttons, tapes, pins, or tasseled cords. The fullness of the skirt in the back became extended into a train. Hemlines went to the floor. The exception was the tunic style overgown, which, like earlier Directoire versions, was cropped to about mid-calf revealing the skirt of the gown.

Sleeves displayed the first distinct signs of the Romantic era's penchant for adapting styles of the past. Set-in long sleeves with flared cuffs covering the hands to the knuckles were modeled on styles of the Middle Ages. One of the most popular sleeve revivals was reminiscent of the Renaissance with its two-piece construction of a puffed upper section at the shoulders and a long, close-fitting cylinder to the wrist. (Figure 19-2.) Similarly, some sleeves were made slightly full in order to be bound round with silk cords or ribbons to simulate the puffed styles of the late 1500s. Necklines also were transformed by

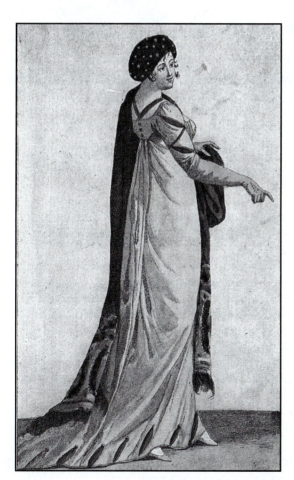

Figure 19-1. In the early years of the Empire period, Neoclassical gowns featured more complex designs. The skirt and bodice were cut as separate sections sewn together. Bodices were constructed of multiple pieces that usually included a center back closure and crossed sections in the front that supported the bust. "Modes Asiatiques" from *Les Elegances de la Toilette*, 1802.

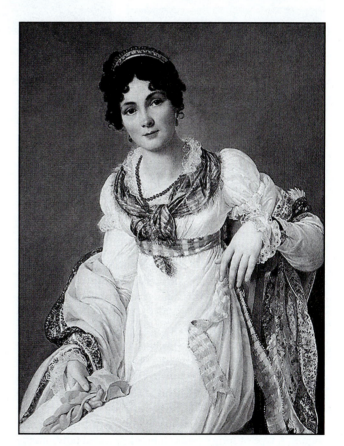

Figure 19-2. The Empire gown began to show influences of Romanticism. Sleeves displayed adaptations of medieval and Renaissance models. Necklines featured variations of the sixteenth-century Medici collar. Vivid colors and textile patterns were reintroduced. *Portrait of a Woman* by Henry-Francois Mulard, c. 1810.

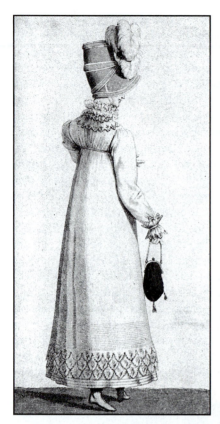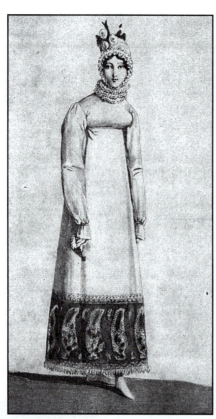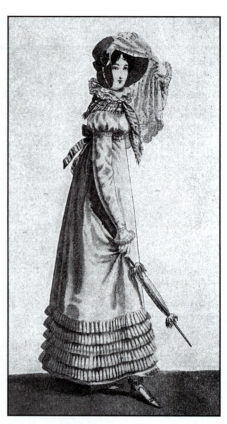

Figure 19-3. Through the 1810s, the draping of the Empire gown evolved from the chiton-inspired Neoclassical model to a structured conical shape. The silhouette retained the high waistline though. "Costumes de Promenade" from *Costume Parisien,* left, 1813; center 1815; right, 1818.

Romantic revivals such as a variant of the Medici collar—a stand-up ruff high in the back and tapering to the front. The 1804 coronation gown of Josephine and those of her ladies-in-waiting were constructed with a combination of Romantic historical influences including adaptations of the Medici collar, the Renaissance puffed upper sleeve, and the knuckle-length cuff of the Middle Ages. Other types of soft, ruffled collar treatments like that shown in the Mulard portrait recalled the chemises of the late-seventeenth century.

In addition to changes in the silhouette of the Neoclassical gown, a myriad of colors, textures, and textile patterns was reintroduced. Although white remained the preferred color, especially for eveningwear, day dresses gradually became tinted with soft, muted hues. By the early teens, vibrant jeweltone colors like ruby, amethyst, malachite, and lapis were worn by trendsetters. At this time also, a wide assortment of textured fabrics imported from India were used in making women's gowns and accessories. **Madras** muslin was woven with a thick, soft weft thread on a sheer warp base. One variety featuring fine, sheer stripes was formed by **drawn-thread** techniques. A type of sprig or spot embroidery called **tambouring** was achieved by stretching the fabric over a frame, or tambour, to which a fine chain stitch was applied by a hook underneath. Allover textile patterns for gowns were less prevalent until the

late teens and then included gingham checks, narrow vertical stripes, and petite-prints of blossoms or repeat geometrics.

Throughout the 1810s, the high waistline of the Empire gown remained the mode. However, the draping of the skirt l'antique was superceded by a more structured, conical cut. (Figure 19-3.) The front of the skirt fell straight and smooth while gathers or pleats at the back shaped the flared contours. Trains disappeared, and hemlines rose to the ankles. Fabrics were opaque and less fluid, which, when coupled with the conical shape, made for an elegant sweeping motion when a woman walked or danced. Decorative treatments drew inspiration from Romanticism. Skirts were edged with crenulated tiers adapted from medieval dagging or with wide borders of richly patterned prints. A profusion of ruffles was added to collars, necklines, cuffs, sleeve caps, and skirts. Variations of the Elizabethan ruff were ubiquitous into the early 1820s. Even slashing reappeared. (Color Plate 11.)

WOMEN'S OUTERWEAR, UNDERGARMENTS, AND ACCESSORIES 1800–1820

The primarily types of outerwear for women of the early Empire period were wraps of assorted styles and sizes. Large shawls, long scarves, and stoles not only simulated the Greek

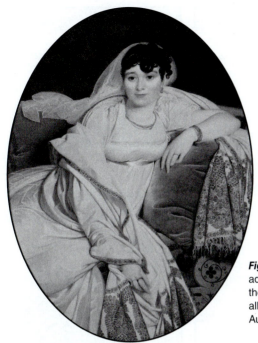

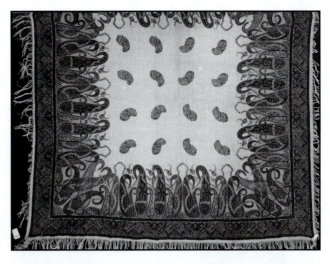

Figure 19-4. Another influence of Romanticism in women's fashion was the adaptation of exotic textile patterns. One of the most popular and enduring was the paisley motif, which was usually applied as a border treatment rather than an allover print. Left, *Marie-Francoise Beauregard, Madame Riviere* by Jean-Auguste-Dominique Ingres, 1806; right, detail of a cashmere shawl, c. 1810–30.

himation but also served the same basic purpose as their ancient predecessors—to cover bare arms and shoulders in chilly or damp weather. As Romanticism began to influence fashions of the decade, exotic Eastern motifs replaced the classical palmettes and Greek key designs as decoration on wrap garments. East Indian patterns, especially the gourd-shaped **paisley**, became immensely popular. (Figure 19-4.) Similarly, the stylized buta floral shape was translated into the pine cone motif by English textile manufacturers. In fact, French and English textile designers assiduously reproduced and reinvented the "modes asiatiques," thus spreading the trend.

Fabrics of wrap garments ranged from airy silk **organdy** to thick wool. Selective breeding of sheep in England and Spain during the eighteenth century led to the development of the soft, supple **Merino wool** that was especially preferred for wraps. From India came downy-soft **cashmere**, a textile made from the silken hair of the goats from the Kashmir region.

In addition to the light wraps, heavy wool capes and cloaks, many with hoods, also continued to be common forms of outerwear for women of all classes.

Another type of women's outerwear was an adaptation of a men's jacket called the **spencer**. (Figure 19-5.) The masculine version, which had emerged at the end of the 1700s as an English eccentricity, was cropped at the waist without a skirt or tails. Because of the high-waisted silhouette of women's gowns, the hemline of the feminine spencer extended to just under the bosom. Variations of the spencer—some sleeveless—also were designed of lightweight wool or silk for indoor wear.

For winter weather and travel, three types of women's overcoats were fashionable during the Empire period.

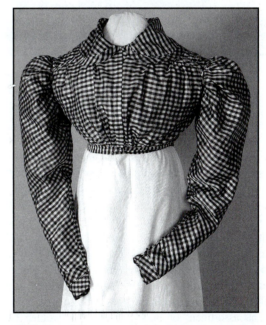

Figure 19-5. One of the menswear influences on women's fashions was the spencer jacket. Unlike the masculine version that ended at the waist, the women's Empire spencer was cropped just under the bustline. Spencer jacket of purple gingham silk with brass hook and eyes, c. 1810–1815.

(Figure 19-6.) The cropped, open front of the eighteenth-century redingote was redesigned into a closed, "round" style with the hemline to the feet. The high-waisted silhouette of Empire gowns was applied to the new coat form by constructing a separate bodice with set-in sleeves and a long,

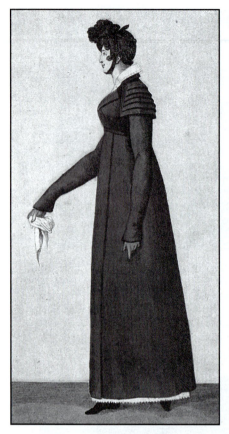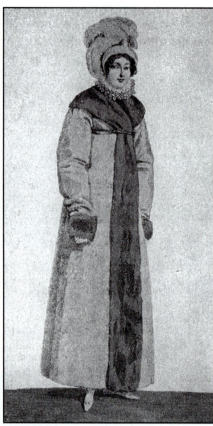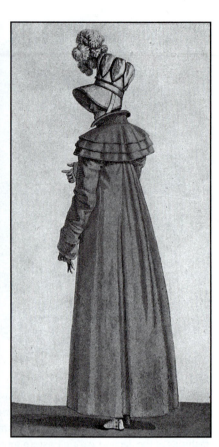

Figure 19-6. During the Empire era, three types of women's overcoats were fashionable. The old cutaway redingote was redesigned into a closed or "round" version. The fuller pelisse was usually fur lined and included large fur cuffs that served as a muff. The carrick was made with tiered layers of three to five capelets cropped to the line of the Empire waist. Left, redingote, 1809; center, pelisse, 1816; right, carrick, 1815. Plates from *Costume Parisien.*

conical skirt. The fitted sleeves often ended with flared cuffs that extended to the fingertips to keep the hands warm. A similar overcoat of the time was the **pelisse**, which was cut fuller than the redingote and usually featured fur trim or lining. Cylindrical sleeves were wide with long, fur cuffs that served as a muff when the hands were clasped. In the mid-1810s, a feminine adaptation of the English coachman's coat called a **carrick** became widespread on the Continent. The carrick featured layers of three to five capelets that covered the shoulders to the line of the Empire waist.

The assortment of undergarments for women became more complex and varied in the nineteenth century. The cotton or linen chemise remained the most prevalent type of underclothing. It was cut to conform to the short-sleeved or sleeveless gowns with their deep decolletage necklines. Decorative treatments such as trim and ruffles were kept to a minimum so as not to ruin the smooth, contouring drapery of the gown. During the height of the "undress" period of about 1797 to 1802, the chemise was cropped above the knees to allow light through the diaphanous muslins, revealing the outline of the legs. By the 1810s, styles of the chemise were once again lengthened to the ankles and constructed with long sleeves and high necklines.

Women's knee-length drawers of cotton or linen were more widely worn beginning in the Empire period. Although types of drawers had been in existence since the late sixteenth century, women seldom wore them. It was the change in girl's clothing styles to short skirts and trousers in the first few years of the 1800s that influenced the widespread adoption of feminine drawers. Most types of drawers were made of woven cotton or linen, but examples of knitted silk are known to have been worn by aristocratic women. The legs of drawers were left as loose tubes of fabric or were gathered into kneebands. The version of drawers based on men's pantaloons was called **pantalettes**, which extended to mid-calf or even the ankles. Some styles of drawers and pantalettes were made as separate leggings tied to a waistband with strings—a convenience in manipulating skirts over a chamberpot but a potential embarrassment if not properly secured to the waistband. One woman wrote in 1820 that one of her leggings fell off in public at which she was so mortified that she stepped out if it and continued walking, leaving it behind her.

Even though many young women of the early Empire period abandoned their corsets and reduced the layers of their undergarments to a simple half chemise, those ladies who lacked

the requisite youthful, slender contours of a Hellenistic statue relied on the artifice of a constricting corset for figure control. Layers of canvas reinforced with whalebone and tightly laced up the back ensured a rigid fit of the corset. False bosoms made of cotton padding aided women without sufficient natural contours to fill the deep decolletage of their gowns.

At the close of the eighteenth century the bustle silhouette and the padded hip roll were abandoned for the natural, nude look of antiquity. Around 1810, though, a form of the bustle returned to support the gathered or pleated fullness of the skirts at the back of the gown. A shallow, crescent-shaped version of the hip roll fitted across the back only and was secured with strings that wrapped around the front and to the back again. Fillings included goose or swan's down, fleece, or cotton padding.

Hats of the Empire period were seemingly limitless in their variety. Key changes in silhouette were particularly notable with bonnets. (Figure 19-7.) In the first decade of the century, the elongated shape followed the Neoclassical hairstyles arranged at the back of the head. Sometimes designs reversed the profile by extending the visor in the front to an exaggerated length. In the 1810s, bonnets became tall and narrow, often bristling with an abundance of ribbon loops, feathers, bows, and silk flowers. Brimless forms of these tall, tapering hats were called **toques**. The **capote** was a bonnet style made with a soft fabric crown and a stiff brim, often of straw. Silk and satin turbans became all the rage for eveningwear following Napoleon's occupation of Ottoman Egypt in 1799. Influences of masculine headgear in the early years were largely limited to adaptations

of silk top hats. In the teens, the men's **jockey cap** was appropriated by women; its soft, beret-style crown was affixed to a leather rim with a short, polished visor at the front. Surprising, despite much of Europe being at war during this time, few women's hats were inspired by military styles.

Shoe styles in the early years of the 1800s remained complementary to the Neoclassical look although sandals were discarded entirely by 1804. Flat slippers without heels were the prevalent footwear into the late teens. Some featured long ribbons that laced across the instep and about the ankles. Toe shapes were slightly pointed in the early years but became more rounded by the end of the first decade. Color became as important as shape when gowns became vividly hued and hemlines rose to the ankles. Upper-class women had satin shoes dyed to match perfectly the velvet and silk textiles of their gowns. During the mid-1810s, ladies donned buttoned spats like those shown in Figure 19-6. For a promenade stroll, lace-up ankle boots, also heelless, were functional and fashionable.

Other accessories of the early Empire period were adopted in the name of modesty. Even though the emulation of classicism was regarded as noble, many social critics of the time, particularly in England, objected to the modern interpretations of Greco-Roman costume. An 1803 magazine editorial criticized women "who were dressed or rather undressed in all the nakedness of the mode . . . as it was trespass against modesty." For fashionable women who were less daring with a deep decolletage and bare arms, a variety of concealing accessories was available that did not detract from the Neoclassical look. Besides shawls, stoles, and neckerchiefs,

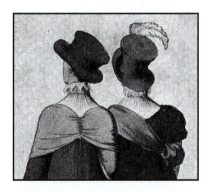

Figure 19-7. In the early years of the Empire period, women's hats reflected the influences of Neoclassicism with their elongated shape. By the 1810s, hats became tall and narrow, often excessively decorated with ornaments that emphasized the height. Hat plates from *Elegances of Fashion,* left, 1804; center, 1806; right 1816.

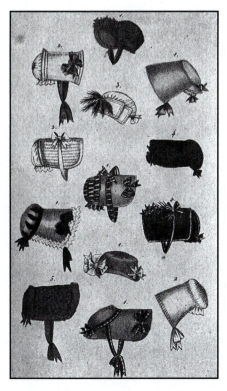

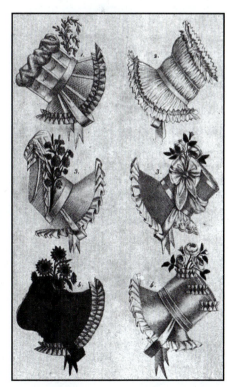

women also wore the "**bosom friend**," a sort of partlet that filled in the neckline. A similar accessory was the **pelerine**, which was more of a shaped shoulder scarf that fitted like a capelet.

Women's purses, called "pockets" at the time, had previously been concealed beneath panniered skirts. But the close draping of the Neoclassical gown required the purse to be hand carried. Although numerous fashion plates depict these small purses carried as accessories, some contemporary literature suggested that carrying a purse ("pocket")—an article once concealed beneath one's skirts—was in a similar category of immodesty with that of exposed arms and shoulders. Possibly this social criticism led to the origin of the other name for the purse—**reticule** or redicule. The small purses were of fabric, some richly embroidered, attached to a metal clasp frame or stitched with a draw-string closure.

Other feminine accessories included fans, parasols, lace-trimmed handkerchiefs, long gloves, decorative combs, and muffs made of fur or down-filled fabric. Jewelry remained inconspicuous although bracelets a la grecque encircled the bare upper arms for eveningwear.

WOMEN'S ROMANTIC ERA DRESSES 1820–1850

By 1820, women's fashions had moved completely away from the influences of Neoclassicism. Even the waistline that had remained in the Empire mode for two decades had dropped from just under the bosom to slightly above the

natural waistline. (Figure 19-8.) Sleeves began to widen, increasing the breadth across the shoulders. To balance this horizontal profile, skirts also widened, taking a bell shape. Waists were rigidly corseted as small as physiologically possible to emphasize the new hourglass silhouette—a significant departure from the natural look of Neoclassical fashions. Color became more vivid and ornamentation more fanciful. The Romantic Age was reaching a crescendo, and the anachronistic combinations of historical elements were unbridled. Textile patterns such as plaids and floral prints were bolder.

The most innovative change to the silhouette of the late 1820s was the immense width of the sleeves. (Figure 19-9.) An adaptation of Elizabethan leg-of-mutton styles called a **gigot** may have been inspired by a renewed interest in Shakespeare, whose plays were avidly attended by the Romanticists in both London and Paris. Two key differences distinguish the nineteenth-century leg-of-mutton sleeve from the original. First, the armscye of the 1820s dropped off the shoulder, pushing the fullness of the sleeve down the arm. Second, the gigot was not always padded into a swollen, smooth shape. When the Romantic era sleeves were padded, however, the filler was often a down-filled pillow form.

A variation of the leg-of-mutton shape was formed by a double sleeve construction. A large gigot of a sheer fabric was stitched over a two-piece Empire sleeve with its short puff at the upper arm and a fitted cylinder to the wrist.

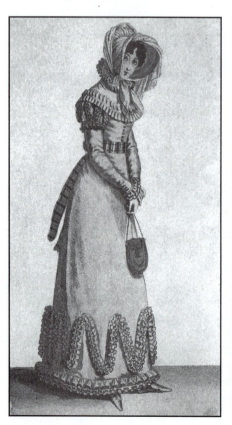
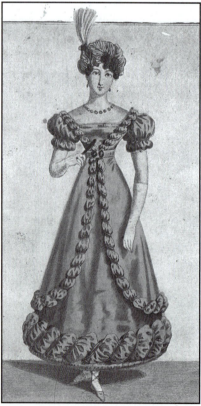

Figure 19-8. By 1820, women's fashions had abandoned the influences of Neoclassicism. The waistline dropped from just under the bosom to slightly above the natural waist. Sleeves began to widen the breadth of the shoulders and skirts became a fuller bell shape. Left, promenade gown, 1820; right, evening gown, 1823. Plates from *Costume Parisien.*

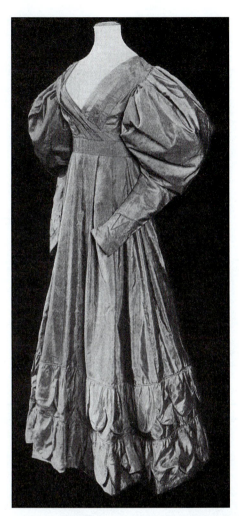

Figure 19-9. The most innovative change to women's dresses in the early Romantic Age was the immense expanse of the sleeves. Armscyes were dropped off the shoulder, shifting the fullness of the sleeves down the arm. By the end of the 1820s, the width of the sleeve was supported by padding, usually made from down-filled pillows. Brown silk gown, c. 1825.

Throughout the 1820s, skirts continued to widen, at first with the addition of gores and then later by a gathered or pleated fullness at the waist. As the skirts became wider, the size of bustles increased. A greater fullness and length was added to the back of the skirts for the lift provided by the larger, padded hip roll. Hemlines remained at the ankles.

Necklines were widely varied depending upon the purpose of the dress and the time of day it was worn. Informal day dresses might have a high neckline finished with a variety of collars including revivals of the ruff, which endured until about 1823. V-shaped necklines were formed either by a surplice front or by the pointed cut of the bodice front. When applied to formal promenade dresses, various forms of fine linen fillers were worn. Deep square or rounded necklines were usually reserved for evening gowns.

As the 1820s advanced, the waistline was lowered to about the natural position. The cut of the waistline was generally straight although a few examples of V-fronts are seen in fashion plates of the period. Belts, sashes, and waistbands most often were wide.

Decorative trim along the hemline of the skirts reinforced the widened silhouette. The gown in Figure 19-9 features two rows of scallops, which would have fluttered kinetically in the sweeping motion of the skirt. A similar trim called **vandyking** (named for the sharply pointed beard of the painter Anthony Van Dyke) was a variant of the zigzag dagging of the Middle Ages. Flounces of sheer fabric, lace ruffles, banded tucks, ruching, appliques, and numerous other fussy treatments along the lower edge of the skirt functioned in the same manner.

Between 1828 and 1837, these exaggerated, flamboyant trends reached their apogee. (Figure 19-10 and Color Plate 12.) Because of the excessive mix of decorative treatments, both in fashion and in interior design, this period is sometimes referred to as the Second Rococo.

Bodices were fitted and the waistline had dropped to the natural contours of the figure. The cut of the waistline remained predominantly straight.

Off-the-shoulder armscyes gave a long, sloping line to the profile of the neck and shoulders. Designs of the gigot sleeve were exceptionally diverse and fanciful. Tucks, pleats, and gathers ensured the maximum width. Ruffles and tiers of lace or other trimmings reinforced the breadth. The **imbecile sleeve** was a full, sack-like shape from the armscye to the wrist where it was gathered into a band. The name possibly originated from a type of sleeve used to restrain inmates in asylums. **Marie sleeves** were spiral bound or tied at intervals to form multiple puffs. Shoulder caps called **mancherons** were derived from a medieval form of sleeve and ranged from simple ruched bands or ruffles at the armscye to long wings extending out over much of the sleeve. Pillow padding and stiffened linings supported the voluminous sleeves. In 1832, a new method of support was reported in *Lady's Magazine* consisting of "small balloons of soft, impervious material . . . filled with compressed air and put under the sleeves."

The expansiveness of the shoulder area was also enhanced by the cut and treatments of the neckline. For high necklines, wide cape-like collars resembling the falling bands of the early 1600s extended over the shoulders. Open necklines daringly exposed the shoulders in a deep oval or V-cut front. Additional lateral emphasis of the upper bodice was achieved with the attachment of a **bertha**—a wide, deep collar pinned to the edge or revers of the low, open neckline all around.

By the end of the 1830s, a distinct change in the silhouette of dresses was apparent. The gigantic sleeves had begun to diminish. Initially, the fullness was maintained, but the pillow and balloon supports were removed. This new direction in sleeves prompted *Lady's Magazine* to assert in 1836 that "they flap in dancing almost audibly and make a frightful outline." By 1840, the transition to narrow sleeves had decisively occurred. (Figure 19-11.) The armscye continued

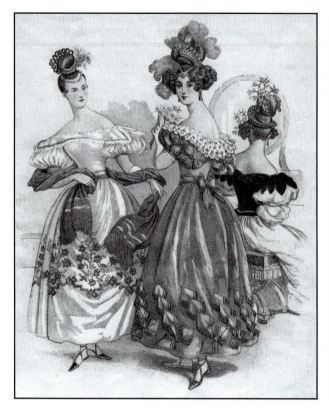
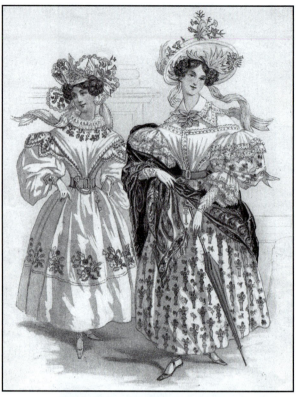

Figure 19-10. The exaggerated, flamboyant trends of women's fashions in the Romantic Age reached its height between 1828 and 1837. Sleeves were enormous. Waistlines were cinched by rigid corsets. Skirts were widened to balance the top-heavy look of the shoulderline. All manner of decorative treatments ornamented surfaces and seams. Plates from *Le Follet Courrier des Salons,* top left, 1829; top right, 1830; bottom left, 1833; bottom right, 1837.

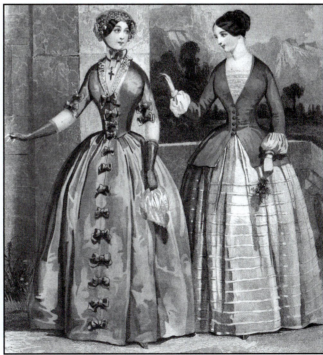

Figure 19-11. After 1840, the emphasis of women's dress designs shifted from the lateral expanse of the sleeves to a widening of the skirt. Bustles were more pronounced and hemlines dropped to the floor. Form-fitting bodices were constructed with curved or slanted darts in the front and back. Sleeves were narrow although the armscye remained off the shoulder until the end of the decade. Plates from *Godey's Lady's Book:* top, 1841; bottom two, 1849.

to be placed off the shoulder until the end of the decade when the seam became more vertical. Around 1848, sleeves were shortened and widened at the wrists to display the sleeve of various underbodice garments. For eveningwear, short sleeves and exposure of the shoulders and cleavage remained the epitome of sophistication.

Bodices were made tightly form-fitting with curved or slanted darts in the front and back. Most waistlines were cut straight although the deep V-front became increasingly popular throughout the 1840s. Queen Victoria's white satin wedding gown from 1840 featured a V-front waistline. The shape of necklines shifted from a horizontal expanse to a V-cut. A type of underbodice or **camisole** called a **chemisette** filled the opening with assorted forms of contrasting decorative fronts including lace or ladders of tucks. Other V-fronts were inset with panels of the same material as the rest of the dress for a more unified look. Pelerines fitted more like capelets closely draping over the shoulders.

Whereas the expanse of sleeves was the most striking component of the silhouette in the 1830s, the spread of the skirt marked the 1840s and heralded the crinoline age. The shape of skirts was full and round. Numerous starched petticoats were needed to support the circular fullness of the widened skirt. Bustles—referred to as "dress-improvers" in periodicals—became larger and expanded around the hips at the sides. In addition, hemlines dropped to the floor, at which ladies' magazine editorials vehemently objected. *La Belle Assemblee* complained in 1843 that "nothing can be more awkward or ungraceful than the manner in which the skirt drags upon the ground." One solution was the addition of **chatelaines** attached to the waist. These decorative chains featured hooks on the ends or spring-loaded clamps that lifted the skirts slightly above the ground. This new fashion inspired one magazine to suggest that besides protecting the skirt from becoming soiled, the lifted hem offered men "a glimpse of a pretty foot."

WOMEN'S OUTERWEAR, UNDERGARMENTS, AND ACCESSORIES 1820–1850

During the 1830s, when the massive sleeves of dresses made greatcoats impossible, shawls, capes, cloaks, and other wrap garments—or "envelopes" as they were called at the time—were the principal forms of outerwear. The variety of styles was similar to that of preceding decades except for the fuller, more circular cuts that were required to encase the padded sleeves and wide skirts. With the reduction of sleeves in the 1840s, coats reappeared although the various types of wraps had become so popular that they remained ubiquitous. Among the new styles of wraps was the **paletot**, a three-quarter-length cape with two or more tiered layers and slits for the arms. (Figure 19-12.) Other wraps included a hooded, Arabian-style cloak called a **burnous** (also bournousse) and

a **pelerine mantelet** that featured an elbow-length cape with lappets tied in the front.

Once dress sleeves were reduced in size in the 1840s, fitted coats reemerged. (Figure 19-13.) As with the silhouette of dresses, shoulders of coats were rounded with dropped armscyes. Waists were close fitting and skirts flared wide into a bell shape. Hemlines usually extended to a three-quarter length.

Developments in women's undergarments of the second quarter of the century included the new camisole-style chemisette described previously. A plain type of white woolen camisole, referred to as a women's waistcoat in England, was worn over the corset but under the chemise for added warmth in winter. Extant examples are short-sleeved with a short, flared skirt to extend over the hips. The knee-length chemise also remained fairly plain.

As skirts increasingly widened in the 1830s and 1840s, the petticoat evolved into new forms of support. Initially, layers of starched petticoats provided the fullness necessary but the excess of fabric about the legs was cumbersome. An innovative solution came in the form of the **crinoline**

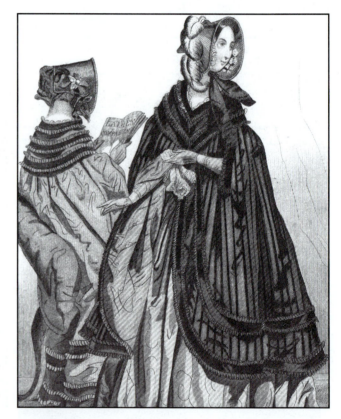

Figure 19-12. Wrap garments had become the outerwear of choice during the 1830s when padded sleeves were so wide. Although a variety of coats was once again feasible in the 1840s, wraps continued to be a favored form of outerwear. A new type of wrap, called a paletot, featured tiered layers and slits for the arms. Detail of plate from *Godey's Lady's Book,* 1842.

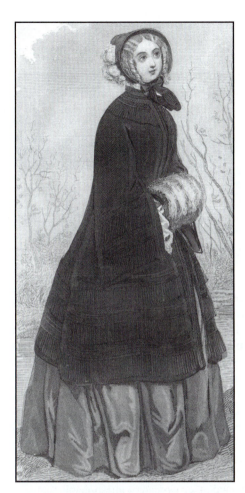

Figure 19-13. New silhouettes of overcoats were introduced in the 1840s. Bodices were fitted and bell-shaped skirts were wide enough to fit over the dress. Detail of plate from *Godey's Lady's Book,* 1849.

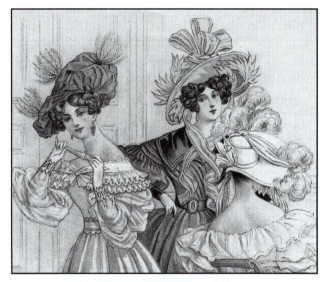

Figure 19-14. At the height of the Romantic Age, women's hats became enormous to balance the wide sleeves and skirts of dresses. The top-heavy scale of hats was further emphasized by excessive ornamentation. Detail of plate from *Le Follet Courrier des Salons,* 1830.

petticoat—not to be confused with the "cage" crinoline of the 1850s. Crinoline was a dense fabric woven of horsehair and linen. Thick bands of stiff crinoline were applied to the hems of petticoats up to about the knees, which effectively supported the spreading dome shape of skirts. Another variety of wide petticoat was made with the addition of bands of stiffened horsehair cords around the border that superbly held its circular shape. A third, more expensive type of petticoat was a down-filled variety. In 1842, Mrs. Archer Clive wrote in her diary that the forty-eight yards of material in the skirt worn by Lady Aylesbury were supported by a down-filled petticoat, which swelled out this enormous expanse and floated like a vast cloud when she sat down or rose up.

Drawers had become an indispensable undergarment by this time. *The Handbook of the Toilet* advised in 1841 that "the drawers of ladies may be made of flannel, angola [a napped twill], calico, or even cotton stocking-web; they should reach down the leg as far as it is possible to make them without their being seen." In most styles, that length extended

only to the knees, contrary to Hollywood's preference in showing ankle-length pantalettes at the hemlines of women's costumes for this period.

Corsets grew in size to cover the bosom and flare over the hips. Day corsets even featured shoulder straps and cup shapes for support of the breasts. Whalebone corsets of the 1830s became so rigid and constricting that they provided little give or bend. Fainting from lack of adequate respiration was common. By the 1840s, though, an important advance in the design of corsets was made possible with the perfecting of **rubberized thread**. The elasticized bodice was commercially called the **corset amazone** because of the greater freedom of movement it afforded women.

With the higher skirt hemlines in the 1830s, more attention was focused on stockings. White ribbed silk stockings were worn with all formal dresses. *Lady's Magazine* noted in 1833 that "most ladies, under their silk stockings, wear stockings of flesh-colored cashmere." Younger women were seen with embroidered sprays of flowers at the ankle of their stockings. On excursions to the country, women preferred gray or brown knit woolen varieties; black silk became the favorite for daytime dress.

Through much of the 1820s, women's hats were unobtrusive accents to the fashionable ensemble. Small toques, turbans, and bonnets fitted closely to the head and were trimmed more simply than in the previous decade. Beginning about 1828 through the end of the 1830s, hats became enormous to balance the lateral expansion of the sleeves and skirt. (Figure 19-14.) Turbans were great, billowing puffs of fabric, and the brims of bonnets expanded into platter-sized arcs and disks. Adding to the oversized scale of these hats were huge

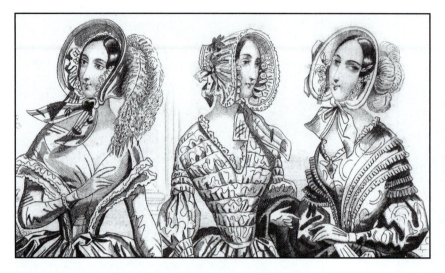

Figure 19-15. Women's hats of the 1840s were reduced in scale and styles once again fitted more compactly to the head. Towering decorative trim was eliminated, replaced instead by drooping feathers and veils. Plate from *Godey's Lady's Book,* 1841.

ribbon loops, clusters of feathers, lace ruffles, and rosettes of cutwork. For eveningwear, extravagant hairstyles such as those shown in Figure 19-10 imitated the excessive decorations of hats. Elaborate hair arrangements of loops, plaits, and twists—some over wire supports—were combined with plumes, strands of beads, jeweled combs, and all sorts of similar hair ornaments. As sleeves diminished in size in the 1840s, hats likewise reverted to smaller shapes with less decoration. (Figure 19-15.) The wide-brimmed bonnet with a flat-back crown was the most prevalent hat style of the decade. Some types of bonnet included long veils attached to the crown that could be worn down or arranged up over the hat. A **bavolet bonnet** featured a ruffle at the back of the neck to protect against the sun. Decorative interest was primarily provided by vivid colors and the richness of fabric. For everyday domestic wear indoors, women continued to cover their hair with assorted types of white linen or soft muslin caps.

The most popular type of footwear in the 1820s and 1830s remained the flat, heelless slipper with ribbon lacings. The shape of shoes changed almost imperceptibly in the late 1820s from round-toed to a blunt, square end like those shown in Figure 19-10. Since skirt hemlines were short during this period, the color and materials for shoes were especially important. By the 1840s, when skirts once again dropped to the floor, lace-up ankle boots with low heels replaced slippers as the favored ladies' shoe, especially once it became publicized that Queen Victoria preferred the style. Bootmakers took advantage of the new, durable types of rubberized materials to add inserts of elasticized fabric at the sides of shoes for a more comfortable fit. Rubberized materials were also used in the manufacture of **galoshes**—overshoes for inclement weather.

A form of short, fingerless gloves called **mitts** became popular for the promenade ensemble in the 1840s. Mitts were most commonly made of knit materials, but the more elegant types were of lace or **bobbinet**, the machine-made netting produced for the base of lacework. Long gloves continued to be appropriate for short-sleeved or sleeveless evening gowns. Kid gloves in assorted colors were for winter wear or riding.

Various types of scarves accessorized necklines. The **canezou** was a layered garment that ranged from a type of short-sleeved or sleeveless spencer to an elbow-length capelet, both with scarf-like ends that tied in the front.

The use of cosmetics disappeared after the Empire period. The middle-class puritanism of the Victorian Age had taken root. In the changing mores of the period, respectable women, at most, might have indulged in a light application of rice powder to the face and neck for a wan look. Rouged cheeks and tinted lips were for "painted ladies" such as actresses and other women of questionable repute.

MEN'S SUITS 1800–1820

As a result of the turmoil of the French Revolution, many of Paris' best tailors fled to England where they set up shop. There, expatriate French clothing makers were influenced by the superlative cut and the subdued color palette of English menswear. During the Empire period, these sartorial influences were filtered back across the Channel where they were eagerly adopted by Parisians during their Anglomania phase despite the best efforts of Napoleon to make his court a scintillating center of French fashion and style.

In London, the Prince Regent and his circle set the standards for a gentleman's dress and comportment. These dandies regarded clothing and etiquette worthy of a man's whole attention and study. Foremost among London's fashionably elite was George Bryan Brummell, known more familiarly as Beau Brummell. His claim to fame was a mastery of the art of being well dressed, a role he played until debt forced him to flee the country in 1816. He was not an innovator of fashion but rather built his reputation, as Lord Byron wrote of him, "by an exquisite harmony in dress"—his eye for proper grooming, the perfect fit, and the correct details of fashion. His fastidiously knotted cravats, for instance, were legendary.

The masculine suit of the Empire-Regency period evolved by degrees of refinement rather than by dramatic change in silhouette. (Figure 19-16.) The jacket retained the cut-in or stepped-back front cropped at the waist, which was first seen in the 1790s. Square front closures were both single- and double-breasted. The tails were shorter than the Directoire versions—most cropped a few inches above the knees and some almost at mid-thigh. Tails were cut separately and sewn to the jacket body. The swallowtail variety was attached at the front of the hips and swept in a diagonal line to the back. Spade-shaped tails were attached farther back at the sides and dropped vertically in a straight or slightly curved line. Collars were constructed with a wider band to sit high on the neck. The **notched collar** was formed by the intersection of the folded back lapels and the high turned-down collar.

The sleeveless vest was one of the two remaining men's garments—along with neckwear—that retained some degree of Rococo fancifulness in the nineteenth century. Although Beau Brummell insisted on wearing vests of neutral buff-tones, many men indulged their personal expression with styles made in vivid colors, prints, and patterns. In the 1810s, men even layered two or three vests of contrasting hues for added richness of color and dimension. To allow for the frill fronts of shirts and for the end lengths of the cravat to hang free, vests were either worn partially unbuttoned at the neckline or were cut with a deep U-front. Most vests were still cropped straight at the waist, usually a couple of inches longer than the bottom edge of the jacket front. High, stiff collars extended upright to the ears.

Men's shirts became more differentiated in style and purpose during the nineteenth century. The frilled fronts of the Rococo style were reserved for formal occasions and eveningwear though without the lace trim. Day shirts were made with a front panel insert of horizontal tucks or vertical ruching. Both evening and day shirts remained pullovers with keyhole front openings at the neckline. All were of crisp white linen or bleached white muslin. An extant example worn by George IV is fastened by three mother-of-pearl buttons at the neckline. Other typical shirts included only one or two buttons. Cuffs lost their ruffles to starched wristbands. Collars were high, starched bands that extended to the jawline. Starched stocks fastened in the back over the shirt collar.

The cravat encircled the collar two to three times before being tied in various knots at the throat. The lengths of the ends varied from short bow-like tendrils—the precursor of the bow tie—to long, scarf-like lengths filling the shirt fronts and sometimes puffed and fixed with an ornamental stud.

The look of the Neoclassical nude hero particularly prevailed in the form-fitting cut of breeches and pantaloons. The cut-in front of the jacket with its tapering tails at the sides

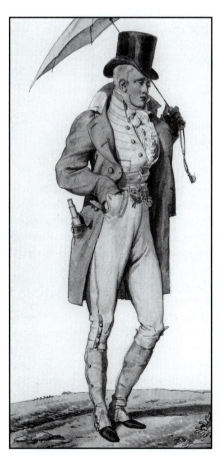

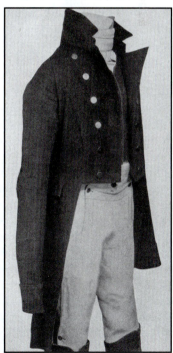

Figure 19-16. Men's suits of the Empire era changed little from the styles of the Directoire period. Neoclassicism prevailed still in the fitted tail coats with cut-in fronts and vests cropped at the waist that framed the hip and thigh area in a continued sexual display of the Antique hero. Some types of breeches and pantaloons were even made of knit materials to be more form-fitting. Left, fashion plate by Horace Vernet, 1814, right, man's suit, c. 1810.

framed the abdomen, hips, and thighs. Buttons at the outside knees ensured a snug fit. Small side-slash pockets, usually covered with button flaps, were inserted high on the hips.

Trousers gradually gained in popularity but did not begin to eclipse breeches until the 1820s. The fit of trousers in the Empire period was narrower than the baggy sans-culottes styles of the 1790s. To reinforce the slender look, instep straps, or **stirrups**, were attached to the cuffs to prevent the legs from riding up. The drop-front flap of breeches was also applied to trousers.

MEN'S OUTERWEAR, UNDERGARMENTS, AND ACCESSORIES 1800–1820

Men's overcoats were greatly varied in the nineteenth century. The voluminous carrick with its layers of three to five capelets and high collar was similar to the women's version shown in Figure 19-6. In the 1810s, the French military greatcoat worn by Napoleon was widely adopted by civilians. It was a simple design with an ankle-length hemline, a double-breasted closure, and a high, turned-down collar. Cloaks were more commonly worn for riding and travel.

Undergarments for men included a sort of undershirt for winter, which was a simpler version of the day shirt with a short banded collar and plain front panel. Knee-length drawers were made of cotton, linen, silk, or for winter, thick worsted.

Top hats became the most prevalent type of headwear in the nineteenth century. Both tall and short crowns were combined with brims of varying widths. Prior to 1820, however, the most common shape was a tall, straight crown with a shallow, rolled brim that dipped in the front and back. (Figure 19-17.) The two-sided bicorne continued to be worn into the 1820s though mostly by military men, even when not in uniform. General Andrew Jackson wore the bicorne pointed front to back, but Napoleon wore the style pointed laterally. Today the bicorne remains a component of certain official uniforms throughout Europe.

Slipper-style shoes with low, rounded heels and rounded toes were the most common form of men's indoor footwear in the Empire period. However, assorted styles of boots were the most popular. The **Wellington boot**—named for the British general who defeated Napoleon—featured a high, curving top that extended to just under the knee but dipped lower in the back. The **jockey boot**, shown in Figure 19-17, was made with a tall, snug top that was worn turned down to display a contrast lining. The **Hessian boot** was named for the German mercenaries who spread the style of their military footwear as they fought in wars on both sides of the Atlantic. The top of the Hessian boot was cut in a heart-shaped curve with a tassel at the dip in the center. Beau Brummell listed the Hessian as his favorite.

Other accessories of the gentleman included straight-handled walking sticks, pocket watches with a cluster of ornamental fobs, and made-to-measure kid gloves. Jewelry was limited to rings and the occasional studded pin for the spread cravat.

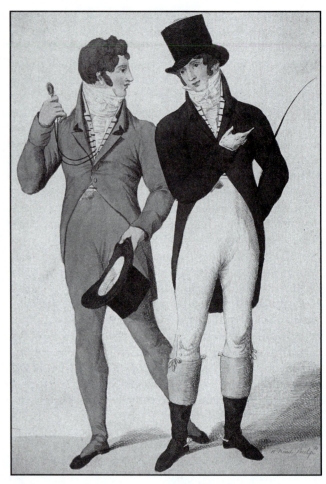

Figure 19-17. Top hats remained the most popular headgear for most men except the lowest classes. Crowns of varying heights were combined with brims of assorted widths to provide a broad variety of choices. Fashion plate from *La Mesangere,* 1808.

Powdered wigs had disappeared in the aftermath of the French Revolution although the temple curls and long queues at the nape of the neck had remained. Neoclassicism inspired the shearing of long hair to imitate the short, cropped styles of Greco-Roman statues. Wisps of hair were swept forward all around the clean-shaven face. In the 1810s, side whiskers were neatly shaped into crescents along the jawline.

MEN'S SUITS 1820–1850

Although women's clothing had completely abandoned Neoclassicism by the second quarter of the nineteenth century, men's suits continued to evolve new interpretations that displayed the idealized silhouette of the antique hero: fitted coats were padded to shape broad shoulders and pigeon-breasted chests, waists were cinched by a corset, and pantaloons and trousers were smooth and slim.

These tailored and corseted men's fashions were exclusively the styles of the elite bourgeoisie and the revitalized aristocracy of the Louis-Philippe court. By 1830, the mantle of

dandyism had passed to the next generation of beaus led by the young and handsome Count Alfred D'Orsay of Paris and the debonair Benjamin Disraeli of London. As with Beau Brummell before them, the young dandies of the Romantic Age cultivated refinement and elegance. They delighted in sartorial perfection rather than innovation—the correct shape of the jacket, the harmonious symmetry of the vest, the proportion of the cravat knot, the proper dimensions and angle of the hat.

The Anglomania that had swept France in the Empire period left a lasting impression of the importance of well-tailored clothing on almost all men except those of the laboring classes. Certainly, the majority of men did not squeeze into a corset or pad their calves, but a wider audience of men became keenly conscientious of the cut, fit, and simplicity of line in men's apparel. From Paris and London, this masculine self-awareness was disseminated throughout Europe, its colonies, and the Americas during the Romantic Age. Even as ready-to-wear became increasingly available to the middle classes, men ordinarily had their manufactured suits altered for a more tailored fit, a practice still common today. In 1849, *Godey's Lady's Book* emphasized the importance of well-tailored menswear: "The remark has often been applied to some of our most exquisite friends; 'a fine looking man, but his tailor made him'; and, on scrutinizing the dress of our Adonis, it has been found to be a truthful remark."

The tail coat of the 1820s was cut in at the front as before except the fit was closer at the hips and the fullness across the chest stood away from the body. The expanse of the shoulders was broadened with padding to further emphasize the narrow waist. The front closures included both single- and double-breasted styles. A high rolled collar joined at the notch of the wide lapels. For a brief period in the early 1830s, some varieties of coat sleeves were fuller at the shoulders forming a narrow puff above the armscye and tapering to a trim fit at the wrists, somewhat resembling a reduced version of the leg-of-mutton sleeve. By the middle of the 1830s, the full sleeves were replaced universally with close-fitting cylindrical types. Shortly afterwards, around 1838, the exaggerated padding of the shoulders and chest disappeared and the collars were reduced in height. The cinched waist remained.

In the late 1820s, the full-skirted frock coat was revived for daywear. (Figure 19-18.) This was the first significant countermeasure to the thirty-year prevalence of Neoclassicism in menswear. Coat skirts of the 1830s were full and flared; hemlines usually extended to the knees although some were cropped at mid-thigh. By the 1840s, skirts narrowed and were shortened above the knees. The bodice of the Romantic era frock coat featured most of the same design details as the tail coat including the fitted waist, pigeon-breasted front, high collar, and double or single breasted closure. In the late 1840s, the waistline of frock coats dropped to the hips in a long-line silhouette and padding was reduced. The pigeon-breasted front was replaced by a narrower fit. At about this

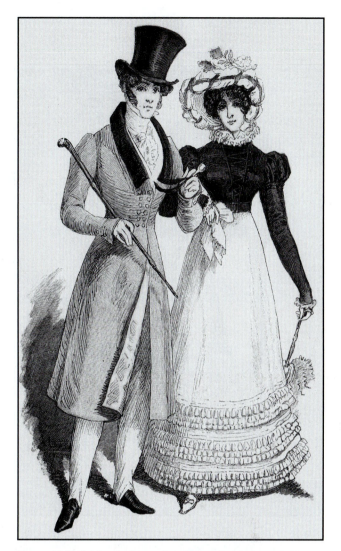

Figure 19-18. During the late 1820s, the men's full-skirted frock coat was revived. The new Romantic Age styling featured a tightly fitted, pigeon-breasted bodice, raised collar, and flared skirt extending below the knees.

time the frock coat eclipsed the popularity of the tail coat for both day wear and formal occasions. In 1844, *Punch* described the correct morning dress as a blue frock coat with white linen twill trousers. For the time being, the tail coat was relegated to a less fashionable secondary choice for formal occasions and eveningwear.

Vests continued to provide men of the Romantic Age with the opportunity for colorful self-expression in their wardrobes. (Figure 19-19.) Bold checks or prints and flashy hues endured into the 1840s. Men still sometimes layered two vests for an extra dash of color and as an additional form of padding support for the pigeon-breasted contours of the coat. The high collars of the 1810s were gradually lowered until the late 1820s when they were reduced to a simple edge folded flat around the neckline. In the mid-1830s, a short stand-up collar reappeared, and the shallow roll collar also was developed. By the end of the

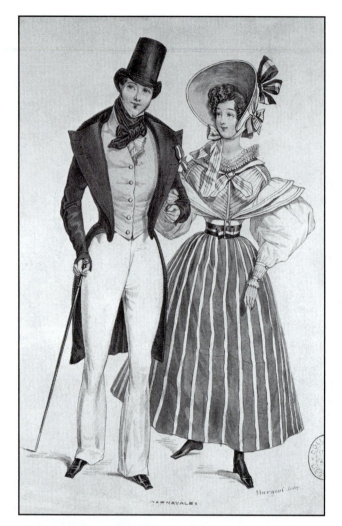

Figure 19-19. As men's clothing of the Romantic era became drab in color and devoid of ornament and pattern, vests and neckwear were the only garments that provided men an acceptable means of personal expression. Vivid colors and vibrant textile patterns were limited to the cravat or bow tie and to the vest front. For fashionable young men of the 1820s through the early 1840s, trousers commonly were skin tight, sometimes made of form-fitting knit fabrics. Fashion plate, 1830.

1830s, the length of the vest dropped to the hips where it has largely remained to this day.

Men's suit shirts changed little in the second quarter of the century. Fronts continued to feature keyhole necklines with one to three buttons at the closure. Decorative panels of tucks and frills were inserted to fill the open neckline of the vest. Hemlines were still cut in a straight line usually with slits at the sides. The high, stiff collar that extended up to the jawline only receded in the late 1820s. Narrow collars were fitted with a button at the back to fasten a linen stock in place. Linen cuffs were wide enough to fold back double. Although some versions of the cuff link band appeared as early as the end of the 1700s, the link hole style did not become widespread for formal dress until the 1840s. A

menswear guide of 1830 advised that since only the collar, cuffs, and front were ever to be seen, the sleeves and body of a shirt could be made of inexpensive India cotton, reserving linen for the exposed parts.

The double-wrapped volume of the Empire era cravat was reduced in the 1820s although, for another decade, dandies continued to favor the fuller styles with ends spread across the chest. Instead of a loose, rounded knot with dangling ends, a squared, flat bow was introduced about 1825. In the 1830s, black cravats like the one shown in Figure 19-19 became most prevalent for day wear, and white was worn only in the evening. By the 1840s, the cravat had been replaced by the narrow bow tie. Although black was the most common color for neckwear, during the second half of the 1840s, some men jauntily sported bow ties of polka dots, stripes, or checks of varying color combinations. Caricaturists lampooned men who tied their colorful neckwear into the ostentatious **butterfly bow**.

Beginning in the 1820s, trousers became increasing favored over breeches and pantaloons, both of which became associated mostly with specialty ensembles such as hunting sportswear or riding habits. Trousers were not made of the same material as the frock coat. For a short period in the mid-1820s, foppish young men experimented with a pleated version of trousers that were full to the knees but then pegged at the ankles. Skintight trousers, some made of form-fitting knit materials like those shown in Figure 19-19, remained popular with younger men of the elite classes until around 1840. Most men, though, preferred a looser but not baggy fit to their trousers. (Figure 19-20.) Shoulder braces attached at the waistband by buttons and instep stirrups at the cuff ensured a smooth fit without the discomfort of tightness. In the 1840s, the drop-front construction was gradually replaced by the revival of the button **fly front**, which had been forgotten since the end of the seventeenth century. The button closure was concealed by an edging of fabric unlike the button fly of Neoclassical breeches, which was beneath a fall-front flap. Also during this decade, the instep straps disappeared and cuffs were left to sweep about the ankles. The correct cuff line covered the heel of the shoe and broke in front over the instep—the proper length of suit trousers still today.

MEN'S OUTERWEAR, UNDERGARMENTS, AND ACCESSORIES 1820–1850

During the second quarter of the nineteenth century, the great expansion of the Industrial Revolution spurred a rapid rise in business travel for many middle-class men. As a result, cloaks once again became a prevalent form of outerwear. The huge circular cloak of the Empire era was gradually narrowed and shortened to just below the knees after 1825. Front openings were fitted with a variety of fasteners such as a row of wide tabs. Some riding cloaks were made with a slit partially

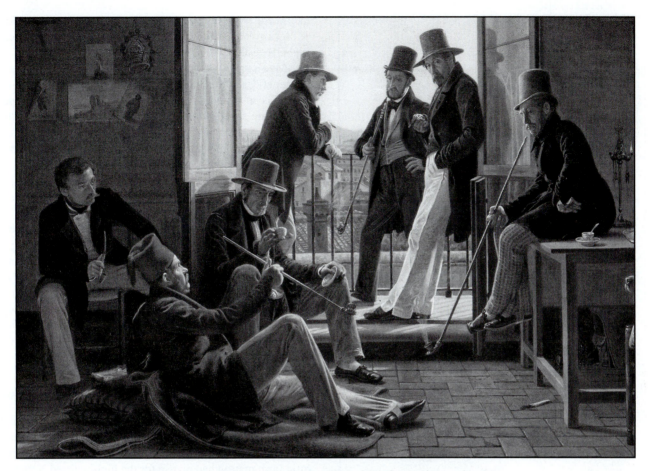

Figure 19-20. Although the dandy dressed in tightly fitted jackets and trousers with a flash of color to the vest and cravat, most men opted for loose-fitting, somber clothing. Frock coats and stirrup trousers were comfortable enough even to wear lounging upon the floor or squatting on a door step as seen in this 1837 painting. Detail of *Meeting of Danish Artists in Rome* by Carl Hansen.

up the back, secured by buttoned tabs that could be unfastened to more easily drape over the saddle.

One of the new developments in the design of men's overcoats in the 1820s was the separate bodice and skirt construction. Previously, the long military-style coat of the Empire period had been made in a single piece from the shoulder to the hem. The pelisse-style greatcoats of the Romantic Age, though, became more fitted. Collar treatments followed the trends of the suit coats, including high rolled styles cut with and without lapels. Pockets were placed high on the hips, sometimes at the waist seam with deep flaps. For the dandy, a pelisse-style overcoat of the 1830s featured a wide collar, often of velvet, a cinched waist, and a full, bell-shaped skirt—a silhouette replicating women's dresses of the time. (Figure 19-21.) Greatcoats retained their comfortable boxy capaciousness through the entire period. The carrick was all the more massive with the layers of capes sewn to the collar.

Manufactured rainwear first emerged during this period. In 1823, the Scottish chemist, Charles MacIntosh, patented a waterproof fabric made by cementing thin sheets of India rubber between woven textiles. The resulting raincoat, called a **mackintosh**—a variation of the inventor's name—was not a commercial success because the coal-tar naphtha glue reeked an intolerable odor. Within a decade of the first mackintoshes, though, Thomas Burberry developed a closely woven twill fabric, later patented as **gabardine**, that caused water droplets to run off the surface. The new weather resistant textile was made into a variety of outerwear, which was later sold in his own retail shop. Today, the **Burberry** line of ready-made outerwear and rainwear is still a quality branded product.

Men's drawers and undershirts remained basically the same as those developed in the 1810s. As trousers became more prevalent during the 1830s, a new form of ankle-length **trouser drawers** was introduced. After 1840, drawers were more commonly made of knit fabrics—cotton for summer and wool for winter. Also, at that time, the drop-front flap was replaced with a buttoned fly adapted from the new styles of trousers.

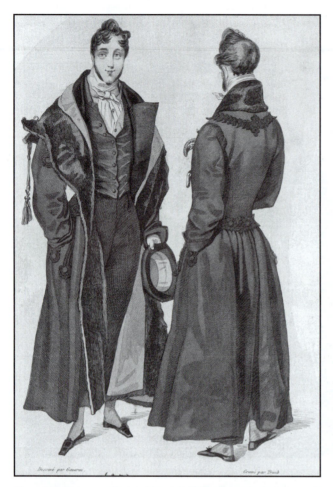

Figure 19-21. Men's pelisse-styled overcoats of the 1820s and 1830s replicated the hourglass silhouette of women's versions. Collars were wide and bodices were fitted to a cinched waist. Skirts were full and flared all around. Fashion plate of a Russian Pelisse from *Costume Parisien,* 1830.

lateral edges were more subtle. Sleek and shiny beaverskin or black silk was used for dress hats; straw suited a more casual street suit.

Men's shoes of the 1820s were similar to the shallow slipper styles of the Empire period. In the late 1820s, lace-up shoes became more prevalent for day wear and the slipper styles were worn primarily in the evening. At this time, the heel became somewhat higher, and toes were squared. Assorted types of boots were still the favored footwear for travel and outdoor activities.

Gloves, walking sticks, handkerchiefs, and pocket watches were the main types of accessories of the gentleman of the Romantic Age.

In the 1820s, side whiskers began to lengthen and expand. By the 1840s, bushy **mutton chops**, resembling a fleecy sheep's leg, extended down the temples to the jawline. Beards and mustaches also returned after an absence of almost 150 years. The outer strands of each side of the mustache were waxed into upturned curled points. Hair remained cropped above the collar. In the 1820s and 1830s, a thick mound of curls atop the head was fashionable. By the 1840s, men's hair was closely cut and tamed with oils.

CLOTHING OF ORDINARY PEOPLE 1800–1850

During the Empire period and the Romantic Age, women of the working classes were impervious to the rapidly changing trends of fashion. The urban factory worker and the rural farm matron had no use for the high-waisted Neoclassical gown with its short sleeves and gathered train nor the Romantic dress with its massive sleeves, wide skirt, and fussy embellishments. Quite the contrary, fashion was simply too inconvenient and uncomfortable for the daily tasks of ordinary women. Instead, working women needed practicality, comfort, and durability in their clothing. Simple dresses had hardly changed since the previous century. Bodices were fitted but loose enough for physical exertion and deep breathing. Corsets were an unthinkable restriction of the body, not to mention an expensive pretension. Skirts were gathered or pleated to allow sufficient fullness for ease of movement. Modesty was satisfied with hemlines at the ankles or, for field workers, just below the knees. Sleeves were usually long and full enough to roll up for dirty or wet labors. Decorative treatments were minimal—a small ruffle at the neckline or border of the skirt for a Sunday-go-to-meeting dress. The one area where ordinary women enjoyed some sense of fashion and personal expression was in fabric choices. As the textile mills of the Industrial Revolution became more efficient, a wide assortment of cheap, colorful fabrics in fancy prints and varied textures were readily available.

Accessories also had to be functional. Aprons were a necessity everyday. Simple, white cotton caps and head-wraps covered the hair. Shawls, capes, and similar wrap

Stays for men were not new to the Romantic Age. As noted in the previous chapter, the ideal physique of the Neoclassical man was athletic and youthful, a silhouette that sometimes required engineered undergarments to achieve. Similarly, the cinched waist of the mid-1820s through the early 1840s was accomplished with the use of a corset even if the man were slender to begin with. In 1829, a contemporary of the twenty-five-year-old Disraeli, future prime minister to Queen Victoria, wrote that the young man's suit coat was so tightly fitted that the lines of his stays showed through at the back. The masculine corset was constructed more as a cone than the curvaceous hourglass shape of women's versions. Laces were in the back, and short basques extended over the hips to smooth the line.

The cylindrical top hat remained the predominant headwear for both day and evening. The combinations of crown heights and brim widths continued to be as varied as those of the Empire period. After 1830, the dip in the front and back of the brim was less pronounced, and the rolled

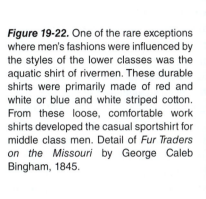

Figure 19-22. One of the rare exceptions where men's fashions were influenced by the styles of the lower classes was the aquatic shirt of rivermen. These durable shirts were primarily made of red and white or blue and white striped cotton. From these loose, comfortable work shirts developed the casual sportshirt for middle class men. Detail of *Fur Traders on the Missouri* by George Caleb Bingham, 1845.

garments were the most prevalent outerwear. For church and special occasions, an inexpensive manufactured straw bonnet could be embellished with wildflowers or a bit of ribbon.

Men's clothing, likewise, changed little from the previous century. Trousers had been worn by the lower classes decades before they were adopted by fashionable men. Some men continued to prefer breeches, though, and, ironically, the garment endured with the lower classes and the courtiers long after the middle classes had abandoned the style. Cropped spencer-type jackets and, later, frock coats were more suitable for working-class men than tail coats. Among the earliest standardized garments produced by the first ready-to-wear manufacturers were men's jackets. Vests were a hindrance to movement so most ordinary men wore only their long-sleeve shirts under their coats. For strenuous tasks, men worked comfortably in just their shirt sleeves and trousers.

One of the influences on men's fashion derived from the bottom of the social strata up was an early version of sportshirts. The long-sleeve **aquatic shirt** was originally worn by rivermen. (Figure 19-22 and Color Plate 15.) It was made of durable blue and white or red and white striped cotton. Most were made without collars and cuffs, but as the style became adopted by the middle classes for casual wear, narrow wristbands and turned-down collars were added.

CHILDREN'S CLOTHING 1800–1850

Few changes occurred in the design of infants' clothing in the first half of the nineteenth century. Swaddling mostly had been abandoned by the end of the 1700s except for some isolated areas where superstitions and entrenched customs persisted. Instead, everyday clothing for infants became more loose and longer than ever before. An early nineteenth-century encyclopedia of childcare advised mothers to dress their babies in gowns long enough to keep their feet covered. The presentation and christening gowns continued to be made of fine fabrics and laces and cut exceedingly long to display the family's affluence. One change was the disapproval of caps for baby by childcare authorities. Caps and hats could harm "the delicate tissues of the head," warned one publication.

Even though infants wear changed little during the first quarter of the nineteenth century, significant changes were made to children's clothing, which became increasingly regressive in the 1820s. Initially, though, girls continued to enjoy the ease and comfort of chemise-styled dresses made of cotton or linen although the silhouettes became more columnar like the Neoclassical gowns of their mothers. Further liberation was accorded small girls with hemlines shortened to mid-calf. As a girl got older, the hemline fell incrementally with age until her skirt reached the appropriate length of young a woman's dress—a practice that remained in effect until after the First World War.

As hemlines rose on girls' dresses, the legs—or "limbs" in polite society—had to be covered. The solution was an appropriation of trousers similar to the styles worn by their little brothers. These pantalettes were usually made of cotton and trimmed with ruffles, lace, or embroidery. (Figure 19-23.) In some instances, for the sake of feminine modesty, girls were required to wear leggings bound at the knees in the absence of the full pantalettes.

During the 1830s and 1840s, the class consciousness of the affluent middle classes influenced major changes in girls' apparel. The simple white chemise dress presented no cachet of social status. Consequently, parents once again began to dress their girls in miniature versions of women's fashions.

Figure 19-23. The full, loose chemise-style dresses worn by girls in the last decades of the 1700s were replaced by short, columnar styles of the Empire period. For modesty, a form of trousers called pantalettes was adapted from menswear to fully cover the girl's "limbs." *Portrait of Little Mary* by William Beechey, c. 1810.

(Figure 19-24.) Like the fine furniture in their parlors, their children were upholstered in heavy fabrics trimmed with ruffles, fringe, and other decorative treatments. Girls were once again forced into tight bodices made smooth by corsets. Bell-shaped skirts required layers of petticoats made of stiff, heavy crinoline. Bonnets and oversized hats additionally impeded girls' movements.

Boys, too, suffered a fate similar to that of their sisters. The skeleton suit that had been so ideal for the freedom of active small boys was gradually replaced by a revival of dresses beginning in the late 1820s. In Charles Dickens' *Sketches from Boz* of 1838, the skeleton suit is referred to as an "ingenious contrivance" that had gone out of style although, in actuality, the garment remained in use into the 1850s. The adaptation of dresses for young boys was called the **tunic suit**. The five-year-old boy shown in Figure 19-24 wears a fancy version of this new tunic top from 1841. The tunic bodices were fitted and made with a full, knee-length skirt attached. Usually, the waist was articulated by a belt, sash, or waistband. Beneath the tunic, boys wore trousers or, sometimes, even pantalettes trimmed with lace and ruffles.

Around the age of six or seven, depending on the child's height, boys graduated to the suit styles of their fathers. In the first quarter of the century, the components of the suit included breeches, vest, and tail coat. In the 1840s, the boy's basic suit changed to long trousers and a short jacket. (Figure 19-25.) Long-sleeved jackets were cropped at the waist with front openings cut straight or rounded to the hips. Various types of lapels and collars were applied to the new

Figure 19-24. To reflect their success and affluence, the burgeoning middle classes of the Industrial Revolution dressed their girls in miniature versions of women's fashions, including constricting corsets and layers of crinoline petticoats. Preschool-age boys donned the new tunic suits, which included adaptations of dress silhouettes worn over trousers. Detail of plate from *Godey's Lady's Book,* 1841.

Figure 19-25. By the 1840s, the components of suits for school-age boys featured various forms of a short coat and trousers. Plate from *Godey's Lady's Book,* 1849.

form of short jacket. In England, the short jacket, trousers, and white shirt with a turned-down collar came to be known as an **Eton suit**, named for the London boys' school where the ensemble was a mandated uniform. This style of suit would remain as the predominant basic clothing for boys throughout the rest of the century.

REVIEW

In the first two decades of the nineteenth century, the imperial dominance of Napoleonic France perpetuated influences of Neoclassicism throughout Western culture and society. Art, architecture, interior design, and fashions of the Empire period reflected the modes l'antique that had first emerged in the late 1700s. Women's gowns with the high waistline just under the bosom are still known today as the Empire waist. Skirts fluidly draped over the uncorseted body, and the necklines and bare arms simulated the look of the ancient Greek chiton.

However, within the first years of the nineteenth century, women's fashions began to show elements of change inspired by the counter-cultural movement that would become the Romantic Age. Sleeve styles from assorted past eras were adapted to the Empire silhouette. Versions of the ruff were revived. Textile prints incorporated exotic motifs and colors of Africa, the Islamic Empire, and the Far East.

By the end of the 1820s, Neoclassicism had been completely superseded by Romanticism. The waistline of women's dresses gradually dropped to its natural position, becoming once again cinched by constricting corsets. Skirts, at first, became conical and then wide bell shapes in the 1830s. Sleeves presented the most innovative change with their immense lateral fullness supported with padding.

As Romanticism faded into Victorianism in the 1840s, the emphasis of dress designs shifted from sleeves to the ever-widening skirt. Petticoats made of a stiff horsehair and linen fabric called crinoline provided support for the great expanse of the circular skirts.

Men's suits of the Empire period also remained influenced by Neoclassicism. The fitted tail coat with its cut-in front cropped at the waist and the tight, short vest evolved in points of refinement rather than innovative change in silhouette. Breeches and pantaloons were tight and form fitting.

In the second quarter of the nineteenth century, the form of men's suits was dramatically altered with the revival of the closed-front frock coat and the transition from breeches to trousers. Colors became muted and ornament was minimized although the vest made of richly patterned fabrics provided some men with the opportunity for self-expression. Ostentatious neckwear receded to the simple bow tie. A middle-class conformity in dress developed that would dominate menswear well into the following century.

Children's clothing became regressive. Girls once again were dressed in miniature versions of women's styles including corsets and layers of crinoline petticoats. For young boys, the practical skeleton suit was replaced by tunic suits, which featured adaptations of feminine dresses worn over trousers. School-age boys wore versions of their father's somber suits.

Chapter 19 The Nineteenth Century 1800–1850
Questions

1. What was the most significant technological development in the first half of the nineteenth century that revolutionized the production of clothing? Who were the three principal contributors and what were their achievements? What has been the impact of this technology?

2. How were advances in the refinement of rubber applied to textiles and clothing?

3. Which elements of the Empire gown featured influences of Neoclassicism? How was the Empire gown altered by influences of Romanticism?

4. What was the transition of the Empire gown from a Neoclassical profile to the Romantic silhouette in the 1810s and 1820s?

5. Identify the primary elements of dress design at the height of the Romantic Age in the 1830s.

6. What was the shift in emphasis on the design of dresses in the 1840s? What was a key development in textiles that made possible the new silhouette of the 1840s? To what purpose and how was this new fabric applied to women's garments?

7. How did men's suits of the Empire period reflect influences of Neoclassicism? What were the subtle changes of the Empire coat, vest, and collar from that of the Directoire styles?

8. As men's clothing became more drab in color, what two garments afforded men some degree of personal expression with color and textile pattern?

9. What dramatic changes to men's suits occurred in the 1820s? What was significant about these changes? How did these new types of garments evolve in the 1840s?

10. Identify and describe the men's garment that emerged from the lower classes to become a widespread masculine fashion in the 1840s.

11. How did children's clothing of the early nineteenth century become regressive? Contrast the styles of the late eighteenth century with those of the Romantic Age.

Chapter 19 The Nineteenth Century 1800 –1850
Research and Portfolio Projects

Research:

1. Write a research paper on the influences on fashion derived from the visual arts of the Romantic movement. Examine why historians often conclude that stylistic novelty rather than innovation prevailed in fashions of the first half of the nineteenth century.

2. Write a research paper on the Anglomania phases of French fashion in the nineteenth century. Explore the social and economic causes of the importation of English culture and how these forces impacted French style. Identify the specifics of French fashion design that were affected by Anglomania.

Portfolio:

1. Select ten portraits of women painted during the 1830s in which the sitter wears examples of revivalisms of costumes from earlier periods or elements from non-European cultures. Mount a photocopy or digital scan of each on a standard page with a written description of the revivalisms and their historical origins. Include details of the painting title, artist, date.

2. Compile a reference guide of women's accessories of the early nineteenth century designed with motifs "a la grecque." Research artwork of the period as well as modern auction catalogs and antiques magazines for:

 • 10 examples of jewelry
 • 10 examples of textiles used for accessories
 • 10 examples of other items (fans, parasols, combs, reticules, handkerchiefs, belts)

 Next to each photocopy or digital scan include a written description of the item including details of the featured Greco-Roman motif.

Glossary of Dress Terms

aquatic shirt: a form of men's sportshirt derived from the red and white or blue and white striped cotton work shirts of rivermen

bavolet bonnet: a close-fitting hat style with a ruffle at the back of the neck

bertha: a wide, deep collar usually attached to the edge of the low, open neckline of the Romantic dress

bobbinet: machine-made netting used in women's accessories and as a base for lacework

bosom friend: the early nineteenth-century term for a dickie-style neckline filler

Burberry: any of a type of men's or women's outerwear or rainwear made of a weather resistant gabardine

burnous (also bournousse): a hooded Arabian-style cloak

butterfly bow tie: a men's necktie knotted in the center front with a large bow

camisole: a form of short-sleeved or sleeveless underbodice

canezou: a women's layered garment that ranged from a type of short sleeved or sleeveless spencer to an elbow-length capelet, both with scarf-like ends that tied in the front

capote: a bonnet style made with a soft fabric crown and rigid brim

carrick: a men's or women's overcoat with layers of three to five capes sewn to the collar

cashmere: a downy-soft textile made from the silken hair of the goats from the Kashmir region

chatelaines: decorative chains with hooks or clamps on the end to loop up the hems of overskirts; later affixed with decorative items such as charms, scissors, lockets, or watches

chemisette: a type of underbodice made with a decorative front panel to fill open necklines

corset amazone: a corset style made from elasticized fabric

crinoline: a dense fabric woven of horsehair and linen

crinoline petticoat: a petticoat made with wide, thick bands of crinoline applied around the hem

drawn-thread technique: the removal or drawing out of selected warp or weft threads to form a pattern or texture

elasticized fabrics: textiles produced in the early nineteenth century from yarns made with rubber

Empire waist: a high waistline positioned just under the bosom

Eton suit: a boy's short jacket, trousers, and white shirt with a turned-down collar; named for the London boys' school where the suit was a manditory uniform

fall-front bodice: two pieces of lining material that fastened across the inside front of an Empire waist bodice to lift the bust

fly front: the vertical slit in the front of men's trousers or drawers

gabardine: a closely woven twill fabric

galoshes: overshoes made waterproof with rubberized materials

gigot: a form of leg-of-mutton sleeve padded with feather pillows in the Romantic Age

Hessian boot: a men's high boot with a heart-shaped top and a tassel at the dip in the center

imbecile sleeve: a full, sack-like sleeve gathered into a band at the wrist; thought to have originated from a similar type of sleeve used to restrain inmates of asylums

jacquard: a fabric with an intricately woven design of raised patterns

jockey boot: a men's tall boot worn with the snug top turned down

jockey cap: a men's and women's cap made with a soft beret-style crown affixed to a leather brim with a polished visor in the front

mackintosh: a raincoat made from layers of sheet rubber cemented to fabric; named for the inventor of the material, Charles MacIntosh

madras: a fine-gauge cotton fabric usually made with a woven pattern or drawn-thread texture

mancherons: shoulder caps ranging in style from simple ruching at the armscye to long wings extending over much of the sleeve

Marie sleeves: full sleeves spiral bound or tied in intervals to form multiple puffs

Merino wool: soft, supple wool from specially bred sheep in England and Spain

mitts: women's fingerless gloves, usually made of knit materials

mutton chops: men's long, bushy side whiskers

notched collar: the V-cut gap formed at the intersection of the lapel and collar piece

organdy: a stiff, transparent fabric of silk or cotton

paisley: a gourd-shaped design element popular in early nineteenth-century textiles

paletot: a women's three-quarter-length cape with two or more layers and slits for the arms

pantalettes: a version of women's long drawers that extended from mid-calf to the ankles

pelerine: a wide scarf or capelet fitted to the shoulders

pelerine mantelet: a women's elbow-length cape with lappets tied or secured by a belt in the front

pelisse: a long, capacious overcoat, usually lined with fur

reticule (also redicule): a women's small purse of assorted types

rubberized thread: spun yarns reinforced with an application of vulcanized rubber used to create elasticized fabrics

spencer: a women's Empire jacket cropped to fit just below the bosom

stirrups: strips of fabric sewn to the cuff of men's trousers that fit under the instep of a shoe

tambouring: embroidery done on fabric stretched over a frame called a tambour

toque: a woman's tall, brimless hat usually tapering to the top

trouser drawers: men's ankle-length underwear commonly made of knit fabrics

tunic suit: a boy's skirted top worn over pantaloons or trousers

vandyking: a form of trim cut in points resembling the sharply pointed beard of Anthony Van Dyke

Wellington boot: a men's high boot with a curving top in the front and a dipped curve in the back; named for the British general who defeated Napoleon at Waterloo

Legacies and Influences of Early Nineteenth-Century Styles on Modern Fashion

The most distinctive element of early nineteenth-century women's fashions that modern designers have repeatedly adapted is the Empire waistline. The high-waisted silhouette with its long, fluid draping of the skirt had been a particularly popular look in the 1930s, 1960s, and 1970s, and remains a favorite today.

The pelerine of the Romantic Age has also recurred frequently in modern interpretations. Variations include separate scarf-like collar extensions and capelets sewn to dress bodices and suit jackets.

Many of the most prevalent types of modern men's clothing originated in the first half of the nineteenth century. The pleated fly-front trousers of today fit and function primarily the same as their antecedents of the 1840s. As the frock coat became more common in the 1820s and 1830s, the fitted cutaway coat was relegated to formal attire where

it remains still. Men's neckwear lost its frills and ostentation to the simplicity of a basic bow tie in the Romantic era although periodically the wide butterfly bow tie asserts itself as a reminder of the earlier forms of flamboyant neckwear.

As the technological advances of the Industrial Revolution led to new types of textiles, wardrobes were profoundly altered and expanded. Elasticized yarns made with rubber have evolved into a myriad of synthetic versions. Where once elasticized fabrics added comfort to constricting corsets and tight ankle boots, today a multimillion-dollar activewear industry produces hundreds of types of sports garments made entirely of stretch materials.

Similarly, weatherproofing techniques developed in the early nineteenth century led to specialized rainwear and all-weather coats and accessories for both men and women.

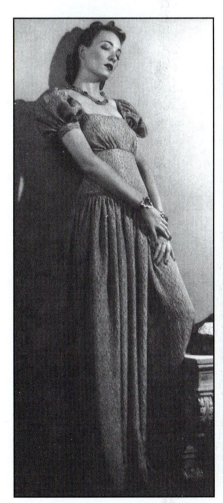
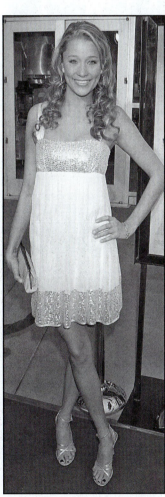

The high-waisted Empire silhouette has been repeatedly adapted to modern fashions. Left: textured rayon gown by Henri Bendel, 1938; right, after-six beaded miniskirt, 2008.

Modern adaptations of the pelerine have been applied to suit jackets, dresses, and outerwear. Wool dress with pelerine by Louise Barnes, 1947.

Pleated trousers were introduced in the 1820s. Left, Ferris wool sports trousers, 1938; right, reverse pleated trousers, 2002.

The everyday cutaway coat of the Empire era became relegated to formal attire in the Romantic Age, where it has remained through today. Full-dress wool tail coat with satin lapels by Stein Bloch, 1935.

The precursors of modern elastic synthetics originated with the development of rubber-integrated yarns in the 1840s. Spandex cropped tank and shorts by Nike, 1988.

Silk butterfly bow tie by Jiffy Ties, 1972.

THE NINETEENTH CENTURY
1850–1900

French Second Empire ruled by Napoleon III 1852–1870	Transatlantic Cable laid 1858	U.S. Civil War 1861–1865	U.S. purchased Alaska from Russia 1867	First electric motor 1869	Italy united 1870
Crimean War 1853–1855	Japan opened to the West by U.S. Commodore Perry 1854	Butterick paper patterns developed 1863	U.S. transcontinental railroad completed 1869		Germany united under the Second Reich 1871
Great Exhibition, London 1851	Walt Whitman's *Leaves of Grass* 1855	Darwin's *Origin of Species* 1859	*Harper's Bazaar* first published 1867	Suez Canal opened 1869	First exhibit of the Impressionists 1874

1850 1875

British buy Suez Canal 1875	Edison's electric light bulb 1879	First motorcar prototypes made in Germany 1885	George Eastman's first amateur cameras 1888	Marconi invented wireless telegraph 1895	Spanish-American War 1898
Mark Twain's *Tom Sawyer* 1875	Bell invented the telephone 1876	American Red Cross founded 1881	Safety bicycle introduced 1889	Roentgen discovered X-rays 1895	U.S. annexed Hawaii 1898
U.S. Centennial Exposition in Philadelphia 1876		Robert Louis Stevenson's *Treasure Island* 1882	Van Gogh's *Starry Night* 1889	First Olympics since ancient times 1896	Queen Victoria died 1901

1875 1900

NATIONALISM, INDUSTRIALISM, AND VICTORIANISM 1850–1900

Where the first half of the nineteenth century was hallmarked by dramatic and profound changes—technological, economic, political, societal—the second half was marked by an ever-increasing rapidity of change across all these fronts. The former was deep and intimate, a redefining of the order of things in the Romantic Age; the latter was wide, an evangelizing of change through Western nationalism and socioeconomic imperialism around the world.

This new, widely flung imperialism of technology, economics, and politics was showcased on the world stage in 1851 with the Great Exposition in London. Gathered beneath the lofty iron-and-glass casing of the Crystal Palace were the technological wonders of the EuroAmerican Industrial Revolution and the astounding array of machine-made products it could produce. Equally significant, among the cultural displays from around the globe was a clear statement of the preeminence of Britain as the world's greatest colonial power. Queen Victoria had been on the throne for fourteen

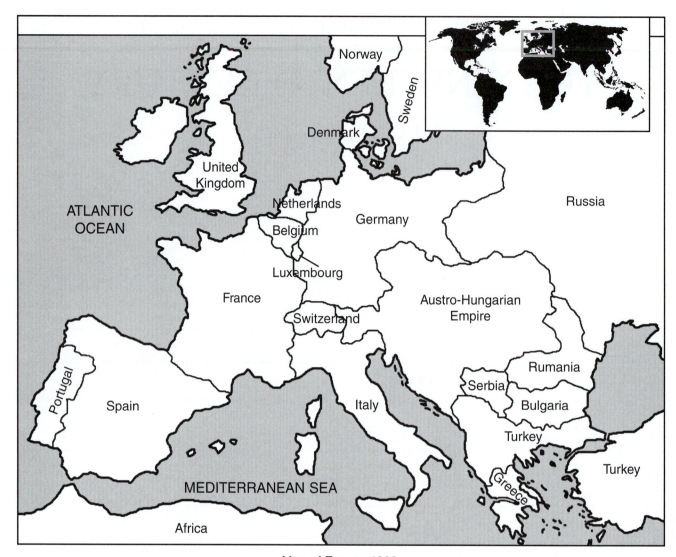

Map of Europe 1899

years when she opened the Great Exposition and she would reign another fifty years, giving her name to the era. Her husband and consort, Prince Albert, was instrumental in influencing progressive economic and national changes in Britain although many historians credit him for the regressive social attitudes that came to be associated with Victorianism.

In France, a coup d'etat in 1852 by Louis Bonaparte, the nephew of Napoleon, led to the reestablishment of an imperial government. Louis became Napoleon III, and the period is known as the Second Empire. The following year, the emperor married the beautiful Spanish countess, Eugenie, and established a glittering court in the Tuileries Palace. In their efforts to make Paris once again the cultural center of the world and reestablish the dominance of the French fashion industry, the emperor and empress surrounded themselves with fashionably dressed aristocrats. They held dazzling formal balls to which guests flocked wearing the newest finery from the Paris fashion houses. Although the emperor succeeded in these cultural and economic endeavors, his foreign policy

acumen was dismal, leading to a war with Germany in 1870. The Prussian army captured both Paris and the emperor, forcing him to abdicate and flee into exile with his family. The Third Republic that was formed after the departure of Napoleon focused on the nation's industrialization and colonial expansion, especially territories in Africa.

Prussia continued to be the most powerful and modernized state in the German Confederation. Under the leadership of its chancellor, Otto Von Bismarck, Prussia triumphed in wars with the Hapsburgs of the Austro-Hungarian Empire in 1866 and the French in 1870, gaining territory from both conflicts. With deft diplomacy, Bismarck persuaded the thirty-seven German statelets to unify under a constitutional monarchy in 1870 headed by Prussian Kaiser Wilhelm. From this point of national solidarity and military power, the new Germany embarked upon its own imperialistic ventures, acquiring large sections of Africa and establishing a colonial presence in China and Japan.

The last feudal stronghold in Europe was Italy. A peasant insurrection in 1860 was whipped into a nationalist

rebellion led by Giuseppe Garibaldi who was inspired by the romantic vision of ancient Italy reunited. With the fall of Naples the following year, a parliament was formed, and Victor Emmanuel II was proclaimed King of Italy. Rome resisted the unification, aided by a French garrison, until 1870 when the troops were pulled out during the Franco-Prussian War. The Italian army swept into Rome and a fully united Italy was ruled from the capital of the caesars.

The rapid changes that occurred in the United States during the second half of the nineteenth century began with a "Manifest Destiny," a nationalist purpose in which Americans viewed the coast-to-coast expansion of the nation as a divinely ordained mission. The price, however, was a threat to the balance of power between slave states and free states—a dichotomy of cultures, societies, economies, and politics. The inevitable result was a prolonged, destructive civil war (1861–1865). The costly national crisis preserved the union and strengthened the central government over that of individual states. In 1869, a symbol of this new unity was the completion of the transcontinental railroad. With the expansion of the western frontier and the rapid industrialization of the North during the Civil War, the United States was second only to Britain in manufacturing might by the time Americans celebrated their centennial with a grand exposition in Philadelphia in 1876. By the end of the century, the United States had even become a global imperial power with the annexation of Hawaii in 1898 and the acquisition of Puerto Rico, Guam, and the Philippines following the Spanish-American War in 1898.

REVOLUTIONS IN SCIENCE AND THE ARTS

The astonishing force and speed with which the Industrial Revolution progressed in the nineteenth century were fueled by the rapid and continual advances in technology and science. Unlike the intellectual quests of enlightenment in the 1700s, though, the scientific and technological discoveries of the 1800s were made principally for the advancement of the EuroAmerican industrialized economic systems. Electric power replaced steam; electric lighting expanded the hours of a workweek; electric tools and machinery increased productivity. The telephone provided direct, instantaneous communication for businesses and the home in a way the telegraph could not. The internal combustion engine was adapted to automobiles and farm equipment.

Many of the singular discoveries of the era ultimately had broad applications that still impact our daily lives today. In attempting to solve spoilage problems for dairies and wineries, Louis Pasteur developed the process of "pasteurization"—a method of heating liquids to destroy bacteria. Joseph Lister developed antibiotics and antiseptics to fight disease and reduce postoperative fatalities. Wilhelm Roentgen discovered X-rays. Pierre and Marie Curie isolated radium, the first known radioactive element—the first step toward harnessing atomic energy.

Just as science and technology continually crossed new thresholds in the late nineteenth century, startling new social and cultural perspectives challenged established ideas and traditions. Charles Darwin's *Origin of Species* (1859) horrified the devoutly religious and further contributed to a secularization of Western society. Sigmund Freud and Havelock Ellis popularized psychology and opened a public dialog on the taboo subject of sexual motivation in human behavior.

The women's movement gained momentum with the widely publicized Declaration of Sentiments drafted at the 1848 conference of women in Seneca Falls, New York. Women's demands for equal citizenship, political rights, opportunities in education and employment, dress reform, and voluntary motherhood were thrust upon the nation's consciousness. However, it was an advance in technology that provided the most significant boost in helping women achieve greater independence. In 1889, the chain-driven safety bicycle was introduced, launching a cycling craze that opened new gates for cloistered Victorian women. In droves, women escaped the confines of the kitchen and the nursery to explore new horizons far and wide. Women gained confidence in their new-found independence and in their self-assured operation of these mechanical conveyances. In addition, bicycling impelled clothing reform such as less constricting types of corsets and a broader acceptance of feminine forms of trousers. (Figure 20-1.)

In the visual arts of the mid-century, Romanticism began to evolve in new directions. In France, America, and Russia, schools of naturalism produced highly realistic studies of nature populated with raw representations of common people. From the foundations of the naturalists developed the Impressionist movement in the 1870s and 1880s. Led by Monet, Degas, Renoir, and Pissarro, the Impressionists focused on the spontaneous recording of light and color. By the mid-1880s, a group of artists, later categorized as Post-Impressionists, reacted against Impressionism by developing expressive painting styles that forecast the modernist art of the next century. Cezanne, Van Gogh, and Gauguin reconstructed the natural world with imagination rather than fidelity to the actual appearance of things. For absolute realism, there was photography. Although photographic techniques had been developed in the 1830s, a reproducible negative was not invented until 1851. In 1888, George Eastman introduced the first amateur box camera, popularizing photography with the masses.

Although Neoclassicism and Romanticism had had significant influence on the design of clothing for both men and women, the principal art movements of the second half of the century had little effect on fashions. The exception was the Art Nouveau style of the 1890s. Art historian H. W. Janson describes Art Nouveau as "primarily a decorative style, inspired by Rococo forms and based on sinuous curves that often suggest organic shapes." The look had wide appeal and was applied to architecture, furniture, home decorative items, mass media, and fashion and accessories through the 1910s. (Figure 20-2.)

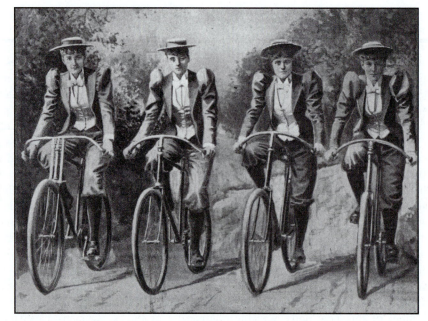

Figure 20-1. The bicycling craze of the 1890s advanced women's clothing reform more rapidly than had thirty years of feminist advocacy. Women discarded corsets and adopted practical clothing such as forms of trousers and shortened or split skirts.

Figure 20-2. From the 1890s through the First World War the decoration of women's fashions and accessories was influenced by the Art Nouveau movement. Surfaces and contours were dissolved into sinuous, undulating lines and soft, organic shapes. Left, dress with inset panels of an Art Nouveau pattern, 1896; right, Gorham silver jewelry, 1901.

WORTH AND COUTURE

Prior to the mid-nineteenth century, the arbiters of fashion were the great ladies of the various eras such as Isabella d'Este, Catherine de Medici, and Madame de Pompadour. Very few dressmakers and tailors achieved the status of fashion designer to whom their patrons yielded style direction. Rose Bertin designed for Marie Antoinette and was nicknamed the "Minister of Fashion" in the 1780s. At the court of Napoleon, J. H. Leroi designed Neoclassical styles for both Josephine and Marie Louise.

coated with rubber. In 1858, Charles Worth opened his couture salon in Paris with a collection of dresses that featured enormous bell-shaped skirts supported by the hooped crinoline. In actuality, though, the hoops were probably revived as early as 1854. A fashion editorial in the January 1855 issue of *Graham's Magazine* commented that hoops "appear to threaten to come into fashion again" since some of the Paris skirts from the previous season had "a very thin whalebone inserted in the hem." For a couple of years, the fashion debate was which wide skirt silhouette to prefer: one smoothed by hoops or one "au naturel" with "the enlivening folds" of deep pleats or gathers. (Figure 20-6 and Color Plate 13.) For those women who chose hoops, the *Graham's* editors cautioned against "scant skirts falling in an unsightly manner over them," thus altering the fashion from "the sublime to the ludicrous." The ludicrousness of hoops was especially tempting as a visual topic for cartoonists who produced dozens of scenarios ridiculing the cage crinoline. (Figure 20-7.) This "question of the philosophy of wearing hoops," as a *Graham's* article put it, is possibly why some costume historians credit Worth with inventing the cage crinoline. With the launch of his 1858 collection, the crinoline was de rigueur. Worth's success, of course, was only with the acceptance of the crinoline by the Empress Eugenie, from whom Paris and, hence, the fashionable world, took its cue. In fact, by 1860, *Godey's* reported from Paris that Eugenie had tired of the crinoline already and predictions were that it was "tottering to its fall." However, the fashion editor noted, "I cannot help thinking that the Empress will repent of her hasty decree, and return again to the much-abused crinoline."

Indeed, the crinoline prevailed for several years more despite the imperial fiat. Throughout the early 1860s, dozens of new patents were registered for improvements in the crinoline—an indication that hoops continued strongly as the mode of the era. Equally significant was the pervasiveness of the crinoline across classes. Unlike the Elizabethan farthingale or the Rococo panniers, which were exclusive to the upper classes, the Second Empire crinoline was inexpensively mass produced and widely available in the burgeoning retail markets. Almost all women except the lowest classes and advocates of clothing reform indulged in the crinoline even if only for their Sunday-best dress. Women's magazines from the time reported that even house servants wore versions of the crinoline as part of their domestic costume despite the impediment it created for their work.

Around 1861, the shape of the crinoline began to shift from a rounded, bell shape to a more conical silhouette. By 1863, the half crinoline, with only half hoops in the back, flattened the front of the skirt and concentrated the fullness at the back. (Figure 20-8.) Instead of deep gathers at the waistline, the excess fabric was folded into flat box pleats to fall more vertically in the front. Another construction method to achieve the flattened front was goring. Long sections of fabric that extended from the shoulders to the hemline were shaped with a narrow, curved cut at the waistline, thus reducing excess material from the skirt front. Also at this time,

Figure 20-6. In the late 1850s, the petticoat made of crinoline material was replaced by the structural cage crinoline. The thin hoops of whalebone, cane, or steel were lighter than layers of heavy linen petticoats. Left, detail of fashion plate from *Godey's*, 1857; right, silk taffeta dress, c. 1855–59.

Figure 20-4. Mass production and mass marketing of ready-to-wear democratized fashion. Advertising instilled aspiration across a wider social spectrum, and manufacturing and rapid distribution quickly brought the newest trends and styles to the masses. Detail of ready-to-wear and retail fashion ads from *Harper's Bazaar,* 1873.

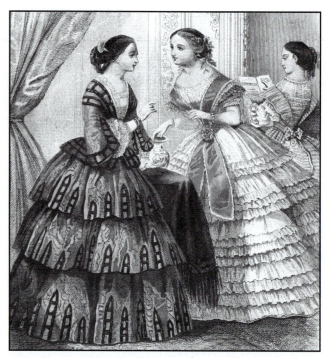

Figure 20-5. As the bell-shaped skirt of the 1850s expanded in width, the addition of flounces and extravagant border trim created even more of an optical illusion of a horizontal silhouette. Fashion plate from *Graham's Magazine,* 1855.

and New York. *Godey's Lady's Book* apologized in the December 1888 issue for not having fashion plates of the coming new trends because the modistes had returned late from Paris and current styles "could not be obtained earlier in the season." In addition to the made-to-measure dress shops, the emerging women's ready-to-wear industry looked to the couturiers and their collections for models to adapt to mass production. When coupled with advertising and mass media, the easy availability of ready-to-wear encouraged an aspiration for fashion across a broader range of social classes.

WOMEN'S DRESS: THE CRINOLINE PERIOD

The bell-shaped skirt of the late 1840s continued to expand into an ever-widening circle in the early 1850s. This horizontal silhouette was further enhanced in the mid-1850s by flounces, many of which were given even more expanse by trimming edges with ruffles, ruching, scallops, or vandyking. (Figure 20-5.) Another optical border treatment for

emphasizing the breadth of flounces was a technique of fabric roller printing called "**à disposition,**" in which patterns were designed specifically for the edges of flounces.

To support the increased volume and weight of the skirt, multiple starched petticoats or stiff horsehair crinoline petticoats were layered underneath. This additional weight and mass of fabric was uncomfortably heavy and cumbersome, especially when coupled with the added volume of capacious sleeves and the discomfort of tightly laced corsets. Simply walking was an arduous task when a woman was weighted down with an ensemble made of velvet or taffeta.

By the mid-1850s, though, relief appeared in the form of a newly constructed petticoat formed with a cage of airy hoops and tapes. Also called a crinoline, its superstructure of cane or whalebone and later, steel hoops, was sufficient to spread the circumference of the skirt without multiple layers of heavy, starched or ruffled petticoats.

The distinction between the two types of crinolines can be confusing. The petticoats of the late 1840s were reinforced with strips of the stiff horsehair-and-linen blended fabric called crinoline and the undergarment came to be named after this textile. After the mid-1850s, the **cage crinoline**, serving the same purpose as its heavier predecessor, continued the name of the earlier petticoat style.

Many costume historians use one of two dates as the beginning of the Crinoline Period: 1856 or 1858. In 1856, a hooped petticoat was introduced made with bands of watch spring steel

Ready-to-Wear Manufacturing and Retail Fashion

The industrialization and urbanization of Europe and the Americas in the nineteenth century created an ever-widening consumer middle class. From the needs and wants of this cash-endowed populace emerged new opportunities for the fashion industry. Even as early as the mid-1700s, industrious tailors in the seaports of England and its North American colonies set up "slop shops" in which they produced and sold ready-made men's apparel, primarily to sailors seeking civilian clothes when off duty. Basic jackets, shirts, and breeches were hand-sewn in somewhat general sizes comparable to our small-medium-large standards today. During the 1820s, the first ready-to-wear factories were founded in England and soon afterward in the United States, mainly producing uniforms and selected types of men's and boy's clothing. At the end of the 1850s, a greater variety of women's apparel was available as ready-made. By the 1870s, women's three-piece wool suits were advertised in *Harper's Bazaar* at $3.75.

During the 1850s, mass production of clothing quadrupled as manufacturers invested in new technologies, particularly industrial fabric cutters and sewing machines. Electrical versions of these machines were introduced in 1890, increasing the speed and precision of production even more. Other important developments in the clothing industry included the discovery of **aniline dyes** in 1856 from which a rich palette of synthetic dyestuffs was produced, providing manufacturers and consumers with a vast array of color options. In 1868, the first commercially viable plastic was invented called **Celluloid.** This sturdy, durable product made from cotton and cellulose was used in the production of collars, cuffs, shirt fronts, buttons, buckles, ornaments, and jewelry.

There was no shortage of skilled labor in the cities to work in clothing factories, especially in the United States where liberal open-door policies encouraged immigration. From these huddled masses, desperate men, women, and children were easily recruited to slave long hours in sweat shops producing high quality goods for meager wages. Although throughout the nineteenth century numerous garment industry unions were formed to advocate changes and challenge abuses, most were ineffectual and disbanded. Only in the 1890s did a union achieve national status with the organization of the United Garment Workers of America (UGWA).

As mass production increased, new methods of sales distribution and marketing developed. The warehouse slop shops of the late 1700s evolved into larger specialty stores offering a wider choice of related manufactured and custom goods. From these specialized stores emerged the first grand emporiums, or department stores, in the 1840s and 1850s. The Bon Marche (meaning "great bargain") in Paris is often credited with being the first retail giant in this arena. Founded in 1838, the Bon Marche brought together under one roof full lines of apparel and accessories for men, women, and children as well as a wide range of household goods. The doors of these emporiums were open to the public, and all classes of society were invited to view the wondrous products of the mechanized age available for purchase.

The third wheel that drove the success of the ready-to-wear industry in the 1800s—after manufacturing and retail merchandising—was advertising. Mass media during the early Industrial Revolution consisted largely of newspapers and magazines, both of which featured limited advertising. In the second half of the nineteenth century, though, publishers discovered they could operate their periodicals at a loss, but make substantial profits on advertising—the principal business model of mass media today. As ready-to-wear manufacturers increased output and retailers faced rising competition, both turned to advertising to inspire the masses to buy. With the advertising barrage from newspapers, magazines, catalogs, mailers, billboards, posters, and handbills, the nineteenth-century consumer—from the meanest of the laboring classes to the wealthiest of the bourgeoisie—aspired to the acquisition of more variety and better quality goods.

Indeed, the very notion of fashion itself became democratized with ready-to-wear. Nineteenth-century fashion magazines such as *Harper's Bazaar, Vogue, Delineator,* and *McCall's* featured the newest styles of ready-to-wear in both editorials and advertising. (Figure 20-4.) In 1875, a *Harper's Bazaar* fashion column advised readers that retailers "are providing ready-made suits at such reasonable prices and of such varied designs that something may be found to suit all tastes and purses." In the 1890s, *Vogue* regularly featured a column titled "Seen in the Shops" in which ready-to-wear and accessories were described in detail including retail prices. In addition, mail order catalogs—profusely illustrated with the latest fashions—made ready-to-wear clothing and accessories accessible wherever the post office or mass-transportation delivered.

The recurring cycle of mass production, marketing, and consumption became entrenched in the socioeconomic patterns of EuroAmerican society by the end of the 1800s. The cycle survives with us today and continues to drive the ready-to-wear industry on a multibillion-dollar global scale.

In the 1850s, though, a young Englishman altered the course of the fashion industry with inventive new marketing methods. Charles Frederick Worth had worked at various jobs in Paris dress shops for several years when he began to design dresses for his wife to wear at her job as a sales assistant in the upscale Maison Gagelin. When customers began to request similar gowns, Worth was permitted to establish his own dressmaking operation in the shop. By 1858, he had become so successful that he partnered with a wealthy Swede cloth merchant to open his own salon. The following year, Worth's wife presented her husband's design portfolio to the newly arrived Princess Pauline de Metternich, wife of the ambassador from the court of the Austro-Hungarian Empire. When the princess wore one of Worth's gowns to a court ball, the ensemble caught the eye of the Empress Eugenie who asked about its creator. Worth's fortune was made. (Figure 20-3.) For the next thirty-five years, he set the fashion trends not only for Paris but for all the style centers of the world. His designs were worn by the Empress of Austria, the Queen of Italy, the Czarina of Russia, and through her own dressmakers, Queen Victoria. After the collapse of the Second Empire during the Franco-Prussian War of 1870, the House of Worth continued to prosper despite a brief setback from the loss of his aristocratic patrons. With

equal flair he designed for the wealthy bourgeoisie of the Third Republic as well as for innumerable Americans on the Grand Tour and for infamous actresses and courtesans.

As a designer, Worth is often credited with the revival of the hooped petticoat, or cage crinoline, as it came to be known. Whether or not this is true, he popularized the look in the 1850s and 1860s. His authority as fashion master was particularly evident in his radical alteration of the gown silhouette in 1866. He eliminated the crinoline and narrowed the skirt with a draping to the back, launching the bustle era. One of Worth's most quoted statements is his claim that he "dethroned the crinoline."

Worth's marketing acumen paved the path for all couturiers from the late nineteenth century to today. Among the innovative practices he established was the use of live models, or mannequins as they were later called, to display his designs. In the 1870s, Worth introduced the fashion collection—at first biennial, then, by the 1880s, biannual. He was able to achieve this by developing designs that were engineered with interchangeable parts; any variety of sleeve styles would fit an assortment of bodices, which themselves could fit various types of skirts. He also sold his designs wholesale to "modistes," or agents for dressmakers and retailers, who took the designs back to London, Rome, Vienna, Berlin, Madrid,

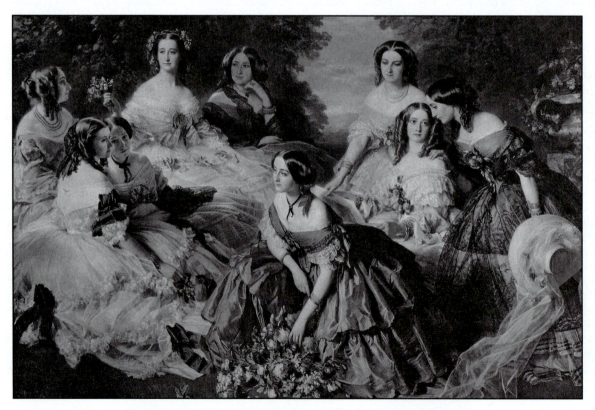

Figure 20-3. In the 1850s and 1860s, the elegance and fashion leadership of Empress Eugenie and the court of the Second Empire advanced France's preeminence in fashion and style throughout the world. The Empress Eugenie and her ladies-in-waiting by Franz Xavier Winterhalter in 1855.

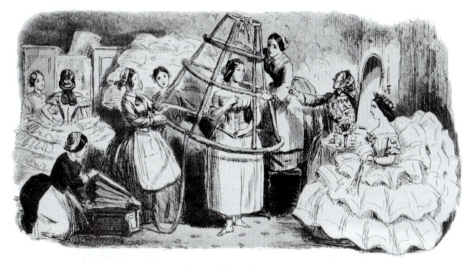

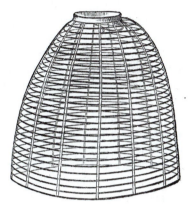

Figure 20-7. The many varieties of cage crinolines with their particular encumbrances were favorite targets of social cartoonists of the 1850s. Left, cartoon from *Punch*, 1857; right illustration of steel crinoline from *Godey's,* 1859.

Figure 20-8. In the early 1860s, the silhouette of the crinoline skirt shifted from a round, bell shape to that of a cone with a flattened front. By shifting the mass of the skirt to the back, the circumferences expanded to the most exaggerated widths of the era. Fashion plate from *Peterson's,* 1864.

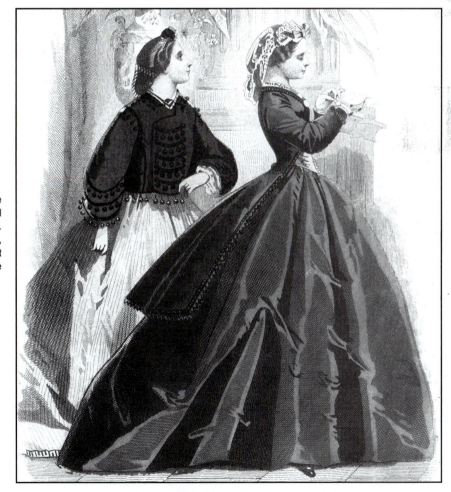

skirts became the widest of the era, some as much as eighteen feet in circumference. The emphasis on the back of the skirt was sometimes further exaggerated with a hemline that extended into a deep, full train.

Some styles of dresses, especially those for promenade and eveningwear, were shortened to the ankles for a brief period in the early 1860s. (Figure 20-9.) When *Godey's* first got news of the shorter hemlines in 1861, the editors were skeptical of its acceptance in the United States. "All the importations are much shorter than the American taste will at present admit," wrote the fashion editor, "for as we are told . . . it requires full six months to persuade the popular taste to change materially, no matter what designs rule in Paris."

Another skirt design that shortened the hemline was a revival of the polonaise, called the **porte jupe Pompadour**, which had begun around 1855 and lasted through about 1868 when hoops were abandoned. The purpose was to keep dresses from dragging in the dirt. Cords or tapes were affixed to the underside of the skirt that could draw it up into swags exposing about one third of a short, decorative petticoat. This underskirt, though, was not shortened to the ankles when the hemlines of other dress styles rose between 1860 and 1863.

The tightly fitted bodices of crinoline dresses were usually shaped by curved seams in the back and darts in the front. With the reduction of multiple petticoats—and their thick, layered waistbands—the contours of the bodice waistline appeared all the more slender over a tightly laced corset. The most common dress construction featured the bodice sewn to the skirt with a variety of waistlines including V-fronts, U-fronts, or straight-line cuts. The **princess style** was made of one long piece (or long, gored pieces) from the shoulder to the hem with no waist seam. Toward the end of the 1850s, the separate bodice and skirt became increasingly popular. The two pieces could be of the same material or mixed with contrasting pieces in different colors or fabrics. Some bodices included basques, or short, skirt-like tabs that extended down from the waist. In the 1850s, basques were usually cut in one piece with the bodice; after about 1860 they were separate pieces sewn to the waist and often cropped at an oblique contour longer in the back. (Some costume historians refer to these basques as peplums.)

Dress sleeves were created in an endless variety. Armscyes remained "dropped," or positioned off the shoulder. As a complement to flounced skirts, some sleeves repeated the tiered look with layers of ruffles or flared sleeves within sleeves. The **pagoda sleeve** was shaped like an inverted funnel with a narrow fit at the shoulder and upper arm and an abrupt flare at the elbow, usually with an opening short in the front and longer in the back like the examples shown in Figure 20-6. A large, bell-shaped sleeve was similarly cut with a more gradual flare from the shoulder that ended between the elbow and the wrist. For more conservative tastes, long sleeves extending to the wrist in narrow cylinders continued from the 1840s. The short sleeves of evening gowns were hardly more than brief ruffles or puffs of fabric that daringly bared the arms and shoulders.

A wide assortment of decorative undersleeves were made for dresses with wide sleeve styles or with sleeves cropped at the elbow. (Figure 20-10.) These were usually half sleeves pinned or buttoned above the elbow. In 1855, *Graham's Magazine* cautioned ladies always to secure their

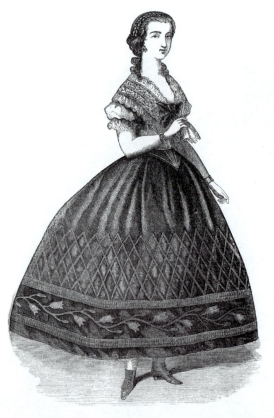

Figure 20-9. For a brief period in the early 1860s, certain types of dresses were shortened to about the ankles, revealing the latest in colorful, decorative shoes and embroidered stockings. Fashion plate from *Godey's*, 1861.

Figure 20-10. Bodices and jackets of the Crinoline Age were fashionably made with half or three-quarter sleeves. To cover bare forearms, ladies attached separate undersleeves usually made of bleached white muslin or linen. The infinite variety of decorative treatments at the cuffs of undersleeves also added variety to a wardrobe of plain bodices and jackets.

undersleeves properly so as not to have them "come down into your soup plate at a public table."

In place of the separate bodice, many women began to wear muslin shirts called **waists** that were based on menswear styles. Although similar shirts had been worn under women's riding jackets for almost two centuries, and the separate blouse and skirt had become popular as early as the 1820s, it was only after the proletariat uprisings in Italy, Germany, and France in 1848 that the style became widespread in the middle classes. The red Garibaldi, for example, was based on the big-sleeved tunics of soldiers who fought with General Giuseppe Garibaldi during the war for unification of Italy.

Other masculine military influences included jackets ornamented with braid, tassels, and metal buttons. The **Zouave jacket** was "all the rage" in 1861 according to *Godey's*. The style was adapted from the colorful uniform of the French infantry and featured passementerie along its edges and seams, and sometimes appliques simulating military insignia. (Figure 20-11.) The Zouave jacket came in numerous bodies including short, fitted varieties cropped at the waist with narrow sleeves and longer, more capacious versions with wide sleeves.

CRINOLINE DRESS ACCESSORIES AND OUTERWEAR

In skimming though the many women's magazines of the 1850s and 1860s, one might be surprised by the numerous illustrations of assorted dress accessories. Some pieces such as detachable collars, sleeves, and cuffs were devised for easy laundering, particularly since women often wore the same dress day after day, especially in winter. Victorian modesty was another factor in the layering of accessories, such as undersleeves to cover the bare arms exposed by dresses with half sleeves, or chemisette neck fillers for scoop necklines that revealed more shoulder than was acceptable in daytime.

More importantly, though, was fashion variety. Then, as now, a limited wardrobe of dresses could be expanded into a wide range of looks by adding a few decorative accents. (Figure 20-12.)

The canezou that first made its appearance during the Empire period was equally as varied in the Second Empire years. The term applied to everything from short, muslin jackets to elaborate neckline fillers. Other accessories were more specifically styled and named, some new and some revivals. **Bretelles** were described at the time as a pair of "braces" made of bands of ribbons or lace that attached at each shoulder and tied together at the waist with a bow. Fichus of the period were cape-like or scarf-like coverings for low necklines. Most fichus included lappets of varying lengths that extended to the waist where they were tied, tucked into a belt, or cross-wrapped around to the back and secured in a bow. For evening dresses, berthas and half berthas of ribbon and lace were also popular accents for minimizing the exposure of deep decollete necklines. Plain skirts were enlivened with fanciful silk or fine linen aprons ornamented with combinations of embroidery, lace, ruching, and similar decorative elements.

The three silhouettes of outerwear of the crinoline age included various wrap garments, snugly fitted jackets and coats, and loosely fitting jackets and coats. The terms that were applied to the assorted styles of outerwear can be confusing because contemporary editorials sometimes used them interchangeably. Even at the time, editors were aware of the fluid use of fashion terms. Of the many styles of mantelet, noted *Graham's* in 1855, "the **echarpe** [a collarless promenade cloak of taffeta or moire silk festooned with flounces and corded silk embroidery] is the favorite name, and that is divided into some twenty different styles of cut." Similarly, the **pardessus** was shown in one 1857 issue of *Godey's* as a long-sleeve, fitted jacket with a finger-tip length skirt, but the pardessus featured in 1859 editions was a long

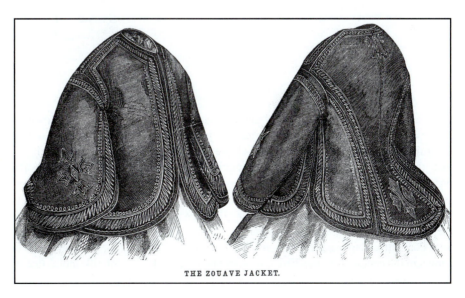

Figure 20-11. The Zouave jacket was inspired by French infantry uniforms of the late 1850s. Although the cut of the jackets varied from tightly fitted to full and loose, the distinctive common element of Zouave jackets was an abundance of braid and military ornaments. Fashion plate from *Godey's*, 1860.

THE ZOUAVE JACKET.

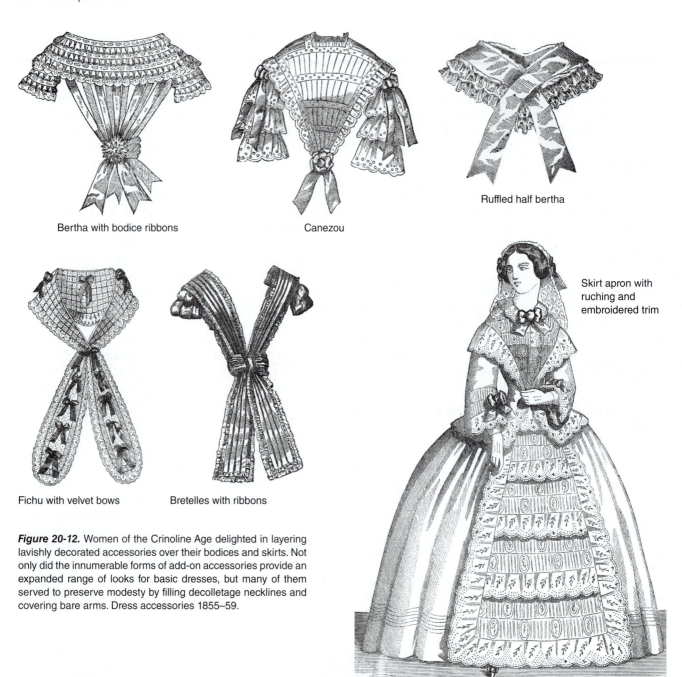

Bertha with bodice ribbons

Canezou

Ruffled half bertha

Fichu with velvet bows

Bretelles with ribbons

Skirt apron with ruching and embroidered trim

Figure 20-12. Women of the Crinoline Age delighted in layering lavishly decorated accessories over their bodices and skirts. Not only did the innumerable forms of add-on accessories provide an expanded range of looks for basic dresses, but many of them served to preserve modesty by filling decolletage necklines and covering bare arms. Dress accessories 1855–59.

cloak extending almost to the hem of the skirt with long, full sleeves. Often confused with the pardessus jacket is the **basquine**, which was also a fitted, long-sleeve jacket except that the fingertip-length skirt was comprised of flared basques all around. Another loosely applied outerwear term is burnous, which was a hooded cloak revived from Romantic Age versions during the Crimean War (1853–1855). By the end of the decade, though, any variety of cloaks made with decorative flaps and capelets at the back, such as that shown in the center of Figure 20-13, was commonly called a

burnous. Likewise, the paletot was illustrated as a short, fitted jacket as well as a loose, dome- or cone-shaped jacket. (Figure 20-14.)

The most popular form of outerwear was the wrap garment. A wide assortment of shawls, capes, and mantles was circular cut to fit adequately over the enormous crinolined skirts. The **talma** was a short, bell-shaped cape with slits for the arms and a front closure that fastened with frogs or passementerie eyes and buttons. The **moresco** was a fringed shawl of silk moire that was cut short at the sides and shaped to a

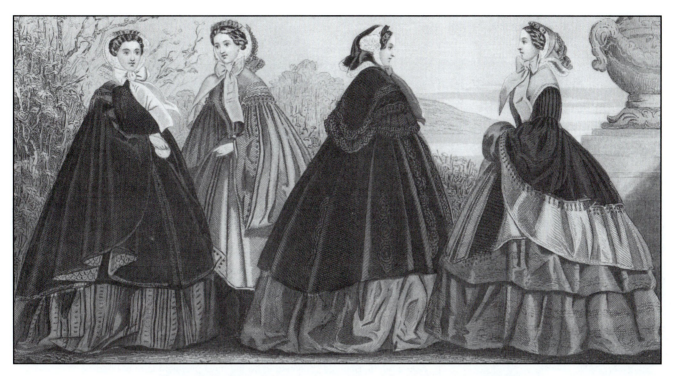

Figure 20-13. Although innumerable varieties of fitted jackets and capacious long coats were fashionable during the Crinoline Age, wrap garments were the most versatile forms of outerwear for the wide crinoline silhouette. Fashion plate from *Godeys*, 1859.

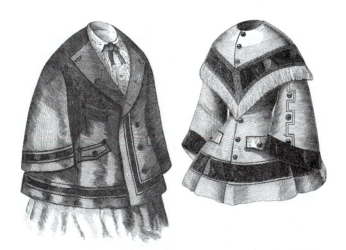

Figure 20-14. Many of the fashion terms applied to outerwear of the 1850s and 1860s were often used interchangeably in editorials of the day. For example, the paletot was featured in fashion articles sometimes as a wide, loose-fitting jacket and other times as a fitted style. Illustrations of paletots from *Godey's:* left,1856; right, 1859.

point in the front and back. Mantillas were formal wrap garments, frequently of colorful taffetas and richly embroidered and beaded. Mantillas came in a wide range of tailored constructions that featured collars, lapels, and front panels with any number of fanciful hemline cuts. Opera mantles

(worn in any chilly interior during winter, not just the opera) were the most lavishly ornamented, many with combinations of fringe, beadwork, tassels, embroidery, insets of lace or cut velvet, and ribbon trim.

Outerwear accessories included fur muffs and detachable fur cuffs that could function as a muff when the hands were tucked inside opposite sleeves. Gloves were among the easiest items to standardize for mass production so that fine-quality kid gloves were widely available. An example of the subtleties of style at the time was an admonition by a fashion editor in 1856 against wearing white kid gloves in the street; white was for indoors use only. Separate traveling hoods called "Arctic hoods" by *Godey's* were made of thick plush and lined with quilted satin. Some hoods only had a bavolet to protect the neck, and other styles were made with capelets that fully covered the shoulders to the upper arms.

The most prevalent type of headwear was the bonnet. (Figure 20-15.) During the 1850s and 1860s, the close-fitting styles were shaped to sit back on the head, exposing the facial profile entirely and much of the hair in the front. Caps likewise were close fitting and usually arranged back on the head with the hair up in a chignon or plait. Chenille or silk cord hair nets called **snoods** of assorted sizes covered the knots and held false hair pieces in place. Velvet, satin, felt, beaver, and **Neapolitan** (horsehair) were the principal fabrics for winter bonnets and hats; for summer, "everything in the

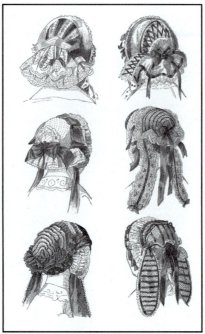

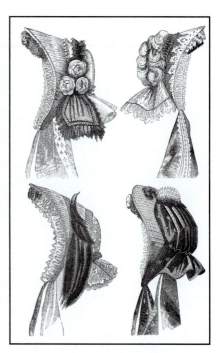

Figure 20-15. Bonnets continued to be the most prevalent form of headwear during the crinoline period. Styles were designed to sit back on the head to complement rather than conceal the face and hair. Other forms of hats were made with low crowns and brims of varying widths that dipped provocatively in the back and front. Hat styles 1857–61.

shape of bonnets is with straw or trimmed with straw," declared a fashion editorial in 1855.

Other forms of hats included riding caps with a low crown and a wide, ovoid brim that dipped in the front and back to protect the face and neck from the sun.

For eveningwear and formal events like weddings, hairstyles were arranged with coronets called **torsades** that were comprised of ribbons twisted or plaited with cording or even chains and decorated with all forms of artificial fruit, foliage, spangles, feathers, beading, or tassels.

Bonnets and caps were also richly adorned with an abundance of decorative treatments. Unlike designs of the Romantic Age, though, feathers, silk flowers, ribbon loops, bows, and lace ruffles on the hats of the Second Empire did not project outward in an exuberant display, but rather clung closely to the structure of the cap or bonnet in a rich surface embellishment. Bavolets of lace, ribbon, satin, or velvet at the nape of the neck remained a consistent element throughout the period. In a famous scene in *Gone with the Wind,* Scarlett deliberately ties a new French bonnet upside down with the bavolet on top to tease Rhett Butler.

For day wear in the home, white cotton or linen caps, still referred to in the 1860s as the "mob" or "Charlotte Corday cap," were most common. For matrons and elderly women, house caps were decorated with various types of lappets at each side and sometimes in the back.

The hightop boot continued to be the favorite style of footwear for women. Heels became increasingly higher into the 1860s. The square-toed button top boots shown in Figure 20-9 were typical of the era. As skirts got shorter, more attention was focused on the look of shoes, which included the revival of satin bow rosettes and vividly colored kid to coordinate with dresses. At the 1867 Paris Exposition, shoe styles featured high, tapered heels and a revival of the thick, curved Louie heel named for the style favored by Louis XV. Extravagant trimmings of feathers, fur, jet beads, and large metal buckles were liberally applied. (Figure 20-16.)

Other accessories included assorted hand-carried items. Parasols were a necessity for the lady of quality to preserve her prized alabaster skin. Handkerchiefs were embroidered by hand not only as a symbol of refinement but as a display of sewing skills. Women's magazines were profusely illustrated with patterns and techniques for hand embroidering. Various forms of small purses with chain or cord handles were made of colorful plain fabrics or rich tapestries and beadwork. The **porte-monnaie** was a small clutch bag made of cut velvet (crimson, *Godey's* recommended in 1859) or tooled leather.

Jewelry was more subdued in design than in the Romantic Age. A strict protocol of what, when, and how to wear jewelry was constantly reiterated in fashion editorials. *Graham's*

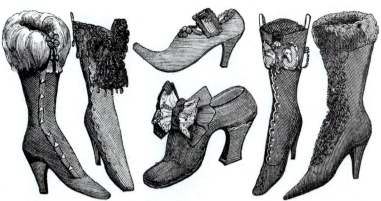

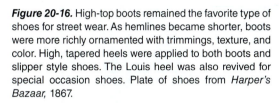

Figure 20-16. High-top boots remained the favorite type of shoes for street wear. As hemlines became shorter, boots were more richly ornamented with trimmings, texture, and color. High, tapered heels were applied to both boots and slipper style shoes. The Louis heel was also revived for special occasion shoes. Plate of shoes from *Harper's Bazaar,* 1867.

insisted, "In summer, when the daylight and not the gaslight illumines festive doings, all jewelry should be avoided—the simplest gold bracelet, the plainest gold brooch, of evident necessity, can be allowed." Diamonds were never to be worn in daytime. Earrings were small and unobtrusive. Wire styles of earrings were to be avoided since pierced ears were counter to the Victorian sentiment of the body as a temple, and editorials criticized women "who preserve the savage custom of perforating the ears."

WOMEN'S DRESS: THE BUSTLE ERA

In August 1868, *Harper's Bazaar* lamented the demise of the crinoline. "A little while since it was predicted that the crinoline, which had filled for so long a time such a large space in the world, was gradually slinking away, and was destined to disappear altogether. . . . That tyrant, Fashion, may issue against them his edict, which no one dare refuse to obey." But the change in silhouettes was not abrupt. The crinoline of the early 1860s had already begun to develop the contours of a bustle. By 1866, Worth and the Empress Eugenie had abandoned the wide, circular crinoline. In its place, the skirt had a flat front and the excess material was swept to the back in various arrangements. Over the following two years, assorted types of bustle supports were developed for the increasingly extravagant cut and draping of the skirt. The Grecian Bend profile of the late 1780s had been revived, aided by high-heeled shoes that further tilted the posture forward to balance the weight and volume of skirt in the back. (Figure 20-17.) This first of three distinct phases of the bustle silhouette lasted from 1868 until around 1876.

The skirt was the focal point of dress designs during this period. The complexity of draping and the mixed combinations of textures and colors astound us still today. At its zenith in the mid-1870s, the bustle dress featured aprons and swags of fabric that draped from the waist to the hemline in all sorts of busy lines—diagonals, curves, zig-zags, or even straight edges—and pleats, flounces, ruffles, ruching, tucks, and

fringe trim abounded. A revival once again of the polonaise was the perfect addition to back and hip interest. Its overskirt was variously arranged in puffs and swags revealing a separate underskirt, sometimes of a different shade of the same color as the dress. Dresses were further overloaded with the addition of decorative fichus at the neckline and wide ribbon bows variously tied about the hips. Many skirts also were cut with excessive trains that extended behind in yards of material despite the street-sweeper results and the dangers of being trod upon. In 1875, *Harper's Bazaar* warned ladies about ball gowns with excessive trains loaded with delicate trimmings: "Nothing, or almost nothing, is left of a dress of tulle made with a full train; everybody has stepped on its trimmings, and no further account need be given of its condition on reaching home."

Bodices were most commonly the separate jacket styles with basques cut in a variety of shapes and lengths. Some basques were short peplum versions, and others were long enough to drape to the back like a shortened overskirt. The bodice fit was tight and smooth over a constricting corset, reinforcing the new narrowness of the dress silhouette. Necklines for day dresses were usually high and closed, most with some form of standing collar. When cut in an open square or V-shape, the neckline was filled by a lace- or frill-front chemisette. Formal gowns continued to bare the arms and shoulders. Some eveningwear bodices plunged to the waist in both the front and back over a sleeveless chemisette with decorative facings.

Sleeves were much simpler than those on crinoline dresses. The armscyes were now set at the shoulder, squaring the upper bodice. Most sleeves were narrow cylinders extending to the wrists although three-quarter lengths were popular for afternoon tea gowns. The same extravagance of surface embellishments was applied to sleeves as to the skirts, particularly over the forearm and at the wrists.

Between 1876 and 1878, the contours of the bustle dress were significantly reduced, becoming ever more trim and vertical. In 1878, *Harper's Bazaar* credited Worth with popularizing the new "draped yet clinging" skirt styles. The cut

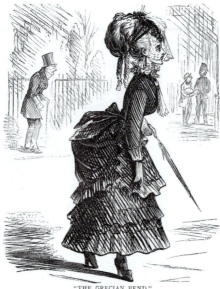

"THE GRECIAN BEND."
Does not Tight-Lacing and High Heels give a Charming Grace and Dignity
to the Female Figure?

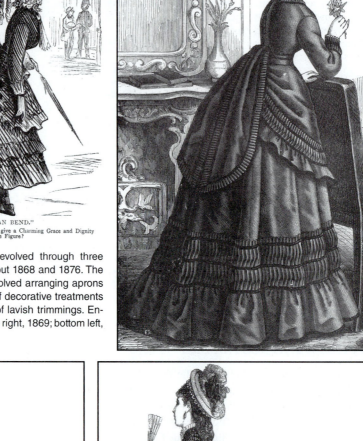

Figure 20-17. The bustle treatment of skirts evolved through three phases, the first of which occurred between about 1868 and 1876. The complexity of draping the dress bustle often involved arranging aprons and swags of contrasting fabrics with all sorts of decorative treatments such as pleats, flounces, ruffles, and a wealth of lavish trimmings. Engravings from *Harper's Bazaar:* top left, 1869; top right, 1869; bottom left, 1874; bottom right, 1875.

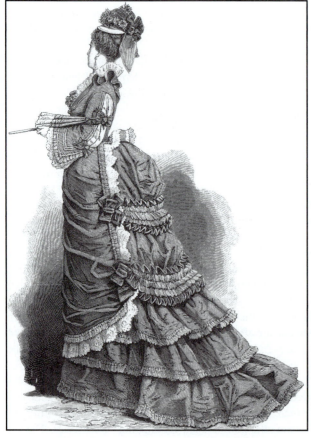

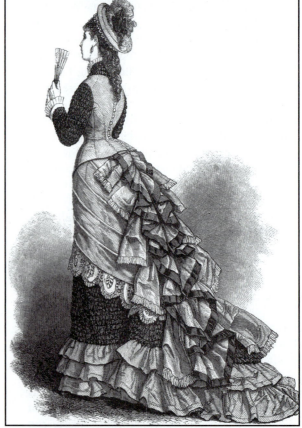

of skirts became so narrow at the knees that a woman's movement was restricted to short, mincing steps. (Figure 20-18.) Decorative treatments lacked the volume of a few years earlier and were concentrated low on the back of the skirt. Trains remained long for most formal dresses. The projecting structural bustle was eliminated although petticoats were engineered with "closely lapped frills of crinoline" or a "small pad filled with [horse] hair" at the back and often included a cascade of ruffles down the back to the floor.

One of the key design elements of the tight, vertical silhouette was the **cuirass bodice**, formed by a sheath-like construction that fitted tightly and extended over the hips. To ensure the smooth, long line of the bodice or jacket, decorative treatments were less pronounced than previously, even on evening gowns. Sleeves likewise became closely fitted with minimal decoration.

The pencil-thin skirt designs with their shallow bustles were short lived, lasting until around 1882. By the summer of 1883, *Harper's Bazaar* alerted readers that at fashionable centers such as Newport and Saratoga, dresses had exhibited "the preference for large tournures [bustles] and a tendency

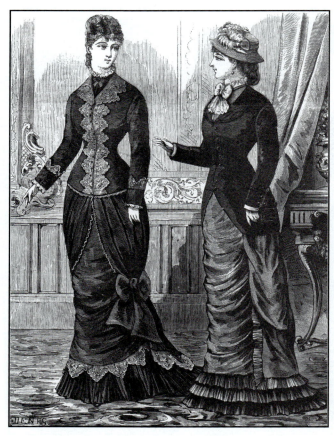

Figure 20-18. Between about 1876 and 1882, the second phase of bustle dress designs featured narrow skirts with a clinging fit. Bustles were reduced to small pads, and decorative treatments were concentrated low on the back. Fashion plate from *Harper's Bazaar*, 1879.

toward fuller skirts." The lavish use of material in gathers, folds, tucks, ruching, and similar volumetric treatments was revived. "Drapery is more bouffant on the hips and back," reaffirmed *Harper's Bazaar* a few months later. The structural bustle had returned with a vengeance thrusting the skirt out almost horizontally at the back. Costume historian Blanche Payne wrote that the "preposterous" look of the new bustle dress appeared "as if the wearer had inadvertently become attached to an overflowing pushcart." The long-line bodice endured, positioning the fullness of the skirt bustle treatment lower on the hips than the styles of the early 1870s. (Figure 20-19 and Color Plate 14.) Evening dresses were even more exaggerated with additional volume fashioned from lightweight tulles or frilly trimmings such as starched lace ruffles and garlands of silk flowers. Both the long, sleek bodice and the horizontal bustle remained the fashionable silhouette until 1889.

BUSTLE DRESS ACCESSORIES AND OUTERWEAR

Victorian ladies loved to layer their ensembles with an endless variety of detachable decorative accessories. As mentioned previously, the terms applied to many of these accessories are often confusing since they were sometimes used interchangeably for multiple items. A frilly lace neckpiece may have been called a fichu, jabot, cravat, or **plastron**, and yet all generally resemble each other in size, shape, and placement. (Figure 20-20.) Similarly, some fichus featured in magazines of the time looked identical in shape and size to wide, cape-like berthas. Even so, all of these various forms of fabric confectionery delighted the fashionable woman and provided a wide assortment of fresh looks for plain bodices and jackets.

Outerwear categories of the bustle era were largely the same as those of mid-century: wraps, jackets, and long coats. Although new constructions were necessary for the shape of longer coats to fit over bustles, shorter types of jackets were still cut with much of the same fullness and hip treatments as those of the crinoline period. Jackets with wide, conical-shaped bodies that draped loosely from the shoulders were cropped anywhere from the hips to the knees. Fitted jackets with basques or flared peplums also worked as effectively over the bustle as over the round expanse of a crinoline. One trend that was popular with both full and fitted jackets from the late 1870s into the 1890s was a front closure that fastened with hooks and eyes for a smooth, gapless look of a seam. Organpipe gathers at the back of some skirted jackets were a new decorative treatment that added a complementary flourish to the bustle arrangement.

Familiar styles of long coats such as the pelisse and redingote featured innumerable types of collars, cuffs, front closures, and trim. Most were cropped shorter than the hemline of the dress ranging from three-quarter to seven-eighths

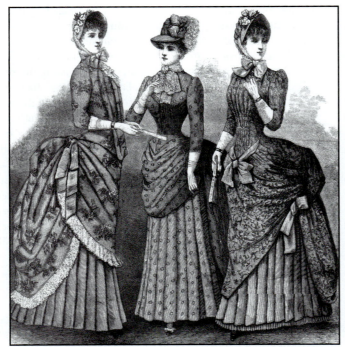

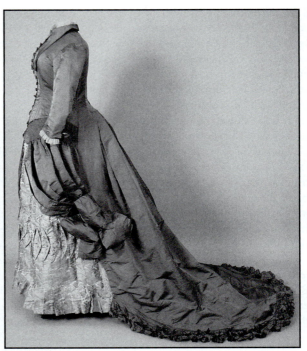

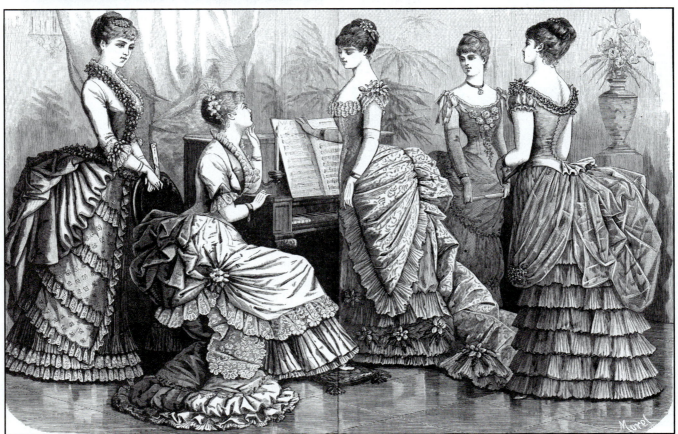

Figure 20-19. With the third phase of bustle dresses, the structural bustle returned in its most extreme forms. The bouffant treatment of excess fabric and decoration further emphasized the exaggerated horizontal silhouette. Top left, fashion plate from *Harper's Bazaar*, 1884; top right, silk faille reception gown, 1888; bottom, fashion plate from *Harper's Bazaar*, 1884.

Figure 20-20. Many of the decorative dress accessories that became popular during the Crinoline Age were carried over into the bustle period. Ornamental neckwear, for example, served the same purposes as before—to provide modest concealment and wardrobe variety. Many of the styles that looked basically the same were cataloged in magazines with a confusing array of fashion terms. Illustrations from *Harper's Bazaar*, 1883.

CRAPE AND LACE FICHU-COLLAR.

Fig. 1.—LACE COLLAR WITH JABOT.

Fig. 2.—VELVET COLLAR WITH LACE PLASTRON.

Fig. 3.—VELVET COLLAR WITH CRAVAT OF VELVET, GAUZE, AND LACE.

lengths. (Figure 20-21.) Some were layered with detachable hoods and elbow-length capes. The **ulster** was a new form of long coat made of water resistant serge, which was ideal for "traveling or walking," according to *Peterson's* in 1886.

Mantles, capes, cloaks, and other circular wrap garments varied little from the designs of the 1850s. A new type of short cape with wide sleeves was called the **dolman**, which was regarded as a garment for older women. When venturing outdoors in the coldest weather, women often added heavy mantles over their topcoats.

Transitional outerwear—called **demi-saison** styles— were lighter garments for cool days in autumn or spring. These types of jackets and coats were frequently made of furry-looking but lightweight textiles such as **boucle wool** or **frise wool**. Among the new types of light outerwear were sleeveless jackets made of muslin or knit cashmere that looked like vests with basques or peplums. These were worn over dress bodices in chilly weather and should not be confused with the cropped varieties of vests that were worn under suit jackets.

The knit **jersey** was a fashion phenomenon of the 1880s that originated in England. Although the knitted woolen tops worn by fishermen of the Channel Islands had been known as jerseys (also guernseys) since the 1600s, fashion lore holds that the famous actress Lillie Langtree popularized the garment when she donned one to play tennis. Because Lillie was from the Isle of Jersey, her sobriquet was "the Jersey Lily," from which the knit tops are said to have been named. At first the jersey was a plain, long-sleeve top that fitted smoothly over the hips. By 1883, though, *Harper's Bazaar* noted that, "since the Jersey has been deprived of its scant look and improved in shape by American modistes, who have added a collar, cuffs, and pleatings at the back . . . it has become both a popular and a fashionable garment." Because the Jersey was an easy garment to manufacture, the style became widely adopted by middle- and working-class women through the mass-marketing of ready-to-wear makers. (Figure 20-22.)

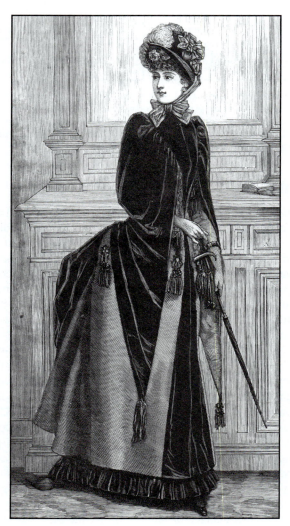

Figure 20-21. During the bustle era, many traditional forms of outerwear such as the pelisse and redingote were easily adapted to the bustle silhouette. Fashion plate of velvet and worsted pelisse from *Harper's Bazaar*, 1883.

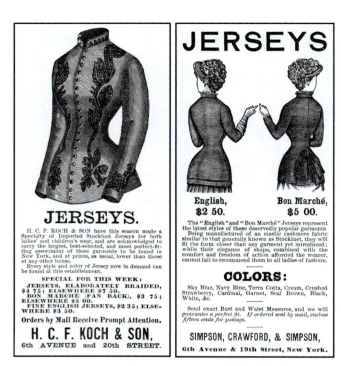

Figure 20-22. In the early 1880s, the knit jersey top became a comfortable alternative to fitted bodices and jackets. Ready-to-wear makers mass produced and marketed affordable versions for fashion-minded women of the middle and working classes. Ads from *Harper's Bazaar*, 1883.

THE 1890s

Between 1889 and 1892, the bustle silhouette diminished and the emphasis shifted from the skirt to the sleeves and bodice. The cage bustle was discarded although back interest on skirts was retained with small hip pads or by the fullness of pleats and gathers at the waistline. Skirts became more conical with a smooth fit over the hips all around. During the transition, some draped effects of the 1880s lingered, but by 1895, virtually all skirts fell from a fitted hipline to a flared bell-shape at the hem.

Initially, sleeves expanded into a typical leg-of-mutton style with a puffed fullness at the shoulder and upper arm that tapered to a close-fitting cylinder from the elbow to the wrist. From 1893 to 1895, the volume of the sleeves ballooned into enormous proportions reminiscent of those of the 1830s. (Figure 20-23.) In fact, much was written at the time comparing the two eras and the styles of each. In 1895, a *Vogue* editorial conceded that "we, at the end of the nineteenth century, are copying the fashions of the early second quarter to a very marked degree." In magazines and catalogs, the gigantic sleeves were even more commonly referred to as gigot sleeves rather than leg-of-mutton. Unlike the gigot sleeves of the 1830s, though, the styles of the 1890s were not padded with feather pillows and balloons. Some support was provided by inner linings of layered crinoline or a cambric base,

but upon removing a wrap or coat, women were required to fluff the crushed fullness of their sleeves back into shape.

Bodices either were smooth fitting with rigid constructions of boning and stiff linings or were full and loosely tucked into a belt or sash. New forms of constricting corsets that ended just under the breasts pushed up the fullness of the bosom (natural or padded) and extended a sleek line over the hips sculpting the much vaunted hourglass contours. The forward tilt of the Grecian bend was now supplanted by an erect, vertical posture.

High, stiff collars reinforced the upright look. *Vogue* noted in 1893 that the woman of fashion "ransacks her mamma's, aye even her grandmamma's treasure boxes, to discover any old lace collars that might have been laid away." In addition to choker-style lace collars, other types included revivals such as narrow pleated or fluted ruffs. The **cavalier collar** was a high band that flared into a shallow roll similar to styles of the 1590s. The new **Marie Stuart collar** curled out from a high-standing band into five points. Still other high-standing collars were inspired by those on men's military tunics, especially during the 1898 Spanish-American War, and included braiding and crisp, piped edges.

Bodices were further exaggerated in volume and ornament by the addition of a wide variety of short, cape-like treatments called **collets**. These were cut as extended collar tabs or as revivals of the pelerine. Also, pagoda-like sleeve caps or stiff frills jutted upward over sleeve puffs like giant insect wings, and soft lace berthas draped limply around the shoulders. Fixtures of bows, silk flowers, and ribbon loops punctuated the expanse of the sleeves and the tiers of decorative layers with even more fussiness.

Between 1897 and 1899, the balloon sleeves were reduced and took on new shapes. (Figure 20-24 and Color Plate 16.) The fullness remained primarily at the shoulders and upper arms, however. The **mushroom puff sleeve** fitted tightly over the full length of the arm and was capped at the shoulder by a shallow, flattened puff. The **mousquetaire sleeve** featured shirring in rows that formed deep crosswise creases to the elbow or sometimes the full length of the sleeve.

Bodices remained tightly fitted over rigid corsets or billowed from the gathers or pleats of a shirt-waist look tucked into a wide belt like those shown in Color Plate 16. Bell-shaped skirts continued to feature back interest through gathers or pleats supported by petticoats with padded hips and a fall of ruffles down the back. Complex skirt constructions of five to nine gores assured a smooth fit over the hips and just the right flare at the hem.

The short **bolero jacket** had been a recurring but tentative dress bodice enhancement since the 1830s. By the 1890s, though, the style was all the rage. "Boleros are worn by everyone having pretensions to smartness," gushed *Vogue* in 1896. The styles of bolero jackets at the end of the century were more of a cropped vest with a rounded cutaway front extending to about the bottom of the ribcage. The bolero was commonly fitted with the cavalier or Marie Stuart collar

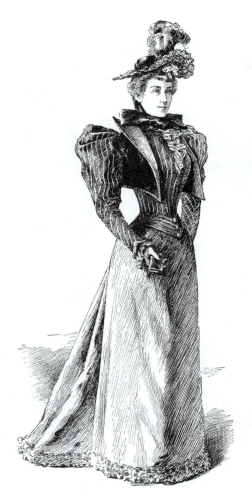

Figure 20-23. In the 1890s, fashion drama shifted from the bustle skirt to the sleeves and bodice. Huge leg-of-mutton sleeves, high collars, and all sorts of cape-like frills and treatments transformed the upper half of the dress silhouette into massive proportions. Left, detail of a Hilton Hughes dress, 1893; right, illustrations from *Vogue*, 1895.

during this period. Other boleros were attached to all sorts of shoulder treatments. A typical example is shown in Color Plate 16, in which a lace bolero is joined to a matching bertha with fluted frills that stand out over the mushroom puff sleeves. Some forms of the bolero were simply two front panels sewn to the shoulder and side seams of the bodice.

As women became more independent and sought employment in business offices and retail establishments, the tailor-made suit of a matching jacket and skirt worn with a blouse became indispensable to the modern woman's wardrobe. The tailor-made suit was not the same as a made-to-measure suit, which required fittings and custom tailoring. Instead, apparel retailers took the woman's measurements (or received them through the mail) and placed orders to a factory where the pre-cut components were assembled. Ads for tailor-made suits

often claimed that their suits were produced by "men tailors" for the cachet of a quality superior to manufactured ready-to-wear. Prices for tailor-made suits of the time were mostly in the five- to ten-dollar range. The majority of the tailor-made suit styles were almost severely plain with obvious influences from menswear. Women often wore masculine neckwear with these suits and, sometimes, even a cropped vest of a contrasting fabric such as corduroy. Other types of suits substituted for the promenade dress when women went out for a stroll or public event. Suit styles for these purposes featured more decorative treatments and trimmings although still much less than dresses.

Suit jackets came in a delightful variety of cuts, whether plain or fancy. One of the most popular forms of the 1890s was the fitted **Eton jacket**. Most were cropped in a straight line at the waist or, sometimes, with a pointed dip at the

Figure 20-24. By the end of the 1890s, sleeves were reduced and re-shaped. One of the most innovative sleeve styles was the mushroom puff shown at the right. Fashion plate from *Delineator*, 1897.

Figure 20-25. By the 1890s, the shirtwaist was manufactured in numerous specialized styles ranging from casual sports shirts to sophisticated versions for evening and dinner ensembles. Ad 1898.

front; notched lapels often included a collar of velvet or even of coordinating colored kid. Eaton jackets were usually worn open to allow the rolled lapels to stand out.

In addition to popularizing the tailor-made suit, advertising by apparel manufacturers and retailers also helped make the **shirtwaist** and skirt ensemble universal. The big wishbook catalogs from Sears and Montgomery Ward featured dozens of blouses called shirtwaists—commonly called waists—priced from fifty cents to a dollar. Initially, waists were worn informally with friends and family by the middle classes. For working-class women, the waist was ideally suitable for factory work or similar jobs where comfortable and easy-care garments were necessary. By the end of the century, waists were acceptable even for the most formal occasions. Designs were made of fine fabrics with as much attention to detail and decoration as dress bodices. The 1898 ad shown in Figure 20-25 lists specialized waists for evening and dinner wear as well as versions for sports and "hundreds of other styles."

Outerwear during the 1890s followed the top-heavy silhouettes of dresses. Coats and jackets for outdoors featured

huge sleeves to accommodate the volume of dress and blouse sleeves. Shoulder-widening details and trim were applied to both coats and wrap garments. Capes, cloaks, dolmans, and mantles were newly constructed with high collars and frills. In the United States, military forms of coats and wraps were made with braid and large brass buttons during the Spanish-American War.

UNDERGARMENTS

The three prevalent fashion silhouettes of the second half of the nineteenth century could not have been achieved without unique and extraordinary undergarments. The cage crinoline of the 1850s and 1860s has been discussed earlier in the chapter and is shown in Figure 20-7. During the transition from the wide, circular crinoline to the bustle, numerous varieties of experimental bustle-and-crinoline combinations appeared briefly. (Figure 20-26.) One form, the **crinolette**, was a flat-front petticoat with steel half hoops at the back that widened in segments from hip to hem.

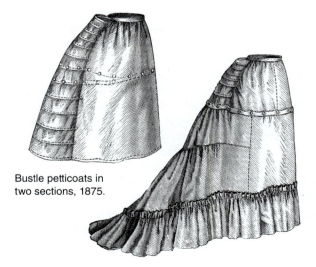

Transitional crinoline and bustle combination
undergarments, 1868.

Bustle petticoats in
two sections, 1875.

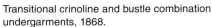

For the oppressive weight of bustles, layers
of petticoats, and heavy dresses, skirt sup-
porters were fitted with suspenders. Ad 1875.

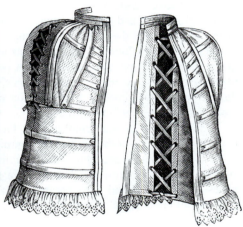

Bustle pad and petticoat, 1879.

New form of the revived bustle, 1884.

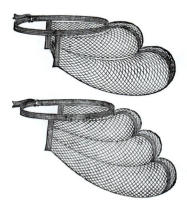

Lightweight wire bustles, 1888.

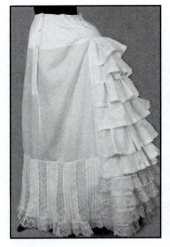

Bustle petticoat, c. 1885.

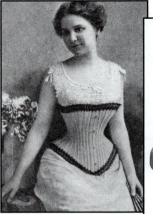

Corset and corset waist, 1899.

Figure 20-26. The exaggerated dress silhouettes of the 1870s through the 1890s
could not have been achieved without the amazing assortment of structural bus-
tles, engineered corsets, and a host of other support undergarments.

During the early 1870s, innumerable versions of bustles and bustle petticoats were marketed, some with structural supports and others laden with flounces of heavy batiste. Bustle petticoats were made in two sections that buttoned together at about midthigh, which allowed for easier laundering since the hems soiled easily and needed to be washed more often than the bustle pad. For dresses made of heavy materials requiring layers of petticoats with the bustle, the weight could be oppressive, requiring additional support garments fitted with suspenders.

By the late 1870s, when the silhouette of skirts became narrow and vertical, the projecting bustle was replaced by thin pads called **pannier bustles**. Petticoats were cut with the upper rear portion removed, as shown in Figure 20-26, to which could be buttoned or tied various sizes of padded bustles or a flounced petticoat extension.

In the early 1880s, the exaggerated bustle look returned with a more pronounced profile than ever. Heavy frames called **tournures** made of steel, duck, laces, and tapes were needed to support and shape the massive volume of skirts. With ingenuity and the technology of mass production, inventors engineered light, airy wire bustles in the late 1880s that replaced the heavy structural petticoat versions. For only twenty-five cents, a woman could strap on a wire frame bustle over which was layered a light cotton petticoat for the most fashionable silhouette of the day.

The chemise of the crinoline and bustle periods remained short, at about the knees, and continued to be made of cotton or fine-gauge linen. Most chemises were short-sleeved or, for eveningwear, sleeveless. In the 1870s, chemises were constructed with breast seams to prevent the fabric from bunching at the front of the corset, and gussets were added under the armscyes to ease the tightness caused by the rigidly laced stays. During the 1880s, plain white linen and cotton were replaced by colored and patterned textiles including bright red knits, luxurious silks, and **nainsook**, a woven striped cotton from India whose name means "delight for the eye" in Hindi.

The tight-fitting bodices of crinoline and bustle dresses fitted smoothly over corsets that could cinch a woman's waist measurement to as little as seventeen inches according to contemporary sources. Through the mid-1870s, corsets were short, extending just over the hips. As the dress silhouette became narrow and vertical, the line of the corset dropped lower over the hips forming the slender hourglass figure. By the 1890s, the corset was reduced at the top to fit just under the breasts, but retained the long line over the hips. Versions of the **corset waist** fully covered the upper torso and included a constructed bosom support with shoulder straps. For full-figured women who opted for the low-cut corset, an early form of the brassiere called a **bust bodice** provided additional coverage and lift. If a woman lacked the amplitude to fill a decollete bodice, then a padded **bust improver** might be attached to the chemise.

Camisoles, also called underbodices or corset covers, and basic drawers changed little during the late 1800s. In the 1870s, the camisole and drawers were sewn together to form "**combinations**" in both knit and woven varieties. By the 1890s, these had come to be known as **union suits**, not because they were produced by union labor, but because the camisole top was united with the drawers into one garment.

SPORTS ATTIRE

As noted at the beginning of this chapter, women of the late nineteenth century became increasingly independent and self-assured with new perspectives about the traditional roles of the Victorian housewife and mother. Among the contributing factors in advancing women's ideas of self and place in society were athletics. Besides the cycling craze, other sports activities pursued by women included golf, tennis, fishing, hiking, canoeing, hunting, and swimming. Advertising saturated mass publications with sports images and messages of health and fun in pursuing an active, outdoor life. In addition, famous artists whose work appeared regularly in popular-culture magazines such as *Life* and *Cosmopolitan* perpetuated the modernity of the athletic woman in their editorial illustrations. The epitome of this idealized woman was the Gibson Girl who was not only confident and athletic but also a fashion style-setter. Named for the illustrator Charles Dana Gibson, the Gibson Girl was the female icon of the era. (Figure 20-27.)

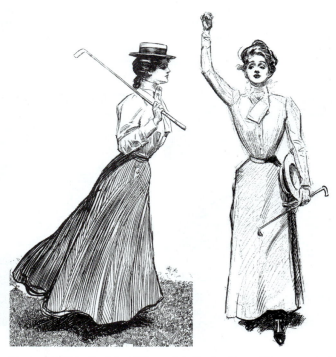

Figure 20-27. In the late 1890s, artist Charles Dana Gibson created the ideal American woman in his mass-media illustrations. The Gibson Girl was tall, athletic, confident, and most especially, a fashion style-setter.

The specialized clothing that emerged for women's sports activities ranged from everyday clothing with simple adjustments such as shortened shirts and reengineered corsets to innovative styles like the breeches shown in Figure 20-1. The introduction of trousers for women was not new in the 1890s. In fact, the first audacious steps in that direction had occurred in the late 1840s with the advent of the American women's movement. A few feminist leaders in the mid-nineteenth century experimented with the **turkish trouser**, which had full, baggy legs tied at the ankles and was worn under a knee- or calf-length skirt. Because the feminist lecturer, Amelia Bloomer, wore the ensemble on lecture tours in the 1850s, the style came to be popularly called **bloomers**. (Figure 20-28.) However, few women adopted the bloomer costume until the 1890s when shorter, less voluminous versions were accepted as a safe and comfortable alternative to long skirts for cycling or gymnastics. Related to bloomers were **knickerbockers**—or more commonly called knickers—which were a type of knee breeches named after similar garments worn by Dutchmen. By the mid-1890s, various forms of bloomers, knickers, and leggings for women's sports had become almost commonplace. A women's magazine

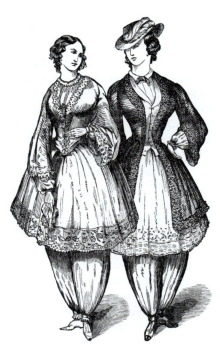

Figure 20-28. Trousers for women were introduced in the late 1840s by clothing reform advocates. The early forms were made like Turkish trousers with voluminous legs tied at ankles and worn with knee-length dresses. One of the first proponents of the look was feminist lecturer Amelia Bloomer, for whom the garment was named. Bloomer dresses from *Peterson's,* 1851.

suggested in 1895 that activewear ensembles featuring calf-length split skirts or trousers were, "in fact, another form of habit," for which "propriety" should be observed in putting the ensemble together.

Women's participation in sports inspired dress reform with numerous other garments as well. Skirts that were cropped above the ankles for active pursuits or walking on rainy days came to be known popularly as "**rainy-daisies.**" Split skirts that extended to mid-calf were a compromise for the cycling enthusiast who was less bold with knickerbockers. Middy blouses, usually made with a wide, flat sailor's collar, were loose through the shoulders and neckline—ideal for lunging after a tennis ball. Most significant was the alteration or even elimination of the corset for sports activities. Various types of sports corsets were widely advertised in women's magazines. The bicycle waist was cropped short and included elasticized side panels and shoulder straps that "give with every motion of the body" as an 1897 ad promised.

Second, perhaps, to women's trousers in fashion controversy and social drama were women's bathing suits. (Figure 20-29.) Although as early as the eighteenth century women wore loose sack gowns or sack jackets with petticoats for immersion into spa pools, specific costumes for public seaside dips in the surf were not developed until the nineteenth century. One fashion editor complained in the 1850s that there simply was "no *becoming* bathing costume," only "various attempts to make a pretty thing out of an ugly thing." That being asserted, the editor advised on an "appropriate" costume for those women intent on such "healthful" pursuits as swimming, but warned that it was nonetheless "morally unbecoming to seek the conspicuous or to strive to attract in the operation of bathing." The dress recommended at the time "should consist of trousers, made full and fastened round the ankle with a button . . . and a full tunic reaching to the knee." A broad straw hat was suggested to help protect against sunburn.

By the 1860s, bathing suits consisting only of the trousers and a shirtwaist were "objected to by many ladies as masculine and fast," according to *Harper's Bazaar.* "But experience proves that they do not expose the figure more than a wet clinging robe, and are much more comfortable in the water, where all superfluous drapery should be dispensed with." However, for those women who preferred a modest appearance over practicality, the wool serge or flannel "polonaise" bathing dress was recommended even though many an unwary bather drowned from such heavy, voluminous garments when wet.

In the 1890s, bathing suits became briefer with short skirts, short sleeves, and decollete necklines, though they were just as impractical for swimming as earlier versions. The huge leg-of-mutton sleeves, full skirts, baggy bloomers, and thick wool stockings dangerously encumbered and weighed down the bather.

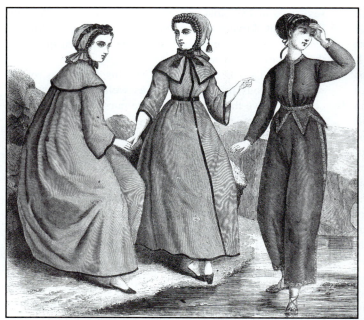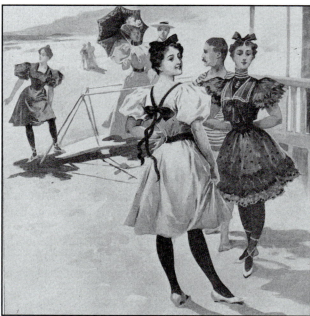

Figure 20-29. Among the most daring and controversial forms of women's clothing in the second half of the nineteenth century were bathing costumes. Throughout the period, though, as styles changed with the fashions, bathing suits nonetheless remained cumbersome and impractical for swimming. Left, fashion plate from *Harper's Bazaar*, 1868; right, detail of Salvacea ad, 1895.

HATS, SHOES, AND ACCESSORIES
1870s–1980s

Hats of the 1870s and 1880s were high, vertical, and excessively decorated to balance the horizontal silhouette of the bustle dress. (Figure 20-30.) Brimless toques and hats with shallow, rolled or turned-up brims were given additional height with ribbons, rosettes, feathers, ruching, silk flowers, lace, and similar trimmings arranged in all sorts of combinations. For the riding habit, a small version of the masculine top hat, often draped with a fine silk veil, lent an air of upper class formality. The more commonplace bonnet was less formal than the tall toques even though some styles could be as elaborately decorated. The old forms of mobcaps, or Charlotte Corday caps, were mostly reserved for the elderly and the bedridden by this time although similar "breakfast caps" of sheer materials were worn by the leisure classes to cover the hair prior to getting dressed for the day.

In the 1890s, hairstyles and dressy hats were less towering. Soft, free-form types of fabric hats like those shown in Figure 20-30 resembled small turbans that echoed the look of the tight, busy hair arrangements. For blocked hats, crowns were flattened and brims expanded in width. Brims were bent, crimped, slashed, and curled into an infinite variety of exaggerated shapes. Some hats were even made with double brims between which rolls or plaits of vividly

colored fabric could be added to match any day ensemble. Wide-brimmed straw hats, called **leghorns** after the name for a type of bleached wheat straw, were fashioned in all shapes. Plain straw boaters or sailor's hats like those of the Gibson Girls in Figure 20-27 were the most ubiquitous of the period. Elaborate combinations of trim remained the favorite treatment for formal hats. Popular decorations for street hats included pairs of birds' wings jutting up into space or even entire artificial birds appropriately covered with real feathers.

Shoes became more round-toed in the 1870s and 1880s, but returned to a pinching, long point in the 1890s. (Figure 20-31.) Heels were thicker and less high for dressy shoes, and street shoes often featured medium heels of about three-quarters of an inch high. Button-top boots were eventually replaced with lace-up models. Footwear for the tailor-made suit of the nineties was adapted from men's shoe styles including sturdy, two-tone **oxfords** with low heels. Formal slippers were covered in fine fabrics like satin dyed to match gowns and accented with faceted beads, pearl-encrusted buckles, and stand-up ribbon bows. For the cycling enthusiast, a type of high spats called **leggins** (not to be confused with trouser-like leggings) buttoned over the boot instep and extended to mid-calf or even the knee.

The most indispensable fashion accessory for women in the late nineteenth century were gloves. A lady never went out

Figure 20-30. Ladies' hats of the bustle era were high and sumptuous to balance the horizontal silhouette of the bustle dress. In the 1890s, hats were much more varied ranging from low, soft turban styles to winged leghorns. Left, fashion plate from *Harper's Bazaar,* 1874; right, fashion plate from *Delineator,* 1898.

Figure 20-31. Shoes of the 1890s became narrow with long, pointed toes. Heels were lower and thicker than in the bustle period. For street wear, the high-top button boot was richly decorated. Plainer, more utilitarian boots were usually secured with laces. Slipper-style shoes for special occasions were made of opulent fabrics and ornaments. Illustrations from *Vogue,* 1897.

of her house without an appropriate pair of gloves for her ensemble—short kid or fabric gloves for summer, heavier leather for winter, and long, silk styles for eveningwear. Hand-carried accessories such as purses, fans, muffs, and parasols changed little in style and shape beyond colors and trimmings that coordinated with ensembles. Two art movements that influenced the decoration of virtually all accessories, especially jewelry, was the Arts and Crafts style of the 1880s with its handcrafted, textured look, and Art Nouveau of the 1890s with its sinuous, undulating lines and organic motifs. (Figure 20-2.)

COSMETICS AND HAIR TREATMENTS

In the 1850s and 1860s, the Empress Eugenie was equally as influential with the fashion of hairstyles as with dress styles. She particularly preferred to wear her luxuriant, dark Spanish hair parted in the center and swept outward from the temples with ringlets over one shoulder, a look even Queen Victoria adopted. Variations of this hairstyle are shown in Figure 20-3 including arrangements with the ringlets symmetrically at

each side. The chignon and assorted other forms of knots at the nape of the neck remained popular, some accented with a corded silk snood. In the 1870s and 1880s, younger women wore their hair more loosely with masses of curls, plaits, and twists down the center back. Matrons wore their hair in high, almost vertical arrangements on the back of the head, sometimes with a few short ringlets to the shoulders. By the 1890s, the hair was worn piled atop the head in tight, close curls and coils, usually with a curly fringe at the front, to better accommodate the smaller, excessively decorated hats. For women who preferred simpler hats like straw boaters or no hat at all, the Gibson Girl pompadour was widely copied.

The cult of the Victorian woman's hair spawned a multimillion-dollar patent medicine industry with all sorts of promises for thicker, longer hair and youthful, natural color. In the biblical sentiments of one hair tonic ad, "beauty is shorn of her strength when shorn of her hair." *Harper's Bazaar* recommended in 1873 that, for healthy hair, women might try restoratives such as ammonia, oil of mace (nutmeg), sperm whale oil, and even bear's grease if one could find the genuine article. A suggested home remedy for hair dye to disguise the first telltale gray hairs was a concoction made from boiled potato skins.

The use of make-up in the Victorian era was possibly not as rare as we might think although it was undeniably viewed with distaste by polite society. An editorial in 1855 espoused that "artificial coloring . . . is, excepting on the stage, entirely confined to a class whose morality and principles are as false as their complexions." Beyond the moral dangers associated with cosmetics were very real health concerns, which the editor further noted. White skin foundation, made from bismuth and chalk mixed with rose water, "besides destroying the skin, destroys the play of the features and the expression of the face." In addition, "rouge, whether carmine, vegetable or liquid, is injurious, because it obstructs the natural perspiration from the pores of the skin."

The other problem with the rudimentary cosmetics of the age was application. The difference between subtle tinting and garish painting was a matter of delicate touch. An 1895 satirical cartoon in *Vogue* depicts a fashionable woman exclaiming to her companion upon glimpsing an overly made-up acquaintance, "What excuse has she for making up as she does?"; the friend replied, "Her natural complexion."

Flawless alabaster skin was universally associated with youthful beauty and health, so eventually the use of white facial powder became widely acceptable. In 1868, *Harper's Bazaar* advised that "the best of all artificial applications to the complexion is a little starch or rice powder." Manufacturers mass marketed all types of tinted face powders that claimed to be undetectable even in daylight. (Figure 20-32.) If a dusting of powder was inadequate, though, recipes for homemade skin bleaching were commonly published in women's magazines. Some formulas included benzoin, borax, tannin, sulphur, camphor, orris root, or acetic acid.

Figure 20-32. The proper Victorian lady might have used a bit of facial powder on occasion, but avoided the stigma of the "painted lady" who tinted her lips and daubed rouge on her cheeks. The use of facial powder was such a common practice that innumerable varieties were manufactured and mass marketed during the period. Ad 1897.

Snake oil makers advertised commercial face "bleaches" that could "remove tan, freckles, pimples, eczema and all diseases the skin is heir to." Since this was before the U.S. Food and Drug Administration required disclosure of product ingredients, one can only imagine the deadly chemical compounds used to bleach the skin available by mail order.

MEN'S CLOTHING 1850–1900

The men's suit, comprised of a coat, vest, and trousers, continued to evolve subtly and cautiously in the second half of the nineteenth century. Permutations occurred without abruptness and drama and never strayed from the easy-fitting sheath that articulated and covered almost the whole surface of the body. The classic assemblage of its three basic components, along with correct accessories, was expressive of a confident adult masculinity—purposeful, disciplined, and proper. The modern Victorian man's suit was also a uniform of official patriarchal power devoid of the quixotic fancifulness associated with women's fashions of the time. The suit remains thus today. Moreover, men's ready-to-wear suits leveled the class field, providing the proletariat with a quality ensemble for Sundays and special occasions, suits that were virtually indistinguishable in appearance from custom-made versions except upon close inspection.

Men's suit jackets were categorized into four prevalent types, each one for specific social functions and each one

with a number of variations depending upon the decade. Textiles of jackets were predominantly of somber, solid colors although sporty plaids and checks were tried by younger men hoping to break with staid conventions of their fathers and grandfathers. "Men in general like the simplicity of quiet and well-harmonized colors," *Graham's* affirmed in 1855.

The frock coat suit and top hat were the gentleman's correct daytime dress when making social or business calls. By the 1870s, the style was frequently called the **Prince Albert coat** since it had been the favorite style of Queen Victoria's consort. Its design remained largely unchanged from the 1840s except for a reduction in the fullness of the skirt. The closely fitted cut and long line of the waist were retained by the frock coat design throughout the second half of the century.

Morning coats were a variation of the frock coat cropped at the waist in the front and with a knee-length skirt that was cut away in a tapering contour to the back. Morning coats, too, formed a semi-formal day suit although, for social functions, the frock coat was an increasingly popular alternative. By the 1860s, the morning coat was most often worn as the dress of professional men. Financiers, clergymen, politicians, diplomats, and judiciaries, to name a few, ordinarily wore the morning coat as town dress. Costume historian Vittoria de Buzzaccarini noted that, in Italy, the distinction between a clergyman and a banker was a miniscule but distinct length of the morning coat hemline.

The tail coat, or now more appropriately, the dress coat, retained its cut-in front cropped above the waistline and tails in the back variously shaped as a "coffin" or "swallow's tail." The dress coat was mostly worn at formal evening affairs although the caliber of certain day events such as weddings or funerals might warrant formal attire. At the court of the Second Empire, the dress coat was still required with breeches and silk hose for high state functions. Ironically, the formality of the dress coat, sometimes with breeches, also came to be applied to certain categories of servants, such as butlers and footmen, as well as to specialized professions, such as undertaking. Even at the end of the century, *Vogue* was lobbying its society readers to "find a costume which shall be included in the wardrobe of a gentleman, but not that of a servant...to prevent awkward mistakes."

The most significant innovation in men's suit designs during this period was the introduction of the **sack coat**. (Figure 20-33.) The style first emerged around 1856 as an eccentricity adopted by the English dandy Count D'Orsay. It

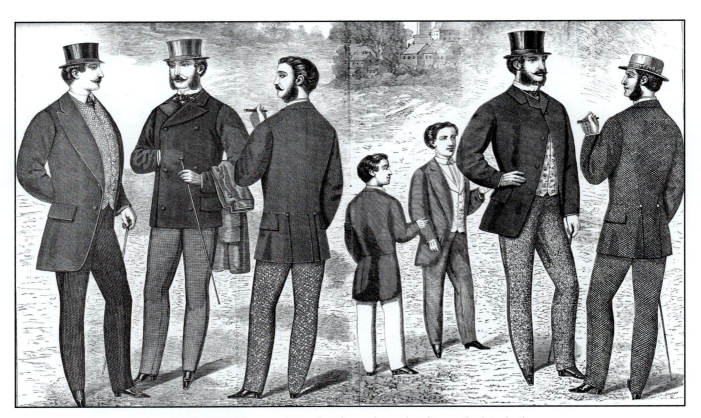

Figure 20-33. The most innovative change in men's suits was the introduction of the sack coat in the late 1850s. The cut was loose and square without the fitted, seamed waistline of the frock coat. Initially the sack coat was a casual day wear garment. By the 1860s, though, it was commonly accepted as a component of the business suit. Fashion plate from *Harper's Bazaar,* 1868.

was cut to hang straight from the shoulders with no waist seam, and the shortened hemline was cropped just below the hips. The three- or four-button, single-breasted closure was usually worn with only the top button fastened. The fresh new look quickly became a fad with stylish young men in London and Paris—from which the influence spread to the rest of Europe and the Americas. As with many dramatic fashion trends, the sack coat became a scandal at first, derided by social traditionalists (and tailors) as a "real terrorism against propriety." Nevertheless, the sack coat quickly grew in popularity, aided by the rapid and easy mass production of this simple new style by ready-to-wear makers. Later versions included the two-button, fingertip length **D'Orsay coat** shown at the far left of Figure 20-33, and a cropped, square derivative, the double-breasted **veston** on the second figure from the left. Variations also included subtleties such as covered buttons and lapels edged with grosgrain ribbon. During the 1860s, the vest and trousers worn with the sack coat frequently were made of the same fabric and came to be known as a **ditto suit**, a term commonly used until the First World War.

Initially, the sack coat with its matching vest and trousers was regarded as casual attire only for day time and was even labeled a **lounge suit** in England and America. By the mid-1860s, though, the sack coat suit was more accepted as town wear and proper office dress. The ditto suit shown at the far right of Figure 20-33 is described in *Harper's Bazaar* as a "business suit." Indeed, the social protocol for the sack coat suit was in constant evolution throughout the remainder of the century. In the 1870s, the King of Italy received the Czar of Russia in Rome wearing a sack jacket, but then later changed into a dress coat to be introduced to the Czar's daughter at a theater. Innumerable photos from the 1870s and 1880s show men wearing the sack jacket as their Sunday best—some as ditto suits and others with trousers or vests of contrasting fabrics. (Figure 20-34.)

By the end of the century, even dress versions of the sack coat had emerged for formal occasions. The **tuxedo**, named for a style of dinner jacket first worn in New York's Tuxedo Park Club in the 1880s, married design elements of the dress coat such as silk-faced lapels with the boxy cut of the sack jacket.

Another derivative of the sack jacket that first appeared in the late 1880s was the **blazer**. Among the possible origins for the casual style and its unusual name were the scarlet uniform jackets of the Cambridge College Boat Club or, perhaps, the jersey top styles worn by the sailors of the ship

Figure 20-34. The lounge suit, comprised of a sack jacket, vest, trousers, starched collar, and necktie became the Sunday-best attire for most ordinary men. Ready-to-wear makers mass produced affordable "ditto" suits made entirely of the same material although trousers or vests of contrasting fabrics remained popular throughout the period. Photos c. 1885–95.

H.M.S. *Blazer*. Whatever its beginnings, the blazer with its loose, boxy fit and patch pockets became widely popular especially as tennis attire in the 1890s.

The suit vest, or waistcoat in England, continued to be made in a great variety of styles with both single- and double-breasted closures. Necklines varied in depth from high at the throat to a deep V-cut at mid-torso. Vests with lapels were about equally popular as plain fronts. For evening dress, vests were cut deep, almost to the waistline, and extended slightly longer than day suit styles. The suit vest was still a garment with which men could feel free to indulge in a bit of peacock flash with textures, colors, and textile patterns. Fashion plates throughout the period show a spectacular assortment of day vests in striking brocades, matelasse, printed pique, dotted velvet, and striped satins, most in vivid hues. In fact, what would appear to us today as a clash of mixed patterns between checked vests and plaid trousers, or floral vests and striped trousers were, at the time, the epitome of sophisticated taste. Vests for evening dress were usually white, but could be black for dinner parties or the theater.

Trousers fitted straight, narrow, and smoothly although the cut fluctuated widely from tight to full year to year. Hemlines might be pegged, open, or even slightly flared, all of which could be seen concurrently on a city street. Patterned textiles for trousers, especially checks, plaids, and pin stripes were fairly constant throughout the era. Waistbands were affixed with buttons for fastening the ends of braces. It is unclear when or how belt loops were revived from ancient times and reintroduced to the construction of trousers although, by the 1880s, illustrations of sports clothes depicted belted versions.

Two stylistic treatments of today's trousers, creases and cuffs, originated in the late nineteenth century. A number of sources are credited with initiating the trend of steam creasing trouser legs including England's style leader, the Prince of Wales (later Edward VII). Two different methods of creasing are evident in photos of the time. The earlier form had the creases at the sides with a smooth front and back. The second, with the creases down the center front and back, became the standard, most likely because the crisp ridges helped prevent an age-old problem of baggy knees. The look was quickly adopted by style setters, and it has endured as the proper look for both dress and casual trousers.

Trouser cuffs, however, were met with resistance. Initially called "roll-ups" or "turn-ups," the practice of forming cuffs to protect the hem of trousers against damp and mud was a common practice. As a stylish innovation, though, the cuffed trouser leg originated with men's sports attire of the 1860s, particularly for cricket and rowing clubs. The hems were turned up and tacked with a couple of stitches at the sides that could easily be clipped for laundering. Even when Prince Edward appeared at Ascot wearing cuffed pants, the look continued to be criticized by sartorial purists, a controversy of style that lingered until the Edwardian era.

Men's pullover shirts through the 1870s remained full and loosely fitting. (Figure 20-35.) By the 1880s, the construction of the shirt was largely the same as that of the Second Empire except for a more narrow, fitted cut. The long sleeves ended in a wide assortment of cuffs including turned back **French wrists** fastened with cuff links. Hemlines were either square or rounded with side slits. The shirt **breastplate front** sometimes called a **shield front** or **bosom** was usually fastened by two or three buttons or, for formal shirts, by jeweled studs. Fronts were elaborately decorated with vertical and horizontal tucks and pleats or even with delicate embroidery if a wife's sewing skills were adequate. As shirt fronts disappeared beneath high vest necklines and a variety of neckwear, they were gradually simplified. By the 1880s, *Harper's Bazaar* advised readers that "all ornament is

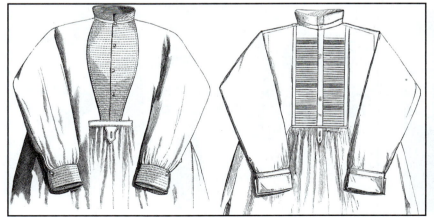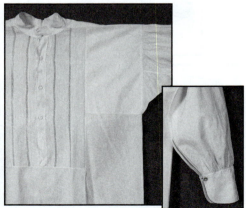

Figure 20-35. Through the end of the 1800s, men's shirts were made with bosom or shield fronts and had to be pulled on over the head. Left, shirt patterns from *Godeys,* 1860s; right, detail of linen shirt with mother-of-pearl buttons from the Karen Augusta Collection, c. 1850–60.

useless for these bosoms as they are entirely concealed by the high vest and scarf."

Sometime in the early 1890s, a new form of shirt was introduced with a front closure that opened the full length from the collar to the hem. Since the design was modeled on the sack coat, it came to be called a "**coat front shirt**." Fashion lore holds that the innovative style originated when a famous stage actor accidentally tore open the front of his bosom shirt while changing for a performance. Exclaiming that this was the way all shirts should be made, he promptly ordered a number of shirts from his tailor with a coat front closure. Demand spread quickly and ready-to-wear makers responded with mass production of the new design.

Shirt collars were ordinarily shallow to which would be buttoned any number of detachable collars. Magazines often recommended detachable collars because they could more easily be starched to a satisfactory rigidity to properly tie neckwear. The collars shown in Figure 20-36 are examples of the change in height from the 1850s to the 1890s. By the end of the century, collars could be up to three inches high. Moreover, collars became a form of identity expressing, on the one hand, a man's socioeconomic status, and on the other, his personality and lifestyle. A gaping, V-front collar might represent an artist or writer of some success, whereas the rigidly starched neck-brace styles were the mark of a bourgeois gentleman or businessman. For the uppermost classes, shirts were customized with the proper collar and cuffs attached.

Although most men preferred shirts bleached brilliant white, a surprising palette of colors became acceptable for Victorian men's day shirts. In the 1890s, *Vogue* described cambric and percale shirts of blue, pink, lilac, heliotrope (purple), browns, and ecrus. Some men, noted the editors, daringly donned shirts in patterns of "colored hair-line stripes or pin figures," or even of "colored grounds with white stripes broad, and white lattice-work."

Types of men's neckwear and the methods of tying each were incredibly varied in the second half of the nineteenth century. (Figure 20-37.) A magazine article on men's ties in 1895 opened with: "Here we have fancy let loose." Bow ties, long ties, cravats, and scarfs were made in all sorts of fabrics from fancy silks and fine linen to colorfully patterned madras. By the 1870s, a number of preknotted ready-to-wear ties were available that "could be affixed to the neck in a matter of seconds, with no preliminary study, and independently of any personal dexterity." Yet the sophisticated and subtle conventions for how and when to wear certain forms and colors of ties were equally complex and varied. Magazine articles not only reported on the newest neckwear styles for the season but often emphasized which neckwear or colors *not* to wear. For example, in 1883, *Harper's Bazaar* warned that white satin ties were "tabooed" for dinner parties. Similarly, certain knots and shapes became recognizable by popular names just as they are today. In the 1890s, for instance, the **toreador** was a narrow four-in-hand knot and the **ascot** was a wide, scarf-like cravat that filled the open neckline of the vest.

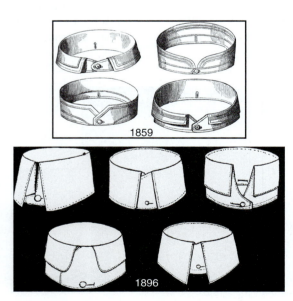

Figure 20-36. A variety of detachable collars buttoned to the shirt collar. Between the 1850s and 1890s collars became higher and more rigidly starched. Top, collars from *Godey's,* 1859; bottom, collars from *Vogue,* 1896.

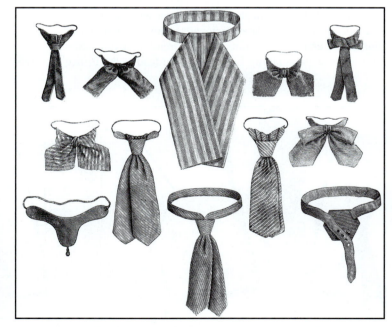

Figure 20-37. Men's neckwear of the second half of the 1800s was greatly varied in size, shape, knot, and fabric. However, strict standards governed what type or color of tie was appropriate for any given social circumstance. Ties from *Harper's Bazaar,* 1868.

MEN'S OUTERWEAR, UNDERWEAR, AND SPORTS ATTIRE

Types of outerwear for men between 1850 and 1900 were versions of classic overcoats in double- and single-breasted styles. Lengths of coats were mostly cropped just below the knees although, by the 1890s, hemlines dropped almost to the ankles on some styles. Long frock coat variants with a fitted bodice and separate flared skirt sewn at the waist were popular through to the end of the century. A version of the long frock overcoat with a fuller skirt and multiple flap pockets was the **coachman's coat**, which became a trend of the 1880s and 1890s. (Figure 20-38.) The fitted **chesterfield topcoat** was detailed with a velvet collar and a fly front that concealed the buttons. The ulster was any of a number of long, capacious overcoat styles, some worn belted and with a detachable hood or cape. The **Inverness cape coat** featured a full, circular cape that covered the shoulders to the forearms; some versions were made with double capes. The odoriferous rubber mackintosh, called a slicker in America, was the most effective rainwear despite its chemical smell and shapeless fit.

Through the 1880s, men's underwear was primarily two basic pieces, drawers in knee- and ankle-length varieties, and an undershirt, often called the undervest. Both were made in knit or woven cotton, linen, wool, or silk. Colored underwear for men is known from the 1850s but did not become more common until the 1880s. *Vogue* noted in the mid-nineties that purple and black underwear were seen in men's shops in London and New York but were not yet universally popular. The combination or union suit described earlier in the chapter was also adapted to menswear and, by the end of the century, was the most prevalent type of underwear for men.

Men's corsets were abandoned for the most part after about 1850. Although advertisements for men's corsets persisted throughout the late Victorian era, few men suffered them. Masculine forms were mostly a wide, elasticized waistband stiffened with light boning.

The most common form of men's sleepwear was the pullover nightshirt. Most men wore long versions, extending to midcalf or the ankles, but in summertime, some men opted for knee-length variants. In the late 1870s, sophisticated men began to wear a type of trouser suit to bed called **pajamas** (pyjamas in England). By the 1880s, flannel pajamas came in a number of colors and textile patterns including assorted vertical stripes, plaids, and bold polka dots.

During the second half of the nineteenth century, sports and physical exercise became an obsession of all classes. The Olympics were resurrected in 1896, and numerous sports organizations like the AAU (Amateur Athletic Union) were founded during this period. In America, newly created sports for the masses such as baseball, football, and basketball joined the established aristocratic activities of rowing, polo, and sailing as healthful pastimes. Other sports

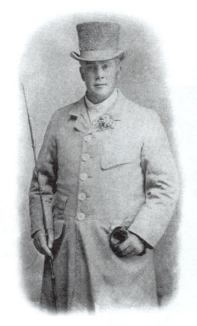

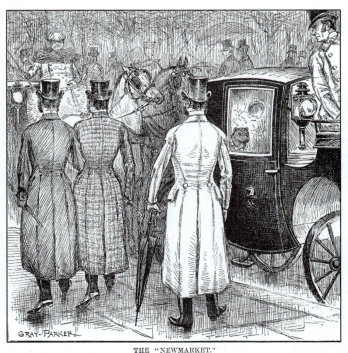

THE "NEWMARKET."

JEAMES. "WELL, IF THAT HAIN'T HENOUGH TO DISGUST ONE WITH THE SERVICE! GENTLEMEN TOO, THEY CALL THEIRSELVES! TAKING THE VERY CLOTHES OFF OUR BACKS."

Figure 20-38. One of the popular new styles of men's outwear for the 1880s was an adaptation of the coachman's coat. The design included a fitted body, pleated skirt at the back, and capacious pockets with flaps. Left, photo of coachman, 1894; right, cartoon from *Harper's Bazar,* 1883.

such as tennis, golf, and cycling appealed to a broad segment of the social spectrum, blurring class boundaries. As sports became organized into clubs and intramural competitions, specialized attire for safety and ease of movement was developed. These forms of activewear became mass produced and mass marketed by ready-to-wear makers, furthering the appeal of sports for the average weekend enthusiast.

One of the earliest types of casual sports clothes for men was knickerbockers, a highly practical and comfortable garment that women later adapted for their own pursuits of outdoor fun. Men's knickerbockers first became fashionable for hunting, fishing, hiking, and canoeing in the 1860s when the Prince of Wales adopted them for his trips to country estates. The typical example of knickerbockers from the 1890s shown in Figure 20-39 depicts full legs that blouson over the knee bands, side-slash front pockets, welt back pockets with flaps, and a waistband with belt loops. Worn with knickerbockers for traipsing about in the woods was the **norfolk jacket**, named for the region around Sandringham Castle where the Prince of Wales often went on hunting excursions. The jacket was loose-fitting with an attached belt, large patch pockets, and double box pleats in the front from shoulder to hem.

For swimming and some types of competitive sports, like track and field events or bicycle racing, men preferred tight-fitting, briefer garments. Knit shorts cropped above the knees were cut basically the same as drawers, and short-sleeve knit tops or sweaters were similar in construction to undervests. Wool was recommended for bathing suits since wool retained heat even when wet, but breathable knit cotton was the fabric of choice for strenuous exertion in the sports arena.

MEN'S ACCESSORIES

The most indispensable men's accessory of the second half of the nineteenth century was a hat. (Figure 20-40.) Seldom would a man, even the poorest, go outdoors bareheaded. For the upper bourgeoisie, the top hat was the requisite headgear for town. The topper was worn with the frock coat or dress jacket but never a lounge suit. A strict code of hat etiquette could betray the uninformed. For instance, as one style guide of the time advised, when greeting a lady, a gentleman should remove his hat in a manner that would not allow the inside to be seen as "a poor man would hold out his hat for charity." In addition, the sartorially savvy man knew when and where he could wear his hat indoors and how to dispose of it unobtrusively when making social visits. The most common daytime hat was the rounded top **derby**, called a **bowler** in England, which became the prevalent headwear complement for the lounge suit. The **fedora** featured a high, conical crown with a deep crease on top front to back and a wider brim than the derby. A shorter variant of the fedora with a narrower brim edged in grosgrain came to be known as a **homburg** when the style was adopted by the Prince of Wales following his tour of a hat factory in Homburg, Germany. Men's **crushers** were low, round-top hats with turned-up, saucer-like brims; the name originated from the hat's three-ounce weight as compared to the more substantial five-ounce fedora or eight-ounce top hat. For summer, the shallow, cylindrical **boater** of a natural, light straw was ubiquitous. Sports hats included the soft **deerstalker cap** with its turned up ear flaps—more familiar today as the Sherlock Holmes cap. Numerous other forms of hats and caps included adaptations of military styles worn for yachting, travel, and certain sports.

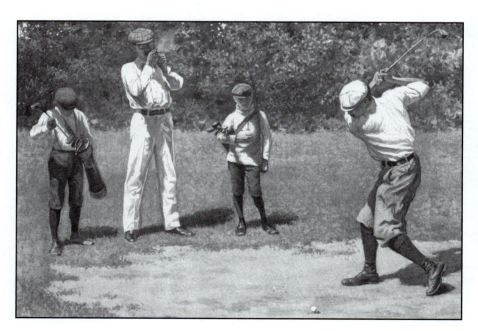

Figure 20-39. Beginning as early as the 1860s, knickerbockers were worn by men for sports activities. In the 1890s, the garment became more associated with bicycling and especially golf.

Men's shoes and ankle boots became more varied after 1850. It is difficult to determine precisely when round toes, square toes, or pointed toes may have been most fashionable at any given season during this period. In 1883, *Harper's Bazaar* reported with uncertainty, "There is a tendency to broaden the toes of all shoes that have been worn nearly pointed on account of the closely fitted trousers; but sensible men have never followed either of these fashions to the extreme." Twenty years later, all three toe shapes were similarly offered in the Montgomery Ward wishbook. (Figure 20-41.) One of the key changes to men's footwear was a dual construction of the half-boot with leather vamps over the instep and toes but dyed-to-match canvas uppers around the ankles. This style was often described as a **gaiter boot**, named for the spats-style look of the fabric upper. Gaiters were both lace-up

and button-topped with plain vamps or embellished with decorative perforated edging. Some walking types of gaiters featured elasticized insets for added comfort. So-called "low" shoes, or oxfords, were principally worn with dressy suits for social occasions. Except for formal patent leather slipper styles called "pumps," most low shoes were constructed as lace-ups and included assorted decorative treatments—even two-toned designs.

Among the new categories of accessories for men in the late nineteenth century were belts. As mentioned previously, belt loops were reintroduced during this period after centuries of absence. Belted waistbands were initially applied to sports pants for the obvious effectiveness of securing the garments during strenuous activities. In retail catalogs of the nineties, men's belts were featured with the specific sports attire such

Figure 20-40. Victorian men rarely went outdoors without a hat or cap. New to the second half of the nineteenth century were the round-crown derby, or bowler in England, and the fedora with its deeply creased top. By the end of the century, catalogs offered a wide assortment of specialty hats and caps appropriate for specific attire. Assorted hats from the 1895 Montgomery Ward catalog.

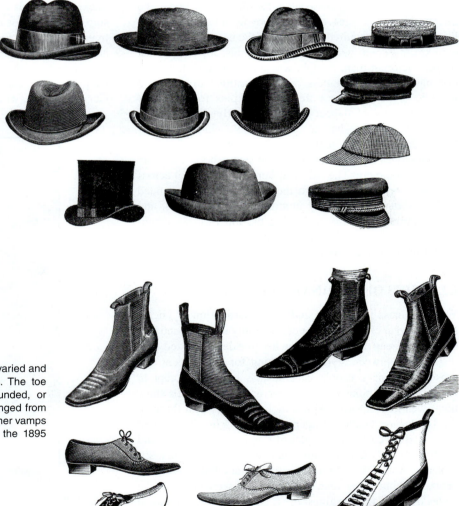

Figure 20-41. Men's shoe styles became as varied and specialized as headgear in the late 1800s. The toe shapes might concurrently be pointed, rounded, or squared during any one season. Designs ranged from basic gaiter boots with fabric uppers and leather vamps to flashy two-tone kid oxfords. Shoes from the 1895 Montgomery Ward catalog.

as tennis or cycling rather than collectively in the men's furnishings section. Both woven fabric and leather belts were fitted with buckles of various metals and electroplates.

Despite the ease and practicality of the belt, suspenders, or braces in England, remained the most prevalent form of support for trousers through the First World War. As with neckwear and vests, suspenders were often colorful and richly decorated. An acceptable gift for a man from a lady was a pair of suspenders that she had hand embroidered.

Among the controversial accessories that emerged in the late 1800s was the cummerbund, a wide, vividly colored sash worn with the tuxedo in place of a vest. French magazines blasted the cummerbund as "grotesque" and in "bad taste" when it first appeared. Only after the dinner jacket began to be accepted as semiformal dress in the late 1890s did the hostility toward the cummerbund ease.

Other typical accessories of the well-dressed man included walking sticks. Gentlemen carried sticks with ornately carved buckhorn or repousse silver handles. In the 1890s, the Shepherd's crook stick became more fashionable. Gloves, likewise, were a required accessory of the gentleman—tan or ecru kid for street wear, white for evenings. Jewelry for the proper Victorian man, though, was limited to cuff links and one plain gold ring, unless one was entitled to display a heraldic or military crest. Jeweled stickpins for neckwear were a favorite of dapper young men. "But little jewelry should be worn by a gentleman;" chided *Vogue,* "watchchains, charms, seals, etc., are vulgar."

Hairstyles for men remained the same short crop from the Napoleonic era. The side whiskers that had crept across the cheek or jawline through the Romantic Age expanded into all sorts of full, bushy mutton chops, mustaches, and beards through the 1880s. During the nineties, the clean-shaven look of the Gibson Man made men appear more youthful, healthy, and well-groomed.

CLOTHES OF ORDINARY PEOPLE

With the mass production and mass distribution of cheap, ready-to-wear clothing for the entire family in the second half of the nineteenth century, fashion became democratized. The distinction between styles of clothing for the affluent and those of ordinary people became less apparent except in materials. Depictions of female servants of the 1850s show them wearing uniforms with crinolined skirts, and those of the 1880s have bustle arrangements. The $5 men's ditto suit replicated the customized styles of London's Savile Row and the $5 women's tailored suit was modeled on the latest silhouettes from Paris. Similarly, mass-marketed casual and sports clothing, outerwear, and underwear were based on the styles displayed in the finest dress shops and carriage-trade stores. Even fashion accessories were manufactured with inexpensive trim and decorative motifs that simulated the most current trends.

This is not to say there were not significant and evident differences between the daily dress of the privileged classes and that of the working classes. Town streets were filled with factory and shop girls in shirtwaists without jackets or hats, and laboring men in shirtsleeves and soft caps without a sack coats, collars, and neckties.

In addition, certain categories of work clothes were specifically identified with ordinary people. For example, the term "pantaloons" was still commonly used through the end of the century to refer to men's casual or work types of trousers. In ready-to-wear catalogs of the period, the word became shortened to "pants" as they are known today.

A famous type of work pants that was created during this time was blue jeans. In 1853, German immigrant Levi Strauss set up a business in California to sell supplies to the gold-rush miners and other retailers. In 1872, he was contacted by one of his customers, a tailor in Nevada with an idea for riveting the corners of pants pockets to secure them against tearing. Lacking the funds for a patent, the tailor suggested a partnership, which Strauss accepted. The following year the two entrepreneurs began to manufacture a riveted overall made of a heavy French twill cotton called **serge de Nimes**, from which we get the word **denim**. (Figure 20-42.) The fabric—and later the pants—also came to be called **jeans** after the "genes," or Genoese sailors, whose trousers were made of the material.

Figure 20-42. In 1873, Levi Strauss began manufacturing riveted workpants made of heavy cotton serge de Nimes, or denim. Note that even jeans were made with suspender buttons instead of belt loops. Photo of California miners from the Levi Strauss & Co. Historical Collection, c. 1890.

Various other forms of denim work pants were also mass produced in assorted colors by other ready-to-wear makers. Through the First World War, jeans were largely sold in the West as work pants for farmers, ranchers, cowboys, and field hands. Following the tourist boom of the 1920s, Easterners became enamored with the cachet of the Old West and began to bring jeans back from vacations for weekend casual wear.

CHILDREN'S CLOTHING

As during the early phases of the Industrial Revolution in the Romantic Age, children of the second half of the nineteenth century were likewise dressed to reflect the prosperity and social prestige of the parents. This parental preoccupation with the elaborate attire of their children was an example of what the economist Thorstein Veblen later labeled "vicarious consumption," the degree of which was in accordance with the parents' ambition. Victorian girls usually wore clothes very similar to those of their mothers, including restrictive corsets and lavishly ornamented accessories. Toddler boys were dressed virtually identical to girls until about age three or four. Until age ten or eleven, boys were dressed in a wide

assortment of suits and fantasy costumes, often of sumptuous materials, including tunic dresses, kilts, and diminutive military uniforms. The clothing of older boys were replicas of menswear with the trappings of starched collars and cravats like those worn by the boys in Figure 20-33.

During the crinoline period, small girls wore dresses modeled after those of adults with tight bodices, open necklines, and wide skirts cropped at the knees; older girls wore hooped skirts shortened to about the ankles. (Figure 20-43.) The dresses, jackets, coats, and accessories of the children of bourgeois families were often made of the same opulent materials and trimmings as their mothers' styles. Lace or ruffle edged pantalettes continued to be worn by both girls and toddler boys until the late 1860s.

By the 1870s, girls' dress styles shifted to bustle silhouettes similar to those of adults. (Figure 20-44.) The short skirts for young girls continued the conventions of previous decades. Bodices were fitted and skirts were layered with aprons, polonaise overskirts, frills, and all manner of trim. As with women's bustle dresses, girls' versions followed the same three phases of the period: large bustles until the late 1870s; narrow profiles with reduced back treatments placed low on the skirt until the early 1880s; finally, a return to large, exaggerated bustles.

Figure 20-43. During the Crinoline Age, girls' dresses were shortened versions of their mothers' styles with tightly fitted bodices and wide, hooped skirts. The hemlines of young girls were cropped just below the knees, and for older girls the skirt extended to the ankles. Plate from *Godey's* 1857.

Figure 20-44. Girls' dresses of the 1870s and 1880s followed the same three phases of bustle treatments as adult versions. Large bustles prevailed until the late 1870s when skirts narrowed and decorative elements dropped low on the back; exaggerated bustles returned in the early 1880s and remained the fashion until around 1890. Plate from *Harper's Bazaar,* 1873.

When narrow, bell-shaped skirts and gigantic leg-of-mutton sleeves replaced the bustle dress around 1890, girls' styles followed those of their mothers. (Figure 20-45.) The full array of fashion accoutrement—jackets, shirtwaists, skirts, capes, coats, and accessories—were likewise made in diminutive styles for girls.

One should be cautioned, though, on thinking that the clothing depicted in fashion plates and photographs of the period represented girls' everyday wear. A more realistic view of their day dresses and playwear is famously represented by Alice of the Wonderland notoriety. In the 1865 book, she wears a plain bodice dress with a full, gathered skirt, short, puff sleeves, and a narrow, turned-down collar. Six years later, in *Through the Looking Glass,* Alice has added a simple apron with frilled cap sleeves to her plain dress. Only at the end of the story when she is transformed into a queen does her costume become a fashion plate replete with a bustle polonaise.

The clothing of boys during this period is far more confusing to understand than that of girls. Along with plain, simple suits of dark woolen jackets and pants that emulated the attire of their fathers were any number of costume eccentricities that are perplexing to our modern perspectives. In

Figure 20-45. In the 1890s, the gigantic leg-of-mutton sleeves and bell-shaped skirts of women's fashions were applied to girls' dresses. Illustration from *Delineator,* 1896.

Figure 20-46. Toddler boys were commonly dressed in frilly skirts, lace pantalettes, and an excess of overly decorated accessories. To the Victorian parent, though, the differences between the boy's attire and that of his sister were distinct. In this 1859 plate from *Godey's,* the boy's costume is evident by the pleated bosom shirt, open jacket, and short skirt.

examining photographs and engravings of children, the gender of many toddlers seems undefined. In many instances, boys were recognizable by their short cropped hair—although not always—but their dresses and accessories often appear virtually identical to that of girls. The four-year-old boy depicted in Figure 20-46 wears an outfit from 1859 that included a full skirt, lace pantalettes, embroidered Zouave jacket, sash, and straw hat with feathers and ribbons. Yet *Godey's* assured readers that this "outfit for boys" would "distinguish them from their sisters on the one hand, and from monkeys on the other." Among the subtle masculine differences that were quite distinct to Victorian parents were the pleated bosom shirt, open-front jacket, and the shortened hemline of the skirt.

Another category of fanciful ensembles for boys was the assorted adaptations of military garb. One of the earliest types of pretend uniforms was the sailor's outfit sometimes called the **Jack Tar suit**, variations of which endure still today. (Figure 20-47.) Costume tradition holds that the Victorian obsession with children's pretend uniforms began in 1846 when the five-year-old Prince of Wales boarded the royal yacht wearing a miniature replica of a white naval uniform. The portrait of the prince sailor was later painted by Winterhalter of which engravings were widely distributed. The little sailor suit was modified over the decades by new blouse and jacket styles and trouser lengths but the wide, square-back collar and assorted types of embellishments resembling naval insignia remained constant. Instead of white serge, though, navy blue wool or cotton was the most prevalent fabric.

Figure 20-47. Numerous types of military-inspired costumes were worn by boys throughout the second half of the nineteenth century. The most prevalent version was the sailor suit with its square-back collar and nautical trim. Left, illustration from *Harper's Bazaar,* 1879; right, illustration from *Delineator,* 1896.

The sailor suit was also adapted to versions for girls. Ready-to-wear makers mass produced sailor shirtwaists, called the **middy**, after midshipman, for everyday wear. From the 1880s through the 1930s, school girls wore variants of the middy with bloomers and short skirts for athletic activities.

Among other military-inspired ensembles for boys were the Highlander's kilt, Zouave jackets and trousers, and the Italian soldier's uniform called a Garibaldi suit. Although these specialty costumes had less wide appeal than the sailor suit, similar derivatives of military suits became the basis for innumerable school uniforms.

In addition to dresses, tunics, skirts, kilts, and military uniforms were variations of the cavalier or Stuart-inspired suit that came to be known as the **Fauntleroy suit.** Based on the outfit of the character in the children's book *Little Lord Fauntleroy* by Frances H. Burnett (1886), the fantasy suit was usually made of dark velvet or satin and was comprised of knee breeches with a satin sash, short jacket, wide falling-band collar, and wide cuffs. The look became an absolute mania in Britain and the United States for the upper bourgeois until around World War I.

REVIEW

In the second half of the nineteenth century, the evolution of fashion was affected by three significant developments. First was the emergence of the couturier as arbiter of fashion and style. Second was the continued specialization of ready-to-wear manufacturing with its rapid advances in technology and methods of production. Third was sales distribution, supported by mass marketing and advertising, which led to a democratization of fashion across virtually all social classes.

By the 1850s, these three socioeconomic changes were already well underway when the cage crinoline was introduced to women's fashion. Skirts had continued to widen throughout the 1850s becoming massive, bell-shaped expanses of fabric. To ease the burden of the skirt's weight, the hooped crinoline replaced layers of petticoats, allowing skirts to expand into their widest silhouettes in the 1860s.

Toward the end of the 1860s, the crinoline was discarded in favor of a bustle treatment of the skirt. The trend for large bustles prevailed until the late 1870s when skirts narrowed and decorative elements dropped low on the back. By the early 1880s, exaggerated horizontal bustles returned and remained the fashion until the end of the decade.

In the 1890s, fashion drama shifted from the skirt to the sleeves and shoulders. The leg-of-mutton form of sleeve reemerged in dimensions not seen since the gigot styles of 1830s. The mammoth sleeves, tightly constricted waistline, and the bell-shaped skirt combined to shape the hourglass silhouette that defines the decade.

For men, the comfortable outwear frock coat of the late eighteenth century became the daytime suit coat of the Victorian era worn with a top hat. Cutaway morning coats and tail coats became reserved for formal occasions. Innovative of the period was the sack coat with its loose, boxy fit. When combined with a vest, dress trousers, starched collar, and a necktie, the sack coat formed the business suit—a legacy surviving to this day. Among the subtle but significant and enduring changes to menswear of the period were pant creases, cuffs, and belt loop waistbands.

The variety of fashion categories for both men and women dramatically increased in the last quarter of the nineteenth century. Specialty sportswear included bathing suits and knickerbockers for sports activities like bicycling. Casual clothes such as the shirtwaist for women and the colorful, patterned sportshirt for men were widely adopted across all classes.

Girls' dress styles reflected the vicissitudes of women's fashions through the crinoline period, followed by the three phases of the bustle dress, and finally to the revival of the leg-of-mutton sleeve. Boys' attire was far more diverse, ranging from conservative replicas of their fathers' plain, dark suits to eccentricities of pretend military uniforms and fanciful cavalier costumes.

Chapter 20 The Nineteenth Century 1850–1900
Questions

1. How did Charles Frederick Worth alter the course of fashion production? What were some of the significant contributions Worth made to fashion styles of the 1850s and 1860s?

2. Which three business components drove the success of the ready-to-wear industry in the second half of the nineteenth century? How did each contribute to the democratization of fashion?

3. Identify the distinctions between the crinoline of the 1840s and that of the late 1850s. How did the crinoline silhouette change in the 1860s?

4. When and how did the transition from the crinoline to the bustle dress occur? Which were the three phases of the bustle dress silhouette? Describe the dress design elements of each phase.

5. Which three key elements of women's dress design formed the hourglass silhouette in the 1890s? How did the new forms of corsets contribute to the hourglass contours?

6. As Victorian women increasingly participated in sports activities, especially bicycling, what were some resulting innovations in clothing?

7. Identify and describe the three principal types of Victorian men's suit jackets that continued as standard styles from the Romantic Age. Which social protocols governed how and when each style was worn?

8. Identify and describe the innovative style of men's jacket introduced in the 1850s. Which two derivatives of the style became popular in the 1890s, and how did they vary in design from the prototype?

9. Which three common elements of today's men's trouser designs were innovative features in the late nineteenth century? What were the origins of these elements?

10. How was boys' attire more diverse than girls' wear? Identify and describe an example of each of the three categories of boys' suit styles.

Chapter 20 The Nineteenth Century 1850–1900
Research and Portfolio Projects

Research:

1. Write a research paper on the House of Worth. Trace the development of the salon from its inception through the end of the nineteenth century. Explain the significance of the House of Worth in its influence on fashion of the second half of the 1800s.

2. Write a research paper on the women's movements in America and Britain and their contributions to dress reform. Identify which advocacies of change in women's clothing had broad public support and which ones were viewed as eccentricities.

Portfolio:

1. Research the style and motifs of Art Nouveau and design a sketchbook set of matching women's accessories as they would have been worn in the late 1890s. The set should consist of: a brooch, belt buckle, hair comb, and purse.

2. Research the construction of a cage crinoline and reproduce a life-size model made of thin strips of posterboard for the hoops and paper or muslin for the connecting tapes. Demonstrate for the class how the cage crinoline was put on.

Glossary of Dress Terms

á disposition printing: a technique of fabric roller printing in which patterns were designed specifically for the edges of skirt flounces

aniline dyes: synthetic dyestuffs first developed in the 1850s

ascot: a wide, scarf-like cravat that filled the open neckline of the vest

basquine: a woman's fitted, long-sleeve jacket cropped at the fingertips

blazer: a variant of the men's sack jacket made with patch pockets and worn as casual attire, particularly for sports events

bloomers: women's long, baggy trousers named for Amelia Bloomer who wore them while on tour as an advocate for women's rights

boater: shallow, cylindrical straw hats worn by both men and women

bolero jacket: a woman's short, cropped jacket or vest, often with a rounded cutaway front

bosom: see breastplate front

boucle wool: a lightweight, furry-looking textile made with a raised nap

bowler: see derby

breastplate front (also shield front or bosom front): the front panel of men's shirts often made of fine linen and embellished with tucks or pleats; the slit closure usually fastened with two or three buttons

bretelles: a pair of decorative braces for women's bodices that attached at each shoulder and tied together at the waist

bust bodice: an early form of brassiere

bust improver: padding for the decollete bodice

cage crinoline: a petticoat reinforced with hoops of whalebone or watch spring steel

cavalier collar: a woman's collar designed as a high band that flared into a shallow roll similar to styles of the 1590s

Celluloid: a nineteenth-century type of plastic produced from cotton and cellulose

chesterfield topcoat: a men's or women's topcoat detailed with a velvet collar and a fly front that concealed the buttons

coachman's coat: a men's heavy overcoat featuring a fitted bodice, full skirt in the back, and large flap pockets

coat front shirt: men's shirts of the 1890s designed with a button front closure from the collar to the hem

collets: short, cape-like treatments for women's collars resembling the pelerine

combinations: women's underwear made with the camisole and drawers sewn together

corset waist: a form of corset that fully covered the upper torso and included breast support with shoulder straps

crinolette: a flat-front petticoat with steel half hoops of widening sizes top to bottom

crusher: low, round-top hat with turned-up, saucer-like brims; ironically named for its light three-ounce weight

cuirass bodice: a sheath-like bodice that fit tightly over the hips producing a long-line dress silhouette

deerstalker hat: a men's sports cap with-turned up earflaps

demi-saison styles: various transitional outerwear for men and women made of lightweight materials

denim: a heavy cotton twill named for the French serge de Nimes

derby: a men's round crown hat with a narrow brim; also called bowler

ditto suit: a men's three-piece combination of lounge jacket, vest, and trousers all made of the same fabric; also called lounge suit

dolman: a woman's short cape with wide sleeves

D'Orsay jacket: a later version of the sack jacket featuring a two-button closure and fingertip length

echarpe: a woman's collarless promenade cloak of taffeta or silk festooned with flounces and corded silk

Eton jacket: a woman's fitted jacket with lapels of a contrasting material and a straightline crop at the waist

Fauntleroy suit: a boy's velvet or satin suit that included knee breeches, short jacket and a wide falling-band collar

fedora: a men's hat with a high, conical crown with a deep crease front to back

French wrists: turned-back cuffs that fastened with cuff links

frise wool: a raised-nap fabric with a frizzy texture

gaiter boot: a style of men's and women's shoe made with leather vamps over the instep and toes and a fabric upper around the ankles

homburg: a shorter version of the fedora; named for a style adopted by the Prince of Wales after his visit to a hat factory in Homburg, Germany

Inverness cape coat: a men's heavy travel coat that included a circular cape that covered the shoulders and arms to the elbows

Jack Tar suit: a boy's or girl's sailor suit featuring a middy top and nautical trousers or skirt

jeans: denim workpants named after the "genes" or Genoese sailors who brought boatloads of the material from France

jersey: a women's or children's long-sleeve knit top that fit snugly over the hips

knickerbockers: knee breeches worn by both men and women for sports activities, especially bicycling and golf

leggins: high, buttoned spats worn by men and women over their shoes for sports activities

leghorns: wide-brimmed straw hats named for the type of bleached wheat straw used in their construction

lounge suit: see ditto suit

Marie Stuart collar: a high-standing collar that curled out into five points

middy: a square-collar sailor's shirt named after midshipmen worn by both women and children

moresco: a fringed shawl of silk moire cut short at the sides and shaped to a point in the front and back

mousquetaire sleeve: a close-fitting sleeve with shirring that formed deep, crosswise creases

mushroom puff sleeve: a tight, cylindrical sleeve capped at the shoulder by a shallow, flattened puff

nainsook: a woven striped cotton from India whose name means delight the eye in Hindi

Neapolitan: a smooth, horsehair fabric used for women's winter bonnets

Norfolk jacket: a men's loose-fitting jacket with an attached belt and double box pleats from shoulder to hem

oxford: a stout, low shoe for men and women, often designed with contrasting tones of material

pagoda sleeve: a style of sleeve cut with a narrow fit at the shoulder and upper arm and an abrupt flare at the elbow

pajamas (pyjamas in Britain): men's trouser sleepwear suit

pannier bustle: a thin, padded form of bustle worn with the narrow skirts of the early 1880s

pardessus: ladies' long-sleeve, fitted jacket with a finger tip length skirt; also a long cloak extending almost to the hem of the skirt with long, full sleeves

plastron: a woman's frilly lace neckpiece often embellished with ribbon bows

porte jupe Pompadour: a revival of the polonaise for crinoline skirts

porte-monnaie: a small clutch bag usually of cut velvet or tooled leather

Prince Albert coat: the name given to men's dressy frock coats of the last quarter of the 1800s

princess bodice: a style of dress made of one long piece (or long, gored pieces) from the shoulder to the hem with no waist seam

rainy-daisies: skirts with shortened hemlines worn for walking on rainy days or for sports activities

sack coat: a men's short coat cut to hang straight from the shoulder with no seam or tapered line at the waist

serge de Nimes: a heavy cotton twill from which the word *denim* was derived

shield front: see breastplate front

shirtwaist: women's blouses of various styles and fabrics

slop shops: early retail tailor shops specializing in ready-made clothing for men

snood: chenille or silk cord hair net

talma: a woman's short, bell-shaped cape with slits for the arms and a front closure that fastened with frogs or braid

toreador: a narrow four-in-hand necktie knot

torsades: hair ornaments of ribbons twisted or plaited with cording and other ornaments

tournure: a bustle frame of steel, duck, tapes, and laces worn in the mid-1880s

turkish trouser: a form of women's trousers from the mid-1800s featuring voluminous legs fastened at the ankles

tuxedo: a version of the men's sack jacket that incorporated elements of the dress coat such as satin lapels; named for New York's Tuxedo Park Club

ulster: a capacious overcoat for traveling and lengthy stays outdoors in winter; versions for both men and women sometimes included hoods or capes

union suits: one-piece underwear for both men and women; so named for the union of the top and drawers

veston: a shortened version of the men's boxy, square-cut sack jacket

waists: another name for shirtwaists; see shirtwaists

Zouave jacket: military-inspired jackets for women and children featuring braid and appliques resembling military insignia

Legacies and Influences of Late Nineteenth-Century Styles on Modern Fashion

Although nineteenth-century hooped petticoats, polonaise bustle treatments, and leg-of-mutton sleeves were revivals of earlier forms, modern designers often refer to the styles in terms that conjure notions of Victorian precedence, such as "Gibson Girl" sleeves or "Gone With the Wind" hoops. In addition to modern crinolines, numerous varieties of bustle treatments and gigot sleeves have repeatedly reappeared since the First World War. Similarly, women's bloomers and knickerbockers—radical innovations in the 1800s—continued as functional sports attire in the early twentieth century, and later, as high fashion looks. But a far more popular and enduring influence from the Victorian era has been the application of jersey knits to casual and dressy fashions for both women and men.

For modern men, the fashion legacy of the nineteenth century is even more pronounced. The fundamental design of the loose, boxy sack coat of the 1850s has remained constant ever since its introduction. Only details such as lapel widths, collar designs, and pocket treatments have been subtly modified periodically to suggest a newness. Cousins of the sack coat, the blazer and dinner jacket (tuxedo), have been virtually standardized for more than a century. Other garments like the norfolk jacket and golf knickers endured well into the 1950s. Variants of the norfolk jacket reappeared in the 1960s as the safari coat and 1970s as the leisure suit jacket. Still other menswear changed in protocol but little in design, such as Levi's jeans—once the sturdy work pants of ranchers and cowboys but, in the twenty-first century, seen in Fortune 500 company offices on "casual Fridays."

Left, embroidered gown with gathered bustle by Ande Kim, 2008; right, lace and silk jacquard gown with flounced bustle by Jessica McClintock, 1987.

Top, gown with leg-of-mutton sleeves from I. Magnin, 1937; bottom, quilted peplum jacket with leg-of-mutton sleeves by Scott McClintock, 1988.

The elegance of a wide crinoline skirt and its opulent use of fabric have repeatedly inspired fashion designers to revive the style throughout the modern era. Taffeta flounced gown by Adrian, 1948.

Jersey knitwear evolved into a variety of dressy and sports wear for both men and women. Left, rib knit jersey top and skirt by Bradley, 1937; right, knit jersey shirts by Van Heusen, 1957.

Some forms of Victorian styles of menswear, such as knickers and the norfolk jacket, endured well into the second half of the twentieth century before losing popularity. Left, knicker suits by Bruner Woolens, 1928; right, norfolk jacket of herringbone tweed by Krafft and Phillips, 1937.

Chapter 21

THE TWENTIETH CENTURY
1900–1920

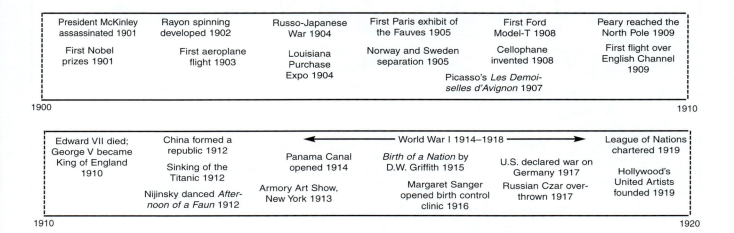

1900					1910
President McKinley assassinated 1901	Rayon spinning developed 1902	Russo-Japanese War 1904	First Paris exhibit of the Fauves 1905	First Ford Model-T 1908	Peary reached the North Pole 1909
First Nobel prizes 1901	First aeroplane flight 1903	Louisiana Purchase Expo 1904	Norway and Sweden separation 1905	Cellophane invented 1908	First flight over English Channel 1909
			Picasso's *Les Demoiselles d'Avignon* 1907		

1910					1920
Edward VII died; George V became King of England 1910	China formed a republic 1912	←———— World War I 1914–1918 ————→			League of Nations chartered 1919
	Sinking of the Titanic 1912	Panama Canal opened 1914	*Birth of a Nation* by D.W. Griffith 1915	U.S. declared war on Germany 1917	Hollywood's United Artists founded 1919
	Nijinsky danced *Afternoon of a Faun* 1912	Armory Art Show, New York 1913	Margaret Sanger opened birth control clinic 1916	Russian Czar overthrown 1917	

THE EDWARDIAN ERA

In January 1901, Queen Victoria died. Her successor, the Prince of Wales, became Edward VII, for whom the first decade of the twentieth century was named. The new king was an amiable, portly man, whose life had been spent indulging in gambling, dalliances, and fashionable pursuits. After decades of somberness and stifling formality during Victoria's forty-year widowhood, the British court was revitalized by Edward with a cheerful emphasis on social life and fashion. His consort, Queen Alexandra, was a tall, slender beauty whose every public appearance showcased fashions of the era.

Edward had inherited a Britain that was still the world's greatest naval power. The nation's imperial reach extended over every continent of the world and included India, Canada, Australia, and vast sections of Africa. This empire was cause of much jealousy from other European countries and resentment by many nationalists in the lands over which England held dominion.

During the last quarter of the 1800s, France and Germany asserted themselves on the world stage with colonial acquisitions through conquest, commercial investment, and political concessions and treaties that allowed them to compete globally with Britain. The subterfuge and crises that arose from these international military and economic ventures laid the path to the First World War.

In Germany, young Kaiser Wilhelm II led the way in overcoming political resistance to economic growth and industrialization on a national scale. As in Britain and the United States, private enterprise was encouraged, financed

Map of Europe after World War I

by a strong banking system. The education of German children emphasized technology and industrial vocation so that, by the beginning of the 1900s, Germany had caught up with Britain and the United States as a world leader in the progress of science- and technology-based industries. Politically, though, Germany was governed by an elitist minority of aristocrats and industrialists whose international blunderings hurtled the country toward its disastrous fate in 1914.

France, on the other hand, struggled with internal instability as the Third Republic continued to confront right-wing monarchal constituencies. During the Dreyfus Affair in the 1890s, the French right and the Catholic Church supported a military leadership that tried to cover up a scandal in which officers had forged and concealed evidence in the conviction of a Jewish army captain wrongly charged with espionage.

The republicans used the nation's sense of outrage at the miscarriage of justice as a catalyst to suspend participation of the Church in government and to wrest supervision of the educational system from religious control. Anti-clericism dominated France's domestic agenda in the early 1900s, leading eventually to the confiscation of Church property and the irrevocable separation of Church and state.

The reform efforts were a significant drain on France's political energies, impeding the nation's efforts toward an industrial parity with the United States, Britain, and Germany. Although France's status was unsurpassed as producer of the world's finest luxury goods—couture fashion, textiles, furniture, perfume, cosmetics—there was minimal interest in developing large manufacturing operations until World War I.

The Changing Role of Women

During the early 1900s, technology, mass production, and consumerism had a profound impact on the role of women in industrialized nations. Electric home appliances eased the labor of housework, affording women more leisure time. Manufactured food products conveniently packaged in bottles, jars, cans, and cellophane-wrapped boxes reduced the time spent in the kitchen. Household cleaning products became more specialized and efficient, ranging from granulated laundry soap powder to cleansers just for the toilet bowl. (Figure 21-1.)

The truest form of freedom for women, though, was financial independence. For the overwhelming majority of the female populace of industrialized nations, financial independence was achieved through the increasingly greater opportunities for employment. During the last quarter of the nineteenth century, the mechanical typewriter caused a restructuring of office work as more and more women were hired as operators of the newfangled equipment. Other technologies such as the telephone switchboard provided work and income for women. During the First World War, millions of women confidently went to work outside the home in all sorts of heavy industry and services once thought solely the domain of men.

Politically, suffragettes in Europe and America redoubled their efforts for enfranchisement. In addition to massive parades and marches, suffragists resorted to civil disobedience, including handcuffing themselves to the White House fence, to keep up the pressure. In the United States, only two states had granted women the right to vote by 1900 so suffragists coordinated their efforts for a drive toward a constitutional amendment. Twenty-one other nations had already enfranchised women by the time the United States finally adopted the Nineteenth Amendment to the Constitution in 1920, granting American women the right to vote.

As the political and economic climate changed for women, so too did society and culture. Colleges and universities began to admit women into science and technology programs that had been the exclusive bastions of men. Women entered the public sports arena, competing in all forms of intramural events including, for the first time, swimming at the Olympics in 1912. Sex education and methods of birth control were made available at the clinics founded by Margaret Sanger. Movies, magazines, and advertising besieged women of all socioeconomic classes with images of the modern, fashionable woman. By the 1910s, it was no longer the painted ladies of questionable reputation who reddened their lips and cheeks, and accented their eyes with kohl. The demure, reclusive alabaster lady of 1900 metamorphosed into an independent, self-confident woman of the high-tech, fast-paced "moderne" era in less than a generation.

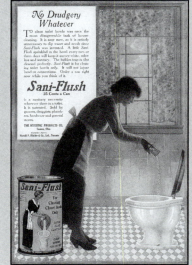

Figure 21-1. Advances in technology and mass production provided the modern woman of the early 1900s with conveniences throughout the home. Electrical appliances eased burdensome tasks, and manufactured products reduced time and effort in food preparation and household cleaning.

The United States at the beginning of the twentieth century found itself as an imperial power following territorial cessations from Spain in 1899 that included the Philippines, Guam, and Puerto Rico. The continental expanse forged by Manifest Destiny throughout the nineteenth century had been carved into forty-five interlocking states stretching from coast to coast. At the dawn of the twentieth century, the nation's population was seventy-six million, of which almost a third were immigrants who had arrived in the years since the Civil War.

America had embraced the Industrial Revolution and thrived on the newness of technological advances. In the years before the First World War, the wider availability of electricity coupled with manufacturing mass production and mass marketing broadened the consumer base with affordable labor-saving devices for the home. The automobile, too, became more accessible to ordinary folk when Henry Ford began mass production of his Model-T in 1908, eventually providing Fords priced less than $500. In addition, a new buy-now-pay-later concept called the finance installment plan made such high-end goods as cars and home appliances more available to the masses. Fashionable advertising campaigns by auto manufacturers, especially marketed to the modern twentieth-century woman, greatly appealed to their continued aspiration for independence and mobility. (Figure 21-2.) Telephone wires spread across the country, connecting businesses and reaching into ever more homes. In North Carolina, the Wright brothers successfully flew the first aeroplane in 1903. A few years later, a group of creative film makers moved to a sleepy little town in California called Hollywood to establish a new industry there.

Elsewhere in the world, the stagnant, autocratic government of imperial Russia spawned a revolutionary movement that would eventually topple the czarist regime. In Asia, colonialist Europeans destabilized the Chinese imperial government causing its collapse and the birth of the Republic of China in 1912. Japan came to dominate Korea after defeating Russia in a territorial war in 1905.

THE WORLD AT WAR

The road that led to the First World War (1914–1918) was paved by decades of European jealousies, rivalries, and dynastic resentments: France's surrender of territory and loss of its 200-year supremacy in Europe following the Franco-Prussian War in 1870; the growing pains of nationalism in Germany, a newly unified nation in 1871; political maneuverings in the Balkans by Russia and its rival, the Austro-Hungarian Empire; the naval arms race with Britain, which expanded beyond the emerging European powers to include Japan and the United States.

The powder keg finally exploded in 1914 when the heir to the Austro-Hungarian throne was assassinated in Serbia. An outraged Vienna government declared war on the tiny

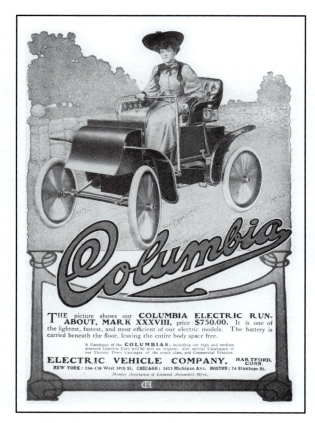

Figure 21-2. Early automobile manufacturers targeted women in advertising campaigns with the promise of mobility, freedom, and modernity. Columbia ad, 1903.

Balkan principality setting off a chain reaction of conflict all across Europe. Russia mobilized its army to aid its Slavic ally, Serbia. Germany became alarmed at a perceived military threat on both its eastern border by Russia and its western border by long-time enemy, France. The Kaiser decided to knock France out of the war early and then deal with Russia. Germany marched on France through Belgium, whose neutrality had been assured by treaty with England, then drawing the British into the war on the side of France. Germany was halted by Allied forces just inside the northern French border, and the war settled into a deadly trench warfare for the next four years in which less than ten miles of devastated landscape repeatedly changed hands.

The United States managed to remain neutral until 1917 when Germany declared that all merchant ships entering waters blockaded by the Allies would be subject to submarine attack. After the United States lost four unarmed ships to German U-boats, America declared war and joined the Allies.

Most Americans had been sympathetic to the British and French anyway, pouring millions of dollars in aid to war causes. The Allied propaganda drive in the United States had been highly successful, spreading reports and rumors of

a wartime Wooltex ad. Similar messages repeatedly filled editorials of the fashion press.

Despite all the restrictions and limitations with materials, labor, shipping, and finance, Paris couturiers continued to produce collections on time each season throughout the war. Although some designers, notably Poiret and Molyneux, closed their salons and enlisted in the military, the other houses did all they could to provide for the export demands. A French correspondent for *Vogue* wrote in 1918, "The manufacture of materials and articles of luxury is so very much on the decline that we must watch over it and support it in every possible way. This is a national duty." Even though there were movements in the United States and England to take this opportunity to establish their own couture industry, all eyes around the world still turned to Paris for fashion direction, and the mass media continued to report excitedly on the French collections.

In the first years after the war ended, couturiers seemed uncertain how to design for the modern, postwar woman. Shortages persisted as industries converted to peacetime manufacturing and international trade recovered, so designers continued to face limited options with fabrics and materials. Skirts varied widely in width and shape as well as in length—from mid-calf to just at the ankles. All sorts of panniers, hoops, and bustle treatments were tried. Waistlines were more confusing than ever, ranging from the raised Empire line to the dropped "Oriental" line just below the hips, and several points in between. (Figure 21-12.) Attempts were made to revive the constricting corset, but women overwhelmingly refused them. Poiret failed to connect with the new woman and repeatedly tried to revive styles that were richly ornamented casings of the body, which were rejected by all but the nouveau riche.

Although some women were ready for a return to the glamour, indulgence, and femininity of prewar fashions, by and large, most women of the postwar years wanted modernism—clothes with comfort and ease, and a look that was a clear departure from the frilly, corseted Edwardian or hobbled styles. A few designers—Molyneux, Patou, and Chanel, in particular—were forward thinking enough to focus on the straight, simple chemise that would be the prevalent look of the coming decade.

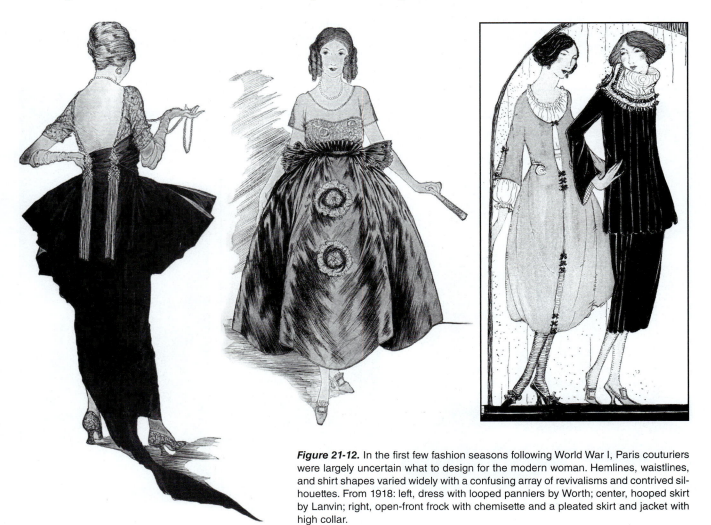

Figure 21-12. In the first few fashion seasons following World War I, Paris couturiers were largely uncertain what to design for the modern woman. Hemlines, waistlines, and shirt shapes varied widely with a confusing array of revivalisms and contrived silhouettes. From 1918: left, dress with looped panniers by Worth; center, hooped skirt by Lanvin; right, open-front frock with chemisette and a pleated skirt and jacket with high collar.

WOMEN'S OUTERWEAR 1900–1920

Outerwear for the Edwardian woman was shaped and ornamented much differently than dresses. The **covert coat** frequently featured in magazines and catalogs of the period was a loose-fitting, three-quarter overcoat made of twill (covert) wool. The look was masculine and usually plain without the typical Edwardian decorative trim. Coats that covered the entire skirt to the ground were less popular since a brush-down of the hem to remove mud and dust could take as much as an hour after each wearing as opposed to an easily laundered skirt. Jackets, capes, and cloaks of varying lengths were equally popular. Capes were often richly decorated with ornamental top-stitching, embroidery, or passementerie. Wide **collarettes** in the fashion of the dog-collar look of the era were often attached to coats and capes for an extra layer of warmth over the shoulders.

Also during the early years of the twentieth century, long, durable coats, called **dusters**, made of rubberized cotton duck or twill were worn for sojourns in open automobiles. Natural-colored silk serge was another favorite fabric for motoring costumes. Leather jackets with matching goggles and visored chauffeur's hats were more preferred by younger women.

In the second half of the Edwardian period, Orientalism was all the rage. Kimono style coats and capes constructed with full, T-cut sleeves were an influence from the East following the victory of Japan in its war with Russia.

By the beginning of the 1910s, coats narrowed in keeping with the trend of the hobble skirt. Most outerwear was designed with an unmarked waistline. Hemlines were more varied than a few years earlier, ranging from just above the knees to ankle length. Decorative treatments were minimal. Wrap coats became the fresh trend just before World War I, especially styles with cutaway tulip hemlines.

When skirts widened during the war, coats were cut full and loose to accommodate the new silhouettes. Military accoutrement such as epaulets, braid, oversized patch pockets, and gauntlet cuffs were adapted from menswear. When dress hemlines began to rise, coats were cropped shorter as well, usually a few inches above the skirt edge. Quilted hoods were revived from the previous century. Since buildings were often unheated and women had to walk more due to a shortage of taxis, the use of fur increased during the war years—including an abundance of pelts from opossums, foxes, and other more common varieties. Similarly, as wool became scarce for civilian clothing, heavy cotton corduroy was commonly used for coats and jackets.

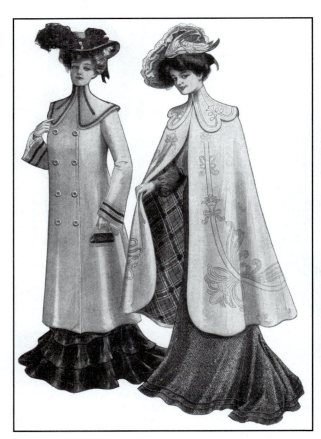

Coat and cape from *Delineator*, 1902.

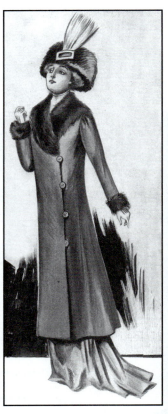

Wool coat with fur collar and cuffs, 1909.

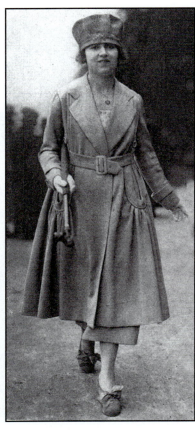

Wartime coat, 1916.

WOMEN'S SPORTS APPAREL 1900–1920

As noted in the previous chapter, by the end of the nineteenth century, women of all classes had loosened their corsets and shortened their skirt hemlines to participate in all sorts of sporting activities. One of the first specialized sports costumes for women, besides swimsuits, had been the knickerbocker suit, worn primarily for bicycling, hiking, and canoeing. During the Edwardian era, athletic women appreciated the freedom of knickerbockers and continued wearing versions of them.

In the years just before World War I, women of the leisure classes began to play polo, which, unlike hunting and jumping, required them to ride astride the horse. Although some equestrian costumes had begun to include jodhpurs just after the turn of the century, they were almost completely hidden by long jacket skirts extending to the ankles. By the early teens, though, some jacket hemlines had been cropped to mid-thigh for the polo equestrienne.

Another specialized sports costume that continued into the twentieth century from the late Victorian period was the one-piece gymsuit, comprised of a jumper top and knee-length bloomers. A variation was the middy blouse worn with separate bloomers. Gymsuits were largely a school uniform for girls and college women active in intramural sports.

For the most part, though, women participating in sports wore looser fitting versions of day clothes. Strenuous activities such as golf, tennis, bowling, and skating (both ice and roller) were especially challenging to women's skill levels since they had to contend with volumes of skirt fabric encumbering the legs as well as layers of undergarments, thick stockings, accessories, and even "sports" corsets. Vented jackets, box-pleated norfolks, and slit skirts provided some relief from the constriction of fashionable clothing for the female athlete.

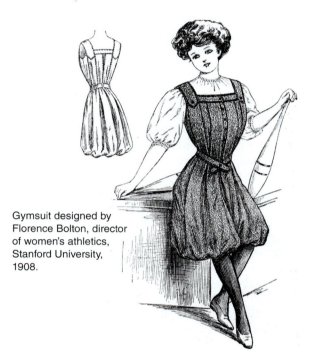

Gymsuit designed by Florence Bolton, director of women's athletics, Stanford University, 1908.

Wool flannel sports dress, 1905.

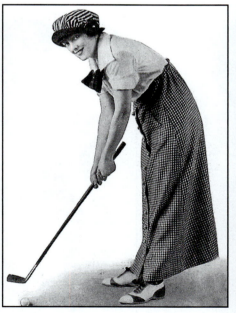

Cotton short-sleeve blouse and gingham skirt, 1916.

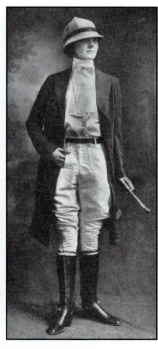

Polo togs: doeskin breeches, long cheviot coat, and silk shirt, 1915.

WOMEN'S UNDERWEAR
AND SLEEPWEAR 1900–1920

Corsets of the Edwardian era were more than just an undergarment, they defined the silhouette of fashion. The S-bend corset, commonly advertised as the "health" corset, was engineered to reduce the binding stress on the internal organs caused by the hourglass Victorian styles that were indented at the waist all around. Although the S-bend was made with a straightline front, it nevertheless continued to constrict the waist. Moreover, the S-bend further contorted the body into a kangaroo stance by pushing the torso forward into a pouter pigeon contour and thrusting the hips back almost at a pronounced angle.

By the end of the Edwardian period, corsets were once again dramatically redesigned to an upright construction with less constriction of the waist. The lines were longer, extending low over the hips, and more narrow with an emphasis on a youthful-looking, slim figure—a significant change from the ideal looks of the curvaceous, full-figured, mature woman of earlier years.

In the early part of the twentieth century, a decently dressed woman had to layer two or three petticoats beneath her skirt. During the early years of the first decade, undergarments became exceedingly frilly, especially petticoats. Hemlines were laden with flounces, pin-tucks, ruffles, ruching, and lace trim. When the hobble skirt dispensed with the petticoat, froufrou treatments of underwear were also minimized. Only when skirts became full again during World War I were petticoats revived to the extent they had been during the Edwardian years.

Drawers, camisoles, and chemises were the other most common components of women's underwear. Victorian styles of combinations—a camisole and drawers sewn together in one piece—continued to be worn but became particularly prevalent after skirt silhouettes narrowed and bulky underwear was abandoned. Long union suits were favored more by ordinary women until the early war years when skirt hemlines rose. **Camiknickers**, or **chemiknickers** in England, were a sort of short slip with a button and loop at the hem that could be fastened between the legs to form a divided underskirt.

As the tops of corsets were cut ever lower in the front between 1900 and 1910, a camisole-type of the **brassiere** became a more comfortable and practical alternative to the Victorian bust improver or bust bodices. The first designs constructed specifically with an articulated support for the bosom were patented in the mid-1910s.

Sleepwear for the Edwardian lady was primarily the silk princess style nightgown, or **negligee**, and matching robe, called a **wrapper** or **dressing sacque**. The simple nightshirt of linen, flannel, or cotton was preferred most by ordinary women. Throughout the early years of the period, nightgowns were as extravagantly trimmed with lace, ribbons, ruffles, and flounces as undergarments. Although women's pajamas were available by the late Victorian years, the style only became widely adopted during World War I when large numbers of women experienced the comfort of overalls and trousers while working outside the home.

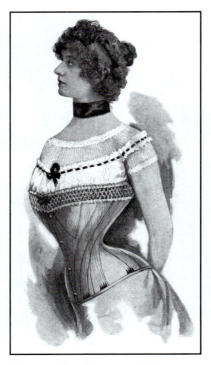

S-bend, or "health" corset, 1900.

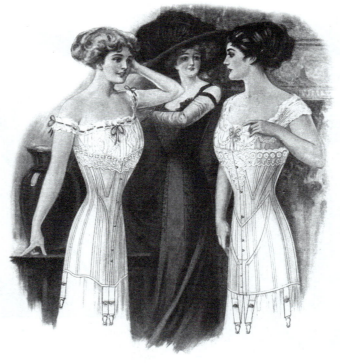

Upright, longline corset, 1910.

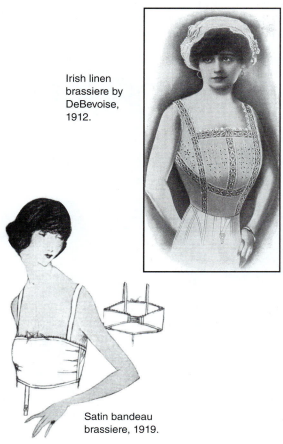

Irish linen brassiere by DeBevoise, 1912.

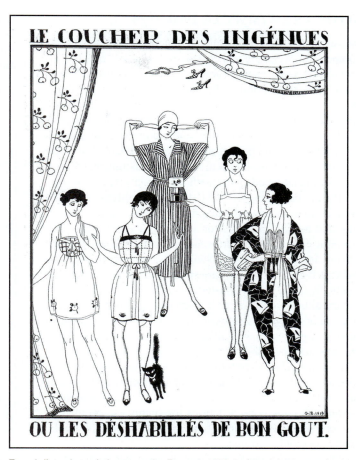

French lingerie and sleepwear by Premet, 1919. Left to right: two embroidered chemises, striped silk "travelling" nightgown, satin camisole, and print pajamas.

Satin bandeau brassiere, 1919.

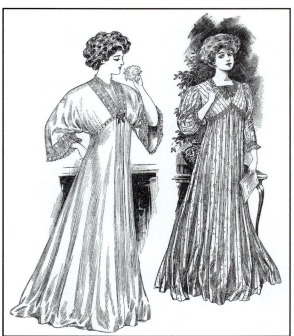

Empire revival wrappers of chambray and silk by *McCall's* patterns, 1907.

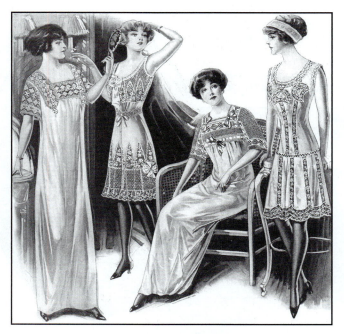

Chemises and combination drawers of nainsook and Cluny lace, 1912.

WOMEN'S SWIMWEAR 1900–1920

The swimsuits of the Edwardian woman varied little from the bloomer suit styles that first appeared at resort beaches almost twenty years earlier. Tunics and overskirts still extended to the knees covering voluminous bloomers, and thick, opaque wool or silk stockings covered the legs. Bodices were the most daring with short sleeves and deep scoop or V-neck decolletes exposing flesh to the sun and to masculine gazes. The most significant design change was the adaptation of the S-bend silhouette, usually achieved by a waistline that dipped to the front and a bodice cut with the pouter pigeon contour.

By the beginning of the 1910s, the proliferation of affordable, mass-produced autos made weekend excursions to lakes and beaches possible for a broader spectrum of socio-economic classes. Ready-to-wear makers tapped into the new demand for beachwear and swimsuits, producing inexpensive knock-offs of chic couture styles seen at the fashionable resorts. In 1912, *Vogue* insisted that it was "absolutely compulsory to have a bathing suit as charming and becoming as an evening gown." Swimwear overskirt designs became as varied as day dresses with all the complexities of cut and line. The new narrow silhouette of dresses was also adapted to swimwear, forcing a reduction in the volume of bloomers although skirt hemlines remained at the knees and bodices were still sleeved. At the same time, colorfast silks and taffetas were the most popular fabrics for swimwear. Women on the Continent even began to scandalously appear on public beaches without stockings.

During the First World War, women adopted various forms of men's trousers for work clothes, sleepwear, and swimwear. The sleeveless jersey tunic and cropped trunks that had been a standard swimsuit for men for decades were appropriated by women with little modification for a feminine fit or decorative treatments.

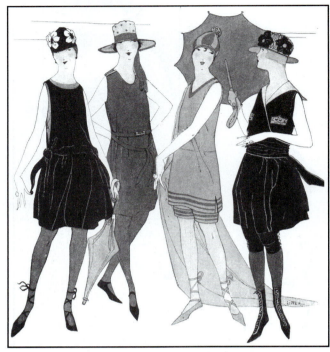

Women's swimwear, including menswear styling, from Bonwit Teller, 1917.

Edwardian swimsuits were comprised of a blouse, skirt, knickerbockers, opaque hose, and canvas shoes. Left, from *Harper's Bazaar,* 1902; right, from *McCall's,* 1908.

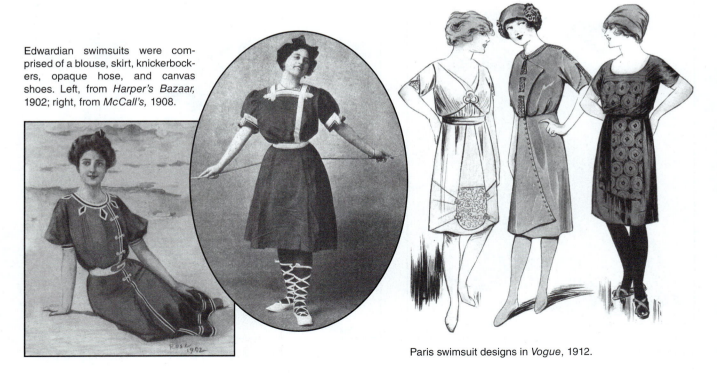

Paris swimsuit designs in *Vogue,* 1912.

WOMEN'S SHOES 1900–1920

In 1902, *Harper's Bazaar* noted that women's shoes had changed significantly from the "flat, broad" styles of the preceding years. "The heels are so much higher, there is so much more curve under the instep, and the toes are so much more pointed." These new contours of the Edwardian woman's shoes would remain the prevalent shape—or the **last** as it was commonly called in editorials—until the First World War. The high arched insole, sharply pointed toe, and high heel (at about 2 to 2 1/2 inches) were applied to all styles of shoes except utility footwear such as riding boots.

The ankle boot remained the most common form of street shoe. As with nineteenth-century versions, they were made of leather or with the high tops of stiff, waterproof fabric stitched to leather vamps. Both lace-up and button styles were equally popular. Following the Spanish-American War, the Cuban heel became a favorite alterative to the ogee-curved Louis XV heel. The thicker Cuban heel with its beveled slant looked sleek and modern. Pumps of satin or velvet were still the proper shoe for eveningwear. For utilitarian purposes, such as riding, hiking, or other similar activities, the design of tall boots with wide comfortable soles, low heels, and sturdy, thick leather uppers remained constant.

Shoes of all types were predominantly black, except in summer when white and pale neutrals such as sand or mushroom were acceptable. Even so, *Harper's Bazaar* further advised in 1902 that "shoes made of the same material as the dress are charming for evening wear and to wear with tea gowns." Satin, velvet, and suede shoes were dyed the soft colors favored for dresses and visiting suits in the first decade of the century: dusty blue, rose, mint green, and pale ecru. Poiret's influence changed this penchant for pale hues when he introduced shoes and hosiery of vibrant colors in the early teens. Women in the vanguard of fashion then slipped into shoes of jeweltone colored satin or kid.

Shoe ornamentation was minimal—punched overlays, instep straps with light beading or embroidery, and simple buckles, bows, or rosettes. The more flashy ornamentation such as rosettes of silvery tulle or chiffon were usually only for house shoes and boudoir slippers.

As hemlines rose, shoe makers began to offer more varied designs and colors of shoes. By the early 1910s, pumps were increasingly more common for street wear than ankle boots except in inclement weather although the high-top button shoe remained common into the early 1920s. For street pumps, the vamp was usually high, covering the instep to the ankles with a tongue for lace-ups or a variety of strap treatments for buckle styles. For eveningwear, pumps were cut lower with a throat opened to the toes and even pierced sides. In 1917, *Vogue* noted with a play on words that "the last is the first in footwear . . . slim and squared at the tip is the new last." The sharply pointed toe that had continued since the beginning of the century was now reshaped with a subtly chiseled square tip.

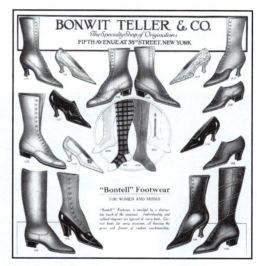

Bontell pumps, street shoes, and boots featuring Louis heels, Cuban heels, and low or flat heels, 1917.

Walking shoes with low or Cuban heel, 1907.

Edwardian dress pumps, 1908.

Sport shoes by J & J Slater, 1918.

WOMEN'S JEWELRY 1900–1920

For women of the Edwardian age, the most popular types of jewelry were the richly detailed and ornamental looks that their Victorian grandmothers had worn. In 1907, *Vogue* advised readers that the Rococo styles of Louis XV jewelry added "the very most up-to-date air to one's costume," and "to be in the mode one should have these little trinkets among one's accessories." In addition, jewelry with a distinct look from the distant past or distant lands remained as popular as in the nineteenth century. When the affluent went on their European Grand Tours, they purchased varieties of jewelry with motifs from antiquity such as Roman cameos, Greek coin busts, and Egyptian scarabs. In addition, the Art Nouveau trend remained a powerful influence on all the decorative arts, including jewelry design, well into the 1910s.

Costume jewelry makers such as Whiting & Davis, Trifari, and Napier mass produced high-quality adaptations of fine jewelry that were widely distributed through mail-order and five-and-dime retailers. In considering the degree of quality of some costume jewelry, *Vogue* suggested in 1907 that the new "imitation jewels are quaintly and artistically set, which for wear with the pretty light frocks in summer seem much more appropriate than the costly gems used with elaborate costumes."

In the pre–World War I years, a favorite jewelry style was the lustrous look of seed pearls in aggregate forms. Another popular trend was with the exotic Eastern motifs made with colorful stones or enameling—an influence from Poiret's vividly hued fashion designs. By the second half of the teens, jewelry began to reflect the influences of art movements such as the Jugenstil in Germany and the Viennese Secession—precursors of the art deco style of the twenties. Jewelry was scaled down in size compared with Edwardian pieces, and designs were geometric and clean-edged.

Seed pearl jewelry from Frederic's Jewelers, 1912.

Edwardian jewelry design was a pastiche of Victorian neo-styles mixed with the modern look of Art Nouveau. Ad 1902.

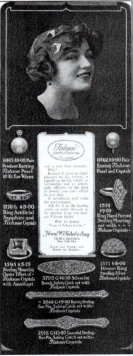

The streamlined, geometric jewelry of the late 1910s presaged the art deco styles of a few years later. Ad 1918.

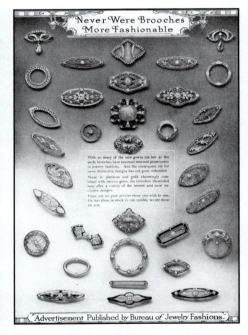

"With so many of the new gowns cut low at the neck, brooches have assumed renewed prominence in jewelry fashions," advised this 1915 ad from the Bureau of Jewelry Fashions.

WOMEN'S HAIRSTYLES AND MAKEUP 1900–1920

For the woman of the early 1900s, the Victorian cult of hair remained firmly in place. A woman's hair was her glory as haircare product advertising emphasized with its images of women displaying long, thick tresses that extended down the back to the hips or even longer. When a woman was not satisfied with the length or volume of her natural hair, she could attach any variety of hair pieces to achieve the desired effect. Horsehair pads could also be concealed under a woman's hair to add dimension and shape to hairstyles, especially for the **pompadour**, which was a high, bouffant arrangement with a chignon at the back.

By the early 1910s, some French and English women in the vanguard of high fashion began to experiment with short hairstyles. American women lagged behind in escaping the Victorian cult of hair. The compromise was the much reduced pompadour and other coiled or knotted arrangements that kept the hair up off the neck and shoulders. When fashionable stars of the cinema picked up the trend of short hair and appeared in contemporary-themed films, women around the world adopted the modern looks. During the First World War, practical needs inspired many women working in factories to shear off lengthy locks for convenience and safety needs.

The use of makeup likewise underwent a pronounced transition from the early Edwardian period through the war years. At the beginning of the century, the social stigma of the painted lady persisted from the Victorian era, and only an actress or a demimonde brazenly appeared in public wearing makeup. The ideal was the alabaster lady with pale, flawless skin. Soap and cold cream manufacturers advertised specialized products that would "assist nature" by "improving bad complexions" and "preserving good complexions," as one 1902 Ingram's facial cream promotion avowed. When soaps, skin creams, and genetics failed to result in a smooth complexion, the application of a little rice powder, sometimes tinted, or facial powders made with talc or chalk was acceptable in polite society. U.S. manufacturers produced such excellent quality vanity products, including fragrances, that *Vogue* advised readers in 1907: "Once, all the world turned to Paris for toilet things, as well as for shoes. Now both these things manufactured in America are often preferable."

In the early 1910s, though, social mores began to change toward makeup. Movies exalted women made beautiful and glamorous with eyeliner, eyeshadow, cheek rouge, and lipstick. Five-and-dime department store chains like Woolworth's began to stock a wide assortment of makeup that office girls and salesclerks could afford. By the end of the Great War the use of makeup was so pervasive that women felt at ease to touch up their lipstick or face powder in public, previously a private function of the boudoir toilette.

Pompadour hairstyles in *Ladies' Home Journal,* 1905.

Lablache face powder in "flesh, white, pink, and cream tints," 1900.

A 1918 Rigaud's ad included lipstick and the purse compact.

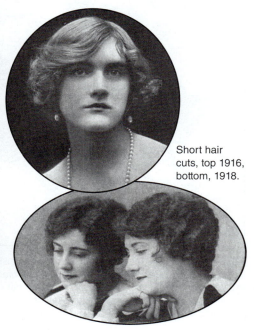

Short hair cuts, top 1916, bottom, 1918.

WOMEN'S HATS 1900–1920

To most women of the first half of the twentieth century, the hat was the most important fashion accessory. "A question which occupies our attention at the beginning of a new clothes season," wrote a fashion editor in 1918, "is the question of hats. This problem is even more important to us than that of gowns." A hat was a statement of social status for some women and, for others, an expression of personality or even mood. In 1902, *Harper's Bazaar* noted, "Every season the fashions show more and more that individual tastes and individual looks are to be consulted in headgear. One shape may be becoming to the majority of faces, and is consequently dubbed the leading style, and is of course copied in various modified designs, all built on the same principles, but each hat is altered to suit each wearer." The alterations that the Edwardian woman considered were not markedly different from the choices her Victorian mother had to make—the right hat for the season, the climate, and, of course, her own taste.

The hat styles of 1900 to 1910 gradually expanded in size from the compact models of the previous decade to scales not seen since the eighteenth century. Pompadour

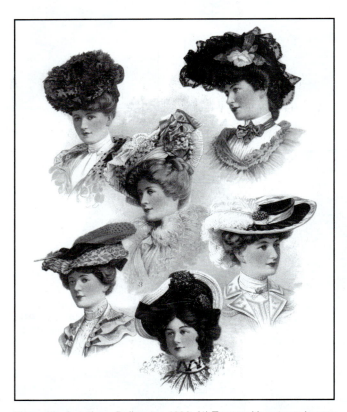

Edwardian hats from *Delineator*, 1902. (1) Toque with autumn leaves and berries; (2) velvet hat with Chantilly lace; (3) braided satin edged with lace encircling a wire frame; (4) low crown hat edged with fancy felt and accented with a plume; (5) girl's hat of braided felt with matching felt cabochons; (6) picture hat with ostrich plume affixed by a pearl cabochon.

hairstyles added further dimension for an even more impressive silhouette. The assortment of hat designs was enormously varied. Wide-brimmed picture hats were particularly popular with younger women. One of the newest looks of the period was the **Mercedes toque** that featured a circular crown with a brim turned straight up the same height as the crown. Hat revivals included the "Marie Antoinette turban" and the eighteenth-century tricorne. Straw hats, including the enduring boater, were not worn before mid-April unless travelling to a southern climate in winter.

All dressy hats of the period were lavishly decorated with an excess of Edwardian frills such as ribbons, rosettes, feathers (and entire stuffed birds usually referred to simply as "wings"), artificial fruit, silk flowers, lace, chiffon swags, beading, and all manner of other trim. Ornaments included long hat pins with decorative ends and **cabochons**, which were large, rounded clasps used to hold the ends of feathers or ribbons to the hat.

From the end of the first decade through the early 1910s, hats reached huge proportions. The massive sizes also changed the fit so that, as *Vogue* observed in 1912, brims seemed to "brood low and darkly over the face." A cartoon of the time suggested that milliners cut eyeholes in the descending brims for practicality. As the shapes became larger, the decorative treatments likewise increased in size and quantity. Enormous bows spread across picture hats, feathers cascaded down the back or towered upward, and turbans were piled high with volumes of fabric and trim.

During World War I, hats were much reduced in size and decoration. "Doubtless it is the war," commented an editor upon seeing the "frugal trimmings" of Paris hats in 1915. Instead of mass and piles of trim defining the contours of hats, designs of the late 1910s were sculpturally linear. Broad picture hats remained popular, though now with crisp, aerodynamic looking brims and minimal trim. The most striking look of the period was the verticality of hats. Tall toques and turbans rose closely from the sides of the head, and the crowns of other models were high cylinders, somewhat resembling the Victorian man's top hat with a wide brim. Feathers or the tips of bows often pointed sharply skyward to reinforce the vertical lines. The **cloche** at this time was a high crowned hat with a shallow brim that angled downward over the brow.

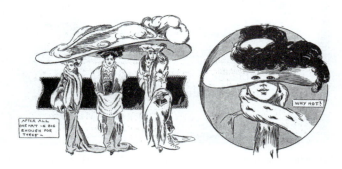

Cartoons from *New York Times,* 1909.

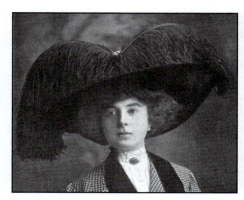

Picture hat with ostrich plumes by Marie Louis, 1909.

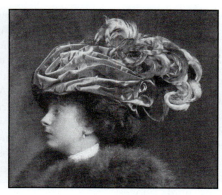

Velvet turban with coque feathers by Lewis, 1909.

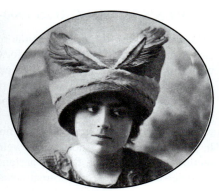

Turban with wings by Madeleine Lechat, 1911.

Rose trimmed picture hat by Weiss, 1911.

Straw hat with velvet bow by Hennard, 1912.

Straw hat with taffeta ruffles by Carlier, 1912.

Cloche by Jeanne Lanvin, 1916.

Tailored straw hat by Lucie Hamar, 1916.

Close turban of chenille by Joseph, 1918.

Velvet hat with ostrich plume by Joseph, 1918.

Velvet hat by Thurn, 1918

"Aircraft" hat by Bendel, 1918.

Braided turban by Jeanne Duc, 1918.

WOMEN'S ACCESSORIES 1900–1920

"The Little Things of Dress" was the title of *Vogue's* regularly featured article on accessories for the properly dressed woman of the early 1900s. One of the recurring themes of the editorials was that accessories may be small in size but they can make—or break—the image a woman wanted to project in society. Then, as now, the variety of accessories with which a woman could accent her ensemble was considerable. In addition to the hats, shoes, and jewelry shown in separate sections of this chapter, the Edwardian woman also accoutered herself with belts, collar treatments, handbags, hatpins, watches, boas, scarves, handkerchiefs, fans, muffs, gloves, parasols, and hair ornaments.

In the early years of the 1900s, belts were important for defining the S-bend silhouette with its angled waistline. Styles of belts reflected the Edwardian delight in lavish decoration. Belts of tapestry, embroidery, beadwork, and tooled leather were punctuated with large, ornamental buckles. In the war years, though, practicality and simplicity won out over decoration and belts became more plainly utilitarian.

Neck dressing was an easy way to make plain shirt waists or dress bodices more fashionable and varied. High, detachable collars of the Edwardian period were machine embroidered or decorated with lace insets and scalloped edging. Jabots of lace or pleated handkerchief linen provided still more options for fashion variation.

Lace trim and ornaments were also a favorite accessory, that could be basted or pinned to a collar, hat band, jabot, or bodice for a fresh look. Although machine-made lace was affordable and greatly varied in design, the snob appeal of handmade lace led to a "fascinating fad" of collecting antique lace, according to a women's magazine in 1911. "Gowns may become priceless creations when encrusted with rare old laces from milady's cabinet." Even as fashions became more simplified during World War I, lace remained a favorite accent for necklines, hats, and purses.

Handbags did not change much in shape or size from those of the late 1800s. Instead, textiles and surface embellishment with Art Nouveau or Asian motifs gave the new models a modern distinction.

Fur muffs were the most fashionable and functional accessory for winter. The upper classes indulged in rare furs such as sable, but opossum and fox pelts made muffs an affordable fashion accessory for middle classes as well.

In cold or warm weather, a lady always wore gloves when going out. Unlike most other accessories of the period, gloves were not richly decorated. According to *Harper's Bazaar* in 1902, gloves "should be made as simply as possible"; any "eccentricity is considered bad form."

Scarves were also a popular accessory to protect against winter winds. Styles ranged from narrow stoles to large shawl-like sizes. A more decorative form for summer evenings was the **boa**, which came in a wide variety of materials besides the traditional feather arrangements including lace or tulle flounces, taffeta petals, silk netting, and crochetwork.

For rainy or snowy days, the plain, functional umbrella was a necessity to protect hats and hairstyles from the damp. In the summer months, a sun parasol was still a popular accessory for the proper lady to prevent sunburn and to toy with coquettishly. Edwardian parasols were small, domed confections of flounces, ruffles, lace trim, pleats, and tucks. Handles were often ornamented with carved ivory or coral, faceted rock quartz, repousse metals, and inlaid woods.

Other less common accessories cited in fashion publications included corsages of artificial fruit or flowers and canes, of which *Vogue* assured readers in 1907 that "there is not great danger of these things becoming common."

Crocheted boa for evening, 1902.

Detachable collars and jabots, 1907.

Tapestry and tooled leather belts, 1907.

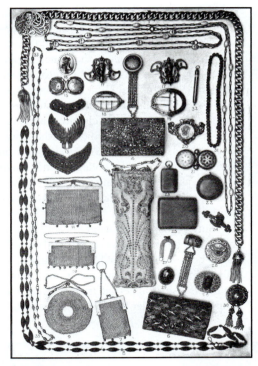

Handbags, belt buckles, and chain necklaces, 1902.

Wristwatch, handbags, combs, and jewelry from 1906.

Gloves, 1913.

Fox muff and stole, 1917.

Combs, 1913. Flat satin hair bow, 1914.

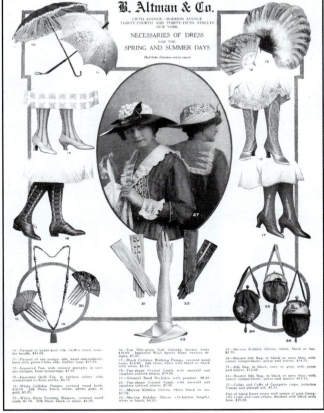

"Necessaries of dress," from a 1917 B. Altman ad. Parasols, collars and cuffs, fans, hair pins, gloves, handbags, and hosiery.

MEN'S FASHIONS 1900–1920

The sack suit (called a lounge suit in England) was the standard everyday attire for all but the laboring classes. It had continued to gain in popularity even in urban business arenas, where it replaced the long frock coat as proper town attire. By the beginning of the twentieth century, ready-to-wear makers mass produced such high-quality men's suits that, in 1902, a fashion editor was compelled to note: "There has been so great an improvement during the last few years in the general cut and finish of men's clothes, that it would be snobbish as well as untrue to say that it is not possible to buy a ready-made suit of any kind that will fit and look well." Almost every man could afford at least one ready-made blue serge suit priced about $5.00 to $8.00 in the Sears, Roebuck catalog at the time.

Although women's fashions of the Edwardian period were dramatically altered by the S-bend corset, men's styles evolved slowly and subtly. The cut of the suit coat in the first decade of the 1900s was long, loose-fitting, and bulkily padded. (Figure 21-13.) Hemlines were either cut straight across or rounded at each side of the front-closure. Some lengths also extended almost to the knees, though these were looks for young men and should not be confused with long frock coat styles of the time. Lapels initially were narrow and placed high with a button closure to the throat. Around 1905, the neckline opening dropped slightly and lapels were widened. Single-breasted jackets more commonly had three-button closures although the Victorian four-button style persisted until the end of the decade. Double-breasted jackets were viewed as more sporty, and were usually favored by collegiate men. In tailor-made catalogs, the jackets for **outing sack suits** were distinguished by patch pockets and bolder textile patterns such as checks, plaids, or herringbone.

Suit trousers were **pegged**—cut full around the hips and thighs and tapering to a close fit at the ankles. Belted waistbands became more popular, especially in the United States, although suspenders continued to be commonly worn. During this transitional period, trousers were made with both belt loops and suspender buttons at the waistband.

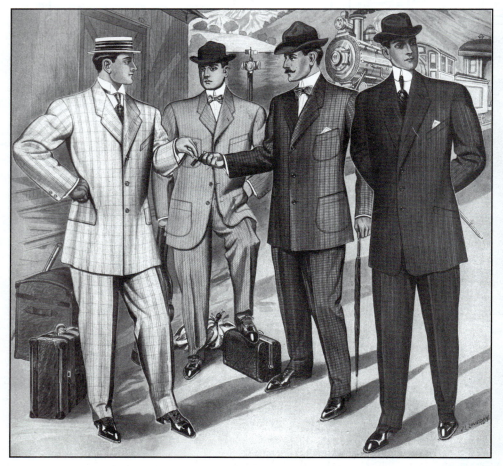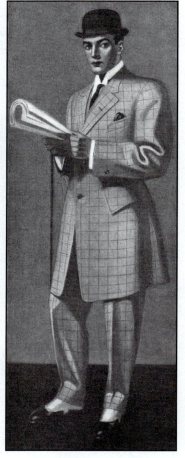

Figure 21-13. Edwardian men's suits featured heavily padded and loose fitting sack coats with baggy, pegged trousers. More casual suit jackets were made with patch pockets and bold textile patterns. Left, suit styles from Tailor-Made Clothing catalog, 1908; right, Society Brand ditto suit, 1909.

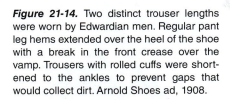

Figure 21-14. Two distinct trouser lengths were worn by Edwardian men. Regular pant leg hems extended over the heel of the shoe with a break in the front crease over the vamp. Trousers with rolled cuffs were shortened to the ankles to prevent gaps that would collect dirt. Arnold Shoes ad, 1908.

One of the subtle but significant distinctions of menswear in the first two decades of the century was the length of trousers. Two varieties are clearly evident in ads of the time, especially when both styles are shown together. (Figure 21-14.) Regular trousers were cut with leg hems that draped over the shoe to the sole heel. The front crease broke at a gentle angle over the instep of the shoe. Trousers with rolled cuffs were cropped high at the ankles with a front crease that fell in a straight line. Wide rolled cuffs added weight to ensure a clean leg line and minimize bagging at the knees. In addition, the shortened leg prevented cuffs from gaping and collecting dirt. Men with fashion flair emphasized the high cut by wearing brightly colored and patterned socks that showed clearly at the ankles, and with shoes that were laced with grosgrain ribbons tied in large bows. The trend of the shortened cuffed trousers lasted until the First World War.

The properly suited Edwardian male cast an imposing silhouette, appearing to possess a physique with broad shoulders, barrel chest, and massive thighs. A 1908 cartoon in *Cosmopolitan* derided the foppish dandy of the day with a costume of exaggerated dimensions and clashing patterns that were not too far from reality. (Figure 21-15.) However, by the early 1910s, the silhouette of men's clothing changed to follow that of women's with an emphasis on narrow, trim, youthful contours. (Figure 21-16.) Young men were at the forefront of the civilized world's consciousness as a world war erupted and vast armies of youths were sent off to fight each other in distant lands.

Even though during the late Edwardian period men's suits had begun to show some shape at the waist, the new look of the 1910s was a marked contrast. Jackets were snugly fitted and waistlines were raised "in the new military tendency" as one menswear ad noted. Hemlines were shortened, emphasizing the longer, leaner look of trouser legs.

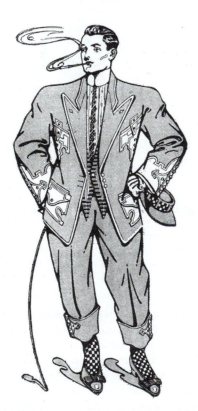

Figure 21-15. The exaggerated dimensions of the Edwardian men's suit combined with the boldly patterned accessories of the dandy were a favorite topic for editorial cartoonists of the period. Cartoon from *Cosmopolitan,* 1908.

Shoulders and sleeves were stripped of their excessive padding for a more natural shoulderline. The five yards of fabric that had been required for a suit of 1905 was reduced to 3 1/2 yards by 1915.

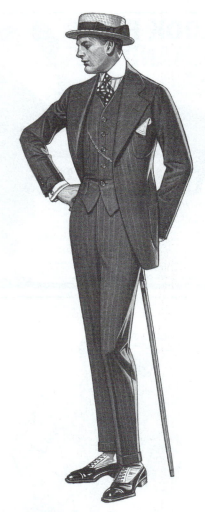

Figure 21-16. As women's fashions became narrow and slim in the early 1910s, men's styles also adopted a more trim, youthful look. Padding was eliminated from jackets and waistlines were more fitted. Trousers narrowed for a longer, leaner look. Kuppenheimer suit, 1915.

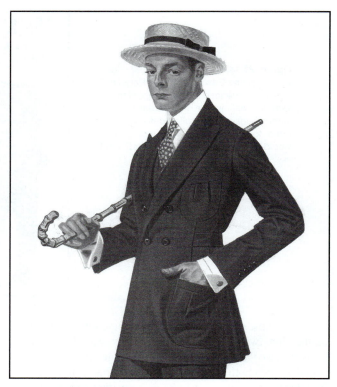

Figure 21-17. Sport jackets with half belts in the back defined the waistline and reinforced the trim youthful looks of the time. Kuppenheimer sport jacket, 1917.

Sport jackets were likewise contoured to the new slender masculine ideal. Belted varieties of jackets flattered the youthful, narrow waist. During the 1910s, the sport jacket became more integrated into the masculine wardrobe and often substituted for the sack suit jacket at business or social functions. According to the copy in a 1917 Kuppenheimer ad, from which the artwork is shown in Figure 21-17, sport jackets were "as much sought after for general wear as for sports and the country."

When the war ended and droves of young men returned to civilian life, they were eager to discard their military uniforms for "civvies" (civilian dress) and a return to normalcy. Menswear designers continued to emphasize youthful, slender styling that was well-suited to the lean builds of the returning war heroes. The fitted, natural-shoulder jacket and slim, leggy trousers continued as the prevalent silhouette—a look that would dominate the subsequent decade as well.

The other component of men's suits, the vest (or waistcoat in England) gradually became less important through the first two decades of the century. It remained integral to the business suit and formal attire but was usually abandoned in other forms of the sack suit, particularly the outing suit or more casual sport jacket ensemble. Most vest styles were single-breasted although the double-breasted vest was commonly offered in tailor-made catalogs as well. Vests were made with notched collars in a V-closure or shawl collars with a deep, scoop opening. As a standard, suit vests were made of the same fabric as the coat and trousers. For men who wished their vests to express an individuality, some were still made in colorful materials and with novelty closures like the one shown in Figure 21-18. In addition, as men replaced their pocket watches with wristwatches in the late 1910s, the utilitarian importance of the vest with its watch pocket diminished as well.

Despite the formidable, oversized proportions and bulky fit of the Edwardian man's sack suits, evening apparel was, instead, sleek and trim. The traditional styling of the fitted tail coat and slim trousers did not change much from the Victorian cut and contours. Some shoulder padding and wider sleeves

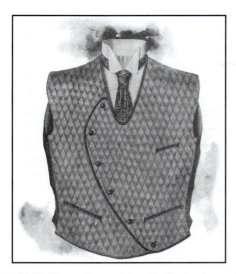

Figure 21-18. The vest, or waistcoat in England, remained an integral component of the business sack suit, but became less important for more casual forms of suits. *Vogue* featured this English novelty vest in 1902 but judged it to have a "peculiar" and "not overly attractive" arrangement of buttoning.

updated evening wear, and trousers were only slightly pegged. The matching black or contrasting white vest also featured the traditional deep scoop front to display the brilliantly white, starched, bosom-front shirt—the pullover type with a keyhole neckline. Increasingly, though, the tuxedo, or dinner jacket as it was more frequently called, was worn on occasions where previously the tail coat was required. If the social event was more formal than business, men might elevate the appearance of the tuxedo by wearing the stiff, bosom-front shirt instead of a pleat-front, coat cut version.

The coat cut shirt, first introduced in the 1890s, continued to grow in popularity during the Edwardian years. Ready-to-wear makers mass produced a broad variety of affordable styles in assorted fabrics, colors, and prints. (Figure 21-19.) Despite the success of the coat cut shirt, though, the bosom-front styles continued to be worn until after the First World War when returning soldiers much preferred the convenience of the open-front styling.

Also increasingly popular was the dress shirt with an attached collar. Although numerous varieties of "fancy percale shirts" with an attached turned-down collar had been sold by ready-to-wear catalogers and retailers for decades, these types of shirts were largely regarded as little more

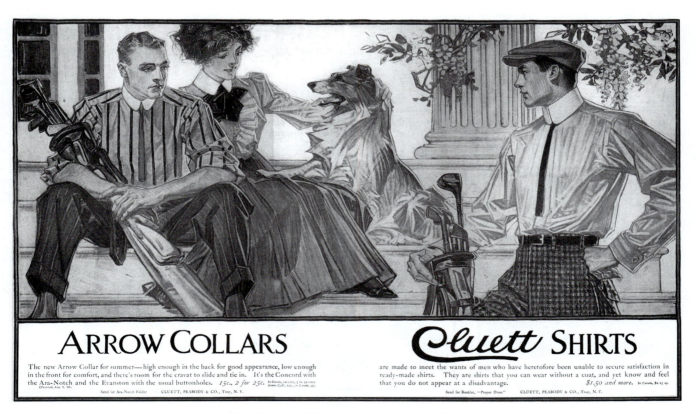

Figure 21-19. During the Edwardian period, the open-front coat cut shirt gradually replaced the pullover bosom-front styles. Until the First World War, though, both types of men's dress shirts were worn with a high, stiff detachable collar. Cluett-Peabody ad, 1910.

than ordinary work or casual shirts. Proper dress shirts worn to offices or for dressy social occasions were made with shallow, banded collars to which stiff, bleached white detachable collars were affixed by a button in the back. However, during World War I, governmental regulations required manufacturers to find ways of conserving commodity materials, and the superfluous detachable collar was a style casualty of war rationing. When the war ended, men who had become accustomed to the comfort and ease of the turned-down collar of the uniform shirt refused to return to the high, stiff detachable collars.

SPORTS ATTIRE AND OUTERWEAR

Specialized sports attire and playwear were primarily worn only by the sports professional, varsity athlete, or the avid enthusiast. Uniforms for baseball, football, track and field, and other competitive sports had become fairly standardized by the early 1900s. (Figure 21-20.) Olympic committees and amateur athletic associations strictly regulated the design and materials for competition clothing. Comfort and unrestricted movement were the principal tenets of athletic wear. The non-binding elastic comfort of knitwear was preferred by the athlete. Not only was the weight of knitwear variable for warmth or coolness, but the knitted fabrics were adaptable to a broad range of garment types and functions.

For the weekend golfer or tennis player, ordinary street clothing continued to suit their sportswear needs. For the most part, men simply rolled up the long sleeves of their shirts although shirts with half sleeves began to appear at club competitions in the early 1910s. In 1911, *Vogue* reported on an innovative new "**tennis shirt**" that included attached drawers cut as a single piece shoulder to hem to prevent shirt tails from coming undone during a game. For golfers, knickerbocker suits remained a common outfit. Hunters and fishermen might also wear knickerbockers for ease of putting on tall boots.

Riding costumes of the early 1900s remained the prerogative of the elite. The English "pink" (actually scarlet) frock coat with white stock about the neck, white breeches, and black boots were still the proper attire for a fox hunt. For urban park riding, the black cutaway coat, dark blue saddle trousers, and top hat lingered as the correct dress of the elite in Europe, but in America, the upper classes opted for the more casual ditto riding habit with its short sack coat, jodhpurs, gaiters, and derby.

During the first decade of the 1900s, men's outerwear had to be capacious enough to adequately cover the bulky, oversized sack suit. Hemlines were long, usually from mid-calf to just above the ankles. (Figure 21-21.) Most Edwardian overcoat styles changed little from the Victorian versions except in volume. Ulsters often came with a detachable hood or cape. The chesterfield featured a velvet collar and a fly-front closure that concealed the buttons. The mackintosh became a generic name for almost any style of raincoat. A somewhat fitted paletot of finest vicuna was worn over formal attire. Town commuters increasingly preferred the

Figure 21-20. By the early twentieth century, varsity and professional athletic uniforms had become fairly standardized. Most garments were styled for ease of movement and comfort. Knit shirts, shorts, and sweaters were particularly popular for their elastic give and versatility.

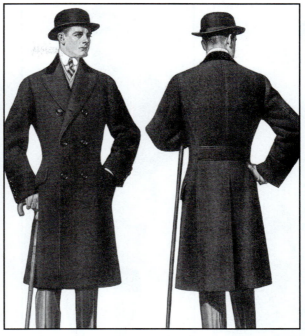

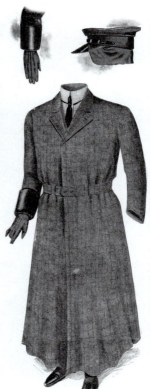

Figure 21-21. Men's outerwear of the Edwardian era was cut wide and long to fit over the padded, oversized suit styles of the time. During the 1910s, though, coats and jackets became narrow and more fitted with natural shoulderlines and shorter hemlines. For a few years at the beginning of the century, varieties of waterproofed motorcar dusters were added to men's outerwear wardrobes. Left, wool greatcoats from Hart, Schaffner & Marx, 1905; center, fitted topcoat by Kuppenheimer, 1913; right, waterproofed motorcar duster with driving gauntlets and visored cap, 1902.

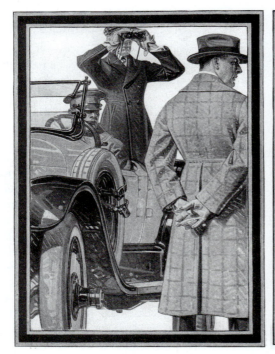

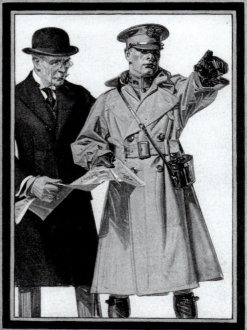

Figure 21-22. During World War I, men's outerwear designs were influenced by military styles. Trim waistlines were raised and skirts became fuller. Sleeves were widened for greater ease of movement. Kuppenheimer coats, 1918.

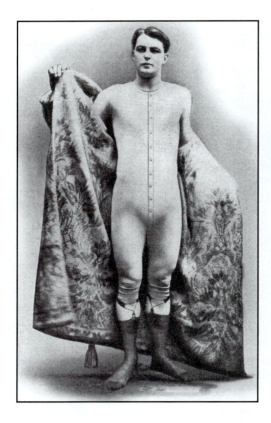

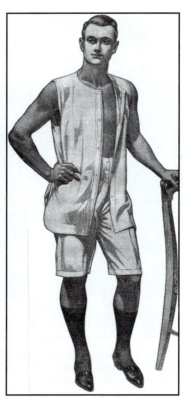

Figure 21-23. The Victorian union suit remained the most prevalent form of men's underwear through World War I. In warm weather, short-sleeve or sleeveless tops and knee-length drawers were preferred. Left, union suit by Munsing, 1907; right, coat cut undershirt and knee-length drawers from B.V.D., 1909.

fingertip-length topcoat, which was less cumbersome on trains and trams.

Also in the early years of the century emerged a new outerwear costume—the motoring ensemble. In 1902, *Vogue* illustrated the correct automobile dress to wear when driving the large, open touring cars of the period. (For driving a small runabout, the editors noted, "there is no distinct dress.") The ankle-length belted duster shown at the right in Figure 21-21 is made of a checked, lightweight silk although other varieties were usually of more durable, weather-resistant materials like rubberized cotton duck or leather. As covered cars became more common in the early 1910s, the motor costume became redundant.

During the first years of the 1910s, men's outerwear adopted the slender, fitted proportions of suit jackets. Sleeves were narrow and hemlines were shortened to about the knees. Waistlines were trim, often emphasized by half belts in the back that defined the youthful silhouette like the style shown in the center illustration of Figure 21-21. As with suit jackets, the natural shoulderline was applied to outerwear as well.

From about 1914 until the end of the decade, the design of men's outerwear was influenced by the ease and comfort of military apparel. (Figure 21-22.) Sleeves were fuller and collars wider. The raglan sleeve, introduced as a military style in the mid-nineteenth century, afforded more freedom

of movement and was applied to many types of outerwear. Waistlines remained slim but were raised above the natural position. On belted coats, skirts flared fuller.

Fur coats became especially popular with men in the late 1910s. As with cloth coats, fur styles were fitted to the slender masculine contours. Fur coats with half belts in the back were the favorite.

MEN'S UNDERWEAR AND SWIMWEAR 1900–1920

Men's undergarments through the first quarter of the century varied little in style from those of their Victorian fathers. (Figure 21-23.) The form-fitting knit union suit—so named for the uniting of the shirt and drawers into one piece—remained the most common type. Long-sleeved and ankle-length winter versions, called longjohns, were made of soft lamb's wool that was nonetheless maddeningly itchy in the overheated offices and parlors of the time. Summer styles were of lightweight wool or cotton knits, including a new form of cool, mesh fabric, branded as Porosknit. Separate tops and drawers were also popular although these were cut fuller and looser than the union suits. Knee-length drawers and short sleeve or sleeveless tops were primarily for warm seasons. The new open-front coat cut style was adapted to undershirts. During the war years, when wool was strictly

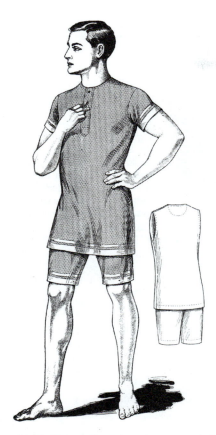

Figure 21-24. Styles of men's swimwear varied little from those of the late Victorian years. Assorted types of long tunics cropped to mid-thigh were worn over knee-length trunks. Drawstring trunks with short sleeve or sleeveless tunic by *McCall's* patterns, 1909.

rationed, some men's underwear was often made of the more readily available silk.

Fine wool or silk knits were also used in manufacturing men's socks. Perhaps surprising to many today is the wide assortment of colorful and patterned socks that men of the early 1900s popularly wore. "Fancy silk embroidered socks" were even offered in the Sears catalogs of the time—at the pricey thirty-five cents a pair compared with eight cents a pair for solid colored knit cotton socks. For men who wished to avoid rumpled socks bagging about the ankles, especially considering that cuffed trousers of the period were cropped high, elasticized garters were strapped about the calves just below the knees to secure their silk knit "half hose" for a smooth fit. Specialty hose and knit leggings for sports were also knitted in bold patterns such as diagonal plaids and vibrant colors like bright red or yellow, many with "fancy colored roll tops."

Swimwear also remained basically the same as late nineteenth-century styles and still resembled forms of men's knit underwear. (Figure 21-24.) Pullover tunics with placket button fronts or tank styles were cut long to the upper thighs for modesty. The knee-length trunks—sometimes called tights—were secured with a drawstring waist. Dark blue wool flannel was the most common fabric for men's swimsuits. Competitive swimmers, though, wore the regulation wool knit **racer**, a sleek, one-piece tank-style suit with legs cropped to the upper thighs.

MEN'S ACCESSORIES 1900–1920

The most important accessory for the Edwardian man was a hat. Men seldom went out of doors bareheaded. The assortment of hat styles available for men through the early decades of the 1900s was enormously varied although not much changed in shapes, materials, or dimensions from designs of the late Victorian years. In any urban crowd of men, a vast array of hat types would be ordinarily mixed, depending upon the season. Even men of limited means or sartorial interest knew not to wear a straw hat in winter. Most importantly, each style of hat bespoke the social status—and perhaps even mood—of the wearer. (Figure 21-25.) The high, shiny silk top hat, when worn during the day, asserted the dignity of a politician, professor, or businessman of some importance. Smooth felt derbies were the hat of choice to complement the somber suit of the serious executive. The soft, creased fedora proclaimed a bit more flair and personality—the hallmark of dashing youth. The office boy or mature tradesman preferred the easy casualness of the low, visored cap, sometimes called a golfer's cap or a newsboy's cap. Other men expressed their personality or regionalism with high domed stetsons, military styled fatigue hats, or lightweight fedora-like "crush" hats. In the summer months, low straw boaters were everywhere, from city streets to resorts. During the years the United States built the Panama Canal, and especially after it opened in 1914, a wide variety of high crowned straw hats became popular and were collectively called **panamas**.

Men's footwear was also basically a continuation of nineteenth-century styles. (Figure 21-25.) The shape most commonly illustrated in shoe ads and catalogs featured wide, rounded toes. A raised "**bulb-toe**" styling became increasing popular after the turn of the century, particularly since it was regarded as the correct shape to wear with high-cropped cuffed trousers. Both button and lace-up types of shoes were equally popular until World War I when the more practical lace-ups better suited the fast-paced times. The high-topped shoe we would call an ankle boot today was the preferred style for everyday, including with business suits. Versions featured all-leather uppers or leather vamps with fabric tops. Both types were made with or without pull tabs at the back of the heel. The low, lace-up oxford was styled by the Edwardian dandy with wide laces that formed broad, decorative bows. Some oxfords also were made with a two- or three-button closure. For a short period around

The great variety of men's hat styles reflected social status, age, and, at times, even the wearer's mood. Detail of ad, 1913.

Figure 21-25. Depending on social status, the Edwardian man's variety of accessories could be extensive. Besides a vast array of hats and shoes, the wardrobe of the well-dressed man included assorted neckwear, detachable collars, socks, gloves, scarves, jewelry, and walking sticks.

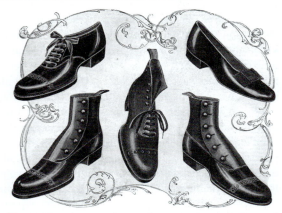

The hightop shoe was the most common men's footwear of the Edwardian period. Jantzen shoes, 1901.

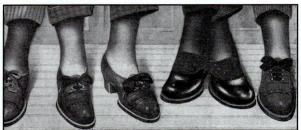

Fancy bows and laces adorned the men's shoes of 1908.

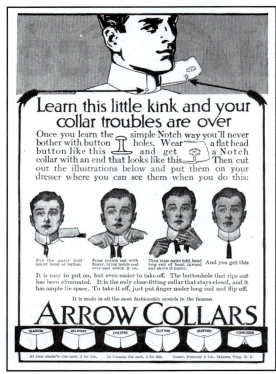

Learn this little kink and your collar troubles are over

Once you learn the simple Notch way you'll never bother with button holes. Wear a flat head button like this and get a Notch collar with an end that looks like this Then cut out the illustrations below and put them on your dresser where you can see them when you do this:

Put the outer fold under head of button.

Press button out with finger, bring notch end over and notch it on.

Then raise outer fold, bend long end of band inward and above it under.

And you get this

It is easy to put on, but even easier to take off. The buttonhole that rips out has been eliminated. It is the only close-fitting collar that stays closed, and it has ample tie space. To take it off, just put finger under long end and flip off.

It is made in all the most fashionable models in the famous

ARROW COLLARS

GLASGOW BELMONT CHESTER CLIFTON BEDFORD CONCORD

At your dealer's—15c each, 2 for 25c. In Canada 20c each, 3 for 50c. Cluett, Peabody & Co., Makers, Troy, N. Y.

Advertising by collar makers sometimes included instructions for attaching dress collars. Ad 1910.

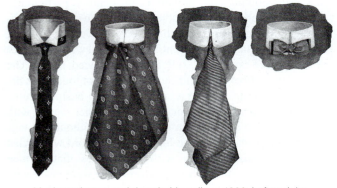

Men's neckwear and detachable collars, 1902. Left to right: four-in-hand knotted tie, ascot, imperial tie, and bow tie.

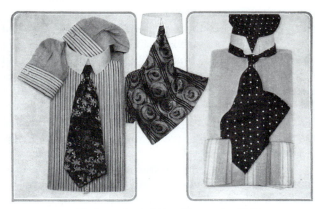

Men's coat cut shirts with cravats, 1916.

1905–1909, trendy young men stepped out in oxfords with a high heel of about 1 1/2 inches. The convenient, comfortable oxford began to be more favored than high-top boots during the war years. For formal dress a patent leather slipper with an open throat and a grosgrain ribbon bow was proper.

Neckwear in the early 1900s was as varied as the late Victorian period. The type of flared, pointed tip tie familiar to us today was usually called a cravat at the time. Unlike our contemporary styles, though, once knotted the lengths were short, sometimes extending only to mid-abdomen rather than to the belt buckle—just long enough to tuck into a vest. The four-in-hand knot was the most prevalent. The term "ties" usually applied to bow ties, which could have flat, rounded, or pointed ends. Ascots were wide, scarf-like neckwear that were folded over at the throat and fastened with a stickpin. Most forms of ties were woven silk although some knit varieties were listed in catalogs of the period. Instructions on tying ties and affixing detachable collars were frequently featured in catalogs, product brochures, and advertising. (Figure 21-25.)

Gloves were more of a seasonal accessory than they had been in earlier decades. The gentleman and dandy still wore or carried their softly dressed kid gloves when in public or making social calls. Colors were usually gray, tan, or brown. Heavier calfskin or buckskin gloves were worn for motoring or winter wear.

Jewelry remained an accessory of limited use for men. Besides the wedding ring, the gold pocket watch and fob were the most common masculine jewelry. A matching watch chain usually extended across the front of the vest or looped from the vest watch pocket to the trouser pocket. During the First World War, the more convenient wristwatch gained in popularity and would eventually make the pocket watch a quaint anachronism. Cuff links, collar buttons, shirtstuds, vest buttons, and tie stickpins were the other forms of jewelry permitted men, and then only if subtle and subdued. Even wealthy men were cautious on diamond stickpins or oversized cuff links. *Vogue's* long-running editorial, "The Well-Dressed Man," frequently chided men for excessive jewelry or flamboyance. When grudgingly the editors acknowledged some new trend, such as the "fad" of jeweled vest buttons in 1901, they usually also included the caveat, "if not too conspicuous to be bad style."

Walking sticks were still a status symbol that no gentleman would go into the street without. Whereas men eschewed flashy jewelry, they could indulge in fanciful excess with the handles of their walking sticks. Some handles were gold, sterling silver, or carved ivory sculptures of animals or allegoric heads; others were inlaid with large gems, mother-of-pearl, cloisonne, contrasting metals, or other decorative treatments from the jeweler. In summer, cane, bamboo, or wood carved to simulate exotic woods were acceptable alternatives to formal, jeweled types.

Rounding out the accessory wardrobe for men were handkerchiefs and scarves of varying weaves or knits, colors, and patterns.

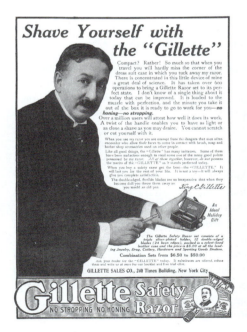
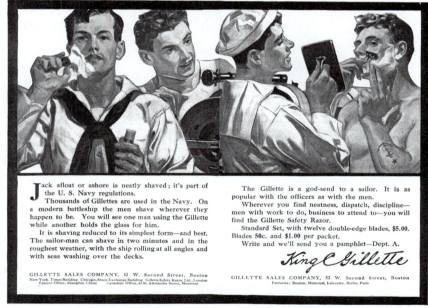

Figure 21-26. With the aid of mass marketing, Gillette sold millions of his safety razors and disposable blades within the first decade of production. The images of smooth-shaven young men promoted the whiskerless face as the preferred modern masculine look. Gillette ads, left 1907, right 1910.

MEN'S GROOMING
AND HAIRSTYLES 1900–1920

For most of the second half of the nineteenth century, facial hair of all kinds was common to men young and old. Around the turn of the twentieth century, though, two disparate influences contributed to the return of the clean-shaven face—one from technology and the other from popular culture.

In 1903, an enterprising traveling salesman, King Gillette, collaborated with a professor from the Massachusetts Institute of Technology to invent a safety razor with a disposable razor blade. The idea was an instant success. With the aid of mass marketing and advertising, Gillette sold a half million blades within the first three years of production. (Figure 21-26.) During World War I, the U.S. government ordered 3.5 million Gillette razors and thirty-six million blades, which were sent overseas to American doughboys who introduced the concept around the world.

In addition to images of smooth-shaven young men in Gillette ads, a new ideal of masculine aesthetic appeared in the mass media that promoted the whiskerless face. Depictions of handsome, square-jawed young men created by the famous artists Charles Dana Gibson and J. C. (Joseph Christian) Leyendecker were featured by the hundreds in magazines and advertising. So popular were these images that the shirtmaker Cluett-Peabody received thousands of

fan letters from women—including several proposals of marriage—addressed to the Arrow shirt man illustrated in Leyendecker's ads. (Figure 21-19.)

Besides the successful marketing of the safety razor and a media saturation of compelling images of clean-cut young men, a barrage of magazine and newspaper editorials also urged the "cleanly fashion" of shaving for health reasons. In 1907, for example, *Harper's Bazaar* affirmed that the clean-shaven face was "peculiarly gratifying and should be encouraged in all proper ways." The editors further reported on "scientific experiments" in which the lips of a woman were "sterilized" before she kissed a man with a moustache; afterwards, her lips were tested and discovered to be "literally swarming with malignant microbes."

By the 1910s, men were further encouraged to be clean shaven when menswear and popular culture began to emphasize youthful looks. Facial hair became more associated with men of mature years and bygone Victorian and Edwardian times.

Men's hairstyles of the period remained closely cropped around the sides with the volume on the top—a necessity of grooming for a proper fit of a hat. Most men parted their hair on the left. The center part was more common with boys and college men. Hair coloring products were available but only actors, politicians, or other men in the public eye indulged in the use of hair dyes. The greatest fear was baldness. Since the genetic causes were not understood at the time, many massaging devices and restoration treatments were sold to balding men with promises of reversing hair loss. (Figure 21-27.)

CHILDREN'S CLOTHING 1900–1920

Although the swaddling of infants had largely been discontinued in industrialized nations, except in remote, rural regions, babies of the early 1900s were nevertheless weighed down with layers of multiple garments. In 1902, the superintendent of the New York Babies Hospital wrote in an article for *Harper's Bazaar*, "There is no reason why the baby of today should not have just as dainty, as fine and expensive a wardrobe as the one of a few years ago, and there is every reason why he should not have all the weight and discomfort of the old one." She then listed an eleven-part layette that actually varied little from the Victorian ensemble except in the shorter lengths of the dresses.

Childcare experts recommended that, to ward off colds and other ailments, an infant should be wrapped chest to hips in a warm flannel band or cotton webbing before dressing. This differed from swaddling in that the baby's arms, legs, and head were left free to move about. Over the binding was then layered the full layette—a diaper, a gown, a petticoat, a vest or sacque, socks, knit bootees or moccasins, a knit bonnet, and shawl. If the child were to be taken out of doors or if visitors were expected, additional layers might include

Figure 21-27. The Edwardian man who suffered from male pattern baldness was susceptible to advertised promises of hair restoration. Scalp massager, 1905.

Figure 21-28. The Edwardian infant was layered with multiple garments and accessories in a misguided attempt to safeguard the baby from chills that most parents still thought caused all sorts of illnesses. A layette from *Harper's Bazaar,* 1902.

Figure 21-29. During the First World War, shortages of materials led to fewer components of the layette. Garments and accessories were also more simply made with fewer frills and decorative treatments. Macy's ad, 1918.

frilly, starched aprons, bibs, detachable collarettes, tall caps, mits, and lace-up fabric or kid shoes, all usually lavishly embellished with embroidery, lace, flounces, pin tucks, ruching, ruffles, and other decorative trimmings. (Figure 21-28.) Such Edwardian excesses for babies were not confined solely to the upper classes. Proud, aspiring parents of the middle classes equally indulged in ornamenting their children with superfluous clothing, especially with the increased availability of mass-produced infants wear from ready-to-wear makers.

By the First World War, the exigencies of rationing and shortages affected even the fetishism of overdressing babies. Layettes were reduced to a full, loose dress—long for newborns and shortened to the ankles once the child could sit up—combined with a short, loose vest or wide sacque, and booties. (Figure 21-29.) Even bonnets were now reserved primarily for chilly days and outings. Ornamentation, too, was greatly simplified.

Edwardian girls were subjected to the same types of restrictive clothing that their Victorian mothers had endured in their childhood. Heavily boned corsets were still common for girls as young as four or five. Teen girls were expected to reflect the fashionable taste of their mothers and consequently were harnessed into S-bend corsets for the proper profile. (Figure 21-30.) Dress lengths continued the conventions of

the late nineteenth century with toddlers and girls through about age twelve wearing hemlines at the knees, teen girls of about thirteen to fifteen with crops at mid-calf, and young misses of age fifteen to seventeen with skirts to the ankles. Waistlines were the fashion news for girls. Belts and waist seams for young girls dropped low on the hips, almost to the upper thighs. The waistline contours of teen girl's dresses and skirts fitted snugly over S-bend corsets and dipped to the front. In keeping with the trends of the Edwardian era, girl's frocks were as lavishly decorated with assorted forms of trim as were their mothers' styles.

In glancing through pictorial magazines of the early 1910s, one will notice that the hemlines of some young girls' dresses were thigh-high short, many hardly more than a band of fabric or a ruffle attached to the edge of the hip-line waist. Yet this was not a pervasive trend judging from the illustrations in catalogs and the several editions of *Vogue's* "Children's Fashions Number" at the time. Instead, hemlines of girl's dresses during the 1910s remained constant with those of the preceding three decades as described above. (Figure 21-31.) Even when the vertical, columnar look of the hobble skirt was

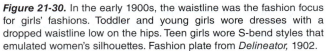

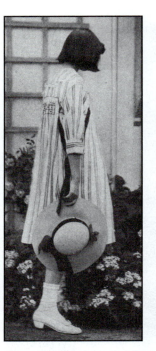

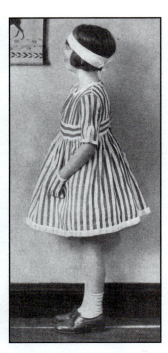

Figure 21-31. At the end of the 1910s, girls' dresses were comfortably loose-fitting and full. Girls could move more freely in the high-waisted or chemise styles. Girl's dresses from *Vogue,* 1918.

Figure 21-30. In the early 1900s, the waistline was the fashion focus for girls' fashions. Toddler and young girls wore dresses with a dropped waistline low on the hips. Teen girls wore S-bend styles that emulated women's silhouettes. Fashion plate from *Delineator,* 1902.

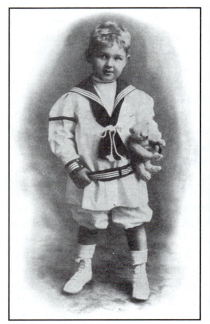

Figure 21-32. Some form of the knickerbocker suit was the principal attire for the Edwardian boy. Boy's suits from 1907: left, sailor suit from De Pinna; center, belted wool knickerbocker suit from De Pinna; right, corduroy knickerbocker suit from *Vogue.*

applied to all forms of women's fashions in the early 1910s, young girl's dresses remained full and loose—leading the way to the fit of women's styles in the 1920s.

Some toddler boys of the Edwardian period suffered the same torments of fashion traditions as had their Victorian fathers as youngsters. Until about the age of three or four, depending upon the child's growth, boys wore dresses or short, kilt-like skirts with shirts. Unlike the childhood of their fathers, though, most boys in the early twentieth century did not have to be bothered with long, curled tresses although the tradition lingered primarily with the leisure classes until the war years.

Older boys had the advantage of trousers for comfort and maneuverability. From about the age of four or five through their mid teens, boys wore knickerbocker suits with a variety of jackets. (Figure 21-32.) The sailor suit also remained a perennial favorite for boys throughout the era, some styles of

which were depicted in magazines of the time with long, bell-bottom trousers instead of knickerbockers. For special occasions such as weddings, boys might wear long pants with a vest and a tuxedo jacket or a short, cropped Eton coat. Once boys were in high school, they began to wear the same styles of suits and sports clothes as adult men.

In the 1910s, knee-length short pants were widely adapted from active sportswear costumes and applied to young boys' suits although older boys continued to dress in knickerbocker suits. Legs were bared with the new cropped pants styles, but long, thick stockings continued to be required for knickerbockers. During the war, elements of military uniforms were adapted to boy's clothing including the raised waistline, epaulets, braid, and insignia. (Figure 21-33.) High-top shoes remained more common with boys than with girls into the 1920s.

Figure 21-33. During the years of the First World War, boy's clothing featured many elements adapted from military uniforms. For young boys, short pants replaced knickerbockers and long, heavy stockings were discarded in favor of bare legs. Macy's ad, 1918.

Playwear for both girls and boys afforded the first real freedom for children since the clothing of the late eighteenth century. Boys enjoyed the comfort of overalls and short sets. Girls could romp in nonbinding, high-waisted dresses, some with empire waists or shoulderline yokes, and full, chemise styles that hung loosely from the shoulders. Heavy, black hose and high, button shoes were discarded in favor of short, knit socks and low, strappy shoes.

REVIEW

As the twentieth century dawned, women's fashions were transformed by the invention of a new form of corset that altered the silhouette from the Victorian hourglass contours into the Edwardian S-bend stance. Gored skirts fitted smoothly over rounded hips in a flared bell shape and bodices and blouses projected forward into a pouter pigeon fullness. Frills and lavish surface embellishment abounded.

Affordable tailor-made suits were mass produced for working women. Similarly, ready-to-wear shirtwaists and skirts became increasingly popular alternatives to dresses and suits.

At the end of the first decade of the new century, three key fashion changes occurred that swept away the S-bend silhouette. First was a change in the configuration of the corset, which became more vertical with a longer line extending low over the hips. Second was a revival of the columnar silhouette of the Directoire dress, including a shift of the waistline up under the bosom. Third was the discarding of layers of petticoats in favor of a simpler slip-style chemise.

From these dramatic changes, designer Paul Poiret introduced his radical new concept of the narrow, vertical hobble skirt, which became the universal look of the early 1910s. Throughout the prewar years, Poiret's designs were innovative and influential. His jupe-culottes, or Turkish trousers, forecasted a trend of casualwear trousers for women that would become increasingly common in subsequent decades. His minaret tunics inspired fresh new looks by his peers and ready-to-wear makers alike.

When World War I erupted in Europe, fashion reacted with an abrupt shift in the fit and shape of clothes. Busy women active in war efforts needed comfort and ease of movement. Fitted bodices and long, narrow skirts disappeared in favor of loose-fitting, full skirts with shorter hemlines. Waistlines were raised. Jackets and coats became full and shapeless. Colors were more subdued and decorative treatments were minimal. Women went to work outside the home wearing trousers for practical and safety needs. As wartime shortages of fabric and other material became acute, fashions once again became narrow, though with a softer and easier fit than the hobble skirt looks of the early part of the decade.

Menswear of the Edwardian period also had a distinctive look that differed from the Victorian styles. The sack suit became even more prevalent, replacing the frock coat as the preferred business attire. The cut of the Edwardian sack coat was long, loose-fitting, and heavily padded. Pegged trousers were full about the hips and tapered to a close fit at the ankles. When women's styles adopted a more youthful, slim silhouette in the early 1910s, menswear likewise became trim and more shaped. Jackets were shortened and fitted with an emphasis on a natural shoulderline and a slender waist. Trousers were cut narrow.

Another important shift in menswear during the 1910s was the increased popularity of the open-front coat cut shirt that would eclipse the old bosom-front styles. In addition, the high, stiff detachable collar gradually disappeared as dress shirts with attached turned-down collars became the preferred type.

Children's clothing began an evolution toward freedom and comfort. For young girls, the Edwardian dresses with dropped waists and frilly excesses were replaced in the 1910s by simple, loose-fitting styles. Where teen girls of the Edwardian period wore constricting S-bend corsets, the young miss of the 1910s enjoyed the natural fit of the youthful fashions, which were more suited to the trim, adolescent figure. Boy's clothing also began to shift more toward ease and comfort with the adaptation of playsuits with shorts as an alternative to knickerbockers.

Chapter 21 The Twentieth Century: 1900–19200
Questions

1. In 1900, which innovation dramatically altered the silhouette of women's fashions? How did the Edwardian woman's silhouette differ from that of her Victorian predecessor of the 1890s?

2. Identify the key characteristics of the Edwardian woman's dress designs.

3. Which three key changes in women's fashions of 1908 and 1909 helped sweep away the S-bend silhouette?

4. Who is credited with designing the hobble skirt? Describe the style and how women adapted to the fit.

5. How did World War I impact the design of women's fashions?

6. What were three different forms of trousers worn by women in the 1910s?

7. Compare and contrast the cut and line of men's everyday sack suits of the Edwardian period with those of the 1910s.

8. What two significant changes occurred with the design of men's shirts in the first two decades of the 1900s?

9. During the Edwardian period, how did the dress designs of young girls differ from that of teen girls?

10. What was the principal form of dress for boys in the early 1900s and how did it evolve in the 1910s?

Chapter 21 The Twentieth Century: 1900–1920
Research and Portfolio Projects

Research:

1. Write a research paper on how women's changing roles in society between 1900 and 1919 impacted fashion. Identify the causes of social change and which types of clothing were altered by the changes.

2. Write a research paper on the revivalisms of women's fashions between 1900 and 1919. Compare and contrast the twentieth-century adaptations with the period originals.

Portfolio:

1. Research the construction of S-bend corsets and replicate a life-size version of one in papier-mache. Include details of panels, seams, and laces.

2. Create modern adaptations of Paul Poiret's jupe-culottes and minaret tunic in your sketchbook. Imitate the couturier's use of color, textile pattern, and texture in a modern version, retaining the essence of the pre-World War I silhouette, but updating the concepts with today's fit, accessories, and hairstyles. Include color photocopies or digital scans of the Poiret designs used as models, with a written description of each.

Glossary of Dress Terms

bishop's sleeve: women's sleeve with a fullness between the elbow and wrist

boa: a decorative scarf made of feathers or materials cut or knit in a feathery treatment

brassiere: various forms of bust support garments

bulb-toe shoe: men's shoes with a wide bulbous-shaped toe

cabochon: large rounded clasps or pins used as ornaments on women's hats

camiknickers (also chemiknickers): a type of short slip with a button or loop at the hem that could be fastened to form a divided underskirt

cloche: a high crowned hat with a shallow brim that angled downward over the brow; in the 1920s, the style became the more familiar bell-shaped "skull helmet," as it was called by milliners

collarettes: wide capelets with a dog collar neckline used as an attachment to Edwardian women's outerwear

covert coat: a women's loose-fitting, three-quarter overcoat made of twill (covert) wool

dog-collar neckline: high, stiff collars of Edwardian women's fashions

dressing sacque: a woman's loose dressing robe

duster: long, waterproofed coats for men and women initially used for motoring in open cars

hobble skirt: a slim, tube skirt that tapered to a narrow opening at the hemline, some with a strip of material at the ankles called a hobble garter

jupe-culotte: women's wide-legged pantaloons of the early 1910s; also called Turkish trousers

lampshade tunic: short panniered tunics that flared into a funnel shape from the waist; also called a minaret tunic

last: industry term applied to the shape of a shoe

lingerie look: the excessive use of laces and ribbons as decoration for Edwardian women's fashions

Mercedes toque: a woman's hat with a circular crown and a brim turned straight up the same height as the crown

minaret tunic: see lampshade tunic

negligee: a woman's loose nightgown or dressing robe

outing sack suit: men's suits made with a sack jacket with patch pockets and bold patterned textiles

panama hat: a high crowned straw hat that became popular during the construction of the Panama Canal

pegged trousers: men's trousers cut full around the hips and thighs and tapering to a close fit at the ankles

Peter Pan collar: low, rounded neckline with a petal-shaped collar used on women's and children's clothing

pompadour: women's hairstyles arranged up on the head in a high bouffant shape with various knots at the back

racer: a sleek, one-piece tank-style swimsuit initially worn by men in competition sports

S-bend corset: corset designed with a straightline busk and long hipline that thrust the chest forward and shifted the hips back into a kangaroo stance

tennis shirt: men's combination shirt and shorts

Turkish trousers: see jupe-culotte

wrapper: a woman's loose dressing robe

Chapter 22

THE TWENTIETH CENTURY
1920–1940

First meeting League of Nations 1920	Tutankhamen's tomb discovered 1922	Death of Lenin 1924	Paris Decorative Arts Expo 1925	Stalin assumed power in USSR 1927	Penicillin discovered 1928	U.S. Stock Market Crash 1929
U.S. women granted right to vote 1920	Italy's Mussolini became "Duce" 1921	First Nazi congress in Munich 1923	Fitzgerald's *Great Gatsby* 1925	Lindbergh's solo flight across Atlantic 1927	Hirohito made Emperor of Japan 1928	First Academy Awards 1929
Prohibition began in U.S. 1920	Valentino in *The Sheik* 1921	Gershwin's *Rhapsody in Blue* 1924		First talking movie *The Jazz Singer* (1927)		Thomas Wolfe's *Look Homeward, Angel* 1929

1920 1930

Great Depression began 1930	Hitler named German chancellor 1933	Italy invaded Ethiopia 1935	England's Edward VIII abdicated; George VI ascended throne 1936	Du Pont patented nylon 1937	Germany invaded Poland; start of World War II 1939
Empire State Building completed 1931	Franklin Roosevelt's "New Deal" program 1933	Cole Porter's *The Gay Divorcee* 1934	Spanish Civil War 1936–1939	Germany annexed Austria 1938	
Jean Harlow in *Platinum Blonde* 1931	Prohibition ended in U.S. 1933			Disney's *Snow White* 1937	Clark Gable in *Gone with the Wind* 1939

1930 1940

POLITICS AND NATIONS OF THE 1920s

In the aftermath of World War I, central Europe was entirely reshaped. Following their capitulation, Germany, Russia, and the Austro-Hungarian Empire were carved into new countries or ceded vast territories to existing nations. Among the new countries were the republics of Austria, Hungary, Czechoslovakia, Finland, and Yugoslavia, along with a reconstituted Poland and Lithuania. Democracy was further expanded across Europe when all three of the defeated imperial powers replaced their monarchies with other forms of government.

One of the primary concerns that the newly formed League of Nations had dealt with in redrawing the map of Europe was the fear of revolution. In the last years of the war, Russia had been torn apart by its civil war, which ultimately resulted in the seizure of power by the communists. The

League tried to make the new democratic nations as large and strong as possible to resist the expansion of communism. It was this "Red Scare" that gradually empowered the fascist parties and governments that emerged in Italy, Germany, and Spain during the 1920s and 1930s. Totalitarianism seemed to be the most certain method of extinguishing the violence and dangers of communism. Demagogues such as Benito Mussolini of Italy and Adolf Hitler of Germany ascended to power largely through the promise of resisting communism.

Even in the United States of the 1920s, fear of the Red Menace was pervasive. Perceived alien Reds were deported to Russia, and more than 6,000 suspected radicals were jailed by the U.S. Attorney General.

More significant for the United States in the postwar years than the communist threat was its shortsighted

isolationism. Despite President Wilson's herculean efforts, the U.S. Congress refused to allow America to join the League of Nations. Americans had entered the war with an idealism and enthusiasm "to make the world safe for democracy," but at the end, they were disappointed that the Allies did not march to Berlin, did not hang the kaiser, and did not occupy Germany. Almost three years after the Armistice, the Harding administration finally negotiated separate peace pacts with Germany and Austria that deliberately excluded the types of obligations and ideas for nation building Wilson had proposed.

In the Middle East, the decaying Ottoman Empire, which had entered the war on the side of Germany, was divided up into "mandates" by the League that were parceled out between France and Britain. These territories were not colonies but became protectorates, which Europe would help modernize until they could stand alone as independent nations. Even as the mandates concluded in the 1930s, Britain and France continued to exercise indirect rule through treaty rights for another generation.

In Asia, Japan rose to supremacy during this time by a rapid modernization modeled on the industrialized economies of the West. By the beginning of the 1920s, Japan had a powerful army and the third largest navy in the world.

China, however, still struggled with unification following the establishment of a republic in 1912. Well into the 1930s, much of China was under the dominion of local warlords who controlled the regional armies to their own purposes. It was during the 1920s, also, that an alliance with Russia laid the groundwork for a Chinese communist party.

CULTURE AND SOCIETY IN THE 1920s

When the Great War ended, soldiers and home front citizens alike wanted more than anything for a return to normalcy. But the extreme circumstances of the war had so utterly shattered the comfortably familiar that the pieces of everyday life as it once had been could not be put back together again. During the war years, changes in technology, economics, and social order had been so enormous and dramatic that, even as they happened, the effect on society was palpable to its very core. The war had not ended as most had hoped—in Europe or America. U.S. doughboys returned stateside to a postwar recession, prohibition, and the New Woman who was financially independent and now enfranchised. The political idealism of Wilson and his Democratic administration had been supplanted by the rancorous Republicans, led by Harding and the most corrupt administration since Grant. It was anything but normalcy. In 1920, F. Scott Fitzgerald captured the spirit of the day in his novel, *This Side of Paradise*: "All gods dead, all wars fought, all faiths in man shaken."

The disillusionment and cynicism of the postwar period only gradually eased when the economy turned around. The

famous bull market of the twenties began its joyride of boom-or-bust trading and wild speculation in 1922. Everyone from barbers and office girls to dowager socialites and captains of industry seemed to be buying stocks "on margin"—that is, with a small down payment—and cashing in quick.

The dam of pent-up needs and wants that had accrued from the privations and shortages during the war years burst in an orgy of consumerism in the prosperous 1920s. Materialism was the new idol of the jazz-and-gin era. Enticing advertising was everywhere, from the magazines and direct mail pouring into homes daily to billboards, posters, and store window displays, urging consumption. (Figure 22-1.) The newly devised payment installment plans encouraged consumers to buy beyond their means—bigger cars, refrigerators, radios, phonographs, and similar high-end goods. The binge of spending further fueled the blazing economy and the decade came to be called the Roaring Twenties.

This insatiable consumerism also had a profound impact on social change. The affordable, mass-produced automobile opened new worlds for previously isolated rural folk. In the reverse, the automobile made possible suburbia and a different lifestyle for urban workers. The automobile is also credited (or blamed) for the revolution in sexual morality. As many social cartoonists of the time depicted, the car was an ideal, mobile parlor where a boy and girl might escape from chaperoning elders.

The rapid erosion of traditional values was further aided by the radio. The first commercial radio station began broadcasting in 1920. Within five years, consumers spent $400 million on radio equipment. Small town America was exposed to a world of popular culture they may not otherwise have known. Over their "wireless" radio, listeners heard instantaneous news reports, political speeches and debate, and new forms of music. Dramas and sophisticated comedies brought new ideas of social diversity and change into their living rooms night after night.

Motion pictures similarly had a significant influence on changing social values. In the 1920s, movie palaces proliferated across the landscape. Upon silver screens flickered the images of the beautiful people of the era wearing the latest fashions, hairstyles, and makeup. Hollywood stars demonstrated modern behavior and social trends, including the new, permissive rituals of romance. By the millions, women and men of all ages emulated their movie idols in dress, appearance, and mannerisms.

The decade was especially a youth-oriented era—the first youth rebellion. The young drank hard and played hard. Sheiks and shebas danced the Charleston to the cacophony of jazz bands, drank bathtub gin in speakeasies, and necked in the backseats of flivvers. Girls, in particular, embraced change and all that modernism had to offer. The flapper wore her skirt to her knees, smoked cigarettes, painted her lips and rouged her cheeks, and experimented with premarital sex.

Figure 22-1. The booming economy of the 1920s was fueled by the robust mass production of new consumer goods and by mass marketing that inculcated a broader socioeconomic class of consumers with the aspiration of better living.

The heady Great Euphoria of the 1920s, sustained by its blend of materialism, consumerism, and social change, continued to soar frenetically right through to the end of the decade.

THE GREAT DEPRESSION OF THE 1930s

In October 1929, the soaring prosperity came to an abrupt and ruinous end when the U.S. stock market crashed. In one day, the value of shares on the New York Exchange dropped 14 billion dollars. The speculative bubble had finally burst. The economic disaster caused a calamitous chain reaction around the world plunging global economies into a deep and sustained business depression.

In the three years from 1930 to 1932, 86 thousand U.S. businesses failed, 9 million savings accounts were wiped out, and wages fell by sixty percent. More than 5,000 banks collapsed. Unemployment spiked sharply from less than 1 million in 1929 to almost 12 million in 1932. Countless thousands lost their homes and farms to foreclosure.

Because President Hoover had been slow to act in providing decisive measures of relief for the hard times, he lost the election of 1932 to Franklin Delano Roosevelt. In his first 100 days, Roosevelt pushed through Congress many of the essentials of his New Deal program aimed at the three R's: relief, recovery, and reform. An "alphabet soup" of federal agencies was developed to provide employment such as the WPA (Works Progress Administration) and the PWA (Public Works Administration). Government relief prevented mass starvation and eased suffering, but economic recovery was slow. Only with the onset of the Second World War did the Great Depression finally come to an end.

In Europe, the Depression further fanned the fears of revolution and communism. Germany yielded democracy for the perceived stability of fascism. In 1933, Adolf Hitler became chancellor, and within a year had established a Nazi

Party dictatorship. Almost immediately Hitler began rearming Germany. In 1938, he seized Austria and part of Czechoslovakia. A year later, he sent German troops into Poland, instigating the start of World War II.

Italy, too, was subjected to a totalitarian government headed by Benito Mussolini. In a quest to revive the glory that was the Roman Empire, Italy attacked Ethiopia in 1935 and occupied the territory as a colony.

The emergence of fascism in Spain resulted in a brutal civil war between 1936 and 1939. Aided by Hitler and Mussolini, General Francisco Franco overthrew the republican government in Madrid and established his own iron-fisted dictatorship.

In Asia, Japanese imperialists took advantage of the West's preoccupation with the Depression to conquer Manchuria in 1931. By 1937, Japan had expanded its aggression to all of China. This full-fledged war was a proving ground for Japan's militarists who would enter the Second World War in 1941 by attacking the United States at Pearl Harbor, Hawaii.

INFLUENCES AND TECHNOLOGIES OF FASHION 1920–1940

During World War I, Paris had remained the arbiter of fashion and style despite the shortages of materials and restrictions on shipping and communications. In the months after the armistice, couture shops that had been converted to uniform manufacturers were quickly refurbished, and salons that had closed for the duration reopened. Molyneux, Patou, and Poiret returned from military duty to energetically resume fashion design. The fashion press and retail buyers flocked to Paris season after season to see and buy the fresh collections.

Although U.S. designers had received more press coverage during the war years than ever before, as a group, they were unable or unwilling to take advantage of the publicity and name recognition to emerge from beneath the shadow of Paris as innovative fashion leaders. Most American designers traditionally worked for ready-to-wear manufacturers producing seasonal collections based on trends from Paris. Similarly, some "carriage-trade" department stores had custom shops that also provided copies or adaptations of Paris originals. American designers continued to comfortably maintain the convention of following Paris dictates.

However, the American ready-to-wear industry came into its own during the twenties. Between 1918 and 1921, a group of investors and about fifty clothing manufacturers built a complex of showrooms and workshops on Seventh Avenue in New York to serve as a one-stop buying center for clothing merchants. Over the following years, additional buildings along the avenue were added to the fashion co-op. The organization also addressed the concerns of garment workers' unions for fire safety and improved working conditions by setting high standards of building construction and shop layout. As the leases were sold, apparel makers filled the

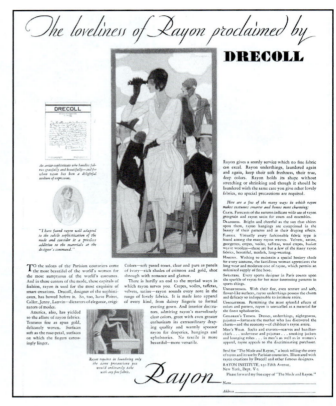

Figure 22-2. After decades of production refinement, the synthetic substitute for silk, named "rayon" in 1924, at last could be produced with a high quality suppleness and finish to be widely used for apparel. Rayon Institute ad, 1928.

suites with modern, high production equipment that could more efficiently keep pace with the booming consumer demand of the era. Today Seventh Avenue—better known as **"Fashion Avenue"** or simply the "market"—is still the central hub of American ready-to-wear.

As in the 1890s and early 1900s, one key influence that flowed from America to Paris was sportswear designs. During the 1920s, women broke through the barriers of competitive sports setting records, winning Olympic medals, and excelling in highly publicized championships. Increasingly, women were encouraged to participate in all forms of athletics for which designers created comfortable, easy-care clothing. These active sportswear styles soon became integrated into everyday wardrobes. As *Vogue* observed in 1924, "It has been said, with more or less truth, that the ultramodern woman wears only two types of clothes in summer: sports things all day and dance frocks all night." Paris recognized that the New Woman of the twenties not only wanted the ease and comfort of sports clothes, but delighted in the youthful look of the styles. Gabrielle (Coco) Chanel especially embraced this change in women's attitudes and designed comfortable jersey knit suits that were widely copied.

Another American influence on Paris fashions came from technology. Although synthetic silk made of cellulose had been invented by the French in the 1880s, early forms of the filament produced textiles with too much sheen to be a convincing substitute for real silk. Over the subsequent decades, U.S. firms refined the processes of synthetic yarn production and weaving, patenting numerous improvements. Two different forms of artificial silk, both of which came to be known as **rayon**, were developed in the early part of the century: **viscose rayon** and **cellulose acetate**. By the end of World War I, artificial silk fabrics—popularly referred to as "art silk" at the time—could be produced supple and fine enough to be used in women's lingerie and hosiery. In 1924, the term rayon was first used commercially by a U.S. manufacturer for its synthetic silk. (Figure 22-2.)

In 1928, the U.S. chemical manufacturer DuPont began experimenting with molecular engineering to create polymers that would form the basis of numerous synthetic materials including **nylon**. In 1938, durable, resilient nylon yarns were introduced. The following year, nylon stockings created

a sensation at the 1939 New York World's Fair. Because nylon became an important war material during the Second World War, the widespread application of the material in fashion was deferred until the late 1940s.

One of the most often cited examples of American influence on fashion of this period was the movies. In the 1920s, though, film studios commissioned Paris couturiers such as Molyneux, Lanvin, and Chanel to design costumes that were exaggerated and theatrical, not necessarily the mode of the season. As costume historian Jane Mulvagh noted, to remark on a 1920s look with "Whew! Pretty Hollywood" was an insult. In the 1930s, though, movie studios established wardrobe departments headed by some of America's most talented designers: Adrian at MGM, Edith Head at Paramount, and Walter Plunkett at RKO to name a few. The costumes they designed for both historical and contemporary themed movies often broadly influenced mainstream fashions. The designers themselves even came to be as famous as film stars and frequently designed freelance for fashion firms or, as with Adrian, established their own salon and label.

The Zipper

An especially important American invention that eventually impacted fashion worldwide was the **zipper.** The slide closure design of today with its interlocking teeth affixed to fabric evolved from various types of mechanical hook-and-eye fasteners first introduced in the 1890s. In the 1920s, the rubber manufacturer, B. F. Goodrich, produced galoshes with an improved form of the "hookless fastener" and christened the zipper with its onomatopoetic name. The zipper was soon applied to all sorts of accessory items like purses, luggage, shoes, money belts, tobacco pouches, and some garments such as outerwear and children's playwear. (Figure 22-3.) Only in the 1930s did tailors and designers begin to add the zipper to couture styles and made-to-measure clothing. Charles James' famous spiral zippered dress was designed in 1933, and Schiaparelli used oversized and colored zippers as decorative accents in 1935. (Color Plate 27.) The Prince of Wales requested his first pair of zipper-fly trousers in 1934.

Figure 22-3. Initially the zipper was used primarily for accessories, luggage, and utilitarian garments like jackets. Left, Goodrich ad, 1926; right, Talon ad, 1928.

WOMEN'S FASHIONS 1920–1929

In the first few seasons following the end of the Great War, Paris designers continued to produce a myriad of looks that seemed to have few things in common. In 1920, *Vogue* reported that "straight lines will be the rule of daytime, and fantasies from all parts of the world and all periods of the mode will prevail for evening." The straight silhouette that *Vogue* had observed was achieved by the dropped waistline—a look that would persist throughout the decade and come to define the fashions of the era. Initially, the waistline was lowered only slightly, but after the high placement of the waist throughout the 1910s, the effect was dramatic. (Figure 22-4.) Between 1922 and 1924, the line further shifted downward to mid-hip where it remained till the end of the decade.

Despite the dominance of the loose, straight cut of dresses, some designers offered other styles as well. The Empire waist had continued throughout the war years and was still making its appearance into the early twenties. Panniered and bustle enhancements with a natural placement of the waistline were also favorite looks of the early years. Even hooped skirts and infanta revivals continued as options. In 1922, the discovery of King Tutankhamen's tomb also inspired designers to sprinkle their collections with interpretations of costume styles from ancient Egypt, Persia, and China.

Hemlines became the most newsworthy topic of design throughout the first half of the decade. In the spring of 1920, *Vogue* assured readers that "street clothes remain short," which at that time meant at midcalf. Barely ten months later, though, hemlines descended almost to the ankles—about "eight to ten inches from the floor," advised *Vogue*—which is where designers tried to keep skirt lengths over the next couple of years. The problem was that women did not like the long skirts. As Paul Nystrom noted in his 1928 landmark study *The Economics of Fashion*, not only did dress sales decline when hemlines dropped, but "alterations expenses mounted rapidly" as women demanded shorter skirts. By the end of 1923, sagging sales and a flood of complaints from retailers convinced designers to shorten hemlines—first,

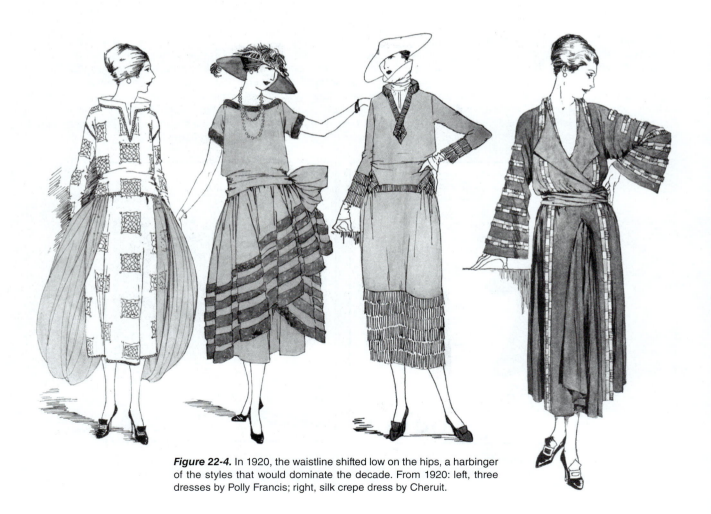

Figure 22-4. In 1920, the waistline shifted low on the hips, a harbinger of the styles that would dominate the decade. From 1920: left, three dresses by Polly Francis; right, silk crepe dress by Cheruit.

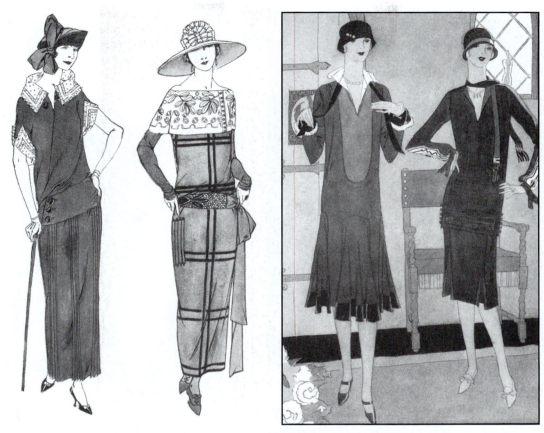

Figure 22-5. From 1921 through 1923, couturiers persisted in designing long skirts—some barely eight inches from the floor—despite resistance from consumers. Finally, in 1924 skirts were shortened and within a year rose to knee length. Left, serge dress with lingerie collar by Worth and gabardine dress with muslin collar and beaded belt by Jenny, 1922; right dresses from Carolyn Modes, 1925.

returning them to about where they were in 1920, at midcalf, and then up to the knees by 1925. (Figure 22-5 and Color Plates 23 and 24.)

Besides the lengths, the treatment of skirt hemlines was equally important to the styles of both day wear and eveningwear of the early twenties. **Handkerchief skirts** were cut with uneven, pointed hemlines all around. Other treatments included scalloped and tulip-edged hems. Asymmetrical overskirts and off-center gathers or pleats added further hemline interest.

The most popular forms of eveningwear in the 1920s were lavishly decorated versions of the short, sleeveless chemise. Some styles even featured the barest of deep decolette necklines supported only by thin, spaghetti shoulder straps. In the early twenties, after-six dresses often included a long, trailing panel, sometimes split in two or lined with contrasting fabrics, that dropped from the back of the bodice, waistline, or hips. In the later part of the decade, these extensions were often simplified into a longer hemline in the back although some designs retained the train-like effect. (Figure 22-6 and Color Plate 26.)

Suits adapted the long, lean silhouette of dresses by dropping design elements of jackets low on the torso. Buttons, especially for double-breasted styles, fastened at the hips rather than at the waist and bust. Lapels descended in long lines and deep openings. Patch pockets were placed low in the front, sometimes at the hemline. Jacket belts encircled hips. Wide box jackets were worn open to display the dropped line of blouses underneath.

To apply the dropped waist look to sportswear separates, many types of blouses were designed to be worn untucked. Some were long tunics and others were fitted with belts at the hips. One of the most popular blouses featured banded hems at the hips. (Figure 22-7.) Loose, comfortable knit versions were especially popular with active, young women. Certain styles of soft, bow front tops called **jabot-blouses** were made to be tucked but were cut wide and full to allow a deep blouson over the skirt waistband.

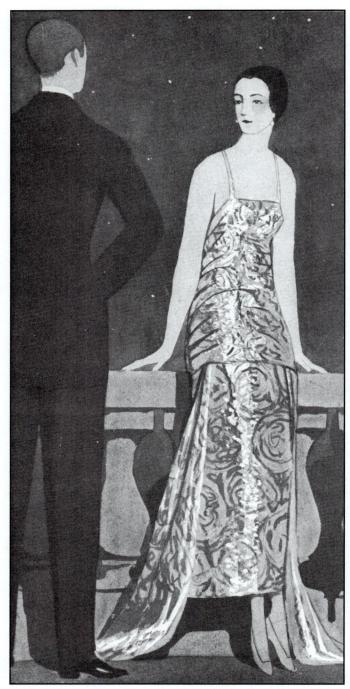

Lanvin, 1921.

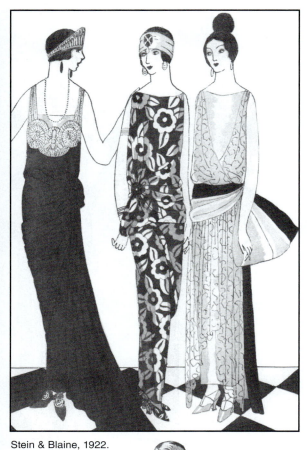

Stein & Blaine, 1922.

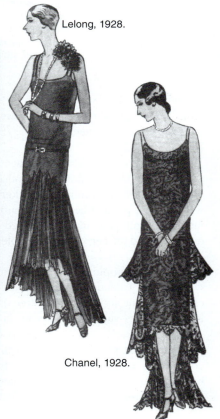

Lelong, 1928.

Lanvin, 1928.

Chanel, 1928.

Figure 22-6. As hemlines rose in the 1920s, floor length evening gowns were abandoned in favor of shorter styles. During the early part of the decade, after-six dresses were often embellished with trains or trailing appendages of fabric. In the late twenties, this treatment evolved into a longer hemline that dipped in the back.

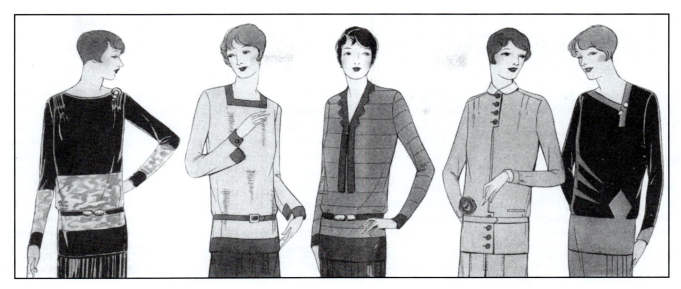

Figure 22-7. The long line of the dropped-waist chemise was carried over to sportswear separates with tunic-style blouses that mostly were designed to be worn out over skirts. The dropped waist was emphasized with belts and banded hemlines at the hips. Blouses from Fashion Service, 1927.

By 1925, the look that defined the twenties had been perfected. The ideal feminine figure was that of a young boy—virtually devoid of curves of any form except for the legs. Shirt hemlines cropped at the knees now exposed more of a woman's legs than at any time in the history of the Christianized West. If a woman possessed a full bosom, she compacted the contours of her breasts within tight-fitting bandeaus. Any hint of a waistline was obscured by boxy, straight bodices. "This is our ideal today, gone are the busts, the hips, the curves of yesteryear," asserted a fashion editor in 1923; "Woman's figure is the exclamation point of the world!"

This boyish look was the fashion style of the flapper—a term initially applied to certain vivacious young women of the twenties. In 1922, *Vogue* declared, "This is that strange product indigenous to this generation—the flapper—hair bobbed, lips reddened, cigarette in hand—everybody knows her." However, the look of the flapper became universal for women by mid-decade. The *New Republic* noted in 1925 that the style of the nineteen-year-old "Flapper Jane" was adopted "by ladies who are three times Jane's age, and look ten years older, and by those twice her age who look a hundred years older."

The boxy, straightline silhouette of fashions in the 1925 to 1929 period was further emphasized by **art deco** textile patterns and graphical treatments of fabrics. (Figure 22-8 and Color Plate 24.) The geometric shapes and purity of line that characterized the art deco movement embodied the dynamism and modernity of the machine age. Many of the designs, color palettes, and motifs of art deco were derived from prewar art movements such as Cubism, Futurism, Viennese Sezessionism, and German Jugenstil, as well as ethnic and folk art influences.

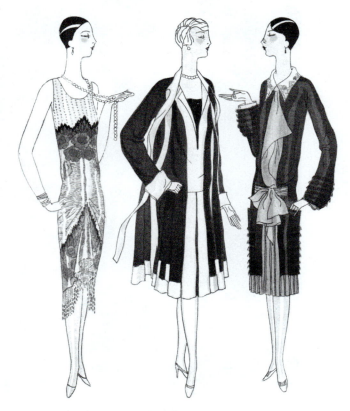

Figure 22-8. Virtually all types of garments and accessories of the late 1920s were variously produced with geometric cuts, textile patterns, or surface embellishments influenced by the art deco movement. Dress designs by Magdeleine des Hayes, 1926.

Called "modernistic" at the time (the term "art deco" was coined in the 1960s), the style culminated in the Exposition Internationale des Arts Decoratifs et Industriels Modernes hosted by Paris in 1925. There, architecture, painting, sculpture, and, particularly, the decorative and applied arts—including fashion—exhibited the cohesive, comprehensive look of the era. From this international expo, Paris reclaimed preeminence as the world's leader of style and fashion.

WOMEN'S FASHIONS 1930–1940

As the economic conditions of the industrialized world worsened in the first years of the 1930s, the fashion industries of Paris, London, and America suffered significant losses in sales and business failures. Some houses such as Doucet and Doeuillet merged to survive, while other salons, notably Poiret's, went bankrupt and closed permanently. Innumerable ready-to-wear operations on both sides of the Atlantic folded. Designers presented fewer models in their collections as there were fewer couture clients and merchant buyers.

One of the misconceptions today of fashion change during the period between the World Wars was that the onset of the Great Depression was the catalyst for the shift in silhouettes from the flapper's short, straightline chemise to the curvaceous contours and long skirts of the 1930s. In actuality, the change had already begun well ahead of the catastrophic collapse of the U.S. stock market. Reporting on the autumn collections of 1929, the Paris editor of the *Ladies' Home Journal* advised readers that the "vast majority of the leading dressmakers" now designed a "normal waistline," thus allowing "a smart figure to follow nature's curves in the outlines of dress." In addition, the editor noted, hemlines for street dresses had dropped "a few inches below the knees," and for afternoon dresses, skirts were now "well down, at least half way to the ankle." The following year *Vogue* was more specific, citing measurements of hemlines "from thirteen to fifteen inches from the ground." By the worst period of the Depression in 1932, many fashion depictions showed hemlines almost at the ankles. (Figure 22-9 and Color Plate 28.)

The new interest in feminine curves, though, did not extend to a renewal of the voluptuousness and mature proportions of the Edwardian woman. The feminine figure of the 1930s was delineated but not exaggerated by the shape of clothing.

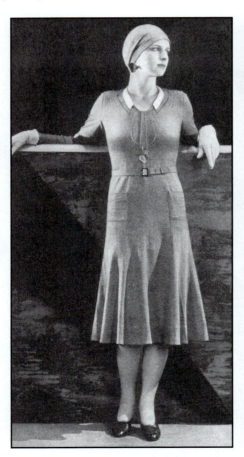
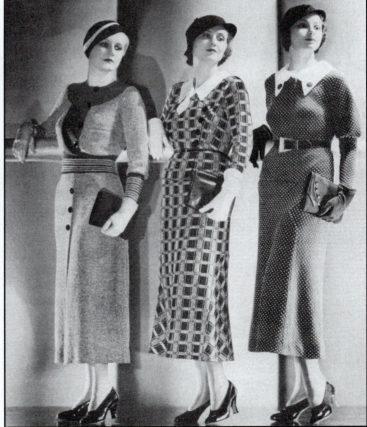

Figure 22-9. By the end of 1929, hemlines had begun to drop below the knees and the waistline returned to its natural position. Within two years, skirts had descended almost to the ankles. Left, worsted jersey dress from Durene, 1930; right, wool knit dresses from Marinette, 1932.

The waist was defined but not cinched, the bust was shaped but small, and hips were rounded but slender. Legs may have vanished beneath longer hemlines but the narrow cut of the skirts contoured the hips and thighs redefining feminine sensuality. The slim, form-fitted silhouette was reinforced with snug bodices, blouses, and sweaters, and with skirts made with the addition of gores and bias-cut sections set into hip-line yokes.

In the opening years of the Depression, fashions were simplified and conservative. The flash and dazzle of the flapper were left behind. Shimmering materials such as taffeta were replaced with matte fabrics like satin-faced silk or rayon, and the lavish use of beading, fringe, and embroidery largely disappeared. Colors were more somber to reflect the mood of the moment. Long sleeves were more prevalent, even in warm weather.

One reason for the more simple, subdued clothing designs during the early thirties was economy—clothes were meant to last for several seasons without appearing to be out of style. Women's magazines devoted many pages to advice on thrift and frugal shopping. Even upscale *Vogue* introduced new feature articles such as "Tips on the Shop Market" to keep readers informed of affordable styles in ready-to-wear.

By the mid-thirties a slow but perceptible economic recovery had begun. The darkest days of the Depression were over and people once again dared hope for better times.

Designers began to reflect the renewed optimism with a return of opulence and a touch of frivolity of style and color.

Leading the charge out of the doldrums of the Depression was Elsa Schiaparelli, whose association with the Surrealists, particularly Salvadore Dali and Jean Cocteau, inspired her to design many quirky, eye-catching fashions of the period. "Shocking Elsa," as she was nicknamed, thrust vibrant color into the fashion arena reminiscent of Poiret a generation earlier. Her trademark hue was a vivid pink appropriately called "shocking pink." Later, when she introduced a house perfume, she labeled it "Shocking." Among her most memorable creations were hats sculpted like upside down high heels or lamb chops, purses shaped like desk telephones or giant padlocks, and costume jewelry of lifelike insects. More importantly, though, Schiaparelli's fashions were very wearable. Her suits with bolero jackets were widely copied and remained popular through the Second World War. Equally significant was her persistent use of wide, exaggerated shoulders, an influence that endured until the mid-forties. (Figure 22-10 and Color Plate 29.)

Inventive and luxuriant movie costumes also influenced both mainstream fashions as well as Paris couture during the 1930s. For instance, among the most popular styles of evening gowns of 1933 were replicas of Adrian's white satin gown worn by Jean Harlow in *Dinner at Eight*. Historical

Figure 22-10. As global economies eased out of the Depression during the mid-thirties, fashion designers reintroduced flair and fancifulness into fashion. Shoulders were broadened by new, exaggerated interpretations of puffed and padded sleeves. Suit styles by Carolyn, 1936.

films such as the *Merry Widow* (1934), *Mary of Scotland* (1936), *Camille* (1937), *Marie Antoinette* (1938), and *Gone with the Wind* (1939) inspired various revivals of bustles, crinolines, Medici collars, and panniers.

Despite the occasional exaggerated revival and the persistence of broad shoulders and big sleeves, the silhouette primarily remained trim and fitted to the feminine curves. Skirts hugged hips and thighs, with a flare at the hem for added fluidity of motion. Hemlines began to rise in 1933 to about fourteen inches from the floor, and gradually continued upward about another four inches by the end of the decade.

The exception to the rule of curves were some styles of women's tailored suits. Many suit designs adopted strong masculine lines that were further enhanced by boxy jackets with padded shoulders and wide lapels and slim skirts. (Figure 22-11.) The squared shapes of bolero suits particularly disguised the feminine form, especially when jackets were worn opened or draped around the shoulders. As Europe's war machines began to mobilize in the second half of the decade, military details like metal buttons and grosgrain ribbon or braid trim became popular embellishments for women's suits. Firm, durable fabrics and strong textile patterns such as houndstooth checks, glen plaids, and chalkline stripes reinforced the menswear look.

Eveningwear of the 1930s was especially enhanced by the redefined waistline and natural proportions. Sweeping floor-length gowns returned, often with flowing trains. Opulence was concentrated on fabric and cut rather than the lavish surface embellishments favored in the previous two decades. Most dramatic of all, though, were the backless gowns, many of which were open fully to the waist. (Figure 22-12.) To emphasize the

Figure 22-11. As a contrast to the contoured, curvaceous fit of dresses, many suits adopted the look of menswear that altered or disguised the feminine form. Suits from Carolyn, 1936.

Figure 22-12. Eveningwear elegance in the 1930s was hallmarked by a return of the flowing, floor-length gown and sumptuous, fluid fabrics. Fashion drama was achieved with daring open backs, some of which plunged to the waistline. Backless gowns from Symphonie, 1932.

expanse of bare flesh, designers sometimes added all types of eye-catching, fussy trim and detailing to the back openings. As legs disappeared beneath longer skirts, the bare back became the new displayed erogenous zone. Patou's dramatic halter styles of 1933 daringly laid bare the entire back, shoulders, and arms. Such open designs challenged couturiers to develop innovative constructions of internal bras and bodice boning to hold the garments in place. By mid-decade, exaggerated sleeves provided a fresh look to eveningwear. Shoulderlines ranged from wide, leg-of-mutton revivals to the **pagoda sleeve** with its high, peaked shoulderline. (Figure 22-13.) The deep dolman cut, commonly called the **batwing sleeve**, was a softer alternative to the broad, puffed construction.

The category of resort sportswear—trousers, shorts, culottes, knit tops—had continued to grow in popularity throughout the 1920s and, in the 1930s, increasingly became standard everyday casual attire for most women across all demographics. Trousers—usually referred to as **slacks**—were particularly adapted to women's wardrobes for leisure activities and relaxing at home. (Figure 22-14.) Hollywood stars such as Katherine Hepburn and Marlene Dietrich became trendsetters by appearing in movies wearing slacks and being photographed wearing various trouser styles in public. Ready-to-wear makers, especially those from California, mass produced slacks tailored to the female form with a more flattering fit than Poiret's Turkish trousers or the functional work pants of the World War I years. Similarly, shorts migrated from active sports arenas to the playwear wardrobes of women where colorful and patterned variants were worn for summer leisure.

Figure 22-13. Fun and frivolity were applied to evening gowns of the mid-1930s through revivals and adaptations of oversized sleeves and broadened shoulderlines. The pagoda sleeve was constructed with a distinctive, peaked exaggeration. Gown by Nettie Rosenstein, 1936.

Figure 22-14. Women's trousers—called slacks in the 1930s—increasingly became a wardrobe staple for leisure activities. Ready-to-wear makers of the period designed slacks to better fit female curves and proportions than earlier trouser styles. Slacks, 1938.

WOMEN'S OUTERWEAR 1920–1940

Outerwear of the early 1920s was a mix of modern looks and revivals. Adaptations of eighteenth-century styles such as the fitted redingote and caped pelisse were the result of a flurry of period plays and movies popular in those years. Long, straight overcoats, though, were the most prevalent through about 1924. By the mid-twenties, coats were as short as skirts. The dropped waistline of dresses was applied to coats by lowering closures and lengthening lapels. Large fur collars were ubiquitous from the second half of the 1920s into the mid-1930s. **Cape coats** were popular as transitional outerwear for fall and spring. Wrap coats, called **clutch coats**, were favorites of college girls.

In the 1930s, coats were reshaped to follow the natural contours of the feminine form. Waists were defined with belts or by tapered cuts on princess lines, though not tightly cinched, and hemlines grazed just above the ankles by 1931. Military detailing began to appear in the early thirties, primarily influenced from Schiaparelli's "soldier" collections. As the war machines of Italy and Germany became constant headlines in the news, military looks for women's outerwear such as epaulets and padded shoulders gained in popularity.

Wide shoulders and exaggerated, oversized sleeves—including leg-of-mutton and pagoda styles—dominated mid-decade. Fuller cut, three-quarter lengths were more common as hemlines shortened in the second half of the thirties.

Camel's hair coat from College Club, 1923.

Wool coats with fox collars by House of Swansdown, 1927.

Princess line coats, 1933.

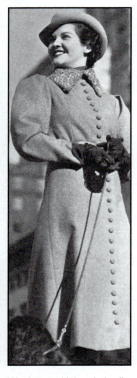

Wool coat with karakul collar from Fashion Firsts, 1936.

WOMEN'S SPORTS APPAREL 1920–1940

Throughout the 1920s, the New Woman discovered new arenas for expressing her independence and self-confidence. Sports particularly provided opportunities for women to compete and demonstrate youthful agility and athletic skills. By the 1930s, when New Deal programs built public parks, sports facilities, and community swimming pools, sports that were previously regarded as activities for the affluent, such as tennis and golf, became more popular with the middle classes. Women increasingly explored winter sports like skiing and ice skating, especially following the highly publicized 1932 Winter Olympics in Lake Placid, New York.

Knit garments of all kinds were the preferred clothing for active sports. Track and field competitors wore form-fitting one-piece short suits with modesty skirts extending to the upper thighs. (See also women's swimwear, page 594.) Bloomer suits and middy blouses were still the most common attire for school athletics. In place of cumbersome coats for winter sports, assorted pullover sweaters, cardigans, and vests were layered to peel away as exertion warmed the active body.

For weekend recreation, women primarily wore everyday casual clothes to neighborhood tennis courts and community golf ranges. Pleated skirts were favored for the ease of movement they provided, especially the short styles of the late twenties. Split skirts, now more commonly called **culottes**, remained a comfortable, practical alternative to flying hemlines when lunging for a ball or traipsing over windblown golf greens. White was the correct color for skirts and tops at country clubs although soft colors like peach and pale yellow were acceptable at sunny resorts where suntans were fashionable.

Knickerbocker suits for women remained a common outfit for golfing, hiking, canoeing, camping, hunting, and other country activities. The transition from knickers to slacks for sports was gradual throughout the 1930s. Jodhpurs and short jackets were still the preferred casual uniform for riding. A similar ensemble was trendy for skiing at winter resorts. Jodhpurs also became a fashionable pant style for women when hunting was a mixed social event, such as shooting grouse.

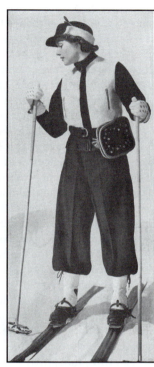

Knit sheepskin skisuit, 1936.

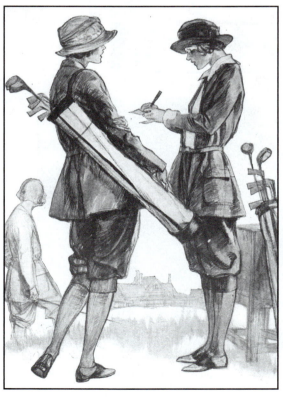

Golf knicker suits, 1923.

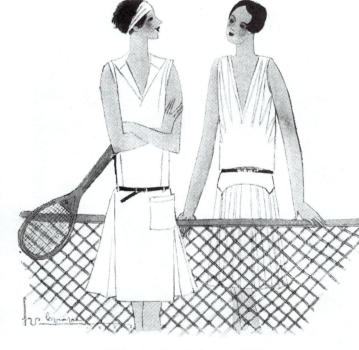

White pique tennis dresses, 1927.

WOMEN'S UNDERWEAR AND SLEEPWEAR 1920–1940

During the 1910s, women had begun to free themselves from constricting, heavily boned corsets, replacing them, instead, with more comfortable, elasticized foundation garments that smoothed more than shaped the figure. By the 1920s, corsets were engineered to compress the feminine form into the fashionable boyish contours of the era. All-in-one **corselettes** that encompassed the bust and hips were preferred by full-figured women, but most women opted for the abbreviated girdle styles that could better slim the hips and buttocks. Younger women, especially the flapper, discarded the corset altogether.

In the 1930s, foundation garments, as the category of corsets, girdles, and bras came to be known in retail, were revolutionized by changes in fibers, finishes, and fasteners. The fashionable silhouette was now curvaceous but slim. Corsets once again became substantial, not only to shape the figure, but also to control any bulges and sagging of the natural form. Advances in knitting technologies allowed for elasticized yarns to be shaped into seamless tubes for corsets that could be rolled on. Similarly, the introduction of the zipper to foundation garments eased the strain of squeezing into corsets and girdles.

The camisole type of brassiere that had developed in the 1910s was gradually pared down in the 1920s. Bandeau bras of elasticized fabrics that concealed and flattened the bosom were particularly popular for the correct draping of the boxy chemise dresses of the time. When feminine curves returned in the 1930s, though, new emphasis was placed on the bust, and bras were reengineered into cup models to shape and delineate the contours of the breasts. In 1935, Warner's introduced the alphabet cup sizes to ensure the best fit.

From World War I into the 1930s, a myriad of combination undergarments, drawers, and panties were developed by manufacturers. Styles ranged from full-length knit union suits of the early twenties to diaphanous steps-ins of the flapper (called **singlettes**) and the brief-style "**skanties**" of the early thirties. Fine lingerie was made of crepe de chine, silk tricot, or voile, and cheaper varieties were of linen, cotton, or rayon.

Other basic types of intimate apparel included assorted styles of petticoats and chemises, now called **slips** in this era because they were a mere "slip" of their former volume and weight. Camisoles were also a common covering over bras and corsets to disguise telltale seams and fasteners.

Sleepwear likewise became widely varied in design and fabric. Negligee ensembles made of the new art silk, rayon, were lavishly trimmed with machine-made lace and embroidery. As skirt hemlines rose, nightgowns were shortened. Empire waist and princess-line gowns were the most common. The kimono and other wrap robes remained favorite cover-ups for the boudoir or dressing room. In the 1930s, nightgowns were made sexier with bias cuts based on form-fitting eveningwear styles. The most important change in women's sleepwear, though, was the increasingly popularity of pajamas, which, since the 1890s, had been selectively appropriated from menswear. By the 1920s, women's sleepwear pajamas and lounging pyjamas were widely advertised by ready-to-wear makers and mail order retailers.

Silk jersey brassiere by G.M. Poix, 1927.

P.N. Practical Corset, 1923.

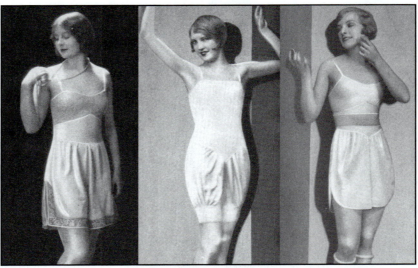

Silk undergarments from Van Raalte, 1927: left singlette with lace-trimmed panties; center, sport or dance singlette with breeches; right, bandeau and panty set.

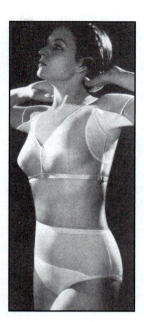

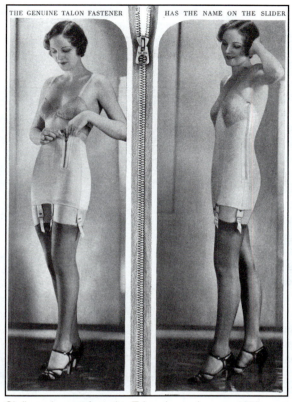

THE GENUINE TALON FASTENER HAS THE NAME ON THE SLIDER

Girdle and corset featuring Talon zipper closures, 1932.

Bra and "scant" panties
from Kleinert's, 1936.

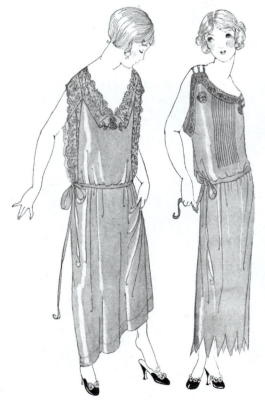

Crepe de Chine nightgowns from Franklin Simon, 1924.

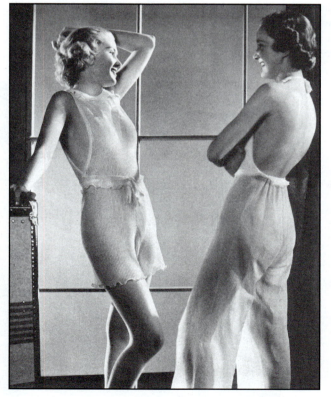

Pleated shortie pajamas and halter-neck one-piece pajamas in sheer knit
cotton from Kayser, 1936.

WOMEN'S SWIMWEAR 1920–1940

During the 1920s, the automobile made vacations and weekend excursions to lakes and seashores available to the masses. Ready-to-wear makers happily mass produced chic, affordable beachwear and playwear modeled on the latest styles worn by the leisure classes at the resorts. At the beginning of the 1920s, versions of the Edwardian full tunic, bloomers, and hose lingered as the most prevalent bathing suits for women. Adaptations of men's swimwear that had emerged during World War I increasingly became the feminine standard. In 1920, knit manufacturer Carl Jantzen introduced skintight, stretch swimsuits for both men and women "that changed bathing to swimming," as their logo floorline of the era advertised. "A Jantzen suit always fits trimly—and with scarcely a wrinkle," promised the copy in a 1926 ad. But initially not all women were eager to reveal so much of themselves on a public beach. In fact, in some areas of the United States and Britain, women wearing the second-skin, one-piece swimsuits were arrested for indecent exposure. Only in the later part of the twenties did the sexy, new look gain popular acceptance. By then, the trunks had risen from the knees to the upper thighs, armholes had become deeper, and hose had been discarded. When tanning became the rage at the end of the decade, swimsuits with low backs and even midriff cutouts made tentative appearances on the beach.

During the 1930s, swimwear continued to evolve ever briefer lines for the maximum exposure of skin. Halter styles and backless racers were favorites. (Color Plate 30.) By the mid-thirties the first two-piece swimsuits bared midriffs in public. Fabrics made of Lastex and other elasticized yarns held their shape and color better than knitted wool for a flattering delineation of the female form. Although swimwear continued to become more revealing, social prudery still dictated that for two-piece suits, bottoms must be cut high to conceal the navel, and many styles retained "modesty skirts" that extended low over the hips.

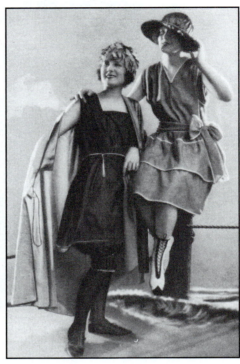

Left, taffeta bloomer suit by Plage; right, chambray bathing frock by Rivage, 1922.

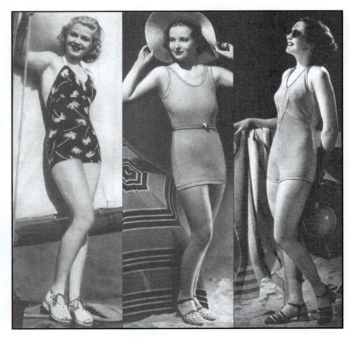

From 1936: left, halter suit by Mabs; center, skirted maillot by Kohn; right, tank suit by Ocean.

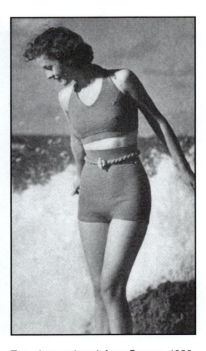

Two-piece swimsuit from Sacony, 1936.

WOMEN'S SHOES 1920–1940

During the war years of the late 1910s, the availability of shoe styles and colors had been limited due to war rationing and production restrictions. By the 1920s, a pent-up demand for more fashion variety, coupled with a robust economy and a surge in manufacturing, led to a tremendous assortment of new shoe designs. The utilitarian high-top walking shoe was widely advertised still, but finally disappeared around 1923. Versions of low-heeled boots remained a necessity for horseback riding and outdoor enthusiasts though. With more leg showing as hemlines rose in the midtwenties, new fashion emphasis was placed on the shoe. Except for sport shoes, most styles were high-heeled with pointed toes. The curvy Louis XV heel was dominant throughout the era although straight heels and the tapered Cuban heel were also typical. Straps crossed the instep in single strips and crisscrossing arrangements of multiples.

Materials were equally varied in the 1920s. In addition to dyed kid, suede, or patent, the different types of leathers were often appliqued in cutwork layered one over the other, or even over textiles like velvet or silk, for contrasting effects. Genuine reptile skins or leather textured to resemble lizard or alligator were a favorite dressy look. Exotic fabrics such as embroidered or beaded silk and gold or silver lamé were popular for evening shoes.

Ornamentation included a vast array of buckles ranging from simple squared metal forms to elaborately jeweled medallions. After 1925, art deco motifs were applied to all types of footwear both as surface embellishment and as decorative attachments.

Color was especially important in the 1920s with virtually every hue available ranging from vibrant jeweltones to soft pastels. (Color Plate 25.) No longer did the tints of shoes have to match precisely the color of a gown as with the Edwardian lady. A fad of Flapper Jane even included vividly colored galoshes worn unzipped as street shoes, rain or shine.

In the first years of the Great Depression, comfort and durability were key considerations in shoe designs. Heels were lower and more solid with less pronounced curves than the Louis ogee. Toes were more rounded and wider but became squared after 1935. The shape was higher over the instep and lace-ups returned as an alternative to buckle straps.

When the global economic outlook appeared to improve in the mid-thirties, fashion began to exhibit the fun and frivolity of big sleeves and fanciful revivals, and sportswear—including culottes, shorts, and slacks—became common everyday wear. Footwear also developed some of the most dramatic eccentricities since the seventeenth century. Open-toe shoes and slingbacks for daytime made their debut. Sandals and the rubber-soled "**tennis shoe**" were now seen on the street. In 1937, cork platform "**Lido shoes**" first appeared at the resorts. Colors were less vibrant than in the 1920s, but still came in a huge variety of deep, rich tones such as burgundy, hunter green, russet, and deep blue.

Walk-Over Brand Shoes, 1936.

Queen Quality Brand Shoes, 1932.

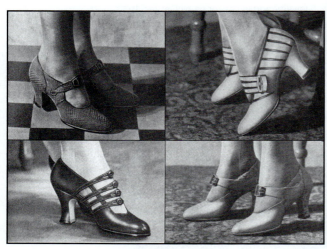

"Replicas from the famous bootiers of France" states the copy from a Best Co. ad, 1927.

Dancing shoes, 1928. Vitality Brand Shoes, 1938.

WOMEN'S JEWELRY 1920–1940

Throughout the 1920s and 1930s, art deco (called "moderne" at the time) was the predominant design style of jewelry. The sleek, geometric look of art deco evolved from influences of modern art movements such as Cubism, Fauvism, and Futurism, blended with visual elements derived from technology of the Machine Age. Following the discovery of Tutankhamen's tomb in 1922, the decorative patterns of ancient Egyptian art and similar motifs from other distant, exotic cultures also influenced jewelry designs of the period. Through mass production and mass distribution of chain stores, moderne designed costume jewelry was available to all socioeconomic classes.

During the 1920s, the flapper emphasized the long lines of the dropped-waist chemise and her short, bobbed hair with dangling earrings and long ropes of beads. Ankle bracelets glittered above the airy straps of Louis-heel shoes. For eveningwear, chain and pendant necklaces were worn backward to accent dresses cut with low, open backs. Chanel popularized piling on mounds of costume jewelry necklaces and adorning both wrists and several fingers with numerous bracelets and rings.

When the Great Depression hit, novelty plastic jewelry provided women with affordable and fun adornment for many of the drab fashions of the time. Early **phenolic plastics** like **Bakelite** and **Catalin** were used in the mass production of colorful jewelry, hair and hat ornaments, shoe attachments, belt buckles, buttons, and other accessories.

As historical revivals became more popular in fashions of the mid-thirties, jewelry makers also replicated designs from earlier eras, especially styles from the eighteenth century. Sparkling jewels were once again favored. Large brooches with clusters of faceted stones were worn with menswear suits to feminize the look. Small-link chain necklaces and bracelets of precious metals complemented the fluid draping of fashions.

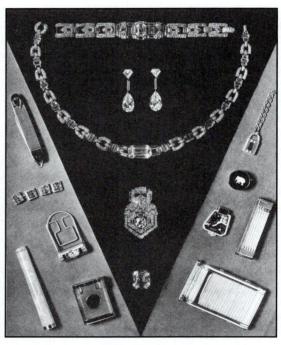

Jewelry and accessories by Cartier, 1933.

Oreum ad, 1928.

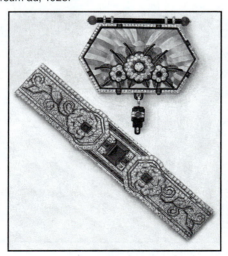

Bracelet and compact by Mauboussin, 1927.

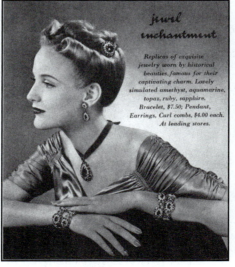

"Replicas of exquisite jewelry worn by historical beauties" in Leo Glass ad, 1938.

WOMEN'S HAIR STYLES AND MAKEUP 1920 –1940

The stigma of the painted lady had begun to diminish during the war years of the late 1910s when women began to enjoy a greater independence and self-confidence. They had shorn their long Edwardian tresses to work outside the home, and they took their cue from Hollywood movies and fan magazines on how modern women looked with makeup.

Short hair became the hallmark of the flapper. "The cut's the thing—whether the hair is straight or waved," declared a *Vogue* editorial in 1927. Women flocked to barber shops rather than beauty salons to have their hair sheered into bobs or shingled into a close crop with a straight razor. Hair salons opened by the thousands to provide "permanents"—waves and curls made long-lasting with chemicals electrically heated by the tentacles of the **marcel**.

In the years after World War I, cosmetics makers saturated mass media with ads promoting the tinted face powders, cheek rouge, and the lipstick in a metal tube, newly invented in 1915. The image of women in cosmetic ads changed from the demure user of rice powder to the sexually alluring vamp. Her lips were shaped into a crimson cupid's bow with lipstick. Her eyes were enlarged with kohl liner and eyelash mascara, and given depth with colored eyeshadows. Her eyebrows were plucked to a fine arc and defined with a penciled line. Her nails were oval shaped and polished with a pink wax. Her underarms and legs were shaved. Mass distribution of cosmetics through chain stores and mail order catalogs provided office girls and shop clerks everywhere with easy access to inexpensive beauty indulgences.

In the 1930s, short hair remained the most popular look although the cuts were fuller with soft curls over the ears and at the back of the head. By the end of the decade hairstyles became more sculptural with greater mass, though still predominantly worn up.

The application of makeup in the thirties became more refined and sophisticated, especially with the advent of color movies in which women could see up close how Max Factor and other professionals accentuated different face shapes and features. The caricatured mask of the 1920s was replaced by the sculpted, refined face of the 1930s. A dual layer of tinted foundation and powder was then accented with eyeshadows and lipsticks that suited the woman's hair color and skin tones. Rouge was used to shape and define cheekbones rather than rose tint the surface. The beauty regimen that was advertised by cosmetics mass marketers like Helena Rubinstein, Elizabeth Arden, and Dorothy Gray became a daily routine for women of all ages and classes in the 1930s.

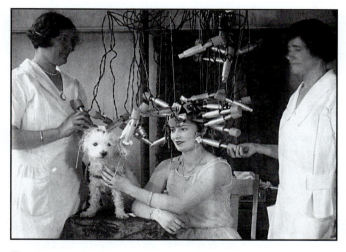

Electric tentacles of the marcel permanent wave system, 1928.

1933

1936

1938

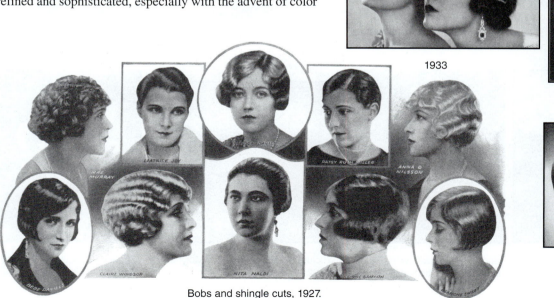

Bobs and shingle cuts, 1927.

WOMEN'S HATS 1920–1940

The cloche is the hat style most associated with the 1920s. As noted in the previous chapter, though, the close-fitting cloche had emerged during the First World War when working women cropped their hair and needed a hat style that did not require pins to stay on. As the bell-shaped cloche evolved in the mid-twenties, some styles lost their brims entirely and others extended the narrow brims well down over the brows. Milliners referred to the style as "skull helmets." By the end of the decade, the fronts of cloches receded back from the brows or were turned up to reveal the popular makeup looks of the flapper.

A close second to the cloche in popularity in the 1920s was a variety of toques. In the early part of the decade, the toque was the favorite base for milliners to design fanciful embellishments with ribbons, feathers, flowers, and lace. In the second half of the twenties, the toque was ornamented with deco trimmings and geometric surface treatments.

For special daytime events, the wide picture hat remained the favorite style. Brims were sometimes made of contrasting, semitransparent materials. For eveningwear, be-feathered and beaded bandeaux or low turbans of sumptuous materials were preferred. Hollywood influences included occasional revivals such as the cavalier hat of 1923 when the *Three Musketeers* was released. The tricorne hat also reappeared periodically.

Since hairstyles largely remained short into the 1930s, hats also continued to be made close fitting although now they sat back away from the face. Most notable about hats of the thirties was that, despite the style, virtually all varieties were worn at a sharp angle. By the end of the decade when hairstyles increased in volume but were still worn up, hats were pushed forward onto the brow. When fashion designers began to show fantasy and frivolity in their collections of the mid-thirties, milliners joined the creative fun. Schiaparelli's famous upside-down shoe hat and other Surrealistic sculptural headwear made fashion headlines, but most women, instead, opted for any of numerous hat styles laden with exuberant arrangements of feathers, ribbons, flowers, and other colorful trimmings. Also, in the latter part of the decade, verticality dominated the newer looks. Toques, fedoras, and turbans were shaped with tall crowns. Even low hats such as pillboxes and tams were given a vertical line by the addition of a feather or bow pointing skyward. Verticality was further achieved by the extreme side angle of a wide brimmed picture hat. Other popular styles of the late 1930s included the so called **"toy" hats**—miniaturized versions of contemporary styles—that were tied with wide ribbons under the chin or in the back anchored by knots of hair. Veils of all sorts of netting were the epitome of elegance and were attached to almost all varieties of hats. In 1939, the snood reappeared and would become a practical form of headwear during the Second World War when women working in factories needed to protect their hair from the dangers of machinery.

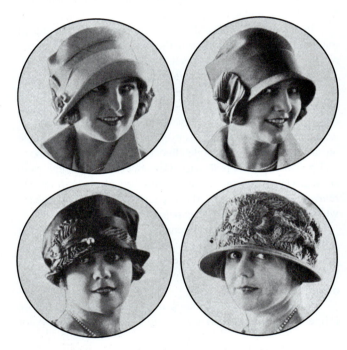

Cloches from H.L. Distillator Milliners, 1926.

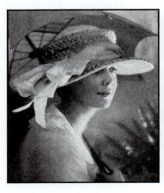

Straw hat from De Marinis, 1920.

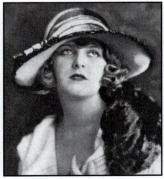

Sport hat draped with Roman scarf from Dobbs Hats, 1922.

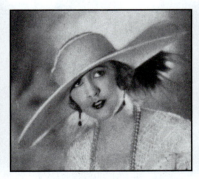

Picture hat with feathers by Molyneux, 1922.

Beaded cloche by Mallory Hats, 1924.

Felt cloche with ribbon band from Dobbs Hats, 1927.

Cloche with turned-back brim from Catalina, 1928.

Hat from Germaine Millinery, 1932.

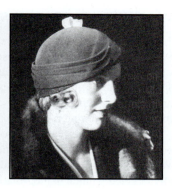

Felt turban from Stetson, 1932.

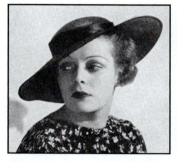

Straw broad-brim hat by Jane Engel, 1935.

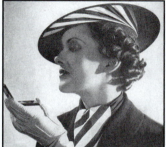

Silk lined straw sailor with matching scarf by Howard Hodge, 1935.

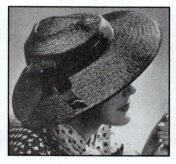

Leghorn broad-brim hat from Stetson, 1936.

Curled-brim hat from Chalfonte, 1936.

Turban with petite plumes by Maria Guy, 1938.

Felt sailor with wings by Rose Valois, 1938.

Hat with "corkscrew" crown by Peck & Peck, 1938.

Velvet toque with veil by Molyneux, 1938.

Straw tricorne with veil by Daché, 1938.

Felt hat with swirled crown and rope band from Stetson, 1938.

Bandbox straw sailor with veil from Bonwit Teller, 1939.

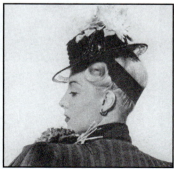

Toy hat from Carolyn, 1939.

WOMEN'S ACCESSORIES 1920–1940

The accessories of the well-dressed woman of the early 1920s remained basically those of the late Edwardian period—only updated in design and color. Just as with high-top button shoes, though, some categories of accessories became obsolete during the 1920s, including walking sticks, parasols, and evening fans.

However, some new accessories reflected the changing social mores and status of women at the time. During the twenties, tobacco companies had aggressively and successfully targeted women in their marketing efforts. The cigarette case became a new addition to the handbags of many women. Similarly, the flapper's beauty regimen expanded beyond facial powder to include rouge, lipstick, mascara, eyeliner, eyeshadow, and eyebrow pencils. Not only did handbags become more capacious to accommodate all of these feminine accoutrements but compact **vanity cases** were created to hold all the necessities for touch up, including a mirror. In addition, as an increasing number of women went to work after World War I, accessories for the office girl or career woman could include small leather items such as appointment books, notepads, pencil holders, day journals, and business card cases.

Neckwear in the early twenties included a variety of jabots and collar treatments that disappeared as the dropped-waist chemise became the standard style. Instead, long scarves and shawls were preferred for accenting the straightline cut of fashions. In the 1930s, scarves were smaller and arranged about the neck and shoulders to accent the sleeve and shoulder interest of the period. Jabots and bow collars returned.

Belts were a key accessory during both decades for defining the fashion silhouette. Thin variations were worn at the hips in the twenties, and wide versions fit snugly at or above the natural waist in the thirties.

For a polished look, few women went out without gloves. Simple, plain types had been preferred by the Edwardian lady, but in the 1920s, art deco styling was applied to all accessories, including gloves. Gauntlet styles with long, flared cuffs, sometimes worn turned down to display a contrasting color, were a favorite. Long gloves for eveningwear disappeared temporarily in the mid-twenties but were revived again in the thirties.

In winter, fur muffs remained a popular accessory. Coats of both decades often featured huge fur collars and sometimes matching cuffs, which were often complemented by an oversized muff.

Cigarette cases by International Sterling, 1926.

Beaded gloves by Grewen, 1926.

Compact with powder, rouge, and lipstick by Tre-Jur, 1924.

Deco watches by Elgin, 1928.

Handbags by Isakof, 1926.

Amalfi batiste shawl from Brightwood, 1925.

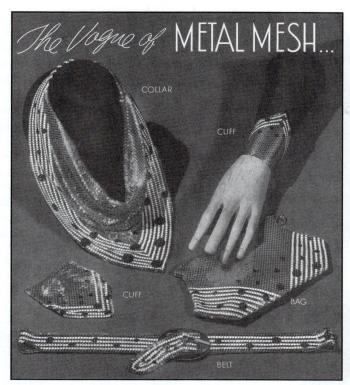

Metal mesh accessories by Whiting & Davis, 1935.

Evening bag with vanity and matching cigarette case and compact from Gold Seal, 1938.

Schiaparelli handbags designed for Whiting & Davis, 1938.

Patent belts from Slote & Klein, 1931.

Glentex silk scarves and clips, 1937.

Gloves from Van Raalte, 1937.

Talon handbag, 1932.

MEN'S FASHIONS 1920–1940

The young men who had survived the Great War wanted to distance themselves from the trauma, disillusionment, and privations of that time. As the 1920s heated up, they danced hard to jazz music, drank bootleg whiskey, smoked too much, drove too fast, and indulged in all the hedonistic and carnal pleasures so readily available to them with the surplus of women. Flaming youth of the twenties also used fashion more aggressively than in any previous period to assert their independence from the older generations. The emphasis on the trim, youthful look in men's clothing during the 1910s evolved into a virtual fetishistic obsession—a youth cult—in the 1920s.

The two- and three-button, natural shoulder suit with its trim V-line jacket, snug vest, and narrow, leggy trousers was the proper attire for both young and mature businessmen of the 1920s. Jackets with notched lapels were the most common although some dapper lounge models featured rounded lapels or **peaked lapels** with the points angled upward. (Figure 22-15.) The greatest sartorial debate of the time seems to have been the proper way to button the jacket. Catalogs of the period show all variations: on a two-button jacket, the top or bottom button, or both, fastened; on a three-button jacket, the center only, or the top only, or all three.

By mid-decade, though, college youths traveling to London, brought back with them a look that differentiated their suit styles from those of their fathers. The suits of the Oxford and Cambridge students featured new lines and proportions that were fresh but still emphasized the slender, youthful ideal. Jackets were cut with straight hanging lines for a close fit over the hips. Most jackets were unvented, or only had a

Notched lapels, 1926.

Variant of peaked lapels, 1928.

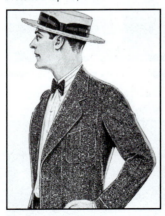

Rounded notch lapels, 1928.

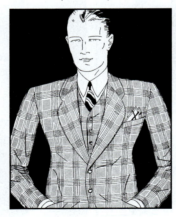

Clover lapels, 1928.

Figure 22-15. The dominant silhouette of men's business suits of the 1920s was the trim, natural-shoulder jacket with narrow, leggy trousers that had developed in the previous decade. New features included bold textile patterns and varied lapel treatments. Right, suits with peaked lapels from Bruner, 1928.

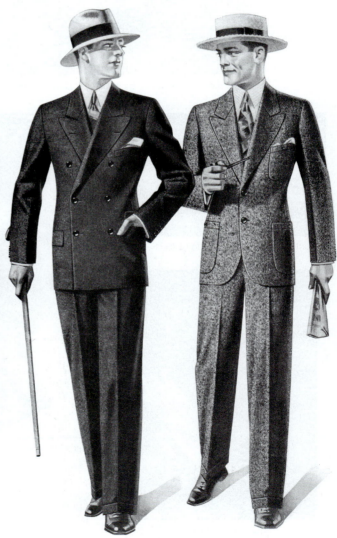

short, overlapping vent in the back. Hemlines were shortened slightly. Lapels were high and narrow, especially on the three- and four-button styles, which were often worn fully buttoned. The most distinctive change in the cut of the college man's suit, though, was the trousers. **Oxford bags**, as they were called at the time—were cut with bottoms at about twenty-two to twenty-five inches in circumference. The trousers of the businessman were still made at a slim seventeen to eighteen inches at the cuffs. Fashion lore holds that the students at Oxford and Cambridge were forbidden to wear the loose-fitting, comfortable knickers on school grounds, so they simply wore the wide-legged flannel trousers over the knickers when on campus for a quick change after classes. As the look evolved into a fad, the cuffs of Oxford bags expanded as much as forty inches around. (Figure 22-16.)

During the 1920s, the influence of sports attire on daytime dress was significant. The ease and comfort of clothing worn for active sports greatly appealed to the postwar generation, who assimilated many types of garments from the sports arena into their everyday wardrobes. For example, the Victorian knickerbocker suit had been worn primarily for bicycling, hiking, or golf at the turn of the century. By the twenties, a variant of the old types of knickers became casual attire for young men not only for a weekend in the country but also for leisure time in the city. The American Ivy Leaguer who returned from London with Oxford bags in the second half of the twenties also brought home a new type of knickers: the **plus fours.** These were a longer form of golf knickers with wide, baggy legs that would blouson about four inches over the kneeband. (Figure 22-17.) The plus fours suit was usually worn with a dress shirt and tie, and either a jacket, sometimes with a vest, or a pullover sweater. The style endured into the 1930s, primarily on the golf course and ski slopes, but was gradually phased out by the end of the decade.

Instead of tailored suits, young men in the twenties increasingly preferred sports jackets for leisure time and informal social events. The most notable form of sports jacket, the blazer, had been a perennial favorite since the second half of

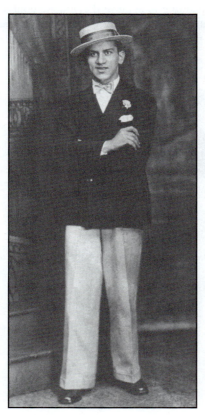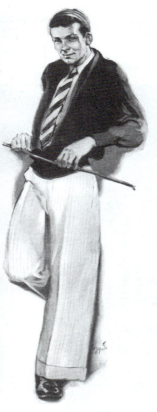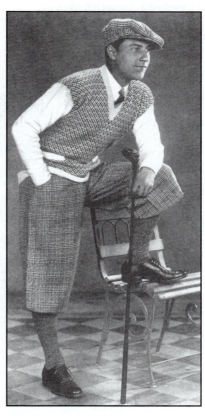

Figure 22-16. The wide-legged trousers, called Oxford bags, originated at Oxford and Cambridge in England in the mid-1920s. Among the college fads of the period in the U.S. were variations of the trouser with legs ranging from twenty-five inches up to forty inches in circumference at the bottom. Left, photo of a college man in Oxford bags, c. 1925; right, Oxford bags from Duchess Trousers, 1926.

Figure 22-17. Golfing knickers of the 1920s, called plus fours, were cut full and baggy enough to blouson over the kneebands about four inches below the knees. The style was also commonly worn by young men as casual daytime wear. Tweed plus fours in a glen plaid by Charles Merton, 1927.

the nineteenth century. Now, the blazer was a conservative fixture in the wardrobe of the upper class male. Most blazers were usually in navy although other somber colors such as chocolate brown and slate gray were acceptable if worn with the obligatory dress shirt, necktie, and white or cream flannel trousers. For the more rebellious youth of the era, though, sports jackets provided new opportunities for self-expression. Besides vivid colors, sports jackets were made in a wide array of weaves and textile patterns from more subtle honeycomb patterns to bold awning stripes. (Figure 22-18.) In the 1930s, some of the novelty and frivolity of clothing design that affected women's fashions similarly appeared in menswear, including unconventional jacket styles like the **weskit**, a jacket with a short, vest-cut hemline that appealed to men in the arts.

By the beginning of the 1930s, the wave of Anglomania in menswear that had begun after the war was further bolstered by two significant influences from Britain that reshaped and redefined the masculine wardrobe into much of what it is today: the personal style of the Prince of Wales (later King Edward VIII, and, after his abdication, the Duke of Windsor), and the drape cut of men's suits developed by the Savile Row tailor Frederick Scholte.

The style leadership of the Prince of Wales paralleled that of his grandfather as a young man, whose every nuance of dress had been equally influential on men's attire at the end of the Victorian era. In the 1920s, the young prince had been instrumental in the change to "soft" dressing for men. Instead of high, stiff detachable collars, the prince preferred the soft, turned-down styles. He opted for roomy trousers with belts rather than suspenders—or he even went beltless if the trousers were made with an adjustable-tab waistband.

In the 1930s, the prince was in the vanguard of men's fashion with his unlined, unconstructed sports jackets and his zipper fly trousers. He dared bold pattern mixing of glen plaid jackets and striped or patterned ties. He shocked old-guard society with his colorful shirts, including a pink one worn on an official visit to France.

But the Prince of Wales was more of an advocate of style rather than a menswear innovator. That distinction belonged to Frederick Scholte, who, like Giorgio Armani fifty years later, deconstructed the men's suit with innovative new cuts and master tailoring. Scholte had been the tailor for the elite officers of the royal guards. He admired the lean, athletic image projected by the guards, and developed three principles of cut from the construction of their tunics and greatcoats: wide shoulders, slim waists, and roomy armholes. Scholte did not resort to padding to achieve the athletic contours of his jackets. Instead, by masterful draping he broadened the shoulders with a full sleevehead and tiny tucks that aligned

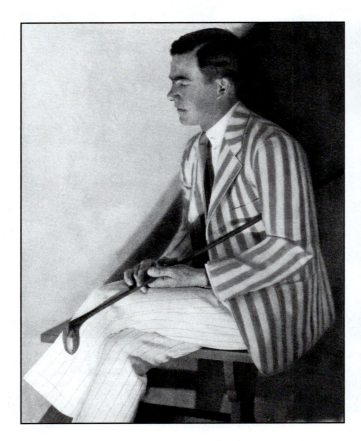

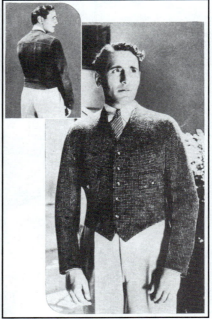

Figure 22-18. Sports jackets were a popular alternative to the tailored suit jacket for informal social gatherings. Textile patterns and colors became bolder in the postwar years. Left, awning stripe jacket with pin stripe flannel trousers by Palm Beach Suits, 1927; right, novelty tweed weskit from Ganter, 1935.

the tip of the jacket shoulder with the triceps, and then subtly tapered the sleeve to the wrist. Additional material at the armhole filled out and softly draped over the shoulder blades and chest for greater ease of movement. It is from this feature that the style came to be called the **drape cut** (also **London cut** or **blade cut**.) Finally, lapels were rolled rather than pressed flat, adding dimension to the chest. (Figure 22-19 and Color Plate 32.)

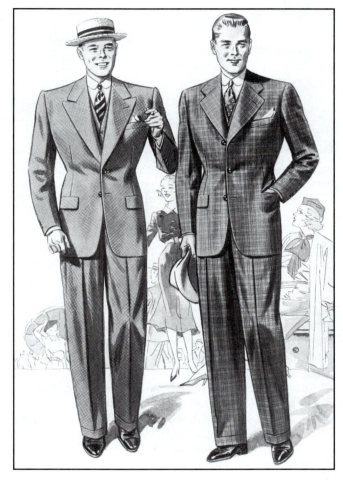

Figure 22-19. The drape cut suit of the 1930s featured a jacket with broad, unpadded shoulders, a tapered waist, and narrow hips worn over wide-legged trousers. Suit styles by Oliver Woods, 1937.

The drape cut suit particularly appealed to men of the 1930s because it reflected the revitalized classical ideal of the athletic masculine silhouette. Throughout the 1920s and 1930s, sports of all forms were immensely popular with young men. Hollywood also projected this new ideal of the athlete with movies like the Tarzan series depicting a nearly nude Johnny Weissmuller displaying the well-toned physique of an Olympic champion. The slender, narrow-shouldered contours of previous men's styles now seemed almost effeminate, or at best, juvenile, compared to the new athletic profile.

Technology also aided the new fit and construction of suits in the 1930s when zipper fly fronts were introduced. (Figure 22-20.) Although tailors were initially reluctant to experiment with the device—some claiming the inherent safety hazards of its location—when the Prince of Wales began to have his trousers fitted with zipper flies in 1934, the new standard was set.

An American variant of the drape suit made of light-weight tropical fabrics came to be called the **Palm Beach suit** after the Florida resort. In the mid-1930s, **seersucker**, a puckered textile that derived its name from the Persian "shirushakar," especially became a favorite summer suit fabric as a substitute for linen and shantung, both of which wrinkled badly in hot, humid climates. *Esquire* declared in 1935 that men should "sail for a seersucker for a cool change."

A shift in men's formal wear also occurred during this era. The tuxedo continued to gain in popularity, replacing the tail coat at many high social events. The white dinner jacket, made with a variety of front closures and non-satin lapel styles, was a favorite of Ivy Leaguers by the end of the twenties. In the 1930s, the dinner jacket was ubiquitous, and ready-to-wear makers mass produced versions to be worn for everything from high school proms to wedding suppers. Also in the 1930s emerged the short **mess jacket**, resembling a naval officer's dinner dress. The requisite for the mess jacket was a youthful, slim waistline since the style was cropped high and fit snugly. The tail coat continued to be worn for selected special occasions, particularly by older men in urban settings. "The usual question is 'black or white tie?'—meaning tail coat or dinner jacket," observed *Vogue* in 1936. But the editors conceded, "Requirements differ, depending on

Figure 22-20. One of the technological advances in men's suit construction in the 1930s was the replacement of gaping, button-fly fronts on trousers with the zipper fly front. Detail of a Talon Fastener ad, 1936.

locality." Similarly, the cutaway morning coat suit endured for formal day events like England's Ascot or weddings although it, too, was worn less commonly in the thirties.

In keeping with the quest for greater comfort and ease in dressing, men of the 1920s abandoned the stiffly starched detachable shirt collar in favor of the "soft shirt"—commonly referred to at the time as a **negligee shirt**—with an attached, turned-down collar and coat front opening. Many styles of the new forms of dress shirts also had attached French cuffs to keep them from too closely resembling casual sportshirts. After the success of using rayon as a textile substitute for natural fiber yarns during the First World War, the fabric became more commonly used for men's shirts. A variety of madras and English broadcloth prints were featured in all the ready-to-wear catalogs by the mass merchandisers of the period. In the second half of the 1920s, color and pattern were key elements of dress shirt designs. The wardrobe of F. Scott Fitzgerald's Jay Gatsby was punctuated with "shirts with stripes and scrolls and plaids in coral and apple green and lavender and faint orange." As color and prints became more prevalent in dress shirts, a look especially popular with the Prince of Wales, men had to put more thought into their clothing selections, coordinating ties, jackets, and trousers more assiduously. (Color Plate 33.) As evidence that men in general had become more fashion conscious, *Esquire* was launched in 1933 to advise on men's dressing among other topics of masculine style.

The pullover bosom shirt, however, did not vanish completely but, instead, remained the preferred style for formal attire. As the ready-to-wear maker Cluett Peabody noted in a 1923 ad, the variety of shirt options for the well-dressed man ranged from "the immaculate bosom shirt of the Ball Room to the good looking oxford of the [golf] links."

As noted previously, young men of the 1920s often made fashion selections with one of two purposes in mind—as a distinction from the older generations, and for easy, comfortable dressing. From these tenets a burgeoning sportswear industry rapidly expanded offering a broad range of casual style options that, by the 1930s, were common in most men's wardrobes. Many types of active sports clothing that once had been worn only for athletics were adapted for everyday dress during this transition period. Menswear catalogs provided some guidance in putting together these various garments but, for the most part, there was not a dress protocol for sportswear. In 1936, *Vogue* advised, "With clothes of this sort, there are no rules except those dictated by a man's own good taste." More importantly, though, was *where* men wore these new forms of clothing. Even into the late thirties, magazines like *Esquire* and *Vogue* tried to stem the tide of casual sportswear indecorously appearing in the wrong places. For example, *Vogue* insisted that men must never appear in the city dressed in "country wear" such as "rough tweed suits— sometimes of a loud pattern—white flannel trousers or the

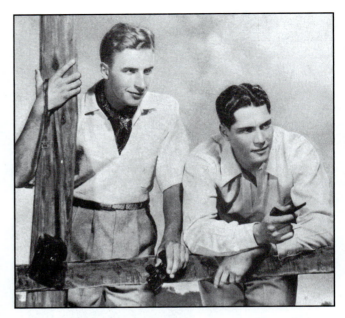

Figure 22-21. Casual, open-throat shirts became increasingly acceptable to wear in public places where previously a necktie and jacket had been required. Sportshirts from Wilson Brothers, 1935.

still more popular grey flannels, polo shirts in wool or cotton, flannel shirts with collars attached, pullovers of every variety, careless-looking corduroy slacks, rubber-soled brogues, golf shoes, soft felt hats, windbreakers, leather jackets, cardigans, and what-nots." Yet these "what-nots" were exactly what men increasingly wore in public and on city streets. The Prince of Wales, especially, led the change from staid sartorial correctness to personal style, with the emphasis on comfort.

Among the changes seen on city streets and in public places like race tracks and urban parks were the many new designs of the sports shirt, worn without a tie and with the collar throat open. (Figure 22-21.) When worn with a sportscoat or even a tweed or seersucker suit, the collar of the shirt would be spread over the lapels, much to the chagrin of traditionalists.

Just as the color palettes of dress shirts exploded into every conceivable variation, sports shirts likewise were produced in hues that only the most confident of men might wear. In the late 1930s, vividly colored **Hawaiian print shirts** appeared at the resorts and were quickly copied by ready-to-wear makers for mass distribution. By the start of World War II, most men had at least one pineapple or palm print shirt for vacation picnics and backyard barbeques.

Knit shirts also became mainstream apparel from the late 1920s onward. The increasing popularity of the short-sleeve **polo shirt** with its knit Eton collar and placket front was duly noted in the fashion press. Some polos were made with banded bottoms, but most were worn tucked. (Figure 22-22.)

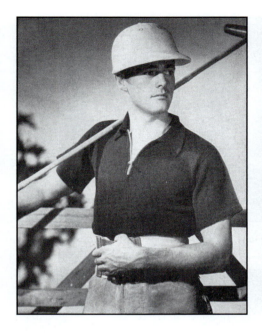

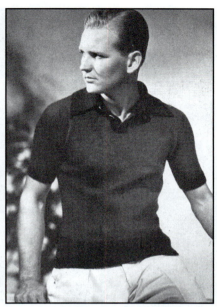

Figure 22-22. Another type of active sports clothing that became mainstream attire was the knit short sleeve polo shirt with a placket front closure and knit Eton collar. Variations of the style were common by the 1930s. Knit polo shirts from Minerva, 1934.

In the 1930s, a variation was the **dishrag shirt**, which featured a bodice, and sometimes sleeves, in an open-mesh weave, somewhat resembling the textiles used for household cleaning cloths. The comfortable, easy-care polo shirt quickly became a favorite of all ages.

Other forms of knit sportswear that were adapted from active sports clothing (and also from the working man's attire) became staples in men's wardrobes. Throughout this period, pullovers, cardigans, twin sets, and sweater vests were often worn as substitutes for sports jackets or in place of tailored suit vests. (Figure 22-23.) Knicker suits, especially, were often topped with sweaters—with and without ties— that often included stockings of the same pattern to match. The V-neck pullover was by far the most popular, having been prevalent as tennis wear for more than fifty years. In the mid-1930s, zippers were added to cardigans and sweater vests for an updated look.

In addition to the diversity of nontraditional casual wear such as Hawaiian shirts, weskits, and patterned knit tops, the cowboy look gained popularity in the 1920s and 1930s. The proliferation of affordable automobiles and New Deal highways made long-distance travel more accessible to the masses. As the middle classes from east of the Mississippi River vacationed in the Old West, they returned home with jeans, Western cut shirts, fringed jackets, Stetson hats, and fancy cowboy boots as novelty items for their casual wardrobes. In 1938, *Esquire* avowed, "We can't figure out whether it is in spite of their flamboyancy or because of it, but these [cowboy] outfits come highly recommended by those who know as being the McCoy." Few Easterners went for the whole cowboy look on the streets of Philadelphia or Baltimore, but the popularity of

jeans and dropped-yoke denim jackets revealed the influence of Western style that would remain a recurring theme in menswear to the present day.

MEN'S SPORTS ATTIRE AND OUTERWEAR 1920–1940

In the 1920s, sports of all kinds became a favorite pastime of men of every age and socioeconomic standing. The radio broadcasted live sporting events and movie theater newsreels featured current reports on champions and championships. A surge in college enrollment of demobilized doughboys attending university, often with their younger siblings, expanded interest in varsity sports. In 1932, the United States hosted both the Summer Olympics in Los Angeles and the Winter Olympics in Lake Placid, New York, from which the youth of America were introduced to exciting new forms of sports and advances in sports equipment and correct attire.

Among the fastest growing sports of the period was golfing. Virtually every community of any size had a country club or public links by the end of the twenties. The standard apparel for playing golf was the full-cut plus fours, stockings, and a loose-fitting shirt, often worn with a pullover such as that shown in Figure 22-17. A necktie was required for the country club set, but most men preferred the comfort of an open-throat shirt, especially in hot weather. News from Palm Beach in 1928 reported on the trend of trousers instead of knickers on the golf courses of the resorts. By the 1930s, both plus fours and trousers were equally prevalent for golfing until the end of the decade. By the mid-thirties, fashion magazines were reporting on

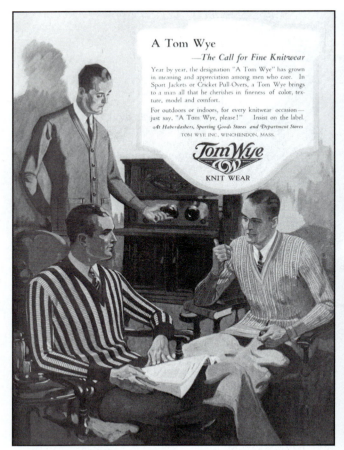

Cardingas and pullovers from Tom Wye, 1926.

Bateau neckline sweater, 1934.

Sweater vest, 1934.

Twinset cardigan and pullover, 1934.

Patterned Shetland sweater, 1934.

Figure 22-23. Knitwear was not only comfortable and versatile casual wear, but the wide variety of types, vivid colors, and striking patterns provided men with the opportunity to express their personal style.

knee-length shorts seen on the greens at resorts. Worn with knee-high stockings, the cool and comfortable shorts became the alternative to plus fours.

The other sport that had widespread appeal and a correctness of dress was tennis. The Edwardian look of white flannel trousers and crisp white cotton shirts with white, tan, or buckskin shoes remained constant throughout this period. To break the monotone of tennis whites, some men with fashion flair wore a vividly colored silk scarf at the waist instead of a belt. The obligatory blazer in blue, slate, or bottle green was a welcome dash of color as well. Although in the 1920s white flannel shorts were frequently seen on collegiate courts, it was not until champion Bunny Austin wore them in the 1932 U.S. National Championship that the style became widely accepted. Another change that altered the tennis

costume in the late 1930s was the introduction of the **tennis shoe**, made with a crepe outsole and white duck upper with white laces.

As winter sports gained in popularity, fashion and "physical culture" periodicals recommended how to dress properly for strenuous activities on snowy slopes. Well into the early 1930s, plus fours with thick woolen stockings and layers of knit tops were the preferred winter playwear. In the 1930s, moisture-repellent rayon fabrics were developed to make new types of lightweight skiwear, including long trousers with elastic bands at the ankles, and jackets or pullover tops with knit cuffs and waistbands as a barrier against snow. (Figure 22-24.) Thick knit gloves, goggles, and wool caps with ear flaps or knit "helmets" protected the body's extremities.

Figure 22-24. Winter sports became especially popular with the middle classes in the United States following the 1932 Winter Olympics in Lake Placid, New York. By the end of the decade, moisture repellent, colorfast rayon replaced thick, heavy wool knits for winter active sports attire. Puritan Sportswear ad, 1938.

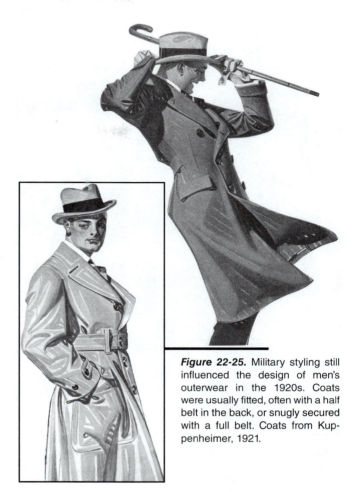

Figure 22-25. Military styling still influenced the design of men's outerwear in the 1920s. Coats were usually fitted, often with a half belt in the back, or snugly secured with a full belt. Coats from Kuppenheimer, 1921.

Knits of all kinds also continued to be the most preferred types of garments for most warm weather athletics, including track and field events, team ball games, and swimming and diving. Knitwear was nonbinding and comfortable yet warm and lightweight enough to be layered for easy removal as the body warmed during exertion.

Men's outerwear of the early 1920s still reflected the military influences of World War I. The fit of overcoats was slender and high waisted with a belt, half belt at the back, or a waist seam with a tapered bodice. (Figure 22-25.) After about 1923, the hemline dropped from knee length to mid-calf. The single-breasted, fly-front topcoat with the natural shoulderline was the most popular throughout the twenties although double-breasted styles were featured in all the menswear catalogs. The exception was the fur coat, which was preferred full, long, and opulent with a massive collar and sleeves. The fad of **raccoon skin coats** among Ivy League sheiks and shebas was a favorite theme of cartoonists in the twenties. For the most part, though,

coat makers and retailers took their cue from London. Tweeds abounded on all types of outerwear. When the Prince of Wales was photographed in a raglan sleeve overcoat in 1929, demand for the style instantly swept America and Paris, and remained popular through the next decade.

In the early 1930s, American men adopted the dark blue **guards coat**, modeled after the uniform outerwear of the British Grenadiers. It featured a double-breasted closure, a half belt in the back, wide lapels, and center back pleat that extended the full length from collar to hem. As suit shoulders widened to the new athletic silhouette, coats reflected the delineated V-line profile. Raglan sleeves provided capacious shoulder room to adequately fit over the drape cut suit jacket. (Figure 22-26.) Lengths shortened somewhat to just below the knees. Easily removed zipper linings provided overcoat versatility for transitional weather in autumn and spring when heavy linings were not needed.

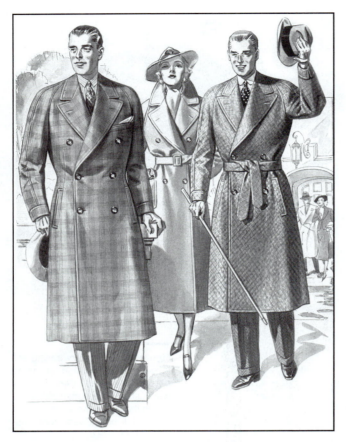

Figure 22-26. Men's coat styles of the 1930s were often tailored to complement the new athletic silhouette of suit jackets. The raglan coat sleeve especially provided ample room to fit over the wide shouldered, drape cut jackets. Raglan sleeve coats by Oliver Woods, 1937.

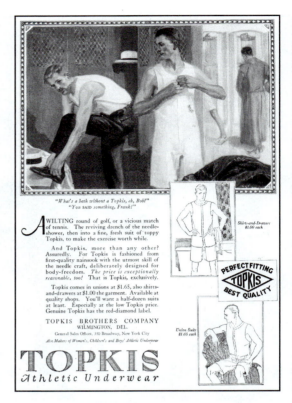

Figure 22-27. Boxer shorts and tank style undershirts were the more popular forms of underwear for young men of the 1920s. By the end of the decade, boxers had been shortened from the knees to the upper thighs, and pullover undershirts were more popular than button front versions. Topkis underwear, 1920.

Also in the 1930s, fingertip-length leather coats became a trend among the American collegiate set, primarily in the Midwest and West. Suede was usually preferred to that of smooth, finished leather. The cropped sheepskin coats that became prevalent in the twenties continued to be best sellers for mass merchandisers. For the working classes who could not afford leather sheepskin coats, variants were made of "imitation leather"—a rubberized, waterproof fabric with the look of leather.

MEN'S UNDERWEAR AND SWIMWEAR 1920–1940

The union suit was still the most common form of men's underwear throughout the 1920s. Younger men, especially those who had been in the military during World War I, had come to prefer the briefer and more comfortable boxer shorts and the tank style undershirt, both similar in cut to swimwear at the time. (Figure 22-27.) Increasingly, the long union suit—with or without long sleeves—was more often reserved

for winter wear in northern climates. Similarly, the button front undershirt became less favored than the easy, pullover versions. By the end of the decade, boxer shorts had been shortened from knee-length to the upper thighs. As improvements were made in the production of woven rayon in the mid-twenties, the soft, durable fabric was applied to all types of men's undergarments.

Dramatic change in the cut of men's underwear styles occurred during the 1930s, principally influenced by newly engineered swimwear designs. (Figure 22-28.) In 1934, knitwear maker Coopers introduced "**Jockeys**," a knit cotton brief with a "Y-front" opening and elasticized waistband. "Jockeys are snug and brief," declared the copy in a 1936 ad, "molded to your muscles." Men's underwear had suddenly become erotic although advertisers heavily airbrushed photos that were too revealing. The new look was a sensation and an instant success. Other underwear makers followed suit with their own versions of briefs that "fit like your skin," as a Scandal's ad promised in 1935. Still other new types of brief, formfitting underwear were

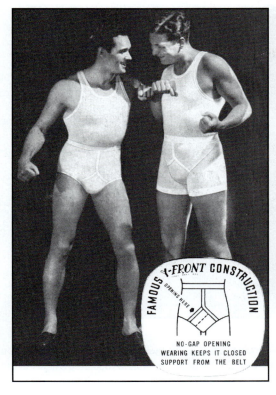

Figure 22-28. In 1934, the form-fitting Jockey brief was introduced by Cooper's, based on young men's swimwear styles that had appeared at resorts in the early thirties. Competitors quickly produced their own versions, including reinforced types for figure control. Left, Jockey briefs, 1936; center, Scandals brief-cut union suit, 1935; right, support briefs by Bracer, 1938.

influenced by the dominance of the youthful, athletic suit silhouettes of the period. "Bracer" control underwear was made with the improved two-way stretch Lastex yarns to provide older men with a defense against "a growing waistline bulge."

The other bare necessity that almost all men had in some form was a swimsuit. As noted in the section on women's swimwear, the formfitting knit suits produced by Jantzen in the 1920s "changed bathing to swimming." (Figure 22-29.) The heavy flannel trunks and tank top of the prewar era were abandoned in favor of the snug, knit one-piece, often advertised as a "**speedsuit**" since it was favored by U.S. swim teams at the Olympics. During the second half of the 1920s, Jantzen introduced the "**twosome**" swimsuit, which was a one-piece suit that looked like two pieces with short trunks and a tank of a contrasting color or horizontal stripes. The design of the speedsuit and twosome was a radical leap since it eliminated the modesty skirt of previous styles. In addition, with the fad of suntanning that emerged in the late 1920s, swimsuit armholes were extended much deeper, and some versions had cutout backs and sides, called "crab backs," to expose as much skin as possible to the sun. Although topless swimming was prohibited at most all public

beaches, in the 1920s young men at resort spots like the Riviera and Hawaii began to wear trunks with no tops for the first time.

The transition to swim trunks without a top of any kind was gradual in the 1930s, as community ordinances changed and athletes began to compete in trunks alone. As a contingency for either circumstance, Jantzen even produced a swimsuit with a zipper at the waistband that separated the tank top from the trunks.

The brief style trunks with its high-cut leg openings first appeared around 1932 although some one-piece suits of the previous couple of years were cut with arcing leg openings. As with the bottoms of women's two-piece styles, the waistbands had to be high enough to cover the navel. (Figure 22-30 and Color Plate 31.) By the end of the decade, the knit brief style was commonly offered in mass merchandising catalogs. Colorful patterns and prints provided an endless variety of swimwear options. Some experimental forms of the brief were made with such high-cut leg openings that they resembled the men's bikinis that first appeared in the 1960s, although this look did not become a trend and was primarily limited to the upscale Mediterranean resorts. For most men, though, madras swim shorts in solid colors and bold prints and plaids became the preferred style.

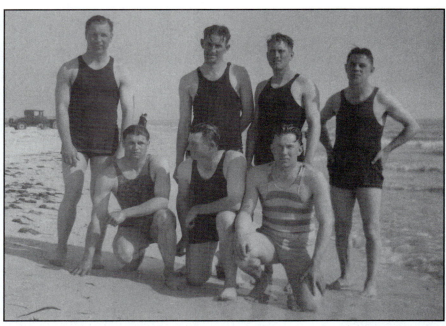

Figure 22-29. Although the modesty skirt persisted with some styles of men's swimsuits through the 1920s, most swimwear makers introduced ever briefer cuts with shorter trunks and tank tops with deeper armholes and open backs. Jantzen's "twosome" was a one-piece design with sollid colored trunks and a tank top of a contrasting color or stripes. Photo c. 1928.

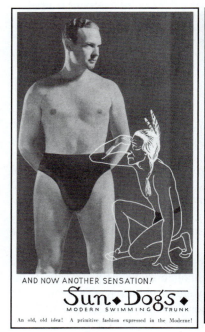

AND NOW ANOTHER SENSATION!

Sun • Dogs •
MODERN SWIMMING TRUNK

An old, old idea! A primitive fashion expressed in the Moderne!

Figure 22-30. The topless brief form of men's swimwear first appeared at resorts in the early 1930s. By the second half of the decade, the style was common at all public beaches and pools. Left, Sun Dogs high-cut brief, 1935; right, Catalina tropical print brief, 1938.

MEN'S ACCESSORIES AND SLEEPWEAR 1920–1940

The wardrobe of the well dressed man of the 1920s and 1930s included an even wider array of accessories than his Edwardian predecessor. (Figure 22-31.) The style-conscious man paid as much attention to the little details of dress as he did to the newest cut of a suit jacket. Aided by a proliferation of style guides and articles in magazines like *Esquire*, he knew when, where, and with what to wear the correct accessory in the right style, color, and material.

Subtle changes in men's hats made for fresh new looks in the 1920s. One of the most popular hats with flaming youth was a soft fedora with a wide brim and high, tapered crown. Called a **snap-brim fedora**, its pliable brim could be "snapped" down in the front or up at one side or in the back. A variety of the fedora with a pair of dents on each side of the front was called a **pinched-crown hat**. Older men still preferred the stiffly blocked homburg with a curled brim and center creased crown. For summer, broad-brimmed panamas were modeled on the new shapes of fedoras. For young men who wanted to express themselves differently than the older generations, there was the beret, brought back by soldiers from France after World War I. Many times, newspapers reported on the Prince of Wales sporting a beret angled to one side of the head. The soft, flat golf cap with a stiff visor covered with the same fabric was still popular with the young set although it was also recommended headwear for the casual knicker suit for men of all ages. The classic straw boater also remained a favorite of young and old alike. Color provided drama in the look of men's headwear. The brown derby became so common that a restaurant by that name opened in Hollywood. Dark green fedoras were an influence from the Alpine resorts. Striped grosgrain hatbands added color and panache to natural leghorn panamas. In the early 1930s, much ado appeared in the press about men in Palm Beach going about without a hat of any kind, though the trend did not spread nationwide. In 1935, when the Prince of Wales visited Vienna, he bought several Austrian hats fashioned with a wide brim, tapered crown, and a feather in a corded band.

Figure 22-31. The well-dressed man of the 1920s and 1930s possessed a substantial wardrobe of accessories to suit specific occasions and seasons. Some hat styles became softer and sportier, such as the snap-brim fedora and the Tyrolean. Shoes were wide and comfortable. A broader assortment of jewelry became acceptable for men to wear. Neckwear included knit styles and silks in vibrant colors and moderne prints.

Leghorn boater, 1926.

Snap-brim fedora, 1927.

High-top style from Hanover Shoes, 1923.

Two-tone art deco styling from Wescot, 1926.

Camel's hair beret, 1926.

Left, topstitched fedora; right Tyrolean, 1938.

Wide toe "balloon" shoes were favored by young men in 1920s for their comfort and as a complement to the Oxford bags. Selz brand shoes, 1927.

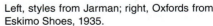

Left, styles from Jarman; right, Oxfords from Eskimo Shoes, 1935.

Adaptations of the Austrian style came to be called **Tyroleans** and remained popular into the 1960s.

Men's shoes of the early 1920s changed little from those of the war years. The high-top styles were still common through the decade. Footwear of the second half of the 1920s reflected two style trends of the era. As young men's trouser legs expanded in width and volume, shoes also were widened

to balance the look. Broad, square-toed oxfords, bluchers, and brogues—collectively called **balloon shoes** at the time— were favorites of college men who put in a lot of mileage hiking across campus to classes. The second style trend was the influence of art deco on men's shoe designs. Although two-tone oxfords appeared in the 1890s, the geometric shapes of the contrasting layers were ideal for moderne styling. For

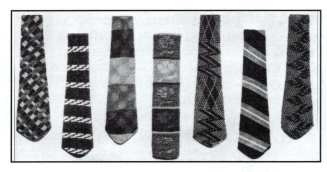

Knit ties in Jazz Age designs from Berkley Knitwear, 1926.

A vivid palette of colors for men's shirts and ties by Arrow, 1937.

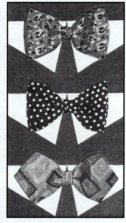

Formal jewelry sets from Hickok, 1935.

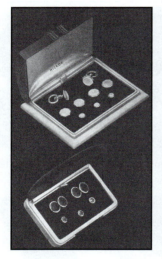

Bow ties remained a sporty option of neckwear. Spur silk ties, 1929.

Deco-styled wrist watches, photo locket, cigarette holder, cigarette lighters, and cuff links from Brand-Chatillon Jewelers, 1929.

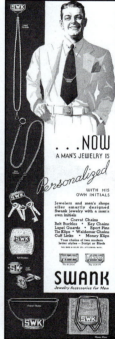

Jewelry by Swank, 1936.

Monogrammed silk mufflers and linen handkerchiefs from A. Sulka, 1926.

Hickok summer belts, 1938.

business attire, though, traditional rounded-toe wingtips were preferred throughout the 1920s and 1930s. Also in the thirties, a moccasin style slip-on, later called **loafers**, was introduced from Norway, first to London and then to the United States by returning tourists. The demand for comfort that began in the previous decade continued in the Depression years with the broad appeal of sandals and other casual styles of

shoes, especially **huaraches**, an adaptation of Mexican peasant sandals made of woven strips of leather over the toes and a single strap at the heel.

Neckwear in the 1920s was transformed on two fronts—first by a new technique of construction with an interlining of bias cut wool that kept its shape after unknotting, and second by men's demands for striking hues and modern, Jazz Age

patterns and prints. Vividly colored and patterned knit ties of wool and wool/silk blends were particularly popular with college men throughout the decade. More subdued silk foulards were standard for business attire. Bow ties were at opposite ends of correct dress—white or black for formal attire and flashy prints for golf suits and casual sportswear. In the 1930s, the assortment of neckwear and colors were more dazzling than ever despite the gloomy economic conditions. New in the period was the wash-and-wear cotton tie for summer in both long and bow tie styles.

As comfort and casual elegance came to dominate men's dress in the twenties and thirties, day gloves and walking sticks were gradually abandoned as cumbersome accoutrement of bygone times. Utilitarian purposes still necessitated stylish gloves for winter and for sports, especially golfing.

Jewelry became a more important accessory for men after the Great War than in previous decades. (Color Plate 34.) That men of the 1920s and 1930s enjoyed a wide variety of jewelry was noted in a trade magazine of the time: "Given the chance, and if fashion indicated, they would wear earrings and nose rings." In fact, new types of jewelry created for the rapidly changing styles of clothing added even more options for men. As shirts with stiff detachable collars were abandoned in favor of the soft-collar shirts, collar pins, collar bars, and **collar grips** became an important jewelry accessory for holding soft collars smoothly in place with a necktie. Jewelers revived interest in tie clasps by replacing ornate Victorian designs with die cuts and engravings of horses, game animals, sailboats, and sports motifs such as tennis rackets. Wristwatches continued to be preferred over pocket watches although the pocket model with a gold chain was an elegant accent for formalwear. Art deco styling of cuff links added a smart touch to the turned back cuffs of French style shirts. Men even slipped on gold chain bracelets in emulation of Hollywood sheik, Rudolph Valentino.

Another accessory that became more significant was the belt. During the youth-oriented twenties and athletic thirties, men with slender waists preferred belts to suspenders, which became associated with men of more rotund proportions. As with shoes, belts were designed to coordinate correctly with the clothing depending upon purpose and season.

Sleepwear for men became much more of a fashion item in the 1920s than it had been for the prewar generation. (Figure 22-32.) Although pajamas had been a common type of night wear for decades, designs in the twenties featured a huge assortment of collar and sleeve treatments, and fabrics in fun, allover prints and wild color combinations. Some pajama styles were modeled after exotic costumes of the Far

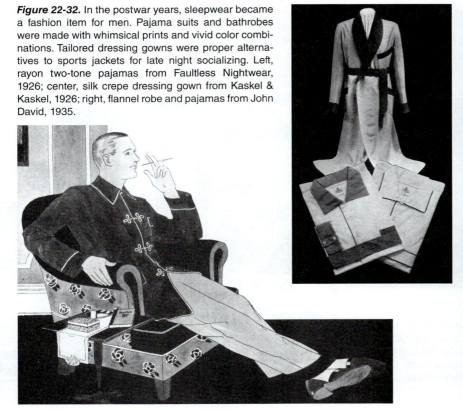

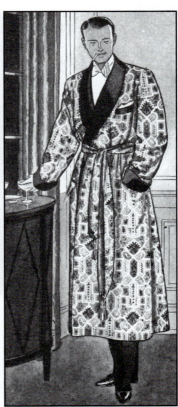

Figure 22-32. In the postwar years, sleepwear became a fashion item for men. Pajama suits and bathrobes were made with whimsical prints and vivid color combinations. Tailored dressing gowns were proper alternatives to sports jackets for late night socializing. Left, rayon two-tone pajamas from Faultless Nightwear, 1926; center, silk crepe dressing gown from Kaskel & Kaskel, 1926; right, flannel robe and pajamas from John David, 1935.

East that included mandarin collars, passementerie trim, and braid frog closures. The **cossack pajama suit** blended the stand-up Chinese collar with an off-center closure and a wide sash modeled after a Russian officer's tunic. With the athletic influence of menswear in the 1930s came pajama prints with hunting scenes, nautical themes, and sports motifs in addition to bold tartans, awning stripes, and white polka dots.

Robes came in two forms—a bathrobe to accompany pajamas as sleepwear or a dressing gown worn over regular clothes. The basic wrap bathrobe was a utilitarian garment for a warm coverup out of bed in the morning or a wrap for lingering around a late night radio program. Varieties of collar treatments were the principal distinction on the standard, T-shape cut of bathrobes. Fabrics included terrycloth, waffled cotton, seersucker, quilted wool, or patterned heavy flannel called **blanket cloth**. Dressing gowns, also called **house coats**, were worn in the intimacy of private moments at home with family or the closest of friends. These were not sleepwear robes, like those worn with pajamas, but were loungewear, worn over trousers and a shirt, often with a tie or a silk scarf. Styles of dressing gowns were usually more tailored than robes, some with fitted contours and others modeled after foreign costumes such as kimonos and kaftans. Fabrics were often luxurious—satins, brocades, embroidered silks, and rayon.

MEN'S GROOMING AND HAIRSTYLES 1920–1940

Men's hairstyles of the 1920s and 1930s were of two varieties: cut long or cut short. The more common long cut was cropped close around the ears and back, but left full and long enough on top to be brushed straight back or parted at the side or center. Pomades and hair oils were worked into the hair, which was slicked back into a fixed, shiny helmet. (Figure 22-33.) In the youth-oriented mood of the era, older men more frequently colored their hair than a generation earlier. Haircare product makers continually targeted men who suffered from male pattern baldness with promises (or dire warnings) in their advertising.

Faces were mostly clean shaven in keeping with the emphasis of youth and athleticism of the times. In 1931, Schick introduced the commercial electric razor. Mustaches returned in the late twenties and lasted through the thirties. Instead of the full, bushy, brush-like versions of the Edwardian man, though, new styles were small and waxed into sculpted comma shapes with curled ends or trimmed into narrow, pencil mustaches like that favored by Clark Gable. Massive Victorian beards, sideburns, vandykes, goatees and the like were still worn by elderly men or eccentrics such as bohemian artists and poets.

CHILDREN'S CLOTHING 1920–1940

The trend toward greater freedom and comfort in children's clothing that had begun during the Edwardian era continued to develop in the 1920s and 1930s. Whereas Paris dictated women's fashions and London set the looks for men's dress, America was the principal leader in childrenswear. While European garment and textile industries rebuilt after World War I, U.S. ready-to-wear makers expanded and modernized businesses that had flourished during the 1910s. Among the vast volumes of manufactured goods exported to a recovering Europe were shiploads of children's clothing, Americanized.

 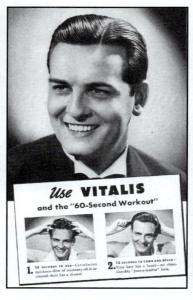 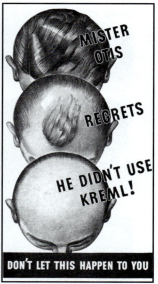

1926 1926

Figure 22-33. The well-groomed man of the 1920s and 1930s was clean shaven and kept his hair closely cropped. Various hair oils were applied for a slicked back, shiny helmet look. Makers of haircare products capitalized on men's terror of baldness with ads promising prevention or restoration.

1937 1935

Figure 22-34. Simple, loose-fitting dresses allowed small girls comfort and freedom. Dresses for older girls of the 1920s adopted the boxy, dropped waist styles of the flapper. In the 1930s, the waist was once again raised, and puff sleeves reflected women's styles. Left, short, shoulder-yoke summer dresses, 1922; center, dropped-waist chemise, 1928; right, flock dot frocks, 1938.

Infants were at last freed of the remaining forms of Victorian shackles of constricting, excessive clothing. The smothering layers of garments that comprised the layette were reduced to gown, diaper, and blanket—with a loose jacket, bootees, and bonnet for cool weather. Even headcoverings were largely discarded except for outdoors. Gowns were reduced from about twenty-eight inches long in the pre-war years to a standardized twenty-four inches. The frills and flounces that had been common on virtually all infant's clothing now were reserved for christening gowns and accessories.

Little girls continued to wear simple, shoulder-yoke dresses cropped at just above the knees. (Figure 22-34.) Shorter versions, at about mid-thigh, were worn with bloomers, often of the same fabric as the dress. Older girls of the early 1920s wore longer dresses—to mid-calf for teenagers—styled with the new dropped waists. By the second half of the decade the boxy chemise with its hipline waist and knee-length skirt was the most prevalent look. During the 1930s, the short, shoulder-yoke dress remained the most common for small girls. Older girls of the thirties once again became smaller versions of adults and wore the same soft dressing, knitwear, and playwear as their mothers. Waists returned to the natural position and exaggerated puff sleeves were adapted to all forms of girls wear. Costume styles of clothing, such as sailor suits that included trousers, were a particular influence from Hollywood in the thirties. Films and advertising images of petite Darla of the "Our Gang" serials and especially of Shirley Temple wearing trendy fashions inspired millions of mothers to dress their daughters similarly. (Figure 22-35.) In England, mothers modeled the dress of their daughters after the clothing worn by Princesses Elizabeth and Margaret.

Figure 22-35. Mothers and daughters alike were influenced by the fashions and hairstyles worn by Hollywood's child stars such as Shirley Temple. Testimonial ad featuring Shirley Temple, 1937.

Figure 22-36. Clothing for toddler boys continued the trend toward greater freedom with easy, comfortable short sets and skeleton suits. Older boys adopted the baggy forms of plus fours and knitwear for school and play. Teen age boys donned scaled down versions of men's styles.

Skeleton suit, 1922.

Sailor suit, 1923.

Schoolboy's knicker suit, 1937.

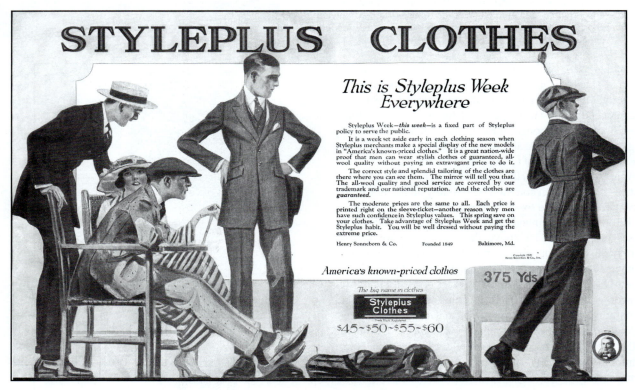

Teenage boy's suits, 1921.

Small boys of this era were no longer dressed as girls although many toddlers of the upper classes often still endured long hair. The tunic and shorts outfits of the Edwardian era were now standard forms of boys wear. Variants included revivals of the eighteenth-century skeleton suit with separate tops and bottoms that fastened together into a one-piece.

(Figure 22-36.) Toddlers enjoyed the additional comfort of being free of long stockings, which their older siblings still wore. School-age boys continued to wear the knicker suit until the Second World War. As with the cut of adult styles of the time, the knickers were loose and baggy, worn with assorted types of matching jackets, blazers, or sweaters. For

teenage boys, one of the rites of passage was a graduation from knee britches to long pants. The suit styles of older boys were principally those of adult men. Teenage boys also wore scaled-down versions of men's overcoats, formalwear, swimwear, and other categories of clothing. As menswear trends shifted and evolved, boys wear followed. When Jockey briefs were introduced for men in 1934, underwear makers produced sizes for boys as well. Brief style swimsuits were also scaled to boys' sizes. Similarly, as team sports for boys proliferated, especially intramural school programs, specialized apparel such as active sports uniforms and competition attire were modeled on adult versions, including construction of protective padding engineered for the immature physique.

REVIEW

Following World War I, women's fashions were transformed on ever shorter cycles of change. In the early 1920s, the short, high-waisted dresses of the war years were narrowed into long, straight lines emphasized by a lowered waistline and hems dropping nearly to the ankles. When women resisted the long skirts, designers responded with the boxy, dropped waist chemise and shorter hemlines to the knees by 1925—the flapper look. Eveningwear became shorter as well with a myriad of revivalisms and asymmetrical hemlines.

Women now smoked and put on makeup in public, so handbags were filled with new forms of accessories such as cigarette cases, compacts, and vanity cases. Hair was sheered off into bobs and shingle cuts allowing the redesigned cloche to hug the head like a helmet without hat pins.

At the beginning of the 1930s, the Great Depression had commenced. Simultaneous with this global trauma, the fashion look again shifted dramatically. Feminine curves returned with a renewed focus on the hips and bust. The waistline moved back to its natural position, or even slightly higher, and hemlines dropped almost to the ankles. Floor-length evening gowns also returned, now with emphasis on open backs and bare shoulders. By mid-decade, exaggerated sleeves and wide shoulders prevailed in the design of dresses, evening gowns, suits, coats, and playwear. The modern woman was confident in her new wardrobe options that included slacks, shorts, and two-piece swimsuits.

New technologies also significantly impacted fashion design. Designers experimented with the high quality synthetic fabrics produced at the time, including rayon, nylon, and Lastex. The convenient zipper was applied to everything from accessories and outerwear to couture gowns and intimate apparel. Plastics were used in jewelry and fashion ornaments.

For men, a youth-oriented casual style influenced changes in their postwar wardrobes. The trim, natural-shoulder suit reflected the youth cult of the 1920s. Art deco ties added a modern flair. Shirts with starched, detachable collars were abandoned in favor of versions with attached soft collars. Trouser legs were widened, some to the extreme dimensions of the Oxford bags. Baggy plus fours became a casual style adapted from golf knicker suits for everyday leisure wear. The variety of sportswear styles exploded into exciting new forms of shirts, jackets, trousers, shorts, knitwear, and athletic attire. The polo shirt was introduced. Swimwear became more erotic with ever briefer styles and form-fitting fabrics. Within a dozen years, the tank-style one piece with long trunks and a modesty skirt was reduced to the brief alone with no top. Underwear followed the changes toward brevity with the introduction of Jockey briefs.

In the 1930s, Anglomania dominated menswear. The contours of men's suits shifted from the trim, natural shoulder silhouette of the previous decade to the athletic drape cut, sometimes called the London cut. Trousers with the new zipper fly front solved the age-old problem of gaps in button closures. New textiles such as seersucker were introduced for suits. Blazers and sport jackets increasingly substituted for the suit jacket even in some business circles.

The Prince of Wales led the way to greater comfort and casualness in men's dress. Unconstructed jackets and open-throat shirts were worn to public events. Men went hatless at resorts. Bermuda shorts appeared on golf courses. Versions of the polo shirt, the Hawaiian print shirt, and a wide variety of knitwear became ubiquitous weekend wear.

Children's wear continued to evolve toward its own versions of casual comfort. Short sets and skeleton suits were ideal for active boys. School-age boys enjoyed the ease of baggy knickers and soft-collar shirts. Older boys wore the styles of their fathers: the trim natural-shoulder suit in the twenties and the triangular drape cut in the thirties. For small girls, the short, shoulder-yoke dress styles allowed comfort and ease of movement. Older girls dressed in scaled-down versions of women's fashions including the dropped-waist chemise in the 1920s and exaggerated sleeve styles of the 1930s.

Chapter 22 The Twentieth Century: 1920–1940
Questions

1. Which were the key features of the silhouettes of women's dresses between 1920 and 1924, 1925 and 1929, 1930 and 1933, 1934 and 1939?

2. Compare and contrast the prevalent styles of women's eveningwear of the 1920s and 1930s.

3. How did the zipper impact women's and men's fashions? Give specific examples of how couturiers and tailors first used the zipper in the 1930s.

4. What influence did the Paris Exposition Internationale des Arts Decoratifs et Industriels Modernes of 1925 have on men's and women's fashions?

5. How did the silhouette of young men's dress suits evolve in the 1920s and 1930s?

6. How did the young man's demand for casual elegance and distinction from older generations alter the course of menswear and masculine style in the 1920s and 1930s?

7. What were the dramatic changes in women's and men's swimwear of the 1930s?

Chapter 22 The Twentieth Century: 1920–1940
Research and Portfolio Projects

Research:

1. Write a research paper on the emergence of New York's Seventh Avenue ready-to-wear market and the impact it had on American fashions between 1925 and 1940. Identify the key labels of the era and their chief designers.

2. Write a research paper on the key fashion design innovators of Hollywood's movie studios in the 1930s. Include brief biographies of the leading designers and identify the movie costume designs that influenced mainstream fashion.

Portfolio:

1. Choose a colorful art deco brooch from the 1920s and design in your sketchbook matching earrings, necklace, bracelet, ring, beaded handbag, and leather belt. Write an accompanying paragraph explaining the art deco elements or motifs used to coordinate all the pieces.

2. Compile a reference guide of art deco accessories from the 1920s and 1930s. Photocopy or digitally scan ten examples each of jewelry, handbags, shoes, and hats. Include a written description of each with designer or maker, materials, date, and the design elements that define the items as art deco.

Glossary of Dress Terms

art deco (also known as moderne): a decorative art style featuring geometric shapes and a pure linearity

Bakelite and **Catalin:** brand names of phenolic plastics used for costume jewelry, buttons, and ornaments

balloon shoes: men's broad, square-toed shoes of the 1920s

batwing sleeve: a deep, softly draped, dolman sleeve style, wide at the shoulder tapering to a close fit at the wrist

blade cut suit: see drape cut suit

blanket cloth: thick, flannel fabrics in bold plaids and patterns used for men's bathrobes

cape coat: women's coats of the 1930s made with an attached cape that extended to the hips

cellulose acetate: a cellulose-based fiber used in the production of rayon

clutch coat: a wrap style of coat popular with the flapper

collar grips: a metal clasp affixed to the tips of the collar behind the knot of the necktie to hold the collar smooth on men's dress shirts

corselette: an all-in-one corset style of the 1920s that encompassed the bust and hips

cossack pajamas: men's sleepwear suit with tunic top cut with an off-center closure and a stand-up round collar

culottes: short styles of the split skirt

dishrag shirt: men's short sleeve knit shirt with mesh bodice

drape cut suit: men's jacket style of the 1930s featuring broad, unpadded shoulders, a smooth fit across the shoulder blades, roomy armholes, a tapered waistline, and rolled lapels; also called London cut and blade cut

Fashion Avenue: the name generally applied to the New York City apparel market located on Seventh Avenue

guards coat: an adaptation of the dark blue, double breasted greatcoat of the British Grenadiers with center back pleat and half belt

handkerchief skirt: skirt style draped with uneven, pointed hemlines resembling handkerchiefs

Hawaiian print shirt: casual, short-sleeve sportshirts in vividly colored, tropical motif prints

house coat: men's dressing gown worn over regular clothes during late night or early morning hours

huaraches: an adaptation of Mexican peasant sandals with woven leather toes and a strap at the heel

jabot blouse: women's blouses of the 1920s with frilly neck treatments and a wide cut that could form a deep blouson over the skirt waistband

Jockey briefs: men's formfitting knit underwear cut with high leg openings, an elasticized waistband, and a Y-front closure; introduced in 1934

Lido shoes: any variety of women's thick, cork soled shoes of the 1930s

loafers: a moccasin style of slip-on casual shoe introduced from Norway in the 1930s

London cut suit: see drape cut suit

marcel: a hair curling device used in salons of the 1920s and 1930s for "permanent" waves

mess jacket: men's dinner jacket cropped at the waist and resembling a naval officer's dinner dress

negligee shirt: men's dress shirt with coat cut front opening and attached turn-down collar

nylon: an amide synthetic used to produce resilient yarns used in textiles

Oxford bags: trousers with wide legs worn by young men of the 1920s

pagoda sleeve: wide, exaggerated sleeves with a high, peaked shoulderline

Palm Beach suit: men's lounge style suit made of lightweight tropical fabrics; named for the Florida resort in the 1930s

peaked lapel: the wide, pointed style of lapel first popular on suit jackets of the 1920s

phenolic plastic: a resinous plastic made from benzene

pinched-crown hat: men's brimmed hat with a pair of dents in the front of the crown

plus fours: loose, baggy knickerbocker trousers worn by both men and women in the 1920s and 1930s for sports activities, and by men as casual country attire

polo shirt: short-sleeve knit shirt with placket button closure and knit Eton collar

raccoon skin coat: long, voluminous fur coat with large collar worn by collegiate men and flappers of the 1920s

rayon: a synthetic fabric commonly known as artificial silk

seersucker: a puckered textile that derived its name from the Persian "shirushakar"

singlette: lightweight step-in underwear favored by young women of the 1920s

skanties: women's brief style panties of the 1930s

slacks: the generic term applied to women's or men's tailored casual trousers

slip: the generic term usually applied to petticoats and chemises since the 1930s

snap-brim fedora: men's hat with a pliable, wide brim and high, tapered crown

speedsuit: men's one-piece swimwear with short trunks and a tanktop

tennis shoe: sport shoe with rubber sole and canvas upper originally worn on tennis courts

toy hat: miniaturized versions of women's hat styles popular in the late 1930s

twosome swimsuit: men's one-piece swimwear with short trunks and a tank of a contrasting color or pattern

Tyrolean: men's hat of the 1930s with a wide brim, tapered crown, and feather in a corded hatband

vanity case: handbag cosmetic containers with small, touch-up amounts of makeup and a mirror

viscose rayon: fabric made from synthetic yarns produced with viscous cellulose

weskit: a men's jacket with a short, vest-cut hemline

zipper: a slide closure of interlocking teeth affixed to fabric or other material

Chapter 23

THE TWENTIETH CENTURY
1940–1960

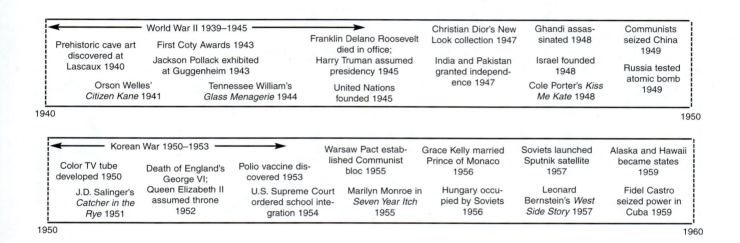

World War II 1939–1945

Prehistoric cave art discovered at Lascaux 1940

First Coty Awards 1943

Jackson Pollack exhibited at Guggenheim 1943

Orson Welles' *Citizen Kane* 1941

Tennessee William's *Glass Menagerie* 1944

Franklin Delano Roosevelt died in office; Harry Truman assumed presidency 1945

United Nations founded 1945

Christian Dior's New Look collection 1947

India and Pakistan granted independence 1947

Ghandi assassinated 1948

Israel founded 1948

Cole Porter's *Kiss Me Kate* 1948

Communists seized China 1949

Russia tested atomic bomb 1949

1940 1950

Korean War 1950–1953

Color TV tube developed 1950

J.D. Salinger's *Catcher in the Rye* 1951

Death of England's George VI; Queen Elizabeth II assumed throne 1952

Polio vaccine discovered 1953

U.S. Supreme Court ordered school integration 1954

Warsaw Pact established Communist bloc 1955

Marilyn Monroe in *Seven Year Itch* 1955

Grace Kelly married Prince of Monaco 1956

Hungary occupied by Soviets 1956

Soviets launched Sputnik satellite 1957

Leonard Bernstein's *West Side Story* 1957

Alaska and Hawaii became states 1959

Fidel Castro seized power in Cuba 1959

1950 1960

THE SECOND WORLD WAR

Unlike the First World War, which came almost as a surprise to the Europeans who had been drawn into the conflict, World War II was an inevitability that had been brewing for years. After Germany had seized Austria and Czechoslovakia in 1938, Western democracies did nothing, preferring appeasement of Hitler over war. In September 1939, though, Germany resumed its aggression by invading Poland, at which Britain and France declared war. While Europe erupted into a conflagration, in Asia, Japan extended its war with China into a conquest of resource-rich territories around the Pacific rim. Despite the neutrality acts passed by the U.S. Congress,

America shipped millions of dollars worth of equipment and supplies to Europe through the Lend-Lease program, and hindered Japan's intents by embargoes. In December 1941, Japan attacked the U.S. fleet at Pearl Harbor, and America declared war. A few days later, Germany declared war on the United States, and Americans also entered the conflict in Europe.

Changes on the homefront for Americans recalled those of 1917. As 15 million men joined the armed services, huge numbers of women went to work outside the home filling those critical positions in manufacturing, agriculture, and services left vacant by enlisted men. (Figure 23-1.) The Great

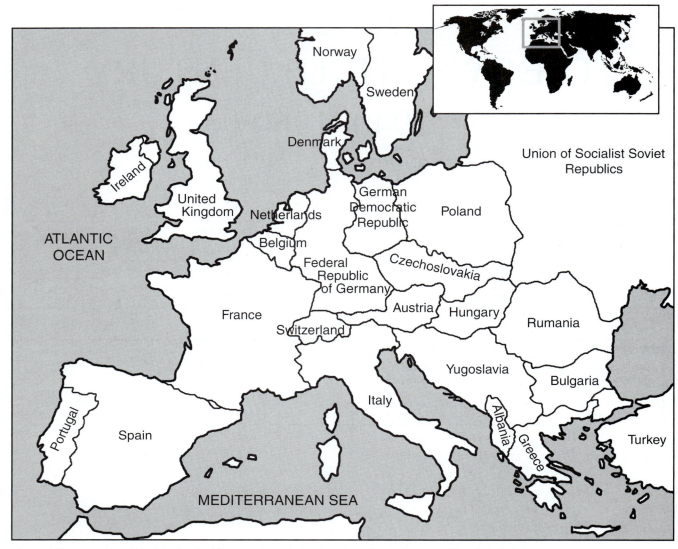

Map of Europe after World War II. (Compare with the borders following the First World War on page 538.)

Depression was clearly and finally at an end as unemployment dropped to 1.2 percent. Labor unions agreed to no-strike pledges. Retired folks volunteered for civil defense duties. Rationing was immediate for food, rubber, metals, gasoline, and heating fuels. To supplement food shortages, Victory Gardens were cultivated in backyards and city parks nationwide. Price controls were put in place to stem inflation.

Even with the powerful economic might of the United States behind the Allies, the tide of the war turned with agonizing slowness. In 1943, the Allies began their invasion of fortress Europe from the shores of North Africa across to Italy. D-Day, or the cross-channel invasion of France from England, was June 6, 1944. Meanwhile, the Russians pushed westward into Germany, meeting up with the Americans just south of Berlin the following spring. Hitler committed suicide in his bunker, and on May 7, Germany surrendered.

In Asia, the turning point in the war with Japan came in 1942 at the Battle of Midway in the Pacific. The U.S. strategy of "leapfrogging," or bypassing certain heavily fortified islands to set up airfields and then return to neutralize enemy bases, effectively moved the Americans within easy roundtrip bombing of Tokyo by 1944. Fanatical resistance on many of the outer islands convinced President Truman to unleash the atomic bomb on Hiroshima in August 1945. Only after the second atomic bomb annihilated Nagasaki three days later did Japan capitulate, at last bringing an end to World War II.

THE COLD WAR

In the aftermath of the war, the newly founded United Nations struggled to establish itself as a guarantor of a warless world. Instead, Russia, having been granted one of five seats on the

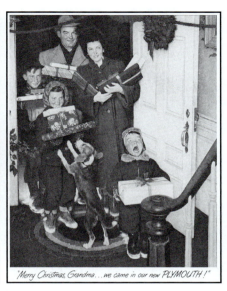

Figure 23-2. In the postwar years, suburban living and a preoccupation with materialism and consumerism became the American dream. Advertising and television programming of the 1950s perpetuated a sanitized myth of the American middle-class nuclear family.

through 1964. As more houses went up and the population increased, demand for consumer goods soared. In addition, those who had remained on the home front had made high wages but had little to buy during the war. The pent-up demand for new cars, furniture, appliances, clothes, and luxury items contributed to the most robust consumption economy since the 1920s. Materialism returned with a vengeance in the 1950s.

Into suburbia moved millions of American families, eager to put the war trauma behind them and get on with life. (Figure 23-2.) Weekends became a ritual of lawn mowers, car washes, and backyard barbeques. Sales of patio furniture quadrupled between 1950 and 1960. Bowling leagues and little league baseball teams gave neighbors a sense of community. Teenagers went to sock-hops at school gymnasiums and danced the Bop, the Stroll, or the Calypso to the new sounds of rock and roll.

Among the most prevalent social issues that challenged the contentment and conformity of American society were economic inequalities and racial injustices. In 1954, the Supreme Court finally set aside the "separate but equal" doctrine that had been in place since the 1890s by ordering public school integration. Compliance was tied to federal funding of education. Despite efforts by regional demagogues, most Southerners accepted integration rather than no public schools for their children. Encouraged by this and similar decisions by the courts, African-American leaders such as Martin Luther King, Jr., effectively organized marches, "sit-in" demonstrations and boycotts to advance voting rights, desegregation of public transportation and facilities, and nondiscrimination in jobs. In 1957, Congress acted with the first civil rights legislation since Reconstruction.

Other rifts in the comfortable conventions of postwar American society occurred when the children of this "silent generation" began to rebel against the complacency of their elders. In 1953, Marlon Brando represented the rebellious leather-clad biker and his antisocial view of America in *The Wild One*. Two years later, James Dean portrayed the quintessential modern adolescent struggling for his own identity, free of conformity, in *Rebel without a Cause*. Another counterculture movement was that of the Beats—a term alternately used as a contraction of "beatitude," since they felt they had been blessed with mystical qualities, and also as a symbol of those who had been "beaten down" and excluded from the American dream. These first voices of dissent and disillusionment paved the path for a more vocal and activist generation in the 1960s.

AMERICAN FASHION ON ITS OWN

Not only was the American fashion industry pinched by shortages of leather, wool, silk, and nylon during the Second World War, but the innovative guidance of Paris came to a halt as well. In the face of a German invasion in the spring of 1940, Parisian couturiers moved their operations to the resort town of Biarritz in southwestern France where they struggled with shortages of labor, equipment, and materials to produce limited collections. Despite the dangers of travel that year, American retailers and ready-to-wear makers made significant purchases. When the Germans marched into Paris in June, though, the borders of France were closed, and for the next four years, Americans received little information about what Paris couturiers were designing. Even the French edition of *Vogue*

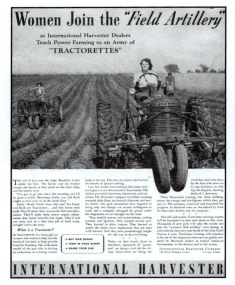

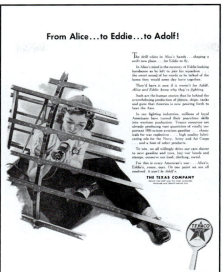

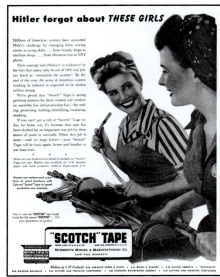

Figure 23-1. During World War II, women by the millions stepped into trousers and went to work in industry, agriculture, and services in answer to the nation's call for help with the labor shortage. Ads 1942 and 1943.

kingpin Security Council, vetoed scores of resolutions that they regarded as an interference with their schemes for world revolution. Immediately after the war, the Soviet Union dropped the Iron Curtain of communist dominion over the nations of central Europe. In China, the communists took over in 1949. The Cold War between democracies and communism had begun.

In 1949, the Russians further shocked the world by successfully testing its own atomic bomb. The arms race intensified when the United States responded with the thermonuclear hydrogen bomb in 1952, which was matched by the Russians in 1955. For a moment in the war of wills, the Russians outpaced America by being first into space with the Sputnik satellite in 1957. The United States entered this new phase of the Cold War with its first satellite the following year.

A shooting phase of the Cold War erupted not in Europe, where tensions were continually high along the Iron Curtain, but in Korea. After the world war, the Allies had divided up the nations formerly occupied by the Axis powers into zones of reconstruction. In Korea, Russia administered the northern half, which became communist, and the United States accepted the southern half, which was democratized. Less than a year after U.S. troops withdrew in 1949, belligerent communists invaded the south. Although the United Nations voted to defend the south, the bulk of the air and naval materiel, and most of the men, except for the South Koreans, were supplied by the United States. The Chinese joined the North Koreans and the conflict was fought to a stalemate at the 38th parallel. An uneasy truce was finally negotiated in 1953 leaving one of the most heavily fortified and armed borders in the world.

Throughout the 1950s, the global expansion of communism threatened French Indochina (Vietnam), Greece, Turkey,

Egypt, and even France and Italy. One counter measure against the Soviet Union was the Marshall Plan, named for U.S. Secretary of State George Marshall, which pumped tens of millions of dollars of economic aid into nations that agreed to resist communism. Another deterrence against the spread of communism was the formation of the North Atlantic Treaty Organization (NATO) in Europe and, later, the South East Asia Treaty Organization (SEATO), both of which assured member nations that an attack against any one of the member nations would be regarded as war against them all.

In the Middle East, the Arab League was formed in 1945 to advance national interests in the Near East against European imperialism. When the British abandoned its Palestine mandate in 1948, an Arab-Jewish war ensued in which Egypt and Jordan suffered humiliating military reversals. With the truce agreement the following year, an independent Israel was founded.

THE POSTWAR UNITED STATES

When the Second World War ended with the awesome awfulness of an atomic explosion, the United States was confronted once again with demobilization. Despite the threat from communism, the United States began dismantling its massive war production machine and rapidly brought home millions of service men and women to resume civilian life.

Because of war rationing, little new housing had been built during the first half of the 1940s. Immediately after the war, every American city contended with a sprawling suburbia partitioned with endless rows of new development homes. The housing boom assured plenty of jobs for returning ex-soldiers. A more notable boom was the surge in births from 1946

Television

One of the most potent and pervasive influences on American pop culture of the 1950s was television. (Figure 23-3.) Programs often depicted an illusory representation of the ideal white, middle-class American family, which was perpetuated in long-running series like *The Adventures of Ozzie and Harriet* and *The Donna Reed Show*. "Mr. Television," Milton Berle, kept millions of viewers home Tuesday nights to see if he would appear in drag, and everyone loved Lucy on Mondays.

With the expansion of television stations across the continent during the 1950s, marketers capitalized on this new medium for advertising. Sponsors of television programs controlled virtually every aspect of production. Scripts for talk shows were interwoven with dialog promoting the sponsor's products, and game show sets were plastered with product brand logos at every camera angle. Ready-to-wear makers and clothing retailers vied with each other to provide wardrobes for the program characters or hosts with the promise of an acknowledgement in the credits or a mention on the air. Only with the quiz show scandals of 1959—when it was revealed that many contestants had been given the answers ahead of time—were television networks able to wrest control of programming from sponsors.

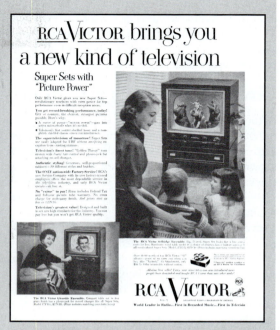

Figure 23-3. Television became an integral part of family life in the postwar years. Commercials fueled aspirational consumerism, and programming idealized the American home and family. Ad 1952.

shut down for the duration. Despite their isolation, the couturiers continued to create limited collections only for the French and German market. At one point, Germany's ministry of culture even considered relocating the entire couture industry to Berlin, but Lucien Lelong, as president of the Chambre Syndicale de la Couture, courageously persuaded the Germans of the inadvisability of such a venture.

For the first time, American designers were on their own without any creative guidance from Paris. "The fashion spotlight turns on New York," declared *Vogue* in 1940. Many designers who had achieved notoriety in the thirties gained greater prominence as they took up the mantel of fashion leadership. The fashion press and ready-to-wear makers cast an anxious eye to Hattie Carnegie, Henri Bendel, and Adrian, as well as to the new labels of Norman Norell, Adele Simpson, Claire McCardell, and Clare Potter.

These, and numerous other U.S. designers, created fashions during the war years that reflected the ease and casualness of the American woman. Claire McCardell's sportswear, especially, led the way in dispensing with exaggerated shoulder pads and restrictive foundations. Many styles of suits and dresses were made with a duality in mind—comfortable for day time and elegant enough for evening.

When the United States entered the war in December 1941, a long list of raw materials and manufactured goods were immediately rationed for war needs. The U.S. War Production Board instituted the **L-85 regulations** that restricted the kinds and quantities of materials that could be used in apparel manufacturing. Most American designers, though, went one step farther and created fashions that were even more narrow and trim than L-85 measurements required saving an estimated 15 million yards of fabric by war's end.

TECHNOLOGY AND TEXTILES

Within three years after the end of World War II, textiles had become the second largest industry in the United States with more than 6,000 makers employing about one and a quarter million people. During the decade following the war, numerous textile manufacturers relocated to the South where not only labor and land were cheap but labor unions were scarce, resulting in a twenty-two percent decline in the northeast textile industry.

Advances in technology expanded the varieties and availability of yarns beyond those made with natural fibers to include a host of new synthetics and treated materials. In 1947, the Dan Rivers Mills began production of cotton fabrics prepared with a synthetic resin that made them wrinkle-resistant. In 1949, Dynel was introduced as a fire-resistant, moth- and mildew-proof fiber used in fake furs and later for wigs. Du Pont launched Orlon acrylic in 1950, and Dacron in

1953. In 1958, Eastman Chemicals produced the Kodel polyester fiber. Synthetic yarns and treated fabrics made possible a wide array of shrink-resistant, **wash-and-wear** apparel, sales of which leapt from $45 million in 1952 to $285 million just four years later. (Color Plate 54.)

WOMEN'S FASHIONS DURING WORLD WAR II

Before Germany had occupied France and closed its borders in June 1940, American and British journalists, retail buyers, and consumers took away fashions from the Paris spring showings that reflected the mood and needs of wartime. The cinched-waist and long skirts that had briefly appeared in 1939 were abandoned for trim, easy-fitting lines. Dresses retained the defined waist of the thirties, but bodices and sleeves were looser and skirts were shortened to the knees. Suit jackets were less fitted and armholes were roomier although the occasional peplum added a touch of feminine flair to otherwise tubular bodices.

Behind the fortress of occupied France, Parisian couturiers continued to design seasonal collections with about two-thirds fewer models than previously. Fewer designers

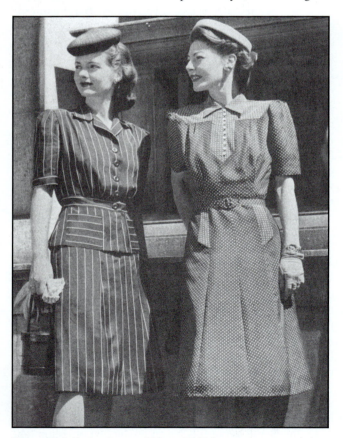

Figure 23-4. During the war, U.S. and British government restrictions on the use of materials and the construction of clothing determined the fashion silhouette, Women's suits became more masculine looking with narrow, simplified styling, squared shoulders, and skirts cropped to the knees. Austerity L-85 dressing from 1943.

also remained in business. Schiaparelli and Mainbocher went to New York, but Schiaparelli worked as ambassador for French couture, writing for fashion publications and making personal appearances rather than reopening her salon. Molyneux and Worth moved their ateliers to London. Chanel remained in Paris but ceased designing, becoming mistress to a German Nazi officer instead, for which she would suffer arrest as a collaborator and a ten-year exile to Switzerland after the war.

The styles that Paris couturiers created during the war years featured excesses that were forbidden to American and British designers. Gathers, pleats, shirring, flounces, and other construction details that required excessive amounts of fabric were in abundance on French fashions. In 1943, when a collection of French haute couture arrived in New York in the wardrobe of a visiting French dignitary's wife, American journalists were perplexed by what they saw. *Life* reported that the styles were hardly more than "vulgar exaggerations of famous silhouettes." For many couturiers, though, the excessive use of fabric meant less yardage available to the Nazi occupiers, and for French women, wearing these fashions was a gesture of patriotism.

In Britain, the Utility Scheme was introduced in the spring of 1941. Government restrictions on the use of materials and the making of apparel largely dictated the fashion silhouette of the time. Measurements for everything from collar widths to hemline revers were regulated. Not only was the intent to reduce the amount of fabric used by the clothing industry, but by standardizing garments, retooling of machinery and retraining the limited labor force were eliminated. From these dictates, fashion inventiveness was largely shackled, and the usual cycles of innovative change ceased. In place of fashion choice emerged a nationalized, functional war costume. In essence, the **Utility look** was one of squared shoulders, narrow hips, and skirts at the knees—but not above the kneecaps. (Color Plate 35.) Trimmings disappeared, and substitutes for many scarce materials had to be found. Simplicity was the objective of the day with no fussy details to suggest a squandering of precious resources.

In the United States, the War Production Board introduced similar utility restrictions with the L-85 regulations. Measurement specifications included limiting skirts to seventy-two inches at the hem, pant legs to nineteen inches around in circumference, and suit jacket lengths to twenty-five inches, which was just at the hips. Turned-back cuffs, double yokes, and multiple patch pockets were among the details now prohibited. The use of certain materials was rigidly controlled, particularly wool needed for uniforms and blankets, silk and nylon needed for parachutes, and leather needed for military boots. As with the British silhouette, the American austerity look was trim and narrow. Shoulders remained wide and squared, bodices were loose with natural waistlines, and skirts were slim and cropped to the knees. (Figure 23-4 and Color Plates 36 and 37.)

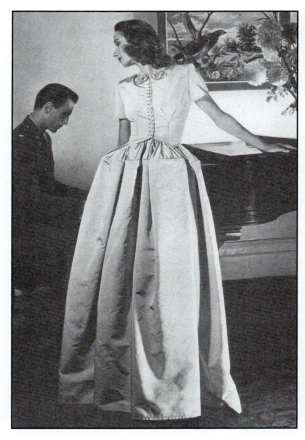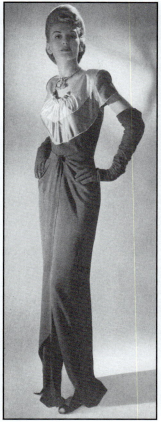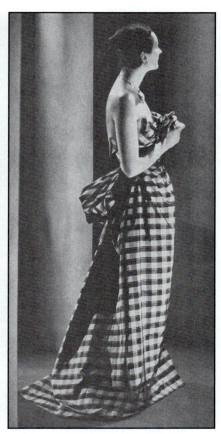

Figure 23-5. Fabrics not needed for the war effort such as velvet, taffeta, and rayon were in sufficient supply for designers to create opulent eveningwear. Left, taffeta gown by Henri Bendel, 1942; center, rhinestone studded gown by Pattullo, 1943; right, bustle gown by Adrian, 1944.

Sportswear continued to gain wider acceptance for everyday town dress. As huge numbers of women went to work outside the home, slacks were more commonly seen on city streets and in public offices as war workers rushed about taking care of personal business during lunch hours and after work.

Not all clothes were restricted to the L-85 specifications. Textile manufacturers were encouraged to produce plenty of materials not needed for the war, especially cotton and rayon, that could be used for casual sportswear, playwear, and eveningwear. Luxurious velvets, taffetas, and silky rayons were fairly plentiful for special occasion dressing. Although most designs of after-six dresses followed the slim, vertical lines of day wear, some styles offered a contrast with full skirts or revivalisms such as bustle treatments, large back bows, overskirt swags, or deep peplums. (Figure 23-5 and Color Plates 39 and 40.) However, ostentation was viewed as an unpatriotic display of extravagance that disregarded the austerity needed to win the war. Hence, excessive use of sequins, beading, embroidery, and similar embellishments were largely eschewed.

Despite limited resources and the hazards of shipping abroad, Britain's fashion industry continued to export apparel to the Americas. Woolen knitwear was especially in demand as home heating fuel shortages and rationing forced everyone to turn down thermostats and close off furnace vents. Americans were encouraged to help support the fight for democracy by buying British-made clothing. "A new sweater puts another nail in a plane for Britain," wrote a journalist in 1942. Competing American knitwear makers also extensively advertised the practical and fashionable new looks of their styles. For GIs far from home, photos of Hollywood sweater girls like Lana Turner, Betty Grable, and Rita Hayworth were favorite pin-ups. Sweaters made with silk lamé or trimmed with fur collars such as the designs by Mainbocher became popular eveningwear. (Figure 23-6.)

When Paris was liberated in the fall of 1944, couturiers abandoned frilly and frivolous fashions they had created during the German occupation and, instead, adopted the narrow, simpler silhouettes of American and British austerity styles. Even in the months following the end of the war in August 1945, materials were scarce and official restrictions

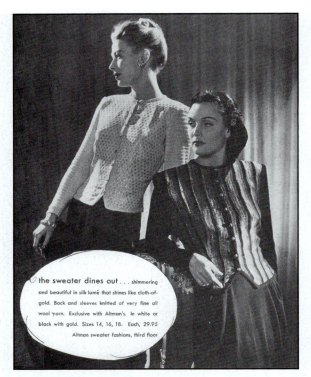

Figure 23-6. Wartime knits were luxuriously embellished with silk lamé or trimmed with fur for a formal, sumptuous look. Eveningwear sweaters from Altman's, 1943.

on clothing designs remained in effect. By 1947, though, women were more than ready for a dramatic change in fashion. After years of privations and the monotonous austerity styles, almost everyone was anxious for a new look.

THE NEW LOOK 1947–1959

During 1946, Paris designers began to experiment with elements that were contrary to the utility styles of the war years—full, long skirts, natural shoulderlines, and a small waistline. The "**spool torso**" was a fitted bodice attached to a shapely fullness at the hips formed by a peplum, pannier, or hoops. Swags of fabric and bustle treatments were also used to emphasize the hips and smaller waist.

The pivotal change, though, came with the debut collection of Christian Dior in the spring of 1947. The couturier had left his chief designer post at Lelong the year before to open his own salon at the urging of a wealthy textile magnate. Dior's "Corolle" collection crystallized the postwar woman's fantasies of graceful and elegant fashions into a cohesive, ultrafeminine look—the "**New Look**" as *Harper's Bazaar* christened it. (Figure 23-7 and Color Plate 43.) The common denominators of the clothes he designed, he later wrote, were "rounded shoulders, full, feminine busts, and hand-span waists above enormous spreading skirts." His fashions were meticulously constructed and detailed, very much in the

traditional haute couture approach to design. Many dresses had built-in corsets and boning, and all were lined with cambric or taffeta. To these fundamentals of construction, Dior added head-to-toe accessories—the right hat and handbag, earrings, necklaces and many bracelets, gloves, opera pumps, and even parasols.

As revolutionary as Dior's fashions seemed to be at the time, the New Look was actually a rejuvenation of the mock-Edwardian revivals that had emerged just before the outbreak of the Second World War. The timing for Dior, though, could not have been more perfect. Amidst the confusion and intensity of the Cold War, coupled with the still raw memories of the cataclysmic death and destruction of the world at war, women overwhelmingly embraced the nostalgia the New Look engendered. The safety and security of a conventional lifestyle was all many women now wanted. The New Look provided the trappings of traditional femininity that women sought to secure their illusory ideas of a return to normalcy. The new silhouette was that of a fertility goddess, and the postwar baby boom confirmed its effectiveness.

Season after season, Dior led the way with innovative collections that subtly evolved from the previous season's styles into a fresh variation on the New Look theme. In the spring of 1950, he launched the "Vertical Line" collection, which reintroduced the trim, fitted sheath—"the single most important day fashion," avowed *Vogue* at the time. (Color Plate 45.) Between 1954 and 1956, he introduced his influential alphabet lines. The **H Line** featured a dropped waist (an adaptation of Balenciaga's **middy** styles of 1953), which differed dramatically from the 1920s looks in that the bodice snugly contoured the figure, emphasizing the cinched waist, rounded hips, and fuller bosom. (Color Plate 46.) The **Y Line** was a slender body with shoulder details like puffed sleeves and pelerine collars or decollete necklines that formed the converging V-top shape of the "Y." The **A Line** was a loose, triangular cut that contrasted sharply with the earlier fitted styles of the New Look. By the end of the decade, the A line evolved into its most extreme contours with the **trapeze cut** launched by Dior's protege, Yves St. Laurent, in 1958. (Figure 23-8.) The trapeze line—short for trapezium, a quadrilateral with no parallel sides—featured a full, tent shape with a high bust and a back that fell from the shoulders.

Dior's many variations of the New Look were sensational. Each collection had a youthful vitality that appealed to women of all ages. From the start, the impact of Dior's New Look on the entire fashion industry was immediate. Few designers were impervious to its influence. Ready-to-wear makers were ecstatic with the market's unceasing demand for New Look styles, even if mass-produced adaptations like those shown in Figure 23-7 and Color Plates 47 and 52 required significant compromises on the perfection of the couturier's craftsmanship.

Almost overnight, Paris was once again the preeminent center of style. But competition from London, Rome, and

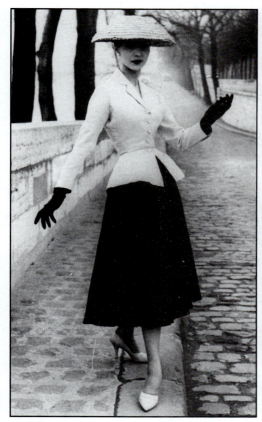

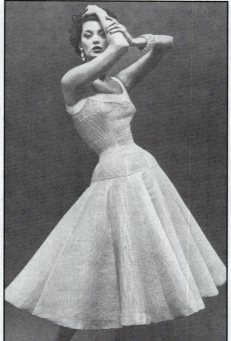

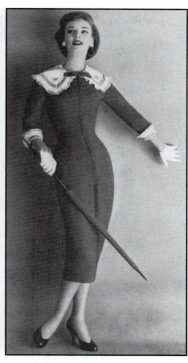

H Line middy silhouette of pin-tucked cotton by Molly Parnis, 1953.

Y Line sheath by Karen Stark, 1955.

Christian Dior's debut collection, the Corolle, launched the New Look in 1947.

Figure 23-7. In 1947, Christian Dior launched the New Look with his pivotal debut collection. Fashions of the following fifteen years would emphasize the cinched waist, rounded shoulders and hips, and a full bustline.

New York now forced changes that the prewar Chambre Syndicale de la Couture had viewed with disdain. Although some couturiers, such as Patou, Lelong, and Chanel, had begun producing ready-to-wear boutique collections as early as the 1920s, the French fashion industry only began a consolidated effort toward mass production in the late forties. At that time a group of French businessmen went to the United States to study American ready-to-wear expertise. The result was French **prêt-à-porter**—high quality and high style ready-made clothing tailored to the U.S. and British mass market.

The success of the French prêt-à-porter collections were indicative of the international fashion market that emerged in the 1950s. London's premier couturiers, Norman Hartnell and Hardy Amies, had begun expanding their interests in ready-to-wear during the early 1940s as a financial life line to the Americas. After the war, the member firms of the Incorporated Society of London Fashion adopted American sizing, and set a calendar of showings the week before the Paris openings to attract U.S. buyers on their way to France.

Italy, too, entered the international fashion arena in the 1950s, achieving widespread acclaim primarily for its resort wear, knitwear, and leather goods. Emilio Pucci, Donna Simonetta, Roberto Capucci, and the Fontana sisters were among the innovative designers who brought an exciting inventiveness and bold use of color to fashion. Italy especially became the fashion leader in footwear during the fifties with the popularity of the four-inch stiletto high heel. A decade later, Italian boots similarly would be in demand around the world.

After four years without influence from Paris during the Second World War, American designers continued at the forefront of fashion with an endless variety of casual dressing. The elements of the New Look—delineated bust, tiny waist, and full hips—were easily adapted to comfortable mix-and-match separates and the ubiquitous **shirtwaister** that were in every American woman's wardrobe. (Figure 23-9 and Color Plate 48.) The California casual style that had begun to expand eastward in the 1930s was ideal for the new suburban living. In addition to assorted types of tailored trousers, women's pant styles now included slim **capris** cropped just above the ankles, **pedal pushers** extending a few inches below the knees, and shorts at lengths from long **bermudas** to thigh-high cuts. (Figure 23-10.) Durable jeans,

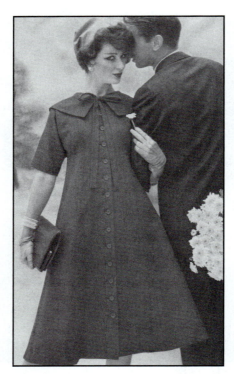

Figure 23-8. At the end of the 1950s, Yves St. Laurent introduced the trapeze line, the most extreme counter to Dior's original concept of the New Look. Trapeze line by Nelly Don, 1958.

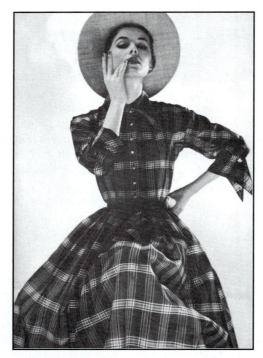

Figure 23-9. In the 1950s, the silhouette of the enduring shirtwaist dress reflected the influences of the New Look styling with its fitted bodice and full skirt. Shirtwaister in plaid Organsari by Dorothy Cox, 1950.

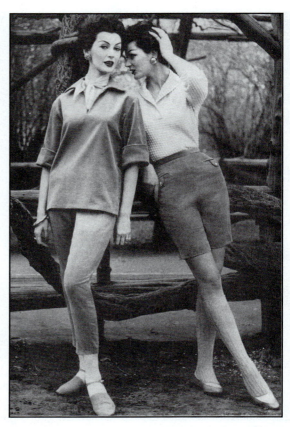

Figure 23-10. Postwar suburban living inspired a proliferation of casual pant styles and shorts. Corduroy tunic top with matching cropped pants, and corduroy shorts with popcorn knit shirt from Fligelman, 1956.

which had become a common work pant for women during the war, were transformed to a style of 1950s youth and made fashionable with colored denim and matching jackets. (Color Plate 53.)

Soft sweaters were a particulrly favorite casual top worn with tailored slacks and jeans as well as with full and pencil skirts in the 1950s. The pullover and cardigan twinset was revived from the 1930s not only for casual dress but also as a wardrobe option for the office pool. (Color Plate 55.)

Part of the American youth look also included crinolined **circle skirts** decorated with three-dimensional appliques of stylized poodles, music notes, hearts, and even actual vinyl records or Christmas ornaments. Teen girls, called **bobbysoxers,** wore scuffed black-and-white saddle oxfords or penny loafers with turned-down white cotton socks and hung out at music stores or drug store soda fountains.

Hollywood continued to exert some influence on the fashion and beauty industries, though it was less pronounced than it had been in the 1930s. Audrey Hepburn was first among equals of the great Hollywood beauties of the era, which included Elizabeth Taylor, Grace Kelly, Natalie Wood, and Lauren Bacall. Her large, well-defined eyes, sharply

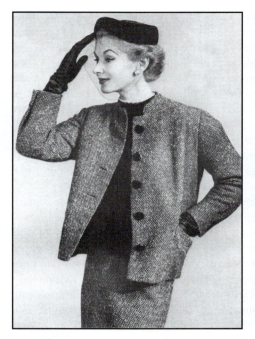

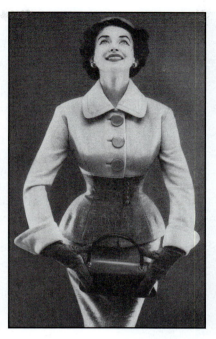

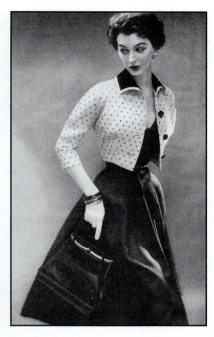

Mandarin collar box jacket suit by Adele Simpson, 1952.

Peplum suit of cashmere and mohair by Lilli Ann, 1953.

Bolero suit by Herbert Sondheim, 1954.

Figure 23-11. After years of masculine, austerity suit styles during World War II, women overwhelmingly embraced the ultrafeminine variations of New Look fashions.

drawn eyebrows, and pouty lips were the composite for a new ideal in beauty. Clothes of all types fit her ultra-thin angularity beautifully. *Vogue* wrote of Hepburn in 1954, "Nobody ever looked like her before World War II. Yet we recognize the rightness of this appearance in the relation to our historical needs. And the proof is that thousands of imitations have appeared."

Women's suits of the New Look era were infinitely varied, often with a hyperfemininity as a reaction to the dowdy, menswear styling of the wartime utility styles. (Figure 23-11.) Through the mid-1950s, rigidly tailored jackets followed the body-conscious tenets of the New Look with fitted bodices that rounded the bosom and short, flaring peplums or wide, hip-length hemlines. Many jackets were belted to emphasize the cinched waistline. Both pencil-thin skirts and full, gathered or pleated skirts worked easily with the shapely jackets. Throughout the 1950s numerous versions of the cropped bolero remained popular, including fitted Edwardian revivals and capacious A Line cuts. (Color Plate 44.) In 1954, Chanel returned to Paris after a fifteen-year absence from fashion during her exile in Switzerland. She reintroduced the ease and softness of the boxy suit styles that had been her staple before the war. Despite criticism from the fashion press that Chanel offered nothing new, many of her contemporaries appreciated the nonchalant lines and

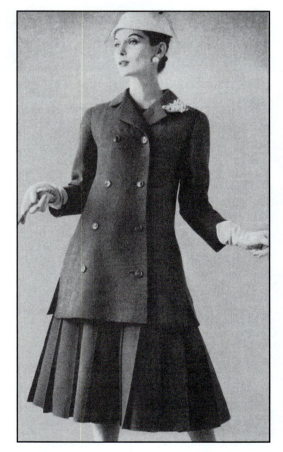

A Line silk and flannel suit by Christian Dior, 1955.

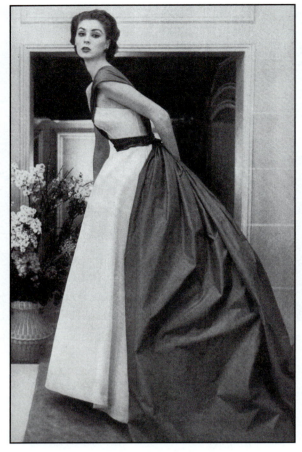

Christian Dior, 1952.

simplicity of her designs. At about the same time, other designers concentrated on revitalized variations of the long, straight suit lines that had reappeared in 1951. Balenciaga created tunic suits, and Dior launched his loose-fitting A Line suits. New attention on English tweeds resulted from the highly publicized coronation ceremonies of Elizabeth II in 1953. In the second half of the decade, skirts became shorter and by 1958 were nearly at the same knee-length they had been during the war. Also at the end of the decade, Yves St. Laurent's trapeze-line suits were fresh options for the modern women's wardrobe—although fitted, New Look styles endured.

The ultrafemininity and fullness of the New Look were extended to eveningwear with the addition of panniers, crinolines, and hip pads. (Figure 23-12 and Color Plates 49–51.) Greater fullness was added with bustle treatments, gathered overskirts, and tiers of flounces. Sumptuous fabrics once again were in abundance and designers lavished their creations with yards of material, including matching evening coats, capes, and wraps. Bodices, though, were tight with natural shoulderlines or with deep decollete necklines. After 1950, eveningwear reflected the popularity of the narrow, form-fitting sheath although bouffant skirts dominated throughout the decade. At the end of the decade, innovative eveningwear styles included adaptations of St. Laurent's trapeze line and avant-garde silhouettes such as puffball skirts.

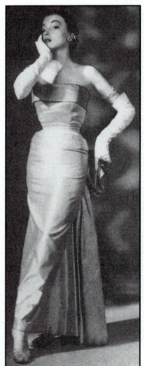

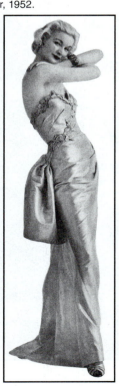

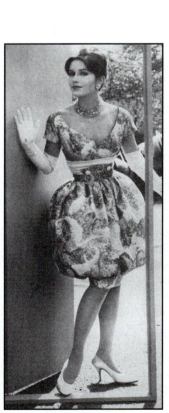

Figure 23-12. New Look styling was applied to eveningwear either through the sumptuous abundance of fabric or with formfitting sheaths that accentuated the curvaceous line of the female form.

Nettie Rosenstein, 1950. Philip Hulitar, 1958. Oleg Cassini, 1959.

WOMEN'S OUTERWEAR 1940–1960

During the Second World War, utility regulations restricted the lengths of coats and the dimensions of collars, lapels, pockets, and sleeves. Shoulders were still squared but without the expanse of sleeves popular in the years before the war. (Color Plate 38.) Masculine, military styling, particularly the belted trenchcoat, was the most common look for women's outerwear by 1943. The tubular **cigarette silhouette** was popular in both fingertip and knee lengths and was easy to mass produce with the limited labor available. Three-quarter-length coats and hip-high reefers were two solutions to fabric shortages.

The silhouette of the New Look was applied to coats and jackets with molded, fitted bodices and full, flaring skirts or peplums. The fitted cut was usually the shoulder-to-hem princess line that was often cinch-belted. Short **toppers** cropped to about mid-thigh were preferred with wide skirts. Most coats, though, were cut full from the shoulders with a variety of wide sleeves including roomy raglan and kimono styles. (Color Plate 56.) Wrap coats, called **cocoons,** had appeared soon after the war, but remained a favorite look for younger women with slender, angular figures. **Martingale coats** with half belts in the back were made with both fitted and wide cuts in the mid-1950s. With the easy availability of fabrics, coats and jackets featured an endless array of opulent details such as pleats and tucks, large turned-back cuffs, detachable capelets, deep saddlebag patch pockets, and expansive collars and lapels. As with suits, English tweeds

became especially popular for outerwear following the coronation of Elizabeth II in 1953.

Furs continued to be every woman's dream, whether a simple evening fox stole or a full-length wild mink. American ready-to-wear makers capitalized on this market with high quality fake furs, especially those replicating exotic skins like leopard and tiger.

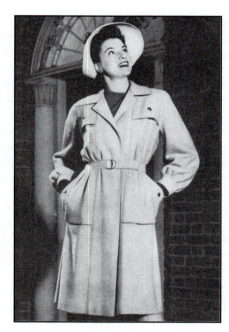

Pre-L-85 "Coat Militaire" from I. Magnin, 1942.

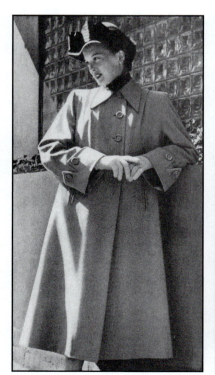

Flared back coat with notched cuffs from Sycamore, 1948.

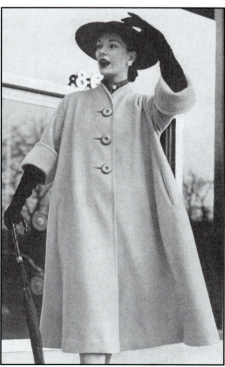

Vicuna coat by Originala, 1951.

Princess line coat with black velvet appliques by Lilli Ann, 1956.

WOMEN'S SPORTS APPAREL 1940–1960

The line between active sports attire and casual, everyday sportswear continued to blur during the 1940s and 1950s. There still were fine distinctions in many specialty quarters, though. Of the numerous forms of trousers worn by women for war work, most would not have been appropriate attire for skiing, tennis, or golf. At resorts and country clubs, tailored slacks and shorts became more acceptable on the links or courts. Jodhpurs remained the preferred trousers for riding. In the fifties, slacks narrowed. Thigh-high short skirts became common for tennis, some of which were made as wrap skirts to fasten over matching shorts. Most tennis leagues continued to require all whites for play although pastels were favored by vacationers for leisure time tennis. The knit polo top was adopted from menswear. Golfers were increasingly less restricted on the proper attire for the courses although jeans, short shorts, playsuits, and similar casual playwear were prohibited. Winter sports clothing became more lightweight and snugly fitting. Improved stretch yarns and knitting technologies made ski pants fit as smoothly as a second skin. After the war, nylon jackets in vibrant colors were especially popular on the slopes. Attire for other active sports such as bicycling, hiking, and neighborhood ballgames included a wide assortment of comfortable playwear, particularly knit tops, shorts, one-piece playsuits, and cropped pant styles.

Crisp rayon sharkskin trousers, shorts, sport skirt, and sports shirts from B. Altman, 1942.

Side zip riding jodhpurs from Spiegel, 1941.

Cotton knit sports shirts from Ship 'n Shore, 1958.

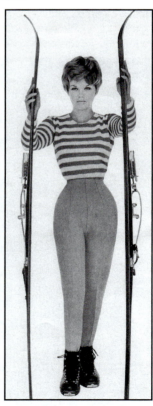

Formfitting ski pants and ribbed top from Jax, 1959.

WOMEN'S SWIMWEAR 1940–1960

The swimwear industry was hit with the same restrictions and shortages as all other apparel makers during World War II. Rayon crepe and sharkskin, waffled linen, and cotton velour replaced the preferred silk and wool. As with undergarments, rubberized yarns such as Lastex were in short supply for swimsuits so new techniques of construction had to be developed. Side lacings and horizontal shirring provided some degree of the snug fit of prewar styles. One-piece maillots were the most common swimsuits, usually still made with the thigh-length modesty skirt. The two-piece that had developed in the 1930s continued to be made with the same bandeau or bra-cut top and high-waisted bottom that covered the navel, though the style was not popular in the U.S. because it too closely resembled underwear to most women.

The great leap forward in women's swimwear occurred immediately after the war when Jacques Heim and Louis Reard independently of each other designed the **bikini** in 1946. Because of the atomic bomb tests that the United States was conducting near the Bikini Islands in the Pacific, Heim named his swimsuit the "**Atome**" since it was the tiniest swimsuit of the time. Reard called his design the bikini possibly because of the many beach and poolside "bikini parties" that were popular during that summer. The drama of the bikini was its lowered waistline that exposed the navel, otherwise, the style differed little from other two-piece designs. American women who had clamored for everything French and New Look after the war resisted the bikini until the late 1950s, and even then, the style was still viewed by many as shocking in public.

In keeping with the idealized femininity of New Look fashions, swimwear makers of the 1950s produced the **constructed swimsuit,** engineered with all types of clever devices to sculpt, control, and idealize the female body. (Color Plate 57.) Bodices were boned to cinch waistlines and bras were molded, wired, and padded to emphasize the bust. Ruffles, bows, beading, peplums, and even fur trim embellished the New Look swimsuits of the decade. Colors were vibrant and textile patterns were bold, including exotic animal skin prints.

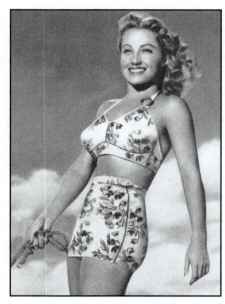

Two-piece "Aleutian Flower Print" suit by Mabs of Hollywood, 1944.

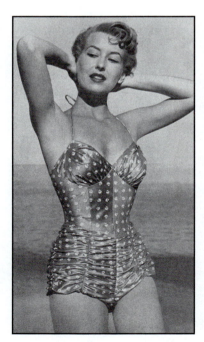

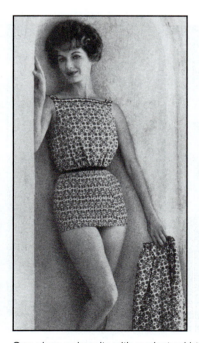

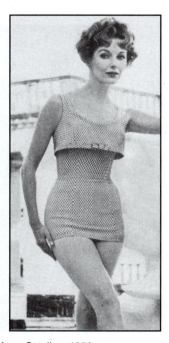

Shirred Orlon suit by Gantner, 1954. One-piece swimsuits with modesty skirts from Catalina, 1959.

WOMEN'S UNDERWEAR
AND SLEEPWEAR 1940–1960

Functionality was the keyword for women's undergarments during the war years. The attempted return of the cinched-waist corset in 1939 faded as materials shortages and wartime restrictions preoccupied underwear makers. The amount of rubber used in textiles was greatly reduced by the War Production Board so that girdles and bras had to be made with panels of elasticized yarns that were inserted into knit rayon or cotton. Advertisers depicted lingerie models in active poses to emphasize the flexibility of the new forms of undergarments, but the fit was much more stiff and uncomfortable than prewar versions.

Simplification and freedom from constraint were the focus of lingerie makers during the war. Slips and petticoats were narrowed and shortened to the knees. Panties were cut with higher leg openings; some were even made with elasticized control panels to replace girdles. In addition, as supplies of imported lace were quickly depleted and stocks of silk were reserved for parachutes, lingerie became plainer. Nylon, too, which had only been introduced in yarns for hosiery in 1939, was scarce as supplies were diverted to war production. Instead, women painted their legs with various commercial skin dyes to simulate hosiery, often with a seam drawn up the back with an eyebrow pencil.

With the conclusion of the war and the launch of Dior's New Look, greater emphasis was placed on undergarments. The constricting **guimpe,** or **waspie** as it was commonly called, was a bust-to-hip corset that reappeared to provide the necessary contours for the ultrafemininity in fashion. Some versions even included old-fashioned forms of laces and hooks. Improved girdles made with better elasticized yarns were the preferred foundation garments for most women. Some forms were reduced to only an eight-inch waistband to more comfortably cinch the waist. As the 1950s progressed, undergarments continued to alter the female form into ultrafeminine silhouettes. The waist remained tiny and the hips full and sloping, but the rounded bosom of the 1940s was sculpted into exaggerated proportions and shapes by the mid-fifties. The **torpedo bras** with their spiral cup stitching and padded linings enlarged and separated the breasts into a stylization of the bosom that remained popular until the end of the decade.

Frilly treatments and lace and ribbon trimmings returned to slips and petticoats in abundance. Stiff mesh net crinolines were layered under the full, New Look skirts to hold the shape, some as smooth and conical as sixteenth-century Spanish court styles.

During the war, sleepwear was often designed with the same plain practicality as other intimate apparel. Nightgowns and wraps ceased to resemble formal eveningwear as they had in the thirties, and, instead, were sometimes even cut like men's nightshirts, many with high necks and long sleeves. Square shouldered housecoats replicated functional men's versions. Flannel pajamas and thick cotton chenille robes were preferred for chilly nights when thermostat settings were lowered in fuel-rationed homes.

In the postwar years, feminine curves were accentuated by gowns with the empire waistline and billowing skirts of pleated or gathered nylon. Lace and ribbon trim, rosettes, ruffles, and other frills embellished nightgowns, pajamas, and robes. Shortie pajamas with cropped tunic tops and matching shorts or bloomers were a favorite of teen girls in the 1950s. Thigh-high versions of nightshirts and sexy, sheer negligees likewise became popular with young women.

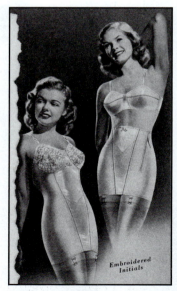

Wartime corset and girdle with elasticized sides and taffeta front panels from C.M.O. Company, 1942.

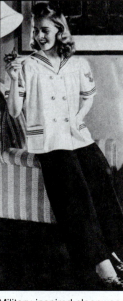

Military inspired sleepwear from Spiegel, 1942.

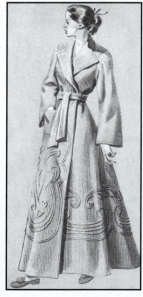

Chenille robe from Spiegel, 1948.

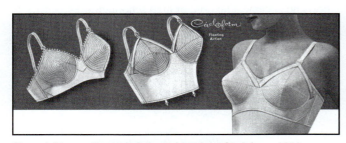

"Torpedo" bras with concentric stitching from Circloform, 1954.

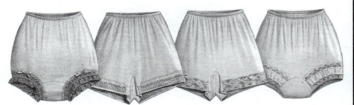

Lace trimmed nylon tricot panties from Montgomery Ward, 1952.

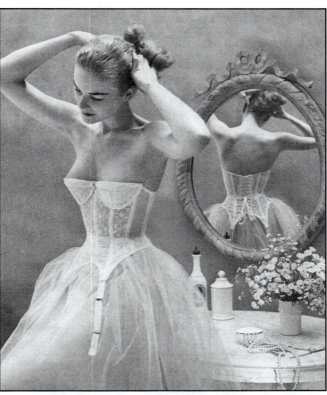

Warner's Cinch-Bra "makes your waist more diminutive, more appealing," promised ad copy in 1951.

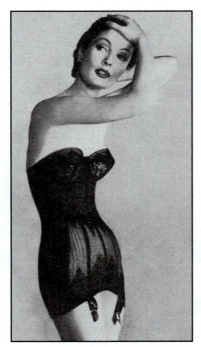

Merry Widow corselette by Warner's, 1956.

Shortie nightgown of nylon tricot by Rogers Lingerie, 1956.

Print flannel pajamas by Pat Hilton, 1957.

WOMEN'S SHOES 1940–1960

Wartime utility regulations applied to shoes as well as clothing. Leather particularly was needed by the military since soldiers wore out a pair of boots about every month. In the United States and Britain, civilian leather shoes were rationed, requiring coupons when a supply became available. The English had to "make do and mend" much more than Americans. As with clothing, the emphasis on shoe designs was practicality as well as conservation. Heels were limited to two inches. For women working in plants and services, open-toe and strapped styles were banned as unsafe. Trodding about in sturdy, masculine-looking lace-ups confirmed a woman's patriotic duty. Since fabric uppers and synthetic or wooden soles were not rationed, some fashion variety in footwear was still possible.

In the postwar years, high heels and ankle straps returned. Sandal toes and other peep-toe styles were everywhere. In the early 1950s, the shape was everything. Four-inch Italian **stilettos** were all the rage. Heels became more slender, almost spiked. The thick, round **spool heels** of 1952 were one of the exceptions. The heel of the foot also became more exposed with **sling-backs** and open-toe mules. By comparison, younger women opted for tomboyish flats that featured wider, **egg-point toes. Ballet slippers** were completely without any heel and became a favorite of high school girls.

Stiletto pump by Pandora Footwear, 1957.

Wartime utility leather shoes from Montgomery Ward, 1943.

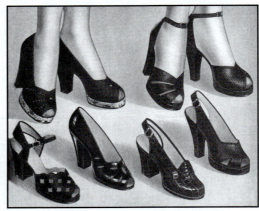

High heels, platform soles, slingbacks, and open toes from Spiegel, 1948.

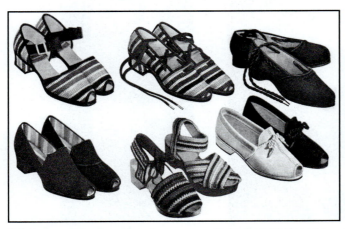

Fabric shoes did not require ration coupons. Styles from Montgomery Ward, 1943.

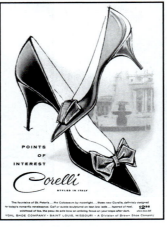

Italian "décolleté" lasts and low, spiked heels by Corelli, 1957.

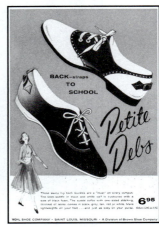

Saddle oxfords and back-straps for teens by Wohl Shoes, 1957.

WOMEN'S JEWELRY 1940–1960

During World War II, metal-based jewelry became more costly and scarce. As cheap base metals used in costume jewelry became reserved for war efforts, makers used more sterling silver, which was plentiful and not rationed. The designs of the period were a mix of moderne high style and retro-Victorian revivals. Patriotic motifs such as the letter "V" for victory and adaptations of military insignia were popular. Also pieces made with a combination of red, white, and blue enamels or rhinestone settings were everywhere.

New Look fashions required a full regalia of accessories including an abundance of jewelry, real or costume. Complete ensembles of matching necklace, earrings, bracelet, brooch, and sometimes even rings, wrap and stole clips, or shoe and hat ornaments were not uncommon. To meet the surge in demand, jewelry makers developed cheaper methods of mass production. Casting processes were replaced by high-speed stamping methods, and stones were glued in instead of set with prongs. Glittery rhinestone pieces were especially popular throughout

the period. Fun, casual jewelry was even created for playwear such as colorful plastic pop-beads that could be made into necklaces of varying lengths or bracelets with an infinite variety of color combinations. As the space age got underway at the end of the 1950s, comets and atomic motifs for pendant necklaces, charm bracelets, and pins became favorites of teen girls.

White plastic and goldtone necklaces from Coro Jewelry, 1956.

Beaux ankle bracelet, 1956.

Bracelets and earrings by Whiting and Davis, 1959.

Patriotic red, white (diamonds), and blue jewelry by Rubel, 1944.

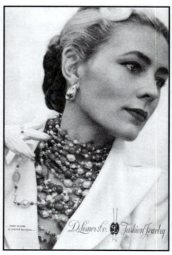

Baroque faux pearls and beads from D. Lisner, 1948

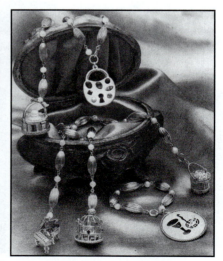

Charm bracelets from Bergère, 1954.

WOMEN'S HATS 1940–1960

As with cosmetics during World War II, women's hats were integral to the nation's morale—keeping women pretty for the fighting boys. Hats also provided some degree of individuality for women in the face of the monotonous utility clothing of the time. (Color Plate 42.) The two primary millinery tenets of the war years centered on the hairstyle. If the hair was worn down or full in the front, the hat sat back on the head. If the hair was worn up in the back then the hat sat forward, some pushing low onto the brow at a forty-five-degree angle. This latter style has come to be most associated with hats of the war years.

After the war, the Edwardian grand hat was revived with its great expanse and piles of fabric and trimmings. Feathers became popular again, adding not only dimension but also sumptuous texture. To complement the New Look fashions of the 1950s, hats were created in one of two camps. The "more-hat" contingency encouraged large hats adorned with swathes of tulle and netting, mounds of flowers, large bows, ribbon rosettes, and even fur trim. The "less-hat" advocates preferred diminutive headwear such as pillboxes, half turbans, skullcaps, and soft berets; trim was usually minimal, if any at all. Regardless of the dimensions, though, millinery styles were often cut with sharp, sculptural silhouettes inspired by the exaggerated lines of New Look fashions. (Color Plate 58.)

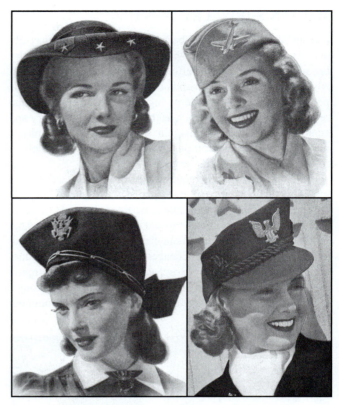

Military inspired hats from Spiegel, 1941.

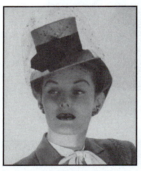

Toy hat from Swansdown, 1943.

Netted velvet hat by Reine, 1943.

Combination snood and netted veil by Lilly Daché, 1944.

Feathered felt topper by Dobbs Hats, 1944.

Dobbs pinched crown felt hat, 1945.

Quilted tam by Hattie Carnegie, 1945.

Feather picture hat by Lilly Daché, 1948.

Red velvet broad brim hat by John Fredericks, 1951.

Flower pot hat from Christian Dior, 1951.

Skullcap with veil and pinfeather by Harryson, 1952.

Open crown hat by John Fredericks, 1953.

Lampshade hat by John Fredericks, 1954.

Short brimmed sailor by Irene of New York, 1954.

Porkpie hat from Bonwit Teller, 1954.

Mushroom hat by Adolfo, 1955.

Safari hat by Emme, 1956.

Straw tassel hat from Bonwit Teller, 1956.

Cartwheel straw hat from Bonwit Teller, 1957.

Flowered straw tam by Sally Victor, 1957.

Mushroom hat by Rex, 1958.

High straw toque by Emme, 1959.

WOMEN'S ACCESSORIES 1940–1960

Superfluous accessories for most women during the war years were discarded in keeping with the national call for utility, simplification, and conservation. Fashion editorials and ads still featured women dressed in the full accoutrement including matching handbag, shoes, belt, hat, jewelry, and gloves, but such ensembles were largely reserved for special daytime occasions or evenings. To be decked out in so much finery suggested a flouting of patriotic duties.

New Look accessories, though, were vital for the correct finishing touches on almost everything a woman wore, whether dressy or casual. Magazine editorials and fashion ads depicted women with head-to-toe accessories carefully chosen to coordinate perfectly with the New Look dress, suit, or evening gown. It was the total look, not the parts, that was so critical. The properly attired woman of the period carefully matched her shoes, belt, and handbag, which sometimes included assorted matching small leather items like change purse, checkbook cover, key holder, compact, and cigarette case. Equal attention was devoted to coordinating her hat and veil, gloves, necklace, earrings, bracelets, wristwatch, handkerchief, the occasional scarf, and possibly a parasol. Even casual wear required special attention to accessories, whether simply by coordinating shoes, belts, and purses, or by adding other touches like colorful popbeads, sunglasses, or a neckerchief.

Silk scarf, alligator handbag, and doeskin gloves from Georg Jensen, 1944.

Military motifs on wartime handbags and gloves, 1941.

Duvasuede handbags with mock tortoise shell closures by Bienen Davis, 1943.

Wartime utility hosiery of reinforced cotton and rayon, 1943.

Elasticized cinch belts from Dorothy Hughes, 1952.

Rayon simulated karakul stole, 1956.

Carry-all vanity and cigarette case from Elgin American, 1954.

Lunch totes for the career girl, 1956.

Eyeglasses frames from Better Vision, 1956.

Van Raalte cotton gloves, 1952.

Tote and matching umbrella, 1956.

Belts with switchable buckles from Roger Van S, 1954.

Mesh belt and bag by Whiting and Davis, 1959.

Leather Grab Bag by Kressline, 1959.

Simulated leopard bag, belt and hat, 1956.

WOMEN'S HAIRSTYLES
AND MAKEUP 1940–1960

Of all the shortages women endured during the war, cosmetics were among the most missed. Many key ingredients used in the manufacturing of cosmetics, especially alcohol and petroleum, were restricted by the War Production Board even though lipstick and face powder were classified as "necessary and vital products." In addition, availability was reduced when some cosmetics factories were converted to the production of war needs such as medical ointments and sunblock creams for desert fighting. Although more women were working and had disposable incomes, there was less to buy. A resourceful GI could capture the attentions of a pretty girl with a gift of a tube of lipstick or a scarce pair of nylon stockings. But despite the shortages of raw materials, cosmetics makers did not shut down operations. Wartime advertising actually promoted the need for women to use makeup. "America expects its women to keep busy—and keep beautiful," cajoled one 1943 ad. In contrast to the drab colors of utility clothing, makeup was bold and bright. Lipsticks with names like "Flame Swept Red" and "Dragon's Blood Ruby" emphasized the strong reds for lips and fingernails. (Color Plate 41.) The pencil thin "surprised" eyebrows of the 1930s were replaced by the wider, more strongly angled eyebrows exemplified by Joan Crawford.

When the war ended, New Look emphasis was on the eyes with heavy liners, thick mascara, and rich colors of eyeshadow. Layers of foundation creams and powders provided a smooth mannequinesque uniformity over which soft cheek blushes and scarlet lipsticks were applied.

Hairstyles of the war years were longer than in the thirties despite the urging of safety organizations to cut it short. Even when Veronica Lake cut her blond tresses on camera "for the duration," most women preferred the longer styles. Bandanas were a practical solution to managing long hair while at work in the munitions factory. Netted snoods were a more fashionable option for other jobs. Whatever the length, the style usually was arranged high, whether in bilateral twin rolls or huge curls on top or in asymmetrical waves and pompadours that pushed forward onto the brow.

By the 1950s, hairstyles were carefully coiffed into a myriad of styles, long and short, curled and straight. Home permanent kits were perfected after the war, which encouraged women to vary their hairstyles more frequently. One distinctive look of the period featured short bangs cut in a sharp, straight line high above the eyebrows. Mamie Eisenhower and Edith Head were among those noted for this cut. Another fifties look was what *Vogue* called the "rat nibbled hair" of Audrey Hepburn with its short crop and errant wisps framing the face. "Does she, or doesn't she?" was the big question of the era posed in mass advertising by Miss Clairol hair coloring. In unprecedented numbers, women experimented with hair dyes, not so much to conceal aging as for a change of fashion.

Linear makeup
by Coty, 1958.

Gabrieleen permanent, 1942.

Adaptation of the pompadour, 1944.

The studied casualness of hairstyles in the late fifties.
Prom Home Permanent ad, 1955.

Figure 23-13. The athletic look of the English drape cut remained the preferred suit silhouette through the 1940s. Left, three-button suit in Donegal tweed; right two-button suit in rayon/wool blend, 1943.

MEN'S FASHIONS 1940–1960

During the Second World War, men's suit styles retained the English drape cut that had become the standard in the 1930s. The athletic silhouette with its broad shoulders, roomy armholes, tapered waist, and narrow hips remained the preferred masculine look. (Figure 23-13.) The three-button jacket with its rolled notch lapels was the most common for mature men, and the two-button jacket with the long line lapels was favored by younger men. Peaked lapels were usually for double-breasted styles. Since wool was strictly regulated, rayon blends became acceptable alternatives. Military influences included fabrics in "air blue" based on the color of U.S. Army Air Force uniforms and variations of khaki such as tans and olive browns. Because of the trim, pared-down simplicity of men's drape suits, few design changes were imposed by the War Production Board—primarily limitations on trouser cuffs and pleats, and elimination of patch pockets and back belts on jackets. Still, some streamlining occurred with trouser leg widths reduced a half inch at the hem, jackets shortened slightly, and lapels narrowed a bit.

Although the obsession with youth that dominated men's suit styles of the 1910s and 1920s had been replaced with the mature masculine styling of the English drape cut, many young men sought styles that provided some individuality to distinguish their generation from that of their

Figure 23-14. The zoot suit was popular with segments of urban, young Latino and African-American men in the early 1940s. The exaggerated look featured an oversized coat, high-waisted pegged trousers, and a long watch chain. Photo, 1942.

elders. In France, the new Incroyables of the wartime years came to be called the **zazous.** The term may have originated from American swing music such as Cab Calloway's popular "Zah Zuh Zah" or similar refrains by the French crooner Johnny Hess. Contrary to the tailored looks of the conventional drape suit, the zazous instead donned fingertip-length jackets with sloping shoulders and pegged sleeves worn with baggy stovepipe trousers pegged at the hems and cropped three or four inches above the ankles. Thick soled shoes and brightly colored socks emphasized the shortened pant length. For the zazous, everything American was a fad— cigarette brands, movies, novels, and especially music. The zazou trend was short-lived, though, lasting but a few years in the early forties due primarily to hostility from Vichy government officials who resented this influence of American pop culture.

In the United States, the swing generation also expressed their individuality and youthful vigor with fashions all their own. The **zoot suit** was a uniquely original American creation that emerged from the Harlem nightclub scene in the late thirties. (Figure 23-14.) The outfit featured an oversized jacket, often double breasted, with enormous, overly padded shoulders

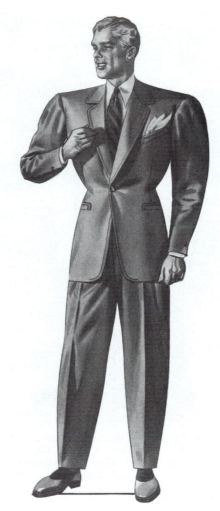

Figure 23-15. Mainstream variations of the youthful zoot suit, called swank suits, included jackets with huge, padded shoulders and a fitted waist worn with pegged trousers cropped at the ankles. Young men's swank suit by Pioneer Tailoring, 1942.

and huge lapels. The waists were tightly fitted and hemlines sometimes extended to mid-thigh. Baggy, pegged trousers often had a long crotch that was pulled up high by suspenders or a cinch belt so that the waistband fitted over the ribs. Accessories included bold print ties, a long pocketwatch chain that hung to the knees, and a wide-brimmed fedora. Less extreme versions of the zoot suit, called **swank suits,** were adopted by white suburban teens to wear to swing dances. (Figure 23-15 and Color Plate 59.) When the War Production Board L-85 restrictions went into effect in mid-1942, young men who continued to wear swing style suits were viewed as being unpatriotic in their excesses. In 1943, violence erupted between uniformed Marines and zoot-suiters on the West Coast that lasted for weeks, bringing the trend to its end.

After the war, men's suits began a transition away from the English drape cut. Jacket shoulders remained wide and hips

were still snug, but instead of a tapered waist, the lines became more straight hanging, which eliminated the drape cut back.

In addition to the beginning of a new look in suits, bolder accessories and new dress shirt collars hallmarked men's business dress in the late 1940s. The Windsor-knot tie, socks with wide ribbing and decorative clocking, colorful pocket squares with wide borders, and assorted types of jewelry were key to the new masculine style of the late forties, referred to at the time in fashion journalism as the "**bold look.**" Shirts featured the "command collar," with its bold top stitching a half inch in from edge instead of the traditional one-eighth inch.

In the early 1950s, the straight-hanging suit completed its evolution into the **Ivy League style.** The look was that of a shapeless, tubular sack. Jackets were cut with natural shoulders, no waist, narrow lapels, and single-breasted three-button closures. Trousers were slimmer and usually pleatless with narrow, tapered legs. (Figure 23-16.) "That undraped, unpadded, unpleated silhouette in the tradition of Bond Street and Brooks Brothers," was the description of the Ivy League suit from a *Vogue* editor in 1953. It was the ideal look for the postwar man, reflecting the social conformity and conservatism that Americans embraced in the face of the Korean War, McCarthyism, racial unrest, and global communist aggression.

Easy care rayon and rayon blends continued to be popular for men's suits in the postwar years. In addition, a plentiful supply of **silk shantung** was imported from Italy setting the trend for other slub yarn fabrics. For the first time in American menswear, silk suits and sports jackets were no longer exclusively for the upper-income classes.

Of greater significant to menswear, both in the United States and Europe, was the entry of Italian designers into the fashion spotlight. In 1952, Italy sponsored its first Men's Fashion Festival at which the distinctly Italian style suits—often called the **Continental look** in the press—were presented to an international audience. Jackets were slightly shorter than the Ivy League models and were shaped with a more fitted line including tapered waist and sloping, natural shoulders. Styles included one-, two-, and three-button closures although the two-button model with semipeaked lapels shown in Figure 23-16 became the most popular in the United States during the second half of the 1950s.

Italian suit trousers were close-fitting with plain, straight fronts and narrow legs. In his study of men's fashions, Farid Chenoune suggests that the slim Italian trousers were derived from the tight-fitting jeans and chinos worn by American GIs in the postwar years. This trim fit of American menswear produced a "certain swagger"—an exaggerated masculine look that was adopted first by Italian teenage boys and then applied to business suits by tailors. From the Italian influence, men's trousers became increasingly more trim and snug until at the end of the decade leg openings were barely fourteen inches in circumference.

Just as American youth had regressed into the comfortable conservatism of the Ivy League look and Italian young men

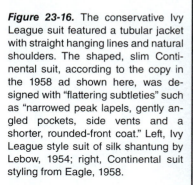

Figure 23-16. The conservative Ivy League suit featured a tubular jacket with straight hanging lines and natural shoulders. The shaped, slim Continental suit, according to the copy in the 1958 ad shown here, was designed with "flattering subtleties" such as "narrowed peak lapels, gently angled pockets, side vents and a shorter, rounded-front coat." Left, Ivy League style suit of silk shantung by Lebow, 1954; right, Continental suit styling from Eagle, 1958.

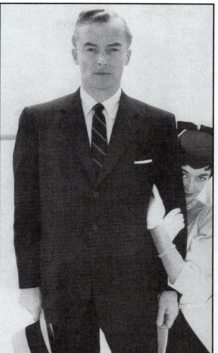

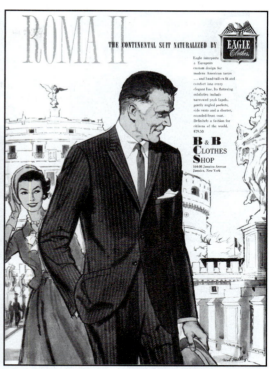

adopted a more masculine exhibitionism, British adolescents began to develop their own unique fashion identity in the 1950s. The **Teddy boys** were working class teenagers who adopted a sort of neo-Edwardian dandyism with dress. Named for the cockney sobriquet for Edward VII ("good ol' Teddy"), these young men preferred fingertip-length boxy jackets cut with no center back seam so the line fell long and straight. Some styles featured velvet collars and cuffs adapted from the chesterfield coat preferred by the upper classes. Ted dress trousers were narrow, without cuffs, and often cropped short at the ankles. Accessories included thick, crepe soled shoes called **"beetle crushers"** and string neckties called **"slim jims."** Ted boys shopped for their unique styles in specialty shops far from the upscale Savile Row—a forecast of the emergence of Carnaby Street boutiques in the mod sixties. By the end of the 1950s, though, the Ted dress look became associated with hoodlum street gangs and racist violence, and the style movement rapidly declined. Even so, the Teddy boys, who had numbered in the tens of thousands, reinforced the economic significance of teenage consumerism in the 1950s.

Formalwear for men during the war was more strictly affected by L-85 restrictions than day suits. The excesses of the double breasted dinner jacket and the tail coat were prohibited. Instead, the one-button, single-breasted dinner jacket was the correct look. Black was the conventional choice for evening-wear although younger men with fashion flair adopted the new midnight blue styles, especially with the grosgrain shawl collar.

In the postwar years the single-breasted dinner jacket followed the evolution of daytime suit coats. (Figure 23-17.)

Figure 23-17. Tuxedo jackets of the 1950s largely followed the conservative silhouette of the Ivy League look although the Italian cut became popular at the end of the decade. Vividly colored or boldly patterned ties and cummerbunds added flair. Shawl collar tuxedo jacket in white silk shantung by Rudofker, 1959.

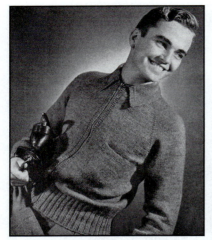

Zipper-front raglan style, 1941.

Jacquard pattern, 1948.

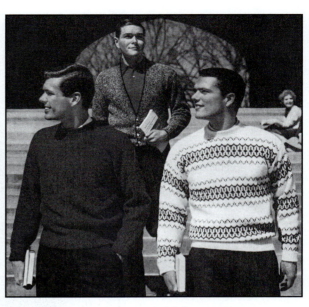

Orlon wash-and-wear sweaters by McGregor, 1958.

Figure 23-18. In the 1940s and 1950s, advances in commercial knitting technologies and new synthetic yarns widened the range of sweater styles for men.

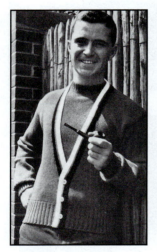

Trompe l'oeil mockneck with simulated cardigan front, 1958.

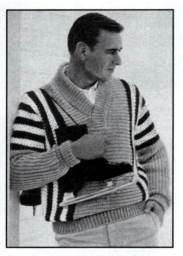

Shawl collar pullover from Catalina, 1958.

For semiformal events, style-conscious men wore a pale **French blue** or white double-breasted jacket. Similarly, after-six jackets for warm weather and resorts became vividly colored in the mid-1950s, ranging from soft "parfait" hues to palettes of jeweltone colors. During the same time, the short, white mess jacket, that came to be called the **Janeiro jacket,** was popular with young men possessing trim waistlines. With the Italian influence of the Continental look in the second half of the fifties, formalwear often adopted the shorter, shaped jacket and narrow, plain front trousers. Matching sets of thin bow ties and wide cummerbunds appeared in striking colors and patterns such as bold tartans and paisleys.

Men's sportswear continued its extensive diversification from the 1930s. Knit tops and sweaters that had been adapted from athletic wear to everyday wardrobes became even more prevalent during the war. Comfortable and casual knit shirts made wartime civilian activities easier such as working in victory gardens or running scrap metal and paper collection drives. Indoors, the chill of minimally heated rooms was offset by thick sweaters in all sorts of variations including the traditional cable stitch pullovers and cardigans as well as new zipper front windbreaker styles. With the L-85 restrictions on wool usage, yarns of rayon and rayon/cotton blends were increasingly common in knitwear.

Despite the onset of a conservatism in men's business dress during the Cold War period, the variety of knit sportswear expanded with new shapes, textures, patterns, and colors. The polo shirt in all hues was a perennial Father's Day gift. A variation, the Lacoste knit shirt with its distinctive cuffed sleeves and long back tail, was introduced in 1953. New techniques in high-speed commercial knitting made possible mass-produced sweaters with colorful, graphical insets and border designs. (Figure 23-18.)

Sports shirts of the 1940s continued the range of colors and prints from the previous decade. The tropical motifs in Hawaiian print shirts even expanded into a unisex look with matching his-and-her sets. Military influences appeared in "campaign stripes"—colors and alternating widths inspired by service ribbons. In the 1950s, sports shirt styles were the exception to the conservative rule in menswear. Wash-and-wear synthetics made possible a wide array of brilliant colors, bold patterns, and vivid prints. (Figure 23-19.) Textured weaves with nubby surfaces such as India madras and silk shantung became fashion staples for sports shirts. For the reserved Ivy Leaguer,

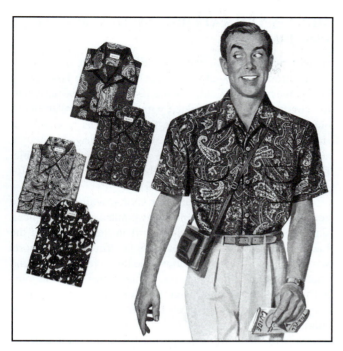

Figure 23-19. In the 1950s, men could express their peacock personal style with the vibrant colors and prints of sports shirts. Van Heusen shirts, 1952.

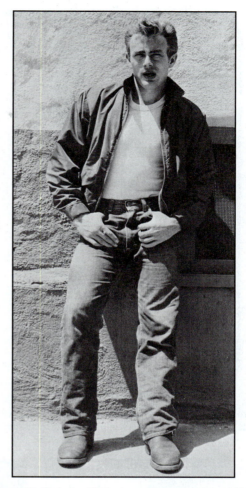

Figure 23-20. In the 1950s, jeans were associated with pop-culture segments ranging from the clean-cut cowboy myth to the inner city teenage hoodlum. James Dean in *Rebel Without A Cause,* 1955.

though, button-down collars and subtle petite-prints or baby blue and mint green solids were the most daring choices.

Casual trousers of the war years were also subject to L-85 restrictions. Cuffs were eliminated and leg widths were pared down. Straight, plain front slacks increasingly replaced multiple-pleat styles. Even with wartime shortages and rationing, cotton fabrics, especially corduroy and denim, were plentiful for manufacturing slacks and shorts.

After the war, GIs headed off to college and vocational schools in casual pant styles most familiar to them: khaki-colored cotton twill **chinos.** The styleless uniform of chinos and the button-down oxford has remained the ubiquitous American male dress for the last sixty years. Cuffs and pleats returned until the second half of the decade when the Continental look influenced a slim-fitting, straight line for slacks. New treatments of waistbands included self-belt styles and elastic insets at the back for added comfort. Backstraps with buckles were a popular trend with teenagers in the mid-1950s.

Shorts were the constant fashion news for menswear throughout the 1950s as the style increasingly appeared in public arenas other than resorts, golf courses, and community parks. The protocol for this social infringement, though, was length and cut. Tailored bermuda styles were acceptable for some restaurants, museums, and government offices, but thigh-high sports shorts were not. "Why it's easy for a man to look smart in shorts," advised *Vogue* in its 1953 menswear edition, "there's only one length to consider, just above the knee." For a brief time in the mid-fifties, tailored bermuda

shorts were even worn with suit jackets, dress shirts, and ties to some downtown offices in the heat of summer before air conditioning became more common.

The cachet of jeans ranged widely during the 1940s and 1950s, depending upon brand advertising and popular culture. During the war, jeans were promoted as a durable, impermeable work pant for both men and women. In the fifties, counterculture groups adopted jeans as the foundation of their distinct image. Bikers, as exemplified by Marlon Brando in *The Wild One* (1953), opted for tight-fitting jeans with long legs turned up or rolled into deep cuffs over thick soled boots. Rebellious youth differentiated themselves from conformist Ivy Leaguers in faded jeans as worn by James Dean in *Rebel without a Cause* (1955). (Figure 23-20.) There was also the cowboy look, or "dude" clothes, as advertised by Levis, Wrangler, Lee, and Arrow, among others, and personified by mass marketing of the Marlboro man. (Color Plate 60.)

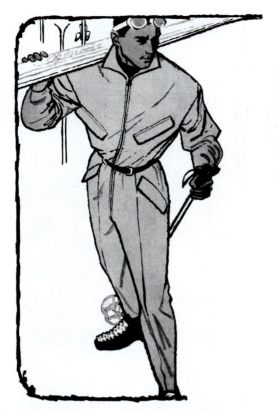

Figure 23-21. Many of the new synthetic fabrics, especially stretch nylons, made possible lighter weight and more comfortable winter sportswear. One-piece skisuit by John Cobb, 1958.

MEN'S SPORTS ATTIRE AND OUTERWEAR 1940–1960

As with women's wear, the distinction between men's active sports attire and casual sportswear had become less clearly delineated by the beginning of the 1940s. Some specialty outfits continued to be associated with specific sports throughout the war years and into the fifties such as jodhpurs for riding and knickers for golfing. On most fairways, though, almost any variety of casual tops and slacks was acceptable. Knee-length walking shorts even became widely popular for golfing in the second half of the 1950s.

For tennis, white flannels or shorts, white shirt, white cotton socks, and white or blue canvas sneakers were typical. The cool and comfortable polo shirt in the forties and the Lacoste knit shirt in the fifties were favorites. Tennis shorts were cropped a few inches above the knees in the 1940s and climbed to mid-thigh by the end of the fifties. Fashion journalists repeatedly emphasized that short shorts versus knee-length bermuda walking shorts should only be worn as active sports attire or beachwear and not as street clothes.

Skiwear of the war years primarily continued the styles of the previous decade. Moisture-resistant rayon fabrics were used to make jackets and wide legged ski pants with elastic cuffs at the ankles and wrists. Heavy knit sweaters in winter-theme and moderne patterns were most common on the slopes as well as around the lobby fireplaces at resorts. In the 1950s, nylon fabrics were used for a more sleek, fitted trouser. By the

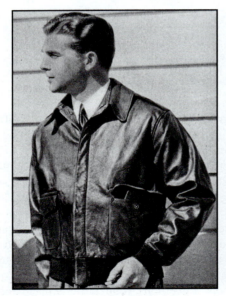

Civilian bomber's jacket, 1943.

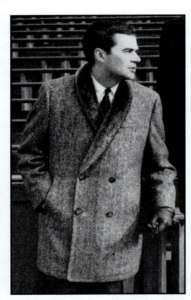

Car coat, or suburban, 1956.

Figure 23-22. Military influences on civilian outerwear of the Second World War included adaptations of the bomber's jacket and the duffle coat. By the 1950s, suburban living inspired cropped car coats that were easier to drive in. For urbanites and commuters, knee length all-weather topcoats were preferred.

All-weather knee breaker topcoat from Hudson's, 1959.

end of the decade, formfitting knit ski pants and one-piece jumpsuits made of synthetic fabrics and lined with nylon fleece were introduced to minimize wind drag. (Figure 23-21.)

Outerwear for men became narrower and shorter during the early 1940s. (Figure 23-22.) Buttons on double-breasted styles were set closer together, and hemlines rose to just below the knees. English tweeds were used for almost every style of outerwear. Four military inspired civilian coats of World War II were the U.S. battle jacket, bomber's jacket, a revival of the canadienne, and the introduction of the duffle coat. Adaptations of the U.S. **battle jacket** were made with the same big pockets, buttoned waistband, and fly front as the original military version. The **bomber's** (also bombardier's) **jacket** was a short, leather style with high pockets and snug-fitting knit waistband and wrists; corduroy and gabardine variants were mass produced in lieu of leather for civilian wear. The **canadienne** was a rustic, goat skin jacket with fleece lining that originated in Canada during the First World War and was revived in the 1940s. The three-quarter length **duffle coat,** or **toggle coat,** featured a hood, square shoulder yoke, huge patch pockets, and rope frogging that hooked over wooden peg buttons. The bomber's jacket and duffle coat remained favorites of teenagers throughout the postwar years. (Color Plate 61.)

With the expansion of suburban sprawl in the fifties, an increased reliance on the automobile led to shorter varieties of coats, sometimes called **car coats** or **suburbans.** Most styles, such as that shown in Figure 23-22, were cropped at fingertip-length to allow free range of motion for the legs to operate the floorboard pedals.

Tweed variations of the fly-front chesterfield and ulster topcoats were preferred by businessmen. The traditional wide, straightline fit was conservative and an ideal complement to the gray flannel suit. By mid-decade, the full-cut raglan coat featuring a **bal collar**—a banded type of turned-down collar derived from the Scottish **balmacaan** topcoat—slash pockets, and sleeve tabs became a stylish outerwear option. Tweeds reflected men's renewed interest in color and were often interwoven with blue, ochre, or red nubs. At the end of the decade, a revival of the 1920s buttonless wrap coat with broad sash belt became a trendy look for collegians.

The most common form of rainwear was the oyster-colored all-weather topcoat, made with a variety of water repellent fabrics. In the early 1950s, clear vinyl raincoats were introduced, and although the style was truly waterproof, not just moisture resistant, men did not like the look. Instead, **rain topcoats** made of lightweight nylon, the new polyesters, or other synthetic textiles appealed to men because of their all-weather, all-season versatility.

MEN'S UNDERWEAR AND SWIMWEAR 1940 TO 1960

Short boxers and formfitting knit briefs remained the two most prevalent types of men's underwear during the forties and fifties. (Figure 23-23.) Boxers were made in assorted colors and patterns but briefs were only in white, for the time being. Mass merchandise catalogs still offered longjohns as winter wear. Both the tank-style and T-cut undershirts were

Boxers and briefs from Spiegel, 1948.

Figure 23-23. Through the 1940s and 1950s, the two most common forms of men's underwear were the basic white cotton brief and the patterned boxer. In the late fifties, underwear designs adopted the briefer cuts of swimwear, including the introduction of the bikini for men.

Briefs and athletic and T-shirts from E-Z, 1951.

Bikini Skants in fashion colors from Jockey, 1959.

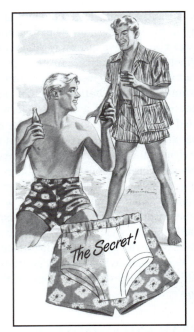

Boxer swim trunks with brief-cut liner from Cooper's, 1948.

Figure 23-24. The high-waisted brief and short, baggy boxer were the most common forms of men's swimwear until the 1950s. Gradually brief styles were reduced in cut and boxers became more snug.

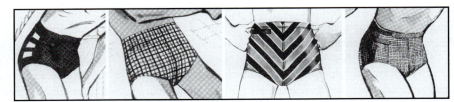

Knit Lastex brief style swim trunks by Gantner, 1954.

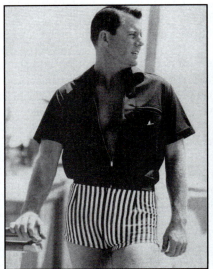

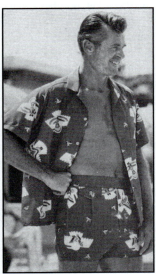

Striped boxer trunks and print cabana set from Catalina, 1958.

equally common. During the 1950s, underwear manufacturers began to experiment with some of the new synthetic fabrics including polyester/cotton blends and nylon. In the second half of the decade, as men's swimwear began to be reduced in cut, inching down from the waist and higher up on the hips, underwear styles also began to reflect this briefer look. In 1959, Jockey introduced the Skants brief made of stretch nylon in fashion colors including red, yellow, blue, and black. The advertising copy in Skants ads emphasized that the nylon fabric "molds to your body . . . with minimal coverage."

Short boxers and formfitting knit briefs were also the two principal forms of men's swimwear. Despite the conservatism of much of men's clothing in the 1950s, swimwear designers explored a wide assortment of eye-catching prints and revealing cuts that allowed men to express their personal style. (Figure 23-24.) In contrast to the briefer forms of swimwear in the second half of the fifties, new types of longer, fuller cut swim trunks were introduced. In 1957, the knit bermuda-length **swim-walker** made fashion news although the look was not especially popular since it resembled the old-fashioned Edwardian drawer styles. A compromise between the snug brief and the baggy boxer appeared in the mid-fifties with fitted boxer styles made either of stretch knits or woven fabrics.

MEN'S SLEEPWEAR AND ACCESSORIES 1940–1960

Candy-striped broadcloth cotton pajamas were the favorite men's sleepwear through the 1940s and 1950s. Fly-front bottoms with elasticized waist and one-pocket, button-front tops were the most popular. Collarless V-neck and placket-front pullover tops were more prevalent for younger men. Knit athletic pajama sets with pullover crewneck tops and ribbed sleeve and ankle cuffs to prevent bunching up were preferred by teenagers. (Figure 23-25.) Shortie pajama sets with knee-length bottoms and short-sleeve tops were options for warm weather.

Robes were shortened to the knees during the war and were only slightly longer in the postwar years. Styles of robes made of terrycloth or cotton blanket cloth were a sleepwear accompaniment for pajamas while silk, rayon, and seersucker robes, sometimes advertised as **pullman robes,** were for travel or late evening and morning loungewear worn over regular clothing—with dress shirt and tie if entertaining close friends. Clashing pattern mixing of robes and pajamas were the norm. In the fifties, fabric was the key selling point for sleepwear. Pajamas and robes made of the new wash-and-wear synthetics and blends were best-sellers for catalog retailers.

"Bold Look" ties by Beau Brummell, 1946.

Collar bars and tie chains, 1943.

Skinny ties from Herbert Bergheim, 1958.

Identification bracelet watch, 1958.

Wallets and keycases by Prince Gardner, 1951.

Sunglasses, 1959.

Countess Mara logo ties, tie clips, and cuff links, 1958.

Braided elastic belts, 1952.

from assorted lengths of soft bangs over the forehead to the slicked back "ducktail" with its swept-back point at the nape of the neck. The high rounded front of the pompadour was popularized by young rock celebrities like Elvis Presley and Ricky Nelson.

CHILDREN'S CLOTHING 1940–1960

Infant's clothing of the 1940s and 1950s continued the simplicity that had begun following the First World War. The layettes of the period usually included a long-sleeve cotton wrap shirt cropped to about the hips, a long gown to cover the feet, and a matching open-front wrapper. Diapers, socks, and a receiving blanket completed the dressing necessities. With

the baby boom of the postwar years, innumerable types of easy-access, wash-and-wear garments were designed for babies including one-piece footed sleepers and zip-front sleeved sleep sacks. Licensed images such as Disney and Warner Brothers cartoon characters were especially popular in this marketing-driven period.

The design of children's clothing in the early 1940s was largely guided by the American L-85 and Britain's utility restrictions. Just as with men's apparel, boys' suits lost patch pockets, multiple pleats, and trouser cuffs. Girls' dresses were narrowed and shortened, and full-around pleats or excessive trimmings were forbidden. Shirt tails for both boys and girls were reduced to save every inch of material possible for the war efforts.

Crewcut, 1957.

Ducktail, 1959.

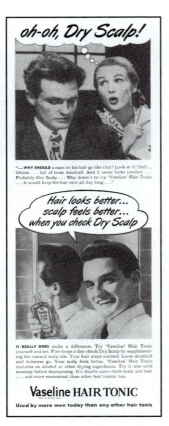

Vaseline Hair Tonic ad, 1946.

Figure 23-27. Men, young or mature, were mostly clean shaven throughout the 1940s and 1950s. Hairstyles were greatly varied, especially among teenagers, and ranged from buzz-cut military flat tops to well-oiled pompadours and slicked-back D.A.s.

The styles of girls' dresses remained largely unchanged from those of the 1930s. (Figure 23-28.) Bodices were fitted with a high waist and short, puffed sleeves. Loose-fitting princess styles featured shoulder to hem gores. For toddler girls, skirt hemlines were about mid-thigh, and for school-age girls the hemline was at the knees. During the war, silhouettes were narrow and suits were cut with the same utility plainness as women's styles. In the 1950s, New Look influences included fitted waistlines and fuller skirts. Mother-and-daughter sets of matching styles were especially popular in suburbia. Playwear for little ones was often unisex shorts and knit tops, creeperalls, and one-piece jumpers, differentiated by gender-appropriate colors and decorative motifs.

Boyswear was largely miniature versions of men's clothing, even to outerwear, underwear, shoes, and accessories. (Figure 23-29.) During the war, uniforms of virtually every branch of the military were replicated in diminutive proportions for boys. The knicker suit, though, disappeared even though it remained a country squire style for adults into the late fifties. This fundamental social change, suggests historian Perry London, was because the wartime boy "was expected to mature earlier, assume more responsibilities, and

Wartime utility dressing from Montgomery Ward, 1943.

Figure 23-28. Girls' dresses and suits of the war years followed the short, narrow utility lines of the time. In the postwar period, the New Look influenced girls' clothing by replicating fitted bodices and full, sweeping skirts.

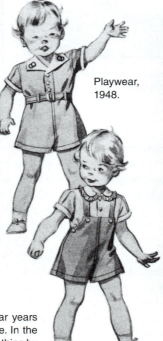

Playwear, 1948.

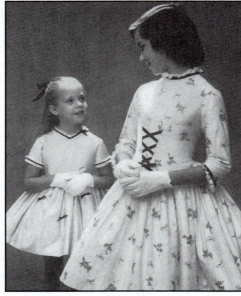

New Look influence of fitted waists and full skirts from R.A.R. Moppets, 1956.

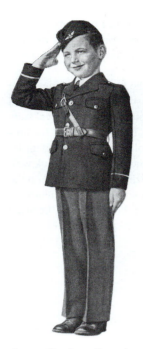

Army officer's uniform for boys, 1943.

Lone Ranger shirt, 1956.

Tab-back trousers, 1957.

Screenprints of licensed TV program characters, 1956.

Figure 23-29. Boys' clothing was primarily miniature versions of menswear—from the draped suit cut of the 1940s to the dual styles of the Ivy League and Continental looks in the fifties. Fun and personal style could be expressed with a wide assortment of costumes and licensed images from TV programs.

Sports jacket, reversible vest, and solid slacks from Spiegel, 1952.

devote less time to living in a state of hibernation." When the Ivy League and Italian Continental looks became popular for men in the 1950s, boys' suits were similarly cut and tailored with the details that made each style distinctive. Boys' wide, handpainted ties of the forties were replaced by skinny rayon and knit varieties in the fifties. Licensed logos and images from TV programs were screenprinted, appliqued, or embroidered on all types of children's garments. Among the most popular for boys was the fringed suede jacket and 'coonskin cap of Davy Crocket fame in the mid-1950s.

In the postwar years, tons of used and new children's clothing were shipped from the United States to bombed-out families in war-ravaged Europe. As ready-to-wear industries in Britain, France, and Germany rebuilt and resumed production, they began to adopt many of the comfortable playwear styles from America in response to homeland consumer demand for "Yank" childrenswear.

REVIEW

During the Second World War, America and Britain were cut off from the fashion dictates of Paris. In addition, homegrown and exiled designers were further challenged by materials shortages and governmental utility restrictions on clothing construction. Women's dresses and suits were narrow and simple in silhouette with squared shoulders and short skirts. Men's suits continued the athletic look of the English draped cut with some paring down of details and elimination of others like trouser cuffs and belted jackets.

For both women and men during the war years, sportswear became ever more important. Women wore a wide variety of slacks and casual tops to work in factories and the service sector as well as for leisure time on weekends. Men similarly dressed down, preferring sports jackets and knitwear when business and social protocol permitted.

With the conclusion of the war, Paris once again reclaimed fashion preeminence with the launch of Christian Dior's New Look in 1947. After several years of austerity clothing and privations, women adored Dior's high style, yards of fabric, and head-to-toe accessories. The ultrafeminine New Look silhouette with its rounded shoulders, full bosom, cinched waist, and wide, spreading skirts over curvaceous hips would dominate women's fashions for the following fifteen years. Year after year, throughout the late forties and fifties, Dior led the fashion way with innovative variations on his famous New Look theme that evolved gradually and decisively from the formfitting oval line, through the alphabet lines of the mid-1950s, and finally culminating in

the freedom of the trapeze line of his protege and successor, Yves St. Laurent.

For men, fashion of the postwar years was almost counter to that of women's styles. The Ivy League look was a conservative style that shifted away from the athletic draped cut. Suits featured natural shoulder jackets with straight hanging lines and smooth, unpleated trousers with narrow legs. In the second half of the 1950s, the Continental suit jacket became a stylish alternative to the Ivy League look. Influenced by Italian designs, the Continental suit was shaped with a more fitted line including a tapered waist and sloping shoulders; trousers were trim and straight.

Among the important news for men's fashions were the new wash-and-wear synthetic fabrics used in sportswear. With the wide array of vibrant colors and bold prints, men were able to break out of their conservatism and express themselves with vividly hued sports shirts, sweaters, swimwear, and weekend clothes.

Fashions for girls and boys of the forties and fifties were largely miniature versions of adult styles. Girls' dresses and suits of the war years were narrow and simplified. Boys' suits were cut on the English drape line. The knicker suit for preteen boys finally disappeared. Following the war, girls' dresses and suits reflected the influence of the New Look with fitted bodices and full skirts. Boys' suits were modeled on the boxy straight lines of the Ivy League look. The influence of TV added fun and flair to children's fashions with licensed logos and replicas of Western theme or space age costumes.

Chapter 23 The Twentieth Century: 1940–1960
Questions

1. What were the three purposes of the wartime utility restrictions?

2. How did utility restrictions affect the design of women's clothing during World War II? What was one key exception to the restrictions and how was it applied to women's fashion?

3. What were the principal elements of Dior's New Look?

4. What were the contributions of the Italian fashion designers in the postwar years?

5. How did technological advances in the production of textiles affect clothing of the 1950s?

6. What was the basic look of men's suits in the 1940s? Which changes in men's clothing resulted from wartime utility restrictions?

7. Identify the time, place, and look of the zazous, zoot suiters, and Teddy boys.

8. Compare and contrast the men's Ivy League suit with the Italian influenced Continental styles.

Chapter 23 The Twentieth Century: 1940–1960
Research and Portfolio Projects

Research:

1. Write a research paper on the development of the prêt-à-porter segment of the Paris fashion industry in the 1950s. Compare the influences of prêt-à-porter collections versus couture on American ready-to-wear of the time.

2. Write a research paper on the emergence of American fashion design without the influence of Paris during the Second World War. Identify the key designers and their innovative contributions to American fashion.

Portfolio:

1. Select a dress style from any of today's fashion catalogs and recreate that dress in your sketchbook in the Dior alphabet lines (A line, H line, Y line). Keep the fabric color or textile pattern and trimmings of the modern dress. Add New Look accessories from the 1950s to complement each design. Attach a color photocopy, digital scan, or tearsheet of the catalog image.

2. During World War II, shortages of materials inspired French designers to create new ways of fastening garments without standard buttons, toggles, or zippers. Design five different ways for fastening the front closure of a jacket without the usual type of buttons, toggles, or zippers. Construct individual sample cards with each closure type mounted, and demonstrate to the class how they function.

Glossary of Dress Terms

A Line: one of Dior's 1955 collections that featured dresses, suits, and coats that flared out into wide triangles from narrow shoulders

Atome: the name given to the 1946 bikini swimsuit design by Jacques Heim

Australian bush boots: men's short ankle shoes with side elastic panels of the 1950s

bal collar: banded type of turned-down collar derived from the Scottish balmacaan topcoat

ballet slippers: women's wide, flat slip-on shoes with no heel

balmacaan: raglan sleeve overcoat with narrow, turned-down collar

battle jacket: civilian version of the military jacket with big pockets, buttoned waistband, and fly front

beetle crushers: men's thick, crepe-soled shoes of the 1950s

bermuda shorts: tailored, knee length shorts for both women and men

bikini: women's two piece swimsuit of the late 1940s with a bandeau or bra-cut top and low waisted bottom; men's low-rise brief style of swimsuit of the late 1950s

bobbysoxers: teenage girls who wore turned down white cotton socks with saddle oxfords or penny loafers

bold look: the term applied to menswear of the late 1940s in which accessories were vividly colored and patterned

bomber's jacket: men's short leather or fabric jacket with high pockets and banded bottom

canadienne: men's goatskin jacket with fleece lining

capri pants: women's and men's casual pants cropped just above the ankles

car coat: any variety of men's or women's coat cropped between the upper thighs and hips to allow greater freedom of motion for driving; also called a suburban

chinos: khaki-colored cotton twill trousers

cigarette silhouette: the slim, tubular cut of women's outerwear during World War II

circle skirt: fully round skirts usually worn with crinolines by girls and teenagers of the 1950s

cocoons: slim wrap coats worn by young women in the early postwar years

constructed swimsuit: women's swimwear of the 1950s with various engineered devices to sculpt, control and idealize the female body

Continental suit: a variety of Italian-inspired looks including shortened jackets with natural shoulders, shaped waistlines, narrow lapels, and rounded fronts

duffle coat: men's hooded, square-shoulder coat with patch pockets and rope frogging that hooked over wooden pegs; also called a toggle coat

egg-point toes: women's flat shoes of the 1950s with wide, rounded toes

French blue: a pale shade of blue popular for men's suit jackets and dress shirts of the late 1940s

guimpe: a bust-to-hip corset; see also waspie

H Line: one of Dior's 1954 collections that featured dresses with a dropped waistline

Ivy League style: conservative men's suits of the 1950s with columnar, straight hanging jackets and unpleated, narrow trousers

Janeiro jacket: the 1950s adaptation of the mess jacket

L-85 regulations: restrictions and guidelines for making clothes instituted by the U.S. War Production Board in 1942

loungers: men's moccasin style slip-on shoes

martingale coat: a variety of women's wide or fitted coats with half belts in the back

middy: dress silhouette of the mid-1950s with a dropped waistline and fitted torso

New Look: the term applied by the fashion press in 1947 to describe Christian Dior's debut collection; the look featured rounded shoulders, full busts, cinched waists, and spreading skirts

pedal pushers: casual pants cropped just below the knees for women and men

prêt-à-porter: French high style, high quality ready-to-wear tailored to the U.S. market

pullman robe: men's tailored dressing robes

rain topcoats: a variety of all-season outerwear made of light-weight nylon, polyester, or other durable synthetic textiles

shirtwaister: the 1950s version of the shirtwaist dress with a fitted bodice and full skirt

silk shantung: a nubby silk weave

slim jims: men's string neckties

sling-backs: women's shoes with a back strap over an open heel

slope-crown hat: men's styles of hats in the 1940s that featured a crown blocked higher in the front than the back

spool torso: a fitted dress bodice of the early post–World War II years

spool heels: women's shoes with thick, rounded heels resembling a spool of thread

stilettos: women's shoes with thin, high spiked heels

suburban: another name for car coat; see car coat

swank suit: a less extreme variation of the zoot suit featuring a jacket with broad, padded shoulders, trim waist, and wide lapels

swim-walker: men's knit, bermuda-length swim trunks

Teddy boys: British working class teenagers of the early 1950s who dressed in a mock Edwardian style with long, boxy suit jackets, string ties, and cuffless trousers cropped at the ankles

toggle coat: another name for duffle coat; see duffle coat

toppers: women's loose-fitting coats usually cropped at the waist or high on the hips

torpedo bra: a style of bra constructed with spiral cup stitching and padded linings

trapeze cut: a cut featuring a full, tent shape with a high bust and a back that falls from the shoulders

utility look: the simplified, utilitarian styles of World War II fashions

wash-and-wear: apparel made of various shrink-resistent synthetic yarns and treated fabrics

waspie: a constricting corselette popular in the early years of the New Look

Y-Line: one of Dior's 1955 collections that featured dresses with balloon sleeves and other shoulder emphasis over slim skirts

zazou: young Frenchmen of World War II who dressed in long jackets with baggy, pegged trousers

zoot suit: an urban American men's suit of the late 1930s and early 1940s with an oversized, padded jacket and baggy, pegged trousers

Chapter 24

THE TWENTIETH CENTURY: 1960–1980

First manned space flights by U.S. and Soviet Union 1961

Birth control pill approved for use in U.S. 1960

John F. Kennedy assassinated 1963

Cuban missile crisis 1962

Khrushchev ousted as Soviet Premier 1964

Beatles appeared on U.S. television 1964

First U.S. space walk 1965

Julie Andrews in *The Sound of Music* 1965

U.S. Vietnam War 1965–1975

First heart transplant 1967

Israeli-Arab Six Day War 1967

Assassinations of Martin Luther King, Jr. and Robert Kennedy 1968

U.S. moon walk 1969

Woodstock music festival 1969

1960

1970

U.S. Vietnam War 1965–1975

China admitted to United Nations 1971

Egypt's Aswan Dam completed 1970

Robert Redford in *The Great Gatsby* 1973

President Nixon visits China 1972

Resignation of President Nixon 1974

Arab oil embargo 1973

U.S.-Soviet space-crafts linked 1975

Monarchy restored to Spain 1975

U.S. Bicentennial celebrations 1976

John Travolta in *Saturday Night Fever* 1977

First test-tube baby 1978

Shah of Iran ousted 1978

Polish Cardinal elected Pope John Paul II 1978

Margaret Thatcher, first woman British Prime Minister 1979

Egypt-Israel peace treaty 1979

1970

1980

NATIONS AND POWERS 1960–1980

Three giant powers dominated events of this era: the United States, the Soviet Union, and China. The modern ideologies of each drove global economies, altered regional politics, and transformed ancient cultures almost overnight.

The Cold War intensified in hot spots around the world and, in 1962, teetered on the brink of nuclear conflict. When Russia installed ballistic missiles in Cuba, the United States "quarantined" the island and threatened to sink Soviet ships that crossed the blockade. War was averted when Russia offered to remove the missiles if the United States would

agree not to invade Cuba and would withdraw American missiles from bases in Turkey.

Only the year before the Cuban missile crisis, the Soviets and Americans faced off in divided Berlin, where the United States had retained the western sector in the heart of Communist East Germany since the end of the Second World War. The most tangible symbol of the Iron Curtain was a concrete and barbed-wire wall constructed by the Russians in 1961 to stem the flood of East Germans into the U.S. sector. Hundreds were killed over the years trying to escape to the west over the wall.

At the opposite side of the globe, the United States also challenged communism in Asia. In 1961, the Kennedy administration began sending military "advisors" to aid the South Vietnamese army in their battles against the Communist North Viet Cong. By 1965, though, American combat units were fully deployed to southeast Asia, and the United States sank into the mire of the Vietnam War that quickly expanded to encompass Cambodia, Thailand, and Laos by the end of the decade. After much pressure from both the home front and the world community, the United States arranged a cease-fire between the North and the South in 1973. When the Americans pulled out two years later, the North overran the South, reuniting the halves into one nation.

Although China had supported the expansion of communism in Asia, the governing leadership had far greater concerns internally. In 1966, Chairman Mao Tse-tung inaugurated what came to be known as the Cultural Revolution during which the entire country was subjugated by a harsh, totalitarian regime whose policies were violently enforced by the zealous Red Guards. Only after Mao's death in 1976 did China begin to move away from the Maoist concept of communism, a shift that included relaxed international contacts.

The great divide that bisected Europe into the prosperous west of the democracies and the blighted east under communist dominance remained a hard line of reality throughout the sixties and seventies. The European Common Market continued to expand providing member countries agricultural advantages and an end to internal tariffs. The nations of the Soviet bloc, though, struggled with repressive communist governments and inefficient state-run industries. When Czechoslovakia began to initiate some modest democratic reforms in 1968, Soviet tanks and troops clamped down. Only in the late seventies did the grip of communism in Europe begin to slip. In 1978, a Polish cardinal was elected Pope John Paul II, the first non-Italian Pope in more than 400 years. A renewed nationalism swept Poland and inspired a trade union movement that set the stage for the democratic reforms of the 1980s.

In the Middle East, the tensions between the Arab nations and Israel once again erupted into war in 1967 in which the Israelis defeated Arab armies and made significant gains in territory. Another full-scale war developed in 1973 over these lands that Israel occupied, ultimately resulting in the defeat of Egypt. Two years later, though, the Sinai was returned to Egypt, and, in 1978, the two nations signed a peace accord.

All across the gigantic continent of Africa, national liberation movements led to an end of exploitative colonialism and the birth of dozens of new countries. In some of the newly formed nations, the native populations had gained some experience in government administration before independence, making the transition to statehood less difficult. For others, tribal strife led to civil war, which, many times, encouraged intervention from non-African governments.

CAMELOT TO DISCO FEVER: AMERICAN CULTURE 1960–1980

As noted in the previous chapter, the American obsession with youth that had begun in the 1950s was different from that of the 1920s, when youth was viewed as collegiate rather than adolescent. By the beginning of the 1960s, the first Baby

1967

1968

1969

Figure 24-1. Mass marketing and advertising directly targeted the young: left, Polaroid's camera named the "Swinger" reflected the sexual revolution of the sixties; center, the Campbell's Soup kids became psychedelic teenagers; right, the economic power of young career women was a focus of car makers.

Technology and Textiles

Throughout the 1960s, new and improved synthetic fibers continued to be introduced in great varieties. Among the innovations of the time were spun-bonded polyesters with soil-release properties, non-static tricots, and permanently textured, crimped, or "**crepeset**" monofilament nylons. Fabric fasteners called **velcro** were made of nylon strips of material with a filament nap of hooks that held fast when pressed together. The first **permanent press** garments were commercially marketed in 1964. In 1968, Du Pont launched **Qiana** with its look and feel of silk combined with the performance of nylon. That same year, the consumption of synthetic fibers surpassed that of natural fibers, aided in part by millions of dollars in marketing. Manufacturers of "miracle fabrics" were as relentless as other consumer product makers in targeting the youth market with advertising in the 1960s. (**Figure 24-2.**)

In the 1970s, sophisticated laboratory research continued to improve the quality and performance features of synthetic fibers. The development of new, high-speed textile production machinery greatly increased output and reduced costs of fabrics. In 1972, Congress established the Consumer Product Agency to conduct research and develop testing methods for textiles and other materials used in consumer goods. In 1975, the **Kevlar** aramid fiber was first used in protective clothing called "soft body armor." By the end of the 1970s, the world production of synthetic fibers exceeded 28 billion pounds, compared to only 3 billion of wool.

Boomers were in high school, and by the end of the decade, almost one-third of the U.S. population was under the voting age. In the fifties, marketers had quickly recognized teenagers as a unique and economically viable segment of the population, and aggressively targeted them with mass advertising and mass merchandising. These multimillion dollar marketing efforts grew exponentially as the youth market continued to expand throughout the sixties. (Figure 24-1.)

Reinforcing the youth-oriented shift in American culture was the election of America's youngest president, John F. Kennedy, in 1960. His beautiful and cultured wife, Jackie, possessed a sense of fashion that set the standards for a casual, yet elegant, American style that was emulated around the world. With their two young children, the First Family projected the epitome of youthful optimism and vitality for the new era. Their cachet was the magical romance of Camelot—a legacy perpetuated by the popular press after the president's assassination in 1963 when it was disclosed that Kennedy used to play a soundtrack recording of that musical for his children at bedtime.

Unlike the silent generation of the post–World War II years, the youth of the 1960s demanded to be heard. They were not complacent about America and set about to make changes. Almost from the instant the Vietnam War began in 1965, antiwar protests and student demonstrations rocked campuses across the nation. Civil rights activists participated in pickets and sit-ins throughout the South to force desegregation and advance other issues of the civil rights movement including voting rights and equal opportunities in education and employment. Young women revitalized the feminist movement with the founding of NOW (National Organization of Women) in 1966 and demanded an end to sex discrimination. The gay rights movement emerged from the 1969 Greenwich Village riots against police harassment and began a quest for equal protection under the law. Many thousands of America's young also joined the Peace Corps and went to far-flung communities around the world to help in education, healthcare, and civil engineering.

Figure 24-2. The fashion-conscious youthquake generation of the 1960s was a prime target of marketing efforts by chemical and fabric makers. Du Pont ad, 1969.

In addition to the young advocates of political and social change, American youth across all walks of life in the 1960s rejected the values of their parents and grandparents. To many, the older generations had made a mess of America—and the world—by perpetuating war, social injustices, and environmental pollution. "Trust no one over thirty," was a popular refrain of the young. The hippies—a name derived from the word "hip," meaning aware or "with it"—epitomized the disaffected youth who disavowed the materialistic and

sociopolitical baggage of their elders. "Do your own thing," was the mantra of the hippies that became universal for the youth of the era. Teenagers celebrated the freedom and exhilaration of youth. Many experimented with recreational drugs and explored new and open sexual experiences, freed from unwanted pregnancies with the introduction of the birth control pill in 1960. They gathered by the tens of thousands for the Summer of Love in San Francisco in 1967, for a peace rally in Chicago in 1968, and for a rock festival at Woodstock, New York, in 1969. Flower power became an image and a credo of the antiwar advocates who wore flowers in their hair and inserted blossoms into the rifles of police and guardsmen who were often deployed to antiwar rallies. Symbolic flowers of peace were painted on faces and cars, embroidered on clothing, and shaped in various materials into jewelry, belt buckles, and assorted other ornaments. From this street trend, fashion makers adapted a colorful assortment of flower power motifs to women's, men's, and children's fashions and accessories.

The sixties was an intense, invigorating, and traumatic decade. Youth around the world was in revolt. The arms race between the Soviet Union and the United States escalated, especially after the triumph of America's moon landing in 1969. The fabric of Southern society was repatterned as institutional segregation was dismantled. Race riots destroyed communities in Los Angeles, Detroit, Newark, and Washington, D.C. National leaders were assassinated: John F. Kennedy, Robert Kennedy, and Martin Luther King, Jr. The Vietnam War dragged on.

By 1970, there was a palpable relief felt by most people that the turbulent sixties had ended. But a new decade did not mean a clean slate and a fresh start as so many had naively hoped. The war in southeast Asia spilled over from Vietnam into Cambodia in 1970, setting off some of the most violent campus demonstrations yet—the worst being at Kent State where National Guardsmen shot and killed or wounded a dozen unarmed student protesters. Three years later, the United States brokered a cease fire agreement between North and South Vietnam. When America pulled out in 1975, the communists overran the south amidst the chaos. In 1972, a break-in at the Democratic headquarters in the Watergate complex by Nixon administration operatives led to a cover-up and the eventual resignation of the president two years later. An oil embargo in 1973 set by Arab nations to punish the United States for its support of Israel during the Yom Kippur War set off a global economic crisis.

From the continued social unrest of the early seventies came significant progress, though. In 1972, the Equal Rights Amendment (ERA) was passed by Congress, and in 1973 the women's movement cheered the Supreme Court's decision overturning state laws against abortion. Science offered new hope for women wanting children when the first test-tube baby was born (from an "in vitro" fertilized egg) in 1978. Environmentalism brought millions of supporters into the streets nationwide for the first Earth Day in 1970, followed by legislation to protect habitat and endangered species. The National Gay Task Force lauded the 1973 decision by the American Psychiatric Association to remove homosexuality from its clinical list of mental disorders.

By the mid-seventies, Americans prepared to celebrate the bicentennial of the birth of their nation. A feeling of introspection swept the country. The second wave of the baby boomers (1956–1964) came of age. Their generation was less idealistic than their older siblings had been in the sixties. The 1970s became the "Me Decade," meaning "What's in it for me?" College men took business courses instead of the humanities. Women discarded their miniskirts and donned pantsuits to pursue corporate careers.

In popular culture, the glittery glam rock of the early seventies gave way to a Saturday night fever and the hedonistic disco era in the second half of the decade. Punk rock inspired an iconoclastic look and a lifestyle of revolt against all social conventions. The sexual revolution of the 1960s evolved into an uninhibited casualness toward sex in the 1970s. The search for novelty—in lifestyle, personal relationships, sex, fashion—was a driving force that crossed all generations and incomes.

Figure 24-3. The ultrafeminine New Look silhouette that endured into the early 1960s was revitalized with a fresh focus on sleeves, particularly half and three-quarter varieties. Worsted suit by Lilli Ann, 1961.

WOMEN'S FASHIONS 1960–1980

Despite the bold proclamations of "change" and "new" on the covers of fashion magazines of 1960, in actuality, Dior's New Look still largely prevailed. *Vogue,* for instance, reported in its January 1960 edition of cinched waists and fitted clothes made with the "female-feminine" look of "gently curved proportions." Hemlines remained at knee length. What added a fresh touch to the lingering New Look silhouettes, though, was sleeve interest. Rather than exaggerated, constructed styles like those of the 1930s and 1940s, sleeve drama of the early sixties was created by the three-quarter length that was cut in various shapes and applied to virtually all types of garments from casual sportswear and dresses to evening gowns. (Figure 24-3.)

Innovative style leadership in the United States was conspicuously absent during the early 1960s. The icon of American style and fashion at the time was First Lady Jackie Kennedy, whose look was quietly elegant for public functions and unassumingly casual in her private role of wife and mother. Even her designer of choice, Oleg Cassini, tempered his usually flamboyant designs with a simpler, more conservative feel. Other top names in American fashion, such as Claire McCardell, Adele Simpson, Norman Norell, Oscar de la Renta, and Pauline Trigére, likewise focused on traditional silhouettes and a simplicity of line.

Coinciding with the escalating youth movement of the 1960s was the emergence of the **mod looks** (short for "modern" or "modernist") from London. Mary Quant and her protege Kiki Byrne adapted the looks of street-scene youth to their collections of simple chemises, tunic dresses with flounced or pleated skirts, and tweed cardigan dresses—all with hemlines cropped about six to eight inches above the knee.

The debate over who created the **miniskirt** has continued unabated since the early sixties. Mary Quant is often credited with the innovation although she denied it in interviews, stating, instead, that she merely popularized a youth look that was common in the streets of London at the time. On the other hand, Andre Courrèges frequently claimed to have originated the miniskirt—a style he first presented in his 1962 collections.

Despite the fresh and imaginative miniskirt designs from London, Paris, and Italy, the huge American ready-to-wear market initially resisted the radical look. Instead, for most young women, hemlines only gradually rose to just slightly above the knees by the mid-sixties before finally climbing thigh high in the second half of the decade. (Figure 24-4 and

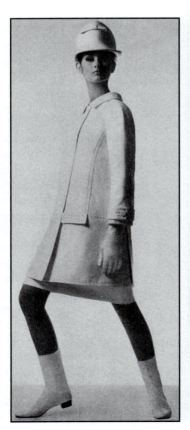
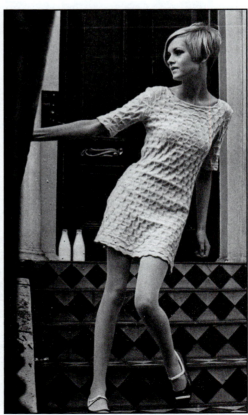

Figure 24-4. Although the miniskirt had become commercially popular with urban teenage girls in the early years of the 1960s, most hemlines had only risen slightly above the knees by mid-decade. By the second half of the sixties, hemlines were thigh high. Left, kidskin coat and short skirt by Samuel Robert, 1964; right, iconic sixties model Twiggy in knit miniskirt, 1967.

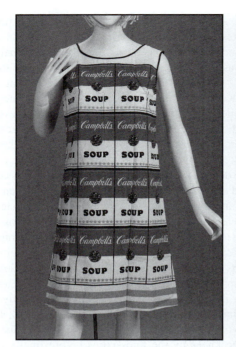

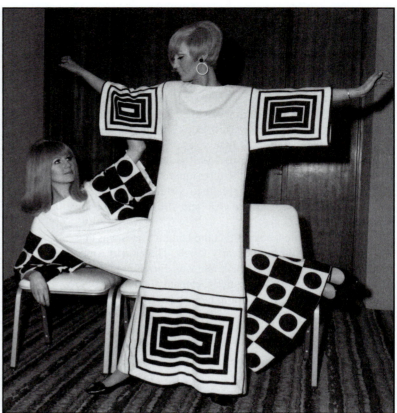

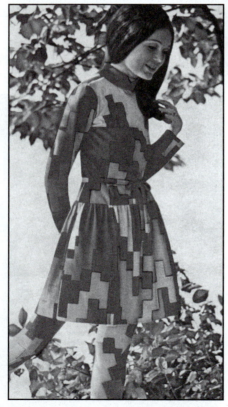

Figure 24-5. Pop, Op, and Kinetic art provided textile manufacturers and clothing designers with fresh fashion looks throughout the sixties and seventies. Top left, "Souper" dress inspired by Andy Warhol's Pop art paintings of Campbell's soup cans, 1966; right, Op art inspired kimonos by Naka, 1967; bottom left, Oscar de la Renta dress and matching tights, 1967.

Color Plates 63 and 64.) Even then, few women over thirty wore skirts cropped much above the knees.

In 1964, international fashion headlines were made by Andre Courrèges with his "Space Age" collection. The futuristic looks were based on the perfect cut and clean, minimalist lines. For some of the more abbreviated garments, Courrèges added one-piece knit **body stockings** popularly called **catsuits** because of their neck-to-toe sleek fit. The influence of the **space age style** was widespread ranging from smooth, A line dresses and coats to high-domed space helmet hats. Synthetic and metallic materials used in textiles added to the space age styling. (Color Plate 65.) In addition, the short white boots that Courrèges' models wore on the runway sparked the **"go-go" boot** fad that lasted several seasons in the mid-sixties.

Fashion designers of the mid-sixties also found inspiration from the three key art movements of the decade. The graphical images of American pop culture such as soup cans and the Sunday comics were a source of imagery for paintings and prints by Pop artists Andy Warhol, Roy Lichtenstein, and Peter Max, among others. Textile makers produced endless varieties of prints and patterns based on the Pop artists' stylizations of everyday images. The Op artists experimented with the optical illusions of bold flat patterns and vivid, clashing color combinations—another favorite source of design for fabric makers. (Figure 24-5 and Color Plates 66 and 69.)

A precursor of the Pop and Op artists was Piet Mondrian, whose paintings of bright, primary colored rectangles were adapted to the rectilinear chemise by Yves St. Laurent in 1965. In the second half of the decade, the Kinetic artists created visual dynamics through motion, which fashion designers adapted to modern clothes with the use of surface embellishments such as fringe, metal plates, crushed cellophane, or plastic tiles.

Like short skirts, the new cuts of women's pants were designed for the young, slender figure of the teenager. *Vogue* had observed in 1964 that **flamenco pants** were "riding low on the hips and flared below the knees." Within the year, all types of casual pants, tailored trousers, and even jeans sported the new low-rise cuts with **bell bottoms**. By the end of the decade some forms of **hiphuggers** featured wide waistbands for three-inch belts while other styles were made with a simple facing without belt loops at the top for a smooth fit across the hips.

The youthquake—a term coined by a *Vogue* editor in 1963—came to full fruition in the second half of the 1960s. A myriad of counterculture looks sprang from the assorted groups of restless young people who gathered in city parks and urban bookstores or set up communes where they could do their own thing. The self-styled looks of the flower children were widely and wildly varied ranging from pattern-mixed gypsy costumes that featured colorful print peasant blouses and long dirndl skirts to everyday ready-to-wear

miniskirts or bell bottom hiphuggers, all accented with leather fringe vests, scarves, floppy suede hats, love beads, and flowers in the hair. (Figure 24-6.) Tie-dyeing and flower power prints and textures were favorites of both women and men, looks that were appropriated by mass merchandisers for mainstream clothing and accessories.

Social changes within ethnic populations also influenced fashions of the 1960s. The plight of the American Indians and the substandard conditions of the federally regulated reservations were among the social injustices many young folks took up as a cause. The American Indian look of fringed leather jackets and skirts or pants worn with buckskin boots and beaded headbands became popular on high school and college campuses not only as fashion but as a social statement.

Black women in both America and Europe began to commemorate their cultural identity by wearing adaptations of traditional African costumes. Long, T-cut tunics called **dashikis** were made of brilliantly hued kente cloth or fabrics printed with motifs evocative of African heritage. Tall, meticulously arranged **headwraps** were particularly expressive of the emergence of the new black consciousness in the sixties. Black celebrities such as Aretha Franklin wore flowing tunics, voluminous wrap garments, and elegant headwraps for interviews and concert performances. (See chapter 12, page 282.) The Pan-African celebration of Kwanza was established in the 1960s, and blacks were

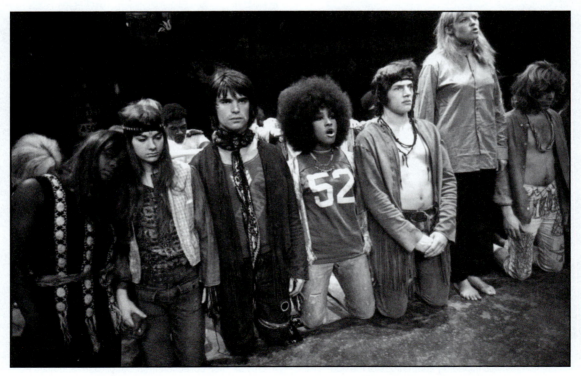

Figure 24-6. The self-styled looks of the sixties flower children were both statements of youthful rebellion as well as expressions of personal styles. Cast of *Hair,* 1969.

encouraged to wear combinations of the three colors of the Kwanza flag.

Commercially successful revivalisms of the 1960s were principally inspired by two sources—the romantic dress of the flower children and the period movies from Hollywood. A streetscene reaction to the ultramodern space age styles of Andre Courrèges, Paco Rabanne, and Pierre Cardin was manifested in **Victoriana** looks that adapted elements from late nineteenth-century fashions. Ankle-length calico **granny dresses** were made with high collars, puff sleeves, and ruffled hemlines. Teen girls wore them with soft, high boots or strappy sandals and wire framed eyeglasses with small oval or circle lenses in yellow, pink, or blue glass. In England, Laura Ashley opened her first shop in 1968 selling similar dress styles and smock tops for a look that later came to be called "**milkmaidism**," a reference to the simplicity of rural life of a bygone era.

Revivalisms of Edwardian styles stemmed from the theatrical costumes that became popular with rock bands in the late 1960s. The Beatles went from the cohesive but drab uniform-like suits worn in their movie *Hard Days Night* (1964) to an individualism expressed with the neo-Edwardian looks of Sergeant Pepper's Lonely Hearts Club Band in the animated film *Yellow Submarine* (1968). Young women and men began adding to their wardrobes velvet jackets, lace collars, ruffled shirts, brocade vests, and awning striped pants.

In 1966, an arts exposition in Paris called *Les Années '25* commemorated the birth of the art deco style forty years earlier. A renewed interest in the high style of art deco and moderne design greatly influenced the graphic arts, architecture, decorative arts, and fashion of the sixties. The following year when Julie Andrews starred in the movie *Thoroughly Modern Millie,* she wore adaptations of flapper looks that became widely copied by ready-to-wear makers. (Figure 24-7.) The innumerable varieties of dropped-waist chemises with miniskirt hemlines already had been popular for a few years but now were accessorized with soft cloches, long strings of beads, and interpretations of art deco jewelry and scarves.

Probably one of the most controversial fashion trends of the second half of the sixties was the **midi** with its hemline at

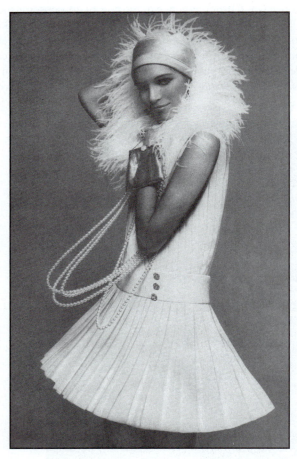

Figure 24-7. Hollywood movies of the late 1960s inspired numerous fashion revivals including adaptations of the flapper looks of the twenties. Silk crepe chemise from Leslie Faye, 1969.

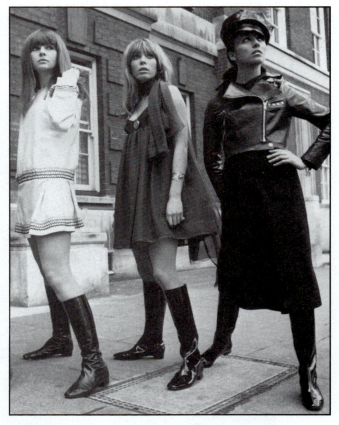

Figure 24-8. Revivals of thirties styles included longer hemlines introduced in the late 1960s as the mid-calf midi and the ankle-length maxi. Fall 1968 collection from Ossie Clark and Alice Pollock: left, silk dropped-waist miniskirt; center, silk Empire miniskirt; right, asymmetrical leather jacket with midi skirt.

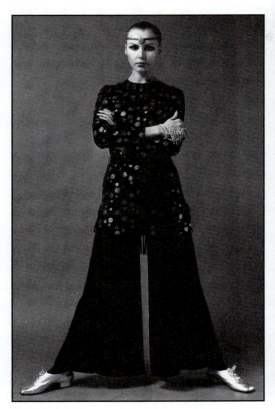
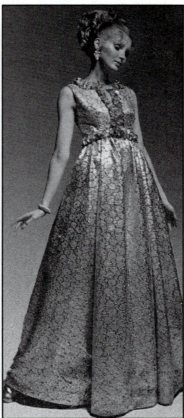
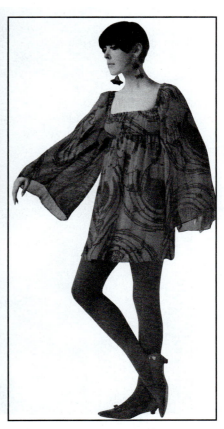
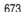

Figure 24-9. Eveningwear fashions of the 1960s ran the gamut from traditional ball gowns to trendy miniskirts and the increasingly popular pantsuits. Left, sequined silk tunic and crepe palazzo pajamas, 1966; center, brocade evening gown from Simplicity Patterns, 1969; right, after-six Empire miniskirt from McCall's Patterns, 1967.

mid-calf. In 1967, the hit movie *Bonnie and Clyde* starred Faye Dunaway who made fashion news with the sexy, curvaceous styles of thirties dresses and skirts she wore in the film. After several years of skirts cropped above the knees, fashion designers relished the idea of a fresh, contrasting silhouette and introduced the midi. (Figure 24-8 and Color Plate 76.) Women, though, rejected the midi and continued to prefer the leggy look of the miniskirt. Nevertheless, throughout the late sixties and into the early seventies, designers repeatedly produced variations of the midi as well as the ankle-length **maxi**. Some skirts were even made with button or zipper front-closures that could be worn open up to mid-thigh, but the longer hemlines continued to be regarded as eccentricities by most women until the mid-1970s. The one form of the midi and especially the maxi that had moderate commercial success was in outerwear. The longer lengths were a practical solution to the miniskirt's exposure of knees and thighs in winter. (See page 680.)

Despite the excitement and drama of the 1960s revivalisms and counterculture looks, the overwhelming majority of women wore less extreme clothing. Dresses in the mass merchandise catalogs of Sears, Penney's, and Spiegel in the late sixties showed hemlines fairly uniformly at just above the knees. The designs of tailored suits particularly were more reserved in cut and skirt length. Young career women began to break the dress code barriers in corporations by wearing tailored menswear-styled pantsuits or blazers and trousers of varying widths. (Color Plates 72 and 73.) The more casual **vest suits** featured sleeveless tops with knee-length skirts or wide legged trousers variously made of matching or contrasting fabrics.

Eveningwear of the 1960s provided women with the widest range of options since the 1920s. (Figure 24-9.) Just as short dresses were more popular than long gowns in the flapper era, the mod woman of the sixties went to cocktail parties and discotheques in dressy miniskirts. Fabrics and trimmings rather than silhouette usually determined after-six styles. Similarly, like the evening pyjamas of the twenties that had been worn by women in the vanguard of fashion, luxurious wide-legged pantsuits called **palazzo pajamas** and

Figure 24-10. For a few seasons in the early 1970s, tight short shorts, called hot pants, were acceptable town attire. Hot pants by Bonnie Doon, 1971.

jumpsuits became a popular evening fashions of the confident and assertive woman of the sixties. (Color Plate 68.) Concurrent with pantsuits and miniskirts for nightlife were opulent evening gowns in the New Look tradition often made of the newest synthetic textiles such as silky nylon Qiana or richly textured Trevira polyester.

As the 1970s opened, the seeming confusion of fashion styles that developed at the end of the sixties became even more pronounced. The couturiers and fashion leaders of Paris, London, and Milan had long since ceased to provide the dictatorial style leadership of the Dior era, and that most potent barometer of the most current trends, the hemline, was at lengths all up and down the leg. "There are no rules," insisted *Vogue* in 1970. "Let's relax, wear whatever length—or as many lengths—as we want." Ready-to-wear advertising and retail catalogs perpetuated the confusion by showing hemlines at most every length: thigh-high, above the knee, at the knee, covering the knee, mid-calf midi, and ankle-grazing maxi.

For young women, the preferred length remained thigh-high short. Responding to the demand of the market for short, European designers in 1970 experimented with tailored varieties of short shorts in upscale fabrics and materials such as linen, lamé, and suede. The following year, **hot pants**, as they came to be labeled, were a fashion phenomenon. (Figure 24-10 and Color Plate 82.) Most hot pants were worn with textured and colorful body stockings or ribbed tights and, especially, tall boots. The trend was short lived, however, and vanished from daytime wardrobes because the look quickly became associated with prostitutes.

One of the most important developments of women's fashion in the early 1970s was the emphasis on pant styles. The pantsuit that had begun to emerge as a career woman's option in the late sixties increasingly became accepted business attire as corporations dismantled archaic dress codes. Instead of the traditional menswear jacket styles, pantsuits were made with comfortable, loose-fitting tunic tops, cardigans, and long vests. The new suits of the seventies also were made with easy-care polyester knits in vibrant colors such as turquoise, kelly green, royal blue, and burnt orange that would not fade. (Figure 24-11.) In addition, advanced commercial knitting techniques made possible durable jacquards and other richly textured surfaces for an added feminine touch to pantsuits.

Besides pantsuits, other forms of trousers provided women of the seventies with comfortable and varied alternatives to the miniskirt. Midi-length versions of culottes, called **gauchos**, and tweed knickers were worn with the requisite knee-high boots. Even the jodhpur was reintroduced from the equestrienne costume to street wear suits, usually topped with a bolero jacket. Variants of gauchos and knickers made of velvet or satin were similarly worn with brocaded jackets or vests and patent leather or embroidered suede boots for eveningwear. Wide-legged trousers also continued to be favorites for the theatre and cocktail parties. By 1970, leg widths were so enormous that the bifurcation was swallowed up in the voluminous fabric, and the trousers looked more like long, full skirts such as the Mary Qaunt design shown in Figure 24-11. In the mid-seventies, Japanese designers, notably Kenzo and Miyake, presented loose, baggy variations called **kimono trousers** that draped somewhat like harem pants. In the second half of the decade, the Japanese experimented with totally new approaches to the construction of trousers such as cropping one pant leg at the knee and leaving the other at the ankle. Less extreme pant styles included adaptations of the men's straightline Oxford bags with wide cuffs. (Color Plate 80.) For casual wear, hiphugger bell bottoms remained popular with slender teenagers. The fit was snug around the hips and thighs but the legs flared out to enormous widths—a style marketed in boutiques as **elephant bells**.

Teenagers coming of age in the 1970s sought to define their own identity with a distinction from that of their older youthquake siblings. Although many hippies and flower children lingered on into the early seventies, teens viewed the Age of Aquarius as passé and irrelevant to the times. As with their predecessors of the sixties, young people of the 1970s

Hiphugger jeans from Sears Junior Bazaar, 1972.

Rayon gabardine elephant bells from FBS, 1973.

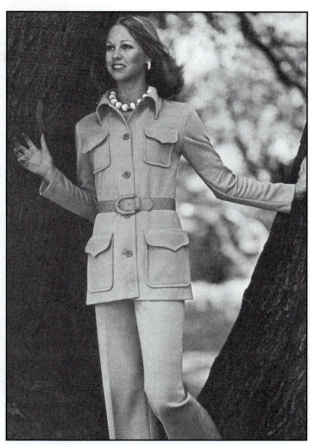

Double knit polyester pantsuit from Spiegel, 1973.

Cuffed baggies from SImplicity Patterns, 1973.

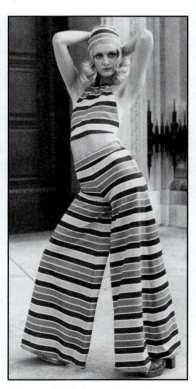

Halter and wide-legged pants from Mary Quant, 1971.

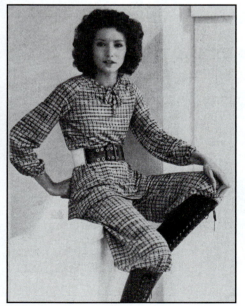

Jacquard knit knicker suit from FBS, 1971.

Figure 24-11. Pants of all varieties were the key fashion emphasis throughout the 1970s. Styles ranged from polyester double knit suit trousers to the exaggerated elephant bells.

found inspiration for new looks and new attitudes from rock and roll. In 1972, **"glam" or "glitter rock"** burst onto the pop culture landscape when David Bowie went on tour with his Ziggy Stardust show. Bowie performed in thickly applied glittery makeup, crimson-dyed spiked hair, and lavish costumes. At the same time Mick Jagger, Elton John, and other rock stars similarly developed concert images centered on gender ambiguity, more commonly referred to in the press as androgyny. For young people emulating their pop idols, the lines of gender fashion often became blurred. Many basics became unisex glam, from rhinestone-studded elephant bells and sequined skinny-rib shirts to platform high heels and feathered shag haircuts.

In the mid-1970s, edgy punk rock groups such as the Sex Pistols and the Ramones gathered substantial followings of urban teenagers who were disillusioned with their personal lives and the values of a class-conscious society. In addition to their iconoclastic music, these bands and their fans expressed their rebellious discontent through antisocial looks, which included jackets and T-shirts embellished with obscenities, pornographic images, swastikas, cultist symbols,

and anything else that could create shock value. The **punk look** especially featured clothes that were slashed or ripped and then pinned together with rows of safety pins or patched with duct tape. Other garments were inventively constructed with the discards of industry such as bits of colorful plastic, rubber, or other high tech synthetic materials. Their hairstyles were flamboyant and distinct ranging from short, spiked cuts dyed magenta, purple, or green to wildly exotic crests such as Mohawks and rooster's combs. (Figure 24-12.)

British avant-garde designer Vivienne Westwood led the front for punk-influenced high fashion in London, while French designers Jean-Paul Gaultier, Claude Montana, and Thierry Mugler selectively found inspiration for their haute couture collections based on the drama of both the punk looks and glam rock style.

As the youth of the seventies defined their niche looks, mainstream fashions also began to shift dramatically. In 1975, the thigh-high miniskirt finally faded from fashion— but only for a few years. Hemlines for ready-to-wear dresses and skirts that had been above the knees for ten years now universally dropped well below the kneecap. By 1977,

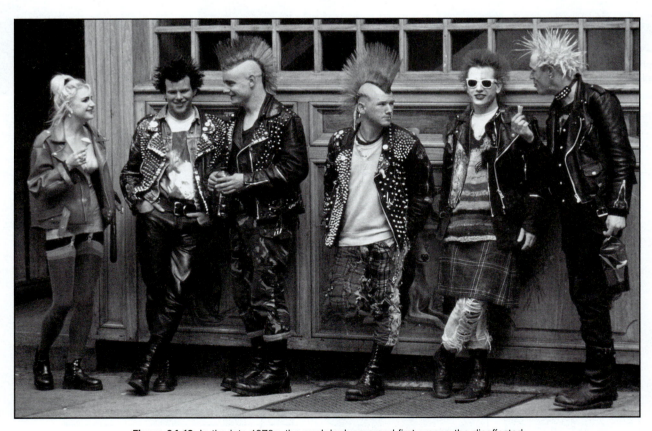

Figure 24-12. In the late 1970s, the punk look emerged first among the disaffected youth of Britain. Their antifashion styles included slashed and torn garments, jackets and T-shirts embellished with obscenities, and hairstyles dyed vivid colors and shaped into spikes, crests, and mohawks.

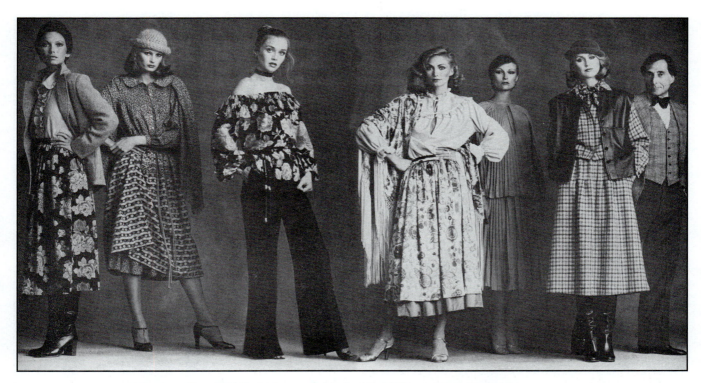

Figure 24-13. In the second half of the 1970s, women dressed for success in longer hemlines, mix-and-match coordinates, and layers of accessories such as scarves and wraps. Separates by Kasper, 1977.

hemlines were commonly at mid-calf and some even to the ankles. (Figure 24-13.)

Throughout the decade, designers on both sides of the Atlantic constantly searched for ways to combine novelty with versatility. When Richard Nixon made his epochal trip to China in 1972, designers rediscovered the mandarin collar, kimono sleeves, and the qi pao dress—an Asian sheath style usually with a mandarin collar and slits at the sides or front of the skirt. (See Chapter 9, page 207–08.) Fabric makers reproduced endless varieties of traditional Asian motifs and textile patterns. In 1978, Yves St. Laurent presented an entire collection of Chinese inspired fashions and, two years later, launched his Opium fragrances and licensed bamboo logo for home furnishings. Ready-to-wear makers capitalized on the mass market's continued interest in the East by producing innumerable adaptations and interpretations of Asian garments and accessories.

Another source of novelty for designers was the Russian peasant look. Among St. Laurent's series of ethnic inspired designs during the second half of the seventies were his Cossack collections of 1976 and 1977, which included "rich peasant" styles like gold lamé dresses adorned with passementiere or trimmed with fur, and everything layered with sumptuously patterned shawls and scarves. Although

most of St. Laurent's ethnic designs were largely theatrical drama, the collections repeatedly made international fashion headlines, influencing popular trends such as the layered "**folklorica**" looks shown in Figure 24-13 and especially textures, patterns, and color palettes of knits.

Despite all the excitement and theatricality of the counterculture or ethnic inspired fashions from St. Laurent, Gaultier, Mugler, Montana, and Westwood, working women could not wear these styles to the office. For them, a closet full of polyester pantsuits and double knit coordinates provided variety, functionality, and ease of dressing. In 1977, this comfort zone of professional attire was reinforced by the best-selling fashion guide *Dress for Success* by John Molloy. Career women were advised of wardrobe do's and don'ts for succeeding in a corporate world dominated by men. Subtlety and simplicity were key to that success. American designers like Calvin Klein, Anne Klein, Geoffrey Beene, Bill Blass, Liz Claiborne, and Ralph Lauren provided collection after collection of wearable fashions with a simplicity of silhouette that fitted the criteria of dressing for success. These and numerous other American designers produced an endless array of masterfully tailored suits and suit separates, especially blazers—the single most important component of a career woman's

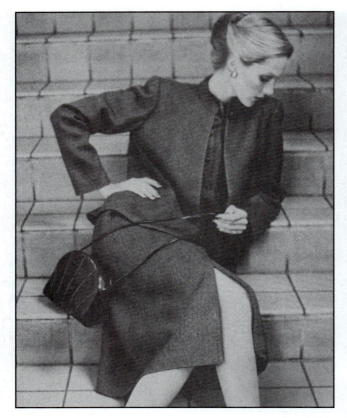

Figure 24-14. Tailored suits and suit separates became integral to the career woman's wardrobe of the 1970s. Tweed suit by Ferragamo, 1979.

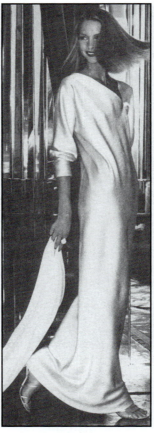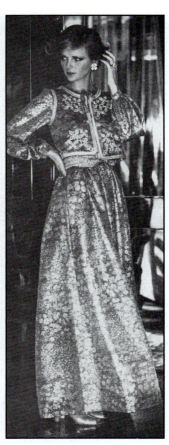

Figure 24-15. Revivals dominated eveningwear of the 1970s. Sleek, bias-cut 1930s gowns and adaptations of historical silhouettes such as the Empire waist were revitalized with the sumptuous synthetic fabrics of the time. Left, bias cut satin gown by Halston, 1976; right, folklorica vest over lamé gauze gown by Oscar de la Renta, 1976.

wardrobe in the 1970s. Besides the basic menswear styles, some blazers featured subdued but elegant touches such as grosgrain piping, ornamental buttons, or braid trim. The day-into-evening versatility of the blazer was especially appealing to busy career women. The transition from the colorful polyester double knit pantsuits of the early 1970s to the tailored powersuits of the 1980s had begun. (Figure 24-14 and Color Plates 77 and 78.)

Dressy suit jackets may have been appropriate for many after-six social events, but luxurious evening gowns were still the preferred look for the most formal affairs. (Figure 24-15.) Bold prints and textile patterns especially dominated eveningwear in the early seventies. The striking graphics of the Op and Pop art movements and the renewed interest in art deco design continued to influence fabric makers. Revivalisms also abounded in the 1970s. Historical details such as ruffs, leg-of-mutton sleeves, and bustle treatments were reinterpreted with new fabrics and modernist construction by Cardin, Capucci, and Givenchy. (Color Plate 87.) The corset bodice was freshly reengineered as bustiers by St. Laurent, Westwood, and Mugler. The empire waistline was everywhere. American designers delighted in slinky, sexy, bias-cut styles reminiscent of the 1930s.

One of the most significant impacts on nighttime fashion glamour in the late seventies was the disco phenomenon. In 1977, the hit movie *Saturday Night Fever* showcased John Travolta gyrating to the pulsing music of the Bee Gees across a strobe-lit dance floor in a dazzling white suit. Disco was an instant hit and became the ideal hedonistic party for the conclusion of the me-decade. Sex, drugs, and rock and roll all merged into the wild club scene of New York's famed (or infamous) Studio 54—and hundreds of hometown versions scattered around the globe. Few young people of any industrialized nation were impervious to the throbbing beat of disco music and the lure of the boogie night life. Disco fever dressing, according to *Vogue* in 1978, had to show "a lot of body." Designers and wearers alike were obliging. Pencil slim pants and skin-tight designer label jeans were worn with halters, tube tops, or at least shirts with a few buttons strategically opened. Anything that shined and glittered was right for night. Shoes and hose shimmered with metallic allure. Sparkling jewelry accented the body in motion. (Figure 24-16.)

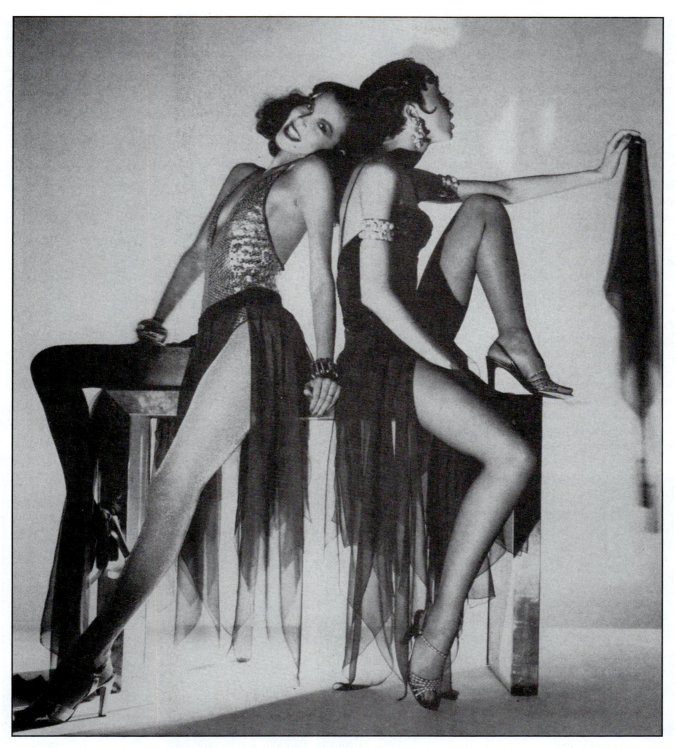

Figure 24-16. At the end of the 1970s, disco fashions were designed to display a lot of body and to attract attention with glitter, shimmer, and shine. Body-revealing nightlife styles by Valentino, 1978.

WOMEN'S OUTERWEAR 1960–1980

Through the first half of the 1960s, the favorite silhouette of coats continued to be the straightline shapes of the New Look years, which could be worn loose and free or cinch belted. The flared A line cut was particularly popular. As skirts steadily climbed above the knees, the hemlines of coats were shortened as well. By 1966, coats were cropped as thigh-high as miniskirts. A year later, though, the midi and maxi coats appeared. Even though women largely rejected the longer lengths for dresses, the midi and maxi were popular in winter with the miniskirt wearer for practical reasons. Some maxi coats were designed with zip-away bottom sections that could change to a mini in an instant.

In the early 1970s, outerwear featured Asian influences such as kimono sleeves and mandarin collars following the renewal of U.S.-China diplomatic and economic relationships. At about the same time, the Big Look of the Japanese designers inspired voluminous styles of coats and jackets with full skirts, rounded shoulders, capacious sleeves, and large patch pockets. At the other end of the spectrum, wrap styles, called **dressing-gown coats**, were made of luxurious fabrics and were worn as a snugly belted cocoon. Leather jackets and coats were everywhere, many of which were constructed in a multicolor patchwork. Denim was equally popular for both jackets and long dusters. During the mid-1970s, synthetic fake fur jackets and coats were heavily promoted as an alternative to real fur, which had become socially unacceptable in light of new laws protecting endangered species. In the second half of the seventies, both skirts and coats were well below the knees, some almost to the ankles. The Russian peasant looks of St. Laurent and the many folklorica derivatives inspired an interest in rich textiles such as tapestries for outerwear. The modern look at the end of the decade ranged from the oversized quilted **duvet coats** by de Castelbajac, which were widely copied, to the simple, finely tailored dress coats of Halston and Lauren.

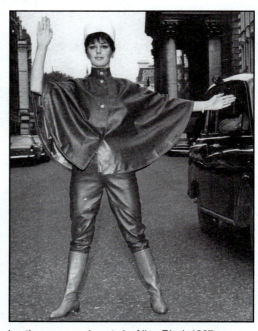

Leather cape and pants by Nina Ricci, 1967.

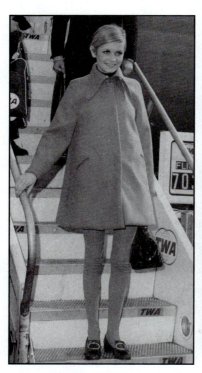

A Line miniskirt coat, 1968.

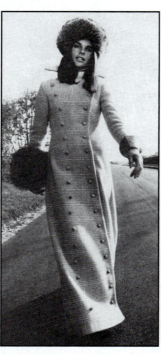

Maxi coat in blanket plaid wool by Ali, 1969.

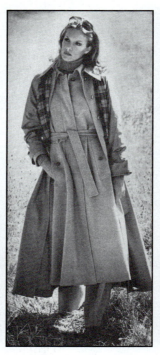

Big Look coat-on-coat styling by Calvin Klein, 1975.

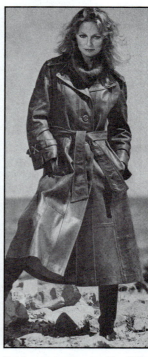

Patchwork leather coat by Skin Gear, 1978.

WOMEN'S SPORTS APPAREL 1960–1980

From the youthquake of the 1960s through the disco period at the end of the 1970s, a cult of the body developed as millions of women joined the emerging fitness craze of the era. Mature women who wanted to wear the sixties miniskirt or the seventies painted-on jeans obsessively jazzercised, jogged, and swam laps, and young women who wanted to retain their youthful figures played tennis and racquetball, roller skated, and cycled on ten-speed bikes.

Specialized workout apparel in the 1960s was primarily based on functional, school gym styles—shorts and T-shirts or sweatpants and sweatshirts. In the 1970s, though, women of all ages joined one of the many private membership clubs and spas that invaded the suburbs. Magazine editorials and apparel marketers advised women to think fashion even when exercising. Makers of active sports clothes such as Jantzen and Danskin expanded speciality lines with colorful mix-and-match leotards, shorts, tanks, tights, leggings, warm-up fleece, jackets, and coordinating accessories like caps, totes, gym bags, and wrist and head bands.

Downhill skiing grew in mass popularity during the 1960s with the extended TV coverage of the 1964 and 1968 Winter Olympics. The sleek look of nylon and polyester skipants, jackets, and coats that developed in the late fifties continued to dominate the slopes. Mod color and pattern mixes updated the styles. In the 1970s, the one-piece unitard became the trendy skiwear, especially in stretch metallic fabrics. Despite their bulk, thickly quilted jackets, vests, and coats lined with down or synthetic fillers were preferred by cross-country skiers.

Tennis wear retained its specialty look well into the late 1970s. Uniforms of shorts, culottes, little skirts, and camp shirts in crisp, white fabrics were a must for most tennis clubs. Soft pastels, especially knit polo shirts, were more common at resort courts. Color and even prints became more widely acceptable after 1972 when women were permitted to play in color attire at Wimbleton.

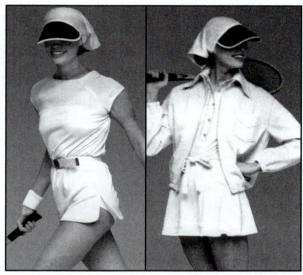

Tennis shorts, skirt, jacket, and tops from Vogue Patterns, 1976.

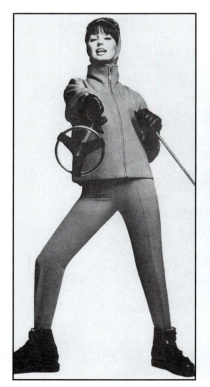

Nylon skiwear with a sleek, space age line, 1968.

Basic leotard and tights from Danskin for isometrics workouts, 1968.

Cotton woven interlock jogsuit and sportswear by Jantzen, 1978.

WOMEN'S UNDERWEAR
AND SLEEPWEAR 1960–1980

Through the first few years of the 1960s, the styles and construction of women's lingerie continued the forms of the New Look. Torpedo bras and waist-cinching corsets or girdles defined the fashion silhouettes. As the youthquake movement began to influence fashion, the ideal feminine figure somewhat reverted to that of the flapper—tall, slender, and boyish. With hemlines at mid-thigh and dresses with cutouts and cutaway midriffs, bras and panties became ever briefer and lighter. The bikini brief followed the reduced cut of swimwear. Bras softly contoured the breasts rather than reshaping them. In 1965, Rudi Gernreich created the sheer nylon "No Bra" bra. Teenage girls with small bosoms even discarded the bra altogether with the help of Bandaids to prevent nipple show-through. Bulky garter belts and garters were also abandoned in the late sixties when control-top **pantyhose** were introduced. Colorful and textured body stockings served as both underwear and fashion accent. Half slips were hardly more than a snip of nylon tricot with a thin elastic waistband.

In the sixties, new lightweight synthetic yarns like Lycra were widely used for lingerie and sleepwear. (Color Plate 71.) The flexible knits produced with these synthetics were three times stronger than earlier elastics and were more resistant to damage by perspiration and detergents. Colors and prints were vibrant. Lingerie collections were color or pattern coordinated—especially vivid flower power prints.

By the beginning of the 1970s, undergarments were in their briefest forms. Bras became transparent and triangular with a deep décolleté. As the fitness boom increased, a subcategory of sportsbras became big business for manufacturers. Bikini panties were further reduced to barely more than a thin rouleau low on the hips. Girdles were only worn by women needing figure control. Slips largely disappeared except for midi skirts until about mid-decade when dress hemlines dropped below the knees.

In the second half of the seventies, luxurious natural fabrics such as silk crepe de chine and satin returned. Colors were more subdued but rich—apricot, teal, olive, coffee, burgundy. All types of undergarments were lavishly adorned with lace insets, trimmings, or appliques.

During the disco craze, sleek, glossy lingerie complemented the glittery, body-conscious fashions for night clubbing. Sexy corsets, garters, and frilly undergarments made a comeback.

Sleepwear of the sixties and seventies had a less dramatic evolution than underwear. Knee- and ankle-length nightgowns continued to be the most common—all with coordinating wraps or robes. The baby doll gown or "little girl sleeper" with its short, hip-length top and bloomers remained a favorite of teens. In the 1970s, revival styles of sleepwear were popular. Bias cut nightgowns and flowing robes were modeled on 1930s originals. Similarly, flapper era pyjamas in sumptuous silk fabrics were an alternative to the utilitarian cotton pajama. Many women opted for any type of easy, comfortable garment for bedtime, including men's shirts or pajama tops, long T-shirts, or simply their underwear.

Print bra, pantie-girdle, and shortie robe from Artemis, 1963.

This is the one. Rudi Gernreich's 'No Bra' bra for Exquisite Form.

The sheer, nylon tricot "No Bra" bra designed by Rudi Gernreich in 1965.

Sheer body stocking by Emilio Pucci, 1969.

Bra, bikini, slip, half slip, and mini-nightgown by Kayser, 1968.

Asian motif print kimono from Kasper, 1973.

Animal print briefs in acetate tricot, 1968.

Sheer "baby doll" gowns from Van Raalte, 1968.

Lacy bra and bikini by Donald Brooks for Maidenform, 1978.

WOMEN'S SWIMWEAR 1960–1980

At the beginning of the 1960s, women's swimwear retained much of the construction rigidity that shaped and accented the rounded, mature female figure. By mid-decade, though, the slim, angular, boyish figure of Twiggy and the surfer girls in the popular beach movies epitomized the mod ideal of feminine beauty. Swimwear was redesigned without boning, wires, padding, and modesty skirts. The new spandex nylon fabrics were sleek and formfitting. The bikini became the preferred style of youthquake girls. By the end of the decade, bikini bottoms had been pared down from about five inches wide at the sides to thin straps of fabric barely a half inch wide. Tops ranged from strapless bandeaus to widely spaced triangles of fabric. In 1964, Rudi Gernreich made fashion headlines worldwide with his monokini—a topless one-piece with a high waist and a pair of straps at the center front that fitted over the shoulders. Other one-piece styles of the sixties reflected the influence of space age theme fashions with geometric cut outs and necklines. Psychedelic prints and acid colors were particularly popular with teens.

In the 1970s, the string bikini, and even thong styles, allowed the maximum exposure to the sun. At the opposite end of the swimwear spectrum, one-piece racers and similar maillots were made of contouring Antron nylon and Lycra without any darts. Many simple one-piece styles were given a new look with retro details like skirts and bodice detailing. The tank necklines and square-cut legs of the flapper era were also among the revivals. Swimwear makers extended product lines to include beachwear coordinates including shorts, cabana pants, wrap skirts, beach robes, and coverups. (Color Plate 81.)

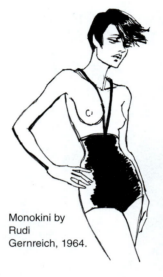

Monokini by Rudi Gernreich, 1964.

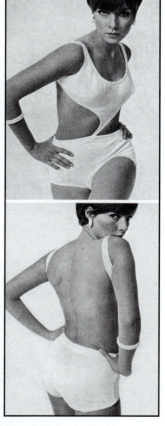

Cut-out design by Bill Blass, 1965.

Polka dot bikini from Catalina, 1968.

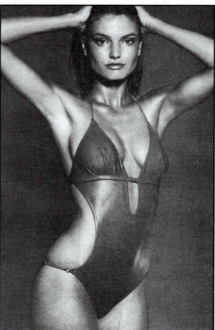

The "Chain Suit" by Marc Vigenron, 1977.

WOMEN'S SHOES 1960–1980

The heel and toe shapes of shoes in the early 1960s were primarily the same as those of the late fifties. The stiletto had been lowered but was still finely chiseled and toes were sharply pointed. British mod designers such as Mary Quant changed the shape of women's shoes by pairing wide, rounded little girl styles with the miniskirt. Variations in the second half of the decade became more square toed and square heeled. Some broad heels flared outward for a shape wider at the base than the top. Revival fashions of the 1960s, such as the flapper or the Bonnie and Clyde look, inspired retro shoe styles from those eras. Both the Louis heel from the 1920s and the strappy, thick heeled silhouette of the Depression period reappeared. At the end of the decade, adaptations of the forties-styled platforms set a trend that would last through the mid-seventies. The most important footwear news of the 1960s, though, was the enormous popularity of boots. Courrèges' short white kid boots shown with his 1964 Space Age collection launched a go-go boot mania. Boots were designed in every imaginable color and texture of leather, suede, plastic, rubber, and fabric. Frosted and metallic finishes coordinated with similar lipsticks and eyeshadows. As hemlines became shorter, boots climbed higher, to mid-thigh in some instances.

In the early seventies, platform shoes and boots rose to exaggerated heights and shapes—some with heels as high as five inches. Many variations of platform shoes were molded of new age materials such as acrylic, aluminum, synthetic rubber, or plastics. At the end of the decade, tall, sculpted wedges replaced the high heel platforms. Thigh-high boots worn with miniskirts in the sixties were adopted to hot pants in the early 1970s. Throughout the seventies, the innumerable eclectic looks of fashions inspired one of the most varied assortments of shoe designs of the century. Women's closets were crowded with mules, sandals, flats, wedges, stiletto heels, moccasins, and boots of all heights in all sorts of

materials and colors. Of particular note were the beaded, sequined, or metallic disco shoes with open designs that bared much of the foot. The footwear industry also responded to the seventies fitness boom with branded active sports shoes in designer colors and materials.

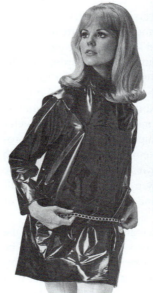

30-inch thigh-high stretch vinyl boots, 1968.

Little girl shoe styles from Auditions, 1967.

Platforms from Sole Shoes, 1973.

Go-go boots from Desco Shoes, 1966.

Wedges and wood sole clogs and sandals from Brazil, 1978.

WOMEN'S JEWELRY 1960 –1980

Jewelry in the early 1960s was understated and classic. Pearls, real or simulated, were especially popular because they were a favorite of Jackie Kennedy. By the middle of the decade, though, the brevity of clothes with cut-outs, decollete necklines, and above-knee hemlines was balanced by heavy boots below and big hair and oversized jewelry above. The sculptural, geometric shapes of mod jewelry were inspired by two key sources—the hard-edged looks of space age fashion collections, such as those by Courrèges and Cardin, and the revival of art deco design. (Color Plates 74 and 75.) Huge, dangling earrings, massive cuff bracelets, and dome rings of plastic in psychedelic color combinations were the quintessential sixties look. Counterculture groups opted for jewelry that made a personal statement such as the peace sign, horoscope symbols, or mystical emblems like the Egyptian ankh and the yin-yang circle. A few years later, the punks made similar social statements about their personal style with multiple ear piercings, nose studs, and the use of safety pins or other found objects as jewelry.

Oversized costume jewelry remained popular through the early 1970s. Replications of art deco jewelry continued to be in such huge demand that makers like the 1928 Jewelry Company produced full lines of matching sets each year. After Nixon's 1972 visit to China, jewelry with Asian motifs became trendy, particularly jade, carved cinnabar, and luminous cloisonne. In the second half of the seventies, patriotic jewelry in red, white, and blue was prevalent in America for the celebration of the U.S. bicentennial in 1976 and in Britain to honor the Queen's Silver Jubilee (twenty-fifth anniversary) in 1977.

Toward the end of the seventies, jewelry in natural materials and earth tones complemented the resurgence of natural fibers in clothing and the wood and raw leather prevalence in footwear. Terracotta and glazed stoneware ornaments, wooden beads, handwrought metals, and fiber crafts provided a fresh look after the polished machine-perfect plastics of the previous twenty years.

In contrast to the return to nature was the high gloss style of the disco divas who required eyecatching jewelry that glittered and shined but did not overwhelm. Thin rhinestone necklaces and diamond tennis bracelets or finely wrought gold chains added just the right sparkle to accentuate the body in motion on the dance floor. Zodiac pins and pendants served as a conversation opener for the opposite sex.

Oversized mod earrings, 1966–1967.

Mod wrist and ring watches from Old England Watches, 1967.

Lucite mod watches from Vendome, 1967.

Handcrafted porcelain jewelry by Capri, 1978.

WOMEN'S HAIRSTYLES AND MAKEUP 1960–1980

As with shoes and jewelry in the 1960s, hair, too became an oversized compensation to the cropped and shortened proportions in fashions. Big boots, oversized jewelry, and piled-up hair seemed to balance the miniskirt and slim fit of other clothes. The teased and lacquered bouffant of Jackie Kennedy was a presage of things to come. By the mid-sixties fashion news was made by the **beehive hairstyle**, created by the spiral twist of tresses in a cylindrical arrangement atop the head. In the second half of the decade, though, youthquake girls rejected the artifice of the teased, hair-sprayed mounds and curls and opted for natural, flowing hair. The preferred look was the soft, straight hair of Cher or Candice Bergen, which for many women required a great deal of maintenance with hair relaxers or ironing. Also in the late sixties, African American women began wearing their hair in its natural state rather than chemically straightening it. The full, bushy **afro** became a potent statement of black identity for both women and men.

Hairstyles of the 1970s were predominantly soft and long. The fluffy, feather cuts of the actresses on the TV series *Charlie's Angels* epitomized the studied casualness of hairstyles of the era. In addition, the carefree pageboy crop of 1976 Olympic gold medal skater, Dorothy Hamill, became a favorite cut for teen girls with thick, straight hair. Retro-fifties chic fashions also inspired some women like Liza Minelli to trim their hair to the close crop of Audrey Hepburn, circa 1955.

Makeup in the 1960s emphasized the eyes above all else. The boldly colored and glittery accented eyeshadows worn by Elizabeth Taylor in *Cleopatra* (1963) revolutionized the cosmetics industry. By the time big-eyed, waif-like models, such as Twiggy, came to represent the ideal in feminine beauty in the second half of the decade, cosmetics makers were producing eyeshadows and liners in a wide variety of vibrant colors. Mascara and false eyelashes were huge

sellers. On the other hand, lipstick colors either became softer and more natural or, for mod girls, were emphatically unnatural. White, silver, and even stark shades of blue and green were options of body paint for the lips that were often blended with the warm earthtones of commercial lipsticks for frosted looks. Nail polish also came in palettes of frosted shades to coordinate with the shimmer of lips and eyes. Mod fashions were sometimes accentuated with eyes that were painted with psychedelic colors and patterns, especially flower power motifs. In 1967, Twiggy appeared on the cover of *Vogue* with the surround of one eye painted as a lavender and red flower to match a similar motif on her sweater.

In the 1970s, make-up continued a move toward natural looks with soft-toned lipsticks and negligible eyeshadows. For the career woman, dressing for success meant understated makeup—coral lipsticks and, perhaps, just a touch of a mauve blend of eyeshadow around the eyelids for depth. For the disco nightlife, though, makeup was applied for seduction. Wet-looking lip glosses in deep shades of red, glittery cheek blushes, and smoky eyeshadows enhanced feminine features to stand out in the dimness of night spots.

Bouffant styles of 1964.

Twiggy false eyelashes, 1967.

Singer Roberta Flack's full afro, 1970.

Soft, natural make-up and fuller hair styles of 1977.

WOMEN'S HATS 1960–1980

With the advent of the high bouffant hair arrangements of the early 1960s and the youthquake-inspired hairstyles of the second half of the decade, hats ceased to be the crowning accessory for the fashionable woman. Increasingly, women abandoned wearing hats except for special occasions like Easter Sunday or weddings. As a result, many upscale retailers closed their millinery departments and focused on casual headwear that the accessory industry mass produced.

During the transition years of the early sixties, hat designs were shaped tall and full mirroring the hairstyles of the period. Decorations were often exuberantly horticultural with masses of silk flowers, fruit, and foliage. The height was retained in mid-decade but the styles were streamlined with space age silhouettes such as the round domed British Bobbie's helmet that had a futuristic look of a space helmet. Stetsons were given a modern look with wide chin straps, often of contrasting colors.

In the second half of the 1960s, mod looks and revivals prevailed. The **Nureyev cap**—named for the famed Russian ballet dancer who popularized the style—was made in bold colors and prints to coordinate with mod fashions. Floppy, wide brimmed "swinger" hats with flower power prints were fun styles for the young. Soft cloches were revived from the twenties and thirties, and snap brim fedoras recalled the smart looks of the forties. Fake fur caps and toques were inspired by the costumes in *Dr. Zhivago* (1965) and berets from *Bonnie and Clyde* (1967).

In the 1970s, hats largely vanished from most women's wardrobes. Mass merchandise catalogs that once featured multiple pages of millinery now only included a few versatile, easy-care utilitarian hats. Soft, knit caps of all shapes and colors were particularly popular. As a fashion statement, many women in the early seventies wore scarves as headwear, an influence from the dress of the Rhoda character on the *Mary Tyler Moore Show*. Unrelated to the scarf fashion trend was the headwrap adopted by some urban African American women as a statement of black awareness in the late 1960s and early 1970s. During the second half of the seventies, richly decorated and patterned folklorica fashions inspired a renewed interest in hats, especially exotic shapes and ornamentation. Women who dressed for success opted for tailored fedoras to complement their menswear coats and blazers in daytime and small retro styles with sophisticated touches like veiling and Edwardian cabochons (jeweled clips) for evening.

Houndstooth British Bobbie's helmet by Tannél Jomana, 1964.

Pillbox from Arthur Jablow, 1961.

Silk grenadier's cap by Georgia Bullock, 1962.

Space age helmet hat from McCall's Patterns, 1966.

Adaptation of the Nureyev cap from McCall's Patterns, 1966.

Bonnie and Clyde beret by Simplicity Patterns, 1968.

Gaucho hat from Christian Dior, 1969.

Visored skull cap from Cole of California, 1969.

Javanese-style plantation hat by Chester Weinberg, 1969.

Felt "swinger brim" hat with paisley scarf band, 1970.

Tweed Eton cap from Blassport, 1971.

Mass-produced casual hat in polyester, 1976.

Feathered pillbox, 1974.

Ethnic peasant turban by St. Laurent, 1977.

Sueded poly/cotton newsboy cap from Thornes, 1978.

WOMEN'S ACCESSORIES 1960–1980

With the lingering New Look, styling of fashions in the early 1960s remained the full accoutrement of head-to-toe accessories. Handbags, belts, and shoes had to match, or at minimum, coordinate. An abundance of understated, classic styles of jewelry were an important finishing touch. No well-dressed woman would leave the house without her hat and gloves, both of which had specialized styling depending upon the time of day, season, and type of suit or dress worn.

In the wake of the youthquake, though, accessories took on a different meaning from that of fashion complement. Besides abandoning hats and gloves, young women also disregarded the traditional tenets of coordinating accessories. Instead, accessories in any combination were an expression of personal style. The gypsy look with its piling on of accessories of mixed styles had wide appeal even for mainstream dress. (Color Plate 75.) The clean lines of space age design met the retro-geometric styling of art deco in small leathers, handbags, and scarves. Ethnic influences included American Indian beaded belts, headbands, wristlets, and purses. Chain belts draped low over the hips emphasizing the lowered waistbands on hiphuggers. Exotic versions of chain belts ranged from harem coin skirts to mock cache-sex styles reminiscent of African adornment.

Simplification and functionality were the guides for accessorizing in the early 1970s. The predominance of the perfectly coordinated separates collections, often with matching self belts, detachable collar bows, scarves, or dickies,

removed the uncertainty of choosing accessories. Neutral woven fabric, knit, or leather totes went with almost everything, regardless of season.

With the layered looks of the second half of the seventies, accessories once again became important fashion details that required thought and planning. In addition, dressing for a corporate career in the late seventies involved a lengthy checklist of right and wrong wardrobe choices for business attire. Retro fashions, Western wear, and peasant looks were also more purist than in the sixties with accessories as important accents to the thematic looks.

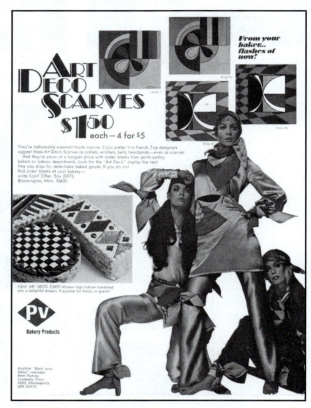

Art deco motif scarves, 1969.

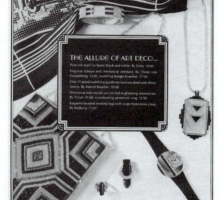

Retro art deco scarf, belt, jewelry, and beaded handbag by Walborg, 1974.

Beaded headband, 1967.

Chain belts by Napier, 1969.

Flower power hosiery from Hanes, 1968.

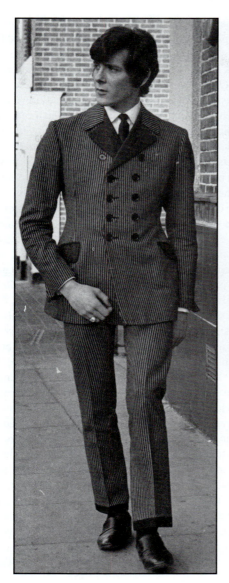

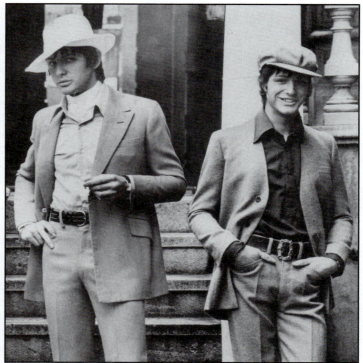

Figure 24-17. Men's suit styles were transformed during the Peacock Revolution of the 1960s. Mod modes featured new shapes and contours, vivid colors, and bold textile patterns. Left, 10-button double-breasted suit jacket with contrasting lapels and pocket flaps, 1967; right, square front suit jacket and collarless suit jacket from Blades, 1969.

MEN'S FASHIONS 1960–1980

As with women's fashions of the early 1960s, men's clothing was largely a continuation of fifties styles. The ubiquitous gray flannel suit of either the straightline Ivy League cut or the more fitted Continental style evolved only minimally. London's Savile Row recaptured preeminence in men's suit tailoring with a subtly new jacket silhouette that featured lightly padded shoulders, slightly wider rolled lapels, and a more flared skirt. The deep V-line of the opening exposed a greater expanse of the shirt and gave men the appearance of possessing a broad, athletic chest. The new suit silhouettes created a look of the mature man somewhat reminiscent of the 1930s draped cut, though without the exaggerated padding and shaping. The two-button front closure was the favorite style of the time, made especially popular with American men by President Kennedy.

Meanwhile, not far from the long-established, traditionalist businesses of Savile Row, a cultural phenomenon was gaining momentum with its nerve center along a few short blocks of Carnaby Street in Soho. Throughout the early 1960s, throngs of teenage boys migrated to the numerous menswear boutiques there seeking the newest styles of mod clothes that collectively came to be called the **Carnaby Street look**: skinny-rib knit body shirts vividly colored in cherry red, fuchsia, yellow, pink, and lavender; dress shirts in bold prints and stripes; pastel hued jeans and skin tight knit or suede hiphuggers; and fitted Edwardian jackets in silk or velvet. Accessories for young men now included scarves, ascots, and ties in vibrant floral or art deco revival prints. Shoes and belts were embellished with oversized buckles and chains. Necklaces and bracelets adorned throats and wrists. Men also began to grow their hair long—first over the ears, then to the collars, and finally down to the shoulders.

By mid-decade, even the mainstream press was commenting on the "**Peacock Revolution**"—a hedonism in masculine dress that shattered the prosaic conformity of menswear. (Figure 24-17.) It was fashion from the bottom up—youth on a budget setting the trends that soon transcended age and income. High society and the realm of the couturier no longer set the dictates of style; fashion followed the street.

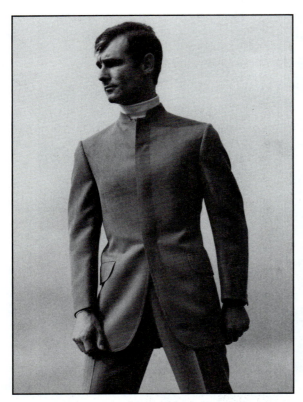

Figure 24-18. The round collared Nehru suit was named for the prime minister of India, who usually dressed in a traditional native tunic of similar design. Shaped Nehru jacket from Schwartzman of Sweden, 1968.

The mod mode was further bolstered by the enthusiastic adoption of peacock styles by rock and roll bands such as the Beatles, the Rolling Stones, The Who, and numerous other top pop groups. In the early part of the sixties, the Fab Four, as the Beatles were called, dressed alike in mod styled suits inspired by the avant-garde designs of Pierre Cardin. Beginning in 1960, Cardin had transformed the traditional male suit by dramatically reconstructing jackets with a collarless, high jewel neckline, shortened hemline, vented cuffs, and slim fit. In the second half of the decade, though, the Beatles were completely immersed in the Peacock Revolution and opted for individuality and self expression through the **Sergeant Pepper suits**, which blended Edwardian dandyism with psychedelic-patterned fabrics and color combinations. Similarly, Pete Townsend, lead guitarist for The Who, made famous the controversial **Union Jack jacket** constructed with red, white, and blue panels stitched together to resemble the British flag. In the United States, adaptations of the jacket made of the Stars and Stripes sparked their own controversy, and sometimes even incited violence against the wearer.

For most American men, though, mod suit styles were a remote, teenage fad. Fashion editorials and menswear ads largely focused on the traditional suit styles of the mature businessman rather than the teenager. Even the male models used

for suits depicted in *GQ* and *Esquire* during the sixties, whether in photographs or illustrations, mostly looked fortyish rather than collegiate. In the second half of the decade, though, the peacock influence began to manifest itself in several ways. In 1967, *GQ* examined the "mod aftermath" and the resulting fashions designed "with little concern for traditional concepts of what men's clothing should look like." The three predominant influences on American suit styles, according to *GQ*, were color, textile pattern, and "the new love of sport coatings." Colors of sports coats became vibrant, especially turquoise, orange, royal blue, and assorted shades of gold and yellow. Bold windowpane checks, oversized houndstooth patterns, and plaids were combined with these intense colors for more visual dash. Some sports jackets were even produced in paisley and flower power prints for the truly flamboyant male. As a result of this new patterning of the sports jacket, the tailored business suit, too, began to appear in stronger glen plaids and gangster pin stripes, particularly following the movie *Bonnie and Clyde*.

Of the radical changes in men's suit silhouettes, the most widely accepted was the Nehru collar styling. In 1965, French designer Gilbert Féruch presented a collection of men's suit designs that included a fitted tunic jacket with a stand-up mandarin collar, which the pro-Chinese French called the "**Mao collar**." In English-speaking countries, though, the style was adapted a couple of years later as the **Nehru jacket**, named for the peace advocate Jawaharlal Nehru, prime minister of India, who, for decades, had worn a similar tunic that was a national male garment. (Figure 24-18.) As a substitute for the conventional business suit, the Nehru style was made of flannel or woven worsted in subdued colors. Fancy versions were cut with an off-center closure, and collars and cuffs were edged with embroidery or grosgrain piping. Eveningwear styles were made of rich brocades, silks, and velvets. Young men of the "in-crowd" often wore heavy chains with jeweled or zodiac pendants, or even long strands of love beads with their Nehru jackets. The trend was popular only briefly from 1967 through 1968.

In the early 1970s, Hollywood exerted a powerful influence on men's suit designs. Movies like *Cabaret* (1972), *The Sting* (1973), and especially *The Great Gatsby* (1974) featured vintage suits with the English draped cut silhouettes of the 1930s. Ralph Lauren achieved international fame with his menswear costumes for *Gatsby*, styles which were universally adopted by tailors and ready-to-wear makers. In the spring of 1974, *GQ* devoted an entire edition to "the movie that's influencing what you wear." Unlike the drape cut of the thirties, though, **Gatsby style** jackets were shaped with rigid padding and inner lining construction to achieve the illusion of an ideally proportioned, athletic male. (Figure 24-19.) Lapels were huge, spreading across most of the expanse between the V-front opening and the shoulder seam. The vest was back. Colors were rich—not in vibrant peacock flamboyance but in the taste of F. Scott Fitzgerald's era: caramel, cream, slate blue, and even the softest peach or dusty rose.

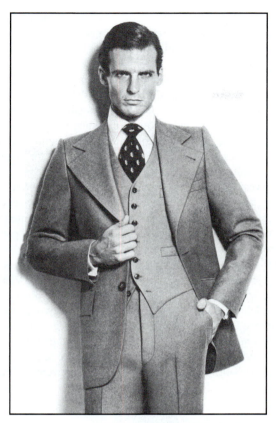

Figure 24-19. The classic look of the English drape suit was revived in the early 1970s. Adaptations were made in the new polyester double knits as well as traditional fabrics. Gatsby style suit from St. Laurie, 1976.

Parallel with the high style of the Gatsby look in the early seventies was the persistent demand in the menswear market for greater ease and comfort in suiting. The durable, easy-care synthetic knits that had continued to gain popularity throughout the sixties became integral to suit and sports jacket designs of the 1970s. The polyester double-knit or stretch denim **leisure suit** was a casual alternative to the tailored sports jacket or blazer based on the safari coat of the 1960s. (Figure 24-20 and Color Plate 86.) The shirt-like jackets with big patch pockets and wide collars were unconstructed—without the lining and padding of tailored suit jackets. Some were cropped bolero style, but most were worn like an untucked shirt, often with an unfastened front. Flared trousers were of the same material as the jacket with

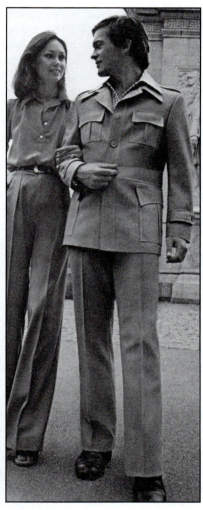

Figure 24-20. The leisure suit was a popular alternative to tailored sports jackets in the 1970s. Variations included the vest suit for young men and styles with oversized patch pockets based on the safari coat. Left, tweed vest suit with matching overcoat by Jon Jolcin, 1970; right, polyester double knit leisure suit by John Hampton, 1975.

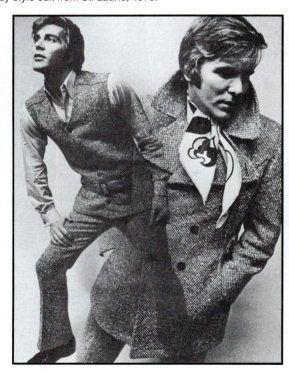

sharp, permanently creased edges and, often, detailing that matched the tops such as contrast top stitching or buttoned pocket flaps. A variation of the leisure suit for young men was the vest suit, featuring a variety of long, sleeveless tunic-like jackets, usually belted. The vest suit was worn with a colorful print or vibrant hued shirt with a wide pointed collar either open throated or with a broad necktie. Ethnic varieties of the 1970s leisure suit were some of the most imaginative styles of the decade. Inspired by so-called "blaxploitation" movies like *Shaft* (1971) and *Superfly* (1972), African-American men expressed their urban modernity in smoothly fitted polyester suits that blended vivid colors and textile patterns with a mixed styling of historic details such as Napoleonic collars, pagoda shoulderlines, pelerines, frock coat lengths, and gathered Renaissance sleeves.

At the end of the 1970s, the idiom of the classic male suit underwent a profound reworking that set the path for men's suit and sports jacket design ever since. The new look came not from London, Paris, or New York, but from Italy, led by the innovative Giorgio Armani. With his first menswear collection in 1975, Armani revolutionized men's suit silhouettes. Through several iterations in subsequent years, Armani deconstructed the rigidly shaped Gatsby jackets by removing padding and shifting proportions. Lapels were elongated and buttons pushed low for a longer, leaner look. Jackets were cut with a plenitude of drapery that fell fluidly from natural shoulders and glided with the wearer as he moved. The Armani suit redefined masculinity with a nonchalance and sensuality that culminated in the styles he created for Richard Gere in *American Gigolo* (1980).

As men's tailored suits evolved during the sixties and seventies, eveningwear kept pace with the dynamic shifts in style. The straightline Ivy League tuxedo was replaced by the English cut with its lightly padded shoulderline, wider lapels, and slightly flared skirt. In the second half of the sixties, though, richly colored and patterned versions were alternatives to the black-and-white penguin tradition in formalwear. (Figure 24-21.) An elegant Edwardian opulence was revived in the sumptuous jeweltone velvets and brocades of jackets and in the frilly jabot-front shirts. At the same time, modernism further eroded convention when sophisticated men appeared at formal events dressed in embroidered silk or velvet Nehru suits. In the 1970s, the Gatsby look inspired a return of the traditional black mohair dinner jacket, now updated with a broad expanse of peaked satin lapels spreading across the shoulders. Enormous butterfly bow ties and ruffled front shirts were the legacy of the Edwardian revivalisms of the previous decade.

As in the 1950s, men's sportswear of the sixties and seventies was widely diverse. Knit and woven sports shirts were designed with all sorts of collar, sleeve, and pocket treatments. Shirt jackets were cut with straight hems and vented sides so as not to resemble the careless appearance of an untucked shirt. Sports shirts in the early 1960s had continued the vivid prints and colors of the fifties. New additions to the fabric maker's repertoire were international motifs and patterns taken from Aztec, Persian, American Indian, East Indian, and Asian traditions. Paisleys especially were hugely popular.

The Peacock Revolution first made inroads into American culture in the second half of the 1960s with the hippies. Young men wishing to express their rebellion against the staid conventionality of their elders found the ideal solution in flamboyant clothing that their parents viewed with alarm as effeminate or homosexual. (Figure 24-22 and Color Plates 70 and 84.) Shirts in paisley or flower power prints, fringed jackets and vests, embroidered ponchos, tight jeans, bell bottomed hiphuggers, kaftans, beaded headbands, brightly colored scarves and bandanas, love bead necklaces, and painted sandals were all assembled into a hodgepodge tapestry of pattern, texture, and color that expressed the personal style of the wearer. Portions of the American flag were used as patches on ragged jeans and jackets as a visual protest against the Vietnam War or social injustices. Tie-dyed everything replicated the psychedelic, color-blended LSD trip that many young people experienced while listening to the Beatles' *Lucy in the Sky with Diamonds*. Unpleated pants retained the trim cut of the fifties but became increasingly slimmer in the second half of the decade with straight-leg cuffs at a narrow seventeen inches.

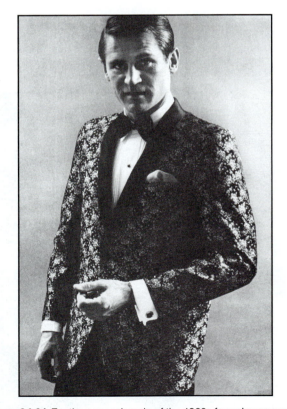

Figure 24-21. For the peacock male of the 1960s formalwear was enriched with opulent fabrics and vivid hues. Shawl collar floral silk brocade dinner jacket from First Nighters Formalwear, 1968.

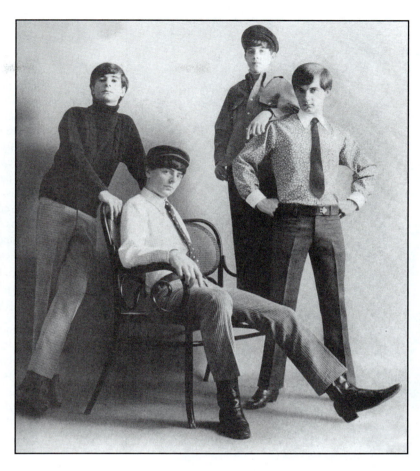

Figure 24-22. The mod looks in menswear of the 1960s were a frontal assault on the conventions of masculine dress. Young men donned flowered shirts, vividly hued jackets, tight hiphuggers, and a colorful abundance of accessories. Hiphuggers and print shirts by London Gear accessorized with Nureyev caps and Chelsea boots, 1966.

The defiant, hip, antifashion style of the hippies coupled with the Carnaby Street looks of the rock and roll bands gradually filtered into ready-to-wear for the youthful masses to selectively adopt piecemeal—just enough to be a part of mod culture without appearing to wholly rebel. Bell bottom hiphuggers, colorful body shirts, commercially tie-dyed T-shirts, and the occasional Nehru top were fashion forward enough without seeming radical, especially when mixed with, and, hence, diluted by, the conventional khakis, Levis, oxford button-downs, and similar everyday clothes typical of most young men.

The styles of the peacock male continued to evolve into the early 1970s. Youthquake men had discovered that colorful plumage appealed to girls who saw in the hippie looks or the Carnaby Street modes a chic modernism that the ordinary boy-next-door lacked and the elders at home could not comprehend. In the 1970s, men's sportswear expanded the color and print palettes of previous years with adaptations of Op art patterns and art deco graphics in light, silky nylon fabrics. (Color Plate 88.) The popularity of glitter rock music inspired rhinestone studded T-shirts, casual jackets, and jeans. Reptile skin prints were applied to men's tops, pants, and accessories. New shirt styling included wide, pointed collars and stretch materials that molded to the youthful, slender torso. Shirts made with an "athletic" cut indicated side seams tapered to

fit snugly at the waist. "If you're fat and forty, forget it," advised an ad in 1971. (Color Plate 85.) In addition, shirts were worn open several buttons down the front to display a hairy chest—the epitome of machismo sexuality in the seventies—usually emphasized by chains and pendant necklaces.

Men's hiphugger pants in the early seventies were also cut to fit with a trim smoothness that emphasized the young physique. Despite the tight fit of trousers around the hips and thighs, pant legs became more varied. In addition to the usual straight leg cut, the bell bottoms were expanded into a wide assortment of dimensions, especially when high platform shoes became a trend. Most flared pants measured about twenty inches in circumference at the hem. At the extreme end were twenty-eight-inch elephant bells that were worn completely covering the shoes and dragging the ground. As a contrast to the skintight fit of hiphuggers, retro high-rise **baggies** were introduced in 1972. The fit, too, was still smooth about the hips but widened higher on the thigh and dropped to a wide, cuffed hem about twenty-two inches around. (Figure 24-23.) By mid-decade pleats reappeared with the new high-waist styles.

At the end of the 1970s, menswear lost much of its peacock flair. Natural fibers and earthtones replaced the vibrant hued nylon skins of early shirt styles. Shirt collars narrowed. A revival of the banded-collar shirt from pre-1920s styles

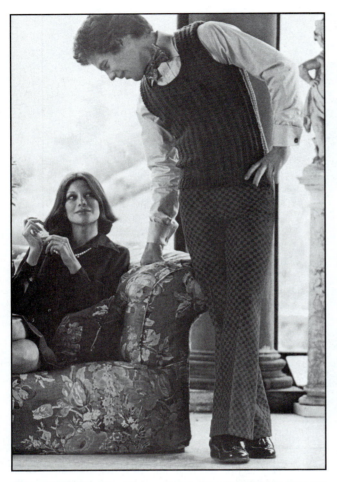

Figure 24-23. The seventies versions of the Oxford bags were produced in a wide assortment of colors and textile patterns. Baggies fit smoothly about the hips and widened from the thighs to the deep cuffs at the hem. Polyester double knit baggies by Williamson-Dickie, 1973.

(without the detachable spread collar) became a popular look for casual dress in 1977.

Since the late 1950s, the Italians dominated knitwear with innovative new shapes and detailing of sweaters and luxurious knit patterns like complex **intarsias**, meaning inlaid. Natural fiber knits reclaimed fashion status in the late 1970s. Cardigan-front sweater vests worn with sports jackets became favorite alternatives to the tailored three-piece business suit. Richly textured raw silk and Shetland cardigans and twinsets replaced the leisure suit for casual elegance. Different knit patterns were layered for a richness of contrasting textures. (Figure 24-24.)

Pants were cut fuller with a high waistband. The hiphugger and bell bottoms vanished. Pleats were on almost every type of pants from casual gabardine khakis to worsted suit trousers. Even jeans makers experimented with pleated varieties.

MEN'S SPORTS ATTIRE
AND OUTERWEAR 1960–1980

Vibrant color and bold patterns had become standards of golf apparel in the 1950s. Throughout the sixties and seventies, the big plaids and checks of shorts and trousers, and the combinations of colors like kelly green and pink or fire-engine red and yellow seen on fairways were often the punch line of many jokes. Nylon zipper jackets, also in brilliant hues, were constructed with a lightweight hood that could be rolled up and tucked into a snap or zipper pouch collar. Sweaters for golfing were capacious and long, some covering the hips. In the late sixties, trousers were made with a velcro-flap pocket for golf balls and a detachable terrycloth towel for drying wet equipment. Knit knickers reappeared for a few years into the early seventies, only trimmed down to a plus-twos fullness rather than the archaic plus-fours bagginess.

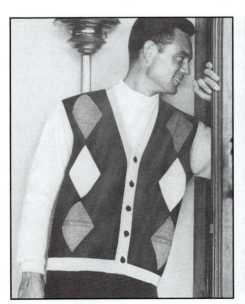

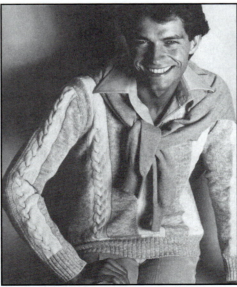

Figure 24-24. Knitwear of the 1960s and 1970s was dominated by Italian makers, which produced innovative new shapes and knit patterns for sweaters and accessories. Left, intarsia cardigan by Gino Paoli, 1966; right, layered sweaters by Valentino, 1976.

Tennis wear was more resistant to change than other sports attire. White shorts, white knit tops and sweaters, white socks, and white canvas top shoes remained the most common ensemble for exclusive tennis clubs. A hint of navy, hunter green, or maroon was acceptable as a collar stripe, for piping on shorts, or as a solid color for blazers. For the most part, except for the tighter fit and briefer, thigh-high cut of the shorts, the tennis outfit was basically that of the 1930s. At the end of the sixties, though, and especially throughout the seventies, tennis clothes exploded with color. (Figure 24-25.) Shorts and polo shirts in bold primary solids and stripes were fashionable on the court but not strong plaids or prints.

As the first baby boomers turned thirty in the mid-1970s, many men joined gyms and took up a variety of sports activities to keep trim and youthful looking. In response, men's ready-to-wear makers produced an endless assortment of active sportswear in easy-care cotton and synthetic blends. Among the most popular styles were short, tight-fitting shorts, often with side vents and piping worn with rib-knit tank or sleeveless muscle shirts. Warm-up suits of terrycloth or fleece were made in vivid colors to mix and match nonchalantly. (Color Plate 83.)

On the ski slopes of the early 1960s, fashion trends for men continued the nylon quilted parkas and jackets with form-fitting stretch pants that had developed in the late fifties. As with golfwear, color in skiwear and winter knits included such vibrant combinations as royal blue with orange or lime green. For the youthquake male, though, parkas in neon colored fake furs of Orlon pile were a fad of the mid-sixties. Another trend of the same time was Western-styled outfits made of tan stretch denim; leather and jeans jackets sported dropped V-cut yokes of contrasting colors or piped seams. Knickers were revived for several seasons into the 1970s, which were worn like their pre-World War II predecessors with boldly patterned knee high stockings. Through the latter part of the seventies, winter sport suits and hooded jumpsuits of nylon shells insulated with polyester fiberfill were lightweight and functional. Bib snowpants resembling overalls were cut with a deep U-front and narrow shoulder straps for greater freedom of upper torso movement.

The newest look for men's outerwear of the early 1960s was actually a fresh take on a fifties favorite—the raglan sleeve. Modified variations included the **split raglan**, which had a set-in sleeve effect in the front but diagonal raglan seams in the back. By the mid-sixties, the men's topcoat silhouette began to reflect the hemline changes in women's apparel. The **knee-breaker coat** was cropped at or slightly above the knees. (Figure 24-26.) Simultaneous with the shortened hemline, coats began to follow the shaped and fitted contours of the tailored suit. In the second half of the decade, men's coat lengths were adapted to the styles of women's outerwear. Some men's coats were cropped at mid-thigh, more resembling jackets than topcoats, while others were cut with the midi length below the knees and the ankle-length maxi.

The most popular style of the midi and maxi was the military greatcoat look with a double-breasted closure, large flap pockets, and wide Napoleonic collar. Nehru collars were also adapted to outerwear for a couple of years.

Of particular appeal were coats and jackets of leather, suede, or fur. Unlike the black leather-and-chain versions of the 1950s biker, the mod leather coats were in rich colors and finishes including suede and patent leather. A favorite variety of the hippies was the fringed cowboy jacket or long duster with dropped shoulder yokes inspired by the wardrobe choices of Texas native President Lyndon Johnson. Revivals of belted safari and Norfolk jackets in wide-wale corduroy or waterproof gabardine appeared in the late sixties.

Furs of all kinds, too, made a comeback with wealthier men in the 1965 to 1969 period after an absence since the 1920s. Fur enthusiasm ran the gamut from mink collars to full-length muskrat maxis. With the emergence of the ecological movement in the early 1970s, though, fur coats for men and women became less socially acceptable in industrialized nations. For a brief transitional period in the early 1970s, fun furs made of synthetic pile fabrics were widely promoted as substitutes for the real thing, but

Figure 24-25. By the 1970s traditional tennis whites were eclipsed by outfits in pastels and bold primary colors. Gant sportswear, 1973.

Figure 24-26. Coat hemlines remained at the knee-breaker length through the end of the seventies when lengths dropped below the knees. Left, knee-breaker trench coat in melton cloth from F.B.S., 1973; right, wool velour overcoat from St. Laurie, 1978.

the fakes matted and soiled easily. During the early seventies, coat lengths remained at just above the knee, but then dropped to mid-calf lengths in the second half of the decade. Trench coat styles, in both all-weather fabrics and heavy worsteds were the

most ubiquitous. Suburbans, peacoats, and similar fingertip-length coats retained the look of the fifties, only now made in durable synthetic materials.

MEN'S UNDERWEAR AND SWIMWEAR 1960–1980

The reduced silhouettes of underwear and swimwear that had developed at the end of the fifties became ever briefer during the youth-oriented 1960s. The low-rise hipster and bikini underwear complemented the trim contours of trousers, casual pants, and summer shorts. The white cotton brief, though, remained the best-selling style of underwear. (Figure 24-27.) Boxers were a more common undergarment for the older

Figure 24-27. Basic white briefs and print boxers remained the most prevalent masculine underwear styles of the period. Some peacock males, though, opted for the exhibitionism of underwear in revealing cuts and sheer, formfitting fabrics. Left, White cotton brief and T-shirt from Matador Mates, 1961; right, poly/cotton Elance bikini from Jockey, 1978.

Figure 24-28. As with underwear styles, new forms of men's swim suits of the 1960s and 1970s became exhibitionistic with ever briefer shapes and contouring materials. Most men, though, preferred traditional boxer styles. Color-block surfer jams; nylon knit bikini; belted, low-rise boxers; 1967.

Figure 24-29. New forms of sleepwear for men such as jumpsuits, kaftans, and pajama suits were designed to serve also as loungewear. Cabana caftan from McCall's Patterns, 1975.

businessman whose looser suit trousers could adequately conceal the excess volume of fabric.

On the beaches of Europe and the Caribbean, men indulged in an exhibitionism years ahead of American men. Hipster swimsuits, some belted to emphasize the low-rise line, and the tiniest of bikinis were made of formfitting nylon spandex and other synthetic knits. (Figure 24-28.) Despite these trends, though, the most common swimwear for men globally continued to be loose-fitting cotton or nylon shorts or, for teens, the baggy bermuda-length surfer jams in wild tropical or floral prints.

In the 1970s, the demarcations between the silhouettes, colors, and prints of fashion underwear and swimwear were confusingly blurred. In many cases, the only distinction was that underwear was made of more lightweight fabrics such as nylon tricot. In addition, the briefest forms of underwear that had developed in the 1960s became more mainstream in the 1970s as men discovered that women enjoyed the sexual objectification of the young male physique. (*Playgirl* made its debut in 1973 and completely sold out its first run of 600,000 copies.) During the disco era at the end of the decade, both underwear and swimwear were reduced to their barest essence with the string bikini and thong styles. Novelty underwear, a favorite Valentine's Day gift to men, featured screenprints of graphics or messages such as allover prints of lipstick kisses or licensed cartoon characters. For the man who wanted to do the Hustle or the Bump at the disco without his shirt tail coming lose, the **turtlesuit** was a one-piece, fitted body shirt with a snap closure pouch for the crotch—an abbreviated revival of the "tennis shirt" from the Edwardian era.

MEN'S SLEEPWEAR AND ACCESSORIES 1960–1980

Since the late nineteenth century, the varieties of fabric prints used in making men's pajamas and robes had always included a wide assortment of whimsical patterns and prints. During the sixties, the mod, psychedelic, and art deco revival

motifs were made even more intensely vivid by the new synthetic and permanent press fabrics. The pajama short set that had been popular as summer sleepwear for decades became the preferred year-round nighttime wear for young men in the second half of the sixties. Ensembles often included matching short sleeve top, boxers, and a kimono style robe cropped at the knees. At the same time, the sleepshirt made a comeback, only now shortened above the knees and often screen printed with bold graphical images or pop captions.

The line between sleepwear and loungewear became less distinct in the 1970s. Exotic kimonos and kaftans were not only sleepwear but also replaced the lounge robe for intimate evening social gatherings. (Figure 24-29.) Pajama suits were made with shirt tops, sometimes belted, in assorted prints with contrasting solid bottoms, and jumpsuits often featured elements of day clothing such as hiphugger styling and bell bottoms.

The protocol of the correct accessories for the well dressed man had already become a thing of the past by the mid-1960s. The Peacock Revolution dismantled the predictable traditions of masculine attire. The self-expressive fashion and personal style of the Carnaby look men and the hippies had a widespread influence on menswear conventions, including the finishing details of accessories. (Figure 24-30.)

Figure 24-30. Accessories were far more important to the peacock male than they had been to the post-World War II generation. The masculine wardrobe was expanded to include scarves, platform shoes, and a greater variety of jewelry. Hats ceased to be an essential part of men's dress.

Chelsea boots, 1965.

Square toe shoes, 1968.

Skinny ties from Wembley, 1962.

Wide necktie, ascot, and butterfly bow tie from Butterick Patterns, 1973.

Earth shoes, 1974.

Two-tone platform shoes from Italia, 1972.

Gatsby-inspired hat revivals from Stetson, 1976.

Men's jewelry, 1976.

Medallion necklace for Nehru jackets, 1968.

Wittnauer watch, 1975.

Prior to the Kennedy years, men regarded a hat as an essential part of correct dress. The young president, though, began to spell the end of the hatted gentleman since he seldom donned headwear of any kind, even in cold weather. In addition, young men began to grow their hair longer and fuller, an expression of youthful style they wished to display, not conceal beneath a hat. For those men who tenaciously clung to the tradition of headwear, the British influence dominated hat shapes of the early sixties. Crowns were tapered and narrow brims had deep rolls in the back and sides but only a slight turn-up at the front. Mod-look hats for young men included the Nureyev cap, a fashionable adaptation of the Soviet proletarian worker's hat named after the Russian ballet dancer who defected to the West in 1961 and was frequently photographed wearing the style. Despite the long hair of hippies, the flower child of the late sixties and early seventies often wore variations of floppy wide brimmed hats of felt, suede, or patchwork leather. In the 1970s, hats enjoyed a resurgence of sorts with the popularity of Gatsby revival looks. The snap brim fedora with a wide brim and wide hatband complemented the wide jacket lapels, big shirt collars, and broad ties.

The most important footwear news for men in the 1960s was the boot in all its variations. In the early part of the decade, **Chelsea boots**—short ankle boots with pointed toes, elastic side gussets, and Cuban heels—became a must-have for teenage boys when the Beatles wore them. The hippies adopted lace-up knee-high boots of soft suede or pliable, pieced leather, often trimmed with fringe around the top. Also a favorite of flower children were sandals, which were worn in cold weather with socks of wild patterns and colors. During the second half of the sixties, toes for both boots and traditional forms of footwear became squared. In the 1970s, men's footwear reached extremes not seen since the eighteenth century. High-heeled platform shoes and thick-soled wedges came in a variety of heights and thicknesses. A famous scene at the beginning of *Saturday Night Fever* featured a close-up of the high-heeled platforms worn by John Travolta as he strutted down the street to the music of the Bee Gees. At the opposite end of the spectrum were **Earth shoes**, or "negative heel" shoes, which were constructed with molded soles shaped with a lowered heel and elevated toe that, according to the ads, allowed the wearer to "walk in a gentle rolling motion." By the end of the decade, though, classic oxfords and loafers returned to dominance, especially designs from high-end branded makers like Gucci.

The skinny tie that complemented the Continental and Ivy League suits of the late fifties remained the most prevalent neckwear of the early 1960s. Ties gradually widened to about 3 1/2 inches at the point by mid-decade and then to as broad as 5 inches in the early 1970s. Coming full circle, suit ties modulated to around 2 1/2 inches wide by the late seventies and disco styles revived the 1 1/2-inch-wide skinny ties of the fifties. Vividly hued shirts and suits of the era were adorned with equally colorful neckwear. Floral prints in pinks, lavenders, and similar vibrant colors shattered the conventions of men's ties. In addition, Carnaby Street young men revived the ascot, also in the brightest shades. In the late sixties, American men wore adaptations of the ascot, called **Apache scarves**, tied around the neck with an open-throat collar or tucked under the collar and secured with an ornamental ring. Bow ties had largely vanished in the early 1960s—relegated to the image of the styleless professor or civil servant. With the fashion revival influences of movies like *Bonnie and Clyde* and, later, *The Great Gatsby,* huge butterfly bow ties were rediscovered.

The narrow range of gender-appropriate jewelry for men that had become standardized in the fifties was disregarded as young men, instead, slipped on multiple chain and cuff bracelets, necklaces of all kinds, and oversized rings. Costume jewelry pendants with flashy faux jewels or mystical emblems and sociopolitical symbols such as peace signs were the fashion accent for Nehru collar jackets and shirts. Hippies doubly expressed their social views with strings of handmade love beads that not only avowed their make-love-not-war philosophy, but also rejected the commercialism of mass-produced jewelry. In the 1970s, gold chain necklaces were important for sexual display as men unfastened their top shirt buttons to reveal hairy chests. The punks further broke masculine traditions by piercing their ears and wearing studs, hoops, and dangling chain earrings.

With the exception of long hair on men in the sixties, few cultural and fashion changes were as shocking to conventional men (and conventional women) as the man bag. The shoulder bag styles that first emerged in Europe in 1970 looked more like women's carry-on luggage or utility camera bags. Gradually, though, the practicality of the man bag became evident in the late 1970s. Pockets had been an effective solution for carrying a wallet, keys, comb, and excess change for decades, but the accouterment of the modern male was expanding far beyond the capacity of ordinary pants pockets. Address books, organizers, pocket calculators, pen sets, business card cases, manicure implements, hair brushes or picks, breath mints, and business receipts could all be effectively stored in a small, sectionalized shoulder bag. American men only began to carry shoulder bags and envelopes in the late 1970s when styles were made more to resemble business cases.

MEN'S GROOMING AND HAIRSTYLES 1960–1980

The youthquake of the 1960s sent powerful shockwaves through grooming and haircare businesses as well as the fashion industry. In droves, young men began to do the unthinkable; they grew their hair long. (Figure 24-31.) Since the Napoleonic era, long hair for men had been the peculiarity of eccentric musicians and symphony conductors (Leopold Stokowski), bohemian artists and aesthetes (Oscar Wilde), and "egg head"

Figure 24-31. As men began to grow their hair longer, traditional hair grooming tonics and oils were replaced by haircare regimens that included specialized shampoos, conditioners, and hairspray formulated for men. Sales of small, portable hair dryers surged as men bought handheld versions for home, travel, and the gym. Top left, varieties of men's long hair, The Who, 1969; top right, open shirt display of hairy-chested machismo, 1979; bottom left, Pantene men's haircare regimen, 1974.

scientists (Albert Einstein). Now, young men undermined the very foundation of gender-role social order by adopting hair lengths and styles that, for generations, had been exclusively women's. "Is that a boy or a girl?" queried the caption of a 1964 *Sunday Times Magazine* photo of a teen boy with long hair shot from the back. For hippies, long hair was an anti-establishment protest; for teenagers and collegiate young men, it was an affirmation of the youthquake generation.

As more men allowed their hair to grow long, two key industries keenly felt the impact. Hair oils suffered a significant drop in sales. Ads for shampoos in the late 1960s proclaimed "the wet head is dead." On the other hand, makers of hair dryers and styling implements enjoyed a boom. In addition, long hair required more specialized care than the neighborhood barber could provide. Just as the flapper had invaded men's barber shops in the 1920s, now men made appointments for shampoos and styling at beauty salons. By the 1970s, lines of men's haircare products included regimens of specialized

shampoos, conditioners, and hairspray. Mature men, too, responded to the youthquake obsession with hair and subjected themselves to hair dyes and even toupees to conceal the telltale signs of aging.

Facial hair also returned. Sideburns inched down to the earlobes in the early 1960s and finally to the jawline at the end of the decade. Mustaches became the symbol of machismo sexuality in the 1970s.

CHILDREN'S CLOTHING 1960–1980

Changes in infantswear were primarily in the application of the many new miracle fabrics developed during the 1960s and 1970s. Garments made of knit or woven blends of Orlon, acetate, acrylic, and nylon yarns were comfortable, durable, and easy to clean. Clothes in pink for girls and blue for boys continued to be best sellers although parents increasingly opted for gender-neutral colors and prints. In the seventies, U.S. consumer advocacy groups succeeded in getting federal regulations enacted that prohibited childrenswear from being treated with flame-retardant chemicals. Mass merchandising retailers like Sears and J. C. Penney placed disclaimers on garment tags and within the childrenswear sections of their catalogs to assure consumers that they were compliant with these regulations.

The snap-front coverall made of soft, stretch terrycloth remained the prevalent form of infantswear. (Figure 24-32.) The sleeved sleeping bag with its easy access zip front or drawstring bottom was the modern day equivalent of swaddling clothes although without the restrictive binding. For an outing, parents might dress their babies in sacque sets, which featured full, hip-length smock tops with matching snap-closure panties lined with moisture-repellent vinyl.

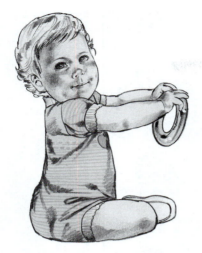

Figure 24-32. Stretch terry "sleep 'n play" coveralls continued to be the most popular form of safe, comfortable clothing for infants. Snap-front coveralls from Tiny World, 1965.

Just as in previous decades, girls' clothing of the 1960s and 1970s reflected the drama of women's fashions. (Figure 24-33.) The mod look of the 1960s translated easily into the diminutive girl's styles. Hemlines rose above the knees by mid-decade and to thigh-high in the late sixties. Textured and patterned tights matched knit tops and kept legs warm in chilly weather. Go-go boots were mass-produced in miniature sizes for school girls who wanted to emulate their teen

sisters. Psychedelic prints, art deco motifs, and vibrant neon colors abounded on all types of girlswear. As women increasingly adopted the pantsuit for business attire, girl's versions became acceptable for school. Peripheral trends for girls included ankle-length granny dresses in the sixties and midi-length skirts in the seventies.

Boyswear was similarly transformed in the 1960s. The Peacock Revolution in menswear inspired a transition of boys' attire from basic clothing into fashion during this period. (Figure 24-34 and Color Plate 79.) The ubiquitous short sets and short jumpsuits that had been the everyday year-round playwear for toddler boys since the 1920s were now reserved primarily for warm weather. Preschool boys, instead, more often dressed in long pants that replicated adult styles in miniature. Hiphugger bell bottoms of the sixties and polyester double knit trousers of the seventies were produced for boys in the same colors, textures, and prints as those of their teen brothers. Wild prints, particularly vividly colored paisleys and florals, were popular throughout both decades. Color blocked tops reflected the designs of men's space age looks. Scaled-down versions of the Nehru jacket, vest suit, and leisure suit were made in boys' sizes. In addition, as the baby boomers became parents, they dressed their children in the branded jeans and denim jackets they had preferred to wear as children. Stretch denim was introduced to childrenswear in the early seventies.

The television generation as young as preschool age was persuaded by advertising to demand certain types of clothing. Makers of licensed clothing advertised heavily on TV promoting their products and inculcating children with brand awareness and the notion of style. The colorful Muppets from

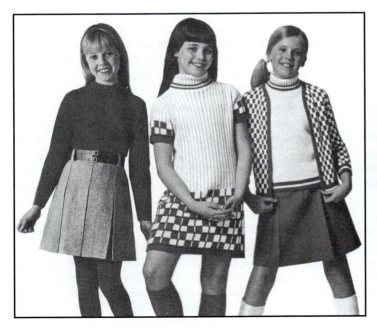

Figure 24-33. Girls' fashions of the 1960s and 1970s followed the trends of adult styles from miniskirts to pantsuits.

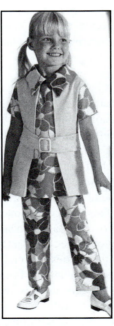

Flower power pant suit, 1970.

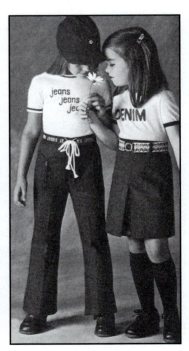

Denim skirts and jeans, 1978.

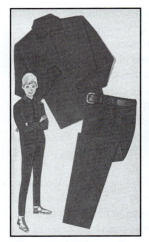

Space age pullover and hiphuggers, 1967.

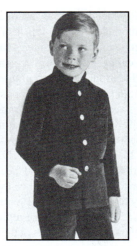

Corduroy Nehru suit, 1968.

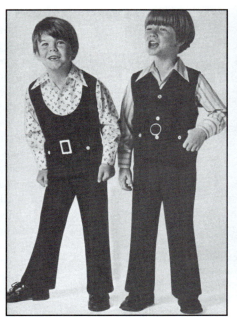

Polyester double knit vest suits, 1972.

Polyester three-piece suit, 1977.

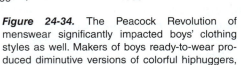

Figure 24-34. The Peacock Revolution of menswear significantly impacted boys' clothing styles as well. Makers of boys ready-to-wear produced diminutive versions of colorful hiphuggers, Nehru jackets, vest suits, and Gatsby suits.

Sesame Street became perennial favorites for everything from screenprinted T-shirts to appliqued tennis shoes. School-age boys and, to a lesser degree, girls as well, were swept up with images from the TV space fantasies *Star Trek* and *Lost in Space* in the 1960s and the blockbuster movie *Star Wars* in the 1970s. Comic book super heroes had never waned as favorite icons on clothing. Sleepwear and underwear sets imprinted with emblems and images to resemble the costumes of Superman, Spiderman, and Batman were hugely popular.

REVIEW

The 1960s was a decade of dramatic social and fashion change. As the baby boom generation came of age, they sought fashion looks that not only differentiated them from their elders but also was evocative of the modern, space age era. Swinging London became the hub of youthful mod fashions. Key to the new looks of youthquake women was the miniskirt with its above-the-knee hemline that climbed to thigh-high by mid-decade. Fashion fads that complemented the miniskirt included textured tights or catsuits, go-go boots, especially short white versions, and oversized pendant earrings. During the second half of the sixties, several revivalisms provided variety and excitement in fashion. Romantic Victoriana featured long granny dresses, wire-framed eyeglasses, and wide picture hats. Influences from movies included 1920s flapper looks, replete with dropped waist chemises and soft cloches, and thirties style skirts called midis with hemlines at mid-calf. Counterculture styles

of streetscene youth ranged from the pattern-mixed gypsy looks of the hippies to the protest ensembles of altered military garments and adaptations of American Indian dress.

In the early 1970s, the emphasis in women's fashion was on pants. As more women entered the corporate workplace, pantsuits became acceptable business attire. Varieties of pantsuits in opulent fabrics also were popular for eveningwear. Sophisticated styles of city trousers included culottes, gauchos, jodhpurs, and knickers. For casual wear, hiphuggers, baggies, and elephant bells were simultaneous options. Urban short shorts, called hot pants, were a brief trend.

In the second half of the seventies, all hemlines were below the knee, some almost at the ankles. The miniskirt vanished. Career women dressed for success in layered separates and tailored menswear suits. For night time play at the discos, skintight designer label jeans, tube tops, halter dresses, and any body-conscious fashions that glittered and shined under the dance floor strobe lights were requisites.

Men's fashions underwent an even more dramatic change with the Peacock Revolution of the 1960s. Decades of staid conformity in menswear were overthrown by young men who donned the mod styles of flowered shirts, slim hiphugger pants, and flamboyant accessories like ascots and psychedelic print ties. Suits were reshaped and vividly colored and patterned. The conventions of gender were further dismantled as men grew their hair long. For the hippie, dress was a statement of protest against society, commercialism, or events of the time. The "peacenik" flower child layered on love beads,

scarves, headbands, and fringed vests, belts, and boots; the militant dressed in altered military garments mixed with street clothes appliqued with the American flag or protest emblems.

In the early 1970s, a duality of men's suiting emerged. The demand for comfort led to the leisure suit with its unconstructed shirt-like jacket and sharply creased trousers of polyester double knits. Business attire, though, revived the look of the English drape cut of the Great Gatsby era. Casual clothes were refreshed with boldly colored Op art patterns and art deco motifs. Trousers came in a wider assortment of styles ranging from tight, hiphugger elephant bells to highrise, cuffed baggies.

In the second half of the decade, Italian suit styles dominated menswear. Padding was removed and proportions were shifted for a more fluid, sensual fit. The peacock flair subsided in favor of subdued earthtone colors and natural fibers.

Children's clothing reflected the trends of adult styles. Girls wore miniskirts, mod pantsuits, flower power accessories, and go-go boots. Boys donned Nehru jackets, paisley print shirts, hiphuggers, Chelsea boots, and Nureyev caps.

Chapter 24 The Twentieth Century: 1960–1980
Questions

1. Describe women's mod looks of the mid-1960s including accessories.

2. Which three contemporary American art movements of the 1960s influenced fashions and how?

3. What were four key revivals of women's fashions in the 1960s? Describe the modern adaptations inspired by them.

4. Which social changes in the early 1970s led to a fashion emphasis on pant styles for women? Identify and describe three varieties of women's pantsuits popular in the early seventies.

5. How did mainstream women's fashions change in the second half of the 1970s? What book influenced fashions for the career woman and how?

6. Where is Carnaby Street and what was its influence on men's fashions in the 1960s?

7. What was the Peacock Revolution? How did it transform men's fashion and masculine style?

8. Compare and contrast the Gatsby men's suit of the early 1970s with the Italian deconstructed styles at the end of the decade.

Chapter 24 The Twentieth Century: 1960–1980
Research and Portfolio Projects

Research:

1. Write a research paper on how the revitalization of the women's movement in the 1960s and 1970s impacted the traditional ideals of beauty and fashion. Examine how the ready-to-wear industry focused on fashions for the new career woman.

2. Write a research paper on the space age designers of the 1960s. Explore the influences of technology on the cut and line of their designs. Include details of the designers' use of nontraditonal textiles and materials.

Portfolio:

1. Research movies of the 1960s and 1970s that influenced mainstream fashions of the era. Compile a reference guide with a photocopy or digital scan of a period costume featured in the movie on one page and a corresponding fashion adaptation on the facing page. Write a description of each outfit including the name of the film, costume designer, and date for the movie, and the name of the maker or designer and date of the fashion adaptation.

2. Compile a swatch book of textiles influenced by Pop, Op, and Kinetic art from the era. Make color photocopies or digital scans for the swatches from bound periodicals or books. Write a description of each textile design identifying the art style of influence and its characteristics.

Glossary of Dress Terms

afro: full, bushy hair cut worn by African-American men and women.

Apache scarf: American adaptations of the ascot worn by men in the late 1960s

baggies: men's and women's high-waisted trousers with wide legs

beehive hairstyle: high, cylindrical arrangement of long hair popular in the mid-1960s

bell bottoms: pants that flare at the bottom of the legs

body stocking: long sleeve, one-piece knit suit; also called a catsuit

Carnaby Street looks: young men's mod styles of the 1960s that included vividly colored shirts, tight hiphugger pants, and brightly hued ascots, scarves, and neckties; named for the shopping district in London's Soho section

catsuit: see body stocking

Chelsea boots: men's short ankle boots with pointed toes, elastic side gussets, and Cuban heels

crepeset: permanently textured or crimped monofilament nylon fabric

dashiki: long, T-cut tunics made of kente cloth or fabrics evocative of African heritage

dressing-gown coat: women's wrap coats of the 1970s

duvet coat: women's oversized quilted jacket or coat of the late seventies

Earth shoes: "negative heel" styles of low shoes made with molded soles shaped with lowered heel and elevated toes; popular briefly in the early 1970s

elephant bells: women's and men's pants of the early 1970s that fit snugly about the hips and thighs but flared into enormous bell shapes over the feet

flamenco pants: women's pants of the mid-1960s with a low-rise waistline and flared legs below the knees; a precursor to bell bottom hiphuggers

folklorica: women's fashions and accessories of the late 1970s that featured peasant or folk art motifs and decorative embellishments

Gatsby suit: men's suit styles of the mid-1970s with jackets that were padded and shaped in the style of the English drape cut of the 1930s

gauchos: midi length versions of culottes

glam or glitter rock styles: androgynous looks of the early 1970s that included sequined or rhinestone studded tops and pants, platform shoes, and feathery haircuts of both women and men

go-go boots: any of a variety of boots of the 1960s but usually the short white styles with flat heels and wide uppers; named for the wild go-go dancing of the period

granny dress: ankle-length calico dress often made with Victorian details such as high collars, puffed sleeves, and ruffled hemlines

headwrap: meticulously arranged fabric headdress resembling styles worn by European and American black women in tribute to their African heritage

hiphuggers: men's and women's pants cut with a low waistline that fit tightly about the hips

hot pants: city short shorts of the early 1970s often made of upscale materials

intarsias: Italian word meaning inlaid applied to multicolored knitwear patterns that appear to have inset panels

Kevlar: aramid fiber used in protective clothing as "soft body armor"

kimono trousers: women's baggy, Japanese-inspired trousers resembling harem pants

knee-breaker coat: men's outerwear of the 1960s and early 1970s cropped at or slightly above the knees

leisure suit: casual menswear of the early 1970s that featured shirt like jackets with wide collars and matching trousers, usually of polyester double knits or stretch denim

Mao collar: the French term for the rounded stand-up collar on men's jackets and shirts of the late 1960s; named for Chinese Communist leader Mao Tse-tung

maxi: a skirt or coat with a hemline near or to the ankles

midi: a skirt or coat with a hemline at mid-calf

milkmaidism: the English term applied to women's Victoriana revivals in the 1960s

miniskirt: dress or skirt with a hemline above the knees

mod looks: short for "modern" or "modernist" fashions for women and men of the 1960s

Nehru jacket: menswear style of the late 1960s that featured a tunic-style jacket with a rounded stand-up collar; named for Indian prime minister Jawaharlal Nehru

Nureyev cap: Russian worker's cap with short visor and wide headband; named for ballet dancer Rudolf Nureyev

palazzo pajamas: women's wide-legged evening pants

pantyhose: seamless, one-piece knit hose combining stockings and panty introduced in the mid-1960s

Peacock Revolution: the hedonistic changes in menswear of the 1960s in which men adopted colorful clothes and styles that broke with conventional masculine dress

permanent press: treated fabrics that resist wrinkling introduced in 1964

punk look: the self-styled looks of disaffected youths of the mid seventies such as clothes and accessories slashed and pinned together or embellished with images and found objects that could create shock value

Qiana: Du Pont synthetic silk introduced in 1968

Sergeant Pepper suits: menswear of the mid-1960s that blended a form of Edwardian dandyism with psychedelic patterned fabrics and color combinations; named for the costumes of the mythical band in the Beatles' *Yellow Submarine*

space age style: sleek, minimalist women's and men's fashions of the mid-1960s with clean, smooth lines and simple shapes

split raglan coat: men's outerwear with sleeves that featured a set-in effect in the front but diagonal raglan seams in the back

turtlesuit: men's one-piece, fitted body shirt with a snap closure pouch at the crotch

Union Jack jacket: mod sports coat constructed with red, white, and blue panels stitched together to resemble the British flag

velcro: nylon strips of material with a filament nap of hooks that hold fast when pressed together

vest suit: a women's or men's long, sleeveless top with matching trousers or skirt popular in the early 1970s

Victoriana: clothing and accessories that featured revivalisms from the age of Queen Victoria (1837–1901)

Chapter 25

THE TWENTIETH CENTURY: 1980–PRESENT

First Space Shuttle flight 1981	First artificial heart transplant 1982	Apple introduced the Macintosh computer 1984	Gorbachev became Soviet premier 1985	Statue of Liberty Centennial 1986	U.S.-Soviet INF Treaty to reduce nuclear arsenals 1987	Poland, Bulgaria, Hungary, East Germany, Czechoslovakia, Rumania ousted Communist rule 1989
AIDS virus identified 1981	Michael Jackson's *Thriller* 1983			U.S. stock market crash 1986		
Iraq-Iran War, 1980–1988	Debut of MTV 1981	Madonna's *Like a Virgin* 1984				

1980 1990

Nelson Mandela freed from prison 1990	U.S.-Iraq Persian Gulf War 1991	Balkan Wars 1992–1999	Israeli-Palestinian Peace Accord 1993	Apartheid ended in South Africa 1994	Dolly the sheep cloned 1997	Y2K global computer conversions 2000	U.S-Iraq War began 2003
East and West Germany reunited 1990	Launch of World Wide Web 1991	First McDonald's in China 1992	Spielberg's *Jurassic Park* 1993		Britain's Princess Diana killed in auto crash 1997	Terrorists destroy New York World Trade Center 2001	Barak Obama elected first African-American U.S. President 2009

1990 Present

THE END OF THE COLD WAR

In the four decades following the end of World War II, global politics were dominated by the Cold War—an ideological conflict between capitalist nations led by the United States versus the Soviet Union with its communist allies. During this period, the efforts of the United States to oppose the expansion of communism by military action had lead to the stalemate of the Korean War and the quagmire of the Vietnam War. By the 1970s, such costs had compelled President Nixon to seek friendlier relations with the Soviets—a relaxing of tensions called detente.

However, when Ronald Reagan took office as president in 1981, the Cold War was reignited by the "Reagan Doctrine" of aggressively containing communism worldwide. His administration initiated a massive arms race with the Soviets, including a plan for a space-based, computer controlled program referred to as "Star Wars" that was not only impossible to build but threatened to destabilize the fragile mutual deterrence.

When reformer Mikhail Gorbachev became Soviet Premier in 1985, he advocated two key policies: *glasnost,* the Russian word for openness, and *perestroika,* meaning economic restructuring. Among the first steps toward glasnost was a series of arms summits with Reagan. Much to the chagrin of the president's hawkish administration and Soviet hard-line bureaucrats, Reagan and Gorbachev signed the 1987 INF (Intermediate Nuclear Forces) Treaty to reduce missile arsenals.

Gorbachev's many internal reforms had a more far-reaching impact than even he could have foreseen. When he publicly denounced the Stalin regime, Soviet citizens dared to experience the freedom to dissent. Most important of all, though, in 1989, when Gorbachev announced that the Soviet Union would no longer prop up the communist leaderships of the east European satellite states, the power structures within those countries collapsed. In that one year, communist governments were ousted in Poland, Bulgaria, Hungary, East Germany, Czechoslovakia, and

Rumania. Perhaps the most poignant symbol of the "Year of Miracles" was the toppling of the Berlin wall.

In the Middle East, turmoil continued as Iraq and Iran went to war in 1980 over ownership of adjoining oil-rich territories. In 1982, Israel invaded Lebanon against the Palestine Liberation Organization (PLO). As retaliation for U.S. support of Israel, Islamic terrorists bombed the American embassy and Marine headquarters in Beirut killing more than 300. Because of the instability of the region, OPEC struggled to maintain oil prices, which negatively affected global economies of the 1980s.

In Asia, China marked the thirty-fifth anniversary of its communist regime in 1984 by announcing a move toward capitalism in which some state-owned enterprises were permitted to set prices according to supply and demand in the market. Japan became a world economic power through aggressive competition in manufacturing, particularly autos and electronics.

In the United States, the 1980s was the Reagan era. The American people wanted to believe the Reagan campaign slogans of a new "morning in America"—promises of a renewed prosperity following the failed economic policies of the Ford and Carter administrations, a reestablishment of U.S. preeminence in the world arena after the hostage stand-off in Iran, and a revitalization of the presidency after the scandals of Nixon and Ford (who was tainted by his pardon of Nixon).

Reagan had become the standard bearer for the Republican base of conservatives in the 1960s and 1970s. He projected a personable style and a confidence in the nation's destiny that was reassuring to many Americans. He was highly effective in shaping broad themes for his administration and keeping staffers focused on them. Reagan's view of the economy was grounded in a laissez-faire "supply-side" theory in which drastic reductions in federal spending coupled with tax cuts for the wealthy would increase investment in productive enterprises, thus creating new jobs and economic growth. Despite doubling the national debt, this plan, often labeled Reaganomics, gradually led to an economic recovery by mid-decade. But the "trickle-down" benefit to middle and lower income families had not occurred. At the end of Reagan's second term, one in five Americans was living in poverty, a twenty-four percent increase during Reagan's eight years in office.

Also under Reagan's aegis, a New Right came of age in the 1980s. With open support by the administration, a conservative coalition of unlikely allies flourished: libertarians who wanted to dismantle government and slash taxes; social arch-conservatives who pushed an agenda of antiabortion, anti-ERA, antiwelfare, antigay, and antiaffirmative action issues; and militant Christian groups who demanded school prayer, book bans, and an end to sex education. On the national level, the women's Equal Rights Amendment (ERA) was defeated; on the state and local level, countless legislative acts chipped away at access to abortion, affirmative-action policies, and equal protection regulations.

One of the most notable societal products of the decade was the yuppie (young urban professional) whose self-absorption and obsession with financial success became the new work ethic. "Greed is good," evangelized the protagonist in the 1987 movie *Wall Street*. The yuppies drove themselves hard to make money quickly and to buy the most expensive material goods to reflect their achievements. Madonna's song *Material Girl* became an anthem of the era.

In technology, the IBM personal computer made its debut in 1981, and three years later came the revolutionary graphical interface of Apple. Sophisticated video games, both for home and the mall arcade, became the entertainment of choice for all new-agers.

Also in 1981, a pernicious virus was identified as the cause of the Acquired Immunodeficiency Syndrome, or AIDS—a pandemic disease for which no cure could be found. The epidemic spread through unprotected sexual contact, use of infected needles by drug addicts, contaminated blood transfusion, or from mother to unborn child. Among the top fashion designers who died of AIDS were Halston, Perry Ellis, and Willi Smith.

Emerging from the shadow of Reagan, his vice president, George H. Bush, became president in 1989. Although the free world celebrated the collapse of communism and the end of the Cold War, Bush was low-key about the dramatic events to avoid any perception of the United States gloating.

Only a year later, though, in the summer of 1990, Iraq invaded neighboring Kuwait in an attempt to gain more control of oil reserves. Over the following few months, Bush assembled a coalition of 30 nations to intervene. In January 1991, Operation Desert Storm was launched and the Persian Gulf War commenced. Though successful in liberating Kuwait, Bush was criticized for not continuing on to Baghdad and capturing the dictator Saddam Hussein.

Despite the high approval ratings Bush enjoyed for his foreign policy leadership, on the home front, his administration struggled with the aftermath of Reaganomics and the resulting recession. In the 1991 campaign war room of the Democrats, a handwritten poster read, "It's the economy, stupid." The voters agreed and Bush lost his bid for reelection.

THE DIGITIZED 1990S AND A NEW MILLENNIUM

As the 1990s opened, "the iron curtain rusted and flaked away," wrote journalist Mort Rosenblum. The Soviet Union had dissolved into fifteen independent republics. The former Warsaw Pact nations of central Europe continued to struggle stoically with a conversion to democratic self-government and to a free market economy. East and West Germany reunited. After the dissolution of Yugoslavia into six separate countries in 1992, the Balkans erupted into a war of "ethnic cleansing," in which hundreds of thousands of Muslims were killed in a genocide purge. Through the intervention of NATO led by the United States, peace was restored, and Serbian military leaders were brought before a war crimes tribunal.

The Internet

In science and technology of the 1990s, the United States—and the world—became increasingly digitized. Between 1990 and 2005, U.S. households with a home computer had leapt from 15% to almost 80%. The World Wide Web became the "information superhighway" with its e-mail, cyber chat rooms, and millions of Web site pages. The number of online retailers and service businesses, called "dot-coms" after the period ("dot") and domain name ("com") of their Web addresses, was explosive. (Figure 25-1.) All categories and price ranges of fashion were instantaneously accessible around the globe.

In the new millennium, the Internet continued to gain ground over bricks-and-mortar retail operations as the destination for shoppers. According to Forrester Research, Internet users worldwide spent $172 billion online in 2005, and continued growth was projected to leap to $329 billion by 2010. All major retailers had robust Web stores with extensive merchandise catalogs. E-commerce shopping malls gathered these Web stores together into one portal under an affiliates program in which they received a percentage of every purchase made at the e-tailer from the mall's visitors. Browser search engine marketing and e-mail programs enticed savvy Web users to the online malls with loyalty rewards programs and discount offers. Where, for decades, the day after Thanksgiving was called Black Friday (the busiest shopping day of the year in which sales for many retailers put their balance sheets into a profitable black vs. negative red), the Monday after the holiday became known as Cyber Monday during which millions of office workers continued their weekend of shopping online from their desks. In just ten years, the Internet had evolved from a communications and product information tool of business to a multibillion-dollar retail enterprise globally.

Figure 25-1. By the beginning of the new millennium, the Internet had made fashion easily accessible worldwide. From the comfort of their homes consumers could shop online malls for all their favorite retailers. Ad for fashionmall.com, 2000.

Other historic events of the 1990s included two peace accords signed by Israel and the Palestine Liberation Organization in 1993 outlining areas of agreement and a timeline for resolving issues. But two years later, a Jewish religious fanatic assassinated Israeli leader Yitzak Rabin, effectively derailing the plan and setting off years of further violence in the region. In South Africa, apartheid ended with the enfranchisement of blacks in 1994.

The 1992 U.S. election sent Democrat Bill Clinton to the White House. Clinton's economic plans disproved the premise of Reaganonics and, in spite of tax increases and governmental expansion, the U.S. economy was the most robust in thirty years. The national debt was even eliminated. During Clinton's second term, though, a sex scandal involving the president led to an impeachment effort spearheaded by Congressional Republicans. In the end, the Senate voted not to remove Clinton from office.

The election of 2000 was one of the most contentious and divisive in decades. For weeks after election day, the results were inconclusive whether Vice President Al Gore or former Texas governor George W. Bush was duly elected. Although Gore had received 500,000 more popular votes than Bush, neither candidate had received the requisite number of electoral college votes. As ballots were recounted by hand in Florida, whose electoral votes would determine the outcome, the U.S. Supreme Court intervened with a decision that favored Bush.

On September 11 the following year, a group of Muslim terrorists highjacked U.S. planes, crashing them into the Pentagon and the New York World Trade Center killing thousands. The Bush administration immediately launched military action against terrorist organizations by invading Afghanistan and destroying the bases and support of such groups. In 2003, the Bush administration expanded its military objectives in the region by invading Iraq to depose the regime of Saddam Hussein.

Despite the unpopularity of the president and a bitterly polarized electorate, Bush was narrowly reelected in 2004. His second term was defined by the prolonged war in Afghanistan and a U.S. military occupation of Iraq. In addition, he instituted a Reaganesque tax cut for the wealthy and implemented deregulation policies that led to a financial crisis and a stock market crash in 2008, which many viewed as the worst since 1929.

In the presidential election of 2008, a record 132 million Americans went to the polls, electing Barack Obama, the first African-American President of the United States. "Change has come to America," Obama declared in his election night speech. Although Obama was sent to the White House on the promise of a fresh direction for the nation, the new president first had to deal with significant unfinished business left by

the Bush administration including a deep recession, a trillion-dollar deficit, a financial crisis on Wall Street, the highest unemployment in thirty years, and the costly wars in Iraq and Afghanistan.

In the world of science, cloning became a hot topic of debate in 1997 when researchers in Scotland cloned a lamb named Dolly from a single cell of an adult sheep. In 2001, the Human Genome Project completed mapping all 30,000 genes in human DNA with the aid of super computers. The twenty-first century dawned with the promise of technologies that could aid in the diagnosis and therapy of human disease.

Despite such dramatic advances in science and technology, social issues in America almost seemed to be regressive in some respects. High-profile cases of racism and gender-bias repeatedly made national headlines. Yet in spite of the nation's crisis of conscience on race and gender, ethnic Americans and women made significant achievements. Tiger Woods became the youngest golfer ever to win the Masters Tournament. Michael Jordan led the Chicago Bulls to six National Basketball Association titles. Venus Williams won her first Grand Slam at Wimbledon in 2000. Madeleine Albright became the first female U.S. Secretary of State, and Janet Reno became the first female Attorney General. Ruth Bader Ginsburg joined the Supreme Court as a Clinton-appointed justice. Condoleezza Rice was at the forefront of the Bush administration's security council during the 2003 U.S.-Iraqi War, and in 2005, became U.S. Secretary of State. And in 2009, Barack Obama became the 44th President of the United States.

On other social fronts, the gay community made headway in its efforts for equal rights. In 2003, the U.S. Supreme Court reversed its 1986 ruling that had allowed states to criminalize acts of intimacy between consenting same-sex adults in the privacy of the home. Hate-crime laws were broadened to include acts against gays. Major corporations such as Disney and Xerox extended benefits to same-sex domestic partners. Massachusetts and Connecticut were the first states to grant same sex marriage rights.

In U.S. pop culture, electronic gadgets for both business and personal use proliferated. By the start of the new millennium, pagers, cell phones, digital cameras, hand-held video games, personal digital assistants (PDAs), and laptops were everywhere. The Internet evolved from an informational tool with limited capabilities into an electronic universe of communications, marketing, and sales. Digitized special effects were big box office for movies such as *Jurassic Park, Titanic,* and *Harry Potter.* Popular music since 1990 was a mix of the teen pop of boy's groups, Latin pop of Ricky Martin, crossover country of Faith Hill, grunge, gangsta rap, and hip-hop. TV hits seemed to suggest a dysfunctional modern society as depicted in long-running programs like *The Simpsons, Seinfeld, NYPD Blue,* and cable series like the *Sopranos* and *Sex and the City.* In the early 2000s, reality TV programming captured top ratings with staged competitions pitting ordinary people against each other, and updated versions of the landmark 1973 PBS documentary *An American Family,* in which cameras intruded into the daily lives of households.

THE BUSINESS OF FASHION

Since the 1970s, fashion has become increasingly pluralistic—many widely diverse styles, silhouettes, and branded labels in each wardrobe. Personal style became a catch phrase used incessantly by fashion marketers, meaning an individual's look of the moment to suit one's mood or a total lifestyle look. Ready-to-wear makers focused on producing clothing for niche consumer groups whose preferences ranged from safe "classics" of style represented by a continuum of standardized garments like polo shirts, cableknit sweaters, chinos, and trench coats to the antifashion tribalist looks of punk, goth, grunge, and hiphop, among others. In the modern industrialized societies of today, writes Anne Hollander, "fashion has claimed its place in a new mutable optical world where no one view of anything is acknowledged to be the true one... Everyone is essentially talking to himself, like a poet.... Designers merely provide the vocabulary." From this pluralism of postmodern fashion developed specialized marketing strategies and economies for the designer, manufacturer, and retailer.

As noted in the previous chapter, couture did not vanish in the wake of the social revolution of the 1960s despite dire predictions by the fashion pundits. The adaptation of ready-to-wear programs (prêt-a-porter) by the top names in couture ensured economic stability for the house while allowing the seasonal couture collections to demonstrate the designer's creativity and innovation. Logo branding became a key component in the marketing strategy of major design labels. (Color Plate 94.) With this shift to a pluralism of fashion trends and away from the supremacy of haute couture as style-setter, two divergent approaches developed for designing clothes. For classicists like Giorgio Armani and Ralph Lauren, the design objective was a perfection of existing styles, not unlike the preoccupation with correct dress of the nineteenth-century dandies. The other perspective was inventive and capricious, such as the avant-garde designs of Vivienne Westwood, Jean-Paul Gaultier, and Thierry Mugler. "What I am trying to say with extravagant clothes is that everything is possible," asserted Mugler in 1998. "I create clothes women will wear in imaginary adventures." Some exceptional designers such as Gianni Versace and John Galliano succeeded in creating both—fantasy fashion that extended a wider name recognition for the label and real-world styles that achieved mass appeal.

The merchandising of fashion in the last couple of decades primarily has expanded upon marketing tactics first developed in the early twentieth century. Licensed products peripheral to the designer's apparel collections—particularly accessories, lingerie, and fragrances—added substantial income to the house accounts as well as broadened brand recognition. Designer name awareness percolated through the socioeconomic

strata to the middle and working classes through advertising and logo branding. Large retailers expanded upon the 1950s idea of boutique floorsets to attract niche consumers who shopped for certain styles or specific designer labels. Visual merchandising was tailored to those specialty shoppers, even at the cost of a cohesive look of the store as a whole. Outlet malls and off-price retailers provided opportunities for a mass market to indulge in high style with designer labels at a discount.

Among other marketing strategies of fashion makers and retailers was the sophisticated use of demographics for defining and targeting customers. By the mid-1980s, the baby boomers—75 million individuals born in the United States between 1946 and 1964—all were over the age of thirty; in 2006, the first boomers turned sixty. As such a large segment of the population aged, clothing preferences and needs changed considerably. By the beginning of the new millennium, more than one-third of Americans were overweight. In response to these changing demographics, clothing makers extended product lines to include large size fashions constructed with contours, fabrics, and details that suited the fuller figure. (Figure 25-2.) Similarly, businesses relaxed dress codes and allowed casual Fridays or business casual attire everyday. The boomer who

grew up wearing jeans and sportswear abandoned tailored dresses and suits for a wider variety of comfortable, casual clothes. Apparel makers modified traditional cuts of garments and produced "relaxed-fit" versions. Stretch fabrics were adapted to jeans, jackets, trousers, and other forms of rigidly constructed garments. At the other end of the spectrum, stretch velvet and similar hybrids of "noble" materials (silk, linen, and wool) inspired designers to create body-conscious fashions for the fitness-obsessed consumer. Fine gauge microfibers and other high-tech materials made of synthetics and blends were applied to virtually all categories of clothing from daytime wear to eveningwear.

In the new millennium, the male as fashion consumer became known as a **metrosexual**, who according to cultural author David Coad, is a young, urban man for whom "attention to appearance and self-care are central...shopping for clothes, accessorizing, and using body products." Numerous style guides were published in the early 2000s advising the metrosexual on fashion and taste. The media's favorite metrosexual was the British soccer star David Beckham, whose personal look included varying hairstyles, earrings, nail polish, sarongs, and bikini swimwear. (Figure 25-3.)

Figure 25-2. Clothing makers responded to the changing demographics of the market by extending product lines to include well-made and stylish fashions for large size women. Lane Bryant fashion show, 2001.

Figure 25-3. In the new millennium, the male as fashion consumer became known as a metrosexual. He enjoyed shopping for clothes and enhancing his personal appearance with gym memberships and body care products. Photo of the quintessential metrosexual David Beckham as Captain of Manchester United soccer team, 2003.

WOMEN'S FASHIONS OF THE 1980s

The 1980s are often viewed as a New Gilded Age, comparable to the original Gilded Age of the 1880s during which robber barons of the Industrial Revolution became immensely wealthy and flaunted their status in opulent displays of grandiose mansions, magnificent collections of art and antique treasures, and lavish dress. As with their nineteenth-century predecessors, the affluent of the 1980s unashamedly indulged in opulence, ostentation, and materialistic exhibitionism. Conspicuous consumption became the social norm. "You can have it all!" proclaimed a bold banner headline in the 1985 ad campaign from Anheuser-Bush. Armani suits, Gucci footwear, Rolex watches, and Lacroix evening gowns were more than status symbols for the yuppie, they were badges of achievement.

Another symbol of personal accomplishment for the yuppie was a svelte and well-toned body. The fitness boom that had begun in the 1970s exploded into a national obsession in the eighties. Billions of dollars were spent on fitness club memberships, personal trainers, exercise guides and videotapes, physical training equipment, vitamin regimens, and health foods.

As a result of the swelling ranks of the nouveau riche worldwide, couture enjoyed a rebound in sales during the 1980s. European designers delighted in creating luxurious, body-conscious fashions for a daring new clientele willing to proclaim their self-confidence and status through their wardrobes. Azzedine Alaia's "Mermaid" gowns were made of sea-green acetate knit that clung to every contour of the body like a second skin. At Chanel, Karl Lagerfeld deconstructed the classic boxy tweed jacket suit with new, softer forms of jackets in denim and stretch materials, and with skirt hemlines that grazed the ankles or rose to mid-thigh. Christian Lacroix created the definitive yuppie eveningwear of the 1980s—a strapless pouf dress that cinched the waist and exaggerated the hips in a voluminous meringue of fabric. Vivienne Westwood integrated elements of theatrical costume into her designs to produce collections based on whimsical themes such as "Pirates," "Witches," and an urban cowgirl look called "Buffalo." Jean-Paul Gaultier focused on gender bending and other aspects of sexuality with fashions that included outer corsets and similar form-fitting fetishistic components. One of the most exaggerated body-conscious innovations of the 1980s was the red plastic molded bustier by Issey Miyake with its indentation of a navel and protrusions of nipples combining the form-fitting look of spandex with a high-tech sleekness. (Figure 25-4.)

Such avant-garde fashions were fun to look at in magazines but were seldom worn outside of narrow, high-style circles. In the United States, designers were only selectively inspired by the innovative directions of the couturiers of Paris and Milan. Most significantly, the androgynous looks of many European styles were translated into masculine

Figure 25-4. For those women of the eighties who aerobicized their bodies into a svelte healthiness, designers created body conscious fashions. Garments were made of clinging knits, stretch materials, and other fluid fabrics, or were superbly crafted to be form-fitting. Among the more exaggerated body-conscious designs was the red molded plastic bustier by Issey Miyake from 1983.

powersuits that became the quintessential emblem of the eighties career woman. Broad, padded shoulders, narrow hips, and a trim waistline emulated the ideal physique of the youthful, vigorous male—the Darwinistic top of the food chain in nature's hierarchy, and the top of the power chain in a corporate hierarchy. The 1980s silhouette of the inverted triangle was applied to both women's business suits and dresses. (Figure 25-5.)

Although the androgyny of European designs was a strong influence on American versions of the powersuit, the look and attitude was actually an evolution of style that had been emerging since the early 1970s when women first donned pantsuits for the office. In 1977, the significance of the powersuit became the gospel for millions of career women in John Molloy's best-selling fashion guide, *Dress for Success.* "The executive suite is an upper socio-economic business club, and in order to get in you must wear the club uniform," asserted Molloy. In 1988, at the height of the yuppie prestige, Molloy advised that ten years earlier he had said that "the suit was the most effective outfit a woman could wear, [and] that statement is still true."

As women of the early 1980s took Molloy's checklist shopping for a power wardrobe, they discovered that the traditional blazers and bolero jackets of the previous thirty years had been dramatically recut and reshaped. Tailored suit jackets were constructed to resemble men's versions with shoulder-broadening pads and stiff sleeve interlinings. Classic details such as notched lapels, straight-edge pocket flaps, and

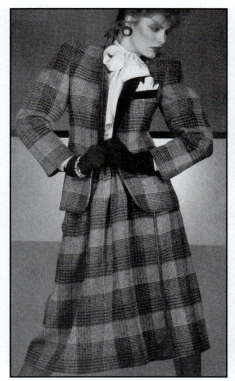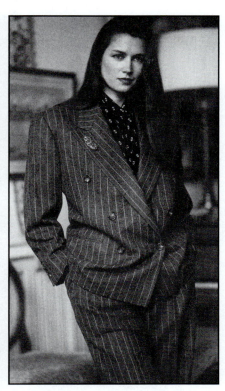

Figure 25-5. The most prevalent look for career women of the eighties was the powersuit, which emulated men's styles with broad, padded shoulders, a tapered waistline, and narrow hips. Left, plaid suit with bow blouse by Escada, 1984; right, menswear pinstriped trouser suit by Ralph Lauren, 1984.

plain buttons were appropriated from menswear. However, despite Molloy's recommendation that "serious" suits for women should be limited to the same gray, blue, or brown wool as men's styles, many women instead asserted their femininity by wearing suits and jackets made in bold, new color palettes of vivid jeweltones like sapphire, emerald, ruby, and topaz. Variations of bolero jackets in feminine textile patterns and softer, lighter colors became a prevalent component of jacket dresses and business separates.

Another alternative to the stiffly tailored business suits was the softly draped jackets of Giorgio Armani. "I altered the way jackets were buttoned and radically modified the proportions," Armani told author Marshall Blonsky in 1987. "What used to be considered a defect became the basis for a new shape, a new jacket." This new jacket shape featured a longer lapel, lowered buttons, and shoulders that dropped yet remained broad and powerful. Armani also used softer luxury fabrics like cashmere and silk/wool blends for a more fluid, sensual fit. He expanded the repertoire of neutral colors by warming or cooling grays and beiges with hints of teal, olive, ecru, and sienna, or by creating his own colors, like "greige," a smooth, clear puree of gray and beige. The Armani suit was a superlative symbol of a career woman's self-assurance and elegance.

The top-heavy, angular silhouette of the powersuit was also applied to both daytime and evening dress styles. In fact, it was a particular challenge for designers at this time to create versatile dresses that provided a day-into-night look for the busy career woman who rushed from the office to a cocktail party or dinner engagement. One solution was a renewed emphasis on the chemise. (Figure 25-6.) Although the silhouette had remained a wardrobe staple since the 1950s, the basic dress had been eclipsed by the popularity of coordinates and separates in the 1970s. In the eighties, though, the chemise not only worked as a dressy, feminine alternative to the business powersuit, but its classic elegance was equally suitable for a wide range of social occasions. In addition, the soft draping of the chemise flattered the feminine form and accentuated the results of all those hours at the gym.

Besides the adaptation of the powersuit contours to dresses, one of the most notable changes of the 1980s was the shortening of hemlines. After almost a ten-year absence, hemlines rose above the knees in the mid-eighties, even in the workplace. By the end of the decade, short skirts were ubiquitous, including thigh-high miniskirts.

In spite of warnings by John Molloy that "fashionable clothing" (especially short skirts!) sent a message that a woman was a "lightweight, not the kind of person who can be trusted with important matters," many women also found relief from the severity of the masculine powersuit in the **Romantique modes** of the early 1980s. (Figure 25-7.) Designers like Valentino and Yves St. Laurent created whimsical new takes on ruffs, gigot sleeves, fichus, engageantes, and

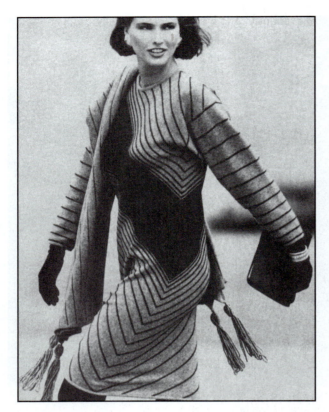

Figure 25-6. A renewed emphasis on the chemise by designers provided busy career women with a versatile day-into-night wardrobe option. Cashmere chemise with matching shawl by Laura Biagiotti, 1987.

Figure 25-7. The ultrafeminine Romantique looks of the 1980s were a reaction to the severity of the powersuit silhouette. Frilly details such as lacy cuffs, ruffled fichus, puffed sleeves, and similar revivalisms from the Romantic Age appealed to many women who preferred femininity over corporate power images. Ralph Lauren tunic with lace collar and cuffs, 1982.

similar Romantic Age revivals. Ralph Lauren added paisley or lace cravats and gold watch fobs to velvet suits. Laura Ashley achieved new prominence with the Victoriana details and motifs of her fashions. In 1981, Princess Diana's much publicized wedding gown and bridal trousseau inspired millions of women worldwide to add a touch of frou-frou femininity to their wardrobes.

Opulent court fashions, of sorts, also provided women with opportunities of ostentatious display and conceits. In the United States, the First Families of the 1970s—the Nixons, the Fords, the Carters—had conspicuously lacked extravagance and glamour. The Reagans, however, were from Hollywood and understood the significance of image. For eight years, the White House court of the Reagans sparkled brilliantly with the glitterati of A-list society that projected a public image of style, wealth, and privilege.

Popular culture of the eighties provided a second arena of court fashions. Movie stars and the elite of the rock and roll music industry attended well publicized soires, movie premieres, and awards ceremonies dressed in sumptuous couture fashions and lavish jewels. The line between fantasy and reality was further blurred by prime-time TV soaps such as

Dynasty and *Dallas* in which beautiful people dressed in an endless variety of luxuriant clothes and perfectly coordinated accessories.

Across the Atlantic, a genuine royal court of the Old World revived its preeminence as a fashion leader when Lady Diana Spencer became the Princess of Wales in 1981. Throughout the decade, the world watched with fascination as the tall, beautiful young princess experimented with hairstyles and sophisticated wardrobes.

The wealth, glamour, and exhibitionism of these various courts of style inspired fashion designers—most especially European couturiers—to extraordinary excesses. The rich look fashions of the 1980s were dazzling expressions of wit and fantasy combined with extravagant historical revivalisms, luscious fabrics, and a carnival of color mixes. Haute couture once again epitomized conspicuous consumption, class distinction, and style leadership. (Figure 25-8 and Color Plate 93.) For the aspiring bourgeoisie, ready-to-wear makers found an eager market of women willing to buy an adaptation of their favorite designer's creation, even if only for limited wear on special occasions like a wedding, reunion, or community charity ball.

Figure 25-8. During the 1980s, conspicuous consumption was once again socially acceptable after a twenty-year hiatus. Designers responded with dazzling rich look fashions that proclaimed the wearer's affluence and social status. Left, beaded gown and opera jacket by Bob Mackie, 1984; center, pouf dress by Louis Feraud, 1985; right, crinoline cocktail dress by Oscar de la Renta, 1987.

At the forefront of the rich look was Christian Lacroix, whose famous bouffant cocktail dress of 1986, called the **pouf** or **bubble**, had broad appeal from Kuwait to California. Said Lacroix of his work, "The trick is to add precisely the right dose of fantasy without falling into le gag." Ready-to-wear makers mass produced knock-offs of the fantasy look in all price ranges.

The other great proponent of rich look fashions was Karl Lagerfeld, whose iconoclastic modernizing of the House of Chanel in 1982 contributed significantly to reviving haute couture. By many accounts in the fashion press, the most beautiful dress of the mid-1980s was Karl Lagerfeld's extravagant "Atys" evening dress made of red satin and lavishly embellished with gold embroidery.

In the second half of the 1980s, the rich look extended beyond fantasy cocktail poufs and evening gowns to provide sophisticated alternatives to classic, conservative powersuits with sculpted body fashions. (Figure 25-9 and Color Plate 92.) *Vogue* announced in 1985 that "This is a year of newly shaped and fitted clothes, day, night, across the board . . . with a shape that starts right at the shoulder—a shoulder defined by cut or by padding . . . And you'll see a small waist, held or belted; a gentle roundness over the hips." Slim skirts,

often short, and soft fabrics such as wool jersey and cashmere knits contoured and flattered the hips and thighs. Large, sculptural belts defined and cinched waistlines. Bold, oversized accessories balanced the strong silhouettes and proclaimed the aplomb of a woman who could confidently wear them.

In Paris, the second wave of Japanese designers made a significant impact on established concepts of fashion. Whereas in the 1970s, Issey Miyake initiated his designs from the abstract shape of the traditional kimono, the avant-garde Japanese designers of the 1980s, instead, introduced clothing that owed nothing to conventions of fit and construction. Rei Kawakubo and Yohji Yamamoto presented collections of loose, oversized clothing in which asymmetry and imperfections of rips, slashes, fraying, and irregularities in the fabric weave were key elements. (Figure 25-10.) Black, with its many shades, was the preferred color of Japanese designers, a portent of the monochromatic mania of the late eighties.

The Japanese big look especially influenced EuroAmerican knitwear designers. Sweaters, tunics, jackets, and other knit tops were dramatically shaped with broad shoulders, oversized collars and cowls, big sleeves, and bulky mass.

Figure 25-9. The sculpted body look of the mid-1980s featured strong silhouettes of architectural garment construction. Large, sculptural belts and oversized accessories complemented the commanding statements of style. Left, Maryll Lanvin suit, 1986; right, Albert Nipon suit, 1988.

Knit surfaces reinforced the big look with large gauge yarns knitted into deep, three-dimensional patterns of knots, openwork, intarsias, and sculptural trimmings. (Color Plate 91.)

Throughout the decade, several counterculture looks were adapted by couturiers and ready-to-wear makers. The antifashion style of punk from the 1970s appealed to many young people of the sybaritic eighties. Along with the spiked hair, pierced body parts, and tattoos of the disaffected youth were added ripped clothing held together with rows of safety pins or duct tape, tight T-shirts, and oversized leather or denim jackets. Vivienne Westwood and Malcolm McLaren, the self-proclaimed originators of punk fashion, expanded on the theme with fetishistic leather corsets and shirts with leather strap harnesses. Other designers likewise experimented with counterculture attitudes and influences. The biker's leather jacket adorned with chains and other metal hardware inspired sculptural variations by Claude Montana, Katherine Hamnett, Sonia Rykiel, and Gianni Versace. Karl Lagerfeld introduced Chanel combat boots and Fly Girl Lycra bra tops.

Among the more traditional and enduring subculture themes that surfaced in eighties versions was the look of the American West. Cowboy (and cowgirl) styles and motifs were immensely popular with the French and Italian designers. Fringed leather jackets and cowboy hats, boots, and leather vests repeatedly appeared in collections. (Figure 25-11.) "Down the runways of Europe sashay an assortment of cowboys and Indians as designers engage in a range war of unabashed camp," reported *Vogue* in 1989. On the U.S. home front, the Western theme was more palatable to ready-to-wear makers than most other subculture looks, and hence was marketed to a broader segment of consumers in various forms year after year. Its recurring popularity peaked when hit movies like *Urban Cowboy* (1980) and TV programs like *Dallas* featured traditional Western costumes and glamorized the interpretations.

One other trend in fashion and youth style that carried over into the eighties from the previous decade was androgyny. Unlike the 1970s glam look of rock and roll stars like David Bowie for men and the menswear replications for

Figure 25-10. In the 1980s the second wave of avant-garde Japanese designers presented diverse collections of loose, oversized clothing with deliberate textile imperfections such as rips and frayed edges. Slashed and tied top with matching skirt by Rei Kawakubo for Comme des Garçons, 1983.

Figure 25-11. The allure of the American West was irresistible for designers of the 1980s. Western style and the prairie look were a constant fashion subtheme throughout the decade. In the late 1980s, fringed pants, skirts, and especially leather jackets were widely popular in both haute couture and ready-to-wear. Western inspired suede jacket by Perry Ellis, 1988.

women, a truly unisex style became widespread in the 1980s. Unisex clothes defied conventional notions of the cut, color, and fit of gender-based designs. Loose, bulky clothing like sweaters, T-shirts, and sweatshirts, or layered, oversized garments like jackets and big shirts disguised rather than defined the physique of the wearer. Pants, in all their numerous varieties, were as much an ordinary garment for women as for men. Vivid colors and textile patterns were subject to gender bending by designers and ready-to-wear marketers like Benetton, Banana Republic, and the Gap. (Figure 25-12.) Fashion advertising often emphasized the new asexual androgyny by featuring male and female models with similar facial types and hairstyles.

At the end of the 1980s, the high-flying times seemed to come to an abrupt end. Reaganomics led to a stock market crash in 1987, followed by a recession and prolonged high unemployment and then another recession in 1990. The trickle down economic theory had failed. Jobless numbers rose, statistics on crime were alarming, AIDs became an epidemic. During this period of social and economic anxiety worldwide, a sense of nostalgia undulated through Western industrialized societies. As we have seen in previous eras of crisis, a nation's people sometimes looked to their past as an

imagined simpler, easier time. The fashion industry responded by stepping back from the excesses and modernity of the eighties for revivals of styles from recent decades, particularly those of the New Look years. (Figure 25-13.) Designers on the threshold of the 1990s, noted *Vogue*, "fall for fifties chic, Audrey Hepburn nights." Shirtwaists with full circle skirts recalled the TV mom look of the 1950s. Christopher Morgenstern rediscovered the simplicity and classic lines of the sheath. The traditional preppie look of Ralph Lauren gained new ground with young people. Perry Ellis inspired a resurgence of 1940s navy-and-white nautical styles with his sailors collection of separates. These and numerous other fashion revivalisms of the recent past rolled over into the 1990s and have continued to resurface through today.

WOMEN'S FASHIONS OF THE 1990S

The fashion pluralism of the 1980s expanded into even more segments of style during the 1990s. The key difference between the two decades was an attitude change of consumers. From the start in the 1990s, individualism was the buzzword among the fashion cognoscenti. More than with any preceding era, fashion was the wearer's choice—what to wear, how

Figure 25-12. The androgyny of the 1980s was less glam and more conventionally unisex than a decade earlier. Basic sweaters, sweatshirts, T-shirts, pants, and accessories like knit hats, mufflers, mittens, and big socks were plied with gender bending colors that denied the usual linearity of women's and men's clothing. Benetton collection, 1985.

Figure 25-13. Fashions at the end of the 1980s found relief from the excess of earlier years in a retro-styles, especially revivals of the fifties New Look. Adolfo suit with matching bag and lampshade hat, 1988.

to wear it, and with what. "Be Yourself," declared ads by Calvin Klein. Women rejected a dogmatic fealty to what Karl Lagerfeld called the "diktats of fashion." In response to women's assertion of style individuality, designers and ready-to-wear makers offered ever more choices: a wide array of skirt lengths and widths; pleated and plain front trousers; cropped, cuffed, pegged, or flared pant legs; variously constructed jackets with all types of lapel and pocket treatments; dresses of every imaginable cut and fabric.

Coupled with a deep recession and a wartime mood in the early nineties, this new penchant for an individual, personal style also spelled an end to the rich look that had prevailed through much of the eighties. In addition, the political tone in America and Europe shifted. Margaret Thatcher had been deposed in Britain, and the Bushes moved into the White House as the new U.S. First Family. Instead of the nouveau riche glitz of the Reaganites and Thatcherites, Barbara Bush and the Washington social circle presented a reserved, patrician elegance. In London, Princess Diana replaced her youthful glam of the eighties with a mature refinement and dignity. On both sides of the Atlantic women of the privileged classes opted for a quieter taste in clothing. (Color Plates 105 and 106.) The international media maintained a constant focus on the appearance of Barbara, Diana, and the many other women of elite society who had discarded the rich look in favor of their own individual styles. From throughout the industrialized world, affluent corporate yuppies and Main Street moms alike similarly sought to simplify their lifestyles and wardrobes.

With this pluralism of fashion, the principal question of the early nineties was the relevance, and hence, survivability, of haute couture. Designers produced collections of clothing that were astonishingly unwearable including leather bondage and biker ensembles, underwear on the outside, near-nude ethnic costumes, transparent "spiderweb" dresses, and collage garments embellished with paper, plastic, and even computer chips. In 1991, *Vogue* viewed these couture shows as "the theatre of the absurd." As a result of the changing social climate and the declining market of couture clients in the 1990s, financial losses for the major houses were substantial. The luster of some stars of fashion design dimmed somewhat, most notably that of Christian Lacroix who seemed out of touch with the changing market. Among the fashion business fatalities was the closing of the New York salon of Carolyn Roehm, whose lavish day ensembles and sumptuous evening-wear had dressed the era's nouvelle society.

Nevertheless, the extravagant haute couture collections and theatrical runway shows served two important purposes that helped sustain the industry during the transitional period of the early nineties. Foremost was fashion innovation. The high art and drama produced by so many of the haute couture designs of the early 1990s helped to urge fashion onward, past the lingering irrelevancies of the eighties styles. Second was public relations and its importance to branding the designer's label. (Color Plate 103.) In 1992, fashion writer Alice Mackrell suggested that haute couture had actually become "redundant for anything except PR purposes." Where once fashion houses allocated about two percent of their annual budget to marketing and public relations, that expenditure had jumped to about twenty-five percent by 2000.

The aggressive marketing of fashion labels in the 1990s provided consumers with a universal language of style. With mass licensing, mass production, and mass retailing, almost everyone could afford a number of favorite designer signature garments or accessories. (Figure 25-14.) Wearing logos expanded on the new-age tribalism that began in the eighties, representing a form of continuity amidst the sometimes bewildering array of ephemeral looks that filled stores, catalogs, and fashion magazines. Logo wear was a comfort zone for those women who lacked the independent bravado or time to experiment with a uniquely personal style.

Wearing logos was also a new source of consumer aspiration. The brand images disseminated through mass media conveyed types of lifestyles and attitudes that appealed to specific market segments. Ralph Lauren's polo rider logo projected the cachet of country gentry. Donna Karan's DKNY acronym expressed a sophisticated urban style. The CK of Calvin Klein attested to sensuality and sexuality. Tribal markings for the elite included curious symbols that subtly bespoke of an affluence, and signalled the status of the wearer to other PLUs ("people like us"). Among the most visibly marketed house logos in the 1990s were Chanel's linked C's, the heraldic JPG emblems of Jean-Paul Gaultier, the interlocking F's by Fendi, the Medusa head of Versace, the serif E of Escada, and the DG of Dolce & Gabbana to name a few. The upscale fashions and accessories

Figure 25-14. In the 1990s, the multimillion-dollar branding and mass marketing efforts of designer labels established images of lifestyles and attitudes that appealed to niche market segments of women customers. Wearing a specific designer logo was a form of tribalism for many women—a comfort zone that provided continuity and certainty of style. Left, Chanel logo print tunic and accessories, 1999; right, Balmain logo tank, 1998.

that sported these branded logos instilled an envious aspiration in many of those who recognized the coded language but could not afford to participate in the exclusive community.

Another segment of the market that continued to be very profitable for fashion houses in the nineties was that of the career woman. The female yuppie did not vanish with the stock market crash and recession that ended the New Gilded Age of the eighties. Although it was no longer fashionable to flaunt success through conspicuous consumption, women with high incomes, nonetheless, indulged in clothing of subtle elegance, refined detailing, and superlative tailoring. Princess Diana was a fashion leader in this arena as she became more actively engaged with highly publicized daytime functions and official royal visits.

The nineties answer to the 1980s powersuit emerged in several forms. The **deconstruction**, or reinvention, of the Chanel suit that Karl Lagerfeld had begun when he joined the house in 1983 reached an apogee in the 1990s. Since the 1960s, the Chanel trademark ensemble—the little jacket and narrow, knee-length skirts worn with pearl ropes and chain belts—had been the standard costume of wealthy matrons in the fifty-plus age bracket. Lagerfeld, instead, brilliantly transformed the Chanel suit while staying true to the unmistakable elements of the style. He shortened skirt hemlines and varied their contours from narrow fitted types to flowing pleated variants. He even replaced the skirt entirely with city shorts. Most especially, Lagerfeld experimented with fabrics. In 1991, he shocked Chanel traditionalists with a jeans look suit in which denim was combined with luxurious tweed edged in blue and pink piping. The following year he initiated a leather biker look worn on the runway by voluptuous glamazon supermodels. In the mid-nineties, he created a three-piece tweed suit that featured a boned corselet that fitted snugly over a cotton logo T-shirt. (Figure 25-15.) The fresh, updated suits greatly appealed to younger women and sold well, rejuvenating the Chanel image. Ready-to-wear makers were quick to adapt Lagerfeld's many reinterpretations of the classic Chanel suit for the mass market.

In addition to inventive avant-garde creations and deconstructionist innovations, fashion designers of the nineties often revisited styles of the past. Ransacking the past for inspiration was not new to the fin de siecle designers. In chapter 20, we saw that a century earlier *Vogue* had wondered why fashion designers of 1895 seemed to be replicating many of the styles of the 1830s. Indeed, as has been shown in other chapters, fashion revivals were a common source of inspiration for designers, including the most innovative leaders. The retro fashions of the 1990s, though, were only minimally nostalgic. When appropriating the styles of the past, modern designers stripped them of their original meaning. For instance, Vivienne Westwood combined an eighteenth-century officer's tunic with striped Directoire trousers and an exaggerated tricorne hat for her 1996 "Vive la Cocotte" collection, but the result was a feeling of whimsy ("cocotte" means

Figure 25-15. The Chanel trademark suit was deconstructed by Karl Lagerfeld in the eighties and nineties. By varying skirt hemlines and contours, reshaping the jackets, and experimenting with contemporary fabrics, Lagerfeld transformed the Chanel suit, thus rejuvenating the house image and appealing to a younger demographic. Chanel pink tweed suit with corselet by Lagerfeld, 1994.

floozy), not a statement of aristocratic or military authority. (Figure 25-16.) Nor was Ralph Lauren's velvet hacking suit of 1996 a replication of an Edwardian carriage driver's uniform, but rather an amusing variation on women's suiting. (Color Plate 102.)

The two most popular decades of the recent past that designers of the nineties enjoyed revisiting were the 1950s and 1960s. "The fifties movie-star look is back," confirmed *Vogue* in 1990. Comfortable, easy interpretations—not copies—of crisp poplin shirtwaists, cashmere sweater sets, and linen stovepipe pants were produced by Oscar de la Renta, Michael Kors, Donna Karan, Bill Blass, and scores of ready-to-wear makers. The biker look from American pop culture of the fifties was particularly intriguing to European designers. Hanae Mori, Thierry Mugler, Claude Montana, Yves St. Laurent, and Gianni Versace experimented with biker chic styles. Marlon Brando leather jackets were combined with short pleated skirts in sherbet colors, and sequined evening gowns were accessorized with thick-soled biker's boots and motorcycle chain jewelry. The ensembles were more camp than fashion, and customers selectively bought the odd piece to spice up their wardrobes rather than the whole look.

Among the favorite revivals from the sixties of both American and European designers were Op and Pop art

Figure 25-16. In appropriating design elements from historic dress, designers stripped them of their original meaning to create modern visions of whimsy and nostalgia. Tricorne hat and Directoire militaire tunic and trousers by Vivienne Westwood, 1996.

motifs. (Color Plate 108.) These witty graphics and fun, bold colors were a relief from the extravagant glitz and glitter of the eighties. Variations of Andy Warhol's prints were especially popular, including a multiple print of the Marilyn Monroe portrait on a silk gown by Versace and a take-off of Warhol's Mao prints on a nylon mesh T-shirt dress by Vivienne Tam.

Nostalgic revivals of the sixties peaked in the mid-nineties soon after Jackie Onassis died in May 1994. Coffee table books filled with images of Camelot were everywhere. The highly publicized 1996 Sotheby's auction of many items from Jackie's estate, including 1960s jewelry, period photos, artwork, and numerous mementos, inspired a renewed interest in the former First Lady's elegant style. For instance, copies of her triple-strand fake pearls, which sold for an astonishing $211,500, were mass marketed in costume reproductions as well as fine jewelry replicas.

Fashion elements of the more distant past, though, were among the favorite points of departure for some of the most inventive designers of the 1990s. As noted previously, Vivienne

Westwood explored the eighteenth century with panniered peplums and ruffled cuffs in her 1996 Cocotte collection. St. Laurent's Infanta wedding gown of 1995 expanded laterally over padded panniers modeled on those in the seventeenth-century paintings by Velazquez. John Galliano's Empire gowns for Givenchy maintained the high waistline of the Directoire original but brought to the front the gathered fullness from the back of the 1795 designs. And Lagerfeld's long pelisse coats of 1997 featured wide, stand-up Napoleonic collars.

The corset in its many forms also continually resurfaced throughout the nineties, just as it had in the 1970s and 1980s. The numerous wide belt corselets of Alexander McQueen were made of varieties of material and constructed to tightly shape the waist between the hips and just under the breasts. The flat front bodice corsets of Azzedine Alaia, Lacroix, Lagerfeld, and Westwood constricted the waist with laces and compressed the breasts with an enveloping cylindrical construction much as their sixteenth-century antecedents had. Other forms of the corset, such as the bustier, were cut to define and shape the contours of the breasts, and often featured the same types of front, back, or side lacing as the lingerie corset. Lainey Keogh's purple latex corset was worn under a shimmering transparent gown of metallic yarns. Galliano's Maasai-inspired beaded corsets cinched slinky silk gowns. Gaultier's hook-and-eye corsets with garters secured his diaphanous Joan-of-Arc tulle dresses. The many looks of the corset were so popular throughout the period that even ready-to-wear makers mass produced versions in all kinds of materials for both daytime and evening ensembles. (Figure 25-17 and Color Plate 101.)

In addition to retro-looks, contemporary street style continued to be a constant source of inspiration for designers of the nineties, as has been seen by the continuation of punk and biker chic styles. From the American Pacific Northwest, though, came the first unique look of the decade—**grunge**. The youth culture phenomenon originated in the rock clubs of Seattle, where, observed *Vogue* in 1992, "frustrated students and minimum-wage slaves banded together and created a lifestyle, ever cynical and utilitarian, that more accurately reflected their conditions." Bands from the region such as Nirvana and Pearl Jam popularized the look internationally through their concerts, music videos, and TV appearances. Grunge emphasized a dishevelled, rumpled casualness. (Figure 25-18.) Layers of ratty sweaters, old flannel shirts, rock tour T-shirts, ripped jeans, and baggy corduroy pants were assembled with an attitude of carelessness. The ubiquitous flannel shirt—preferably with holes or patches, or with sleeves roughly cut off at the shoulders—was worn over floral pattern dresses, or simply tied around the shoulders or waist. The grunge look was accented with knit hats, baseball caps, and heavy workboots or clunky Dr. Marten's shoes.

Many designers embraced grungemania in 1993. Down the runways of Paris and New York trudged models in thick-soled boots and knit caps. Anna Sui and Marc Jacobs preserved the serendipitous look of grunge with layers of

Figure 25-17. The fitted, sometimes cinching, bodice corset, bustier, and belt-like corselet remained perennial favorites of designers throughout the 1990s. Ready-to-wear makers capitalized on the popularity of the look, mass producing a wide assortment of corset-inspired tops and dresses for both day and evening. Bustier of nylon/spandex satin by Natori, 1995.

Figure 25-18. The hobo chic look of grunge featured a serendipitous assembly of clothes that included layers of oversized sweaters and dresses, flannel shirts, rock concert T-shirts, and baggy pants in wrinkled, faded, and distressed materials. Teens in coffee shop, 1993.

superbly crafted garments of fine fabrics in clashing patterns and colors. Christian Lacroix offered silk dresses that looked as worn as an old flannel shirt. Antonio Beecroft produced high-end sweaters with dropped stitches and oversized shapes that hung slightly askew.

Unfortunately for the fashion industry, both critics and consumers responded negatively. Fashion journalists savaged grunge styles because the look was viewed as ugly and impractical for any woman over the age of nineteen. Customers simply refused to buy clothing that resembled ready-to-wear "irregulars" and thrift-shop discards. Consequently, grunge-mania barely lasted a year. Yet the attitude of grunge street wear had broadened the repertoire of many designers, in some instances bringing a more relaxed and accommodating perspective to their oeuvre.

In the second half of the decade, advances in fiber technology opened fresh arenas for designers. Fabrics were woven with threads of metal or plastic to create surfaces that prismatically reflected light. (Figure 25-19.) Spandex was blended with cotton and wool for unprecedented comfort in slim pants and tailored jackets. David Chu of Nautica applied Teflon coatings to white cotton for greater stain resistance. Cynthia Steffe utilized computer-generated sequins in place

of costly hand beading. Other **technotextiles** were made of latex, neoprene, polyurethane, nylon, and rubber. In 1999, Hussein Chalayan took the molded garment one step further than Miyake's bustier shown in Figure 25-4 and fashioned his knee-length "airplane" dress of fiberglass. Even the nonrip paper used in making express delivery envelopes was experimentally applied to dresses by Donna Karan.

The use of technofabrics was also combined with elements of street style and historic dress to create **cyberstyle**. Like the futuristic costumes of sci-fi movies of the time, cyberstyle fashions incorporated pieces of body armor such as Mugler's metal and clear plastic "cyborg" suit of 1995 and Anela Takac's 1994 breastplate with 3-D holograms. CD-ROMs and hard drive chips were attached to clothes as ornamentation. Alexander McQueen's 1999 trouser suit jacket featured an allover white-on-black pattern of a computer chip schematic. Precision slashing was produced by computer for Antonio Berardi's PVC jacket of 1997. Into the new millennium, technovision and a dynamic technotextile market have enabled designers to exploit the properties of new materials and achieve creative innovations in cut and construction, and perpetuate that most basic element of fashion—change.

Figure 25-19. In the second half of the 1990s, the futuristic look of cyberstyle combined forms of street style and historic costume with technotextiles to anticipate new-age fashions of the twenty-first century. Polyvinyl jeans by Todd Oldham, 1998.

WOMEN'S FASHIONS 2000–PRESENT

In the spring of 2000, *Vogue* ventured on a quest for the new millennium's NBT (Next Big Thing) in fashion. The editors interviewed designers and retailers but eventually concluded that "if you look for it, you won't find it." Part of the uncertainty about the NBT in fashion was the continued fragmentation of the market, which was even more balkanized than in the nineties. The pluralism of fashion had become the standard, and most women were content to find their own personal style with, perhaps, only negligible advice from fashion journalism and marketers. No one designer, atelier, or syndicate could dominate the fashion industry as had Poiret in the 1910s or Dior in the 1950s—eras when daughter, mother, and even grandmother all wore the same silhouette. Designers and ready-to-wear makers of the twenty-first century, instead, focused on their niche target market, usually the daughter *or* mother, seldom both.

One significant impact on the fashion market was a depressed world economy that became severe following the U.S. banking crises of 2008. Many "re-" words appeared in print and on TV style shows: *recycle, revamp, rethink, reconstruction, reconfiguration,* and *recuperation.* This attitude of recycling impacted both designers and consumers.

Couturiers stocked up with vintage textiles, linens, clothing, and accessories to reuse the materials in truly unique fashions. A recycled garment often ensured that no one else would be wearing the identical thing. Miguel Adrover presented dresses made from elaborate antique tablecloths. London's Kerry Seager introduced halter tops that tied in the back with sleeves cut from men's button-down dress shirts. Patchwork clothes abounded. "Whoever buys my clothes appropriates their past," summed up Parisian designer Marc Le Bihan. The Internet, especially online auctions like eBay with its more than 200 million registered users, provided easy access to vintage clothing and textiles. The thrift shop look of mixed styles continued to be popular on college campuses.

For the mass market, though, the recycled look of vintage fabrics and patchwork styles was not in itself a major trend. Instead, magazine articles recommended that women "buy one new piece, then dig in your closet for a few classics from years past." In rummaging through the back of a closet for favorite clothing from the nineties, women invariably would find a revival style that, suddenly, was fresh again.

As in the 1990s, designers of the new millennium continued to glance over their shoulders to the past. The sixties remained a favorite era to revisit, most probably because its range was so dramatic—from the remnants of the New Look at the start of the decade to the Age-of-Aquarius youthquake at its end. One of the most pervasive revivals from the sixties—a look that has recurred every succeeding decade since—was the trouser and dress ensemble (though the style actually dates back to the 1850s in the United States and 1,000 years before that in the Far East.) (Figure 25-20.) Marni's side slit floor-length dresses revealed the surprise of boldly patterned pajama pants. Veronique Branquinho matched horizontal striped trousers with a diagonal striped short dress. Similar retro-duos were on the runways of Galliano, Chanel, Gaultier, and Devon Aoki. Also sixties inspired were Pop art print silk shirts from Missoni, faux leopard pants from Tom Ford, Empire waistline dresses from Martine Sitbon, and sleeveless shifts in acid colors by Prada, all of which were modernized with new technofabrics, deconstructionist cuts, and anachronistic accessories. (Color Plate 107.)

Besides a host of revivalisms in the early 2000s, women found innumerable options for expressing their individualism with some basic styles. That staple commodity of ready-to-wear, jeans, were painted-on tight, hip-hop baggy, logo-branded, tie-dyed, bleach splattered, low-rise, flared, fringed, sueded, faded, distressed, and embellished with all manner of detailing. (Figure 25-21.) New jeans labels challenged established brands. Rogan Gregory's jeans featured triple-needle

Figure 25-20. In the early 2000s, designers continued to find inspiration in the looks of the past. The trouser and dress ensemble appealed to a new generation of designers and wearers as much as it had in the previous four decades. Chanel logo print dress over corded knee-patch pants, 2001.

Figure 25-21. The hiphugger pants of the sixties were revived in the early 2000s. Some ready-to-wear makers offered retro-treatments like tie-dyed patterns and embroidered motifs; others presented totally new approaches to cut and fit such as short crops and reconstructed waistbands. Distressed low-rider jeans from Baby Phat, 2004.

stitching and four-piece waistbands. Parasuco denim was embroidered and pierced with grommets. Stephen Hardy jeans were cut apart and repieced like a mosaic with gutters of leather between each section. Established brands countered the onslaught of fashion jeans with new takes of their own, such as "dirty denim" from Calvin Klein, camouflage patterns by Donna Karan, and capri length crops by Sergio Valente. Pop stars like Britney Spears and Jennifer Lopez squeezed into a new form of hiphugger pants called **low riders**, which were cut so shallow at the inseam and fly that when the wearer sat down or bent over, the requisite red or black silk thong was visible in the back.

The **"borrowed" look** also provided opportunities for fashion individualism. If dad, hubbie, or big brother objected to having his clothes borrowed by the women of the house, designers offered alternatives with a distinction. Martin Margiela folded over the waistband of baggy men's pleated trousers at the center front creating a hybrid split skirt look. Ralph Lauren combined a men's black tail coat and a white U-neck vest with a long flounced skirt. Marc Jacobs kept the same boxy cut and shape of men's wrap coats from the

forties, but added big square metal buttons as a vital new detail. Other designers featured similar adaptations from men's wardrobes including accessories such as fisherman's boots and silk scarves tied as cravats.

Not surprising, logos and licensing continued to be a boon to house profits. The effectiveness of multimillion-dollar marketing budgets for label branding was undeniable in the twenty-first century. The new approach to logo fashions was to cover every inch of the garment or accessory with a repeat pattern of trademark initials. "If you've got it, flaunt it!" declared a fashion editor on the subject of high-end fashions with logos. In popular TV programs like *Sex and the City*, characters regularly bandied about their favorite famous brand fashion names in dialog and prominently displayed designer logos on clothing, accessories, and shopping bags. Tom Ford wallpapered jackets, pants, hats, shoes, bras, and bikini underwear with a diamond pattern of the Gucci double G. A new calligraphic Dior logo was strung together in a repeat lacy stripe for denim vests, skirts, and matching stiletto boots. The interlocked F's of Fendi's logo became an allover repeat pattern covering maxi-length leather coats. At the

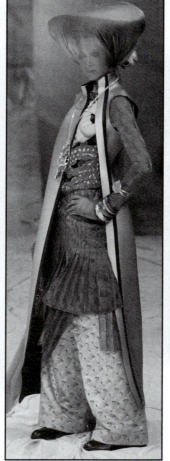

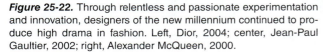

Figure 25-22. Through relentless and passionate experimentation and innovation, designers of the new millennium continued to produce high drama in fashion. Left, Dior, 2004; center, Jean-Paul Gaultier, 2002; right, Alexander McQueen, 2000.

more extreme edge of brandishing logos, the linked C's of Chanel were bleached into hair extensions.

Despite all the demands and niche marketing of retro styles, logo fashions, and commodity clothing, the innovation and fantasy of fashion design did not diminish in the new millennium. (Figure 25-22 and Color Plate 116.) Designers became fascinated with the idea of culture collisions: punk meets *Showgirls*; olde Hollywood mixed with Mexican religious imagery; *Dr. Zhivago* crossed with *Scheherazade*. In Paris, the self-named **"absurdists"** produced dramatic, experimental art school styles, which included sleeves that extended over the hands to the knees, high collars that covered the face up to the eyes, and exaggerated cowboy boot poulaines. Junya Watanabe constructed coats and cocktail dresses with volumes of honeycombed fabric somewhat resembling gigantic fold-up paper Christmas ornaments. Hussein Chalayan's "topiary" dress was a sleeveless mass of dense ruffles looking like well-manicured lawn shrubbery. Versace's thigh-high corset dresses from the "RocKoko" collection were luxuriously adorned with antique silver lace.

Lagerfeld's twenty-first century iteration of the Chanel suit featured meticulously tailored jackets with frothy skirts of embroidered tulle. Galliano replaced traditional substructures like whalebone and crinolines with foam to reshape feminine contours. Gaultier revisited the grandeur of the Viennese Hapsburgs with his three-tiered wedding cake skirt adorned with swirling hussar trimmings and hip epaulets.

As the first decade of the new millennium concluded, the fashion establishment, with its big business perspective, had succeeded in identifying and marketing to its many niche consumer groups. The designers in the pluralistic global market of the 2000s continually fulfilled women's demands for versatile and modern clothing that suited their quest for individualism and personal style. In spite of a declining market, haute couture nonetheless endured and thrived with imaginative and passionate designers at the helm. And into the ateliers of Paris, London, Milan, and New York have continued to enter the future new guard of fashion—talented and inspired young designers eager to make fashion magic.

WOMEN'S OUTERWEAR 1980–PRESENT

In the 1980s, the designs of women's coats and jackets were influenced by the Japanese Big Look and by the prevailing inverted triangle silhouette of other fashions. Outerwear was massive; shoulders, sleeves, collars, and bodices had to be capacious enough to fit adequately over the broad shoulders of powersuits and dresses. (Color Plate 95.) Details like epaulets, box-pleated backs, and capelets added dimension. Even standardized forms of outerwear, such as trenchcoats, peacoats, and suburbans were reconfigured with widened and padded shoulders. Lengths of outerwear extended to almost every point from the hips to the ankles. In keeping with the prevailing attitude of conspicuous consumption, fur coats were more popular than any time since the fifties. Furriers offered long, luxurious coats with massive sleeves and collars. Similar looks for the ready-to-wear market were mass produced in faux furs, some in brilliant jeweltone colors.

By the 1990s, coats and jackets were narrow and slim. Classic styles were most popular—a reaction to the excesses of the eighties and the unwelcomed looks of grunge. The lines of coats and jackets appeared longer, even with the fingertip and thigh lengths. Menswear wrap coats were comfortable alternatives to dressy tailored styles. Although the fur industry was impacted by animal advocacy groups, traditional styles of furs in the 1990s returned to the classic cuts of the New Look era.

Throughout the first half of the 2000s, fur trim was everywhere on outerwear—leather coats, knit wraps, denim jackets. Shearling was favored for coats and jackets of all designs. A century-old tradition of conservative simplicity ended at Burberry's in 2002 when they began offering made-to-measure trench coats with the customer's choice of vividly dyed cashmere linings.

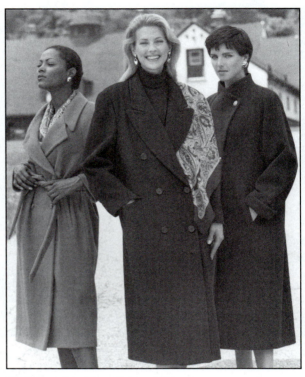

Wool coats from Evan-Picone, 1994.

Leather jacket by Vakko, 1986.

Mink coat from Carol and Irwin Ware, 1986.

Toscana shearling maxi coat by Dominic Bellissimo, 2002.

WOMEN'S UNDERWEAR AND SLEEPWEAR 1980–PRESENT

The diverse categories of women's undergarments remained extensive in the closing decades of the twentieth century. Panties, garter belts, stockings, pantyhose, tights, slips, teddies, camisoles, bras, corsets, and girdles filled up large segments of floor space in department stores. Specialty chains like Victoria's Secret and makers like Calvin Klein marketed fashion underwear not only as little private indulgences but also as erotic enhancements for intimate moments. Varieties of designs, colors, and fabrics were infinite.

Innovation, though, occurred more with engineering than with style. In the mid-1980s, Bali introduced the Fit Dimension line of bras that fitted both the woman's size and the shape of her breasts. A decade later, the Wonderbra was engineered as a "push-up plunge bra" that reshaped almost any woman's breasts to form a distinct cleavage. As clothing became more narrow and form-fitting in the 1990s, under garments were engineered for figure control and support. Constricting corsets and even padded bustle panties were integral to the contours of many fashions.

Sleepwear ranged from long, lacy gown and robe ensembles to footed flannel jammies. Menswear pajama tops with boxer shorts have remained popular since the mid-1980s.

Oversized T-shirts and ankle-length T-cut nightshirts were favorite dorm sleepwear. In the early 1990s, revivals of sexy, bias-cut gown and robe ensembles of the thirties were inspired by the popularity of the voluptuous glamazons in fashion editorials and ads. In the second half of the decade, floor-length chenille robes of the forties and fifties reappeared along with matching bedspreads and pillow shams.

Teddy of Du Pont Monece by Maidenform, 1985.

Wonderbra ad, 1995.

Maidenform bra camisole, petti, teddy, underwire bra, and bikini panty, 1982.

Lily of France bras, bikini, and thong, 2006.

WOMEN'S SWIMWEAR 1980–PRESENT

The pluralism of fashion was especially evident in the extensive variety of women's swimsuit options. Traditional maillots, some with skirts, and the bikini continued to be the standard forms of swimwear with infinite variations of colors, textile patterns, and decorative treatments that reflected the times. Kinetic application of leather, fringe, and beads occurred throughout the eighties. (Color Plate 90.) The string bikini and variant, the thong, both introduced in the early 1970s, became more daring with even less fabric coverage. The string variants were often called the "**rio**," having first appeared on the beaches of South America. In the mid-eighties, the leg openings of swimsuits were cut in a high arc or V-shape, which for the bottoms of two-piece suits, required the waistband to shift much higher on the hips, almost to the natural waistline. Also new in the 1980s was the cropped athletic top that resembled a sportsbra. Among the revivals of the 1990s was the **hipster**, with its forties-style, high-waist cut that was often paired with wide, architectonic bandeau tops. Revived from the thirties Olympics was the **racer**, with its open back, wide shoulder straps, and sleek, full-coverage front. By the 1990s, designers blurred the line between underwear and swimwear with the "lingerie look" that featured swimsuits cut like undergarments and made of shimmering, silky-looking fabrics. In the early 2000s, the **tankini**—a tank top and bikini bottom—was introduced and appealed to a broader age range of consumers than the maillot. The retro-forties hipster look of the nineties evolved into the squared shorts-style bottom worn with various tops of contrasting materials.

String bikini by La Lail, 1980.

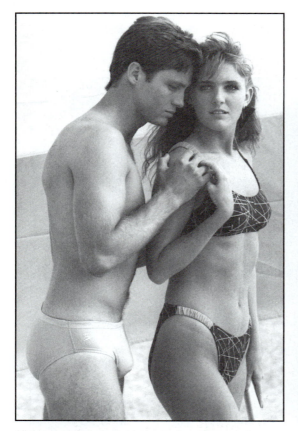

High waist bikini of nylon/spandex from Oscar de la Renta; men's Speedo bikini, 1987.

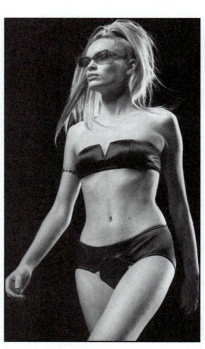

Notched bikini by Todd Oldham, 1997.

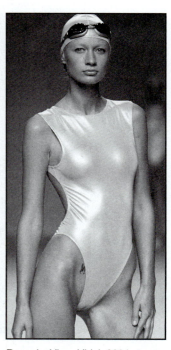

Racer by Vives Vidal, 2004.

WOMEN'S SPORTS ATTIRE 1980–PRESENT

The trend for exercise and fitness continued to grow throughout the eighties and nineties as more baby boomers crossed those critical thresholds of ages thirty, forty, and fifty. Jazzercize became dance aerobics, which in turn evolved into step aerobics, and finally into forms of martial arts training routines like tae kwan do and tae bo.

To dress for sports activities, women abandoned bulky sweatshirts, sweatpants, and big tees for formfitting spandex tank tops, shorts, and pants engineered to fit like a second skin. The sleek fitted jumpsuit eclipsed knit pants and tops on ski slopes. Lightweight technotextiles supported muscles during warm-ups, and cooled and dried the skin during intense workouts. Leotards and unitards were fitted with internal support to eliminate the need for binding undergarments. Neon colors and wild pattern combinations were most popular in the 1980s, but palettes became softer in the nineties. Shoes were also engineered for specialized activities to provide proper support and prevent injury.

For traditional sports such as tennis and golf, sports clothing largely remained conventional. Clubs and associations retained archaic rules of conduct and appearance including decades-old dress codes. Tennis skirts and shorts were worn with polo shirts usually embroidered on the chest with a tiny logo of an alligator, polo player, mounted knight, or abstract swoosh, among others.

Headbands, wristbands, visors, sunglasses, ski goggles, canvas totes, duffles, towels, socks, and spillproof water bottles were design and color coordinated by activewear manufacturers to match sports clothing collections.

Since the end of the eighties, comfortable and colorful sports attire continued to find its way into everyday dress. Running suits were easy to slip into for Saturday errands. Spandex tanks were worn as sexy undershirts beneath jackets and big shirts.

"Babe Sport Suit" of cotton/acrylic blend from Faberge, 1982.

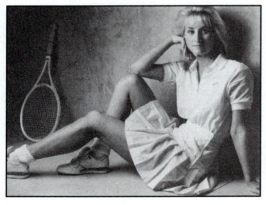

Traditional hip-pleated tennis skirt and polo shirt by Nike, 1988.

Nylon racer's ski suit, 1982.

Nylon spandex sportsbra and cycling pants, 1996.

WOMEN'S HATS 1980–PRESENT

Between the end of the 1960s and the beginning of the 1980s, hats largely had been utilitarian, worn as accoutrement of winter wear or as summer protection from the sun. By the mid-eighties, though, many women rediscovered the glamour and class distinction of fashion hats, which when combined with an abundance of other accessories, perfectly suited the materialistic exhibitionism of the New Gilded Age. Sculptural forms of headwear coordinated with the architectonic silhouettes of sculpted style clothing. Menswear fedoras complemented powersuits, and oversized newsboy caps reinforced assertive tomboy looks. Fifties-style mushroom hats and wide, winged picture hats with veils were revived in colors more vivid than the originals. Adaptations of toques, exotic turbans, and ethnic-inspired headgear were worn with opulent evening gowns. Glitz and glitter accented both day and after-six hats and caps.

In the 1990s, lavish hats were too integrally linked to the extravagance of the previous decade to endure as a significant trend. First Lady Hillary Clinton's wide hairbands and simple winter felt hats reflected the return to a practical utility of head dressing in the nineties. Oblong scarves covered the hair and wrapped about the neck for a touch of forties Hollywood glamour.

The emphasis on simplicity and ease in dress in the early 2000s further diminished hat wearing. Models in fashion advertising and editorials were predominantly bareheaded. Hats were incompatible with the ragged hair cuts and gelled bed head styles of the decade. Traditional tams, berets, fedoras, and knit caps remained cold weather favorites. Some revivals of fashion hats such as the Nureyev cap of the sixties appealed to young women.

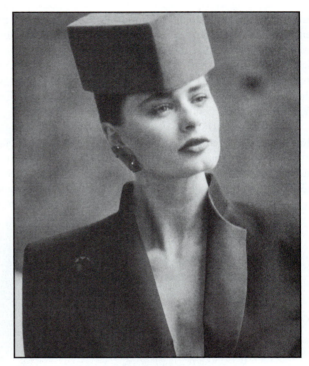

Box hat from Yves St. Laurent, 1988.

Fifties revival hats from Pierre Cardin, 1986.

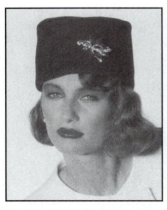

Toque from Schrader, 1984.

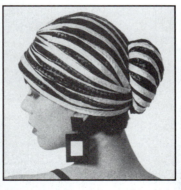

Silk crepe turban by Louis Feraud, 1986.

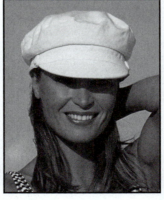

Adaptation of Nureyev cap, 1995.

Wool blend beret, 2007.

WOMEN'S SHOES 1980–PRESENT

In 1985, Imelda Marcos, wife of the deposed president of the Philippines, fled the country, abandoning a shoe wardrobe consisting of over 1,000 pairs. Since hats virtually disappeared from most women's wardrobes, shoes were, arguably, the most important accessory. After all, women with a sense of style could wear the same watch and basic earrings, and carry the same neutral hangbag day after day, but not wear the same shoes.

During the early 1980s, stiletto heels remained the favored footwear for the longer dresses of the period. By the end of the decade, as hemlines rose, a wider variety of low heels were produced. In keeping with the big silhouettes and oversized accessories of the eighties, shoes were often sculpted with large cutouts, wide straps, appliques, and curvaceous heels. The glitz and glitter of beading, sequins, metallic finishes, and lace adorned the entire outer surface of evening shoes. The conspicuous consumption attitude of the era inspired a renewed popularity in reptilian skins for shoes and other accessories. For daytime, detachable shoe ornaments such as velvet and satin bows, metal and tortoise shell buckles, or faux jewels were clipped onto the throats or sides of shoes for added variety and fashion interest. Boots for both dresses and pants were a wardrobe staple. For casual wear, vividly colored Converse sneakers were adapted from hip-hop street looks—worn with laces undone or removed entirely. The urban career woman often laced up comfortable athletic shoes to trek to and from the office, and carried her dress shoes in an oversized tote.

In the 1990s, sculpted drama and glitz of footwear were replaced with revivals of the thick, straight heel styles and platform soles of the seventies. The retro looks were updated with new contours that included wide, blunted toes. More foot was exposed with plunging throats and open, strapped varieties. High-heeled mules were worn with both casual and dressy ensembles.

In the early 2000s, heels were pushed to the back edge of the sole and flattened into a one-by-two proportion. Toes were widened and squared off at the end, requiring a longer vamp. Geometric silhouettes were often decorated with art deco inspired shapes in contrasting colors. By mid-decade, versions of medieval poulaines appeared with narrow, sharply pointed toes that extended beyond the end of the foot an inch or more.

Top, *Buttons* sandal by Jean-Paul Gaultier; bottom, *Apollo* sandal by Thierry Mugler, 1985.

Thigh-high boots by Maud Frizon, 1985. Left, nappa leather; right, suede.

High heels from Susan Bennis/Warren Edwards, 1986.

Retro-seventies platform sandal and wedge from Aldo, 1996.

Leopard print ponyskin pump by Dolce & Gabbana, 1998.

Modern poulaine by Steve Madden, 2006.

WOMEN'S JEWELRY 1980–PRESENT

That most ancient form of body ornamentation—jewelry—reached an apogee of variety and splendor in the 1980s. From golden Byzantine opulence to colorful plastic watches worn in multiples, jewelry in the decade of conspicuous consumption was designed to complement the exhibitionism of the era. "Jewelry—and more jewelry—is a focal point of all [runway] collections," reported *Vogue* from Paris in 1988. (Color Plate 89.)Art deco revivalisms resurfaced. Just as the design of clothes, shoes, and accessories of the eighties became bold and sculptural, jewelry, too, developed into substantial three-dimensional forms of fashion art worn in excess.

Fads of the 1980s included quartz jewelry of all kinds since crystals were thought to have mystical powers and could ward off bad karma. Baroque fresh water pearls were a popular novelty. Ankle bracelets and toe rings adorned the feet. Punk style expanded its counterculture repertoire to feature small hoops or studs inserted through pierced eyebrows, lips, tongues, upper ears, nostrils, navels, and nipples. Safety pins, paper clips, and found junk worn as jewelry were a street statement of antifashion.

In the early 1990s, retro jewelry from the fifties and sixties was everywhere. In 1994, when Jackie Onassis died, pearls in classic forms of jewelry were again popular after her famous three-strand necklace went on the auction block. In 1993, *Jurassic Park* launched a mania for genuine amber, which was especially prized if it contained a fossilized insect. By the end of the decade, jewelry became more subdued—simpler in ornament and smaller scale.

In the new millennium, jewelry was further minimized except for the most flamboyant haute couture shows. Pages of fashion editorials in magazines were conspicuously devoid of jewelry except for the occasional charm bracelet, simple strand of pearls, or small chain necklace.

Romantique revival jewelry, 1994.

Belt buckles, necklace, and earrings by Alexis Kirk, 1986.

Oversized necklace and earrings from Polly Bergen, 1986.

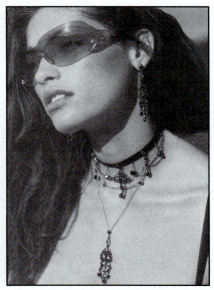

African-inspired silver and ebony bracelets by Dinny Hall, 1987.

Native American chokers and pendants from Billy Martin's, 2003.

Jewelry collection from Guess, 2002.

WOMEN'S ACCESSORIES 1980–PRESENT

In the 1980s, accessories reached a new level of importance not seen since the height of Dior's New Look in the fifties. The utility of belts, handbags, gloves, sunglasses, and scarves was often secondary to the style statement provided by their shape, color, texture, or logo. Applying superfluous accessories for the sake of fashion was an important component of conspicuous consumption, which was reinforced in pop culture by the sophisticated exhibitionism shown on TV programs like *Dynasty* and *Dallas,* and the extravagance of the glitterati in the court of the Reagan White House. In 1985, *Vogue* reported that accessories were "displaying remarkable character to a dazzling effect—for ornamentation, for special effects, for pure glamour." Women once again dressed head to toe with an attention to fashion detail. Large sculpted belts complemented the architectonic silhouettes of the era. Sculptural handbags did not necessarily match belts and shoes. Daytime gloves returned in vibrant colors to be worn or carried as accent pieces. Scarves added dimension to the big shoulders of suit jackets and dresses or were tied to handbags as a decorative treatment.

As the excesses of the eighties dissipated during the economic recession at the close of the decade, extraneous accessories were discarded. Instead of piling on accessories for show, women of the 1990s preferred simplicity. They wanted style combined with practicality. A single key accessory bespoke elegance and sophistication more effectively than the visual confusion of a multitude of accessories. Gone were the pretensions—and inconvenience—of carrying daytime gloves merely as color extensions for an ensemble, or of tying on a designer signature scarf simply to display a logo. The exception was with haute couture shows in which many designers still exploited the theatricality of excess throughout the 1990s.

In the new millennium, the subdued, simplified approach to accessories developed into an even more minimalist attitude. It was function over form, and quality over quantity. Colors were muted; black and earthtones much preferred. Even when exaggeration was at play, particularly with fashion revivals of the fifties and sixties, the focus was on one component, not the full replication of the past: the Audrey Hepburn *Breakfast at Tiffany's* sunglasses or the architectural go-go earrings of *Hullabaloo*. Along the same lines, a Bruno Magli woven handbag (or its mass-produced knock-off) was enough punctuation for casual weekend wear, or a Judith Leiber rhinestone bag (or, likewise, a manufactured derivative) was sufficient for evening wear without the addition of glitz and glitter to the gown, neck, ears, wrists, and feet.

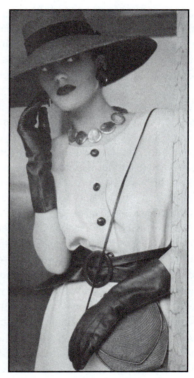

Yves St. Laurent hat, handbag, belt, and gloves, 1984.

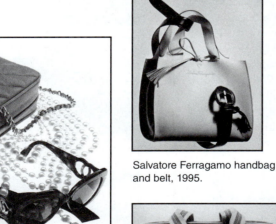

Salvatore Ferragamo handbag and belt, 1995.

Coach handbag, 2006.

Chanel handbag, wallet, sunglasses, and jewelry, 1995.

Anne Klein oversized sunglasses and silk scarf, 1985.

WOMEN'S HAIRSTYLES AND MAKEUP 1980–PRESENT

Most hairstyles of the 1980s followed the trends of clothing and accessories: big and eyecatching or styled with deliberate self expression. Whether long or short, though, hair of the decade was decidedly big—bouffant on top for almost all lengths, and mane-like for longer styles. Despite the soft look of the teased out tresses, most big hair was heavily lacquered into shape against humidity and wind.

Also in keeping with the pluralism of fashion during this period, many women opted for a variety of hairstyles to suit the mood of the moment. Mousse and gels made possible sculpted hair to match sculpted clothes. Many black women in Europe and the Americas adopted bouffant styles that required hair straightening treatments, which had largely been abandoned a decade earlier. Similarly, manageable shorter cuts of naturally curly styles for blacks replaced the massive afros of the 1960s and 1970s. Many cross-cultural hairstyles became mainstream during the eighties. Following the 1979 release of the movie *10* in which Bo Derick wore a cornrowed and beaded fringe hair arrangement, many younger women in the early 1980s experimented with variations that ranged from beading a few strands to braiding the entire head. Punk and androgyny influences inspired close crops and spiked crests. Bright, nonpermanent hair colors allowed young women to experiment safely and temporarily with street looks.

In the 1990s, hairstyles that were comfortable and convenient replaced the high-maintenance looks of the eighties. Revival fashions of the fifties and sixties inspired adaptations of hairstyles from those eras. The closely cropped Audrey Hepburn look returned. Instead of big hair, career women chose more elegant upswept styles such as the Grace Kelly French twist. Versions of the sixties beehive and bubble cut were softened and eased. Deep bangs were popular for long and short cuts. The feather-edged "Rachel" cut, named for the early look of Jennifer Aniston on the TV program *Friends* was widely copied.

Gels and other stylers returned in the early 2000s to add volume and textural interest rather than artificially sculpt the hair as in the eighties. The mussed **bed head** look was named for "stylizer" products from Tigi Haircare. Irregular and asymmetrical cuts became popular by mid-decade. Black women experimented with honey-blonde hair following the lead of celebrities like Grammy winner Christine Shea.

Makeup of the eighties strongly delineated and accented facial features. Eyeliner was thick and eyeshadows were dark and applied over more surface beneath the brows. Lipsticks were deep reds and berry colors. Blush was used to sculpt the cheekbones and to narrow nosebridges. Fingernails were long, squared, and polished with brilliant colors. A weekly trip to the salon for new false nails was a must for most yuppie women.

In the 1990s, makeup was softer and lighter. Cosmetics marketing repeatedly emphasized "natural" as the makeup look of the time. Eyeliner and eyeshadows were more subtle. Lipsticks were light, retro-sixties pinks and corals. In some fashion magazine editorials the heroin drug addict look with its pale, gaunt features and circles under the eyes was used as a dramatic contrast to the healthy, girl-next-door vitality featured in cosmetic ads.

The fresh-scrubbed, no-makeup look extended into the new millennium. The clean, youthful look projected in the images of cosmetics ads induced many aging baby boom women, the first of whom turned sixty in 2006, to try Botox muscle relaxant injections for smoothing crow's feet and frown lines. Other women explored new appearances with less painful efforts such as colored contacts.

African inspired braids called "Meet You At The Crossroads," 1998.

Big hair look of the eighties, 1984.

Androgyny, 1986.

Diverse looks of the new millennium, 2007.

MEN'S FASHIONS 1980–PRESENT

Throughout the 1980s, the emphasis for menswear was on the Italian lead, notably that of Giorgio Armani and Gianni Versace. "Italian fashion is changing the man," affirmed the header of an advertising campaign in 1985. To Italian designers, the body should inhabit the garment, not be defined by it. The fluid naturalness produced by cut, workmanship, and soft fabrics was a new concept in the design of men's suits. At the same time, the Italian style was often labeled classical because of its closed, unified form as opposed to the ambiguous, open form of the Japanese Big Look.

American designers gradually merged Italian style with techniques of British tailoring for a polished look with a relaxed fit. (Color Plate 97.) In 1984, *GQ* identified the "big four" American menswear designers as Perry Ellis, Ralph Lauren, Calvin Klein, and Alexander Julian, each of whom looked to a traditionalism as their point of departure for suit designs. Lauren commented that his suits captured "that particularly British custom-tailored look that always begins with very rich, expensive fabrics and ends with easy yet precise tailoring." Ellis noted that his suits "fit well on the body yet look easy; therefore, they're cut fuller and looser."

This fuller and looser deconstruction of the men's suit jacket was key to the transformation of business attire in the 1980s. The scale was big, and an eclecticism in the proportions of details kept such looks variable and fresh: both wide and narrow lapels (and corresponding neckwear), fluctuating collar sizes, and shifting button count. (Figure 25-23.) As with women's powersuits of the decade, men's professional dress was assertive in its strong profiles and linear details. Rich fabrics in bold plaids, checks, houndstooth, and other powerful patterns reinforced the unabashed self-assuredness of the wearer.

The sport jacket was an important dressy alternative to the suit coat. (Figure 25-24 and Color Plate 96.) Sport jackets were often designed with the same emphasis on oversized scale and bold patterns as that of suits. Similarly, the variety of new-wave jackets and suits that had first emerged in menswear in the 1960s continued to be popular for younger men through the eighties. Short crops, besom pockets, sculpted shoulders, and novel textiles characterized the experimental looks of the decade. In the mid-1980s, the TV crime drama *Miami Vice* inspired a casual, but well-put-together sportiness in men's suits. Ice cream colors were applied to unconstructed sport jackets, which were worn open and with the sleeves pushed up to the elbows.

With the stock market crash and recession at the end of the 1980s, the exaggerated Big Look silhouettes of suits vanished and a pared down classic look had returned by the beginning of the 1990s. In 1993, *GQ* forecast that "the nineties suit is a symbol of understated savvy in dress: less in-your-face than the shoulder-padded uniform that fairly proclaimed, Look at me!" Jacket padding was minimal and high-waisted, billowy trousers were trimmed in proportion

as well. A look to Savile Row and custom British tailoring resumed prominence, though far from diminishing the influences from Milan. Variety and a touch of personality were provided by the play of button treatments. Armani and Versace made the nineties jacket more open and provocative with a dropped, one-button closure. At the other end of the spectrum was Zanetti's ten-button double-breasted suit jacket that closed up the torso entirely. In between were three-button revivals of the drape cut from the 1930s and five-button interpretations of the fitted sixties space age look.

The visually jarring pattern mixing that dominated the eighties became more subdued but continued as a way to break the monotony of the pervasive traditional dark suit with its two-button, notch collar jacket. Surprising to many was the lead from Britain in the successful blending of patterns and colors that only the most daring North American male might try. Catalogs and magazine editorials offered endless advice on what to wear together without risking "a phone call from Barnum & Bailey's."

At the same time, a casual dress code for Fridays became the corporate policy for businesses of all sizes around the world. Neckties were discarded and cotton gabardine or rayon blend pants replaced tailored wool trousers. Textiles such as denim and khaki that were taboo in business offices a decade earlier became common even in executive suites and boardrooms. By the end of the decade, many companies permitted a casual look for the entire week, causing a significant drop in sales of professional attire.

At the beginning of the 2000s, the ultraslim, fitted look of the 1960s was revived by men's suit designers, and the silhouette became the suit look of the new millennium. (Figure 25-23 and Color Plate 113.) Natural shoulders returned and details such as lapels and pocket flaps were scaled down to emphasize the new, trim proportions. Some designers also shortened the jacket skirt to emphasize the lanky look of the narrow sleeves and trouser legs. A favorite jacket style of young men was the one-button closure, which emphasized their youthful, trim waistline. Likewise, trousers were cut with a low-rise waistband and plain, unpleated front.

The tuxedo continued to be the most prevalent evening wear. (Figure 25-25.) The diversity of colorful solids and patterns that first emerged in the 1960s and the trend of contrasting jackets and trousers that developed in the 1970s still provided men with innumerable options for formal dress. The continuing nostalgic interest in the 1950s, due in part to TV programs like *Happy Days* and *Laverne and Shirley,* inspired the return of the crisp white dinner jacket. Ruffled and pleated shirts, often in vivid colors, added flair to the starkness of plain jackets. The only significant debate about tuxedo style was "between straight and wing collars" for shirts, both of which, *GQ* concluded in 1985, "are eminently suitable." The silhouettes of tuxedo jackets in the 1980s remained more classic in scale with minimal padding rather than the Big Look typical of business

Figure 25-23. In the 1980s, menswear designers redefined the business suit by innovative construction, exquisite tailoring, new fabrics, and a looser, softer fit. The scale was big and the details were fresh and eclectic. The strong silhouettes of the eighties powersuit were a statement of the wearer's self-confidence and assertiveness. By the 1990s, the exaggerated proportions had been deflated to a more classic silhouette. In the early 2000s, a new short, trim look prevailed with shortened jackets, natural shoulderline, and low-rise trousers. Left, Single and double breasted suits by Hugo Boss, 1987; right, double- and single-breasted power suits from Hamilton Collection, 1992; below, two-button sharkskin suit by Vivienne Westwood, 2008.

powersuits. By the early 2000s, though, designers offered versions of tuxedos modeled on the new, youthful ultraslim suit styles. Jackets were made with natural shoulderlines and satin lapels were narrowed for a longer, vertical line. Trousers featured the low-rise waistband, even though many sartorial purists objected to the bit of white shirt that showed between the bottom jacket button and the belt buckle.

Men's sportswear and playwear of the past twenty-five years have been as diverse as women's styles. In the 1980s, designers began to experiment with new technofabrics for men's clothing. Tight-fitting parachute pants made of silky nylon blend textiles were introduced in the early eighties. (Figure 25-26.) Sleek satin trousers were popular with young men for nightlife. Snug, leather pants were shaped and textured to differentiate the look from plain biker styles. All sorts of "distressed" varieties of jeans were produced, from

Figure 25-24. Sports jackets offered a variety of dressy alternatives to the suit coat. The eighties looks ranged from oversized, sculpted silhouettes to a *Miami Vice* casual sportiness. Left, cropped wool jacket from Hardware, 1980; center, silk blend sport jacket from International Male, 1985; right, plaid wool blazer by Gian Marco Venturi, 1985.

Figure 25-25. The tuxedo jacket of the 1980s was designed in a wide array of colors and textile patterns, many of which were worn with contrasting trousers. Left, Pierre Cardin tuxedo, 1983; right, Canali tuxedo and white dinner jacket, 1983.

Figure 25-26. In the 1980s new textiles were applied to men's trousers, such as silky nylon blends used for parachute cargo pants. Pants from Gabrielle, 1984.

Figure 25-27. Retro looks of men's jeans designs included new interpretations of sixties style hiphuggers and revamped traditional looks such as well-worn "dirty denim" varieties. Low rider jeans by Dsquared2, 2008.

acid and stone washes that faded the dyes to versions with threadbare spots and shredded knees. (Color Plate 99.)

By the 1990s, though, comfort was the governing factor for most men in selecting pants. The fit was loose and full, even in jeans. Fuller cut "relaxed fit" pants were marketed to the aging baby boomers. Changing corporate dress codes permitted easy-care cotton gabardine or rayon blend trousers for business casual dress.

In the early 2000s, men's jeans, as with women's styles, became even more widely varied in design. One of the most prevalent looks was a revival of the hiphugger styles of the late sixties and early seventies, commonly called "low riders" by mid-decade. (Figure 25-27.) As in the 1960s, the style particularly appealed to the slim young, although baby boomers whose fitness routines kept them trim also opted for the nostalgia of the new hiphuggers. Other jean varieties ranged from basic "dirty denim" produced by assorted designer labels to painter's styles with cargo pockets and hammer loops at the side seams.

In the 1980s, the Japanese-inspired Big Look—reinforced by the yuppie desire for a statement of power through their wardrobes—particularly influenced the silhouettes of most sportswear. Padded shoulders, wide yoke constructions, and other lateral designs of shirts, sweaters, and tops adapted the inverted triangle look from suit coats. Equally bold and strong were textile patterns and colors. (Figure 25-28.)

From the 1990s into the 2000s, the fit of sportswear tops and sweaters largely remained loose and casual. The oversized shoulders and padding were abandoned. Colors became more muted and drab although men's wardrobes usually still included the occasional pop of a strong color, print, or pattern.

Men with a more individualistic personality, though, might opt for an eye-catching novelty garment to break out from the pack of the ordinary. Jean-Paul Gaultier's muscle shirt of 1995 was screen printed with a startling trompe l'oeil depiction of an athletic torso. (Color Plate 110.) Ralph Lauren replaced the thumbnail-sized polo rider logo with a hand-size heraldic lion embroidered in golden thread on some polo shirts in 2006. Pedro Diaz redefined the everyday jeans in 2004 with an exposed zipper that extended up from the fly and around the waistband. (Color Plate 111.)

As with designers of women's fashions, menswear designers used runway shows to present drama and fantasy

Figure 25-28. The big look of men's sportswear in the 1980s not only featured exaggerated shoulder silhouettes, but also included bold textile patterns, powerful colors, and strong textures. Sweater by Claude Montana, 1984.

Figure 25-29. Year after year in the twenty-first-century, a diversity of skirts for men appeared in collections of menswear designers. Men's skirt and shoulder bag by Vivienne Westwood, 2006.

styles for the new-age male. One of the most talked about looks of the new millennium was the wide array of skirts for men. (Figure 25-29 and Color Plate 112.) Gaultier, Westwood, Galliano, and McQueen were among many designers offering up varieties of men's skirts and other gender-bending clothes that shattered traditions and conventions of EuroAmerican masculine identity. As a modern concept, though, skirts for men were not unique to the 2000s but had a legacy dating back to the 1960s when male hippies donned wrap skirts, sarongs, kaftans, and long tunics as a way to express their anti-establishment view of gender rules and stereotypes.

For traditionalists, clothing branded with logos offered a safe haven of style choices. In addition to designer signature labels, categories of logos ranged from sports and consumer product brands to pictorials and messages on T-shirts and sweatshirts. (Figure 25-30.) Sports logos were particularly important to men who wanted to publicly show their support for their favorite sports team. Many men had seasonal logo attire for fall (football), winter (basketball and hockey), and spring and summer (baseball). Men who might never otherwise wear certain colors, such as kelly green or bright orange, enthusiastically layered garments in the hue that matched their favorite team's logo or college colors, especially during championship playoffs.

For the athletic male of the period, the fit and effectiveness of the activewear were more important than a brand or team loyalty. For a jog outdoors on chilly mornings, fleece warm-up tops and pants were often worn with an indifference to color and logo combinations—despite the marketing efforts of makers and retailers to promote color coordinated mix-and-match collections. During the 1980s, active sportswear manufacturers responded to men's increased interest in workout regimens with new garment engineering and innovative fabric technologies. Spandex bicycle shorts, influenced by European designs, were made with reinforced seats and seams that smoothly contoured the muscles like a second skin. (Figure 25-31.) T-tops, tanks, and similar athletic garments were likewise reengineered for a more accommodating fit for strenuous activities. On the slopes of the ski resorts, however, the look of the outfit was still all-important for the yuppie who wanted to proclaim his affluence. Upscale winter apparel makers combined technotextiles and high-style design in collections of brightly colored skiwear coordinates. (Color Plate 98.)

Figure 25-30. In the 1980s, the proliferation of logo fashions was dramatic. Every category of men's sportswear was subject to some form of logo or branding treatment. From 1986: Armani jacket, and Reebok activewear.

Figure 25-31. In the 1980s, active sportswear makers introduced new forms of athletic wear. Garments were engineered for better support, and new fabric technologies enhanced physical performance. Spandex bicycle shorts, 1987.

In the 1990s, though, most of the baby boomers who had comprised the largest portion of health club enthusiasts of the eighties, opted for loose-fitting—and concealing—big tees and oversized warm-up suits as they combated the expanding girth of middle age on their treadmills and exercycles. Younger athletic men tended to reject the exhibitionism of the 1980s and often preferred baggy gym shorts layered over their form-fitting sweatpants or spandex bicycle shorts for the sake of masculine modesty. The activewear short-shorts of the 1980s disappeared in favor of street-inspired knee-length knit shorts with legs so wide and baggy they often resembled a split skirt.

In the 2000s, a resurgence of protest message T-shirts recalled the activist looks of the late 1960s and early 1970s. In the United States, both sides of the abortion issue asserted their views across their chests during marches. Participants in annual Gay Pride parades displayed their unity against discrimination with rainbow-embellished T-shirts. One of the best-selling T-shirt messages against the war in Iraq read "We will not be silent" in English and Arabic together—a protest against remarks from the Bush administration that critics of the invasion were unpatriotic.

Men's outerwear styles retained most of the classic versions that had remained standard for more than a century. The yuppie businessman often complemented his powersuit with the appropriate chesterfield overcoat or long greatcoat. Shoulder silhouettes were expansive and armholes were deep to adequately fit over the padded shoulders of powersuits. Coats and jackets were constructed with an abundance of oversized details that reinforced the sculpted shape. (Figure 25-32 and Color Plate 100.) Much was written in the fashion press at the time about the influence of the Japanese in reinterpreting classic styles of men's coats. Yohji Yamamoto and Mitsuhiro Matsuda reworked classic silhouettes with harmonious geometric cuts that softened the typically rigid contours of men's outerwear. In the early 2000s, Junya Watanabe revisited the 1960s kneebreaker trenchcoat but with new collar treatments and shimmering synthetic textiles. (Color Plate 114.) From the Italians in the 1980s and 1990s came an endless array of coats and jackets of new luxury fabrics in subtle but distinctive patterns. Likewise, the British reinvented traditional tweeds with innovative textures and fluid weaves that set apart men's outerwear from earlier styles.

Figure 25-32. In the 1980s, classic styles of men's outerwear were reinterpreted by the Japanese with new geometric cuts and sculpted shapes. Italian designers softened the look of traditional outerwear with easy, luxury fabrics. The British modernized men's coats with tweeds in new textures and weaves. Left, leather jackets from Tannery West, 1983; right, wool greatcoat by Perry Ellis, 1987.

MEN'S ACCESSORIES 1980–PRESENT

Among the categories of men's accessories, the most significant drama occurred with neckwear. (Figure 25-33.) In the early 1980s, neckties continued to narrow. Younger men wore **skinny ties** that were usually about two inches wide at the flared end. Since this narrow cut had been prevalent in the early sixties, many men bought vintage silk ties from thrift shops. In response to this trend, neckwear manufacturers produced innumerable varieties of ties in retro textile patterns and prints from the forties, fifties, and sixties. The skinny ties of the 1980s, though, often were made of distinctly modern fabrics such as synthetics, leather, and knits. The ultimate skinny tie was the **bolla**—an appropriation of the cowboy string tie with metal **ferrule** tips and an ornamental fastener. From the 1990s into the 2000s, ties remained fairly uniform in width—about three and a half to four inches—although prints, colors, and fabrics varied widely. Novelty styles included cut-to-shape ties such as the fish series in the mid-nineties that were realistic screenprints of fish cut and quilted to the contours of the species. In the early 2000s, skinny ties reappeared in young men's boutiques ironically as one of many revivalisms of the eighties.

Beginning in the late 1990s, and especially in the first decade of the new millennium, jewelry for men underwent a resurgence of popularity not seen since the iconoclastic excesses of the 1960s peacock male. International celebrities such as the British athlete David Beckham unabashedly donned bold types of jewelry as defiant expressions of their nonconformist personalities. The body piercings that once had hallmarked the shock values of the urban punk style in the mid-seventies were now ubiquitous among young men worldwide. Varieties of pierced earrings for men expanded from the simplicity of the punk safety pin, silver stud, or tiny gold hoop to Celtic crosses, dangling chains, and sociopolitical symbols. Some men now wore pairs rather than solo earrings, or even multiples in each ear. In addition, tongues, lips, noses, eyebrows, navels, nipples, and genitals were pierced with studs and hoops of varying sizes and metals. Cuff bracelets and pendants of mixed materials were adopted by style-conscious men as coordinating fashion accessories. Large black steel rings were studded with oversized red jasper or other colorful, natural stones. Less subtle but equally symbolic was **bling-bling** (usually shortened to just "bling"), a term coined by a rapper group in the late nineties meaning flashy jewelry, particularly oversized diamond-studded pieces, or a showy style of dress that represented disposable wealth and the confidence to display it. (Figure 25-34.)

Shoes and boots of the 1980s and 1990s changed little from the traditional styles that had returned to prevalence after the extreme platforms, wedges, and sandals of the seventies. In the eighties, upscale Italian labels such as Gucci and Bruno Magli were favored by yuppies. Also, a renewed interest in rare skins such as lizard, snake, and alligator for footwear (and a disregard for ecological concerns) suited the ostentation of the New Gilded Age. Branded athletic footwear

Figure 25-33. By the early eighties, men's ties had narrowed to thin strips of fabric barely two inches wide. During the same time, the string tie, or bolla, was adapted from the cowboy costume. Left, rayon skinny tie from Merry Go Round, 1983; right, braided leather bolla with silver clasp by Shady Character, 1985.

loafers outsold lace-up wingtips. Thicker soles and slightly higher heels reemerged in the early 2000s, but these were not a revival of the platform shoes of the seventies. Instead, the look was an adaptation of the heavy, workboot footwear that had been popular with street subcultures like the punks and bikers since the seventies. By the early 2000s, men's footwear followed the diverse trends in women's styles and included both the blunt, squared toes and the long, pointed poulaines concurrent with traditional lace-ups and loafers.

Except for winter wear in northern climates, hats remained an occasional accessory. Knit caps served the utilitarian purpose well although felt fedoras were worn by businessmen as a smart suit accent. A visor or wide brimmed straw hat might be worn if activities required extended periods in the summer sun. The tall, wide brimmed Stetson enjoyed a brief resurgence in popularity during the 1980s as a result of the movie *Urban Cowboy* and the prime time TV soap *Dallas*. From the 1990s into the 2000s, men of all ages wore baseball caps everywhere, even inside public buildings, bars and restaurants, and theaters. Teenagers turned the brim backward or at an angle to the side as a generational distinction.

Figure 25-34. At the end of the twentieth century and into the new millennium, men's jewelry reflected the pluralism of masculine style. Men expressed their personalities, social status, and emotional sentiments with a wide variety of jewelry ranging from subtle and simple to opulent and ostentatious. Rapper 50 Cent displaying his bling-bling, 2003.

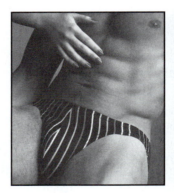

Mariner bikini underwear, 1982. Boxers from ACA Joe, 1987.

Cutaway brief from Calvin Klein, 1990. Boxer brief from Jockey, 2005.

Figure 25-35. In the 1980s, men's underwear styles ranged from the most minimal cuts to the standard white briefs and print boxers. Famous designers extended their lines of ready-to-wear to include men's underwear branded with their signature logos. Beginning in the 1990s, knit boxer briefs engineered with contoured pouches were a preferred fashion option to European cuts and commodity boxers and briefs.

became a huge business. In the mid-eighties, Adidas sneakers were worn without laces by hip-hop musicians and their fans—a style called "**shell toes**." By the 1990s, men wanted simplicity and comfort in their footwear. Tassel and penny

MEN'S UNDERWEAR AND SWIMWEAR 1980–PRESENT

Men's underwear and swimwear continued to be influenced by European style through the 1980s. (Figure 25-35.) For traditionalists, the basic white cotton brief remained the most common style of underwear—and the industry's best seller—although briefs in colors, especially black, steadily increased in popularity from their mass market introductions in the 1970s. Designers like Calvin Klein and Perry Ellis began to brand their underwear styles with bold typeface logos repeated around the waistbands. Extensive advertising promoted the cachet of designer signature underwear as fashion and lifestyle. During the 1990s, underwear makers reengineered the brief into a myriad of contoured styles constructed to more comfortably envelop and support rather than compress the genitals. In the 2000s, new makers such as 2(X)ist, N2N, and C-IN2, among others, entered the lucrative underwear market with aggressive magazine ad campaigns that targeted a new generation of young, fit males.

Loose-fitting boxer shorts also were common, particularly for ex-military men who were conditioned to wearing the style. A huge assortment of theme prints and patterns made boxers a popular novelty gift item especially for Valentine's Day. In the late 1980s, form-fitting knit boxer briefs became a fashionable alternative to the loose, baggy woven varieties. As with briefs, knit boxers also were constructed with contouring seams at the crotch and seat and, as low-rise trousers were revived in the early 2000s, versions were made with a lowered waistband. In the 1990s, some urban teen boys began to wear oversized, baggy jeans pushed low on the hips, exposing their colorfully patterned boxers as an anticonformity statement.

On the beach, surfers continued to wear long, loose-fitting jams in wild prints and colors that had first appeared in California in the sixties. (Figure 25-36.) Also from the sixties came revivals of the low-rise and belted boxer swimsuits, though now made of sleek spandex-blend fabrics rather than thick knit materials. Most men, though, wore the same short

Briefs, bikini, and boxer swimwear from Eminence, 1982.

Surfer jams and logo T-shirt from Swatch, 1986.

Board shorts, 2008.

Figure 25-36. Through much of the 1980s, swimwear designs continued the trend of brevity. For teenage boys, surfer jams remained long and baggy, updated season to season with new color palettes and prints. In the 1990s, most men of all ages wore board shorts, modeled after the loose-fitting, knee-length cut of active sports shorts.

boxer trunks in woven cotton or nylon that had developed in the 1930s. The bikini remained a favorite swimsuit for athletic-built men, with sales peaking during Olympic years when swimming and diving champions were publicized wearing the style. The thong that had been introduced as underwear in the seventies was adapted to swimwear in the 1980s with designer label versions produced by Gucci, among others. During the 1990s, the barest, most revealing styles of swimwear were ubiquitous on the beaches of Europe, the Caribbean, and South America, but U.S. men were less inclined to wear the briefer forms of swimwear. In 2000, a new type of neck-to-ankles bodysuit swimwear made of a high-tech fabric called **Fastskin** was introduced at the Sydney Olympics. The texture of the material was developed with the aid of computers to simulate the smooth, V-shaped ridges of sharkskin, which reduced the drag of friction even better than the swimmer's shaved bare skin. In 2008, the high-tech Speedo LZR racer, which covered the swimmer from neck to ankles, was credited with establishing thirty-eight world records in swimming during the Beijing Olympics.

MEN'S COUNTERCULTURE STYLES 1980–PRESENT

Besides the numerous standardized categories of men's clothing styles just discussed, counterculture groups and ethnic cliques developed their own distinct looks in the eighties and nineties. (Figure 25-37.) **Skinheads** shaved or closely cropped their hair and appropriated a working class look that included heavy workboots and wallets attached to thick belt chains. Punks extended their antifashion agenda into the realm of excessive body piercing and lavishly applied tattoos. At the end of the 1990s and into the 2000s the **cyberpunk** look was a blend of technology and media that featured clothing of neoprene and other technotextiles accented with metal and molded plastic details. Experiments with "smart clothes" included clothing wired to receive electronic information such as email and GPS navigation guidance. (Color Plate 115.) **Rockabilly** incorporated vintage casual looks of the American 1950s, notably bowling league shirts and pompadour hair cuts, with modern retro interpretations. The "crews" of inner city **B-Boys** of the 1980s breakdanced to hip-hop music in their soft Kangol hats with down-turned brims, oversized quilted jackets, big gold chains, and Adidas sneakers with no laces. In the mid-1990s, B-Boy style became more ethnocentric with symbols of African-American roots such as colonial trade beads and textile prints resembling ashanti cloth. In the 1990s, the grunge style emerged from the Seattle area with its rumpled, layered casualness of old flannel shirts, faded rock T-shirts, ripped jeans, and baggy corduroy pants, all accented with baseball caps and heavy workboots. The gay community, according to pop culture author Shaun Cole, split into "clone" factions that

Figure 25-37. Counterculture groups expressed their antifashion and antisocietal attitudes with looks that often included distinct tribalistic uniforms of sorts. Punk teenager, 1987.

included the cowboy clone, biker leather clone, lumberjack clone, and punk clone, to name a few—each of which adopted the uniform of its prototype, but was distinguishable from the original by the fit and meticulous assemblage of the dress components.

MEN'S GROOMING AND HAIRSTYLES 1980–PRESENT

Men's grooming looks were as diverse and reflective of an individual's personal style as clothing. By the beginning of the twenty-first century, sales of men's personal care products and services had topped a billion dollars annually worldwide. Manufacturers of fragrances offered almost as many varieties of scents for men as for women. Using the same tried-and-true formulas of advertising that had appealed to women for decades, skincare marketers successfully targeted men with messages ranging from preserving a healthy, youthful appearance to finding romance. Even cosmetics were developed for concealing masculine age lines and other telltale signs of advancing years.

For the most part, men remained clean shaven. The full, heavy mustaches of the late seventies lingered into the early eighties briefly as exemplified by Tom Selleck in the TV drama *Magnum P.I.* By the mid-eighties, though, the *Miami Vice* look with its neatly trimmed two-day stubble appeared

Figure 25-38. Since the 1980s men's hairstyles have remained broadly diverse. Hundreds of haircare products for men such as fixative sprays, gels, and nonpermanent colors provided even more options for distinct looks.

in fashion editorials, but was seldom actually seen along Main Street. The rough, casual look only worked well for men with strong, chiseled features and a dark, even growth of beard.

Also lingering from the seventies was the preference for displaying chest hair by unfastening the top two or three shirt buttons. By the mid-eighties, though, that look was derided as a disco-era holdover and men with hairy chests encountered the emergence of a new ideal of masculine aesthetic—the classically smooth, hairless torso of the Greek statue. Reinforcing the new trend, the male actors who portrayed the lifeguards on the nineties TV series *Bay Watch* shaved their torsos to better display athletic physiques. Numerous articles also appeared in men's magazines about effective methods for getting rid of body hair. The term "**manscaping**" entered the lexicon of masculine grooming. In 2005, the movie *Forty-Year-Old Virgin* emphasized the sustained popularity of the hairless masculine torso even at the expense and pain of hair removal by body waxing.

Men's hairstyles of the period came in every conceivable cut, length, volume, and color. (Figure 25-38.) A 1996 car ad featured the headline "Life is full of complicated decisions," and showed twenty distinct men's short hair styles, all of which were common at the time. When added with long variants and ethnic styles, the realistic list of men's hairstyle options was substantial. Hair care shampoos, conditioners, hairspray, gels, mousse, and dozens of other similar products were specially formulated, packaged, and promoted specifically for men. As the baby boomers aged, hair coloring products were heavily advertised. The hair restorative, Rogaine, was approved by the U.S. Food and Drug Administration in 1988 for men with thinning hair. The growing multimillion dollar hair transplant and hair weaving industries were testimony of the importance men continued to place on a great head of hair.

Figure 25-39. Parents chose clothing for their infants and toddlers that successfully combined comfort and safety for the child, ease of quick change, and visual appeal. Bib overalls and knit mockneck top by Oshkosh B'Gosh, 1990.

CHILDREN'S CLOTHING 1980–PRESENT

Clothing for infants and toddlers was designed to fit the child but appeal to the parents. Garments of all types for preschool youngsters were largely made of fabrics in pastel colors and muted tones or petite-print patterns. (Figure 25-39.) Traditional powder blue for boys and pink for girls remained the

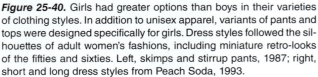

Figure 25-40. Girls had greater options than boys in their varieties of clothing styles. In addition to unisex apparel, variants of pants and tops were designed specifically for girls. Dress styles followed the silhouettes of adult women's fashions, including miniature retro-looks of the fifties and sixties. Left, skimps and stirrup pants, 1987; right, short and long dress styles from Peach Soda, 1993.

prevalent gender identifiers. From the early 1980s through today, more vivid colors, especially bright primary hues, and bold, graphical prints became equally popular. Comfort for the children and easy access for the parents—for quick and easy clothing changes—were the principal guidelines for designers of childrenswear. One-piece outfits and overalls in short or long lengths, depending on the season, best satisfied the needs of both children and parents.

In the 1980s, greater attention was focused on child safety, including clothing designs and textiles. Strict legislation was passed and numerous new regulatory policies were put into effect to better protect children. Manufacturers faced costly recalls and retailers were slapped with stiff fines by the U.S. Consumer Product Safety Commission (CPSC). Mass marketers such as Britain's Marks & Spencer even banned pins and staples from the packaging of children's clothing. A proliferation of articles in women's magazines cautioned parents on dangers such as tie strings on hoods and mittens, buttons or ornaments that could become detached and swallowed, and especially flammable fabrics. Rather than buy sleepwear garments chemically treated with fire retardants, though, many parents dressed their children in oversized T-shirts and other loose-fitting clothing that were, nevertheless, fire hazards. In a controversial policy change in 1996, the CPSC allowed children's sleepwear to be made of flammable materials like untreated cotton, provided the garment was fitted.

The trend of unisex types of children's clothing that developed in the 1960s and grew rapidly through the seventies has become a standard. Sweatshirts, tees, sweaters, pull-on pants and shorts, overalls, and dozens of other clothing styles were manufactured identically in shape, style, and colors for both girls and boys. Despite the commonality of unisex garments, though, parents and children's peers perpetuated gender-role socialization through certain subtleties of color and decoration of these unisex garments, particularly for boys. A purple sweatshirt might be worn by both sexes, but the same garment in lavender or pink was usually taboo for school-age boys; similarly, girls might wear Batman or the Hulk emblems on their tees, but boys would never be seen in a shirt bearing a Barbie or Holly Hobbie image. Only with the increased popularity of bright primary colors and nonrepresentational prints in the eighties was the line sufficiently blurred for social comfort. This deliberate blurring of traditional roles and stereotypes was often a central theme in the advertising of childrenswear makers like Benetton and Esprit throughout the eighties and nineties.

For girls, standardized forms of unisex clothes could be conventionally feminized with embellishments such as embroidered collars, ribbon trim, lace edging, scalloped borders, and faux jewel or beaded appliques. Pants were variously cropped between midcalf and the ankles, and sweaters were extended into thigh-high **skimps** sometimes worn as casual dresses with colorful or patterned tights. (Figure 25-40.)

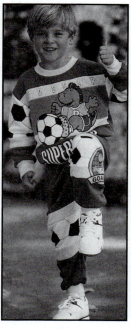
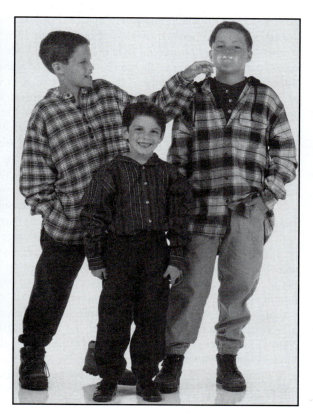

Figure 25-41. For boys, conventional pants and tops could be arranged in ensembles that conveyed specific looks ranging from preppy to street looks. Left, Ralph Lauren signature collection for children, 1982; center, Dynokids fleece set, 1991; right, flannel shirts and Bugle Boy twill pants, 1994.

Although girls' wardrobes were filled with an infinite variety of casual and activewear fashions, dresses remained the preferred garment for special occasions. In the 1980s, the variable hemlines and shoulder contours followed the looks of women's dresses. In the 1990s, retro-sixties dress styles with dropped waists and short skirts were popular with baby boom moms who dressed their daughters in favorite looks from their own childhood. During holidays, crinolined dresses of rich fabrics reinforced the nostalgia of the season.

School-age boys dressed in a diverse combination of tops and pants. (Figure 25-41.) Most styles reflected those of adult men. Preppy ensembles included conventional dress shirts with button-down collars or casual polo styles, usually with an embroidered alligator or polo rider to match Dad's. Boys also often identified with their parent's favorite sports teams by wearing almost any apparel or accessories decorated with licensed team emblems and franchise colors. On the top of most children's clothing wish lists was anything bearing images from the most current hit movie, cartoon, or TV program, especially depictions of superheros, dinosaurs, and Harry Potter. By the 1990s, the oversized, baggy street looks of big brother were in demand by preteen boys, for which manufacturers produced garments with dropped shoulders and wider cuts. In the 2000s, hip hop styling included distressed baggy jeans and hooded nylon jackets called "**hoodies**." Logos of rappers such as Sean John were plastered over almost every

surface of shirts, tees, and jackets. Boys' "iced out" plastic watches were studded with rhinestones to simulate the glittering bling-bling of their favorite hip hop bands. When required to dress up for a special occasion, boys preferred sports jackets and blazers with chinos rather than a suit.

REVIEW

The pluralism of fashion—many widely diverse clothing types, silhouettes, branded labels, and lifestyle looks—that had emerged in the 1970s expanded rapidly in the eighties becoming an overarching economic signpost for the fashion industry that endures still. Throughout the last twenty years, fashion makers and retailers recognized that most consumers wanted clothing that suited their personal lifestyles irrespective of trends featured on the runways or in editorials of fashion magazines. Niche marketers reacted to changing consumer attitudes by promoting the idea of individuality, and specialty manufacturers and retailers responded to the growing consumer pluralism by providing clothing designs more suited to modern segmented demographics: an age group, a size range, a social status.

However, this pluralism did not preclude the emergence of key fashion themes and trends that were broadly popular. In the New Gilded Age of the 1980s, a surge of worldwide prosperity inspired unabashed exhibitionism of sociopolitical

power and wealth among the newly affluent classes. The inverted triangle silhouette of fashions, for both men and women, was the quintessential style image of the decade. The broad, padded shoulders of the powersuit expressed self-confidence and authority. Similarly, the big sculpted looks were adapted to almost all forms of fashions in the eighties, from sportswear to sumptuous evening gowns. Colors and textile patterns were equally bold—vibrant hues, big plaids, strong graphics. For women, the opulence of billowing pouf dresses or crinolined skirts exemplified the extravagance of the era. Skirt hemlines became widely varied from thigh-high miniskirts to ankle sweeping retro-looks of the fifties.

For men, a new perspective of masculine sensuality emerged with the deconstructed suits designed by Armani and Versace. In 1980, many men were uneasy watching Richard Gere in *American Gigolo* meticulously arrange ensembles of matching garments in his bedroom, but by mid-decade, men were commonly doing the same thing even in public as they shopped in department stores.

By the end of the 1980s, a Wall Street crash followed by a recession caused a backlash against the excesses of the New Gilded Age, and led to the end of the big, sculpted looks. Fashion pluralism expanded to fill the vacuum. Individuality and personal style became even more significant during the closing decade of the century. At the opposite end of the spectrum from the eighties rich look emerged brief fashion episodes such as grunge, a dishevelled, rumpled casualness of the youth culture. Cyberstyle combined street looks with technotextiles and the paraphernalia of the technological age. For those who were uncertain of their individuality, at least with fashion, the cachet of mass marketed brand logos provided a form of group identity—from high-end couture house labels to licensed sports team emblems. In addition, a plethora of revivalisms of styles from the fifties and sixties continued to offer some refuge of comfort with the familiar.

With the dawn of the twenty-first century, fashion cognoscenti searched in vain for the Next Big Thing in fashion. Instead, the pervasive quest of consumers for their own individual styles sustained a fragmented, niche-oriented market. New retro-looks included a revival of low-rise jeans and pants for both men and women. Men's suits of the 2000s adopted the narrow, trim silhouettes of forty years earlier. Vintage clothing and accessories, made all the more accessible through Internet auctions and vintage clothing sites, were mixed with modern styles for a truly unique look. In Paris, Milan, and New York, designers continued to fulfill consumers' demands for versatile and comfortable clothing while experimenting with imaginative avant-garde fashions, from which, just on the horizon, may come the Next Big Thing.

Chapter 25 The Twentieth Century: 1980–Present
Questions

1. What styles of women's fashions of the 1980s exemplified the exhibitionism of the era? Give examples of silhouettes, fabrics, and accessories.

2. How did the fitness boom of the eighties influence fashions of both women and men? Identify examples of body-conscious fashions of the decade.

3. Define the qualities of the rich look of the eighties. What examples of popular culture and social "courts" perpetuated the rich look of the 1980s?

4. As fashion became more pluralistic and niche-oriented in the 1990s, what two principal purposes did haute couture serve?

5. Why was logo wear particularly popular in the 1990s? What were some key designer logos that achieved mass recognition?

6. What were some of the 1990s revivalisms from the fifties, sixties, and the more distant past? Identify at least one designer with each retro-style.

7. Compare and contrast the grunge and cyberstyle looks of the 1990s. What cultural changes influenced the emergence of each style? Identify three designers whose fashions were influenced by these pop culture styles, and explain how.

8. In the early 2000s, what source of fantasy particularly inspired experiment and innovation among designers? Identify three designers and how they expressed their inventiveness.

9. How did Italian style and British tailoring change traditional men's suit jackets in the 1980s and 1990s?

Chapter 25 The Twentieth Century: 1980–Present
Research and Portfolio Projects

Research:

1. Write a research paper on the internationally significant pop-culture, social, or news events since 1990 that have contributed to revivalisms in fashion. Include examples of the resulting revivals, their makers, and the correlation to the event.

2. Write a research paper on today's five top couture houses. Who are their chief designers and what is innovative about their collections? Which business practices, such as licensing, off-shore manufacturing, or brand marketing, have added to the profitability of each?

Portfolio:

1. Compile a reference guide to the top-selling 100 fashion brand logos of the twenty-first century. Use photocopies or digital scans of each logo and mount them in alphabetical order. Label each with the full name of the designer, fashion house, or ready-to-wear maker.

2. Research current magazines and catalogs to find 10 women's revival styles, each representing influences from different historical eras. Mount enlarged photocopies or digital scans of each image on an 11×14 board. Beneath each image write a description of the revival and the original period inspiration for the look. Explain how the revival has been adapted to modern tastes. Include details of each designer or maker, fabrics, colors, and date

Glossary of Costume Terms

absurdists: a Parisian group of avant-garde fashion designers of the early 2000s

B-Boys: inner city street looks of the 1980s that included Kangol hats, big gold chains, sneakers without laces, and oversized quilted jackets

bed head: the mussed hair look of the early 2000s

bling-bling: flashy jewelry, especially diamonds, or a showy style of dress

bolla: a string tie popular in the 1980s

borrowed look: the adaptation of men's clothing styles to women's fashion

cyberpunk: a youth look of the 1990s that featured clothing of technotextiles accented with metal and molded plastic details

cyberstyle: a futuristic look of the late 1990s that combined technotextiles with street looks and elements of historic dress

deconstruction: the rejection of conventional rules of clothing cuts, form, or fit

Fastskin: a synthetic fabric that simulated sharkskin that was applied to swimsuits

ferrule: the metal tips of laces and bolla strings used to prevent unravelling

grunge: a youth pop culture look of the early 1990s that emphasized a disheveled casualness and ensembles of distressed and mismatched clothing

hipster: a women's high-waist swimsuit bottom of the 1990s that was a revival of a style from the forties

hoodies: any type of lightweight hooded knit or woven top worn by both men and women

low riders: a new form of women's hiphugger pants cut extremely shallow at the inseam

manscaping: trimming, waxing, or shaving unwanted hair from any part of the body below the neck

metrosexual: straight men of the twenty-first century with a cosmopolitan sense of style and taste; a term later modified as "metro male" by style editors to minimize confusion with homosexual

Miami Vice look: a men's sporty suit look of the 1980s that included unconstructed jackets worn with the sleeves pushed up, colored T-shirts, relaxed fit trousers, and shoes with no socks

pouf dress (also called bubble dress): a bouffant cocktail dress of the 1980s constructed with a voluminous, rounded skirt

powersuit: men's and women's business suits of the 1980s usually designed with an inverted triangle silhouette formed by broad, padded shoulders and tapered, narrow hips

racer: a women's one-piece swimsuit with an open back and wide shoulder straps modeled on Olympic swimsuits of the forties

rio: a string bikini or thong first introduced on the beaches of Rio de Janeiro

rockabilly: a youth look of the 1980s that incorporated vintage casualwear of the fifties with modern retro styles

Romantique: women's fashions of the 1980s that featured frilly, feminine elements of nineteenth-century styles

shell toes: sneakers worn without the laces in the 1980s

skimp: a girl's long sweater extending to mid-thigh worn with tights or form-fitting knit pants

skinheads: a counterculture group of 1980s disaffected young men who shaved their heads and dressed in working class garb

skinny ties: men's thin neckties of the 1980s

tankini: a women's swimsuit comprised of a tanktop and bikini bottom

technotextiles: synthetic materials produced in the 1990s that were applied to apparel and accessories

Chapter 26

THE FASHION MAKERS

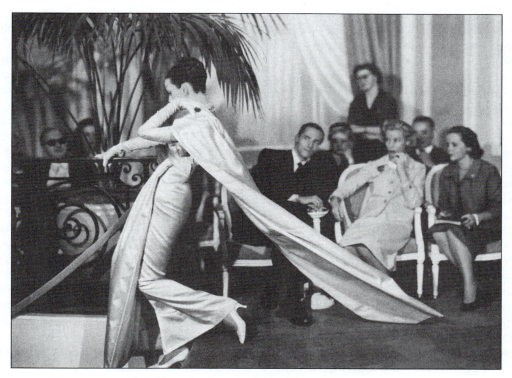

Fashion show at the House of Dior, 1956.

THE PREEMINENCE OF THE DESIGNER

Over the 30,000-year history of human dress, the significance of the individual designer as the acknowledged arbiter of style has been relevant only since the mid-nineteenth century. Numerous names of clothing and accessory designers, along with the evidence of their contributions to the history of fashion and style, populate the preceding pages of this survey. Some designers—and the looks they created—have come to be inextricably associated with a specific period, such as Christian Dior and the 1950s, while others, like Yves St. Laurent, have dominated several decades. Many other once prominent designers have been relegated to footnotes in specialized studies on fashion. Countless others have been lost, decade by decade, to anonymity in history. We get a glimpse of the magnitude of this loss in the 1928 study of the

fashion industry by economist Paul Nystrom, who reported that there were 80,000 dressmaking shops in Paris alone, from which "not less than 25,000 . . . *new designs* in women's apparel" were created each year. And this is but a sliver of time and place in the global arena of fashion history.

It should be noted, too, that, although the words couturier and designer are often use interchangeably, there is a pronounced distinction. In the 1972 book, *Couture*, contributing writer and former Balmain Directrice Ginette Spanier, emphasized the difference. A true couturier was a master of the craft of cut and fit who always strove for perfection. "I have seen the lining of a dress started over five times because the dart at the bust was not at the perfect angle even though the lining did not show through the dress," noted Spanier. "Of such stuff is the haute couture made."

On a less lofty pedestal were those designers who possessed a more fundamental working knowledge of their craft and primarily focused on style innovation and pioneering inventiveness. One is reminded of the simplicity of Mary Quant's designs or the nontraditional approaches of Paco Rabanne and Kansai Yamamoto. This is not to negate the significant or influence of these designers in the realm of fashion history, though.

The third tier in the rarified dominion of fashion design is that of the fashion product stylist. This sometimes pejorative label has been applied, for example, to commodity ready-to-wear makers whose efforts most often focused on choosing new colors or fabrics for standardized garments such as men's dress shirts, and basic clothing like polo shirts, sweatshirts, turtlenecks, T-tops, and the like. For a number of branded stylists, successful marketing and product merchandising rather than fashion innovation have provided them with the cachet of a designer. Ralph Lauren, who himself often denies the label of fashion designer, is one of the premier thematic stylists of today.

The importance of the designer from a historical perspective also may be determined by the era in which he or she worked. As fashion historian Linda Watson noted, in the century and a half since Worth became the first couturier, the designer "was considered a dictator, then a director, and a suggestor." Through the 1950s, the fashionistas, retail buyers, ready-to-wear manufacturers, and journalists eagerly awaited the semiannual shows in Paris to learn what the dictators of fashion had prescribed that the modern, stylish woman, man, and child *must* be wearing in the coming season. In the 1960s, though, when the youth cult of the era inspired individualism, the designer as director emerged. "Do your own thing" was a common phrase, to which designers responded with a broad spectrum of looks that blended space-age innovations with historic costume and street styles. This idea of the customer's quest for personal style continued to gain momentum through the seventies and eighties. Since the end of the 1980s, the designer has largely provided suggestions for a fragmented, niche market filled with consumers who choose and mix looks that define a style of their own.

DRESSMAKERS AND ARTISTES

As the end of the twentieth century drew to a close, the duality of fashion as an art form as well as an industry became more sharply evident than during any previous period. From the perspective of many in the world of fashion, particularly designers, the business half has become the dominant of the two. It is the financiers, corporate conglomerates, and marketers who have taken over, preferring, it seems, to work with dressmakers rather than artistes. In 1999, the fashion corporate raider, Bernard Arnault, who had acquired Dior, Givenchy, and Louis Vuitton, among others, succinctly stated, "The reason to be a designer is to sell. Fashion is not pure art. It is creativity with the goal of having as many customers as possible wearing the product." Those designers who understood this shift in the fashion paradigm continued to thrive, finding their niche and defining the parameters in which their creativity could be expressed.

For those designers who were unable or unwilling to understand the nature of the beast in its fin de siecle form, few continued to succeed on their own terms. The consequences more often than not were dire. In recent memory is the example of Isaac Mizrahi, a case study which still echoes down New York's Seventh Avenue. Mizrahi was the most prolific American designer of the 1990s, offering one innovation after another under his own label and winning a number of "best designer" awards. (Color Plate 109.) Despite the adoration of the fashion press, though, sales were disappointing. "Look, it is all I can do to make fabulous clothes," the designer later explained; "I can't imagine how it will translate at retail." The reality of retail, though, eventually forced the closing of the House of Mizrahi in 1998. (He later learned retail fashion marketing during his five-year alliance with Target Stores and, in 2008, headed ready-to-wear label Liz Claiborne.) The era of the designer as dictator, or even as director, had passed.

Yet the reality signs were clearly evident everywhere for the business-savvy designer to recognize (or at least for his silent business partner to read). In 1994, for instance, a Paris-based market research firm asked European women, "Who or what do you emulate when you try to be fashionable?" Seventy percent of the respondents answered, "No one; I just want to maximize me." Designers as the creative force of fashion had to adapt to this new global pluralism. No longer did the design talents, in league with the trend setters of high society and style journalists, determine what everyone would wear season after season. The successful designer of the twenty-first century is an amalgam of artiste, dressmaker, and retailer. The artiste provides glamour, fantasy, and innovation—fashion as drama and high art; the designer as dressmaker provides the market with fashion as real, wearable styles that allow each customer to "maximize me"; the designer as retailer understands commodity marketing, public relations, and the industry's business cycles.

In the following biographical index are some of the most famous and important names in fashion design of the past 150 years. The 98 designers featured here have been selected by the author for their innovation in fashion design, for their imaginative leadership in the fashion industry, and especially for their enduring legacy in the realm of fashion.

THE FASHION MAKERS

Adolfo (b. 1933)

Born in Havana, Cuba, Adolfo Sardina came from an affluent family of lawyers. As a boy he visited Paris with his sophisticated aunt, who introduced him to couture fashion. He later became a milliner at the House of Balenciaga, where he learned the importance of cut, fit, and line. In 1948 he moved to New York to design hats for Bergdorf Goodman. During the 1950s, as chief designer for the millinery wholesaler, Emme, he established the distinct techniques of shaping hats by cut and stitching rather than wires and padding. In 1962, he began his own design firm, expanding into clothing as well as hats. Adolfo won the Coty Award twice for millinery (1955 and 1969). Throughout the sixties, he utilized theatrical design elements for styles such as a melton officer's greatcoat with epaulets and large brass buttons, Gibson Girl blouses, organdy jumpsuits, and patchwork evening skirts. During the 1970s and 1980s, his collections featured tailored designs with clean, straight lines. His fashions were a favorite of Washington, D.C. socialites, particularly Nancy Reagan. He retired in 1993.

Adri (b. 1934)

Adri was the label name for the Missouri-born Adrienne Steckling. She studied at the Parson's School of Design where Claire McCardell lectured. In the fifties, Adrienne designed for the ready-to-wear maker, B.H. Wragge, followed in the sixties by a design position with Anne Fogarty, Inc. In 1972, she established her own line of clothing with an emphasis on easy, comfortable separates. She won a Coty American Fashion Critics "Winnie" in 1982.

Adrian, Gilbert (1903–1959)

Adrian was born into a fashion family; his parents owned a successful millinery shop in Connecticut. His first work as a designer was in the theatre, which led to a career as a studio costumer in Hollywood during the 1920s and 1930s. His slouch hat for Greta Garbo in *A Woman of Affairs* (1929) set a style trend for the next ten years. Similarly he popularized the snood during World War II, which he created for Heddy Lamarr in *I Take This Woman* (1939). His "Letty Lyton" dress with its wide shoulders and ruffled sleeves was designed for Joan Crawford in the movie of the same name (1932), and was widely copied by ready-to-wear makers who sold thousands of the style. Among his most famous Hollywood creations was the white satin gown cut on the bias to accentuate the voluptuous figure of

Jean Harlowe in *Dinner at Eight* (1933). Adrian left the studios in 1942 to open his own atelier in Beverly Hills. Although never taken seriously by the fashion press due to his theatre pedigree, he won a Coty American Fashion Critics "Winnie" in 1945. He became famous for exquisitely tailored suits designed with complex cuts and precision stitching.

Alaia, Azzeline (b. 1940)

Tunisian art student Azzeline Alaia went to Paris in the late fifties where, over the next two decades, he worked in a succession of jobs in the fashion industry. By the 1970s, he had secured a following of clients, including Tina Turner and Paloma Picasso, who encouraged him to launch his own label. His first show was held in New York in 1982. The body-conscious designs of Alaia were perfect for the eighties: little black dresses and acetate knit halter gowns that accentuated the slender, curvaceous figure. In the 1990s, his use of hardware such as rivets and industrial zippers combined with formfitting technotextiles showed the influence of Mugler and Montana.

Albini, Walter (1941–1983)

Originally a fashion illustrator in Paris, Walter Albini returned home to Italy in 1960 where he worked as a ready-to-wear designer for Krizia and Basile. In 1965, he opened his own salon, designing glamorous clothes inspired by the costumes featured in movies of the 1930s and 1940s, particularly the styles of Katherine Hepburn and Marlene Dietrich. Throughout the 1970s, Albini integrated elements of global ethnic costumes and hippie-styled layering of mixed looks into his sophisticated, cleverly cut sportswear creations.

Amies, Hardy (1909–2003)

Hardy Amies was one of Britain's most prolific and famous fashion designers. In the 1930s, he trained at the couture house of Lachasse where he became managing director as well as chief designer. During World War II, Amies developed collections of beautifully tailored suits within the rationing restrictions of the government's Utility Scheme. In 1945, he opened his own couture salon, making dresses for most of London society, including Princess Elizabeth. He is best known for his superbly tailored tweed suits and sumptuous ball gowns. In 1955, he was awarded the royal warrant by the Queen. In 1961, he expanded his venture to include menswear.

Armani, Giorgio (b. 1934)

The one word most frequently associated with Giorgio Armani is perfectionist; a secondary label is deconstructionist. Armani began his fashion career as a department store menswear buyer where he first developed a keen eye for garment cut and construction as well as an understanding of the fashion retail business. In the 1960s, he became a designer with suit manufacturer Nino Cerruti and later with Emanuel

Giorgio Armani, 1992.

Balenciaga, 1927.

Bill Blass, 1986.

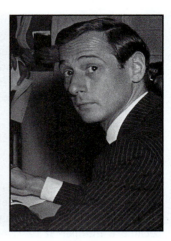

Marc Bohan, 1965.

Ungaro. After Armani established his own firm in 1975, he began to deconstruct men's suits by rethinking the fit and removing the padding, interlining, and stiffness. He combined luxurious fluid fabrics with perfect cuts and superb tailoring to design a new form of men's suit. The result was an understated elegance, comfort, and a sensuous masculinity. In 1980, he was catapulted to international prominence when he designed the wardrobe for Richard Gere in *American Gigolo*. Throughout the eighties, the Armani label was the quintessential symbol of the successful yuppie, male or female. Armani also applied his principles of cut, fit, and quality fabric to designing women's fashions—an unusual reverse transition in the industry. His designs are always well represented at highly publicized events such as the Oscars.

Ashley, Laura (1925–1985)

The manufacturing empire of Laura Ashley, Ltd., began in 1953 as a cottage industry in rural England when she and her husband, Bernard, began hand-printing textiles for use in table linens and head scarves. In 1968, Ashley opened a shop selling cotton short-sleeve smock tops and voluminous dresses with capacious patch pockets. As the business grew during the 1970s, she created ankle-length dress styles based on Victorian and Edwardian models—a look sometimes called "milkmaidism." The high collars, billowing sleeves, and petit-print textiles recalled an era of innocence before the First World War. During the 1980s, her frilly blouses and floral print dresses were popular with women who preferred the Romantique look to that of the powersuit wardrobe. Since 1990, the company has expanded its lines to include more international styles made with blended fabrics and jersey knits. Her love of prints, patterns, and textiles were additionally applied to a coordinating total look approach to home furnishings including upholstery, wallpaper, paints, furniture, fixtures, china, and decorative accessories.

Balenciaga, Cristobal (1895–1972)

When Balenciaga retired in 1968, many fashion aficionados declared that true haute couture had ended for all time. In more than fifty years, Balenciaga was the benchmark by which most other couturiers were measured. Each collection he designed made a clear, pertinent fashion statement that evolved logically from previous collections. Balenciaga began as a tailor in Spain and, in 1916, opened a dressmaking shop. He escaped Franco's repressive regime in 1937 and went to Paris to reopen his atelier. Unlike Worth, Poiret, and Dior, whose innovations altered the course of fashion, Balenciaga created styles of enduring perfection—the classicist's view of scale, proportion, and balance achieved by the perfect cut. His guiding principle of design was the elimination of detail. His colors were of Spain: brilliant reds and yellows, Mediterranean turquoises, and warm earthtones. In many instances, his designs were also ahead of their time. He forecast the New Look in 1939 with designs featuring cinched waists and rounded shoulders and hips. In 1956, his loose chemise dress, called the sack, anticipated the fuller looks of the sixties. His name is still associated with a stand-away collar design and the use of oversized buttons.

Balmain, Pierre (1914–1982)

Although the Balmain family owned a wholesale drapery business, young Pierre was initially interested in architecture, which he began studying in Paris. Instead of completing his studies, though, he became an illustrator for Robert Piquet in the early 1930s. He then spent five years with Edward Molyneux, after which he joined the house of Lucien Lelong. At Lelong, he collaborated with Dior and they considered opening an atelier together, but Balmain instead opened his own salon in 1945. From the start, his glamorous but nonfussy designs appealed to society's elite. He dressed royalty, statesmen's wives, and Hollywood stars. Among

his famous clients were the Duchess of Windsor, the Queen of Siam, and Sophia Loren. In the fifties he popularized the sheath dress worn with loose, full jackets. He set trends with cossack capes and full coats with half belts. In 1951, he expanded into ready-to-wear with designs that successfully translated French fashion into clothing for the taller American woman.

Bates, John (b. 1935)

Most famous for his 1960s costume designs for Diana Riggs in *The Avengers,* John Bates was one of the most innovative British designer of the Swinging London era. He trained at the Chelsea couture house of Herbert Sidon in the 1950s and became the chief designer of the ready-to-wear maker Jean Varon in the 1960s. He introduced tube dresses with matching tights in 1964 and popularized cutaway looks including dresses with a bare midriff. In 1972, he launched his own label with superbly crafted maxi coats and sophisticated eveningwear. After his business went bankrupt in 1980, he moved to Wales and continued designing for select clients.

Beene, Geoffrey (1927–2004)

Throughout his life, Geoffrey Beene retained the soft Southern accent he acquired as a boy in his native Louisiana. He changed his plans to pursue a medical degree and, according to lore, became interested in fashion upon seeing Adrian's designs for Joan Crawford in *Humoresque* (1946). He studied in New York at the Traphagen School of Fashion Design followed by the Académie Julian and the Molyneux tailoring studio in Paris. During the fifties, Beene worked for a number of U.S. ready-to-wear makers including Teal Traina. In 1963, he set up his own company. He was noted for his use of bold colors and for the unusual mixing of materials such as rhinestones and flannel or jersey and taffeta. Many of his designs presented unexpected touches of fantasy like football jersey evening gowns replete with player numbers on the back. He described his boutique line, named Beene Bag in 1971, as "romanticized sportswear." A feud with the trade paper *Women's Wear Daily* began in 1967 when he refused to provide advance details of the wedding dress he designed for President Johnson's daughter. Despite the clash with *WWD* that lasted for decades, Beene's firm thrived, and the designer won eight Coty awards.

Blass, Bill (1922–2002)

Before the Second World War, Bill Blass worked as a fashion artist for ready-to-wear manufacturers. Following a stint in the military, he joined the Anna Miller company as a designer through the 1950s. When the firm merged with another ready-to-wear maker, Maurice Rentner, Blass became a vice president until he bought the company in 1967. Three years later he renamed the company Bill Blass. He is best known for his American luxury sportswear characterized by simple,

soft lines and a fluid fit. This same simplicity of line was combined with sumptuous fabrics and rich details for elegant, urbane eveningwear throughout the sixties and seventies. In the 1980s, he created cocktail dresses with exaggerated ruffles and opulent trimmings that well suited the exhibitionism of the nouveau riche of the era. His keen business acumen led to more than thirty licensing agreements, including accessories and bed linens. In addition he launched a high-style, moderately priced sportswear line called Blassport in 1972. He won numerous fashion awards and held three honorary doctorates.

Bohan, Marc (b. 1926)

As a boy, Marc Bohan had been encouraged to design clothing by his milliner mother. After receiving his diploma in art from the Lycée Lakanal in 1946, he spent the next ten years designing for three of the most prestigious houses in Paris: Piquet, Molyneux, and Patou. He joined the house of Dior in 1958 and was sent to London to design the ready-to-wear collections. When Yves St. Laurent left Dior in 1960, Bohan became artistic director and returned to Paris. Over the following three decades, he produced traditionalist couture. His designs were understated and elegant. Among his most notable looks were the fur-trimmed collection of 1965 based on the costumes of the movie *Dr. Zhivago* (1965), and his evening gowns with large, bustle-like bows. In 1990, he returned to London to take over at Hartnell, where he ended his career when the financially ailing firm finally closed.

Capucci, Roberto (b. 1929)

Trained at the Accademia delle Belle Arti in Rome, and apprenticed under Emilio Schumberth, the precocious Roberto Capucci opened his own salon at the age of twenty-one. A decade later he was persuaded to relocate to Paris, but returned to Rome after six years. Capucci was one of the first post–World War II Italian couturiers to enjoy international fame. His design style is often compared to that of Balenciaga—crisp, architectural, and meticulously cut and draped. His critics frequently accused him of viewing his fashion designs as more important than the wearer. He constantly experimented, extending the perimeters of design with daring new cuts and striking use of fabrics. His 1985 ball gowns of pleated rainbow taffeta appeared to be engineered as a series of gigantic shoulder-to-floor bows—an ideal look for the exhibitionism of the decade.

Cardin, Pierre (b. 1922)

As a teenager during World War II, Pierre Cardin was apprenticed to a tailor in Vichy making suits for women. After the war, he went to Paris and worked for Paquin and Schiaparelli. He joined Dior in 1947 just as the New Look was launched. Three years later, Cardin established his own firm. During his early career, he also designed costumes for theatre and movies,

Oleg Cassini, 1961.

John Cavanagh, 1950.

Chanel, 1960.

Courreges, 1970.

which had a significant impact on his fashion designs. In the fifties, Cardin's bubble skirts were the precursor of the 1980s pouf dresses, and his loose chemises were the prototype for the revivals of the 1990s. In the sixties, he applied similar design solutions to both genders, for which he is often credited with the creation of unisex fashions. He pushed the boundaries of cut and inventiveness, including knit tube dresses, tabard tops over bodystockings, and bias cut spiral dresses that featured Op Art cutouts and plastic geometric appliques. The Cardin name became known world-wide through his aggressive licensing program that appeared on products ranging from furniture and luggage to wigs and cookware.

Carnegie, Hattie (1889–1956)

When Hattie Carnegie's family immigrated to the United States, they changed their Viennese name from Kanengeiser to that of the richest man in America—Carnegie. As a teenager, Carnegie worked in the millinery department of Macy's where she learned the basics of design and retail. In 1909, she opened a hat shop with a partner who made dresses. Although Carnegie could not sew or draw, she had a keen fashion eye and understood the stylistic needs of the American woman. She imported Paris couture and produced adaptations with an American feel under the label Hattie Carnegie Originals. She also employed some of America's leading designers including Claire McCardell and Norman Norell. Carnegie expanded her business interests beyond retail to include her own ready-to-wear factories and distribution.

Cashin, Bonnie (1915–2000)

Inspired to clothing design by her mother, who was a dress-maker, and by her study of art and dance, Bonnie Cashin became a costume designer for the theatre in the 1930s while still a teenager. She expanded her repertoire by also designing ready-made sportswear in the thirties, but then went to Hollywood as a costume designer for 20th Century Fox in the 1940s. In 1949, she opened her own business in New York, where she created clean, uncomplicated designs despite the prevalence of the cinched and tight-fitting New Look. She was one of the first American designers to develop layered looks with easy, functional garments that could be added or discarded as the climate or weather demanded. She is most often associated with popularizing the poncho. Many of her sportswear designs, based on squares, rectangles, and triangles, have a timeless quality and are still relevant today.

Cassini, Oleg (1913–2006)

As a boy, Oleg Cassini helped his mother run an exclusive dress shop in Florence. In the 1930s, he trained at Patou in Paris before going to New York, where he worked for various ready-to-wear makers. In 1940, Cassini went to Hollywood as a costumer for the movie industry, working for a while under Edith Head. He was engaged to Grace Kelly but eventually married Gene Tierney. He opened his couture salon in 1950 and was best known for glamorous sheath dresses and opulent eveningwear. In 1961, he became the official designer for Jacqueline Kennedy. The Empire waist gowns and tailored suits he designed for the First Lady were widely copied around the world, as were his little pillbox hats.

Castelbajac, Jean-Charles de (b. 1950)

At age eighteen, Castelbajac began designing clothing for his mother's ready-to-wear company in France. In 1975, he opened his own business. His modernist, high-tech designs revealed the influence of Pierre Cardin and Paco Rabanne. Though his clothing was a skillful mixture of fantasy and futurism, the attitude was most always functional and natural. In the 1980s, he became famous for "wearable art" featuring handpainted fabrics and revivals of Pop Art imagery. He also

designed for the theatre, cinema, and concert arena, including costumes for the Rolling Stones and Talking Heads.

Cavanagh, John (b. 1914)

In 1932, John Cavanagh became an assistant to Molyneux in Paris. After serving in the British army during World War II, he returned to Paris and worked for Pierre Balmain. In 1952, Cavanagh opened his own couture shop in London, designing elegant, understated styles with long, lean lines that appealed to English high society. Among his notable clients were Princess Alexandra, Princess Marina, and the Duchess of Kent. His salon closed in 1974.

Cerruti, Nino (b. 1930)

At age twenty, Nino Cerruti became head of the Italian textile firm his family had established in 1881. In his early years, he produced avant-garde menswear with clean, superb tailoring—in particular his "Hitman" collection of 1957 and a knitwear line in 1963. Armani worked for him a number of years, learning the importance of the perfect cut and line. In 1967, Cerruti opened a boutique in Paris and launched his luxury ready-to-wear label. A women's line followed in 1977. He also designed costumes for over sixty movies including eighties aspirational looks for *Wall Street* and *Baby Boom*. He retired in 2001.

Chanel, Gabrielle (Coco) (1883–1971)

The details of Chanel's childhood and teenage years were purposely kept obscure by the designer throughout her lifetime. As a young woman, she was mistress to a number of wealthy and powerful men, one of whom backed her first shop in 1914. Over the next few years, Chanel introduced revolutionary designs that were based on her own preference for comfortable and practical clothes. She created simple chemise dresses to be worn without corsets, reducing the stiff linings for a lighter, less rigid fit. Her early suits were made of jersey, a fabric typically used for casual tops and underwear. Chanel particularly liked to adapt menswear to women's fashions, including the pea jacket and oversized cardigans. In the 1920s, she expanded on the practical trouser styles first worn by working women during World War I and designed bell-bottom "yachting pants" and wide-legged day pajamas. By the 1930s, the Chanel look was already classic— the little black dress, the collarless suit jacket and slim skirt, and an abundance of colorful costume jewelry. She closed her salon at the start of World War II in 1939, but remained in Paris where she became the mistress of a German officer. After the war, she barely escaped having her head shaved as a collaborator, and fled to Switzerland. In 1954, she was persuaded to return to Paris and reopen her salon, in part to boost sales of her fragrances. She resumed producing the classic Chanel suit in soft tweeds or jersey—a timeless style that changed little, even a decade after her death. The house of Chanel was revitalized when Karl Lagerfeld became designer for the firm in 1983.

Claiborne, Liz (b. 1929)

A Belgian by birth, Liz Claiborne studied fine arts before winning a *Harper's Bazaar* fashion design contest in 1949. She worked for various New York ready-to-wear makers including Tina Leser and Omar Kiam. During the sixties she was instrumental in designing collections of mix-and-match separates that crossed the typical categories of special occasion clothing. In 1976, she formed her own company based on divisions that produced primarily youthful, well-made sportswear particularly suited to the American market. She retired in 1989.

Clarke, Ossie (1942–1996)

While still an art student at the London Royal College of Art, Ossie Clarke began designing clothing for the boutique Quorum in the early sixties. He had an instinctive feel for the female anatomy, producing body-conscious dresses with plunging necklines, open backs, and ethereal wrap-around silhouettes. He married textile designer Celia Birtwell and used many of her fabrics in his collections.

Courréges, Andre (b. 1923)

Although trained to be a civil engineer, Courréges changed careers and returned to school to study textiles and fashion design. In 1949, he joined Balenciaga and, over the next decade, learned from the Spanish master to be a serious perfectionist in cut and design. In 1961, he opened his own atelier. Along with Pierre Cardin and Paco Rabanne, Courréges led the visionary thrust of minimalist fashion design in the sixties. Because his styles were geometric, sharp-edged, and uncluttered, with a disciplined reduction of excess material and superfluous decoration, he came to be known as the "space age" designer. His futuristic collections featured stark, trapeze-style dresses and coats and tube-shaped pants cut on the bias. His stiff, square miniskirts were declared by *Vogue* to be the shortest in 1965. He also popularized calf-high white go-go boots. In the seventies his designs lost the edginess of his earlier work, but retained the well-tailored, delineated line of the master couturier.

Crahay, Jules Francois (b. 1917)

During his teenage years, Crahay worked in his mother's dressmaking shop in Liège, and later for the house of Jane Regny in Paris. In 1952, he became the chief designer for Nina Ricci, creating superbly tailored suits and sumptuous eveningwear. In 1963, he moved to Lanvin where he directed the collections for twenty years. He is best known for his trendy peasant and gypsy styles of the late sixties.

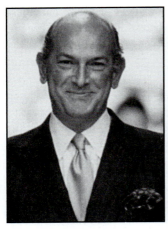

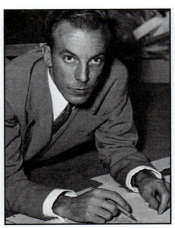

Oscar de la Renta, 1990. Christian Dior, 1956. Jacques Fath, 1950. Gianfranco Ferre, 1990.

De La Renta, Oscar (b. 1932)

While studying fine art in Madrid, some of Oscar De La Renta's fashion sketches were shown to the wife of the U.S. Ambassador who subsequently commissioned him to design her daughter's debut gown. The dress was featured on the cover of *Life* magazine and De La Renta's career in fashion was set. He worked at the Madrid couture house of Balenciaga until 1961 when he went to Paris as an assistant to Antonio del Castillo at Lanvin. In 1963, he joined Castillo at Elizabeth Arden in New York, and in 1965, established his own firm. De La Renta is best known for sophisticated suits and especially opulent eveningwear, often elaborately trimmed with embroidery, ruffles, and other lavish ornamentation. Among his clients were Jackie Onassis, Liza Minelli, Nancy Reagan, Faye Dunaway, and Joan Collins.

Demeulemeester, Ann (b. 1954)

Experimental and deconstructive, Ann Demeulemeester is one of today's most imaginative fashion designers. Trained at the Royal Academy of Fine Arts in Antwerp, she freelanced until launching her own line in 1985. In 1992, she opened her showroom in Paris, and four years later, presented her first menswear collection. Her style is a blending of punk and gothic with a decided influence from the Japanese Big Look of the 1980s. Madonna and Courtney Love have donned designs by Demeulemeester.

Dior, Christian (1905–1957)

The pivotal point in twentieth-century fashion was created by a shy, middle-aged Frenchman whose 1947 New Look shook the world of style. As a teenager, parental pressure had forced Dior to study political science in preparation for a diplomatic career. He instead wanted to be an architect, but ended up managing an art gallery. When the Great Depression interrupted that venture he occasionally found work as a freelance

fashion illustrator for magazines and couture houses. In 1938, his impoverished years as a gypsy ended when he became a design assistant to Robert Piquet. During World War II, he worked for Lucien Lelong in Paris, where he met the millionaire fabric manufacturer, Marcel Boussac. In 1946, Boussac offered to finance Dior as an independent couturier, and the forty-one-year-old designer opened his own atelier. The following February, he presented his first collection, which he named the Corolle line. The New Look, as it was dubbed by *Harper's Bazaar,* was an instant sensation and spectacularly successful. Dior had launched a counterrevolution that was actually more anachronistic than new: cinched waists, padded hips, tight bodices, and huge skirts that harkened back to the Edwardian era. But his timing was impeccable. After years of austerity and privations during the Depression and Second World War, women enthusiastically bought the New Look. Dior's colleagues likewise responded to this reassuring fashion statement with design adaptations of their own. Not only did Paris couture flourish again, but Dior led its evolution from the more sedate, formal process of prewar years to the choreographed drama and theatre it is today. His fashion shows were spectacle and high art with their ballets of models swirling full skirts and yards of fabric provocatively past the audience as the name of each style was announced. Dior was also a consummate marketer, keeping demand high for his creations with new collections every six months that built on the previous looks but offered something fresh and significant. In the tradition of Balenciaga, the cut and the line were all important to Dior—color was almost incidental. In addition, lucrative licenses for jewelry, scarves, hosiery, furs, perfume, gloves, and even men's ties helped to expand the House of Dior into a multimillion dollar empire. When Dior died suddenly of a heart attack in 1957, he was succeeded briefly by his assistant, Yves St. Laurent. In 1960, Marc Bohan assumed leadership of the house until 1989, when Gianfranco Ferré replaced him. The baton then passed to the brilliant maverick, John Galliano, in 1996.

Dolce & Gabbana—Domenico Dolce (b. 1958) and Stefano Gabbana (b. 1962)

The widely publicized fantasy designs of Dolce & Gabbana are scintillating visions of mixed metaphors and Italian stereotypes. Sexy corsets and cleavage are accessorized with rosary beads and sequined icons; bold Mafioso pinstripe suits are offset by the simplicity of little black dresses and headscarves of Sicilian widows. Dolce & Gabbana achieved worldwide fame when they created the costumes for Madonna's *Girlie Show* tour in 1993. Though they have been noted for the sensuality and glamour of vintage Hollywood since they launched their label in 1985, Stefano insists the duo principally designs "clothes women can wear to work." The D&G logo is also licensed for a variety of accessories, as well as $30—$600 signature jeans.

Ellis, Perry (1940–1986)

With a master's degree in fashion merchandising, Perry Ellis began his career as a sportswear buyer for a department store in the 1960s. He went to John Meyer as design director in 1968, and six years later to the Vera Company. The success of his Portfolio sportswear collections earned him his own label in 1978, and a Coty the following year. The clean lines and natural, textured fabrics of his clothes are in the Anne Klein tradition. Although he experimented with exaggeration—particularly unusual proportions—his designs never slipped into fantasy. His menswear looks were ideal for the career woman of the 1980s.

Fath, Jacques (1912–1954)

Fath tentatively emerged on the Paris fashion scene in 1937 with a small collection of twenty designs. He had an innate understanding of the movement and sensuality of feminine form and a forward-looking genius that even anticipated the fitted New Look styles of a decade later. He often draped fabric directly onto a live model rather than working from sketches. His clothes were sexy and young without being vulgar. In 1948, he was invited by the U.S. ready-to-wear maker, Joseph Halpert, to translate that European feel into designs for the American market. Nearly half the revenue of the Fath firm came from boutique sales. He died of leukemia at age forty-two in 1954.

Fendi, Adele Casagrande (1897–1978)

The Italian leather and fur design house founded by Adele Casagrande Fendi in 1918 is today one of the world's most important fashion empires. Her five daughters gradually assumed leadership of the firm beginning in 1954, and the third generation has already been elected to the board of directors. In 1962, the company engaged Karl Lagerfeld to add his high fashion aesthetic to Fendi's fur collections. Since then, Lagerfeld has helped redirect the Fendi label from anonymity to a high-profile brand. The Fendi logo with its tete-beche F's is famous globally and has become an aspirational symbol for the fashion conscious. The firm's chic accessories have sold extremely well and continue to be in demand around the world.

Ferré, Gianfranco (b. 1945)

In the late sixties, Ferré studied to be an architect and initially worked in the design studio of a Milan furniture company. By the early 1970s, he had applied his architect's sense of form, outline, and study of detail to designing fashion accessories and jewelry. In 1972, he began designing ready-to-wear freelance, and established his own house in 1978. His intellectual approach to fashion design produced clothing with all the power and beauty of modern sculpture. He was artistic director for Dior from 1989 to 1996, and has since continued his own label collections including Ferre Sport and Ferre Studio.

Fogarty, Anne (1918–1981)

While studying drama and working as a fashion model, Anne Fogarty began designing freelance for various New York ready-to-wear makers. In 1948, she joined the Youth Guild and won a Coty for her 1951 "Paper Doll" dresses. She then spent five years designing for Saks Fifth Avenue before establishing her own company in 1962. Her clothes were soft and feminine in subtle color palettes.

Fortuny, Mariano (1871–1949)

As a young man, Fortuny was a painter and an inventor. He designed set decorations for the theatre and became fascinated with the effects of light. In the 1890s, he began to experiment with textiles and dyes, developing new methods of printing and stencilling silk, cotton, and particularly rich, lustrous velvets. He registered a pleating process of running horizontal folds of fabric between copper plates and ceramic tubes to create permanent irregular accordion pleats resembling those of ancient Greek textiles. He viewed his clothing concepts more as inventions than fashion. His dress designs were far removed from the precision cutting and corseted fit of haute couture. His famous Delphos gown was a loose-fitting, cylindrically shaped garment made of pleated silk that fluidly draped over the body and tied into place with cords like the ancient Ionic chiton. It was often worn with a pleated overblouse or kimono style jacket. The timeless simplicity of Fortuny's clothing designs and the superlative handmade textiles used to construct them are as stunning and captivating today as when first created. Museums and collectors still vie to acquire them whenever possible.

Galanos, James (b. 1925)

After completing his studies at the New York Traphagen School, James Galanos succeeded in selling design sketches to several ready-to-wear makers, including Hattie Carnegie. He

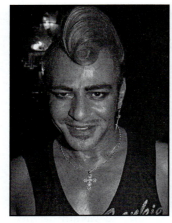

John Galliano, 2006. Hubert de Givenchy, 1985. Halston, 1968. Donna Karan, 2004.

briefly worked with Robert Piquet in Paris and at Columbia Pictures in Hollywood. In 1951, he opened his own design firm in California. His luxurious ready-to-wear clothes were expensive because he used the finest materials combined with the flawless cutting of the couturier. His eveningwear designs were a favorite at the White House court of the Reagans. Galanos was elected to the Coty Hall of Fame in 1959. He retired in 1998.

Galliano, John (b. 1960)

Often described as incurably romantic, John Galliano is one of the most talented and inventive designers of the twenty-first century. His rise to preeminence was slow and difficult despite *Vogue's* acclaim of his college graduate collection in 1984. He was twice named British Designer of the Year. In 1994, he moved to Paris, and two years later was appointed design director at Dior. A couturier at heart in the tradition of Balenciaga and Vionnet, Galliano has become the unequalled modern master of the bias cut. He has resurrected many of the special cut and construction techniques of the great couturiers to create fashions that are a remarkable blend of innovation, history, and superb craftsmanship.

Gaultier, Jean-Paul (b. 1952)

From the beginning of his career, Gaultier's witty and eclectic style has challenged the French fashion establishment. His first job was with Cardin in 1970, followed by a series of ready-to-wear makers before launching his own label in 1978. Since then, he has successfully produced both couture and ready-to-wear that have run the gamut in menswear from tailored suits to kilts and in womenswear from corset dresses to luxurious evening gowns. His inspiration is often from the London street scene, especially punk looks, as well as global ethnic costume. Gaultier's more unorthodox designs are for the very young and self-assured, such as Madonna, who wore his mix of satin corsetry and black bondage costumes during her 1990 *Blonde Ambition* tour.

Gernreich, Rudi (1922–1985)

Born in Austria, Gernreich's family fled their Nazi occupied homeland and moved to California in 1938. Through much of the forties, he was a dancer and costume designer for his troupe, during which he developed a fascination with fabrics and body-based clothing. In the 1950s, he freelanced, designing youthful sportswear for boutiques such as Jax in Los Angeles. In 1964, he established his own firm. Gernreich is often considered America's answer to Courrèges, Quant, and Cardin. His fashion ideas were revolutionary. During the youthquake of the sixties, his futuristic designs included dresses with plastic inserts, transparent blouses, bodystockings, and the nylon "No-Bra" bra. He is best remembered for his designs of swimwear in the mid-1960s that scandalized the fashion world, such as the topless monokini and the first unisex thong.

Givenchy, Hubert de (b. 1927)

Trained at Fath, Piquet, Lelong, and Schiaparelli in the 1940s, Givenchy opened his own atelier in Paris at age twenty-five. Inspired by his mentor, Balenciaga, Givenchy strove for perfection of cut and line in his haute couture designs rather than avant-garde innovation. His luxurious, high-style evening dresses were a favorite look for many of the world's most elegant women, including Jacqueline Kennedy, the Duchess of Windsor, and especially Audrey Hepburn, for whom he designed costumes for *Funny Face* (1957) and *Breakfast at Tiffany's* (1961). In 1988, Givenchy sold his label to LVMH, retiring in 1995. Since 1996, the vivacious Alexander McQueen has guided the house of Givenchy into the future.

Grès, Alix (1903–1993)

As a young woman, Alix Grès studied to become a sculptor. During those early years, she earned money by selling toiles of her clothing designs to various Paris fashion houses. In 1934, she opened her own salon as Alix, but changed the label brand

to her husband's name, Grès, following World War II. She preferred to work in silk and wool jersey, which she fluidly draped and molded to the feminine form with deceptively precise construction. Decade after decade, her classically simple dress designs transformed women into elegant, living statues.

Gucci, Guccio (1881–1953)

Rather than work in his family's failing straw hat factory, Gucci ran away to London, where he got a job as a maitre d' at the Savoy. When he returned home to Florence in 1922, he opened a saddlery and leather shop producing small accessories with equestrian motifs and harness or stirrup hardware. In the 1930s, he designed the logo of the interlocking G's for his alliterative name (although some sources credit his son Aldo with that icon). The Gucci style and superior product quality sustained the business over the decades. During the aspirational 1980s, the Gucci brand enjoyed a surge in popularity among status-conscious yuppies. In 1989, Dawn Mello, the former president of Bergdorf Goodman, became creative director for the firm and revitalized the label with new best-selling reinterpretations of Gucci classics, including the bamboo bag and small leathers with the hand-shaped clasp. From 1994 till 2004, Tom Ford's fashion designs for the Gucci label were a must-have for trend-setting celebrities and fashionistas worldwide.

Halston (1932–1990)

A true son of the American Midwest, Roy Halston Frowick was born in Iowa and attended school in Indiana and Illinois. During the 1950s, he operated his own millinery salon in Chicago designing for celebrities such as Deborah Kerr and Gloria Swanson. In 1957, he moved to New York to work for Lilly Daché, and the following year joined Bergdorf Goodman as milliner. In 1966, he began designing ready-to-wear for the store with great success. Two years later, he opened his own salon. Halston recognized in the late sixties that women were beginning to tire of the gypsy and European fancy-dress styles of the era. Instead, he offered clean line, classic designs based on minimalist art: jersey halter dresses, ultrasuede shirtwaists, boxy jackets, day-into-night cashmere chemises, and denim pantsuits. Among his jet-set clients were Liza Minelli, Ali McGraw, Bianca Jagger, and Diana Vreeland. In 1974, he was elected to the Coty Hall of Fame.

Jacobs, Marc (b. 1964)

Following his graduation from Parson's School of Design in 1984, Marc Jacobs designed on his own for two years before going to Perry Ellis as a sportswear designer. He has repeatedly received rave reviews for his collections of simple, American-style clothes, frequently made of luxurious materials. In 1997, Jacobs took the post of creative director at Louis Vuitton, where he has designed fashions that, in his words, are "deluxe but that you can throw in a bag and escape town with."

James, Charles (1906–1978)

By many accounts, Charles James was the greatest couturier of the twentieth century. Balenciaga, Dior, and Mainbocher were among the preeminent masters who have paid homage to him, and in later years, Halston sought him out to design for his salon. At age nineteen, James began his career as a milliner in Chicago. Between 1928 and 1947, he ranged between the United States and Europe, designing for private clients, department stores, and the salons of Hardie Amies and Elizabeth Arden. He was a genius and knew it. His contrary, eccentric personality usually led to disastrous business and personal relationships. Bankruptcy and litigation followed him wherever he settled. For him, nothing superceded his design work. His approach to fashion design was a rare blend of intellect and artistry. Over the years, he developed about 200 design modules engineered with interchangeable parts from which he could create thousands of variations. His sumptuous ball gowns were masterpieces of mathematical precision and sculpted elegance. His petal gowns of the early 1950s are the quintessential James design with their foliate bodices and flowing, monumental skirts. (See chapter 18, page 457.) Although he retired in 1958, he continued to teach at the Pratt Institute and the Rhode Island School of Design. The last years of his life were spent meticulously documenting his work.

Johnson, Betsey (b. 1942)

During her studies at Syracuse University, Betsey Johnson had designed sweaters and knitwear for herself and friends. Upon graduation in 1964, she began her career as a journalist with *Mademoiselle*, but continued to design clothes freelance. In 1969, she began her own boutique, "Betsey, Bunk and Nini" and, in 1978, established her sportswear label, Betsey Johnson. Among her quirky, clever, and fun creations were cowhide wrap miniskirts, a clear vinyl dress kit that came with paste-on stars, silver motorcycle suits, and jersey "noise" dresses trimmed with jangling grommets or shower curtain rings.

Kamali, Norma (b. 1945)

After graduation from New York's Fashion Institute of Technology in 1964, Norma Kamali worked as an airline stewardess for a few years. Her trips to Europe inspired her to open a boutique with her husband in 1968. After her divorce a decade later, she established her label OMO (On My Own). Her inventive designs in utilitarian materials such as fleeced cotton ran counter to the structured, formal styles of the 1980s, and presaged the chic comfort looks of the nineties. Among her most influential styles were sleeping bag coats padded with eiderdown, short rah-rah skirts, parachute fabric pantsuits, and disposable all-white holiday ensembles made of nylon paper.

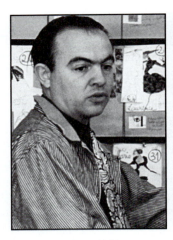

Christian Lacroix, 1985.

Karl Lagerfeld, 1990.

Jeanne Lanvin, 1936.

Ralph Lauren, 1987.

Karan, Donna (b. 1948)

While attending classes at Parson's School of Design in New York, Donna Karan went to work as a sketcher for Anne Klein, which eventually led to a permanent design position there. She left briefly to work for the ready-to-wear maker, Addenda, returning to Anne Klein in 1968. Following Klein's death in 1974, Karan co-designed with Louis Dell' Olio until 1984, when she set out on her own. Her collections of practical, wearable clothes were designed with the young urban career woman in mind. Her sportier range of styles bear the label DKNY.

Kawakubo, Rei (b. 1942)

In 1966, Rei Kawakubo left her job in advertising to pursue freelance fashion design. Three years later, she founded Tokyo's Comme des Garçons but did not open her first shop until 1974. When she first showed in Paris in 1981, her iconoclastic approach to design shocked the French fashion establishment. For Kawakubo, fashion was a fine art expressed with a new conceptual aesthetic. Although her work is founded in Japanese rather than European clothing traditions, her designs do not exhibit the restrained formality of the tea ritual and Noh theatre, but rather evoke the violent drama of the samurai warrior and the Kabuki performance. Her slashed, crumpled, and knotted designs with random ruching, irregular seams, and unfinished edges look accidental but are actually precisely planned and cut. Kawabuko has consistently strived to unravel preconceived ideas of fashion, fit, and gender. Her collection of 1996 included removable padded humps—dubbed the Quasimodo look by the press—that recontoured the natural body into a fresh perspective of physical beauty.

Kenzo (b. 1939)

Kenzo Tadaka studied at the Bunka College of Fashion in Tokyo before going to Paris in 1965 to design freelance. In 1970, he opened a boutique, which he named Jungle Jap because it was decorated with jungle prints. Young trendsetters were immediately drawn to Kenzo's wearable smocks, tunics, wide-legged pants, and similar clothing based on traditional Japanese styles. His most significant impact was made with his vibrant, contemporary knitwear, especially vividly colored sweaters. Unlike his fellow Japanese designers, Kenzo avoids conceptual fashion design with its deconstructionist cuts and radical silhouettes, and instead focuses on easy-to-wear clothing for both men and women.

Khanh, Emmanuelle (b. 1937)

During the late 1950s, Emmanuelle Khanh began her fashion career as a model for Balenciaga and Givenchy. She started to design clothes in 1959, working for Dorothee Bis and Cacharel through the 1960s. In 1970, she established her own label. Khahn rejected the structured stiffness of haute couture in favor of interpretations of the soft, fluid looks of the 1930s. Her "Droop" collections featured slim, clinging dresses and long, gentle jackets. She is often credited with introducing the sixties' youthquake to France through her sexy, body-conscious clothes.

Klein, Anne (1923–1974)

From age fifteen into her mid-twenties, Anne Klein worked for various ready-to-wear makers on New York's Seventh Avenue. In 1948, she and her husband, Ben Klein, founded Junior Sophisticates. Twenty years later she launched Anne Klein & Co. Klein's clothing epitomized the ease and comfort of American sportswear. She championed soft, comfortable materials—even jersey for eveningwear—and clean, simple lines in her designs. Her mix-and-match separates were sensible wardrobe solutions for the modern American woman, a concept that her successor, Donna Karan, continues to build upon.

Klein, Calvin (b. 1942)

A graduate of New York's Fashion Institute of Technology in 1962, Calvin Klein worked as a coat designer until he started his own firm six years later. Key to Klein's success was his keen understanding of the times in which he designed: the disco era of the seventies, the status-conscious eighties, and the simplified nineties. His classic sportswear collections in natural fabrics have had a timeless appeal to both women and men; his color sense introduced an international flavor to American clothing. In 1993, his versatile talents were acknowledged by the fashion world when he was voted both Womenswear and Menswear Designer of the Year. Klein's marketing acumen is unsurpassed, and his sexually charged advertising campaigns have made his label a world-famous brand. In addition to his ready-to-wear, the Klein signature is affixed to shoes, handbags, furs, fragrances, and bed linens.

Lacroix, Christian (b. 1951)

In college, Christian Lacroix studied art history to become a curator, and fell in love with the fancifulness, splendor, and opulence of the Rococo era. His wife, Françoise, encouraged him to direct his interests and talents toward fashion rather than museum work. He got a job as a sketcher at Hermès and later became a design assistant to Guy Paulin. In 1981, Lacroix joined Patou as chief designer, where, with wit and daring, he created fashions that blended modern street influences with the sumptuousness and grandeur of the eighteenth century. Although highly skilled in couture cut and construction, Lacroix was less concerned with wearability than fun and theatricality. His pouf dresses, usually in alarming color combinations, were ideal for the exhibitionism of the 1980s. In 1987, he established his own salon in Paris with the backing of LVMH. His love of color and decoration was applied with enthusiasm to his ready-to-wear collections launched in 1988 and to his sportswear line begun in 1994.

Lagerfeld, Karl (b. 1938)

At age seventeen, Karl Lagerfeld won a fashion design competition, which landed him a job working for Balmain. Three years later, he went to Patou, and then freelanced for various ready-to-wear makers, including Krizia. In 1963, he started working for Chloé, where he remained for twenty years. He also continued to freelance throughout the 1960s and 1970s, including designing furs for Fendi, shoes for Valentino, and menswear for Club Roman. In 1983, he went to Chanel as design director, revitalizing the label with endless variations of the little Chanel suit. Young American women especially responded to the fresh ideas Lagerfeld created for the House of Chanel as well as the deluxe ready-to-wear for his own KL label. Decidedly confident and astonishingly prolific, Lagerfeld is one of the most influential designers of today.

Lanvin, Jeanne (1867–1946)

As a young girl of thirteen, Jeanne Lanvin was apprenticed to a dressmaker. In 1890, she opened a millinery shop in Paris. When her customers took notice of the dresses she designed for her younger sister and her daughter, Lanvin produced copies to sell in the store. She introduced a line of matching mother-daughter dresses and, in 1926, menswear. The House of Lanvin was the only couture salon that dressed all ages of the family. Her "robes de style" collections of the 1910s were based on eighteenth-century looks, and remained popular into the 1920s. Although Lanvin favored designing picturesque frocks and romantic clothing based on the full-skirted styles of earlier eras, she also produced lavishly embroidered deco opera capes, sleek dinner pajamas, and exotic eveningwear with Asian influences.

Laroche, Guy (1923–1989)

While still in his mid-teens, Guy Laroche went to Paris to apprentice with a milliner. After World War II, he designed hats in New York, but returned to France in 1949 to design ready-to-wear for Jean Desses. By the time Laroche opened his own house in 1957, he had mastered an architectural style of couture cutting and precision tailoring that was often compared to that of Balenciaga. In 1960 he added a line of ready-to-wear, and over the next two decades created lively collections that particularly appealed to young women—delicate Empire dresses in the sixties and superbly tailored pantsuits in the seventies. The Laroche empire of couture, women's ready-to-wear, and licensed products expanded in 1966 when he began designing menswear.

Lauren, Ralph (b. 1939)

Born Ralph Lipschitz in the Bronx, New York, Lauren began his fashion career in retail. He had no design training and often negates the label of designer. "I never learned fashion; I was never a fashion person," Lauren told *Vogue* in 1992. Yet he is a skilled fashion product designer and a superb marketer who went from selling men's neckwear to head of a multimillion dollar fashion empire. In 1967, he established the "Polo by Ralph Lauren" label for men's ties, which he expanded to include men's ready-to-wear the following year. In 1971, he launched his women's sportswear line. Rather than cut and silhouette, Lauren focuses on themes and narratives with his fashion product styling, especially the looks of the American West and of the gentrified Ivy League East. His sophisticated advertising campaigns, featuring tableaus of waspish beautiful people in old-money settings particularly appealed to the nouveaux riches of the aspirational eighties. He, as the ultimate customer of the Lauren label, often appears in his own ads.

Lucien Lelong, 1938.

Claire McCardell, 1954.

Alexander McQueen, 2006.

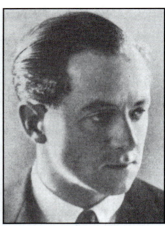

Edward Molyneux, 1929.

Lelong, Lucien (1889–1958)

Lucien Lelong went to work as a designer in his family's textile and dressmaking business in 1907. Following his release from military duty after World War I, he opened his own house. During the hard times of the Great Depression, Lelong developed a line of ready-to-wear, one of the earliest Paris designers to do so. While serving as President of the Chambre Syndicale de la Couture during the Second World War, he courageously persuaded the occupying Germans not to relocate the Paris couture industry to Berlin. As a designer, Lelong was better known for his superior workmanship of luxurious fabrics rather than for innovative styles. Dior, Balmain, and Givenchy were among the fashion luminaries who trained at the House of Lelong.

Mainbocher (1890–1976)

Main Rousseau Bocher studied art and music in Chicago, New York, and Europe. After serving with an American hospital unit during the First World War, he went to Paris to pursue a singing career. In 1922, he abandoned his musical ambitions and became an illustrator for *Harper's Bazaar*. A year later, he went to French *Vogue* as a fashion editor. Abruptly in 1929, he decided to open a couture atelier, holing up in his studio for months practicing cutting and draping techniques. As the only American to open a couture salon up to that time, he merged his names into one for a more French sound. His connections through fashion journalism ensured success when he opened in 1930; his collections of elegant and refined designs sustained that success. He achieved worldwide notoriety in 1937 when he designed the wedding dress and trousseau for Wallis Simpson, the Duchess of Windsor. He closed his Paris salon in 1940 just ahead of the German occupation and reopened it in New York where he remained until his retirement in 1971. The designs of Mainbocher were elegantly simple with crisp, clean lines, often cut on the bias in the tradition of Vionnet. His sumptuous

evening suits were usually made with a long, dark skirt and a contrasting jacket, often luxuriously trimmed with fur.

McCardell, Claire (1905–1958)

Purposeful is the one word that best seems to describe Claire McCardell's clothing. Her approach to design was to allow the body to determine what a garment should look like with none of the artificial pretensions of shoulder pads, boned linings, or superficial decoration. She studied at Parson's School of Design, and began her career in 1929 as a sketcher for a ready-to-wear maker. During the 1930s, she evolved as a designer of simple clothing in basic fabrics that included her popular "monastic"—a bias-cut tent dress that could be worn loose or belted. In 1940, she began designing under her own label, creating what is often referred to as the foundation of the American look in clothing—sporty styles that were relaxed, comfortable, and most especially, practical.

McFadden, Mary (b. 1938)

Having studied fashion at the Traphagen School of Design and sociology at Columbia, Mary McFadden began her career with Dior as public relations director in 1962. In 1970, she became a special projects editor for *Vogue*. Three years later she created a collection of tunics from rare African and Chinese silks that were featured in the magazine. She continued to design and founded her own business in 1976. Her classic silhouettes were austerely cut but enlivened with exotic, cross-cultural prints and kinetic pleating. Her trademark looks are slim dresses and quilted jackets, often of sumptuous hand-printed textiles.

McQueen, Alexander (1969–2010)

Self-styled as a "fashion schizophrenic," Alexander McQueen has produced both exhibitionistic styles—such as the bloody,

tattered lace dresses for his 1996 "Highland Rape" collection—as well as wearable, luxury clothing like his superbly tailored suits for Givenchy. Even before he graduated from London's St. Martin's School of Art and Design, he had considerable experience and technical skill with his craft. He had apprenticed at a Savile Row tailor, had done pattern cutting at Kohji Tatsumo in Tokyo, and had worked at Romeo Gigli in Milan. When he presented his graduate collection in 1992, his designs caught the attention of a *Vogue* editor who included pieces in a magazine shoot that fall. In 1996, McQueen again made fashion headlines with his low-cut "bumster" pants that displayed the "plumber's crack" frequently parodied in skits twenty-years earlier on *Saturday Night Live*. That year he also was voted British Designer of the Year and received the invitation to design for the House of Givenchy. Despite his irreverence for the house founder, referring to the shadow of Hubert de Givenchy as "irrelevant," McQueen's fashions for the label nevertheless continued to follow the master couturier's tenets of the perfect cut and wearability. McQueen died at age 40 by suicide.

Missoni, Rosita (b. 1931) and Ottavio (b. 1921)

The Italian knitwear company, Missoni, was founded in 1953 by the husband-and-wife team, Tai (Ottavio) and Rosita. After World War II, he had begun manufacturing knit athletic wear, and she had come from a family of bedding textile makers. Tai created the bold, geometric textile patterns and Rosita developed the garment shapes by draping directly on live models. The knitwear they produced was sold under other labels until 1966 when they presented their first collection under their own name. Their vibrantly colored sweaters, jackets, suits, coats, and dresses were produced in limited runs, making them popular international status symbols. In 1997, the reins of the firm were handed to the duo's daughter, Angela.

Miyake, Issey (b. 1935)

A graphics design graduate of Tama University, Issey Miyake went to Paris in 1964 to study at the Chambre Syndicale de la Couture. He then worked for Guy Laroche and Givenchy in Paris and for Geoffrey Beene in New York until 1971 when he launched his own label. Along with his compatriots, Rei Kawakubo and Yohi Yamamoto, Miyake revolutionized traditional perspectives of bodies and clothing. He once noted that, in the West, the body determines the cut of a garment, but in Japan, it is the fabric. He is often compared to Fortuny in his exploration of the properties and aesthetics of textiles. For him, technology was an art form, and he was constantly researching new fibers and fabrics. "Taking the spirit of the kimono" in all his work, his clothing designs de-emphasized the body and focused on freedom of movement. His Issey Sport collections were loose, comfortable, and wearable garments, designed to be mixed and matched and layered.

Mizrahi, Isaac (b. 1961)

Described as a "shooting star" by the press with his debut in 1989, Isaac Mizrahi was a casualty of the cut-throat fashion business barely a decade later. He graduated from Parson's School of Design in New York in 1982 and worked for Perry Ellis and Calvin Klein before setting up his own shop in 1992. His witty creativity mixed unusual fabrics and vibrant colors for sportswear designs that were fresh and fun in the nineties. Despite the success of his collections, his ready-to-wear operations were not financially successful, and he was forced to close his firm in 1998. In the new millennium, Mizrahi found his niche as a style host on cable TV programming. In 2004, he began designing moderately priced ready-to-wear for Target Stores and, in 2008, joined Liz Claiborne.

Molyneux, Edward (1891–1974)

Edward Molyneux was working as an illustrator when one of his sketches won a design contest sponsored by the House of Lucile in 1911. He traveled with Lucile (Lady Duff Gordon) to her salon branches in Paris, New York, and Chicago, learning all aspects of the couture business. After a distinguished career as captain during World War I, in which he was wounded three times and lost an eye in battle, he opened his own salon in Paris in 1919. From the mid-1930s through World War II, he was based in London where he dressed the English elite. He opened salons in the playgrounds of his clientele: Monte Carlo, Cannes, and Biarritz. He achieved worldwide notoriety when he designed the wedding gown and trousseau for Princess Marina of Greece in 1934. The simple classicism of his petit-print silk dresses and softly tailored suits was achieved by the perfect cut and proportion. His elegant style was an understatement of the British upper classes. As the vision of his remaining eye began to fail, he retired in 1950.

Montana, Claude (b. 1949)

In the late sixties, Claude Montana began designing papier-maché jewelry decorated with rhinestones that he sold in London street markets. In 1972, he returned home to Paris and joined the leather firm, MacDouglas, for five years before starting his own label in 1977. Throughout the 1970s, he produced leather and knit fashions with strong, masculine shapes. Since much of his early work was in black leather, he was often accused of producing fascistic or fetishistic costumes, so he began to introduce potent color palettes of plums, reds, and in the eighties, jeweltones. In the 1980s, Montana's aggressive outlines of the broadest shoulders, cinched waists, and narrow hips complemented the power-dressing of the era. Between 1989 and 1992, his couture creations for Lanvin brought him new respect as a craftsman in the tradition of his idol, Balenciaga.

Thierry Mugler, 1993.

Paul Poiret, 1922.

Emilio Pucci, 1960.

Mary Quant, 1968.

Mori, Hanae (b. 1926)

Encouraged by her husband, whose family operated a textile business, Hanae Mori returned to college to study fashion design after the births of her two sons. In the early fifties, her family connections provided opportunities for costume design work in Japanese cinema. By the mid-1950s, she had opened a boutique in Tokyo selling ready-to-wear. She opened a couture salon in New York in 1973, followed four years later by one in Paris. Despite the Western styling of Mori's fashions, she had drawn much from her cultural background, especially eveningwear based on the obi-belted kimono. She used her own fabrics, dyed and printed to her specifications in Kyoto. Hanae Mori retired in 1999, and her daughter-in-law, Penelope Mori, became creative director of the house.

Mugler, Thierry (b. 1948)

Thierry Mugler began making his own clothes at age fourteen. In the sixties, he danced with a ballet company and later worked as a window decorator for a department store. He continued designing clothes and presented his first collection for Cafe de Paris in 1971. Two years later, he began designing under his own label. Mugler's styles reshaped the body into an ideal female and male silhouette. Women are made to look like goddesses and men as superheros—both with an electric, aggressive sexuality. Like Jean-Paul Gaultier and Azzedine Alaia, who have been influenced by Mugler, he designs for individuals with aplomb and unique personal style.

Muir, Jean (1933-1995)

Fashion was not an art to Jean Muir; it was a craft—a trade—requiring technical expertise and skilled workmanship. She started out as a salesclerk in Liberty's London store in 1950. She trained in the made-to-measure department there, eventually working her way up to sketcher. In 1956, she went to Jaeger as a designer for seven years, followed by four years designing for the Jane & Jane label with the Susan Small organization. In 1966, she began designing under her own name. Muir's classic designs could be deceptive in their simplicity, requiring as many as eighteen pattern pieces to construct a basic coat. For her dresses, she preferred soft fabrics such as jersey and suede for a fluid, flattering fit.

Norell, Norman (1900–1972)

Born Norman Levinson, Norell left his Indianapolis home in 1919 to go to New York to study fashion. He graduated from the Pratt Institute and began his career as a costume designer for the New York studio of Paramount Pictures. During the mid-1920s, he also designed for a theatre costume company and a ready-to-wear maker. In 1928, he went upscale when he joined Hattie Carnegie. Thirteen years later, the clothing manufacturer, Anthony Triana, persuaded him to form Triana-Norell. In 1960, Norell established his own company. His legacy is simple, precisely tailored silhouettes. He was a trendsetter who introduced long evening skirts topped with sweaters, fur-lined trenchcoats, after-six culottes, and harem pants. His elegant, sophisticated clothes, made of luxurious fabrics, were equal to the fashions of Paris at the time. His leadership in American high style influenced the next two generations including Halston, Galanos, and Mizrahi.

Paquin, Jeanne (1869–1936)

Soon after Isador and Jeanne Paquin were married in 1891, they established a couture house in Paris. Madame Paquin, as she came to be known, had learned her craft at the Maison Rouff. Her collections helped popularize the hobble skirt and the directoire revivals of the 1910s. She made a fortune selling design models for reproduction and exporting to department stores around the world. By most accounts she is often

regarded as the first major female couturier. Although she retired in 1920, the Paquin house remained open into the 1950s.

Patou, Jean (1887–1936)

Jean Patou began his fashion career as a boy working in his father's tannery and his uncle's fur business. His first salon had just been opened when the First World War erupted in 1914. After the Armistice, he reopened his salon with modern sporty fashions that appealed to the active, emancipated woman of the era. A prolific designer, his large collections had to be shown in two parts—the morning for sportswear and casualwear, and the afternoon for suits and formal styles. In 1929, Patou altered the fashion silhouette of the boyish flapper by shifting waistlines back to their natural position and lengthening hemlines—a presage of the look of the thirties. He also understood the importance of publicity. In 1925, he made headlines when he imported six tall American beauties as showroom models. Patou's simple, comfortable, and wearable designs were a permanent influence on fashion, comparable to that of Chanel. Both Chanel and he despised each other and were jealous of the other's success and innovation. The debate persists today which of the two had the most profound influence on modern women's fashion.

Poiret, Paul (1879–1944)

As a teenager, Paul Poiret began his career selling design sketches to Paris couture houses including that of Madeleine Cheruit. In 1896, he went to work as a designer for Doucet from whom he learned the business of couture as well as personal refinement and elegance. In 1900, Poiret went to the House of Worth, but felt stifled and went out on his own four years later. His lifelong love of exoticism and orientalism was first piqued during the Russo-Japanese War (1905) when Eastern artwork, prints, and textiles became widely popular in Paris. Later in the decade when he saw the lavish, ornamental costumes by Bakst for the Ballets Russes, he developed a complete collection of oriental-inspired styles including harem pants and feathered skirts. In 1908, he recut the flared, bell-shaped skirts of the Edwardian era into a radically new form that tapered tightly to the ankles, creating the hobble skirt. The new look made him both notorious and famous worldwide. Capitalizing on this fame, he toured Europe and the United States with his collections in the years before the First World War. During the war he converted his salon into a uniform factory and then joined the French army. When he reopened in 1919, the fashion world had changed significantly. Patou and Chanel had redefined clothing for the modern woman but he attempted to dress them in the richly ornamental styles of preswar years. He could not understand the demand for what he called Chanel's "poverty de luxe." His firm was bankrupt by the end of the twenties and he died in poverty.

Pucci, Emilio (1914–1992)

The fashion career of the aristocratic Marchese Emilio Pucci de Barsento began in 1947 when *Harper's Bazaar* photographed him wearing ski pants he had designed. The magazine invited him to design some women's winter wear, which was subsequently sold in New York stores like Lord & Taylor's. In 1950, he opened a couture salon in the Palazzo Pucci in Florence, producing smart and easy sportswear in boldly colored prints and abstract patterns. His palazzo pyjamas became a favorite resort ensemble of the jet-set and were worn by Elizabeth Taylor, Grace Kelly, and Lauren Bacall. Pucci fashions and accessories quickly became the chic label to own and, today, are highly sought after collector's items.

Quant, Mary (b. 1934)

The youthquake that would rock the fashion world of the 1960s had its roots in British and American urban street scenes of the late fifties. When Mary Quant opened her boutique in 1955, which she named Bazaar, she was young and energetic, creative, and totally attuned to the social changes emerging at the time. Initially her shop sold ready-to-wear, but Quant became frustrated with trying to find clothing that young people wanted, so she began to design her own. She was inspired by what dancers wore to rehearsals, especially easy tops, short skirts, and colorful tights and leggings. Although she never claimed to have created the miniskirt, her designs nevertheless popularized the look in "swinging London" with hemlines rising above the knees by 1960 and to mid-thigh by 1963. Her simple designs sold so well that she began exporting to the United States under the Ginger Group label. After 1970, she became increasingly involved with her cosmetics lines and licensed products, including accessories and home textiles, and her creative fashion leadership waned.

Rabanne, Paco (b. 1934)

Paco Rabanne began his fashion career by applying his training as an architect to designing hardline fashion goods such as handbags, shoes, jewelry, and even buttons. In 1965, he began exploring the use of modern materials for clothing. The following year he presented his first collection of dresses made from a chain mail of plastic disks, which were more sculpture than clothing. Subsequent designs included molded Plexiglas garments and dresses made of crinkled paper, aluminum plates, or leather tiles riveted together. Although the press declared his designs unwearable, his futuristic ideas were revolutionary in the 1960s. He was in constant demand as a costume designer for movie studios and the ballet. The influence of his sculptural and architectonic creations is evident in the experimental work of the next generation, particularly Miyake's molded corsets and Versace's chain mail designs. He retired in 1999.

Paco Rabanne, 1989. Zandra Rhodes, 1985. Yves St. Laurent, 1962. Elsa Schiaparelli, 1938.

Rhodes, Zandra (b. 1942)

Trained as a textiles designer in the early 1960s, Zandra Rhodes began to make dresses that she felt best interpreted her fabric designs. In 1968, she bought an interest in the Fulham Road Clothes Shop and launched her own label. Far ahead of the fashion curve, her conceptual chic collections of the 1970s incorporated street styles and punk looks including dresses with embroidered rips and safety pin jewelry. In the eighties, her effervescent crinoline and bubble dresses were of tulles, silks, and chiffons in vibrant colors and exotic hand-printed abstract patterns. Over the years, Rhode's fantastic and inventive designs have been added to the collections of museums and collectors around the world who, like Rhodes herself, view her creations as works of art.

Ricci, Nina (1883–1970)

At age thirteen, Nina Ricci went from making clever clothes designs for her dolls to an apprenticeship with a dressmaker. As she honed her skills in cutting and draping, she worked her way up to become a premier couturier. With the encouragement of her husband, Louis Ricci, a jeweler, and assisted by her son, Robert Ricci, she opened her own Paris salon in 1932. Her designs were not at the vanguard of fashion, a role she yielded to contemporaries like Elsa Schiaparelli. Instead, she established a reputation for providing superbly made chic styles to wealthy mature women. During the 1950s, she collaborated with Jules François Crahay and, after 1963, Gérard Pipard became her chief designer.

Rochas, Marcel (1902–1955)

Marcel Rochas was one of the most innovative and influential designers of the thirties and forties. With the encouragement of his friend Paul Poiret, he opened his Paris salon in 1924. He is thought to have created the broad-shouldered military look ahead of Schiaparelli, who made the silhouette

her trademark. He also anticipated Dior's New Look with his long, full skirts of 1941 and his long-line corset, or guepiere, of 1946. Many of his ensembles featured three-quarter length coats, well before the style became widely popular, and he is one of the first couturiers to construct skirts with pockets.

Rykiel, Sonia (b. 1930)

Christened the "Queen of Knitwear" by the American press, Sonia Rykiel began her lifelong work with knits by making her own warm and easy maternity clothes in the early sixties. She then designed figure-hugging sweaters for her husband's boutique, Laura, until 1968, when she opened her own shop. Her fluid, softly feminine knit skirts, jumpers, jackets, capes, scarves, and pants were comfortable but never baggy. In the 1970s, she added menswear, childrenswear, and home textiles to her label. Although untrained in couture, she became vice-president of the Chambre Syndicale du Pret-à-Porter des Couturiers, a post she held for twenty years.

St. Laurent, Yves (1936–2008)

At age seventeen, Yves St. Laurent won a fashion design contest in 1954, which, the following year, led to a job as Dior's assistant. The skinny, emotionally fragile St. Laurent immersed himself in his work, absorbing all he could from the master of the house. When Dior died suddenly in 1957, St. Laurent was appointed head designer by the board of directors. His first collection, based on the little girl silhouette of the trapeze line, was a huge success. Subsequent collections were less well received, and his 1960 Left Bank collection inspired by the street looks of beatniks, shocked Dior patrons. When he was drafted for military service during the Algerian War, he was replaced at Dior by the more conservative Marc Bohan. After a few weeks of vicious harassment in the army, St. Laurent had a nervous breakdown and was

released. With his business-savvy companion, Pierre Bergé, at his side, he opened his own house in 1962. Four years later, he launched his ready-to-wear line, Rive Gauche, a menswear line in 1974, and childrenswear in 1978. His YSL signature became world famous and the initials signed most everything to do with fashion, including accessories, swimwear, fragrance, and bed linens. St. Laurent is universally regarded as a genius and the greatest designer of the last forty years. Where Dior owed an allegiance to the past, St. Laurent preferred to break new ground, to surge ahead with visionary experiment and inventiveness like Schiaparelli before him, whom he often cited as a significant influence. Among his most noteworthy creations were his Mondrian dresses of 1965 and the Rich Fantasy Peasant collection of 1976. He introduced a masculine flavor to many women's styles that have since become fashions staples: safari jackets, pantsuits, and particularly, tuxedo jackets. However, many of his more avant garde looks were not a complete success, such as his transparent blouses of the sixties and their periodic revival in the eighties and early nineties. As a result, his career has been a rollercoaster of rhapsodic acclaim and scathing criticism from the fashion press, which often pushed the high-strung St. Laurent into periods of depression and substance abuse. In 1983, the New York Metropolitan Museum of Art presented a retrospective exhibit of his work, the first living designer to be so honored. On his thirtieth anniversary in 1992, he passed design direction of his ready-to-wear line to Alber Elbaz, so he could concentrate his efforts on couture. He retired in 2004.

Sant' Angelo, Giorgio (1936–1989)

Brought up in Argentina and educated in Italy and France, Giorgio Sant' Angelo initially worked as a textile designer in the early sixties. In 1966, he began to design ready-to-wear under his own label, winning a Coty only two years later. He was an influential designer during the youthquake of the 1960s, creating popular interpretations of patchwork hippie styles and peasant looks. During the seventies, he was in and out of favor, but rebounded in the 1980s with his body-conscious designs of Lycra and richly ornamented, hand-beaded sweaters.

Scaasi, Arnold (b. 1931)

Born Arnold Isaacs, he reversed the letters of his last name for added flair. He studied fashion at the Montreal Design School and at the Chambre Syndicale in Paris. He trained at Paquin before going to New York as assistant to Charles James. In 1957, he began his own ready-to-wear line, followed by his haute couture salon in 1964. His specialty was superbly made eveningwear in luxurious fabrics. Among those he dressed were Elizabeth Taylor, Ivana Trump, and First Lady Barbara Bush.

Schiaparelli, Elsa (1890–1973)

Elsa Schiaparelli arrived in Paris from New York in 1922 following a divorce from a husband who had abandoned her and their daughter. With no money or training for a job, fate intervened when a department store buyer saw her wearing a black sweater with a white trompe l'oeil bow collar she had designed. The store ordered forty of the sweaters and Schiaparelli was in the fashion business. In 1927, she opened her own shop and produced easy, comfortable sportswear in the American mode as well as wildly eccentric, witty designs that sensationalized the fashion world throughout the thirties. She had collaborated with some of the most prominent avant-garde artists of the era, most notably Salvadore Dali, to merge art and fashion. Her inventiveness was boundless. She made sumptuous gowns elaborately embroidered with amusing, graphical images by Jean Cocteau. Her hats were shaped like lamb cutlets, ice cream cones, or upside down high heel shoes. Buttons were padlocks, drawer pulls, butterflies, or miniature sculptures of acrobats and circus ponies. She popularized the broad, padded shoulder silhouette that remained a major fashion look through the Second World War. In 1940, Schiaparelli fled the war and returned to the United States for the duration. She reopened her Paris salon in 1945, but fashion had changed and Dior's New Look soon dominated. She retired after her last collection in 1952, living comfortably from the sale of her perfumes.

Simpson, Adele (1903–1995)

While studying fashion design at the Pratt Institute in the mid-twenties, Adele Simpson also worked for a ready-to-wear maker, gaining valuable practical experience. After designing for various firms during the thirties and forties, she founded her own company in 1949 by buying out Mary Lee, Inc. Simpson's conservative designs were chic and current without being ahead of their time. In the 1950s, she produced a widely popular chemise dress with attached belts that could be fastened in the front or back. Her practical and versatile coordinates were a particular favorite of politician's wives ranging from Mamie Eisenhower to Rosalyn Carter.

Trigère, Pauline (1912–2002)

By the age of ten, Pauline Trigère already possessed sufficient sewing skills to assist her parents with their tailoring business. Later, when she was apprenticed to a couture house in Paris, she only stayed briefly because there was nothing they could teach her. In 1937, she came to the United States and worked at Hattie Carnegie. In 1942, she opened her own business. She was a master of cutting and draping, preferring to work directly with the fabric on a mannequin. The intricate construction of her ready-to-wear was nearer couture than to mass production. Her urban chic clothes blended French high style

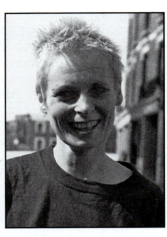

Pauline Trigére, 1962. Emanuel Ungaro, 2002. Gianni Versace, 1992. Vivienne Westwood, 1988.

with American simplicity and ease. She introduced coats and dresses with detachable collars and scarves, and dresses with attached jewelry. Her outerwear made her famous, particularly reversible coats and capes with vibrant colors on the inside.

Ungaro, Emanuel (b. 1933)

As a young boy, Emanuel Ungaro was trained to sew by his tailor father and worked in the family business until 1955. He then went to Paris and apprenticed with Balenciaga for six years, followed by a brief period with Courrèges. In 1964 Ungaro opened his own company. At the peak of the youth-oriented sixties, his architectural A line dresses and futuristic coats and suits were inspired by Courrèges but made with the skillful discipline of Balenciaga. When he began to collaborate with fabric designer Sonia Knapp, his clothes became softly flowing and fluid. He became a brilliant colorist, mixing prints and layers for more grown-up looks than his earlier work.

Valentino (b. 1932)

The Italian Valentino Clemente Ludovico Garavani studied at the Accademia Dell'Arte in Milan and the Chambre Syndicale in Paris. At age nineteen, he won a fashion contest and was offered a job by Jean Desses. Five years later he went to Guy Laroche and, in 1959, returned to Italy to open a couture house in Rome. Instead of succumbing to the youth cult of the sixties, Valentino made a name for himself with collections of elegant, glamorous designs. His 1968 White collection became world-famous when Jacqueline Kennedy selected a dress from the group for her marriage to Aristotle Onassis. In 1969, Valentino launched his women's ready-to-wear line, followed in 1972 by menswear. His gracefully cut gowns with dramatic touches like big bows and lavish beadwork or embroidery recall the feminine elegance of the thirties and fifties. Over the years Valentino's design empire expanded to include licenses for jewelry, sunglasses, leather goods, perfume, home products, and even an Alfa Romeo edition.

Versace, Gianni (1946–1997)

Gianni Versace began his fashion career assisting his dressmaker mother in Calabria, Italy. In the 1970s, he designed for various Milan firms before opening his own business in 1978. He quickly became known as an originator, especially in the development and use of new fabrics and trimmings. His leather accented knitwear for both men and women was widely copied. He worked directly on the model, creating bias-cut styles that sensuously wrapped the body. Versace's sexy, richly colored designs were a favorite of the high-profile social elite, including Elton John, Sting, Prince, George Michael, Madonna, and Princess Diana. When he was murdered at his Miami, Florida home by a deranged fan in 1997, his sister, Donatello, assumed the mantle of head designer for the Versace label.

Vionnet, Madeleine (1876–1975)

Apprenticed at age eleven to a Paris seamstress, Madeleine Vionnet became highly skilled at dressmaking by the time she was sixteen. She worked for various houses in London and Paris, including Doucet, before opening her own business in 1912. After being closed during the First World War, Vionnet resumed her design work in 1922. Hers was the creative vision of a sculptor who dressed the body in fabric with a minimalist perfection. Although she did not invent the bias cut, as is often stated, she mastered the technique and sewed ingenious seams that fluidly followed the body and its movement. She ordered fabric produced two yards wider than usual to accommodate her masterful cuts. To Vionnet, the pinnacle of her craft was a dress made with a single seam that achieved the perfect fit. She was not a colorist, preferring shades of white, and used decorative embellishments sparingly. After she retired at the outbreak of World War II, she was virtually forgotten outside of the fashion industry. Yet she is idolized even today by contemporary designers who

recognize that her unequalled, almost mysterious techniques had once transformed simple geometric shapes of fabric into liquid sculptures.

Westwood, Vivienne (b. 1941)

Undisputedly one of the most courageous and influential designers of the last thirty years, Vivienne Westwood unleashed her quirky, eccentric creativity on the world of fashion in 1970 when she opened a boutique in London's King's Road. Through her association with Malcolm McClaren and his anarchic pop group the Sex Pistols, Westwood provided her customers with the attitudinal looks that reflected the urban youth culture of the time. Her confrontational styles were based on leather and rubber fetishism, raw sexuality, and especially punk. At the beginning of the 1980s she began a long-running interest with historic silhouettes—exploiting and reinventing the aesthetics of the past. Her thematic collections have included Pirates, Buffalo Girls, Anglomania, Mini-Crini, and Witches. Among her fashion shockwaves have been underwear worn on the outside, constricting corset dresses, the bottom cage crinoline, S&M platform shoes, and a men's twinset with pearls. She was voted British Designer of the Year in 1991 and received the Order of the British Empire the following year.

Worth, Charles Frederick (1825–1895)

Universally acclaimed as the Father of French couture, Worth was an Englishman who inauspiciously arrived alone in Paris in 1845 with little money and no connections. Since he had apprenticed in London at a draper's shop and later with a tailor, he found work as a sales clerk at the House of Gagelin. He met his wife there and began to dress her in his own designs. When so many customers expressed interest in Mme. Worth's gowns, he was permitted to open a shop in the store. In 1858, he opened his own salon, becoming a favorite of Empress Eugenie, then the world's arbiter of fashion.

In the early 1860s, he reshaped the crinolined gown into an oval with a flattened front and an enormous train. By 1868, he had discarded the crinoline and began the radical transition to the bustle. Worth changed the role and status of the clothing designer from that of dressmaker, who primarily executed the ideas of the customer, to that of the style creator who guided the fashionable elite with his ideas of what was current and suitable for them. After his death in 1895, the House of Worth continued under the directorship of his sons and grandsons until 1954 when it was taken over by Paquin.

Yamamoto, Kansai (b. 1944)

Trained as a civil engineer, Kansai Yamamoto instead turned to fashion design while studying at Nippon University. He worked for Hisashi Hosono Studio before establishing his own label in 1971. Four years later he presented his first Paris show. His work was a dynamic blend of ancient Japanese forms with Western sportswear styles such as sumptuous satin pyjamas emblazoned with giant embroidered cartoon graphics. He designed David Bowie's spectacular wardrobe for Ziggy Stardust. His shows were extravaganzas, one of which attracted more than 40,000 people to a stadium in New Delhi in 1998.

Yamamoto, Yohji (b. 1943)

Yohji Yamamoto began his career assisting his war widow mother with her dressmaking business. He got his degree from the Bunka College of Fashion in Tokyo and worked as a freelance designer until starting his own firm in 1972. In 1981, he opened a shop in Paris and began showing his collection as part of fashion week. His intellectual, nontraditional designs, with their tears and slashing, illogical pocket flaps, and asymmetrical closures, created a sensation with the press. He was constantly exploring the relationship of fabric and body. Yamamoto's clothing was draped, wrapped, and knotted to disavow gender, sexual exhibitionism, and the conventional view of fashion glamour.

BIBLIOGRAPHY

GENERAL

Arnold, Janet. *Patterns of Fashion: English Women's Dresses and Their Construction 1660-1860.* London: Wace, 1964.

Ashdown, Emily. *British Costume During XIX Centuries.* London: T. C. and E. C. Jack, 1910.

Ashelford, Jane. *The Art of Dress: Clothes and Society 1500-1914.* London, National Trust, 1996.

Baclawski, Karen. *The Guide to Historic Costume.* New York: Drama, 1995.

Bailey, Adrian. *The Passion for Fashion: Three Centuries of Changing Styles.* Limpsfield, UK: Dragon's World, 1988.

Baines, Barbara. *Fashion Revivals from the Elizabethan Age to the Present Day.* London: B. T. Batsford, 1981.

Barber, Elizabeth. *Women's Work: The First Fifty Years.* New York: W. W. Norton, 1994.

Barfoot, Audrey. *Discovering Costume.* London: University of London, 1959.

Barnes, Ruth, and Joanne Eicher, eds. *Dress and Gender: Making and Meaning.* New York: Berg, 1992.

Bassett, Lynne Zacek. *Modesty Died When Clothes Were Born.* Hartford, CT: Mark Twain House and Museum, 2004.

Batterberry, Michael, and Ariane Batterberry. *Mirror, Mirror, A Social History of Fashion.* New York: Holt, Rinehart and Winston, 1977.

Bigelow, Marybelle. *Fashion in History: Western Dress, Prehistoric to Present.* Minneapolis, MN: Burgess, 1979.

Black, J. Anderson, and Madge Garland. *A History of Fashion.* New York: William Morrow, 1981.

Blanc, Charles. *Art in Ornament and Dress.* Detroit: Tower, 1971.

Boucher, Francois. *A History of Costume in the West.* London: Thames and Hudson, 1967.

Bradfield, Nancy. *Costume in Detail 1730-1930.* Boston: Plays, 1968.

Bradshaw, Angela. *World Costumes.* New York: MacMillan, 1969.

Braun-Ronsdorf, Margarete. *Mirror of Fashion: A History of European Costume 1789-1929.* New York: McGraw-Hill, 1964.

Brooke, Iris. *A Short History of European and American Shoes.* London: Pitmans, 1972.

——————. *English Costume 1066-1820.* London: Adam and Charles Black, 1963.

——————. *Western European Costume and Its Relation to the Theatre: 13th Century to 17th Century.* New York: Theatre Arts, 1963.

Brown, William. *American Men's Shirts 1750-1900.* Gettysburg, PA: Thomas, 1999.

Burrow, Ed J., ed. *A History of Feminine Fashion.* London: Ed J. Burrow, 1928.

Buzzaccarini, Vittoria de. *Elegance and Style: Two Hundred Years of Men's Fashions.* Milan: Lupetti, 1992.

Calasibetta, Charlotte. *Essential Terms of Fashion.* New York: Fairchild, 1986.

Calthrop, Dion C. *English Costume from William I to George IV 1066-1830.* London: Adam and Charles Black, 1937.

Carolyn, G. Bradley. *Western World Costume.* New York: Dover, 2001.

Carter, Alison. *Underwear: The Fashion History.* New York: Drama, 1992.

Carter, Ernestine. *The Changing World of Fashion.* New York: Putnam's, 1977.

Cassin-Scott, Jack. *Costume and Fashion in Color 1760-1920.* New York: MacMillan, 1971.

——————. *The Illustrated Encyclopedia of Costume and Fashion from 1066 to the Present.* London: Studio Vista, 1998.

Chenoune, Farid. *A History of Men's Fashion.* Paris: Flammarion, 1993.

Coleman, Elizabeth. *Of Men Only: A Review of Men's and Boy's Fashions 1750-1975.* Brooklyn: Brooklyn Museum, 1975.

Contini, Mila. *Fashion from Ancient Egypt to the Present Day.* New York: Odyssey, 1965.

Cosgrave, Bronwyn. *The Complete History of Costume and Fashion from Ancient Egypt to the Present Day.* New York: Checkmark, 2000.

Crawford, M. D. C. *One World of Fashion.* New York: Fairchild, 1947.

Cremers-Van de Does, Eline. *The Agony of Fashion.* Trans. Leo Van Witsen. Poole, UK: Blandford, 1980.

Crill, Rosemary, et al. *Dress in Detail from Around the World.* London: Victoria and Albert Museum, 2002.

Cumming, Valerie. *Understanding Fashion History.* New York: Costume and Fashion Press, 2004.

Cunnington, C. Willett, and Phillis Cunnington. *A Dictionary of English Costume 900-1900.* Philadelphia: Dufour, 1960.

_____. *Handbook of English Costume in the Eighteenth Century.* Boston: Plays, 1972.

_____. *The History of Underclothes.* London: Michael Joseph, 1951.

Cunnington, Phillis. *A Picture History of English Costume.* New York: MacMillan, 1960.

_____. *Children's Costume in England from the Fourteenth to the End of the Nineteenth Century.* London: Adam and Charles Black, 1965.

_____. *Costume in Pictures.* London: Herbert, 1981.

_____. *Costume of Household Servants from the Middle Ages to 1900.* London: Adam and Charles Black, 1974.

_____. *English Costume of Sports and Outdoor Recreation from the Sixteenth to the Nineteenth Century.* London: Adam and Charles Black, 1978.

_____. *Occupational Costume in England from the Eleventh Century to 1914.* Adam and Charles Black, London, 1967.

D'Assailly, Gisele. *Ages of Elegance, Five Thousand Years of Fashion and Frivolity.* London: MacDonald, 1968.

Davenport, Millia. *The Book of Costume.* New York: Crown, 1948.

Dorner, Jane. *Fashion: the Changing Shape of Fashion through the Years.* London: Octopus, 1974.

Earle, Alice Morse. *Two Centuries of Costume in America 1620-1820.* New York: Macmillan, 1903.

Earnshaw, Pat. *Lace in Fashion from the Sixteenth to the Twentieth Centuries.* New York: Drama, 1985.

Epstein, Diana. *Buttons.* New York: Walker, 1968.

Evans, Mary. *Story of Textiles.* Boston: Little, Brown, 1942.

Ewing, Elizabeth. *Everyday Dress 1650-1900.* London: B. T. Batsford, 1984.

_____. *History of Children's Costume.* New York: Charles Scribner's Sons, 1977.

Fairholt, Frederick. *Costume in England: A History of Dress to the End of the Eighteenth Century.* London: George Bell, 1896.

Flugel, J. C. *The Psychology of Clothes.* London: Hogarth, 1950.

Fukai, Akiko, et al. *Fashion: A History from the Eighteenth to the Twentieth Century.* Los Angeles: Taschen America, 2005.

Geijer, Agnes. *A History of Textile Art.* London: Phillip Wilson, 1982.

Gillow, John. *World Textiles: A Visual Guide to Traditional Techniques.* Boston: Bulfinch, 1999.

Ginsburg, Madeleine. *The Hat: Trends and Traditions.* Hauppage, NY: Barron's Educational, 1990.

Glynn, Prudence. *Skin to Skin: Exoticism in Dress.* New York: Oxford University, 1982.

Gorsline, Douglas. *What People Wore.* New York: Viking, 1952.

Harris, Jennifer, ed. *Textiles: Five Thousand Years.* New York: Harry N. Abrams, 1993.

Harris, Kristina. *The Child in Fashion 1750-1920.* Atglen, PA: Schiffer, 1999.

Harrold, Robert. *Folk Costumes of the World.* London: Blanford, 1986.

Harvey, John. *Men in Black.* Chicago: University of Chicago, 1995.

Heard, Gerald. *Narcissus: An Anatomy of Clothes.* New York: E. P. Dutton, 1924.

Hecht, Ann. *The Art of the Loom: Weaving, Spinning, and Dyeing across the World.* New York: Rizzoli, 1990.

Hill, Margot, and Peter Bucknell. *The Evolution of Fashion: Pattern and Cut from 1066-1930.* London: B. T. Batsford, 1967.

Hollander, Anne. *Seeing through Clothes.* New York: Avon, 1978.

Holmes, Martin. *Stage Costumes and Accessories in the London Museum.* London: Her Majesty's Stationery Office, 1968.

Kemper, Rachel. *Costume.* New York: Newsweek, 1977.

Keyes, Jean. *A History of Women's Hairstyles 1500-1965.* London: Methuen, 1967.

Koda, Harold. *Extreme Beauty: The Body Transformed.* New York: Metropolitan Museum of Art, 2001.

Kohler, Carl. *A History of Costume.* Trans. Alexander Dallas. New York: Dover, 1963.

Kutchta, David. *The Three-Piece Suit and Modern Masculinity: England 1550-1850.* Berkeley: University of California, 2002.

Kybalova, Ludmila. *The Pictorial Encyclopedia of Fashion.* Trans. Claudia Rosoux. London: Hamlyn, 1968.

Langner, Lawrence. *The Importance of Wearing Clothes.* New York: Hastings House, 1959.

Laver, James. *Clothes.* London: Burke, 1952.

_____. *A Concise History of Costume and Fashion.* London: Thames and Hudson, 1979.

_____. *Costume and Fashion.* London: Thames and Hudson, 1995.

_____. *Costume in the Theatre.* New York: Hill and Wang, 1964.

_____. *Costume through the Ages.* London: Thames and Hudson, 1969.

_____. *Dandies.* London: Weidenfeld and Nicolson, 1968.

_____. *Dress: How and Why Fashions in Men's and Women's Clothes Have Changed during the Past Two Hundred Years.* London: John Murray, 1950.

_____. *Modesty in Dress.* London: Heinemann, 1969.

Lester, Katherine, and Rose Kerr. *Historic Costume.* Peoria, IL: Charles A. Bennett, 1977.

Lurie, Alison. *The Language of Clothes.* New York: Henry Holt, 2000.

Mackrell, Alice. *An Illustrated History of Fashion: Five Hundred Years of Fashion Illustration.* New York: Drama, 1997.

_____. *Art and Fashion: The Impact of Art on Fashion and Fashion on Art.* London: B. T. Batsford, 2005.

MacPhail, Anna. *The Well-Dressed Child: Children's Clothing 1820-1940.* Atglen, PA: Schiffer, 1999.

Mann, Kathleen. *Peasant Costume in Europe.* New York: MacMillan, 1938.

Marly, Diana de. *Dress in North America: The New World 1492-1800.* New York: Holmes and Meier, 1990.

_____. *Fashion for Men: An Illustrated History.* New York: Holmes and Meier, 1989.

Martin, Richard, and Harold Koda. *Infra-Apparel.* New York: Metropolitan Museum of Art, 1993.

McNabb, Nan. *Body Bizarre, Body Beautiful.* New York: Fireside, 1999.

Montgomery, Florence. *Textiles in America 1650-1870.* New York: W. W. Norton, 1983.

Moore, Doris. *Fashion through Fashion Plates 1771-1970.* New York: Clarkson Potter, 1971.

Murphy, Michelle. *Two Centuries of French Fashion: An Album of Mannequin Dolls.* New York: Charles Scribner's Sons, 1950.

Norris, Herbert. *Ancient European Costume and Fashion.* Mineola, NY: Dover, 1999.

Nunn, Joan. *Fashion in Costume 1200-1980.* New York: Schocken, 1984.

Parsons, Frank. *The Psychology of Dress.* Garden City, NY: Doubleday, Page, 1921.

Peacock, John. *The Chronicle of Western Fashion from Ancient Times to the Present Day.* New York: Harry N. Abrams, 1991.

_____. *Costume 1066-1966: A Complete Guide to English Costume Design and History.* New York: Thames and Hudson, 1992.

_____. *Men's Fashion: The Complete Sourcebook.* New York: Thames and Hudson, 1996.

Racinet, Albert. *Historical Encyclopedia of Costume.* New York: Facts on File, 1995.

Ribeiro, Aileen. *Dress and Morality.* New York: Holmes and Meier, 1986.

_____. *The Visual History of Costume.* New York: Drama, 1997.

Ribeiro, Aileen, and Valerie Cumming. *The Visual History of Costume.* London: B. T. Batsford, 1989.

Roach, Mary Ellen and Joanne B. Eicher, eds. *Dress, Adornment, and Social Order.* New York: John Wiley and Sons, 1965.

Robinson, Julian. *Body Packaging: A Guide to Human Sexual Display.* Los Angeles: Elysium Growth, 1988.

_____. *The Fine Art of Fashion: An Illustrated History.* New York: Bartley and Jensen, 1989.

Ruby, Jennifer. *Costume in Context: Underwear.* London: B. T. Batsford, 1996.

Rudofsky, Bernard. *Are Clothes Modern?* Chicago: Paul Theobald, 1947.

Russell, Douglas. *Costume History and Style.* Englewood Cliffs, NJ: Prentice Hall, 1983.

Saint-Laurent, Cecil. *The Great Book of Lingerie.* New York: Vendome, 1986.

Schnurnberger, Lynn. *Let There Be Clothes: 40,000 Years of Fashion.* New York: Workman, 1991.

Selbie, Robert. *The Anatomy of Costume.* New York: Crescent, 1977.

Shover, Edna. *Art in Costume Design.* Springfield, MA: Milton Bradley, 1920.

Sichel, Marion. *History of Men's Costume, Roman to 1930s.* London: B. T. Batsford, 1984.

_____. *History of Children's Costume.* London: Batsford Academic and Educational, 1984.

_____. *History of Women's Costume.* London: Batsford Academic and Educational, 1984.

Snowden, James. *The Folk Dress of Europe.* New York: Mayflower, 1979.

Squire, Geoffrey. *Dress and Society 1560-1970.* New York: Viking, 1974.

Steele, Valerie. *Men and Women, Dressing the Part.* Washington, DC: Smithsonian Institution, 1989.

Stuart, Dorothy. *Boy through the Ages.* London: George Harrap, 1947.

Thieme, Otto Charles. *Simply Stunning: Two Hundred Years of Fashion from the Cincinnati Art Museum.* Cincinnati: Cincinnati Art Museum, 1988.

Tilberis, Elizabeth, ed. *Vogue: Seventy-Five Years.* London: Conde Nast, 1991.

Tilke, Max. *Costume Patterns and Designs.* New York: Frederick A. Praeger, 1957.

Tortora, Phyllis and Keith Eubank. *Survey of Historic Costume.* New York: Fairchild, 1998.

Truman, Nevil. *Historic Costuming.* London: Isaac Pitman, 1936.

Uzanne, Octave. *Fashion in Paris: The Various Phases of Feminine Taste and Aesthetics from 1797 to 1897.* London: William Heinemann, 1898.

Waugh, Norah. *Corsets and Crinolines.* London: B. T. Batsford, 1954.

_____. *The Cut of Women's Clothes 1600-1930.* New York: Theatre Arts, 1968.

Webb, Wilfred. *The Heritage of Dress.* London: Times Book Club, 1912.

Wheeler, R. E. M. *Costume 1558-1933.* London: Lancaster House, 1934.

Wilcox, Turner. *Dictionary of Costume.* New York: Charles Scribner's Sons, 1969.

_____. *Five Centuries of American Costume.* New York: Charles Scribner's Sons, 1963.

_____. *Folk and Festival Costume of the World.* New York: Charles Scribner's Sons, 1965.

_____. *The Mode in Costume.* New York: Charles Scribner's Sons, 1958.

_____. *The Mode in Footwear.* New York: Charles Scribner's Sons, 1958.

_____. *The Mode in Furs.* New York: Charles Scribner's Sons, 1951.

_____. *The Mode in Hats and Dresses.* New York: Charles Scribner's Sons, 1945.

Wykes-Joyce, Max. *Cosmetics and Adornment.* New York: Philosophical Library, 1961.

Yarwood, Doreen. *The Encyclopedia of World Costume.* New York: Bonanza, 1978.

_____. *Fashion in the Western World 1500-1990.* New York: Drama, 1992.

CHAPTER 1, PREHISTORY

Brown, Dale, ed. *Early Europe: Mysteries in Stone.* Alexandria, VA: Time-Life, 1995.

Hawkes, Jacquetta. *The Atlas of Early Man.* New York: St. Martin's, 1976.

Haywood, John. *The Illustrated History of Early Man.* New York: Smithmark, 1995.

Patent, Dorothy. *The Secrets of the Ice Man.* New York: Benchmark, 1999.

Roberts, David. "The Ice Man: Lone Voyager from the Copper Age." *National Geographic,* June 1993, 36–67.

Scarre, Chris. *Exploring Prehistoric Europe.* New York: Oxford University, 1998.

Spindler, Konrad. *The Man in the Ice.* New York: Harmony, 1994.

CHAPTER 2, THE ANCIENT NEAR EAST

Amiet, Pierre. *Art of the Ancient Near East.* New York: Harry N. Abrams, 1977.

Crawford, Harriet. *Sumer and the Sumerians.* Cambridge: Cambridge University, 1991.

Curtis, John. *Ancient Persia.* London: British Museum, 1989.

Gowlett, John. *Ascent to Civilization.* London: Collins, 1984.

Harper, Prudence. *The Royal City of Susa: Ancient Near Eastern Treasures in the Louvre.* New York: Metropolitan Museum of Art, 1992.

Herodotus. *The Histories.* Trans. Aubrey de Selincourt. New York: Penguin, 1972.

Herzfeld, Ernst. *Iran in the Ancient East.* New York: Hacker, 1988.

Hodges, Heury. *Technology in the Ancient World.* New York: Alfred A. Knopf, 1970.

Houston, Mary. *Ancient Egyptian, Mesopotamian, and Persian Costumes and Decoration.* London: Adam and Charles Black, 1964.

Kramer, Samuel. *The Sumerian: Their History, Culture, and Character.* Chicago: University of Chicago, 1971.

Lloyd, Seton. *The Archaeology of Mesopotamia.* London: Thames and Hudson, 1978.

MacQueen, J. G. *The Hittites.* London: Thames and Hudson, 1996.

Moorey, P. R. S. *Ur of the Chaldees.* New York: Cornell University, 1982.

Nardo, Dou. *The Assyrian Empire.* San Diego: Lucent, 1998.

_____. *The Persian Empire.* San Diego: Lucent, 1997.

Nemet-Nejat, Karen. *Daily Life in Ancient Mesopotamia.* Westport, CT: Greenwood, 1998.

Nissen, Hans. *The Early History of the Ancient Near East 9000-2000 BC.* Chicago: University of Chicago, 1988.

Oats, Joan. *Babylon.* London: Thames and Hudson, 1986.

Payne, Blanche. *History of Costume from the Ancient Egyptians to the Twentieth Century.* New York: Harper and Row, 1965.

Postgate, J. N. *Early Mesopotamia: Society and Economy at the Dawn of History.* London: Routledge, 1992.

Pritchard, James. *The Ancient Near East: An Anthology of Texts and Pictures.* Princeton, NJ: Princeton University, 1958.

Reade, Julian. *Mesopotamia.* London: British Museum, 1991.

Roux, Georges. *Ancient Iraq.* New York: Penguin, 1980.

Sneider, Ursula. *Persepolis and Ancient Iran.* Chicago: University of Chicago, 1976.

Snell, Daniel. *Life in the Ancient Near East 3100-332 BC.* New Haven: Yale University, 1997.

Woolley, Leonard. *Ur: The First Phases.* London: King Penguin, 1946.

CHAPTER 3, EGYPT

Brier, Bob, and Hoyt Hobbs. *Daily Life of the Ancient Egyptians.* Westport, CT: Greenwood, 1999.
Casson, Lionel. *Everyday Life in Ancient Egypt.* Baltimore: Johns Hopkins University, 2001.
Corteggiani, Jean-Pierre. *The Egypt of the Pharaohs.* London: Scala, 1987.
David, Rosalie. *Handbook to Life in Ancient Egypt.* New York: Oxford University, 1998.
Davies, Vivian. *Egypt Uncovered.* New York: Stewart, Tabori and Chang, 1998.
Davis, Rosalie. *The Egyptian Kingdoms.* New York: Peter Bedrick, 1988.
Fleming, Fergus, et al. *The Way to Eternity: Egyptian Myth.* London: Duncan Baird, 1997.
Gahlin, Lucia. *Egypt: Gods, Myths and Religion.* New York: Barnes and Noble, 2002.
Gilbert, Katharine, ed. *Treasures of Tutankhamun.* New York: Metropolitan Museum of Art, 1976.
Grimal, Nicholas. *A History of Ancient Egypt.* Oxford, UK: Blackwell, 1992.
Hornung, Erik. *The Valley of the Kings: Horizon of Eternity.* New York: Timken, 1990.
Houston, Mary. *Ancient Egyptian, Mesopotamian and Persian Costumes and Decoration.* London: Adam and Charles Black, 1964.
Johnson, Paul. *The Civilization of Ancient Egypt.* New York: Harper Collins, 1999.
Lange, Kurt, and Max Hirmer. *Egypt: Architecture, Sculpture, Painting in Three Thousand Years.* London: Phaidon, 1956.
Malek, Jaromir. *In the Shadow of the Pyramids: Egypt During the Old Kingdom.* Norman: University of Oklahoma, 1986.
National Geographic Society. *Ancient Egypt: Discovering Its Splendors.* Washington, DC: National Geographic Society, 1978.
Oakes, Lorna, and Lucia Gahlin. *Ancient Egypt.* New York: Barnes and Noble, 2003.
Postrel, Virginia. *The Substance of Style.* New York: Harper Collins, 2003.
Quirke, Stephen, and Jeffrey Spencer, eds. *The British Museum Book of Ancient Egypt.* London: Thames and Hudson, 1996.
Reeves, Nicholas. *The Complete Tutankhamun.* London: Thames and Hudson, 1990.
Romer, John. *Ancient Lives: Daily Life in Egypt of the Pharoahs.* New York: Holt, Rinehart, and Winston, 1984.
_____. *Ancient Lives: The Story of the Pharoah's Tombmakers.* London: Weidenfeld, and Nicolson, 1984.
Tiradritti, Franceso. *Egyptian Treasures from the Egyptian Museum in Cairo.* New York: Harry N. Abrams, 1999.
Vogelsang-Eastwood, Gillian. *Pharaonic Egyptian Clothing.* New York: E. J. Brill, 1993.

CHAPTER 4, THE AEGEAN

Adkins, Lesley. *Handbook to Life in Ancient Greece.* New York: Facts on File, 1997.
Archibald. Zofia. *Discovering the World of the Ancient Greeks.* New York: Facts on File, 1991.
Berard, Claude. *A City of Images: Iconography and Society in Ancient Greece.* Princeton, NJ: Princeton University, 1989.
Boardman, John. *Athenian Black Figure Vases.* London: Thames and Hudson, 1974.
_____. *Athenian Red Figure Vases.* London: Thames and Hudson, 1989.
_____. *The Oxford History of Classical Art.* Oxford: Oxford University, 1993.
Brooke, Iris. *Costume in Greek Classical Drama.* New York: Theatre Arts, 1962.
Brown, Dale, ed. *Wondrous Realms of the Aegean.* Alexandria, VA: Time-Life, 1993.
Browning, Robert, ed. *The Greek World.* London: Thames and Hudson, 1985.
Castleden, Rodney, *Minoans, Life in Bronze Age Crete.* London: Routledge, 1990.
Chadwick, John. *The Mycenaean World.* Cambridge: Cambridge University, 1976
Cottrell, Arthur. *The Minoan World.* New York: Charles Scribner's Sons, 1980.
Dickinson, Oliver. *The Aegean Bronze Age.* Cambridge: Cambridge University, 1994.
Donovan, Hedley, ed. *Lost World of the Aegean.* New York: Time-Life, 1975.
Doumas, Christos. *Thera: Pompeii of the Ancient Aegean.* London: Thames and Hudson, 1983.
Edey, Maitland. *Lost World of the Aegean.* New York: Time-Life, 1975.
Fine, John. *The Ancient Greeks: A Critical History.* Cambridge: Harvard University, 1983.
Finley, Moses. *Economy and Society in Ancient Greece.* New York: Viking, 1981.
Freeman, Charles. *The Greek Achievement.* New York: Viking, 1999.
Graham, James. *The Palaces of Crete.* Princeton, NJ: Princeton University, 1987.
Grant, Michael, and Rachel Kitzinger, eds. *Civilization of the Ancient Mediterranean: Greece and Rome.* Vol. 3. New York: Charles Scribner's Sons, 1988.
Hanson, Victor. *Hoplites: The Classical Greek Battle Experience.* London: Routledge, 1991.
Harding, Anthony. *The Mycenaeans and Europe.* London: Academic, 1984.
Higgins, Reynold. *The Archaeology of Minoan Crete.* New York: Henry Walck, 1973.
_____. *Minoan and Mycenaean Art.* London: Thames and Hudson, 1981.

Honor, Alan. *Secrets of Minos.* New York: McGraw-Hill, 1961.

Hopper, Robert. *The Early Greeks.* New York: Harper and Row, 1977.

Houston, Mary. *Ancient Greek, Roman and Byzantine Costume and Decoration.* London: Adam and Charles Black, 1959.

Johnson, Marie, ed. *Ancient Greek Dress.* Chicago: Argonaut, 1964.

Lapatin, Kenneth. *Mysteries of the Snake Goddess.* Boston: Houghton Mifflin, 2002.

Laver, James. *Costume in Antiquity.* New York: Clarkson N. Potter, 1964.

Ling, Roger. *The Greek World.* New York: Peter Bedrick, 1988.

MacGillivray, Joseph. *Minotaur: Sir Arthur Evans and the Archaeology of the Minoan Myth.* New York: Hill and Wang, 2000.

Matz, Friedrich. *The Art of Crete and Early Greece.* New York: Greystone, 1962.

Mylonas, George. *Mycenae and the Mycenaean Age.* Princeton, NJ: Princeton University, 1966.

Palmer, Leonard. *Mycenaeans and Minoans.* New York: Alfred A. Knopf, 1965.

Pedley, John. *Greek Art and Archaeology.* New York: Harry N. Abrams, 1998.

Platou, Nicolas. *Crete.* Cleveland: World Publishing, 1966.

Rasmussen, Tom, ed. *Looking at Greek Vases.* Cambridge: Cambridge University, 1991.

Richter, Gisela. *The Sculpture and Sculptors of the Greeks.* New Haven: Yale University, 1967.

Samuel, Alan. *The Mycenaeans in History.* Englewood Cliffs, NJ: Prentice Hall, 1966.

Sandars, N.K. *The Sea Peoples: Warriors of the Ancient Mediterranean 1250-1150 BC.* London: Thames and Hudson, 1978.

Sichel, Marion. *Costume of the Classical World.* London: Batsford Academic and Educational, 1984.

Taylour, William. *The Mycenaeans.* London: Thames and Hudson, 1983.

Warren, Peter. *The Aegean Civilizations.* New York: Elsevier Phaidon, 1975.

CHAPTER 5, ETRURIA AND ROME

Andreae, Bernard. *The Art of Rome.* New York: Harry N. Abrams, 1977.

Bonfante, Larissa. *Etruscan Dress.* Baltimore: Johns Hopkins University, 1975.

Bothius, Alex, et al. *Etruscan Culture: Land and People.* New York: Columbia University, 1962.

Brilliant, Richard. *Roman Art from the Republic to Constantine.* New York: Phaidon, 1974.

Brown, Dale, ed. *Etruscans: Italy's Lovers of Life.* Alexandria, VA: Time-Life, 1995.

_____. *Rome: Echoes of Imperial Glory.* Alexandria, VA: Time-Life, 1994.

Brown, Peter. *The World of Late Antiquity.* New York: Harcourt, Brace, Jovanovich, 1971.

Cornell, Tim, and John Matthews. *Atlas of the Roman World.* New York: Facts on File, 1982.

Dyson, Stephen. *Community and Society in Roman Italy.* Baltimore: Johns Hopkins University, 1992.

Freeman, Charles. *The World of the Romans.* New York: Oxford University, 1993.

Gibbon, Edward. *Gibbon's Decline and Fall of the Roman Empire.* Chicago: Rand McNally, 1979.

Grand, Michael. *The Etruscans.* New York: Charles Scribner's Sons, 1980.

_____. *The Roman Forum.* New York: MacMillan, 1970.

_____. *A Social History of Greece and Rome.* New York: Charles Scribner's Sons, 1992.

Hadas, Moses. *Imperial Rome.* New York: Time-Life, 1969.

Hale, William, ed. *The Horizon Book of Ancient Rome.* New York: American Heritage, 1966.

Hamblin, Dora Jane. *The Etruscans.* New York: Time-Life, 1975.

Hanfmann, George. *Roman Art: A Modern Survey of the Art of Imperial Rome.* Greenwich, CT: New York Graphic Society, 1964.

Heintze, Helga Von. *Roman Art.* New York: Universe, 1971.

Houston, Mary. *Ancient Greek, Roman and Byzantine Costume and Decoration.* London: Adam and Charles Black, 1959.

Moretti, Mario, and Guglielmo Maetzke. *The Art of the Etruscans.* New York: Harry N. Abrams, 1970.

Ramage, Andrew, and Nancy Ramage. *Roman Art.* New York: Harry N. Abrams, 1991.

Reich, John. *Italy Before Rome.* Oxford: Elsevier Phaidon, 1979.

Scarre, Chris. *Chronicle of the Roman Emperors.* London: Thames and Hudson, 1995.

Vickers, Michael. *The Roman World.* New York: Peter Bedrick, 1989.

White, Lynn. *The Transformation of the Roman World.* Berkeley: University of California, 1966.

Williams, Derek. *The Reach of Rome.* New York: St. Martin's, 1996.

CHAPTER 6, BYZANTIUM

Aubert, Marcel, et al. *Larousse Encyclopedia of Byzantine and Medieval Art.* New York: Prometheus, 1963.

Demus, Otto. *Byzantine Art and the West.* New York: New York University, 1992.

Franzino, Enno. *History of the Byzantine Empire.* New York: Funk and Wagnall, 1967.

Grabar, Andre. *The Golden Age of Justinian.* New York: Odyssey, 1967.

Hetherington, Paul. *Byzantium: City of Gold, City of Faith.* London: Orbis, 1983.

Hirschfeld, Yizhar. *The Judean, Desert Monasteries in the Byzantine Era.* New Haven: Yale University, 1992.

Houston, Mary. *Ancient Greek, Roman and Byzantine Costume and Decoration.* London: Adam and Charles Black, 1959.

Hutter, Irmgard. *Early Christian and Byzantine Art.* New York: Universe, 1971.

Kitzinger, Ernst. *Byzantine Art in the Making.* Cambridge, MA: Harvard University, 1977.

Lowden, John. *Early Christian and Byzantine Art.* London: Phaidon, 1997.

Mango, Cyril. *Byzantium, the Empire of New Rome.* New York: Charles Scribner's Sons, 1980.

Mathews, Thomas. *Byzantium from Aniquity to the Renaissance.* New York: Harry N. Abrams, 1998.

Nigg, Walter. *Warriors of God: The Great Religious Orders and Their Founders.* New York: Alfred A. Knopf, 1959.

Norris, Herbert. *Church Vestments: Their Origin and Development.* London: J. M. Denton, 1949.

Norwich, John. *Byzantium; The Apogee.* New York: Alfred A. Knopf, 1992.

Rice, David. *Art of the Byzantine Era.* London: Thames and Hudson, 1993.

_____. *The Art of Byzantium.* New York: Harry N. Abrams, 1959.

Vasiliev, A. A. *History of the Byzantine Empire.* Madison: University of Wisconsin, 1970.

CHAPTER 7, NORTHERN EUROPE IN THE EARLY MIDDLE AGES

Briard, Jacques. *The Bronze Age in Barbarian Europe.* London: Routledge, 1979.

Bruce-Mitford, Rupert. *Aspects of Anglo-Saxon Archaeology: Sutton Hoo and Other Discoveries.* New York: Harper's Magazine, 1974.

Burns, Thomas. *Barbarians Within the Gates of Rome.* Bloomington: Indiana University, 1994.

_____. *A History of the Ostrogoths.* Bloomington: Indiana University, 1984.

Calthrop, Dion C. *English Costume Painted and Described.* London: Adam and Charles Black, 1907.

Cantor, Norman. *The Civilization of the Middle Ages.* New York: HarperCollins, 1993.

Carver, Martin. *The Age of Sutton Hoo.* Woodbridge, UK: Boydell, 1992.

Coles, John, and A. F. Harding. *The Bronze Age in Europe.* New York: St. Martin's, 1979.

Collins, Roger. *Early Medieval Europe 300-1000.* New York: St. Martin's, 1991.

Dixon, Philip. *Barbarian Europe.* Oxford, UK: Elsevier Phaidon, 1976.

Dodwell, Charles. *Anglo-Saxon Art, A New Perspective.* Ithaca, NY: Cornell University, 1982.

Glob, Peter Vilhelm. *The Bog People: Iron Age Man Preserved.* Trans. Rupert Bruce-Milford. London: Faber, 1969.

Hubert, Jean, et al. *Europe of the Invasions.* New York: George Braziller, 1969.

Klindt-Jensen, Ole. *Denmark Before the Vikings.* London: Thames and Hudson, 1962.

Kock, Hannjoachim. *Medieval Warfare.* London: Prentice Hall, 1978.

Lang, Jennifer. *Warriors of the Dark Ages.* Sutton: Phoenix Mill, 2000.

Owen, Francis. *The Germanic People.* New York: Bookman, 1960.

Perowne, Stewart. *The End of the Roman World.* New York: Thomas Crowell, 1966.

Quennell, Marjorie. *Everyday Life in Roman and Anglo-Saxon Times.* New York: Dorset, 1987.

Randers-Pehrson. *Justine, Barbarians and Romans.* Norman: University of Oklahoma, 1983.

Rice, Mary, and Margaret Howell. *From Barbarism to Chivalry.* London: Oxford University, 1972.

Todd, Malcolm. *Everyday Life of the Barbarians.* New York: Dorset, 1972.

CHAPTER 8, ISLAMIC EMPIRE

Atil, Esin. *The Age of Sultan: Suleyman, the Magnificent.* New York: Harry N. Abrams, 1988.

_____. *Turkish Art.* New York: Harry N. Abrams, 1980.

Blair, Sheila, and Jonathan Bloom. *Art and Architecture of Islam 1250-1800.* New Haven: Yale University, 1995.

Bravmann, Rene. *African Islam.* Washington, DC: Smithsonian Institution, 1983.

Ettinghausen, Richard, et al. *The Arts of Islam.* Trans. Klaus Brisch. New York: Harry N. Abrams, 1982.

Frankfort, Henri. *The Art and Architecture of the Ancient Orient.* Baltimore: Penguin, 1955.

Gabrieli, Francesco. *Muhammad and the Conquests of Islam.* Trans. Virginia Liling. New York: McGraw-Hill, 1968.

Grosvenor, Gilbert, ed. "Modern Life in the Cradle of Civilization," *National Geographic* (April 1922), 390–407.

Guindi, Fadwa El. *Veil: Modesty, Privacy and Resistance.* Oxford, UK: Berg, 2000.

Hillenbrand, Robert. *Islamic Art and Architecture.* London: Thames and Hudson, 1999.

Kennet, Frances. *Ethnic Dress.* New York: Facts on File, 1995.

Kuhnel, Ernest. *Islamic Art and Architecture.* Trans. Katherine Watson. Ithaca, NY: Cornell University, 1966.

Mayer, Leo. *Mamluk Costume.* Geneva: Albert Kundig, 1952.

Mutahhari, Murtaza. *The Islamic Modest Dress.* Trans. Laleh Bakhtiar. Chicago: Kazi, 1993.

Rice, David. *Islamic Art.* New York: Praeger, 1965.

Ros, Fred, et al. *Dreaming of Paradise: Islamic Art from the Collection of the Museum of Ethnology.* Rotterdam, Netherlands: Centre of Islamic Culture, 1993.

Ross, Heather. *The Art of Arabian Costume.* Fribourg, Switzerland: Arabesque Commercial, 1981.

Rugh, Andrea. *Reveal and Conceal: Dress in Contemporary Egypt.* Syracuse, NY: Syracuse University, 1986.

Scarce, Jennifer. *Women's Costume of the Near and Middle East.* London: Unwin Hyman, 1987.

Stillman, Yedida. *Palestinian Costume and Jewelry.* Albuquerque: University of New Mexico, 1979.

Topham, John. *Traditional Crafts of Saudi Arabia.* London: Stacey International, 1981.

Walther, Wiebke. *Woman in Islam.* Trans. C. S. Salt. Montclair, NJ: Abner Schram, 1981.

CHAPTER 9, CHINA

Bullis, Douglas. *Fashion Asia.* NY: Thames and Hudson, 2000.

Dickinson, Gary, and Linda Wrigglesworth. *Imperial Wardrobe.* Berkeley, CA: Ten Speed, 2000.

Fairservis, Walter. *Costumes of the East.* Riverside, CT: Chatham, 1971.

Froncek, Thomas. *The Horizon Book of the Arts of China.* New York: American Heritage, 1969.

Garrett, Valery. *Chinese Clothing: An Illustrated Guide.* Oxford: Oxford University, 1994.

_____. *Traditional Chinese Clothing in Hong Kong and South China 1840-1980.* Oxford: Oxford University, 1989.

Jenyns, Soame. *Chinese Art.* New York: Rizzoli, 1982.

Kahlenberg, Mary Hunt. *Asian Costumes and Textiles.* Milan: Skira, 2001.

Ko, Dorothy. *Every Step a Lotus: Shoes for Bound Feet.* Berkeley: University of California, 2001.

Levy, Howard. *Chinese Footbinding.* New York: Walton Rawls, 1966.

Mailey, Jean. *Costumes of the Ch'ing Dynasty 1644-1912.* New York: Metropolitan Museum of Art, 1981.

Rogers, Howard, ed. *China 5,000 Years.* New York: Guggenheim Foundation, 1998.

Scott, Adolphe. *Chinese Costume in Transition.* Singapore: Donald Moore, 1958.

Sickman, Laurence, and Alexander Soper. *The Art and Architecture of China.* New Haven: Yale University, 1968.

Steele, Valerie, and John Major. *China Chic: East Meets West.* New Haven: Yale University, 1999.

Sullivan, Michael. *The Arts of China.* Berkeley: University of California, 1977.

Tregear, Mary, ed. *Arts of China.* Tokyo: Kodansha, 1968.

Vollmer, John. *Clothed to Rule the Universe: Ming to Qing Dynasty Textiles at the Art Institute of Chicago.* Seattle: University of Washington, 2000.

Watson, William. *The Arts of China to A.D. 900.* New Haven: Yale University, 1995.

White, Julia, et al. *Adornment for Eternity: Status and Rank in Chinese Ornament.* Denver: Denver Art Museum, 1994.

Wilson, Verity. *Chinese Dress.* London: Victoria and Albert Museum, 1986.

Xun, Zhou, and Gao Chunming. *Five Thousand Years of Chinese Costumes.* San Francisco: China and Periodicals, 1987.

Yang, Shaorong. *Traditional Chinese Clothing: Costumes, Adornments and Culture.* San Francisco: Long River, 2004.

Yuan, Tung-Pei, and Hua Lu. *Traditional Chinese Textile Designs in Full Color.* New York: Dover, 1980.

CHAPTER 10, JAPAN

Dalby, Liza. *Kimono: Fashioning Culture.* Seattle: University of Washington, 2001.

Elisseeff, Daniel, and Vadime Elisseeff. *Art of Japan.* New York: Harry N. Abrams, 1985.

Fujisawa, Norio, et al. *Classic Kimono from the Kyoto National Museum.* San Francisco: Asian Art Museum of San Francisco, 1997.

Giuganino, Alberto, and Adolfo Tamburello. *National Museum, Tokyo.* New York: Newsweek, 1968.

Gunsaulus, Helen. *Japanese Costume.* Chicago: Field Museum of Natural History, 1923.

Hibi, Sadao. *Japanese Detail: Fashion.* San Francisco: Chronicle, 1989.

Hisamatsu, Shin'ichi. *Zen and the Fine Arts.* Tokyo: Kodansha, 1971.

Illing, Richard. *The Art of Japanese Prints.* London: John Calmann and Cooper, 1980.

Ishimura, Hayao. *Japanese Kimonos of the Sixteenth to Twentieth Centuries.* Raleigh: North Carolina Museum of Art, 1988.

Jackson, Anna. *Japanese Textiles in the Victoria and Albert Museum.* London: Victoria and Albert Museum, 2000.

Kennedy, Alan. *Japanese Costume.* New York: Rizzoli, 1990.

Keyes, Roger. *Surimono: Privately Published Japanese Prints in the Spencer Museum of Art.* Tokyo: Kodansha, 1984.

Kidder, Jonathan. *Early Japanese Art.* Princeton, NJ: D. Van Nostrand, 1964.

Koren, Leonard. *New Fashion Japan.* Tokyo: Kodansha, 1984.

Kotz, Suzanne, ed. *A Thousand Cranes: Treasures of Japanese Art.* Seattle: Seattle Art Museum, 1987.

Lee, Sherman. *The Japanese Decorative Style.* Cleveland: Cleveland Museum of Art, 1961.

Minnich, Helen. *Japanese Costume.* Rutland, VT: Charles A. Tuttle, 1963.

Munsterberg, Hugo. *The Japanese Kimono.* Oxford: Oxford University, 1996.

Noma, Seiroku. *The Arts of Japan.* Tokyo: Kodansha, 1968.

_____. *Japanese Costume and Textile Arts.* Trans. Armins Nikovskis. New York: Weatherhill, 1974.

Okugawa, Yoshinobu. *The Shogum Age Exhibition.* Tokyo: The Shogun Age Exhibition Executive Committee, 1983.

Plutschow, Herbert. *Introducing Kyoto.* Tokyo, Kodansha, 1979.

Riel, Paul. *Kimono.* Leiden: Hotei, 2001.

Sichel, Marion. *National Costume Reference: Japan.* New York: Chelsea House, 1986.

Slade, Toby. *Japanese Fashion: A Cultural History.* Oxford, U.K.: Berg, 2009.

Stinchecum, Amanda. *Kosode: Sixteenth to Nineteenth Century Textiles from the Nomura Collection.* New York: Japan Society and Kodansha International, 1984.

Totman, Conrad. *Japan Before Perry.* Berkeley: University of California, 1981.

Treat, Robert, and Alexander Soper. *The Art and Architecture of Japan.* New York: Penguin, 1975.

Turnbull, Stephen. *The Lone Samuai.* London: Arms and Armour, 1990.

Yamanaka, Norio. *The Book of Kimono.* Tokyo: Kodansha, 1986.

Yamanobe, Tomoyuki, ed. *Opulence: The Kimonos and Robes of Itchiku Kubota.* Tokyo: Kodansha, 1984.

CHAPTER 11, INDIA

Alkazi, Roshen. *Ancient Indian Costume.* New Delhi: Art Heritage, 1983.

Barnard, Nicholas. *Arts and Crafts of India.* London: Conran Octopus, 1993.

Bhushan, Jamila Brij. *The Costumes and Textiles of India.* Bombay: Taraporevala, 1958.

Biswas, Arabinda. *Indian Costumes.* New Delhi: Ministry of Information and Broadcasting, 1985.

Boulanger, Chantal. *Saris: An Illustrated Guide to the Indian Art of Draping.* New York: Shakti, 1997.

Brand, Michael. *The Vision of Kings: Art and Experience in India.* Canberra: National Gallery of Australia, 1995.

Brown, Dale, ed. *Ancient India, Land of Mystery.* Alexandria, VA: Time-Life, 1994.

Cooper, Ilay, and John Gillow. *Arts and Crafts of India.* London: Thames and Hudson, 1996.

Ghurye, Govind Sadashiv. *Indian Costume.* New York: Humanities, 1967.

Hambly, Gavin. *Cities of Mughul India.* New York: G. P. Putnam's Sons, 1968.

Johnson, Gordon. *Cultural Atlas of India.* New York: Facts on File, 1996.

Keay, John. *India: A History.* New York: Atlantic Monthly, 2000.

Lynton, Linda. *The Sari: Styles. Patterns, History, Techniques.* New York: Harry N. Abrams, 1995.

Maxwell, Robyn. *Sari to Sarong: Five Hundred Years of Indian and Indonesian Textile Exchange.* Canberra: National Gallery of Australia, 2004.

Mookerjee, Ajit. *The Arts of India.* Rutland, VT: Charles E. Tuttle, 1966.

Pal, Pratapaditya. *Jain Art from India.* New York: Thames and Hudson, 1995.

Pandey, Indu Prabha. *Dress and Ornaments in Ancient India.* Delhi: Bharatiya Vidya Prakashan, 1988.

Pria, Devi, et al. *Aditi: The Living Arts of India.* Washington, DC: Smithsonian, 1985.

Riefstahl, R. M. *Persian and Indian Textiles.* New York: New York University, 1923.

Skelton, Robert, et al. *The Indian Heritage.* London: Herbert, 1982.

Stein, Burton. *A History of India.* Malden, MA: Blackwell, 1998.

Tarlo, Emma. *Clothing Matters: Dress and Identity in India.* Chicago: University of Chicago, 1996.

Van den Beukel, Dorine. *Traditional Mehndi Designs: A Treasury of Henna Body Art.* New York: Random House, 2000.

Wolpert, Stanley. *A New History of India.* 5th ed. New York: Oxford University, 1997.

Woodford, Peggy. *Rise of the Raj.* Speldhurst, UK: Midas, 1948.

Zimmer, Heinrich. *The Art of Indian Asia.* New York: Pantheon, 1960.

CHAPTER 12, AFRICA

Ajayi, J. F. A., ed. *Africa from the Nineteenth Century until 1880.* Paris: Unesco, 1981.

Algotsson, Sharne. *African Style.* New York: Clarkson, 2000.

Asamoah-Yaw, Ernest. *Kente Cloth.* New York: Ghanan Textiles, 1994.

Atmore, Anthony, and Gillian Stacey. *Black Kingdoms, Black Peoples.* London: Orbis, 1979.

Bacquart, Jean-Baptiste. *The Tribal Arts of Africa.* New York: Thames and Hudson, 1998.

Blauer, Ettagale. *African Elegance.* London: New Holland, 1999.

Blier, Suzanne. *The Royal Arts of Africa.* New York: Harry N. Abrams, 1998.

Brown, Dale, ed. *Africa's Glorious Legacy.* Richmond, VA: Time-Life, 1994.

Chesi, Gert. *The Last Africans.* Worgl, Austria: Perlinger Verlag, 1977.

Clarke, Duncan. *Art of African Textiles.* San Diego, CA: Thunder Bay, 1997.

Cole, Herbert. *Icons, Ideas and Power in the Art of Africa.* Washington, DC: Smithsonian Institution, 1989.

El Fasi, M., ed. *Africa from the Seventh to Eleventh Century.* Paris: Unesco, 1981.

Ezra, Kate. *Royal Art of Benin.* New York: Harry N. Abrams, 1992.

Fisher, Angela. *Africa Adorned.* New York: Harry N. Abrams, 1984.

Fraser, Douglas, and Herbert Cole. *African Art and Leadership.* Madison: University of Wisconsin, 1972.

Geoffroy-Schneiter, Berenice. *Ethnic Style, History and Fashion.* New York: Assouline, 2001.

Gould, Margaret. *Mother Africa's Beautiful Styles.* Nairobi: Gould, 1990.

Hendrickson, Hildi. *Clothing and Difference: Embodied Identities in Colonial and Post-Colonial Africa.* Durham: Duke University, 1996.

Iliffe, John. *Africans: The History of a Continent.* Cambridge, UK: Cambridge University, 1996.

Josephy, Alvin. *Horizon History of Africa.* New York: American Heritage, 1971.

Kennet, Frances. *Ethnic Dress.* New York: Facts on File, 1995.

Mazrui, A.A., ed. *Africa since 1935.* Paris: Unesco, 1981.

Monkhtar, G., ed. *Ancient Civilizations of Africa.* Paris: Unesco, 1981.

Niane, D.T., ed. *Africa from the Twelfth to Sixteenth Century.* Paris: Unesco, 1981.

Ogot, B.A., ed. *Africa from the Sixteenth to Eighteenth Century.* Paris: Unesco, 1981.

Omer-Cooper, J. D. *History of Southern Africa.* London: James Curry, 1987.

Perani, Judith, and Norma Wolff. *Cloth, Dress, and Art Patronage in Africa.* New York: Oxford, 1999.

Perani, Judith, and Fred Smith. *The Visual Arts of Africa: Gender, Power, and Life Cycle Rituals.* Upper Saddle River, NJ: Prentice Hall, 1998.

Robbins, Warren, and Nancy Nooter. *African Art in American Collections.* Washington, DC: Smithsonian Institution, 1989.

Rogerson, Barnaby. *Traveller's History of North Africa.* New York: Interlink, 1998.

Roscoe, John. *The Soul of Central Africa.* London: Cassell, 1922.

Schild, Enid, and Curtis Keim. *African Reflections.* Seattle: University of Washington, 1984.

Seymour, Frederick. *Roosevelt in Africa.* New York: McCurdy, 1909.

Sieber, Roy. *African Textiles and Decorative Arts.* New York: Museum of Modern Art, 1972.

Spring, Christopher. *African Textiles: The Treasury of Decorative Art.* Wickford, RI: Moyer Bell, 1997.

Starke, Barbara, et al. *African American Dress and Adornment: A Cultural Perspective.* Dubuque, IA: Kendall-Hunt, 1990.

Visona, Monica, et al. *A History of Art in Africa.* New York: Harry N. Abrams, 2001.

Vogel, Susan. *Africa Explores: Twentieth Century African Art.* New York: Center for African Art, 1994.

Wassing, Rene. *African Art.* New York: Harry N. Abrams, 1968.

CHAPTER 13, THE ANCIENT AMERICAS

Anawalt, Patricia. *Indian Clothing Before Cortes.* Norman: University of Oklahoma, 1981.

Anton, Ferdinand. *Ancient Peruvian Textiles.* New York: Thames and Hudson, 1987.

_____. *Woman in Pre-Columbian America.* New York: Abner Schram, 1973.

Appleton, LeRoy. *American Indian Design and Decoration.* Mineola, NY: Dover, 1971.

Berdan, Frances, and Russell Barbel. *Spanish Thread on Indian Looms.* Trans. Rafael Correa. San Bernardino: California State University, 1988.

Blomberg, Nancy. *Native Arts of North America.* Paris: Terrail, 1998.

Brown, Dale, ed. *The Search for El Dorado.* Alexandria, VA: Time-Life, 1994.

Capture, Joseph D., and George P. Horse. *Beauty, Honor, and Tradition: The Legacy of Plains Indian Shirts.* Minneapolis: University of Minnesota, 2001.

Carr, Lucien. *Dress and Ornaments of Certain American Indians.* Worcester, MA: Charles Hamilton, 1897.

Carrasco, David. *Daily Life of the Aztecs.* Westport: Greenwood, 1998.

Cervantes, Maria. *Treasures of Ancient Mexico from the National Anthropological Museum.* New York: Crescent, 1978.

Cordry, Donald, and Dorothy Cordry. *Costume and Textiles of the Aztec Indians of the Cuetzlan Region, Puebla, Mexico.* Los Angeles: The Southwest Museum, 1940.

_____. *Costumes and Weavings of the Zoque Indians of Chiapas, Mexico* Los Angeles: The Southwest Museum, 1941.

D'Harcourt, Roul. *Textiles of Ancient Peru and Their Techniques.* Seattle: University of Washington, 1962.

Dockstader, Frederick. *Weaving Arts of the North American Indian.* New York: James Kery, 1978.

Dubin, Lois Sherr. *North American Indian Jewelry and Adornment.* New York: Harry N. Abrams, 1999.

Du Solier, Wilfrido. *Ancient Mexican Costume.* Mexico: Ediciones Mexicanas, 1950.

Ferguson, William. *Maya Ruins in Central America in Color.* Albuquerque: University of New Mexico, 1984.

Haire, Frances. *The American Costume Book.* New York: A. S. Barnes, 1934.

Josephy, Alvin. *Five Hundred Nations: An Illustrated History of North American Indians.* New York: Alfred A. Knopf, 1994.

Kaufman, Alice, and Christopher Selser. *The Navajo Weaving Tradition.* Tulsa: Council Oaks, 1999.

Koch, Ronald. *Dress Clothing of the Plains Indians.* Norman: University of Oklahoma, 1977.

Kuhler, George. *The Art and Architecture of Ancient America.* New York: Penguin, 1984.

Laughton, Timothy. *The Maya.* New York: Stewart, Tabori and Chang, 1998.

Longhena, Maria. *Ancient Mexico.* New York: Stewart, Tabori and Chang, 1998.

Lothrop, Samuel. *Treasures of Ancient America.* New York: Rizzoli, 1979.

Lumbreras, Luis. *The Peoples and Cultures of Ancient Peru.* Washington, DC: Smithsonian Institution, 1989.

Meisch, Lynn, ed. *Traditional Textiles of the Andes.* New York: Thames and Hudson, 1997.

Moseley, Michael. *The Incas and Their Ancestors.* London: Thames and Hudson, 1992.

Osborne, Lilly de Jongh. *Indian Crafts of Guatemala and El Salvador.* Norman: University of Oklahoma, 1975.

Paterek, Josephine. *Encyclopedia of American Indian Costume.* Denver: ABC-Clio, 1993.

Paul, Anne. *Paracas Ritual Attire.* Norman: University of Oklahoma, 1990.

Penney, David. *Native Arts of North America.* Paris: Terrail, 1998.

Pettersen, Carmen. *The Maya of Guatemala, Their Life and Dress.* Seattle: University of Washington, 1976.

Reedstrom, Ernest. *Historic Dress of the Old West.* Poole, UK: Blandford, 1986.

Robicsek, Francis. *A Study in Maya Art and History: The Mat Symbol.* New York: The Museum of American Indian, 1975.

Sayer, Chloe. *Costumes of Mexico.* Austin: University of Texas, 1978.

Schele, Linda. *Hidden Faces of the Maya.* New York: ALTI, 1997.

Schevill, Margot. *Costume as Communication.* Seattle: University of Washington, 1986.

_____. *The Maya Textile Tradition.* New York: Harry N. Abrams, 1997.

_____. *Maya Textiles of Guatamala.* Austin: University of Texas, 1993.

Shevill, Margot, Janet Berlo, and Edward B. Dwyer, eds. *Textile Traditions of Mesoamerica and the Andes.* New York: Garland, 1991.

Seton, Julia. *American Indian Arts.* New York: Ronald, 1962.

Smith, Bradley. *Mexico, a History in Art.* New York: Harper and Row, 1968.

Spicer, Dorothy. *Latin American Costumes.* New York: Hyperion, 1941.

Stierdin, Henri. *Art of the Incas.* New York: Rizzoli, 1984.

Stone-Miller, Rebecca. *To Weave for the Sun: Ancient Andean Textiles in the Museum of Fine Arts, Boston.* New York: Thames and Hudson, 1992.

Vincent, Gilbert. *Masterpieces of American Indian Art.* New York: Harry N. Abrams, 1995.

Wade, Edwin, ed. *The Arts of the North American Indian: Native Traditions in Evolution.* New York: Hudson Hills, 1986.

Woodhead, Henry, ed. *The Buffalo Hunters.* Alexandria, VA: Time-Life, 1992.

_____. *The European Challenge.* Alexandria, VA: Time-Life, 1992.

_____. *The First Americans.* Alexandria, VA: Time-Life, 1992.

_____. *The People of the Desert.* Alexandria, VA: Time-Life, 1992.

_____. *The Spirit World.* Alexandria, VA: Time-Life, 1992.

_____. *The Way of the Warrior.* Alexandria, VA: Time-Life, 1992.

CHAPTER 14, THE LATE MIDDLE AGES

Brooke, Chistopher. *The Twelfth Century Renaissance.* New York: Harcourt, Brace, and World, 1970.

Brooke, Iris. *English Costume from the Fourteenth through the Nineteenth Century.* New York: MacMillan, 1937.

_____. *English Costume of the Early Middle Ages, the Tenth through the Thirteenth Centuries.* London: Adam and Charles Black, 1936.

_____. *English Costume of the Later Middle Ages, the Fourteenth and Fifteenth Centuries.* London: Adam and Charles Black, 1935.

_____. *Medieval Theatre Costume: A Practical Guide to Construction of Garments.* London: Adam and Charles Black, 1967.

Calthrop, Dion C. *English Costume: Middle Ages.* London: Adam and Charles Black, 1906.

Camille, Michael. *Gothic Art: Glorious Visions.* New York: Harry N. Abrams, 1996.

Cazelles, Raymond, and Johannes Rathofer. *Illuminations of Heaven and Earth: The Glories of Trés Riches Heures de Duc de Berry.* New York: Harry N. Abrams, 1988.

Crowfoot, Elisabeth, et al. *Textiles and Clothing 1150-1450: Medieval Finds from Excavations in London.* Woodbridge, UK: Boydell and Brewer, 2001.

Dakers, Andrew. *Medieval Costume: Armour and Weapons.* New York: Dover, 2001.

D'Ancona, Paola, and E. Aeschlimann. *The Art of Illumination: An Anthology of Manuscripts from the Sixth to the Sixteenth Century.* London: Phaidon, 1969.

Deuchler, Florens. *Gothic Art.* New York: Universe, 1973.

Egan, Geoff. *Dress Accessories 1150-1450: Medieval Finds from Excavations in London.* Woodbridge, UK: Boydell and Brewer, 2002.

Evans, Joan. *Dress in Mediaeval France.* London: Clarendon, 1952.

Grew, Francis, and Margrethe de Neergaard. *Shoes and Pattens.* London: Museum of London, 1988.

Houston, Mary. *Medieval Costume in England and France: The 13th, 14th and 15th Centuries.* London: Adam and Charles Black, 1939.

Kelly, Frances. *A Short History of Costume and Armour.* New York: Arco, 1972.

Meiss, Millard. *French Painting in the Time of Jean de Berry; The Boucicaut Master.* London: Phaidon, 1968.

Norris, Herbert. *Costume and Fashion: Senlac to Bosworth.* London: J. M. Denton, 1940.

_____. *Costume and Fashion: The Evolution of European Dress through the Earlier Ages.* London: J. M. Denton, 1931.

_____. *Medieval Costume and Fashion.* New York: Dover, 1999.

Pognon, Edmond. *Boccaccio's Decameron: 15th Century Manuscript.* Trans. Peter Tallon. Geneva: Miller Graphics, 1978.

Ruby, Jennifer. *People in Costume: The Medieval World.* London: Chrysalis, 1994.

Shapely, Fern. *Italian Paintings: XIII-XV Century.* London: Phaidon, 1966.

Sichel, Marion. Costume Reference: Roman Britain through the Middle Ages. Vol. 1. New York: Chelsea House, 1995.

Thomas, Marcel. *The Golden Age: Manuscript Painting at the Time of Jean, Duke of Berry.* New York: George Braziller, 1979.

Wagner, Eduard. *Medieval Costume: Armour and Weapons 1350-1450.* London: Hamlyn, 1962.

_____. *Art and Society in Italy 1350-1500.* New York: Oxford University, 1997.

Zarnecki, George. *Art of the Medieval World.* Englewood Cliffs, NJ: Prentice Hall, 1975.

CHAPTER 15, ITALY AND SPAIN IN THE RENAISSANCE 1450–1600

Brucker, Gene. *Florence: The Golden Age 1138-1737.* New York: Abbeville, 1984.

Hale, John. *Renaissance.* Alexandria, VA: Time-Life, 1965.

Hartt, Frederick. *History of Italian Renaissance Art.* Englewood Cliffs, NJ: Prentice Hall, 1975.

Huse, Norbert, and Wolfgang Wolters. *The Art of Renaissance Venice.* Trans. Edmund Jephcott. Chicago: University of Chicago, 1990.

Koues, Helen. "The Click of Modern Knitting Needles Recalls the Time of Good Queen Bess." *Good Housekeeping* (August 1918), 79.

Lemaitre, Alain. *Florence and the Renaissance.* Paris: Terrail, 1993.

Luchinat, Cristina. *Benozzo Gozzoli.* Florence: Scala Istituto Fotografico Editoriale, 1994.

Micheletti, Emma. *Domenico Ghirlandaio.* Florence: Scala Istituto Fotografico Editoriale, 1990.

Newton, Stella. *The Dress of the Venetians 1495-1525.* Aldershot, UK: Scolar, 1988.

Paoletti, John, and Gary Radke. *Art in Renaissance Italy.* New York: Harry N. Abrams, 1997.

Paolucci, Antonio. *Luca Signorelli.* Florence: Scala Istituto Fotografico Editoriale, 1990.

Pedrocco, Filippo. *Titian.* Florence: Scala Istituto Fotografico Editoriale, 1993.

Pignatti, Terisio. *Giorgione.* New York: Phaidon, 1969.

Plumb, J. H. *The Horizon Book of the Renaissance.* New York: American Heritage, 1961.

Vecellio, Cesare. *Vecellio's Renaissance Costume Book.* New York: Dover, 1977.

Weiditz, Christoph. *Authentic Everyday Dress of the Renaissance.* New York: Dover, 1994.

Williams, Jay. *World of Titian.* New York: Time-Life, 1968.

CHAPTER 16, NORTHERN RENAISSANCE

Arnold, Janet. *Patterns of Fashion: The Cut and Construction of Clothes for Men and Women 1560-1620.* New York: Drama, 1985.
_____. *Queen Elizabeth's Wardrobe Unlock'd.* Leeds, UK: Maney, 1988.
Ashelford, Jane. *Dress in the Age of Elizabeth I.* London: B. T. Batsford, 1988.
Brooke, Iris. *English Costume from the Early Middle Ages through the Sixteenth Century.* Mineola, NY: Dover, 2000.
_____. *English Costume in the Age of Elizabeth: The Sixteenth Century.* London: Adam and Charles Black, 1938.
Calthrop, Dion C. *English Costume: Tudor and Stuart.* London: Adam and Charles Black, 1904.
Cunnington, C. W., and J. Cunnington. *Handbook of English Costume in the Sixteenth Century.* London: Faber and Faber, 1970.
Linthicum, M. C. *Costume in the Drama of Shakespeare and His Contemporaries.* New York: Hacker Art, 1972.
Linthicum, Marie. *Costume in the Drama of Shakespeare and His Contemporaries.* Oxford, UK: Clarendon, 1976.
Morrill, John. *The Oxford Illustrated History of Tudor and Stuart Britain.* Oxford: Oxford University, 1996.
Morse, H. K. *Elizabethan Pageantry: A Pictorial Survey of Costume and Its Commentators from 1560-1620.* London: Studio,1934.
Norris, Herbert. *Tudor Costume and Fashion.* Mineola, NY: Dover, 1997.
Roberts, Keith. *Bruegel.* London: Phaidon, 1971.
Singman, Jeffrey. *Daily Life in Elizabethan England.* Westport, CT: Greenwood, 1995.
Strong, Roy. *Gloriana: The Portraits of Queen Elizabeth I.* London: Thames and Hudson, 1987.
_____. *The English Icon Elizabethan and Jacobean Portraiture.* London: Paul Mellon Foundation for British Art, 1969.

CHAPTER 17, THE SEVENTEENTH CENTURY

Brooke, Iris. *Dress and Undress, the Restoration and Eighteenth Century.* Westport, CT: Greenwood, 1958.
_____. *English Costume of the Seventeenth Century.* London: Adam and Charles Black, 1934.
Brown, Christopher. *Van Dyck.* Ithaca, NY: Cornell University, 1982.
Gallienne, Richard Le. *The Diary of Samuel Pepys 1633–1703.* New York: Modern Library, 2001.
Gordenker, Emilie. *Anthony Van Dyck and the Representation of Dress in Seventeenth-Century Portraiture.* Turnhout, Belgium: Brepols, 2001.
Haak, Bob. *The Golden Age: Dutch Painters of the Seventeenth Century.* New York: Harry N. Abrams, 1984.
Hart, Avril, and Susan North. *Fashion in Detail from the Seventeenth and Eighteenth Centuries.* New York: Rizzoli, 1998.
Hatton, Ragnhild. *Louis XIV and His World.* New York: G. P. Putnam's Sons, 1972.
Konigsberger, Hans. *The World of Vermeer.* New York: Time-Life, 1967.
Sichel, Marion. *Costume Reference: Eighteenth Century.* Vol. 4. New York: Chelsea House, 1977.
Thienen, Frithjof Van. *Costume of the Western World: The Great Age of Holland 1600-1660.* Trans. Fernand Renier. London: George Harrap, 1951.
Wheelock, Arthur. *Anthony Van Dyck.* Washington, DC: National Gallery of Art, 1991.

CHAPTER 18, THE EIGHTEENTH CENTURY

Baumgarten, Linda, and John Watson. *Costume Close-up: Clothing Construction and Pattern 1750-1790.* Williamsburg, VA: Colonial Williamsburg Foundation, 2000
_____. *What Clothes Reveal: The Language of Clothing in Colonial and Federal America.* Williamsburg, VA: Colonial Williamsburg Foundation, 2002.
Brooke, Iris. *English Children's Costume Since 1775.* London: Adam and Charles Black, 1935.
Calthrop, Dion C. *English Costume: Georgian.* London: Adam and Charles Black, 1904.
Copeland, Peter. *Working Dress in Colonial and Revolutionary America.* Westport, CT: Greenwood, 1977.
Grand-Carteret, John. *Les Elegances de la Toilette 1790-1825.* Paris: Albin Michel, 1920.
MacMillan, Duncan. *Scottish Art 1460-1990.* Edinburgh: Mainstream, 1990.
Maeder, Edward. *An Elegant Art: Fashion and Fantasy in the Eighteenth Century.* New York: Harry N. Abrams, 1983.
Marly, Diana de. *Dress in North America: The New World, 1492-1800.* New York: Holmes and Meier, 1990.
McClellan, Elisabeth. *Historic Dress in America 1607-1800.* Philadelphia: George Jacobs, 1904.
Nanteuil, Luc de. *Jacques-Louis David.* New York: Harry N. Abrams, 1990.
Ribeiro, Aileen. *The Art of Dress: Fashion in England and France 1750-1820.* New Haven: Yale University, 1995.
_____. *Dress in Eighteenth-Century Europe 1715-1789.* New Haven: Yale University, 2002.
_____. *Fashion in the French Revolution.* London: B. T. Batsford, 1988.
Sitwell, Doris. *Gallery of Fashion 1790-1822 from the Plates of Heideloff and Ackermann.* London: B. T, Batsford, 1949.

CHAPTERS 19 AND 20, THE NINETEENTH CENTURY

Adams, James. *Dandies and Desert Saints: Styles of Victorian Manhood.* Ithaca, NY: Cornell, 1995.

Armstrong, Nancy. *Victorian Jewelry.* New York: Macmillan, 1976.

Breward, Christopher. *The Hidden Consumer: Masculinities, Fashion, and City Life 1860-1914.* Manchester: Manchester University, 1999.

Bryk, Nancy, ed. *American Dress Pattern Catalogs 1873-1909.* New York: Dover, 1988.

Buck, Anne. *Victorian Costume and Costume Accessories.* New York: Thomas Nelson, 1961.

Byrde, Penelope. *Nineteenth Century Fashion.* London: B. T. Batsford, 1992.

Calthrop, Dion C. *English Dress from Victoria to George V.* London: Chapman and Hall, 1934.

Carlyle, Thomas. *Sartor Restartus.* New York: MacMillan, 1927.

Cashen, Marilynn. *A Moment in Time: Images of Victorian Fashions from the Mid-1800s.* South Plainfield, NJ: MAC, 1992.

Coleman, Elizabeth. *The Opulent Era: Fashions of Worth, Doucet, and Pingat.* New York: Thames and Hudson, 1990.

Conner, Patrick. *George Chinnery.* Woodbridge, UK: Antique Collectors' Club, 1993.

Cunnington, C. W. *English Women's Clothing in the Nineteenth Century.* New York: Dover, 1990.

Cunnington, Phillis. *Costumes for Births, Marriages, and Deaths.* New York: Barnes and Noble, 1972.

_____. *Handbook of English Costume in the Ninenteeth Century.* London: Faber and Faber, 1970.

_____. *Your Book of Nineteenth Century Costume.* London: Faber and Faber, 1970.

Dalrymple, Priscilla. *American Victorian Costume in Early Photographs.* New York: Dover, 1991.

Doran, John. *Habits and Men with Remnants of Record Touching the Makers of Both.* New York: Widdleton, 1865.

Downey, Lynn, et al. *This is a Pair of Levi's Jeans: The Official History of the Levi's Brand.* San Francisco: Levi Strauss, 1995.

Emmet, Boris. *Montgomery Ward Catalogue and Buyer's Guide.* New York: Dover, 1969.

Foster, Vanda. *A Visual History of Costume in the Nineteenth Century.* London: B. T. Batsford, 1982.

Gere, Charlotte. *European and American Jewellery 1830-1914.* London: Heinemann, 1975.

Gernsheim, Alison. *Fashion and Reality.* London: Faber and Faber, 1963.

_____. *Victorian and Edwardian Fashion.* New York: Dover, 1981.

Goldthorpe, Caroline. *From Queen to Empress: Victorian Dress 1837-1877.* New York: Metropolitan Museum of Art, 1988.

Greeley, Horace, et al. *Great Industries of the United States.* Hartford, CT: Burr and Hyde, 1872.

Harris, Kristina. *Victorian and Edwardian Fashions for Women 1840-1919.* Atglen, PA: Schiffer, 1995.

Holland, Vyvyan. *Hand Coloured Fashion Plates 1770-1899.* London: B. T. Batsford, 1955.

Kerr, Rose. *One Hundred Years of Costumes in America.* Worcester, MA: Davis, 1981.

Laver, James. *Children's Fashions in the Nineteenth Century.* London: B. T. Batsford, 1951.

_____. *Fashion and Fashion Plates 1800-1900.* London: King Penguin, 1943.

_____. *Victorian Vista.* Boston: Houghton Mifflin, 1955.

_____. *Victoriana.* New York: Hawthorne, 1967.

Levitt, Sarah. *Victorians Unbuttoned.* Boston: Allen and Unwin, 1986.

McClellan, Elisabeth. *History of American Costume 1607-1870.* New York: Tudor, 1969.

Montebello, Philippe de, et al. *The Imperial Style: Fashions of the Hapsburg Era.* New York: Metropolitan Museum of Art, 1980.

Norris, Herbert. *Nineteenth-Century Costume and Fashion.* Mineola, NY: Dover, 1999.

Olian, Joanne. *Children's Fashions 1860-1912.* New York: Dover, 1993.

Perrot, Philippe. *Fashioning the Bourgeoisie: A History of Clothing in the Nineteenth Century.* Trans. Richard Bienvenu. Princeton, NJ: Princeton University, 1987.

Ribeiro, Aileen. *Ingres in Fashion.* New Haven: Yale University, 1999.

Rosenblum, Robert. *Jean-Auguste-Dominique Ingres.* New York: Harry N. Abrams, 1990.

Ruby, Jennifer. *Costume in Context: The Victorians.* London: B. T. Batsford, 1994.

Sichel, Marion. *Costume Reference: Regency.* Vol. 5. New York: Chelsea House, 1978.

_____. *Costume Reference: Victorians.* Vol. 6. New York: Chelsea House, 1986.

Summers, Leigh. *Bound to Please: A History of the Victorian Corset.* New York: Oxford University, 2001.

Thieme, Otto, et al. *With Grace and Favor: Victorian and Edwardian Fashion in America.* Cincinnati: Cincinnati Art Museum, 1993.

Tozer, Jane, and Sarah Levitt. *Fabric of Society: A Century of People and Their Clothes 1770-1870.* Manchester, UK: Laura Ashley, 1983.

Walkley, Christina. *Dressed to Impress 1840-1914.* London: B. T. Batsford, 1989.

Worrell, Estelle. *American Costume 1840-1920.* Harrisburg, PA: Stackpole, 1979.

CHAPTER 21, THE TWENTIETH CENTURY 1900–1920

Brooke, Iris. *English Costume 1900-1950.* London: Methuen, 1951.
Laver, James. *Edwardian Promenade.* Boston: Houghton Mifflin, 1958.
Mackrell, Alice. *Paul Poiret.* New York: Holmes and Meier, 1990.
Ruby, Jennifer. *Costume in Context: The Edwardians and the First World War.* London: B. T. Batsford, 1988.
Sichel, Marion. *Costume Reference: Edwardians.* Vol. 7. New York: Chelsea House, 1978.
Wenzell, A.B. *The Passing Show.* New York: Collier, 1913.

CHAPTER 22, THE TWENTIETH CENTURY 1920–1940

Battersby, Martin. *Art Deco Fashion: French Designers 1908–1925.* New York: St. Martin's, 1974.
Bowman, Sara, and Michel Molinare. *A Fashion for Extravagance: Art Deco Fabrics and Fashions.* New York: E. P. Dutton, 1985.
Chadwick, Luie. *Fashion Drawing and Design.* London: Batsford, 1926.
Costantino, Maria. *Fashions of a Decade: The 1930s.* New York: Facts on File, 1992.
Garland, Madge, et al. *Fashion 1900-1939.* London: Idea, 1975.
Gutner, Howard. *Gowns by Adrian: The MGM Years 1928-1941.* New York: Harry N. Abrams, 2001.
Hall, Carolyn. *The Thirties in Vogue.* New York: Harmony, 1985.
_____. *The Twenties in Vogue.* New York: Harmony, 1983.
Hawes, Elizabeth. *Fashion is Spinach.* New York: Random House, 1938.
Herald, Jacqueline. *Fashions of a Decade: The 1920s.* New York: Facts on File, 1991.
Hunt, Marsha. *The Way We Wore: Styles of the 1930s and '40s.* Fallbrook, CA: Fallbrook, 1993.
Lussier, Suzanne. *Art Deco Fashion.* New York: Bulfinch, 2003.
Maeder, Edward. *Hollywood and History: Costume Design in Film.* London: Thames and Hudson, 1987.
Martin, Richard, and Harold Koda. *Splash! A History of Swimwear.* New York: Rizzoli, 1990.
_____. *Cubism and Fashion.* New Haven: Yale University, 1999.
Olian, Joanne. *Authentic French Fashions of the Twenties.* New York: Dover, 1990.
Peacock, John. *Fashion Source: the 1920s.* New York: Thames and Hudson, 1997.
_____. *Fashion Source: the 1930s.* New York: Thames and Hudson, 1997.
Ruby, Jennifer. *Costume in Context: The 1920s and 1930s.* London: B. T. Batsford, 1988.
Sichel, Marion. *Costume Reference: 1918-1939.* Vol. 8. Boston: Plays, 1978.
White, Palmer. *Elsa Schiaparelli: Empress of Paris Fashion.* London: Aurum, 1986.

CHAPTER 23, THE TWENTIETH CENTURY 1940–1960

Baker, Patricia. *Fashions of a Decade: The 1940s.* New York: Facts on File, 1992.
_____. *Fashions of a Decade: The 1950s.* New York: Facts on File, 1991.
Connolly, Joseph. *All Shook Up: A Flash of the Fifties.* London: Cassell, 2000.
Dior, Christian. *Christian Dior's Little Dictionary of Fashion.* London: Cassell, 1954.
Dorner, Jane. *Fashion in the Forties and Fifties.* New Rochelle, NY: Arlington House, 1975.
Drake, Nicholas. *The Fifties in Vogue.* New York: Henry Holt, 1987.
Hall, Carolyn. *The Forties in Vogue.* New York: Harmony, 1985.
Maeder, Edward. *Salvatore Ferragamo: Art of the Shoe 1896-1960.* New York: Rizzoli, 1992.
Martin, Richard. *Charles James.* New York: Universe, 1999.
Mendes, Valerie. *John French: Fashion Photographer.* London: Victoria and Albert Museum, 1984.
Muir, Robin. *Clifford Coffin: Photographs from Vogue 1945 to 1955.* New York: Stewart, Tabori, and Chang, 1997.
Peacock, John. *Fashion Source: the 1940s.* New York: Thames and Hudson, 1998.
_____. *Fashion Source: the 1950s.* New York: Thames and Hudson, 1997.
Ruby, Jennifer. *Costume in Context 1930-1945.* London: B. T. Batsford, 1995.
Ruttenber, Edward. *The American Male: His Fashions and Foibles.* New York: Fairchild, 1948.
Sichel, Marion. *Costume Reference 1939-1950.* Vol. 9. London: B. T. Batsford, 1987.
Turnudich, Daniela, ed. *1940s Hairstyles.* Longbeach, CA: Streamline, 2001.

CHAPTER 24, THE TWENTIETH CENTURY 1960–1980

Berendt, John. *Esquire Fashions for Men.* Rev. ed. New York: Harper and Row, 1966.

Connickie, Yvonne. *Fashions of a Decade: The 1960s.* New York: Facts on File, 1991.

Drake, Nicholas, ed. *The Sixties: A Decade in Vogue.* New York: Prentice Hall, 1988.

Gale, Bill. *Esquire's Fashions for Today.* New York: Harper and Row, 1973.

Herald, Jacqueline. *Fashions of a Decade: The 1970s.* New York: Facts on File, 1991.

Hix, Charles. *Looking Good: A Guide for Men.* New York: Hawthorn, 1977.

Hyde, Jack, ed. *Generation of Change: A History of Male Fashion Trends, 1956–1980, on the Occasion of the Twenty-Fifth Anniversary of the Founding of the Men's Fashion Association.* New York: Men's Wear, 1980.

Lobenthal, Joel. *Radical Rags: Fashions of the Sixties.* New York: Abbeville, 1990.

Mulvaney, Jay. *Jackie: The Clothes of Camelot.* New York: St. Martin's, 2001.

Peacock, John. *Fashion Source: the 1960s.* New York: Thames and Hudson, 1998.

_____. *Fashion Source: the 1970s.* New York: Thames and Hudson, 1997.

Ruby, Jennifer. *Costume in Context: The 1960s and 1970s.* London: B. T. Batsford, 1989.

CHAPTER 25, THE TWENTIETH CENTURY 1980–PRESENT

Carnegy, Vicky. *Fashions of a Decade: The 1980s.* New York: Facts on File, 1990.

Cassini, Oleg. *In My Own Fashion, an Autobiography.* New York: Simon and Schuster, 1987.

Celant, Germano. *Giorgio Armani.* New York: Harry N. Abrams, 2000.

Chic Simple Partners. *Men's Wardrobe.* New York: Alfred A. Knopf, 1993.

Coleridge, Nicholas. *The Fashion Conspiracy.* London: Heinemann, 1989.

Deloffre, Claude, ed. *Thierry Mugler: Fashion, Fetish, Fantasy.* Los Angeles: General, 1998.

Diamonstein, Barbaralee. *Fashion: The Inside Story.* New York: Rizzoli, 1988.

Feldman, Elane. *Fashions of a Decade: The 1990s.* New York: Facts on File, 1992.

Flocker, Michael. *The Metrosexual Guide to Style: A Handbook for the Modern Man.* Cambridge, MA: Da Capo, 2003.

Flusser, Alan. *Dressing the Man: Mastering the Art of Permanent Fashion.* New York: HarperCollins, 2002.

Fujii, Satoru, ed. *Vision: George Stavrinos.* Tokyo: Tokyo Designers Gakuin College, 1984.

Gan, Stephen. *Visionaire's Fashion 2000: Designers at the Turn of the Millennium.* New York: Universe, 1997.

_____. *Visionaire's Fashion 2001: Designers of the New Avant-Garde.* New York: Universe, 1999.

Graham, Nicolas. *A Brief History of Shorts: The Ultimate Guide to Understanding Your Underwear.* San Francisco: Chronicle, 1995.

Greenwood, Kathryn, and Mary Murphy. *Fashion Innovation and Marketing.* New York: MacMillan, 1978.

Gross, Kim. *Chic, Simple Men's Wardrobe.* New York: Alfred A. Knopf, 1998.

Hannah, Barry, et al. *Men without Ties.* New York: Abbeville, 1994.

Hardy, Karen. *Not Just Another Pretty Face: An Intimate Look at America's Top Male Models.* New York: Plume, 1983.

Hemphill, Christopher. *Antonio's Girls.* New York: Congreve, 1982.

Hix, Charles. *Man Alive: Dressing the Free Way.* New York: Simon and Schuster, 1984.

Karpinski, Kenneth. *Red Socks Don't Work: Messages from the Real World about Men's Clothing.* Manassas Park, VA: Impact, 1994.

Lehnert, Gertrud. *Fashion: A Concise History.* London: Laurence King, 1998.

Malossi, Giannino, ed. *Material Man: Masculinity, Sexuality, Style.* New York: Harry N. Abrams, 2000.

Martin, Richard, and Harold Koda. *Giorgio Armani: Images of Man.* New York: Rizzoli, 1990.

McDowell, Colin. *Fashion Today.* New York: Phaidon, 2000.

McRobbie, Angela. *British Fashion Design: Rag Trade or Image Industry?* London: Routledge, 1998.

_____. *In Culture Society: Art, Fashion, and Popular Music.* London: Routledge, 1999.

Musto, Michael. *Downtown.* New York: Vintage, 1986.

Nixon, Sean. *Hard Looks: Masculinities, Spectatorship and Contemporary Consumption.* New York: St. Martin's, 1996.

Omelianuk, Scott, and Ted Allen. *Esquire's Things a Man Should Know About Style.* New York: Riverhead, 1999.

Peacock, John. *Fashion Source: The 1980s.* New York: Thames and Hudson, 1998.

Polhemus, Ted. *Street Style: From Sidewalk to Catwalk.* London: Thames and Hudson, 1994.

_____. *Style Surfing: What to Wear in the Third Millennium.* New York: Thames and Hudson, 1996.

Ruby, Jennifer. *People in Costume: The 1970s and 1980s.* London: Chrysalis, 1988.

Steele, Valerie. *Red Dress.* New York: Rizzoli, 2001.

Strong, Roy. *Gianni Versace: Do Not Disturb*. New York: Abbeville, 1996.

Swenson, Marge, and Gerri Pinckney. *New Image for Men: Color and Wardrobe*. Costa Mesa, CA: Fashion Academy, 1983.

Tucker, Andrew. *London Fashion Book*. London: Thames and Hudson, 1998.

Versace, Gianni. *Rock and Royalty*. New York: Abbeville, 1996.

_____. *Signatures*. New York: Abbeville, 1992.

Wilcox, Claire. *Radical Fashion*. London: Victoria and Albert Museum, 2001.

GENERAL TWENTIETH CENTURY

Agins, Teri. *The End of Fashion: The Mass Marketing of the Clothing Business*. New York: William Morrow, 1999.

Angeloglou, Maggie. *A History of Make-up*. London: Macmillan, 1965.

Bailey, Perkins, ed. *Men's Wear: History of the Men's Wear Industry 1890-1950*. New York: Fairchild, 1950.

Ball, Joanne. *The Art of Fashion Accessories: A Twentieth Century Retrospective*. Atglen, PA: Schiffer, 1993.

Barnard, Malcolm. *Fashion as Communication*. London: Routledge, 1996.

Baudot, Francois. *The Allure of Men*. New York: Assouline, 2000.

_____. *Elsa Schiaparelli*. New York: Universe, 1997.

_____. *Fashion: the Twentieth Century*. New York: Universe, 1999.

Beaton, Cecil. *The Glass of Fashion*. London: Weidenfeld and Nicolson, 1954.

Bell, Quentin. *On Human Finery*. New York: Schocken, 1976.

Benson, Elaine, and John Esten. *Unmentionables: A Brief History of Underwear*. New York: Simon and Schuster, 1996.

Bergler, Edmund. *Fashion and the Unconscious*. Madison, CT: International Universities Press, 1987.

Biddle, Julian. *What Was Hot: A Rollercoaster Ride through Six Decades of Pop Culture in America*. New York: MJF, 2001.

Binder, Pearl. *The Peacock's Tail*. London: Harrap, 1958.

Blanchard, Tamsin. *Antonio Berardi: Sex and Sensibility*. New York: Watson-Guptill, 1999.

Bond, David. *Glamour in Fashion*. London: Guinness, 1992.

Bonner, Paul, ed. *The World in Vogue*. New York: Viking, 1963.

Bordo, Susan. *The Male Body: A New Look at Men in Public and in Private*. New York: Farrar, Straus and Giroux, 1999.

Bosker, Gideon, and Lena Lencek. *Making Waves: Swimsuits and the Undressing of America*. San Francisco: Chronicle, 1988.

Boston, Lloyd. *Men of Color: Fashion, History, Fundamentals*. New York: Artisan, 1998.

Breward, Christopher. *The Culture of Fashion*. Manchester, UK: Manchester University, 1995.

Brown, Marcia. *Unsigned Beauties of Costume Jewelry*. Paducah, KY: Collector, 2000.

Bure, Gilles de. *Gruau*. Paris: Editions Herscher, 1989.

Buttolph, Angela, et al. *The Fashion Book*. London: Phaidon, 1998.

Buxbaum, Gerda. *Icons of Fashion of the Twentieth Century*. Munich: Prestel Verlag, 1999.

Campbell, Emily, et al. *Inside Out: Underwear and Style in the UK*. London: Black Dog, 2000.

Caranicas, Paul. *Antonio's People*. New York: Thames and Hudson, 2004.

Carter, Ernestine. *With Tongue in Chic*. London: Michael Joseph, 1977.

Carter, Ernestine. *The Changing World of Fashion*. New York: G. P. Putnam's Sons, 1977.

Castelbajac, Kate de. *The Face of the Century: One Hundred Years of Makeup and Style*. New York: Rizzoli, 1995.

Chariau, Joelle. *Gruau*. New York: Te Neues, 1999.

Clark, Fiona. *Hats*. New York: Drama, 1982.

Cobrin, Harry. *The Men's Clothing Industry: Colonial Times Through Modern Times*. New York: Fairchild, 1970.

Coleman, Elizabeth. *Changing Fashions 1800-1970*. Brooklyn, NY: Brooklyn Museum, 1972.

Cooper, Wendy. *Hair: Sex, Society, Symbolism*. New York: Stein and Day, 1971.

Costantino, Maria. *Men's Fashion in the Twentieth Century: From Frock Coats to Intelligent Fibres*. London: B. T. Batsford, 1997.

Cox, Caroline. *Lingerie: A Lexicon of Style*. New York: St. Martin's, 2000.

Craik, Jennifer. *The Face of Fashion: Cultural Studies in Fashion*. London: Routledge, 1994.

Cunningham, Patricia, ed. *Dress in American Culture*. Bowling Green, OH: Bowling Green State University, 1990.

Daves, Jessica. *Ready-Made Miracle*. New York: G. P. Putnam's Sons, 1967.

DeMarly, Diana. *The History of Haute Couture 1850-1950*. New York: Holmes and Meier, 1980.

Devlin, Polly. *Vogue Book of Fashion Photography 1919-1979*. New York: Simon and Schuster, 1979.

Doughty, Robin. *Feather Fashion and Bird Preservation*. Berkeley: University of California, 1975.

Earle, Alice. *Customs and Fashions in Old New England*. New York: Charles Scribner's Sons, 1893.

Edwards, Tim. *Men in the Mirror: Men's Masculinity and Consumer Fashion*. London: Cassell Academic, 1997.

Eichler, Lillian. *The Customs of Mankind.* New York: Doubleday, 1924.

Evans, Caroline. *Fashion at the Edge: Spectacle, Modernity, and Deathliness.* New Haven: Yale University, 2003.

Evans, Mike, ed. *Key Moments in Fashion.* New York: Hamlyn, 1998.

Ewing, Elizabeth. *Dress and Undress.* New York: Drama, 1978.

_____. *History of Twentieth Century Fashion.* Lanham, MD: Barnes and Noble, 1992.

Farrell-Beck, Jane, and Colleen Gau. *Uplift: The Bra in America.* Philadelphia: University of Pennsylvania, 2002.

Feldman, Egal. *Fit for Men: A Study of New York's Clothing Trade.* New York: Public Affairs, 1960.

Finlayson, Iain. *Denim: The American Legend.* New York: Fireside, 1990.

Fischer-Mirkin, Toby. *Dress Code: Understanding the Hidden Meanings of Women's Clothes.* New York: Clarkson N. Potter, 1995.

Flusser, Alan. *Clothes and the Man.* New York: Villard, 1985.

Frankel, Susannah. *Visionaries: Interviews with Fashion Designers.* New York: Harry N. Abrams, 2001.

Fraser, Kennedy. *The Fashionable Mind.* New York: Alfred A. Knopf, 1981.

Friedan, Betty. *Feminine Mystique.* New York: Laurel, 1983.

Gaines, Jane, and Charlotte Herzog, ed. *Fabrications: Costume and the Female Body.* New York: Routledge, 1990.

Garland, Madge. *Fashion: A Picture Guide to Its Creators and Creations.* Harmondsworth, UK: Penguin, 1962.

Glynn, Prudence. *In Fashion: Dress in the Twentieth Century.* London: George Allen and Unwin, 1978.

Gold, Annalee. *One World of Fashion.* New York: Fairchild, 1987.

Grappa, Carol Di. *Fashion: Theory.* New York: Lustrum, 1980.

Grass, Milton. *History of Hosiery: From the Piloi of Ancient Greece to the Nylons of Modern America.* New York: Fairchild, 1955.

Graveline, Noel. *Jeans: Levis Story.* Paris: Minerva, 1990.

Griffin, Gary. *The History of Men's Underwear from Union Suits to Bikini Briefs.* Los Angeles: Added Dimensions, 1991.

Gross, Elaine, and Fred Rottman. *Halston: An American Original.* New York: HarperCollins, 1999.

Hall, Lee. *Common Threads: A Parade of American Clothing.* Boston: Bulfinch, 1992.

Hansen, Joseph, et al. *Cosmetics, Fashions, and the Exploitation of Women.* New York: Pathfinder, 1986.

Harris, Alice. *The White T.* New York: Harper Style, 1996.

Harrison, Martin. *Beauty Photography in Vogue.* New York: Stewart, Tabori and Chang, 1987.

Haye, Amy de la, ed. *The Cutting Edge: Fifty Years of British Fashion, 1947-1997.* Woodstock, NY: Overlook, 1997.

_____. *Fashion Source Book: A Visual Reference to Twentieth Century Fashion.* Secaucus, NJ: Wellfleet, 1988.

Haye, Amy de la, and Cathie Dingwall. *Surfers, Soulies, Skinheads and Skaters.* New York: Overlook, 1996.

Haye, Amy de la, and Shelley Tobin. *Chanel, the Couturier at Work.* New York: Overlook, 1995.

Haye, Amy de la, and Elizabeth Wilson, eds. *Defining Dress: Dress as Object, Meaning and Identity.* Manchester, UK: Manchester University, 1999.

Henley, Clark. *The Butch Manual: The Current Drag and How to Do It.* New York: New American Library, 1982.

Hill, Daniel Delis. *Advertising to the American Woman 1900-1999.* Columbus: Ohio State University, 2002.

_____. *American Menswear from the Civil War to the Twenty-first Century.* Lubbock: Texas Tech University, 2011.

_____. *As Seen in Vogue: A Century of American Fashion in Advertising.* Lubbock: Texas Tech University, 2004.

_____. *History of Men's Underwear and Swimwear.* San Antonio: Daniel Delis Hill, 2010.

Hoobler, Dorothy, and Thomas Hoobler. *Vanity Rules: A History of American Fashion and Beauty.* Brookfield, CT: Twenty-First Century, 2000.

Howell. Georgina. *In Vogue: Seventy-Five Years of Style.* London: Conde Nast, 1991.

Hurlock, Elizabeth. *The Psychology of Dress: An Analysis of Fashion and Its Motives.* New York: Ronald Press, 1929.

Jobling, Paul. *Man Appeal: Advertising, Modernism, and Menswear.* Oxford, UK: Berg, 2005.

Joselit, Jenna Weissman. *A Perfect Fit: Clothes, Character, and the Promise of America.* New York: Metropolitan, 2001.

Jouve, Marie-Andree. *Balenciaga.* New York: Universe, 1997.

Kaiser, Susan. *The Social Psychology of Clothing.* New York: Macmillan, 1990.

Keenan, Brigid. *Dior in Vogue.* New York: Harmony, 1981.

Klein, Bernat. *Design Matters.* London: Secker and Warburg, 1976.

Klein, Kelly. *Underworld.* New York: Alfred A. Knopf, 1995.

Kunzle, David. *Fashion and Fetishism.* Totowa, NJ: Rowman and Littlefield, 1992.

Kurella, Elizabeth. *The Complete Guide to Vintage Textiles.* Iola, WI: Krause, 1999.

Lakoff, Robin Tolmach and Rachel L. Sherr. *Face Value: The Politics of Beauty.* London: Routledge & Kegan Paul, 1984.

Lee, Sarah, ed. *American Fashion.* New York: Fashion Institute, 1975.

Lee-Potter, Charlie. *Sportswear in Vogue since 1910.* New York: Abbeville, 1984.

Lees, Elizabeth. *Costume Design in the Movies.* London: BCW, 1976.

Lehnert, Gertrud. *A History of Fashion in the Twentieth Century.* Cologne: Konemann, 2000.

Levin, Phyllis. *The Wheels of Fashion.* Garden City, NY: Doubleday, 1965.

Ley, Sandra. *Fashion for Everyone, the Story of Ready-to-Wear 1870s-1970s.* New York: Charles Scribner's Sons, 1975.

Liberman, Alexander, ed. *On the Edge: Images from One Hundred Years of Vogue.* New York: Random House, 1992.

Lipovetsky, Gilles. *The Empire of Fashion.* Trans. Catherine Porter. Princeton, NJ: Princeton University, 1994.

Lloyd, Valerie. *The Art of Vogue Photographic Covers.* New York: Harmony, 1986.

Loring, John. *Tiffany in Fashion.* New York: Harry N. Abrams, 2003.

Lynam, Ruth, ed. *Couture.* Garden City, NY: Doubleday, 1972.

Mansour, David. *From Abba to Zoom: A Pop Culture Encyclopedia of the Late 20th Century.* Kansas City, MO: Andrews McMeel, 2005.

Marcus, Stanley. *Minding the Store.* New York: Little Brown, 1974.

Marly, Diana de. *Christian Dior.* New York: Holmes and Meier, 1990.

_____. *Fashion for Men, an Illustrated History.* London: B. T. Batsford, 1985.

_____. *The History of Haute Couture 1850-1950.* New York: Holmes and Meier, 1980.

_____. *Worth: Father of Haute Couture.* New York: Holmes and Meier, 1991.

Martin, Richard. *American Ingenuity: Sportswear 1930s-1970s.* New York: Metropolitan Museum of Art, 1998.

_____. *Fashion and Surrealism.* New York: Rizzoli, 1996.

_____. *Versace.* New York: Universe, 1997.

Martin, Richard and Harold Koda. *Jocks and Nerds: Men's Style in the Twentieth Century.* New York: Rizzoli, 1989.

_____. *Giorgio Armani: Images of Man.* New York: Rizzoli, 1990.

_____. *Orientalism: Visions of the East in Western Dress.* New York: Metropolitan Museum of Art, 1994.

McDowell, Colin. *Hats: Status, Style, and Glamour.* New York: Rizzoli, 1992.

_____. *A Hundred Years of Royal Style.* London: Muller, Blond, and White, 1985.

_____. *The Man of Fashion.* London: Thames and Hudson, 1997.

_____. *McDowell's Directory of Twentieth Century Fashion.* Englewood Cliffs, NJ: Prentice Hall, 1985.

_____. *Shoes: Fashion and Fantasy.* London: Thames and Hudson, 1992.

Meller, Susan, and Joost Elffers. *Textile Designs: Two Hundred Years of European and American Patterns.* New York: Harry N. Abrams, 1991.

Mendes, Valerie, and Amy de la Haye. *Twentieth-Century Fashion.* London: Thames and Hudson, 1999.

Metzner, Sheila. *Form and Fashion.* Santa Fe, NM: Arena, 2001.

Milbank, Caroline. *New York Fashion.* New York: Harry N. Abrams, 1996.

Mo, Charles. *Evening Elegance: One Hundred Fifty Years of Formal Fashions.* Charlotte, NC: Mint Museum of Art, 1998.

Moffitt, Phillip, et al. *The American Man 1946-1986.* New York: Esquire, 1986.

Morris, Bernadine. *The Fashion Makers.* New York: Random House, 1978.

_____. *Valentino.* New York: Universe, 1996.

Morris, Bob, and Ben Widdicombe. *The Blue Jean.* New York: Powerhouse, 2002.

Mulvagh, Jane. *Costume Jewelry in Vogue.* London: Thames and Hudson, 1988.

_____. *Vogue: History of Twentieth Century Fashion.* London: Viking, 1988.

Mulvey, Kate, and Melissa Richards. *Decades of Beauty: the Changing Image of Women 1890s-1990s.* New York: Reed Consumer, 1998.

Newman, Cathy. *Fashion.* Washington, DC: National Geographic Society, 2001.

Nystrom, Paul. *Economics of Fashion.* New York: Ronald, 1928.

O'Hara, Georgina. *The Encyclopaedia of Fashion.* New York: Harry N. Abrams, 1986.

O'Keefe, Linda. *Shoes: A Celebration of Pumps, Sandal, Slippers, and More.* New York: Workman, 1996.

Packer, William. *The Art of Vogue Covers 1909-1940.* New York: Bonanza, 1980.

_____. *Fashion Drawing in Vogue.* New York: Thames and Hudson, 1983.

Panati, Charles. *Panati's Extraordinary Origins of Everyday Things.* New York: Perennial Library, 1987.

Pavia, Fabienne. *The World of Perfume.* New York: Knickerbocker, 1996.

Peacock, John. *Fashion Accessories: The Complete Twentieth-Century Sourcebook.* New York: Thames and Hudson, 2000.

_____. *Men's Fashion: the Complete Sourcebook.* London: Thames and Hudson, 1996.

Picken, Mary Brooks. *The Secrets of Distinctive Dress: Harmonious, Becoming, and Beautiful Dress—Its Value and How to Achieve It.* Scranton, PA: The Woman's Institute of Domestic Arts and Sciences, 1918.

Poiret, Paul. *My First Fifty Years.* Trans. Stephen Guest. London: Victor Gollancz, 1931.

Probert, Christina. *Hats in Vogue since 1910.* New York: Abbeville, 1981.

_____. *Lingerie in Vogue since 1910.* New York: Abbeville, 1981.

_____. *Shoes in Vogue since 1910.* New York: Abbeville, 1981.

_____. *Swimwear in Vogue since 1910.* New York: Abbeville, 1981.

Raymond, Walter, ed. *Menswear: Seventy-Five Years of Fashion.* New York: Fairchild, 1965.

Roetzel, Berhard. *Gentlemen: A Timeless Fashion.* Cologne: Konemann Verlagsgesellschaft, 1999.

Ross, Josephine. *Beaton in Vogue.* New York: Clarkson N. Potter, 1986.

Sato, Pater. *Fashion Illustration in New York.* Tokyo: Graphic-Sha, 1985.

Schoeffler, O. E., and William Gale. *Esquire's Encyclopedia of Twentieth Century Men's Fashions.* New York: McGraw-Hill, 1973.

Seeling, Charlotte. *Fashion: The Century of the Designer 1900-1999.* Cologne: Konemann Verlagsgesellschaft, 1999.

Shaw, William. *American Men's Wear 1861-1982.* Baton Rouge: Oracle, 1982.

Simonds, Cherri. *Costume Jewelry.* Paducah, KY: Collector, 1997.

Smith, Desire. *Fashion Footwear 1800-1970.* Atgen, PA: Schiffer, 2000.

Spignesi, Stephen. *American Firsts: Innovations, Discoveries, and Gadgets Born in the USA.* New York: Barnes and Noble, 2004.

Squire, Geoffrey. *Dress, Art and Society.* London: Studio Vista, 1974.

Steele, Valerie. *Fashion and Eroticism: Ideals of Feminine Beauty from the Victorian Era to the Jazz Age.* New York: Oxford University, 1985.

_____. *The Corset: A Cultural History.* New Haven: Yale University, 2001.

_____. *Fifty Years of Fashion: New Look to Now.* New Haven: Yale University, 1997.

_____. *Handbags: A Lexicon of Style.* New York: Rizzoli, 2000.

_____. *Paris Fashion: A Cultural History.* New York: Oxford University, 1988.

_____. *Shoes: A Lexicon of Style.* New York: Rizzoli, 1999.

Swan, June. *Shoes.* London: B. T. Batsford, 1982.

Taylor. Lou. *The Study of Dress History.* Manchester, UK: Manchester University, 2002.

Tolkien, Tracy. *Dressing Up Vintage.* New York: Rizzoli, 2000.

Torrens, Deborah. *Fashion Illustrated: A Review of Women's Dress 1920-1950.* New York: Hawthorne, 1975.

Trahey, Jane, ed. *One Hundred Years of the American Female.* New York: Random House, 1967.

Vreeland, Diana. *Allure.* Boston: Bulfinch, 2002.

Warwick, Edward, et al. *Early American Dress.* New York: Benjamin Blom, 1965.

Watson, Linda. *Vogue: Twentieth Century Fashion.* London: Carelton, 1999.

Waugh, Norah. *The Cut of Women's Clothes.* New York: Theatre Arts, 1968.

White, Palmer. *Poiret.* New York: Clarkson Potter, 1973.

Wilcox, Claire, and Valerie Mendes. *Modern Fashion in Detail.* Woodstock, NY: Overlook, 1991.

Wilson, Carrie. *Fashions Since Their Debut.* Scranton, PA: International Text, 1945.

Winters, Peggy, et al. *What Works in Fashion Advertising.* New York: Retail Reporting, 1996.

Zahm, Volker. *The Art of Creating Fashion.* Pocking, Germany: Mondi, 1991.

ADVERTISING PERIODICALS

Advertising Age (1930 to present)

Adweek (1960 to present)

Journal of Advertising (1960 to present)

Ladies' World (1880–1918)

Printers' Ink (1888–1967)

FASHION, COSTUME, AND POPULAR CULTURE PERIODICALS

Allure (1991 to present)

American Magazine (1876–1956)

Apparel Arts (1931–1957)

Arthur's Home Magazine (1852–1898)

Bride's (1934 to present)

CIBA Review (1937–1975)

Collier's (1888–1957)

Cosmopolitan (1886 to present)

Country Gentleman (1853–1955)

Delineator (1873–1937)

Details (1982 to present)
Dress (1975 to present)
Ebony (1945 to present)
Elle (1985 to present)
Esquire (1933 to present)
Essence (1970 to present)
Fashion Theory: The Journal of Dress, Body and Culture (1997 to present)
Flair (1950–1951)
Genre (1991 to present)
Gentlemen's Quarterly (GQ) (1957 to present)
Glamour (1939 to present)
Godey's Lady's Book (1830–1898)
Good Housekeeping (1885 to present)
Graham's (1839–1858)
Harper's Bazaar (1867 to present)
Ladies' Companion (1834–1844)
Ladies' Home Journal (1883 to present)
Ladies' Repository (1841–1876)
Lady's Book (1830–1839)
Life (1936–1972)
Look (1937–1971)
M: The Civilized Man (1983-1990)
Mademoiselle (1935–2001)
McCall's (1876 to present)

McClure's (1893–1929)
Men's Guide to Fashion (MGF) (1984–1991)
Men's Vogue (2006–2009)
Men's Wear (1890–1983)
Mirabella (1989–2000)
Modern Bride (1949 to present)
Munsey's (1889–1979)
National Geographic (1888 to present)
Peterson's Magazine (1837–1898)
Redbook (1903 to present)
Rolling Stone (1967 to present)
Sassy (1988 to present)
Saturday Evening Post (1821–1969)
Seventeen (1944 to present)
Sew News (1984 to present)
Threads (1985–1991)
Town & Country (1846 to present)
Vanity Fair (1913–1936, 1983 to present)
Vogue (1892 to present)
Vogue Pattern Book (1925 to present)
W (1971 to present)
Woman's Day (1937 to present)
Woman's Magazine (1896–1920)
Women's Wear Daily (1910 to present)

PHOTO CREDITS

The author and Pearson Education thank the following individuals, image archive services, museums, libraries, institutions, and corporations for their contributions to this survey of world costume and fashion:

Chapter 1
F. 1-1: Venus of Lespugue. About 25,000 years old. Carved mammoth tusk. Aurignacian (Paleolithic). Musee de l'Homme, Paris, France. Scala/Art Resource, NY. **F.1-2:** Head of the "Woman of Brassempouy". Paleolithic sculpture, mammoth ivory. Musee des Antiquites Nationales, Saint-Germain-en-Laye, France. Reunion des Musees Nationaux. J.G. Berizzi/Art Resource, NY. **P. 11 (left):** Ian Showell, Getty Images Inc.—Hulton Archive Photos; **(top right):** CORBIS-NY; **(bottom right):** Lucas Dawson/Getty Images, Inc.

Chapter 2
F. 2-1: Art Resource, NY. **F. 2-3:** Courtesy of the Oriental Institute of the University of Chicago. **F. 2-4:** Gudea. Diorite statue. 2140 BCE, from Tello, ancient Girsu, Iraq. Louvre, Paris, France. Erich Lessing/Art Resource, NY. **F. 2-5 (top):** British Musuem, London, UK, The Bridgeman Art Library International; **(bottom):** The King Leading His Army. Detail from the Stele of Vultures. Limestone. Sumerian, from Lagash. Musee du Louvre, Paris, France. Reunion des Musees Nationaux. Herve Lewandowski/Art Resource, NY. **F. 2-6 (left):** Head of a divinity. Neo-Sumerian, ca. 2140 BCE. From Tello. Louvre, Paris, France. Erich Lessing/Art Resource, NY; **(right):** Gudea, King of Lagash. Diorite head, 2120 BCE. Musee du Louvre, Paris, France. Erich Lessing/Art Resource, NY. **F. 2-7 (left):** Rolled headband on maiden from Ur, c. 2300 BCE. Marble Head of Ningal, consort of Nannatt, the moon god. University of Pennsylvania Museum (image #150104); **(right):** Tel Agrab: right front view of white limestone head of a woman. Collection of the Iraqi National Museum. Courtesy of the Oriental Institute of the University of Chicago. **F. 2-9:** The Code of Hammurabi (1792–1750 BCE), 282 laws. Hammurabi standing before the sun-god Shamash. Engraved black basalt stele (1st half 18th BCE, 1st Babylonian Dynasty). Originally from Babylon, found at Susa, Iran. Overall height 225 cm. Louvre, Paris, France. Erich Lessing/Art Resource, NY. **F. 2-10 (left):** Goddess with vase. Stone F. Syrian, early 2nd millennium. Location: National Museum, Damascus, Syria. Erich Lessing/Art Resource, NY; **(right):** Mythological Hero (Gilgamesh). F. of a genie holding a pole.Terra cotta. Location: Louvre, Paris, France. Herve Lewandowski/Art Resource, NY. **F. 2-11 (left):** The Reign of Napir Asu; Elamite inscription, ca. 13th c. BCE. Bronze, Susa, Iran. Louvre, Paris, France. Reunion des Musees Nationaux/Art Resource, NY. **F. 2-12:** Warrior with lance. Ca. 1200 BCE. Hittite orthostat. Vorderasiatisches Museen zu Berlin, Berlin, Germany. Bildarchiv Preussischer Kulturbesitz/Art Resource, NY. **F. 2-13 (left):** Statue of Ashurnasirpal II (883–859 BC), magnesite. Neo-Assyrian, from Nimrud (ancient Kalhu), northern Iraq. The statue of King Ashurnasirpal II was placed in the Temple of Ishtar Sharrat-niphi to remind the goddess Ishtar of the king's piety. British Museum, London, Great Britain. HIP/Art Resource, NY. **F. 2-17:** Female head from Nimrud, Assyrian, 720 BCE. Location: Iraq Museum, Baghdad, Iraq. Scala/Art Resource, NY. **F. 2-18 (left):** © HIP/Art Resource, NY. **F. 2-18 (right):** Ashmolean Museum, Oxford, England, U.K. **F. 2-19:** Procession of life-size archers. Enamelled tile frieze (515 BCE) from the palace of Darius the Great (522–86 BCE). Susa, Iran. Louvre, Paris, France. Erich Lessing/Art Resource, NY. **F. 2-20:** Courtesy of the Oriental Institute of the University of Chicago. **F. 2-21 (left):** The "Alexander Sarcophagus" from the Phoenician royal necropolis at Sidon, was made for Abdalonymos, King of Sidon. Short face: Abdalonymos (on horse) during the battle of Gazza (312) in which he was killed. Late 4th BCE; marble, 195 × 318 × 167 cm. Archaeological Museum, Istanbul, Turkey. Erich Lessing/Art Resource, NY.

Chapter 3
F. 3-1 (left): Nobleman's wife—The Woman of Tovi. 18th dynasty (1570–1314 BCE). Location: Louvre, Paris, France. Scala/Art Resource, NY; **(right):** Nofret. Detail of Prince Rahotep and his wife Nofret. Painted limestone. Egypt, 4th dynasty, c. 2580 BCE. Egyptian Museum, Cairo, Egypt. Scala/Art Resource, NY. **F. 3-2 (left):** The "Narmer Palette" (reverse), a late pre-dynastic schist ceremonial palette. H. 63.5 cm. Pharoah Narmer is shown wearing the Red Crown, subduing Lower Egypt. Narme rectangular cartouche on top of the palette. Two mythical animals with intertwined necks. From Hierakonpolis, Kom el-Ahmar. Egypt, 1st dynasty. Egyptian Museum, Cairo, Egypt. Erich Lessing/Art Resource, NY. **F. 3-3 (1st image):** A group statue of King Mycerinus between the goddess Hathor and the personification of the nome of Hu or Diospolis Parva (the 17th nome or province of Upper Egypt). The statue was found in the valley temple of Mycerinus at Giza. Full view. Egypt, Old Kingdom, 4th dynasty (c. 2590–2470 BCE). Grewyacke, h. 92.5 cm. Egyptian Museum, Cairo, Egypt. Werner Forman/Art Resource, NY; **(2nd image):** Detail of statue of High Priest Ranufer. Statue of Ranufer from Saqqarah. Egypt, 5th dynasty. Location : Egyptian Museum, Cairo, Egypt. Scala/Art Resource, NY; **(3rd image):** Hirmer Fotoarchiv, Munich, Germany; **(4th image):** Detail of statue of High Priest Ranufer. The rich man Ti from Saqqarah. Old Kingdom (III-X dynasty). Location: Egyptian Museum, Cairo, Egypt. Scala/Art Resource, NY. **F 3-4:** Tutankhamun the Harpooner, standing on a boat of papyrus stems and holding a coil of rope in his left. Painted and gilded wood. Egypt, 18th dynasty. Location: Egyptian Museum, Cairo, Egypt. Scala/Art Resource, NY. **F. 3-5:** © The British Museum. **F. 3-7:** Copyright Petrie Museum of Egyptian Archaeology, University College London. UC28614B1. **F. 3-8:** The goddess Hathor/Isis leads Queen Nefertari by the hand.19th Dynasty, c. 1290–1220 BCE. Tomb of Nefertari, Valley of the Queens, Thebes, Egypt. E. Strouhal/Werner FormanArt Resource, NY. **F. 3-9 (top left):** The Art Archive / Dagli Orti; **(top right):** Bust of a Ruler of Amarna (Akhenaton). Reign of Akhenaton (Amenophis IV). Gypsum, h. 64 cm. Louvre, Paris, France. Reunion des Musees Nationaux. Herve Lewandowski/Art Resource, NY; **(bottom left):** Queen Ankhesenamun and King Tutankhamon. Detail from the back of the Golden throne of King Tutankhamon. The Queen is holding a salve-cup and spreads perfumed oil on her husband's collar. Egypt.18th dynasty. Egyptian Museum, Cairo, Egypt. Scala/Art Resource, NY; **(bottom right):** Ramesses II (1290–1224 BCE). Detail of black granite F., probably from Karnak, Egypt. 19th Dynasty, New Kingdom. Museo Egizio, Turin, Italy. Erich Lessing/Art Resource, NY. **F. 3-10:** © The J. Paul Getty Trust, (1991). All rights reserved. **F. 3-11 (left):** Headress of wife of Thutmosis III. Metropolitan Museum of Art, New York/Werner Forman Archive; **(right):** Bust of Queen Nefertiti. From the workshop of Thutmosis. Profile towards right. Ca. 1350 BCE. Egypt, 18th dynasty. Painted limestone, h. 50 cm. Aegyptisches Museum, Staatliche Museen zu Berlin, Berlin, Germany. Bildarchiv Preussischer Kulturbesitz. Margarete Busing/Art Resource, NY. **F. 3-13:** Woman grinding grain to prepare bread. Painted wood. Egypt, Old Kingdom, 5th dynasty (2565–2420 BCE). Museo Archeologico, Florence, Italy. Nimatallah/Art Resource, NY. **F. 3-15:** ANCIENT ART & ARCHITECTURE / DanitaDelimont.com. **F. 3-16:** Battle against the Nubians. Panel from the stuccoed and painted wooden chest of Tutankhamun. H. of scene: 15.3 cm. Egypt, 18th dynasty. Egyptian Museum, Cairo, Egypt. Scala/Art Resource, NY. **P. 59 (top left):** By permission of In Mocean Group, LLC. **P. 59 (bottom left):** Necklace, Courtesy Franklin Mint, 1988.

Chapter 4

F. 4-1: Idol from Petsofa, middle Minoan period. Archaeological Museum, Heraklion, Crete, Greece. Scala/Art Resource, NY. **F. 4-2:** The prince. Minoan fresco, 1700–1400 BCE. Archaeological Museum, Heraklion, Crete, Greece. Erich Lessing/Art Resource, NY. **F. 4-3:** Bull dancing, fresco, 1700–1400 BC Minoan, from Knossos, Crete. Heraklion Museum/Dagli Orti/The Art Archive. **F. 4-4:** Harvest vase, steatite, c. 1700–1600 BC Minoan, from Haghia Triada, Crete (detail). Heraklion Museum/Dagli Orti/The Art Archive. **F. 4-5:** Getty Images/De Agostini Editore Picture Library. **F. 4-6 (left):** Minoan, earthenware F. of snake goddess. 1700–1400 B.C. Location: Archaeological Museum, Heraklion, Crete, Greece. Erich Lessing/Art Resource, NY; **(right):** Statuette of a snake goddess, Early Aegean, Minoan, Bronze Age, Late Minoan I Period, about 1600–1500 B.C. or early 20th century, gold, ivory, height: 16.1 cm (6 5/16 in.). Photograph © 2008 Museum of Fine Arts, Boston. Gift of Mrs. W. Scott Fitz, 14.863. **P. 70 (left):** Photo used courtesy of Macy's Archives; **(center):** Sergio Dionisio / Getty Images, Inc.; **(right):** Warner's Merry Widow corset 1955. The Bridgeman Art Library International. **F. 4-8:** National Archeological Museum, Athens/Art Resource, NY. **F. 4-11:** Woman called the Lady of Mycenae, fresco, 13th century BC Mycenean from the centre of the cult at Mycenae. National Archaeological Museum, Athens/Dagli Orti/The Art Archive. **F. 4-12 (left, right):** Terracotta lekythos (oil flask), ca. 550–530 B.C.: Archaic, attributed to the Amasis Painter, Greek, Attic, Terracotta; H. 6 3/4 in. (17.15 cm). The Metropolitan Museum of Art, New York, NY, U.S.A. Image copyright © The Metropolitan Museum of Art. Art Resource, NY. **F. 4-13:** Amazon by Polykeitos, 340 BCE. Location: Braccio Nuovo, Vatican Museums, Vatican State. Art Resource, NY. **F. 4-14 (left):** Feminine statuette, called "the Lady of Auxerre". Ca. 630 BCE. Limestone sculpture, from Crete, h. 75 cm. Frontal view with the plinth. Louvre, Paris, France. Reunion des Musees Nationaux. W. Lewandowski/Art Resource, NY. **F. 4-15 (left):** Attic grave stele of Dexileos, 394 BCE. Kerameikos Museum, Athens, Greece. Foto Marburg/Art Resource, NY; **(right):** Kurt Scholz, SuperStock, Inc. **F. 4-16 (bottom left):** Nick Nicholls © The British Museum; **(right):** Praxiteles (c. 400–330 BCE). Artemis, so-called "Diana of Gabies", probably an antique copy of the "Artemis Brauronia" by Praxiteles, dedicated on the Acropolis in 346–345 BCE. Louvre, Paris, France. Erich Lessing/Art Resource, NY. **F. 4-17:** Museo Joseph Whitaker, The Bridgeman Art Library International. **F. 4-18 (right):** Caryatid. South porch of the Erechtheum. Ancient Greek from the Acropolis in Athen, 421–405 BCE. Erechtheion, Acropolis, Athens, Greece. Werner Forman/Art Resource, NY. **F. 4-19:** Orpheus Painter (5th BCE), "Orpheus among the Thracians", Red-F. crater from Gela, ca. 450 BCE; H: 50.5 cm, view 1/2 INV. V.I. 3172. Photo: Johannes Laurentius. Antikensammlung, Staatliche Museen zu Berlin, Germany. Bildarchiv Preussischer Kulturbesitz / Art Resource, NY. **F. 4-20 (left):** Kore. Attic, 5th century. National Archaeological Museum, Athens, Greece. Scala/Art Resource, NY. **F. 4-21 (left):** Hulton Archive/Getty Images; **(center):** Woman dressed in a chiton and coat, with a pointed hat and a fan. Classical Greek, ca. 320 BCE. Terracotta figurine from Tanagra, h. 33 cm. Inv. TC 7674. Location: Antikensammlung, Staatliche Museen zu Berlin, Germany. Photo: Juergen Liepe/Bildarchiv Preussischer Kulturbesitz/Art Resource, NY; **(right):** "Penelope Painter" with son. Musee du Louvre/RMN Penelope Vasepainter. Penelope at her loom with Telemachus. Attic red-F.d skyphos, 5th BCE. Museo Archeologico, Chiusi, Italy. Erich Lessing/Art Resource, NY. **F. 4-23 (left):** Stele of Aristion. Archaic Greek relief, ca. 510. National Archaeological Museum, Athens, Greece. Scala/Art Resource, NY; **(bottom right):** Detail of a red-F. vase with various articles of Greek armor including a helmet, breastplate, shield and sword. 1st quarter 5th BCE. From Athens, found at Vulci. H: 36 cm. Louvre, Paris, France. Reunion des Musees Nationaux. Herve Lewandowski/Art Resource, NY. **F. 4-24 (left):** Skyphos with theater scene. Greek red-F. vase painting. Scala/Art Resource, NY; **(right):** Side A of a redF.d vase painting on a calyx crater, from Nola. Produced in Paestum, 3rd quarter 4th BCE. H. 37 cm. Inv. 3044. Ingrid Geske/Bildarchiv Preussischer Kulturbesitz/Art Resource, NY. **P. 90 (left):** 1968.C.751. IRENE. Gold brocade evening dress with beige silk chiffon scarf. 1958. Collection of Phoenix Art Museum, Gift of Mrs. B. J. Leonard. Photo by Ken Howie. **P. 91 (bottom right):** Photo used courtesy of Macy's Archives.

Chapter 5

F. 5-1 (left): Figure making a sacrifice, flutist and cithara player. Etruscan wallpainting. Early 5th c. BCE. Tomb of the Leopards, Tarquinia, Italy. Scala/Art Resource, NY; **(right):** Dagli Orti/The Art Archive, Picture Desk, Inc./Kobal Collection. **F. 5-2:** Bronze statuette of warrior with helmet from Castiglion Fiorentino near Arezzo Italy 560–550 BC Etruscan. Archaeological Museum, Florence/Dagli Orti/The Art Archive. **F. 5-3:** Scala; Art Resource, N.Y. **F. 5-5:** Mars, the god of War. Etruscan bronze sculpture. Museo Archeologico, Florence, Italy. Scala/Art Resource, NY. **F. 5-6 (right):** Emperior Titus. Roman statue. Bracco Nuovo, Vatican Museums, Vatican State. Alinari/Art Resource, NY. **F. 5-7:** Dagli Orti; Picture Desk, Inc./Kobal Collection. **F. 5-8 (left):** Susan Van Etten; PhotoEdit Inc.; **(right):** Dagli Orti (A); Picture Desk, Inc./Kobal Collection. **F. 5-10:** Pompeiian ladies with their slave

hairdresser, wallpainting from Herculaneum, Italy. Museo Archeologico Nazionale, Naples, Italy. Erich Lessing/Art Resource, NY. **F. 5-11:** Detail of the "Ten Girls Mosaic" depicting women athletes. From the Villa of Casale, Piazza Armerina, Siciliy. Earth 4th C BC. Werner Forman/Art Resource, NY. **F. 5-12 (left):** Portrait bust of a Flavian patrician lady. Musei Capitolini, Rome, Italy. John Ross/Art Resource, NY; **(center):** Empress Julia Domna—Bust of Julia Domna (d. 217 CE), second wife of Emperor Septimius Severus. Location: Musei Capitolini, Rome, Italy. Scala/Art Resource, NY; **(right):** "Marciana", Roman, Imperial Period, Trajanic, about A.D. 100, Marble, height × length (of face): 26.5 × 15.5 cm (10 7/16 × 6 1/8 in.). Photograph © 2008 Museum of Fine Arts, Boston. Arthur Mason Knapp Fund, 16.286. **F. 5-13 (left):** Trajan's Column. Detail. Roman soldiers taking care of the wounded. Column of Trajan, Rome, Italy. AlinariArt Resource, NY. **P. 115 (top right):** By permission of In Mocean Group, LLC.

Chapter 6

F. 6-1 (left): Ivory diptych of Boethius, consul 487. 5th century. Museo Civico dell'Eta Christiana, Brescia, Italy. Scala/Art Resource, NY. **F. 6-2:** Ivory diptych of Boethius, consul 487. 5th century. Museo Civico dell'Eta Christiana, Brescia, Italy. Foto Marburg/Art Resource, NY. **F. 6-3:** Court of Emperor Justinian. Ca. 547 CE. Early Christian mosaic, 264 × 365 cm. S. Vitale, Ravenna, Italy. Scala/Art Resource, NY. **F. 6-4 (left):** Fragment Taming the Beast Charioteer, from the Treasure of Aix-la-Chapelle (silk textile) (b/w photo) by Byzantine School (7th century). © Musee National du Moyen Age et des Thermes de Cluny, Paris/ Giraudon/ The Bridgeman Art Library; **(center):** © Musee D'Auxerre. Collection J.P. Brale; **(right):** Taming of the Wild Animal, Byzantine tapestry fragment, 6th–7th Century (silk) by © Victoria & Albert Museum, London, UK/ The Bridgeman Art Library. **F. 6-5 (top):** Christ Crowning the Emperor Constantine VII (wood) by Byzantine Master (10th century). © Pushkin Museum, Moscow, Russia/ The Bridgeman Art Library; **(bottom):** © Dumbarton Oaks, Byzantine Collection, Washington, DC. **F. 6-6:** Christ crowning Romanos IV and Eudokia. Central part of the triptych. Cover of the Evangelaryof Saint John of Besancon. Byzantine, 11th c. Bibliotheque Nationale, Paris, France. Erich Lessing/Art Resource, NY. **F. 6-7:** Saint Eudokia, Empress of Bysantium. From the church of Lips Monastery, now Fenasi Isa Mosque. End 10th-early 11th. Coloured stone inlay in marble. H: 66 cm. Archaeological Museum, Istanbul, Turkey. Erich Lessing/Art Resource, NY. **F. 6-8:** Emperor John II Komnenus (1118–1143), from the votive mosaic in the south gallery, 12th c. Hagia Sophia, Istanbul, Turkey. Erich Lessing/Art Resource, NY. **F. 6-9 (left):** Emperor Nikephoros III Botaneiates between Saint John Chrysostom and the archangel Saint Michael. From the Homilies of Saint John Chrysostomus. Constantinople, ca. 1078 CE. Bibliotheque Nationale, Paris, France. Bridgeman-Giraudon/Art Resource, NY. **F. 6-10:** Plaque, Casket, "Adame and Eve Harvesting" and "Adam and Eve at the Forge", 10th or 11th century, Middle Byzantine, Constantinople, ivory, gilt, polychromy, overall: 2 5/8 × 3 11/16 × 3/16 in. (6.7 × 9.3 × 0.5 cm). The Metropolitan Museum of Art, New York, NY, U.S.A. Gift of J. Perpont Morgan, 1917 (17.190.138). Image copyright © 1996 The Metropolitan Museum of Art. Art Resource, NY. **F. 6-11:** National Library, Athens, Location:16; Werner Forman Archive Ltd. **F. 6-12:** Magyar Nemzeti Muzeum. **F. 6-13 (top right):** Scylitzes chronicle. Folio 217.v. The final defeat of the Bulgars by Michael IV the Paphlagonian, who is seated on his throne. The Bulgars put up a wooden palisade near Prilep Scylitzes chronicle. Location : Biblioteca Nacional, Madrid, Spain. Werner Forman/Art Resource, NY; **(bottom right):** Siege of Thessaloniki by the Bulgars. Byzantine forces are making a sortie fr. the gates of the city and putting the Bulgar horsemen to flight. Scylitzes chronicle. 11th CE. Byzantine. Biblioteca Nacional, Madid, Spain. Werner Forman/Art Resource, NY. **F. 6-14 (left):** Saint Ursicinus, mosaic. © Scala/Art Resource, NY; **(right):** Saint Apollinaris. Detail from the mosaic of Saint Apollinaris among sheep. Byzantine, ca. 533–549 CE. S. Apollinare in Classe, Ravenna, Italy. Cameraphoto Arte, Venice/Art Resource, NY. **F. 6-16:** Angelico, Fra (1387–1455). Crucifixion. 1441–1442. Fresco. Museo di S. Marco (monastery), Florence, Italy. Scala/Art Resource, NY. **F. 6-17:** Giovanni di Paola, (ca. 1400–1482), "Saint Catherine of Siena Receiving the Stigmata", Tempera and gold on wood, 11 × 7 7/8 in. (27.9 × 20 cm). The Metropolitan Museum of Art, New York, NY, U.S.A. Robert Lehman Collection, 1975 (1975.1.34). Image copyright © The Metropolitan Museum of Art. Art Resource, NY. **P. 140 (top left):** Photo used courtesy of Macy's Archives; **(top right):** Michael Loccisano/FilmMagic; Getty Images Inc.

Chapter 7

F. 7-1: Landesmuseum Mainz. **F. 7-2:** Breviary of Alaric: the King, the Bishop, the Duke, and the Count. 9th CE. Bibliotheque Nationale, Paris, France. Snark/Art Resource, NY. **F. 7-4 to 7-6:** National Historical Museum, Denmark. **F. 7-7:** Adoration of the Magi, Ratchis relief, c. 745 CE. Museo Cristiano del Duomo, Cividale del Friuli, Italy. Scala/Art Resource, NY. **F. 7-8:** © Dumbarton Oaks, Byzantine Collection, Washington, DC. **F. 7-9:** The Warrior of Hornhausen. Frankish relief of the Migration Period, 7th CE. Landesmuseum fuer Vorgeschichte, Halle, Germany. Foto Marburg/Art Resource, NY. **F. 7-10:** German School Museum; The Bridgeman Art

Moller / Dorling Kindersley © Royal Pavilion Museum and Art Galleries, Brighton. **F. 12-13 (left):** Neg./Transparency no. 111806s. Courtesy Dept. of Library Services, American Museum of Natural History; **(center):** Neg./Transparency no. 112165s. Courtesy Dept. of Library Services, American Museum of Natural History; **(right):** Neg./Transparency no. 112165s. Courtesy Dept. of Library Services, American Museum of Natural History. **F. 12-15:** © GAVRIEL JECAN / DanitaDelimont.com. **F. 12-16:** © ART WOLFE / DanitaDelimont.com. **F. 12-17:** University of Pennsylvania Museum of Archaeology and Anthropology. **F. 12-19:** Radu Sigheti; CORBIS-NY. **P. 282 (left):** Johnny Nunez/WireImage; Getty Images Inc.; **(center):** Michael Ochs Archive; Getty Images Inc.; **(top right):** Lee Lockwood; Getty Images/Time Life Pictures; **(bottom right):** Pierre Andrieu/Agence France Presse/Getty Images.

Chapter 13

F. 13-2 : Figurine of a woman weaving. Maya, 600–900 CE. Terracotta, from the Island of Jaina. Coll. Dr. Kurt Stavenhagen, Mexico City, D.F., Mexico. Werner Forman/Art Resource, NY. **F. 13-3:** Gillett G. Griffin. **F. 13-4 (left):** Mark Godfrey; The Image Works; **(right):** Dagli Orti; Picture Desk, Inc./Kobal Collection. **F. 13-5:** Bill Pogue; Creative Eye/MIRA.com. **F. 13-7:** Clay figurines of Olmec woman, c. 1300–800 BC. Dancer, from Tlatilco. Olmec. Location: Museo Nacional de Antropologia e Historica, Mexico. Scala/Art Resource, NY. **F. 13-11:** "The Princeton Vase". Late Clasic. Maya. ('Codex' style). A.D. 600–800. Granular gray-buff ceramic, mineral inclusions with orange-red and brown-black slip decoration. H″ 21.5 cm. (8 7/16″). D: (rim) 16.6 cm. (6 9/16″). Made in Nakbe Region, Central Lowlands, Maya era, Peten, Guatemala, Mesoamerica, North America. Princeton University Art Museum. Museum Purchase, gift of the Hans A. Widenmann, Class of 1918, and Dorothy Widenmann Foundation (y1975–17). Rollout Photograph K511 © Justin Kerr. **F. 13-12:** © The British Museum. **F. 13-13:** Maya nobleman wearing xicolli, c. 600–900 CE, Statuette called "El charro". Aztec. Location: Museo Nacional de Antropologia e Historia, Mexico City, D.F., Mexico. Scala/Art Resource, NY. **F. 13-14:** Michel Zabe © CONACULTA-INAH-MEX. Authorized reproduction by the Instituto Nacional de Antropologia e Historia. **F. 13-15:** Lord Pacal. Head, from tomb at the Temple of the Inscriptions, Palenque. Maya, mid-late 7th century; stucco, height 43 cm. Museo Nacional de Antropologia e Historia, Mexico City, D.F., Mexico. Michel Zabe/Art Resource, NY. **F. 13-17:** Museo Nacional de Antropologia, Mexico City, Mexico/Bildarchiv Steffens/Henri Stierlin/The Bridgeman Art Library. **F. 13-18:** Biblioteca Nacional, Madrid, Spain/Giraudon; The Bridgeman Art Library International. **F. 13-19:** © Dorling Kindersley. **F. 13-20:** The Granger Collection. **F. 13-23:** Tunic. Peru, South Coast, Paracas Culture, c. 300 BC-AD 200. Plain weave with embroidery, plain weave with warp substitution; camelid fiber, 147.3 × 73.7 cm. The Cleveland Museum of Art. The Norweb Collection, 1946.227. **F. 13-24:** Museum Fur Volkerkunde, Berlin; Werner Forman Archive Ltd. **F. 13-25:** Museo Nacional de Antropologia y Arqueologia, Lima, Peru/Bildarchiv Steffens/Henri Stierlin/The Bridgeman Art Library. **F. 13-26:** The Granger Collection, New York. **F. 13-27 (left):** Inuit Group with Tent, Great Whale River (Poste-de-la-Baleine) Labrador 1896. © Canadian Museum of Civilization, photo Albert Peter Low, 1896, Image Number 18704. **F. 13-29:** British Museum/Private Collection; The Bridgeman Art Library International. **F. 13-30:** Harper Collins Publishers; Picture Desk, Inc./ Kobal Collection. **F. 13-31:** Rochester Museum & Science Center, Rochester, New York. **F. 13-32 (right):** Lynton Gardiner © Dorling Kindersley, Courtesy of The American Museum of Natural History. **F. 13-34 (right):** DRESS: Native American (Plains, Upper Missouri River Region), 19th Century, deerskin, brass bells, glass beads and fabric, ca. 1840, 54 3/4 × 49 inches. Collection of the Flint Institute of Arts, Museum purchase from the Chandler/Pohrt Collection, 1985.34. **F. 13-35:** "Freckle Face, Southern Arapaho", 1898, Frank A. Rinehart, photography, platinum process, 9 1/2 in. × 7 1/2 in. Autry National Center, Southwest Museum of the American Indian. **F. 13-36:** "SWM Southwest Hall, Navajo Wearing Blankets", Larry Reynolds, photography, 4 in. × 5 in. Autry National Center, Southwest Museum of the American Indian. **F. 13-37:** Arizona State Museum, University of Arizona. **P. 316 (top left):** (a) 1977.C.65.A-B. DONALD BROOKS. Black silk crepe full-length evening dress with egret skirt. 1976. Collection of Phoneix Art Museum, Gift of Mrs. Kitty Carlisle Hart. (b) 1974.C.17. PIERRE BALMAIN. Black velvet evening dress with black and white clipped ostrich feathers. 1970. Gift of Mrs. Joseph W. Alsop. Collection of Phoenix Art Museum. Photo by Ken Howie; **(top right):** Bob Grant/Fotos International; Getty Images Inc.; **(bottom left):** Courtesy, Black, Starr and Frost; **(bottom right):** Jean-Paul Aussenard/WireImage; Getty Images Inc.

Chapter 14

F. 14-1: leads the army of Israel/Combat between David and Goliath/David with head of Goliath. b) David playing the harp for King Saul/Anointment of David. c) Death of Absalom/David mourning Absalom. Single leaf. England, Winchester, Cathedral Priory of St. Swithin, Ca. 1160–1180. The Pierpont Morgan Library, NY/Art Resource, NY. **F. 14-2 (left):** Bildarchiv Foto Marburg / Werner Forman / Art Resource, NY; **(right):** Dagli Orti; Picture Desk, Inc./Kobal Collection. **F. 14-4:** Detail of illuminated manuscript depicting the poet Konrad von Altstetten with his

lady, c. 1275–1300. Universitatbibliotek Heidelberg. **F. 14-5:** The Seducer, from the parable of the Foolish Virgins. Gothic sculpture, after 1230. From Strasbourg Cathedral. Musee de l'Oeuvre Notre-Dame, Strasbourg, France. Erich Lessing/Art Resource, NY. **F. 14-6:** Dissection, from "Liber notabilium Philipi septimi francorum regis, a libris Galieni extractus" written by Guy de Pavia. 1345. 32 × 22 cm. Musee Conde, Chantilly, France. Reunion des Musees Nationaux. R.G. Ojeda/Art Resource, NY. **F. 14-7:** Annunciation to the Shepherds. Relief from the west facade, south portal, tympanon. Cathedral, Chartres, France. Bridgeman-Giraudon/Art Resource, NY. **F. 14-8:** Boaz, seeing Ruth gleaning in his field, asks his foreman whose damsel she is and bids her to go on gleaning (Ruth II: 4–9); Ruth eats with Boaz and the reapers (Ruth II: 14); the barley stack of Boaz (Ruth II:23). France (probably Paris) c. 1250 CE. The Pierpont Morgan Library, NY/Art Resource, NY. **F. 14-9:** Norman Knights fallen under the Hill of Senlac. Bayeux Tapestry. Musee de la Tapisserie, Bayeux, France. Scala/Art Resource, NY. **F. 14-10:** Communion of a knight. Sculpture in the choir. Cathedral, Reims, France. Scala/Art Resource, NY. **F. 14-13 (top):** Philip III the Good, Duke of Burgundy, receiving a manuscript. Dedication Page, Chroniques de Hainault, 1468. Ms.9243. Location : Bibliotheque Royale Albert I, Brussels, Belgium. John R. Bibliotheque/Art Resource, NY; **(bottom):** Master and Fellows of Trinity College Cambridge. **F. 14-15:** Piero della Francesca (c. 1420–1492). Legend of the True Cross: Torture of the Jew. Ca. 1450–1465. Post-restoration. S. Francesco, Arezzo, Italy. Scala/Art Resource, NY. **F. 14-16:** Signorelli, Luca (1441–1523). Conversion of St. Paul. Ca. 1470. Fresco. Santuario della Santa Casa (Holy House), Loreto, Italy. Scala/Art Resource, NY. **F. 14-17:** Bouts, Dieric the Elder (c. 1415–1475). Martyrdom of Saint Erasmus with Saints Jerome and Bernard of Clairvaux. Ca. 1470. St. Pierre, Louvain-Leuven, Belgium. Scala/Art Resource, NY. **F. 14-19 (left):** By permission of The British Library; **(right):** Detail of the Ghent altarpiece; The Just Judges and the Knights of Christ, detail from the left hand panel of the Ghent Altarpiece, 1432 (oil on panel) by Hubert Eyck (c.1370–1426) & Jan van (1390–1441). St. Bavo Cathedral, Ghent, Belgium. The Bridgeman Art Library. **F. 14-20:** Detail of illuminated manuscript c. 1450; Ms 5072 f.6v How the Duchess of Aigremont gave birth to two sons and lost them in the same hour in a wood), from the Renaud de Montauban cycle (vellum) by Loyset Liedet (fl.1448–78). Bibliotheque de l'Arsenal, Paris, France/ Giraudon / The Bridgeman Art Library. **F. 14-21:** Louvre, Paris, France/The Bridgeman Art Library. **F. 14-22 (left):** Liedet, Loyset or Louis (a. 1460–1478). Marriage of Renaud and Clarissa (Wedding procession), from "Renaud de Montauban". Flemish. Biblioteque de l'Arsenal, Paris, France. Bridgeman-Giraudon/Art Resource, NY; **(right):** Portrait of a Woman and a Man at a Casement. Ca. 1440.Tempera on wood, 25 1/4 × 16 1/2 in. (64.1 × 41.9 cm). Marquand Collection, Gift of Henry G. Marquand, 1889. The Metropolitan Museum of Art, New York, NY, U.S.A. Image copyright © The Metropolitan Museum of Art / Art Resource, NY. **F. 14-23 (left):** © British Library, London, UK/ © British Library Board. All Rights Reserved/The Bridgeman Art Library; **(center):** Detail: The Garden of Love at the Court of Philip the Good, in the Gardens of the Chateau de Hesdin in 1431 (oil on panel) (detail of 32980). The Bridgeman Art Library; **(right):** Ferrarese (Italian) "The Meeting of Solomon and the Queen of Sheba" c. 1470–73, tempera and gold leaf on wood, panel diameter: 36 3/8 in. (92.3 com), frame (frame diameter): 36 7/16 × 2 1/2 in. (92.6 × 6.4 cm). The Museum of Fine Arts, Houston:The Edith A. and Percy S. Straus Collection. **F. 14-24 (left):** Limbourg Brothers (15th CE). May (Festival of May. In the background, the Chateau de Riom). Calendar miniature from the Tres Riches Heures du Duc de Berry. 1416. Musee Conde, Chantilly, France. Reunion des Musees Nationaux. R.G. Ojeda/Art Resource, NY; **(right):** Geoff Dann © Dorling Kindersley, Courtesy of the Wallace Collection, London. **F. 14-25 (left):** Sculpture of infant in swaddling clothes, c. 1450, late 16th century CE. Location: Louvre, Paris, France. Reunion des Musees Nationaux/Art Resource, NY; **(right):** Mantegna, Andrea (1431–1506). Francesco and Sigismondo, sons of Lodovico Gonzaga. Fresco (1471–1474) in the Camera degli Sposi. Camera degli Sposi, Palazzo Ducale, Mantua, Italy. Erich Lessing/Art Resource, NY.

Chapter 15

F. 15-1 (left): Gozzoli, Benozzo (1420–1497). The Adoration of the Magi. Detail of Piero de Medici and groom with nobleman. Palazzo Medici Riccardi, Florence, Italy. Erich Lessing/Art Resource, NY; **(right):** Gozzoli, Benozzo (1420–1497). The Adoration of the Magi. Possible portrait of Joseph, Patriarch of Constantinople, as the first of the Three Magi. 1459. Palazzo Medici Riccardi, Florence, Italy. Erich Lessing/Art Resource, NY. **F. 15-2:** Detail of Stories from the Life of St. Benedict by Luca Signorelli, c. 1498. Erich Lessing/Art Resource, NY. **F. 15-3:** Macaccio (Maso di San Giovanni) (1401–1428). Saint Peter baptizing the new converts. Fresco. Brancacci Chapel, S. Maria del Carmine, Florence, Italy. Scala/Art Resource, NY. **F. 15-4:** Ghirlandaio, Domenico (1448–1494). Miracle of the Young Boy (Spini child), detail. Ca. 1486. S. Trinita, Florence, Italy. Scala/Art Resource, NY. **F. 15-5:** Piero della Francesca (c. 1420–1492). Portrait of Battista Sforza. Post-restoration. Ca. 1465. Tempera on wood, 47 × 33 cm. Uffizi, Florence, Italy. Scala/Art Resource, NY. **F. 15-6:** Giorgione (da Castelfranco) 1477-after 1510). Moses put to the test of

Gallerie des Modes et Costumes Francais. Designed by: Pierre-Thomas LeClerc, French, about 1740– after 1799 Engraved by: Nicolas Dupin, French. Publisher: Esnauts et Rapilly, French, 18th century. "Cette Robe à la Circassienne d'un nouveau gout . . ." French, 1778. Hand-colored engraving on laid paper. The Elizabeth Day McCormick Collection, 44.1339. Photograph © 2010 Museum of Fine Arts, Boston. **F. 18-34:** Greuze, Jean-Baptiste (1725–1805). The village Bethrothal, 1761. Louvre, Paris, France. Reunion des Musees Nationaux, France. J.G. Berizzi/Art Resource, NY. **F. 18-35:** Colonial Williamsburg Foundation, Williamsburg, VA. **F. 18-36:** Jean Simon Cardin (1699–1779) "The Morning Toilet". Oil on canvas, 49 × 39 cm. © foto Erik Cornelius. Nationalmuseum, Stockholm. NM 782. **F. 18-37:** George Romney "Portrait of Mr. Adye's Children (The Willett Children)", 1989–90, 60 × 48 inches (152.4 × 121.9 cm), oil on canvas. Philadelphia Museum of Art: The George W. Elkins Collection, 1924. **P. 456 (left):** General Motors Corporation. Used with permission, GM Media Archives. **P. 457 (top right):** CHARLES JAMES. Black velvet and ivory satin ball gown with full skirt. 1951. Collection of Phoenix Art Museum, Gift of Mrs. Eleanor S.W. McCollum. Photo by Ken Howie.

Chapter 19
F. 19-2: Francois Henri Mulard (1769–1850) "Portrait of a lady wearing a white dress with a paisley shawl and holding a glove." Ca. 1810, Oil on canvas, 39.4 × 31.7 in. / 100 × 80.6 cm. Photo by H. Churchyard. Wikipedia, The Free Encyclopedia. **F. 19-4 (left):** Ingres, Jean Auguste Dominique (1780–1867). Mme. Riviere. Oil on canvas, 116 × 90 cm. Louvre, Paris, France. Reunion des Musees Nationaux/Gerard Blot/Art Resource, NY; **(right):** The Design Library, New York, USA; The Bridgeman Art Library International. **F. 19-5:**www.antique-fashion.com/Karen Augusta. **F. 19-17:** Bibliotheque Nationale de France. **F. 19-19:** Musee de la Ville de Paris, Musee Carnavalet/Lauros/Giraudon; The Bridgeman Art Library International. **F. 19-20:** Constantin Hansen "A Group of Danish Artists in Rome" 1837. Statens Museum for Kunst, Soelvgade. Photo by Hans Petersen. **F. 19-21:** Bibliotheque des Arts Decoratifs, Paris, France/Archives Charmet; The Bridgeman Art Library International. **F. 19-22:** George Caleb Bingham (American, 1811–1879) "Fur Traders Descending the Missouri" 1845, oil on canvas, 29 × 36 1/2 in. (73.7 × 92.7 cm). The Metropolitan Museum of Art, New York, NY, U.S.A. Morris K. Jessup Fund, 1933 (33.61). Image copyright © The Metropolitan Museum of Art. Art Resource, NY. **F. 19-23:** Sir William Beechey "Portrait of a Young Girl (Little Mary)". Philadelphia Museum of Art: Gift of Mrs. John S. Williams, 1946. 1946-88-1. **P. 487 (center):** Gregg DeGuire; Getty Images—WireImage.com. **P. 488 (top right):**Photolibrary. com; **(bottom right):** Commercial Pattern Archive, University of Rhode Island Library, Special Collections.

Chapter 20
F. 20-3: Winterhalter, Franz Xaver (1805–1873). Empress Eugenie surrounded by the ladies of her court, 1855. Oil on canvas, 300 × 420 cm. Chateau, Compiegne, France. Reunion des Musees Nationaux/Art Resource, NY. **F. 20-6 (right), F. 20-19 (top right), F. 20-26 (bustle petticoat), F. 20-35 (right, inset):** www.antique-fashion.com/Karen Augusta. **P. 533 (left):** Lisa Maree Williams; Getty Images—Asia Images Group; **(center):** Courtesy Jessica McClintock, Inc.; **(top right):** Photo used courtesy of Macy's Archives; **(bottom right):** Courtesy Scott McClintock, Inc. **P. 534 (bottom right):** We would like to acknowledge and thank Phillips-Van Heusen Corporation, the owner of the VAN HEUSEN, IZOD, and ARROW trademarks.

Chapter 21
F. 21-11 (left): National Archives and Records Administration; **(right):** © CORBIS All Rights Reserved.

Chapter 22
F. 22-1 (1st row, 1st image): Courtesy, Chrysler LLL.; **(1st row, 4th image):** Used with permission of General Electric; **(2nd row, 3rd image):** Courtesy Bell & Howell, Inc.; **(2nd row, 4th image):** Used with permission from RCA Trademark Management S.A. **F. 22-3 (2nd):** Courtesy, Goodrich Corporation; **(right):** Courtesy, Talon. **F. 22-13, P. 591 (bottom right):** Photo used courtesy of Macy's Archives. **P. 593 (bottom right):** Courtesy Kayser-Roth Corporation—Makers of HUE and No Nonsense. **P. 596 (top right):** Courtesy Cartier Archives © Cartier. **P. 597 (top right):** CORBIS- NY; **(center):** Courtesy, Revlon. **P. 599 (1st row, 1st image):** Courtesy The John B. Stetson Company; **(1st row, 2nd image):** By permission of In Mocean Group, LLC.; **(2nd row, 3rd image):** Courtesy The John B. Stetson Company; **(4th row, 1st image):** Photo used courtesy of Macy's Archives. **P. 601 (top left):** Courtesy of Whiting & Davis, A Sperian Company; **(2nd row, 3rd image):** Courtesy of Whiting & Davis, A Sperian Company. **F. 22-28 (left):** Used with permission from Jockey International, Inc. **F. 22-30 (right):** By permission of In Mocean Group, LLC. **F. 22-31 (2nd row, right):** Courtesy The John B. Stetson Company; **(3rd row, center):** Courtesy Genesco Inc. **P. 614 (top right):** We would like to acknowledge and thank Phillips-Van Heusen Corporation, the owner of the VAN HEUSEN, IZOD, and ARROW trademarks; **(bottom right):** Courtesy Swank, Inc. **F. 22-33 (left):** We would like to acknowledge and thank Phillips-Van Heusen Corporation, the owner of the VAN HEUSEN, IZOD, and ARROW trademarks.

Chapter 23
F. 23-1 (left): Courtesy Navistar, Inc.; **(center):** Image copyrighted by Chevron Corporation and/or its subsidiaries and used with permission; **(right):** Courtesy 3M Corporation. **F. 23-2 (center):** Courtesy of AT&T Archives and History Center; **(right):** Courtesy Chrysler LLC. **F. 23-3:** Used with permission from RCA Trademark Management S.A. **F. 23-5 (right):** Photo used courtesy of Macy's Archives. **F. 23-7 (left):** AP Wide World Photos. **F. 23-12 (right):** © Oleg Cassini. Used by permission. **P. 635 (top right):** Photo used courtesy of Macy's Archives. **P. 636 (bottom left):** Courtesy Spiegel Brands Inc. **P. 637 (bottom right):** By permission of In Mocean Group, LLC. **P. 638 (center, right):** Courtesy Spiegel Brands Inc. **P. 639 (top right and bottom left):** Courtesy of Warnaco. **P. 640 (top row):** Photo used courtesy of Macy's Archives; **(2nd row, 2nd image):** Courtesy Spiegel Brands Inc.; **(3rd row, 3rd image):** Courtesy Brown Shoe Company, Inc. **P. 641 (1st row, 2nd image):** Courtesy of Whiting & Davis, A Sperian Company. **P. 642 (top row):** Courtesy Spiegel Brands Inc. **P. 642 (2nd row, 3rd image and 3rd row, 1st image):** Courtesy The John B. Stetson Company. **P. 642 (3rd row, 3rd image) and P. 643 (1st row, 1st image):** Revlon. **P. 643 (2nd row, 3rd image):** Courtesy Irene of New York. **P. 643 (4th row, 2nd image):** Photo used courtesy of Macy's Archives; **(4th row, 3rd image):** Courtesy The John B. Stetson Company. **P. 644 (top left):** Courtesy Spiegel Brands Inc.; **(top right):** Courtesy Georg Jensen. **P. 645 (1st row, 1st image; 2nd row, 2nd image; 3rd row, 3rd image; center):** Courtesy Spiegel Brands Inc.; **(3rd row, 1st image):** Courtesy of Whiting & Davis, A Sperian Company. **P. 646 (top right):** Coty, Inc. Used by permission. **F. 23-14:** © Bettmann/CORBIS. **F. 23-18 (top center):** Courtesy Spiegel Brands Inc.; **(bottom right):** By permission of In Mocean Group, LLC. **F. 23-19:** We would like to acknowledge and thank Phillips-Van Heusen Corporation, the owner of the VAN HEUSEN, IZOD, and ARROW trademarks. **F. 23-20:** John Kobal Foundation/Hulton Archive/Getty Image. **F. 23-23 (left):** Courtesy Spiegel Brands Inc.; **(right):** Used with permission from Jockey International, Inc. **F. 23-24 (top right):** Courtesy Perform Group LLC; **(left):** Used with permission from Jockey International, Inc.; **(right):** By permission of In Mocean Group, LLC. **F. 23-25:** Courtesy Spiegel Brands Inc. **F. 23-26 (top right; 2nd row, 1st & 2nd image):** Courtesy The John B. Stetson Company; **(3rd row, 2nd image):** Courtesy Spiegel Brands Inc.; **(3rd row, 3rd image):** Courtesy Wolverine World Wide, Inc. **P. 657 (1st row, 1st image):** Courtesy Beau Brummel Company; **(3rd row, 1st image):** Warnaco; **(3rd row, 2nd image):** Courtesy Randa Accessories. **F. 23-27 (right):** Courtesy Unilever. **F. 23-28 (center):** Courtesy Spiegel Brands Inc.; **(right):** Photo used courtesy of Macy's Archives. **F. 23-29 (top, 2nd image; right):** Courtesy Spiegel Brands Inc.; **(top, 3rd image):** Dickies®, Williamson-Dickie Manufacturing Company.

Chapter 24
F. 24-1 (left): Ad used with the permission of Polaroid Corporation; **(center):** TRADEMARKS, CAMPBELL SOUP COMPANY. ALL RIGHTS RESERVED; **(right):** Courtesy Chrysler LLL. **F. 24-4 (right):** CORBIS-NY. **F. 24-5 (top left):** 2004.36.A. UNKNOWN, UNITED STATES. The Souper Dress. Printed, non-woven, paper and cellulose fabric. 1966, Collection of Phoenix Art Museum, Gift of Stephen and Gail Rineberg. Photo by Ken Howie; **(top right):** Reg Speller; Getty Images Inc.—Hulton Archive Photos. **F. 24-6:** Larry_Ellis; Getty Images Inc.—Hulton Archive Photos. **F. 24-8:** Ron_Case; Getty Images Inc.—Hulton Archive Photos. **F. 24-9 (left):** Getty Images Inc.—Hulton Archive Photos. **F. 24-9 (center, right); F. 24-11 (bottom right); P. 681 (top right); P. 687 (bottom right):** Photo used courtesy of Macy's Archives. **F. 24-29; F. 24-30 (1st row, 4th image):** Commercial Pattern Archive, University of Rhode Island Library, Special Collections. **F. 24-11 (top left):** Courtesy Sears® Brands, LLC; **(top right):** Courtesy Spiegel Brands Inc.; **(bottom center):** Getty Images Inc.—Hulton Archive Photos. **F. 24-12:** Paul Chesley; Getty Images Inc.—Stone Allstock. **F. 24-15 (left, right):** Photo used courtesy of Macy's Archives. **P. 680 (top row):** Getty Images Inc.—Hulton Archive Photos; **(2nd row, 1st image):** AP Wide World Photos; **(2nd row, 3rd & 4th image):** Photo used courtesy of Macy's Archives. **P. 683 (top left):** Courtesy Kayser-Roth Corporation—Makers of HUE and No Nonsense; **(top right):** Courtesy Jones Apparel Group; **(center right):** Courtesy Spiegel Brands Inc.; **(bottom right):** Maidenform. **P. 684 (left. center):** By permission of In Mocean Group, LLC. **P. 685 (top left):** Courtesy Spiegel Brands Inc.; **(top right):** Courtesy Mason Companies, Inc. **P. 687 (top right):** Getty Images Inc.—Hulton Archive Photos; **(bottom center):** Jack Robinson; Getty Images Inc.—Hulton Archive Photos. **P. 689 (1st row, 1st image):** Getty Images Inc.—Hulton Archive Photos; **(1st row, 2nd image):** Photo courtesy of the National Cotton Council of America; **(1st row, 3rd & 4th image):** Copyright Trevira; **(3rd row, 1st image):** Photo used courtesy of Macy's Archives. **P. 690 (bottom right):** Courtesy Hanes Brands Inc. **F. 24-17 (left, right):** Getty Images Inc.—Hulton Archive Photos. **F. 24-18:** Getty Images Inc.—Hulton Archive Photos. **F. 24-20 (right):** ENKA®, Used by permission. **F. 24-22:** We would like to acknowledge and thank Phillips-Van Heusen Corporation, the owner of the VAN HEUSEN, IZOD, and ARROW trademarks. **F. 24-23:** Dickies®, Williamson-Dickie Manufacturing Company. **F. 24-25:** Archive photo provided by Gant. Used by permission. **F. 24-30**

(2nd row, 1st image): Courtesy Earth, Inc., Waltham, MA-www.EARTH.US.; (2nd row, 2nd image): © Dorling Kindersley; (2nd row, 3rd image): Courtesy The John B. Stetson Company; (3rd row, 3rd image): A Product of the Bulova Corporation. Used by permission. F. 24-31 (top left): Steve_Wood; Getty Images Inc.—Hulton Archive Photos; (top right): Robin Platzer; Getty Images/Time Life Pictures. F. 24-33 (left); F. 24-34 (1st, 2nd, 3rd image): Courtesy Spiegel Brands Inc.

Chapter 25

F. 25-2 : Dimitrios Kambouris/WireImage; Getty Images Inc. F. 25-3: Phil Noble/Pool/Reuters Media News, Inc.; CORBIS-NY. F. 25-4: Bustier, 1980–81 (fiberglass resin & felt) by Miyake, Issey (b.1938). National Gallery of Victoria, Melbourne, Australia. The Bridgeman Art Library. F. 25-10: The Museum at FIT. F. 25-14 (left): Jean-Pierre Muller/Agence France Presse/Getty Images; (right): Pierre Verdy; Getty Images Inc. F. 25-15: The Museum at FIT. F. 25-16: Pierre Verdy; Getty Images Inc. F. 25-18: Andrea Bucci; Getty Images/Time Life Pictures. F. 25-19: DMI; Getty Images/Time Life Pictures. F. 25-20: Petre Buzoianu/Avantis; Getty Images/Time Life Pictures. F. 25-21: Lawrence Lucier/Stringer; Getty Images Inc. F. 25-22 (left): Eric Ryan; Getty Images Inc.; (center): Jean-Pierre Muller; Getty Images Inc.; (right): Jean-Pierre Muller/Agence France Presse/Getty Images. P. 728 (bottom center): Photo used courtesy of Macy's Archives. P. 729 (bottom, top left): Maidenform; (bottom right): Omar Torres/Agence France Presse/Getty Images. P. 730 (top right): George Rose; Getty Images Inc.; (bottom center): Mark Mainz; Getty Images Inc.; (bottom right): Lluis Gene; Getty Images, Inc.—Agence France Presse. P. 731 (top right): Faberge; (bottom left): Courtesy of Pepsi-Cola North America; (bottom right): Philip Gatward © Dorling Kindersley. P. 732 (1st row, 1st image): Pierre Cardin; (2nd row, 3rd image): V.C.L.; Getty Images, Inc. – Taxi; (2nd row, 4th image): EyeWire Collection; Getty Images—Photodisc-Royalty Free. P. 733 (left): Courtesy Warren Edwards Shoes; (top left): Courtesy Grendha Shoes Corp.; (bottom center): Urbano Delvalle; Getty Images Inc. P. 734 (2nd row, 1st image): Courtesy, Dinny Hall, www.dinnyhall.com; (2nd row, 2nd image): James Keyser; Getty Images/Time Life Pictures. P. 735 (top center): Salvatore Ferragamo SPA. P. 736 (top right): Henning Christoph/DAS FOTOARCHIV; Peter Arnold, Inc.; (bottom right): Marc Dolphin; Getty Images Inc.—Stone Allstock. F. 25-23 (top right): EyeWire Collection; Getty Images—Photodisc-Royalty Free. F. 25-23 (bottom right): Karl Prouse/Catwalking; Getty Images Inc. F. 25-24 (center): Reprinted with permission from Brawn, LLC. All rights reserved. (right): Photo used courtesy of Macy's Archives. F. 25-27: Karl Prouse/Catwalking; Getty Images Inc. F. 25-29: Bryan Bedder; Getty Images Inc. F. 25-30 (right): Photo used courtesy of Macy's Archives. F. 25-34: AP Wide World Photos. P. 745 (top left): Courtesy Eminence; (bottom left): Kristin Scholtz/ASP/Covered Images; Getty Images Inc.; (right): Photo used courtesy of Macy's Archives. F. 25-38 (left): Terry O'Neill/Hulton Archive/Getty Images; (right): Gordon, Larry Dale; Getty Images Inc.—Image Bank. F. 25-40 (left): Photo used courtesy of Macy's Archives.

Chapter 26

P. 753: General Motors Corporation. Used with permission, GM Media Archives. P. 756 (1st image): Andrea Blanch; Getty Images; (2nd image): Lipnitzki; Getty—Roger Viollet Collection; b: Ron Galella; Getty Images—WireImage.com; (4th image): Getty Images Inc.—Hulton Archive Photos. P. 758 (1st image): © Oleg Cassini. Used by permission; (2nd image): Getty Images Inc.—Hulton Archive Photos; (3rd image): Photo: Roger Schall © Collection Schall; (4th image): Reg_Lancaster; Getty Images Inc.—Hulton Archive Photos. P. 760 (1st image): CORBIS-NY; (2nd & 3rd image): Getty Images Inc.—Hulton Archive Photos; (4th image): Christian Dior. P. 762 (1st image): Eric Ryan; Getty Images Inc.; (2nd image): Cary Wolinsky; Aurora Photos, Inc.; (3rd image): Bernard Gotfryd; Getty Images; (4th image): The Donna Karan Company LLC. P. 764 (1st image): Abbas/Magnum; Magnum Photos, Inc.; (2nd image): Mike Segar; Getty Images Inc.—

Hulton Archive Photos; (3rd image): Dave M. Benett; Getty Images Inc. P. 768 (1st image): Steve Eichner; Getty Images—WireImage.com; (2nd image): Lipnitzki/Roger Viollet; Getty—Roger Viollet Collection; (3rd image): Getty Images Inc.—Hulton Archive Photos. P. 770 (1st, 2nd, 3rd image): Getty Images Inc.—Hulton Archive Photos. P. 772 (2nd image): Carlos Alvarez; Getty Images Inc.; (3rd image): Dave Cheskin; AP Wide World Photos; (4th image): Getty Images Inc.—Hulton Archive Photos.

Color Plates

CP 1: [The Art Archive / Musee du Louvre Paris / Dagli Orti]. CP 2: Portrait of a young girl (fresco) by Roman (1st century AD). Museo e Gallerie Nazionali di-Capodimonte/Lauros/Giraudon/The Bridgeman Art Library. CP 3: "Theodora and Attendants". The Court of Theodora. Mosaic. San Vitale, Ravenna, Italy. Scala/Art Resource, NY. CP 4: Attributed to: Emperor Huizong, Chinese, 1082–1135. "Court ladies preparing newly woven silk (detail)." Chinese, Northern Song dynasty, early 12th century. Ink, color, and gold on silk, 37×145.3 cm (14 9/16 × 57 3/16 in.). Special Chinese and Japanese Fund, 12.886. Photograph © 2010 Museum of Fine Arts, Boston. CP 5: Private Collection/Boltin Picture Library; The Bridgeman Art Library International. CP 6: Giovanna Tornabuoni, nee Albizzi, 1488, detail (oil on panel) by Domenico Ghirlandaio (Domenico Bigordi) (1449–94). Thyssen-Bornemisza Collection, Madrid, Spain / The Bridgeman Art Library. CP 7: Victoria and Albert Museum, London, Great Britain; Art Resource, N.Y. CP 8: Queen Henrietta Maria and her dwarf Sir Jeffrey Hudson, c.1633 by Sir Anthony van Dyck (1599–1641). Private Collection/The Bridgeman Art Library. CP 9: Declaration of Love, 1731 (oil on canvas) by Jean Francois de Troy (1679–1752). Schloss Charlottenburg, Berlin, Germany / The Bridgeman Art Library. CP 10: Madame de Pompadour, 1759 (oil on canvas) by Francois Boucher (1703–70). ©Wallace Collection, London, UK / The Bridgeman Art Library. CP 11: Madame de Senonnes, 1814–16 (oil on canvas) by Jean Auguste Dominique Ingres (1780–1867). Musee des Beaux-Arts, Nantes, France/ Giraudon / The Bridgeman Art Library. CP 15: Ferrymen Playing Cards, 1847 (oil on canvas) by George Caleb Bingham (1811–79)/St. Louis Art Museum, Missouri, USA/The Bridgeman Art Library. CP 27: Crown Zippers. CP 29: Courtesy Spiegel Brands Inc. CP 35: ENKA®, Used by permission. CP 36: Photo used courtesy of Macy's Archives. CP 42: Courtesy The John B. Stetson Company. CP 44, 60: We would like to acknowledge and thank Phillips-Van Heusen Corporation, the owner of the VAN HEUSEN, IZOD, and ARROW trademarks. CP 47, 50, 71: Celanese. CP 51, 58: ENKA®, Used by permission. CP 54: Courtesy of The American Sheep Industry Association, Inc. All rights reserved. CP 57: By permission of In Mocean Group, LLC. CP 63, 73: Bill Ray/Life Magazine; Getty Images Inc. CP 65: Image courtesy Knoll, Inc. CP 66, 68: Photo Courtesy of the National Cotton Council of America. CP 69: Collection of Phoenix Art Museum, Gift of Mort and Marilyn Bloom 2005.106 and 2005.99. CP 70, 72, 77, 78, 81, 83: Commercial Pattern Archive, University of Rhode Island Library, Special Collections. CP 76: John Dominis; Getty Images/Time Life Pictures. CP 80: Courtesy Bobbie Brooks, Incorporated. CP 82: H. Armstrong Roberts/Retrofile; Getty Images Inc. CP 90: Bill Ballenberg; Getty Images/Time Life Pictures. CP 91: Courtesy Vivienne Poy, 1985. CP 99: Courtesy Visage as an English design company. CP 101 and 109: AP/Wide World Photos. CP 102: Richard Drew; AP Wide World Photos. CP 103: Kathy Willens; AP Wide World Photos. CP 104: Noel Quidu; ZUMA Press—Gamma. CP 105: Linda Allard. CP 106: Dan Lecca; Bill Blass Ltd. CP 107: Jeff Moore; The Image Works. CP 108: Nancy Kaszerman; Shooting Star International Photo Agency. CP 110: Getty Images Inc.—Hulton Archive Photos. CP 112, 113, 114: Chris Moore/Catwalking; Getty Images Inc. CP 115: Sam Ogden; Photo Researchers, Inc. CP 116 (top left): Karl Prouse/Catwalking; Getty Images Inc.; (top right): Kiyoshi Ota; Getty Images Inc.; (bottom left): Dave M. Benett; Getty Images Inc.; (bottom right): Francois Guillot/Agence France Presse/Getty Images.

INDEX